DICTIONARY OF
AMERICAN
SCULPTORS

"18th Century to the Present"

DICTIONARY OF
AMERICAN
SCULPTORS

"18th Century to the Present"

Illustrated with over 200 photographs.

Edited by Glenn B. Opitz

Published By
APOLLO

Poughkeepsie, NY
1984

Thanks to –

everyone involved with this significant project,
especially the staff: Cindy Spano, Patty Carey,
Shari Hubner, Christopher Melley, Luane
Remsburger, Linda Campbell, and Chris Lettieri.
Special thanks to Edwin A. Ulrich for his continued
support and encouragement.

Dedicated to –

my children, Adam and Nancy, and all my friends
who have stuck by me through the "trials and
tribulations" of this undertaking--thanks.

Copyright 1984 by Apollo Book
ISBN 0-938290-03-7

Printed in the United States of America

Apollo Book
391 South Road Poughkeepsie, N.Y. 12601
800-431-5003 N.Y.S. ONLY 800-942-8222
914-452-0660

FOREWORD

For museum curators, art dealers, and collectors, one of the first tasks in examining an art object is to establish the identity of its author. The principal tool to aid in that task is the use of a biographical dictionary.

The *Dictionary of American Sculptors*, as a compendium of basic information on these artists, fills a considerable gap. For someone without access to Charles Caffin's *American Masters of Sculpture* (1903), or Lorado Taft's *The History of American Sculpture* (1924), basic data on nineteenth century American sculptors is extremely difficult to obtain. Comparably, the basic modern text on the subject, Wayne Craven's *Sculpture in America*, is already out of print.

Mr. Opitz has succeeded in bringing together a variety of information sources, and this volume is especially valuable in its wide inclusion of 20th century figures. Used in conjunction with Janis Ekdahl's excellent bibliography, *American Sculpture: A Guide to Information Sources*, the *Dictionary of American Sculptors* should offer a good starting point for art historical investigations of the subject. Additionally, the simple and direct application of computer technology here promises to be of use in further related publications.

High Museum of Art
Atlanta
May 1984

Peter Morrin
Curator of
20th Century Art

PREFACE

Publication of the *Dictionary of American Sculptors* continues the project which began with our revised and updated edition of Mantle Fielding's classic *Dictionary of American Painters, Sculptors and Engravers*. While both dictionaries include artists working in sculpture, painting, and other media, the new dictionary contains only those who worked or are working in sculpture either exclusively or at some time in their careers.

The names of over 5,000 American sculptors have been assembled in this one volume, with biographical information drawn from an extensive library of source material which includes both readily available and many out of print references. The reader will find comprehensive biographies of artists who have exhibited at fine arts museums and galleries all over the world, as well as artists who specialize in specific styles or regions, such as those of the American West.

Among its many entries, the *Dictionary of American Sculptors* includes the biographies of a large number of living and recently deceased artists. Resumes submitted in response to our solicitation for information about contemporary sculptors constitute a significant contribution. Selection criteria included the presence of the artist's work in exhibitions or collections in major cultural centers of the US. Artists of strictly local significance have generally been omitted.

The *American Art Annuals* from 1898 through 1933 constitute another source of information. All entries from the *Annuals*, which were largely written by the artists themselves and which contain information about their professionalism, are reproduced here in their entirety. Only those entries with just an address were omitted.

Over two hundred full-page, glossy black and white photographs appear in the last section of the book. These represent the work of a variety of the sculptors listed in the dictionary. For making these photographs available, I am indebted to the National Sculpture Society, New York City; Sally Mills, Curator of the Vassar College Art Gallery, Poughkeepsie, New York; Bob Bahssin of the Post Road Gallery, Larchmont, New York; Victor D. Spark in New York City; as well as the artists who submitted photographs with their resumes.

As in all such work, it is impossible to include every significant name. There will be unfortunate omissions until an addendum or update is prepared. Despite such inevitable oversights, this single volume offers an impressive scope of American sculptors. I welcome additional accurate biographical information about these and other American sculptors. Additions and corrections will then be made in a later volume or supplement.

For their generous assistance, sincere appreciation is extended to Theodora Morgan, Managing Editor of the *National Sculpture Review* at the National Sculpture Society; and Claire A. Stein, Executive Director of the National Sculpture Society, New York City. As always, I am grateful for the dedication and patience of the writers, proofreaders, editors, and word processor operators who have worked with me on this volume.

Glenn B. Opitz
Editor,
Publisher

List of

Illustrations

ILLUSTRATIONS

List of

Abbreviations

ABBREVIATIONS

AA - Art Association (preceded by place name)
AAA - Allied Artists of America; American Art Association, when
 preceded by Paris
AAS - American Art Society
A. Bookplate S. - American Bookplate Society
AC - Art Club (preceded by place name)
Acad. - Academy, Academie
ACC - Arts and Crafts Club (preceded by place name)
ACD - Art Center College of Design
A. Ceramic S. - American Ceramic Society
ADC - Art Directors' Club
AEF - American Expeditionary Force
AFA - American Federation of Arts; Academy of Fine Arts, when
 preceded by place name
AFAS - American Fine Arts Society, New York
A. Fellowship - Artists' Fellowship, Inc. (formerly A. Aid S.)
A. Fund S. - Artists' Fund Society, New York
AG - Artists Guild (preceded by place name)
AI - Art Institute (preceded by place name)
AIA - American Institute of Architects
AIC - Art Institute of Chicago
AI Graphic A. (AIGA) - American Institute of Graphic Arts
AL - Artists' League, Art League (preceded by place name)
Alliance - Art Alliance of America
Allied AA (All. A.) - Allied Artists of America
Am., Amer. - American
Am. Acad. A.L. - American Academy of Arts and Letters
Am. APL - American Artists Professional League
Am. Soc. PS and G. - American Society of Painters, Sculptors
 and Gravers
ANA - Associate of the National Academy of Design, New York
Ann., - annual
AP - Associated Press
arch., archit. - architect, architecture, architectural
Artists G. - see GFLA
AS - Art Society (preceded by place name)
ASL of NY (ASL NY, NY ASL) - Art Students' League of New York
A.S. Min P. - American Society of Miniature Painters, New York
Asn., Assn., Asso., Assoc. - Association, Associate
ATA - Art Teachers' Association
AUDAC - American Union of Decorative Artists and Craftsmen.
auth. - author
AV - Audiovisual
Ave. - Avenue

AWCS - American Water Color Society, New York
AWCW - Art Workers' Club for Women, New York
A. Women's A.A. of Paris - Paris American Women's Art
 Association
AWS - American Watercolor Society
Bd. - Board
Bibliog. - Bibliography
bldg. - building
Boston GA - Guild of Boston Artists
Boston SA - Boston Society of Architects (Chapter AIA)
Boston SAC - Boston Society of Arts and Crafts
Boston SWCP - Boston Society of Water Color Painters
BPC - Brush and Palette Club (preceded by place name)
Brit. - Britain, British
Brooklyn S. Min. P. - Brooklyn Society of Miniature Painters
Brooklyn S. Modern A. - Brooklyn Society of Modern Artists
Buffalo SA - Buffalo Society of Artists
Calif. AC - California Art Club
Calif. PM - Print Makers' Society of California
Calif. PS - California Painters and Sculptors
Calif. SE - Calif. Society of Etchers
Calif. WCS - California Water Color Society
Can., CN - Canada, Canadian
CCAD - Columbus College of Art and Design
CCNY - City College of New York
Cent. - Center
Century Assoc. - Century Association of New York
Char. C. - Charcoal Club, Baltimore
Chicago AD - Chicago Academy of Design
Chicago AFA - Chicago Academy of Fine Arts
Chicago Gal. A. - Chicago Galleries Association
Chicago NJSA - Chicago No-Jury Society of Artists
Chicago PS - Painters and Sculptors of Chicago
Chicago SAC - Chicago Society of Arts and Crafts
Chicago SE - Chicago Society of Etchers
Chicago S. Min. P. - Chicago Society of Miniature Painters
CI - Carnegie Institute, Pittsburgh, PA
Cleveland Arch. C. - Cleveland Architectural Club
C.L.W. Art C. - Catherine Lorillard Wolfe Art Club
Co. - Company, County
C. of C. - Chamber of Commerce
Col., Coll. - College, Collegiate, Collection(s)
Columbus PPC - Columbus Pen and Pencil Club
comn. - commission(s)
comp. - competition
Cong. - Congress
Conglist. - Congregationalist
Conn. AFA - Connecticut Academy of Fine Arts, Hartford
contemp. - contemporary
Contemporary - Contemporary Group
Copley S. - Copley Society of Boston
corp. - corporate, corporation(s)
coun. - council
Ct. - Court

Ctr. - Center
CU - Cooper Union
Czech. - Czechoslovakia
Detroit S. Women P. - Detroit Society of Women Painters
Dir. - Director
Dr. - Drive
EAA - Eastern Arts Association
East. - Eastern
Eng. - England, English (also engineer, engineering)
Eur., Europ. - Europe, European
Exh., Exhib. - Exhibit(s), Exhibition(s)
Exp., Expo. - Exposition(s)
F. - Fellow
FA - Fine Arts
FAS - Famous Artists School
Fellowship PAFA - Fellowship of the Pennsylvania Academy of the
 Fine Arts
Fed., Fedn. - Federation
Fel. - Fellow, Fellowship
FIT - Fashion Institute of Technology
Found. - Foundation
FR, Fr. - France, French
GA - Guild of Artists (preceded by place name)
GAG - Graphic Artists Guild
Gal. - Gallery(ies)
GB - Great Britain
GCSA - Grand Central School of Art
Gen., Gen'l. - General
Ger. - Germany, German
GFLA - Artists Guild of the Authors' League of America, New York
Grand Cent. AG - Grand Central Art Galleries
Hartford ACC - Hartford Arts and Crafts Club
hist. - history
hon. - honorable, honorary
Hoosier Salon - Hoosier Salon, Chicago
H.S. - High School
I., Illus., Illustr. - Illustration, Illustrator
incl. - including
Indust. - Industry(ies), Industrial
Inst. - Institute, Institution
Int., Inter., Int'l. - International
Inter. Soc. A.L. - International Society of Arts and Letters (also
 given as Soc. Inter. des Beaux Arts et des
 Lettres)
Inter. Soc. SPG - International Society of Sculptors, Painters and
 Gravers
KCAI - Kansas City Art Institute
LC - Library of Congress
lect. - lecturer, lecture(s)
Lib., Libr. - Library
lit. - literary, literature
lith., litho. - lithograph, lithographer
MA - Museum of Art

MacD. C. - MacDowell Club, New York
mem. - member, membership(s)
men. - mention
Mex. - Mexico
Min. PS and G Soc. - Miniature Painters, Sculptors and Gravers
 Society
Minneapolis AL - Minneapolis Artists' League
MMA (Met. Mus. Art) - Metropolitan Museum of Art, New York
mod. - modern
Modern AA - Modern Artists of America, New York
MOMA - Museum of Modern Art, New York
munic. - municipal
Municipal AS - Municipal Art Society (preceded by place name)
Mural P. - National Society of Mural Painters, New York
Mus. - Museum(s), Musee, Museo
Mystic SA - Society of Mystic (Conn.) Artists
NA - Academician of the National Academy of Design, New York
NAC - National Arts Club, New York
NAD - National Academy of Design, New York (used chiefly for
 school)
Nat., Nat'l. - National (also Natural)
Nat. AAI - National Alliance Art and Industry
Nat. Gal. - National Gallery, Washington, D.C.
Nat. Inst. A.L. - National Institute of Arts and Letters
NA Women PS - National Association of Women Painters and
 Sculptors, New York
New Eng. - New England
New Haven BPC - New Haven Brush and Palette Club
New Haven PCC - New Haven Paint and Clay Club
New Soc. A. - New Society of Artists, New York
NJSA - No-Jury Society of Artists (preceded by place name)
NL Am. Pen Women - National League of American Pen Women
N.O. - New Orleans
NOAA - Art Association of New Orleans
NO ACC - New Orleans Arts and Crafts Club
North. - Northern
North Shore AA - North Shore Arts Association, Gloucester, Mass.
NSS - National Sculpture Society, New York
NY Arch. Lg. - Architectural League of New York
NYPL - New York Public Library
NYSC - New York Society of Craftsmen
NYSWA - New York Society of Women Artists
NYU - New York University
NYWCC - New York Water Color Club
Ohio WCS - Ohio Water Color Society, Columbus
PAFA - Pennsylvania Academy of the Fine Arts, Philadelphia
Paris AAA - American Art Association of Paris
Paris Groupe PSA - Groupe des Peintres et Sculpteurs Americains de
 Paris
Paris Women's AAA - Paris American Women's Art Association
Paris SAP - Paris Society of American Painters
Pa. S. Min. P. - Pennsylvania Society of Miniature Painters
Pastelists - Society of Pastelists, New York
PBC - Pen and Brush Club of New York

PCC - Paint and Clay Club (preceded by place name)
Phila. ACG - Arts and Crafts Guild of Philadelphia
Phila. Alliance - Art Alliance of Philadelphia
Phila. Sketch C. - Philadelphia Sketch Club
Phila. Soc. AL - Philadelphia Society of Arts and Letters
Photo. Sec. - Photo-Secession, New York
PI - Pratt Institute, Brooklyn, New York
Pittsburgh AA - Associated Artists of Pittsburgh
Pittsburgh AS - Pittsburgh Art Society
Plastic C. - Plastic Club of Philadelphia
PM - Print Maker's Society (preceded by place name)
PM of Am. - Print Makers of America
port. - portrait(s)
Port. P. - National Association of Portrait Painters, New York
P.-P. - Panama-Pacific
PPC - Pen and Pencil Club (preceded by place name)
PR - Puerto Rico
pres. - present, president
prof. - professor, profession, professional
Providence HC - Providence Handicraft Club
PS - Painters and Sculptors (preceded by place name)
PSD - Parsons School of Design
PS Gallery Assoc. - Painters' and Sculptors' Gallery Association,
 New York
ptg., ptgs. - painting(s)
ptr. - painter
publ. - published, publisher, publication(s)
RISD - Rhode Island School of Design
Rd. - Road
RD - Rural Delivery
rep. - represented, representative
Rome Acad. Alumni - Alumni Association American Academy in Rome
RSA - Royal Scottish Academician
SA - Society of Artists (preceded by place name)
SAA - Society of American Artists, New York
SAC - Society of Arts and Crafts (preceded by place name)
Salma. C. - Salmagundi Club, New York
Scarab C. - Scarab Club, Detroit, Michigan
Sch. - School(s)
sci. - science
SE - Society of Etchers (preceded by place name)
SFA - Society of Fine Arts (preceded by place name)
SI (S of I) - Society of Illustrators
S. Indp. A. - Society of Independent Artists
S. Min. P. - Society of Miniature Painters (preceded by place
 name)
SMPF West - Society of Men who Paint the Far West
Soc. - Society
Soc. Am. E. - Society of American Etchers
Soc. of Med. - Society of Medalists
SPNY - Society of Painters, New York
SSAL - Southern States Art League
St. - Street, Saint

St. Louis AG - St. Louis Artists' Guild
SVA - Society of Visual Arts
SWCP - Society of Water Color Painters (preceded by place
 name)
Switz. - Switzerland
S. Women P. - Society of Women Painters (preceded by place name)
2x4 Soc. - Two by Four Society, St. Louis
tech., techn. - technology, technical, technique
Ten Am. P. - Ten American Painters
Ten Phil. P. - Ten Philadelphia Painters
TID - The Institute of Design
UCLA - University of California at Los Angeles
Univ. - University(ies)
US - United States
USA - United States Army
USAF - United States Air Force
USMC - United States Marine Corps
USN - United States Navy
USPO - United States Post Office
Vet. - Veteran(s)
var. - various
WCC - Water Color Club (preceded by place name)
WCS - Water Color Society (preceded by place name)
West. - Western
Wilmington SFA - Wilmington Society of Fine Arts
Wis. PS - Wisconsin Painters and Sculptors
Woman's AC - Woman's Art Club (preceded by place name)
WW I - World War I
WW II - World War II
Yugos., Yugosl. - Yugoslavia

CITY AND STATE ABBREVIATIONS

AK - Alaska
AL, Ala. - Alabama
AR, Ark. - Arkansas
AZ, Ariz. - Arizona
CA, Calif. - California
Chic. - Chicago
CO, Colo. - Colorado
CT, Conn., Ct. - Connecticut
CZ - Canal Zone
DC - District of Columbia
DE, Del. - Delaware
FL, Fla. - Florida
GA, Ga. - Georgia
HI - Hawaii
IA, Ia. - Iowa
ID, Id. - Idaho
IL, Ill. - Illinois
IN, Ind. - Indiana
 (Ind. - also Indianapolis)
KS, Kans. - Kansas
KY, Ky. - Kentucky
LA, La. - Louisiana
L.A. - Los Angeles (also LA)
MA, Mass. - Massachusetts
MD, Md. - Maryland
ME, Me. - Maine
MI, Mich. - Michigan
MN, Minn. - Minnesota
MO, Mo. - Missouri
MS, Miss. - Mississippi
MT, Mont. - Montana
NC, N.C. - North Carolina
ND, N.D., N. Dak. - North Dakota
NE, Neb., Nebr. - Nebraska
NH, N.H. - New Hampshire
NJ, N.J. - New Jersey
NM, N.M., N. Mex. - New Mexico
NO, N.O. - New Orleans
NV, Nev. - Nevada
NY, N.Y. - New York
NYC - New York City
NYS - New York State
OH, Oh. - Ohio
OK, Okla. - Oklahoma
OR, Ore. - Oregon
PA, Pa., Penn., Penna. - Pennsylvania

Phila. - Philadelphia
RI, R.I. - Rhode Island
SC, S.C. - South Carolina
SD, S.D. - South Dakota
S.F., S. Fran., San Fran., San F. - San Francisco
TN, Tenn. - Tennessee
TX, Tex. - Texas
UT, Ut. - Utah
VA, Va. - Virginia
VT, Vt. - Vermont
WA, Wash. - Washington
WI, Wis., Wisc. - Wisconsin
WV, W.V., W. Va. - West Virginia
WY, Wyo. - Wyoming

A

AARONS, GEORGE.
Sculptor. Born in Lithuania, April 6, 1896; US citizen. Pupil of Museum of Fine Art School, Boston; Beaux-Arts Institute of Design, NYC. In collections of Art Museum, Ein Harod, Israel; Fitchburg (MA) Art Museum; Museum de St. Denis, France; others. Exhibitions: Philadelphia Museum; Institute of Contemporary Art, Boston; Whitney; MIT. Member of National Sculpture Society. Living in Gloucester, MA, in 1976. Died in 1980.

ABADI, FRITZIE.
(Mrs. Al Hidary). Sculptor and painter. Born in Aleppo, Syria, in 1915. Studied at Art Students League, under Nahum Tschacbasov, in NY. Exhibited: Whitney Museum of American Art, NY; Annual Print Invitational, Library of Congress, Washington, DC. Awards: Acrylic Painting Award; National Association of Women Artists, 1974; and the American Society of Contemporary Artists, 1978. Member: National Association of Women Artists; American Society of Contemporary Artists; NY Society of Women Artists. Represented by Phoenix Gallery, NYC. Address in 1982, 201 West Phoenix Gallery, 30 West 70th St., NYC.

ABANAVAS, CONSTANTINE E.
Sculptor and painter. Born in Newark, NJ. Spent formative years in Greece. One-man shows: Several in NYC; University of Pittsburgh; Ohio State University; Oberlin College; Museum of Albany, NY; Athens Museum, Athens, GA; Manhattanville College. Group exhibitions: Thoughout US, Austria, Germany, and England.

ABBATE, PAOLO S.
Sculptor and lithographer. Born in Villarosa, Italy, April 9, 1884. Educated in Italy and in the US. Member of International Fine Arts Society. Exhibited at National Sculpture Society, NY. Works: Dante monument, Newburgh, NY; "Fiat Voluntas Tua," Brown University, Providence, RI; "People without Vision Perish," terracotta, Evangelical Church, Cliffside Park, NJ. Busts: Professor L. Carnovale, Stilo, Italy; H. Husserl, Dr. Husserl College, Newark, NJ; Enrico Caruso, NYC; Dante monument, RI; Ruvolo memorial, Torrington, CT; David monument to Joyce Kilmer, France. Address in 1934, 1931 Broadway, New York City. Died in 1972.

ABBE, ELFRIEDE MARTHA.
Sculptor, engraver and illustrator. Born in Washington, DC, in 1919. Studied: Cornell University and Syracuse University. Awards: Cornell University, 1938, 1940; Tiffany Foundation Fellowship, 1948; gold medal, National Arts Club, 1970, and Academy of Artists Association, Springfield, MA, 1976; E. Liskin Cash Award, Salmagundi Club, 1979. Work: World's Fair, New York, 1939; Memorial panels, Ellis Room, Wiegand Herbarium, 1953 and Mann Library, 1955, Cornell University; Cincinnati Art Museum; and Boston Museum of Fine Arts. Exhibited: San Diego Fine Arts Gallery 1960; Carnegie-Mellon University, 1968; National Academy of Design; National Arts Club, NY, 1969 and 70. Commissions: Bronze sculptures, Clive McCay memorial, 1967; Napoleon (bronze head), McGill University Library; The Hunter (large statue), NY World's Fair, 1939. Member: National Sculpture Society (fellow); National Arts Club. Medium: Wood. Address in 1982, Manchester Center, VT.

ABBETT, ROBERT K.
Sculptor and painter. Born in Hammond, IN, January 5, 1926. Studied: BA, University of Missouri and Chicago Academy of Fine Arts. Works: Over twenty editions of limited prints, two editions of bronze, "Outdoor Paintings of Robert K. Abbett," Bantam Books; "Fall Colors of Robert K. Abbett," KTVY, Oklahoma City. Exhibited: Group and Gallery shows since 1970. Member: Society of Animal Artists; Who's Who in the East; Who's Who in Art; Society of Illustrators. Collections: Cowboy Hall of Fame, Oklahoma City; Parker Collection, Tulsa; Jernigan Collection, Oklahoma City; Dangerfield Collection, Ardmore, Oklahoma. Media: Paintings, oil; Sculpture, wax. Address in 1983, Bridgewater, CT.

ABBOTT, BERENICE.
Sculptor and photographer. Born in Ohio, 1898. Studied: Berlin and Paris with Bourdelle and Brancusi. She began her career as a sculptor, but is best known as a photographer. Was photographic assistant to Man Ray, 1923. Had own studio in Paris. From 1923 to 1925 photographed expatriates and celebrities in Paris. Returned to NY in 1929 to photograph the City. Worked in experimental photography from 1940. Collections: Museum of the City of NY. Taught: New School of Social Research, 1938, for more than twenty years.

ABBOTT, W. H.
Sculptor. Address in 1926, 46 Greenwich Ave., NY.

ABDELL, DOUGLAS.
Sculptor. Born in Boston, MA, March 16, 1947. Studied at Syracuse University, BFA (sculpture), 1970. Work in Corcoran Gallery of Art, Washington, DC; Edwin Ulrich Museum of Art, Wichita State University, Kansas. Has exhibited at Andrew Crispo Gallery, New York, 1975, 1978 and 1979-82; Dartmouth College, NH, 1980; and others. Received awards: National Institute of Arts and Letters; Silvermine Award; and others. Works in cast or welded bronze, and oil. Address in 1982, 458 Broadway, NYC.

ABEL, JEAN (CHRISTINE JEANNETTE).
Sculptor, painter, and educator. Born Maxwell, CA, in 1890. Studied: California Schools of Fine Arts, 1915; graduate art studies California School of Arts and Crafts, Oakland, University of California at Berkeley, University of California at Los Angeles, University of Southern California, Columbia; Chouinard Art Center; worked with Armin Hansen Monterey, Xavier Martinez, and Ramos Martinez. Exhibit in retrospect at Glendale College Library, 1950, Santa Barbara Artists Work Shop, 1959; one-man show, Los Angeles Museum of History, Science, and Art, 1928; produced 11 original ballets for Glendale High School shown at Greek Theatre, Los Angeles, Pasadena Community Play House, Occidental Bowl, Redlands Bowl, Los Angeles Allied Arts. Awards: California School of Fine Arts, San Francisco, 1915; water color prize, Palace of Fine Arts, San Francisco, 1924; Glendale Art Association, 1951. Member: Santa Barbara Art Association, Santa Barbara Museum of Natural History, Santa Barbara Historical Society, Music Academy of West, Glendale Art Association, Art Teachers Association of Southern California (president 1928-29, treasurer 1930-31), Pacific Arts Association (council member 1939-40), The Fine Arts Foundation (president 1943-44), Santa Barbara Botanical Gardens, Council of Arts, Santa Barbara Delta Epsilon. Taught: Glendale (CA) High School, 1921-38; art instructor Glendale College, 1938-43, 46-56; Toll Jr. High, Glendale, 1943-45. Address in 1962, Santa Barbara, CA.

ABEL, LOUISE.
Sculptor. Born in Wurttemberg, Germany, Sept. 7, 1894. Studied: Cincinnati Art Academy; Art Students League; Kunstgewerbe Schule, Stuttgart. Work: Cincinnati Museum Association; Trail Side Museum, Cincinnati; Employees Country Club, Endicott, NY. Exhibited: Cincinnati Museum, 1925, 45; Penna. Academy of Fine Arts, 1925, 45; Art Institute of Chicago, 1926, 40; National Ceramic Exhibition, 1937, 41; Andrews Gallery, 1942; others. Position: Sculptor, designer, Rockwood Pottery, 1921-32. Address in 1953, Cincinnati, OH.

ABELL, MARGARET NOEL.
Sculptor, cartoonist, and craftsman. Born in New York City, December 3, 1908. Studied: Art Students League, with Alexander Archipenko; Breckenridge School, Gloucester, Mass. Member: National Association of Women Artists, New York; American Artists Professional League. Exhibited: Provincetown Art Association; National Association of Women Artists. Address in 1953, Georgetown, Conn.

ABEND, ARLENE.
Sculptor. Studied: Cooper Union, New York City; Syracuse University, New York. Awards: New York State Fair; Syracuse Ceramic Guild; New York State Exposition. Exhibitions: Rochester Memorial Museum, New York; Corning Museum, New York; Associate Artists Gallery.

ABISH, CECILE.
Sculptor and teacher. Born in NYC. Studied Brooklyn College, BFA. Exhibited: Detroit Institute of Art, Fairleigh Dickinson University, Aldrich Museum of Contemporary Art, and Newark Museum; Hamburg Kunsthaus, Germany; Museum of Modern Art, NY; Natur-Skulptur, Kunstgebaude, Stuttgart, Germany. Commissions: Boxed Monuments—3, Multiples, Inc., 1969; Renaissance Fix, Independent Curators, Inc., 1979; Field quartering, Lakeview Center for the Arts, Peoria, IL; Atlanta Arts Festival, Piedmont Park, GA, 1980. Received National Endowment for Arts Fellowship, 1975 and 77. Taught as an instructor of art, Queens College, NY; University of Mass., Amherst, MA; Cooper Union, New York; and Harvard University. Address in 1982, P.O. Box 485 Cooper Station, NYC.

ABRAM, PAUL JR.
Sculptor and painter. Born in Bloomington, IN, 1933. Employed in commercial and billboard art work until 1974, when began painting exclusively. More recently began sculpture. Paintings have appeared on covers of *Western Horseman* and other magazines. Awards: Gold, for mixed media, Geo. Phippen Memorial Day Show; American Indian and Cowboy Artist Show. Member: American Indian and Cowboy Artists. Specialty: Historic American West. Media: Watercolor, mixed media, oil; bronze. Represented: Overland Trail Galleries, Scottsdale, AZ; Newsom's Gallery, Las Vegas, NV. Address since 1975, Scottsdale, AZ.

ABRAMOVITZ, CARRIE.
Sculptor. Born: New York City, in 1913. Studied: Brooklyn College and Columbia University. Lived in Paris 1962-63. Awards: Morrison medal, Oakland Museum in 1960. Exhibited: Mostly in San Francisco area.

ABRAMS, EDITH LILLIAN.
Sculptor. Born in New York, NY. Studied at Brooklyn College, BA, 1974; Pratt Institute, MFA, 1978. Work in Evansville Museum of Arts and Science, Ind. Has exhibited at Brooklyn Museum, 1979 and 1981; Catharine Lorillard Wolfe Art Club, National Arts Club, New York; Audubon Artists Annual Exhibition, New York; and others. Received awards: Audubon Artists; Anna Hyatt Huntington Bronze Medal, Catharine Lorillard Wolfe Art Club. Member of the National Association of Women Artists; Catharine Lorillard Wolfe Art Club; and others. Works in bronze, and polyester resin. Address in 1982, Brooklyn, NY.

ACCONCI, VITO.
Sculptor. Born in NYC, Jan. 24, 1940. Studied at Holy Cross College in Worcester, MA, 1962; University of Iowa, MFA, 1964. Individual shows: Rhode Island School of Design, Providence, 1969; Gain Ground Gallery, NYC, 1970; Art Institute, Chicago, 1970; Museum of Conceptual Art, San Francisco, 1971; John Gibson Gallery, NYC, 1971; California Institute of the Arts, Valencia, 1972; Sonnabend, NYC; Modern Art Agency, Naples, Italy, 1973. Group shows: Dwan Gallery, NYC, 1969; Museum of Seattle, Washington, 1969; Vancouver Art Gallery, British Columbia, 1970; Jewish Museum, NYC, 1969; John Gibson Gallery, NYC, 1971; Kunsthalle, Duesseldorf, Germany, 1971; Kassel, Germany, 1972; Kennedy Center for the Performing Arts, Washington, DC, 1974; and others. Taught: Art theory at the School of Visual Arts,

NYC, 1968-71. Address in 1982, c/o Sonnabend Gallery, 420 West Broadway, NYC.

ACOSTA, MANUEL GREGORIO.
Sculptor, contemporary painter, illustrator, and muralist. Born in Villa Aldama, Chihuahua, Mexico, 1921; raised in El Paso, TX. Studied: University of Texas at El Paso; University of California; Chouinard Art Institute in Los Angeles; and with Urbici Soler, sculptor. Apprenticed in 1952 to Peter Hurd. Work in Museum of New Mexico; El Paso Museum; West Texas Museum; Time Collection; murals in Western banks. Commissions: Southwest History (aluminum mural), Casa Blanca Motel, Logan, NM, 1956; aluminum fresco mural and history panels, Bank of Texas, Houston; fresco mural, First National Bank, Las Cruces, NM, 1957. Specialty: Western and Mexican subjects. Represented by Baker Collector Gallery, Lubbock, TX. Address in 1982, El Paso, TX.

ACTON, ARLO C.
Sculptor. Born May 11, 1933, Knoxville, Iowa. Studied: Washington State University, 1958, BA; California Institute of Arts, 1959, MFA. Exhibited: Bolles Gallery, San Francisco, 1962; Nicholas Wilder Gallery, LA, 1965; San Francisco Museum of Art Annuals, 1960, 61, 62, 63; Stanford University, Some Points of View for '62, 1962; Fort Worth, 1962; Whitney, Fifty California Artists, 1962-63; III Paris Biennial, 1963. Awards: San Francisco Museum of Art, Edgar Walter Memorial Prize, 1961; California State Fair, 1961; Richmond (Calif.) Art Association Annual, 1961; San Francisco Art Association, 1964. In collection of San Francisco Museum of Art. Address in 1982, San Francisco, California.

ADAMS, ALICE.
Sculptor. Born in NYC, November 16, 1930. Studied at Columbia University, BFA, 1953; Fulbright travel grant, 1953-54; French government fellowship, 1953-54; L'Ecole Nationale d'Art Decoratif, Aubusson, France. Exhibited: Sculptures in wood and metal at the Whitney Museum of American Art, 1970-71, 73; Penthouse Gallery Exhibit, at the Museum of Modern Art, NYC, 1971; American Women Artists, Kunsthaus, Hamberg, West Germany, 1972; 1955 Mercer, NY, 1970, 72, 73, and 75; Neuberger Museum, Purchase, NY, 1979-80. Awards: National Endowment for the Arts Grant, 1979; a fellowship in the Humanities from Princeton University in 1980. Noted for her constructions. Address in 1982, 55 Walker Street, NYC.

ADAMS, CLIFTON E.
Sculptor. Born in La Place, Ill., 1904. Address in 1934, Lohrville, IA. (Mallett's)

ADAMS, HERBERT.
Sculptor. Born January 28, 1858, Concord, VT. Studied at Mass. Institute of Technology, Mass. Normal School, and pupil of Mercie in Paris. Awards: Honorable mention, Paris Salon, 1888 and 89; gold medal, Phila. Art Club, 1892; gold medals, Charleston Exp., 1902, and Louisiana Purchase Exp., St. Louis, MO, 1904; hors concours, Pan-American Exp., Buffalo, NY, 1901; medal of honor, P.-P. International Exp., San Francisco, 1915; gold medal, NY

Architectural League, 1916; Elizabeth N. Watrous gold medal, National Academy of Design, 1916. Member: American Academy of Arts and Letters; National Academy of Design; National Sculpture Society; NY Municipal Art Society; Federal Commission of Fine Arts. Works: Fountain, Fitchburg, MA; Pratt memorial, Emmanuel Baptist Church, Brooklyn, NY; Hoyt memorial, Judson Memorial Church, NYC; bronze doors, statue of Joseph Henry and other works, Library of Congress, Washington, DC; Joseph Smith, Fairmount Park, Philadelphia, PA; W. E. Channing, Boston, MA; bronze doors and marble tympanum, St. Bartholomew's Church, New York; Matthias Baldwin, Philadelphia, PA; Gen. Joseph Hawley memorial, State Capitol, Hartford, CT; A. A. Humphreys, Fredericksburg, VA; Michigan State monument, Vicksburg National Military Park, Vicksburg, MS; John Marshall, Rufus Ranney, Simon de Montfort and Stephen Lagton, County Court House, Cleveland, OH; Statues, Painting, Sculpture, Oratory, Philosophy, Brooklyn Museum, Brooklyn; MacMillan Fountain, Washington, DC; William Cullen Bryant, Bryant Park, New York City; Welch memorial, Theological Seminary, Auburn, NY; portrait relief, Joseph Choate, Union League Club, New York; portrait bust, Julia Marlowe, Cleveland Museum, Cleveland, OH; bust, Jeunesse, in pink Milanese marble, Metropolitan Museum, New York, and other works. Exhibited at National Sculpture Society, 1923. Address in 1934, 131 West 11th St., New York. Died in 1945.

ADDISON, BYRON KENT.
Sculptor and teacher. Born in St. Louis, MO, July 12, 1937. Studied at Washington University, St. Louis, MO, BFA, 1959; University of Notre Dame, South Bend, IN, MA, 1960. Exhibited: Louisiana Technical University Gallery, in Ruston, LA, 1980; Mall Galleries, London, England, 1981; and others. Awards: Watercolor, Skyledge Award, 1981; Award for Sculpture, Marth I Love, 1964; Cash Award, Strathmore Paper Co., 1981. Member of numerous art clubs and associations. Taught: Drawing and sculpture at Maryville College in St. Louis, MO, 1961-81. Commissions: Forest Park Sculpture, in St. Louis, MO, 1965; entrance wall sculpture, for the Continental Telephone Co., in Wentzville, MO, 1967; wall sculptures, Westinghouse Electric Corp., Abington, VA; fountain and sculpture, United Methodist Church, Sun City, AZ, 1974; religious sculpture, St. Joseph Church, Manchester, MO, 1980. Works are executed in welded steel and watercolor. Address in 1982, Ballwin, MO.

ADDISON, WALTER NICHOLS.
Sculptor, illustrator, and muralist. Born in Spokane, WA, March 15, 1914. Studied at National Academy of Design, 1932-35. Worked as staff illustrator for Bronx Zoo, 1937-38. Works: Animal murals such as watering hole at Gov. Clinton Hotel, NYC; fountain, ten Haitian mermaids; murals for August Schmeidigen, in Haiti, 1949-51; Polar Bear (marble); and all the animal figures for the General Motors Exhibition Hall, "The World of Tomorrow," New York World's Fair, 1964. Exhibited: Feragil Gallery, NYC, 1950; Burr Gallery, NYC. Awards: Bok Sculpture Fellowship, Tiffany Foundation award, 1940. Died September 9, 1982.

ADELMAN, BUNNY.
Sculptor. Born in New York, NY, May 7, 1935. Studied at Mt. Holyoke College; Columbia University, BA, 1956; National Academy School of Fine Arts, with Stephen Csoka & Evangelos Frudakis, scholarship, 1976. Has exhibited at National Academy of Design, NY; Salmagundi Club Annual, NY; Pen and Brush Society, NY, 1981; and others. Received awards: Gold Medal, Catherine Lorillard Wolfe Annual Show; Nat'l. Sculpture Soc.; and others. Member of the National Sculpture Society. Address in 1982, Tenafly, NJ.

ADELSPERGER, MARY.
Sculptor, in Chicago, 1909-1910. Address in 1910, Chicago, IL.

ADICKES, DAVID PRYOR.
Sculptor and painter. Born in Huntsville, TX, January 19, 1927. Studied at Kansas City Art Institute, 1948; Sam Houston University, Huntsville, TX, BS, 1948; Atelier Fernand Leger, Paris, 1948-50. Exhibited: Museum of Fine Art, Houston, 1951; New Works, Witte Museum of Art, San Antonio, 1957; Laguna Gloria Art Museum in Austin, 1957; and a retrospective of his works at Ft. Worth Art Center, 1966. Awards: First Purchase Prize, Houston Artists, Contemporary Arts Association, Museum of Fine Arts, in Houston, 1955; Seix y Barral, Barcelona, Spain, 1962. Taught: Painting at the University of Texas, at Austin, 1955-57. Media: Bronze and oil. Address in 1982, Houston, TX.

AFROYIM, BEYS (EPHRAIM BERNSTEIN).
Sculptor and painter. Born Ryki, Poland, January 2, 1893. Studied: Art Institute of Chicago; National Academy of Design; and with Boris Anisfeld. Member: Artists League of America. Work: Moscow Museum of Art; U.S. public buildings. Position: Director and teacher, Afroyim Experimental Art School, 1927-46. Address in 1953, 1 West 95th St., New York City.

AGAM, YAACOV.
Sculptor, painter, multi-media artist, and lecturer. Born Israel, 1928. Studied at Bezalel School of Art, Jerusalem. Went to Paris, 1951. Deeply influenced by Hebrew conception that reality cannot be represented in a graven image, seeks to create an image which cannot be seen completely at any one time. Has expressed these concepts in monumental architectural works: "Jacob's Ladder," ceiling of National Convention House, Jerusalem; "Double Metamorphosis II," Museum of Modern Art, NY; mural for passenger ship "Shalom;" visual environment, Civic Center at Leverkusen, 1970; Environmental Salon, Elysee Palace, Paris, 1972, which includes all the walls, kinetic ceiling, moving transparent colored doors and a kinetic tapestry on the floor; mural, President's Mansion, Jerusalem, 1972; monumental musical fountain, Paris, 1977; mural, Eye Foundation Hospital, Birmingham, AL, 1982. One-man shows: Craven Gallery, Paris, 1953, (first one-man show of kinetic art); Marlborough-Gerson Gallery, NY, 1966; Tel Aviv Museum, 1973; Gallery Attali opening in Paris, first worldwide presentation of video researches by Agam, 1974; Jewish Museum, NY, 1975; Janus Gallery, Washington

DC, 1977; S. African National Gallery, 1977; and many other solo and group shows, US and abroad. Group shows: First group show of kinetic movement, Galerie Denise Rene, Paris, 1955; Gallery Attali, Paris, 1976. Retrospectives: National Museum Modern Art, Paris, 1972; exhibition traveled to Stedelijk Museum, Amsterdam, 1972, and Dusseldorfs Kunsthalle, 1973. Awards: First prize for creative research, Biennial, Sao Paulo, 1963; Chevalier de l'Ordre des Arts et Lettres, 1974; Honorary Doctorate of Philosophy, Tel Aviv University, 1975; Medal of Council of Europe, 1977. Guest-lecturer, theory of advanced visual communication, Harvard University, 1968.

AGOPOFF, AGOP MINASS.
Sculptor. Born in Sliven, Bulgaria; US citizen. Studied with Kiril Shivarov and Professor George Nicholov, Varna, Bulgaria; Atelier Damian, Constantza, Roumania; Columbia University; National Academy of Design with Charles Keck. Work includes heroic portrait plaque of John F. Kennedy, Hyannis, Mass.; and others. Has exhibited at the National Academy of Design, from 1943; National Sculpture Society, from 1960; American Artists Professional League, from 1969. Received awards: Daniel Chester French Medal, National Academy of Design, 1971; The Therese and Edwin H. Richard Memorial Prize, National Sculpture Society, 1975. Member: National Academy of Design; American Artists Professional League (fellow); and National Sculpture Society. Media: Clay, granite, and bronze. Address in 1982, Denville, NJ.

AGOSTINI, PETER.
Sculptor. Born in New York City, February 13, 1913. Studied: Leonardo da Vinci Art School, NYC. Exhibited: Galerie Grimaud, NYC, 1959; Stephen Radich Gallery, NYC 1960, 62-65, 67, 68; New School for Social Research; Jewish Museum, 1964; Whitney, 1964, 70, 72; Museum of Modern Art; Art Institute of Chicago, 1962; Wadsworth Atheneum, 1962; Battersea Park, London, International Sculpture Exhibition, 1963; National Institute of Arts and Letters, 1972. Work: Brandeis University; Wadsworth Atheneum; MIT; Museum of Modern Art; University of Southern California; University of Texas; Whitney; Walker. Awards: Longview Foundation Grant, 1960, 61, 62; Brandeis University, Creative Arts Award, 1964. Address in 1982, 151 Avenue B, New York City.

AHL, HENRY HAMMOND.
Sculptor and painter. Born in Hartford, Conn., December 20, 1869. Studied: Royal Academy, Munich, Germany, with Alexander Wagner, Franz Stuck; Ecole des Beaux Arts in Paris, with Gerome. Work: Worcester Museum of Art; Springfield (Mass.) Art Museum; L.D.M. Sweat Memorial Museum, Portland, ME; Whistler Memorial Home, Lowell, Mass.; Vanderpoel Collection; Wellesley College; church murals in Boston, Mass.; Providence, RI. Exhibited: National Academy of Design; American Watercolor Society of New York; Washington Art Club; Penna. Academy of Fine Arts; Boston Museum of Fine Arts; Boston Art Club; Worcester Museum of Art; Hartford Atheneum; Corcoran Gallery of Art; North Shore

Art Association. Address in 1953, Newbury, Mass. Died in 1953.

AHVAKANA, ULAAQ.
(Lawrence Reynold Ahvakana). Sculptor and glass blower. Born in Fairbanks, Alaska, July 8, 1946. Studied at Institute of American Indian Arts, Santa Fe, New Mexico, sculpture with Allen Houser, 1966-69; Cooper Union School of Art, 1969-70; Rhode Island School of Design, Providence, BFA (sculpture/glass). Work in Anchorage History and Fine Arts Museum; sculpture, Institute of American Indian Arts. Has exhibited at the American Art Show, Brooklyn Museum, NY, 1971; Institute of American Indian Arts, New Mexico, 1981. Artist in residence, glass blowing and sculpture, Community of Barrow, 1972-74; instructor in sculpture and glass, Institute of American Indian Arts, Santa Fe, New Mexico, 1977-80; and others. Address in 1982, Santa Fe, New Mexico.

AIDLIN, JEROME.
Sculptor and instructor. Born in Cleveland, Ohio, August 6, 1935. Studied at Cleveland Institute of Art, diploma in industrial design, BFA in sculpture; Carnegie-Mellon University; also with William McVey. Work in Cleveland Art Museum and others. Has exhibited at Butler Museum of American Art; Museum of Contemporary Crafts, NY; Cleveland Institute of Art and others. Teaching at Cleveland Institute of Art, from 1965. Works in forged steel, copper, cast bronze, aluminum. Address in 1982, Cleveland, OH.

AIRY, JOHN.
Sculptor. Active in Cincinnati.

AITKEN, ROBERT INGERSOLL.
Sculptor. Born May 8, 1878, in San Francisco. Studied Mark Hopkins Institute of Art, San Francisco, under Arthur F. Matthews and Douglas Tilden. Professor of sculpture, Mark Hopkins Institute of Art (University of California), 1901-04. Worked in Paris, 1904-07. Instructor National Academy of Schools Sculpture Class. Taught at Art Students League. Awards: Phelan gold medal for sculpture; Helen Foster Barnett prize, National Academy of Design, 1908, for the G. R. Clark monument, University of Virginia, Richmond, VA; gold medal of honor for sculpture, New York Architectural League, 1915; silver medal of sculpture, P.-P. International Exposition, San Francisco, CA, 1915; Elizabeth N. Watrous gold medal, National Academy of Design, 1921. Member: National Sculpture Society, 1902; Associate National Academy of Design, 1909; National Academy of Design, 1914; New York Architectural League, 1909; National Institute of Arts and Letters; Allied Artists of America; National Arts Club. Works: Busts, Mme. Modjeska, D. Tilden, Dr. J. L. York, C. J. Dickman, CC. R. Peters, A. Thomas, D. Warfield, R. F. Outcault, G. Bellows, ex-President Taft, H. A. Jones; monuments, to W. McKinley at St. Helens, CA, 1902, and Golden Gate Park, San Francisco, 1903; to Bret Harte, 1904, to Hall McAllister, 1904, and to the American Navy, San Francisco, CA; Tired Mercury; Dancing Faun; Burrill memorial, New Britain, CT; George Rogers Clark monument, University of Virginia, Richmond, VA; doors for Greenhut and John W. Gates Mausoleums,

Woodlawn cemetery, NY; The Fountain of the Earth and The Four Elements, P.-P. Exposition, 1915; "The Flame," Metropolitan Museum, NY. He designed the $50 dollar gold piece for the exposition and the half-dollar for the Missouri Centennial, 1921. Exhibited at National Sculpture Society, 1923. Worked in Paris, 1904-7. Address in 1934, 154 West 55th Street, NYC. Died January 3, 1949.

AKAMU, NINA.
(Nina Akamu Sheppard). Sculptor. Born in Midwest City, OK, July 11, 1955. Studied at Maryland Institute of Art, BFA, 1976. Exhibited: Game Conserve International, San Antonio Conservation Center, in TX, 1980; Annual Society of Animal Artists, Salmagundi Club, NY, 1981; Society of Animal Artists and Wildfowl Carvers Exhibit, Museum of Natural Science, Philadelphia, PA, 1981; National Sculpture Society Annual, NY, 1982; one-woman show, National Aquarium, Baltimore, 1981; National Academy, NY, 1982. Member: National Sculpture Society; Society of Animal Artists. Media: Bronze, clay, and terra cotta. Address in 1982, Florence, Italy.

AKED, ALEEN.
Sculptor, painter, craftsman, and lecturer. Born in England. Studied: Ontario College of Art; Ringling School of Art; and with Sydney March, Abbott Graves, Robert Brackman. Member: Sarasota Art Association. Awards: prizes, Ontario College of Art; Ringling Museum of Art, 1938. Exhibited: Canadian National Exhibition, 1936-38; Royal Canadian Academy, 1938; Allied Artists of America, 1939; Southern States Art League, 1938-40; Sarasota Art Association; Studio Guild, 1939, 40; New York Public Library, 1940; St. George Public Museum, 1940; Ontario Society of Artists, 1938; Toronto Golf Club, 1946-52 (one-woman). Address in 1953, Ontario, Canada.

AKELEY, CARL ETHAN.
Sculptor, naturalist, and inventor. Born in Claredon, NY, in 1864, and was a member of the National Sculpture Society, 1914; Architectural League of NY; National Institute of Social Sciences; Franklin Institute. He became associated with the American Museum of Natural History in 1909 and was in Africa collecting specimens for that institution at the time of his death. He was chiefly noted as a collector and mounter of wild life specimens and as a sculptor, but he also had a notable record as an engineer. He is represented by a bronze, "The Chrysalis," in the West Side Unitarian Church, NY; two animal studies in the Brooklyn Institute Museum; and numerous groups in the American Museum of Natural History, NY. Address in 1926, NYC. Died in Kabale, Uganda, Central Africa, November 17, 1926.

AKERS, BENJAMIN PAUL.
Sculptor, painter, and author. Born July 10, 1825, in Westbrook, ME. Studied painting in Portland, ME, and in 1849 studied plaster casting with Carew in Boston. Made his first visit to Europe, visiting Florence, Italy, where he remained during the year 1852, and studied under Powers. He travelled to Europe again in 1855-57 and in 1859. Among his works are: "Peace," "Una and the Lion," "Girl Pressing Grapes," "Isaiah," "Schiller's Diver,"

"Reindeer," "The Lost Pearl Diver," "St. Elizabeth of Hungary," "Milton," "Diana and Endymion;" portrait busts of Tilton, Longfellow, Samuel Appleton, Edward Everett, Prof. Cleveland, Gerrit Smith, Sam Houston, and Justice John McLean. Died May 21, 1861, in Philadelphia, PA.

AKERS, CHARLES.
Sculptor. Born near Hollis, Maine, October 15, 1835 or 36. He also worked as a crayon portrait draughtsman. He went to Rome in 1855 to study art with his brother, Benjamin Paul Akers, sculptor. His studio was in New York, 1860-69. In 1875 he was working in Waterbury, Conn., and in 1879 he had returned to New York. Died September 16, 1906, in New York City.

ALAUPOVIC, ALEXANDRA V.
Sculptor and instructor. Born in Slatina, Yugoslavia, December 21, 1921; US citizen. Studied at Academy of Visual Arts, University of Zagreb, sculptor and teaching certification, 1948; Academy of Visual Arts, Prague, 1949; University of Illinois, Urbana-Champaign, 1959-60; University of Oklahoma, M.F.A., 1966. Exhibitions: Exposition Association Peintres, Graveurs et Sculpteurs de Croatie, Dubrovnik, Yugoslavia, 1956; 35th Annual Springfield Art Museum, Missouri, 1965; On Music, University of Oklahoma Museum of Art, 1968; Annual Eight State Exhibit of Painting and Sculpture, Oklahoma City, 1971; one-woman show, Oklahoma Art Center, 1973. Awards: Jacobson Award, University of Oklahoma, 1964; First Sculpture Award, Philbrook Art Center, Tulsa, 1970. Member: The MacDowell Club Allied Arts; National Society of Literature and Arts. Instructor of sculpture at the Oklahoma Science and Arts Foundation from 1969-75, and at Oklahoma City University, 1972-77. Media: Marble, metals. Address in 1982, Oklahoma City, OK.

ALBERT, CALVIN.
Sculptor. Born November 19, 1918, Grand Rapids, MI. Studied: Grand Rapids Art Gallery with Otto Bach; Institute of Design, Chicago, with Lazlo Moholy-Nagy, Gyorgy Kepes, Alexander Archipenko. Taught at Institute of Design, Chicago; NYU; Brooklyn College; Pratt. Exhibited: Paul Theobald Gallery, Chicago, 1941; Puma Gallery, NYC, 1944; Calif. Palace, 1947; Laurel Gallery, NYC, 1950; Grace Borgenicht Gal. Inc., 1952, 54, 56, 57; The Stable Gallery, 1959; Galleria George Lester, Rome, 1962; Metropolitan Museum of Art, 1952; University of Nebraska, 1955; Walker, 1954; Jewish Museum, 1960; Museum of Modern Art, Recent Drawings USA, 1956; Whitney Annuals, 1954, 55, 56, 58, 60, 62; Brooklyn Museum, Golden Year of American Drawing, 1956; Art Institute of Chicago; Penna. Academy of Fine Arts, 1949, 53, 64. Awards: Detroit Institute, The Haass Prize, 1944; Tate, London, International Unknown Political Prisoner Competition, Honorable Mention, 1953; Audubon Artists, First Prize, 1954; Fulbright Fellowship, 1961; L. C. Tiffany Grant, 1963, 65; Guggenheim Foundation Fellowship, 1966. Commissions for churches and temples, including Park Avenue Synagogue, NYC. Collections: Brooklyn Museum; Art Institute of Chicago; Detroit Institute; Jewish Museum; Metropolitan Museum of Art;

University of Nebraska; Provincetown, Chrysler; Whitney. Address in 1983, 325 W. 16th St., New York City.

ALBERT, DRUSSILLA.
Sculptor. Born in 1909. Exhibited in Seattle, Washington, 1934.

ALBRECHT, CLARENCE JOHN.
Sculptor, lecturer and teacher. Born Waverly, IA, September 28, 1891. Pupil of H. R. Dill, James A. Wehn, Charles Eugene Tefft. Works: Grizzly Bear Group, California Academy of Sciences; Sea Lion Group, American Museum of Natural History; Deer, Bear and Goat groups, State Museum, University of Washington. Address in 1929, American Museum of Natural History, New York, NY.

ALBRECHT, MARY DICKSON.
Sculptor and painter. Born in Dothan, AL, June 4, 1930. Studied at University of Houston; Texas Woman's University, BS, (sculpture, with honors), 1970. Exhibited: Dallas Museum of Fine Arts, 1971; 61st Annual National Exhibit, 1972; Laguna Gloria Museum, Austin; Joslyn Art Museum, Omaha, NE, 1976; Del Mar College, Corpus Christi, TX, 1976. Awards: Juror's choice and circuit merit awards, Texas Fine Arts Association State Citation Show, 1971 and 72; Purchase award, art acquisition committee, University of Texas, Arlington, 1972. Media: Steel, bronze, metal, and plastic. Address in 1982, Dallas, TX.

ALBRIGHT, HENRY JAMES.
Sculptor and painter. Born July 16, 1887, in Albany, NY. Pupil of Wm. St. John Harper, John F. Carlson, C. W. Hawthorne, S. L. Huntley, and C. L. Hinton. Member: American Federation of Arts; Society of Independent Artists. Designer and Sculptor; bronze tablets marking Gen. Knox Highway, Ticonderoga to Boston. Director of Troy Art Institute. Address in 1933, Glenmont, Albany Co., New York. Died in January, 1951.

ALBRIGHT, IVAN LE LORRAINE.
Sculptor, painter, and lithographer. Born in North Harvey, IL, Feb. 20, 1897. Studied at Ecole Regionale Beaux-Arts, Nantes, France, 1919; Art Institute of Chicago, 1920-23, Ph.D., 1977; National Academy of Design, NYC, 1924; Penna. Academy of Fine Arts; and others. In collections of National Gallery, Washington, DC; Metropolitan Museum of Art, Museum of Modern Art, Guggenheim, Whitney, in NYC; others. Exhibited at Carnegie Institute; NY and Brussels World's Fairs; Museum of Modern Art; Art Institute of Chicago; Corcoran Gallery, Washington, DC; National Academy of Design and Whitney, NYC; and many more. Awards: Honorable mention, Art Institute of Chicago, 1926, and Shaffer prize, 1928; medal, painting, 1942, and Metropolitan Museum prize, 1952, at Metropolitan Museum of Art; Silver medal, Corcoran Gallery, 1955; others. Member of National Institute of Arts and Letters; American Water Color Society; American Academy of Arts and Letters; Academician, National Academy of Design; fellow, Penna. Academy of Fine Arts. Represented by Kennedy Galleries, NYC. Working at Albright Studios in Warrenville, IL, in 1929. Living in

Woodstock, VT, in 1982.

ALBRIGHT, MALVIN MARR.
Sculptor and painter. Born Chicago, IL, Feb. 20, 1897. Studied at Art Institute of Chicago; Penna. Academy of Fine Arts; Beaux Arts Institute of Design, NYC; with Albin Polasek, Charles Grafly. Work: San Diego (CA) Fine Arts Gallery; Corcoran Gallery, Washington, DC; Toledo (OH) Museum of Art; Butler Institute, Youngstown, OH; Penna. Academy of Fine Arts; and others. Exhibited at National Academy of Design, Whitney, Museum of Modern Art, all in NYC; Penna. Academy of Fine Arts; Carnegie Institute and more. Awards: Fountain prize, Chicago Daily News, 1922; Jenkins prize, Art Institute of Chicago, 1929; Altman prize, National Academy of Design, 1942 and 62; Corcoran Silver Medal; Dana Medal, Penna. Acad. of Fine Arts, 1965; others. Member: Fellow, Penna. Academy of Fine Arts; Art Institute of Chicago Alumni; Laguna Beach Art Association; National Academy of Design; fellow, Royal Society of Arts; International Institute of Arts and Letters; National Sculpture Society; and others. Working at Albright Studios in Warrenville, IL, in 1929. Address in 1982, Chicago, IL.

ALBRIZIO, HUMBERT.
Sculptor. Born in New York City, December 11, 1901. Studied: Beaux-Arts Institute of Design; New School Social Research. Member: National Sculpture Society; Sculptors Guild; Audubon Artists; Minnesota Sculptor Group. Awards: medal, National Sculpture Society, 1940; prizes, Walker Art Center, 1945, 46, 51; Des Moines, IA, 1946; Denver Mus. of Art, 1947 Audubon Artists, 1947; Joslyn Art Museum, 1949. Work: Walker Art Center; United States Post Office, Hamilton, NY; State University of Iowa; Joslyn Art Museum; Worcester Museum of Art. Exhibited: Metropolitan Museum of Art; Whitney Museum of Art; Brooklyn Museum; National Academy of Design; Philadelphia Museum of Art; Carnegie Institute; Penna. Academy of Fine Arts; Albany Institute of History and Art; Art Institute of Chicago. Associate Professor, Sculpture, at State University of Iowa, Iowa City, Iowa. Address in 1953, State University of Iowa; h. Iowa City, Iowa. Died 1970.

ALDEN, LOWELL WAVEL.
Sculptor, painter, etcher, and lecturer. Born in Jonesboro, LA, July 16, 1911. Studied: Louisiana Polytechnic Institute, B.A. Member: Association Art Houston; Southern States Art League. Exhibited: Museum of Fine Arts of Houston; Dallas Museum of Fine Arts; Southern States Art League. Address in 1953, Houston, Texas.

ALDRICH, MARY AUSTIN.
(Mrs. Malcolm Fraser). Sculptor and craftsman. Born in NYC, February 22, 1884. Studied with Partridge, Lober, Fraser. Works: Altar piece "Christ Child" and panels, St. Anne's Convent, Kingston, NY; bronze memorial figure, Christ Child, National Cathedral, Washington, DC; various figures in concrete and bronze in private schools and gardens. Member: National Association Women Painters and Sculptors; National Arts Club; NY Society of Craftsmen. Address in 1933, Brookhaven, Long Island, NY.

ALEXANDER, JON H.
Sculptor, painter, and illustrator. Born in Rochester, NY, December 8, 1905. Studied: Mechanics Institute, Rochester, NY; Nat'l. Acad. of Design, with Robert Aitken, Charles Hawthorne; University of Rochester, School of Medicine. Works: Pittsford, NY; Rochester Memorial Art Gallery. Taught: Diorama Artist, Sculptor, Model Builder, Archaeology Division, Rochester Museum, 1941-52. Address in 1953, Rochester Museum, Rochester, NY.

ALEXANDER, JULIA STANDISH.
Sculptor, craftsman, writer, and teacher. Born Springfield, Mass. Pupil of Art Students League of NY; Victor Brenner. Member: Alliance; NY Society of Craftsmen; American Federation of Arts. Director, Art and Craft Department, Heckscher Foundation for Children, New York City. Address in 1934, Mount Vernon, New York.

ALEXANDER, MARIE DAY.
(Mrs. Ernest R. Alexander). Sculptor. Born in Greenfield, MA, October 31, 1887. Pupil of Augustus Vincent Tack, Philip Hale, William Paxton. Work: "Green River in Autumn," Mass. Federation of Women's Clubs, Boston. Member: North Shore Art Association; National Association of Women Painters and Sculptors. Address in 1934, Greenfield, MA.

ALEXANDER, MARY LOUISE.
Sculptor, writer, and teacher. Pupil of Meakin, Duveneck, Barnhorn, Grafly, Nowottny. Member: Cincinnati Women's Art Club; MacDowell Society, Cincinnati; Pen and Brush Club. Work: Vincent Nowottny tablet, Cincinnati Art Academy. Address in 1934, Cincinnati, Ohio.

ALEXANDER, PETER.
Sculptor. Born in Los Angeles, CA, February 27, 1939. Studied at the University of Penna.; University of London, University Park, England, 1960-62; University of California, Berkeley, 1962-63; University of Southern California, Los Angeles, 1963-64; University of California, Los Angeles, 1964-68, MFA. Individual shows: Robert Elkon Gallery, NYC, 1968; Janie C. Lee Gallery, Dallas, TX, 1969; Locksley/Shea Gallery, NYC, 1969; Nicholas Wilder Gallery, Los Angeles, 1970; Robert Elkon Gallery, NYC, 1970; Michael Wall Gallery, San Francisco, CA, 1971; Akron Art Institute, OH, 1972; San Francisco Museum of Art, 1976. Group exhibitions: California State College, Los Angeles, 1967; Art Museum, Seattle, Washington, 1968; White Chapel Art Gallery, London, 1970; Documenta V, Kassel, Germany, 1972. Taught: As artist-in-residence at the California Institute of Technology, 1970-71. Address in 1982, Topanga, CA.

ALEXANDERSEN, GENEVIEVE CONSTANCE.
Sculptor. Born in Bergen, Norway. Member: North Shore Art Association. Awards: prize, Norwegian National League, 1929. Exhibited: Art Institute of Chicago; Centennial Building, Springfield, Ill. Address in 1953, Chicago, Ill.

ALFANO, VICENZO.
Italian sculptor. Born in Naples, Italy, 1854. Exhibited in

1902 at the Sculpture Society in New York, "Cicerone." Died in 1918.

ALFORD, GLORIA K.
Sculptor and printmaker. Born in Chicago, Illinois, October 3, 1938. Studied at University of California, Berkeley, BA; Art Institute of Chicago; Penland School of Crafts, NC; Columbia University; Pratt Graphics Center. Exhibitions: Environ-Vision, National Competitive Exhibit, Everson Museum, Syracuse and NY Cultural Center, NY, 1972; New Talent Show, Gimpel and Weitzenhoffer, NY, 1973; In Her Own Image, Philadelphia Museum of Art, 1974; 19th Annual Print Exhibit, Brooklyn Museum, 1974; Wisconsin Directions, Milwaukee Art Center, 1975. Awards: Top Honors, University of Wisconsin Art Show, Richland Center, 1972. Address in 1982, Santa Cruz, CA.

ALLEN, FREDERICK WARREN.
Sculptor and teacher. Born North Attleboro, MA, May 5, 1888. Pupil of Pratt, Landuski, Bartlett. Member: Boston Guild of Artists; Boston Sculpture Society; National Sculpture Society; Concord Art Association. Work: "Toreo" at Penna. Academy of Fine Art, 1924; in Boston Museum of Fine Arts; Boston Art Club; Boston City Hall; New England Historic Genealogical Society; Metropolitan Museum, NY; Boston Public Library; Trinity Church; Concord Museum; WWI Veteran Memorial, Mt. Hope Cemetery, Boston; and others. Instructor, Museum of Fine Arts Schools, Boston. Address in 1934, Boston, MA; h. Concord, MA; summer, North Haven, ME. Died 1961.

ALLEN, G.
(See also Allen, George.) Sculptor and writing master. Active in Boston, MA, 1716. Specialty was gravestones.

ALLEN, GEORGE.
Sculptor. At Charleston, South Carolina, 1787, 1795. Specialty was gravestones.

ALLEN, GREGORY SEYMOUR.
Sculptor. Born in Orange, NJ, July 8, 1884. Pupil of G. Borglum, Shrady, P. Martini, and H. N. Bushbrown. Major work in Los Angeles Museum of Art. Address in 1933, Glendale, CA. Died in 1935.

ALLEN, HAZEL LEIGH.
Sculptor. Born Morrilton, Ark., December 8, 1892. Pupil of Art Institute of Chicago and Ferdinand Koenig. Exhibited: Penna. Academy of Fine Arts, 1929; Milwaukee Art Institute, 1923, 29, 31, 33, 38; Walrus Club, Milwaukee, 1946-52; Layton Art Gallery, 1941, 49. Member: Wisconsin Painters and Sculptors Society; Walrus Club; Southern States Art League. Address in 1953, Milwaukee, Wis.

ALLEN, JOHN.
Sculptor. Born in Maryland, 1835. At NYC, 1860.

ALLEN, LENNOX.
Sculptor, painter and writer. Born in Glenview, KY, December 20, 1911. Studied: Rollins College, with Pfister, Able; Cincinnati Art Academy. Member: Southern States Art League; National Arts Club. Exhibited: National Arts Club; Louisville, KY, 1945; Ky.-Ind. Exhibition, 1946. Address in 1953, Louisville, KY; h. Glenview, KY.

ALLEN, LOUISE.
(Mrs. Louise Allen Hobbs). Sculptor. Born Lowell, MA. Studied RI School of Design and Boston Museum Fine Arts. Member: National Association Women Painters and Sculptors; Copley Society of Boston; National Sculpture Society; Boston Sculptors Society; North Shore Art Association; Providence Art Club. Exhibited at Penna. Academy of Fine Arts; National Academy, NY; Art Institute Chicago; Albright Galleries, Buffalo; Museum Fine Arts, Providence, RI; National Sculpture Society, 1923. Represented in Cleveland Museum. Works include: World War Memorial, East Greenwich, RI; World War Tablet, Gloucester, MA; memorial tablet, Bancroft Hall, Annapolis, MD; also ideal bronzes, portraits, and garden sculptures. Address in 1928, Boston, MA; summer, East Gloucester, MA.

ALLEN, MARGO.
(Mrs. Harry Shaw). Sculptor and painter. Born in Lincoln, MA, December 3, 1895. Studied: Boston Museum of Fine Arts; British Academy, Rome; marble carving at Gelli Studio, Italy; pupil of Frederick Allen, Charles Grafly, Bela Pratt. Award: Junior League, Boston, 1929; Delgado Museum of Art. Collections: Busts, bas-reliefs, US Frigate "Constitution;" HMS "Pragon;" Cohasset War Memorial; Church, Winchester, MA; Clearwater Art Museum; Butler Art Institute; Cincinnati Museum Association; Von Pagenhardt Collection; Museum of New Mexico, Santa Fe; National Museum, Mexico and Dallas Museum of Fine Art. Commissions include 34 terra-cotta reliefs for the First National Bank of Lafayette, LA; bronze eagle, New Iberia Bank, LA. Exhibited at National Academy of Design, NY; Penna. Academy of Fine Arts; NY Architectural League; and others. Member: National Sculpture Society; National League of American Pen Women; Boston Sculptors Society; and others. Lived in Louisiana in 1953; summer, Cohasset, ME. Address in 1982, Longboat Key, FL.

ALLEN, MARTHA.
Sculptor and craftsman. Born in Appleton, Tenn., September 22, 1907. Studied: Alabama College, AB; Teachers College, Columbia University, MA. Member: Birmingham Art Club; Alabama Watercolor Society; Alabama Art League. Exhibited: Alabama Watercolor Society; Birmingham Art Club; Junior League Gallery. Taught: Associate Professor of Art, Alabama College, Montevallo, Alabama, from 1932. Address in 1953, Montevallo, Ala.

ALLEN, MARY GERTRUDE.
Sculptor and painter. Born Mendota, IL, October 7, 1869. Pupil of Anna Hills, Michel Jacobs, Dudley Pratt. Member: Seattle Art Institute; Women Artists of Washington; Laguna Beach Art Association. Work: "Portrait of Narcissa Prentiss Whitman," Prentiss Hall, Whitman College, Walla Walla, WA; frieze, convalescent childrens ward, Everett General Hospital, Everett, WA; altar pieces, First Lutheran Church, Portland, OR, and Cedarholme, WA. Address in 1934, Lake Stevens, WA.

ALLEN, TOM JR.
Sculptor and designer. Born in Havana, Cuba, January

23, 1927. United States citizen. Studied at University of Havana, architecture; University of Madrid, literature; Royal Academy of Fine Arts, San Fernando, Spain; Corcoran School of Art; George Washington University, AA. Work in American Numismatic Society, NY; Carnegie Museum of Natural History; Metropolitan Museum of Art, NY. Has exhibited at the National Sculpture Society; Philadelphia Museum of Art and others. Member of the Artists Equity Association. Address in 1982, Somerset, NJ.

ALLMAN, MARGO.
Sculptor and printmaker. Born in NYC, February 23, 1933. Studied at Smith College; Moore College of Art; University of Penna.; 7 Delaware Area Sculptors, University of Delaware, 1975; with Reginald Marsh and Hans Hofmann; Windham College, Putney, Vermont, 1973. Exhibitions: Philadelphia Artists Who Have Received Prizes in Recent Years, Philadelphia Museum of Art, 1962; Philadelphia Women in the Fine Arts, Moore College of Art, annual, 1962-68; National Biennial, National League of American Pen Women, Salt Lake City, 1970 and Washington, DC, 1972. Awards: Mildred Boericke Prize, 32nd Annual National Exhibit of Woodcuts and Wood Engravings, Print Club of Philadelphia, 1958; Drawing Prize, 51st Annual Show, Delaware Art Museum, 1965; Best Landscape Painted by Delaware Artist, Wilmington Trust Bank Prize, Delaware Art Museum, 1969. Media: Wood and stone; acrylic paint and woodcuts. Address in 1982, West Grove, PA.

ALLWELL, STEPHEN S.
Sculptor. Born in Baltimore, MD, October 15, 1906. Study: MD Institute, Baltimore. Work: Metromedia Permanent Collection, private collections, including commissions. Exhibitions: Miniature Painters, Sculptors and Gravers Society, Washington, DC, 1967-71. Awards: Miniature Painters, Sculptors and Gravers Society, 1969; etc. Member: Artists Equity Association; MD Federation of Art; Rehoboth Art League; and others. Address in 1982, Baltimore, MD.

ALMENRAEDER, FREDERICK.
Sculptor. Born in Wiesbaden, Germany, 1832. Pupil of Stadel's Institute, Frankfort-am-Main, Germany. Address in 1910, Chicago, IL.

ALSTON, CHARLES HENRY.
Sculptor, painter and teacher. Born in Charlotte, NC, November 28, 1907. Studied: Columbia University, B.A., M.A. Awards: Dow Fellowship, Columbia University, 1930; Rosenwald Fellowship, 1939-40, 1940-41; prizes, Atlanta University, 1941; Dillard University, 1942. Work: Metropolitan Museum of Art; Detroit Institute of Art; Ford Collection; IBM; murals, Golden State Mutual Life Insurance Co., Los Angeles; portrait, Louis T. Wright Memorial Library, Harlem Hospital, NY. Exhibited: Metropolitan Museum of Art, 1950; Whitney Museum of Art, 1952-53; Penna. Academy of Fine Arts, 1952; High Museum of Art, 1938; Baltimore Museum of Art, 1937; Downtown Gallery, 1942; Museum of Modern Art, 1937; Corcoran Gallery of Art, 1938; Art Students League, 1950-52; Museum of Modern Art, 1970. Illustrator for

leading publishers. Contributor illustrator to Fortune, New Yorker, Reporter, and other magazines. Instructor, Art Students League, NYC, from 1949; Joe and Emily Lowe Art School, NYC from 1949. Address in 1976, c/o Kennedy Galleries, 20 East 56th St., NYC. Died in 1977.

ALTSCHULE, HILDA.
(Mrs. Hilda Altschule Coates). Sculptor and painter. Born in Russia. Studied: Hunter College, BA; Cornell University, MA. Awards: Prizes, Rochester Memorial Art Gallery, 1935, 40, 42, 44; Albright Art Gallery, 1939; Lillian Fairchild award, Rochester, 1945; Finger Lakes Exhibition, 1950; NY State Exhibition, Syracuse, 1950. Work: Rochester Memorial Art Gallery. Exhibited: Rochester Historical Society; Rochester Memorial Art Gallery, 1929-46; Albright Art Gallery, 1939, 52; Finger Lakes, 1946-52; NY State Exhibition, Syracuse, 1951. Address in 1953, Rochester, NY.

AMATEIS, EDMOND ROMULUS.
Sculptor. Born in Rome, Italy, February 7, 1897. Son of Louis Amateis. Pupil of Beaux-Arts Institute of Design and Julian Academy in Paris. Member: Alumni Association American Academy in Rome; National Sculpture Society; NY Architectural League; American Federation of Art; National Institute of Arts and Letters; Academician, National Academy of Design. Award: Penna. Academy of Fine Arts, 1933; Morris prize, National Sculpture Society; Prix de Rome, 1921 to 1924; Avery prize, Architectural League, 1929. Work: Sculptured groups for Baltimore War Memorial; Metopes for Buffalo Historical Building; colossal relief for Rochester Times-Union; Brookgreen Gardens, SC; George Washington University; medal for Society of Medalists; many others. Exhibited: National Academy of Design; Penna. Academy of Fine Arts; National Sculpture Society. Address in 1953, Brewster, NY. Died in 1981.

AMATEIS, LOUIS.
Sculptor. Born in Turin, Italy, December 13, 1855. Educated in the schools of Turin, and a graduate of the Institute of Technology and the Academy of Fine Arts of Turin, where he was awarded a gold medal upon his graduation. His first sculptural work of importance was a bas-relief purchased by a committee of sculptors for the Art Gallery of Turin. In a competition he was awarded the commission for the sculptural decorations for the Palace of Fine Art of Turin. In 1884 he came to the United States and became a naturalized citizen of this country. He was the founder of the School of Architecture and Fine Arts of the Columbian University, Washington, DC, and a member of the National Sculpture Society. Among his works are many portraits, busts, and the bronze doors in the Capitol, Washington, DC. Address in 1910, Washington, DC. Died in West Falls Church, VA, March 18, 1913.

AMBELLAN, HAROLD.
Sculptor and industrial designer. Born in Buffalo, NY, May 24, 1912. Member: Sculptor Guild; Artists Equity Association. Address in 1953, 324 West 26th Street, New York City.

AMEN, IRVING.
Sculptor, painter, and engraver. Born in New York City, July 25, 1918. Studied: Art Students League; Pratt Institute Art School; Academy Grande Chaumiere, Paris. Commissions include a Peace Medal (in honor of the Vietnam War); 12 stained glass windows, 16 ft. high, Agudas Achim Synagogue, Columbus, OH; others. Member: Society of American Graphic Artists; Artists Equity Association. Awards: F. H. Anderson Memorial prize, 1950; Erickson award, 1952. Work: Metropolitan Museum of Art; Library of Congress; Museum of Modern Art; Smithsonian Institute; US National Museum; Phila. Museum of Art; Pennell Collection; NY Public Library; Bibliotheque Nationale, Paris; Bibliotheque Royale, Brussels. Exhibited: Society of American Graphic Artists, 1949-52; Library of Congress, 1947-52; Brooklyn Museum, 1948-52; Museum of Modern Art, 1949; Penna. Academy of Fine Arts, 1948; National Academy of Design, 1949. One-man shows: New School of Social Research, 1948; US National Museum, 1948; Argent Gallery, 1949, 51; Tribune Gallery, 1950; Pratt Institute, 1950. Publication: *Irving Amen Woodcuts 1948-1960, Irving Amen: 1964, Amen: 1964-1968*, and *Amen: 1968-1970*. Address in 1983, Boca Raton, FL.

AMENDOLA, ROBERT.
Sculptor. Born in Boston, Mass., April 24, 1909. Studied: Mass. School of Art; Yale University, BFA; American Academy in Rome. Member: Liturgical Art Society; Wellesley Society of Artists. Awards: Mass. School of Art; 1930; American Academy in Rome, 1933. Work: Yale University Chapel; church sculpture in Braintree, Gloucester, Boston, Natick, Mass.; Avon, Connecticut; University of Connecticut Catholic Chapel; Convent of the Immaculate Conception, Bristol, Connecticut; sculpture for the SS "United States," in collaboration with Austin Purves. Exhibited at Wellesley SA, 1930-42. Address in 1953, Natick, Mass.

AMES, ALEXANDER.
Wood carver. Active near Buffalo, New York, 1847. Works include "Head of a Child," in polychromed oak, and "Head of a Boy."

AMES, POLLY SCRIBNER.
Sculptor and painter. Born in Chicago, IL, in 1908. Studied at University of Chicago, Ph.D.; Art Institute of Chicago; Chicago School of Sculpture, scholar; also with Jose De Creeft and Hans Hofmann, NY; Hans Schwegerle, Munich, Germany. Exhibitions: One-woman shows, Cultural Center, Netherlands, West Indies, 1947, Galerie Chardin, Paris, 1949, Cercle Universite, Aix-en-Provence, 1950 and Esher-Surrey Gallery, The Hague, Holland, 1950; also Closson Gallery, Cincinnati and many others. Awards: Bronze award for Young Satyr and Friend, Illinois State Museum, 1962. Address in 1982, Chicago, IL.

AMES, SARAH FISHER CLAMPITT.
(Mrs. Ames). Sculptor. Born in Lewis, Delaware, August 13, 1817. Studied art in Boston, and Rome, Italy. She was the wife of Joseph Ames, portrait painter. She was personally acquainted with President Lincoln and her bust of him is considered excellent. Among her other portrait busts are General Grant and Ross Winans. Died in Washington, DC, March 8, 1901.

AMINO, LEO.
Sculptor and teacher. Born in Tokyo, Japan, June 26, 1911; US citizen. Studied at NY University; American Artists School, NYC. Exhibited: Museum of Modern Art, 1950; Metropolitan Museum of Art, NYC, 1951; Whitney Museum of American Art, 1956; Jewish Museum, NY, 1970. Taught: Instructor of Sculpture at the Black Mountain College, 1946 and 50; Instructor of Sculpture at Cooper Union School of Art, 1952-77. Media: Mostly in plastic. Address in 1982, 58 Watts Street, NYC.

AMORE, JOHN.
Sculptor. Born in Genoa, Italy, February 28, 1912. Studied: Beaux-Arts Inst. of Design, NYC; Fontainebleau School of Fine Arts; National Academy of Design. Member: American Academy in Rome. Awards: Beaux-Arts Institute of Design, NY, 1935, Rome prize, 1937; Competition gold medal design for City of New York, 1948; National Sculpture Society, 1951. Work: Zodiacal spheres, lobby of Louisville Times-Courier Journal Building; figures, St. Francis College, Biddeford, ME; St. Claire's Hospital, New York; decorations, SS "Independence" and SS "Constitution;" medallions, Alvey Ferguson Co., Cincinnati; Northwestern University. Address in 1953, 156 East 39th St., New York, NY.

AMUNDSEN, RICHARD.
Sculptor and painter. Born in the Sacramento Valley, CA, 1928. Initially worked as an illustrator for an art service in San Francisco. Began free lancing in 1963. Obtained commissions from Golden Books, Random House, *Field and Stream, Reader's Digest, Outdoor Life*. Turned to fine arts painting while living in Cody, WY, and later Bozeman, MT. Awarded Presidential Seal for commissioned painting of Theodore Roosevelt, presented to Pres. Nixon. Has exhibited with Northwest Rendezvous group; and at Trailside Galleries, Scottsdale, AZ. Specializes in wildlife, both in painting and bronze statuettes. Address in 1982, Bozeman, MT.

ANARGYROS, SPERO.
Sculptor. Born in New York, NY, January 23, 1915. Studied with William Zorach, NY, 1934-35; assistant to Mahonri Sharp Young, Salt Lake City, Utah, 1944-47. Exhibited at the National Academy of Design; De Young Memorial Museum; National Sculpture Society; others. Awards: National Sculpture Society. Member: Art Students League; National Sculpture Society; International Institute of Arts and Letters. Works in bronze, marble, and stone. Address in 1982, San Francisco, CA.

ANDERS, WILLI.
Sculptor and painter. Born in Hanover, Germany, July 19, 1897. Studied: Kunstgewerbe Schule, Hanover, and with Robert von Neumann, Myron Nutting. Member: Wisconsin Painters and Sculptors. Awards: Prizes, Wisconsin State Fair, 1938, 39, 45; University of Wisconsin, 1934, 1935, 38; Milwaukee Art Institute, 1936, 38, 51; Mead Public Library, Sheboygan, Wisconsin, 1951. Work: Mil-

waukee Art Institute. Exhibited: Art Institute of Chicago, 1935; Penna. Academy of Fine Arts, 1939; Wisconsin Salon; Wisconsin Painters and Sculptors; Kansas City Art Institute; Great Lakes Exhibition, 1938, 39; Milwaukee Institute, 1944 (one-man). Address in 1953, Milwaukee, Wis.

ANDERSON, DAVID PAUL.
Sculptor and instructor. Born in Los Angeles, Calif., February 3, 1946. Studied at San Francisco Art Institute; assistant to Peter Voulkos, 1972-73. Has exhibited at San Francisco Museum of Art; Oakland Museum, California; Whitney Museum, NY; San Francisco Art Institute; and others. Received National Endowment Arts Fellowship Grant, 1974 and 1981. Works in welded steel. Address in 1982, Santa Fe, New Mexico.

ANDERSON, DENNIS.
Sculptor, illustrator and painter. Studied at the Art Center School in Los Angeles, CA. Worked with the Dept. of Defense as scientific Illustrator and artist, also for Hallmark Cards, Inc. Exhibitions: Wildlife World Museum, Monument, CO, (two-man show), 1981; Shriver Gallery, Taos, NM; Corpus Christi Art Gallery; Folger Ranch Gallery, Midland, TX; The Peacock Gallery, Scottsdale, AZ & Jackson, WY; The Artists Union Gallery, Bozeman, MT; American Legacy Gallery, Kansas City, MO; Gallery Select, Seattle, WA; Face Bear, Denver, CO; and Call of the Wild Gallery, Dallas, TX. Awarded Best Wildlife & Best Big Game, Ducks Unlimited Mid-West Wildlife Show. Bronze Medal at the Cowboy Hall of Fame Wildlife Show. Kansas City Art Directors Award of Merit; Society of American Artists Award of Merit for Sculpture. Taught: Kansas City Art Institute. Illustrated for *Readers Digest, Sports Afield, Literary Guild*, Avon Books, *The Saturday Evening Post*, numerous others. Address in 1983, El Dorado Springs, MI.

ANDERSON, DOROTHY VISJU.
Sculptor, painter, teacher, and writer. Born in Oslo, Norway. Studied at Art Institute of Chicago, and with William M. Chase. Member: California Art Club. Awards: Prize, Springfield, IL; medal, Los Angeles Museum of Art, 1937. Work: Vanderpoel College. Exhibited: Salon d'Automne, Paris; Art Institute of Chicago; San Diego Fine Art Society; Tilton School, Chicago; Los Angeles Museum of Art, and extensive exhibitions abroad. Among many portraits are those of President Franklin D. Roosevelt; Countess du Nord, Paris, France, and Lt. Col. Percy, Chicago. Address in 1953, Hollywood, CA.

ANDERSON, ERNFRED.
Sculptor. Born in Esperod, Sweden, August 28, 1896. Studied: Societe Industrielle de Lausanne. Member: Brooklyn Painters and Sculptors; Brooklyn Art Society; Scandinavian American Artists; Elmira Art Club. Awards: Prize, Swedish Club, Chicago; Work: Monuments, Elmira, Horseheads, NY. Exhibited: National Sculpture Society, 1935-40; National Academy of Design, 1933-35; Rochester Memorial Art Gallery; Swedish Club. Author: "Public Art in Elmira," 1941. Position: Director, Arnot Art Gallery, from 1943. Taught: Instructor, Elmira College, NY. Address in 1953, Elmira, NY.

ANDERSON, F. W.
Sculptor, painter, and craftsman. Born Sweden, August 28, 1896. Member: Brooklyn Painters and Sculptors; Brooklyn Society of Artists; Scandinavian American Artists. Address in 1929, Brooklyn, NY.

ANDERSON, HENDRICK CHRISTIAN.
Sculptor. Born Bergen, Norway, 1872; family moved to United States, settling at Newport, RI, 1873; studied art and architecture at Boston, Paris, Naples, Rome. Principal works: "Fountain of Life," "Fountain of Immortality," "Jacob Wrestling with the Angel," "Study of an Athlete," etc.

ANDERSON, JACOB S.
Figurehead carver. In NYC, 1830-57. Partner, Jacob Anderson & Co. 1830-33; Dodge & Anderson 1845; J. S. Anderson & Son, 1856-57. Died probably in 1857.

ANDERSON, JAMES P.
Sculptor. Born in Tulsa, OK, March 30, 1929. Studied: Eastern New Mexico University, B.A., 1954; Hardin-Simmons, M.A., 1960; Vanderbilt, Ed.D., 1965. Visited Italy in 1973 and 74, where his bronze Benjamin Franklin was cast. Represented by work in Columbus, OH; Museum of Modern Art, Milan, Italy; and in Iowa, Arizona, California, Kentucky, and Australia. Has exhibited at galleries and museums in Milan; Scottsdale, AZ; Davenport, IA. Professor and chairman of Art Dept., Northern Arizona University, from 1974. Works in marble; subjects include Western. Represented by Maxwell Gallery, Ltd., San Francisco; Ianuzzi Gallery, Scottsdale, AZ. Address in 1982, Davenport, IA.

ANDERSON, JEREMY RADCLIFFE.
Sculptor. Born October 28, 1921, Palo Alto, CA. Studied: San Francisco Art Institute, with David Park, Clyfford Still, Robert Howard, Mark Rothko, S. W. Hayter, Clay Spohn, 1946-50. Work: University of California; Museum of Modern Art; Pasadena Art Museum; San Francisco Museum of Art. Exhibited: Metart Gallery, San Francisco, 1949; Allan Frumkin Gallery, Chicago, 1954; The Stable Gallery, 1954; Dilexi Gallery, San Francisco, 1960-62, 1964, 66; San Francisco Museum of Art Annual, 1948, 49, 51-53, 58, 59, 63 and retrospect in 1966; Whitney Annual, 1956, 62, 64; Whitney, Fifty California Artists, 1962-63; Kaiser Center, Oakland, California Sculpture, 1963; Musee Cantonal des Beaux-Arts, Lausanne, II Salon International de Galeries Pilotes, 1966; Los Angeles County Museum of Art, American Sculpture of the Sixties, 1967. Awards: San Francisco Museum of Art, Edgar Walter Memorial Prize, 1948; Abraham Rosenberg Foundation Traveling Fellowship, 1950; San Francisco Art Association, Sculpture Prize, 1959. Taught: San Francisco Art Institute, from 1958. Address in 1982, Mill Valley, CA.

ANDERSON, JESSIE SYLVESTER.
Sculptor. Born in Bearlake, Michigan. Exhibitions: Salon des Artistes Francais, 1922.

ANDERSON, JOHN K.
Sculptor, painter, and architect. Born in Buffalo, NY, De-

cember 31, 1904. Studied at Cornell University College of Architecture. Member: Buffalo Society of Architects. Exhibited: Albright Art Gallery, 1937-44; Buffalo Society of Architects, 1942-46, 50, 51. Address in 1953, Buffalo, NY.

ANDERSON, JOHN S.
Sculptor. Born April 29, 1928, in Seattle, Washington. Studied: Art Center School, Los Angeles, 1953-54; Pratt Institute, 1954-57, with Calvin Albert. Work: Museum of Modern Art. Exhibited: Allan Stone Gallery, 1962, 1964, 65, 67; Whitney, 1964, Sculpture Annual, 1965, 67, 69; World House Galleries, NYC, 1965. Awards: Guggenheim Foundation Fellowship, 1966, 67. Taught: Pratt Institute, 1959-62; School of Visual Arts, NYC, 1968-69; University of New Mexico, 1969. Address in 1982, Asbury, NJ.

ANDERSON, PETER BERNARD.
Sculptor. Born in Sweden in 1898. Pupil of J. K. Daniels. Address in 1926, St. Paul, Minn.

ANDERSON, TENNESSEE MITCHELL.
Sculptor. Born Jackson, Mich. Member: Art Club of Chicago; Chicago NJ Society of Artists; Romany Club. Address in 1929, Chicago, Ill.

ANDRE, CARL.
Sculptor. Born September 16, 1935, Quincy, Mass. Studied with Patrick Morgan, Frank Stella. Exhibited: Tibor de Nagy Gallery, 1965, 1966; Dwan Gallery, Los Angeles and NYC; Konrad Fischer Gallery, Dusseldorf, 1967; Galerie Heiner Friedrich, Munich; Jewish Museum, Primary Structures, 1966; Los Angeles County Museum of Art, American Sculpture of the Sixties, 1967; Documenta IV, Kassel, 1968; The Hague, Minimal Art, 1968; Museum of Modern Art, 1968, 73; Guggenheim Museum, 1970; St. Louis Art Museum, 1971. In collections of Museum of Contemporary Art, Chicago; Aldrich (Ridgefield, CT) Museum; Brandeis University; Albright-Knox Art Gallery, Buffalo, NY; Art Institute of Chicago. Awards: National Council on the Arts, 1968. Represented by Paula Cooper, NYC. Address in 1982, New York City.

ANDREI, GIOVANNI
Sculptor. Born in Carrara, Italy, 1770. Worked: Washington, Baltimore, 1806-c. 1815. In Italy c. 1815. Died in Washington, 1824.

ANDREWS, J. A.
Sculptor. Active 1865. Patentee—Soldiers Monument, 1865.

ANDREWS, OLIVER.
Sculptor. Born June 21, 1925, Berkeley, Calif. Studied: University of Southern California, 1942; Stanford University, 1942-43, 1946-48, BA; University of California, Santa Barbara, 1950-51; with Jean Helion, Paris, 1948-49. Work: Los Angeles County Museum of Art; San Francisco Museum of Art; Santa Barbara Museum of Art. Exhibited: Santa Barbara Museum of Art, 1950, 56, 63; The Alan Gallery, New York City, 1955, 59, 61, 66; Gallery Eight, Santa Barbara, 1961; Municipal Art Gallery, Los Angeles (two-man), 1963; David Stuart Gallery, 1967; Los Angeles County Museum of Art, 1953, 56, 57, 59, 61;

Whitney Annual; Art Institute of Chicago Annual; Museum of Modern Art, Recent Sculpture USA, 1959; Wadsworth Atheneum, Smallscale Sculpture, 1960; San Francisco Museum of Art Annual, 1960, 61, 63, 66; Guggenheim, The Joseph H. Hirshhorn Collection, 1962; Whitney, Fifty California Artists, 1962-63; Albright, Contemporary Sculpture, 1963. Awards: Los Angeles County Museum of Art, 1957, 61; County MA, 1957, 61; University of California Institute for Creative Work in the Arts, Travel Fellowship, 1963. Address in 1976, Santa Monica Canyon, CA.

ANDRIEU, JULES.
Sculptor and painter. Born in New Orleans, LA, March 1844. Pupil of Ernest Ciceri of Paris, France. Address in 1910, P.O. Box 74, Pass Christian, Miss.

ANDRUS, ZORAY.
Sculptor, painter, designer, craftsman, and illustrator. Born in Alameda, CA, April 27, 1908. Studied at California College Arts and Crafts, BA; University California, with Hans Hofmann; Mills College, with Alexander Archipenko. Member: California Water Color Society. Awards: Prize, Denver Art Museum, 1942. Exhibited: Reno, Nevada, 1943; Virginia City, Nevada, 1945; San Francisco Art Association, 1943-45; Denver Art Museum, 1941, 42; California Water Color Society, 1942-44; Elko, Nevada, 1948; Carson City, Nevada, 1952. Work: murals, Veterans Hospital, Reno, Nevada. Address in 1953, Virginia City, Nevada.

ANGEL, JOHN.
Sculptor, teacher, lecturer, and illustrator. Born in Newton Abbott, Devon, England, November 1, 1881. Studied at Albert Memorial, Cheltenham and Royal Academy Art Schools, England. Member: Academician of National Academy of Design; F., Royal Society British Sculpture; Artist Workers Guild; National Sculpture Society; Architectural League. Awards: Landseer Scholarship, two silver medals, gold medal and traveling scholarship, 1907, 1911; Litt. D., honorable degree, Columbia University, 1936. Work: Sculpture, St. John the Divine Cathedral, NY; statues: Vincennes, IN, Chicago, IL, St. John's Church, Youngstown, OH (5), Archbishop Williams H. S., Braintree, MA; St. Patrick's Cathedral, NY, and others at Concord, NH, Austin, TX, Rice Institute, Houston, TX; panels: East Liberty Presbyterian Church, Pittsburgh, PA; St. Paul's School, Concord, NH. War memorials at Exeter, Bridgewater and Rotherham, England. Exhibited: Royal Academy London, 1912-27; Penna. Academy of Fine Arts, 1938. Illustrated, article on Cathedral Sculpture in "The Cathedral Age." Lectures on sculpture. Address in 1953, Sandy Hook, CT. Died in 1960.

ANGELA, EMILIO.
Sculptor. Born in Italy, July 12, 1889. Studied at Cooper Union, Art Students League, National Academy of Design, and was pupil of A. A. Weinman. Membership, National Sculpture Society, American Federation of Fine Arts, New York Architectural League. Works: "Goose Boy," "Barking Seals," "Boxer," "Goose Girl," "Baby Angela," "Mirthfulness," figures, bronzes, fountains.

Awards: First prize for composition, second prize for sculpture, National Academy of Design. Exhibited at National Sculpture Society, 1923. Address in 1953, Chatham, NJ. Died 1970.

ANGELL, TONY.
Sculptor and painter. Born in Los Angeles, CA, November 15, 1940. Studied at University of Washington, BA, 1962. Exhibited: University of Washington, 1972; James Ford Bell Museum, Minneapolis, 1974; Royal Ontario Museum, Toronto, 1975-76; Tacoma Art Museum, Washington, 1979; and others. Taught: Guest lecturer of sculptural interpretation and illustration at the University of Washington Society of Illustrators, 1979. Media: Oils, pen and ink, and marble. Address in 1982, Seattle, WA.

ANGELO, VALENTI.
Sculptor, painter, illustrator, engraver, designer, and writer. Born in Massarosa, Italy, June 23, 1897. Member: American Institute of Graphic Arts. Work: Library of Congress; NY Public Library; Daniel Estate, Bristol, VA. Exhibited: Penna. Academy of Fine Arts; Gump's Gallery, San Francisco; Dalzell-Hatfield Gallery, Los Angeles; Ferargil Gallery. Author, I., "Nino;" "Golden Gate;" "Paradise Valley;" "Look Out Yonder;" " The Rooster Club;" "The Bells of Bleecker Street;" "The Marble Fountain," 1951; "A Battle in Washington Square." Address in 1953, Bronxville, NY.

ANGMAN, ALFONS JULIUS.
Sculptor, painter, and writer. Born in Stockholm, Sweden, January 14, 1883. Self-taught. Member: College Art Association; American Federation of Arts. Address in 1933, Oklahoma City, Okla.

ANISFELD, BORIS ISRAELEVICH.
Sculptor and painter. Born in Russia, 1879. Address in 1934, Chicago Ill. (Mallett's)

ANKER, SUZANNE C.
Sculptor. Born in Brooklyn, NY, August 6, 1946. Studied at Brooklyn College, B.A.; University of Colorado, M.F.A. Work in St. Louis Art Museum, MO; Denver Art Museum, CO; and others. Has exhibited at New Ways With Paper, National Collection of Fine Arts, Smithsonian Institute, Washington, DC; Walker Art Center, Minneapolis; and others. Works in paper and stone. Address in 1982, 101 Wooster St., NYC.

ANNESLEY, (ROBERT H.) BOB.
Sculptor, painter, and printmaker. Born in Norman, OK, 1943. Studied: University of Oklahoma and Oklahoma City University, fine arts. Numerous shows and awards. One-man retrospective given by Cherokee Nation, 1976. Artist reviewed in *Southwest Art*, June 1981. Prints published by Annesley & Associates. Represented by Art Market, Tulsa, OK; Indian Paintbrush Gallery, Siloam Springs, AR. Specialty: Western and Cherokee subjects. Media: Bronze; silverpoint and 24 karat goldpoint, watercolor, mixed media. Address since 1966, Houston, TX.

ANNIBALE, GEORGE OLIVER.
Portrait sculptor. Born about 1829. Executed medallion heads and cameos. He had a studio in the Hoppin Build-

ing in Providence, RI, and in 1850 cut a cameo portrait of Dr. Nathan B. Crocker, the rector of St. John's Church. In 1852 cameos were exhibited by Annibale and were described as "capital likenesses and finely executed." He received a silver medal, the highest premium for portrait busts in marble and cameos. Besides the portraits of Dr. Chapin, Mr. Chapin, and Dr. Crocker, Annibale cut a cameo likeness of James S. Lincoln, the portrait painter. Annibale's cameo portraits are cut in shell and were usually about an inch and a half tall. Died April 22, 1887, in Brooklyn, NY.

ANNIS, NORMAN L.
Sculptor and administrator. Born in Des Moines, IA, May 26, 1931. Studied at the University of Northern Iowa, BA, 1953; Drake University; University of Iowa, MFA, 1959. Work at St Paul Art Center, Minn.; Corcoran Gallery of Art, Washington, DC; and others. Has exhibited at St. Paul Art Center, Minn., 1961 and 63; Washington Area Artists Series, Corcoran Gallery of Art, Washington, DC, 1965. Taught at Gettysburg College, 1960-78, professor of sculpture; Southwest Missouri State University Springfield, from 1978, head of art department. Received awards from St. Paul Art Center, 1963, Purchase Award; Corcoran Gallery of Art, 1963, Anna Hyatt Huntington Award. Works in bronze, and welded steel. Address in 1982, Springfield, MO.

ANSON, LESIA.
Sculptor. Born Kassel, West Germany, January 14, 1946; US citizen. Studied: Westchester Community College, NY, AAS Degree; Art Students League, NYC. Exhibited: National Association of Women Artists; Society of Animal Artists; Allied Artists; Audubon Artists; Salmagundi Art Club; Catherine Lorillard Wolfe Art Club; Hudson Valley Art Association; National Academy of Art, NYC; Academy of Natural Sciences, Philadelphia, PA; National Arts Club, NYC; Lever House Gallery, NYC; and others. Awarded: Bronze medal, Anna Hyatt Huntington Award, 1977, bronze medal, Award of Merit, 1980, both from the Society of Animal Artists; Excalibur Award, Knickerbocker Artists, 1980. Member: Society of Animal Artists; National Association of Women Artists; Catherine Lorillard Wolfe Art Club; New York Artists Equity. Media: Marble and stone. Represented: Gallery Madison 90, NYC. Address in 1984, 60 East 83rd Street, NYC.

ANTHONISEN, GEORGE RIOCH.
Sculptor. Born in Boston, MA, July 31, 1936. Studied at University of Vermont, B.A., 1961; National Academy of Design, 1961-62; Art Students League, 1962-64. Work in Carnegie Hall, NYC; Chrysler Museum, Norfolk, VA; numerous commissions. Has exhibited at Allied Artists of America show, 1970, 81; National Sculpture Society, 1972-79; Audubon Artists, Inc., 1979; others. Received Suydam Bronze Medal, National Academy of Design, 1968. Member of the National Sculpture Society. Works in bronze, aluminum, and stainless steel. Address in 1982, Solebury, PA.

ANTOGNILLI, DAVID.
Sculptor. At New Orleans, 1853.

ANTONAKOS, STEPHEN.
Sculptor. Born November 1, 1926, in Greece. Came to USA in 1930. Studied: Brooklyn (NY) Community College. Work: Finch College; University of Maine; Miami Museum of Modern Art; Milwaukee; University of North Carolina; Aldrich; Museum of Modern Art; Guggenheim; Whitney. Exhibited: Avant Garde Gallery, NYC, 1958; Schramm Galleries, Fort Lauderdale, Fla., 1964; Fischbach Gallery, New York City, 1967-70, and 72; Eindhoven, Holland, Kunst-Licht-Kunst, 1966; Kansas City, Sound, Light, Silence, 1966; Whitney, 1966, 68-70; Carnegie, 1967; Trenton, NJ, Focus on Light, 1967; UCLA, 1969; A Shade of Light, San Francisco Museum of Art, 1978; Minimal Tradition, Aldrich Museum of Contemporary Art, Ridgefield, CT. Received the NY State Creative Artists Public Service Program Award; Individual Artist's Grant, National Endowment for the Arts. Address in 1982, 435 West Broadway, New York City.

ANTONOVICI, CONSTANTIN.
Sculptor and lecturer. Born in Neamt, Romania, February 18, 1911. United States citizen. Studied at Fine Arts Academy, Romania, MA; Fine Arts Academy, Vienna, Austria, with Professor Fritz Behn, 1942-45; with Constantin Brancusi, Paris, 1947-51. Work in Le Salon des Artistes Independants, Paris; Museum of Fine Arts, Montreal; Cathedral of St. John the Divine, NY; and others. Has exhibited at New Jersey Museum of Art Annual, 1964; National Sculpture Society Annual Exhibition, NY, 1971-81; and others. Member of the National Sculpture Society (fellow). Works in marble, bronze, and wood. Address in 1982, 310 West 106th Street, New York, NY.

ANTONOW, WILLIAM.
Sculptor. Born in Detroit, MI, 1941. Studied: Wayne State University, M.A. Exhibitions: Michigan Artists Exhibition, The Detroit Institute of Arts, 1966, 69, 71; Willis Gallery, Detroit, 1972; All Michigan II, The Flint Institute of Arts, 1973; Detroit Bank and Trust Artists Invitational, 1974. Awards: Jurors' Citation, All Michigan II, 1973. Member: Society of Arts and Crafts. Address in 1975, Detroit, MI.

APEL, MARIE.
Sculptor. Born in England, 1888. Member of National Association of Women Painters and Sculptors; Societe International des Beaux-Arts et des Lettres, Paris. Exhibited at National Sculpture Society, 1923. Work: bronze portrait statue of Chin Gee Hee, Hong-Kong, China; stone spandrel figures, Bagshot Park, England; fountain group in stone, England; P. T. Morgan memorial, San Francisco, Calif.; Sleicher memorial, Troy, NY; Langdon memorial, Augusta, GA; Gardner memorial, Easthampton, LI; Malo memorial, Denver, CO; marble and bronze fountain, Pasadena, Calif.; Hodges Memorial, St. Paul's Church, Baltimore, MD. Address in 1926, 3 Washington Square, New York.

APPEL, ERIC A.
Sculptor. Born in Brooklyn, NY, December 26, 1945. Studied at Pratt Institute, 1963-67, B.I.D., 1967; Tyler School of Art in Rome, 1967-68; Tyler School of Art, Temple University, Philadelphia, PA, 1967-70, M.F.A.

(painting), 1970. Has exhibited at Museum of Contemporary Crafts, NY; Gardens of Delight, Cooper-Hewitt Museum, NY; and others. Represented by Yves Arman Gallery, NYC. Address in 1982, 102 Christopher St., NYC.

APPEL, JACK.
Sculptor. Born in NYC, October 28, 1915. Studied at NY University; Beaux-Arts Institute of Design; and with Cecere, Snowden, Manship, Piccirilli. Member: National Sculpture Society; honorable member Australian Fauna Preservation Society. Specialized in sculpture of Australian animals. Address in 1953, 308 West 47th St.; h. 674 West 161st St., NYC.

APPEL, KAREL.
Sculptor and painter. Born in Amsterdam, Holland, April 25, 1921. Study: Royal Academy of Fine Arts, Amsterdam, 1940-43. Work: Tate Gallery, London; Museum of Modern Art, NYC; Stedelijk Museum, Amsterdam; Museum of Fine Arts, Boston. Comn.: Numerous in Amsterdam, Rotterdam, The Hague, Holland. Exhibition: Studio Fachetti, Paris, 1954; Stedelijk Museum, Amsterdam, 1962; Guggenheim Foundation Works, NYC, 1969; Kunsthalle, Basel, Switzerland, 1969; Canadian museums, 1972-73; retrospectives in Mexico City, Caracas, Venez., Bogota, Colombia, Germany, and Holland. Awards: UNESCO Prize, International Biennale, Venice, 1954; International Painting Prize, 5th Sao Paulo Biennale, 1959; 1st Prize, Painting, Guggenheim International Exhibition, NYC, 1960. Media: Acrylic; aluminum, and wood. Address in 1982, c/o Martha Jackson Gallery, NYC.

APPLEGATE, FRANK G.
Sculptor and painter. Born in Atlanta, Ill., Feb. 9, 1882. Studied under Frederick at the University of Illinois, under Grafly at the Penna. Academy of Fine Arts, and in Paris under Verlet. Exhibited water colors at Penna. Academy of Fine Arts, Philadelphia, 1925. Member: New Mexico Painters; Santa Fe Artists. Address in 1926, Santa Fe, New Mexico. Died in 1931.

APPLETON, ELIZA B.
(Mrs. Everard Appleton). Sculptor. Born November 9, 1882. Studied with M. Ezekiel in Rome. Member of the Providence Art Club. Address in 1933, Providence, RI.

ARCHIPENKO, ALEXANDER.
Sculptor, painter, illustrator, etcher, craftsman, and teacher. Born Kiev, Ukraine, May 30, 1887. Studied at Ecole des Beaux-Arts, Kiev, 1902-05; Moscow, 1906-08. Exhibited in Moscow, 1906; at Salons in Paris, where he arrived in 1908; and in major cities in Europe and US until his death. Travelled to Berlin, 1920-23; came to US in 1924. Founded Archipenko Art School, NYC; Ecole d'Art in NY, 1924; also taught at Art Students League, NYC; Chouinard Art Institute, LA, CA, 1933; Mills College, 1933, 34; Bauhaus, Chicago, 1937. Invented "animated painting," known as "Archipentura;" figured significantly in Cubist movement in his early years. Represented in Museums in Osaka, Japan; Frankfort, Mannheim, Leipzig, Hanover, Essen, Hamburg, Germany;

Vienna; Rotterdam; Kiev; Moscow; National Gallery, Berlin; Brooklyn, NY; Guggenheim, NYC; Museum of Modern Art, Paris; and others. Address in 1953, 1947 Broadway; h. 624 Madison Avenue, NYC; summer, Woodstock, NY. Died February 25, 1964.

ARDISSON, GAITAN.
Sculptor. Born in Italy; died in Milford, Conn., November 11, 1925. (Mallett's)

ARMAN, ARMAND.
Sculptor. Born in Nice, France, November 17, 1928. US citizen. Studied at Ecole de Louvre; Ecole Nationale des Arts Decoratifs. Co-founder, Groupe des Nouveaux Realistes, 1960, and L'Ecole de Nice, 1961. In collections of Stedelijk Museum, Amsterdam; Brussels; Albright-Knox; Museum of Modern Art; museums in Cologne, Eindhoven (Holland), Paris, Helsinki, Copenhagen, Munich, Rome, Stockholm, Venice. Exhibited in many galleries in US and abroad, including Galerie du Haut Pave, Paris, 1956; Gallera Apollinaire and Galleria Schwarz, Milan; Cordier and Warren, NYC, 1961; Dwan Gallery, Los Angeles; Janis Gallery, NYC; Feigen Gallery, Chicago; XXXIV Venice Biennial, 1968; retro. at Stedelijk Museum, Palais des Beaux-Arts, Brussels; galleries in Paris, Gstaad and Lausanne in Switzerland, Venice, Stockholm, Brussels. Awards: IV International Biennial Exhib. of Prints, Tokyo, 2nd prize, 1964; Premio Marzotto, 1966. Address in 1982, 380 West Broadway, NYC.

ARMIN, EMIL.
Sculptor and painter. Born in Radautz, Rumania, April 1, 1883. Studied at Art Institute Chicago. Award: Silver medal, Chicago Society of Artists, 1932. Member: Chicago Society Artists; Chicago No-Jury Society Artists; Ten Artists (Chicago). Address in 1933, Chicago, Ill.

ARMSTRONG, J. CHESTER.
Sculptor. Born in Berkeley, CA, 1948. Traveled to Central America; moved to Vermont, where he worked with wood and learned to use tools in the pioneer style; settled in the Pacific Northwest. Exhibits personally and at Rendezvous Gallery, Anchorage, Alaska; Ace Powell Gallery, Kalispell, MT. Reviewed in *Southwest Art*, April, 1980. Executes wildlife subjects in wood. Address in 1982, Sisters, OR.

ARMSTRONG, J. S.
Sculptor. Active 1866-67. Patentee—Military Monuments, 1866 and 1867.

ARMSTRONG, JANE BOTSFORD.
Sculptor. Born in Buffalo, NY, February 17, 1921. Studied at Middlebury College; Pratt Institute; Art Students League, with Jose De Creeft. Works: Hayden Gallery, Mass. Institute of Technology; Columbus Gallery of Fine Arts, OH; New Britain Museum of American Art, CT; Worcester Polytechnic Institute, MA; Montefiore Hospital, Bronx. Commissions: Three marble animals, World of Birds, NY Zoological Society, Bronx, 1972; large white marble free-form, Research Triangle Institute, Research Triangle Park, NC, 1974. Exhibitions: One-woman shows, Frank Rehn Gallery, NY, 1971, 73, and 75, Columbus Museum of Fine Arts, OH, 1972, North Carolina

Museum of Art, Raleigh, 1974, and Columbia Museum of Art, SC, 1975; Critics Choice, Sculpture Center, NY, 1972. Awards: Gold Medal, National Arts Club, NY, 1968, 69, and 72; Medal of Honor, Audubon Artists, NY, 1972; Council of American Artists Society Prize, National Sculpture Society, NY, 1973. Address in 1983, Highland Beach, FL.

ARNESON, ROBERT.
Sculptor. Born in Bernicia, CA, September 4, 1930. Studied at California College of Arts and Crafts, Oakland, B.A., 1954; Mills College, M.F.A., 1958. Teaching at University of California, Davis, from 1962. In collections of Oakland Art Museum; National Museum of Modern Art, Kyoto, Japan; San Francisco Museum of Modern Art; others. Exhibited at Oakland Art Museum; Allan Stone Gallery, NYC; San Francisco Museum of Art; Museum of Contemporary Art, Chicago; Allan Frumkin Gallery, NYC and Chicago; Museum of Contemporary Crafts, NYC; Museum of Modern Art; Smithsonian, Washington, DC; Whitney, NYC; National Museum of Modern Art, Kyoto, Japan; Everson Museum, Syracuse; Stedelijk Museum, Amsterdam; and others. Works in clay and ceramic. Represented by Hansen-Fuller-Goldeen Gallery, San Francisco, CA. Address in 1982, Art Dept., University of California, Davis.

ARNETT, ELEANOR.
Sculptor. Born in 1895. Address in 1935, Philadelphia, PA. (Mallett's)

ARNOLD, BERNARD.
Sculptor. At San Francisco, 1858.

ARNOLD, ELDRIDGE.
Sculptor. Studied: Maryland Institute of Art, 1948-51; Cranbrook Academy of Art, Bloomfield Hills, Mich. Member: Society of Animal Artists. Exhibitions: 6 Best-of-Shows at various competitions across U.S.A.; National Audubon Society, NY, 1976; Leigh Yawkey Woodson Art Museum; Cape Cod Museum of Natural History. Prizes: Design Medal, Cranbrook Academy of Art. Media: Wood. Specialties: Birds. Address in 1983, Greenwich, Conn.

ARNOLD, NEWELL HILLIS.
Sculptor, craftsman, teacher, etcher, and lithographer. Born in Beach, North Dakota, July 10, 1906. Studied at University Minnesota, BA; Minneapolis School of Art; Cranbrook Academy of Art, with Carl Milles. Member: St. Louis Artists Guild; Minn. Sculptors Group; Artists Equity Association; Group 15, St. Louis. Work: City Art Museum of St. Louis; Walker Art Center; Monticello College; University Minnesota; Minn. Dept. Health; US Post Office, Abingdon, IL; World War II Memorial, St. Louis, MO; St. Anne's Church, Normandy, MO. Exhibited: Architectural League, 1937; NY World's Fair, 1939; City Art Museum of St. Louis; Wichita, KS; Artists Guild. Taught: Institute, Sculpture, Ceramics, Monticello College, Godfrey, IL, from 1938. Address in 1953, Godfrey, IL.

ARNOLD, PANSY DAVIS.
Sculptor. Born in Winfield, Missouri. Exhibited: Salon

des Artistes Francais, 1931, and 1932.

ARONSON, CYRIL (MISS).
Sculptor, painter, designer, teacher, and lecturer. Born in Boston, MA, June 13, 1918. Studied at Wayne University, BA, MA. Member: Detroit Society of Women Painters and Sculptors; Detroit Water Color Society. Awards: Prizes, Detroit Society of Women Painters and Sculptors, 1941, 43. Exhibited: Art Institute of Chicago, 1941; Michigan Art, 1940, 41, 44, 45; Detroit Society of Women Painters and Sculptors, 1941-45. Address in 1953, Detroit, MI.

ARONSON, DAVID.
Sculptor and painter. Born in Shilova, Lithuania, October 28, 1923. US citizen. Study: School of Museum of Fine Arts, Boston, with Karl Zerbe, 1945; National Society of Arts and Letters Grant, 1958; Guggenheim Fellow, 1960. Work: Atlanta University; Museum of Fine Arts, Boston; Bryn Mawr; Art Institute of Chicago; Whitney Museum; Metropolitan Museum of Art; Smithsonian Institute Exhibition; Metropolitan Museum of Art, Museum of Modern Art, Whitney, NYC; Zappeion, Athens; Musee d'Arte Moderne, Paris; 1964 World's Fair, and others. Awards: Boston Institute of Contemporary Art, 1944; Boston Arts Festival, 1952-54; National Academy of Design, 1973-75. Teaching, Boston Museum of Fine Arts School, 1943-54; Boston University, 1954-63. Medium: Bronze. Address in 1982, Sudbury, MA.

ARONSON, SANDA.
Sculptor. Born NYC, February 29, 1940. Study: SUNY Oswego, BS, 1960; with Jose De Creeft, Paul Pollaro, New School for Social Research, NYC; Tulane University, New Orleans; Art Students League, NY. Exhibitions: Women Self Image, Women's Interart Center, NYC, 1974; Women Showing/Women Sharing, US Military Academy, West Point, NY, 1975; Works on Paper, Brooklyn Museum, NY, 1975. Exhibited for Women Artists, Manhattan Community College for Performing Arts, 1975; travelling show, Fairleigh Dickinson University, Chatham College, SUNY Binghamton, 1976; Four Artists, Women in the Arts Foundation, NYC, 1976; Nine/Plus or Minus, US Military Academy, 1977, and Arsenal Gallery of NYC, 1978; NY/Artists Equity Association, NYC, 1980; Artists in Res. Gallery, NYC, invitation show, 1981. Awards: Honorable mention, Sculpture, Women Showing/Women Sharing, US Military Academy, West Point, New York, 1975. Member: Women in the Arts Foundation, Board Member-at-large, NYC, 1975-76; NY Artists Equity Association. Commission: Handprinted editions, woodcuts by Clem Haupers, 1982. Published: Frontispiece, *Hear the Wind Blow*, John Beecher, International Publishers, NYC, 1968, woodcut. Teaching: Artist-in-Residence, New York Foundation for the Arts, 1977-79. Media: Clay, pen & ink drawing, woodcut. Address in 1983, 70 West 95th St., NYC.

ARTHUR, REVINGTON.
Sculptor, painter, illustrator, and teacher. Born in Glenbrook, Conn. Studied with K. Nicolaides, G. P. Ennis, A. Gorky, etc. Member: American Water Color Society; Sa-

lons of America; Darien Guild of Arts. Address in 1970, Glenbrook, Conn.

ARTIS, WILLIAM ELLISWORTH.
Sculptor. Born in Washington, North Carolina, Feb. 2, 1914. Studied at Alfred University; Syracuse University; Penna. State University. Work in Walker Art Center, Minneapolis; Slater Memorial Museum, Norwich, CT. Has exhibited at Joslyn Art Museum; National Sculpture Society; Whitney; others. Member of American Ceramic Society; National Sculpture Society; others. Address in 1976, Mankato State College, MN. Died in 1977.

ARTSCHWAGER, RICHARD ERNEST.
Sculptor and painter. Born December 26, 1924, in Washington, DC. Studied: Privately with Amedee Ozenfant; Cornell University, BA. Work: Nelson Gallery, Kansas City; Museum of Modern Art; Milwaukee; Aldrich; Art Institute of Chicago; Whitney. Received National Endowment for the Arts Award, 1971. Exhibited: Leo Castelli Inc., 1965, 67; Albright, 1964; Dwan Gallery, Boxes, 1964; Guggenheim, 1966; Whitney, Contemporary American Sculpture, 1966, Sculpture Annual, 1966, 68; Museum of Modern Art, The 1960's, 1967; Documenta IV, Kassel, 1968 and 72; Berne, When Attitudes Become Form, 1969; Herron, 1969; York University, Toronto, 1969; Hayward Gallery, London, 1969; Milwaukee, Aspects of a New Realism, 1969; La Jolla Museum of Contemporary Art, CA, 1980. Represented by Leo Castelli Gallery, New York City. Living in Charlotteville, NY, in 1982.

ARUM, BARBARA (MANDELBAUM).
Sculptor. Born in Des Moines, IA, October 9, 1937. Studied at Scarsdale Art Studio, with Raymond Rocklin; Silvermine Guild of Artists, with Vincent Leggiadro and Jane Colburn; Educational Alliance, with Chaim Gross; State University of NY, Purchase, with Phillip Listengart; with Anthony Padavano. Has exhibited at Knickerbocker Artists, NY; Berkshire Museum, Pittsfield, MA; Allied Artists of America, NY; others. Work: "Vertical Maze," welded stone. Received Certificate of Merit, Salmagundi Club, 1980; others. Member of National Association of Women Artists; American Society of Contemporary Artists; NY Artists Equity Association. Works in wood and steel. Address in 1983, Scarsdale, NY.

ARYE, LEONORA.
Sculptor. Born in NYC, May 22, 1931. Studied at Art Students League, 1964-66; with Hana Geber, 1965-70; with Lorrie Goulet, 1970-72; University of Mexico. Work at Albany Institute of History and Art, NY; Museum of Art, Bogata, Colombia; Jewish Community Center, Harrison, NY. Has exhibited at Hudson River Museum, Yonkers, NY; Silvermine Guild of Artists, New Canaan, CT; Salmagundi Club, NY; National Association of Women Artists, City Gallery, NY; others. Awards: Kellner Award, National Association of Women Artists, 1980; Purchase Award, Sculpture Society, 1981. Member of National Association of Women Artists; American Society of Contemporary Artists; Silvermine Guild of Artists. Address in 1983, Harrison, NY.

ASAWA, RUTH (LANIER).
Sculptor and painter. Born in Norwalk, California, January 27, 1926. Studied at Milwaukee State Teachers College; Black Mountain College with Josef Albers. Exhibited: Whitney Museum of American Art, 1955, 56, 58; Museum of Modern Art, 1958; San Francisco Museum of Art, 1954, 63, 73; one-woman shows include the De Young Memorial Museum, San Francisco. Address in 1982, San Francisco, CA.

ASBJORNSEN, SIGVALD.
Sculptor. Born in Christiania, Norway, 1867. Pupil of B. Bergslieu and M. Skeibrok, Middeltun. Address in 1910, Chicago, IL.

ASCHENBACH, (WALTER) PAUL.
Sculptor and educator. Born in Poughkeepsie, NY, May 25, 1921. Studied at Rhode Island School of Design, 1940-41; with Randolph W. Johnson, Deerfield, MA, 1942-45; I. Marshall, Philadelphia, 1946-48. Work in Sculpture Park, St. Margarethen, Austria; De Cordova, Lincoln, MA; Bundy Art Gallery, Waitsfield, VT; forged mild steel crucifix, Trinity College, Burlington, VT; and others. Teaching art at University of Vermont, from 1956. Works in steel and marble. Address in 1982, Charlotte, VT.

ASHER, ELISE.
Sculptor. Born in Chicago, Illinois, January 15, 1914. Studied at Art Institute of Chicago; Bradford Junior College; Boston College, BS, summers. Works: NY University Art Collection; University of Calif. Art Museum, Berkeley; Rose Art Museum, Brandeis University; Geigy Chemical Corporation; First National Bank of Chicago. Commissions: Oil on Plexiglas window, commission by Dr. John P. Spiegel, Cambridge; cover for Poetry Northwest, autumn-winter 1964-65; cover for The Chelsea, No. 27, 1970; jacket for Stanley Kunitz, *The Testing-Tree*(poems), Little, Brown, 1971. Exhibitions: One-woman retrospective, Bradford Junior College, 1964; one-woman shows, the Contemporaries, NY, 1966, and Bertha Schaefer Gallery, NY, 1973; Lettering, traveling show, Museum of Modern Art, NY, 1967; The Word as Image, Jewish Museum, NY, 1970; plus many other one-woman and group shows. Media: Multi-layered densities in oil and enamel. Address in 1982, 37 West 12th Street, NYC.

ASHER, JAMES.
Sculptor, painter, and printmaker. Born in Butler, MO, 1944. Studied: Central Missouri University; Art Center School, Los Angeles. Travels to Mexico and Mediterranean. Exhibits: Trailside Galleries, Scottsdale, AZ. Reviewed in *Southwest Art*, October 1980. Specialty: Subjects of Southwest Indian cultures of today. Address since 1974, Scottsdale, AZ.

ASHER, MICHAEL.
Sculptor and environmental artist. Born in Los Angeles, CA, July 15, 1943. Studied at Orange Coast College, Costa Mesa, Calif.; University of New Mexico, Albuquerque; New York Studio School; University of California, Irvine. Has exhibited at Whitney Museum, NY; Los Angeles County Museum of Art; Otis Art Institue Gallery, Los Angeles; and others. Received John Simon Guggenheim

Memorial Fellowship, 1974; Artist Fellowship Grant, National Endowment for the Arts, 1975. Address in 1982, Venice, CA.

ASHLEY, SOLOMON.
Sculptor. Born in Deerfield, MA, 1792. Portrait in marble, Col. Oliver Partridge, at Hatfield, MA. Specialty was gravestone portrait sculptures.

ASTON, MIRIAM.
Sculptor and painter. Born in New York City. Studied at Society of Arts and Crafts, Detroit, Michigan, 1954-58; Wayne State University, BA & MA; University of Michigan, with Gerald Damrowski and Sarkis Sarkisian. Has exhibited at Detroit Institute of Art, Michigan, 1950-72; Riverside Museum of Art, NY; and others. Taught at California Polytechnical University, Pomona, art instructor of sculpture, from 1975. Received awards from Scarab Club, 1965, Gold Medal; Sacarab Club, Best Sculpture. Address in 1982, Claremont, CA.

ASTON, ROGERS.
Sculptor. Born in Cedar Rapids, IA, 1918. Worked many years in oil exploration and ranch management. Collected American Indian and Western art, now in Roswell Museum, New Mexico. Later began sculpture. Executes statuettes of Old West subjects in bronze. Represented by Trailside Galleries, Scottsdale, AZ. Address in 1982, Roswell, New Mexico.

ATCHISON, JOSEPH ANTHONY.
Sculptor. Born Washington, Feb. 12, 1895. Pupil of George Julian Zolnay, Richard Edwin Brooks. Work: "Round the World Flight Memorial," National Museum, Washington; allegorical frieze, Cleveland Public Auditorium. Address in 1934, Belasco Theatre, Washington, DC.

ATKINS, ALBERT HENRY.
Sculptor. Born Milwaukee, Wis., 1899. Studied at Cowles Art School, Boston, 1896-98; Academie Julien and Academie Colorossi, Paris, 1898-1900. Member of faculty, RI School of Design, Dept. of Sculpture, from 1909. Member: National Sculpture Society, Architectural League of NY, Copley Society of Boston, American Art Association (Paris), Providence Art Club, Boston Architectural Club. Principal works: Copenhagen Memorial Fountain, City of Boston; Lapham Memorial, Milwaukee, WI; Architectural sculptures, Christ Church, Ansonia, Conn., All Saints Church, Dorchester, MA; WWI Memorial, Roslindale, MA; also portraits, ideal sculptures, fountains and garden sculptures. Exhibited at National Academy of Design (New York), Penna. Academy of Fine Arts, Philadelphia, Albright Galleries (Buffalo), Art Institute (Milwaukee), National Sculpture Society, (1923). Awards: Silver medal, Milwaukee Art Institute, 1917. Address in 1933, Boston, MA; summer, Gloucester, MA. Died March 10, 1951.

ATKINS, FLORENCE ELIZABETH.
Sculptor. Born in Pleasant Hill, Louisiana. Pupil of H. Sophie Newcomb Art School, Ellsworth, and William Woodward. Exhibited "Frogs," "Rabbit," at the Penna. Academy of the Fine Arts, Philadelphia, 1921. Address in

1926, San Francisco, California. Died in 1946.

ATKINS, LOUISE ALLEN.
(Mrs. A. H.). Sculptor and teacher. Born in Lowell, MA. Studied at Rhode Island School of Design. Works: World War Memorial, East Greenwich, RI; "The Dreamer," Smith College, Northampton, MA; "Pippa Passes," Cleveland Art Museum. Awards: Esther Groom Memorial prize, North Shore Art Association, 1930. Member: North Shore Art Association; Copley Society of Boston; National Sculpture Society; Providence Art Club; National Association Women Painters and Sculptors; Faculty, Department of Sculpture, Rhode Island School of Design, Providence. Address in 1953, Gloucester, MA. Died 1953.

ATKYNS, (WILLIE) LEE (JR.).
Sculptor, painter, teacher, graphic artist, lecturer, and illustrator. Born in Washington, DC, September 13, 1913. Member: Society of Washington Artists; Washington Water Color Club; Puzzletown Artists Guild; All. A. Johnstown; Indiana (PA) Art Association; Washington Art Club; Newport Art Association. Awards: Prizes, Society Washington Artists, 1947; Washington Art Club, 1946; All. A. Johnstown, 1948, 49, 50. Exhibited: Butler Art Institute; Carnegie Institute; University Chicago; American Watercolor Society; National Academy of Design; Washington Art Club; Smithsonian Institute; Corcoran Gallery; Phillips Memorial Gallery; Whyte Gallery; Toledo Museum of Art; Springfield Art Association; L.D.M. Sweat Memorial Art Museum; Utah State Institute; Terry Art Institute; Catholic University; Indiana State Teachers College; Baltimore Museum of Art; and many one-man exhibitions. Work: Phillips Memorial Gallery; Allied Artists Johnstown; Hospital, Lexington, KY. Position: Director, Lee Atkyns Studio School of Art, Washington, DC and Duncansville, PA. Address in 1982, Lee Atkyns Puzzletown Art Studio, Duncansville, PA.

AUBIN, BARBARA.
Sculptor and painter. Born in Chicago, IL, January 12, 1928. Studied art at Carleton College, 1949, BA; Art Institute of Chicago, 1954; and during a George D. Brown foreign travel fellowship to France and Italy, 1955-56. Noted for her sculpture utilizing fiber, feathers, and beads in assemblages. Exhibited: Butler Institute of American Art, OH, 1961, 62; Norfolk Museum of the Arts and Sciences, 1963; 10th Annual National Prints and Drawings Exhibitions, Oklahoma Art Center, 1968; Fairweather-Hardin Gallery, Chicago, 1975, 78, and 81. She is also involved in writing for various magazines such as *Artists News*, 1977, 78; also an art critic. Has received numerous art awards. Taught: Assistant professor of painting, drawing, and watercolor at the Art Institute, Chicago, 1960-68; and Loyola University, Chicago, 1968-71; at St. Joseph's College, 1971-74; and at Chicago State University from 1971. Member: College Art Association of America; American Association Museums; Women's Caucus for Art. Address in 1982, Chicago, IL.

AUGUR, HEZEKIAH.
Sculptor. Born February 21, 1791, in New Haven, Conn. He was self-taught, his artistic studies being carried out in New Haven, Conn. His group "Jephthah and his Daughter" is in the Yale College Gallery; also represented at U.S. Supreme Court. Exhibited at the National Academy, 1827-28; Penna. Academy of Fine Arts, 1831; Boston Athenaeum, 1832. He died in New Haven, January 10, 1858.

AUSTIN, ALFRED N.
Sculptor. Born in Terre Haute, IN.

AUSTIN, AMANDA PETRONELLA.
Sculptor. Born in Carrolton, Missouri, in 1856. Exhibited: Societe des Artistes, Francais, 1911. Died in 1917.

AUSTREIK, (DR.) W. M.
Sculptor. Address in 1934, New York. (Mallett's)

AVERY, HOPE.
Sculptor and painter. Member: National Association of Women Painters and Sculptors. Address in 1926, Pittsford, VT.

AVRAM, NATHANIEL.
Sculptor. Born in Roumania, 1884; came to NY when eighteen years of age. Worked with H. A. MacNeil and Karl Bitter. Died in NY in November 1907.

AXELROD, MIRIAM.
Sculptor. Born in Russia; US citizen. Studied at Art Students League, 1935, studied with Yasuo Kunyoshi, Robert Cronbach, and Jason Seeley; Pratt Institute, certified, 1940; Brooklyn Museum Art School, 1945. Has exhibited at Brooklyn Museum, NY, 1945; Audubon Artists, NY, 1963, 66, and 70; and others. In collections at Brooklyn College, NY; IBM, Long Island, NY; Nassau Community College, Garden City, NY; others. Received honorable mention, Audubon Artists; and others. Address in 1982, 1727 Roberta Lane, NYC.

AYCOCK, ALICE.
Sculptor and teacher. Born in Harrisburg, PA, November 20, 1946. Studied at Douglass College, New Brunswick, NJ, 1964-68; Hunter College, NY, 1968-71, MA, under Robert Morris. Noted for large architectural structures which the artist calls "psycho-architecture." Works: Outdoor configurations entitled "A Simple Network of Underground Wells and Tunnels," 1975; "Flights of Fancy," 1979; "Machine that Makes the World," 1979; "How to Catch and Manufacture Ghosts," 1979; and "The Savage Sparkler," 1981. Exhibited: 26 Women Artists, Aldrich Museum, Ridgefield, CT, 1971; Inventions in Landscape, Mass. Institute of Technology, Cambridge, MA, 1974; Whitney Biennial, 1979; numerous one-man shows. Taught: Adjunct lecturer of art at Hunter College, 1972-73; artist-in-residence at Williams College, 1974; Instructor of Sculpture at the School of Visual Arts, NY, 1977. Commissions: One located in the Projects Room of the Museum of Modern Art. Address in 1982, 62 Greene St., NYC.

AYRES, MARTHA OATHOUT.
Sculptor. Born in Elkader, Iowa, April 1, 1890. Studied: Carleton College. Awards: Art Institute of Chicago, 1914; Los Angeles County Fair, 1915. Collection: Forest Lawn Cemetery, Glendale, California. Statues and bas-reliefs in

many high schools and colleges in the United States. Address in 1934, Inglewood, Calif.

AYTON, CHARLES WILLIAM.
Born in St. Louis, MO. Pupil of Dubois and Gauquie in Paris, St. Gaudens in America. Honorable mention, Paris Salon, 1903; bronze medal, St. Louis Exposition, 1904. Address in 1910, Paris, France.

AZARA, NANCY J.
Sculptor and painter. Born in New York City, October 13, 1939. Studied: Finch College, NY, AAS, 1957-59; Lester Polakov Studio of Stage Design, NYC, 1960-62; Art Students League, NYC, sculpture with J. Hovannes, painting and drawing with E. Dickinson, 1964-67; Empire State College, BS, 1974. Has exhibited at Sonraed Gallery, NYC; Fourteen Sculptors Gallery, NYC; Brooklyn College; Bard College, all solos; Brooklyn Museum; Azuma Gallery, NYC; Fourteen Sculptors Gallery, NYC; "Whitney Counterweight," NYC; Gallery 10 Ltd., Washington, DC; Sculpture Center, NYC; A.I.R. Gallery, NYC; Jack Tilton Gallery, NYC; others. Has worked in theatrical costume design, NYC; art consultant; faculty of Brooklyn College, Brooklyn Museum Art School, New York Feminist Art Institute (also board of directors), and others. Address in 1984, 46 Great Jones Street, NYC.

AZZI, MARIUS A.
Sculptor. Born in NJ, in 1892. Studied under Karl Bitter and Stirling Calder; Art Students League, NY; also in Rome, and at the Royal Academy in Milan, Italy, and in France. Works: Portraït busts of Lincoln, Roosevelt, Harding; The Fisherman; On-sentry-go; fountain, Sesquicentennial Exposition, Philadelphia. Exhibited statuettes at the Penna. Academy of the Fine Arts, Philadelphia, 1921. Awards: Municipal silver medal for sculpture, Milan, 1910. Taught sculpture at the American University, established by the American Expeditionary Forces at Beaune, Cote d'Or, France, 1919. Address in 1926, 120 West 11th St., New York. Died 1975.

B

BACH, FLORENCE JULIA.
Sculptor and painter. Born Buffalo, NY, June 24, 1887. Member of Art Students League; National Association of Women Painters and Sculptors. Pupil of William M. Chase and DuMond at Art Students League. Represented in the Buffalo Fine Arts Academy. Address in 1933, Buffalo, NY.

BACHMAN, HENRY.
Sculptor and engraver. Born in Germany, about 1838. Listed as working in Philadelphia, June 1, 1860. Exhibited "Silenus" at the Penna. Academy, 1861-63, executed in ivory.

BACHMANN, MAX.
Sculptor. Born 1862. Died in New York City, January 13, 1921. He designed the allegorical figures of the continents for the Pulitzer Building in New York City.

BACKUS, GEORGE J. (MRS).
(Miss Fallis). Sculptor. Born in Attica, Ind. Pupil of Art Institute of Chicago and Minnesota School of Fine Arts. Address in 1906, Minneapolis, Minn.

BACKUS, HENNY.
Sculptor and actress. Born in Philadelphia, PA, March 21, 1914. Exhibited sculpture at the R.C.A. Galleries, Anderson Galleries, NYC; Lane Gallery, Los Angeles. Works: Portrait busts of various well-known persons, such as Joan Crawford, Katherine Hepburn, Clifton Webb, Madam Chiang Kai Shek, Bette Davis, John Barrymore, Orson Welles. Address in 1962, home, Los Angeles; office, Hollywood, CA.

BACON, IRVING R.
Sculptor, painter, illustrator, and teacher. Born in Fitchburg, MA, November 29, 1875. Pupil of Chase in NY; Carl von Marr and Heinrich von Zugel in Munich. Work: "Village Street Scene," Louisville Association; "The Little Old Man of the Woods," D. & C. Steamer, Detroit; "The Conquest of the Prairie," Book Tower Building, Detroit; Hotel Irma, Cody, WY; Fellowcraft Club, Detroit. Sculptor of automobile radiator mounts, "Grayhound" for Lincoln and "Quail" for Ford. Exhibited: National Academy of Design; Penna. Academy of Fine Art; Chicago Art Institute. Address in 1953, Miami, Fla.

BACON, LOUIS.
Sculptor. At San Francisco, 1856-60.

BAER, LILLIAN.
Sculptor. Born New York City, 1887. Student of Art Students League, pupil of Jas. E. Fraser and K. H. Miller. Works: "The Dance," shown at International Exhibition at Rome, 1911. Exhibited at National Sculpture Society, NY, 1923. Specialty, statuettes, book-ends, etc. Address in 1926, 601 Madison Ave., New York City.

BAERER, HENRY.
Sculptor. Born in Kirchheim, Germany, in 1837, he came to the United States as a young man in 1854. Among his best known works are his statue of Beethoven in Central Park, General Fowler in Fort Green Park, and General Warren in Prospect Park, Brooklyn; also in New York Historical Society; National Academy of Design, 1866-89. He was a member of the National Sculpture Society. He died in New York, December 7, 1908.

BAGG, LOUISE ELEANORA.
Sculptor and painter. Born in Springfield, MA. Pupil of Desvergnes in Paris. Bronze medal, St. Louis Exposition, 1904. Member, Lyceum Club, London. Address in 1910, 2 Rue Pierre -Charron, Paris.

BAHNC, SALCIA.
Sculptor, painter, etcher, and teacher. Born Dukla, Austrian Poland, Nov. 14, 1898. Pupil of Art Institute of Chicago; Chicago Academy of Fine Art. Work: "Torso," Arts Club, Chicago, IL. Exhibited at Art Institute of Chicago; Penna. Academy of Fine Arts; Salon des Tuileries, Paris; others. Address in 1953, 101 West 85th Street, NYC.

BAILEY, ADOLPH.
Sculptor. Born in France, c. 1822; living in Philadelphia, July 16, 1860.

BAILEY, BEN P., JR.
Sculptor, painter, illustrator, and educator. Born in Houston, TX, December 28, 1902. Studied at University of Texas; Columbia University; Colorado State College of Education; Claremont Graduate School of Education, and with Gutzon Borglum, Charles Lawler, and others. Member: Texas Fine Arts Society; Texas Water Color Society; Southern States Art League; South Texas Artists League. Awards: Prizes, Texas Water Color Society, 1951; GI Exhibition, San Antonio; Corpus Christi Art Foundation, 1946-48, 1950. Work: IBM; Texas Memorial Museum, Austin, Texas. Exhibited: Texas Water Color Society, 1950-52; Texas Fine Art Society; Corpus Christi Art Foundation Institute, "The Adventures of Prince Leandro," 1945; "Padre Island," 1951. Taught: Associate Prof., Texas College of Art and Industry, Kingsville, TX. Address in 1953, Kingsville, TX.

BAILEY, CLARK T.
Sculptor and educator. Born in Chickasha, OK, November 10, 1932. Studied at University of Houston, B.F.A.; Instituto Allende, San Miguel de Allende, Mexico; with R. Hunt. Exhibited at National Academy of Design, NYC; National Sculpture Society; others. Member of the National Sculpture Society. Awards: C. Percival Dietsch

Sculpture prize, 1970, National Sculpture Society; Mahonri Young award, National Academy of Design; others. Living in Chickasha in 1976. Died in 1978.

BAILEY, CLAYTON GEORGE.
Sculptor and educator. Born in Antigo, WI, March 9, 1939. Studied at University of Wisconsin-Madison, B.A., 1961, M.S., 1962. Work in Museum of Contemporary Crafts, NY; Addison Gallery of American Art, Andover, MA; Milwaukee Art Center; and others. Has exhibited at Milwaukee Art Center; M. H. De Young Museum, San Francisco; and others. Received artists grants, Louis Comfort Tiffany Foundation, 1963; National Endowment for the Arts, 1979; and others. Works in ceramic and metal. Address in 1982, Port Costa, CA.

BAILEY, RICHARD H.
Sculptor. Born in Dover, DE, June 24, 1940. Studied at Delaware Art Center, Wilmington; Art Students League; New School for Social Research; in Carrara, Italy; also with Jose De Creeft, Lorrie Goulet, Leroy Smith, and Oya Eraybar. Work in American Museum of Natural History, NY; and others. Has exhibited at Silvermine Guild of Artists, New Canaan, CT; International Exhibition of Sculpture, Carrara, Italy; Randall Galleries, NY. Received Silvermine Guild Award for Sculpture, 1972 and 73. Address in 1982, Smyrna, DE.

BAILLY, JOSEPH ALEXIS.
Sculptor and wood carver. Born in Paris in 1825. Settled in Philadelphia in 1850 and followed his occupation of carving on wood and marble. Later became instructor at the Penna. Academy of Fine Arts. He produced a statue of Washington, at Independence Hall, Phila., also portrait busts of Gen. Grant and Gen. Meade. Member of Penna. Academy, academician, 1856; taught there in 1876-77. Died June 15, 1883, in Phila., PA.

BAILY, JULIUS T.
Sculptor. At NYC, 1858.

BAIN, LILIAN PHERNE.
Sculptor, painter, etcher, and teacher. Born Salem, Oregon. Pupil of F. V. DuMond, Guy Rose, Joseph Pennell. Member: Pennell Graphic Arts Society. Address in 1933, 3917 49th Street, Long Island City, NY; summer, Portland, OR. Died c. 1947.

BAIZERMAN, SAUL.
Sculptor. Born December 25, 1889, Vitebsk, Russia. Came to US in 1910. Studied: Imperial Art School, Odessa; National Academy of Design; Beaux-Arts Inst. of Design, NYC. Fire in studio in 1931 destroyed most of his work. In collections of Univ. of Minnesota; Univ. of Nebraska; Penna. Academy of Fine Arts; Whitney; Walker. Exhibited: Dorien Leigh Galleries, London, 1924; Eighth St. Gallery, NYC, 1933; Artists' Gallery, NYC, 1938, 48, 57; Phila. Art Alliance, 1949; The New Gallery, NYC, 1952, 54; World House Galleries, NYC, 1963; The Zabriskie Gallery, 1967. Retrospective: Walker, 1953; Institute of Contemporary Art, Boston, 1958; Heckscher, 1961. Awards: Penna. Academy of Fine Arts, hon. mention, 1949; American Assoc. of Arts and Letters grant, 1951; Guggenheim Foundation Fellowship, 1952;

Penna. Academy of Fine Arts, Steel Memorial prize, 1952. Taught at American Artists School, NYC; Univ. of Southern Calif.; Baizerman Art School, 1934-40. Died August 30, 1957, in NYC.

BAKER, ANNABELLE.
Sculptor, painter, designer, and graphic artist. Born in St. Petersburg, FL, May 18, 1925. Studied at Hampton Institute and with Viktor Lowenfeld, Leo Katz. Award: Hampton Institute, 1944. Work: Designed series of books for US Naval Education programs, 1944. Exhibited: Atlanta University, 1944, 45; Museum of Modern Art, 1943; Virginia Museum of Fine Arts, 1944, 45, 46. Address in 1953, Hampton, VA.

BAKER, BRYANT.
Sculptor. Born in London, July 8, 1881. Studied at London Royal Academy of Arts; City and Guilds Technical Institute. Came to US in 1915 or 16. His works include bust and heroic statue of King Edward VII; bust of Prince Olav of Norway; many notable persons in England and US, including Grover Cleveland, City Hall, Buffalo; Lincoln, Delaware Park; figure, Brookgreen Gardens, SC. Exhibited at Royal Academy, London; Paris Salon; Corcoran; in NYC. Address in 1953, 222 West 59th Street, New York City. Died 1970.

BAKER, MINNIE (MITCHELL)
Sculptor, painter, teacher, and lecturer. Born in Ardmore, OK, 1901. Studied at Southeastern State College, BA; University of Iowa, MA; Oklahoma University; Ohio State University; and with Tarbell, Merryman, Guston. Member: Oklahoma Art Association; Oklahoma Education Association. Awards: Prizes, Oklahoma State Fair, 1929, 30, 31. Work: Oklahoma Art Center; Robertson Jr. High School, Muskogee, OK; Wilburton High School, Oklahoma. Exhibited: Corcoran Gallery; Oklahoma Art Center; Philbrook Art Center. Associate Professor of Art, Southeastern State College, Durant, OK. Address in 1953, Durant, OK.

BAKER, NATHAN F.
Sculptor. Born c. 1822, Ohio. At Cincinnati, 1841-50. Exhibited: National Academy, Boston Athenaeum, 1847.

BAKER, PERCY BRYANT.
See Baker, Bryant.

BAKER, ROBERT P.
Sculptor. Born London, June 29, 1886. He studied at the Lambeth School of Art, the City and Guilds Technical Institute and the Royal Academy, London; also in Paris and Rome. Awards: First medal for portraiture and first medal for sculpture, Royal Academy. Member: Chelsea Arts Club, London; National Sculpture Society; Salmagundi Club. Work: 42 statuettes for the 15th Century stalls, Beverly Minster, England; collaborated with Adrian Jones on the colossal Quadriga on the Inigo Jones Arch, Hyde Park, London; The Soul Struggle, Belgium; The Kiss, and others in the United States. Exhibited at National Sculpture Society in 1923. Address in 1929, Woods Hole, Mass. Died 1940.

BAKOS, JOSEPH G.
Sculptor, painter, and teacher. Born Buffalo, NY, Septem-

ber 23, 1891. Pupil of J. E. Thompson. Member: Santa Fe Society of Artists. Award: Honorable mention, Denver Annual Exhibition, 1931. Represented in Brooklyn Museum; Whitney Museum of American Art, NY. Address in 1953, Santa Fe, New Mexico. Died 1977.

BALCIAR, GERALD G.
Sculptor. Born Medford, WI, August 28, 1942. Self-taught. Member: Society of Animal Artists; National Sculpture Society. Awards: Honorable Mention, Colorado Celebration of the Arts, 1975; Honorable Mention, Youth Awards, National Sculpture Society, 1977; Dr. Hexter Prize, National Sculpture Society, 1978; Bronze Medal, National Sculpture Society, 1979; Commendation, Youth Awards, National Sculpture Society, 1979. Work: Wildlife World Museum, Monument, Colorado. Exhibitions: National Academy of Design; Allied Artists of America; National Sculpture Society; National Academy of Western Art; North American Sculpture Exhibitions; Society of Animal Artists, and several wildlife conservation shows. Media: Bronze and stone. Address in 1983, Arvada, CO.

BALDREY, HAYNSWORTH.
Sculptor and etcher. Born Cortland, NY, August 24, 1885. Pupil of C. T. Hawley, Charles Grafly, Ephriam Keyser. Member: American Federation of Arts; Baltimore Water Color Club; Handicraft Club of Baltimore; National Sculpture Society; American Artists Professional League; Art Center of the Oranges. Awards: Rinehart prize, Baltimore, 1908, 1909, 1910; first award in sculpture, Art Center of the Oranges Exhibition, 1932, 33. Address in 1933, Newton, NJ. Died in 1946.

BALDWIN, BARBARA.
Sculptor, painter, and writer. Born: Portland, Maine, Jan. 13, 1914. Studied: Portland School of Fine Arts; Pennsylvania Academy of Fine Arts; National Academy of Design; Art Students League; with Bower, Kroll, Du Mond, Laessle, McCartan, and others. Collections: Deering High School, Portland, ME; World's Fair, New York, 1939; Pathe News. Exhibited at National Academy of Design; Society of Independent Artists; others. Address in 1953, Monroe, NY.

BALES, JEAN E.
Sculptor, painter, printmaker, and potter. Born in Pawnee, OK, 1946. Studied: Chickasha Public Schools; Oklahoma College of Liberal Arts, B.A. in fine arts, 1969. Has exhibited at Heard Museum, Phoenix, AZ; Santa Fe Arts Festival; others. Received numerous awards and honors; named Indian Artist of the Year in 1973. In collections of Denver Museum of Natural History; US Dept. of Interior, Washington, DC; others. Reviewed in *Southwest Art*, April 1981. Represented by Tom Bahti Indian Arts, Tucson, AZ; Whitney Gallery, Taos, NM. Address in 1982, Washita, OK.

BALL, ALICE WORTHINGTON.
Sculptor. Born in Boston. Died in 1929. (Mallett's)

BALL, CAROLINE PEDDLE.
Sculptor. Born in Terre Haute, Ind., November 11, 1869.

Pupil of Augustus St. Gaudens and Kenyon Cox, New York. Member: Indiana Sculptors Society. Award: Honorable mention, Paris Exposition, 1900. Work: Sculptor of figure of "Victory" in quadriga on the US building, at Paris Exposition, 1900; memorial corbels, Grace Church, Brooklyn; memorial fountains at Flushing, LI, and Auburn, NY; SPCA Memorial Fountain, Westfield, NJ. Address in 1933, Westfield, NJ. Died 1938.

BALL, RUTH NORTON.
Sculptor. Born in Madison, WI. Pupil of J. Liberty Tadd in Phila.; St. Louis School of Fine Art; Cincinnati Art Acad. Member: Cincinnati Woman's Art Club; Three Arts Club and Crafters Company, Cincinnati; San Diego Artists Guild. Awards: First honorable mention, Calif. Society of Artists, San Diego, 1931. Work: Marston Memorial Fountain, Greenwood Cemetery; bronze "Mother and Child," Fine Arts Gallery, San Diego; City Art Museum, St. Louis; Cincinnati Art Museum; Marine Base, bronze tablet, Boy Scout Headquarters, San Diego, Calif. Represented in City Art Museum, St. Louis. Address in 1933, San Diego, CA.

BALL, THOMAS.
Sculptor. Born in Charlestown, MA, June 3, 1819. His art studies began with silhouette-cutting, miniature and portrait painting; studied sculpture in Italy, 1854-57. Had studio in Boston, MA, 1837-53; also in Boston 1857-64; in Italy again until 1897. After 1851 he devoted himself to sculpture. His prominent works are the Washington monument in Boston, Forrest as "Coriolanus," Emancipation Group, Washington. For his life see "My Three Score Years and Ten," by Thomas Ball, Boston. Died December 11, 1911, in Monclair, NJ.

BALLERINI-BALL, N.
Sculptor, painter, and etcher. Born in Pittsfield, Mass., Feb. 21, 1899. Studied with Philip Hale, Emil Fuchs, George Bridgman, Joseph Pennel, and others. Member: Gloucester Society of Artists. Address in 1933, Hartford, Conn.; summer, Gloucester, Mass.

BALLIN, J.
See Battin, John T. (Batton, Ballin).

BALLOU, BERTHA.
Sculptor, painter, etcher, and teacher. Born in Hornby, NY, February 14, 1891. Pupil of DuMond, Tarbell, Merryman, Bosley, Grafly. Member: Spokane Art Association; Women Artists of Washington. Awards: Second honorable mention, Spokane, Art Association, 1929; third prize, Island Empire Fair, 1930. Work: "The Old Opera Singer," Grace Campbell Memorial Museum, Spokane. By 1953 no longer listed as sculptor. Address in 1953, Spokane, WA.

BALOG, MICHAEL.
Sculptor and painter. Born in San Francisco, CA, April 30, 1946. Studied at Chouinard Art School, Los Angeles, CA, 1959; Ventura College, CA, 1966-67; with Stephan von Huene. Exhibitions: Irving Blum Gallery, Los Angeles, CA, 1970; Leo Castelli Gallery, NYC, 1972; Pasadena Art Museum, CA, 1969; Friends of Contemporary Art, Den-

ver, CO, 1971; Jack Glenn Gallery, Newport Beach, CA, 1974; Museum of Modern Art, NYC, 1974. In collections of Wichita (KS) Art Museum; Joslyn Art Museum, Omaha. Address in 1982, c/o Leo Castelli Gallery, 4 East 77th Street, NYC.

BANCROFT, HESTER.
Sculptor and painter. Born in Ithaca, NY, 1889. Exhibited: National Academy of Design, 1925.

BANKS, ANNE JOHNSON.
Sculptor and printmaker. Born in New London, CT, August 10, 1924. Studied at Wellesley College, BA, 1946; Honolulu School of Art, with Wilson Stamper, 1948-50; George Washington University, with Thomas Downing, MFA, 1968. Work in Lyman Allyn Museum, New London; George Washington University. Exhibitions at Virginia Museum, Richmond, 1971; Northern Virginia Fine Arts Association Area Exhibit, 1972-74; plus others. Received six Merit Awards, Art League, Alexandria, Virginia, 1971-74; Merit Award, Northern Virginia Fine Arts Association, 1972; others. Media: Wood, plastic, silkscreen. Address in 1982, Alexandria, VA.

BARATELLI, CHARLES.
Sculptor. Born in Italy. Died in 1925 in Milford, Conn. (Mallett's)

BARBAROSSA, THEODORE C.
Sculptor. Born in Ludlow, VT. Studied at Yale University School of Art and Architecture, BFA; under Cyrus Dallin, Robert Eberhard, and Heinz Warneke. Exhibited: Whitney Museum in NYC, 1940; National Sculpture Society; National Academy of Design; Allied Artists; Audubon Artists. Awards: Lindsay Morris Memorial prize from the National Sculpture Society, 1949; gold medal for sculpture from Allied Artists, NYC, 1955; Henry Herring Citation for sculpture from the National Sculpture Society, 1961, and the Hexter Prize, 1977. Member: National Sculpture Society; Audubon Artists; Allied Artists, International Institute of Arts and Letters; and academician of the National Academy of Design. Executed many works in stone for the Catholic Church of the Assumption, Baltimore, 1957; five relief panels for the Museum of Science, Boston; two chapels and ten figures for the Catholic Shrine, Washington, DC, 1962-65; others. Address in 1982, Belmont, MA.

BARBEE, HERBERT.
Sculptor, son of William R. Barbee the sculptor. Born in 1848. He studied in Florence, Italy.

BARBEE, WILLIAM RANDOLPH.
Sculptor. Born January 17, 1818, near Luray, VA. His "Fisher Girl" and "The Coquette" were his best known works. Exhibited them in Richmond, Baltimore, NYC, 1858-59; also exhibited bust of Speaker Orr, Pennsylvania Academy, 1859-60. Died June 16, 1868, in Virginia

BARBER, WILLIAM HAROLD.
Sculptor and painter. Born in Glendale, CA, 1940. Self-taught in art. Travel and work immersed him in Western life. Subjects are the American West of the present and the past. Represented by Western Art Classics, Heber

City, UT. Address since 1967, Daniels, UT.

BARD, JOELLEN.
Sculptor and painter. Born in Brooklyn, New York, June 19, 1942. Studied: Pratt Institute with Gabriel Laderman, Dore Ashton, Mercedes Matter; Syracuse University, with Robert Goodenough; Brooklyn Museum Art School. Exhibitions: The Brooklyn Museum Little Gallery, 1973; Gallery 91, 1974; Gallery 26, 1975; Pleiades Gal., NYC, 1975, 77, 79. Address in 1982, 1430 East 24th St., Brooklyn, NY.

BARGER, RAYMOND GRANVILLE.
Sculptor. Born in Brunswick, MD, August 27, 1906. Study: Carnegie-Mellon University, BA; Winchester Fellow, Europe; Yale University, BFA; Special Academy Rome, 2 years. Works include Column of Perfection, H. J. Heinz Co., New York World's Fair, 1939; J.C. Penney, NYC, 1965; J. Mitchelle Collection, NYC, 1968; Bicentennial Bronze, 1975-76. Awards: Title of Cavaliere—San Marino, Italy. Teaching: Rhode Island School of Design, 1939-40; Cooper Union, New York, NY, 1940-45. Member: National Sculpture Society, NYC; Architectural League of New York. Works in welded bronze, wood and stone. Address in 1980, The Mill, Carversville, PA.

BARNARD, GEORGE GREY.
Sculptor. Born in Bellefonte, PA, May 24, 1863. Studied at Art Institute of Chicago, Ecole Nationale des Beaux Arts, 1884-87, with Carlier. Exhibited in Paris Salon, 1894; National Sculpture Society, 1923. Awarded Gold Medal, Paris Exposition, 1900; Gold Medal, St. Louis Exposition, 1904; others. Professor Sculpture, Art Students League, NY; Associate Member of National Academy of Design, and Societe Nationale des Beaux-Arts, Paris; Member of National Institute of Arts and Letters. Work in Metropolitan Museum of Art; Central Park, NYC; heroic-size statue group, State Capitol, Harrisburg, PA; sculpture group, Norway, Sweden; busts of A. S. Hewitt, C. P. Huntington, Dr. Leeds, the latter at Stevens Institute, Hoboken, NJ; Boston Museum; Carnegie Institute; Venus & Cupid, Paris; bronze statues of A. Lincoln, Lytle Park, Cincinnati, OH, Louisville, KY, and Manchester, England; Memorial Fountain, Tampa, FL; marble group Adam & Eve, Tarrytown, NY. He formed the collection of medieval sculpture at the Cloisters, owned by the Metropolitan Museum of Art, NYC. Address in 1933, 454 Fort Washington Ave., NYC. Died in NYC, April 24, 1938.

BARNES, CARROLL.
Sculptor. Born in Des Moines, IA, June 26, 1906. Studied at Wessington Springs Jr. College, SD, 1927-28; Corcoran School of Art, Washington, DC, 1938; Cranbrook Academy of Art, Bloomfield Hills, MI, with Carl Milles, 1940. Work at Fort Worth Art Museum, TX; Los Angeles Co. Museum; Cranbrook Academy of Art Museum; and others. Has exhibited at Whitney Museum, NY; San Francisco Museum of Art; Santa Barbara Museum of Art, CA; and others. Works in steel and wood. Address in 1982, Sebastopol, CA.

BARNETT, EUGENE A.
Sculptor, illustrator, painter, etcher, and writer. Born At-

lanta, GA, March 18, 1894. Pupil of Edward Penfield. Member: Society of Illustrators. Address in 1933, 1 West 67th St., New York, NY.

BARNHORN, CLEMENT JOHN.
Sculptor. Born in Cincinnati, OH, in 1857. Pupil of Rebisso in Cinn.; Bouguereau, Peuch, Mercie, Ferrier at Julien Academy in Paris. Member: National Sculpture Society, Cinn. Art Club. Works: Fountain figures, Hartford, Conn., and Prince George Hotel, NY; "Magdalen," Cinn. Art Museum; Theodore Thomas, Music Hall, Cinn., Ohio; fountain, Shortridge Hill School, Indianapolis, IN; portrait bust, Public Library, Cinn., OH; Madonna and Child, Cathedral facade, Covington, KY; eleven panels, Court House, Cinn., OH; five panels—war memorials, Hughes High School, Cinn., OH; portrait, Maj. C. R. Holmes, Cinn. General Hospital; bas-relief, Dr. P. S. Connor, Good Samaritan Hospital, Cinn., OH; Maenads, relief panel, Queen City Club, Cinn., OH; fountains, Hughes High School, and Conservatory of Music, Cinn., OH; fountain figure, Hartford, Conn. Exhibited at National Sculpture Society, 1923. Awards: Received honorable mention from the Paris Salon, 1895; bronze, silver medals, International Exposition, Paris, 1900; honorable mention, Pan-American Exposition, Buffalo, 1901; silver medal, Louisiana Purchase Exposition, St. Louis, MO, 1904. Address in 1933, Art Museum, Cincinnati, Ohio. Died in 1935.

BARNITZ, MYRTLE TOWNSEND.
Sculptor, painter, craftsman, writer, and teacher. Born Greensburg, PA. Pupil of Charles Francis Browne, Thomas Hovenden, Thomas Eakins, William Gilchrist, Thomas P. Anshutz, Hugh Breckenridge. Member: Fellowship Penna. Academy of Fine Arts; Chicago No-Jury Society of Artists. Work: "Help Belgium" and "Boy Scout," Red Cross, Chicago. Address in 1933, Glen View, IL.

BARR, ROGER.
Sculptor and painter. Born in Milwaukee, WI, September 17, 1921. Studied at University of Wisconsin; National University of Mexico; Pomona College, B.A.; Claremont College, M.F.A.; Jepson Art Institute, Atelier 17. Work in Hirshhorn Museum and Sculpture Garden of Smithsonian Institution, Washington, DC; Boston Museum of Fine Arts; Art Museum of Goteborg, Sweden; and others. Has exhibited at M. H. de Young Memorial Museum, San Francisco; Esther Robles Gallery, Los Angeles; Feingarten Gallery, NY; International Sculpture Exhibition, Museum Rodin; and others. Member of Artists Equity Association; American Federation of Arts. Address in 1982, c/o Smith Andersen Gallery, Palo Alto, CA.

BARRET, ANTHONY.
Sculptor, marble cutter. Worked: New Orleans, 1850-56; partner of Junjel and Barret, 1850-51, sculptors in marble.

BARRETT, BILL.
Sculptor. Born in Los Angeles, CA, December 21, 1934. Studied at University of Michigan, Ann Arbor, B.S. (design), 1958, M.S. (design), 1959, M.F.A., 1960. Work in Cleveland Museum of Art, OH; Aldrich Museum of Contemporary Art, Ridgefield, CT; Norfolk Museum of Art, VA; and others. Has exhibited at San Francisco Museum of Art, CA; Flint Museum of Art, MI; Whitney Museum of American Art Sculpture Annual, NY; Storm King Art Center, Mountainville, NY; Shidoni, Tesuque, NM; NY Botanical Gardens, Bronx. Member of Sculptors Guild of NY. Works in aluminum and bronze. Address in 1982, 11 Worth St., NYC.

BARRETT, LAWRENCE LORUS.
Sculptor, painter, illustrator, printmaker, teacher, and writer. Born in Guthrie, OK, 1897; raised in Hutchinson, KS. Studied: Broadmoor Art Association beginning 1920, the pupil of Robert Reid, Randall Davey, Ernest Lawson, J. F. Carlson, and Boardman Robinson. Work in Metropolitan Museum of Art, Colorado Springs Fine Arts Center, Brooklyn Museum, Carnegie Institute, Library of Congress. Instructor in lithography at Broadmoor and Colorado Springs Fine Arts Center. Award: Guggenheim Fellowship, 1940. Co-author with Rudolph Dehn, 1946, text on lithography. Died in Colorado Springs, CO, 1973.

BARRETT, OLIVER O'CONNOR.
Sculptor, illustrator, educator, and writer. Born in London, England, January 17, 1908. Studied at Fircroft College, England. Member: Sculptors Guild. Awards: Prize, Audubon Artist, 1948, medal, 1950. Work: Birmingham City Museum, England. Exhibited: Penna. Academy of Fine Arts, 1945; Royal Academy, London, 1933; Audubon Artist, 1946, 48, 50; New Orleans Art Association, 1942, 43; Sculpture Center; Whitney. Illustrated, "Anything For a Laugh;" "Little Benny Wanted a Pony," 1951. Contributor to *Town and Country* and other magazines. Position: Instructor of Sculpture at Cooper Union Art School, Museum of Modern Art, NYC. Address in 1970, 313 W. 57th St., NYC.

BARRY, EDITH CLEAVES.
Sculptor, painter, illustrator, and designer. Born in Boston, MA. Studied at Art Students League; NY Institute of Fine Arts; Paris, France. Member: National Association of Women Artists; Conn. Academy of Fine Arts; Art Students League; American Federation of Arts; Montclair Art Association; American Artists Professional League; Art Centre of Oranges; Washington Water Color Society; National Arts Club; Allied Artists of America; National Society of Mural Painters. Awards: Two honorable mentions, Hudson prize, Whitney Studio; Conn. Academy of Fine Art, 1916, 21, 22, 38; medal, Montclair Art Museum, 1928. Work: Three portraits, Mountain Side Hospital, Montclair, NJ; Hospitals and Schools, NJ; Dartmouth College; Dyer Library, York National Bank, Saco, ME; US Post Office, Kennebuck, ME; Mary Wheeler School, Providence, RI; American Artist Professional League; Soldier and Sailors Club, NY. Position: Founder and Director, Brick Store Museum, Kennebunk, ME. Address in 1970, 116 East 66th St., NYC.

BARRY, EILEEN.
Sculptor. Work includes "Twister," bronze, exhibited at National Association of Women Artists. Member: National Association of Women Artists. Address in 1983, Islip Terrace, NY.

BARSKY, SYBLE.
Sculptor. Address in 1935, Pittsburgh, PA. (Mallett's)

BARTH, EUGENE FIELD.
Sculptor, painter, illustrator, and teacher. Born St. Louis, March 4, 1904. Pupil of Fred C. Carpenter. Member: Art Students League of New York. Award: Halsey Ives prize, St. Louis Artists Guild, 1928. Address in 1933, Teaneck, NJ; summer, St. Louis, MO.

BARTH, LARRY.
Sculptor. Studied: BFA in the field of Design, Carnegie-Mellon University. Member: Society of Animal Artists. Prizes: 2nd place in World Decorative Life-size, World Class, 1979; Ward Foundation, World Championship Wildfowl Carving Competition. Exhibitions: Leigh Yawkey Woodson Art Museum Bird Art Exhibition, 1980, 81. Collections: Audubon Society of Western Pennsylvania. Medium: Wood. Specialty: Birds. Address in 1983, Rector, Penna.

BARTH, VALENTINE.
Sculptor. Born in Bremen, Germany, in 1837. At New York City in 1860.

BARTHE, RICHMOND.
Sculptor. Born in Bay St. Louis, Miss., January 28, 1901. Studied: Art Institute of Chicago; Art Students League; Xavier University, Master of Arts; and with Charles Schroeder. Member: National Sculpture Society. Awards: Rosenwald Fellowship, 1931, 1932; Guggenheim Fellowship, 1941, 1942; Hoey Award, 1945; Sculptors Guild; Audubon Award, 1945; grant, American Academy of Arts and Letters, 1946. Work: Whitney; Penna. Academy of Fine Art; monuments, "Toussaint L'Ouverture," "General Dessalines," Haitian Government, 1952; Virginia Museum of Fine Arts; Metropolitan Museum of Art; New York University. Exhibited: Whitney Museum of American Art, 1933-36, 1940-42, 1944; Brooklyn Museum, 1935, 1945; Corcoran Gallery of Art, 1936; Penna. Academy of Fine Arts, 1938, 1940-44; Montclair Art Museum, 1946; Carnegie Institute 1938, 1941; Metropolitan Museum of Art, 1942; Los Angeles Co. Museum, 1976; others. Address in 1982, Pasadena, CA.

BARTHEL, DOUGLAS.
Sculptor. Born in Port Huron, MI, 1950. Studied: Wayne State University, B.F.A. Exhibitions: Wayne State University in Italy, 1971; Detroit Artists Market, 1972; Michigan Focus, The Detroit Institute of Arts, 1974-75. Awards: Florence Davies Memorial, Detroit Artists Market. Address in 1975, Detroit, MI.

BARTHOLDI, FREDERIC AUGUSTE.
French sculptor. Born in 1834. Known in this country from his gigantic statue of "Liberty Enlightening the World" on Bedloes Island in New York harbor. He was a commissioner in 1876 of the French government, at the Centennial Exposition in Philadelphia. His statue of "Lafayette Arriving in America" is in Union Square, New York. Died 1904.

BARTHOLOMEW, EDWARD SHEFFIELD.
Sculptor and painter. Born in Connecticut, July 8, 1822.

He studied at the National Academy and in Italy. A collection of his work is in Hartford, Conn. His full-length statue of Washington belonged to Noah Walker and his "Eve Repentant" to Jos. Harrison of Philadelphia. Exhibited at National Academy; Boston Atheneum; Philadelphia Academy, 1859, 63, 96. He died in Naples in 1858.

BARTLETT, DONALD LORING.
Sculptor and educator. Born in Quincy, IL, September 20, 1927. Studied at University of Texas, with Charles Umlauf, B.F.A.; Cranbrook Academy of Art, with Berthold Schiwetz, M.F.A.; also with Bernard Frazier, summer 1959. Work in Brooks Memorial Art Gallery, Memphis, TN; Laguna Gloria Art Museum, Austin, TX; and others. Has exhibited at Penna. Academy of Fine Arts Annual, 1960; Audubon Artists, NY, 1960; and others. Received Fulbright Grant to France, 1953-54. Member of Texas Society of Sculptors. Teaching sculpture at University of Missouri. Works in bronze and epoxy resin. Address in 1982, Columbia MO.

BARTLETT, MADELEINE ADELAIDE.
Sculptor, painter, and writer. Born in Woburn, MA. Pupil of Cowles Art School, and Henry H. Kitson. Specialty, small bas-reliefs. Exhibited at National Sculpture Society, 1923; portraits at Penna. Academy of the Fine Arts, 1924. Member of CT Academy of Fine Arts. Address in 1953, Boston, Mass.

BARTLETT, PAUL WAYLAND.
Sculptor and painter. Born New Haven, Conn., 1865. Went to France in childhood. Pupil of Cavelier at Ecole des Beaux Arts, Fremiet at Jardin des Plantes, and Rodin. Represented by statue of General Joseph Warren in Boston, equestrian statue of Lafayette in Louvre, Paris, statue of Columbus in Washington. Elected member of National Academy of Design, 1917; American Academy of Arts & Letters; American Art Association of Paris; etc. Painting "The Pond above the Sea" at Carnegie Institute, 1923; exhibited at National Sculpture Society, 1923. Also in collections of Metropolitan Museum of Art; Hartford State Capitol; Penna. Academy of Fine Arts; and Library of Congress. Received awards at Paris Salon, 1887; Metropolitan Museum of Art; Paris Exposition, 1889; Pan-American Exposition, Buffalo, 1901. Died September 20, 1925, in Paris, France.

BARTLETT, TRUMAN HOWE.
Sculptor and teacher. Born in Dorset, VT, 1835. Pupil of Fremiet in Paris. Work: "Wells," bronze statue, Hartford, Conn.; "Benedict," cemetery monument, Waterbury, Conn.; "Clark," cemetery monument, Hartford, Conn.; many busts and statuettes. Writings: "Life of Dr. William Rimmer," "Physiognomy of Abraham Lincoln." Exhibited at National Academy, 1866-80. Instructor of Modelling, MIT, for many years. He died in 1923.

BARTLETT, WILLIAM F.
Sculptor, painter, and illustrator. Studied: Cooper Union. Member: Society of Animal Artists. Illustrator of 15 childrens' and educational books on nature and science. Prizes: Mrs. John Newington Award, Hudson Valley Art

Association. Specialty: Ceramic figures of nature. Media: Painting, oil, watercolor and graphics; sculpture, stone, wood and tin. Address in 1983, White Plains, NY.

BARTON, CATHERINE GRAEFF.
Sculptor. Born in Englewood, New Jersey, July 22, 1904. Studied in Cooper Union Art School, NY; Art Students League; and with Archipenko; Despiau, Gimond, in Paris. Member: New Haven Paint and Clay Club; National Association of Women Artists, NY. Awards: Prizes, Fine Arts Commission, Washington, DC, 1930; National Association of Women Artists, 1931. Work: Dwight School for Girls, Englewood, NJ. Exhibited: National Academy of Design, 1926; Architectural League, 1926; Penna. Academy of Fine Art, 1927; National Sculpture Society, 1940-43; New Haven Paint and Clay Club, 1944-46; others. Address in 1962, Hamden, Conn.

BASHAM, FREDERICK.
Modeler, plasterworker, architect, and draftsman. Active in NYC, 1837-52. Exhibited a model of the Parthenon, the Apollo Association, 1840; drawing (?) "Origin of the Corinthian Capital," the National Academy, 1842.

BASKIN, LEONARD.
Sculptor, painter, and graphic artist. Born in New Brunswick, NJ, August 15, 1922. Studied at NYU, 1939-41; apprenticed to sculptor M. Glickman; Yale School of Fine Arts, 1941-43; Tiffany Foundation Fellowship, 1947; New School for Social Research, AB, 1949, DFA, 1966; Academie de la Grande Chaumiere, Paris, 1949; Academia di Belle Arti, Florence, 1950. Illustrated *Auguries of Innocence* by Wm. Blake, in 1959. In collections of Museum of Modern Art, Metropolitan Museum of Art, Brooklyn Museum, National Gallery in Wash., Fogg Art Museum; others in US and abroad. Exhibited at New School for Social Research, 1967; Sao Paulo, Brazil; Museum of Modern Art, Paris; and others in US and abroad. Received Guggenheim Foundation Fellowship, 1953; medal, American Institute of Graphic Artists, 1965; medal, National Institute of Arts and Letters, 1969; and others. Taught at Smith College, 1953-74. Member: National Institute of Arts and Letters; American Institute of Graphic Artists. Represented by Kennedy Galleries, NYC. Address in 1982, Devon, England.

BASSETT, CARROLL K.
Sculptor. Exhibited 1935, in New York. (Mallett's)

BASSETT, CHARLES PRESTON.
Sculptor, painter, designer, lithographer, teacher, lecturer, and craftsman. Born in Pittsburgh, PA, June 27, 1903. Studied at Carnegie Institute, BA; and with Wilfred Readio, Joseph Bailey Ellis, Emil Grapin. Member: Association of Art Pittsburgh; Pittsburgh Water Color Society. Awards: Prizes, ($11,000) Westinghouse Electric Co., 1933; Brunswick-Balke Co., 1934; 1st prize, design for public fountain, Pittsburgh, PA, 1938. Exhibited: Association of Art, Pittsburgh; Carnegie Institute, 1938-44; Arts and Crafts Center, Pittsburgh, 1945. Address in 1953, Bethel Boro, Library, PA.

BATCHELDER, MRS. E. B. L.
See Longman, (Mary) Evelyn Beatrice.

BATCHELLER, FREDERICK S.
Sculptor and painter. Born in 1837. Worked: Providence. Executed marble busts; turned to painting 1860. Died in Providence, Rhode Island, March 17, 1889.

BATEMAN, CHARLES.
Sculptor. Born in Minneapolis, Minn., 1890. (Mallett's)

BATEMAN, JOHN M.
Born in Philadelphia, Penna. Pupil of Penna. Academy of Fine Arts and of Grafly. Address in 1910, Philadelphia, Penna.

BATEMAN, JOHN.
Sculptor. Born Cedarville, NJ, 1887. Studied at Penna. Academy of Fine Arts; also studied in Paris. Pupil of Charles Grafly. Works: One hundred year Anniversary Fountain and Soldier's Memorial Fountain, Doylestown, PA; large group machinery and three historical bas relief panels for Pennsylvania Building, Sesqui-Centennial Exposition, Philadelphia. Address in 1926, Haddonfield, NJ.

BATES, GLADYS EDGERLY.
Sculptor. Born in Hopewell, NJ, July 15, 1896. Studied: Corcoran School of Art, 1910-21; Penna. Academy of Fine Arts, 1916-21; and with Grafly; Cresson European scholarship, 1920. Exhibited: Art Institute of Chicago; Carnegie; National Association of Women Artists; others. Awards: Penna. Academy of Fine Arts, 1931; National Association of Women Artists, 1934; Conn. Academy of Fine Arts, 1933; Art Institute of Chicago, 1935; Pen and Brush Club, 1944; National Association of Women Artists, 1948; others. Collections: Metropolitan Museum of Art; Penna. Academy of Fine Arts. Member: National Sculpture Society; National Association of Women Artists; Pen and Brush Club. Address in 1982, Mystic, CT.

BATHURST, CLYDE C.
Sculptor. Born in Mount Union, Penna., 1883. Pupil of Grafly at Penna. Academy of Fine Arts. Address in 1933, Rockport, MA. Died in 1938.

BATTENBERG, JOHN.
Sculptor. Born in Milwaukee, Wisconsin, in 1931. Studied at University of Wisconsin; Minnesota State College; Ruskin School of Fine Art and Drawing, Oxford, England; Michigan State; California College of Arts and Crafts. Taught at California College of Arts and Crafts, from 1977; others. In collections of San Francisco Museum of Modern Art; Tate, London; Los Angeles County Museum of Art; others. Exhibited in Artists in Major Museum Collections show at Los Angeles, Oakland, Palo Alto, California; American Federation of Arts Travelling Exhibition; Museum of Modern Art, Belgrade; Denver; Milan; San Francisco Museum of Modern Art. Arranged exhibits at Pennsylvania Academy of Art; Crocker Gallery, Sacramento; James Willis Gallery in San Francisco; others. Works in bronze. Address in 1982, Oakland, California.

BATTERSON, JAMES.
Sculptor. At Cleveland, Ohio, 1850. Specialty was mantels, monuments, Fountains. At Philadelphia, PA, 1857.

BATTIN (or BATTON, BALLIN), JOHN T.
Sculptor. Born in England c. 1805. Worked: New York City, 1841-45; Philadelphia, from c. 1847. Exhibited: Artists' Fund Society, 1840; National Academy. Died after 1860.

BAUER, SOL A.
Sculptor. Born in Cleveland, Ohio, March 11, 1898. Studied at Cleveland School of Art under Walter Sinz. Exhibited at Penna. Academy of Fine Arts, 1933, 34, 37, 38, 42, 46, 50; Art Institute of Chicago, 1938, 40; New York World's Fair, 1939; Daytona Art Museum, 1946 (one man); Ten Thirty Gallery, Cleveland, 1948 (one man); others. Address in 1953, Cleveland, Ohio.

BAUER, THEODORE.
Sculptor. Active in New York in 1925. Exhibited at the National Sculpture Society in New York.

BAUERMEISTER, MARY HILDE RUTH.
Sculptor. Born in Frankfurt am Main, West Germany, September 7, 1934. Work in Museum of Modern Art; Guggenheim Museum; Whitney Museum of American Art, NY; Albright-Knox Art Gallery, Buffalo, NY; Stedelijk Museum, Amsterdam, Holland. Has exhibited at Stedelijk Museum, Amsterdam; Museum of Modern Art, NY; Whitney Museum of American Art; Carnegie, Pittsburgh. Address in 1982, c/o Galeria Bonino, 48 Great Jones St., NYC.

BAUGHER, EVERETT EARNEST.
Sculptor and craftsman. Born in Sedalia, MO, April 28, 1906. Studied at Kansas City Art Institute. Exhibited: Kansas City Art Institute; Joslyn Memorial, 1942, 43; Penna. Academy of Fine Arts, 1942; City Museum of Art, St. Louis, 1942; Denver Art Museum, 1944. Address in 1953, Sedalia, MO.

BAUGHMAN, MARY BARNEY.
Sculptor. Born in Richmond, VA. Pupil of Colarossi Academy. Address in 1926, Richmond, Virginia.

BAUMANN, GUSTAVE.
Woodcarver, figure and landscape painter, woodblock printmaker, and writer. Born in Magdeburg, Germany, 1881; came to US (Chicago) in 1891. Studied drawing and printmaking at the Kunstgewerbe Schule in Munich; Art Institute of Chicago. Settled in Santa Fe in 1918, one of the colony's founders. From 1931, carved small figures for Marionette Theater. Author, illustrator, *Frijoles Canyon Pictographs*. Work in Metropolitan Museum of Art; NY Public Library; Art Institute of Chicago; Museum of New Mexico; Boston Museum of Fine Art; National Gallery of Art; National Gallery of Canada. Died in Santa Fe, New Mexico, 1971.

BAUR, THEODORE.
Sculptor and decorator. Born in Wuerttemberg, Germany, 1835; living in NYC, 1894, active in Germany, 1902. Work includes sculptured ornament, Parliament Houses, Ottawa, Canada, and on NYC mansions; bronze head after the Indian Sitting Bull; "Head of Indian Chief," cast by Bonnard Bronze Co., NYC. Represented in Denver Art Museum. Member: Fellowcraft Club, NY, 1894.

(Havlice gives death date of 1894.)

BAUS, PAUL J.
Sculptor. Address in 1934, Indianapolis, IN. (Mallett's)

BAUSMAN, MARIAN D.
See Walker, Marian D. Bausman.

BAXTER, JOHN.
Sculptor. Born in San Francisco, California, in 1912. Studied: University of California, at Los Angeles; self-taught in the visual arts. Taught at Philadelphia Museum of Art; Philadelphia Museum School; curator of education, San Francisco Museum of Art; instructor, University of California, Davis; also refractories engineer at Gladding, McBean and Co., Los Angeles and Pittsburgh. Exhibited at San Francisco Museum of Art; Willard Gallery, NYC; Phoenix (AZ) Art Museum; de Young Museum, San Francisco; Art Institute of Chicago; Museum of Modern Art; Carnegie Inst.; Whitney; University of Illinois at Urbana; etc. Died in 1966 in Oakland, California.

BAXTER, MARTHA WHEELER.
Sculptor and miniature painter. Born at Castleton, VT, in 1869. Studied at Penna. Academy of Fine Arts and Art Students League of NY, under Mowbray, Cox, Beckwith, and DuMond; also studied miniature painting under Mme. de Billemont-Chardon, and Mlle. Schmitt in Paris, and Mme. Behenna in London; others. Represented by "The Girl in Red," at Penna. Academy Fine Arts in 1924; "Lieut. L. E. Bray, USN," National Gallery, Wash., DC; "Girl with Black Hat," Museum of History, Science and Art, Los Angeles, CA; "Late and Fifth Earl of Chichester" Staumer Park Collection, England; Frick Collection, NYC. Exhibited at Penna. Academy of Fine Arts; Golden Gate Expo., San Francisco, 1939; Los Angeles Museum of Art; others. Received honorable mention at the Paris Exhibition of 1900; and many others. Address in 1953, Hollywood, CA. Died in 1955.

BAYLIS, RICHARD.
Stone and wood carver. At Charleston, SC, 1739.

BAYLOS, ZELMA.
Sculptor, painter, lithographer, and writer. Born in Butka, Hungary. Pupil of National Academy of Design; C. Y. Turner; Courtois; Prinet; Girardot in Paris; Will Low. Painted portrait of General Geo. R. Doyer; "Spirit of Democracy" owned by the American Red Cross; "Reflections after Sunset," Standish Hall, NY; and others. Member: American Artists Professional League. Address in 1933, Lake Mahopac, NY. Died c. 1947.

BAYMAN, LEO.
Sculptor. Exhibited a portrait at the Penna. Academy of Fine Arts, Philadelphia, 1920. Address in 1926, 10 East 14th Street, New York.

BEACH, CHESTER.
Sculptor. Born San Francisco, CA, May 23, 1881. Pupil of Verlet and Roland in Paris; studied in Rome. Member: National Academy of Design, 1924; American Academy of Arts & Letters; New York Architectural League; National Sculpture Society; American Numismatic Society; National Arts Club; New Society of Art; American Feder-

ation of Arts. Exhibited at National Sculpture Society, 1923. Awards: Gold medal, Julian Academy, 1905; Barnett prize, National Academy of Design, 1907; silver medal P.-P. Exposition, San Francisco, 1915; 1st prize National Arts Club, 1923; gold medal, New York Architectural League, 1924; Potter Palmer gold medal ($1,000), Art Institute of Chicago, 1925; gold medal and prize, National Arts Club, 1926; Watrous gold medal, National Academy of Design, 1926. Works: Three large groups on the Main Tower, Court of Abundance, P.-P. Exposition; "The Sacred Fire," Academy of Arts & Letters; marble reredos, St. Mark's Church, NY; "Cloud Forms," Brooklyn Museum; marble portrait head, Art Institute of Chicago; "Dawn," Cleveland Art Museum; "Beyond," California Palace of the Legion of Honor, San Francisco; "Spirit of the Barnard Greek Games," Barnard College; "Fountain of the Waters and Signs of Zodiac," terrace, Gallery of Fine Arts, Cleveland, OH; "Surf," Newark Art Museum; bronze, "Service," with marble figures in relief, Messages of Peace and War, American Telephone and Telegraph Building, NY; portraits of Peter Cooper, Asa Gray, Eli Whitney, S.F.B. Morse, Hall of Fame, NY; Henry Fairfield Osborn, American Museum of Natural History, NY; Augustus Juilliard, Juilliard Musical Foundation, NY; Adolph Lewisohn, Lewisohn Stadium, NY; US Coins, Monroe-Adams half dollar, Lexington-Concord half dollar, Hawaiian dollar. Address in 1953, 207 East 17th St., New York, NY. Died in 1956.

BEAMES, STEPHEN.
Sculptor and teacher. Born Multan, India, March 3, 1896. Pupil of Boston School of Fine Arts and Crafts; Albin Polasek; Beaux-Arts Institute of Design in New York. Work: War Memorial, Evanston, Ill.; sculpture for Chicago Theological Seminary. Instructor: Rockford College, Rockford, Ill. Address in 1933, Evanston, IL.

BEASLEY, BRUCE.
Sculptor. Born in Los Angeles, California, May 20, 1939. Studied at Dartmouth College; University of California at Berkeley. In collections of Museum of Modern Art; Guggenheim; Los Angeles County Museum of Art; Musee d'Art Moderne, Paris; commissions for San Diego, San Francisco, Eugene (Oregon), Miami (FL) International Airport, etc. Exhibited at Richmond (Calif.) Art Center; Kornblee Gallery, NYC; Hansen Gallery, San Francisco; de Young Museum, San Francisco; Museum of Modern Art; Musee d'Art Moderne, Paris; Oakland Art Museum; Jewish Museum, NYC; Osaka (Japan) Exposition; XI International Sculpture Conference, Washington, DC; others. Received Andre Malraux purchase prize, Paris Biennale; Frank Lloyd Wright Memorial purchase prize, Marin (Calif.) Museum Association; San Francisco Arts Festival purchase prize. Works in acrylic plastic and metal. Address in 1982, Oakland, California.

BEATTY, HETTY BURLINGAME.
Sculptor, designer, illustrator, craftsman, and writer. Born in New Canaan, Conn., October 8, 1906. Studied at Boston Museum of Fine Art School, and with Charles Grafly, Albert Laessle, George Demetrios. Work: US Post Office, Farmington, ME. Exhibited: Penna. Academy of Fine Art, 1931-37; Art Institute of Chicago, 1935-37; Macbeth Gallery, 1934; Worcester Museum of Art, 1941 (one-man); Gloucester Festival of Art, 1952. Author and illustrator, "'Topay," 1946; "Little Wild Horse," 1948; "Little Owl Indian," 1951; "Bronto," 1952. Address in 1953, Rockport, MA.

BEAVER, PEGGY.
Sculptor. Born in Greensboro, North Carolina, in 1931. Studied: University of North Carolina at Greensboro; University of South Carolina, Columbia. Awards: South Carolina Craftsmen, 1973; Bigelow Sanford Award of Merit, Guild of South Carolina Artists, 1973; Dutch Folk Art Association, 1974. Collections: Middle Tennessee State University, Murfreesboro; University of South Carolina; Associated Distributing Company, Columbia, South Carolina.

BECK, J. AUGUSTUS.
Sculptor and painter. Born in 1831 in Lititz, PA. Student of H. Powers and Thomas Crawford in Italy. The Penna. Historical Society has several copies of portraits that were made by this artist from original pictures. Independence Hall also has several copies by this artist. Died c. 1915.

BECK, OTTO WALTER.
Sculptor and painter. Member: Cincinnati Art Club. Address in 1903, Art Academy, Cincinnati, OH.

BECK, RAPHAEL.
Sculptor, painter, and illustrator. Studied at Julien Academy in Paris. Address in 1926, 78 Delaware Avenue, Buffalo, New York.

BECK, WALTER.
Sculptor, painter, and etcher. Born in Dayton, OH, March 11, 1864. Pupil of Isaac Broome of Trenton; Munich Academy under Gysis and Loefftz; sculpture under Ruemann. Member: New York Architectural League, 1902; National Arts Club (life); Washington Art Club; American Artists Professional League. Awards: First prize, National competition for mural decorations for the City Hall, Cincinnati, 1897; silver medal, Sesqui-Centennial Exposition, Philadelphia, 1926. Work: "The Life of Christ" (20 pictures) and "Portrait of a Lady," Brooklyn Institute Museum; two paintings illustrating the "Life of Christ," and ten pictures comprising 80 portraits, illustrating the Civil War, National Gallery, Washington, one at Newark Art Association and one in Montclair Museum; "The Way," Phillips Memorial Gallery, Washington, DC. Author: "Self-Development in Drawing as interpreted by the genius of Romano Dazzi and other Children," Putnam's. Address in 1933, Milbrook, NY.

BECKER, HERMAN ALBERT.
Sculptor and craftsman. Born in Essen, Germany, October 7, 1909. Studied at National Academy of Design; Beaux-Arts Institute of Design; Columbia University, with Maldarelli. Member: Palm Beach Art League. Awards: Prizes, National Academy of Design, 1939; Beaux-Arts Institute of Design, 1939-41; Palm Beach Art League, 1946. Exhibited: Palm Beach Art League, 1946. Address in 1953, Miami, FL.

BEDFORD, HENRY EDWARD.
Sculptor, painter, writer, and lithographer. Born Brooklyn, March 3, 1860. Pupil of William Anderson; Heatherly Art School in London. Member: Salmagundi Club. Address in 1926, 2744 Broadway, New York.

BEDFORD, WILLIAM J.
Sculptor. Born in Orange, CA, 1948. Self-taught. Began with welded metal sculpture, 1969; later worked in jewelry, wax modeling, casting. Began casting in bronze around 1975. Specialty: American Indians and birds of prey. Media: Bronze. Reviewed in *Southwest Art*, April 1978. Represented by: Signature Galleries, Scottsdale, AZ. Address in 1982, Laguna Beach, CA.

BEDNAR, JOHN JAMES.
Sculptor, painter, educator, and designer. Born in Cleveland, Ohio, July 1, 1908. Studied at University of Notre Dame, AB; Art Institute of Chicago, BFA, MFA. Awards: Prize, Hoosier Salon, 1945. Work: Murals, St. Edward's University; Architectural Society, University Notre Dame. Exhibited: Hoosier Salon, 1941, 1942, 1945. Taught: Instructor, Head of the Department of Art, University Notre Dame, 1943-45. Address in 1953, South Bend, IN.

BEDORE, SIDNEY NELSON.
Sculptor. Born in Stephenson, MI, March 5, 1883. Pupil of Beaux-Arts Institute of Design, New York; Art Institute of Chicago. Work: Theodore Roosevelt monument, Benton Harbor, Michigan; fountain at T. Roosevelt School, Chicago. Address in 1953, Lake Geneva, WI. Died 1955.

BEECHER, LABAN S.
Figurehead carver. Born c. 1805. He worked in Boston, c. 1822-39. In 1834 commissioned to carve the Andrew Jackson figurehead for the *Constitution*. Moved to the West, about 1843, settling near Sharon, WI.

BEEK, ALICE D. ENGLEY (MRS.).
Sculptor, painter, writer, and lecturer. Born in Providence, RI, June 17, 1876. Pupil of Sidney Burleigh, RI School of Design; Wheeler Art School; Academie Delecluse, Lazar, L'Hermitte, Puvis de Chavannes, and Edward Ertz in Europe. Member: American Artists Professional League. Awards: Grand prix; 2 croix d'honneur; 2 gold medals and 1 silver medal from Expositions Internationales Francaises; grand prize and gold medal at Seattle Exposition, 1909. Represented in European Galleries. Address in 1933, Tacoma, WA.

BEELER, JOE NEIL.
Sculptor and painter. Born in Joplin, MO, 1931. Studied: Tulsa University; Kansas State, B.F.A.; Art Center School, Los Angeles. Work in Gilcrease; National Cowboy Hall of Fame; Phoenix Art Museum; others. Exhibitions: Gilcrease Museum, one-man, 1960; Trailside Galleries, Scottsdale, AZ; National Cowboy Hall of Fame; Heard Museum; others. Won Best of Sculpture, Cowboy Artists of America show, also silver medal for sculpture. Cofounder of Cowboy Artists of America, 1965. Specialty: Western American. Address in 1982, Sedona, AZ.

BEEM, PAUL EDWARD.
Sculptor, painter, designer, illustrator, and lithographer.
Born in Indianapolis, IN, January 12, 1908. Studied at John Herron Art Institute; Art Institute of Chicago, and with Elmer Taflinger, R. L. Coats. Member: Society Typographic Arts; Art Directors Club; Hoosier Salon; Art Institute of Chicago. Awards: Prizes, Herron Art Institute, 1930-34; Hoosier Salon, 1929-40; Cincinnati Museum Association, 1929; Art Institute of Chicago, 1932, 38. Work: John Herron Art Institute; Univ. North Dakota; Indiana Univ.; mural, Orphan's Home, Indianapolis, IN. Exhibited: Art Institute of Chicago, 1932, 38; John Herron Art Institute, 1929-36; Hoosier Salon, 1929-40; Cincinnati Museum Association, 1932; Dayton Art Inst., 1932; Detroit Inst. of Art, 1933; Carnegie Inst., 1934; Delgado Museum of Art; numerous one-man and group shows in Chicago since 1933. Contributor to art magazines and other publications. Position: Art Director, W. E. Long Co., Chicago, IL. Address in 1953, Chicago, IL.

BEGG, JOHN ALFRED.
Sculptor, painter, and designer. Born in New Smyrna, FL, June 23, 1903. Studied at Columbia University, BS, and with Arthur Wesley Dow, Charles Martin. Member: American Institute of Graphic Arts. Work: Indiana Museum of Modern Art; Addison Gallery of American Art; bronze plaque for Readerscope award, 1945; others. Exhibited: Whitney Museum of American Art, 1945, 50; Brooklyn Museum, 1935, 37; Buchholz Gallery, 1943, 45; Wakefield Gallery, 1942 (one-man); Nierndorf Gallery, 1945; New School of Social Research 1948, 49; Worcester Museum of Art, 1948; American Watercolor Society, 1952. Author, technical book reviews; "Form and Format;" "Two Little Tigers and How They Flew." Position: E. Editor, American Book Co., 1932-37; Director of Design and Production, Oxford University Press, from 1939-68. Lectured on typography and design, NYU, 1950-58. Address in 1970, Hastings-on-Hudson, NY. Died in 1974.

BEHL, WOLFGANG.
Sculptor. Born April 13, 1918, Berlin, Germany, US citizen. Studied: Academy of Fine Arts, Berlin, 1936-39; Rhode Island School of Design, 1939-40. Work: Cornell University; University of Hartford; University of Mass.; University of Miami; Penna. Academy of Fine Art; Slater; plus commissions. Exhibited: The Bertha Schaefer Gallery, NYC, 1950, 1955, 63, 65, 68; Amerika Haus, Schweinfurt, Wurzberg, and Munich; Bucknell University, 1965; University of Conn., 1965; Art Institute of Chicago, 1943, 44; Boston Arts Festival, 1946, 47; Silvermine Guild, 1946, 47; Virginia Museum of Fine Art, 1946-49, 1951; Wadsworth Atheneum, 1957; Carnegie, 1962, 64; Penna. Academy of Fine Art, 1964; Harvard University, 1966; Cranbrook, 6th Biennial, National Religious Art Exhibition, 1968. Awards: Art Institute of Chicago, Joseph N. Eisendrath Prize, 1944; Milwaukee, WI. Prize for Sculpture, 1945; Conn. Academy of Fine Arts, 1st Prize for Sculpture, 1961; National Institute of Arts and Letters Grant, 1963; Ford Foundation, 1964. Taught at William and Mary, 1945-53; Silvermine Guild 1955-57; University of Hartford, from 1955. Address in 1983, Hartford CT.

BEIL (or BIEL), CHARLES A.
Sculptor. Active 1920s-60s. Worked as Cowboy in Montana. Friend of Charles Russell. Work in English Royal collection. Subjects are Western. Address in 1975, Red Deer, Alberta, Canada. Died in 1976.

BELDEN, ELLA CELESTE.
Sculptor. Born in Chicago, IL., 1873. Pupil of Art Institute of Chicago. Address in 1924, Chicago, IL.

BELINE, GEORGE.
Sculptor, painter, and teacher. Born in Minsk, Russia, July 23, 1887. Studied: National Academy of Design; Julian Academy, Beaux-Arts, Lycee Charlemagne, Ecole Superieure des Places de Vosges, Paris; and with Jean Paul Laurens. Member: Allied Artists of America; Hudson Valley Art Association; American Artists Professional League; Salmagundi Club. Exhibited: National Academy of Design; Penna. Academy of Fine Arts; American Artists Professional League; and others. Address in 1970, 370 Central Park West, NYC; summer, Frenchtown, NJ.

BELING, HELEN.
(Mrs. Lawrence R. Kahn). Sculptor. Born in NYC January 1, 1914. Studied: City College of NY; National Academy of Design with Paul Manship and Lee Lawrie; Art Students League with William Zorach. Awards: Audubon Artists, 1952; National Association of Women Artists, 1968; Silvermine Guild Art, 1957. Collections: Butler Institute of American Art, Youngstown, Ohio; Jewish Community Center, White Plains, New York; Hirshhorn Museum, Washington, DC; others. Exhibited: Penna. Academy of Fine Arts, 1950-56; Metropolitan Museum of Art, Sculpture Exhibit, 1951; Sculptors Guild Annual, 1954-79; Whitney; and others. Address in 1983, New Rochelle, NY.

BELISLE, VICTOR.
Sculptor. Born in Hot Springs, AR, 1944. Studied: Wayne State University, B.A. Private collections. Exhibitions: Wayne State University (Student Shows), 1969-71; Forsyth Saga, Detroit, 1973; The Little Gallery, Birmingham, 1973-74; Detroit Bank and Trust Artists Invitational, 1974; Michigan Focus, The Detroit Institute of Arts, 1974-75. Member: Journeyman, Millwright Local 1102. Address in 1975, Detroit, MI.

BELL, CARL.
Sculptor. Born in Germany in 1858, and graduated from the Academy of Fine Arts in Munich. Before coming to the US he executed several commissions for King Ludwig of Bavaria, superintending for him the building of castles in the Bavarian Alps. He directed the sculpture for the World's Fair and for the Paris Exposition in 1900. Died in Chicago, IL, June 18, 1927.

BELL, ENID.
(Mrs. Enid Bell Palanchian). Sculptor. Born in London, England, Dec. 5, 1904. Studied in England and Scotland; and with Sir W. Reid Dick, London; Art Students League. Member: NY Society of Craftsmen; Association of Art; National Sculpture Society. Awards: Medal, Paris International Exhibition, 1937; American Artists Professional League, 1934; New Mexico State Fair, 1940, 41; Newark Art Club, 1933; NJ Exhibition, 1949, 51. Work: Congressional medal for Lincoln Ellsworth; carved wood murals, Robert Treat School, Newark, NJ; US Post office, Mt. Holly, Boonton, NJ; others. Exhibited: Penna. Academy of Fine Arts; National Academy of Design; Whitney Museum, NY, 1939; Paris International Expo.; Metropolitan Museum of Art; Brooklyn Museum; Ferargil Gallery, 1929 (one-man); Arden Gallery, 1934. Author: "Tincraft as a Hobby;" "Practical Woodcarving Projects." Taught: Instructor of Sculpture, Newark School of Fine and Industrial Art, NJ, 1944-68. Address in 1976, Englewood, NJ.

BELL, LARRY STUART.
Sculptor. Born in Chicago, IL, December 6, 1939. Studied: Chouinard Art Institute, 1957-59, with Robt. Irwin, Richards Ruben, Rbt. Chuey, Emerson Woelfer. In collections of Tate; Albright; Museum of Modern Art; Pasadena Art Museum; Whitney. Exhibited: Ferus Gallery, Los Angeles, 1962, 63, 65; The Pace Gallery, 1965, 67; Ileana Sonnabend Gallery, Paris, 1967, 68; Amsterdam (Stedelijk), 1967; Walker, 1968; Albright, 1968; VIII Sao Paulo Biennial, 1965; Whitney Museum of American Art Sculpture Annual and Contemporary American Sculpture, Selection I, 1966; Jewish Museum, Primary Structures, 1966; La Jolla, 1966; Museum of Modern Art, the 1960's, 1967; Los Angeles County Museum of Art, American Sculpture of the Sixties, 1967; Guggenheim, Sculpture International, 1967; Documenta IV, Kassel, 1968; San Francisco Museum of Modern Art, 1976; Smithsonian Institution, 1977. Awards: J. S. Guggenheim Fellowship, 1969. Address in 1982, Taos, NM.

BELLAMY, JOHN HALEY.
Wood carver, amateur poet, and inventor. Born in Kittery Point, ME, April 16, 1836. Studied art in Boston and NYC; apprenticeship as a wood carver in Boston. Worked for the Boston and Portsmouth Navy Yards, also commercial ship carving; did decorative work for public buildings and private homes. Known for his "Bellamy" or "Portsmouth Eagles." Died at Portsmouth, NH, April 5, 1914.

BELLI, AMATO.
Plaster image maker. Born in Tuscany, Italy, c. 1836. At Philadelphia, 1860.

BELLI, DOMINICA.
Plaster image maker. Born in Tuscany, Italy, c. 1835. At Philadelphia, 1860.

BELLI, MICHAEL.
Plaster image maker. Born in Tuscany, Italy. At Philadelphia, 1860.

BELSEN, JACOBUS.
Sculptor, painter, and printmaker. Born in Patkino, Russia, in 1870. Studied at St. Petersburg (Leningrad) Academie. Professor at Craftsman School, St. Petersburg; positions at Alexander Lyceum, University for Architects and Engineers, Craft School of Imperial Society for the Benefit of Arts. Created murals for Humanistisches Gymnasium, stained glass windows for Hotel d'Europe, St. Petersburg; other works for churches, public and

private buildings; also painted landscape watercolors, created woodcuts representing Russian aristocracy. Fled to Germany in 1917 or 18, arriving in July 1919. In Berlin he worked in metal, blockprint, oils, painted miniatures, designed furniture for architects Friedmann and Weber, became a sculptor, and created caricatures and political cartoons for newspapers, magazines, some published in Hanfstaengel's *Hitler in the Caricature of the World.* Also published *Russian Winter Pictures, Figures of the Russian Revolution, Illustration of Norwegian and Finnish Tales, Illustrations of Russian Children's Tales*; plus a monogram of his work by F. Paul Schmidt (Ottens, Berlin). In 1924 and 1931, travelled to Holland and the East to sketch. Fled Germany in 1936, arriving in New York City. Commissioned by Metropolitan Opera Co. to paint clouds, water, fire effects on mica for special stage effects. Died September 12, 1937.

BELSKIE, ABRAM.
Sculptor. Born in London, England, Mar. 24, 1907. Studied at Glasgow School of Art, Scotland, with Alexander Proudfoot, Archibald Dawson. Member: Fellow, National Sculpture Society, 1951. Awards: Prize and scholarship, Glasgow, Scotland, 1925-27; prizes, National Sculpture Society, 1951. Work: Brookgreen Gardens, SC; Mariners Museum, Newport News, VA; American Museum of Natural History; Field Museum; Cleveland Health Museum; NY Academy of Medicine. Exhibited: National Academy of Design, 1936, 46. Co-author, "Birth Atlas," 1940. Specializes in medical sculpture, primarily for medical teaching. Position: Sculptor Associate, NY Academy of Medicine, 1939-46. Address in 1953, NY Medical College, Fifth Ave. at 106th St., NYC; h. Closter, NJ.

BEN-SHMUEL.
Sculptor. Exhibited in New York City, 1934. (Mallett's)

BEN-ZION.
Sculptor, painter, and teacher. Born in the Ukraine (Soviet Union), July 7, 1897. Self-taught, painting since 1931. Studied in Vienna. Emigrated to US in 1920, and became a US citizen in 1931. He is one of the founders of the expressionistic group, "The Ten," with whom he exhibited in Paris and NY. Other exhibitions: Advancing American Art, State Department Traveling Show, 1947; Bezalel Museum, Jerusalem, Israel, 1957; a major retrospective at the Jewish Museum in NYC, 1959; Whitney Museum of American Art Review, 1960-61; Collector's Choice, Denver Art Museum, Colorado, 1961; another retrospective in 1975, Museum of Haifa. Taught: Instructor of painting at Ball State Univ., the summer of 1956; also at the University of Iowa, the summer of 1959. Produced a four-volume set of etchings of Biblical themes published by Curt Valentin and printed in Paris, the first two volumes of which appeared in 1952. Address in 1982, 329 West 20th St., NYC.

BENDER, BEVERLY STERL.
Sculptor and environmental artist. Born in Washington, DC, January 14, 1918. Studied: Knox College, BA, Galesburg, Ill.; Art Students League; Sculpture Center, NYC; Museum of Natural History, NYC. Work: Bell Museum of Natural History, Minneapolis; memorial commission, Mystic Seaport, Conn. Exhibitions: National A.F. Club, New York City, 1969-81; Smithsonian; National Academy of Science, Philadelphia; Metropolitan Museum of Art; Society of Animal Artists Museum Tours; others. Awards: Catharine Lorillard Wolfe gold medal, 1969, merit certificate, 1979; Anna Hyatt Huntington cash prize; founders prize and merit award, Pen and Brush Club; Knickerbocker Artists; Society of Animal Artists. Member: Society of Animal Artists; Knickerbocker Artists; Pen and Brush Club; American Artists Professional League; others. Early work, children modeled in miniature; best known for stone animal carvings. Also works in wood. Address in 1983, Pound Ridge, NJ.

BENEDICT, AUGUSTA BURKE.
(Mrs. Stewart B.). Sculptor. Born in New York City, January 21, 1897. Studied with Victor Salvatori. Award: Junior League Exhibit, Newark Museum, 1931. Member: National Association of Women Painters and Sculptors; Plainfield Art Association. Address in 1933, Plainfield, NJ; summer, Shelter Island, NY.

BENGLIS, LYNDA.
Sculptor and painter. Born in Lake Charles, Louisiana, October 25, 1941. Studied: Newcomb College; Tulane University with Ida Kohlmeyer, Pat Travigno, Zolton Buki; and Harold Carney. Awards: Yale-Norfolk fellowship in 1963 and Max Beckman scholarship, Brooklyn Museum, in 1965; and National Endowment for the Arts grant. Exhibited: Milwaukee Art Center; Mass. Institute of Technology; Art Institute of Chicago; Whitney; Guggenheim; and many more. Work: Guggenheim; Museum of Modern Art, NYC; Walker; others. Address in 1980, Paula Copper Gallery, 155 Wooster St., NYC.

BENNETT, BELLE.
Sculptor. Born in New York City in 1900. She studied under Solon Borglum, and at the School of American Sculpture. Address in 1926, 152 East 63d Street, New York.

BENNETT, EMMA DUNBAR.
(Mrs. Harrison Bennett). Sculptor. Born in New Bedford, Mass. Pupil of British Academy in Rome. Member: Copley Society of Boston; MacDowell Club, NY; Lyceum Club of Paris. Address in 1933, Paris, France.

BENNETT, LOUIS (MRS.).
Sculptor. Member: National Association of Women Painters and Sculptors. Address in 1919, 615 Fifth Ave., NYC.

BENOFF, MIKI.
Sculptor. Noted for her bronzes using abstract, organic forms.

BENSADON, J.
Sculptor. At New Orleans, 1852. Worked in marble.

BENSON, EDA SPOTH.
Sculptor and painter. Born in Brooklyn, NY, March 25, 1898. Studied: Art Students League; Beaux-Arts Institute of Design, NYC; with Eugene Steinhof, Leon Dabo, and Alexander Hofer. Award: Prizes, Miami State Exposition, 1929; Palm Beach Art League, 1933, 34; Lime Rock Art

Association, 1932; first prize for landscape, Florida Federation of Arts, Miami, 1930. Member: Brooklyn Society Artists; Lime Rock Art Association; Kent Art Association; Palm Beach Art League; and others. Work: Hartford Library; murals, Pine Villa Hotel, West Cornwall, Conn. Exhibited: Library of Congress, 1943-45; American Federation of Arts traveling exhibition, Brooklyn Museum, 1933-46; National Academy of Design, 1942, 43; Albany Institute of History and Art, 1932 (one-man); and others. Address in 1953, West Palm Beach, FL.

BENSON, JOHN HOWARD.
Sculptor, painter, etcher, craftsman, and teacher. Born Newport, RI, July 6, 1901. Pupil of National Academy of Design; Art Students League of New York under Joseph Pennell. Member: Newport Art Association; Art Students League of New York. Work: Sculpture, Cold Spring Harbor, NY; South Natick, Mass.; Portsmouth, NH. Co-author: "The Elements of Lettering," 1940; Author: "Lettering Portfolio," Boston Museum of Fine Arts; and others. Position: Instructor, Lettering, 1931-44, Head of the Department of Sculpture, 1936-46, Rhode Island School of Design. Address in 1953, Newport, Rhode Island.

BENSON, STUART.
Sculptor and writer. Born in Detroit, Michigan, January 3, 1877. Studied at University of Michigan; studied art at the Joseph Gies School of Art in Detroit. Exhibited: Salon d'Automne, 1932; Tuileries, 1935; National Academy of Design; Carnegie Institute; Penna. Academy of Fine Arts; World's Fair of New York, 1939; Art Institute of Chicago. Notable work: "The Woman Who Came from Siberia" (bronze), 1938. Member: National Sculpture Society. Editor of *Collier's Magazine* in NYC. Died in 1949 at sea.

BENTON, FLETCHER.
Sculptor. Born Feb. 25, 1931, Jackson, OH. Studied: Miami University, BFA. Work: Aldrich; Whitney Museum; others. Exhibitions: Gump's Gallery, 1957; California Palace, 1964; San Francisco Museum of Art; Hansen Gallery, San Francisco, 1965, 66; Esther Robles Gallery, Los Angeles, 1966, 67; San Francisco Art Institute, 1967; La Jolla, 1965; New York World's Fair, 1964-65; University of California, Berkeley; Los Angeles County Museum of Art and Philadelphia Museum of Art, American Sculpture of the Sixties, 1967; Carnegie, 1967; Whitney Museum of American Art Sculpture Annual, 1968; Lytton Art Center, Los Angeles, 1968; UCLA, Electric Art, 1969. Address in 1982, San Francisco, CA..

BENTON, SUZANNE E.
Sculptor. Born in NYC, January 21, 1936. Studied: Queens College, NYC, Columbia University; Brooklyn College, Brooklyn Museum of Art School; Silvermine, Conn. Awards: The International Susan B. Anthony Hall of Fame; Grant from the Connecticut Commission on the Arts. Exhibitions: Metal Masks Sculpture for the Performing Arts, Lincoln Center; Touching Ritual, Wadsworth Atheneum; many others in US and abroad. Creates metal masks for narrative theatre; mask rituals examining stories and ancient tales, such as *Sarah and Hagar*, from Genesis, and others. Commissions: Sculp-

tured theatre sets, Viveca Lindfors I Am a Woman Theatre Company, 1973; The Sun Queen, bronze and corten steel, Art Park, Lewiston, NY, 1975. Member of Artists Equity; American Crafts Council; others. Address in 1982, Ridgefield, CT.

BEREAL, ED.
Sculptor. Born in Los Angeles, CA, 1937. Studied: Chouinard Art Institute, Los Angeles, 1958-62, B.F.A., 1962. Group exhibitions: The Objectmakers, Pomona College, Claremont, CA, 1961; War Babies, Huysman Gallery, Los Angeles, 1961; The Negro in American Art, UCLA Art Galleries, University of California, Los Angeles, 1966; Pasadena Museum of Modern Art, CA, 1973; La Jolla Museum of Contemporary Art, CA, 1975; San Francisco Museum of Modern Art, 1976; Smithsonian, 1977. Address in 1977, Los Angeles, CA.

BERG, ERIC.
Sculptor. Studied: University of Pennsylvania, MFA. Collections: Public Parks, Philadelphia Zoo, Schuyl Valley Nature Sanctuary. Exhibited: Several one person and group shows, New York and Philadelphia. Awards: Best of Show, Bestor Plaza, Chautauqua Institution. Member: Society of Animal Artists. Instructor, Sculpture in stone, Chautauqua Institution, Chautauqua, New York; Animal Sculpture, Philadelphia College of Art. Media: Bronze, stone, wood and steel. Specialty: Realistic animal sculpture; geometric abstractions. Address in 1983, Philadelphia, PA.

BERGE, DOROTHY ALPHENA.
Sculptor and instructor. Born in Ottawa, Canada, May 8, 1923. Studied at St. Olaf College, in Northfield, MN, BA, in 1945; Minneapolis School of Art, BFA, 1950; Georgia State University, Atlanta, GA, 1976. Exhibited: Minnesota Biennial, Minneapolis Institute of Art, 1954; Recent Sculpture, USA, Museum of Modern Art, NYC, 1957; one-person shows, Walker Art Center, 1959, the High Museum of Art, Atlanta, GA, 1968; and others. Instructor of Sculpture, Drawing, and Ceramics, at St. Olaf College, in Northfield, MN, 1946-48; artist-in-residence for sculpture, National Endowment for the Arts, GA, 1971-72. Executes her works in welded metal. Address in 1982, Atlanta, GA.

BERGE, EDWARD.
Sculptor. Born in Baltimore, MD, 1876. He studied at the Maryland Institute, the Rinehart School of Sculpture, Baltimore, MD; the Academie Julien; under Verlet and Rodin, in Paris. Awards: Bronze medal, Pan-Am. Expo., Buffalo, NY, 1901; bronze medal, and gold medal, Louisiana Purchase Expo., St. Louis, MO, 1904; bronze medal, Santiago Expo., South America, 1910; bronze medal, P.-P. International Expo., San Francisco, CA, 1915; Clark prize, Allied Artists of America, Paris. Member: National Sculpture Society; Charcoal Club; National Arts Club. Work: Watson monument and Tattersall monument, Baltimore; Pieta, St. Patrick's Church, Washington, DC; The Scalp, Museum of Honolulu, HI; Gist mem., Charleston, SC; Latrobe and Armistead monuments, Baltimore; On the Trail, an Indian mem., Clifton Park, Baltimore; memorials, Rev. Wynne Jones, Thomas Hayes, Baltimore;

garden and fountain figures; garden figure, Wild Flower, Melbourne, Australia. Exhibited at National Sculpture Society, 1923. Died in Baltimore, Maryland, October 12, 1924.

BERGE, HENRY.
Sculptor. Born in Baltimore, MD, May 29, 1908. Studied at Maryland Institute of Fine Arts; Rhinehart School of Sculpture with J. Maxwell Miller. Work in Hagerstown Museum of Fine Arts; large tympanum relief, Angel of Truth, First Unitarian Church, Baltimore, MD; others. Has exhibited at Baltimore Museum of Art; National Academy of Design, NYC; Penna. Academy of Fine Arts; National Sculpture Society Annual, Lever House, NY; others. Member of the National Sculpture Society. Award: Mrs. Louis Bennett Prize, 1964, National Sculpture Society. Address in 1982, Baltimore, MD.

BERGER, FRANK W.
Architectural sculptor. Born in 1846. Instructor in modeling at Central High School in St. Paul. His works are in a number of Minneapolis churches. Died May 1916, in Minneapolis, MN.

BERGER, HENRY.
Sculptor. In New York City, 1858. His designs for busts of Lincoln, 1865, Von Humboldt, 1868, and a statuette, 1870, were patented.

BERGIER, ARNOLD HENRY.
Sculptor, designer, craftsman, and teacher. Born in Cincinnati, OH, October 22, 1914. Studied at Ohio University; New School for Social Research, and with Joseph Du Be, Robert Gwathmey, Camilo Egas. Member: Artists Equity Association; Sculpture Center. Work: US Navy Combat Art Section; portraits of John Dewey, Toscanini, Admirals Halsey, Nimitz and Turner; James Forrestal and others. Sculpture, in Baltimore Synagogue, 1951. Exhibited: National Academy of Design; Whitney Museum of American Art, 1951; Decatur Museum Naval Historical Foundation, Washington, DC, 1951; Newport Art Association; Honolulu Academy of Art, 1946; Guildhall, East Hampton, LI, 1948; Jewish Museum, 1952. Instructor, Sculpture and ceramics, Lenox Hill Neighborhood Association, NYC. Address in 1953, 447 East 83rd St.; h. 1573 York Ave., NYC.

BERKE, ERNEST.
Sculptor and painter. Born in NYC, 1921. Self-taught. Employed as a commercial artist in animated films and fashion art. Began painting Indian and Western subjects in 1957. Exhibited at Latendorf's Bookstore, NYC, and Kennedy Galleries, NYC, 1962 (sold out). Later began sculpting in bronze. Specialty: Old West subjects. Bibliography, *Southwest Art*, March 1975; *Ernest Berke*, 1980. Represented: Overland Trail Galleries, Scottsdale, AZ. Address in 1982, Scottsdale, AZ.

BERKELEY, SHELIA.
Sculptor. Born in New York City, in 1945. Studied: Syracuse University, New York; New York University, New York City. Exhibitions: Hudson River Museum, New York, 1973; Institute of Contemporary Art, Boston, Massachusetts, 1970; Museum of Contemporary Crafts, New

York City. Commissions and Grants: New York State Council on the Arts, 1969; New York Urban Development Corporation, 1970; Department of Cultural Affairs, New York City, 1973.

BERLANT, TONY.
Sculptor and painter. Born in New York City, August 7, 1941. Moved to California in 1946. Studied at University of Southern California, Los Angeles (painting and sculpture). Taught at UCLA, 1965-69. In collections of Whitney, NYC; Art Institute of Chicago; Los Angeles County Museum of Art; Philadelphia Museum of Art; Wichita (KS) Museum of Art. Exhibited at David Stuart Galleries, LA; Hansen Gallery, San Francisco; Whitney, NYC; Xavier Fourcade, NYC; Houston Contemporary Arts Museum; Dwan Gallery, Los Angeles; Los Angeles County Museum; Art Institute of Chicago; San Francisco Museum of Modern Art; galleries in Seattle, Chicago, and Los Angeles. Works in collage and sculpture. Address in 1982, Santa Monica, California.

BERLENDEZ, VICTOR.
Sculptor. Born in Venice, Italy, January 8, 1867. Pupil of Vincenzo Cadorin. Address in 1910, St. Louis, MO.

BERMAN, WALLACE.
Sculptor. Born in Tompkinsville, NY, in 1926. Studied at Chouinard Art Institute, Los Angeles; Jepson Art School, Los Angeles. Exhibited at Ferus Art Gallery, Los Angeles; Los Angeles County Museum of Art; Whitney, NYC; Otis Art Institute, Los Angeles; Hayward Gallery, London; Dallas Museum of Fine Arts; San Francisco Museum of Modern Art; and others. Died in Topanga, California, in 1976.

BERMINGHAM, DAVE.
Sculptor, painter, and illustrator. Born in Plainfield, NJ, 1939. Self-taught. Employed initially in commercial art and illustration. Member: Society of Illustrators; Northern Plains Artist Association (founding member). Specializes in contemporary Western subjects. Represented by Big Horn Gallery, Cody, WY; Art Eclectic, Billings, MT. Address in 1982, Cody, Wyoming.

BERMUDEZ, JOSE YGNACIO.
Sculptor and painter. Born in Havana, Cuba, August 6, 1922; US citizen. Studied with Roberto Diago, Havana, Cuba, 1952-53; Bell Vocational School, Washington, DC, 1961. Work in Museum of Modern Art, NY; Corcoran Gallery of Art, Washington, DC; Phoenix Art Museum, AZ; Philadelphia Museum of Art; and others. Has exhibited at Martha Jackson Gallery, NY; Corcoran Gallery of Art, Washington, DC; and others. Works in metal. Address in 1982, Phoenix, AZ.

BERNARD, ARNOLD.
Sculptor. Born in France, c. 1815. Worked in San Francisco, 1858-60.

BERNARD, E.
Sculptor. Born in France, c. 1830. Worked in San Francisco, 1860.

BERNAT, MARTHA MILIGAN.
Sculptor. Born in Toledo, Ohio, August 5, 1912. Studied:

Cleveland School of Art; Syracuse University; Budapest School of Industrial Art, Hungary, and with Alexander Blazys, Ivan Mestrovic. Member: Liturgical Art Society; Los Angeles Art Association; Council Allied Artists. Awards: Prizes, Cleveland Museum of Art, 1935; Toledo Museum of Art, 1936, 47; Mansfield Fine Arts Guild, 1947, 48; Rochester Memorial Art Gallery, 1948. Work: Panels, St. Peter's Church, Mansfield, OH; in churches in Hollywood, CA, Pacific Palisades, CA, Norwalk, CA. Exhibited: Cleveland Museum of Art, 1935, 42; Toledo Museum of Art, 1936; Los Angeles Art Association, 1949, 50; Greek Theatre, Los Angeles, 1949, 50; Artists of the Southwest, 1950; Los Angeles Museum of Art, 1950; annual "Madonna" exhibition, Los Angeles, 1949, 50. Address in 1953, Van Nuys, CA.

BERNHEIMER, FRANZ KARL.
Sculptor. Born in Munich, Germany, May 16, 1911. Studied at Munich, Hamburg, Rome, Zurich; Yale University, MA, MFA. Member: College Art Association. Exhibited: Yale University, 1944; Norfolk Museum of Science and Art, 1952; Intermont College, Bristol, VA, 1952; one-man: Philadelphia Art Alliance, 1943; Argent Gallery, 1950. Instructor at Brooklyn College, Department of Design, 1946; Sweet Briar College, Department of Art, from 1946. Address in 1953, Sweet Briar, VA.

BERNSTEIN, EDNA L.
(Mrs. Milton L.). Sculptor and painter. Born in New York City, January 6, 1884. Studied at Art Students League and with William Chase, Howard Chandler Christy, Winold Reiss. Member: National Association of Women Artists. Address in 1953, 885 Park Avenue, NYC.

BERRY, HESTER BANCROFT.
(Mrs. Romeyn Berry). Sculptor. Born in Ithaca, NY, 1889. Address in 1934, Ithaca, NY. (Mallett's)

BERTOIA, HARRY.
Sculptor and graphic artist. Born March 10, 1915, in San Lorenzo, Italy. Came to USA 1930; became a citizen 1946. Studied: School of Arts and Crafts, Detroit; Cranbrook Academy of Art. Work: Albright; Dallas Public Library; Denver Art Museum; MIT; Museum of Modern Art; San Francisco Museum of Art; Utica; Va. Museum of Fine Arts; plus many commissions for corps., banks; Kodak Pavilion, New York World's Fair, 1964, and Phila. Civic Center, 1967. Exhibited: Karl Nierendorf Gallery, NYC, 1940; Staempfli Gallery, NYC; Fairweather-Hardin Gallery, Chicago; Museum of Non-Objective Art, NYC; Smithsonian; Whitney Museum; Museum of Modern Art; Battersea Park, London, International Sculpture Exhibition, 1963. Awards: New York Architectural League, Gold Medal; Graham Foundation Grant ($10,000), 1957. Taught: Cranbrook, 1937-41. Worked in copper and bronze. Living in Barto, Pennsylvania, in 1976. Died in 1978.

BESNER, FRANCES.
Sculptor and designer. Born in NYC, April 15, 1917. Studied at New York School of Fine and Industrial Arts; Parsons School of Design. Awards: Medal, New York School of Fine and Industrial Arts, 1939. Exhibited: New

School for Social Research 1939; ACA Gallery, NYC, 1940; Tribune Art Gallery, 1946. Address in 1953, Bronx, NY.

BEURY, GASTON.
Born in San Jose, CA, of French parents, July 9, 1859. Pupil of Chapu. Member, Societe des Artistes Francais. Address in 1910, Desroches, Boulogne-sur-Seine, France.

BEVERIDGE, KUHNE.
Sculptor. She was born in Springfield, Ill., 1877. Pupil of William Rudolph O'Donovan, New York; Rodin, Paris. Exhibited at National Academy of New York; Royal Academy London; Salon Champs de Mars, Paris; Paris Exposition, 1900. Honorable mention, Paris, 1900.

BEYER, STEVEN J.
Sculptor and lecturer. Born in Minneapolis, MN, August 27, 1951. Studied at Macalester College, St. Paul, MN, BA, 1973. Exhibited at University of Notre Dame, IN, 1973; New works by Twin Cities Artists, Landmark Center, Minneapolis Museum of Art, St. Paul, 1979; Words as Images, University of Chicago, 1981; Walker Art Center. In collections of Walker; Whitney; Newport Harbor Art Museum, Newport Beach, CA; others. Received Guggenheim Fellowship; National Endowment for the Arts Fellowship; others. Technique includes mixtures of sculpture, photographs, and words. Address in 1982, St. Paul, MN.

BIAFORA, ENEA.
Sculptor. Born in St. Giovanni in Fiore in Southern Italy, October 25, 1892. He studied under his father, a sculptor and architect. In 1907 he went to Naples and studied at the Istituto di Belle Arti. He was professor of drawing in the technical and normal schools of Italy. In 1914 he came to New York and later worked in the studio of Paul Manship. Awards: First prize and traveling scholarship at the Institute of Fine Arts, Naples. Works: The Little Centauress, at Metropolitan Museum of Art. Exhibited at National Academy of Design, 1922; National Sculpture Society, NY, 1923. Address in 1933, 315 West 21st Street, New York City.

BICKFORD, NELSON N.
Sculptor and painter. Born in 1846. Pupil of Lefebvre, Boulanger and Bouguereau in Paris. Specialty, animals. Address in 1926, New York City. Died in 1943.

BICKNELL, FRANK ALFRED.
Sculptor and painter. Chiefly painter. Born in Augusta, ME, February 17, 1866. Pupil of Julian Academy in Paris under Bouguereau and Robert-Fleury; also under H. Bicknell at Malden, MA. Work: "October Morning," National Gallery, Wash., DC; "Mountain Laurel," Montclair, NJ, Museum; "Pirate's Cove," Denver Art Museum; others. Member of American Art Association of Paris; Society of American Artists; Associate of National Academy of Design; National Arts Club, NY; Chicago Water Color Society; and others. Address in 1933, Old Lyme, CT. Died in 1943.

BIDDLE, GEORGE.
Sculptor, painter, graphic artist, illustrator, teacher, and

writer. Born in Phila., January 19, 1885. Studied at Penna. Academy of Fine Art; also in Paris and Munich. Works: "Tahitian Family," Penna. Academy of Fine Art; table with design in marquetry, Art Institute of Chicago; lithographs, permanent collections of Metropolitan Museum, Public Library, NY; Newark Public Library; Palace of Legion of Honor, San Fran., CA; and Kaiser Friedrich's Museum, Berlin; Galeria d'Arte Moderna, Venice; Museum of Fine Arts, Boston; John Herron Art Institute, Indianapolis; painting, Whitney Museum of American Art, NY. Wrote and illustrated with fifty drawings "Green Island" (Coward-McCann). Illustrated with ten original lithographs Alexander Block's "The Twelve" (William E. Rudge). Former Vice-Pres., Society of Painters, Sculptors and Gravers; President, Society of Mural Painters. Address in 1970, Croton-on-Hudson, NY. Died in 1973.

BIDWELL, MARY W.
Clay modeler and portrait painter. Born in East Hartford, Conn. Studied drawing there about 1858; later studied with F. S. Jewett. Had a studio in Hartford; winter address in Brooklyn. Exhibited in Brooklyn.

BIEDERMAN, CHARLES (KAREL JOSEPH).
Sculptor. Born August 23, 1906, Cleveland, Ohio. Studied: Chicago Art Institute School, 1926-29, with Henry Poole, van Papelandam, John W. Norton. Resided Prague, Paris, New York. Work: Museum of Modern Art; Phila. Museum of Art; Rijksmuseum; University of Saskatchewan; Tate; Walker. Exhibited: Chicago Art Institute School; Pierre Matisse Gallery, 1936; Arts Club of Chicago, 1941; St. Paul Gallery, 1954; Rochester (Minn.) Art Center, 1967; Albright, 1936; Reinhardt Galleries, NYC, 1936; Galerie Pierre, Paris, 1936; Kunstgewerbemuseum, Zurich, 1962; Marlborough-Gerson Gallery Inc., 1964; Walker; Grace Borgenicht Gallery, NYC; others. Awards: Amsterdam (Stedelijk), Sikkens Award, 1962; Ford Foundation, 1964; National Council on the Arts, 1966; Walker Biennial, Donors Award, 1966; Minnesota State Arts Council, 1969; others. Represented by Grace Borgenicht Gallery, NYC. Address in 1982, Red Wing, MN.

BIESIOT, ELIZABETH KATHLEEN GALL.
Sculptor, etcher, and craftswoman. Born in Seattle, Wash., October 8, 1920. Studied at University of Washington, BA, with Maldarelli; Columbia University; and with Archipenko, Paul Bonifas. Member: Northwest Crafts Workshop; Springfield Art League; American Artists Professional League; Society Ceramic Artists; Lincoln Artists Guild. Awards: Craftsman Guild, 1940; University of Washington, 1942; Denver Art Museum, 1945; Seattle Art Museum, 1945. Exhibited: San Francisco Art Association, 1944, 45; American Artists Professional League, 1945; Springfield Art League, 1944, 45, 46; Oakland Art Gallery, 1945, 46; Denver Art Museum 1945; Mint Museum Art, 1946; Audubon Artists, 1945; Seattle Art Museum, 1940-45; Lincoln Artists Guild, 1945; Position: Instructor, University Nebraska, 1945. Address in 1953, Seattle, Washington.

BIETZ, HUGO H.
Sculptor and painter. Born in Akron, Ohio, February 2, 1892. Studied at Art Institute of Chicago. Address in 1953, Ravenna, Ohio.

BIGGERS, JOHN THOMAS.
Sculptor and painter. Chiefly painter. Born in Gastonia, NC, April 13, 1924. Studied at Hampton Institute, with Victor Lowenfield; Penna. State College, M.A. Work: Murals, Naval Training School, Recreation Center, Hampton, VA; Eliza Johnson Home, Houston, Texas; Dallas Museum of Fine Arts; Reader's Digest Collection. Commissions: Seasons of Want and Plenty; and others. Awards: Prizes, Museum of Fine Art of Houston, 1950; Dallas Museum of Fine Art, 1952; Art Fellowship in Africa, UNESCO, 1957. Exhibited: Museum of Modern Art, 1943; City Art Museum of St. Louis; San Fran. Museum of Art; Portland Art Museum; Boston Museum of Fine Art; Seattle Art Museum, 1945; Virginia Museum of Fine Arts traveling exhibition, 1945, 46; Brooklyn Library, 1946; M. Knoedler & Co., NYC, 1952; one-man show, Houston Museum of Fine Arts, 1968; and others. Teaching: Texas Southern University, from 1949. Address in 1982, Houston, TX.

BILLIAN, CATHEY R.
Sculptor, painter, and instructor. Born: Chicago, Illinois, February 24, 1946. Studied: University of Arizona; Temple University; The Art Students League; The Art Institute of Chicago; Pratt Institute. Exhibitions: Larry Aldrich Museum of Contemporary Art, Ridgefield, Connecticut, 1974; Hudson River Museum, 1975; Elsie Meyer Gallery, 1980, 82; others. Work in Philadelphia Museum of Art; others. Address in 1982, 456 Broome Street, New York, NY.

BILLINGS, HAMMAT.
Sculptor, illustrator, architect, and designer of monuments. Born in Milton, Mass., 1818. In 1867 he patented a statuette. Died in Boston, 1874.

BILOTTI, SALVATORE F.
Sculptor. Born in Cosenza, Italy, February 3, 1879. He studied in Phila., Paris and Rome, studying successively with Charles Grafly, Injalbert and Verlet. Awards: Cresson travelling scholarships, Pennsylvania Academy of Fine Arts, Philadelphia, PA, 1906-1907; collaborative prize, New York Architectural League, 1914. Member: New York Architectural League; National Sculpture Society. Works: Marble statue, Our Lady of Lourdes, Chapel of the Little Sisters of the Poor, New York. The Art Museum of St. Louis, MO, contains examples of his works. His specialty was portrait busts and statuettes. Exhibited at National Sculpture Society, 1923; Penna. Academy of Fine Arts, 1924. Address in 1933, 9 MacDougal Alley, NYC. Died in 1953.

BINFORD, JULIEN.
Sculptor and painter. Born in Fine Creek Mills, VA, December 25, 1908. Studied at Emory Univ., GA; Art Institute of Chicago. Awards: Fellow, Art Institute of Chicago; Fellow, Virginia Museum of Fine Art, 1940; awarded National Competition for mural in Virginia State Li-

brary, Richmond, 1951. Rosenwald F. Work: Phila. Museum of Art; IBM; Boston Museum of Fine Arts; Addison Gallery of American Art; Virginia Museum of Fine Art; New Britain Museum; Springfield Museum of Art; Oberlin College; Univ. Nebraska; W. R. Nelson Gallery Art; others. Exhib.: Salon des Tuileries, Paris; Audubon Artists; Southern Museum Circuit; City Art Museum of St. Louis; Virginia Museum of Fine Arts; Art Institute of Chicago; Penna. Academy of Fine Arts; Corcoran Gallery Art Biennial, Wash., DC; National Academy of Design; Carnegie Institute; Los Angeles Museum of Art; Toledo Museum of Art. Position: Institute, Mary Wash. College, Fredericksburg, VA. Address in 1980, Powhatan, VA.

BINNS, ELSIE.
Sculptor. Exhibited at Penna. Academy of Fine Arts, Philadelphia, 1924. Address in 1926, Alfred, NY.

BINON, J. B.
Sculptor. Born in France. Active in Boston in 1820. Educated in France and studied art there. When in Boston he executed a bust of John Adams. He was an early instructor of the sculptor Horatio Greenough.

BIORSHI, CHARLES.
Sculptor. Active in St. Paul, Minn., 1934. (Mallett's)

BIRD, JOHN.
Sculptor. Born in New York State, 1811. At New York City, 1850.

BISSELL, DOROTHY PENDENNIS.
Sculptor. Born in Buffalo, New York, May 17, 1894. Studied: with Arthur Lee. Member: Buffalo Society of Artists. Specialized in heads of children and animals. Address in 1953, 22 East 17th Street; h. 37 West 8th Street, New York, NY.

BISSELL, GEORGE EDWIN.
Sculptor. Born New Preston, Litchfield Co., Conn., February 16, 1839. In marble business with his father and brother at Poughkeepsie, NY, 1866; studied art in Paris, Rome, and Florence. Public monuments and statues: Soldiers' and Sailors' Monument, and statue Col. Chatfield, Waterbury, Conn.; portrait statue Gen. Horatio Gates on Saratoga Battle Monument; Chancellor John Watts and Col. Abraham de Peyster, New York; Abraham Lincoln, Edinburgh, Scotland; Chancellor James Kent, Congressional Library; bronze statues Admiral Farragut and Gen. Sherman; statue of Lincoln, Clermont, IA; marble bust and bronze statuette in Metropolitan Museum, New York. Died August 30, 1920, in Mt. Vernon, New York.

BITTER, KARL THEODORE.
Sculptor. Born in Vienna in 1867. He came to America in 1889, after studying in Vienna at the School of Applied Arts. Member of National Institute of Arts & Letters, National Academy of Design, and President of National Sculpture Society at the time of his death. Works: Statue of General Sigel, Riverside Drive, NYC; panels in Trinity Church gates, NYC; figures in facade of Metropolitan Museum of Art; statue Dr. William Pepper, Phila.; statue of facade of Brooklyn Museum; statues on Vanderbilt and

Rockefeller estates; and the battle group for Dewey Architecture, NYC. See "Karl Bitter, A Biography," by Schevill, pub. in Chicago, 1917. Died in 1915.

BITTERLY, L. P. (MRS.).
Sculptor and painter. Member: Denver Art Association. Address in 1923, Denver, Colorado.

BJORKMAN, OLAF.
Sculptor. Born in Scandinavia in 1886. Among his best known works: "Beethoven," "The Titan," and heads of Lincoln and Edgar Allen Poe. Address in 1926, New York. Died in 1946.

BJURMAN, ANDREW.
Sculptor, craftsman, and teacher. Born in Sweden, April 4, 1876. Member: California Art Club; Southern California Sculptors Guild. Awards: Bronze medal, San Diego Exposition, 1915; second prize, California Liberty Fair, 1918; popular prize, Southwest Museum, 1923; honorable mention, Los Angeles Museum, 1924; first prize, Pomona, California, 1924 and 1927; honorable mention, Los Angeles Museum, 1927; gold medal, Southwest Exposition, Long Beach, California, 1928. Address in 1933, Alhambra, California. Died in 1943.

BLACK, DAVID EVANS.
Sculptor and educator. Born in Gloucester, MA, May 29, 1928. Studied at Skowhegan School, Maine, summer 1949; Wesleyan University, A.B., 1950; Indiana University, Bloomington, M.F.A., 1954. Work in Addison Gallery of American Art, MA; Dayton Art Institute; Butler Institute of American Art, Youngstown, OH; Neue Nationale Galerie Sculpture Center, West Berlin; and others. Has exhibited at Jewish Museum, NY; Milwaukee Art Center, WI; San Francisco Museum of Art; and others. Received National Endowment for the Arts Award, 1966; Ford Grant, 1979; and others. Address in 1982, Department of Art, Ohio State University, Columbus, OH.

BLACK, LAVERNE NELSON.
Sculptor, painter, and illustrator. Born in Viola, Kickapoo Valley, WI, 1887. Moved to Chicago, studied at the Academy from 1906 to 1908. Worked as an illustrator in Minneapolis and as a newspaper artist in Chicago and NYC. Painted on commission; sculpture sold through Tiffany's. Work in Anschutz Collection, Denver, CO; Harmsen Collection; murals, US Post Office, Phoenix; Treasury Dept. (DC). Specialty, Southwest Indian genre, Arizona pioneers and later cattle and mining industries, Indian bronzes. Lived in Taos, NM, 1925-37, and Phoenix, AZ. Died in Chicago, IL, 1938.

BLADEN, RONALD.
Sculptor and painter. Born in Vancouver, British Columbia, Canada, July 13, 1918. Studied at Vancouver Art School and CA School of Fine Arts. Exhibited: Whitney Museum of American Art, 1966, 68; Guggenheim Museum of Art, 1967; Corcoran Gallery of Art, 1967; The Hague, 1968; Documenta, Kassel, 1968; Green Gallery, 1962. Address in 1982, 5 West 21st St., NYC.

BLAI, BORIS.
Sculptor, lecturer, and teacher. Born in Rowno, Russia,

July 24, 1893. Studied at Imperial Academy of Fine Arts, Leningrad; Ecole Beaux-Arts, Paris; student of Rodin. Member: Phila. Alliance; Fairmount Park Art Association. Work: Rhythm of the Sea (bronze), Philadelphia Museum of Art, PA; busts of all five presidents and other portraits, Temple University, Philadelphia; others. Exhibited: First Open Air Show, Rittenhouse Square, Philadelphia, 1927; Chicago Art Institute, 1932; Philadelphia Academy Annual, 1940; retrospectives, Long Beach Island Foundation of Arts and Science, NJ, 1968, and Harcum Jr. College, PA, 1969. Awards: Page One Award, Philadelphia, 1960; Philadelphia Art Alliance Medal, 1960; Samuel S. Fels Medal, 1962. Founder, professor of art, and dean at Tyler School of Fine Arts, Temple University, 1930-60; founder, Blai School of Fine Arts, PA, from 1972. Address in 1982, Philadelphia, PA.

BLAI, ISABEL S.
Sculptor and craftsman. Born in Trenton, NJ, August 8, 1919. Studied: Temple University, B.F.A., B.S. in Education; and with Boris Blai, Franklin Watkins, Furman Finck. Member: Washington Art Guild. Exhibited: Penna. Academy of Fine Arts, 1941, 1942; Society Washington Artists, 1941; Temple University, 1941; Wash. Art Guild, 1942. Address in 1953, New Brunswick, NJ.

BLAIR, HELEN.
(Helen Blair Crosbie). Sculptor and illustrator. Born in Hibbing, MN, December 29, 1910. Studied at Mass. School of Art, with Cyrus Dallin; Boston Museum School; Archipenko School of Art, with Archipenko. Commissions: Plaques of Dr. Waring, Colorado Medical School, 1969, and of Dr. Porter, Porter Memorial Hospital, Denver, 1970. Exhibitions: One-woman shows, Ardan Studios, NY, 1938, Portraits, Inc., NY, 1941-42, Vose Galleries, Boston, 1944, St. Paul Art Center, Minnesota, 1962, and Martin Gallery, Phoenix, 1973-74. Address in 1982, Phoenix, AZ.

BLAIR, ROBERT NOEL.
Sculptor, painter, etcher, and illustrator. Born in Buffalo, NY, August 12, 1912. Studied at Boston Museum of Fine Arts School; Buffalo Art Institute. Member: Phila. Water Color Club; Portland Water Color Society; El Paso Art Association; Baltimore Water Color Society. Awards: Prizes, Albright Art Gallery, 1940; Art Institute of Chicago, 1948; Buffalo Society of Artists, 1951; med., Buffalo Society of Artists, 1947, 50; Guggenheim Fellow, 1946, 51. Work: Metropolitan Museum of Art; Munson-Williams-Proctor Institute; murals, chapel and hospital, Ft. McClellan, AL. Exhibited: Brooklyn Museum, 1939; Art Institute of Chicago, 1942-44, 48; Metropolitan Museum of Art; Riverside Museum; Albany Institute of History and Art, 1934-46; Baltimore Museum of Art; Albright Art Gallery, 1942 (one-man); Penna. Academy of Fine Arts; numerous others. Illustrator, "Captain and Mate" 1940, and other children's books. Taught: Instructor painting, Art Institute Buffalo, 1938-55, State University of New York College at Buffalo, 1971. Address in 1982, Holland, New York.

BLAKE, (JIM) BUCKEYE.
Sculptor and painter. Born in Fullerton, CA, 1946. Raised in Nevada; later settled in Montana. Work includes large bronzes, Charles Russell funeral procession; stagecoach with six running horses. Specialty, Old West subjects. Represented at Montana Gallery and Book Shoppe, Helena, MT; Eagle Art Gallery, La Jolla, CA. Address in 1982, Augusta, MT.

BLANC, (WILLIAM) PETER.
Sculptor and painter. Born in NYC, June 29, 1912. Studied at Harvard University, B.A.; St. John's University, L.L.B.; Corcoran School of Art; American University, M.A. Work in Virginia Museum of Fine Arts, Richmond; Fort Worth Art Center, TX; and others. Has exhibited at Baltimore Museum of Art, MD; Brooklyn Museum, NY; Corcoran Gallery, Washington, DC; Fogg Art Museum, Cambridge, MA; Museum of Santa Fe, NM; National Collection of Fine Arts, Washington, DC; Whitney Museum of American Art, NY; and others. Received first prize for drawing, Corcoran Gallery of Art; and others. Works in wood. Address in 1982, 161 W. 75th St., NYC.

BLANCHARD, ALONZO.
Sculptor. At work c. 1842. Sculpture patented under Patent Act of 1842.

BLANCHARD, THOMAS.
Sculptor. Worked in Boston. Executed casts of busts in the Library of Congress at Washington in 1847. Exhibited two marble busts at the American Institute, Washington.

BLASY, ALEXANDER.
Sculptor. Exhibited at Penna. Academy of Fine Arts, 1924. Address in 1926, 31 Bank Street, New York.

BLAZYS, ALEXANDER.
Sculptor and teacher. Born in Lithuania, February 16, 1894. Studied with S. Volnuchin. Works: "Russian Dancers," Cleveland Museum of Art, Cleveland, Ohio. Awards: First prize for sculpture, Cleveland Museum of Art, 1926, 27, 28. Address in 1933, Cleveland, Ohio.

BLEIFELD, STANLEY.
Sculptor and instructor. Born in Brooklyn, NY, Aug. 28, 1924. Studied: Albert C. Barnes Foundation, Meryon, PA, 1942-43; Tyler School of Art, Temple University, B.F.A., 1949, B.S. (education), 1949, M.F.A., 1950. Work in Westmoreland Museum, PA; New Britain Museum of American Art, CT; Woman and Child, Stamford Rehabilitation Center, CT; others. Has exhibited at American Federation of Arts, 1966-67; FAR Gallery, NY, 1971, 73, and 77; New Britain Museum of American Art; others. Member of the National Sculpture Society and Artists Equity. Received John Gregory Award, 1964, and bronze medal, 1970, National Sculpture Society; Tiffany Foundation fellowship, 1965 and 67; Shikler Award, National Academy of Design. Taught at Southern Conn. State College and Western Conn. State College, 1953-63; sculpture at Silvermine Guild, New Canaan, CT, 1963-66; teaching at Bleifeld Studio, Westport, CT, from 1966. Address in 1982, Weston, CT.

BLISS, ELIZABETH STURTEVANT (MRS.).
(See Theobald, Elizabeth Sturtevant).

BLOCK, ADOLPH.
Sculptor. Born New York City, January 29, 1906. Pupil of

Hermon A. MacNeil; Edward F. Sanford; Gregory; A. Sterling Calder; Edward McCartan; Beaux-Arts Institute of Design in New York; Fontainebleau School of Fine Arts, Paris. Exhibited: National Academy of Design; Penna. Academy of Fine Arts; Architecture League of New York; National Sculpture Society; Whitney Museum of American Art; plus others. Award: Third Award, National Aeronautic Trophy Competition; prize, Otis Elevator dial design competition; Tiffany Foundation Fellowship; architects' silver medal, Beaux Arts Institute, 1926; Fontainebleau Fellowship, 1927; Paris Prize, Beaux-Arts Institute, 1927; award for most Notable Service, 1970, National Sculpture Society; and others. Member, National Academy of Design (academician); National Sculpture Society (fellow); others. Worked in bronze. Address in 1976, 319 West 18th Street, New York, NY. Died 1978.

BLODGETT, GEORGE WINSLOW.
Sculptor. Born in Northfield, Minn., March 10, 1888. Studied: Oregon State College; Julian Academy, Paris. Work: Metropolitan Museum of Art; Brookgreen Gardens, SC; Cranbrook Academy of Art; Denver Art Museum; Seattle Art Museum; Santa Fe, Albuquerque, NM. Exhibited: Brooklyn Museum; Arden Gallery; Grand Central Gallery; Tulsa, Okla.; Phila. Museum of Art; Cranbrook Academy of Art. Moved to Santa Fe, NM, in 1929. Died there in 1958. Address in 1953, Santa Fe, NM.

BLOODGOOD, ROBERT FANSHAWE.
Sculptor, painter, illustrator, etcher, and teacher. Born New York, October 5, 1848. Pupil of National Academy of Design; Art Students League of New York. Member: Salmagundi Club; Calif. Society of Etchers; National Arts Club. Address in 1929, 64 East 56th St; 112 Park Ave., New York, NY; summer, Setauket, LI, NY.

BLOYDGETT, GEORGE.
Sculptor. Born in Northfield, Mass. Exhibited at the Salon d'Automne, Paris, 1928.

BLUM, ANDREA.
Sculptor. Born in NYC, April 6, 1950. Studied at University of Denver; Boston Museum School of Fine Arts, B.F.A., 1973; School of Art Institute of Chicago, M.F.A., 1976. Work in Art Institute of Chicago; National Collection of Fine Arts, Washington, DC; and others. Has exhibited at Boston Museum School; Art Institute of Chicago; De Cordova Museum, MA; and others. Received National Endowment for the Arts individual grants, 1976 and 78. Address in 1982, c/o Marianne Deson Gallery, Chicago, IL.

BLUMENSCHEIN, MARY SHEPARD GREENE.
(Mrs. E. L. Blumenschein). Sculptor, painter, and craftswoman. Born September 26, 1869, in New York City. Pupil of Herbert Adams in NYC; Collin in Paris. Member: National Academy of Design, 1913; National Association Women Painters & Sculptors, NYC; Society of Illustrators, 1912. Awards: Third medal in the Paris Salon, 1900; second medal, Paris Salon, 1902; silver medal, St. Louis Exposition, 1904; Julian Shaw Memorial

($300), National Academy of Design, 1915; Denver Art Museum, 1934. Represented in Brooklyn Museum. Address in 1953, Taos, New Mexico. Died in 1958.

BLYTHE, DAVID GILMOUR.
Sculptor, portrait and genre painter, carver, panoramist, illustrator, and poet. Born near East Liverpool, OH, May 9, 1815. Was apprenticed to Joseph Woodwell, a carver in Pittsburgh, 1832-35. Worked as a carpenter and house painter at Pittsburgh from 1835-36; went to New Orleans in 1836. While serving in the US Navy as a ship's carpenter, travelled to Boston and the West Indies, 1837-40. Became an itinerant portrait painter in western Penna. and eastern Ohio (1841-45); settled at Uniontown, PA, 1846-51; toured to Cumberland and Baltimore, MD, Pittsburgh, PA, and Cincinnati and East Liverpool, OH. Carved a statue of Lafayette for the County Courthouse at Uniontown. Represented by Kennedy Galleries, NYC; Carnegie Institute; Rochester Museum; Brooklyn Museum; and National Baseball Museum, Cooperstown, NY. Best known for satirical genre paintings of 19th century society. Address in 1865, Pittsburgh, Penna. He died in Pittsburgh, PA, on May 15, 1865.

BOARDMAN, FRANK CRAWFORD.
Sculptor and painter. Born in Hartford, Conn. Pupil of Yale Art School, New Haven, Conn.; Ecole des Beaux-Arts in Paris. Later chiefly painter. Address in 1906, 333 Crown Street, New Haven, Conn. Died in 1938.

BOAS, SIMONE MARTHE.
Sculptor. Born in La Creche, France, February 3, 1895. Came to US in 1904, naturalized, 1921. Received BA from University of Calif. Berkeley, 1917; art student at San Fran. School of Art, 1917, Academie de la Grande Chaumiere, Paris, 1920. Exhibited at Maryland Institute, Museum of Art (all Baltimore); in NYC; throughout US and abroad. In collection of Baltimore Museum of Art. Major works: "Woman" (marble), "La Reine des Eaux" (marble), "Mother and Child" (mahogany). Address in 1962, 8815 Norwood Ave, Philadelphia.

BOBBS, HOWARD.
Sculptor and painter. Born in Pennsylvania, 1910; raised in California. Studied: Otis Art Institute, Los Angeles, California; Hollywood Art Institute; Phoenix Art Institute; National Academy of Design School; Art Students League. Early in career, designed terrazzo floors in St. Louis, MO; later as WPA supervisor, taught art in NYC. Subjects include scenes from the American Southwest and from the countries of his travels (England, Mexico, France, Italy, Scotland). Reviewed in *Southwest Art*, September 1973, April 1979; *Artists of the Rockies*, Spring 1979. Represented by own Howard Bobbs Gallery. Address since 1949, Santa Fe, New Mexico.

BOCCINI, MANUEL (FIORITO).
Sculptor, painter, etcher, and lithographer. Born in Pieve di Teco, Italy, September 10, 1890. Studied at Grande Chaumiere, Paris; Art Students League; Grand Central Art School; and with Andre Favory, Andre Derain. Exhibited: Anderson Gallery, 1927; Gallery Barrero, Paris, 1929, 30; Salon d'Automne; Boccini Gallery, NY, 1938;

Society of Independent Artists; Salons of America. Address in 1953, 988 Second Ave., NYC; h. 470 Midland Avenue, Rye, NY.

BOCK, RICHARD W.
Sculptor. Born in Germany, July 16, 1865; came to America at age of five. Pupil of Schaper, Berlin Academy; Falguiere, Ecole des Beaux Arts, Paris. Work: Ill. State Soldiers' and Sailors' Monument at Shiloh; Lovejoy Monument at Alton, Ill.; bronze group on Public Library at Indianapolis; Soldiers' Monument at Chickamauga, for Lancaster, PA; pediments, Rail Road Station, Omaha, Neb.; many bronze busts; etc. Received medal at Columbian Exposition, Chicago, 1893; first award, American Artists' Professional League, Portland, Oregon, 1932. Member of the Chicago Society of Artists, American Artists' Professional League. Address in 1933, The Gnomes, River Forest, Ill.

BODKIN, SALLY GROSZ.
Sculptor. Born in Budapest, Hungary, November 11, 1900. Studied at Art Students League; Sculpture Center, NY. Works: Private collections. Exhibited: Clay Club, 1942 (one-man); National Arts Club, 1943; Whitney Museum of American Art, 1944; Rochester Memorial Art Gallery, 1943; National Academy of Design, 1944; and others. Awards: National Association of Women Artists, 1949. Address in 1953, 4 West 8th Street; h. 23 West 73rd Street, New York City.

BODO, SANDOR.
Sculptor, painter, and conservator. Born in Szamosszeg, Hungary, February 13, 1920; US citizen. Study: College of Fine and Applied Arts, Budapest, Hungary. Commissions: Bronze reliefs, Hungarian Reformed Federation of America; portrait of Andrew Jackson, Royal Palace, Copenhagen. Exhibitions: National Housing Center, Wash., DC; Smithsonian Institution; Tenn. Fine Art Center, Nashville; Butler Institute of American Art, Youngstown, OH; National Academy Galleries, NYC; others. Awards: American Artists Professional League gold medal, watercolor; National Arts Club, NY, gold medals, sculpture and oil painting; Smithsonian Institution; others. Member: National Arts Club; American Artists Professional League (fellow); Allied Artists of America. Works in oil, watercolor, bronze. Address in 1982, Nashville, Tennessee.

BOERICKE, JOHANNA MAGDALENE.
Sculptor and painter. Born in Philadelphia on February 13, 1868. Pupil of Penna. Academy of Fine Arts, studied in Rome and Paris. Member: Penna. Society of Miniature Painters; Philadelphia Alliance; Fellowship Penna. Academy of Fine Arts; Baltimore Water Color Club; American Federation of Arts. Address in 1933, Philadelphia, PA.

BOERNER, EDWARD A.
Sculptor, painter, and educator. Born in Cedarburg, WI, June 26, 1902. Studied at University of Wisconsin, with Varnum, Colt; Minneapolis Institute of Art, with Cameron Booth; University of Iowa, Museum of Art, with Grant Wood, L. D. Longman. Member: Western Art Education Association; Wisconsin Painters and Sculp-

tors; Milwaukee Art Teachers Association; Wisconsin Education Association. Exhibited: Wisconsin Painters and Sculptors; All-Iowa Exhibition, 1940; Art Institute of Chicago; Wisconsin Allied Art Center traveling exhibition. Position: Head of the Art Department, Rufus King High School, Milwaukee, Wisconsin; Instructor, Institute of Art, Shorewood Opportunity School. Address in 1953, Milwaukee, WI.

BOESEWETTER, MONITA LOW.
Sculptor. Work includes "Wabi X," bardillo, exhibited at National Association of Women Artists. Member: National Association of Women Artists. Address in 1983, 325 W. 45 Street, NYC.

BOGATAY, PAUL.
Sculptor, educator, designer, and craftsman. Born in Ava, OH, July 5, 1905. Studied at Cleveland School of Art; Ohio State University, with Arthur E. Baggs. Member: Columbus Art League; American Ceramic Society. Awards: Fellow, Ohio State University, 1930-33; Tiffany Foundation Scholarship, 1928-30; prizes, Cleveland Museum of Art, 1930, 31; Syracuse Museum of Fine Arts, 1935, 36, 40, 46, 49; Columbus Art League, 1933, 35, 36, 39-41, 43, 46-51. Work: Columbus Gallery of Fine Arts; IBM; Butler Art Institute; Ball State Teachers College. Exhibited: Syracuse Museum of Fine Arts; Phila. Allied Artists; Whitney Museum of American Art; Toledo Museum of Art; American Federation of Arts, Paris; Columbus College of Art and Design; Columbus Art League; Cleveland Museum of Art; Butler Art Institute, etc. Professor of Art, Ohio State University, Columbus, OH. Address in 1953, Columbus, OH.

BOGGS, FRANKLIN M.
Sculptor. Born in Springfield, Ohio, 1855; lived in Paris. Studied at the Ecole des Beaux-Arts and under Gerome in Paris. "A Rough Day, Harbor of Honfleur, France" is owned by Boston Museum of Fine Arts. Died August 11, 1926, in Meudon, France.

BOGHOSIAN, VARUJAN.
Sculptor. Born June 26, 1926, New Britain, Conn. Studied: Yale University, BFA, MFA (with Josef Albers); Vesper George School of Art. Work: Museum of Modern Art; New York Public Library; Rhode Island School of Design; Whitney Museum; Worcester Art Museum. Exhibited: The Swetzoff Gallery, Boston, (many); The Stable Gallery, 1963-66; Cordier & Ekstrom, Inc., NYC, 1969; Museum of Modern Art; Art Institute of Chicago Annual, 1961; Whitney Museum Annual, 1963, 64, 66, 68; Yale University, 1965; Institute of Contemporary Art Boston, 1966; others. Awards: Fulbright Fellowship (Italy), 1953; Brown University, Howard Foundation Grant for Painting, 1966; New Haven Arts Festival, First Prize, 1958; Portland (ME) Arts Festival, 1958; Boston Arts Festival, 1961; Providence Art Club, First Prize, 1967; National Institute of Arts and Letters award. Taught: Cooper Union, 1959-64; Pratt Institute, 1961; Yale University, 1962-64; Brown University, 1964-68; American Academy, Rome, 1967; Dartmouth College, from 1968. Address in 1982, Art Department, Dartmouth College, Hanover, NH.

BOHLAND, GUSTAV.
Sculptor. Born Austria, January 26, 1897. Pupil of A. A. Weinman; Cooper Union; National Academy of Design; Beaux Arts Institute of Design. Exhibited: Nationally, one-man: Sterner Gallery, New York, 1934; World's Fair, New York, 1939; Penna. Academy of Fine Arts, 1933, 40, 49, 51; Florida Southern College, 1952. Work: Corcoran; Carl Graham Fisher Memorial, Miami Beach; Public Library and Art Center, Miami Beach; bronzes, Froedtert Grain and Malting Company, Milwaukee, Wisconsin, and in private collections. Address in 1953, Miami Beach, Florida. Died in 1959.

BOHNENKAMP, LESLIE GEORGE.
Sculptor and instructor. Born in West Point, IA, March 28, 1943. Studied at St. Ambrose College, Davenport, IA, 1964-66; University of IA, Iowa City, BA, 1966, MA, 1971. Exhibited: Otis Institute, Parsons School of Design, Los Angeles, CA, 1979; Betty Parsons Gallery, NYC, 1979; Columbus Invitational, Columbus Museum of Arts; Richmond, VA; others. Received Industrial Grant, Sculpture, National Endowment for the Arts; others. Visiting Sculptor, Worcester Art Museum School, from 1980. Address in 1982, 184 Second Avenue, NYC.

BOLINGER, TRUMAN.
Sculptor. Born in Sheridan, WY, 1944. Studied: Colorado Institute of Art, Denver; Art Students League, NYC. Sculpting full-time since 1968. Executes bronze statuettes; uses multi-colored patinas. Reviewed in *Artists of the Rockies*, summer 1976; *Southwest Art*, October 1979. Represented by The May Gallery, Scottsdale, AZ. Address in 1982, Scottsdale, AZ.

BOLINSKY, JOSEPH ABRAHAM.
Sculptor. Born in NYC, January 17, 1917. Studied: Columbia University; Stourbridge College of Art, England; Skowhegan School of Painting and Sculpture, with Jose De Creeft; Iowa University. Work: Newark (NJ) Museum; Museum of Art, Tel-Aviv, Israel; Albright-Knox; Skowhegan School; others; Synagogue, Waterloo, Iowa; Temple Sinai, Amherst, NY; and more. Exhibitions: Columbia University; Gallery West, Buffalo, NY; Brock University, Canada; Albright-Knox; Skowhegan School; Rome; others. Awards: Des Moines Art Center; Albright-Knox Art Gallery, Buffalo, NY; Rochester Festival of Religious Art; others. Professor of Fine Arts, SUNY Buffalo, sculpture, from 1954; others. Works in bronze and stone. Address in 1982, Tonawanda, NY.

BOLLING, LESLIE GARLAND.
Sculptor. Born in Dendron, VA, September 16, 1898. Self-taught; also studied at Hampton Institute; Virginia Union University; and with William E. Young, Berkeley Williams. Award: Harmon Foundation, 1933; prize, *Science and Mechanic* magazine, 1942. Work: Virginia Museum of Fine Arts; Valentine Museum of Art, Richmond, VA; State Teachers College, Indiana, PA, 1950. Address in 1953, Richmond, VA.

BOLOMEY, ROGER HENRY.
Sculptor and painter. Born October 19, 1918, Torrington, CT. Studied: Academy of Fine Arts, Florence, Italy; Univ.

of Lausanne; Calif. College of Arts and Crafts; privately with Alfredo Cini in Switzerland. Work: Univ. of California; Corcoran; Los Angeles County Museum of Art; Museum of Modern Art; Oakland Art Museum; Aldrich; San Fran. Art Association; San Jose State College; Whitney Museum; Bundy Art Gal., Waitsfield, VT. Exhibited: Passedoit Gallery, NYC, 1951; de Young, 1954; Calif. Palace; 1958; San Fran. Museum of Art Annuals, 1950, 1960-63, 65; Art Institute of Chicago, 1963; Salon du Mai, Paris, 1964; Carnegie, 1964; Whitney Museum of American Art Sculpture Annual, 1964, 66, and Contemporary American Sculpture, Selection I, 1966; Aldrich, 1968; HemisFair '68, San Antonio, Tex., 1968. Awards: San Fran. Museum of Art Purchase Prize, 1960, Sculpture Prize, 1965; Bundy Art Gal., Waitsfield, VT, Bundy Sculpture Competition, 1st Prize, 1963. Address in 1982, Fresno, Calif.

BOLOTOWSKY, ILYA.
Sculptor, painter and educator. Born July 1, 1907, Petrograd, Russia. Came to USA 1923. Studied: College St. Joseph, Canstantinople, Turkey; National Academy of Design, with Ivan Olinsky. Work: Bezalel Museum; Calcutta; Museum of Modern Art; Phila. Museum of Art; Phillips; Chrysler; Rhode Island School of Design; Aldrich; San Fran. Museum of Art; Guggenheim; Slater; Whitney Museum; Walker; Yale University; Williamsburgh Housing Project, NYC, 1936 (one of the first abstract murals); New York World's Fair, 1939; Hospital for Chronic Diseases, NYC, 1941; Cinema I, NYC, 1962. Exhibited: G.R.D. Studios, NYC, 1930; J. B. Neumann's New Art Circle, NYC, 1946, 52; Rose Fried Gallery, 1947, 49; Pratt Institute, 1949; Grace Borgenicht Gallery Inc., (many), NYC; Federation of Modern Painters and Sculptors Annuals; Whitney Annuals; New York World's Fairs, 1939, 1964-65; Seattle World's Fair, 1962; Corcoran, 1963; Albright, Plus by Minus, 1968; Guggenheim, 1974; and others. Awards: Guggenheim Fellowship, 1941; Yaddo Fellowship, 1935; L. C. Tiffany Grant, 1930, 31; National Academy of Design, Hallgarten Prize for Painting, 1929, 30; National Academy of Design, First Prize Medal for Drawing, 1924, 25; The University of Chicago, Midwest Film Festival, First Prize (for "Metanois"); State University of New York Grant, for film research, 1959, 60; Abstract Painting Award, National Institute of Arts and Letters, 1971. Member: Co-founder, American Abstract Artists; co-founder of Federation of Modern Painters and Sculptors; and others. Produced 16 mm experimental films and in 1961 began constructivist painted columns. Taught: Black Mountain College, 1946-48; University of Wyoming, 1948-57; Brooklyn College, 1954-56; Hunter College, 1954-56, 1963-64; New Paltz/SUNY, 1957-65; Long Island University, 1965-74. Represented by Grace Borgenicht Gallery in NYC. Address in 1980, Sag Harbor, NY. Died in 1981.

BOLTON, JOHN.
Wood carver, glass stainer, and architect. Born in Bath, England, February 7, 1818. Family moved to US in 1836. Bolton became an architect; in 1862 was ordained in Episcopal Church. He lived in Pennsylvania. Examples of his stained glass and wood carvings, executed with his

brother William Jay Bolton, are in Christ Church and Pelham Priory (Pelham, NY) and the Church of the Holy Trinity (Brooklyn, NY). Died in 1898 in Pennyslvania.

BOND, GWENDOLINE (MAPLESDEN).
Sculptor, painter, etcher, teacher, writer, and lecturer. Born in India, September 3, 1890. Studied at Columbia University, BA, MA; New York University, D. Education; New York School of Applied Design; Penna. Academy of Fine Arts, with Daniel Garber; Art Students League, with DuMond, Bridgman. Member: National Arts Club; American Federation of Arts. Exhibited: National Academy of Design, 1944; National Association of Women Artists, 1946; National Arts Club; Society of American Graphic Artists; New York Society of Craftsmen. Address in 1953, c/o National Arts Club, 15 Gramercy Park, NYC.

BONEVARDI, MARCELO.
Sculptor and painter. Born May 13, 1929, in Buenos Aires, Argentina. In US since 1958. Studied architecture, painting, sculpture at University of Cordoba. In collections of Museum of Modern Art; Ciba-Geigy Corp.; Brooklyn Museum; NYU; Tel Aviv; U.N.; University of Texas; and Moderno Museum in Buenos Aires. Exhibited at Argentinian Galleries; Pan American Union, Wash., DC; Latow Gallery, NYC; Center for Inter-American Relations, NYC, 1980. Awards: Guggenheim fellowship, 1958; New School for Social Research 1964, 65; Biennal, Sao Paulo. Address in 1982, 799 Greenwich St., NYC.

BONN, MARION.
Sculptor. Born in Barbados, British West Indies, in 1890. Studied at Alfred University. Works: In private collections. Awards: Mt. Vernon Art Association, 1952, 53, 55; New Rochelle Art Association, 1952, 53, 54; Westchester Arts and Crafts Guild, 1952-55; Rye Federation of Women's Club, 1954; Mamaroneck Federation of Women's Club, 1954; Junior League, Mt. Kisco, 1957; Pleasantville Women's Club, 1956; American Artists Professional League, 1956; New Jersey Painters and Sculptors, 1954; Bedford Hills Community House, 1955.

BONNO, PIERRE.
Sculptor. At New Orleans, 1830-35.

BONTECOU, LEE.
Sculptor. Born January 15, 1931, Providence, RI. Studied: Bradford Junior College, with Robert Wade; Art Students League, 1952-55, with William Zorach, John Havannes. Work: Amsterdam (Stedelijk); Albright; Art Institute of Chicago; Corcoran; Cornell Univ.; Houston Museum of Fine Arts; Museum of Modern Art; Penna. Academy of Fine Arts; Wash. (DC) Gallery of Modern Art; Whitney; New York State Theatre, Lincoln Center, NYC. Exhibited: Leo Castelli Inc., 1960, 62, 66; Ileana Sonnabend Gallery, Paris, 1965; Whitney Museum of American Art Annuals; Carnegie; Museum of Modern Art, 1961, 63-64; VI Sao Paulo Biennial, 1961; Seattle World's Fair, 1962; Art Institute of Chicago, 1962, 63, 67; Corcoran, 1963; Albright, Mixed Media and Pop Art, 1963; Jewish Museum, Recent American Sculpture, 1964; Museum of Modern Art, The 1960's, 1967. Awards: Fulbright Fellowship (Rome), 1957, 58; L. C. Tiffany Grant, 1959; Cor-

coran, 1963. Represented by Leo Castelli Inc., NYC. Address in 1970, NYC.

BOOGAR, WILLIAM F. JR.
Sculptor and painter. Born Salem, New Jersey, August 12, 1893. Pupil of Charles Hawthorne; Penna. Academy of Fine Arts. Exhibited at Penna. Academy of Fine Arts; National Academy of Design; Paris International Exhibition 1937. Work: Tablets, Pilgrims Landing, Provincetown, MA; children's fountain, Wawbeek, Wisconsin; Frederick Waugh memorial; and memorial to Henry Major, painter. Address in 1953, Provincetown, Mass. Died in 1958.

BOOMER, JOHN.
Sculptor. Born in Chowchilla, CA, 1945. Studied: California State University, Chico, psychology 1968. Taught elementary school on Arizona Navajo Reservation; later worked as ranch hand. By 1975 had established professional reputation as sculptor; has own studio. Executes Indian figures in wood, stone, and bronze. Reviewed in *Artists of the Rockies*, summer 1976. Address since 1972, Crystal, New Mexico.

BOOTH, ZADIE CORY.
Sculptor, painter, and educator. Born in Crete, NE, December 7, 1905. Studied at Doane College, AB; University of Nebraska; University of Colorado. Exhibited at Josyln Museum of Art, 1940-51; Walker Art Center, 1951; Springfield (MO) Art Museum, 1950; University of Nebraska, 1942-51; William Rockhill Nelson Gallery of Art, 1950; others. Member of Nebraska Art Teachers Association; Lincoln (NE) Art Guild. Chairman of Art Department, Doane College, 1938-51. Address in 1953, Fort Collins, CO.

BORATKO, ANDRE.
Sculptor, painter, and teacher. Born in Austria-Hungary, Jan. 5, 1912. Studied at St. Paul School of Art; Minneapolis School of Art; and with Cameron Booth, Nicolai Cikovsky, Robert Brackman, Hans Hofmann. Awards: Prizes, Minneapolis Institute of Art, 1930-35; Minnesota State Fair, 1931-39; St. Paul Art Association, 1935; Lodi (Cal.) Festival, 1951; Science of the Western Hemisphere, 1942. Work: IBM; murals, Holy Trinity Church, Richmond, CA; Town Hall, Milaca, MN; Minnesota School for the Deaf; sculpture, American Island Park, Chamberlain, SD. Exhibited: Art Institute of Chicago, 1931; San Francisco Museum of Art, 1939; Golden Gate Exp., 1939; Corcoran Gallery of Art, 1941, 42; San Francisco Water Color Society, 1946; University of Washington, 1946; Los Angeles County Fair, 1949; California State Fair, 1949-51. Position: Assistant Professor, California College of Arts and Crafts, Oakland, CA, from 1946. Address in 1953, El Cerrito, CA.

BORGATTA, ISABEL CHASE.
Sculptor and teacher. Born in Madison, WI, Nov. 21, 1921. Studied at Smith College, 1939-40; Yale University School of Fine Arts, BFA, 1944; Art Students League, 1946; New School for Social Research, 1944-45; studio of Jose De Creeft, 1944-45. Works: Wadsworth Atheneum, Hartford, CT; others. Awards: Village Art Center, 1946;

National Association of Women Artists, 1952; Village Art Center, 1951; Jacques Lipchitz award, 1961. Exhibited: Penna. Academy of Fine Arts Annual, Philadelphia, 1949-55; Whitney Museum of American Art, 1951-52; NY Cultural Center, 1973; Brooklyn Museum; and many others. Works in stone and wood. Address in 1982, 617 West End Avenue, NYC.

BORGATTA, ROBERT EDWARD.

Sculptor and painter. Born in Havana, Cuba, January 11, 1921; later became a US citizen. Studied at National Academy of Design, 1934-37; NY University, School of Architecture and Allied Arts, BFA, 1940; Institute of Fine Arts, 1946-53; Yale University School of Fine Arts, MFA, 1942. Exhibited: Audubon Artists Annual, 1953-72; Whitney Museum of American Art Prizewinners Show, 1954; Schettini Gallery, Milan, Italy, 1957; Corcoran Gallery of Art, 1968; including one-man shows such as Babcock Galleries, 1964 and 68; and Southern Vermont Art Center, 1977. Member: Audubon Artists; American Watercolor Society; National Society of Painters in Casein. Taught: City College of NY as professor of painting and drawing, 1947-80. Most of his works are executed in marble and oil. Address in 1982, 366 Broadway, NYC.

BORGHI, GUIDO R.

Sculptor and painter. Born in Locarno, Switzerland, March 29, 1903. Worked as apprentice scenery painter for Famous Players Motion Picture Studios, New York City. Works: mural, "Circus" for the Lexington School for the Deaf and Dumb, New York City, 1937; mural for Minadoka Co., Grange, Idaho, 1940; Melrose, NM, 1971; numerous private homes. Exhibited: Corcoran Museum, 1939; The World's Fair, New York City, 1939; National Academy of Design, New York City, 1940; Society of Independent Artists, 1937; Boise Art Museum, Idaho, 1941; Heyburn Art Institute, Idaho, 1940; Yonkers Museum, NY, 1946; Massilon Museum, OH, 1962; Atlanta High Museum, Atlanta, Georgia, 1962; others. Teaching: Art Instructor for Shell Oil Art Class, Equitable Life Assurance Co., Rockefeller Recreation Center Art Class, and for the Rockettes at Radio City Music Hall. Member: Society of Animal Artists (founder); Society of Independent Artists. Address in 1970, City Island, NY.

BORGLUM, JAMES LINCOLN DE LA MOTHE.

Sculptor, photographer, and writer. Born in Stamford, CT, 1912. Son of Gutzon Borglum. Pupil of his father for 12 years; studied in Europe in 1929 and 1931; also studied in Texas and Wyoming. Work includes color photographs in "This Week" and "The Saturday Evening Post;" 300' statue of Christ and a colossal bust of President Johnson in South Dakota; a religious statue in Texas. Worked at Mt. Rushmore Memorial from 1932. Address in 1976, Harlingen, TX.

BORGLUM, JOHN GUTZON.

Sculptor. Born March 25, 1867, in Idaho. He studied in San Francisco, and with Virgil Williams and William Keith in Kansas, and went to Paris in 1890 where he attended the Academie Julien and the Ecole des Beaux-Arts. He exhibited as painter and sculptor in London and Paris where he resided for long periods. Settled in NYC in 1902. Exhibited at National Sculpture Society, 1923. In collections of Metropolitan Museum of Art; and Los Angeles Museum. Awards: gold medal, Western Art Association; gold medal, Louisiana-Purchase Exp., St. Louis, MO, 1904. Member: Societe Nationale des Beaux-Arts, associate; NY Architectural League; Royal Society of British Artists. Works: Gen. Phil Sheridan Monument, Washington, DC; 12 apostles, Cathedral of St. John the Divine, NY; colossal head of Abraham Lincoln, rotunda of Capitol, Washington, DC; Mares of Diomedes, and Ruskin, Metropolitan Museum, NY; statue of Lincoln, Newark, NJ; Henry Ward Beecher, Brooklyn, NY; Thomas Paine, Paris; numerous marble figures; colossal bronze equestrian statue of Sheridan, Chicago, IL; colossal group, 42 heroic figures in bronze, Newark, NJ; colossal bas-relief on the face of Stone Mountain, near Atlanta, GA, involving several hundred figures; best known for heads of Presidents on Mt. Rushmore. Died March 6, 1941 in New York City.

BORGLUM, SOLON HANNIBAL.

Sculptor. Born Dec. 22, 1868, in Ogden, UT. Studied with his brother, Gutzon Borglum; at Cincinnati Art Academy; and with Fremiet and Puech in Paris. Member of National Sculpture Society; associate, National Academy of Design, (1911). Exhibited at National Sculpture Society, 1923. Received awards at Paris Salon, 1899; Pan-Am. Exp., Buffalo, 1901; Louisiana Purchase Exp., St. Louis, MO, 1904; Buenos Aires Exp., 1910. In collections of Metropolitan Museum of Art; Detroit Institute; University of Iowa; and National Gallery of Canada. Works: Statue of Gen'l. Gordon (Atlanta, GA); Soldiers and Sailors Monument (Danbury, CT); statues "Inspiration" and "Aspiration;" and 8 colossal portrait busts of Civil War generals. Made a specialty of Western life. Died Jan. 31, 1922, in Stamford, CT.

BORGORD, MARTIN.

Sculptor and painter. Born Gausdal, Norway, Feb. 8, 1869. Pupil of Laurens in Paris; and William M. Chase. Mem.: Allied Artists of America; Paris American Art Association; St. Lucas Society, Amsterdam, Holland; Salmagundi Club; American Artists Professional League; American Federation of Arts. Award: Medal, Paris Salon, 1905. Work: "Laren Weaver," Carnegie Institute, Pittsburgh; "Romeo and Juliette," Luxembourg Museum, Paris; "Portrait of Walter Griffen, N.A.," and "Portrait of William H. Singer, Jr., N.A.," National Academy of Design; others. Address in 1933, Riverside, CA. Died in Riverside, CA, 1935.

BORNE, MORTIMER.

Sculptor, painter, etcher, educator, and lecturer. Born in Rypin, Poland, Dec. 31, 1902. Studied at National Academy of Design; Art Students League; Beaux-Arts Institute of Design, and with Hinton, Charles Hawthorne, F. Jones. Member: Society of American Graphic Artists, 1939, 43. Work: Library of Congress; National Gallery of Art; NY Public Library; Syracuse Museum of Fine Art; Rochester Memorial Art Gallery; NJ State Museum. Exhibited: Art Institute of Chicago, 1931; American Institute of Graphic Arts, 1937; Sweden, 1937; NY World's

Fair, 1939; 100 Prints, 1940; Metropolitan Museum of Art, 1942; Museum of Modern Art, 1940; Corcoran Gallery of Art, 1941 (one-man); Montreal Museum of Fine Art, 1942 (one-man); NY Public Library (one-man); Currier Gallery of Art, 1945; Brooklyn Museum, 1950; Wichita Art Association, 1952; NY State Fair, 1950, 51; Carnegie Institute, 1947. Position: Art Lecturer, New School, NY, 1945-67. Author: Idiomatic Specialization, 1952; New Art Techniques, 1969. Address in 1982, Nyack, NY.

BORNEMAN, F. W.
Sculptor. At Charleston, South Carolina, 1851.

BORONDA, BEONNE.
Sculptor and educator. Born in Monterey, CA, May 23, 1911. Studied at Art Students League with Arthur Lee. Awards: National Association of Women Artists, 1938; NJ Society of Painters and Sculptors, 1945, 46; Pen and Brush Club, 1945; Norwich Art Association, 1953; Silvermine Guild Association, 1955. Exhibitions: Whitney Museum, 1940; Pen and Brush Club, 1944, 45; Penna. Academy of Fine Arts, 1935-45; National Academy of Design 1935, 37, 41, 44, 45, 48-51; Art Institute of Chicago, 1937, 38, 40; National Association of Women Artists, 1932-46, 48; World's Fair of NY, 1939; Metropolitan Museum of Art, 1942; Conn. Academy of Fine Arts, 1933-46, 1949-51; Architectural League of NY, 1941, 44; Addison Gallery of American Art, 1950; others. Member of National Sculpture Society; others. Instructor, sculpture, Montclair Art Museum, 1944-45. She is noted for her animal sculpture. Address in 1953, Mystic, CT.

BORST, GEORGE H.
Sculptor. Born Philadelphia, Feb. 9, 1889. Studied: Penna. Academy of Fine Arts, pupil of Charles Grafly, Albert Laessle; Itallo Vagnetti in Florence, Italy; Julian Academy, Paris. Member: Alliance, American Federation of Artists, Fellowship Penna. Academy of Fine Arts, American Artists Professional League. Awards: Stewartson prize and Stimson prize, Penna. Academy of Fine Arts, 1927. Exhibited: Penna. Academy of Fine Arts, 1930-46; National Academy of Design; National Sculpture Society; Philadelphia Art Alliance, 1937 (one-man). Address in 1953, Philadelphia, PA.

BOTERO, FERNANDO.
Sculptor. Born in Madelin, Colombia, 1932. Studied at Academy of San Fernando, Spain, 1953; Prado Museum, Madrid, 1954; University of Florence, Italy, art history with Roberto Longhi. Work in Museum d'Arte Modern del Vaticano, Rome; Museum of Modern Art, NY; Guggenheim Museum, NY. Has exhibited at Museum of Modern Art, NY; Guggenheim Museum; 5th Biennale of Paris, France; Marlborough Gallery, NY. Address in 1982, Marlborough Fine Arts, NYC.

BOTHUM, J. SHIRLEY.
Sculptor. Born in Stafford County, KS, 1938. Raised in Oregon. Self-taught in art. Has been cowboy, rodeo rider, rancher, and farmer. Began clay modelling in early 1970's. Subjects are from contemporary cowboy life; uses live models of horses and cattle. Medium is bronze.

Has exhibited at museum invitational shows; represented by Fowler's Gallery. Address in 1982, Clarkston, WA.

BOTTINI, DAVID M.
Sculptor. Born in Santa Clara, CA, June 1, 1945. Studied at California State University at San Jose, B.A., 1969; M.A., 1970; assistant to John Battenberg (1968), Ron Mallory (1971), and Fletcher Benton (1973). In collections of California universities; sculpture commission for Oakland Museum. Exhibited at De Saisset Art Gallery and Museum, University of Santa Clara, CA, 1970; Esther-Robles Gallery, Los Angeles, 1972; William Sawyer Gallery, San Francisco, 1975; Oakland (CA) Museum, 1976; Reed College; Portland, OR; Roy Boyd Gallery, Chicago and Los Angeles; Lytton Visual Arts Center, Los Angeles; Honolulu Academy of Arts; others in California. Awards: Outdoor Painting Award, Aristocrat Trailers, 1968; Contemporary Art Committee Annual Artist Award, Oakland Museum, 1975. Address in 1982, c/o William Sawyer Gallery, San Francisco, CA.

BOUCHARD, ADOLPH.
Sculptor. At New Orleans, 1857-59.

BOULTON, JOSEPH LORKOWSKI.
Sculptor and painter. Born in Ft. Worth, Texas, May 26, 1896. Studied at National Academy of Design, Art Students League, Beaux-Arts Institute of Design, and with Hermon A. MacNeil. Works: Memorial tablet representing old Ft. Worth, Ft. Worth DAR; "The Devil Dog," Marine Barracks, Washington, DC; "Hop" (bronze mouse), Detroit Institute of Arts. Exhibitions: Penna. Academy of Fine Arts, 1924; National Sculpture Society, 1923; many shows, Hudson Valley Art Association, 1951-68; National Academy of Design, 1953; Allied Artists of America; plus others. Commissions: Coins and medals for Medical Society, State of Penna., Franklin Mint, series of American wildlife, American Sculpture Society, Westport, CT; plus many plaques and busts. Member: League of American Artists; Salmagundi Club; Philadelphia Art Association; American Federation of Arts; Allied Artists of America. Awards: Helen Foster Barnett prize, National Academy of Design, 1921. Address in 1982, c/o Allied Artists of America, 15 Gramercy Park S., NYC.

BOURGEOIS, LOUISE.
Sculptor. Born Dec. 25, 1911, Paris, France. Came to US in 1938. Studied: Lycee Fenelon, 1932; Sorbonne, 1932-35; Ecole du Louvre, 1936-37; Academie des Beaux-Arts, Paris, 1936-38; Atelier Bissiere, Paris, 1936-37; Academie de la Grande Chaumiere, 1937-38; Academie Julian, Paris, 1938; Atelier Fernand Leger, Paris, 1938. Work: Museum of Modern Art; NYU; Rhode Island School of Design; Whitney Museum. Exhibited: The Bertha Schaefer Gallery, Norlyst Gallery, Peridot Gallery, all in NYC; Allan Frumkin Gallery, Chicago, 1953; Metropolitan Museum of Art; San Francisco Museum of Art; Los Angeles County Museum of Art; Brooklyn Museum; Whitney, 1945, 46, 53, 57, 60, 62, 63, 68; Walker, 1954; Claude Bernard, Paris, 1960; Salon de la Jeune Sculpture, Paris, 1965, 69; Rhode Island School of Design, 1966; International Sculpture Biennial, Carrara, Italy, 1969; Bal-

timore MA, 1969; Museum of Modern Art; and many more. Taught: Academie de la Grande Chaumiere, 1937, 38; Brooklyn College, 1963, 68; Pratt Institute, 1965-67, Cooper Union, 1978-79. Address in 1982, 347 W. 20th St., NYC.

BOURLIER, ALFRED J. B.
Sculptor. At NYC, 1853-1860 and again later. Associated with Larmande in 1854; later in 1859 with Gori.

BOUTON, G. B. or (JEAN B.).
Sculptor. At New York City, 1850. Exhibited "Statue of St. Mary" at the American Institute, 1850, executed in wood.

BOWA, PETER.
Sculptor. At New Orleans, 1823. Worked in plaster of Paris.

BOWDITCH, MARY O.
Sculptor. Exhibited at the Penna. Academy of Fine Arts, Philadelphia, 1920. Address in 1926, Boston, Mass.

BOWEN, DANIEL.
Wax modeler and museum proprietor. Born in 1760. Modeled wax portraits of Benjamin Franklin and George Washington. Exhibited a panorama of New Haven in Philadelphia, Pennsylvania, in 1818. He was best known as one of the first museum proprietors in America and for his waxworks in New York City, Philadelphia, and Boston. Died in Philadelphia on February 29, 1856.

BOWERS, BEULAH SPRAGUE.
Sculptor, painter, and craftswoman. Born in Everett, MA, Nov. 5, 1892. Studied at Mass. Institute of Technology, with W. F. Brown; South Boston Art School; Mass. School of Art, B.S. (education), M. (education); Cooper Union Art School; University of New Hampshire. Member: Meriden Arts and Crafts Association; Conn. Art Association. Awards: Prizes, Arts and Crafts Association, Meriden, CT. Exhibited: Meriden Arts and Crafts Association, 1939-46; Kansas Water Color Society; Kansas Art Association; Artists Guild, annually. Lectures: Color; Design. Position: Assistant Professor of Art, University of Wichita, 1929-37; Supervisor of Art, Meriden, CT, from 1939. Address in 1953, Meriden, CT.

BOWES, JULIAN.
Sculptor and teacher. Born in New York City, March 7, 1893. Pupil of Jay Hambidge. Member: NY Society of Craftsmen; Society of Independent Artists, fellow, Royal Hellenic Society; associate, British School of Archaeology. Work in Metropolitan Museum of Art; Columbia University; American Museum of Natural History; Navy Yard, NY. Director, School of Dynamic Symmetry. Author of "Proportions of the Ideal Human Figure," "The Lost Canon of Polykleitos," and "Scripta Mathematica." Address in 1953, Saybrook, CT.

BOXER, STANLEY (ROBERT).
Sculptor and painter. Born in New York, NY, June 26, 1926. Studied at Brooklyn College; Art Students League. Work in Guggenheim Museum, NY; Museum of Modern Art, New York; Albright-Knox Museum, Buffalo, NY.

Has exhibited at Andre Emmerich Gallery, New York and Zurich, 1975-81; Penna. Academy of Fine Arts, Philadelphia, 1976; Museum of Fine Arts, Boston, 1977; and others. Received John S. Guggenheim Memorial Foundation Fellowship, 1975. Address in 1982, 37 E. 18th Street, NYC.

BOYCE, RICHARD.
Sculptor. Born June 11, 1920, in NYC. Studied at Boston Museum School, with Paige fellowship in painting, Bartlett grant in sculpture. Taught at Boston Museum School, at Boston University, and at UCLA from 1963. In private collections, and in Rhode Island School of Design Museum; Wellesley; Harvard; Whitney; Hirshhorn Foundation, Washington, DC. Exhibited at the B. Mirski Gallery, Boston, 1952; Swetzoff Gallery, Boston; Art Institute of Chicago; Penna. Academy Fine Arts; Landau Gallery, NYC; Smithsonian Institution; European travelling exhibition; the Whitney; and others. Living in Santa Monica, CA, in 1976.

BOYD, PHOEBE AMELIA.
Sculptor and painter. Born in Philadelphia, PA, Dec. 29, 1875. Studied with William A. Hoffstetter, Antonio Cortizos. Work: "The Hillside," Circulating Library, Art Alliance, Philadelphia, PA. Address in 1933, Germantown, PA.

BOYIDDLE, PARKER.
Sculptor and painter. Born in Chickasha, OK, 1947. Studied: Institute of American Indian Arts, Santa Fe, New Mexico (with Allan Houser and Fritz Scholder); Pima College, Tucson, AZ. Exhibited: Philbrook Art Exhibit, 1978; American Indian Artist group show in Paris, 1979; others. Awards: Phippen Memorial award for sculpture; first prize, Trail of Tears Art Show; grand prize 1977 and first prize 1980, American Indian and Cowboy Artists show; grand award, Philbrook Art Exhibit, 1978. Member: American Indian and Cowboy Artists. Prints published by Marc Bahti. Represented by Tom Bahti Indian Art Shop, Tucson, AZ; The Files' Gallery of Fine Arts, Big Bear Lake, CA. Media: Acrylic and watercolor; metal, clay, plastic. American Indian subjects. Address in 1982, Los Lunas, New Mexico.

BOYLE, JOHN C.
Sculptor. Born c. 1815, Ireland. Worked: NYC, c. 1845 to after 1860. Was a partner with James Lauder, Jr., 1847-59.

BOYLE, JOHN J.
Sculptor. Born Jan. 12, 1851/52, in New York City. He began life as a stonecarver and studied at the Penna. Academy of Fine Arts under Eakins; Ecole des Beaux-Arts under Dumont; Thomas and E. Millet in Paris. He was elected an Associate of the National Academy and was also a member of the National Sculpture Society; NY Architectural League; National Arts Club; NY Municipal Art Society; and the Societe des Artistes Francais. Represented by sculpture in Lincoln Park, Chicago, and "Plato" in the Library of Congress. Awarded medals, Columbia Expo., Chicago, 1893; Paris Expo., 1900; Pan-American Expo., Buffalo, 1901; St. Louis Expo., 1904. In 1902 he moved to NYC, where he died on Feb. 10, 1917.

BOYLE, GERTRUDE FARQUHARSON (KANNO).

Sculptor and painter. Born in San Francisco, California, in 1878. Studied at Lick School of Mechanical Arts, San Francisco, and Mark Hopkins Institute of Art, San Francisco. Exhibited at San Francisco Museum of Art, 1937; Alaska-Yukon Pacific Exposition, Seattle, 1909; Panama-Pacific International Exposition, San Francisco, 1915; Pen and Brush Club, NYC, 1928; California Art Retrospective, Palace of Fine Arts, San Francisco, 1940. Executed portrait busts of Jack London, Christy Mathewson, John Muir, Luther Burbank, William Keith, and others. Address in 1926, 246 West 14th Street, NYC. Died in San Francisco in 1937.

BRACKEN, CHARLES W.

Sculptor, painter, designer, and illustrator. Born in Corry, PA, December 21, 1909. Studied at University of Washington, B.A.; Chicago Academy of Fine Art. Member: Chicago Free Lance Artists Guild; Society of Typographic Artists; 27 Designers. Exhibited: Art Institute of Chicago, 1946; Seattle Art Museum, 1938; University of Washington, 1930, 31, 46. Position: Art Director, Bracken-Tyler, Chicago, IL, 1943-48; Art Director, Owner, Chas. W. Bracken Studio, Chicago, IL, from 1948. Address in 1953, Chicago, IL.

BRACKEN, CLIO HINTON.

(Mrs. Wm. B. Bracken). Sculptor. Born in Rhinebeck, NY, July 25, 1870. Daughter of Lucy Brownson Hinton, and cousin of Roland Hinton Perry. Studied with Chapu, Carpeaux, and A. Saint-Gaudens. Resided in Boston and Conn. Had studio in New York City. Work: Statues of Gen. Fremont in California; bust of Gen. Pershing; "Chloe," Brookgreen Gardens, SC. Died Feb. 12, 1925, in New York City.

BRACKEN, JULIA M.

(Mrs. William Wendt). Sculptor and painter. Born at Apple River, IL, June 10, 1871. Studied: Art Institute of Chicago under Taft. Her best known work "Illinois Welcoming the Nations," a souvenir of the Columbian Exposition, stands in bronze in the capitol at Springfield, IL. Considered a leading western woman sculptor by her contemporaries. Member: Chicago Society of Artists; Chicago Municipal Art League; California Art Club; National Arts Club; others. Awards: Sculpture prize, Chicago, 1898; Chicago Municipal Art League prize, 1905; Harrison prize, gold medal, Pan.-Calif. Exp., San Diego, 1915; California Art Club, 1918. Address in 1933, Laguna Beach, CA.

BRACKENRIDGE, MARIAN.

Sculptor. Born in Buffalo, NY, April 16, 1903. Studied at Art Students League, NY, 1921, under Leo Lentelli; also studied for several months under A. Phimister Proctor in Hollywood, CA, 1924. In 1925 started working with Ettore Cadorin in Santa Barbara, and still continues her work under the direction of Mr. Cadorin. Works: Bust, Study of a Man. Address in 1929, Santa Barbara, CA; summer, South Pasadena, CA.

BRACKETT, CHRISTOPHER C.

Sculptor. At Cincinnati, 1838.

BRACKETT, EDWARD AUGUSTUS.

Sculptor. Born in Vassalboro, Maine, Oct. 1, 1818. Work: Portrait busts, among which are "President Harrison," "W. C. Bryant," "Wendell Phillips." Exhibited: National Academy, NYC, 1841, 50, 66; Athenaeum Gallery, many times 1843-66; Apollo Association, 1840-41. His group of the "Shipwrecked Mother" is at Mount Auburn, and another of his groups was purchased by the Boston Athenaeum. Died in Winchester, MA, March 15, 1908.

BRACONY, LEOPOLD.

Sculptor. Born in Rome, Italy. Address in 1910, 26 West 28th St., NYC.

BRADDOCK, EFFIE FRANCES.

Sculptor. Born Philadelphia, PA, May 13, 1866. Studied: Penna. Academy of Fine Arts, Student of J. Liberty Tadd, Emily Sartain; School of Industrial Art and School of Design for Women, Philadelphia, PA. Member: American Federation of Arts; Fellowship Penna. Academy of Fine Arts; Plastic Club. Address in 1933, Warren, PA.

BRADFIELD, ELIZABETH V. P.

Sculptor. Exhibited at National Academy of Design, 1925. Address in 1926, Pontiac, Mich.

BRADLEY, DAVID P.

Sculptor, painter, and printmaker. Born in Eureka, CA, 1954; lived in Minnesota and moved to Santa Fe in 1977. Studied: Institute of American Indian Arts, graduated with high honors. Specialty: Contemporary interpretation of Indian and Old West subjects. Awards: Artist of the Year, *Santa Fean* magazine. Represented by Elaine Horwitch Gallery, Santa Fe; and Judith Stern Gallery, Minneapolis, MN. Address in 1982, Santa Fe, New Mexico.

BRADY, MABEL CLAIRE.

Sculptor, teacher, and craftsman. Born in Homer, NY, Oct. 28, 1887 (1877?). Studied at Pratt Institute Art School; NY University; NY School of Fine and Applied Arts; and with Winold Reiss, Henry B. Snell, Maude Robinson. Member: Public Buildings Administration; Keramic Society and Design Guild. Awards: Prizes, Design Guild, 1930. Exhibited: Public Buildings Administration, 1941 (one-man), 1942-45; Argent Gallery, 1945. Lectures: "Creative Expression Through Medium of Clay." Taught ceramics at Haaren High School, NY, 1930-46. Address in 1953, Dryden, NY; h. 50 Central Park West, NYC.

BRALL, RUTH.

Sculptor and teacher. Born in NYC, Dec. 3, 1906. Studied at Columbia University; and with Charles Hafner, Joseph Nicolosi, Oronzio Maldarelli. Works: Columbia University; NY School for Social Work; Paine College, Atlanta, Georgia. Awards: Prizes, NJ Painters and Sculptors Society; medal, Wanamaker bronze medal; Hudson Valley Art Association; and Pen and Brush Club. Member: Allied Artists of America; NJ Painters and Sculptors Society; American Artists Professional League; Pen and Brush Club; Hudson Valley Art Association; Artists Equity As-

sociation. Address in 1953, 67 West 67th St., h. 45 Park Terrace, West, NYC.

BRAMS, JOAN.
Sculptor and painter. Born in Montreal, Province of Quebec, March 30, 1928; US citizen. Studied at Ontario College of Art. Exhibitions: Ft. Lauderdale Museum of the Arts, FL; Columbia Museum of Art, SC; Birmingham Museum of Art, AL; John Herron Museum of Art, Indianapolis, IN; others. Awards: Award of Merit, Ft. Lauderdale Museum, FL, 1965 and 78; first prize, Palm Beach Art Institute, FL, 1975; others. Medium: Bronze; acrylic. Represented by David Findlay Galleries, 984 Madison Ave., NYC; Gallery 99, Bal Harbour, FL. Address in 1982, Palm Beach, FL.

BRANDT, CARL L.
Sculptor and painter. Born in Hamburg, Germany, 1831, he came to America in 1852. He painted portraits of John Jacob Astor, Mr. and Mrs. William Astor, and many other prominent people. Exhibited at the National Academy, 1855, 60, 62-84. He was elected a member of the National Academy of Design in 1872. He died Jan. 20, 1905, in Savannah, GA.

BRANNAN, SOPHIE MARSTON.
Sculptor and painter. Born in Mountain View, CA. Studied: Mark Hopkins Institute of Art, and in Paris. Member: National Association of Women Painters and Sculptors; American Watercolor Society; Conn. Academy of Art; American Federation of Arts; NY Society of Painters; Society Medalists. Awards: Prizes, National Association of Women Artists; Conn. Academy of Fine Art. Work: National Academy of Design; Corcoran Gallery of Art; Art Institute of Chicago; Syracuse Museum of Fine Art; Penna. Academy of Fine Art; Museum of Fine Art, Toronto Canada; Nebraska Art Association; Kansas Art Association; Brooklyn Mus.; Vanderpoel Collection; American Watercolor Society; Union League; Macbeth Gallery; Maryland Institute of Art and Science; and in South America. Exhibited: American Watercolor Society; Syracuse Museum of Fine Art; Art Institute of Chicago; Nebraska Art Association; Penna. Academy of Fine Art; Corcoran Gallery of Art; Macbeth Gallery; Brooklyn Museum; Toronto, Canada, etc. Address in 1953, San Francisco, CA.

BRANSON, KUHNE BEVERIDGE.
(Mrs. W. B. Branson). Sculptor. Born in Springfield, IL, 1877. Pupil of Wm. R. O'Donovan in NY and Rodin in Paris. Honorable mention, Paris Exp., 1900. Address in 1910, London, England.

BRASZ, ARNOLD FRANZ.
Sculptor, painter, illustrator, and etcher. Born in Polk County, WI, July 19, 1888. Pupil of Minneapolis School of Fine Arts; Henri in New York. Member: Wisconsin Painters and Sculptors. Address in 1926, Oshkosh, WI.

BRAUNER, OLAF.
Sculptor, painter, and teacher. Born Christiania, Norway, Feb. 9, 1869. Pupil of Benson and Tarbell in Boston. Member: Gargoyle Society; Central NY Chapter of American Institute of Architects, (hon.); League of Amer-

ican Artists. Work: "Come Unto Me," altar piece in Church of Our Saviour, Chicago; portraits in the Kimball Library, Randolph, VT; in Cornell University Library, Ithaca; in Girls' High School, Boston; in Amherst College, Amherst, MA; sculpture, "Dane Memorial" in Walnut Hill Cemetery, Brookline, MA; war memorial, Kappa Sigma Fraternity, Cornell University; Clifton Beckwith Brown medal, College of Architecture, Cornell University; fountain at Seal Harbor, ME. Taught: Professor of painting, Cornell University since 1900. Address in 1933, Ithaca, NY.

BRAY, JOSEPH W.
Sculptor. At NYC, 1859-60.

BRCIN, JOHN DAVID.
Sculptor. Born Gracac, Yugoslavia, Aug. 15, 1899. US citizen. Pupil of Chicago Art Institute under Albin Polasek, B.F.A., 1922; Ohio State University, M.A., 1949. Member: American Federation of Arts; Chicago Galleries Assoc. Awards: Bryan Lathrop European Traveling Scholarship (Art Institute of Chicago); Certificate of Merit, (Art Institute of Chicago); Shaffer Prize (Art Institute of Chicago); French Memorial gold medal (Art Institute of Chicago); Spaulding prize, Hoosier Salon. Work: Portrait bust of Judge Gary, Commercial Club, Gary, IN; Memorial Relief of Newton Mann, First Unitarian Church, Omaha, NE; Memorial Relief of Benjamin Franklin Lounsbury, Washington Blvd. Hospital, Chicago, IL; Joslyn Memorial Art Museum, NE. Exhibited: National Academy of Design; Penna. Academy of Fine Arts; Art Institute of Chicago; Detroit Institute of Art; Albright Art Gallery; Dayton Art Institute. Address in 1982, Denver, CO.

BRECHT, GEORGE.
Sculptor, painter, assemblagist, and conceptualist. Born in NYC, 1926. Studied: Philadelphia College of Pharmacy and Science, B.Sc.; Rutgers University; New School for Social Research, with John Cage, 1958-59; Samuel S. Fleisher Art Memorial, Philadelphia. In collection of Museum of Modern Art. Commissions for James Waring Dance Comp., NYC (music and sets). Happenings and Theatre Pieces prepared for Fluxus International Festival, NYC, 1962-63; Smolin Gallery, NYC, Yam Festival, A Series of Events, 1963; Arman's Key Event, NYC, 1965. Exhibited: Reuben Gallery, NYC, 1959; Fischbach Gallery, NYC, 1965; Galleria Schwarz, Milan, 1967, 69; Mayer Gallery, Stuttgart, 1969; Los Angeles County Museum of Art, 1969; Martha Jackson Gallery, NYC, New Media—New Forms, I & II, 1960, 61; Stockholm Art in Motion, 1961; Museum of Modern Art; Albright, Mixed Media and Pop Art, 1963; Wadsworth Atheneum, Black, White, and Gray, 1964; Smith College, Sight and Sound; Tate, Pop Art, 1969; Guggenheim, Eleven from the Reuben Gallery, 1965; Chicago Museum of Contemporary Art, 1969; Berne, Art after Plans, 1969. Living in W. Germany in 1982.

BREDIN, CHRISTINE.
Sculptor. Address in 1934, Philadelphia, PA. (Mallett's)

BREER, ROBERT C.
Sculptor and filmmaker. Born September 30, 1926, in

Detroit, MI. Studied: Stanford University, B.A. Lived in Paris 1949-59. Work: Cinematheque de Belgique; Cinematheque Francaise; Krefeld, Germany; Museum of Modern Art; NY Public Library; Stockholm. Exhibited: Palais des Beaux-Arts, Brussels, 1955; Washington Gallery of Modern Art, The Popular Image, 1963: Museum of Modern Art, 1963; Institute of Contemporary Art, Boston, 1965; University of California, Berkeley, Directions in Kinetic Sculpture, 1966; Jewish Museum, 1967; Experimental Film Festival, Brussels, 1967; Museum of Modern Art, The Machine as Seen at the End of the Mechanical Age, 1968; UCLA, Electric Art, 1969; Albright-Knox Art Gallery, Buffalo, NY, 1971; Yale University, 1973; others. Awards: Stanford University, Annual Painting Award, 1949; Creative Film Foundation Awards, 1957-60; Bergamo, Diplome Speciale, 1962; Oberhausen Film Festival, Max Ernst Prize, 1969; Film Culture Independent Film Award, 1972; Guggenheim, 1978. Address in 1982, South Nyack, NY.

BREGLER, CHARLES.
Sculptor and painter. Born in Philadelphia. Studied at the Penna. Academy of Fine Arts. Pupil of Thomas Eakins. Address in 1953, Philadelphia, PA.

BREHM, ADAM.
Sculptor. Born in Germany, Nov. 15, 1901. Studied at Kansas City Art Institute. Member: Kansas City Society of Artists. Address in 1933, Kansas City, MO.

BREIN, JOHN DAVID.
Sculptor. Born in Servia in 1899. Exhibited at Penna. Academy of Fine Arts, Philadelphia, 1924. Address in 1926, Chicago, IL.

BREMER, HESTER.
Sculptor. Born Alsace, July 8, 1887. Pupil of Hudler; Murdach; Art Institute of Chicago. Member: Chicago Society of Artists. Award: Eisendrath prize, Art Institute of Chicago, 1922. Address in 1929, Chicago, IL.

BRENNAN, W. IRVIN.
Sculptor and wood engraver. Address in 1933, Pasadena, CA.

BRENNER, VICTOR DAVID.
Sculptor. Born in Shavely, Russia, June 12, 1871; came to NY 1890. He went to Paris in 1898, and became a pupil of Louis Oscar Roty, 1898-1901, and also of the Academie Julien, under Peuch, Verlet, and Dubois. Awards: Bronze medal, Paris Exposition, 1900; honorable mention, Paris Salon, 1900; bronze medal, Pan-American Exposition, Buffalo, NY, 1901; silver medal, Louisiana Purchase Exposition, St. Louis, MO, 1904; gold medal, Universal Exposition, Brussels, Belgium, 1910; silver medal, P.-P. International Exposition, San Francisco CA, 1915; J. Sanford Saltus silver medal of the American Numismatic Society, for achievement in medallic art, 1922. Member: National Sculpture Society; New York Architectural League; National Arts Club; American Numismatic Society. Works: American Numismatic Society; Boston Museum of Fine Arts; Art Institute of Chicago; Schenley memorial fountain, Pittsburgh, PA; set of medals, Metro-

politan Museum, NY; Luxembourg, Paris; plaques, Carl Schurz; Collis P. Huntington; Fridtjof Nansen; J. Sanford Saltus; James McNeill Whistler; John Paul Jones; Abraham Lincoln Centennial; medal, C. P. Daly prize medal for research, American Geographical Society, NY; George William Curtis; J. Sanford Saltus award medal, National Academy of Design; Panama Canal; New York Historical Society Centennial; Abraham Lincoln; Samuel Putnam Avery; Theodore Roosevelt; Ambrose Swasey; John Hay; Twenty-fifth Anniversary, Clark University; Wilbur and Orville Wright, Aero Club of America; and numerous other plaques and medals. He also designed the model for the US cent, 1909. Exhibited at National Sculpture Society, 1923. Address in 1918, 18 East 8th Street, NYC. Died in NYC, April 5, 1924.

BRESCHI, KAREN LEE.
Sculptor. Born in Oakland, CA, October 29, 1941. Studied at California College of Arts and Crafts, B.F.A., 1963; Sacramento State University, 1960-61; San Francisco State University, M.A., 1965; San Francisco Art Institute, 1968-71. Works: Oakland Museum, CA; Crocker Art Gallery, Sacramento; San Francisco Museum of Art. Exhibitions: Faculty Show Sculpture, San Francisco Art Institute, 1973, Ceramic Sculpture, 1974; Ceramics Invitational, Hoffman Gallery, School of Arts and Crafts Society of Portland, 1973; Ceramics Show, Philadelphia School of Art, 1974; Ceramics and Glass Shows, Oakland Art Museum, 1974; Clay, Whitney Museum, NY, 1974; West Coast Sculptors, Everson Museum, 1978, A Century of Clay, 1979; plus many others. Awards: First Place for Painted Flower, Oakland Art Museum, 1962; Women's Architectural League Award, Crocker Art Museum, 1963; award, California State Fair, 1963. Member: West/East Bag. Medium: Clay. Address in 1982, San Francisco, CA.

BREVOORT, KANE.
Sculptor. Born in New York. Awarded honorable mention, Salon des Artistes Francais, 1937.

BREWSTER, ANNA RICHARDS.
(Mrs. William T. Brewster). Sculptor, painter, and illustrator. Born Germantown, PA, April 3, 1870. Studied: Cowles School of Art, Boston; Metropolitan School of Art; Art Students League; pupil of William Chase, William T. Richards, Dennis Bunker, and H. Siddons Mowbray in America; Constant and Laurens in Paris. Member: National Academy of Women Painters and Sculptors. Award: Dodge prize National Academy of Design, 1889. Address in 1953, Scarsdale, NY.

BREWSTER, GEORGE THOMAS.
Sculptor. Born Kingston, MA, February 24, 1862. Pupil of Mass. State Normal Art School; Ecole des Beaux Arts, under Du Mond; and of Mercie in France. Member: National Sculpture Society, 1898; Architectural League of New York, 1897; New York Municipal Art Society; National Arts Club; New York Society of Craftsmen; others. Instructor Rhode Island School of Design, 1892-93; instructor at Cooper Union from 1900. Work: Portraits of "Thomas R. Proctor," Utica, NY; "J. Carroll Beckwith," Library of New York University and National Academy

of Design; "Robert E. Lee," for Hall of Fame, NYC; "J. S. Sherman," Utica, NY; "Indiana," Crowning statue at Indianapolis; "Hope," crowning statue, State House, Providence, RI; "Greek Statesman" and "Greek Drama," Brooklyn Institute Museum; mural portrait tablets of Judge Andrews and Judge Bischoff, Supreme Court, New York, NY. Address in 1933, Cos Cob, CT. Died 1943.

BREWSTER, MICHAEL.
Sculptor and educator. Born in Eugene, OR, August 15, 1946. Studied at Sao Paulo Graduate School, Brazil, diploma, 1964; Pomona College, Claremont, CA, B.A., 1968, with John Mason and David Gray; Claremont Graduate School, M.F.A., 1970, with David Gray and Mowry Baden. Has exhibited at Herron Gallery, Indianapolis; Whitney Museum of American Art; Los Angeles County Museum of Art; and others. Received Artists fellowship, National Endowment for the Arts, 1976 and 78. Address in 1982, Venice, CA.

BRIDGES, GEORGES.
Sculptor and designer. Born in Chattanooga, TN, March 31, 1899. Studied at Cincinnati Academy of Art; and abroad. Member: Southern States Art League; New Orleans Art Association. Work: IBM; University of Alabama; monuments, Atlanta, GA; Birmingham, AL. Exhibited: Corcoran Gallery of Art. Address in 1953, Birmingham, AL.

BRIDGHAM, ELIZA H.
See Appleton, Eliza Bridgham.

BRIGHAM, BARBARA.
Sculptor. Born in Newark, NJ, 1929. Studied: Skidmore College (art); Art Students League, NYC (painting with DuMond). Lived in Mexico City, where she illustrated books. Began modeling in 1974. Subjects are humorous Western dioramas including the Old West saloon, campfires, doctors' and lawyers' offices, individuals. Media: Figures of wire; modeled, baked and painted heads, hands, etc.; fabric scraps; other found objects. Represented by Husberg Fine Arts Gallery, Sedona, AZ. Address in 1982, Austin, TX.

BRINDESI, OLYMPIO.
Sculptor. Born in Abruzzi, Italy, February 7, 1897. Pupil of Chester Beach, A. Phimister Proctor; Beaux-Arts Institute of Design; and Art Students League. Exhibited at National Sculpture Society, 1923; Penna. Academy of Fine Arts, Philadelphia, 1924; Architectural League of NY; Art Institute of Chicago; Hispanic Society; Baltimore Museum of Art; Rochester Memorial Art Gallery; Brooklyn Museum; Whitney Museum of American Art. Sculpted many animal and human figures in marble. Award: Prize, Architectural League of New York, 1927. Address in 1953, 27 West 15th St.; h. 201 Prince St., NYC. Died in 1965.

BRINES, JOHN FRANCIS.
Sculptor. Born in Westerly, Rhode Island, June 30, 1860. Address in 1903, 14 West 22nd St., NYC.

BRINGHURST, ROBERT PORTER.
Sculptor, craftsman, and teacher. Born at Jerseyville, IL,

March 22, 1855. Studied at St. Louis School of Fine Arts and at Ecole des Beaux Arts, Paris. Principal works: "Awakening Spring," Art Institute of Chicago; "Kiss of Immortality," destroyed at Portland Fair; statue of General Grant, City Hall Park, St. Louis; Minnesota's monument at Gettysburg; Pennsylvania's monument at Shiloh. Awards: First class medal, Columbian Exposition, Chicago, 1893; cash prize, Tennessee Centennial, Nashville, 1897; silver medal, St. Louis Exposition, 1904; medal ($500), St. Louis Art Guild, 1915. Member: St. Louis Art Guild; Two by Four Society, St. Louis. Address in 1918, University City, MO. Died in University City, MO, March 22, 1925.

BRINKMAN, TRACY BEELER.
Sculptor. Born in Los Angeles, CA, 1958. Self-taught in art. Has exhibited at El Prado Gallery of Art. Executes traditional bronze figures. Address in 1982, Mountain Home, TX.

BRODEUR, PAUL A.
Sculptor. Born in Webster, Mass., 1894. Address in 1935, Wellesley Hills, Mass. (Mallett's)

BRODY, SHERRY.
Sculptor and graphic artist. Noted for her clothing sewn to canvas. Also for her ink drawings.

BROMWELL, ELIZABETH HENRIETTA.
Sculptor, painter, teacher, and writer. Born Charleston, IL. Studied in Denver and Europe. Member: Denver Art Association. Address in 1928, Denver, CO.

BRONSON, CLARK EVERICE.
Sculptor, painter, and illustrator. Born in Kamas, Utah, March 10, 1939. Studied: University of Utah; apprenticed to Arnold Friberg. Initially painted, illustrated books; work published in major magazines. Later turned exclusively to sculpture. Exhibited: National Academy of Western Art, National Cowboy Hall of Fame, 1973, 74, 75; C. M. Russell Art Show and Auction, Great Falls, Montana, 1979-81; National Sculpture Society, NYC, 1981. Awards: Silver, for sculpture, National Academy of Western Art; silver for sculpture, National Sculpture Society. Member: National Academy of Western Art; National Sculpture Society; Society of Animal Artists; Wildlife Artists International; Northwest Rendezvous Group. Specialty: Wildlife subjects. Sculpts in bronze. Reviewed in *Southwest Art*, June 1975, January 1980. Address in 1982, Bozeman, MT.

BRONSON, JONATHAN.
Sculptor. Born in Chihuahua, MX, 1952. Studied: University of Utah; Wasatch Bronze Foundry assistant. Self-taught. Spent many years sketching and field study cataloging in the Uinta and Rocky Mountains; studied wolves in Alaska. Exhibited: World Wildlife Fund, Toronto, Canada; Western Heritage Show, Shamrock Hilton, Houston, TX; Game Conservation International, San Antonio, TX; Audubon Society Show, AL; Safari International, Las Vegas, NV; Society of Animal Artists Show, NYC; others. Member: Society of Animal Artists. Many noted works: "Golden Eagles," bronze; "Spring Wind," bronze; "Woolly Mammoth," bronze and mam-

moth tusk; "Silver Tip," bronze; numerous other pieces. Specialty is wildlife. Medium: Bronze. Represented by Nola Sullivan. Address in 1984, Pleasant Grove, UT.

BROOKINS, JACOB BODEN.
Sculptor and consultant. Born in Princeton, MO, August 28, 1935. Studied at Boise Jr. College; University of Oregon, BS (ceramics), MFA (metalsmithing and sculpture); also with Max Nixon, Jan Zach, Robert James, and James Hanson. Exhibited: Museum of Northern Arizona, 1977-79. Positions: instructor jewelry, University of Oregon, 1967-68; instructor sculpture, Northern Arizona University, 1969-75; instructor ceramics, Yavasai College, 1979-80; director, Museum of Northern Arizona Art Institute, 1975-79; founder, Cosnino Foundation. Member: World Crafts Council; American Crafts Council; Arizona Designer Craftsmen (member, board of directors, 1970-75, state president, 1971-72); National Sculptors Conference; others. Address in 1982, Cosnino Foundation Research Center, Flagstaff, AZ.

BROOKS, ALDEN FINNEY.
Sculptor and painter. Born West Williamsfield, OH, April 3, 1840. Pupil of Edwin White in Chicago; Carolus-Duran in Paris. Member: Chicago Society of Artists. Awards: Yerkes prize, Chicago Society of Artists, 1892; Illinois State Fair prize, 1895. Work: "Boys Fishing," Union Club, Chicago; "Gen. George H. Thomas" and "Judge Kirk Hawes," Public Library, Chicago; "Gov. J. R. Tanner," Capitol, Springfield, IL; "Isaac Elwood" and "James Glidden," State Normal School, De Kalb, IL; "Vice-President Sandison," State Normal School, Terre Haute, IN; Vanderpoel Art Association Collection, Chicago. Address in 1933, Chicago, Ill.; summer, Fennville, MI.

BROOKS, CAROLINE SHAWK.
Sculptor and modeler. Born in Cincinnati, April 28, 1840. First known by her modelling in butter exhibited in Paris World's Fair, 1878. She subsequently opened her studio in New York and executed portrait marbles of Garfield, George Eliot, Thomas Carlyle, and a portrait group of five figures representing "Mrs. Alicia Vanderbilt and Family." Died after 1900.

BROOKS, ERICA MAY.
Sculptor, painter, illustrator, craftsman, writer, lecturer, and teacher. Born London, England, July 9, 1894. Pupil of Myra K. Hughes, Norman Garstin, Charles Woodbury. Member: National Association of Women Painters and Sculptors; Paint and Brush Club; National League of American Pen Women. Exhibited: National Association of Women Artists, 1939; Studio Club, 1944, 46, 47; Albany Institute of History and Art, 1950; Hudson Valley Art Association, 1948-52; San Francisco Museum of Art, 1936; others. Award: Honorable mention, National League of American Pen Women, NY, 1928. Address in 1953, St. Agnes School; h. 257 State St., Albany, NY.

BROOKS, RICHARD EDWIN.
Sculptor. Born in Braintree, MA, 1865. Pupil of T. H. Bartlett, Boston, MA, and Jean Paul Aube and Antonin Injalbert, Paris. Works: Busts of Gov. William E. Russell (bronze) and Col. Gardener Tufts (marble), Boston Statehouse; O. W. Holmes, 1897; and Gen. F. A. Walker, Boston Public Library. Awards: Honorable mention, Paris Salon, 1895. Is also represented by statues of Charles Carroll and John Hanson in Statuary Hall, Capitol Building Washington DC; "The Bather" and "Song of the Wave," Metropolitan Museum, NY; figures on State Capitol, Hartford, CT. Member: National Sculpture Society, 1907; National Institute of Arts and Letters; Society of Washington Artists. Awards: Honorable mention at the Paris Salon, 1895; third class medal, Paris Salon, 1899; gold medal, Paris Exposition, 1900; gold medal, Panama-Pacific Exposition, San Francisco, 1915. Address in 1918, Washington, DC; Quincy, MA. Died in Boston, MA, May 2, 1919.

BROOME, ISAAC.
Sculptor. Born May 16, 1836, in Valcartier, Quebec. In 1838, arrived in Philadelphia. Studied at Penna. Academy of Fine Arts. Worked with Hugh Cannon. Member of Penna. Academy of Fine Arts. Exhibited at Penna. Academy of Fine Arts, 1855, 59; Washington Art Association, 1857 and won award at Philadelphia Centennial Exposition of 1876. Specialty: Ceramics. In collection of Penna. Academy of Fine Arts. Address in 1910, Trenton, NJ. Died in Trenton, NJ, May 4, 1922.

BROWERE, JOHN HENRI ISAAC.
Sculptor and painter. Born in New York City, November 18, 1790. Pupil of Archibald Robertson. He also studied in Italy. On his return to America he modeled several busts, and perfected a method of making casts from the living model. Subjects include Jefferson and Lafayette. Represented in New York State Historical Association, Cooperstown, New York Historical Society. Died in NYC, September 10, 1834.

BROWN, BRUCE ROBERT.
Sculptor and painter. Born in Philadelphia, PA, July 25, 1938. Studied: Tyler School of Art, Temple University, BFA 1962, MFA 1964. Work: Museum of Fine Arts, Savannah, GA; Erie Summer Festival; American Academy of Arts. Exhibitions: Penna. Academy of Fine Arts National; American Academy of Arts and Letters, NY; Butler Institute, Youngstown, OH; 21st Annual International Exhibition, Beaumont, TX; plus more. Awards: Carnegie Institute; Ford Foundation; Hallmark Co. purchase award; American Academy of Arts and Letters. Teaching: Monroe Community College of the State University of New York in Rochester. Member: Artists Equity Association, NY; Southern Sculptors Association; Rochester Print Club. Address in 1982, Honeoye, NY.

BROWN, C. EMERSON.
Sculptor. Born in Beverly, Mass., 1869.

BROWN, CHARLES.
Sculptor. Born in Connecticut, c. 1825. At Columbus, Ohio, 1850.

BROWN, HENRY KIRKE.
Sculptor and portrait painter. Born in Mass. February 24, 1814. Beginning as a portrait painter, he took up sculpture early, and after five years' study in Italy, established

himself in New York. Work: "Washington" in Union Square, NY; "Lincoln" in Union Square, NY; "General Scott" and "Nathaniel Greene," Stanton Square, Washington, DC. Elected Member of National Academy in 1851. Exhibited: National Academy; Boston Athenaeum; Penna. Academy of Fine Arts; Washington Art Association. Died in Newburgh, NY, July 10, 1866.

BROWN, IRENE.
Sculptor and painter. Born Hastings, Michigan in 1881. Pupil of William M. Chase, Hawthorne, and Johansen. Member of National Association of Women Painters and Sculptors. Address in 1926, South Orange, NJ. Died in 1934.

BROWN, JOSEPH.
Sculptor and educator. Born in Philadelphia, PA, March 20, 1909. Studied at Temple University, B.S., and with R. Tait McKenzie. Member: National Sculpture Society; American Association of University Professors; American Federation of Teachers; Penna. Academy of Fine Arts; Artists Equity Association. Awards: Medal, Montclair Art Museum, 1941; prize, National Academy of Design, 1944. Work: MacCoy Memorial, Princeton, NJ; Leroy Mills Memorial; Rosengarten Trophy; Raycroft Trophy; Clarke Intra-mural Trophy; Firestone Library; Penna. Academy of Fine Arts; Rhode Island School of Design Museum of Art; Clarence Irvine Memorial, Collingwood, NJ; Lehigh University, and others. Exhibited: National Academy of Design, 1934, 35, 40, 44; Art Institute of Chicago, 1941, 42; Philadelphia Public Library, 1949-51; Philadelphia Museum of Art, 1949; Firestone Library, Princeton, NJ; Woodmere Art Gallery, 1950; Exposition, Montreal, 1967. Taught sculpture at Cleveland (Ohio) College; Western Reserve University, 1950. Address in 1982, Princeton, NJ.

BROWN, JUDITH STETTENHEIM.
Sculptor. Born in NYC, December 17, 1932. Studied at Sarah Lawrence College, B.A. Works: Memorial Art Gallery, Rochester, NY; Evansville Museum of Art; Riverside Museum, NY; Larry Aldrich Museum; Cathedral Cuernavaca, Mexico; plus others. Commissions: Mural sculpture, Lobby, Radio Station WAVE, Louisville, KY; sculpture, Youngstown Research Center, OH; plus others. Exhibitions: Boston Art Festival, 1960 and 64; Silvermine Guild of Artists, 1963 and 64; Dallas Museum of Fine Arts, 1958, 64; Riverside Museum, 1964; Hopkins Art Center, Dartmouth College, Hanover, NH; 2nd Biennial American Paintings, Penna. Academy of Fine Arts, 1959; Recent Acquisitions, Aldrich Museum, 1966; one-man show, Contemporary Arts Gallery, NYU, 1977 and 1980. Awards: Silvermine Guild Artists, 1964; Creative Work in Art, American Academy and National Institute of Arts and Letters, 1976; Sculpture Award, Academy of Fine Arts, Hartford, CT, 1976. Address in 1982, 68 Jane Street, NYC.

BROWN, SOLYMAN.
Sculptor and portraitist. Born in Litchfield, CT, November 17, 1790. Exhibited: National Academy, 1842. Died at Dodge Center, MN, February 13, 1876.

BROWN, SONIA F.
(Mrs. Gordon Brown). Sculptor, painter, and teacher. Born in Moscow, Russia, on January 11, 1890. Came to US in 1914. Studied under Seroff and Nicolas Andrieff. Later went to Paris and worked with Antoine Bourdelle. Works: Rheims, private collection in Belgium; Saint Therese, California; The Negress; Virgin, and a great number of portraits, including one of Eleanora Duse. Exhibited: National Sculpture Society, 1923. Member: New York Society of Women Artists, president, 1927. Address in 1933, 6 MacDougal Alley; h., 70 West 11th St., NYC; summer, Siasconset, MA.

BROWNE, BELMORE.
Sculptor, painter, illustrator, and teacher. Born in Tompkinsville, Staten Island, NY, 1880. Studied with Chase, Carrol Beckwith, and in Paris at the Julien Academy. Worked as an illustrator 1902-12; began easel painting in 1913; wrote and illustrated "The Conquest of Mt. McKinley." Director of the Santa Barbara School of Arts, from 1930. Work in National Gallery of Art, American Museum of Natural History (diorama), Albright Art Gallery, Santa Barbara Museum of Natural History, California Academy of Sciences. Associate, National Academy, 1928. Specialty, mountain landscapes and animals. Died probably in Marin Co., CA, 1954.

BROWNE, ISAAC.
Sculptor. Born in 1836. Died in Trenton, New Jersey, in 1922. (Mallett's)

BROWNE, MATILDA.
(Mrs. Frederick Van Wyck). Sculptor, painter and teacher. Born in Newark, NJ, May 8, 1869. Studied at Julian Academy, Paris; and with Bouguereau, La Haye, C. M. Dewey, H. S. Bisbing and Julien Dupre. Work: Museum City of New York; Corcoran Gallery; Bruce Museum of Art, Greenwich, CT. Member: Nat. Association of Women Painters and Sculptors; American Federation of Arts; American Water Color Society; Society of Animal Painters and Sculptors; Conn. Academy of Fine Arts; National Arts Club; New York Society of Artists; Allied Artists of America; Greenwich Art Association. Awards: Honorable mention, Columbian Exposition, Chicago; Dodge Prize, National Academy of Design; Conn. Academy of Fine Arts, 1919; Greenwich Art Association. Exhibited at National Sculpture Society, 1923. Executed small animal sculpture. Illustrator, "Recollections of an Old NY," 1932. Address in 1953, Greenwich, CT.

BROXTON, MARGARET KALB.
(Margot Broxton). Sculptor. Born in Shrewsbury, Shropshire, England, February 9, 1909. Pupil of Ethel E. Foster, Carl C. Mose, J. Maxwell Miller, Randolph W. Johnston. Member: Art League of Washington; Creative Art Club of Arlington Co., VA. Work: Portrait of Hilda Conkling, Deerfield Studios. Address in 1933, Clarendon, VA; summer Deerfield, MA.

BRUCCINI (or BRUCCIANI), NICOLAO.
Modeler in plaster. Bruccini exhibited four figures made of plaster at the American Institute. Worked 1844 in New York City.

BRUESTLE, BERTRAM G.
Sculptor, painter, writer, lecturer, and teacher. Born New York City, April 24, 1902. Pupil of National Academy of Design with Charles C. Curran, Francis Jones. Work in Ames Memorial Gallery, New London, CT. Exhibited: Lyme Art Association; Salmagundi Club; New Haven Paint and Clay Club. Member: Salmagundi Club; Lyme Art Association; New Haven Paint and Clay Club. Address in 1953, New Haven, CT.

BRULC, LILLIAN G.
Sculptor and painter. Born in Joliet, IL. Studied at Art Institute Chicago, George D. Brown Foreign Travel fellowship, 1955, with Louis Ritman, Robert Lifvendahl and Egon Weiner, B.F.A., 1955, M.F.A., 1964; also with Franz Gorse, Austria and with Mustafa Naguib, sculptor. Works: Major works in permanent architectural environments, smaller works in private collections. Commissions: murals and sculpture, Cardinal's Committee for Spanish Speaking, Chicago, 1963-64; murals, San Miguelito Center, Panama, 1965, metal grillwork design, in process; mural, Chapel, San Miguelito, Panama, 1966; sculptures (assisted by Che Torres and Ruben Arboleda), Chapel and Garden, San Miguelito, 1968-69; murals, Archdiocesan Latin American Committee, Chicago, 1971. Exhibitions: Prints, Drawings, and Watercolors 2nd Biennial by Illinois Artists, Art Institute of Chicago, 1964; one-woman show, Drawings and Lithographs, Casa de Escultura, Panama City, 1969; Murals for People (slide of Chicago Works), Museum of Contemporary Art, Chicago, 1971. Media: Acrylic, mixed media, clay, cement, or plaster; welding. Address in 1982, Joliet, IL.

BRUMER, SHULAMITH.
Sculptor and instructor. Born in Russia, July 5, 1924; US citizen. Studied at Art Students League, with William Zorach; Columbia University, with Oronzio Malderelli. Has exhibited at Sculpture Center, NY, 1965, 68, 73, and 79; Philbrook Museum, Tulsa, OK; National Academy of Design, NY; Virginia Museum of Fine Arts; others. Work includes "Eve," Mexican alabaster exhibited at National Association of Women Artists Annual, NYC, 1983. Received Knickerbocker Prizes, 1957, 76, and 80; Audubon Artists Awards, 1958 and 62; honorable mention, Architectural League, 1966, Allied Artists 1960, 80. Member: National Association of Women Artists; Sculpture Center, NYC; Allied Artists; Knickerbocker Artists; others. Teaching stone and wood carving at Sculpture Center Art School, from 1971. Medium: Stone. Address in 1983, 473 Franklin D. Roosevelt Dr., NYC.

BRUMME, CARL LUDWIG.
Sculptor, painter, writer, and craftsman. Born in Bremerhaven, Germany, September 19, 1910. Studied with Leo Amino. Exhibited: Massillon Museum of Art, 1942-45; Museum Non-Objective Painting, 1943, 44; Pinacotheca, 1944, 45; Dartmouth College, 1944; Whitney Museum of American Art, 1947-51; Worcester Art Museum, 1951; Delaware Art Center, 1948; Munson-Williams-Proctor Institute, 1947; Fairmount Park, Philadelphia, 1949; Penna. Academy of Fine Art, 1949; Am-British Art Center, 1947; Sculpture Center, NY, 1945-

51; l'Institut Endoplastique, Paris, France, 1952. Address in 1953, c/o Hacker Gallery, 24 West 58th St., NYC.

BRUNETTIN, ALFRED JOSEPH.
Sculptor, designer, and craftsman. Born in Chicago, IL, August 28, 1917. Studied at Art Institute of Chicago, with Cheuseng, Wallace; Minneapolis School of Art; Cranbrook Academy of Art, with Carl Milles. Awards: Minneapolis Institute Art, 1939, 40; Prix de Rome, 1940; Fellow, Cranbrook Academy Art, 1941. Exhibited: Art Institute of Chicago, 1940; Minneapolis Institute of Art, 1939, 40; Detroit Institute of Art, 1941; Carnegie Institute, 1939; and in Pittsburgh, Minneapolis, and Milwaukee. Address in 1953, Cicero, IL.

BRUNNER, BRUCE CHRISTIAN.
Sculptor, painter, etcher, illustrator, lecturer, teacher. Born in NY, November 4, 1898. Studied at Cooper Institute of Science and Art; Grand Central School of Fine and Applied Arts. Member: Honolulu Association of Professional Artists Murals; scientific artist, painting coral reefs and marine life on the ocean floor, for larger models and exhibits. Artist for the Department of Lower Invertebrates, American Museum of Natural History, NYC. Address in 1933, Flushing, Long Island, NY.

BRUNSWICK, HYMAN.
Sculpted with wax, manufactured composition figures and artificial noses in NYC, 1844-68. Exhibited: American Institute 1844, 1845, 1848-51.

BRUNSWICK, THOMAS M.
Sculptor in wax. Exhibited crucifixion and six wax dolls, American Institute, 1849 and 1851. Manufactured composition figures.

BRUSH, GEROME.
Sculptor and painter. Born in New York. Address in 1919, 58 West 57th St., NYC; Southampton, Long Island, New York. In Dublin, NH, in 1934.

BRUSH, LEIF.
Sound sculptor and instructor. Born in Bridgeport, Ill., March 28, 1932. Studied at Art Institute of Chicago, Diploma, 1970, fellowships, 1970 and 1972, MFA, 1972. Work in Art Institute of Chicago; plus others. Has exhibited at Minneapolis Institute of Arts; Walker Art Center, Minneapolis; Neuberger Museum, Purchase, NY, 1981; and others. Received awards from Minneapolis State Arts Board, 1979; Bush Foundation, 1980 and McKnight Foundation, 1981; and others. Address in 1982, Duluth, MN.

BRYANT, NANNA MATTHEWS (MRS.).
Sculptor. Born in 1871. Exhibited at Academy of Fine Arts, Philadelphia, 1924. Member: National Association of Women Painters and Sculptors; Newport Art Association. Address in 1929, Boston, Mass. Died in Waltham, MA, 1933.

BUBA, JOY FLINSCH.
Sculptor and illustrator. Born in Lloyd's Neck, NY, July 25, 1904. Studied at Eberle Studio, NY; Staedel Kunst Institute, Frankfurt, Germany; Art Academy, Munich, Germany; also with Theodor Kaerner and Angelo Yank.

Member: National Sculpture Society, fellowship. Works: David Mannes, Metropolitan Museum of Art, NY; Florence Sabin, Statuary Hall, Capitol Bldg., Washington, DC; Norman Thomas and Margaret Sanger, National Portrait Gallery, Washington, DC; John D. Rockefeller, Jr., Rockefeller Plaza, NY; Konrad Adenauer, Palais Schaumberg, Bonn, Germany. Address in 1982, Mt. Pleasant, SC.

BUBB, NANCY (JANE).
Sculptor, writer, and curator. Born in Bronx, NY, Jan. 3, 1945. Studied at State University of NY, Farmingdale; Greenwich House Pottery, with Bob Stull and Jane Hartsook; Clay Art Center with Jim Howard. Exhibitions: Calhoun College Annual Craft Exps. and Symp., Yale University, 1973; Fun and Fantasy, Xerox Corp. Gallery, Rochester, 1973; Folk Roots Contemporary Crafts, Fairtree Gallery, NY, 1975; two-woman show, Clay and Fiber Gallery, Taos, NM, 1975. Awards: Court of Honor/ Ithaca, New York State Craftsmen, 1973. Media: Clay and fabric. Address in 1982, Hampton, NJ.

BUBERI (or BUBERL), CASPAR.
Sculptor. Born 1834 in Bohemia; came to US 1854. Exhibited at the National Academy, 1860's and 1870's. Member of National Sculpture Society. Died August 22, 1899, in New York City.

BUCHANAN, ELLA.
Sculptor. Born in Preston, Canada. Studied: Art Institute of Chicago. Member of the Chicago Society of Artists; California Art Club; Sculptor Guild of Southern California; Hollywood Art Association. Work: "Martha Baker Memorial," Chicago; "Pete" and "Dry Water Hole," Southwest Museum, Los Angeles, CA; drinking fountain, Olive Hill, Los Angeles. Represented in Vanderpoel Art Association Collection, Chicago. Awards: Prizes, California Art Club, 1918; California Liberty Fair, 1918; Ebell Exhibition, 1934. Address in 1953, Hollywood, CA.

BUCHBINDER, GERT.
Sculptor. Work includes "The Mediators," cast in stone, exhibited at National Association of Women Artists Annual, NYC, 1983. Member: National Association of Women Artists. Address in 1983, 177 E. 77 Street, NYC.

BUCK, CHARLES CLAUDE.
Sculptor and painter. Born in New York City. Pupil of Emil Carlsen. Address in 1926, 495 East 188th St., New York City.

BUCK, EMMA G.
Sculptor and painter. Member of Chicago Art Club. Born in Chicago, Ill., in 1888. Work: Wisconsin, Perry's Centennial Medal. Address in 1926, Chicago, IL.

BUCKLEY, JEAN.
Sculptor. Born in Sacramento, CA, in 1925. Studied at Sacramento College; Chouinard Art Institute; Art Students League; California College of Arts & Crafts; University of Southern California. Works: California State College, Sacramento; Immaculate Heart College; Grant Beach School of Arts & Crafts, Oakland, CA. Awards: California Watercolor Society, 1952; Unitarian Exhibi-

tion, Los Angeles, 1954; California State Fair, 1955; Orange County National Exhibition, 1957; Los Angeles Art Festival, 1957.

BUDELL, HORTENSE.
Sculptor. Born in Lyons, France. Address in 1934, Westfield, New Jersey. (Mallett's)

BUDGE, LINDA M.
Sculptor and painter. Born in Salt Lake City, UT, 1940. Self-taught. Initially painted Western ranch and rodeo scenes; now concentrates on wildlife and Rocky Mountain big game. Has exhibited at invitational wildlife shows. Published works: in *Wyoming Wildlife*, *Trident*, and *Mr. Longears*. Member: Society of Animal Artists; Ducks Unlimited; Safari; Foundation for North American Sheep; Audubon; International Wildlife. Reviewed in *Art West*, January, 1982. Media: oil and bronze. Address in 1983, Laramie, Wyoming.

BUFANO, BENIAMINO.
Sculptor. Born in San Fele, Italy, October 14, 1898. Studied: National Academy of Design; Beaux-Arts Institute of Design; Art Students League; and with Paul Manship, James L. Fraser, Herbert Adams. Award: First prize for "Soul of the Immigrant," Whitney Competitive Exhibition; Art Students League, 1914-16. Work: Metropolitan Museum of Art; San Francisco Museum of Art; Sun Yat Sen statue, St. Mary's Park, San Francisco; peace memorial, San Francisco; others. Position: Art Commissioner, City of San Francisco. Address in 1918, 54 Washington Mews, NYC. Address in 1953, San Francisco, CA. Died in 1970.

BUGBEE-JACKSON, JOAN.
(Mrs. John M. Jackson). Sculptor and educator. Born in Oakland, CA, December 17, 1941. Studied at University of Montana; San Jose State College, B.A. and M.A.; Art Students League, with R. B. Hale; School of Fine Arts, National Academy of Design; also with M. Wildenhain, EvAngelos Frudakis, Joseph Kiselewski, Granville Carter, and Adolph Block. Works: Cordova Public Library, Alaska; J. Goldsmith Portrait, commissioned by D. Goldsmith, NY, 1971; Henrietta Shaw Portrait, commissioned by Milton Shaw, NY, 1971, three portraits, commissioned by C. Crawford, Forest Hills, NY, 1972; Merle K. Smith Medal, commissioned by Kenneth Van Brocklin, Cordova, 1972; Bob Korn Commemorative Plaque, City of Cordova, 1974, Bronze Medal, Alaskan Wildlife, 1980. Exhibited: One-woman show, Springvale, ME, 1970; National Sculpture Society Annual, NY, 1970-73; Allied Artists of Amer. Annual, NY, 1970-72; National Academy of Design Annual, NY, 1971 and 74; Joan Bugbee, Retrospective, NY, 1972. Awards: Helen Foster Barnett Prize National Academy of Design, 1971; C. Percival Dietsch Prize, 1973. Media: Fired stoneware clay, cast bronze. Member of the National Sculpture Society and Artists Equity Association. Address in 1982, Cardova, AK.

BUGLINO, JOSEPH.
Sculptor and craftsman. Born in Palermo, Italy, Aug. 7, 1878. Studied at Cooper Union. Address in 1933, 101 Seventh Ave., South, NYC.

BUHLIG, PAUL.
Sculptor. Born in Chicago, IL. Awarded honorable mention, Paris Salon, 1935.

BULL-TEILMAN, GUNVOR (MRS.).
Sculptor, painter, illustrator, writer, and lecturer. Born in Bodoe, Norway, March 14, 1900. Studied at Grande Chaumiere, Julian Academie, Paris; Academy of Fine Arts, Leipzig, with A. Lehnert, A. Miller. Member: Am-Scandinavian Foundation. Awards: Prizes, Albany Institute of History and Art, 1935; Am-Scandinavian Art National Group, 1936. Work: Murals, Waldorf-Astoria Hotel, NY; US Time Corp., NY. Exhibited: Europe, 1922-31; Ferargil Gallery, 1943 (one-man); Brooklyn Museum; Albany Institute of History and Art; Harvard University. Illustrator, Undset's "Sigurd and His Brave Companions," 1943. Contributor to: Magazines with articles on art. Lectures: "Art in Occupied Norway." Address in 1953, 3 Washington Square, North, NYC.

BULLET, CHARLES.
Sculptor. Worked: Brooklyn, 1849; Cincinnati, 1850-60. Exhibited: National Academy, 1849; American Institute, 1893.

BULTMAN, FRITZ.
Sculptor and painter. Born April 4, 1919, New Orleans, LA. Studied: Privately with Morris Graves, 1931; New Orleans Arts and Crafts School; Munich Preparatory School; New Bauhaus, Chicago, 1937-38; Hofmann School, NYC and Provincetown, 1938-41. Work: Chrysler; Rhode Island School of Design; Riverside Museum; Whitney; others, including universities. Exhibited: Hugo Gallery, NYC, 1947, 1950; The Kootz Gallery, NYC, 1952; Martha Jackson Gallery, NYC, 1959, 74, 76; New Orleans (Delgado) 1959; Galerie Stadler, Paris, 1960; Michel Warren Gallery, NYC, 1960; Gallery Mayer, NYC, 1960; Tibor de Nagy Gallery, 1963; Whitney Museum; Art Institute of Chicago; Museum of Modern Art, Hans Hofmann and His Students, 1963-64. Awards: Italian Government Scholarship, 1950; Fulbright Fellowship, 1951, 1964-65 (Paris); Guggenheim Memorial Award, 1975-76. Taught: Pratt Institute, 1958-63; Hunter College, 1959-64; Fine Arts Work Center, Provincetown, MA, 1968-70. Address in 1982, 176 E. 95th St., NYC.

BUNCE, JOHN OSCAR.
Sculptor and architect. Born in New York City, July, 1867. Pupil at National Academy of Design and Art Students League of New York. Address in 1934, Ridgewood, NJ.

BUNN, KENNETH.
Sculptor. Born in Denver, CO, June 1, 1938. Studied: University of Maryland; apprenticed at Smithsonian Institution, Washington, DC, 1953, 54; worked in Denver with taxidermist Coleman Jonas; operated own business producing sculpture for commercial clients and wax museum, until late 1960's. Exhibited at dealer Sandra Wilson's gallery in Santa Fe, NM, and Denver, CO; Kennedy Galleries and Graham Gallery, NYC; 145th-149th Annuals, National Academy of Design; Forrest Fenn Galleries, Santa Fe; 36th 41st Annual, National Sculpture Society; Stremmel Galleries, Reno, NV; Mongerson Gal-

lery, Chicago; Bishop Galleries, Scottsdale, AZ. Elected Associate of National Academy of Design, 1973, and member, National Sculpture Society, 1973; member of National Academy of Western Art; Society of Animal Artists. Received Barnett Prize and an Award of Merit in competition. Address in 1976, Denver, CO.

BUNTING, E. V.
Sculptor. Active 1865. Patentee—bust of Lincoln, 1865.

BUONAGURIO, TOBY LEE.
Sculptor and draftsman. Born in Bronx, NY, June 28, 1947. Studied at The City College of New York, BA (fine arts), 1969, MA (art education), 1971. Work in Heckscher Museum, Huntington, New York; others. Has exhibited at Museum of Contemporary Crafts (The Great American Foot), NY, 1980; Mint Museum of Art, Charlotte, NC, 1980; John Michael Kohler Art Center, Sheboygan, Wisconsin, 1981; Fine Arts Museum of San Francisco, Calif. Represented by Gallery Yves Arman, New York City. Address in 1982, Bronx, NY.

BUREAU, ALBERT GEORGE.
Sculptor. Born in Philadelphia, PA, February 21, 1871. Address in 1910, Philadelphia, Penna.

BURKE, SELMA HORTENSE.
Sculptor, teacher, writer, and lecturer. Born in Mooresville, NC, January 1, 1907. Studied at Columbia University; with Maillol in Paris; Hans Reiss in New York. Awards: Rosenwald Fellow, 1940, 41; Boehler Fellow, 1938, 39; Prize, Atlanta University, 1943. Work: New York Public Library; New York Public School; Bethune College; Teachers College, Winston-Salem, NC; Recorder of Deeds Bldg., Washington, DC; US Government. Exhibited: New York World's Fair, Gallery, 1939; ACA Gallery, 1945; Downtown Gallery, 1939; MacMillen Theatre, 1940; Village Art Center, 1941-46; New York University, 1943; Brooklyn Museum of Art; Newark Museum; Virginia State College; Albany Institute of History and Art; Hampton Institute; Atlanta University; Modernage Gallery, 1945 (one-man). Contributor to: Magazines and newspapers. Lectures: African Sculpture. Position: Director, Student's School S., NYC, 1943-46. Address in 1953, 67 West 3rd St.; h. 88 East 10th St., NYC.

BURLEIGH-CONKLING, PAUL.
See Conkling, Paul Burleigh.

BURLINGAME, SHEILA.
Sculptor and painter. Born in Lyons, KS, April 15, 1894. Pupil of Art Institute of Chicago; Art Students League of NY; Grande Chaumiere, Paris, and with Carl Milles, Zadkine, John Sloan. Member: St. Louis Art Guild; St. Louis Art League; American Federation of Arts; Pen and Brush Club; National Sculpture Society; Architectural League; National Association of Women Artists; Audubon Artists; American Artists Professional League. Awards: Second prize, St. Louis Art League, 1922, 27; gold medal Kansas City Art Institute, 1922; honorable mention, St. Louis Art League, 1926; prizes, St. Louis Art Guild, 1921, 22, 26-28; Pen and Brush Club; American Artists Professional League; National Association of Women Artists. Work: Woodcuts for St. Louis Post Dis-

patch, 1923-24; twenty-three woodcuts for "From the Days Journey," by Harry Burke, 1924. Exhibited: Penna. Academy of Fine Arts; National Academy of Design; Art Institute of Chicago; others. Address in 1953, Provincetown, MA. Died in 1969.

BURNETT, PATRICIA HILL.
Sculptor and painter. Born in Brooklyn, NY. Studied at University Toledo; Goucher College; Corcoran Art School; Society Arts and Crafts; Institute Allende, Mexico; Wayne State University; Truro School of Art; also with John Carroll, Sarkis Sarkisian, Wallace Bassford, Walter Midener, and Seong Moy. Works: Detroit Institute of Arts, Michigan; Bloomfield Art Association, Michigan; Wayne State University; Wooster College; Ford Motor Co. Collection, Detroit. Commissions: Oil portrait, Joyce Carol Oates, Ontario, 1972, Indira Ghandi, Prime Minister, New Delhi, India, 1973, Roman Gribbs, Mayor Detroit, 1973, Hiram Walker, Windsor, 1974 and Benson Ford, Ford Motor Co., Detroit, 1975. Exhibitions: Michigan Artists Show, Detroit Institute of Arts, 1967; Show of Paintings, Palazzo Pruili Gallery, Venice, Italy, 1971; Butler Museum National Art Show, Cleveland, OH, 1972; International Art Show, Windsor, Ontario, 1973; Ms and Masters, Midland Center, Arts, Midland, MI, 1975. Awards: First Prize Sculpture, Scarab Club Gold Medal Show, 1966; First Prize, Painting, Figure Painting Show, Boston, 1969; First Prize, Western Art Show, Albuquerque, New Mexico, 1974. Media: Oil on canvas; wax for casting in bronze and clay. Address in 1982, Detroit, MI.

BURNHAM, CAROL-LOU.
Sculptor, painter, and illustrator. Born in Chicago, IL, February 22, 1908. Studied at Fontainebleau School of Fine Art, Paris; Art Institute of Chicago, and with Fernand Leger, Andre L'Hote, Paul Baudouin. Member: North Shore Art Association. Work: Decatur Art Center; Skoki School, Winnetka, IL. Exhibited: Art Institute of Chicago, 1923-25, 27, 28, 35, 38, 43; Grand Central Art Gallery, 1931 (one-man); Art Institute of Chicago, 1931 (one-man); Paris Salon. Illustrator, "Around the World on a Penny," 1933. Position: Instructor at Layton School of Art, Milwaukee, WI, from 1946. Address in 1953, Winnetka, IL.

BURNHAM, LEE.
Sculptor and painter. Born in NYC, February 16, 1926. Studied at Cranbrook Academy of Art, 1943-45, sculpture with Carl Milles; Art Students League, 1946-47, sculpture with W. Zorach; Syracuse University, 1947-51, sculpture with Ivan Mestrovic; Porta Romano Scuola, Firenze, Italy, 1951-52; Reinhold School of Art, Baltimore, MD, with Sidney Waugh and Cecil Howard. Work includes bronze crucifix, Visitation Convent, St. Paul, MN; bronze head, Daytona Historical Society, FL; St. Joseph's Catholic Church, Zephyrhills, FL; others. Has exhibited at Firenze, Italy; Gallerie St. Placide, Paris; Bicentennial Medal Design Competition, Franklin Mint. Member of the National Sculpture Society. Received Museum of Modern Art Award, 1940; others. Media: Bronze, stone, ceramics, wood, and synthetics. Address in 1982, Hawthorne, FL.

BURNHAM, ROGER NOBLE.
Sculptor, lithographer, and teacher. Born in Boston, MA, August 10, 1876. Studied: Harvard University, and with Caroline Hunt Rimmer. Work: Four colossal figures, City Hall Annex, Boston; panels on main doors, Forsyth Dental Infirmary for Children, Boston; "Uncle Remus" memorial tablet, Atlanta; medallion, "Johann Earnest Perabo," Boston Art Museum; Carrington Mason Memorial, Memphis; figure of Centaur, head of Athena and Tritons on Germanic Art Museum, Harvard; Will Rogers memorial tablet, 20th Century-Fox Studios, Los Angeles. Exhibited: Architectural League; Penna. Academy of Fine Arts; San Francisco Museum of Art; and in Paris, Rome, Ghent, Hawaii; others. Member: American Federation of Arts; California Art Club; others. Instructor in school architecture, Harvard University, 1912 to 1917. Awards: Prizes, Architectural League, 1904; University of California, 1911; Long Beach International Exp., San Francisco Museum of Art; Los Angeles Museum of Art, 1944. Address in 1953, Los Angeles, CA.

BURNS, GEORGE.
Sculptor. At New York City, 1850.

BURNS, SID.
Sculptor and collector. Born in Tulsa, OK, May 10, 1916. Self-taught. Raised in Texas and Kansas. Initially worked in leather Western gear and saddlery in California. Turned to sculpture later in life and moved to Prescott, AZ. Executed 24 bronzes in his relatively brief artistic career. Specialized in frontier action subjects. Represented in National Cowboy Hall of Fame; Gilcrease Institute; Favell Museum. Received bronze medal, Solon Borglum All Sculpture Show, National Cowboy Hall of Fame; George Phippen Memorial Western Art Show; others. Member: Laguna Beach Art Association; Gilcrease Institute Foundation; National Cowboy Hall of Fame Foundation; others. Died in Phoenix, AZ, in 1979.

BURR, EDWARD EVERETT.
Sculptor, painter, and teacher. Born in Lebanon, OH, January 18, 1895. Studied at Art Institute of Chicago, with Leopold Seyffert, Albin Polasek. Member: All-Illinois Society of Fine Arts; Society for Sanity in Art. Awards: Prizes, Society for Sanity in Art; All-Illinois Society of Fine Art; Art Institute of Chicago, 1933. Work: Design, Arkansas Centennial Half-Dollar. Exhibited: Society for Sanity in Art, Chicago, 1938, 41; Art Institute of Chicago, 1926, 27, 31; Illinois Academy of Fine Arts, 1927. Address in 1953, Urbana, IL.

BURR, FRANCES.
(Mrs. Frances Burr Ely). Sculptor and painter. Born Boston, MA, November 24, 1890. Studied: Art Students League; Provincetown School of Art, with Chase and Hawthorne; Fontainebleau School. Member: American Artists Professional League; American Federation of Arts; Art Students League of New York; National Association of Women Painters and Sculptors; Mural Painters. Exhibited: Rochester Memorial Art Gallery; Architectural League; Brooklyn Museum; Metropolitan Museum of Art; Art Institute of Chicago, others. Specialty, panels in gesso relief, painted. Address in 1953, Long Island, NY.

BURR-MILLER, CHURCHILL.
Sculptor. Born in 1904. Exhibited portrait bust at Penna. Academy of Fine Arts. Lived in Wilkes-Barre, PA.

BURROUGHS, EDITH WOODMAN.
(Mrs. Bryson Burroughs). Sculptor. Born October 20, 1871 in Riverdale, NY. Studied at Art Students League; with Kenyon Cox (drawing) and Saint-Gaudens (modeling); and in Paris with Injalbert. Traveled in Europe. Associate member of National Academy of Design (1913), and National Sculpture Society. Works: Bust of John La Farge and "At the Threshhold" (Metropolitan Museum of Art) and "Fountain of Youth." Died in Long Island, January 6, 1916.

BURT, FREDERIC.
Sculptor. Born in Onarga, IL, February 12, 1876. Pupil of Bourdelle; Academie de la Grande Chaumiere, Paris. Member: Society of Independent Artists. Address in 1926, Harrison, NY; summer, Provincetown, MA.

BURTON, GLORIA.
Sculptor and painter. Born in NYC. Studied at Mt. Holyoke College, MA; Art Students League; University of California, Los Angeles. Works: Holyoke Museum of Art, MA. Commissions: Aluminum-bronze sculpture, Stanley Folb Building, Hollywood, 1968; bronze, brass and copper sculpture, Empire Savings & Loan, Santa Ana, CA, 1969; Bronze sculpture, Danmour & Assoc. (in mall), Reseda Village Green, Reseda Village, CA; 2 bronze sculptures, Security Pac Bank, Oxnard, CA, 1972. Exhibitions: Sacramento State Fair; San Francisco Museum of Art; two-person shows, Machinations, Museum of Science & Industry, Los Angeles, 1973 and Chicago, 1975; and Of Art and Medicine, Museum of Science and Industry, Los Angeles, 1975. Awards: Awards for People of the City, Southland Annual, Del Mar, CA, 1969, Decent, Westwood Art Association and Revelation, Santa Monica Annual. Media: Bronze and watercolor. Address in 1980, Los Angeles, CA.

BURTON, HARRIET (B.)
(Mrs. Crawford Burton). Sculptor. Born in Cincinnati, OH, March 29, 1893. Studied with M. Karbel, Abastinia Eberle, Cecil Howard, and Alexander Archipenko. Work: "Turtle and Boy Fountain," Porcupine Club, Nassau, Bahamas. Address in 1933, 40 East 58th St., NYC.

BURTON, SAMUEL CHATWOOD.
Sculptor, painter, illustrator, etcher, educator, and writer. Born Manchester, England, February 18, 1881. Pupil of Laurens in Paris; Lanteri in London. Member: Minneapolis Art Association; American Federation of Arts; Beachcombers' Club, Provincetown; Chicago Society of Etchers; Art Masters of England. Awards: Third prize for painting, 1917; second prize for etching, Minneapolis Institute, 1921. Work: Metropolitan Museum of Art; University of Minnesota; Art Institute of Chicago; others. Professor of architecture and fine arts, and lecturer on art, University of Minnesota. Address in 1953, Minneapolis, MN.

BUSCAGLIA, JOSE.
Sculptor and educator. Born in San Juan, Puerto Rico, September 15, 1938. Studied at Harvard University, B.A., 1960; with Enrique Monjo, sculptor, 1958-62; University of Puerto Rico, M.A., 1977. Work in Robert Frost National Portrait Gallery, Washington, DC; Ponce Museum of Art; Justice, US Federal District Court; monuments, Rio Piedras, Puerto Rico; Bar Association Bldg., San Juan, Puerto Rico. Has exhibited at Harvard University; University of Puerto Rico Museum; Thirty Years of Sculpture, Institute of Puerto Rican Culture; others. Member of National Sculpture Society; Academy of Arts and Science of Puerto Rico. Award: Council of American Artist Societies Award, 1980. Teaching art at University of Puerto Rico, Rio Piedras, from 1963. Works in bronze. Address in 1982, Lexington, MA.

BUSCH, JULIA M.
Sculptor andi writer. Born in Teaneck, NJ, March 27, 1940. Studied at Julliard School of Music; University of Miami, with Eugene Massin and Dr. August Freundlich; Columbia University, with Dr. Douglas Frasier, B.A. Commissions: Acrylic and light mural (with Eugene Massin), City National Bank of Miami, 1973. Awards: Scholar, University of Miami, 1968. Author of A Decade of Sculpture, the New Media of the 1960's, Art Alliance, 1974. Address in 1982, Coconut Grove, FL.

BUSH, BEVERLY.
Sculptor and painter. Born in Kelso, WA. Studied at University of Washington, B.A.; National Academy of Design School of Fine Arts; Art Students League. Executive Secretary of Artists Equity Association since 1958. Exhibitions: National Association of Women Artists, 1958; Art: USA, 1959; Audubon Artists, 1959; Seattle Art Museum, 1964; plus others. Awards: Youth Friends Association Scholar, National Academy of Design, 1954-55; Joseph Isador Merit Scholar, 1955-57. Address in 1982, Seattle, WA.

BUSH-BROWN, HENRY KIRKE.
Sculptor. Born Ogdensburg, NY, April 21, 1857. Studied art at National Academy of Design; Paris at Academie Julien and Italy, 1886-89. Pupil of Henry Kirke Brown. Prominent works: Equestrian Statues Gen. G. G. Meade and Gen. John F. Reynolds, Gettysburg, PA; statues "Justinian," Appellate Court, NY; "Indian Buffalo Hunt," Chicago Exposition, 1893; equestrian statue Gen. Anthony Wayne for Valley Forge, PA; memorial architecture, Stony Point, NY; The Lincoln Memorial, Gettysburg, 1911; Union Soldiers' Monument, Charleston, W. VA, 1912; equestrian statue, Gen. John Sedgwick, Gettysburg, PA. Exhibited at National Sculpture Society, 1923. Represented in Metropolitan Museum of Art; Atlanta (GA) Museum; National Museum, Washington, DC. Member: National Sculpture Society; Architectural League; National Arts Club; American Federation of Arts. Address in 1933, Ambler, PA; 1730 Euclid St., Washington, DC. Died in 1935.

BUSHER, CHARLES.
Sculptor. At Philadelphia, 1857-58.

BUTENSKY, JULES LEON.
Sculptor. Born in Stolvitch, Russia, December 13, 1871.

Pupil of Hellmer and Zumbusch at Imperial Academy of Fine Arts in Vienna; Mercie and Alfred Boucher in Paris. Work: "Universal Peace," Metropolitan Museum, NY; portrait of former president, First National Bank, Brooklyn; "Jacob M. Gordin Memorial," Seward Park, NY; "Exile," White House, Washington, DC; "Ames Prize Medal," Harvard Law School; "Goluth," group at Hebrew Institute, Chicago. Address in 1935, Ramah, Pomona, Rockland Co., NY.

BUTTER, TOM.
Sculptor and instructor. Born in Amityville, NY, October 19, 1952. Studied at Antioch College, 1970-71; Philadelphia College of Art, BFA, 1975; Washington University, St. Louis, MO, MFA, 1977. Work in Minneapolis Museum of Art, Minneapolis. Has exhibited at Borgenicht Gallery, NY, 1981; Stefanotti Gallery, NY, 1981; and others. Teaching at Philadelphia College of Art, from 1978. Received National Endowment for the Arts Grant, 1980. Address in 1982, 63 East Broadway, NYC.

BUTTERFIELD, DEBORAH KAY.
Sculptor. Born in San Diego, CA, May 7, 1949. Studied at San Diego State; University of California at San Diego; graduate of University of California, Davis. Teaching at Montana State University from 1977. In collections of Whitney, NYC; San Francisco Museum of Contemporary Art; Milwaukee (WI) Art Center. Exhibited at University Art Museum, Berkeley; Madison (WI) Art Center; Zolla/Lieberman Gallery, Chicago; Harris Gallery, NYC; Israel Museum, Jerusalem; Walker Art Center, Minneapolis; Oakland (CA) Museum; Krannert, University of Illinois; Whitney, NYC; Albright-Knox, Buffalo; Indianapolis Museum of Art; Renwick Gallery, Smithsonian; other California galleries. Awarded National Endowment for the Arts fellow; Guggenheim Grant, 1980. Works with natural materials and metal. Address in 1982, Bozeman, MT.

BUTTI, GUIDO.
Sculptor and modeler. At New York City, 1853; Washington, c. 1856-64. Exhibited: Pennsylvania Academy, 1856-70. Sculpted decorations over entrance to General Post Office, Washington, DC.

BUTTOLPH, SUSY.
Sculptor. Born in Mariette, Georgia. Exhibited: Salon des Artistes Francais, 1912.

BYRON-BROWNE, GEORGE.
Sculptor and painter. Born in Yonkers, NY, June 26, 1908. Studied with Karfunkle, Aiken, Zorach. Award: Third Hallgarten prize, National Academy of Design, 1928. Member: Allied Art Association; Yonkers Art Association. Address in 1933, 35 Jane St., NYC; summer, Lakewood, NJ.

C

CABLE, BENJAMIN D.
Sculptor. Award: Walton prize, Art Institute of Chicago, 1910. Address in 1916, Chicago, IL.

CABLE, MAXINE ROTH.
Sculptor. Born in Philadelphia, PA. Studied at Tyler School of Fine Art, Temple University, Assoc. of Arts; Corcoran School of Art; George Washington University, AB; American University, with Hans Hofmann. Work in National Academy of Science, Washington, DC; Wolf Trap Farm of Performing Arts, Va, sculpture, 1973; and others. Has exhibited at the Corcoran Gallery of Art, 1955-67; Gallery Ten, Washington, DC, 1975, 76 and 79; and others. Received sculpture award, David Smith, Corcoran Gallery of Art, 1955; First Prize in Painting, Smithsonian Institute, 1967; and others. Address in 1982, Bethesda, MD.

CABOT, HUGH.
Sculptor and painter. Born in Boston, MA, March 22, 1930. Studied at Vesper George School of Fine Arts; Boston Museum of Fine Arts School; College of Americas, Mexico City; Asmolean, Oxford University, Cambridge, England. Work in The Pentagon and National War Museum, Washington, DC; Harwood Foundation of Art, Taos, New Mexico. Has exhibited in Mitsubichi Gallery, Tokyo, Japan; Museum de la Marine, Paris, 1963; National Gallery of Art; and others. Received awards from the Texas Tri State, First, Second, and Third Prizes, 1969; Scottsdale, Arizona, Artist of the Year, 1978. Works in oil, watercolor, and bronze. Was official Navy combat artist in Korean War. Has contributed newspaper and magazine illustrations. Specialty is Southwestern American and Mexican frontier subjects. Address in 1982, Tubac, AZ.

CADMUS, A.
Ceramic modeller. Reportedly working at the Congress Pottery, South Amboy (NJ), about 1850. There are reproductions of his piece, "Bull Calf."

CADORIN, ETTORE.
Sculptor. Born in Venice, Italy, March 1, 1876. Studied in Venice. Member: National Sculpture Society. Award: First medal, Royal Academy, Venice. Work: Two colossal statues, St. Mark's Square, Venice; Wagner memorial, Venice; war memorial, Edgewater, NJ; bronze statue, "Junipero Serra," for California in Statuary Hall, U.S. Capitol, Washington, DC; three large stone statues of the patron saints, Washington Cathedral; large group and two statues for Court House, Santa Barbara, CA. Address in 1933, Santa Barbara, CA. Died June 18, 1952.

CADWALADER-GUILD, EMMA MARIE.
Sculptor and painter. Born in Lanesville, OH, 1843. (Mallett's)

CAESAR, DORIS.
Sculptor. Born NYC in 1892. Studied: Art Students League; Archipenko School of Art; also under Rudolph Belling. Work: Addison Gallery of American Art; Chapel of Our Redeemer, Chappaqua, NY; Conn. College; Daytona Institute of Art; Fort Worth Art Association; Philadelphia Museum of Art; Minneapolis Institute of Art; Newark Museum of Art; University of Iowa; University of Minn.; Utica Public Library; Wadsworth Atheneum; Whitney Museum of American Art; Penna. Academy of Fine Art; Wellesley College; Atlanta Art Center; Erhard Weyhe, whose collection of Caesar's sculpture was shown at Weyhe Gallery, NYC, 1959; many others. Member: Federation of Modern Painters and Sculptors; Sculptors Guild; NY Architectural League; Audubon Artists; others. Exhibited: Metropolitan Museum of Art, 1955; New Burlington Gallery, London, 1956; American Federation of Arts traveling exhibit, 1953-54; Weyhe Gallery, 1933, 35, 37, 47, 53, 57, 59, 61; Brooks Memorial Museum, 1960; Wadsworth Atheneum, Hartford, CT, 1960. Noted works, "Madchen," 1958; "Annunciation," 1958; "Homage," 1958; "St. Francis Receiving the Stigmata," 1958; "Wings," 1962; "Ellipse," 1962; all bronze. Particulary known for her sensitive and repeated artistic treatment of the female form. Address in 1970, Litchfield, Conn. Died c. 1971.

CAGE, ROBERT FIELDING.
Sculptor and painter. Born Charlotte Co., Virginia, October 7, 1923. Study: De Bourgos School of Art, Wash., DC; Salisbury School of Art, Rhodesia; American Student and Arts League, Paris. Exhibitions: Contemporary Gallery of Art, Wash., DC; Smithsonian Institution; National Gallery of Rhodesia; Norfolk Museum of Art; others. In collections of commercial and private organizations in US, France, and Africa. Works: "Free Form," and "Moby Dick." Awards: Mariners Museum Top Sculpture Award, Great Atlantic Realtor, 1971; Award, North Carolina Museum of Art. Address in 1976, South Boston, Virginia.

CAIN, JOSEPH (LAMBERT).
Sculptor, painter, lithographer, and teacher. Born in New Orleans, LA, April 16, 1904. Studied at Chicago Academy of Fine Art; Art Institute of Chicago; Art Students League of NY; and with Kenneth Hayes Miller, and Kimon Nicolaides; and in Paris. Works: Murals, New York State Training School, Warwick, NY. Award: Gold medal, Tiffany Exhibition, November 1931, Anderson Galleries, NY; fellowship, Carnegie Institute. Member: Art Students League of NY; New Orleans Arts and Crafts Club; Contemporary Arts Group. Exhibited: Penna. Academy of Fine Arts; National Academy of Design; Addison Gallery of American Art; Rhode Island School of Design;

Whitney; Museum of Modern Art; and others. Address in 1970, University of Rhode Island, Kingston, RI.

CALABRO, JOHN.
Sculptor. Member of the National Sculpture Society. Address in 1982, Northvale, New Jersey.

CALDER, ALEXANDER (MILNE).
Sculptor. Born Aberdeen, Scotland, August 23, 1846. Pupil of John Rhind in Edinburgh. Studied in England; came to United States in 1868. Pupil of Penna. Academy of Fine Arts under J. A. Bailly and Thomas Eakins. Work: Equestrian statue of Gen. George G. Meade in Fairmount Park, Philadelphia, PA; colossal statue of William Penn, and groups on City Hall, Philadelphia, PA; three portrait busts in Union League Club, Philadelphia; represented in Penna. Academy of Fine Arts and Drexel Institute. Died in Philadelphia, PA, June 14, 1923.

CALDER, ALEXANDER STIRLING.
Sculptor and painter. Born Phila., PA, January 11, 1870; son of Alexander Milne Calder. Pupil of Penna. Academy of Fine Arts; Chapu and Falguiere in Paris. Member: Associate, National Academy of Design, 1906; National Academy of Design, 1913; National Sculpture Society, 1896; Phil. Art Club; Society of American Artists, 1905; New York Municipal Art Society; New York Architectural League, 1910; Century Association; Players'; National Institute Arts and Letters; National Arts Club (life); National Association of Portrait Painters; New Society of Artists. Instructor, National Academy of Design; Art Students League of New York. Had studio in NYC after 1908. Awards: Gold medal, Phila. Art Club, 1893; honorable mention, Pan-American Exposition, Buffalo, 1901; silver medal, St. Louis Exposition, 1904; Lippincott prize, Penna. Academy of Fine Arts, 1905; grand prize, Alaska-Yukon-Pacific Exposition, 1909; designer's medal, San Francisco, CA, 1915; silver medal, Sesqui-Centennial Exposition, Phila., 1926. Work: Statues of Witherspoon, Marcus Whitman and Davies, Presbyterian Building, Phila.; marble sun dial, Fairmount Park, Phila.; monumental archways, Throop Institute, Pasadena, CA; Lea Memorial, Laurel Hill Cemetery, Phila.; Fountain of Energy, etc., P.-P. Exposition, San Francisco, 1915; "The Star," Herron Art Institute, Indianapolis; "Washington Group," Washington Arch, New York; Depew memorial fountain, Indianapolis, IN; "The Island," Viscaya, FL. Represented in permanent collection, Penna. Academy; St. Louis Museum of Art; Franklin Inn Club; Smithsonian Institution grounds, Washington, DC; Metropolitan Museum, NYC; Reading Museum; Telfair Academy, Savannah, GA. Exhibited at National Sculpture Society, 1923. Acting Chief, Department of Sculpture P.-P. Exposition, San Francisco, 1915. Taught: National Academy of Design, and Art Students League, NY. Address in 1933, 11 E. 14th St., NYC. Died in 1945.

CALDER, ALEXANDER (called SANDY).
Sculptor. Born in Philadelphia, PA, July 22, 1898. Study: Stevens Institute of Technology, ME 1919; Art Students League, 1923-26, with G. Luks, G. du Bois, Boardman Robinson, J. Sloan. Work: Museum of Modern Art, Met-

ropolitan Museum of Art, NYC; Wadsworth Atheneum; Museum of Western Art, Moscow, USSR; Philadelphia Museum of Art; others. Commissions: Gen. Motors Corp., 1954; New York International Airport, 1958; UNESCO, Paris, 1958; many others. Exhibits: In leading museums throughout US and abroad. Awards: First prize sculpture, International Exhibition of Contemporary Painting & Sculpture, Pittsburgh, 1958; gold medal award, National Institute of Arts & Letters, 1971; Commander, Foreign Legion of Honor, 1973. Member: National Institute Arts and Letters. Died in NYC, November 11, 1976.

CALDWELL, GLADYS.
Sculptor. Born in Colorado. Exhibited: Societe des Artistes Independents, 1929.

CALEWAERT, LOUIS H.S.
Sculptor, painter, and etcher. Born Detroit, Mich., August 18, 1894. Pupil of Detroit School of Fine Arts under Wicker, and studied in Italy, Sicily, France, and Belgium. Member: Chicago Society of Etchers. Work: Toledo Museum of Art. Address in 1926, Chicago, IL.

CALFEE, WILLIAM HOWARD.
Sculptor and painter. Born in Wash., DC, February 7, 1909. Studied: Ecole des Beaux-Arts, Paris, with Paul Landowski; Cranbrook Academy of Art, with Carl Milles. Member: Wash. Art Guild. Work: Cranbrook Academy of Art; Phillbrook Art Center; Baltimore Museum of Art; Metropolitan Museum of Art; and others. Exhibited: Penna. Academy of Fine Arts; Metropolitan Museum of Art; Whyte Gallery, Wash., DC, 1952 and Corcoran Gallery, (one-man); Carnegie; National Academy of Science, Wash., DC; and others. Collaborator on and Introduction to: "Tradition and Experiment in Modern Sculpture," text by Charles Seymour. Commissions: Eight murals and two sculptures, US Treasury Department, 1936-41; font, altar, and candlesticks, St. Augustine Chapel, Wash., DC, 1969; sculpture, Civic Center, Rockville, MD, 1979. Taught: Chairman Dept. Painting and Sculpture, American Univ., Wash., DC, 1946-54; Instructor, drawing and painting, Phillips Gallery, Wash., DC. Address in 1982, Chevy Chase, MD.

CALLENDER, BESSIE STOUGH.
Sculptor. Born near Wichita, KS, 1889. Studied at the Art Students League; Cooper Union; Paris, in the studio of Bourdelle, in 1926; and for three years with the animal sculptor George Hilbert. Noted work: "Eagle" (marble), 1929. Exhibited: Royal Academy, many times. Collection: National Collection Fine Arts in the Smithsonian Institution in Washington, DC. Died in NYC, 1951.

CALLERY, MARY.
Sculptor. Born June 19, 1903, in NYC. Studied at New York Art Students League with Edward McCartan and with Jacques Loutchansky in Paris, where she lived many years. Was commissioned to create work for NYC Schools and Lincoln Center. Exhibited at Art Club of Chicago; Brussels World's Fair, 1958; Museum of Modern Art; Virginia Museum of Fine Arts; Knoedler & Co., NYC; Salon de Tuileries, Paris. In collections of Museum

of Modern Art; Toledo Museum of Art; Cinn. Art Museum; San Francisco Museum of Art; Wadsworth Atheneum; Whitney; and Alcoa. Address in 1977, Paris, France. Died in Paris, February 12, 1977.

CALLICOT (CALLICO), J. P.
Sculptor. At New Orleans, 1855. Worked in marble.

CALVERLEY, CHARLES.
Sculptor. Born in Albany, NY, November 1, 1833. Apprenticed to a marble cutter in Albany at 13 for a period of over six years. Later employed and studied under E. D. Palmer in Albany from 1853-1868. During this period, he modelled numerous portrait medallions, busts, tablets, and two full statues in marble. Member: Associate, National Academy of Design in 1872, 1875. Executed many groups and figures; especially known for his portrait busts in bronze of Horace Greeley, John Brown, Peter Cooper, and Elias Howe. Represented in Metropolitan Museum of Art by bust of Robert Burns. Died in Essex Fells, NJ, on February 24, 1914.

CAMDEN, HARRY POOLE.
Sculptor. Born in Parkersburg, W. VA, March 10, 1900. Studied: School of Fine Arts of Yale University under Robert Eberhard from 1919 to 1924. Head of the department of sculpture at the University of Oregon, Eugene, Oregon. Works: David; Aphrodite; Storm King; Pandora; Sea Shell fountain; Study of Pavlova; Portrait of an Elf; group, Carnivale; Jeanne d'Arch; Bacchino; bust, Orpheus; altar face, Deposition; figure, The Poet. Awards: Fellowship, American Academy in Rome, 1924-27. Membership: Society of Northwestern Artists; National Sculpture Society. Died in 1943.

CAMERON-MENK, HAZEL.
Sculptor, writer, and lecturer. Born in St. Paul, Minn., November 3, 1888. Studied: Ringling School of Art; George Washington University; Corcoran Art School; and with Eugene Weiss, Richard Lahey, Lesley Posey. Member: Washington Art Club; National Arts Club; Sarasota Art Association; League of American Pen Women. Awards: Prizes, League of American Pen Women, 1933, 1935-37; medal, Society of Independent Artists, 1933; Arlington Women's Club, 1934. Work: Clarendon Library, Arlington, VA. Contributor to: Arlington (VA) Chronicle. Exhibited: Sarasota Art Association, 1947-52; Terry Art Institute, 1952. Address in 1953, Sarasota, FL.

CAMFFERMAN, PETER MARIENUS.
Sculptor, painter, etcher, lithographer, blockprinter, lecturer, teacher, and writer. Born at The Hague, Holland, February 6, 1890. Studied at Minneapolis School of Fine Arts, and with MacDonald-Wright and Andre L'Hote. Award: Second prize, water color, Eighteenth Annual Exhibition of Northwest Artists, Art Institute of Seattle, 1933; Pacific Coast Painters, Sculptors, and Writers, 1939. Address in 1953, Brackenwood, Langley, WA. Died in 1957.

CAMPBELL, C. ISABEL.
Sculptor and painter. Born Brooklyn, NY. Pupil of Phila. School of Design for Women, and with Daniel Garber, Henry B. Snell, and Samuel Murray. Member: Plastic Club; American Federation of Arts. Awards: Silver medal for miniature model and mural decorations, Sesqui-Centennial Exposition, Phila., 1926; Fellowship, Philadelphia School of Design for Women. Work: Miniature models and mural decorations, Commercial Museum. Address in 1953, Commercial Museum, Philadelphia, PA.

CAMPBELL, DOROTHY BOSTWICK.
Sculptor and painter. Born March 26, 1899, in NYC. She studied with Eliot O'Hara, Wash., DC, and Marilyn Bendell, Cortez, FL. Exhibitions: Cooperstown Art Association, both group and one-woman shows, 1965; Sarasota Art Association, FL; Pioneer Gallery, Cooperstown; Cortez Art School, FL, 1972. Awarded Purchase Prize for Watercolor, Cooperstown Art Association, 1965; First Prize for Watercolor, Collectors Corner, Wash., DC. Member of American Art League; American Federation of the Arts. Address in 1982, Sarasota, FL.

CAMPBELL, HARRIET DUNN.
Sculptor, painter, and teacher. Born Columbus, OH, August 16, 1873. Studied at Columbus Art School; Ohio University; Art Students League, with Robert Henri; William M. Chase; Arthur W. Dow; Kenneth Miller; George Bridgman; Charles Hawthorne. Member: Columbus Art League; Ohio Water Color Society; Ohio-Born Women Painters. Awards: Honorable mention for oil, 1920, 1921, for water color, 1923, Columbus Art League; honorable mention, Ohio State Fair, 1922; Robert Wolf water color prize, Columbus Art League, 1927. Exhibited: American Water Color Society, NY, 1934; Boston Art Club, 1934; Art Institute of Chicago, 1935; Columbus Art League; and others. Address in 1953, Columbus, OH.

CAMPBELL, J. ALLAN.
Sculptor. With Campbell & Brother, Louisville, Kentucky, 1859.

CAMPBELL, KENNETH.
Sculptor and painter. Born April 14, 1913, in West Medford, MA. Studied at Mass. School of Art, with E. Major, C. Darlin, R. Andrews, W. Porter; National Academy of Design, with L. Kroll, G. Beal; Art Students League, with Arthur Lee. Taught at Erskine School, Boston; Silvermine, New Canaan; Queens College; Columbia University; and others. Received awards from Longview Foundation (NYC—1962); Ford Foundation; Audubon; and 1965 fellowship, Guggenheim. Exhibited at Stable Gallery, NYC; Art Institute of Chicago; Whitney; Penna. Academy of Fine Arts; others. In collections of Dillard University (New Orleans); Whitney; Walker Art Center (Minn.); and private collections. Member: Artists Club; Art Students League; Sculptors Guild; Audubon Artists; Boston Society of Independent Artists. Address in 1976, 79 Mercer St., New York City.

CAMPBELL, THOMAS E. (F.).
Sculptor and stone engraver. Born c. 1833, Maryland. Worked: Louisville, Kentucky, 1850-59.

CAMPDEN, HARRY P.
Sculptor. Born in 1900. Address in 1934, Ithaca, New York. (Mallett's)

CAMPOLI, COSMO P.

Sculptor. Born in South Bend, IN, March 21, 1922. Study: Art Institute of Chicago, grad. 1950; Anna Louise Raymond traveling fellow to Italy, France, Spain, 1950-52. Work: Museum of Modern Art, NYC; Richmond Museum, VA; Unitarian Church, Chicago; many private collections. Exhibition: New Images of Man, Museum of Modern Art, 1959; US Information Agency Show, Moscow & Petrograd; Chicago School Exhibition, Galerie du Dragone, Paris; sculpture exhibition, Spoleto, Italy; 30-year retrospective, Museum of Contemporary Art, Chicago, 1971; plus many more. Awards: Bronze medal, Deleg. National Education—Fisica, Madrid, 1969; Automotive Association of Spain award, 1969; etc. Teaching: Contemporary Art Workshop, Chicago, 1952-pres.; Inst. of Design, Illinois Institute of Technology, from 1953. Address in 1982, Chicago, IL.

CANFIELD, BIRTLEY KING.

Sculptor. Born in Ravenna, OH, December 12, 1912. Studied in Cleveland, OH. Pupil of Falguiere in Paris. Honorable mention, Paris Salon 1896. Member, NY Architectural League, 1898; Salma. Club, 1901. Address in 1910, 145 East 23d St., NY, and Ravenna, OH. Died in Ravenna, November 30, 1912.

CANFIELD, JANE (WHITE).

Sculptor. Born in Syracuse, NY, April 29, 1897. Studied at Art Students League; James Earle and Laura Gardin Fraser Studio; Borglum School; also with A. Bourdelle, Paris, France. Works: Whitney Museum of American Art; Cornell University Museum of Art. Commissions: Six animals in lead for gate posts, commissioned by Paul Mellon, Upperville, VA, 1940; animals in lead for gym entrance, Miss Porters School, Farmington, Conn., 1960; St. John Apostle in stone, Church of St. John of Lattington, Locust Valley, NY, 1963; herons in stone, Memorial Sanctuary, Fishers Island, 1969; Canadian geese in bronze for pool, Long Lake, Minn., 1971. Exhibitions: Sculpture Pavilion, NY World's Fair, 1939; one-man show, Brit-Am Art Gallery, NY, 1955 and Far Gallery, NY, 1961, 65, and 74; Country Art Gallery, Locust Valley, 1971. Awards: Armstrong Award, Art Institute Chicago, 1971. Media: Stone and bronze. Address in 1982, Bedford, NY.

CANNON, FLORENCE V.

Sculptor, painter, engraver, lecturer, and teacher. Born in Camden, NJ. Pupil of Charles Grafly, Henry McCarter; School of Industrial Art, Phila.; Academy of Fine Art, Phila; Penna. Academy of Fine Art; Academie Chaumiere, Paris. Member: National Association of Women Painters and Sculptors; American Artists Professional League; Washington Watercolor Club; Phila. Alliance; Phila. Plastic Club; Phila. Print Club; Alum. School of Industrial Arts; Fellowship Penna. Academy of Fine Arts; and others. Awards: President's prize for sketching, Penna. Academy of Fine Arts, 1928, 29; first Toppan prize ($300); special watercolor prize; second annual sketch prize, 1930; gold medal for oil, Plastic Club, 1933; special Gimbel anniversary prize, watercolor, 1933; National Association of Women Artists, 1936. Exhibited: Penna.

Academy of Fine Arts; National Association of Women Artists; Corcoran; American Federation of Arts; Art Institute of Chicago, American Watercolor Society; and many others. Work owned by Fellowship of the Penna. Academy of the Fine Arts; New Jersey Federation of Women's Clubs. Address in 1953, Camden, NJ.

CANNON (or CANNAN), HUGH.

Sculptor. Born in Ireland or Pennsylvania c. 1814. He settled in Phila. and there did considerable modelling and carving. Exhibited: Artists' Fund Society, bust of Chief Justice Marshall, 1840; Apollo Association, busts of Henry Clay and Edwin Forrest, 1841; and Penna. Academy of Fine Arts, busts of Clay, Nicholas Biddle, and others, 1851, 1855-56. Work held: Penna. Academy of Fine Arts; Maryland Historical Society.

CANTOR, MIRA.

(Mira Cantor-Piene). Sculptor and graphic artist. Born in NYC, May 16, 1944. Studied at the State University of New York, Buffalo, BFA, 1966; University of Illinois, Champaign-Urbana, MFA, 1969. Work includes numerous portrait commissions. Has exhibited at Musee d'Art Moderne, Yugoslavia, 1972; Norwegian International Print Biennale; Brockton Art Cent., Mass., 1978; Three Dimensional Possibilities, Rose Art Museum, Waltham, Mass., 1979; Mass. Institute of Technology, 1979, 80 and others. Awards: Center for Advancement of Visual Studies Fellowship, Mass. Institute of Technology, 1978-80. Sculpts in soft materials. Address in 1982, Brookline, Mass.

CAPARN, RHYS.

Sculptor. Born July 28, 1909, Onteora Park, NY. Studied: Bryn Mawr College; privately in Paris with Edouard Navellier; privately in NY with Alexander Archipenko. Work: Barnard College; Bryn Mawr College; Colorado Springs Fine Arts; Corcoran; Dartmouth College; Harvard University; La Jolla; Riverside Museum; City Art Museum of St. Louis; Whitney Museum; Butler; Yale University Art Gallery. Exhibited: Delphic Studios, NYC, 1933, 1935; Architectural League of NY, 1941; NY Zoological Park (Bronx), 1942; Wildenstein & Co., NYC, 1944, 47; John Heller Gallery, NYC, 1953; Doris Meltzer Gallery, NYC, 1956, 59, 60; Riverside Museum, 1961; Museum of Modern Art; Whitney Museum, 1941, 53, 54, 56, 60; Musee du Petit Palais, Paris, 1950; Penna. Academy of Fine Arts, 1951-53, 60, 64; Tate, 1953; Silvermine Guild, 1956; National Institute of Arts and Letters, 1968, 76. Awards: Metropolitan Museum of Art, American Sculpture, Second Prize, 1951; NY State Fair, First Prize for Sculpture, 1958; National Association of Women Artists, Medals of Honor for Sculpture, 1960, 61. Member: Federation of Modern Painters and Sculptors; Sculptors Guild; American Abstract Artists; New York Architectural League; International Institute of Arts and Letters. Commissions for Brooklyn Botanic Garden; Wollman Library, Barnard College; private portrait commissions. Taught: Dalton School, NYC, 1946-55, 1960-72. Address in 1982, Newtown, CT.

CAPECCHI, JOSEPH.

Sculptor. Born in Florence, Italy, 1889. Award: $100 for

best design for medal for Minnesota State Art Commission, 1913. Address in 1917, St. Paul, MN.

CAPELLANO, ANTONIO.
Sculptor. Born in Italy; possibly a pupil of Canova. As early as 1815 he was in NY, going from that city to Baltimore, MD, at the request of Max Godefroy, the architect of the Battle Monument of that city. Prior to his work on the Battle Monument, Capellano secured a commission for the execution of two panels in bas-relief upon the front of St. Paul's Church, of which Robert Cary Long was the architect. These two works, "Moses with the Tables of the Law" and "Christ Breaking Bread," were executed for the sum of $1,000 and completed before he began the Battle Monument. Exhibited "The Peace of Ghent," presumably a clay group, at the American Academy, 1816; and a marble bust, "Chloris," at the Pennsylvania Academy, 1824. In September, 1817, Capellano, writing from Baltimore to James Madison at Montpelier, solicited a commission for a marble bust of James Madison, an arrangement which he was unable to complete. Capellano was then employed as a sculptor at the Capitol. In 1827 he offered to execute a statue of Washington for the Washington Monument at Baltimore. Rembrandt Peale met Capellano while in Baltimore in 1815, and again in the Boboli Gardens in Florence in 1830, when the latter resided there. His work is represented in the U.S. Capitol by a relief of Pocahontas and John Smith.

CAPLAN, JERRY L.
Sculptor. Born Pittsburgh, PA, August 9, 1922. Study: Carnegie-Mellon University; Art Students League; University of North Carolina. Work: Raleigh State Art Gallery, NC; Westinghouse Corp.; many private collections. Commissions: Friendship Federation Plaza, Pittsburgh; Westinghouse Ceramic Division, Derry, PA; Kossman Associations, Pittsburgh; Rockwell Corp., Pittsburgh; others. Exhibitions: Butler Institute American Art, Youngstown, Ohio, 1955-75; Carnegie Institute, 1971; others. Awards: Society of Sculptors; Associated Artists of Pittsburgh Annual; Kent State University Invitational Sculpture Show; others. Teaching: Chatham College; Professor in Art at Rochester Institute of Technology, Temple University, Carnegie Mellon University and others. Medium: Terra-cotta. Address in 1982, Pittsburgh, PA.

CAPONI, ANTHONY.
Sculptor and educator. Born in Pretare, Italy, May 7, 1921. Studied at the University of Flore, Italy; Cleveland School of Art; Walker Art Center, Minneapolis; University of Minneapolis, BS & MEd. Work in Minneapolis Institute of Art; Minneapolis Museum of Art. Exhibited at Walker Art Center, Minneapolis, 1947-58; Minneapolis Art Institute Annual; and others. Received Ford Foundation Grant and Four Prizes, Minneapolis Institute of Art, 1947-59; and others. Member of Artists Equity Association; Society of Minneapolis Sculptors. Works in stone. Address in 1982, Art Department, Macalester College, St. Paul, MN.

CARABELLI, JOSEPH.
Sculptor. Born in Italy, in 1850. A former member of the

Ohio Legislature. He carved a statue representing Industry, which is one of the figures on the exterior of the Federal Building in New York. Died in Cleveland, Ohio, April 19, 1911.

CARAVAGLIA, ANGELO.
Sculptor. Born in Erie, PA, 1925. Studied: Cranbrook Academy. Awarded Fulbright, Tiffany, and numerous research grants. Works in wood, bronze, stone. Represented by Ankrum Gallery, El Prado Gallery, Los Angeles, CA. Professor of Art, University of Utah. Address since 1956, Salt Lake City, UT.

CARDELLI, GEORGIO.
Sculptor and painter. Born in Florence, Italy, 1791; came to US in 1816. About 1818 he was commissioned by Trumbull, the artist, to model busts of himself and his wife. He turned his attention to portrait painting and did considerable work in New England. Cardelli worked for some time on the decorations for the Capitol in Washington, DC.

CARDELLI, PIETRO.
Sculptor, architect, and professor of design. Worked in Paris, 1806-1810, and in London in 1815-16. Did some decorative carving for the U.S. Capitol, as well as portrait busts of distinguished Americans, including Jefferson and Madison, all in Washington, DC, 1818-20. Moved to New Orleans 1820, employed as professor of design at the "Establishment" and as architect of the facade of the City Hall. Died in New Orleans, October, 1822.

CAREW, JOHN.
Sculptor. Born in England c. 1820. He was living in Boston (Mass.), August 1850. Exhibited: Annual Artist's Fund Society exhibitions, 1864, 67, NY.

CAREW, JOSEPH.
Sculptor. Active 1849. Worked: Boston, 1843-70. Exhibited: Boston Athenaeum, 1843, 45, 47. Associated with Thomas A. Crew in the firm Carew & Brother, 1844-51 and 54. Died in 1870.

CAREW, THOMAS A.
Sculptor. Patentee—medallion portrait of Theodore Parker, 1860. Worked: Boston, 1843-59, and Cambridge (Mass.), 1860. Exhibited: Boston Athenaeum, 1853, 59, 60. With Joseph Carew in firm of Carew & Brother, 1844-51 and 54.

CARIATA, GIOVANNI.
Sculptor. Born in Rome in 1865, he lived for some years in New York and died there in 1917. He made the bronze medallion presented to Gen'l Joffre.

CARIOLA, ROBERT J.
Sculptor and painter. Born in Brooklyn, NY, March 28, 1927. Study: Pratt Institute Art School; Pratt Graphic Center. Work: Fordham University; Topeka Public Library; and various church, school and private collections. Commissions: St. Gabriel's Church, Oakridge, NJ; Walker Memorial Baptist Church, Bronx, NY; Mt. St. Mary Cemetery, Queens, NY. Exhibitions: Corcoran Gallery; Penna. Academy; National Academy of Design; Boston Museum; Silvermine Guild; others. Awards: John

F. Kennedy Cultural Center Award; Silvermine Guild; etc. Member: Professional Artists Guild; Cath. Fine Arts Society (honorary). Media: Painting—acrylic; sculpture—electric arc and gas welded metals. Address in 1982, Merrick, NY.

CARL, JOAN STRAUSS.
Sculptor and graphic artist. Born in Cleveland, OH, March 20, 1926. Studied at Cleveland School of Art; Chicago Art Institute; Mills College; with Dong Kingman, Boardman Robinson, Carl Morris, and Albert Wein; New School of Art, with Arnold Mesches and Ted Gilien. Works: North Carolina Museum of Art, Raleigh; International Cultural Center for Youth, Jerusalem, Israel. Commissions: Carved walnut pulpit, Methodist Church, Palm Springs, CA, 1967; brazed welded steel Menorah, Eternal Light and Candlesticks, Temple Adat Ariel, Los Angeles, 1969; bonded bronze relief, Capital National Bank, Cleveland, 1972; poly bronze and welded steel relief, Republic Savings & Loan, Los Angeles, 1974; mosaic wall, Mt. Sinai Memorial Park, Los Angeles, 1975. Exhibitions: American Institute Architects Design Center, Los Angeles, 1968; one-woman show, Bakersfield College, 1967; Laguna Beach Art Museum, 1969; Fresno Art Museum, 1971; Muskegon Community College, 1973; Chai (graphics), National and International Traveling Show, 1947-75. Awards: Honorable Mention, National Orange Show, San Bernardino, 1958 and Calif. State Fair, Sacramento, 1970 and 72. Media: Stone, wood, and medal. Address in 1980, Sherman Oaks, CA.

CARLBERG, NORMAN KENNETH.
Sculptor and instructor. Born in Roseau, Minn., November 6, 1928. Studied at Brainerd Jr. College, Minn., 1947-49; Minneapolis School of Art, 1950; University of Illinois, Urbana, 1953-54; Yale University, BFA, 1958, MFA, 1961. Work in Addison Gallery of American Art, Andover, Mass; Whitney Museum of American Art, New York; Penna. Academy of Fine Arts, Philadelphia; and others. Has exhibited at the Museum of Modern Art, NY; Baltimore Museum of Art; Whitney Annual; and others. Teaching at Rinehart School of Sculpture, sculptor in residence, Maryland Institute College of Art, Baltimore, from 1961. Received Fulbright Teaching Grant, Santiago, Chile, 1960; Purchase Award, Ford Foundation, 1962; Baltimore Museum of Art, Museum Prize, 1966. Address in 1982, Baltimore, MD.

CARLING, JOHN.
Wood carver. Born September 11, 1800, in Kingston, New York; moved to Nauvoo, IL, 1840; settled in Utah. Created pattern for oxen to support wooden baptismal font of the Mormon Temple, Nauvoo, Illinois, in the 1840's. Died in Fillmore, Utah, April 2, 1855.

CARLSEN, FLORA BELLE.
(Mrs. Harold). Sculptor and painter. Born in Cleveland, OH, March 7, 1878. Pupil of F. C. Jones; Du Bois; Matzen; Solon Borglum; Lentelli. Exhibited: Paint and Brush Club, 1937 (one-man), National Academy of Design. Member: National Association of Women Painters and Sculptors; Paint and Brush Club. Award: Prize, Literary

Digest cover, 1932. Address in 1953, West 183rd Pinehurst, New York, NY.

CARLSON, GEORGE.
Sculptor and painter. Born in Elmhurst, IL, 1940. Studied: American Academy of Art; Chicago Art Institute; University of Arizona. Lived in Taos, New Mexico, with painter Buffalo Kaplinski. Awarded Prix de West, National Academy of Western Art, 1975. Exhibited in show in Peking, China; Kennedy Galleries, NYC, 1980. Member of National Academy of Western Art; National Sculpture Society. Reviewed in *Southwest Art*, October 1976; *Artists of the Rockies*, summer 1980. Represented by Stremmel Galleries, Reno, NV; and Bishop Gallery, Scottsdale, AZ. Works in bronze. Address in 1982, Franktown, CO.

CARNEVALE, CARMEN RICHARD.
Sculptor, painter, engraver, and blockmaker. Born 1909. Address in 1933, Pittsburgh, PA.

CARPENTER, MARGUERITE.
Sculptor. Worked: NY, c. 1905. Awards: medal, St. Louis Exposition, 1904.

CARR, ALICE ROBERTSON.
Sculptor. Born in Roanoke, VA, 1899. Pupil of A. Stirling Calder. Exhibited: Salon d'Automne, Salon de la Nationale, 1927. Member of Art Students League of New York. Address in 1926, Santa Barbara, CA.

CARR, SALLY SWAN.
Sculptor. Born in Minong, Wis. Studied at New York University; advanced sculpture, Phoenix School of Design; life sketch, Clay Club; also with John Hovannes, Frederick Allen Williams, and wax technique with Paul Manship; Art Students League. Work in American Numismatic Society of NY; Lion of St. Marks (bronze relief), Marco Polo Club, Waldorf Astoria Hotel, NY; Cardinal Virtues (cararra marble reliefs), Riverside Memorial Park, St. Joseph, Mich.; and others. Has exhibited at the National Academy of Design, Allied Artists; Burr Artist, Metropolitan Museum of Art, 1977; National Arts Club, NY. Received A. H. Huntington First Prize trophy, Catharine Lorillard Wolfe Art Club, 1970; Founders Prize and Plaque, Pen and Brush Club, NY, 1970, and Bronze Medal, 1979; and others. Member of the Architectural League of New York; Catharine Lorillard Wolfe Art Club; and others. Works in stone. Address in 1982, 530 East 23rd Street, NYC.

CARR, WILLIAM.
Sculptor. Born in Pennsylvania, c. 1823. At Chillicothe, Ohio, 1850, working in marble works of Jacob Neable.

CARREL, CLAUDIA.
Sculptor. Born in Paris, France, January 11, 1921. Studied at Boston Museum of Fine Arts School Fine Arts; Art Students League; Pratt Graphic Art Center; Hans Hofmann School of Art. Works: Rose Art Museum, Brandeis University; Philip Johnson Museum, Cornell University; Boston Museum of Fine Arts; Norfolk Museum of Arts and Science; Columbia University Art Collections; plus others. Exhibitions: American Federation of Arts Traveling Exhibition, 1968; Fine Arts Foundation, Hartford, CT;

Parrish Art Museum, Southampton, NY; University of Maryland and others; plus many one-man shows, NY. Awards: Prizes, National Academy Design, 1962; Grumbacher Award, Audubon Artists, 1963. Media: Wood. Address in 1976, Brooklyn, NY.

CARROLL, "MIKE" R.W.
Sculptor and painter. Studied: Portland Museum School of Fine Art, Oregon School of Art and Design, California School of Art. Collections: Walter Binson, Arizona, Stern Collection, California. Member: Society of Animal Artists. Exhib.: Calif. Palace of Legion of Honor; Crocker Gallery, Sacramento, California; Oregon Society; Society of Western Art; Grand Central, New York; Peter Wenning Gallery, Johannesburg, South Africa; Signorina Gallery, Rome, Italy. Address in 1983, Salida, Colorado.

CARRON, MAUDEE LILYAN.
Sculptor and painter. Born in Melville, LA. Studied at Creative Arts School, Houston, scholarship, with McNeill Davidson; Lamar University; with Dr. James McMurray. Works: University of Texas, Austin. Commissions: Poster and stage sets for "Glass Menagerie," "Who's Afraid of Virginia Woolf?" and "Macbeth," University of Texas, Austin Drama Dept, 1970 and 72. Exhibited: 16 Southeastern States and Texas Exhibition, New Orleans Museum, 1963; Eight State Exhibition, Oklahoma Art Center, Oklahoma City, 1968; one-man shows, Images, University of Texas Fine Arts Gallery, 1970, Environment 71, University of Texas Austin, 1971 and Et Cetera 3, Southwestern University, 1972. Awards: Miller Award for Incognito, Beaumont Art Museum, 1968 and two awards for A Dangerous Game in Archaic Form, 1970; Award for A Temple for All Delights, Texas Fine Arts Association, 1969. Member: Texas Watercolor Society; Texas Professional Sculptors Society; Texas Fine Arts Association; Beaumont Art Museum; Graphic Society, Lamar University. Media: Metal and acrylic. Address in 1982, Port Arthur, Texas.

CARSON, KAREN.
Sculptor/graphics. Noted for her zippered, canvas sculptures in the early 1970's. Also drawings of plants, horses, and nude women during this period.

CARSTAIRS, JAMES STEWART.
Sculptor and painter. Born in Philadelphia, PA, June 2, 1890. Pupil of Julian Academy in Paris. Member: Union Internationale des Beaux-Arts et des Lettres. Exhibited at Salon d'Automne, 1913. Address in 1913, 10 Rue de Saint-Senoch, Paris, France.

CARSTENSON, CECIL C.
Sculptor and lecturer. Born in Marquette, KS, July 23, 1906. Studied at Kansas City Art Institute; University of Nebraska; Art Institute of Chicago; also with several sculptors in Italy. Works: Joslyn Museum, Omaha, NE; Phoenix Art Museum, AZ; University of Missouri, Kansas City; Nelson Gallery of Art, Kansas City; Jewish Community Center, Kansas City; plus others. Exhibitions: Mid America, Nelson Gallery Art; Joslyn Art Gallery Show; Missouri Pavilion Exhibition, New York World's Fair; St. Louis Museum Show; Denver Art Gallery Show. Awards: Honorable Mention and Purchase Award, Mid America, Nelson Gallery Art. Media: Wood. Address in 1980, Kansas City, MO.

CARTER, DEAN.
Sculptor and educator. Born in Henderson, NC, April 24, 1922. Studied at Corcoran School of Art; American University, BA; Ogunquit School of Painting and Sculpture; Indiana University, MFA; Ossip Zadkine School of Art, Paris, France. Work in Cranbrook Academy of Art, MI; Wichita Art Association Galleries, KS; Roanoke Memorial Hospital, VA; others. Has exhibited at Penna. Academy of Fine Arts, Philadelphia, 1954; Smithsonian Circulating Exhibition, 1969-71; others. Received awards from Festival of Art, Radford, VA, 1979, first prize; Roanoke Fine Arts Center, 1979, Certificate of Distinction; others. Member of Society of Washington Artists; Southern Sculptors Association; American Crafts Council; College Art Association of America; American Federation of Arts; plus others. Teaching at Virginia Polytech Institute and State University, from 1963, founded art dept. Works in bronze and wood. Address in 1982, Blacksburg, VA.

CARTER, DUDLEY CHRISTOPHER.
Sculptor and craftsman. Born in New Westminster, B. C., Canada, May 6, 1891. Studied with Dudley Pratt. Work: "Rivalry of the Winds," wood sculpture, Seattle Art Museum, Seattle, Wash.; Golden Gate Park, San Francisco; Evergreen East, Bellevue, Washington. Award: Times first prize, Seattle Art Institute, 1931; Sculpture, Music and Art Foundation, Seattle, 1948; Achievement Award for Sculpture, Past President Assembly, 1962; International Sculpture, US Department of Housing and Urban Development, 1973. Exhibited: Golden Gate Expositions, San Francisco, 1939; Seattle World's Fair, 1961; US Department Housing and Urban Development, 1973; and others. Member: Seattle Art Museum, Artists Equity Association, British Columbia Sculptors. Address in 1982, Bellevue, WA.

CARTER, GARY.
Sculptor and painter. Born in Hutchinson, KS, 1939. Studied at Art Center College, Los Angeles, CA. Has shown at Tucson, AZ (sold out, one-man show of paintings); Montana Historical Society, 1978. Awarded Best of Show, Montana Historical Society. Founding member, Northwest Rendezvous Group. Has own studio. Prints published by The Wooden Bird. Subjects are historical Northwestern scenes. Address in 1982, West Yellowstone, MT.

CARTER, GRANVILLE W.
Sculptor. Born in Augusta, ME, Nov. 18, 1920. Studied at Portland School of Fine and Applied Art; NYC School of Industrial Art; National Academy School of Fine Arts; Grande Chaumiere, Paris, France; Scuolo Circolare International, Rome, Italy; American Academy in Rome. Work in Smithsonian Institution, Washington, DC; Maine State Museum, Augusta; monumental bust of Alexander Stewart, Garden City, NY; West Texas Pioneer Family Monument (heroic bronze), Lubbock, TX; Brig. Gen. Casimir Pulaski Equestrian Monument (heroic

bronze), Hartford, CT; and others. Has exhibited at American Academy of Rome Annual, 1955; National Sculpture Society, Lever House, NY; American Artists Professional League Annual, NY, 1970. Member of the National Sculpture Society; National Academy of Design (academician); others. Received the Lindsey Morris Memorial Prize, 1966; Henry Hering Memorial medal, 1968; Therese and Edwin H. Richard Memorial Prize, 1980, all National Sculpture Society; gold medals, American Artists Professional League; others. Teaching sculpture at National Academy of Design, from 1966; lecturer on sculpture at Hofstra University, from 1966. Address in 1982, Baldwin, NY.

CARTER, MARC (MARCELLUS CARTER).
Sculptor, painter, cartoonist, and craftsman. Born in North Tarrytown, NY, March 19, 1918. Studied: Art Students League; Westchester Workshop, and with Ruth Nickerson, Ruth Yates. Member: Art Students League; Artists Equity Association; Westchester Arts and Crafts Guild. Work: Altoona Museum of Art. Exhibited: Wellons Gallery, 1951; Arthur Brown Gallery, 1951; Westchester Arts and Crafts Guild, 1947-51. Address in 1953, White Plains, NY.

CARYL, JOAN LEONARD.
Sculptor and painter. Born in Fall River, MA, Jan. 21, 1920. Studied at Bennington College, with Lauterer and Paul Feeley, 1942; Corcoran School of Art, with Heinz Warneke, 1961; studio, with Andre L'Hote, Paris, France, 1952. Work in Washington Co. Museum of Fine Arts, Hagerstown, MD; Georgetown University Library Collection, Washington, DC; John F. Kennedy Bronze Head, Peace Corps Village, Peru, 1970. Has exhibited at Corcoran Gallery of Art; American Crafts Council, NYC; others. Received awards from Smithsonian Institution, 1963, third prize; Corcoran School of Art, 1965, second prize. Has taught at Corcoran Art School and Georgetown University. Works in acrylics, charcoal; wood and stone. Address in 1982, Washington, DC.

CASANOVA, ALDO JOHN.
Sculptor and educator. Born in San Francisco, CA, February 8, 1929. Studied at San Francisco State University, B.A., 1950, and M.A., 1951; Ohio State University, Ph.D., 1957. Work in Whitney Museum, NY; Joseph Hirshhorn Collection, Washington, DC; others. Has exhibited at Esther Robles Gallery, Los Angeles; Santa Barbara Museum, CA; Penna. Academy Annual, Philadelphia; Smithsonian Institution; New Acquisitions, Whitney Museum of American Art, NY, 1970. Received awards from American Academy in Rome, 1958-61, Rome Prize Fellowship Sculpture; Tiffany Foundation, 1969, Louis Comfort Tiffany Award; others. Taught sculpture at Temple University, Philadelphia, 1961-64; professor of sculpture, Scripps College, Claremont, CA, from 1966. Works in bronze, stone, and wood. Address in 1982, Claremont, CA.

CASARELLA, EDMOND.
Sculptor and printmaker. Born in Newark, NJ, September 3, 1920. Studied at Cooper Union, B.F.A., 1942; Brooklyn Museum Art School. Work in Whitney Mu-

seum of American Art, NY; Brooklyn Museum of Art, NY; Speed Museum, Louisville, KY; Library of Congress, Washington, DC. Has exhibited at Corcoran Gallery, Washington, DC; National Print Council Competition; others. Received Fulbright Award for Graphics, Italy, 1951-52; Tiffany Award for Graphics, Louis Comfort Tiffany Foundation, 1955; Guggenheim Fellowship for Graphics, 1959-60. Taught graphics and sculpture, Cooper Union, 1963-70. Works in steel and bronze. Address in 1982, Englewood, NJ.

CASARIN, ALEXANDER.
Sculptor and painter. Born in Mexico and educated in France. Studied with Messonier. Served in Franco-Prussian War. Became interested in sculpture and came to the United States. Specialty was portrait busts. Executed bust of Pres. McKinley. Died May 26, 1907, in NYC.

CASCIERI, ARCANGELO.
Sculptor and instructor. Born in Civitaquana, Italy, February 22, 1902; US citizen. Studied at School of Architecture, Boston Architecture Center, 1922-26; Boston University, 1932-36. Work in Boston College; American War Memorial World War I, Belleau Woods, France and World War II, Margraten, Holland; sculpture on fountain, Parkman Plaza, Boston; others. Has exhibited at Boston Museum of Fine Arts, sculpture exhibit; New England Sculpture Association; others. Member: Fellowship, American Institute of Architects; Dante Alighieri Society; Naples Association of Institute of Architects and Engineers; New England Sculptors Association. Address in 1982, Lexington, MA.

CASELLAS (or CASELLAR), FRENANDO.
Sculptor. Born in Valencia, Spain, in 1842. Came to US in 1876. He designed a statue of Columbus and other decorations for the St. Louis Exposition. He was President of the American Sculpture Society. Died February 12, 1925, in NYC.

CASEY, JOHN JOSEPH.
Sculptor and educator. Born in New London, CT, June 27, 1931. Studied at University of Oregon, B.A.; California College of Arts and Crafts, M.F.A. with Nathan Oliveira. Work in Coos Art Museum, OR; others. Has exhibited at Denver Art Museum; Oakland Art Museum; Oregon Artists Annual, Portland Art Museum; others. Teaching drawing, painting, and sculpture, West Oregon State College, Monmouth, from 1965. Address in 1982, Monmouth, OR.

CASH, HAROLD CHENEY.
Sculptor. Born Chattanooga, TN, September 26, 1895. Studied: Stanford University; University of Virginia, BA; New York School of Fine and Applied Arts; Beaux Arts Institute of Design, New York. Member: National Sculpture Society; Sculptors Guild. Awards: Guggenheim Fellowship, 1930, 31. Exhibited: Penna. Academy of Fine Arts, 1941-43; Whitney Museum of American Art, 1935; Museum of Modern Art, 1930-34; Art Institute of Chicago, 1932-38; Brooklyn Museum, 1931; San Francisco Museum of Art; Metropolitan Museum of Art. Address

in 1953, 14 Bank Street, NYC. Died in 1977.

CASH, SYDNEY.
Sculptor. Born in Detroit, MI, 1944. Studied: Wayne State University, Detroit, MI, B.S. mathematics; L'Alliance Francaise, Paris, France, 1961-62. Exhibitions: Hundred Acres Gallery, NYC, 1971; Woodstock Artists Association, Woodstock, NY, 1974; Dance Studio, NYC, 1976; 112 Greene St. Gallery, NYC, 1980, 81, 82; Human Arts Gallery, Dallas, TX, 1983; all one-man; numerous others. Commissions: Sculpture, Albert Einstein College of Medicine, Bronx, NY, 1973; Free Standing Sculpture, Ronald Abramson, Washington, DC, 1983; others. Taught: Pratt Institute, Brooklyn, NY, 1973; Brooklyn Museum Art School, 1972-75; Friends Seminary, NYC, 1978-79; SUNY, New Paltz, NY, 1983. Address in 1984, Marlborough, NY.

CASHWAN, SAMUEL ADOLPH.
Sculptor. Born in Cherkassi, Russia, December 26, 1900. Studied: City College, Detroit, Michigan; New York Architectural League; and with Bourdelle in Paris. Member: Scarab Club; Metropolitan Art Association, Detroit. Work: Detroit Institute of Art; Vassar College; Jackson Memorial, Jackson, Michigan; and others. Exhibited: Salon d'Automne, 1923; nationally, 1920-46. Address in 1953, Detroit, MI.

CASKEY, ROBERT.
Sculptor. Born in St. Louis, MO, 1934. Exhibited at Detroit Institute of Arts, 1974-75. Address in 1975, Highland Park, MI.

CASS, CAROLINE PICKANDS.
Sculptor. Born in Euclid, Ohio, November 9, 1902. Studied at Cleveland School of Art; School of the Museum of Fine Arts, Boston; H. N. Matzen; Alexander Blazys; Charles Grafly. Awards: Honorable mention, 1931; first prize, 1932; Annual Exhibition of Work by Cleveland Artists and Craftsmen, Cleveland Museum of Art. Address in 1933, Euclid, Ohio.

CASSIDY, MARGARET CAROL.
(Mrs. John Manship). Sculptor and art librarian. Born in Whitinsville, MA. Studied at Framingham State College, B.S., 1944; University of Mass., Amherst, MA, 1949; Rosary College Graduate School of Fine Arts, M.A., 1954. Work in New Britain Museum of American Art, CT; Vatican Collections, Rome; sculpture, Holy Spirit Church, Kyoto; others. Has exhibited at National Academy of Design Annual, NY, 1966-79; New Britain Museum, CT; Metropolitan Museum of Art; others. Received awards from Pen and Brush Club, NY, 1972, silver medal; Catharine Lorillard Wolfe Art Club, NY, 1972, bronze medal; others. Member of Salmagundi Club; Catherine Lorillard Wolfe Art Club (chairman, sculpture); Pen and Brush Club; others. Works in bronze, marble, wood, cement, terracotta, plastics; and stained glass. Address in 1982, Gloucester, MA.

CASTAING, CAMILLE K.
Sculptor, designer, and craftsman. Born in French Guiana, August 16, 1899. Studied: Cooper Union Art School. Member: Society of Plastic Industry. Awards:

Prizes, Anderson Gallery, 1931; medal, Plastics Contemporary, 1937-41; Museum of Modern Art, 1939; Philadelphia Art Alliance, 1940. Address in 1953, Huntington Beach, Calif.

CASTANIS, MURIEL.
(Julia Brunner). Sculptor. Born in NYC, September 27, 1926. Self-taught. Exhibitions: Women Artists at SOHO, New York City; "Feminine Perceptions," Buffalo State University, NY; "Unmanly Art," Suffolk Museum; Portland Museum of Art, Maine; Women in Art, Stamford Museum, Conn.; Contemporary Reflections, Aldrich Museum, Ridgefield, Conn.; Women Choose Women, New York Cultural Museum; and many others. Collections: Andrew Dickson White Museum, NY; Joe and Emily Lowe Museum, Florida. Awards: Tiffany Foundation sculpture grant, 1977; Award for Outstanding Design, Show Business, 1977; Award of Distinction, Virginia Museum of Fine Arts, 1979. Media: Cloth and resins. Address in 1982, 444 Sixth Avenue, New York, NY.

CASTANO, GIOVANNI.
Sculptor and painter. Born in Calabria, Italy, October 2, 1896. Pupil of School of the Boston Museum of Fine Arts; Philip L. Hale, Lesley P. Thompson, Huger Elliot, F.M. Lamb, Henry James. Work includes: "Threatening," Springfield Art Association; "Painted Stage Settings," Boston Opera House; murals, First Baptist Church, Covington, KY; St. Peter's Church, Boston; others. Member: Soc. Arts and Crafts, Brockton; Boston Art C.; Cincinnati Art Club. Awards: Honorable mention, Penna. Academy of Fine Arts, 1918; honorable mention, Springfield Art Association, 1926. Address in 1953, Boston, MA; h. Needham, MA.

CASTELLO, EUGENE.
Sculptor, painter, and writer. Born Philadelphia, January 12, 1851. Pupil of Penna. Academy of Fine Arts under Eakins. Member: Fellowship Penna. Academy of Fine Arts; Salmagundi Club 1904; Philadelphia Print Club (honorary); Arts and Crafts Guild of Philadelphia (honorary); Philadelphia Chapter American Institute of Architects 1871; International Society of Arts and Letters; Philadelphia Art Club; Washington Art Club. Awards: Bronze medal, American Art Society, 1904; prize, Philadelphia Arts and Crafts Guild, 1906; exhibitors bronze medal, Ghent Exposition, 1913. Work in: Historical Society of Pennsylvania; University of Pennsylvania. Correspondent, "The Studio," London. Writer in art magazines. Address in 1926, Philadelphia, PA. Died in Philadelphia, March 3, 1926.

CASTLE, WENDELL KEITH.
Sculptor and designer. Born in Emporia, KS, November 6, 1932. Studied at University of Kansas, B.F.A. and M.F.A.; Maryland Institute of Art, D.F.A. Work in Museum of Modern Art, NY; Philadelphia Museum of Art; Metropolitan Museum of Art; Smithsonian Institution; others. Has exhibited at Wooden Work, Smithsonian Institution; others. Received Louis Comfort Tiffany Foundation and NY State Grants, 1972; National Endowment for the Arts Grants, 1973, 75, and 76; plus others. Taught furniture design, Rochester Institute of Technology, 1962-

70; teaching sculpture, Wendell Castle Workshop, from 1980. Works in wood. Address in 1982, Scottsville, NY.

CASTORO, ROSEMARIE.
Sculptor and painter. Born in Brooklyn, NY, March 1, 1939. Studied at Museum of Modern Art, NY, scholar, 1954-55; Pratt Institute, B.F.A. (cum laude), 1956-63. Works: Berkeley Museum, San Francisco; Woodward Foundation, Washington, DC. Commissions: Procession of Strokes, NY State Council of Arts, 1972. Exhibited: Distillation, Tibor de Nagy Art Gallery, NY, 1966 and one-man shows, 1971-73, 75, 76, 78, 80, and 81, and Hall Broom Gallery, NY, 1978-81; The Drawn Line, 470 Parker St. Gallery, Boston, 1971; Highlights of the 1970-71 Art Season, Painting and Sculpture, Storm King Mountain, NY, 1972, 74, and 75; one-man show, Syracuse University Lubin House Gallery, 1973; Otis Art Institute, Los Angeles, CA, 1976. Awards: Guggenheim fellow, 1971; NY State Council Arts, 1972 and 74; National Endowment Arts, 1975. Address in 1982, 151 Spring Street, NYC.

CATALAW, GUISEPPE.
Sculptor. Award: Second Hopkin prize, Scarab Club, Detroit, 1914. Address in 1918, Fine Arts Building, Detroit, MI.

CATAN-ROSE, RICHARD.
Sculptor, painter, teacher, etcher, lithographer, and illustrator. Born in Rochester, NY, October 1, 1905. Studied: Royal Academy of Fine Arts, Italy, MFA; Cooper Union Art School, New York; and with Pippo Rizzo, Antonio Quarino, J. Joseph, A. Shulkin. Member: American Federation of Arts; Royal Academy of Fine Arts, Italy. Work: Our Lady Queen of Martyrs Church, Forest Hills, LI, NY; Royal Academy of Fine Arts, Italy; murals, Trabia, Sicily. Exhibited: Allied Artists of America, 1939, 40; Vendome Gallery, 1939, 40, 41; Forest Hills, LI, NY, 1944-46 (one-man); Argent Gallery, 1946 (one-man); and in Europe. Taught: President, Catan-Rose Institute of Fine Arts, Forest Hills and Jamaica, LI, NY. Won Gold Medal, Accad. Delli Arti, 1981. Address in 1982, Flushing, NY.

CATCHI, (CATHERINE O'CHILDS).
Sculptor and painter. Born in Philadelphia, PA, August 27, 1920. Studied at Briarcliff Jr. College, 1937; Commercial Illustration Studios, 1938-39; Paul Wood Studio, 1949-55; with Leon Kroll, Harry Sternberg, and Hans Hofmann; also with Angelo Savelli, Positano, Italy. Works: Hofstra University, Hempstead, NY. Exhibitions: Rayburn Hall (by Congressional invitation), Washington, DC, 1968 and 1976; Alfredo Valente Gallery, NY, 1968; Lever House, NY, four times; Royal Academy Galleries, Edinburgh, Scotland; Royal Birmingham Society of Artists Galleries, England. Awards: Grumbacher Award, 1963; Lillian Cotton Memorial Award and Medal of Honor, National Association of Women Artists, 1966; Irene Sickle Feist Memorial Prize, 1971. Media: Stone, cast metals; oil, and watercolor. Address in 1980, Manhasset, NY.

CATHELL, EDNA S.
(Mrs. J. E. Cathell). Sculptor and painter. Born in Richmond, Ind., November 1, 1867. Member: Richmond Art Association; Palette Club, Richmond, Ind. Address in 1933, Richmond, Ind.

CATHERS, JAMES O.
Sculptor and educator. Born in St. Louis, MO, June 2, 1934. Studied at University of Louisville, B.S., 1967; Rhode Island School of Design, M.F.A., 1969. Work in University of Louisville; commemorative gift, Kentucky Opera Association, Louisville, 1967; others. Exhibited at NE Sculpture Open, Brockton Art Center, MA, 1975; works by New England Sculptors, Copley Society, Boston, 1977; Rutgers University, 1980. Received awards from 61st Annual American Exhibition, 1972, first prize sculpture; 65th Annual American Exhibition, Art Association Newport, Gertrude Vanderbilt Whitney, 1976, second prize sculpture. Member of Art Association of Newport; New England Sculptors Association of Boston; others. Works in polystyrene, plaster; acrylic plastic. Address in 1982, Newport, Rhode Island.

CATLETT, ALICE E.
Sculptor. Born 1915. Studied at Howard University; University of Iowa. Award: 1st prize for sculpture at the Negro Exposition in Chicago, 1940.

CATLETT, ELIZABETH.
Sculptor and printmaker. Born in Washington, DC, April 15, 1919. Studied at Howard University, BS (art); University of Iowa, MFA; also with Ossip Zadkine. Work in Museum of Modern Art, NY; Schomburg Collection Black History, NY; Library of Congress, Washington, DC; bronze sculpture, National Polytech Institute, Mexico City; bronze of Louis Armstrong, New Orleans, LA. Has exhibited at Sculpture Biennial, Mexico City; Museum Arte Modern, Mexico City; Indian Sculpture and Prints, Studio Museum Harlem, NY, 1971; and others. Taught sculpture, School of Fine Arts, National University of Mexico, 1958-75; head of department, 1960-73. Represented by Contemporary Crafts, 5271 W. Pico Boulevard, Los Angeles, CA. Works in wood, stone, bronze; lithography, relief prints. Address in 1982, Cuernavaca, MX.

CAUSICI, ENRICO.
Sculptor. Born in Verona, Italy. Working in US about 1822-32. Sculpted "Washington" for the monument at Baltimore, and several subjects for Congress at Washington. Worked on the U.S. Capitol at Washington about 1823-25; modelled an equestrian statue of Washington at New York, which was erected in 1826. He died in Havana.

CAVACOS, EMMANUEL A.
Sculptor and painter. Born Island of Kythera, Greece, February 10, 1885. Pupil of Ephraim Keyser in Baltimore; Jules Coutan and V. Peter in Paris. Member: Baltimore Watercolor Club; Association des Anciens Eleves de l'Ecole Nationale des Beaux-Arts de Paris; Institut Social de l'Enseignement. Awards: Rinehart Paris Scholarship, 1911-1915; honorable mention, Paris Salon, 1913; silver medal, International Exposition of Decorative Arts, Paris, 1925; "Officier de l'Academie," French Government, 1927. Works: "Aspiration," Enoch Pratt Free Li-

brary; "Penseur," Peabody Institute, Baltimore; "Grief," Collection of Queen of Roumania. Address in 1933, Paris, France.

CAVALLITO, ALBINO.
Sculptor. Born in Cocconato, Italy, February 24, 1905. Studied at Trenton School of Industrial Arts; Beaux-Arts Institute of Design; Fontainebleau School of Fine Arts; and with H. R. Ludeke, Lejeune, J. De Creeft. Member: Fellow, National Sculpture Society; Sculptors Guild; Audubon Artists; Allied Artists of America. Awards: prizes, National Institute of Arts and Letters, 1953; Architectural League, 1954; National Academy of Design, 1954; Hudson Valley Art Association, 1955; National Sculpture Society, 1957; gold medal, Allied Artists of America, 1954. Exhibited: National Academy of Design; Art Institute of Chicago; Whitney Museum; Brooklyn Museum; National Institute of Arts and Letters; Metropolitan Museum of Art; and others. Address in 1966, 261 Mulberry Street, NYC. Died in 1966.

CAVANAUGH (CAVANAGH), JOHN.
Sculptor. At New Orleans, 1852-56. Worked in marble.

CAVE, LEONARD EDWARD.
Sculptor and educator. Born in Columbia, SC, October 22, 1944. Studied at Furman University, B.A.; University of Maryland, College Park, with Kenneth Campbell, M.A. Work in Columbia Museum of Art, SC; sculptural menorahs, Beth Torah Synagogue, Hyattsville, MD, others. Exhibited at Southeastern Museum Tour, Corcoran Gallery Art; Sculpture Center, NY, 1979; others. Received awards from National Young Sculptors Guild, 1969, Chaim Gross Sculptor's Exhibit first prize. Member: Sculptors Guild, NY; Artists Equity, Washington, DC; others. Taught at Georgetown University, 1970-77, assistant professor of art. Works in stone; and wood. Address in 1982, Kensington, MD.

CAVERLEY, CHARLES.
(See Calverley).

CECERE, GAETANO.
Sculptor. Born in NYC, November 26, 1894. Studied: National Academy of Design, under Hermon A. MacNeil; Beaux-Arts Institute of Design; American Academy, Rome. Travelled in Europe in 1920. Represented in Metropolitan Museum, NYC; Numismatic Museum, NYC; Brookgreen Gardens, SC; others. Works include "Kneeling Girl," "Mother and Child," "The Hunters," "Persephone," "Roman Peasant," "Boy and Fawn," "Eros and Stag;" statue of John Frank Stevens, Summit, MT; architectural decorations, Stambaugh Auditorium, Youngstown, OH; band of warriors, relief, around flagpole, Plainfield, NJ. Commissions include "Lincoln," Lincoln Memorial Bridge, Milwaukee; "Rural Free Delivery Mail Carrier," Post Office Dept. Building, Washington, DC. Awarded fellowship, American Academy in Rome, 1920-23; Barnett Prize, National Academy of Design, 1924; Garden Club of America Prize, 1929; McClees Prize, Penna. Academy of Fine Arts, 1930; Lindsey Morris Memorial Prize, National Sculpture Society, 1935; National Arts Club award in sculpture, 1968; Audubon

Artists sculpture award; Allied Artists of America, 1970; and many others. Was director of dept. of sculpture, Beaux-Arts Institute of Design; was on faculty of National Academy of Design. Member of National Academy of Design, academician; National Sculpture Society, fellow; NY Architectural League. Address in 1982, 41 Union Square, NYC.

CELMINS, VIJA.
Sculptor and graphic artist. Uses wood and enamel for her sculptures. Her drawings are of the ocean, done in the photo-realist style.

CENCI, SILVANA.
Sculptor. Born in Florence, Italy, August 4, 1926. Studied at Manzoni Institute, Italy; Academy of Fine Art, Italy, 1949; Academie Grande Chaumiere, Paris, 1949, 50. Work in Uffizi Gallery Modern Art, Florence, Italy; Bundy Art Museum, Waitsfield, VT; monumental sculpture, Pavilion of Architecture, New Haven, CT, 1961; others. Has exhibited at New England Sculptors Association, Boston City Hall, 1969; ten-year retrospective, Bristol Art Museum, 1977; and others. Received awards from Medea, Italy, 1958, Gold Hammer Award; Institute of Contemporary Art, 1971; first honorable mention, Design in Transit. Member: Artists Equity Association; others. Works in stainless steel and 24-karat gold. Address in 1982, Spencer, WV.

CERRACCHI, ENRICO FILIBERTO.
Sculptor. Born in Italy, 1880; came to America in 1900, and settled at Houston, Texas. Principal works: Monument to John A. Wharton, State Capitol, Austin, Texas; "The American Doughboy" for Italian Government. Address in 1926, Houston, Texas.

CERRACCHI, GUISEPPE.
Sculptor. Born in Corsica, July 1751. Visited US about 1790 and 1793. He executed a bust of Washington, and also made portrait busts of Jefferson, Clinton, Hamilton, Jay Benson, and Paul Jones; and others. His portrait was painted in miniature by Trumbull, Yale Museum. On returning to France he was guillotined for his conspiracies against Napoleon. Died January 30, 1802, in Paris.

CHALK, JOHN R. JR.
Sculptor. Born in Akron, OH, 1930. Marine combat artist; later worked as illustrator, art director. In 1980 turned full-time to sculpture. Subjects are Civil War and Western figures. Works in bronze. Has own studio, where he exhibits his work. Address in 1982, Pottstown, PA.

CHAMBELLAN, MARCEL CLAUDE.
Sculptor. Born in West Hoboken, NJ, June 26, 1886. Pupil of Verlet and Greber in Paris. Address in 1913, 11 Rue Daniel Stern, Paris, and West Hoboken, NJ.

CHAMBELLAN, RENE PAUL.
Sculptor and architect. Born in 1893. Studied at Julian Academy in Paris and with Solon Borglum. Collaborated with Solon Borglum on dedication panel, Pershing Stadium, Vincennes, France; and with Grosvenor Atterbury on sculptural panels, Russell Sage Foundation Building, NY. Designed John Newbury medal for American Li-

brary Association; memorials, groups, figures, plaques: Catholic Cemeteries, Chicago; Princeton University; Naval Hospital, Beaufort, SC; others. Member of National Sculpture Soc. Address in 1953, Cliffside Park, NJ. Died in 1955.

CHAMBERLAIN, JOHN ANGUS.
Sculptor. Born April 16, 1927, Rochester, Ind. Studied: Chicago Art Institute School, 1950-52; University of Illinois; Black Mt. College, 1955-56. Work: Albright; Los Angeles County Museum of Art; Museum of Modern Art; University of North Carolina; Rome (Nazionale); Whitney Museum. Rep. by Leo Castelli Inc. in Rye. Exhibited: Wells Street Gallery, Davida Gallery, Chicago; Martha Jackson Gallery, NYC, 1960; Dilexi Gallery, Los Angeles, and San Francisco, 1962; Leo Castelli Inc.; Robert Fraser Gallery, London; Contemporary Arts Center, Cincinnati, 1968; Museum of Modern Art; Buenos Aires Museum of Modern Art, International Sculpture Exhibition, 1960; Whitney Museum of American Art Annuals, 1960, 62, 65, Sculpture Annuals, 1966, 68; Galerie Rive Droite, Paris, Le Nouveau Realisme, 1961; VI Sao Paulo Biennial, 1961; Art Institute of Chicago, 1961, 67; Carnegie, 1961, 67; Guggenheim; Battersea Park, London, International Sculpture Exhibition, 1963; Musee Cantonal des Beaux-Arts, Lausanne, I Salon International de Galeries Pilotes, 1963; Tate, Painting and Sculpture of a Decade, 1954-64, 1964; XXXII Venice Biennial, 1964; Jewish Museum, 1964; Herron; NJ State Museum, Trenton, Soft Art, 1969; many more. Awards: Guggenheim Fellowships, 1966 and 1977. Address in 1982, c/o Leo Castelli Inc., 4 East 77th Street, NYC.

CHAMBERLIN, EDNA W.
Sculptor. Exhibited "The Muff" at the Penna. Academy of Fine Arts Philadelphia, 1925. Address in 1926, Summit, NJ.

CHAMBERLIN, FRANK TOLLES.
Sculptor, mural painter, etcher, and teacher. Born in San Francisco, CA, March 10, 1873. Pupil of D. W. Tryon in Hartford; George de Forest Brush and George Bridgman of Art Students League of New York. Member: Beaux-Arts Institute of Design (honorary); California Water Color Soc.; California Printmakers; Mural Painters; Guild of Bookworkers; New York Architectural League, 1913; MacDowell Memorial Association; Calif. Art Club; Beaux-Arts (honorary); Pasadena Fine Arts Club; Los Angeles Museum Patrons Association; American Federation of Arts. Awards: Lazarus Scholarship in mural painting, American Academy in Rome, 1913; Avery prize, New York Architectural League, 1914; 1st prize and commission for mural panel, 1915; Pasadena Art Institute, 1934. Represented in Peabody Institute, Baltimore, New Rochelle (NY) Public Library and Detroit Art Institute. Exhibited: Architectural League, 1913, 14, 20; National Academy of Design; Penna. Academy of Fine Arts; Art Institute of Chicago; California Water Color Society; and many more. Former instructor, University of Southern California; Chouinard School of Arts, Los Angeles; and others. Address in 1953, Pasadena, CA. Died in 1961.

CHAMBERS, FRANK PORTLAND.
Sculptor and architect. Born in 1900.

CHAMBERS, PARK A. JR.
Sculptor and painter. Born in Wheeling, WV, October 29, 1942. Studied at Kent State University, BFA, 1968, MFA, 1970. Has exhibited at 22nd Annual, Butler Institute of American Art, Youngstown, OH, 1970; Fiber Forms, Cincinnati Art Museum, OH, 1978; others. Received awards from Kent State University Graduate School, 1969, research grant; Brunswick Corporation, Chicago, IL, 1969, experimental materials; National Endowment for the Arts, 1976, Individual Grant. Teaching at Art Institute of Chicago, IL, from 1970. Works in rope, wood; photo images, gels. Address in 1982, Albany, NY.

CHAMPLAIN, DUANE.
Sculptor. Born in Black Mountain, NC, April 20, 1889. Student of Art Students League of New York, National Academy of Design, Beaux-Arts Institute of New York; and with I. Konti, A. A. Weinman, A. Stirling Calder, Hermon A. MacNeil. Exhibited at National Sculpture Society, 1923. Member: National Sculpture Society, fellow; Lyme Art Association; Essex Art Association. Awards: Prize, National Academy of Design, 1913; medal, Pan-Pacific Exposition, 1915; Beaux-Arts Institute of Design. Work: Memorial tablet, Peekskill, NY and Jamaica, NY; United States Post Office, Forest City, North Carolina. Address in 1953, Essex, CT. Died in 1964.

CHANDLER, CLYDE GILTNER (MISS).
Sculptor. Born in Evansville, IN. Pupil of Lorado Taft. Second prize, Chicago Artists' Exhibition. Address in 1910, 6010 Ellis Avenue; Chicago, IL.

CHANDLER, ELISABETH GORDON.
Sculptor. Born in St. Louis, MO, June 10, 1913. Studied privately with Edmondo Quattrocchi; Art Students League, anat. Works: Columbia University School of Law; Princeton University School Public and International Affairs; Aircraft Carrier USS Forrestal; Governor Dummer Academic Library; Storm King Art Center, Mountainville, NY. Commissions: Forrestal Memorial Award Medal, National Security Industrial Association, 1954; portrait bust of James L. Collins, commissioned by estate for James L. Collins Parochial School, Corsicana TX, 1955; Timoshenko Medal for Applied Mechanics, American Society of Mechanical Engineers, 1956; Benjamin Franklin Medal, New York University Hall of Fame, 1962; bust of Owen R. Cheatham, Founder, Georgia Pacific Corp., Entrance Hall, Portland, OR, 1970; bust of Albert A. Michelson, Hall of Fame for Great Americans, NYU, 1973. Exhibited: Mattituck Museum, Waterbury, CT, 1949; National Academy of Design Annual, NY, 1950-72; National Sculpture Society Annual, 1953-79; Academy of Artists, Springfield, MA, 1961; Smithsonian Institution, Washington, DC, 1963. Awards: First Prize, Brooklyn War Memorial Competition, 1944; Thomas R. Proctor Prize, National Academy of Design, 1956 and Dessie Greer Prize, 1960 and 1979; Gold Medal, 1975 and Huntington Award, 1976, American Artists Professional League. Media: Bronze and marble. Address in 1982, Old Lyme, CT.

CHANDLER, G. L.
Portrait sculptor. Active in Boston. Exhibited at the Boston Athenaeum in 1842 and 1853.

CHAPIN, CORNELIA VAN AUKEN.
Sculptor. Born: Waterford, CT, in 1893. Studied: in Paris with Hernandez. Member: National Academy of Design; National Sculpture Society; Allied Artists of America; National Arts Club. Awards: National Association of Women Artists, 1936; Paris International, 1937; American Artists Professional League, 1939; Pen and Brush Club, 1942-1945; Meriden, Conn., 1951. Collections: Cathedral St. John the Divine, NY; Rittenhouse Square, Philadelphia; International Business Machines; Dumbarton Oaks, Washington, DC; Brookgreen Gardens, SC; Corcoran Gallery of Art; Brooklyn Museum; Springfield Art Museum; Penna. Academy of Fine Arts; National Zoological Gardens, Washington, DC. Exhibited: World's Fair of New York, 1939; Penna. Academy of Fine Arts, 1938-46; National Academy of Design, 1933-45; San Francisco Museum of Art; Whitney, 1940-42; Metropolitan Museum of Art, 1942; and others. Address in 1953, 166 East 38th Street, NYC. Died 1972.

CHAPLINE, CLAUDIA.
Sculptor. Noted for her use of fiber in making sculpture.

CHAPMAN, (M.) ANNE.
Sculptor and educator. Born in Cleveland, OH, October 14, 1930. Studied at Cleveland Institute of Art, B.F.A. 1952; Cranbrook Academy of Art, M.F.A., 1954, post graduate, 1955. Work in Cleveland Museum of Art, OH; Everson Museum of Art, Syacuse, NY. Has exhibited at 5th Annual Exhibit, Ceramics, Smithsonian Institution, Washington, DC, 1955; Paperworks 1981, Ralph Wilson Gallery, Bethlehem, PA, 1981; and others. Received awards from Everson Museum, Syracuse, NY, International Business Machines Corporation, 1952, first prize sculpture; Rutgers National Drawing, Rutgers University, NJ, 1977. Member of Women's Caucus Art; Printmaking Council, NJ. Works in paper and clay. Address in 1982, Montclair, NJ.

CHAPPELL, BILL.
Sculptor, painter, and a craftsman in leather. Born in Van Zandt County, TX, 1919. Self-taught. Worked as a cowboy; operated saddle and boot shop. Began painting and sculpture in 1953, when he moved to Colorado. Subjects are cowboys and Indians of the Old West. Works in bronze; paints in oil. Member of Texas Cowboy Artists. Reviewed in *The Western Horseman*, Sept. 1971; *Cowboy in Art*; *Bronzes of the American West*. Works include leatherwork portrait of Will Rogers in National Cowboy Hall of Fame; illustrations for magazine covers, *Western Horseman*, *Paint Horse Journal*, *Craftsman*. Address since 1972, South Fork, CO.

CHARD, WALTER GOODMAN.
Sculptor. Born Buffalo, NY, April 20, 1880. Pupil of Charles Grafly; School of the Museum of Fine Arts, Boston; Beaux Arts Institute of Design. Address in 1926, Fenway Studios, Boston, MA; h. Cazenovia, NY.

CHARMAN, LAURA B.
(Mrs. Albert H. Charman). Sculptor. Member: Fellowship Penna. Academy of Fine Arts. Address in 1926, Magnolia, NJ.

CHASE-RIBOUD, BARBARA DEWAYNE.
Sculptor and draftsman. Born in Phila., PA, June 26, 1939. Initiated studies in ceramics and sculpture at the Fletcher Art Memorial School, Phila., 1946-47; Phila. Museum School of Art, PA, 1947-54; Tyler School of Art, at Temple University, Phila., PA, 1954-57; Yale University School of Art and Architecture, New Haven, CT, under Josef Albers and Paul Rudolph, 1958-60, MFA, 1960; American Academy in Rome, 1957-58. Work: Museum of Modern Art; Metropolitan Museum; Museum of Modern Art, Paris; and others. Exhibitions: Cadron Salon, Paris, 1966; Bertha Schaefer Gallery, NYC, 1970; Mass. Institute of Technology, Cambridge, 1970; Carnegie Institute, Pittsburgh, PA, 1965; Boston Museum of Fine Arts, Boston, 1970; Whitney Museum of American Art, NYC, 1971; Museum of Modern Art, Paris; American Cultural Center, Iran, 1975; and others. Awards: National Endowment Arts Individual Grant, 1973; US State Department Traveling Grant, 1975; Outstanding Alumni Award, Temple University, 1975. After travelling to Egypt in 1957, settled in Paris, where she became the promotional art director for the *New York Times*, Paris, 1961. Travelled widely in Asia and Africa. In 1965, travelled to People's Republic of China. Began to publish poetry in 1974. Media: Bronze and aluminum. Address in 1982, Paris, France.

CHASSAING, EDOURD.
Sculptor. Address in 1935, Chicago, Ill. (Mallett's)

CHASSAING, OLGA.
Sculptor. Born in 1897. Exhibited in Chicago, 1934. (Mallett's)

CHATELAIN, JAMES.
Sculptor. Born in Findlay, OH, 1947. Studied: Wayne State University, B.F.A. Private collections. Exhibitions: Willis Gallery, Detroit, 1971, 72 (one-man), 74 (one-man); Detroit Institute of Arts, Works by Michigan Artists, 1974-75. Address in 1975, Detroit, MI.

CHAUDHURI, PATRICIA M.
Sculptor and painter. Born in NYC, July 6, 1926. Studied at Simmons College, BS; Boston Museum of Fine Arts, five year certificate, painting with Karl Zerbe and David Aronson; Skowhegan School of Painting and Sculpture, summer scholar, 1951; Yale Summer Art School, scholar, 1952; also sculpture with George Demetrios. Exhib.: Painting, Boston Arts Festival, 1955 and Sculpture, 1963; New England Sculpture Association, 1969-71. Awards: Louis T. Comfort Tiffany Award for Sculpture, 1961. Address in 1976, Harvard, MA.

CHAVEZ, EDWARD ARCENIO.
Sculptor and painter. Born in Wagonmound, NM, March 14, 1917. Studied at Colorado Springs Fine Art Center under Frank Mechau, Boardman Robinson, Peppino Mangravite, and Arnold Blanch. Exhibited: National Institute of Arts and Letters in NYC; Whitney Museum of American Art, NYC; National Academy of Design, NYC; Metropolitan Museum of Art, NYC. Awards: Childe Hassam Award for painting at the National Institute of Arts &

Letters, 1953. Member: Woodstock Art Association (chairman, from 1949); and the National Academy of Design. Taught: Painting at the Art Students League, 1954-58; visiting professor of art at Colorado College, Colorado Springs, 1959-60; professor of art at Syracuse Univ. School of Art, 1960-62. Commissions: Murals for the Post Offices in Center, TX; Glenwood Springs, CO; Geneva, NE; for the Government Art Commission, 1938; and the West High School in Denver; and a mural for the 200th State Hospital, Recife, Brazil. Address in 1982, Woodstock, NY.

CHAVICCKIOLI(-DIAN), WILLIAM.
Sculptor. Born in Venice, Italy, July 25, 1909. Studied with Chester Beach and Walker Hancock. Award: Morris prize, All. Artists of America, Brooklyn Museum, 1933. Address in 1933, 771 Park Avenue West, NYC.

CHEESEBROW, NICHOLAS RILEY.
Sculptor, illustrator, craftsman. Born in Minneapolis, MN, May 3, 1894. Pupil of L. W. Zeigler. Award: honorable mention for bookplates, Minnesota State Fair, 1914. Address in 1918, St. Paul, MN.

CHENEY, HELEN M.
Sculptor. Born in Wiarton, Ontario, Canada, 1932. Studied: Wayne State University, BFA; Eastern Michigan University, MFA candidate. Exhibitions: Detroit Artists Market; Willis Gallery, Detroit; Eastern Michigan University; Saginaw Art Museum ("Woman Art Show"); University of Michigan ("Detroit Now"); Detroit Institute of Arts, Works by Michigan Artists, 1974-75. Awards: First prize, Saginaw Art Museum ("Woman Art Show"). Address in 1975, Grosse Ile, MI.

CHENEY, WARREN.
Sculptor, lecturer, writer, and teacher. Born in Paris, France, September 19, 1907. Studied at University of Calif.; Ecole des Beaux Arts, and with Hans Hofmann. Awards: Honorable mention, Los Angeles County Fair, Pomona, 1930; honorable mention, Ebell Sculpture Exhibition, May 1933. Exhibited: Gumps Gallery (one man), San Francisco, 1934; Metropolitan Museum of Art, 1934; Weyhe Gallery, 1934-36; San Francisco Museum of Art, 1936, 37; Philadelphia Museum of Art, 1940. Stage sets: "Liliom" and "The Mad Hopes," 1938; "Le Sacre du Printemps," 1938. Position: Instructor, Sculpture and Design, University of California, Los Angeles, 1937-38; Chairman of Art Department, Adjunct Professor of Art, Randolph-Macon Women's College, 1939-40; City College of New York, 1947-48. Member: California Art Club. Instructor in sculpture and lecturer at Mills College; instructor, Cheney-Wessels School of Art, San Francisco. Address in 1953, Flushing, LI, NY.

CHEPOURKOFF, MICHAEL.
Sculptor, designer, painter, craftsman, and etcher. Born in Lugansk, Russia, November 12, 1899. Studied: University of California, AB, MA; and with George Lusk. Awards: Prizes, Wheeler Memorial Medal Design, 1929; San Francisco Art Association, 1940. Work: San Francisco Museum of Art. Exhibited: San Francisco Art Association. Address in 1953, San Francisco, California.

CHERNE, LEO.
Sculptor. Member of the National Sculpture Society. Address in 1982, 50 East 79th Street, New York City.

CHEVALIER, ABRAHAM.
Sculptor and wood carver. Worked: Baltimore, 1805-25; Philadelphia, 1825-27. Exhibited: Pennsylvania Academy, 1827. Work held: Maryland Historical Society.

CHEVALIER, AUGUSTIN.
Sculptor. Worked: Baltimore, c. 1820-30.

CHEYNO, Y. ELBERT.
Sculptor and painter. Born in St. Louis, MO, 1906. For many years employed in aircraft industry. Since 1972, has devoted his time to painting and sculpture. Founder of American Indian and Cowboy Artists Society, 1974. Represented by Files' Gallery, Big Bear Lake, CA; Many Horses Gallery, Los Angeles, CA. Subjects are Indians and cowboys. Address in 1982, Sunland, CA.

CHINNI, PETER ANTHONY.
Sculptor and painter. Born March 21, 1928, Mt. Kisco, NY. Studied: Art Students League, 1947, with Edwin Dickinson, Kenneth Hayes Miller, Julian Levi; Academy of Fine Arts, Rome, 1949-50, with Emilio Sorrini. Work: Denver Art Museum; St. Louis City Art Museum; Whitney Museum. Exhibited: Galleria San Marco, Rome, 1955; Kipnis Gallery, Westport, Conn., 1956; R. R. Gallery, Denver, 1957; Galleria Schneider, Rome, 1957; Janet Nessler Gallery, NYC, 1959, 61; Albert Loeb Gallery, NYC, 1966; Audubon Artists Annuals, 1958, 59, 61, 62; Festival of Two Worlds, Spoleto, 1960; Boston Arts Festival, 1960, 62; Conn. Academy of Fine Arts, 1960, 62; Whitney Museum of American Art Annuals, 1960, 62, 64, 65; Corcoran, 1962; Sculptors Guild, 1963, 64, 66, 68; Carnegie, 1964-65; Heseler Gallery, Munich, 1968; Rome (Nazionale) 1968. Awards: Art Students League, Daniel Schnackenberg Scholarship, 1948; Silvermine Guild, 1st Prize, 1958, 60, 61; Denver Art Museum, 2nd Prize, 1960. Member of Sculptors Guild; Artists Equity, New York. Address in 1983, Katonah, New York.

CHIVERS, HERBERT CHELSEY.
Sculptor, painter, etcher, and writer. Born Windsor, England. Pupil of Luks, Sloan, Robinson, Lever, Young, Preissig, and Pennell. Address in 1929, 16 Morningside Avenue, New York, NY.

CHOATE, NATHANIEL.
Sculptor. Born in Southboro, MA, December 26, 1899. Went to Paris in 1923 to study painting; then to Italy. Returning to Paris, he worked at the Carlo Rossi, Delacleuse, and Roman schools. After visiting Greece in 1924, he decided finally to become a sculptor. Returned to Boston and worked under John Wilson, instructor of sculpture for the Harvard Architectural School and the Mass. Institute of Technology. In 1927 and 28, he went again to Europe and returned to the US in 1929. Studied: Harvard University; Julian Academy; Grande Chaumiere. Member: National Sculpture Society; Associate of the National Academy of Design; Architectural

League; New York Ceramic Society. Works: Statuette, Theseus; Minotaur, companion piece to preceding; Brookgreen Gardens, SC; Harvard University. Address in 1953, 96 East 10th Street, NYC. Died in 1965.

CHODOROW, EUGENE.
Sculptor, painter, and serigrapher. Born in Ukraine, Russia, March 15, 1910. Studied: Education Alliance, NY. Work: murals, US Naval Hospital, Billig Clinic, Oceanside, Calif. Exhibited: ACA Gallery, 1940; Glendale Public Library, 1945; Beverly-Fairfax Community Center, 1945. Address in 1953, Los Angeles, Calif.

CHODZINSKI, KASIMIR.
Sculptor. Member of National Sculpture Society. Address in 1913, 83 Second Avenue, New York City.

CHRISTADORO, CHARLES.
Sculptor. American, active 1920s. Work: Heroic statue of cowboy actor William S. Hart and horse Paint, Billings, Montana, 1927.

CHRISTENSEN, GARDELL DANO.
Sculptor, painter, illustrator, and designer. Born in Shelley, ID, August 31, 1907. Studied: sculpture with Alice Craze, Max Kalish. Member: American Association of Museums; Salmagundi Club. Work: African Hall, North American Hall and Boreal Hall, of the American Museum of Natural History, NY; Museum of Okmulgee National Park, Macon, GA; Custer Battle Field, MT; Colonial Museum, Nairobi, British East Africa. Exhibited: National Academy of Design; Georg Jensen Co., 1939. Illustrated, "Wapiti the Elk," "Animals of the World," "Big Cats," and others. Contributor of articles and illus. to Era, Audubon and other nature magazines. Exhibits Designer, American Museum of Natural History, 1928-41; Assistant Producer and Manager, McArthur 3-Dimensional Adv. Corp., 1947-49; Sculptor, National Park Museum Laboratories, 1950-51; Exhibit Designer, Montana Historical Society, 1952, 53; Hagley Museum, Wilmington, DE, 1956-59; Cabrillo Beach Marine Museum. Address in 1970, San Pedro, CA.

CHRISTIE, KEITH.
Sculptor and painter. Born about 1940. Headed high school arts and crafts department. Built own foundry. Executes statuettes in bronze; paints in oil and tempera. Won Phippen Memorial Show, 1979. Awarded five-year commission for bronzes by Pacific Coast Quarter Horse Association. Represented by Wadle Gallery, Santa Fe, New Mexico; Moran Gallery, Tulsa, OK; and others. Address in 1982, Browns Valley, CA.

CHRISTISENSSEN, W.
Sculptor. Active 1865. Patentee—statues, masonic group, 1865.

CHRISTO, (JAVACHEFF).
Sculptor. Born in Gabrova, Bulgaria, June 13, 1935; came to US in 1964. Studied at Fine Arts Academy, Sofia, Bulgaria; Burian Theatre, Prague, Czechoslovakia; Vienna Fine Arts Academy, Austria. In collections of Museum of Modern Art and Whitney, NYC; Stedelijk, Amsterdam; Tate, London; Albright-Knox, Buffalo; etc.

Projects include Wrapped Kunsthalle, Berne, Switzerland; Wrapped Coast, One Million Square Feet, Little Bay, Sydney, Australia; Running Fence, Marin and Sonoma counties, California; Ocean Front, 150,000 Square Feet, Newport, R.I.; others in Kansas City, Colorado, Milan. Has exhibited widely in Europe; Leo Castelli Gallery, NYC; Walker Art Center, Minneapolis; Museum of Modern Art; de Young Museum, San Francisco; Corcoran; Whitney, NYC; and many more. Address in 1982, 48 Howard Street, NYC.

CHRISTON, NOREEN.
Sculptor and jeweler. Born in Stamford, Connecticut, in 1946. Studied: Monticello College, Godfrey, Illinois; Bridgeport University, Connecticut; Arrowmont School of Crafts, Gatlinburg, Tennessee. Exhibitions: Countryside Briardale Invitational Exhibit, Omaha, 1972; Joslyn Art Museum, Omaha, Nebraska, 1975. Co-founder, Old Market Craftsmen Guild.

CHRYSSA, VARDEA.
Sculptor and painter. Born in Athens, Greece, in 1933; US citizen. Studied: Grande Chaumiere, Paris, and at California School of Fine Art. Collections: Museum of Modern Art; Whitney Museum of American Art; Albright-Knox Art Gallery, Buffalo, NY; and The Solomon R. Guggenheim Museum. Actively exhibiting in major galleries and museums during the 1960's, including Guggenheim, Museum of Modern Art, Carnegie, and Whitney Museum. Address in 1982, 15 East 88th Street, New York City.

CHUPIEN, T.
Carver. In Charleston, SC, 1849. Worked in ivory.

CHURCH, ANGELICA SCHUYLER.
Sculptor, painter, teacher, lithographer, and craftsman. Born Briercliffe, NY, April 11, 1878. Pupil of New York School of Applied Design; Alphonse Mucha. Member: Alliance; New York Salma. Club; Ossining Historical Society. Work: Statue of the Savior, Calvary Church, NY; Mark Twain portrait tablet, at his boyhood home, Hannibal, MO; Seal of Bienville D'Hiberville, Louisiana State Library, New Orleans; four miniature medallions, Louisiana State Museum, New Orleans; "The Rescue," equestrian group, in action, New York City Police Department. Exhibited: New York Municipal Art Society, 1910; Ossining Historical Society. Address in 1953, Ossining, NY.

CHURCH, HENRY.
Sculptor and painter. Born in 1836. Worked: Chagrin Falls, Ohio. Carved large bas-relief in rock over the Chagrin River. Exhibited "Group of Owls" in stone and "Greyhound" in cast iron, at the Museum of Modern Art. Died in 1908.

CHURCHMAN, ISABELLE SCHULTZ.
Sculptor, craftsman, and teacher. Born in Baltimore, MD, April 20, 1896. Studied: Teachers College, Columbia University, BS in Education; Maryland Institute; Rinehart School of Sculpture; and with Ephraim Keyser, Maxwell Miller. Member: San Diego Art Guild; La Jolla Art Center. Work: Tuskegee Institute; Medical Building, Baltimore, MD. Exhibited: Penna. Academy of Fine Arts, 1920-22;

San Diego Fine Arts Society, 1930, 40, 46; La Jolla Art Center, 1945, 46. Taught: Ceramics, Adult Education, San Diego City Schools, 1945-46. Address in 1953, San Diego, California.

CIANFARANI, ARISTIDE BERTO.
Sculptor and designer. Born in Agnone, Italy, August 3, 1895. Studied: Rhode Island School of Design, with Arthur William Heintzelman in France, and in Italy, with Dazzi, Zanelli, Selva. Member: Providence Art Club; Architectural League; Salma. Club; Audubon Artists; International Art Association, Rome. Awards: Prizes, Architectural League, 1942; Allied Artists of America; medal, Bologna, Italy. Work: Brown University; war memorial, Meriden, CT; Northborough, MA; Ogden, Utah; Fall River, MA; Providence, RI; statues, Muhlenberg College, PA; Our Lady of Providence Seminary, RI; Worcester, Mass. Exhibited: Penna. Academy of Fine Arts; Whitney Museum of American Art; World's Fair, New York 1939; Audubon Artists; Architectural League; Ogunquit Art Association; Contemporary American Art; Providence Art Club; Newport Art Association; Rhode Island School of Design. Address in 1953, Providence, RI. Died 1960.

CIANI, VITTORIO A.
Sculptor. Born in Florence, Italy, 1858. Has done some portrait busts. Represented by works at the home of the Vanderbilts; Pabst's Theatre, Milwaukee; Langdon Memorial, Grace Church, NY; St. Bartholomew's Church, NY; Earle Hall, Columbia College, NY. Member: NY Architectural League, 1896; National Arts Club. Address in 1907, 3 West 15th Street, NYC. Died in Perth Amboy, NJ, 1908.

CIAVARRA, PIETRO.
Sculptor. Born Philadelphia, PA, June 29, 1891. Pupil of Charles Grafly, Guiseppe Donato, Charles T. Scott, Penna. Academy of Fine Arts, Philadelphia School of Industrial Art, Alfred Bottiau, Paris. Member: Fellowship Penna. Academy of Fine Arts; American Federation of Arts; Philadelphia Alliance. Represented in Fellowship of the Penna. Academy of the Fine Arts and Samuel Fleisher Galleries. Address in 1933, Germantown, Philadelphia, PA.

CINDRIC, MICHAEL ANTHONY.
Sculptor and educator. Born in Pittsburgh, PA, January 2, 1947. Studied at Indiana State University, B.S. and M.S.; Alfred University, M.F.A. Work in North Carolina Museum of Art, Raleigh; Krannert Art Gallery, Evansville, IN; others. Has exhibited at Southeastern Center for Contemporary Art, Winston-Salem, NC, 1978 and 80; Museum of Art, North Carolina Central University, Durham, 1978; North Carolina Museum of Art, Raleigh, 1979; others. Teaching ceramic sculpture, University of North Carolina, from 1975. Member: American Craftsmen Council; National Council on Education for the Ceramic Arts; Southern Association of Sculptors. Specialty is ceramic sculpture. Address in 1982, Hillsborough, NC.

CIPOLLINI, BENEDICT R.
Sculptor. Born in Carrara, Italy, January 12, 1889. Studied

with Leio Gangeri and Alessandro Pollina. Work: Medal presented by the city of Boston to General Diaz; series of portraits and allegories, Beebe Memorial Library, Wakefield, Mass. Awards: Academy of Fine Arts, Carrara, 1908 and 1909; Quadriennale, international exhibition, Rome, 1911. Address in 1933, Somerville, Mass.

CITAROTO (CITARRATO), JOHN.
Sculptor and wax modeler. Worked: New York City. Exhibited: American Institute, 1856 (wax model of "Tarquin the Proud and the Roman Lucretia;" casting of figure of Washington).

CLAPP, MARCIA.
Portrait sculptor. Born in Hartsville, Indiana, in 1907. Studied at John Herron Art School; Butler University; Art Students League. Awards: Prize, John Herron Art Institute, 1931; fellowship, Tiffany Foundation, 1932, Griffith fellowship, for study abroad. Exhibited: National Academy of Design, 1931, 32, 34; Cincinnati Museum Association, 1931; Hoosier Salon, 1931, 32; Penna. Academy of Fine Arts, 1932; Indianapolis, IN, 1934 (one-man). Instructor of Sculpture and Pottery, Bushkill Pottery. Address in 1953, Bushkill, PA; h. 172 East 75th Street, NYC.

CLARK, ALLAN.
Sculptor. Born June 8, 1896/98, in Missoula, MT. Studied at Puget Sound College. Pupil of Polasek at Art Institute of Chicago; R. Aitken at National Academy of Design, NY; Japanese and Chinese Masters. Member of National Sculpture Society; Society of Independent Artists; American Institute of Arts and Letters; Society of Santa Fe Painters and Sculptors. Taught at Beaux-Arts Inst. Traveled in Orient. Painted in Santa Fe, NM. Award: Rosenwald Memorial prize ($500), Grand Central Art Galleries, 1930. Work: Bronze statue, "The Antelope Dance," marble bust, "Mme. Galli-Curci." In collections of Metropolitan Museum of Art; Honolulu Academy of Arts; Whitney; and Seattle. Exhibited at National Sculpture Society. Address in 1933, Grand Central Galleries, NYC; summer, Santa Fe, NM. Died April 27, 1950.

CLARK, (GEORGE) FLETCHER.
Sculptor and illustrator. Born in Waterville, KS, November 7, 1899. Studied: University of California, BA; Beaux-Arts Institute of Design, in Europe. Illustrated, "Penny Puppets, Penny Theatre and Penny Plays," 1941. Work: Wood Memorial Gallery, Montpelier, VT; private collections. Exhibited at Calif. Palace of Legion of Honor, 1933; Avant-Garde Gallery, NYC, 1959; Gilbert Gallery, San Francisco, 1968; others. Address in 1953, 7 East 9th St., NYC. Address in 1982, San Francisco, CA.

CLARK, HERBERT WILLIS, JR.
Sculptor. Born in Providence, Rhode Island, 1877. Studied sculpture at Rhode Island School of Design. Employed as designer by Gorham Company which made small decorative bronzes. Work: "Saddle Horse" (bronze), 1911. Died in 1920.

CLARK, JAMES LIPPITT.
Sculptor, craftsman, and lecturer. Born Providence, RI, November 18, 1883. Pupil of Rhode Island School of Design. Traveled Africa, Europe, and Orient. Member:

Animal Painters and Sculptors; New York Zoological Society; and National Sculpture Society. In collections of Museum Natural History; Rhode Island School of Design; Ohio State University; and National Museum, Washington, DC. Award: Speyer Memorial prize, National Academy of Design, 1930. Address in 1933, 705 Whitlock Avenue, Bronx, NY; care of the American Museum of Natural History, 77th Street and Central Park; h. 40 West 77th Street, NYC. Died in 1957.

CLARK, JOHN DEWITT.
Sculptor. Born Kansas City, Missouri. Study: Kansas City Art Institute; San Diego State College; with Lowell Houser, Everett Jackson, John Dirks. Work: Palomar College; Southwestern College; La Jolla Museum of Contemporary Art. Exhibitions: The Mexican North American Cultural Institute, Mexico; Findlay Gallery, NY; Eleven Calif. Sculptors, Western Museum Association; Santa Barbara West Coast Invitational; San Diego Fine Arts Gallery. Position: Professor of sculpture and design, Southwestern College, Calif., from 1966. Media: Black granite, bronze. Address in 1982, c/o Art Department Southwestern College, Chula Vista, CA.

CLARK, JOHN W.
(John W. Clark of Gunning & Clark). Carver. Exhibited "Carved eagles, festoon and wreath" at the American Institute, in 1856.

CLARK, NANCY KISSEL.
Sculptor. Born in Joplin, MO, January 27, 1919. Studied at Missouri Southern College, Delaware Art Museum, with Henry Mitchell; Fleicher Art Memorial, Philadelphia, with Aurelius Renzetti. Works: Woodmere Art Gallery; University of Delaware, Newark; Penna. Mil. College, Chester; Provident National Bank Gallery, Philadelphia; Spiva Art Gallery, Missouri Southern College, Joplin. Commissions: Bald Eagle (steel sculpture), Joplin Municipal Building, MO, 1963; Crucifix (metal sculpture), Oblates of St. Francis, Camp Brisson, Childs, MD, 1964; steel sculpture, Walter Piel Memorial, Corkran Gallery, Rehoboth, Delaware, 1965; metal sculpture, Wood-Haven Kruse School, Wilmington, 1966; Christ (5'), Notre Dame Brothers, St. Edmon's Academy Chapel, Wilmington, 1974. Exhibitions: Galeria Municipal, Guadalajara, Mexico, 1966; All. Artists of America Annual, National Art Club Annual, National Arts Club, NY, 1967; June Week, US Naval Academy Museum, Annapolis, 1969; National Sculpture Society Annual, Lever House, New York, 1971-73. Awards: First Binswanger Award, Philadelphia Museum at Civic Center, 1966; First Award, National League of American Pen Women Biennial, Tulsa, Okla., 1966; Artist of the Year Award for Christ in Christmas, Wilmington Council Churches, 1969. Member: Artists Equity Association, Philadelphia; National League of American Pen Women, Diamond State Chapter; Philadelphia Art Alliance. Address in 1982, Wilmington, Delaware.

CLARK, SALLY.
(Mrs. James Lippitt Clark). Sculptor. Address in 1934, New York. (Mallett's)

CLARK, WALTER LEIGHTON.
Sculptor and painter. Born in Philadelphia, Penna., January 9, 1859. Work: Portrait of Eleanora Duse, Asalo, Italy. Member: Grand Central Art Galleries (pres.). Address in 1933, 15 Gramercy Park, NYC; summer, Stockbridge, Mass. Died in 1935.

CLARKE, FREDERICK BENJAMIN.
Sculptor. Born Mystic, CT, in 1874. Pupil of Augustus Saint-Gaudens. Member: Beaux-Arts Institute of Design. Works: "Loton Horton" tablet, "Alfred E. Smith," NY; "Angeline Elizabeth Kirby" tablet, Wilkes-Barre, PA; "Over Door Panel," Grace Dodge Hotel, Washington, DC. Address in 1933, 304 East 44th Street, New York, NY. Died in 1943.

CLARKE, GLADYS DUNHAM.
(Sylvanna Warren). Sculptor, painter, and writer. Born in Southington, Conn., August 24, 1899. Studied with Dickinson, Du Mond, Fogarty, Gruger, Lentelli, Calder, and Bridgman. Member: National Association Women Painters and Sculptors. Address in 1933, Weston, Conn.

CLARKE, JOHN LOUIS.
Sculptor, painter, and woodcarver. Born in Highwood, Montana, 1881. Attended Indian school, then schools for the deaf beginning 1894. Worked in a Milwaukee factory carving altars, around 1900. In 1913, established his studio in East Glacier. Work in Art Institute of Chicago, Montana Historical Society, Museum of Plains Indians (Browning). Specialty was wildlife, preferably bears and mountain goats. Worked in cottonwood, among other material. Died in Cut Bank, Montana, in 1970.

CLARKE, THOMAS SHIELDS.
Sculptor and painter. Born in Pittsburgh, PA, in 1860. Studied painting and sculpture at Ecole des Beaux Arts, Paris, and in Rome and Florence, for 11 years. Exhibited works and won many medals at London, Madrid, Berlin, Paris, Chicago Exposition, and at Exposition of San Francisco and Atlanta, GA. He executed many large works in bronze and marble for New York, San Francisco, Chicago, and other cities. Pictures in Museums of Boston and Philadelphia. Member: Royal Society of Arts, London; National Sculpture Society; Metropolitan Museum of Art; American Museum Natural History; Architectural League; Associate National Academy of Design; National Arts Club. Among his best known paintings is "Night Market, Morocco," owned by the Philadelphia Art Club. Address in 1917, 7 West 43rd street, NYC; h. Lenox, MA. Died November 15, 1920, in NYC.

CLARKSON, JOHN.
Carver and modeller (amateur). Executed portrait busts and heads in wood, plaster of paris, and clay. In Charleston, SC, in 1847.

CLASGENS, FREDERIC.
Sculptor. Pupil of Verlet and Laurens in Paris. Address in 1917, 67 Rue du Montparnasse, Paris, France.

CLAY, GLORIA.
Sculptor. Born near Gillette, WY, 1930. Basically self-taught in art. Portrays subjects of the ranch life she leads.

Represented by Troy's Gallery, Scottsdale, AZ; Western Images Gallery, Cortez, CO. Address since 1959, Laramie, WY.

CLAY, MARY F. R.
Sculptor and painter. Exhibited: Pennsylvania Academy of Fine Arts, 1924. Member: Fellowship Penna. Academy of Fine Arts, Philadelphia; National Academy of Design; Women's Painters and Sculptors Society; North Shore Art Association; Plastic Club. Awards: Proctor prize, National Academy of Design, 1923; Kohnstamm prize ($250); Art Institute of Chicago, 1925. Address in 1933, Bar Harbor, ME. Died in 1939.

CLAYTON, (HENRY) CHARLES.
Sculptor, painter, educator, and lecturer. Born in Goodman, Wis., September 11, 1913. Studied: University Wisconsin, BA, MA, with Wolfgang Stechow, Oskar Hagen, John Kienitz, James Watrous. Member: Artists Equity Association. Awards: Wisconsin Salon, 1947; Wisconsin Annual, 1939. Work: IBM; City of Milwaukee; University of Wisconsin; Beloit College; Gimbel's Wisconsin Collection; North Carolina State Art Society. Exhibited: Grand Central Art Gallery, 1947; Art Institute of Chicago, 1949; Wis. Salon, 1939-42, 1948-50; Milwaukee Art Institute, 1939-42, 47; Gimbels, 1949. Taught: Education Director, Milwaukee Art Institute, 1946-47; Associate Professor, 1947-49, Chm. Department of Art, 1949-51, Beloit College; Professor, Chairman of Department of Art, University Miami, Coral Gables, Florida, from 1951. Address in 1953, University of Miami, Coral Gables, Fla.; h. South Miami, Fla.

CLEAR, CHARLES VAL.
Sculptor, painter, lecturer, and teacher. Born in Albion, IN in 1910. Pupil of John A. Herron Art School; Corcoran School of Art; sculpture with Myra Richards, J. Maxwell Miller, Seth Velsey. Member: Indianapolis Art Association; Elkhart Art League; Society of Washington Artists; Washington Art League; Columbia Water Color Society; American Federation of Arts, NY. Work: Phillips Memorial Gallery, Washington, DC; Society of Washington Artists; John Herron Art Institute; Mt. Rainier Public Library. Director, Art League of Washington. Address in 1953, Akron, OH. Died c. 1968.

CLEARY, FRITZ.
Sculptor and art critic. Born in NYC, September 26, 1914. Studied at St. John's University; National Academy of Design; Beaux-Arts Institute, with Alexander Finta. Commissions include World War II Memorial, Point Pleasant, NJ; John F. Kennedy Memorial, Asbury Park, NJ; others. Has exhibited at National Academy of Design, NY; Penna. Academy of Fine Arts, Philadelphia; Oakland Art Museum, California; National Sculpture Society, Allied Artists and Hudson Valley Art Association Annual; others. Received awards from National Sculpture Society, 1974, John Spring Award; Anna Hyatt Huntington Award for Sculpture, Hudson Vallery Art Association, 1975; others. Member of Allied American Artists; (fellow) National Sculpture Society; Asbury Park Society of Fine Arts. Works in bronze. Address in 1982, Asbury Park, NJ.

CLEAVER, MILDRED DAY.
(Mrs. Chester H.). Sculptor. Born in Newark, NJ, November 7, 1888. Studied: Norton School of Art; and with Genevieve Karr Hamlin. Member: Palm Beach Art League; American Artists Professional League. Exhibited: Palm Beach Art League, 1944, 45, 46. Address in 1953, West Deal, NJ.

CLEAVES, MURIEL MATTOCKS.
(Mrs. H. H. Cleves). Sculptor, illustrator, and teacher. Born in Hastings, NE. Pupil of M. C. Carr, John S. Ankeney, Birger Sandzen, Art Institute of Chicago. Member: Staten Island Institute, Art and Sculpture; Kansas City Society of Artists. Awards: Second and third prizes, water colors, Pueblo, 1922; honorable mention, Kansas City Art Institute, 1923. Address in 1933, Staten Island, NY. Died in 1947.

CLERE, HAZEL.
Sculptor and writer. Born in Syracuse, NY. Studied: Art Students League; Syracuse University; and in Europe. Statues in: St. Lawrence University Law School, Brooklyn, Church of the Heavenly Rest and Chapel of the Beloved Disciple, Fifth Ave., NYC; Church of the Precious Blood, Astoria, NY; St. Andrews, Flushing, NY; Glen Cove (NY) Post Office, Harlem YMCA, NYC, Washington (DC) Cathedral; Church of the Good Shepherd, Brooklyn; Federal Bldg., Everett, PA, Cardinal Hayes Shrine, Peekskill, NY, Bloomfield (NJ) Post Office; statues in private collections, portraits, garden figures. Member: Delta Gamma. Contributor of articles on sculpture. Address in 1953, Hotel Chelsea, 222 West 23rd Street, NYC; Willard Hotel, Washington, DC.

CLERE, VERE.
Sculptor. Address in 1934, New York. (Mallett's)

CLEVENGER, SHOBAL VAIL.
Sculptor. He was born October 22, 1812, near Middleton, OH. Largely self-taught, he executed many busts of prominent men and was enabled to go abroad for study. Travelled to Philadelphia, Washington, Boston, NYC. Work at the Maryland Historical Society and the NY Historical Society. Died September, 1843, at sea.

CLEWS, HENRY, JR.
Sculptor and painter. Born in New York City in 1876. Studied at Amherst College and Columbia University; also at Lausanne and Hanover Universities. Worked independently in Paris and New York City. Several exhibitions held in New York City 1903-14; memorial exhibition, Metropolitan Museum, of Art 1939. Works: "Frederick Delius," English composer (Bronze), 1916-17. Address in 1918, 27 West 51st Street. Died in 1937.

CLIFTON, MICHELLE GAMM.
Sculptor and filmmaker. Born in Los Angeles, CA, July 11, 1944. Studied at Yale University, summer, 1965; University of IL, Urbana-Champaign, B.F.A., 1966, with Lee Chesney; Penna. State University, University Park, M.F.A., 1968, with Carol Summers. Work in Museum of City of New York; Los Angeles Co. Museum of Art, Los Angeles; others. Has exhibited at Library of Congress, Washington, DC, 1969; Smithsonian Institution; Dayton

Art Institute, OH; Great American Foot Show, Museum of Contemporary Crafts, NY; Carnegie Institute; others. Received Cine Golden Eagle Award, 1979; Houston International Film Festival, 1979, grand award. Member of American Crafts Council; National Academy of Television Arts and Science. Works in fabric and stuffing. Address in 1982, Garrison, NY.

CLIVETTE, MERTON.
Sculptor, painter, etcher, writer, lecturer, and teacher. Born in Wisconsin, June 11, 1868. Pupil of Chase, La Farge, Twachtman, Art Students League of NY; Rodin in Paris. Address in 1929, 92 Fifth Avenue, New York, NY; summer, Stamford, CT.

CLOUGH, JANE B.
Sculptor. Born Chicago, IL, March 30, 1881. Pupil of Solon Borglum, Mahonri Young, J. E. and Laura Fraser, Anna V. Hyatt. Member: National Sculpture Society (life); Kansas City Society of Artists. Address in 1933, 1 West 67th Street, New York, NY; h. Kansas City, MO.

CLOVER-BEW, MATTIE MAY (MRS.).
Born in Indianapolis, IN, Aug. 17, 1865. Studied with Robert I. Aitken; Karl Bitter; L. P. Latimer; and G. Cadanasso. Awards: John Herron Art Institute, Indianapolis, 1919-21; California Palace of the Legion of Honor, San Francisco; Indiana State Fair, 1921. Member: San Francisco Society of Women Artists; Indiana Art Club. Address in 1953, San Francisco, CA.

CLUTE, EDWARD C.
Sculptor. At Rochester, New York, 1854. Executed life-size marble bust there.

COBB, CYRUS.
Sculptor, painter, and musician. Born in Malden, MA, August 6, 1834. His twin brother, Darius Cobb, also noted as a painter. Pupil of John A. Jackson. Works: "Soldiers' Monument" on Cambridge Common; "America," "Paul Revere," at Boston; produced many works of sculpture and painting of a national character, besides directing choruses and lecturing on art; wrote and illustrated "Sonnets to the Masters of Art." Member: Boston Art Club. Died in Allston, MA, January 29, 1903.

COBB, DARIUS.
Sculptor and painter. Primarily painter. Born in Malden, Mass., August 6, 1834. Died in Newton Upper Falls, Mass., April 23, 1919. (Mallett's)

COCHRAN, DEWEES.
(Mrs. Dewees Cochran Helbeck). Sculptor, painter, teacher, designer, and craftsman. Born in Dallas, TX, April 12, 1902. Studied: Philadelphia Museum School of Industrial Art; University of Pennsylvania; Penna. Academy of Fine Arts, with Henry McCarter. Member: American Craftsmen's Education Council; honorary member, Doll Collectors of America Inc., Boston; National Institute of American Doll Artists (president, 1967-69, director, from 1975). Creator of the "Portrait Doll," "The Look-Alikes," "The Grow-Up Dolls." Exhibited: Marie Sterner Gallery, 1931; Philadelphia Print Club, 1931; Carpenter Art Gallery, Dartmouth College, 1952; Women's

International Exp., 71st Armory, NY, 1959. Contributor to craft magazines. Taught: Design Director, Instructor, School for American Craftsmen, Hanover, NH, 1946-47; Director, Dewees Cochran Dolls. Address in 1982, Felton, CA.

CODNER, WILLIAM.
Sculptor of gravestones. Born in Boston, Mass., July 24, 1709. Introduced portraits in mortuary art. Sons, Abraham and John, followed same specialty. Died in Boston, Mass., September 12, 1769.

COE, MATCHETT HERRING.
Sculptor. Born in Loeb, Texas, July 22, 1907. Studied: Lamar College; Cranbrook Academy of Art, with Carl Milles. Awards: Prize, All-Texas Exhibition, 1952. Work: Portrait busts, panels, statues, memorials in Beaumont, Houston, Sabine Pass, New London, Texas; animal figures for entrance to zoo at Herman Park, Houston, Texas; American Numismatic Society and Metropolitan Museum of Art, NY; Carnegie Museum, Pittsburgh; Corcoran. Exhibited: National Sculpture Society, 1950, 52; American Numismatic Society Convention, San Diego, 1968; many others. Address in 1982, Beaumont, Texas.

COFFEE, THOMAS.
Sculptor. Born in England, c. 1800. Worked: NYC, 1830-69. Exhibited: Bust of Judge Hitchcock of Mobile, AL, Apollo Gallery, 1839; busts, including "Osceola," National Academy, 1841-42; statue of Henry Clay, American Institute, 1844, 56.

COFFEE, THOMAS JR.
Sculptor. Born in NYC, c. 1839. Worked: NYC with father, Thomas Coffee.

COFFEE, WILLIAM JOHN.
Sculptor and painter. Born in England, c. 1774. Worked: Derby; London; NYC, 1816-1826; Albany, NY, 1827-45. Exhibited: Royal Academy, 1833; Apollo Gallery, 1839. In 1818 he executed busts of Thomas Jefferson, his daughter, and granddaughter; also bas-reliefs for City Hall, Albany, NY. Died c. 1846.

COFFIN, BARRY.
Sculptor. Born in Lawrence, KS, 1946. Studied at Institute of American Indian Art, Santa Fe. Sculpted and was employed at Shidoni Gallery and Foundry. Subjects are satirical Indian figures, executed in clay and bronze. Represented by the Squash Blossom, Aspen, CO; Shidoni Gallery, Tesuque, NM. Address since 1974, Santa Fe, New Mexico.

COGDELL, JOHN STEPHANO.
Sculptor and painter. Born in Charleston, SC, Sept. 19, 1778. He was largely self-taught, but received some help from Washington Allston, and studied abroad. From about 1820 modelled a few busts of distinguished Americans. Exhibited at the National Academy; Penna. Academy; Artists' Fund Society; Boston Athenaeum; and American Academy. Died Feb. 25, 1847.

COGGESHALL, POLA WINSKY.
Sculptor. Born in San Angelo, TX, 1945. Lived on Long Island 1946-58; returned to Texas. Apprenticed in a Dal-

las artist's foundry; studied anatomy. Has exhibited through Shidoni Gallery and Foundry, Tesuque, NM. Subjects are ranch animals. Works in bronze. Address since 1958, Dallas, TX.

COHEN, ADELE.
Sculptor and painter. Born in Buffalo, NY. Studied at Art Institute Buffalo; Albright School of Buffalo; Parsons School of Art, NY. Works: Albright-Knox Art Gallery, Member's Gallery, Buffalo, NY; Museum Arts and Science, Evansville, IN; University of Mass., Amherst; Towson College, Baltimore, MD. Commissions: Stage sets sculpted of polyester resins and fibres for the play, "Fando," Buffalo Fine Arts Academy and Workshop Repertory Theater, NY State Theater, 1967. Exhibitions: Art Across America, Institute of Contemporary Art, Boston, 1965; Western NY Exhibition, Buffalo Fine Arts Academy, 1957-71; Patteran Artists, NY State travel tour, 1975-77; Unordinary Realities, Xerox Corp, Rochester, NY, 1975; Michael C. Rockefeller Arts Center Gallery, State University College, Fredonia, NY, 1975. Awards: Best of Show, Western NY Exhibition, 1964; Painting Award, Annual New England Exhibit, Silvermine Guild Artists, 1965 and 66; Paul Lindsay Sample Memorial Award, Chautauqua Exhibition of American Art, 1967. Member of National Association of Women Artists, Inc. Address in 1982, Snyder, NY.

COHEN, KATHERINE M.
Sculptor and painter. Born in Philadelphia, March 18, 1859. Pupil of Penna. Academy of Fine Arts, Art Students League of NY; under Augustus Saint-Gaudens, and with Mercie in Paris. Among her best known works: Statue of General Beaver, bronze of Abraham Lincoln, "Dawn of Thought," and "Vision of Rabbi Ben Ezra." She died in Philadelphia, Dec. 14, 1914.

COHEN, NESSA.
Sculptor. Born in NYC, in 1885. Pupil of James E. Fraser, NY; and with Despiau and Charles Malfrey in Paris. Studied at Cooper Union and Art Students League. Among her work: "Sunrise," Havana, Cuba, and groups of Indians of the Southwestern United States, American Museum of Natural History. Exhibited at National Sculpture Society, 1923; Penna. Academy of Fine Arts, Philadelphia, 1924. Member of NY Architectural League, National Association of Women Painters and Sculptors, Society of Independent Artists. Address in 1953, Newark, NJ. Died in NYC, Aug. 4, 1915.

COLAC, DENIS.
Sculptor. In New Orleans, 1841-42. Worked in marble.

COLBORN, JANE TAYLOR.
Sculptor and educator. Born in Rochester, NY, July 13, 1913. Studied at University of Rochester, NY, B.A. (English), 1934; Cornell University, Ithaca, summer school, drama and speech, 1935; Silvermine Guild School of Arts, Westport, CT. Work in Springfield Art Museum, MA. Has exhibited at Silvermine Guild of Artists; Wadsworth Antheneum. Received awards from Springfield Art League, purchase award, Best in Show; New England Exhibition, Renaissance Art Foundry, award for metal sculpture; New Haven Paint and Clay Club, Jay

Johnston Award Metal Sculpture. Member of National Association of Women Artists; Artists Equity Association New York; Silvermine Guild Artists; New Haven Paint and Clay Club. Taught at Silvermine Guild of Artists. Works in metal. Address in 1982, New Canaan, CT.

COLBURN, ELANOR (ELEANOR R.).
Sculptor and painter. Born in Dayton, OH, 1866. Pupil of Art Institute of Chicago. Member: Laguna Beach Art Association; San Diego Artists Guild. Awards: Second prize, Laguna Beach Art Association, 1927; third prize, 1928, first prize, 1929, Los Angeles Painters and Sculptors; Lesser Farnum prize, San Diego, 1930; gold medal, Laguna Beach Art Association, 1932. Represented in Chicago Municipal Art League. Address in 1933, Laguna Beach, CA. Died in 1939.

COLBY, VICTOR E.
Sculptor and educator. Born in Frankfort, IN, January 5, 1917. Studied at Corcoran School of Art; Indiana University, A.B., 1948; Cornell University, M.F.A., 1950. Work in Cornell University Museum, Ithaca, NY; Munson-Williams-Proctor Institute, Utica, NY; others. Teaching sculpture at Cornell University, from 1950. Works in wood. Address in 1982, Groton, NY.

COLE, EMILY BECKWITH.
Sculptor. Born New London, CT, January 2, 1896. Pupil of Louis Gudebrod. Address in 1926, Hartford, CT.

COLE, MARGARET WARD.
(Mrs. Alphaeus). Sculptor. Born Haslington, England, in 1874. Pupil of Injalbert and Rollard in Paris. Member: All. Artists of Amer. Work: Mem. tablet of Dr. Clinton L. Bagg, Metropolitan Hospital, Welfare Island, New York City; Memorial Tablet, Akron University, Akron, OH. Address in 1933, 33 West 67th Street, New York, NY; summer, Lower Montville, NJ.

COLETTI, JOSEPH ARTHUR.
Sculptor. Born in San Donato, Italy, Nov. 5, 1898. Studied with John Singer Sargent. Works: Chapel of St. George's School, Newport, RI; Tympanum Chapel of Mercersburg Academy, Mercersburg, PA; Eugene Dodd Medal, Harvard Architectural School and Edward W. Bok gold medal, Harvard Advertising Award, Cambridge, MA; Coolidge Memorial, Widener Library, Harvard University, Harvard War Memorial, "Columbia" and "Alma Mater," also candelabra, Cambridge, MA; Brookgreen Gardens, SC; St. Theresa of Avila statue, Washington Cathedral; Vatican Library, Rome; portrait busts and fountains; many others. Awards: Sachs Fellow, Harvard University, 1924-26; two gold medals, Tercentenary Fine Arts Exhibition, Boston, 1930; Henry Hering medal, National Sculpture Society; others. Exhibited: Penna. Academy of Fine Arts, 1929-31; Museum of Modern Art, 1933; World's Fair of NY, 1939; Philadelphia Museum of Art, 1939; Metropolitan Museum of Art, 1942; Whitney, 1940; Audubon Artists, 1946. Member: National Sculpture Society; Architectural League of NY. Address in 1970, Fenway Studios, Boston, MA. Died in 1973.

COLLENDER, JIM.
Sculptor and painter. Born in Los Angeles, CA, 1935.

Studied: Chouinard Art School, Los Angeles, CA. Worked in aerospace industry as a commercial artist. Paintings have appeared on magazine covers. Has exhibited at Denver and Santa Fe galleries. The Wyoming country provides his painting subjects; he sculpts rodeo subjects. Reviewed in *Southwest Art*, March 1979. Represented by Two Grey Hills, Jackson, WY; Images Gallery, Minneapolis, MN. Address since 1966, Longmont, CO.

COLLIN, JENNY PETRIA.
Sculptor. Born in Sweden. Pupil of Roscoe Mullins, London, England. Member: San Francisco Art Association. Address in 1918, San Francisco, CA.

COLLINS, FREDERIC.
Sculptor. Born in Akron, OH, 1910. Early on he sold wood sapling carvings to Abercrombie & Fitch. Studied at University of Michigan Engineering School. Lived near Cranbrook Academy and met the sculptor Carl Milles. Has executed commissions of dogs, horses, studies of horse breeds. Works in bronze and concentrates on horse subjects. Represented by Shidoni Gallery, Tesuque, NM; Son Silver Gallery, Sedona, AZ. Address in 1982, Santa Fe, NM.

COLLINS, JIM.
Sculptor and educator. Born in Huntington, WV, September 12, 1934. Studied at Marshall University, A.B., 1957; University of Michigan, Ann Arbor, M.P.H., 1961; Ohio University, M.F.A., 1966. Work in Wichita Art Association, KS; Milwaukee Art Center, WI; outdoor sculpture, St. Augustine Church Signal Mountain, TN, 1970; series of five wall reliefs, St. Jude Catholic Church, Chattanooga, 1978. Has exhibited at Arkansas Arts Center, Little Rock, 1973; painting, J. B. Speed Art Museum, Louisville; Southern Association Sculptors Traveling Exhibition; invitational, Mississippi Museum of Art, Jackson, 1978; others. Works in wood and metals. Address in 1982, Signal Mountain, TN. Living in Ohio in 1984.

COLMAN, VIRGINIA O'CONNELL.
Sculptor and designer. Born in Manhasset, Long Island, NY. Studied at Columbia University, B.S. (art), 1947; Teachers College, Columbia University, M.A. (art), 1968; sculpture with Minoru Niizuma; watercolor with Edgar A. Whitney and George Post. Has exhibited at National Academy Galleries, NY, 1974-75, 77 and 79; Silvermine Guild Artists; Newark Museum, NJ. Member of Catharine Lorillard Wolfe Art Club; Sculptors Association of NJ; Stone Sculpture Society, NY. Taught stone carving, Sculpture Center, NY, summer 1980. Works in marble and limestone. Address in 1982, Leonia, NJ.

COLOMBARA, C.
Sculptor. At Charleston, South Carolina, 1855.

COLT, MARTHA COX.
Sculptor, painter, and teacher. Born in Harrisburg, PA, Sept. 16, 1877. Pupil of Philadelphia School of Design for Women; Penna. Academy of Fine Art; NY School of Art; Moore Institute; University of Pennsylvania; and with Kenneth Hayes Miller, Henry B. Snell, and Calder Penfield. Member: Harrisburg Art Association; Plastic Club,

Philadelphia. Work: Bronze bust of Dr. Charles Hatch Ehrenfeld, York Collegiate Institute, York, PA; Philadelphia Museum of Art. Exhibited: Plastic Club; Harrisburg Art Association. Address in 1953, Shiremanstown, PA.

COLTMAN, ORA.
Sculptor and painter. Born Shelby, OH, Dec. 3, 1860. Pupil of Art Students League of NY; Julian Academy in Paris; Magadey Schule, Munich. Member: Cleveland Society of Artists; Cleveland Printmakers. Represented in Cleveland Museum of Art. Address in 1933, Cleveland, OH.

COLTON, MARY-RUSSELL FERRELL.
(Mrs. Harold S.). Sculptor, painter, teacher, serigrapher, writer, and museum curator. Born in Louisville, KY, March 25, 1889. Studied: Moore Institute; Philadelphia School of Design for Women; pupil of Daingerfield; Henry B. Snell. Member: National Association of Women Artists; American Artists Professional League; Philadelphia Watercolor Club; American Watercolor Society of New York; Washington Watercolor Club; American Federation of Arts; Plastic Club. Author: "Indian Art and Folk Lore." Contributor to "Plateau," published by Museum of Northern Arizona. Curator, Museum of Northern Arizona, Flagstaff, AZ, 1928-46. Address in 1953, Museum of Northern Arizona; h. Flagstaff, AZ.

COMANTONIO, ALCAMEDOS GIO.
Sculptor. Address in 1935, Jersey City, New Jersey. (Mallett's)

COMSTOCK, FRANCES BASSETT.
Sculptor, painter, and illustrator. Born Elyria, OH, Oct. 16, 1881. Pupil of Gari Melchers, Frederick W. Freer, and John Vanderpoel. Member: NY Water Color Club. Address in 1929, Leonia, NJ.

CONANT, SYLVIA FERGUSON.
Sculptor. Exhibited: Salon de la Nationale, 1928, 1935; Tuileries, 1933.

CONAWAY, GERALD.
Sculptor and painter. Born in Manson, WA, February 15, 1933. Studied at Everett Jr. College, Washington, A.B.A.; University of Washington, Seattle, B.A. (art education) and M.F.A. (sculpture) with George Tsutakawa and Everett Dupen. Work in Anchorage Fine Arts Museum, Alaska; (marble monument), Mutual Insurance Co., NY and Anchorage Centennial, Anchorage; concrete wall sculptures, Raymond Lawson, AIA. Has exhibited at Sculpture Northwest, Seattle, 1968. Works in wood, stone; steel, plastics. Address in 1982, Anchorage, AK.

CONGDON, WILLIAM.
Sculptor and painter. Born in Providence, RI, April 15, 1912. Studied: Yale University, B.A.; Demetrios School of Sculpture; Provincetown School of Art, with Henry Hensche. Awards: Temple gold medal, Penna. Academy of Fine Arts, 1951; prizes, Rhode Island Museum of Art, 1949, 50; Clark Award, Corcoran Gallery, 1953. Work: City Art Museum of St. Louis; University of Illinois; Detroit Institute of Art; Rhode Island Museum of Art; Boston Museum of Fine Arts; Phillips Collection, Wash-

ington, DC; Whitney; Museum of Modern Art; Metropolitan Museum of Art; others. Exhibited: National Academy of Design, 1939; Penna. Academy of Fine Arts, 1937-39, 1950; Carnegie Institute, 1940, 52, and 58; Whitney Museum of American Art, 1941, 51, 52, 55; Rhode Island Museum of Art, 1948, 49; Addison Gallery of American Art, Andover, MA, 1941; Art Institute of Chicago, 1952; Toledo Museum of Art, 1952; Albright Art Gallery, 1952; California Palace of Legion of Honor, 1952; Contemporary Art Society, Boston, 1951; Los Angeles Museum of Art, 1951; Venice Biennale, 1952; Metropolitan Museum of Art, 1950; Wildenstein Gallery, 1950; Betty Parsons Gallery, 1949, 50, 52; Margaret Browne Gallery, 1951; Duncan Phillips Gallery, 1952; Contemporary Art, 1951; Ferrara, Italy, 1981; others. Illustrated articles in *Life Magazine* and others. Address in 1953, Venice, Italy; h. Providence, RI. Living in Milan, Italy, in 1982.

CONKEY, SAMUEL.
Sculptor and painter. Born in New York City, 1830. Worked: Chicago; New York City. Exhibited: National Academy, 1867-90. Died in Brooklyn, New York, December 2, 1904.

CONKLING, MABEL.
(Mrs. Paul B. Conkling). Sculptor. Born in Boothbay, ME, Nov. 17, 1871. Studied in Paris under Bouguereau and Collin until 1899. In 1900 she studied sculpture under MacMonnies. Work: "The Lotus Girl," "Song of the Sea," and portrait reliefs of Dr. George Alexander, Mrs. James A. Garland, and Hope Garland. Member of National Association of Women Painters and Sculptors; American Federation of Arts; American Numismatic Society; Society of Medalists; Art Workers' Club. Exhibited at National Sculpture Society, 1923. Address in 1933, 26 West 8th St., NYC; summer, Boothbay, ME.

CONKLING, PAUL BURLEIGH.
Sculptor and painter. Born in New York City, October 24, 1871. Pupil of MacMonnies, Falguiere, and Ecole des Beaux-Arts, Paris; and Kensington School of Art, London. Member of Society of American Artists; Society of Independent Artists. Exhibited at National Sculpture Society, 1923. His specialty was portraiture. Address in 1926, 5 MacDougal Alley; 26 West 8th St., NYC; summer, Boothbay, ME. Died March, 1926.

CONLEY, SARAH WARD.
Sculptor, painter, illustrator, craftsman, writer, and teacher. Born Nashville, TN, Dec. 21, 1861. Pupil of Bouguereau, Julian and F. A. Bridgman in Paris; Ferrari in Rome. Member: Nashville Art Association. Work: Woman's Building, Centennial Exp., Nashville, TN; mural decorations in Battle Creek Sanitarium. Address in 1929, Nashville, TN.

CONLON, GEORGE.
Sculptor. Born in Maryland in 1888. Pupil of Injalbert and Bartlett in Paris. Address in 1926, Baltimore, MD. Died in 1980.

CONLON, JAMES EDWARD.
Sculptor and art historian. Born in Cincinnati, OH, December 9, 1935. Studied at Ohio State University, B.Sc. (art education), 1959; M.A. (fine arts), 1962. Work in The Fine Arts Museum, South Mobile. Has exhibited at Southern Association of Sculptors Traveling Exhibition, Smithsonian Institution; Montgomery Museum of Art, 1978, 79; others. Received Award to Develop the Ethnic American Art Slide Library, Samuel H. Kress Foundation, 1972-75; University Research Grant, 1976-77; others. Member of Southern Association of Sculptors; others. Teaching at University of Southern Alabama, Mobile. Works in woods, limestone, cast and laminated plastics. Address in 1982, Citronelle, AL.

CONN, EILEEN.
Woodcarver and painter. Born in Uniontown, PA, 1948. Studied: Carnegie-Mellon University; Carnegie Museum; Ohio University, B.F.A., 1969. Specialty is birds and bird groupings. Birds are carved from basswood; copper foil and wire are used for other parts of groupings; wire is used for birds' legs. Most frequently carves cardinals, chickadees, and quail. Reviewed in *Southwest Art*, April 1981. Address since 1974, Lake Montezuma, AZ.

CONNAWAY, INA LEE WALLACE.
Sculptor and painter. Born in Cleburn, TX, December 27, 1929. Studied at Baylor University; also with Rhinhold Ewald, Hanau, Ger and Junicero Sekino, Alaska; Famous Artist Course, University of Alaska; Corcoran School of Art; George Washington University, B.A. Work: John F. Kennedy Elementary School, Ft. Richardson, AK; Alaskan State Museum, Juneau; P.E. Wallace Jr. High School, Mt. Pleasant, TX; Cora Kelly Elementary School, Alexandria, VA; Kate Duncan Smith DAR School, Alabama. Exhibitions: Lasting Americana, A Series on the US, Ft. Richardson, Juneau, and Anchorage, AK, 1962-65; American Artists Professional League Grand National, 1966; Sovereign Exhibitions Ltd., VA, NC, and SC, 1970-71; US Military Academy Library Exhibition, 1970; DAR Army and Navy Chapter Exhibition, 1971. Awards: Prizes Beaux Arts Ball, Artist of the Month and American Art Week, Anchorage, 1963; Alaska State Fair, Palmer, 1964. Media: Oil, stone, wood, and bronze. Address in 1976, c/o Lynn Kottler Gallery, 3 East 65th Street, NYC.

CONNELL, BUNNY.
Sculptor. Exhibited: One-man shows, St. Louis, Denver, Toronto. Guest Artist, Game Conservation International, Safari Club, and Mezere. Conference work displayed at Sportsmans Edge Ltd., New York; Chrisolm Gallery, West Palm Beach, FL. Member: Society of Animal Artists. Media: Bronze. Address in 1983, Sheridan, Wyoming.

CONNELLY, PIERCE FRANCIS.
Sculptor and landscape painter. Born in Louisiana in 1841; raised in England. Studied art in Paris and Rome; took a studio as a sculptor in Rome about 1860. Visited the U.S. in 1876; went to New Zealand and became a well-known mountain climber and landscape painter. Died in 1902.

CONNER, BRUCE G.
Sculptor, painter, and film maker. Born in McPherson, KS, Nov. 18, 1933. Went to California in 1957. Studied at

University of Wichita, KS, with David Bernard; University of Nebraska, with Rudy Pozzatti; Brooklyn Museum Art School, with Reuben Tam; University of Colorado at Boulder. Taught: California College of Arts and Crafts, Oakland, 1965-66; San Francisco Art Institute, 1972; California State at San Jose, 1974. In collections of Museum of Modern Art; Art Institute of Chicago; Los Angeles Co. Art Museum; Guggenheim; Whitney. Exhibited at East and West Gallery, San Francisco; Allan Gallery, NYC; Batman Gallery, San Francisco; Ferus Gallery, Los Angeles; San Francisco Art Institute; Robert Fraser Gallery, London; de Young Museum, San Francisco; Museum of Modern Art; Whitney, NYC; Los Angeles Co. Museum; Dallas Museum of Fine Arts; Oakland Museum; National Galerie, Berlin; National Museum of Modern Art, Paris; many others. Awards: Copley Foundation Award; gold medal Milan Biennale Nuovo Techniques in Arts; Guggenheim Fellowship. Address in 1982, San Francisco, CA.

CONNER, JEROME.
Sculptor. Born in Ireland, Oct. 12, 1875. Self-taught. Member: Society of Washington Artists. Work: Bronze tablet, "Nuns of the Battlefield," Washington, DC. Address in 1929, Washington, DC.

CONNOR, J. STANLEY
Sculptor. Born in 1860. Self-taught initially; later visited Italy to study sculpture. Most notable sculpture was the marble bust of "Cain."

CONNOR, MAUREEN.
Sculptor. Studied: Pratt Institute, Brooklyn, New York. Exhibitions: Women's Interart Center, New York City, 1973; Adelphi University, "New Reflections," Staten Island Community College, 1974. Presently Vice-President for Sculpture, Architectural League of New York. One of the noted works is entitled "Breathing Flowers," 1972-73; an inflatable sculpture.

CONOVER, CLAUDE.
Sculptor and ceramist. Born in Pittsburgh, PA, December 15, 1907. Studied at Cleveland Institute of Art. Work in Cleveland Museum of Art, OH; Everson Museum of Art, Syracuse, NY; others. Has exhibited at Cleveland Museum of Art; Everson Museum of Art; Butler Institute of American Art, Youngstown, OH; Objects USA, traveling exhibition to some 35 museums in US and Europe; others. Received awards from Everson Museum of Art; Columbus Museum of Art; Cleveland Museum of Art; others. Member of American Crafts Council. Address in 1982, Cleveland, OH.

CONRADS, CARL H.
Sculptor. Born in Germany, 1839, came to New York in 1860. He served in the Union Army. Among his works are statues of Alexander Hamilton, Central Park; "General Thayer," West Point; and "Daniel Webster" for the Capitol at Washington. He resided in Hartford, Conn., after 1866.

CONTI, GINO EMILIO.
Sculptor, painter, and teacher. Born in Barga, Italy, July 18, 1900. Studied: Rhode Island School of Design; Ecole des Beaux-Arts, Julian Academy, Paris. Awards: Prizes, IBM, 1941; Providence Art Club, 1950. Work: Murals, Rhode Island State College; Rhode Island Public School. Exhibited: Paris, 1925; Architectural League, 1929, 30; National Academy of Design, 1929; Penna. Academy of Fine Arts, 1929; City Art Museum of St. Louis, 1930; Providence Museum of Art; Worcester Museum of Art, Worcester, MA; Cincinnati Museum Association; Newport Art Association; Doll & Richards, Boston; Argent Gallery, 1950, 51; Providence Art Club, 1950, 51; Des Moines Art Center, 1951; Addison Gallery of American Art, 1951; Wadsworth Atheneum, 1950; Silvermine Guild Artists, 1952; Ogunquit Art Center, 1951, 52; Springfield Museum of Art, 1952. Member: Architectural League of NY; Providence Art Club; Providence Water Color Club. Address in 1953, Providence, RI.

CONTI, TITO.
Ornamental sculptor. Born in Florence, Italy. Studied there. Just after Civil War came to US and opened studio in Boston. Died there February 21, 1910.

CONTOGURIS, CHRIST.
Sculptor and painter. Born in New York, NY, July 6, 1913. Studied: University of Wisconsin; Layton Art School; Art Institute of Chicago; and with Gerrit Sinclair, Francis Chapin, Olga Chassaing. Exhibited: Art Institute of Chicago, 1944. Address in 1953, Chicago, Ill.

CONWAY, JOHN SEVERINUS.
Sculptor and painter. Born in Dayton, Ohio, in 1852. Pupil of Conrad Diehl, Jules Lefebvre, Boulanger, and Millet in Paris. Work: Mural decorations in Chamber of Commerce, Milwaukee. Sculptor for "Soldiers' Monument," Milwaukee. Member: NY Architectural League, National Sculpture Society. Died Dec. 25, 1925, in Tenafly, NJ.

CONWAY, WILLIAM JOHN
Sculptor and painter. Born in St. Paul, Oct. 26, 1872. Pupil of Colarossi Academy under Collin, Courtois and Prinet in Paris. Member: Whistler Club; Art Workers' Guild; Minnesota State Art Society; Artists' Society, St. Paul Institute. Address in 1933, St. Paul, MN.

COOK, MAY ELIZABETH.
Sculptor. Born Chillicothe, OH, Dec. 1881. Pupil of Paul Bartlett; Ecole des Beaux-Arts and Colarossi Academy in Paris. Member: Columbus League of Artists; American Ceramic Society (associate); Plastic Club; National Sculpture Society; National Arts Club; National Association of Women Painters and Sculptors; Philadelphia Alliance; Gallery of Fine Arts, Columbus; American Federation of Arts; Union Internationale des Beaux-Arts des Lettres, Paris. Represented in Carnegie Library, Columbus OH; Ohio State University, Columbus, OH; National Museum, Washington, DC; memorial panels, Colorado Springs; Chillicothe, OH; war work, wax models from life masks for reconstruction among wounded soldiers. Address in 1933, Columbus, OH; National Arts Club, 15 Gramercy Park, NYC. Died in 1951.

COOK, ROBERT HOWARD.
Sculptor and medalist. Born in Boston, MA, April 8, 1921.

Studied at Demetrios School, 1938-42; Beaux Arts, Paris, under Marcel Gaumont, 1945. Works in Whitney Museum of American Art, NY; Penna. Academy of Fine Arts, Philadelphia; Hirshhorn Collection, Washington, DC; Thespis (12 ft. long bronze), Canberra Theatre Center, Australia, 1965; others. Has exhibited at Institute of Contemporary Art, Boston; Mint Museum of Art, Charlotte, NC; Virginia Museum of Fine Art, Richmond; Penna. Academy of Fine Arts; Whitney Annual; National Academy of Design; others. Received second prize, Prix de Rome, American Academy of Rome; National Academy of Arts and Letters, Cash Award and Best-of-Show; Tiffany Award; others. Member of Sculptors Guild. Works in bronze and wood. Address in 1982, Rome, Italy.

COOK-SMITH, JEAN BEMAN.
Sculptor and painter. Born in New York, March 26, 1865. Pupil of Art Institute of Chicago; Chase. Studied in Holland, France, and Italy. Member: National Academy of Women Painters and Sculptors. Work: "The Maya Frieze," San Diego Museum, CA. Address in 1933, San Diego, CA.

COOKE, KATHLEEN McKEITH.
Sculptor and painter. Born in Belfast, Ireland, Sept. 30, 1908; US citizen. Studied with Arthur Schweider, Samuel Adler, Madeleine Gekiere, Collette Roberts, and Theodoros Stamos. Works: University of Utah, Cornell University, Arts Council Northern Ireland, Bank Ireland, and University of Notre Dame; plus others. Exhibitions: One-woman shows, Betty Parsons Gallery, 1970 and 75, David Hendriks Gallery, Dublin, Ireland, 1971 and 73; Kunstmuseum, Odense, Denmark, 1973, Carstens Gallery, Copenhagen, 1973, Compass Gallery, Glasgow, 1973, Galerie Rivolta, Lausanne, 1973 and Arts Council Gallery, Belfast, 1973; Philadelphia Museum Art, 1971; Hillsborough Art Center, Northern Ireland, 1971; Drawings by Living Americans, National Endowment for the Humanities Traveling Exhibition, 1972; Gordon Lambert Collection, Municipal Gallery of Modern Art, Dublin, 1972; plus others. Media: Clay, stone; oil, and dry point. Address in 1976, 95 Lexington Ave., NYC. Died in 1978.

COONEY-CRAWFORD, THOM M.
Sculptor and painter. Born in Boston, MA, September 23, 1944. Studied at Provincetown Workshop, 1963 and 64; Spring Hill College, Mobile, AL, B.S., 1962-66; Syracuse University, M.F.A., 1966-67; Rhode Island School of Design, 1969. Work includes painting and sculpture, Prickly Mt. Architectural Project, Warren, VT; painting and sculpture, Bundy Art Museum, Waitesfield, VT. Has exhibited at Soho Center of Visual Artists, NY, 1978; Weatherspoon Art Gallery, Greensboro, NC; Tibor De Nagy Gallery, NY, 1981; Aldrich Museum of Contemporary Art, Ridgefield, CT, 1981; others. Works in oil and bronze. Address in 1982, 12-07 Jackson Avenue, NYC.

COOPER, ALICE.
Sculptor. Born in Denver, CO. Among her best known works, "Summer Breeze," "Dancing Fawn," and "Frog Girl."

COOPER, BROTHER ETIENNE.
Sculptor, painter, and teacher. Born in Altoona, PA, July 11, 1915. Studied: University of Notre Dame, A.B.; Catholic University. Exhibited: Hoosier Salon, 1950. Work: Mural, Children's Room, Sts. Peter and Paul Cathedral, Indianapolis. Illustrated "Young Prince Gonzaga," 1944. Taught art at Cathedral High School, Indianapolis, Ind. Address in 1953, Notre Dame, IN.

COOPER, ELIZABETH.
Sculptor. Born in Dayton, OH, 1901. Studied with Sally James Farnham and at American School of Sculpture. Exhibited at National Sculpture Society, 1923. She made a specialty of animals. Address in 1926, Stamford, CT.

COOPER, GEORGE VICTOR.
Sculptor, portraitist, landscapist, lithographer, illustrator, and cameo cutter. Born in Hanover, New Jersey, Jan. 12, 1810. Worked: New York City, 1835-36; California, from 1849. Exhibited: Apollo Association, 1839; National Academy, 1839. Worked with J. M. Lett, *California Illustrated*, 1853; Cooper made the illustrations. Noted work: Portrait of Abraham Lincoln. Died in New York City, Nov. 12, 1878.

COOPER, LUCILLE B.
Sculptor and painter. Born in Shanghai, China, Nov. 5, 1924; US citizen. Studied at University of California, Los Angeles; University of Hawaii; Honolulu Academy of Art. Works: Painting, Hawaii Loa College. Commissions: 48 colleges, Polynesian Hotel, Honolulu, Hawaii, 1960; oil painting, Fiji Hotel, 1971. Exhibitions: 3 Plus 1 Show, Ala Moana, Honolulu; Honolulu Academy of Art Annual; Easter Art Festival; Hawaii Painters and Sculptors League Annual; Honorary Retrospective, Hawaii Loa College, 1970. Awards: Best in Show for Watercolor, Watercolor and Serigraph Society; honorable mention for Watercolor. Member: Hawaii Painters and Sculptors League (secretary); Hawaii Potters Guild; Hawaii Craftsmen (president); honorable member Windward Art Guild (president). Media: Clay, acrylic; oil, and watercolor. Address in 1980, Shanghai, China.

COOPER, MARIO RUBEN.
Sculptor, painter, and illustrator. Born in Mexico City, Mexico, Nov. 26, 1905. Study: Otis Art Institute, Los Angeles, 1924; Chouinard Art School, Los Angeles, 1925; Grand Central Art School, NYC, 1927-37; Columbia University; with F. Tolles Chamberlin, Louis Trevisco, Pruett Carter, Harvey Dunn. Work: Metropolitan Museum of Art; Butler Institute; NASA; and others. Commissions for USAF: painting of Atlas ICBM, planes, capitals of Europe; invited by National Gallery to document Apollo 10 & 11 flights. Exhibitions worldwide. Illustrations in *Collier's, Woman's Home Companion, American, Cosmopolitan*. Head, team of artists to Japan, Korea, Okinawa, USAF, 1956, and to Japan, 1957; art consultant, USAF, 1960; teacher, Art Students League, from 1957, and at National Academy of Design School of Fine Arts, City College of NY, 1961-68, and Grand Central School of Art. Received Audubon Artists Guild Medal of Honor, 1974; Samuel F. B. Morse Gold Medal, National Academy of Design; American Water Color Society High Winds Medal, 1979, 81. Member: Honorary member Royal

Water Color Society of Great Britain; Century Association; Audubon Artists (president, 1954-58); Academician, National Academy of Design; American Water Color Society (president from 1959). Works in watercolor. Address in 1982, 1 W. 67th St., NYC.

COPP, ELLEN RANKIN.
Sculptor. Born in Atlanta, IL, 1853. Pupil of Art Institute of Chicago; Fehr School in Munich. Address in 1903, Chicago, IL.

COPPINI, POMPEO.
Sculptor and painter. Born Moglia, Italy, May 19, 1870. Pupil of Academia de Belle Arti and Augusto Rivalta in Florence; came to America in 1896; citizen of US in 1901. Represented in the US by 36 public monuments, 16 portrait statues and about 75 portrait busts, and in Mexico City by the Washington Statue, gift from Americans to Mexico. Address in 1953, San Antonio, TX; 210 West 14th Street, NYC. Died Sept. 27, 1957, in San Antonio, TX.

COPPOLA, ANDREW.
Sculptor and draftsman. Born in Cophaigue, Long Island, NY, January 6, 1941. Studied at Hartford Art School and Hillyer College, B.F.A., 1963; with Wolfgang Behl and James Van Dyke; Fulbright Hays Fellowship in Sculpture, Florence, Italy, 1964-65. Work in Slater Museum, Norwich Free Academy, CT; sculpture, Berlin Town Hall, CT, 1975; bronze, Amistad Resource Center, Hartford, CT; fountain, Tower Park, Winsted, CT; plus gold and silver jewelry; others. Has exhibited at New Britain Museum of American Art, CT, 1973; Wadsworth Atheneum Museum, 1977; others. Received awards from National Academy of Design, NY, 1971, Sculpture Portrait Prize, Dessie Greer Award; Conn. Council on Arts Individual Artist's Grant, 1977. Taught at Hartford Art School, 1970-71 and Jewish Community Center, West Hartford, 1970-78, instructor of sculpture. Works in carved wood, hammered sheet metal; assemblages. Address in 1982, Hartford, CT.

COPPOLINO, JOSEPH.
Sculptor and designer. Born in New York, NY, November 3, 1908. Studied: Cooper Union Art School, New York; Beaux-Arts Institute of Design, New York; National Academy of Design, and with Piccirilli, Lee Lawrie, Gaetano Cecere; Industrial Design with Dreyfuss, Barnhardt. Awards: Prizes, Beaux-Arts Institute of Design, New York, 1929, 35; Cooper Union Art School, New York; Prix de Rome, 1937, 38. Prosthetic work with Veteran's Administration, New York, NY. Address in 1953, Veteran's Administration, 252 Seventh Avenue, New York, NY; h. 217-09 120th Avenue, St. Albans, NY.

CORBETT, GAIL SHERMAN.
(Mrs. H. W. Corbett). Sculptor. Born in Syracuse, NY, in 1871. Studied modeling with Caroline Peddle (Ball); Art Students League with Augustus Saint-Gaudens, H. Siddons Mowbray, George de Forest Brush. Taught drawing and modeling for 2 years at Syracuse University, 1898-1899. Worked in Paris under the guidance of Saint-Gaudens, and at the Ecole des Beaux-Arts. Awards:

Honorable mention for sculpture, and bronze medal for medals, P.-P. International Exp., San Francisco, 1915. Member: National Sculpture Society; American Numismatic Society; National Association of Women Painters and Sculptors. Works: Hamilton S. White memorial, and Kirkpatrick memorial fountain, Syracuse, NY; tablet to Dean Vernon, Syracuse University, and bust of Dr. Calthrop, May Memorial Church, Syracuse, NY; bronze doors for Auditorium, Municipal Building and Tower, and large bronze zodiac and compass in front of Tower, Springfield, MA; garden fountains, sun-dials, and low relief portraits. Exhibited at National Sculpture Society, 1923. Address in 1933, 443 West 21st St., NYC. Died Aug. 26, 1952.

CORBINO, JON.
Sculptor. Born in Italy, 1905. Address in 1934, New York. (Mallett's)

CORNELL, JOSEPH.
Sculptor. Born in Nyack, NY, Dec. 24, 1903. Studied at Phillips Academy at Andover, MA. Settled in NYC, 1929. Exhibited at Peggy Guggenheim's "Art of this Century" Gallery (1944-45); Egan Galleries (1947-53); Stable Gallery (1953); Allen Frumkin Gallery (1953), Chicago; Museum of Modern Art, 1936, 61; Whitney Annuals, 1962, 66; Galerie des Beaux Arts, Paris, 1938; Carnegie, 1958; others. Associated with the Julien Levy Galleries, exhibiting there from 1932-42. Awards: Chicago Art Institute, 1959; Ada S. Garrett Prize, 1959; American Academy of Arts and Letters, Award of Merit, 1968. Many of his works are now held by the Hirshhorn Museum. Address in 1971, Flushing, NY. Died in 1972.

CORNWELL, MARTHA JACKSON.
Sculptor and painter. Born West Chester, PA, Jan. 29, 1869. Studied at Philadelphia School of Design; Penna. Academy of Fine Arts; and Art Students League of New York; and with Saint-Gaudens, H. Siddons Mowbray, and George de Forest Brush. Member: Art Students League of NY; Fellowship Penna. Academy of Fine Arts. Specialty, portrait bronzes. Exhibited at Penna. Academy of Fine Arts, Philadelphia, 1924. Died before 1926.

CORSE, MARY ANN.
Sculptor and painter. Born in Berkeley, CA, Dec. 5, 1945. Studied at University of California, 1963; California Institute of Arts, Chouinard scholar and B.F.A., 1968. Work: Los Angeles Co. Museum of Art; Solomon R. Guggenheim Museum, NY; Robert Mitchner Collections, University of Texas. Exhibitions: Whitney Sculpture Annual, Whitney Museum of American Art, NY, 1970; Permutations, Light and Color, Museum of Contemporary Art, Chicago, 1970; 24 Young Artists, Los Angeles Co. Museum, 1971; Theodoron Awards, Solomon R. Guggenheim Museum, 1971; 15 Los Angeles Artists, Pasadena Art Museum, 1972. Awards: New Talent Award, Los Angeles Co. Museum, 1968; Theodoron Award, Solomon R. Guggenheim Museum, 1970. Address in 1980, c/o Richard Bellamy, 333 Park S. at 25th, NYC.

CORSO, SAM.
Sculptor and designer. Born in Montevago, Italy, March 6,

1888. Studied: Cooper Union Art School. Member: Union Scenic Art. Awards: Prizes, Cooper Union Art School, 1920, 21. Exhibited: Models of Army, Navy, and Aviation Units of Allied Armed Forces at Grand Central Palace and Museum of Science and Industry, Rockefeller Center, NY. Art Director, Fox Films, Paramount Studios, 1925-32; West Coast Sound Studio, New York, NY, 1953. Address in 1953, 510 West 57th Street, New York, NY; h. Forest Hills, LI, NY.

CORTISSOZ, ROYAL.
Sculptor. Member of National Sculpture Society. Address in 1953, 167 East 82nd St., NYC.

CORWIN, SOPHIA M.
Sculptor and painter. Born in New York. Studied at Art Students League; National Academy School of Fine Arts; Hofmann School; Archipenko School; Phillips Gall. Art School, Washington, DC, with Karl Knaths; NYU. Awards: Phillips Gallery of Art, Washington, DC; Creative Arts Gallery; National Sculpture Competition Award, US Department of Housing and Urban Development. Collection: New York University. Exhibitions: Corcoran Gallery; Baltimore Museum; NYU; Capricorn Gallery, NYC; others. Living in Yonkers, NY, in 1982.

CORY, KATE T.
Sculptor, painter, and muralist. Born in Waukegan, IL, 1861. Studied: Cooper Union, NYC; Art Students League; pupil of Cox and Weir. From 1905 to 1912, lived among Hopis at Oraibi and Walpi. Moved to Prescott, AZ, 1913. Work in Smithsonian Institution; Public Museum, Prescott; University of Arizona, Tucson; Tuzigoot Museum, Clarkdale, AZ. Specialized in portraying the Hopi people and Arizona Landscape. Address in 1957, Prescott, AZ. Died in 1958.

COSMAN, BARD.
Sculptor. Studied: Pratt Institute, Brooklyn, NY; Brooklyn Museum Art School; Scholarship with Chaim Gross, Brooklyn, NY; American Museum of Natural History; Stone Sculpture Art Center of Northern NJ, Leonard Agronsky, Tenafly, NJ. Exhibited: One-man shows, Burrows Gallery, Englewood, NJ, 1973; Caravan House Gallery, NYC, 1973, 76, 79; Tenafly Nature Center (Animal Sculpture), Tenafly, NJ, 1981; group shows: Annual Showing, NY Physicians Art Association, NYC, 1954 to present; New York Bank for Savings, NYC, 1963; Benefit, Planned Parenthood, Bergen County, NJ, 1970; Lever House, NYC, 1974; Metropolitan Museum of Art, New York Physicians Association, NYC, 1974; Springfield Art League, 61st National Exhibition, Springfield, MA, 1980; Salmagundi Club, Third Annual Open, NYC, 1980; multiple subsequent shows, Salmagundi Club, NYC, 1981-82. Awards: First Prize, Sculpture, American Medical Association Art Show, NYC, 1971; Numerous Awards, (Honorable Mention, Second Prize, Sculpture), New York Physicians Art Association, NYC, 1954 to present; honorable mention, Salmagundi Club, NYC, 1981. Member: Society of Animal Artists; Salmagundi Club; New York Physicians Art Association; Art Center of Northern New Jersey. Media: Bronze and stone. Specialties: Birds, rep-

tiles, and amphibians. Address in 1983, Tenafly, New Jersey.

COSSITT, FRANKLIN D.
Sculptor and art editor. Born in La Grange, IL, October 16, 1927. Studied at University of Michigan, 1951; University of Florence, Italy, certificate, 1950. Work in Virginia Museum of Fine Arts, Richmond; Chrysler Museum at Norfolk, VA; outdoor sculpture, City of Chesapeake, VA, 1975 and City of Portsmouth, VA, 1977. Address in 1982, Richmond, VA.

COSTA, HECTOR.
Sculptor and painter. Born, Caltanessetta, Italy, March 6, 1903. Pupil of Prior, Hinton, Nicolaides, Olinsky, and Ellerhusen. Member: Penna. Academy of Fine Arts; Art Students League. Award: Bronze medal, first prize, design, Italian-American Art Exhibition 1928; Tiffany Foundation Fellowship, 1931. Address in 1933, 242 East 83rd Street, New York, NY.

COSTIGAN, IDA.
Sculptor. Born in Germany in 1894. Came to US at early age. Self-taught. Exhibited at National Academy of Design, 1922; National Sculpture Society, 1923; Penna. Academy of Fine Arts, 1924. Address in 1926, Orangeburg, NY.

COUPER, B. KING. (MRS.)
Sculptor and painter. Born Augusta, GA, Feb. 23, 1867. Pupil of Chase, Daingerfield, Du Mond, Breckenridge, and Cox. Member: North Shore Art Association; Columbia (SC) Art Association; Southern States Art League; National Association of Women Painters and Sculptors; Boston Art Club; National Arts Club, NY. Represented in permanent collection, Spartanburg, NC; Currier Gallery of Art, Manchester, NH; Brooklyn Museum of Art; High Museum of Art, Atlanta, GA. Exhibited: Salon d' Automne, Paris, 1930; University of Georgia; Greensboro College, NC. Address in 1953, Tryon, NC.

COUPER, WILLIAM.
Sculptor. Born Norfolk, VA, Sept. 20, 1853. Pupil of Thomas Ball and Cooper Institute in NY; studied in Munich and Florence, where he lived 22 years. Member: National Sculpture Society; NY Architectural League. Award: Bronze medal, Pan-Am. Exp., Buffalo, 1901. Work: "A Crown for the Victor," Art Museum, Montclair, NJ; statues, Henry W. Longfellow and Dr. John Witherspoon, Washington, DC; Capt. John Smith, Jamestown Island, VA; Morris K. Jesup, Natural History Museum, and John D. Rockefeller, Rockefeller Institute, NY; John A. Roebling, City Park, Trenton, NJ; thirteen heroic portrait busts of Scientists, foyer Natural History Museum, New York. Address in 1933, Montclair, NJ. Died in 1942.

COUROW, WILFORD S.
Sculptor. Born in NY. Specialty, medals.

COUSINS, CLARA LEA (MRS.).
Sculptor. Born in Halifax County, VA, April 6, 1894. Studied: Cincinnati Art Academy; Corcoran Art School; Penna. Academy of Fine Arts; Grand Central Art School with Ennis, Snell, and Cecilia Beaux. Works: Stratford

College, Danville, Virginia. Exhibited: Danville Art Club; Richmond Art Center; Morton Gallery; Southern States Art League; National Gallery of Art; others. Member: American Artists Professional League; American Federation of Arts; Southern States Art League; New Orleans Art Association; Mississippi Art Association. Address in 1953, Bremo Bluff, VA.

COUSINS, HAROLD.
Sculptor. Born in Washington, 1916. Studied at Art Students League, NY, under William Zorach. Associated with Zadkine's studio in Paris from 1949 to 1950, working in stone. After 1950, worked primarily with metal, modelling large figurative works.

COVE, ROSEMARY.
Sculptor and painter. Born in NYC, January 11, 1936. Studied at Parsons School of Design, 1954-56; Art Students League, 1964-65; with Knox Martin, 1966-70. Work in collection of CIBA Geigy, NY. Has exhibited at Brooklyn Museum, Works on Paper; Ball State University, 22 Drawings and Small Sculptures; Weatherspoon Gallery of Art, NC, Small Sculpture Show, 1977; others. Member of Women in the Arts. Works in terra-cotta, corten steel; oil, and ink. Address in 1982, 128 Ft. Washington Avenue, NYC.

COWAN, R. GUY.
Sculptor and craftsman. Born East Liverpool, OH, Aug. 1, 1884. Pupil of N.Y.S. School of Ceramics. Member: American Ceramic Society; Cleveland Society of Artists. Awards: 1st prize for pottery, 1917, and Logan medal for applied design, 1924, Art Institute of Chicago; 1st prize for pottery, Cleveland Mus., 1925. Address in 1929, c/o Cowan Pottery, Rocky River, OH, h. Lakewood, OH.

COWELL, JOSEPH GOSS.
Sculptor and painter. Born Peoria, IL, Dec. 4, 1886. Studied: University of Illinois; George Washington University; Boston Museum of Fine Arts School; Bradley Polytechnic Institute; Julian Academy, Paris; pupil of Bridgman, DuMond, Tarbell, and Benson; Laurens in Paris. Member: Boston Art Club, Boston Architectural Club. Work: Murals in Universalist Church, YMCA, Peoria, IL; theater, Holyoke, MA; theatres in Boston, and Tower Theatre, Philadelphia; stained glass windows, St. Mary's Cathedral, Peoria, IL; War Memorial flagstaff base, Wrentham, MA; murals in churches in Boston, Nashua, NH, Whitman, MA, Bridgeport, CT; murals, altars, screens, and altar figures, St. Mary's Cathedral, Peoria, IL, and St. James' Church, NY. Exhibited: Paris Salon, 1920; Architectural League, 1923, 24, 31; Boston Art Club, 1922-26; Rockport Art Association, 1939. Associate Director, Designers Art School, Boston; Director, National Art School, Washington, DC, 1940-42. Address in 1953, Washington, DC; h. Wrentham, MA.

COWLEY, LOIS.
Sculptor and painter. Born in Sutton, NE, 1936. Studied at University of Nebraska, fine art, 1955-59. Specialty is portraits and figures. Most of her paintings are of Indians. Reviewed in *Southwest Art*, Sept. 1978; *Artists of the Rockies*, winter 1975. Represented by Gallery A, Taos, NM.

Address since 1963, Denver CO.

COX, CHARLES BRINTON.
Sculptor. Born in Philadelphia in 1864. Fielding noted that his modeling of animals showed beauty and power. He died in 1905.

COX, ELEANOR.
Sculptor and illustrator. Born Montrose, CO, April 12, 1914. Student of Abbott School of Fine and Commercial Arts, Washington, 1933-35, Corcoran School of Fine Arts, with Hans Schuler, 1934-37, Yard School of Fine Art, with William Marks Simpson, 1937-38, Temple University Art School, with Raphael Sabatini, Boris Blai, 1940-41. One-man sculpture exhibits at Central High School, Washington, 1939, National League of American Pen Women, 1947, Woman's City Club of Washington, 1948, Silver Spring (MD) Gallery, 1954; exhibited in group shows at Corcoran Art Gallery, National Museum Art Gallery, Statler Hotel, International Galleries, Central Branches Public Library and Arts Club, Penna. Academy of Fine Arts, and others. Member: Society of Washington Artists; Society of Miniature Painters, Sculptors, and Gravers of Washington (secretary from 1956); National League of American Pen Women; D.A.R. Conglist. Awards: Prizes, Corcoran School of Art, 1936; League of American Pen Women, 1946. Address in 1962, McLean, VA; office, Dept. Air Force, Washington.

COX, GEORGE J.
Sculptor. Exhibited "The Zodiac" at Annual Exhibition of National Academy of Design, 1925, New York. Address in 1926, 509 West 121st Street, New York.

COX, KENYON.
Sculptor, painter, illustrator, teacher, writer, and lecturer. Born in Warren, OH, October 27, 1856. Studied in Paris under Carolus-Duran and Gerome. Member: Associate Member of the National Academy of Design, 1900; Academician, 1903; Society of American Artists of NY; Mural Painters; NY Architectural League; National Institute of Arts and Letters; American Academy of Arts and Letters; Fellowship of the the Penna. Academy of Fine Arts; Art Students League; Lotus Club. Awards: Second Hallgarten prize, National Academy of Design, 1889; two bronze medals, Paris Exp., 1889; Temple silver medal, Penna. Academy of Fine Arts, 1891; medal, Columbian Exp., Chicago, 1893; gold medal, St. Louis Exp., 1904; medal of honor for mural painting, NY Architectural League, 1909; Isidor medal, National Academy of Design, 1910. Represented by a portrait of Augustus Saint Gaudens and "The Harp Player," Metropolitan Museum, NY; Portrait of Henry L. Fry, Cincinnati Museum; mural paintings: "Venice," Bowdoin College, Brunswick, ME; "Art and Science," Library of Congress, Washington, DC; "The Reign of Law," Appellate Court, NY; "Contemplative Spirit of the East," Minn. State Capitol; "The Progress of Civilization," Iowa State Capitol; "The Beneficence of the Law," Essex Co. Court House, Newark, NJ; "The Judicial Virtues," Luzerne Co. Court House, Wilkes-Barre, PA; "The Light of Learning," Public Library, Winona, MN; "Passing Commerce Pays Tribute to the Port of Cleveland," Federal Building, Cleveland; "The Sources of

Wealth," Citizens' Bldg., Cleveland; statue, "Greek Science," Brooklyn Institute Museum; three drawings in Rhode Island School of Design, Providence; eleven sketches and "Tradition," Cleveland Museum; "Peace and Plenty," Manhattan Hotel, NYC; two lunettes in Oberlin College; "The Marriage of the Atlantic and the Pacific" and four mosaics in the Wisconsin State Capitol; "Plenty," National Gallery, Washington, DC; decorations on corner pavilions, Hudson Co. Court House, Jersey City, NJ; drawings in Carnegie Institute, Pittsburgh. Author of "Mixed Beasts," "Old Masters and New," "Painters and Sculptors," "The Classic Point of View," "Artist and Public," "Winslow Homer," and "Concerning Painters." Address in 1917, 130 East 67th Street, NYC; summer, Windsor, VT. Died in NYC, March 17, 1919.

COX, PAT.
Sculptor. Born in Cleveland, OH, 1939. Studied: Wayne County Community College. Exhibitions: Society of Arts and Crafts, Detroit; Detroit Institute of Arts, Works by Michigan Artists, 1974-75. Member: Society of Arts and Crafts. Address in 1975, Grosse Ile, MI.

COX-McCORMACK, NANCY.
Sculptor. Born Nashville, TN, Aug. 15, 1885. Pupil of Victor Holm, St. Louis; Charles Mulligan, Chicago. Member: National Association of Women Painters and Sculptors; Chicago Art Club; Cordon Club; Nashville Art Association; National Sculpture Society. Work: "Harmony," Nashville Museum; Carmack Memorial, Nashville; bronzes of Rev. John Cavanaugh, University of Notre Dame, South Bend, IN; Dean Craven Laycock, Dartmouth College, Hanover, NH; Perkins Memorial, Perkins Observatory, Wesleyan University, Delaware, OH; "H. E. Benito Mussolini," The Capitol, Rome, copy in Fine Arts Museum, Philadelphia; "Senator Giaccomo Boni," Campedoglio, Rome; Primo de Rivera, Madrid, Spain. Address in 1933, 16 East 8th Street, NYC.

COY, C. LYNN.
Sculptor. Born Chicago, IL, October 31, 1889. Pupil of Art Institute of Chicago; F. C. Hibbard; Albin Polasek; Lorado Taft. Member: Alumni Art Institute of Chicago; Chicago Society of Artists; Illinois Academy of Fine Arts; Chicago Art Club; Chicago Painters and Sculptors; LaGrange Art League. Work: George H. Munroe Memorial, Joliet, IL. Represented in Vanderpoel Art Association Collection, Chicago. Exhibited: Art Institute of Chicago, 1915, 17, 19, 21; Chicago Painters and Sculptors, 1948, 50; Chicago Art Club, 1952. Address in 1953, Chicago, IL; h. Riverside, IL.

COYNE, JOAN JOSEPH.
Sculptor, painter, craftsman, and writer. Born Chicago, IL, June 16, 1895. Pupil of George Mulligan, Leonard Crunelle, and Albin Polasek. Member: Chicago Society of Artists; Society of Independent Artists. Address in 1929, Germantown, Philadelphia, PA.

COZZOLINO, PETER.
Sculptor. Member of the National Sculpture Society. Address in 1982, Englewood, New Jersey.

CRAFT, MARJORIE HINMAN.
Sculptor. Born in Philadelphia, Penn. Exhibited: Salon d' Automne, 1932.

CRAIG, EMMETT JUNIUS.
Sculptor. Born DeWitt, MO, March 3, 1878. Pupil of Merrill Gage and Wallace Rosenhomer. Member: Kansas City Society of Artists. Awards: Silver medal, 1924, and bronze medal, 1925, Kansas City Art Institute. Address in 1933, 1040 Argyle Building; McMillian Building; h. Kansas City, MO.

CRAIG, MARTIN.
Sculptor and restorer. Born in Paterson, NJ, November 2, 1906. Studied at City College of New York, B.S. Works in Nelson A. Rockefeller Collection; Kalamazoo Art Institute, MI; ark and two candelabra, Fifth Avenue Synagogue, NY; sculpture, Temple Beth El, Providence, RI; others. Has exhibited at Salon Jeune Sculpture Annual, Paris, 1950-54; Salon Mai, Paris, 1952-54; Museum of Modern Art, NY; others. Received first prize, Organic Design Competition, Museum of Modern Art 1940; Mark Rothko Award, 1971; others. Lectured on sculpture at Cooper Union Art School; New York University; others. Works in welded metals; plastics. Address in 1982, East Hampton, NY.

CRAMER, MIRIAM E.
Sculptor and painter. Born in Hamburg, Germany, in 1885. Studied at Cleveland, Ohio. Works: Lima, Ohio Public Library.

CRAMER, S. MAHREA.
(Mrs. Paul Lehman). Sculptor, painter, etcher, designer, and illustrator. Born Fredonia, Ohio, March 21, 1896. Studied: John Herron Art Institute; Otto Stark Academy of Fine Arts; Art Institute of Chicago; and with Elmer Forsberg. Member: Assn. Chicago Painters and Sculptors; American Watercolor Society of New York; Ohio Watercolor Society; Chicago Galleries Association. Exhibited: American Watercolor Society of New York, 1942-44, 46; Hoosier Salon, 1941-46; Indiana Art Exhibition, 1943, 44; Chicago Galleries Association, 1943, 45 (one-man). Address in 1953, Chicago, Ill.

CRANE, M. H.
Sculptor. Active 1865. Patentee—bust of Lincoln, 1865.

CRANE, REBECCA RIGGS.
Sculptor. Born in Turin, Italy, May 16, 1875. Pupil of Sherry E. Fry. Address in 1918, 2 Washington Mews; h. 840 Park Ave., NYC; summer, Hewlett, LI, NY.

CRASKE, LEONARD.
Sculptor. Born in London, 1882, he came to America in 1910 and made his home in Boston and Gloucester. Studied at City of London School and London University. Studied medicine and anatomy, St. Thomas Hospital, London; art with the Dicksees; assistant to Paul R. Montford. Exhibited at National Sculpture Society, 1923. Address in 1926, Boston, MA. Died on Aug. 29, 1950.

CRAVATH, RUTH.
Sculptor and teacher. Born in Chicago, IL, Jan. 23, 1902. Studied at Art Institute of Chicago; Grinnell College;

California School of Fine Art. Works: San Francisco Museum of Art; Stock Exchange, San Francisco; Vallejo, CA; Chapel at the Archbishop Hanna Center for Boys, Sonoma, CA; marble group, Starr King School, San Francisco, CA. Exhibited: San Francisco Art Association, 1924, 26-28, 30, 32, 35, 37; San Francisco Museum of Art, 1941; World's Fair of NY 1939; Seattle Art Museum, 1929; San Francisco Society of Women Artists, 1926-28, 32, 34, 38-41, 44. Member: San Francisco Art Association; San Francisco Society of Women Artists; Artists Equity Association. Awards: San Francisco Art Association, 1924, 27; San Francisco Society of Women Artists, 1934, 40. Position: Instructor of Art, Dominican Convent, San Rafael, CA. Address in 1953, San Francisco, CA.

CRAWFORD, THOMAS.
Sculptor. Born March 22, 1811/1814, in NYC. Served as an apprentice in NYC under Frazee and Launitz. In 1835 he went to Rome, and studied with Thorwaldsen. His best known works are the bronze doors and work on the Capitol at Washington, DC; the equestrian statue of Washington at Richmond, VA; and his statue of Adam and Eve. His son was Francis Marion Crawford, the well-known author. Died Oct. 10, 1857, in London.

CRAWLEY, IDA JOLLY.
Sculptor, painter, writer, and lecturer. Born in Pond Creek, London Co., E. TN, Nov. 15, 1867. Pupil of Corcoran Art School; Johannes Oertell in Germany; Sir Frederic Massi in Paris. Member: American Art Union, Paris; American Federation of Arts. Awards: Gold medal, Appalachian Exp., Knoxville; silver medal, East Tennessee Art Association; loving cup and bronze medal, Kenilworth Inn Galleries; bronze medal, Asheville (NC) Gallery. Represented by paintings (fifteen), First National Bank, Champaign, IL; Gayosa Hotel, Peabody Hotel, University School, Memphis, TN; University, Fayetteville, AR; Baptist Church, Mansfield, OH; City Hall, Gardners Hospital and (three hundred) Crawley Museum of Art and Archaelogy. President, Crawley Museum of Art and Archaelogy, Asheville, NC. Address in 1933, Asheville, NC.

CRAWSHAW, LUKE.
Sculptor. Born in St. Louis, MO, Oct 15, 1856. Pupil of Lorado Taft, Art Institute of Chicago; Julian Academy in Paris. Address in 1918, Ogden, UT.

CREAMER, HINDY.
Sculptor. Work includes untitled marble, exhibited at National Association of Women Artists Annual, NYC, 1983. Member: National Association of Women Artists. Address in 1983, 1025 Fifth Avenue, NYC.

CREMEAN, ROBERT.
Sculptor. Born September 28, 1932, Toledo, Ohio. Studied: Alfred University, 1950-52; Cranbrook Academy of Art, 1954, BA, 1956, MFA. Work: Cleveland Museum of Art; Detroit Institute; Los Angeles Museum of Art; University of Miami; University of Michigan; University of Nebraska; St. Louis City Art Museum; Santa Barbara Museum of Art; UCLA. Exhibited: Toledo Museum of Art, 1955; Esther Robles Gallery, LA, 1960-66; The Landau-Alan Gallery, NYC, 1968; Detroit Institute, 1956;

Houston Museum of Fine Arts; Art Institute of Chicago, 1960, 61; San Francisco Museum of Art, Bay Area Artists, 1961; Whitney Museum; Western Association of Art Museum Directors, Light, Space, Mass, 1962; XXXIV Venice Biennial, 1968. Awards: Fulbright Fellowship (Italy), 1954-55; Tamarind Fellowship, 1966-67. Position: Instructor, Detroit Institute of Arts; instructor, University of California, Los Angeles, 1956-57; instructor, La Jolla Art Center, California, 1957-58. Address in 1976, c/o Esther Robles Gallery, Los Angeles, CA.

CRENIER, HENRI.
Sculptor. Born Paris, France, Dec. 17, 1873. Pupil of Falguiere, and Ecole des Beaux-Arts, Paris. Member: National Sculpture Society, 1912; NY Architectural League, 1913. Awards: Honorable mention, Paris Salon, 1897, Society of French Artists, 1907, and P.-P. Exp., San Francisco, 1915. Work: "Boy and Turtle," Metropolitan Museum of Art; pediments and caryatides, City Hall, San Francisco; Fenimore Cooper Memorial, Scarsdale, NY; "Boy and Turtle," Mt. Vernon Place, Baltimore, MD. Exhibited at National Sculpture Society, 1923. Address in 1933, Shore Acres, Mamaroneck, NY.

CRESSON, CORNELIA.
(Mrs. Cornelia Cresson Barber). Sculptor and engraver. Born in New York, NY, February 15, 1915. Studied: With Genevieve Karr Hamlin, Mateo Hernandez. Member: Artists Equity Association, New York. Exhibited: Allied Artists of America, 1938; Art Institute of Chicago, 1940; Ellen Phillips Samuel Memorial, Philadelphia, PA, 1940; Whitney Museum of American Art, 1940; Metropolitan Museum of Art, 1942; Grand Rapids Art Gallery, 1940; Albany Institute of History and Art, 1939, 40; Municipal Art Gallery, NY, 1938; ACA Gallery, 1943; Riverside Museum, 1946; Penna. Academy of Fine Arts, 1947; Silvermine Guild Artists, 1952; Artists Equity Association, New York, 1952. Address in 1953, 496 Avenue of the Americas; h. 59 West 12th Street, New York, NY.

CRESSON, MARGARET FRENCH.
Sculptor and writer. Born Concord, MA, August 3, 1889. Pupil of D. C. French and Abastenia St. L. Eberle; NY School of Applied Design for Women. Member: National Sculpture Society (secretary, 1941-42); National Association of Women Painters and Sculptors; American Federation of Arts; Grand Central Art Galleries; Washington Society of Artists; National Academy; Architectural League of New York, (vice president, 1944-46). Awards: Shaw memorial prize, National Academy of Design, 1927; honorable mention, Junior League Exhibition, 1928; honorable mention, Society of Washington Artists, 1929. Exhibited at Penna. Academy of Fine Arts, 1922, 25, 27-29, 37, 40-42; National Sculpture Society, 1923; National Acad. of Design, many times; Art Inst. of Chicago, 1928, 29, 37, 40; World's Fair of New York 1939; Whitney, 1940; Carnegie, 1941; others. Work: Portrait bust of "President James Monroe," National Museum, Washington, DC; bronze bust of "Daniel C. French," Trask Foundation, Saratoga Springs, NY; bronze relief of "F. F. Murdock," Mass. State Normal School; bronze relief of "William E. Barker," YWCA, Washington DC; bronze

memorial to Mrs. Alvin Klein, St. Paul's Church, Stockbridge, MA; Baron Serge A. Korff Memorial prize, Georgetown School of Foreign Service; bust Com. Richard E. Byrd, Corcoran Gallery, Washington, DC; NYU; Rockefeller Institute; and many portrait busts and reliefs held privately. Contributor to: *American Artist*, *NY Times*, *American Heritage*, *Reader's Digest*. Address in 1970, Stockbridge, MA. Died in 1973.

CRIMMINS, JERRY (GERALD GARFIELD).
Sculptor and assemblage artist. Studied at Minneapolis College of Art, B.F.A., 1965; Pratt Institute, M.F.A., 1967. Work at Philadelphia Museum of Art; Minneapolis Institute of Arts; Pratt Institute, Brooklyn, NY; others. Has exhibited at Philadelphia Museum of Art, 1972, 23 Sculptors; University of California at Berkeley, 1973; others. Teaching at Moore College of Art, Philadelphia, professor of basic arts and sculpture and assistant dean. Address in 1982, Glenside, PA.

CRONBACH, ROBERT M.
Sculptor. Born February 10, 1908, St. Louis, MO. Studied: St. Louis School of Fine Arts, 1925, with Victor Holm; Penna. Academy of Fine Arts, 1927-30, with Charles Grafly, Albert Laessle; assistant in Paul Manship Studio, NYC and Paris, 1930. Work: University of Minnesota; St. Louis City; Springfield (MO) Art Museum; Walker; and many architectural commissions including Social Security Bldg., Wash., DC; Cafe Society Uptown, NYC; 240 Central Park South, NYC; Temple Israel, St. Louis, etc. Exhibited: Hudson D. Walker Gallery, NYC, 1939; The Bertha Schaefer Gallery, NYC, 1951, 52, 60, 67; New York World's Fairs, 1939, 1964-65; Sculptors Guild; Metropolitan Museum of Art; Denver Art Museum; Whitney Annuals, 1948, 1956-59; Riverside Museum, 1957; Silvermine Guild, 1957, 58, 60; Brussels World's Fair, 1958; Penna. Academy of Fine Arts; Architectural League of New York; Brooklyn Museum; Museum of Modern Art. Awards: Penna. Academy of Fine Arts, Stewardson Prize, 1938; Penna. Academy of Fine Arts, Cresson Fellowship, 1929, 30; National Sculpture Competition for Social Security Building, Washington, DC, First Award, 1939. Taught: Adelphi College, 1947-62; North Shore Community Art Center, 1949-54; Skowhegan School, summers, 1959, 60, 64. Member: Sculptors Guild; Architectural League of New York; Artists Equity. Address in 1982, 420 East 86th St., New York City.

CRONIN, ROBERT (LAWRENCE).
Sculptor. Born in Lexington, MA, August 10, 1936. Studied at Rhode Island School of Design, B.F.A., 1959; Cornell University, M.F.A., 1962. Work in Worcester Art Museum, MA; Boston Museum of Fine Arts, MA; Brooklyn Museum, NY. Has exhibited at Institute of Contemporary Art, Boston; Worcester Art Museum, 1974; Carnegie Institute, Pittsburgh, 1981; others. Taught at Bennington College, 1966-68, instructor of painting; Worcester Art Museum, 1971-79, instructor of art. Works in light metals and wire. Address in 1982, 325 W. 15th St., NYC.

CROSBY, CARESSE.
Sculptor. Born in NY, 1892. Exhibited: Salon d'Automne.

CROSBY, KATHARINE VAN RENSELLAER.
See Gregory, Katharine V. R.

CROSMAN, ROSE.
Sculptor, etcher, and painter. Primarily etcher. Born in Chicago, Ill. Studied: Penna. Academy of Fine Arts; Art Institute of Chicago. Member: Chicago Society of Etchers. Exhibited: Chicago Society of Etchers and national etching shows. Lectures: Etching. Address in 1953, Chicago, Ill.

CROSS, LOUISE.
Sculptor. Born in Rochester, Minnesota, November 14, 1896. Studied at Wellesley College; Minneapolis School of Art; Art Institute of Chicago; University of Chicago; and with Harriet Hanley. Works: Memorial reliefs, Minnesota State Capitol; Todd Memorial Hospital, University of Minnesota. Exhibited: World's Fair of New York 1939; Philadelphia Museum of Art, 1934, 40; Metropolitan Museum of Art, 1942; National Sculpture Society; Whitney; Artists Equity Association; Sculptors Guild traveling exhibition, 1940, 41; Franklin Institute, Philadelphia, PA. Award: Minneapolis Institute of Art. Contributor to: Art magazines. Address in 1953, 505 East 82nd Street, NYC.

CROSS, MARIAN LEIGH.
Sculptor. Born in Minneapolis, Minn., March 4, 1900. Studied with Charles S. Wells and Boardman Robinson. Member: National Association of Women Painters and Sculptors. Address in 1933, Brookline, MA; summer, Beaver Bay, MN.

CROSSCUP, DANIEL L.
Sculptor. Born in Pennsylvania, c. 1841. At Philadelphia, 1860, 71.

CROW, CAROL (WILSON).
Sculptor. Born in Christiansburg, VA, July 31, 1915. Studied at Columbia University, with Oronzio Maldarelli, 1958; Beartsi Foundry, Italy, 1965; University of California, with Peter Voulkos, 1968. Has exhibited at Ft. Worth Art Center, TX; Museum of Fine Arts, CA, 1970; Invitational Sculpture Show, San Francisco Museum, CA, 1970; Houston Museum of Fine Arts, TX; others. Member: Artists Equity of Houston; Texas Society of Sculptors; others. Works in clay and bronze. Address in 1982, Houston, TX.

CROW, J. CLAUDE.
Sculptor. Born in Stillwell, Okla., November 30, 1912. Studied: American Art School, with H. Glintenkamp. Member: Art League of America. Work: Brooklyn Public Library; Ft. Hamilton High School, Brooklyn, NY. Exhibited: World's Fair, New York 1939; Springfield Museum of Art, 1938; Whitney Museum of American Art, 1939; Brooklyn Museum, 1946; ACA Gallery, 1939, 40; New School for Social Research, 1940; Hudson Walker Gallery, 1940; Critic's Choice, 1945. Address in 1953, Brooklyn NY.

CROWDER, CONRAD WILLIAM.
Sculptor and lecturer. Born in Hanford, CA, April 3, 1915. Studied: Riverside College California; and abroad. Member: American Federation of Arts, New York. Award:

Latham Foundation poster prize, 1930. Work: Wisconsin State Memorial to Major Richard Bong, State Capitol, Madison, WI; portrait busts of prominent Army and Navy officers. Lectures: Art in the Vatican. Position: Director of Sculpture, Virginia School of Prosthetics, Alexandria, VA, 1947-48. Address in 1953, Berkeley, CA.

CROWE, AMANDA MARIA.
Sculptor. Born in Cherokee, North Carolina, in 1928. Studied: Art Institute of Chicago; Instituto Allende San Miguel, Mexico; De Paul University, Chicago. Awards: John Quincy Adams traveling scholarship, Art Institute of Chicago, 1952; Art Institute of Chicago, scholarship, 1946. Collections: Container Corporation of America; Cherokee Indian School in North Carolina; Museum of the Cerokee Indian, North Carolina.

CROWELL, MARGARET.
Sculptor, illustrator, and painter. Born in Philadelphia, PA. Pupil of Penna. Academy of Fine Arts. Member: Fellowship Penna. Academy of Fine Arts. Address in 1926, Avondale, PA.

CRUCHET, JEAN-DENIS
Sculptor. Born in Lausanne, Switzerland, February 26, 1939. Studied at School of Fine Arts, Geneva, Switzerland, 1957-60; Scuola Di Brera (Studio Marino Marini), 1960-61. Work in Museum of Fine Arts, Lausanne, Switzerland; Hopkins Center, Dartmouth College, Hanover, NH; walnut bas-relief, Unitarian Church, Concord, NH; others. Has exhibited at Centro International, Seravezza, Italy, 1975, International Sculpture; Marion Koogler McNay, San Antonio, TX; Museum of Fine Arts, Santa Fe; Sculptors on Sculpture, Philbrook Art Center, Tulsa, OK; others. Works in marble and bronze. Address in 1982, Friendsville, TN.

CRUMB, CHARLES P.
Sculptor. Born Bloomfield, MO, Feb. 9, 1874. Pupil of O'Neill, Verlet, Barnard, Taft, Lanteri, Bringhurst, Grafly. Address in 1933, Beechwood Park, Delaware Co., PA.

CRUMMER, MARY WORTHINGTON.
Sculptor, painter, etcher, and craftsman. Born in Baltimore, MD. Studied: Maryland Institute; Rinehart School of Sculpture, with Denman Ross; Harvard University. Award: Weyrich Memorial prize, Charcoal Club, 1923; purchase prize, Maryland State Fair, 1928; prizes, Peabody Institute, 1923; Baltimore Museum of Art, 1939. Member: Baltimore Water Color Club; Maryland Inst., Alumni Association; Maryland Historical Society; American Federation of Arts. Address in 1953, Baltimore, MD.

CRUNELLE, LEONARD.
Sculptor. Born Lens, France, July 8, 1872. Pupil of Lorado Taft and Art Institute of Chicago. Member: Chicago Society of Artists; Cliff Dwellers Club; State Art Commission; Chicago Painters and Sculptors. Awards: Medal and diploma, Atlanta Exposition, 1895; special prize, Art Institute of Chicago, 1904; bronze medal and diploma, St. Louis Exposition, 1904; Chicago Society of Artists medal, Art Institute of Chicago, 1911. Work: "Squirrel Boy," Art Institute of Chicago. Address in 1929, Chicago, IL. Died in 1944.

CUINER, W.
Sculptor (amateur). At New York City. Exhibited bust of Washington at the American Institute, 1845 (with J. Conroy).

CUMMENS, LINDA.
(Linda Talaba Cummens). Sculptor and graphic artist. Born Detroit, MI, July 15, 1943. Studied: Detroit Institute of Technology; private instruction with Lois Pety; Illinois Wesleyan University, B.F.A.; Southern Illinois University, M.F.A. Awards: Birmingham (MI) Art Association, 1963; Royal Oak Art Association, Michigan, 1966; Illinois State Museum Craftsmans Award, 1975; Ball State University, 1975; others. Exhibited: One-man, Renee Gallery, Detroit, 1968, and Lewis Towers Gallery, Loyola University, 1975; Library of Congress Print Show, 1965; North Shore Artists, 1980; others. Commissions: Bronze door ornaments, Little Grassy Museum, Southern Illinois University, 1970; bronze sculpture, Directory and Bureau of Budget, State of Illinois, Springfield, 1975; other individual commissions. Member: Womens Caucus for Art; American Association of University Women; Auburn Art Association. Collections: Henry Ford Traveling Print Collection; J. L. Hudson Collection, Grosse Point, MI; McLean County Bank, Bloomington, IL; Albion University Print Collection; Detroit Art Institute Rental Gallery and Collection. Address in 1982, Deerfield, IL.

CUMMING, ALICE McKEE.
(Mrs. Charles A.). Sculptor, painter, lecturer, and teacher. Born in Stuart, IA, March 6, 1890. Studied: State University of Iowa; Cumming School of Art. Member: Iowa Art Guild; Society for Sanity in Art; Des Moines Art Forum. Awards: Medal, Iowa State Fair; prize, Des Moines Women's Club, 1925; medal, Art Institute of Chicago, 1942. Work: Des Moines Women's Club; State Historical Gallery, Des Moines. Exhibited: Society for Sanity in Art, Chicago, 1941; Ogunquit Art Association, 1943-46; Des Moines Art Forum, 1945, 46; Iowa Art Guild traveling exhibit. President, Director, Cumming School of Art, Des Moines, Iowa, from 1937. Address in 1953, Des Moines, Iowa.

CUMMINGS, JAMES HOYT (MRS.).
Sculptor and painter. Born in Lyons, Kansas, April 15, 1905. Student of Kalamazoo College, University of Kansas, Art Students League, NYC, 1940, Grande Chaumiere, Paris, France, 1930. Exhibited in group and one-man shows, including Chicago Art Institute, Penna. Academy of Fine Arts, Buffalo Museum, National Academy, NY, St. Louis Art Museum; represented in permanent collections, including Liomberger Davis Little Museum. Received 1st prize, St. Louis Artists Guild, 1928; sculptor prize St. Louis Artists League, 1921-22; 1st prize Midwestern Artists, 1922; Graphic Art prize, National Association of Women Artists, 1946; sculptor prize, Professional Artists NYC, 1947; sculptor prize, Pen and Brush Club NYC, 1948. Member: National Sculpture Society, Audubon Artists, Cape Cod Art Association, Provincetown Art Association, Chi Omega.

CUMMINGS, MELVIN EARL.
Sculptor. Born Salt Lake City, Utah, August 13, 1876.

Student of Mark Hopkins Art Institute, San Francisco; pupil of Douglas Tilden; Mercie and Noel in Paris. Executed numerous statues in and around San Francisco, notably 11 ft. statue of Robert Burns, Golden Gate Park; also Conservatory Fountain; National Monument to Commodore Sloat, Monterey, CA, etc. Instructor of modeling, University of CA, 1904; instructor at San Francisco Art Institute, since 1905. Member: San Francisco Art Association. Address in 1926, San Francisco, CA. Died in 1936.

CUNEO, AIKO LANIER.
Sculptor. Born in 1950. Studied: Pratt Institute, Brooklyn, New York. Currently working in New York City.

CUNLIFFE, MITZI.
Sculptor. Born in NYC, in 1918. Studied at Columbia University; Art Students League. Awards: Smith Art Gallery, Springfield, Mass., 1940, 43, 45; Widener gold medal, Penna. Academy of Fine Arts, 1949; Irvington NJ Public Library, 1944.

CUNNING, SHIRLEY.
Sculptor. Member of St. Louis Art Guild. Address in 1910, St. Louis, MO.

CUNNINGHAM, J.
Sculptor. Born in Greenwich, CT, September 18, 1940. Studied at Kenyon College, B.A., 1962; Yale School of Art and Architecture, B.F.A., 1963, M.F.A., 1965. Work in Hirshhorn Museum; and others. Has exhibited at Betty Parsons, NY, 1978 and 79, and Barbara Fiedler Gallery, Washington, DC, 1979. Received fellowship in sculpture at University of Penna. 1966. Address in 1982, Saratoga Springs, NY.

CUNNINGHAM, PATRICIA.
Sculptor, painter, teacher, designer, writer, and critic. Born in California. Studied: University of California, A.B., M.A.; and with Hans Hofmann, Andre L'Hote. Awards: Fellow, University of California. Work: Murals, Sea View School, Monterey, California. Taught: Art Center, Carmel Pine Cone-Cymbal, 1942-46; Instructor of Painting, Carmel Art Institute, Carmel, CA, 1940-46. Address in 1953, Carmel, CA.

CURRY, JOHN J.
Sculptor. Born in New York City, 1829. At New York City, 1850.

CURRY, JOHN STEUART.
Sculptor, painter, and lithographer. Born in Dunavant, KS, November 14, 1897. Studied: Art Institute of Kansas; Art Institute of Chicago; Geneva College; pupil of Norton, Reynolds, Shoukheiff. Member: Art Students League. Awards: Purchase prize, Northwest Print Maker, fifth annual exhibition, 1933; second prize, Thirty-first International Exhibition, Carnegie Institute, 1933; gold medal, Penna. Academy of Fine Arts, 1941; prize ($3,000), Artists for Victory Exhibition, Metropolitan Museum of Art, 1941. Work: "Baptism in Kansas," "Kansas Stockman," and "The Flying Codonas," Whitney Museum of American Art, NY. Address in 1933, Westport, CT. Died in 1946.

CURTIS, DOMENICO DE
Sculptor. Born in Roslyn, New York. Exhibited: Salon des Artistes Francais, 1930; Salon des Independents, 1931.

CURTIS, FRANCES ANNE.
Sculptor. Studied: B.A. Fine Arts, University of South Florida, 1978; Smithsonian Institution, technical training; graduate work in ornithology and scientific illustration. Works Published: *Audubon Society Encyclopedia of North American Birds; Smithsonian Contributions to Paleobiology; Journal of the Bombay Natural History Society* and others. Member: Guild of Natural Science Illustrators; Society Animal Artists. Media: Painting, watercolor, sculpture, wood. Specialties, tropical avafauna, avian skeletal anatomy. Address in 1983, Tampa, Florida.

CURTIS, GEORGE CARROLL.
Sculptor. Born in 1872. Died in 1926.

CURTIS, GEORGE WARRINGTON.
Sculptor and painter. He was born in 1869. He was director of the Aeolian Company of New York City. Died in Southampton, LI, NY, September 11, 1927.

CURTIS, LEONA.
Sculptor. Born in Plainfield, NJ, January 26, 1908. Studied: Art Students League; and with Robert Laurent, Jose de Creeft, Concetta Scaravaglione. Member: New York Society of Women Artists; National Association of Women Artists. Awards: Medal, Montclair Art Museum, 1935; prize, National Association of Women Artists, NY, 1941. Work: Bas-relief, Clark High School, Roselle, NJ. Exhibited: Penna. Academy of Fine Arts, 1935; Philadelphia Museum of Art, 1940; National Academy of Design, 1942; World's Fair, NY, 1939; Metropolitan Museum of Art, 1942; Montclair Art Museum, 1935, 36; Newark Museum, 1939; American-British Art Center, 1941; Bonestell Gallery, 1943. Address in 1953, 295 Adelphi Street, Brooklyn, NY.

CURTIS, WILLIAM FULLER.
Sculptor, painter, and worker in applied arts. Born in Staten Island, NY, February 25, 1873. Pupil of Julius Rolshoven, Lefebvre and Robert-Fleury in Paris. Awards: Third Corcoran prize, Society of Washington Artists, 1902; first Corcoran prize, Washington Water Color Club, 1903; silver medal, St. Louis Exposition, 1904. Member: New York Architectural League, 1902; Society of Washington Artists; Washington Water Color Club; Boston Society of Arts and Crafts. Work: Altar panels, Church of St. Michael and All Angels, Geneseo, NY; decorative panels, Cosmos Club, Washington, DC. Address in 1933, Brookline, MA; summer, Ashfield, MA.

CURTIS-HUXLEY, CLAIRE A.
Sculptor. Born in Palmyra, NY. Exhibited: Salon des Artistes Francais; Salon de la Nationale; Salon des Artistes Independents. Awards: Honorable mention, Exposition Universalle, 1900. Works held: Luxembourg Museum, Paris.

CUSHING, ROBERT.
Sculptor. Born in 1841; died 1896. (Mallett's)

CUSHMAN, CORDELIA H.

(Mrs. Paul Cushman). Sculptor. Address in 1934, New York. (Mallett's)

CUSHMAN, HENRY.

Sculptor and craftsman. Born London, England, December 16, 1859. Work: Carved ivory cup, Windsor Castle. Specialty, carved wood and stonework. Address in 1933, Los Angeles, CA.

CUTLER, CHARLES GORDON.

Sculptor. Born in Newton, Mass., January 17, 1914. Studied: Baltimore Museum of Fine Art School. Work: Addison Gallery of American Art, Andover, Mass.; IBM; Fitchburg Art Center; Springfield Museum of Art; Virginia Museum of Fine Arts, Richmond, VA; Cleveland Museum of Art. Exhibited: Penna. Academy of Fine Arts, 1942, 46; Art Institute of Chicago, 1942; Buchholz Gallery, 1943; New England Sculpture, 1942; Rhode Island School of Design, 1938; Fitchburg Art Center, 1946; Whitney Museum of American Art; Fogg Museum of Art; New London, Conn.; Worcester Museum of Art; Corcoran Gallery of Art; one-man: Grace Horne Gallery; Vose Gallery, Boston; Cincinnati Museum Association; Detroit Institute of Art; Framingham, Mass. Taught: Head, Sculpture Dept., Cincinnati Art Academy, from 1952. Address in 1953, South Brooksville, ME; h. Cincinnati, OH.

CUTLER, HARRIETTE (MRS.).

Sculptor. Born in Cleveland, Ohio. Exhibited: Salon des Artistes Francais, 1928.

CYPRYS, ALLAN.

Sculptor. Studied: The New School for Social Research, NYC; Sarah Lawrence College, Yonkers, NY. Exhibited: Nexus Gallery, Philadelphia, PA, 1978; NJ Institute of Technology, 1981; 14 Sculptors Gallery, NYC, 1978, 80, 83, all group shows; one-man shows include The Bronx Council on the Arts, Bronx, NY, 1975; Mamaroneck Artist Guild, Larchmont, NY, 1981, 83; others. Commissions: The Grand Hyatt Hotel, NYC, wall relief; numerous others. Position: Instructor at Christopher Columbus High School, Bronx, NY. Noted work: "Growth Patterns," 1981, wood; "Enclosure," 1982, wood; others. Address in 1984, New Rochelle, NY.

D

DABICH, GEORGE.
Sculptor and painter. Born in California, 1922. Work in Whitney Gallery of Western Art (Cody), Baker Collector Gallery (Lubbock, TX). Worked as a trapper, guide, and hunter in the "high" country in Wyoming for about 20 years. Specialty is subjects of historical Wyoming and the West. Address in 1974, Cody, WY.

DAGGETT, GRACE E.
Sculptor, painter and craftsman. Studied: Yale Art School; Julian Academy, Paris. Member: New Haven Paint and Clay Club, Brush and Palette Club. Address in 1953, New Haven, CT.

DAGGETT (OR DAGGET), MAUD.
Sculptor. Born Kansas City, MO, February 10, 1883. Pupil of Lorado Taft. Member: California Art Club. Award: Silver medal, Pan. California Exp., San Diego 1915. Work: Fountain, Hotel Raymond, Pasadena; drinking fountain; medallion and Memorial Fountain, "Castelar St. Creche Building," City of Los Angeles; "Peter Pan Frieze," Pasadena Public Library; Bertha Harton Orr Memorial Fountain, Occidental College, Los Angeles; four works, American Exhibition of Sculpture, National Sculpture Society, San Francisco, 1933. Address in 1929, Pasadena, CA.

DAHLER, WARREN.
Sculptor, painter, and craftsman. Born in New York, NY, October 12, 1897. Studied: National Academy of Design; University of Chicago; and with George Grey Barnard. Member: Silvermine Guild of Art; National Society of Mural Painters, New York. Awards: Prize, Architectural League, 1915. Work: Murals, Capitol Building, Missouri; St. Francis Hotel, San Francisco, CA; Somerset (VA); stage sets for Broadway plays. Exhibited: National Academy of Design, 1920, 22; Silvermine Guild of Art, 1932 (one-man). Address in 1953, Norwalk, Conn. Died in 1961.

DAILEY, DAN (DANIEL OWEN).
Sculptor and designer. Born in Philadelphia, PA, February 4, 1947. Studied at Philadelphia College of Art, B.F.A. (glass); Rhode Island School of Design, M.F.A. (glass); Mass. Council Arts Fellowship, 1980. Work in Corning Museum of Glass, NY; Metropolitan Museum of Art, NY; Smithsonian Museum, Washington, DC; National Gallery Victoria, Melbourne, Australia; and others. Has exhibited at Mass. Institute Technology Gallery; Theo Portnoy Gallery, NY; New Glass, Corning Museum of Glass, NY; National Museum of Modern Art, Tokyo, Kyoto, Japan; and others. Received Fulbright-Hays Grant as Designer, Fabrica Venini, Murano, Italy, 1972-73; National Endowment for the Arts Fellowship, 1979. Member of Glass Art Society of America. Taught sculp-

ture and glass at Mass. Institute of Technology, from 1975-80; teaching glass at Mass. College of Art, Boston, from 1973. Works in glass and metal. Address in 1982, Amesbury, MA.

DAINGERFIELD, MAJORIE.
Sculptor. Born in New York City. Studied: School of American Sculpture; Grand Central School of Art; and with James Fraser, Edmond Amateis, Mahonri Young, Solon Borglum. Award: Pen & Brush Club, 1956, Anna Hyatt Huntington Award for Bronze; Catharine Lorillard Wolfe Art Club Award. Collections: School of Tropical Medicine, San Juan, Puerto Rico; Hobart College, Geneva, NY; Queens College, Charlotte, NC; Georgetown University. Exhibited: National Sculpture Society; Pen and Brush Club; Catharine Lorillard Wolfe Art Club; National Academy of Design; Duke University, NC. Member: Pen and Brush Club; Catharine Lorillard Wolfe Art Club; National Sculpture Society, fellow. She is perhaps best known for her statuette-emblem for Girl Scouts of America. Address in 1976, 1 West 67th Street, NYC. Died in 1977.

Dal FABBRO, MARIO.
Sculptor and writer. Born in Cappella Maggiore, Italy, October 6, 1913; US citizen. Studied: Institute of Industrial Art, Venice; Magistero Art, Venice. Work: Kemerer Museum, Bethlehem, PA; Museum of Art, Science, & Industry, Bridgeport, CT; Allentown (PA) Art Museum. Exhibitions: Triennial International of Milan, Italy; Allentown (PA) Art Museum; New England Exhibition, Silvermine Guild; Museum of Art, Science, and Industry, Bridgeport, CT; etc. Awards: Sculpture, first prize, City of Vittorio Veneto, Italy; first prize, sculpture, Lehigh Art Alliance; and others. Member: International Academy Tommaso Campanella, Rome; Silvermine Guild. Medium: Wood. Address in 1982, Fairfield, CT.

DALBERG, EVA KRISTINA.
(Eva Kristina Malick Dalberg). Sculptor. Self-taught. Work: Bas-relief in silver, Franklin Mint; sculptures in porcelain, Franklin Mint. Exhibited: Philadelphia Wildfowl Exposition; National Wildlife Art Show; Western Heritage Art Show; Nature Conservancy Exhibit; Women Artists of the American West (WAOAW); Catharine Lorrillard Wolfe Art Club Show. Awards: Roman Bronze Works Award; Catharine Lorrillard Wolfe Art Club Show, 1980. Member: Society of Animal Artists; Women Artists of the American West, and the Catharine Lorrillard Wolfe Art Club. Media: Bronze, original work in wax or plasterline. Address in 1983, Denver, Colorado.

DALLET, LIZA.
Sculptor. Born in New York. Exhibited: Salon des Artistes Francais, 1933.

DALLIN, CYRUS EDWIN.
Sculptor, teacher, and writer. Born Springville, UT, November 22, 1861. Pupil of Chapu and Dampt in Paris; also of Ecole des Beaux-Arts and Academie Julien, Paris. Member: National Academy of Design, 1930; National Sculpture Society, 1893; New York Architectural League; Art Club of Philadelphia, 1895; Boston Art Club; St. Botolph Club, 1900; Royal Society of Arts, London; Boston Guild of Artists; Boston Society of Sculptors; American Federation of Arts. Instructor, Museum of Art, Normal Art School Association, NY, 1888. Awards: Honorable mention, Paris Salon 1890; first class medal and diploma, Columbian Exposition, Chicago, 1893; silver medal, Mass. Charitable Mechanics Association, 1895; silver medal, Paris Exposition, 1900; silver medal, Pan-Am. Exposition, Buffalo, 1901; gold medal, St. Louis Exposition, 1904; third class medal, Paris Salon, 1909; gold medal, P.-P. Exposition, San Francisco, 1915. Work: Lincoln Park, Chicago; Library of Congress Washington; Salt Lake City; Fairmount Park, Philadelphia; "Soldiers and Sailors Monument," Syracuse, NY; marble relief "Julia Ward Howe," Museum of Fine Arts, Boston; "The Hunter," Arlington, MA; "Alma Mater," Washington University, St. Louis, MO; Kansas City, MO; Cleveland School of Art; "Memorial Relief," Provincetown, MA; Storrow Memorial, Lincoln, MA. Address in 1933, Arlington Heights, MA. Died 1944.

DALTON, PETER C.
Sculptor. Born in Buffalo, NY, December 16, 1894. Studied: Art Students League; Beaux-Arts Institute of Design, NY; National Academy of Design. Member: Associate, National Academy of Design; National Sculpture Society; Audubon Artists; National Institute of Arts and Letters. Awards: Allied Art Association 1935; American Academy of Arts and Letters, 1945; gold medal, National Academy of Design, 1950, 1951. Work: USPO, Carthage, Miss. Exhibited: Penna. Academy of Fine Art, 1936, 1941, 1943, 1945, 1950, 1951; Fairmount Park, PA; Carnegie Institute, 1941; Museum of Modern Art, 1951; National Academy of Design, 1950, 1951. Address in 1953, Grandview-on-Hudson, NY. Died 1972.

DALY, RUSSELL F.
Sculptor. Born in Annacontis, WA, 1945. Private collections. Exhibited at Morgan Gallery, Kansas City, MO; E. G. Gallery, Kansas City, MO; Detroit Institute of Arts, Works by Michigan Artists, 1974-75. Address in 1975, Ann Arbor, MI.

DALY, STEPHEN JEFFREY.
Sculptor and educator. Born July 4, 1942, Governors Island, NY. Studied at San Jose State University, Calif., B.A., 1964; Cranbrook Academy of Art, Michigan, with Julius Schmidt, MFA (sculpture), 1967. Work in Oakland Art Museum, Calif.; American Academy of Rome, Italy; others. Exhibited at California Palace Legion of Honor, San Francisco; M. H. DeYoung Memorial Museum, Calif.; Smithsonian Museum; Oakland Art Museum, Calif; others. Awards: Reinhart Fellowship for Sculpture, American Academy of Rome, 1974; Prize de Rome, American Academy of Rome, Italy, 1975; Louis Comfort Tiffany Award for Sculpture, 1977. Works in metals and synthetics. Address in 1982, Austin, TX.

D'AMBROSI, JASPER.
Sculptor. Born in Wilmington, CA, 1926. Studied at University of Southern California. Worked for Douglas Aircraft as technical illustrator. In 1972 turned full-time to sculpture. Work includes edition titled "Muddy Creek Crossin" (sold out); "Blossom Time;" many others, including four monuments commissioned in California, New Mexico, and Kansas. Specialty is statuettes and heroic monuments of Old West subjects. Medium is bronze. Bibliography, Broder's *Bronzes of the American West*. Represented by Way West Gallery, Scottsdale, AZ. Address since 1977, Tempe, AZ.

DAMON, LOUISE WHEELWRIGHT.
Sculptor and painter. Born in Jamaica Plain, Mass., October 29, 1889. Studied: Boston Museum of Fine Art School; and with Charles Hawthorne. Member: Providence Art Club; Newport Art Association. Address in 1953, Providence, RI; summer, Annisquam, Mass.

D'ANDREA, ALBERT PHILIP.
Sculptor, painter, engraver, and educator. Born in Benevento, Italy, October 27, 1897. Studied: City College of New York, B.A., 1918; University Rome; National Academy of Design; Pratt. Member: Brooklyn Society of Art; College Art Association of America, Fellow; Royal Society of Art, England; Honorary Academician, Accademia di Belle Arti, Perugia; National Sculpture Society; Audubon; others. Awards: Prizes, City College of New York, 1933; Library of Congress, 1944; National Sculpture Society, 1963; others. Work: Library of Congress; City College of New York; Museum of the City of New York; New York Historical Society; Smithsonian; Vatican Library; Jewish Museum, NYC; medals for commissions. Exhibited: National Sculpture Society, 1951, 52, 72; American Artists Professional League, NYC, 1972; Audubon Artists 30th Annual Exhibition, NY, 1972; National Academy of Design. Director, Architectural and Engineering Unit, Board of Education, NY, 1947-51; art faculty, City College of New York, 1918-48, professor and chairman of Art Department, 1948-68. Assistant Editor, Theatre Annual, from 1946. Address in 1982, Brooklyn, NY.

DANENHOWER, DOROTHY SCUDDER.
Sculptor, painter, craftsman, lecturer, and teacher. Born in Princeton, NJ, March 18, 1880. Pupil of Pyle, Grafly, etc. Awarded poster prize, Cleveland Electrical Exposition, May, 1914. Address in 1918, Newark, NJ.

DANHAUSEN, ELDON.
Sculptor. US citizen. Studied at Art Institute of Chicago, B.F.A., James Nelson Raymond foreign traveling fellowship, 1947. Work in Hackley Art Gallery, Muskegon, MI; and others. Has exhibited at Chicago Annual Show, Art Institute of Chicago, 1945-60; Rivinia Festival Art Exhibition, 1957, 59, and 60; San Francisco Museum of Art, 1961; Art Institute of Chicago, 1970. Associate professor of sculpture at Art Institute of Chicago, from 1948. Address in 1982, Chicago, IL.

DANIEL, CLARKE.
Sculptor and painter. Born in Washington, DC, 1911. Awards: honorable mention, Paris Salon.

DANIELLI, EDIE.
Sculptor. Born in 1937. Noted for her environmental set-ups, styrofoam objects, and soft cubes.

DANIELS, ELMER HARLAND.
Sculptor and craftsman. Born Owosso, MI, on October 23, 1905. Pupil of Myra Richards, Edward McCarten, Williams, Amateis, Derejenski, Flanagan. Studied at John Herron Art Inst., Beaux-Arts Inst. of Design, NY; and in Europe. Work: Indiana University; Lincoln Memorial, Lincoln City, IN; State Capitol Building, Indianapolis; others. Award: Honorable mention, Indiana Art Association; prize for portrait, Indiana State Fair, 1928; prizes, Hoosier Salon, 1938; Indiana Art Club, 1940. Member: Indiana Art Association; Art Students League; National Sculpture Society; Architectural League; Hoosier Salon, others. Address in 1953, Ann Arbor, MI.

DANIELS, JOHN KARL.
Sculptor. Born in Norway, May 14, 1875. Pupil of Andrew O'Connor and Knut Okerberg. Honorary member of American Institute of Architects. Work: Bronze portrait statues, Minnesota State Capitol, St. Paul; monuments in five U.S. national cemeteries; flagstaff, City of Minneapolis; others. Awards: Gold medal, St. Louis Exposition, 1904; first prize, Minnesota State Art Commission, 1913 and 1914. Address in 1933, Minneapolis, MN.

DANNEMAN, L.
Sculptor. At New Orleans, 1849-51. His name also appears as Denneman in 1849.

DANTE, GIGLIO RAPHAEL.
Sculptor and painter. Born in Rome, Italy, September 4, 1916. Studied: Academy of Rome, Italy. Work: Springfield Museum of Art; Savoy Collection, Naples, Italy; Michelangelo Auditorium, Boston, Mass. Exhibited: Critic's Choice, Cincinnati Museum Association, 1945; Penna. Academy of Fine Arts, 1934-36; Golden Gate Exposition, San Francisco, 1939; Boris Mirski Gallery, 1944, 46 (one-man); Brandt Gallery, 1945, 46 (one-man). Address in 1953, 128 East 16th Street, New York, NY.

DANZIGER, JOAN.
Sculptor. Born in NYC, June 17, 1934. Studied at Cornell University, B.F.A., 1954; Art Students League, 1954-55; Academy Fine Arts, Rome, certificate of art, 1956-58. Work at National Museum of American Art, Smithsonian Institution, Washington, DC; sculptures, AFL-CIO Labor Studies Center, Silver Springs, MD; and others. Has exhibited at Drawing Society National Exhibition, Philadelphia Museum of Art, 1970; California Museum of Science and Industry, Los Angeles; Terry Dintenfass Gallery, NY; Corcoran Gallery, Washington, DC; Virginia Museum of Fine Arts, Richmond; and others. Member of Artists Equity. Teaching sculpture at Smithsonian Institution, from 1970. Address in 1982, Princeton, NJ.

DAPHNIS, NASSOS.
Sculptor and painter. Born July 23, 1914, Krockeai,

Greece. Came to USA in 1930. Self-taught. Work: Baltimore Museum of Art; Albright; Norfolk; Museum of Modern Art; Chrysler; Rhode Island School of Design; Tel Aviv; Carnegie Institute; Whitney Museum. Represented by Leo Castelli Gallery, NYC. Exhibited: Contemporary Arts Gallery, NYC, 1938, 47, 49; Galerie Colette Allendy, Paris, 1950; Leo Castelli Inc., 1959-61, 63, 65, 68; Franklin Siden Gallery, Detroit, 1967; Albright, 1969; Syracuse (Everson) 1969, 77; Carnegie, 1970; Corcoran Biennial, 1959, 63, 69; Whitney Museum of American Art Annual, 1960-65, 67; Walker, Purist Painting, 1961; Guggenheim, Abstract Expressionists and Imagists, 1961; Seattle World's Fair, 1962; Lausanne, I Salon International de Galeries Pilotes, 1963; DeCordova, 1965; University of Illinois, 1969; Birmingham Museum of Art, 1976. Awards: Ford Foundation, 1962; National Council on the Arts, 1966; Guggenheim Memorial Foundation Fellowship, 1977. Member: American Abstract Artists. Taught: Horace Mann School, Riverdale, NY, 1953-58. Address in 1982, 362 W. Broadway, NYC.

DAPHNIS-AVLON, HELEN.
Sculptor and painter. Born in Manhattan, NY, June 18, 1932. Studied at Brooklyn Museum, 1950-53; Colorado Springs Fine Arts Museum, 1953; Hunter College, B.F.A., 1953 and M.A., 1957. Works: Chrysler Museum; Sonnabend Art Collection, NY. Exhibitions: Bertha Schaefer Gallery, NY, 1959-62; Provincetown Art Association, Mass., 1960-79; Wadell Gallery, NY, 1969; Peace Exhibition, Museum of Modern Art, NY, 1970; Westbeth Gallery, NY, 1970; plus others. Awards: Ten Year Outstanding Achievement award, Hunter College, 1963. Media: Acrylic, ceramics, metal, graphics, photo-silk screen. Address in 1982, 463 West Street, NYC.

DARNAULT, FLORENCE MALCOLM.
Sculptor. Born in New York City December 24, 1905. Studied: Radcliffe College; National Academy of Design; Art Students League; and in Europe. Awards: Pen & Brush Club; National Art Club. Collections: City College of New York; US Naval Academy; American Institute of Engineers; Whitehead Metals Company; New York University Medical School; American Telephone & Telegraph Company; Harvard University; Army Officers Club, Governor's Island, NY; Statue, Mexico City; Colombian Government, Cartagena, Colombia. Exhibited: Pen and Brush Club; National Arts Club, NY; National Academy of Design; Allied Artists of America. Member: National Arts Club; Pen and Brush Club. Address in 1953, 222 West 23rd Street, NYC.

DARRICARRERE, ROGER DOMINIQUE.
Sculptor and stained glass artist. Born in Bayonne, France, December 15, 1912; US citizen. Studied at Ecole des Beaux-Arts, Bayonne, 1930-35; Ecole Nationale Superieur des Arts Decoratifs, diploma, 1938; Inst. Metiers, Paris, 1945. Has exhibited at Pasadena Art Museum; Otis Art Institute, Los Angeles; New York World's Fair, 1964-65; Museum of Contemporary Crafts, NY; and others. Received Fine Arts and Craftsmanship Awards, American Institute of Architects, 1958, 59, 61, and 63. Works in steel and glass. Address in 1982, Venice, CA.

DATZ, A. MARK.
Sculptor, painter, and etcher. Born in Russia, October 27, 1889. Studied: National Academy of Design; Cooper Union Art School; Beaux-Arts Institute of Design, New York. Member: Federation of Painters and Sculptors; Society of American Graphic Artists, New York; Artists Equity Association, New York. Work: Whitney Museum; Rochester Memorial Art Gallery; Oshkosh Museum of Art; Los Angeles Museum of Art; New York Public Library; State Teachers College, Indiana, PA; Tel-Aviv Museum, Israel. Exhibited: (One-man) New School for Social Research, 1927; J.B. Neumann Art Circle, 1928; Eighth St. Gallery, 1933, 34; Dorothy Paris Gallery, 1936; Passedoit Gallery, 1938; Montross Gallery, 1941; George Binet Gallery, 1946. Address in 1953, 50 East 56th St., New York, NY. Died in 1968(?).

DAUGHERTY, MARSHALL HARRISON.
Sculptor and art administrator. Born in Macon, GA, September 6, 1915. Studied at Ringling Art School; Mercer University, Macon, GA; Yale School of Fine Arts; Cranbrook Academy of Art, with Carl Milles et al, 1931-38. Has exhibited at Grand Central Galleries, NY; Detroit Art Museum, MI; Mint Museum of Art, Charlotte, NC. Received Yaddo fellowship, Saratoga Springs, NY, 1939; Carnegie grants, 1946 and 47. Address in 1982, Macon, GA.

DAVENPORT, JANE.
(Mrs. Jane Davenport de Tomasi). Sculptor, painter, and teacher. Born Cambridge, MA, on September 11, 1897. Studied at University of Chicago; Art Students League; Grande Chaumiere, Paris; pupil of Stirling Calder, Antonio Bourdelle, and Jacques Louchansky. Member: Art Students League of New York; Society of Independent Artists; American Federation of Arts. Work: "Erbiah," American University Union, Paris, France; Wall Fountain, The Biological Laboratory, Cold Spring Harbor; Tablet (low relief), Buckley School, New York City; Statue, Carnegie Institution, Washington, DC; Medal, George Lane Nichols, Buckley School, New York City. Address in 1929, Cold Spring Harbor, LI, NY.

DAVENPORT, JOHN BYRON.
Sculptor. Born in Provincetown, MA, 1914. Exhibited: American Artists Professional League, Paris, 1938.

DAVIDSON, JO.
Sculptor. Born in NYC March 30, 1883. Pupil of George de Forest Brush and Hermon A. MacNeil. He studied at the Art Students League, NY, and the Ecole des Beaux-Arts, Paris. Exhibited at National Sculpture Society, 1923. Works: Bust of Feodor Chaliapine; panel of dancing figures, Neighborhood Playhouse, New York City; busts, Marshall Foch, President Wilson, Marshal Joffre, Clemenceau, Gen. John J. Pershing, Anatole France, Emile Coue; figure, Gertrude Stein; bronze heads, Joseph Conrad, Bernard Baruch; figure, Ida Rubenstein; bronze statuette, Japanese girl; marble head, The Artist's Wife; bronze statuette, Supplication. Designed US War Industries Badge; designed heroic group for French Government to commemorate first victory of the Marne.

Address in 1933, 8 West 8th Street, NYC. Died January 2, 1952.

DAVIDSON, JOSEPH.
Sculptor. Born in Moscow, Russia, April, 1884. Pupil of Geo. de Forest Brush, H. A. MacNeil. Address in 1910, American Art Association, Paris, France; h. 1267 Fifth Ave., NYC.

DAVIDSON, ROBERT WILLIAM.
Sculptor and educator. Born Indianapolis, IN, on May 13, 1904. Studied at John Herron Art Institute; State Academy Fine Arts, Munich, Germany; Chicago Art Institute; pupil of Myra R. Richards, Albin Polasek, A. Iannelli, Edmond R. Amateis, R. A. Baillie; O. L. Davidson, Ernst Melaun, and Anton Bauer. Member: Indiana Art Association; Chicago Art Association. Awards: First prizes, Indiana State Fair, 1923 and 1924, Grand Prize, 1928; Art Association prize, Herron Art Institute, Indianapolis, 1925 and 1928; Spaulding first prize, Hoosier Salon, Chicago, 1927; Muncie Star prize, Hoosier Salon Chicago, 1928. Work: Indianapolis Museum of Art; University of North Carolina, Greensboro; "Adam," owned by the Colony Artists Association of Chicago; Portrait Busts, Mr. and Mrs. S. E. Raub, Raub Memorial Library, Indianapolis; Peace and War reliefs, exterior Shortridge High School, Indianapolis; bronze medal, Indiana Society of Architecture; Linton A. Cox Memorial Tennis trophy, Hawthorne Tennis Club, Indianapolis; many portrait heads privately owned. Exhibited: National Academy, NY, 1933; Whitney Museum, 1937; New York World's Fair, 1939. Teaching: Resident Sculptor, Skidmore College, Saratoga Springs, NY, 1933-72, professor of art, sculpture, and drawing, 1940-72. Address in 1982, Rock City Falls, NY.

DAVIDSON, THYRA (CLAIRE THYRA WEXLER).
Sculptor and draftman. Born in Brooklyn, NY, October 15, 1926. Studied at National Academy of Design, with John Corbino, 1943-45; Brooklyn Museum Art School, with Milton Hebald, 1945; New School for Social Research, with Robert Gwathmey, 1945-47. Work in Albany Institute of Historical Art, NY. Has exhibited at Woodstock Art Association Group, Riverside Museum, NY; Albany Institute; and Schenectady Museum; others. Received Purchase Prize, Albany Institute. Works in bronze and plaster. Address in 1982, New Paltz, NY.

DAVIES, ARTHUR B.
Sculptor, painter, and patron. Born in Utica, New York, in 1862. Studied at the Academy of Design; worked as an engineering draftsman in Mexico, 1880-82; Art Institute of Chicago; Art Students League in New York; Gotham Art Students School; Italy, 1893, under the sponsorship of William Macbeth and Benjamin Altman. Noted for organizing of Armory Show, 1913. Memorial exhibition held at Metropolitan Museum of Art, 1930. Noted work in sculpture: "Nude" (bas-relief). Also worked as a designer of rugs and tapestries. Died in Florence, 1928.

DAVIS, DAVID
Sculptor. Probably at Charleston, South Carolina, c. 1845.

Noted work: Bust of John Belton O'Neall.

DAVIS, DAVID ENSOS.
Sculptor. Born in Rona de Jos, Romania, August 27, 1920; US citizen. Studied at Beaux Arts, Paris, France, 1945; Cleveland Institute of Art, BFA, 1948; Case Western Reserve University, MA, 1961. Work in Cleveland Museum of Art, OH; Kent State University; Akron Art Institute; sculpture award, Ohio Arts Council; outdoor sculpture (8 feet tall), Beck Cultural Center, Lakewood, OH. Exhibited: May Show Annual, Cleveland Museum of Art, 1972-79; Ohio Painting and Sculpture, Dayton Art Institute, 1974; Materials and Techniques of 20th Century Artists, Cleveland Museum of Art, 1977; Recent Sculpture and Collages, New Gallery Contemporary Art, Cleveland, 1978; others. Received Major Sculpture Cash Prize, May Show, Cleveland Museum of Art, 1977. Member of Cleveland Institute of Art (board of trustees and alumni association); Ohio Arts Council (chairman of visual arts panel). Works in steel, aluminum, bronze and wood. Address in 1982, Beachwood, OH.

DAVIS, EMMA LU.
Sculptor. Born in Indianapolis, IN, November 26, 1905. Studied: Vassar College, BA; Penna. Academy of Fine Arts. Work: Museum of Modern Art; Whitney; others. Exhibited: Penna. Academy of Fine Arts, 1931, 33, 38, 39; Museum of Modern Art, 1942; Whitney, 1951; Terry Art Institute, 1952. Awarded prize and traveling scholarship, Penna. Academy of Fine Arts, 1930. Member of Artists Equity Association. Address in 1953, Chapel Hill, NC.

DAVIS, FAITH HOWARD.
Sculptor, painter, and illustrator. Born in Chicago, Illinois, July 29, 1915. Studied: Sarah Lawrence College, B.A.; and with Peppino Mangravite, Bradley Tomlin, Kurt Roesch. Awards: Prize, Buffalo, NY, 1946. Exhibited: Albright Art Gallery, 1939-46; The Patteran, traveling exhibition. Address in 1953, Snyder, NY.

DAVIS, GOODMAN.
Sculptor. Born in New York. Exhibited: Salon d'Automne, 1930.

DAVIS, HELEN S.
Sculptor. Born in Philadelphia, PA. Studied at Penna. Academy of Fine Arts; Art Students League; Cooper Union Art School. Works: Community House, Coral Gables, Florida; San Francisco, CA; Daytona Beach, FL; St. Petersburg Art Club; Florida Federation of Art. Award: Cooper Union Art School. Member: Plastic Club; National Association of Women Artists; Catharine Lorillard Wolfe Art Club; others. Address in 1953, East Gloucester, MA.

DAVIS, JESSIE FREEMONT SNOW.
Sculptor, painter and teacher. Born Williamson County, Texas, February 22, 1887. Studied: Art Students League with George Bridgman, John Knott, Frank Reaugh. Member: Southern States Art League; National Association of Women Artists, New York; Dallas Art Assoc.; Dallas Craftsman Guild. Awards: Prizes, Dallas Museum of Fine Arts, 1948, 49; San Antonio Craftsman Guild,

1948; Oak Cliff Society of Fine Arts, Dallas, Texas. Work: Dallas Museum of Fine Arts; Oak Cliff Gallery; Technical High School, Dallas; San Angelo (Tex.) Public Library. Exhibited: National Association of Women Artists, New York, 1944; Museum of Fine Arts of Houston, 1945; Dallas Allied Artists, 1943, 44; Southern States Art League, 1946. Taught: Instructor of Art, Dallas (Tex.) Public Evening School. Address in 1953, Dallas, Texas.

DAVIS, OSCAR.
Sculptor. Born in Vermont, 1833. Living in Brattleboro, Vermont, September, 1850.

DAVIS, RICHARD.
Sculptor. Born in New York City December 7, 1904. Studied with Jose De Creeft, John Flanagan, Ahron Ben-Shemeul, Bourdelle. Exhibited New York World's Fair, 1939; Museum of Modern Art; Whitney; Art Institute of Chicago; others. Member: American Art Congress; Society of Independent Artists; National Sculpture Society. Address in 1953, 17 East 96th Street, NYC.

DAVIS, SAMUEL P.
Sculptor. Born in Schenectady, New York, 1864. Worked: Brooklyn, New York. Exhibited: Berlin, 1891; Exposition Universelle, Paris, 1900; Chicago, 1893; Buffalo 1901.

DAVISSON, OSCAR.
Sculptor. Exhibited in New York, 1932. (Mallett's)

DAVY, JAMES BENJAMIN.
Sculptor, painter, and etcher. Born in San Francisco, CA, February 25, 1913. Studied: Rudolph Schaeffer School of Design. Exhibited: Golden Gate Exposition, San Francisco, 1939; San Francisco Art Association, 1941, 42, 45; Oakland Art Gallery, 1943, 44; Library of Congress, 1943. Address in 1953, San Francisco, CA.

DAWLEY, HERBERT M.
Sculptor and writer. Born Chillicothe, OH, March 15, 1880. Pupil of Art Students League of Buffalo, New York. Member: Buffalo Society of Artists. Award: Fellowship prize, 1915, Buffalo Society of Artists. Address in 1933, Chatham, NJ.

DAWSON-WATSON, DAWSON (or WATSON, DAWSON).
Woodcarver, painter, engraver, designer, and teacher. Born in London, England, July 21, 1864. Came to US in 1893. Pupil of Mark Fisher; studied in Paris with Duran and Morot until 1885. Painted in New England 1893-97; briefly back in England; Canada for three years; the Woodstock (NY) art colony; the St. Louis Society of Fine Arts, 1904-15; in Boston, 1926; finally established a studio in San Antonio. Work in City Art Museum, St. Louis; Witte Museum, San Antonio; University of Texas; Oakland (CA) Museum. Won $5,000 Wild Flower Painting Contest, San Antonio, 1926 ("The Glory of the Morning"); awarded a silver medal, Lewis and Clark Exposition, Portland, OR, 1905; silver and gold medals, Sedalia, MD; three first prizes and one second, Illinois State Fair, 1916; others. Member of San Antonio Art League. Specialty, Texas landscape. Art Director, Missouri Centennial; and St. Louis Industrial Exhibition, 1920. Address in

1933, San Antonio, TX. Died there in 1939.

DAY, BENJAMIN.
Sculptor. Worked: Lowell, Massachusetts, 1832-55. He was also a gravestone manufacturer and proprietor of a marble yard. Died August 30, 1916, in Summit, NJ.

DAY, WORDEN.
Sculptor and printmaker. Born in Columbus, OH, June 11, 1916. Studied at Randolph-Macon Womans College, B.A.; New York University, M.A.; also with Jean Charlot, Emilio Amero, Maurice Sterne, Vaclav Vytacil, Hans Hofmann, and Stanley William Hayter. Work in National Gallery of Art and Library of Congress, Washington, DC; Philadelphia Museum of Art; Metropolitan Museum of Art; Whitney Museum of American Art; and others. Has exhibited at Library of Congress; Brooklyn Museum; Philadelphia Museum of Art; Abstract Painting and Sculpture in America, Museum of Modern Art, NY; and others. Received Guggenheim fellowship, 1951-52 and 61-62. Member of Federation of Modern Painters and Sculptors; MacDowell Colony; Art Students League; Sculptors Guild. Taught multimedia at Art Students League, from 1966-70. Address in 1982, Montclair, NJ.

De BELLIS, HANNIBAL.
Sculptor and medalist. Born in Accadia, Italy, September 22, 1894; US citizen. Studied at University of Alabama, MD, 1920; also with Gaetano Cecere, Jean De Marco, and George Lober. Work in Navy Art Museum, Navy Combat Museum, Pentagon and Smithsonian Institution, Washington, DC; portrait medallions; bronze plaques for St. Vincent's Hospital and Medical Center, NY; Salmagundi Club Honor Award Medal; and others. Received Salmagundi Sculpture Prizes, 1960 and 71; American Artists Professional League Award, 1964. Member of Medalist Society; National Sculpture Society; American Artists Professional League; Salmagundi Club. Works in bronze. Address in 1982, Forest Hills, NY.

De BEUKELAER, LAURA HALLIDAY.
Sculptor. Born Cincinnati, OH, 1885. Pupil of Cincinnati Art Academy; St. Louis School of Fine Arts. Member: Cincinnati Woman's Art Club. Work: State Normal School, Geneseo, NY; Washburn College, Topeka, KS. Address in 1926, Topeka, KS.

De BOTTON, JEAN PHILIPPE.
Sculptor and painter. French and US citizen. Studied: Ecole Beaux-Arts, Paris; Sorbonne, Paris; Rollins College; with Antoine Bourdelle, Georges Braque, Jules Romains. Work: Metropolitan Museum, NY, Chester Dale Collection; National Museum of Modern Art, Paris; Wallraff-Richards Museum, Germany; Musee du Luxembourg, Paris; Museum of Art, Atlanta; Fogg Museum, Harvard; and many other museums in Geneva, France, Vienna, US. Commissions: French Government commissions; H. M. King George VI coronation; America at War, City of San Francisco; plus others. Exhibitions: Carnegie; Knoedler & Wildenstein Galleries, NYC & Paris; many others. Awards: Grand prix, Salon d' Honneur Beaux-Arts, French Government; many more. Teaching: Academy Montmartre, Paris and NYC. Member: Salon d'

Automne, Paris; Salon Modern Paris; Salon France Novelle; American Federation of Arts. Address in 1976, 930 Fifth Avenue, New York, NY. Died in 1978.

De BOYEDON, OSCAR HUGH.
Sculptor and craftsman. Born Porto Alegre, Brazil, on June 13, 1882. Pupil of Bourdelle in Paris. Member: Boston Society of Arts and Crafts. Address in 1929, care of Ainslie Galleries, 677 Fifth Ave., New York, NY; Florence, Italy; Paris, France.

De BRENNECKE, NENA.
Sculptor and painter. Born in Argentina, May 7, 1888. Studied: University of London; and with Henri Matisse, W. Wulff. Work: Denver Art Museum; Denver National Bank; United States Post Office, Paulsboro, NY; Coraopolis, PA; Hamlet, NC; Windsor, CT. Exhibited: Brooklyn Museum, 1935; Architectural League 1924; Denver Art Museum; Museum of New Mexico, Santa Fe; London, England, 1914, 17, 20; Paris Salon, 1914. Address in 1953, 320 East 59th St., New York, NY.

De CESARE, JOHN.
Sculptor. Member: National Sculpture Society. Address in 1953, 201 East 35th Street, New York, NY. Died 1972.

De COUX, JANET.
Sculptor. Born in Niles, MI. Studied: Carnegie Institute of Technology; New York School of Industrial Design; Rhode Island School of Design; Art Institute of Chicago; assistant to C. Paul Jennewein, A. B. Cianfarani, Gozo Kawamura, James Earl Fraser, and Alvin Meyer. Awards: Guggenheim Fellowship, 1938-39, 1939-40; Widener medal 1942, Penna. Academy of Fine Arts; Carnegie award; Lindsay Memorial Prize, National Sculpture Society; American Academy of Arts and Letters, grant. Collections: College of New Rochelle; US Post Office, Girard, PA; St. Mary's Church, Manhasset, NY; Society of Medalists; Sacred Heart School, Pittsburgh; St. Vincent's, Latrobe, PA; St. Scholastica, Aspinwall, PA; Crucifixion Group, Lafayette, NJ; altar, St. Margaret's Hospital Chapel, Pittsburgh; Christ King Church of Advent, Pittsburgh; doors, St. Ann, Palo Alto, California; Charles Martin Hall Memorial, Thompson, OH; Brookgreen Gardens, SC. Resident art instructor, Cranbrook Academy, 1942-45. Member of National Academy of Design; National Sculpture Society. Works in stone and wood. Address in 1982, Gibsonia, PA.

De CRANO, FELIX.
Sculptor and painter. Born in France and studied in Paris, London, and Rome; also at Penna. Academy of Fine Arts in Philadelphia. Member of the Art Club of Philadelphia; Philadelphia Artists' Fund Society. His studio was in Philadelphia. Died in Wallingford, PA, September 15, 1908.

De CREEFT, JOSE.
Sculptor. Born in Guadalajara, Spain, November 27, 1884; US citizen; settled in NYC. Studied at Academie Julien, 1906; Maison Greber, 1911-14. In collections of Whitney; Metropolitan Museum of Art; Philadelphia Museum of Art; Miro Foundation, Barcelona; others. Commissions in Puy de Dome, France, soldier war me-

morial; Mallorca, Spain, 200 stone sculptures; Central Park, NYC, Alice in Wonderland bronze group; Bronx (NY) Municipal Hospital; Bellevue (NY) Hospital. Exhibitions at Paris Salons 1919-28; Ford Foundation Traveling Show, US, 1959-60; Festival of Arts, White House, Washington, DC, 1965; New School Art Center, 1974; Kennedy Gallery, NYC, 1979; traveling retrospective, 1980, 81, Spain; others. Received Widener Memorial gold medal, Penna. Academy of Fine Arts, 1945; Brevoort-Eyckemeyer Prize, Columbia University; others. Taught at New School for Social Research, 1932-39, 57-65; Art Students League. Member of Audubon Artists; Fellow, National Sculpture Society; Academician, National Academy of Design; founding member, Sculptors Guild; Fellow, National Institute of Arts and Letters. Media: Lead, quartz, ebony, onyx, marble, wood, terra-cotta, serpentine. Represented by Kennedy Galleries in NYC. Address in 1982, c/o Kennedy Galleries, 40 West 57th Street, NYC. Died in 1983.

De FILIPPO, ANTONIO.
Sculptor. Born in Italy, February 22, 1900. Studied: Beaux-Arts Institute of Design, New York; Tiffany Foundation; American Academy in Rome. Member: National Sculpture Society. Award: Scholarship to American Academy in Rome, Italian American Art Society, 1925. Work: Sculpture, memorial, Winthrop Park, Brooklyn, NY; tablet, Bryant High School, Bronx, NY; memorial, Southampton, NY; Princeton University; and many portrait busts. Address in 1982, Woodside, LI, NY.

De FRANCISCI, ANTHONY.
Sculptor. Born in Italy, on June 13, 1887. Pupil of George T. Brewster at Cooper Union; National Academy of Design; James E. Fraser at Art Students League; and with A. A. Weinman in NY. Member: National Sculpture Society; New York Architectural League; American Numismatic Society (Associate); Allied Artists of America; National Academy. Award: Saltus medal, American Numismatic Society, NY, 1927; Penna. Academy of Fine Arts, 1936; gold medal, Allied Artists of America, 1950; others. Exhibited at National Sculpture Society, 1923. Represented: Cincinnati Museum Association; Numismatic Society Galleries; Metropolitan Museum, NY; Union Square Memorial, NY. Instructor at Columbia University. Address in 1953, 246 West 80th Street; h. 230 West End Avenue, NYC. Died in 1964.

De FRASSE, AUGUSTE.
Sculptor. Born in France, c. 1821. He worked in Santa Cruz, CA and New Orleans, LA, 1854-60.

De GERENDAY, LACI ANTHONY.
Sculptor. Born in Budapest, Hungary, August 17, 1911. Studied at South Dakota School Mines; Ursinus College; National Academy of Design; Beaux Arts Institute, NY. Has exhibited at Penna. Museum, Philadelphia; Gold Medal Exhibition, Architectural League, NY; Museum of Arizona; Boston Museum; Museum of Modern Art National Sculpture Society Annual; others. Member of National Sculpture Society; National Academy of Design; others. Awards: Council of American Artist Societies' Award, 1977, Lindsey Morris Memorial Prize, Silver

Medal of Honor, Mrs. Louis Bennett Prize, all National Sculpture Society. Teaching sculpture at Lyme Academy of Fine Arts, from 1980. Address in 1982, Old Lyme, CT.

De GOGORZA, PATRICIA (GAHAGAN).
Sculptor and printmaker. Born in Detroit, MI, March 17, 1936. Studied at Smith College, B.A., 1958; S. W. Hayter's Atelier 17, Paris, France, 1958-60; Goddard College, Plainfield, VT, M.A. Work in Collection Ville de Paris (Louvre), France; Victoria and Albert Museum, London, England; Boston Museum of Fine Arts; Bard College, Annandale-on-Hudson, NY. Has exhibited at Museum of Art Modern, Paris; Bundy Museum, Waitsfield, VT; and others. Member of Society of American Graphic Artists. Taught print and sculpture at Bard College, from 1966-69. Works carving wood, bronze; color etching, and copper engraving. Address in 1982, East Calais, VT.

De GRAZIA, ETTORE (TED).
Sculptor, painter, printmaker. Born in Morenci, AZ, 1909. Lived in Italy, 1920-24. Studied music and art, University of Arizona, B.A., 1944, B.S. and M.A., 1945. Exhibited in Mexico City (1942) and elsewhere since 1932. Commissions include UNICEF greeting card, 1960. Specialty is religious and Mexican figures. Printmaking media include serigraphy, lithography, etching. Author of numerous books. Represented by DeGrazia Gallery in the Sun; Buck Saunders Trading Post and Gallery, Scottsdale, AZ. Address in 1982, Tucson, AZ.

De HELLEBRANTH, BERTHA.
Sculptor. Born in Budapest, Hungary. Studied at Budapest Academy of Fine Arts; Julian Academy, Grande Chaumiere, Paris. Works: Brooklyn Museum; Fordham University; Scranton University; Florida Southern College; Cistercian Abbey, Trappist, Kentucky. Awards: Budapest, 1938; American Artists Professional League, 1938; Montclair Art Museum, 1941, 56; Florida Southern College, 1951; gold medal, Audubon Art, 1946. Exhibited: Brooklyn Museum; Metropolitan Museum of Art; Penna. Academy of Fine Arts; Art Institute of Chicago; National Academy of Design; National Gallery of Art; others. Member: Philadelphia Watercolor Club; Artists Equity Association; Penna. Academy of Fine Arts; National Sculpture Society; others. Address in 1970, Ventnor, NJ.

De KOSENKO, STEPAN.
Sculptor and designer. Born in Tiflis, Caucasus, Russia, 1865. Pupil of Ecole des Arts Decoratifs, Paris. Mem.: Salmagundi Club; National Sculpture Society; MacDowell Club; Architectural League of New York. Designer in decorative art. Address in 1933, 160 West 73rd St., NYC, h. 18 East 40th Street, NYC.

DE LA MOREUX, DWIGHT.
Sculptor. Born in 1841. He was a Veteran of the Civil War. Died in Chicago, Ill., December 1917.

De LAITTRE, ELEANOR.
(Mrs. Eleanor de Laittre Brown.) Sculptor, painter, craftsman, illustrator, and designer. Born in Minneapolis, Minnesota, April 3, 1911. Studied at Boston Museum of Fine Arts School; and with George Luks and John Sloan.

Works: Walker Art Center; University of Minnesota. Exhibited: American Abstract Artists, 1940-46; World's Fair of New York, 1939; Art Institute of Chicago, 1937-41; Contemporary Art Gallery, 1939 (one-man); others. Member: American Abstract Artists. Address in 1953, 44 West 56th Street, NYC.

DE LANCY, DARRAGH.
Sculptor. Born in East Orange, NJ, 1870. Address in 1934, Waterbury, Conn. (Mallett's)

De LAP, TONY.
Sculptor. Born in Oakland, CA, November 4, 1927. Studied: Menlo Jr. College, CA; California College of Arts and Crafts, Oakland; Claremont Graduate School, Claremont, CA. In collections of Whitney; Walker Art Institute, Minneapolis; Museum of Modern Art; Tate Gallery, London; others. Exhibited at Whitney Sculpture Annual, 1964 and 66; Jewish Museum, NYC, 1966; Los Angeles Co. Museum of Art, 1967; La Jolla (CA) Museum of Art, 1973; Art Institute of Chicago; others. Awarded American Federation of Arts and Ford Foundation Grants, Artist in Residence Program; Nealie Sullivan Award, San Francisco Art Institute; Los Angeles Dept. of Airports, first prize, sculpture. Fine arts lecturer, University of California, Davis; professor, University of California, Irvine, from 1965. Represented by Janus Gallery, Venice, CA; Robert Elkon Gallery, NYC. Address in 1982, Del Mar, CA.

De LAURO, JOSEPH NICOLA.
Sculptor and educator. Born in New Haven, CT, March 10, 1916. Studied at Yale University, B.F.A., 1941; University of Iowa, M.F.A., 1947; also in Italy, 1953, 62, 66, and 71. Work includes stone sculpture, St. Columba Cathedral, Youngstown, OH; bronze sculpture, Detroit Public Library, MI; bronze sculpture, Jewish Community Centre, Windsor, Ontario; others. Has exhibited at Walker Gallery, Minneapolis; Ecclestical Art Guild, Detroit; Art Gallery Windsor, Ontario; Biennale de Fiorino, Florence, Italy. Received Alice Kimball Fellowship, 1940, Tiffany Fellowship, 1941, and Elizabeth Pardee Scholarship, 1941, all Yale University. Member of the National Sculpture Society. Works in bronze and marble. Address in 1982, Plymouth, MI.

De LISIO, MICHAEL.
Sculptor. Born in NYC, January 22, 1911. Studied at NYC High School. Served in the US Navy in Cuba, 1942-45; later a film press agent for MGM, 1945-57. Work: Hirshhorn Collection; Minneapolis Institute; Wichita Museum; others. Exhibited: Nova Scotia College of Art, Halifax, 1969; Hanover Gallery, London, 1970; Minneapolis Institute of Arts, MN, 1971; Wichita Art Museum, KS, 1972; Long Beach Museum of Art, 1973; Princeton University Library, NJ, 1973; The Grolier Club, NYC, 1974; Smith College Museum of Art, Northampton, MA, 1974; Greenwich Library, CT, 1976; Philadelphia Art Alliance, PA, 1976. Media: Bronze and terra cotta. Address in 1982, 32 East 64th Street, NYC.

De LUE, DONALD.
Sculptor. Born in Boston, MA, October 5, 1897. Studied at Boston Museum of Fine Arts School. Received awards from Architectural League, 1942, prizes, 1951, medal; National Sculpture Society, 1942, 46, gold medal; Guggenheim Fellow, 1943-44; National Institute of Arts and Letters, 1945; medal, Allied Artists of America, 1946; American Artists Professional League, gold medal; Sculptors of the Year Award; American Numismatic Association, 1979; Medal, Brookgreen Gardens, 1979; others. Work: Heroic figures, State of LA Memorial; Thomas Jefferson, bronze figure, Jefferson Parish, La, Bicentennial; Court House, Philadelphia, PA; University of Penna.; American Exporter Memorial, NYC; chapels at West Point and Arlington, VA; Harvey Firestone Memorial; Federal Reserve Bank, Boston and Philadelphia; US Military Cemetery Memorial, Omaha Beach, St. Laurent, Normandy, France; The Alamo, San Antonio, Texas; sculpture in bronze, Plaza of the Astronauts, New York World's Fair, 1964-65; and others. Member of National Academy of Design, Academician, Associate; National Sculpture Society; National Institute of Arts and Letters; Royal Society of Arts; American Artists Professional League; Architectural League; others. Media: Bronze, marble, and granite. Address in 1982, Leonardo, NJ.

De LUNA, FRANCIS P.
Sculptor. Born New York, October 6, 1891. Studied: National Academy of Design; Beaux-Arts Institute of Design; Cooper Union Art School. Pupil of Herman A. McNeil. Member: National Sculpture Society; Architectural League of New York. Address in 1953, 11 West 29th Street, New York, NY. Died 1975.

De MARCO, JEAN ANTOINE.
Sculptor. Born in Paris, France, in 1898; US citizen. Studied at Ecole Nationale des Arts Decoratifs, Paris. Works: Whitemarsh Park Memorial, Prospectville, PA; War Department Building, Washington, DC; US Post Office, Weldon, NC; Danville, PA; US Capitol, Washington, DC; Joslyn Memorial Mus.; Memorial, Notre Dame University; Metropolitan Museum of Art; reliefs, Cathedral of the Assumption, Baltimore, MD; Brooklyn Museum. Awards: New Rochelle Art Association, 1940; American Academy of Arts and Letters, 1959; National Academy of Design, 1946; Architectural League, 1958; National Sculpture Society, 1945, 48, 54. Exhibitions: Penna. Academy of Fine Arts (many); National Academy of Design; Metropolitan Museum of Art; World's Fair, NY 1939; Boston Museum of Fine Arts; Fairmount Park, Philadelphia, PA; others. Member: National Academy of Design; National Sculpture Society. Taught at Columbia University; National Academy of Design; Iowa State University. Address in 1982, Prov.-Frosinone, Italy.

De MARIA, WALTER.
Sculptor. Born October 13, 1935 in Albany, CA. Studied: University of California, BA, Museum of Art (with David Park). Work: Museum of Modern Art; Whitney Museum. Exhibited: Nine Great Jones Street, NYC (two-man, with Robert Whitman), 1963; Cordier & Ekstrom, Inc., NYC, 1966; Galerie Heiner Freidrich, Munich, 1968; Dwan Gallery, NYC, 1969; Jewish Museum, Pri-

mary Structures, 1966; Whitney Museum of American Art Sculpture Annual, 1967, 68; Los Angeles County Museum of Art, American Sculpture of the Sixties, 1967; Documenta IV, Kassel, 1968; Berne, Switzerland, When Attitudes Become Form, 1969; Amsterdam (Stedelijk) 1969; Museum of Modern Art, NYC, 1970; NY Earth Room, 1977; others. Awarded Guggenheim Foundation Fellowship, 1969. Address in 1982, NYC.

De MOULPIED, DEBORAH.
Sculptor. Born November 22, 1933, Manchester, NH. Studied: Boston Museum School, with E. Morenon, P. Abate, Russell T. Smith, 1956; Yale University, with Josef Albers, S. Sillman, Robert Engman, E. Hauer, Bernard Chaet, BFA, 1960, MFA, 1962. Work: Chase Manhattan Bank; Museum of Modern Art. Exhibited: Galerie Chalette, NYC, 1961; Museum of Modern Art, Recent American Painting and Sculpture, travelling exhibition, USA and Canada, 1961-62; Whitney Museum; National Institute of Arts and Letters, 1968. Awards: Tuition scholarships to Boston Museum School and Yale University; Boston Museum School, Clarissa Bartlett Traveling Fellowship, 1961-62; MacDowell Colony Fellowship, 1968-69. Address in 1983, Hancock, NH.

DE NESTI, ADOLFO.
Sculptor. Born in Florence, Italy, 1870. Exhibited "Dancing Faun" at Penna. Academy of Fine Arts, 1914. Address in 1926, Philadelphia, PA.

De NIKE, MICHAEL NICHOLAS.
Sculptor and writer. Born in Regina, Sask., Canada, September 14, 1923; US citizen. Studied: National Academy of Fine Arts; with Jean de Marco, Carl Schmitz. Commissions: Young St. Francis (bronze), St. Davids, Kinnelon, NJ; many more. Exhibited: National Academy of Design, NYC, 1964; Audubon Artists, 1965; Knickerbocker Artists, 1965; National Sculpture Society Annual, 1966; American Artist Professional League, 1974; others. Awards: Dr. Ralph Weiler award, National Academy of Design, 1964; Allied Artists of America award, National Academy of Design, 1964; Allied Artists of America award, 1975; others. Member: American Artists Professional League. Teaching: Instructor of woodcarving, Fair Lawn Adult Education, 1968-74; Passaic Co. College, 1976-80. Media: Wood, stone. Address in 1982, Wayne, NJ.

De ORLOV, LINO S. LIPINSKY.
See Lipinsky, Lino S.

De RIVERA, JOSE.
Sculptor. Born September 18, 1904, West Baton Rouge, LA. Studied: Studio School, Chicago, with John W. Norton, 1928-30. Work: Art Institute of Chicago; Metropolitan Museum of Art; Museum of Modern Art; Newark Museum; University of Rochester; San Francisco Museum of Art; St. Louis City; Smithsonian; Utica; Virginia Museum of Fine Arts; Whitney Museum; Smithsonian, Washington, DC; Tate; and many commissions including Moore-McCormack Lines, SS Argentina, and Soviet Pavilion, New York World's Fair 1939. Exhibited: Mortimer Levitt Gallery, NYC, 1946; Grace Borgenicht Gallery

Inc., 1952, 56, 57, 58, 59, 60; Walker, 1957; Brooklyn Museum; Art Institute of Chicago; "The Twelve Americans," Museum of Modern Art; Brussels World's Fair, 1958; American Painting and Sculpture, Moscow, 1959; Whitney Annuals 1934-68; La Jolla, 1972. Awards: Art Institute of Chicago, Watson F. Blair Prize, 1957; National Institute of Arts and Letters Grant, 1959; Brandeis University, 1969. Taught: Brooklyn College, 1953; Yale University, 1954-55; North Carolina School of Design, Raleigh, 1957-60. Address in 1982, c/o Grace Borgenicht Gallery, NYC.

De SANDO, SANDRA.
Sculptor. Born in 1946. Noted for her mixed-media funky food-sculptures.

De SOTO, MINNIE B. HALL.
(Mrs. Emilio Dominguez De Soto). Sculptor, painter, writer, lecturer, and teacher. Born in Denver, CO, May 2, 1864. Studied at Art Students League of New York, Art Institute of Chicago, Henry Read. Member: National Art Club; Denver Art Club. Address in 1933, Denver, CO.

De STAEBLER, STEPHEN L.
Sculptor. Born in St. Louis, Missouri, in 1933. Went to California in 1957. Studied at Black Mountain College, Raleigh, NC; Princeton University (religion); University of California, Berkeley (sculpture). Taught at San Francisco Art Institute, 1961-67; San Francisco State University, 1961-62, and from 1967. Exhibited at Oakland (California) Museum; James Willis Gallery, San Francisco; Oakland Art Museum; Musee d'Art Moderne, Paris; Museum of Contemporary Crafts, NYC; New York World's Fair (Young American Sculpture), 1965-66; Smithsonian; Everson Museum, Syracuse; San Francisco Museum of Modern Art; others.

De WELDON, FELIX GEORGE WEIHS.
Sculptor, painter, teacher, and lecturer. Born in Vienna, Austria, April 12, 1907. US citizen. Studied: Marchetti College, B.A.; University of Vienna School of Architecture, M.A., M.S., Ph.D.; and in Italy, France, England. Member: American Federation of Arts, NY. Awards: Prizes, Vienna, Austria, 1925, 27; St. Andrews, Canada, 1939. Work: Busts, King George V and King George VI, London; Museum, City of Vienna; National Portrait Gallery, London; American Embassy, Canberra, Australia; Naval War College, Newport RI; White House, Washington, DC; State Capitol, Little Rock, AR; Dallas, TX; St. Augustine, FL; Museum, Brisbane, Australia; U.S. Naval Academy, Annapolis, MD; many portrait busts of prominent officials in Scotland, England, and US. Exhibited: Vienna, 1925-28; Paris Salon, 1929, 30, 38; Cairo, Egypt, 1932, 33; Royal Academy of London, 1934-37; Montreal Museum of Art, 1938; Architectural League, NY, 1939; Museum, Montreal, Canada, 1940; Art Association, Newport, RI, 1946; others. Lectures: Hist. of Painting, 12th to 19th Century; etc. Director of Newport (RI) Academy of Fine Arts, 1952-60. Commission of Arts and Science for Pres. Eisenhower, 1952-60; others. Address in 1982, Washington, DC.

De YONG, JOE.
Sculptor and painter. Born in Webster Grove, MO, 1894.

Worked in Russell's studio in Montana from 1916 to 1926, when Russell died. Honorary member, Cowboy Artists of America. Work in Free Public Library, Santa Barbara, CA; mural "Up the Trail," Texas Post Office. Grew up roping and cowboying. Later turned to art; became interested in Indians, learned Indian sign language; served as technical advisor on Indians for movie industry. Specialty was Western subjects in traditional style. Died in Los Angeles, CA, 1975.

de ZORO-dei CAPPELLER, (ETTORE) E.

Sculptor. Born in Cibiana, Italy, January 27, 1894. Studied: Moci College, Italy; Imperial Art Academy, Germany; Andhra Research University, India, D.F.A. Member: Los Angeles Art Association; California Art Club; Societe Academique d'Histoire International; College of Heraldique de France; Atheneum National Science and Art, Mexico; Hon. Comite Cultural, Argentina; Academia Hispano-Americana de Ciencias y Artes, Spain; Society of Fine Arts, Brazil. Awards: Cross Academic Honor, International Academic Council, Washington, DC, 1938; medal, Hispano-Americana Academy of Science and Art, Spain, 1932; Grand Prix, Belgium, 1937; Pacific International Exposition, 1935, etc. Work: Busts, figures, reliefs, San Francisco; Carmel, CA; University of Southern California; Italy, Ecuador, Bulgaria, Mexico, Washington DC, etc. Exhibited: Pacific International Exposition, 1935; Golden Gate Exposition, San Francisco, 1939; Los Angeles Museum of Art; Palos Verdes, CA, 1935-37; California Art Club, 1936; Santa Barbara, CA, 1935-38; Ebell Salon, Los Angeles, 1940-41. Address in 1953, Santa Barbara, CA.

DEAN, GRACE RHOADES.

Sculptor and etcher. Born in Cleveland, OH, on January 15, 1878. Pupil of Cleveland School of Art; Kenyon Cox; Arthur W. Dow; and studied in Munich. Member: National Association of Women Painters and Sculptors; Cleveland Woman's Art Club; Toledo Athena Society; Ohio Water Color Society; American Federation of Arts; Dayton Society of Etchers. Awards: Prize for etching, Toledo Art Museum, 1918; second prize for landscape decoration, 1920, and first water color prize, 1924, Toledo Federation of Art Societies; prize, Ohio State Fair, 1922. Address in 1933, Toledo, OH.

DEARING, WILLIAM.

Ship Carver. Worked: Kittery, ME; Portsmouth, NH; Newburyport, MA, figurehead, *Merrimac*; Salisbury, MA, figureshead, *Warren*.

DEATON, HERMAN L.

Sculptor and painter. Born in Iowa, February 4, 1928. Studied: Self-taught; also with Dimitar Krustev at the Des Moines Art Center, IA. Joined brother's museum exhibit firm in 1964, with clients such as the Smithsonian. At this time learned to model and cast. Set up own studio in 1974. Exhibited: Deaton Museum Studio, Newton, IA; Smithsonian Institution, Washington, DC; St. Paul Science Museum, MN; Herbert Hoover Pres. Library, IA; New York State Museum, Albany; Society of Animal Artists Annuals; many others. Works at Husberg, Se-

dona, AZ; Gallery of the Southwest, Houston, TX; others; and include foundry bronzes "Down on the Farm;" special small-scale commissions, rodeo sculptures for Hesston Corporation, "Bullfighter Clown and Bull," "World Champion All-Around Cowboy." Member: Society of Animal Artists. Noted for anatomical accuracy. Specialty is animals and figures in bronze and other material. Address in 1983, Newton, LA.

DEATON, NORMAN (NEAL).

Sculptor and painter. Born in Des Moines, IA, about 1930. Self-taught. Exhibited: Mitchell Museum, Mt. Vernon; Illinois Gallery Exhibition. Awards: Certificate of Award, Smithsonian. Began own studio in 1959, specializing in "sculpture taxidermy," rather than stuffing, and anatomical modeling for museums worldwide. Work can be seen at Museum of Westward Expansion, St. Louis, MO. Member: Society of Animal Artists, Honorary Life Membership in Art Directors Association of Iowa. Taught: Museum Exhibits Seminars and other various museums and technical organizations. Media: Paintings, oil and acrylic; sculpture, bronze and other mixed media. Specialties: Animal life, human, landscapes of natural wildlife. Address in 1983, Newton, Iowa.

DECKER, ALICE.

(Mrs. Davidson Sommers). Sculptor. Born in St. Louis, MO, 1901.

DECKER, LINDSEY.

Sculptor. Born 1923, in Lincoln, NE. Studied: American Academy of Art, Chicago, 1942-43; State University of Iowa, 1946-50, BFA, MFA. Work: Albion College; Cranbrook; Detroit Institute. Commissions for Eastland Center, Detroit, 1957; Atomic Energy Commission, Oak Ridge, TN. Exhibited: Chiku-Rin Gallery, Detroit; Michigan State University; Kalamazoo Institute; The Zabriskie Gallery, 1959, 60; Art Institute of Chicago, Exhibition Momentum, 1950-54; Philadelphia Art Alliance 1954; Whitney Museum of Art Annuals, 1956, 60; Houston Museum of Fine Art; Museum of Modern Art, Recent Sculpture USA, 1959; Penna. Academy of Fine Arts, 1960; Cincinnati Art Museum, Midwest Sculpture, 1960; Prince St. Gallery, NYC, 1969; others. Awards: Detroit Institute, Cantor Prize, 1956; Italian Government Fellowship for work in creative sculpture, 1957; Fulbright Fellowship (Italy), 1957. Address in 1982, 78 Greene St., NYC.

DECOMPS, S.

Sculptor. Active in 1887. (Mallet's)

DEGEN, IDA DAY.

Sculptor. Born in San Francisco, CA, October 10, 1888. Studied: California School of Fine Arts; Art Students League; and with Ralph Stackpole, William Zorach. Member: San Francisco Art Association; National Association of Women Artists, New York; San Francisco Women Artists; Marin Society of Artists. Awards: Prizes, Marin Co. Garden Center, 1948, 50; Frances Young Gallery, 1949, 50, 51; San Rafael, CA, 1941; Oakland Art Gallery, 1942, 46; San Francisco Museum of Art, 1942, 43, 50, 51. Work: S. Grace Cathedral; de Young Memorial

Museum; Palace of the Legion Honor, all in San Francisco, CA. Exhibited: San Francisco Museum of Art, 1941-45; Conn. Academy of Fine Arts, 1942; Denver Art Museum, 1941, 43, 45; Penna. Academy of Fine Arts, 1942, 52; National Association of Women Artists, New York, 1942, 43, 45, 46; Pomona, CA, 1941; Delgado Museum of Art, 1942; Oakland Art Gallery, 1941, 42, 44, 46; San Francisco Women Artists, 1941-46; California Palace of the Legion of Honor, 1949; California State Fair, 1950. Address in 1953, Mill Valley, CA.

DEGENER, FAUSTINA MUNROE.
Sculptor and painter. Address in 1934 Charlotte, North Carolina. (Mallet's)

DEGENHART, PEARL C.
Sculptor, painter, and teacher. Born in Philipsburg, MT, in 1904. Studied: University of Montana, B.A.; Columbia University, M.A.; University of California; University of Oregon; University of New Mexico. Award: Prize, University of Montana, 1919. Exhibited: San Francisco Art Association, 1932, 37, 40; Contemporary Art Gallery, 1939; Spokane, Washington, 1948; Oakland Art Gallery, 1948; Topeka, KS, 1950; Denver, CO, 1938; Humboldt State College, 1935, 45, 48. Contributor to: School Arts magazine, on arts and crafts. Taught: Instructor of Art, Arcata High School, Arcata, CA, 1928-46. Address in 1953, Arcata, CA.

DEGOUT, MICHEL.
Sculptor. Worked: Nachitoches, Louisiana, mid-18th century.

DeHAAN, CHUCK.
Sculptor and painter. Born near Fort Worth, TX, 1933. Self-taught. Rodeo career; horse training on own ranch; ran own ad agency. Paintings have been reproduced on Western magazine covers. Also published by Guildhall, Inc. Represented by Trammell's Flying T Gallery, Azel, TX; Copenhagen Galleri, Solvang, CA. Specialty is 20th century cowboy. Paints in oils. Address since 1970, near Graford, TX.

DEHNER, DOROTHY.
Sculptor and printmaker. Born in Cleveland, OH, in 1908. Studied at UCLA; Skidmore College, BS; Art Students League, with Nicolaides, K. H. Miller, Jan Matulka; Atelier 17, New York City; Yaddo Foundation Fellow, 1971. In collections of Metropoltian Museum of Art; Museum of Modern Art; Seattle Art Museum; commission, bronze wall sculpture, Rockefeller Center, New York City; others. Exhibited at Whitney Museum; Museum of Modern Art; Hirshhorn, Washington DC; Guggenheim; Carnegie Institute; Dallas Museum of Contemporary Art; San Francisco Museum of Art; Los Angeles County Museum of Art; others. Awarded Tamarind Lithography Institute Artist in Residence, 1970-71; Sculpture Prize, Art USA, 1968; others. Member of Sculptor's Guild; Federation of Modern Painters and Sculptors; Artists Equity Association. Works in bronze and wood. Represented by Associated American Artists, New York City; Parsons-Dreyfuss, New York City. Address in 1983, 33 Fifth Ave., New York City.

Del PIATTA, BEGNI.
Sculptor. Exhibition at the Pennsylvania Academy of Fine Arts, Philadelphia, in 1924. Address in 1926, 12 West 8th Street, New York.

Del PRADO, MARINA NUNEZ.
Sculptor. Born in La Paz, Bolivia. Studied: Fine Art Academy, La Paz, Bolivia. Member: National Association of Women Artists, New York. Awards: Prizes, medal, Bolivia, 1930; Venezuela, 1934; Argentina, 1936; Berlin, 1938; Latin-America Fellow, American Association of University Women, 1940; prize, National Association of Women Artists, New York, 1946. Work: La Paz, Bolivia; National Museum of Fine Arts, Buenos Aires; IBM; many portrait busts of Government officials. Exhibited: Norfolk Museum of Art, 1942 (one-man); Louisville Art Center, 1942; San Francisco Museum of Art, 1942; Zanesville (Ohio) Art Institute, 1943; Association of American Art; in Europe, South America. Address in 1953, 215 East 57th St., New York, NY; h. La Paz, Bolivia.

DELAUNAY, PAUL.
Sculptor and painter. Born in Paris, France, 1883. Director, Birmingham Academy of Fine Arts, Alabama. Member: American Artists Professional League.

D'ELIA, TERESA ILDA.
Sculptor, painter, illustrator, and teacher. Born in Greenwich, Conn., November 18, 1918. Studied: Art Students League; New School for Social Research; and with Simkovitch, Charlot, Picken, Sternberg. Member: Springfield Art League. Awards: Medal, San Francisco Art Association, 1943; prizes, Douglas Aircraft Exhibit, 1943; Springfield Art League, 1945, 46. Exhibited: Penna. Academy of Fine Arts, 1942; American Artists Professional League, 1942; San Francisco Museum of Art, 1943; Northwest Print Maker, 1943; Philadelphia Print Club, 1945; Los Angeles Museum of Art, 1945; Springfield Art League, 1945, 46; Greenwich Society of Artists, 1945; Douglas Aircraft Exhibit, 1943; Palace of Legion Honor, 1946. Address in 1953, Greenwich, Conn.

DELL, JUAN.
(Glenna Juandell Mitchell). Sculptor. Born in West Texas. Studied at South Plains College and privately. Began sculpting in 1968 in Taos, New Mexico; worked in several foundries. Her work is in public collections. Awarded gold medal by Texas Association of Professional Artists, 1977. Member of that organization. Specialty is bronze figures such as fighting Indians. Represented by Gallery Americana, Santa Fe, NM. Bibliography, *The First Lady of Western Bronze*. Address in 1982, Santa Fe, NM.

DELLFANT, MAX.
Sculptor. Member: New Haven Paint and Clay Club. Address in 1926, New Haven, CT.

DELSON, ROBERT.
Sculptor and painter. Worked: Chicago, Illinois, 1909. Member: Chicago Artists Union.

DELUIGI, JANICE CECILIA.
Sculptor and painter. Born in Indianapolis, IN, November 27, 1915; Italian and American citizen. Works: Illinois

Bell Telephone Co., Chicago; Art Institute of Chicago; Civic Museum Revltella, Trieste, Italy. Commissions: Sculpture in memory of John F. Kennedy and Robert F. Kennedy, Community of Milano, Italy, 1969; stained glass windows, San Giorgio Maggiore, Benedictine Monastery, 1973 and Cini Foundation and Benedictine M. Nuovalese, 1973; artistic glass sculpture of Murano for the best film presented at the VII Festival International School of Film and Fiction, Trieste, 1969. Exhibitions: Gallery Art, Muova Spazio, Folgaria, Italy, 1975; Gallery Art, San Marco, Venice, 1975; La Capella, Art Center, Trieste, 1975; Engravings, International Center Graphics, Venice, 1975. Awards: First Prize International Painting and Sculpture, Fruili-Venezia Guilia, 1971; Silver Medal for Painting, Pope Paul VI, 1973. Media: Glass; oil, watercolor. Address in 1982, Venice, Italy.

DEMAREST, EDA LORD.
Sculptor. Born in Blue Earth, Minnesota, 1881. Awards: 1st prize, New Jersey Art Association, Montclair, 1932. Worked: NYC. Address in 1934, NYC.

DEMETRIOS, GEORGE.
Sculptor. Born in Greece, April 1, 1896. Studied with Charles Grafly and Antoine Bourdelle. Exhibited at the Pennsylvania Academy of Fine Arts, Philadelphia, in 1924. Member: Associate, National Academy of Design; National Sculpture Society and Boston Society of Independent Artists. Died in 1974. Address in 1970, Gloucester, MA.

DEMING, EDWIN WILLARD.
Sculptor, painter, muralist, writer, and illustrator. Born Ashland, OH, on August 26, 1860. Pupil of Art Students League of New York; Lefebvre and Boulanger in Paris. Member: Mural Painters; Washington Art Club; (life) National Arts Club. Awards: Silver medal, American Art Society, 1892; bronze medal, St. Louis Exposition, 1904; bronze medal for sculpture, P.-P. Exposition, San Francisco, 1915. Work: Two mural paintings, Morris High School, NYC; "Braddock's Defeat" and "Discovery of Wisconsin," mural decorations, Wisc. Historical Society, Madison, WI; "The Fight" and "Mutual Surprise," two bronzes, Metropolitan Museum, NY; "The Watering Place," "Pueblo Buffalo Dance" and "Sioux War Dance," Art Museum, Montclair, NJ; "Mourning Brave," National Museum, Washington, DC; "Attacked by Bears," gouache; "Bighorn Sheep," bronze; "The Grand Charge that Ended the Fight" against Custer, painting; and others in collections; represented in American Museum of Natural History, NY, Heye Foundation, Explorers Club, National Arts Club; Montifiore Home for Crippled Children; Amon Carter Museum of Western Art; murals of Indian life, Museum of the American Indian, Brooklyn Museum; Whitney Museum of American Art. Traveled in West, studying Indians. Wrote and illustrated articles about Indians with artists DeCost Smith and Frederic Remington. Painting, "Landfall of Jean Nicholet," selected for commemorative US stamp. Modeled bronzes 1905-1910; primarily painter and illustrator. Specialty, Indian and animal subjects of the West. Address in 1933, 15 Gramercy Park, NYC. Died in NYC, 1942.

DEMIRJIAN, LOUISE.
Sculptor. Work includes "Continuum #3," siena marble, exhibited at National Association of Women Artists Annual, NYC, 1983. Member: National Association of Women Artists. Address in 1983, 1 Gracie Terrace, NYC.

DENBY, EDWIN H.
Sculptor and architect. Member of New York Architectural League, 1908. Address in 1934, 333 Fourth Ave., NYC.

DENEGAN, SAMUEL.
Sculptor. At New Orleans, 1841-42.

DENGHAUSEN, FRANZ H.
Sculptor and teacher. Born in Boston, Mass., April 8, 1911. Studied at Boston Museum Fine Arts School, with Charles Grafly; Child-Walker School of Design, with Arnold Geissbuhler. Member: Copley Society; Boston Art Club; North Shore Art Association; Rockport Art Association; others. Exhibited: Penna. Academy of Fine Arts, 1931; National Academy of Design, 1931; World's Fair of New York, 1939; Cincinnati Museum Association, 1935; Addison Gallery, 1939, 51; Wadsworth Atheneum, 1951; many others. Instructor of sculpture, Cambridge Center for Adult Education, Cambridge, MA. Address in 1953, Roslindale, MA.

DENGLER, FRANK.
Sculptor. Born in Cincinnati, Ohio, in 1853. He studied abroad, and on his return to this country was for a time instructor in modeling in the Boston Museum. He resigned in 1877, and moved to Covington, KY, and afterwards to Cincinnati. Among his works are "Azzo and Melda," an ideal head of "America," and several portrait busts. Died in 1879.

DENNETT, LISSY.
Sculptor. Work includes "Glissando," onyx, exhibited at National Association of Women Artists Annual, NYC, 1983. Member: National Association of Women Artists. Address in 1983, Great Neck, NY.

DENNIS, DONNA FRANCES.
Sculptor. Born in Springfield, OH, October 16, 1942. Studied at Carleton College, B.A., 1964; College Art Study Abroad, Paris, 1965; Art Students League, with Stephen Greene, 1966. Has exhibited at Walker Art Center, MN; Whitney Museum of American Art, NY; Hirshhorn Museum, Washington, DC; Indianapolis Museum of Art, IN; others. Received National Endowment for the Arts Grant, 1977, 80; John Simon Guggenheim Foundation Fellowship, 1979; others. Taught at Skowhegan School of Art, ME, 1982. Address in 1982, 131 Duane St., NYC.

DENNISON, GEORGE AUSTIN.
Sculptor and painter. Born in New Boston, Illinois, 1873. Exhibited sculptured enamels in the Louvre Museum, Paris. Address in 1926, Cathedral Oaks, Alma, CA.

DENSLOW, DOROTHEA HENRIETTA.
Sculptor. Born in NYC, Dec. 14, 1900. Studied at Art Students League of New York. Member: Conn. Academy of Fine Arts; American Federation of Arts. Work: Foun-

tain sculpture (Richmond, VA); memorial plaque, Beth Moses Hospital, NYC; Brookgreen Gardens, SC. Exhibited: Syracuse Museum of Fine Art, 1938; Berkshire Museum of Art, 1941; others. Position: Founder and Director, Sculpture Center, NYC, 1928-53. Address in 1970, 167 East 69th St., NYC. Died in 1971.

Der HAROOTIAN, KOREN.
Sculptor and painter. Born in Ashodavan, Armenia, April 2, 1909. Studied at Worcester Museum Art School. Works: Metropolitan Museum of Art; Worcester Museum of Art; Whitney; Penna. Academy of Fine Arts; Arizona State College Museum, Tempe; marble eagle, US Pavilion, Brussels World's Fair, 1958; Fairmount Park Association, Philadelphia, PA. Awards: Springfield Art League, 1945; Audubon Artists, 1950, medal, 1949; gold medal, Penna. Academy of Fine Arts, 1954; American Academy of Arts and Letters, 1954. Exhibited: Whitney, 1956 and prior; Penna. Academy of Fine Arts, 1946-56 Art Institute of Chicago, 1951, 54; Phila. Art Alliance, 1950; Detroit Institute of Art, 1960; others. Address in 1970, Orangeburg, NY.

DERUJINSKY, GLEB W.
Sculptor, painter, lecturer, craftsman, and teacher. Born Smolensk, Russia, on August 13, 1888. Pupil of Verlet, Injalbert in France and of the Russian Academy. Member: National Sculpture Society; New York Architectural League; National Academy of Design; Allied Artists of America. Exhibited at National Sculpture Society, 1923. Award: Silver medal, Encouragement of Art, Petrograd, 1909; gold medal, Sesqui-Centennial Exposition, Philadelphia, 1926; National Academy of Design, 1938, 68; medal, National Arts Club, 1961, 64; Lindsey Memorial prize, 1954, 65; Allied Artists of America, 1958, gold medal, 1966; others. Work: "Theodore Roosevelt," Roosevelt Memorial House, New York. In collections of Metropolitan Museum of Art; Cranbrook and San Diego Fine Art Gallery; others. Address in 1970, 29 West 65th Street, NYC. Died in 1975.

DEUEL, AUSTIN.
Sculptor and painter. Born in Pittsburgh, PA, 1939. Taught art, ran an art gallery, was Marine Corps combat artist in Vietnam; also collected art, both Old Masters and Contemporary. Work has appeared on greeting cards and calendars. Member of American Indian and Cowboy Artists. Reviewed in *Southwest Art*. Represented by Signature Galleries, Scottsdale, AZ; Kessler's Art Gallery, San Diego, CA. Specialty is modern and Old West subjects. Address in 1982, Scottsdale, AZ.

DEUTSCH, JIM.
Sculptor. Born in San Antonio, TX, 1926. Studied at Texas A & M, B.S. agriculture, 1953; self-taught in art. Ran own corporation. In 1974 began sculpting. Specialty is Western cowboy, rodeo cowboy, and wildlife subjects. Works in bronze. Reviewed in *Southwest Art*, June 1979. Represented by Escondido Gallery, Rockport, TX; and Corpus Christi Art Gallery, TX. Address in 1982, San Antonio, TX.

DEVANNIE, FRANCIS.
Sculptor. Born in Italy in 1835. Living in Philadelphia, Penna. in 1860.

DEWITT, JIM.
Sculptor. Born in Muskegon, MI, 1949. Studied: Western Michigan University, M.F.A. Exhibitions: 6th Blossom-Kent Outdoor Sculpture Exhibition, Kent, OH, 1973; Kalamazoo Art Center, 1973-74; Western Michigan University, 1974; Detroit Institute of Arts, Works by Michigan Artists, 1974-75. Commissions: Sculpture in Downtown Mall, Kalamazoo, 1973-74. Address in 1975, Muskegon, MI.

DEXTER, HENRY.
Sculptor. Born in Nelson, New York, October 11, 1806. Self-taught. Among his portrait busts are those of Charles Dickens, Longfellow, Agassiz, Henry Wilson, and Anson Burlingame. His statues include "The Backwoodsman," "The Cushing Children," "Gen'l. Jos. Warren at Bunker Hill," and "Nymph of the Ocean." Exhibited: Boston Athenaeum, 1834. Also executed a series of busts of the governors of the US, 1859-60. Died in Cambridge, MA, June 23, 1876.

DHAEMERS, ROBERT AUGUST.
Sculptor. Born in Luverne, MN, November 24, 1926. Studied: California College of Arts and Crafts, B.F.A., 52, M.F.A., 54. Work: First Christ Lutheran Church, Burlingame, CA; Mills College; others. Commissions: Jerrys Restaurant, San Leandro, CA; First Lutheran Church; science complex, Mills College; Holy Cross Hospital, San Fernando, CA; others. Exhibitions: New York Museum of Contemporary Crafts; Addison Gallery of American Art, Andover, MA; De Young Museum, San Francisco, CA; Brigham Young University; Civic Art Gallery, San Jose; etc. Awards: Gold medal, sculpture, Oakland Museum of Art; first prize, metal work, California State Fair; Mills College faculty research grant. Teaching: Mills College, Oakland, CA, 1957-1980. Member: Western Association Schools & Colleges; Accrediting Commission Senior Colleges & Universities; others. Media: Metal, stainless steel, galvanized painted steel; etching, lithography, silk screen. Address in 1982, Oakland, CA.

Di BONA, ANTHONY.
Sculptor. Born Quincy, MA, on October 11, 1896. Pupil of Philip L. Hale, Charles Grafly, L. P. Thompson, Bela Pratt, and School of the Museum of Fine Arts, Boston; also American Academy in Rome and Paris. Member: Boston Art Club and Boston Sculpture Society; Gloucester Society of Artists; North Shore Art Association. Work: Portrait of Thomas Allen, School of the Boston Museum of Fine Arts; Fountain, War Memorial, Woburn, Massachusetts. Address in 1935, Trudeau, NY. Died in 1951.

Di LORENZO, JOSEPH A.
Sculptor. Member of the National Sculpture Society. Address in 1982, Alpine, NJ.

Di MEO, DOMINICK.
Sculptor and painter. Born February 1, 1927, in Niagara Falls, New York. B.F.A. from Art Institute of Chicago; M.F.A. from University of Iowa (1953). Awarded Guggenheim Memorial Foundation Fellowship in Graphics, 1972-73. In collections of Whitney; University of Mass., Amherst; Art Institute of Chicago; others. Exhibited at Albright-Knox, Buffalo, New York; Art Institute of Chi-

cago; Whitney Museum; International Drawing Competition, Barcelona; and others. Award: Guggenheim Memorial Foundation Fellowship for Graphics, 1972-73. Address in 1982, 429 Broome St., NYC.

Di SPIRITO, HENRY.
Sculptor. Born in Castleforte, Italy, July 2, 1898. Studied: Munson-Williams-Proctor Institute, and with Richard Davis. Awards: Prize, Cooperstown Art Association, 1947, 48, 50, 51. Work: Munson-Williams-Proctor Institute; Sherburne (NY) Public Library; Addison Gallery of American Art, Andover, MA. Exhibited: Whitney Museum of Art, 1951; Art Institute of Chicago, 1951; Museum of Modern Art, 1951; Sculpture Center, 1949; Cortland State Fair, 1948; Cooperstown Art Association, 1947-52; Albany Institute of History and Art, 1951; St. Lawrence University, 1952; Addison Gallery of American Art, Andover, 1952; one-man: Colgate University, 1947; Munson-Williams-Proctor Institute, 1949; Cazenovia Jr. College, 1949; Sherburne Public Library, 1950. Address in 1953, Utica, NY.

Di SUVERO, MARK.
Sculptor and painter. Born in Shanghai, China. Studied at University of California. In collections of Wadsworth Atheneum; New York University. Exhibited at Art Institute of Chicago; Peace Tower, Los Angeles; American Sculpture of the Sixties, Los Angeles County Museum; Whitney; San Francisco Museum of Art; 20th National Print Exhibition; etc. Received Longview Foundation Grant; Walter K. Gutman Foundation Grant; Art Institute of Chicago Award. Address in 1982, 195 Front St., NYC.

Di VALENTIN, LOUIS.
Sculptor and painter. Born in Venice, Italy, November 21, 1908. Studied: California School of Fine Arts; Corcoran School of Art; Art Students League; and in Italy. Award: Prize, National Academy of Design. Work: Catholic University; National Cathedral; St. Matthews, all in Washington, DC. Exhibited: Corcoran Gallery of Art, 1945; Carnegie Institute, 1942-45; National Academy of Design, 1942-45; Toledo Museum of Art, 1943-45; Springfield (Mass.) Museum of Art, 1943-45; Cambridge, Mass., 1944, 45. Address in 1953, 74 East Locust Avenue, White Plains, NY.

DIANA, PAUL.
Sculptor and designer. Born in New York, NY, July 22, 1913. Studied: New York University; National Academy of Design; Art Students League; Beaux-Arts Institute of Design, New York. Awards: Medal, Beaux-Arts Institute of Design, 1932, 33; Leonardo DaVinci Art School, 1934. Exhibited: Architectural League, 1939, 40. Lectures: Sculpture and Architecture. Taught: Assistant Professor of Sculpture, New York University, 1935; Industrial Designer, Everett Worthington, Inc., 1937-40; Instructor, Clay Modeling, Brooklyn Museum School of Art, Brooklyn, NY, from 1946. Address in 1953, 71 Seventh Avenue; h. 77 Bedford St., New York, NY.

DICK, GEORGE.
Sculptor and painter. Born in Manitowoc, WI, 1916; moved to Albuquerque, NM, 1947. Studied at University of Michigan, forestry 1939; University of New Mexico, M.F.A., 1950 (with Randall Davey, Kenneth Adams). Worked for US Wildlife Service and travelled extensively in the West. Work published in magazines such as *Arizona Highways, Saturday Evening Post, New Mexico Stockman*; on Christmas cards. Exhibited nationally. Represented by Woodrow Wilson Fine Arts, Santa Fe, NM. Specialty was wildlife and Western subjects. Bibliography, *Western Painting Today*, Hassvick; *Cowboys in Art*, Ainsworth. Died in 1978 in Albuquerque, NM.

DICKERSON, GRACE LESLIE.
Sculptor and painter. Born in Fort Wayne, IN, August 27, 1911. Studied: Ft. Wayne Art School; Art Institute of Chicago; and with Guy Pene duBois. Member: Indiana Art Club; Hoosier Salon. Awards: Prizes, Ft. Wayne Museum, 1938, 40, 44; Indiana State Fair, 1940, 46; Hon. degree, B.A., Wayne University, 1950. Work: Cathedrals in Ft. Wayne, Evansville, South Bend, IN. Exhibited: Women's National Exhibition, Cincinnati, Ohio, 1933; Hoosier Salon, 1936, 38, 40, 46; Herron Art Institute, 1938, 39, 41, 44; Ft. Wayne Museum, 1938-46; Indiana Art, 1939-45; one-woman: Canterbury College, Danville, IN; Civic Theatre, Ft. Wayne. Address in 1953, Fort Wayne, IN.

DICKEY, DAN.
Sculptor, painter, and teacher. Born in New York, NY, March 17, 1910. Studied: Carleton College, B.A.; National Academy of Design; Art Students League; and with Kroll, Covey, Bridgman, Hofmann. Member: San Diego Art Guild. Awards: Prizes, San Diego Fine Art Society, 1937, 38; San Diego Art Guild, 1945. Work: San Diego Fine Art Society; Otis Art Institute; Carville (La.) Marine Hospital. Exhibited: Cincinnati Museum Association, 1936; San Francisco Museum of Art, 1938, 39; Oakland Art Gallery, 1937, 38, 42; National Gallery of Art, Washington, 1941; San Diego Fine Art Society, 1937, 40, 41; Los Angeles Museum of Art, 1938, 1945; San Diego Art Guild, 1940-46; Los Angeles Art Association, 1941, 46. Address in 1953, San Diego, CA.

DICKINSON, DAISY OLIVIA.
Sculptor, painter, craftsman, and lecturer. Born June 3, 1903, in Bellingham, Washington. Studied at Chouinard Art Institute; Santa Barbara School of Fine Arts; and with Chamberlin, MacDonald-Wright, and Fletcher. Award: Los Angeles County Fair, 1941. Exhibited: Los Angeles Museum of Art, 1929, 33, 39, 40; California State Fair, 1930, 31, 34; Pasadena Art Institute, 1930, 31. Instructor of Drawing and Painting, Children's Class, Santa Barbara (Calif.) School of Fine Arts. Address in 1953, La Crescenta, CA.

DICKSON, THOMAS H.
Sculptor. Born in Denver, CO, 1949. Lived in Kansas. Attended University of Denver; a California welding trade school; Southwestern College. Worked in art foundry, gold mines, and ran art gallery. Began sculpting full-time in 1977. Exhibited at Mattson Galleries, Denver, CO; Trailside Gallery, Scottsdale, AZ. Reviewed in *Southwest Art*, fall 1977. Specialty is wildlife. Works in bronze and stainless steel; bi-metal castings. Address in 1982, Aurora, CO.

DIEDERICH, (WILHELM) HUNT.
Sculptor. Born Hungary, on May 3, 1884. Studied sculpture in Philadelphia, PA, Rome, and Paris. Member: Salon d' Automne, Paris, and Salon des Tuileries. Exhibited at National Sculpture Society, 1923. Award: Gold medal, Architectural League, pottery, 1927. Specialty, animals and figures for monuments. Address in 1933, c/o Milch Gallery, 108 West 57th St., New York, NY; summer, Cagues A. M. France; Burgthaun, Bavaria, Germany.

DIELMAN, ERNEST BENHAM.
Sculptor. Born in New York, 1893. (Mallett's)

DIEMAN, CLARE SORENSEN.
Sculptor. Born Indianapolis, IN. Pupil of Art Institute of Chicago; Columbia University; and with Ozenfant, Zadkine, Archipenko. Work: Collaborating with architects in architectonic sculpture; forty-five models, Denver National Bank; models for Gulf Building, Houston, Texas. Exhibited: Art Institute of Chicago, 1917; Penna. Academy of Fine Arts, 1943, 45; National Association of Women Artists, 1945, 46; others. Member: National Association of Women Artists; Phila. Art Alliance; Santa Fe Painters and Sculptors. Taught: Shipley School for Girls, Bryn Mawr, PA. Address in 1953, 205 East 19th St., NYC.

DIENES, SARI.
Sculptor, painter, and teacher. Born in Debrecen, Hungary, October 8, 1898. US citizen. Studied: Ozenfant School of Art, London, England; and with Andre L'Hote, Fernand Leger, in Paris; Henry Moore, in London. Work: Brooklyn Museum; Museum of Modern Art Print Collection; numerous commissions including stage sets and costume designs. Exhibited: Mortimer Brandt Gallery; Norlyst Gallery; Vendome Gallery; New School for Social Research, 1942, 75; Bronx Museum of Art, 1975; Hecksher Museum, 1979; many others. Taught: Assistant Director, Ozenfant School 1936-41; Instructor, Parsons School of Design, NYC; Director, Sari Dienes Studio, NYC. Received American Federation of Art Grant, 1971; Rothko Foundation Grant; International Women's Year Award, 1976. Address in 1980, Stony Point, NY.

DIETRICH, GEORGE ADAMS.
Sculptor, painter, illustrator, and teacher. Born Clark County, IN, April 26, 1905. Pupil of Charlotte R. Partridge, Garolomo Picolli, Viola Norman; Layton School of Art; Art Institute of Chicago. Member: Wisconsin Painters and Sculptors; Hoosier Salon. Awards: Culver Military Academy prize ($200), Hoosier Salon, 1927; Clement Studebaker water color prize ($100), Hoosier Salon and the Currie Monon prize ($100), Hoosier Salon, 1928; Milwaukee Art Institute Medal and $50 for sculpture, Wisconsin Painters and Sculptors, 1929. Exhibited: Art Institute of Chicago, 1928, 30, 31; Hoosier Salon, 1927-32; Penna. Academy of Fine Arts, 1929, 30. Head of sculpture department, Layton School of Art, 1929-37. Taught: Professor, Sculpture and Painting, University of Michigan, 1937-38. Address in 1953, Milwaukee, WI.

DIETSCH, CLARENCE PERCIVAL.
Sculptor and painter. Born NYC, on May 23, 1881. Studied at New York School of Art; American Academy in Rome; and with William M. Chase, Beckwith, Attilio Piccirilli. Member: Alumni American Academy in Rome; National Sculpture Society 1910; New York Architectural League, 1911. Awards: Rinehart Scholarship in sculpture, American Academy in Rome, 1906—1909; honorable mention, P.-P. Exposition, San Francisco, 1915. Work: Besso Memorial Monument in Rome; panels for Rice Institute, Houston, Texas; "Athlete," Peabody Institute, Baltimore. Exhibited: Penna. Academy of Fine Arts, 1907; American Academy in Rome, 1906-10; National Institute of Design. Address in 1953, Palm Beach, FL. Died in 1961.

DIGIUSTO, GERALD N.
Sculptor. Born in New York, NY, June 30, 1929. Studied at Massachusetts College of Art, 1949-50; Boston Museum School, dipl., 1957; Yale University School of Art, B.F.A., 1958; University of Florence, Italy, 1959-60. Work in Munson-Williams-Procter Institute Museum, Utica, NY; others. Commissions, Great American Eagle, Everson Museum, Syracuse, NY; others. Has exhibited at Institute of Contemporary Art, Boston, MA; Seattle Art Museum; San Francisco Museum of Art; Museum of Fine Arts, Boston, MA. Received awards from Boston Museum School, MA, 1958-60, Mrs. David Hunt Scholarship for study abroad; State University of NY, Research Award, 1977. Works in steel. Address in 1982, Cortland, NY.

DILL, GUY GIRARD.
Sculptor. Born in Duval Co., FL, May 30, 1946. Studied at Chouinard School of Art, Los Angeles, B.F.A. Work in Guggenheim Museum, NY; Museum of Modern Art, and Whitney Museum of American Art, NY; Long Beach Museum of Art, CA; others. Has exhibited at Guggenheim Museum; Ace Gallery, Los Angeles; Whitney Museum of American Art; Walker Art Center, Minneapolis, others. Received Theodoran Award, Guggenheim Museum; National Endowment for the Arts; Chicago Institute of Art, first prize; others. Address in 1982, Venice, CA.

DILLOWAY, GEORGE W.
Sculptor. Born c. 1810, Massachusetts. At New York City, 1850.

DIMOND, JANE.
Sculptor and painter. Address in 1934, New York. (Mallet's)

D'IMPERIO, DOMINIC.
Sculptor. Born Italy, on August 31, 1888. Pupil of Grafly and Leasoly. Member: Penna. Academy of Fine Arts; Philadelphia Alliance. Award: Bronze medal, Spring Garden Institute, 1916. Work: "Sincler Memorial," Church of St. James, Philadelphia; "Pan," Graphic Sketch Club, Philadelphia. Address in 1929, Philadelphia, PA.

DINE, JAMES.
Sculptor and painter. Born in Cincinnati, OH, June 16,

1935. Studied: University of Cincinnati; Boston Mus. School. Work: The Museum of Modern Art, NYC; Tate Gallery, London; Stedelijk Museum, Amsterdam; Whitney, NYC; Albright-Knox, Buffalo, NY. Exhibitions: Guggenheim, NYC, 1963; Venice Biennial, 1964; Whitney Museum, NYC, 1966; Milwaukee Art Center, 1979; many more. Awards: Norman Harris silver medal & prize, Art Institute of Chicago, 1964. Teaching: Visiting professor, Oberlin College, 1965; Cornell University, 1967. Address in 1982, c/o The Pace Gallery, NYC.

DIODA, ADOLPH T.
Sculptor and instructor. Born in Aliquippa, PA, September 10, 1915. Studied: Carnegie Institute; Cleveland School of Art; Art Students League; Barnes Foundation, and with John B. Flannagan. Member: Artists Equity Association, NY; Association of Artists, Pittsburgh. Work: Carnegie Mellon Museum; Penna. Academy of Fine Arts; Philadelphia Museum of Art; others. Awards: Guggenheim Foundation Grant, 1946; medal, Penna. Academy of Fine Arts, 1947; Philadelphia Art Alliance, 1952. Exhibited: Whitney Museum of Art, 1940; Association of Artists, Pittsburgh, 1941-45; Art Institute of Chicago, 1951; Philadelphia Art Alliance, 1951; Carlen Gallery, Philadelphia, PA, 1951; Penna. Academy of Fine Arts, Annuals 1946, 47, 69. Taught: Temple University, 1959-69; Haverford, 1962-69; Penna. Academy of Fine Arts from 1962; etc. Address in 1982, Jenkintown, PA.

DISKA, PATRICIA.
Sculptor. Born in NYC, 1924. Studied: Vassar College, B.A.; in 1947, travelled to Paris as a research assistant where she joined the Academie Julian and attended classes with Joseph Rivier and carving with Marek-Szwarc. Exhibited works at the Salon de la Jeune Sculpture in 1955; several group exhibitions in Paris, London, NYC. Member: Sculptors Guild; French Syndicate of Sculptors. Taught: Sculpture, Sarah Lawrence Summer School, Lacoste, France, 1974, 75. Works mostly in stone on a grand scale. Represented at Finch Museum, NY; Cornell Art Museum; International Sculpture Parks in Austria, Israel, Czechoslovakia, France, Yugoslavia. Address in 1933, 305 West 28th St., NYC.

DISMUKES, ADOLYN GALE.
(Mrs. George). Sculptor, painter, and writer. Born in Memphis, TN, May 14, 1865. Studied: Bethany College. Specialized in tropical and Arctic landscapes. Author: "A Norse Idyll." Contributor to newspapers and magazines. Awards: Honorable mention, Tenth Annual Exhibition of Tennessee Artists, Nashville, 1928; second and third prizes, Mississippi Art Association, 1929. Address in 1953, Biloxi, Miss.

DISQUE, JILL.
Sculptor. Born in Philadelphia, Pennsylvania. Studied: Pennsylvania Academy of Fine Arts; University of Pennsylvania; Parsons School of Design. Exhibitions: Westchester Community College; Fairfield University; Bridgeport University. Collections: Housatonic Art Museum; Westport Public Schools.

DiVITA, FRANK.
Sculptor. Born in Genoa, Italy, 1949; moved to Missoula,

MT, 1960. Studied at University of Montana, B.F.A. art and zoology. Began work as graphic artist and medical illustrator; wildlife illustrator with US Forest Service. Later turned full-time to sculpture and painting. Exhibited at Peking Exhibition of Western Art, China, 1981. Represented by Driscol Gallery, Denver, CO; and others. Specialty is Northwestern wildlife, primarily birds. Works in bronze. Address in 1982, Kalispell, MT.

DIXEY, GEORGE.
Sculptor. Son of John Dixey, an Irish-American sculptor; was born in Philadelphia and studied under his father. He executed "Theseus Finding his Father's Sword," "Saint Paul in the Island of Malta," and "Theseus and the Wild Boar." Exhibited at the American Academy, 1817-20; Penna. Academy, 1818. Followed in his father's gilding and carving business, 1821-32. Died c. 1854.

DIXEY, JOHN.
Sculptor. Born in Dublin, Ireland, c. 1760-1770; settled in Philadelphia towards the close of the eighteenth century. Studied: Royal Academy; Italy, 1789. Did some modeling and stone cutting. Noted works: "Hercules and Hydra;" "Ganymede;" the figures of "Justice" on the New York City Hall and the Albany State House; bust of Alexander Hamilton. Exhibited at Royal Academy, 1788; American Academy; and Penna. Academy. Died in 1820.

DIXEY, JOHN V.
Sculptor and painter. The youngest son of the Irish-American sculptor (John Dixey) was born in Philadelphia and received instruction from his father. In 1819 he modeled "St. John writing the Revelations." Gave up sculpture after 1827. He painted several landscapes in oil that were exhibited at the gallery of the National Academy of Design, the Apollo Association, and the American Academy.

DLUGOSZ, LOUIS FRANK.
Sculptor. Born in Lackawanna, New York, November 21, 1915. Studied: Albright Art Gallery; and in Paris, France. Member: The Patteran, Buffalo, New York. Awards: Guggenheim Memorial Prize, Buffalo, New York, 1939. Exhibited: Albright Art Gallery, 1936-38; The Patteran, 1939; Nierendorf Gallery, 1940; Paris Art Exhibition, 1946. Address in 1953, Lackawanna, NY.

DOBBINS, HELEN E.
Sculptor. Born Trenton, NJ, January 3, 1885. Pupil of Charles Grafly. Address in 1913, Woodbury, NJ.

DOBOS, EUGENE.
Sculptor and painter. Born in Dnepropetrovsk, Russia, 1933; came to Chicago, IL, 1951. Studied at American Academy of Art; Art Students League (scholarship). Exhibits at Heydt-Bair Gallery, Santa Fe, NM; CJS Gallery, Denver, CO. Painting specialty is flowers and floral shapes. Reviewed in *Margaret Jamison Presents*; *Southwest Art*, summer 1976, May 1979; *The Santa Fean*, June 1980. Address since 1963, Taos, NM.

DODGE, CHARLES J.
Sculptor. Born in NYC, 1806. Began as a figurehead and ship carver in 1828, working for his father Jeremiah

Dodge. His first known work is a bust of his father in pine, painted white; donated to the New York Historical Society in 1952. He carved a head for the damaged head of President Andrew Jackson for the frigate *Constitution*. Continued independently as a carver, setting up his studio on South Street, later incorporated his father's carving business after his death in 1860. Attributed wood sculptures of larger than life "Jim Crow," in the Shelburne Museum, Vermont, and a seated Indian figure used at a cigar store. Indian now in the Long Island Historical Society. Gave up sculpture in 1874; died twelve years later, in 1886.

DODGE, JEREMIAH.
Sculptor. Born in 1781. Worked in NYC as a ship and figurehead carver. He studied ship carving with Simeon Skillin, 1798; partner from 1806-1811. Formed a partnership with Cornelius N. Sharpe, from 1815-1828. Later took into the partnership his son, Charles J. Dodge, with whom he worked until 1838. Known works: "Hercules" for the U.S.S. *Ohio*, 1820; heads for the *Lexington* and the *Vincennes*, 1825; and the well-known "Andrew Jackson" for the U.S.S. *Constitution*, 1835. Died in 1860.

DOMBEK, BLANCHE M.
Sculptor. Born in New York City, in 1914. Studied: Graduate Training School of Teachers; with Zeitlin and Amino. Exhibited: Sculpture Center, New York Sculptors Guild, 1980; Canton Art Institute, Ohio, 1981; St. Gaudens Memorial, National Historical Site, Cornish, NH, 1981; others. Awards: Fellowship, MacDowell Colony, 1981; others. Collections: Brooklyn Museum; Randolph-Macon Woman's College. Address in 1982, Hancock, NH.

DONATI, ENRICO.
Sculptor and painter. Born in Milan, Italy, February 19, 1909; United States citizen. Studied at University of Pavia, Italy; Art Students League, 1940; New School for Social Research. In collections of Albright-Knox Art Gallery, Buffalo, New York; Museum of Modern Art; Whitney; Baltimore Museum; Corning Glass, New York; University of Michigan; others. Exhibited at Carnegie International Exhibits, 1945-61; Museum of Modern Art, 1953-54; Guggenheim, 1954-55; Whitney; Penna. Academy of Fine Arts; Staempfli Gallery, New York City, 1962-80; Grand Palais, Paris, 1980; and others, including museums in Rome, Milan, Brussels, Munich, Sao Paulo. Served on advisory board, Brandeis University; Yale University President's Council on Arts and Architecture; others. Also taught at Yale, 1962-72. Represented by Staempfli Gallery, New York City. Address in 1982, 222 Central Park South, New York City.

DONATO, GUISEPPE.
Sculptor. Born Maida, Calabria, Italy, on March 14, 1881. Pupil, Philadelphia Industrial Art School under Grafly and J. Liberty Tadd and Penna. Academy of Fine Arts under Grafly; Ecole des Beaux-Arts; Julian and Colarossi Academies in Paris; and under Auguste Rodin. Member: National Sculpture Society 1909; NY Architectural League; American Art Association of Paris; Union In-

ternationale des Beaux-Arts et des Lettres; Fellowship Penna. Academy of Fine Arts; American Federation of Arts. Awards: Stewardson scholarship, Penna. Academy of Fine Arts, 1900 (first time awarded); Cresson European scholarship, Penna. Academy of Fine Arts, 1903-05 (first time awarded). Exhibited at National Sculpture Society, 1923. Work: City Hall, Philadelphia and in Penna. Academy of Fine Arts. Address in 1933, Philadelphia, PA. Died in 1965.

DONELSON, MARY HOOPER.
(Mrs. P. T. Jones). Sculptor. Born in Hermitage, Tennessee, January 3, 1906. Studied at Vanderbilt University; Art Institute of Chicago; and with Emil Zettler, Guy Pene duBois, and Albin Polasek. Works: Tennessee State Capitol; University of Tennessee; Davidson County Court House. Awards: Art Institute of Chicago, 1928; Proctor & Gamble Company, 1928; Public Health Association, 1929. Exhibited: Penna. Academy of Fine Arts, 1931; National Academy of Design, 1938; Art Institute of Chicago, 1930; Southern States Art League, 1934; Nashville Museum of Art, 1945. Address in 1953, Old Hickory, TN.

DONER, MICHELE OKA.
Sculptor. Born in Miami Beach, FL, 1945. Studied: University of Michigan, B.F.A., M.F.A. Collections: Johnson Wax Collection; John Michael Kohler Arts Center, Sheboygan, WI; Steelcase Collection of Contemporary Art; private collections. Exhibitions: Michigan Artists Exhibition, The Detroit Institute of Arts, 1970; All Michigan, The Flint Institute of Arts, 1971; Gertrude Kasle Gallery, Detroit (two-person), 1971; MacGilman Gallery, Chicago, 1972; John Michael Kohler Arts Center Invitational (Ceramic Sculpture), 1973; Richard Nash Gallery, Seattle, WA, 1974; Works by Michigan Artists, Detroit Institute of Arts, 1974-75. Awards: Dr. and Mrs. Barnett Malbin Prize, 20th Exhibition for Michigan Artists-Craftsmen; Standard Ceramic Company Award, 2nd Invitational Exhibition; Ceramic Award, 2nd Michigan Craftsmen's Council Exhibition. Address in 1975, Franklin, MI.

DONNESON, SEENA.
Sculptor and printmaker. Born in New York City. Studied: Pratt Institute; The Art Students League, New York City; New School for Social Research. Awards: Edward MacDowell Foundation, 1963-64; Tamarind Lithography Workshop, 1968; and ten national competition awards. Exhibited: 15th and 19th Biennial, Brooklyn Museum, 1965 and 75; Finch College, 1971; San Diego Museum, CA, 1975; others. Collections: Finch College, New York; Norfolk Museum, Virginia; Museum of Modern Art, New York; Los Angeles County Museum of Art, CA; plus many others. Member: National Association of Women Artists; Artists Equity Association; Women in Art. Media: Clay, handmade paper, heavily embossed collographs and etching. Represented by Associated American Artists and Grippi Gallery in NYC. Address in 1982, 319 Greenwich St., NYC.

DONOGHUE, JOHN.
Sculptor. Born in Chicago in 1853. Pupil of Academy of Design; also studied in Paris. Principal work: "Young Sophocles," 1885, "Hunting Nymph," 1886, and "St.

Paul," at Congressional Library, Washington, DC; "St. Louis of France," Appellate Court House, NYC; "Egyptian Ibis." Awarded first prize, Columbian Exposition, Chicago, 1893 ("Sophocles Leading the Chorus after Battle of Sallis"); honorable mention, Paris Salon of 1886. Died in July of 1903, Lake Whitney, CT.

DONOHO, GAINES RUGER.
Sculptor and landscape painter. Born in Church Hill, MI, in 1857. He died in NYC, 1916. Pupil of Art Students League and R. Swain Gifford in NY; also studied in Paris at Julian Academy under Lefebvre, Boulanger, Bouguereau, Robert-Fleury. Awards: Silver medal, Paris Exposition, 1889; Hors Concours, Paris Salon, 1890; Webb prize, Society of American Artists, 1892; medal, Columbian Exp., Chicago, 1913; Carnegie Institute, 1911; gold medal, Panama-Pacific Exp., San Francisco, 1915. Represented in Brooklyn Institute Museum by "La Marcellerie."

DONOHUE, HARRY E.
Sculptor. Address in 1935, New York. (Mallett's)

DORIAN, T. H.
Sculptor. Active 1897. Patentee—statuette, 1867.

DORLIAC, NORMA MARCELLA.
Sculptor. Member: National Association of Women Painters and Sculptors.

DOUGHERTY, ELIZABETH ZAVARZINA.
Sculptor. Born in St. Petersburg, Russia, in 1898. Came to US (California) in 1922. Studied at California School of Fine Arts, San Francisco, in the 1920's and 30's; Mills College, Oakland, California, 1950, with F. Carlton Ball; Richmond Art Center, c. 1958-61. Exhibited at Golden Gate International Exposition, San Francisco, 1939; San Francisco Art Association Annuals; San Francisco Society of Women Artists; Oakland Art Museum; others. Died in Piedmont, California, in 1977.

DOUGHERTY, LOUIS R.
Sculptor. Born Philadelphia, 1874. Pupil of Penna. Academy of Fine Arts and Drexel Institute. Member: The Scumblers, Philadelphia; Fellowship Penna. Academy of Fine Arts. Address in 1926, Stapleton, NY.

DOUGLAS, E. BRUCE.
Sculptor. Born at Cedar Rapids, Iowa. Exhibited: Salon des Artistes Francais; Salon des Artistes Independents; Salon de la Nationale.

DOUGLAS, EDWARD BRUCE.
Sculptor. Born in Minneapolis, Minn. Studied under George J. Lober in NY, and in Paris and Rome. Works: Sister Helen Rita memorial, College of St. Elizabeth; fountain figure, Minneapolis, Minn., and a number of portraits and medallions. Membership: New York Architectural League.

DOWLER, DAVID P.
Sculptor and designer. Born in Pittsburgh, PA, February 1, 1944. Studied at Syracuse University, BID, 1969. Work in Corning Museum of Glass, NY; others. Has exhibited at Corning Museum of Glass; Steuben Gallery, NY; Museum of Modern Art, Kyoto, Japan; Cooper-Hewitt Museum, NY; Smithsonian Institution; others. Address in 1982, Corning, NY.

DOWLING, JACQUES MacCUISTON (MRS.).
Sculptor. Born in Texarkana, TX, October 19, 1906. Studied art at Loyola University, Frolich's School of Fine Art, Los Angeles, National Academy of Design, Art Students League, NYC, and with Robert Aitken, Robert Laurent, William Zorach, and others. One man shows held at Federation of Dallas Artists, 1950, Rush Gallery, 1958, Sartor's Gallery, 1958; exhibited in group shows at Dallas Museum of Fine Arts, Museum of New Mexico, Shuttles Gallery, Federation of Dallas Artists, Sartor's Galleries, Ney Art Museum, Oak Cliff Society of Fine Arts, and others. Represented in permanent collections of several corps., many private homes. Member: St. Catherine's Business and Profile Guild (past president), Dallas Art Association, U.D.C. (board member), Federation of Dallas Artists (1st vice president), American Federation of Arts, Oak Cliff Society of Fine Arts. Recipient 1st sculpture, Federation of Dallas Artists, 1950-54, and many others. Address in 1962, Dallas, TX.

DOWNING (or DOWNEY), SABIEN BOARDMAN.
Sculptor. Worked: Philadelphia. Exhibited: Pennsylvania Academy, 1858-68.

DOYLE, ALEXANDER.
Sculptor. Born in Steubenville, Ohio, January 28, 1857. He studied sculpture with Nicoli, Dupre, and Pellicia; and at the National Academies at Carrara and Florence, Italy. Returned to the US in 1878. Among his works are: Bronze equestrian statue of Gen. Albert Sidney Johnston; bronze statue of Gen. Robert E. Lee; marble statue of Margaret Haugherty, for New Orleans, LA; National Revolutionary Monument, Yorktown, VA; bronze statue of Gen. Philip Schuyler, Saratoga, NY; marble statue of Gen. Garfield, Cleveland, OH; bronze statue of General James B. Steedman, Toledo, OH; marble statue of Senator Benjamin H. Hill, Atlanta, GA; bronze statue of Horace Greeley, NY; bronze statue and monument to Henry W. Grady, Atlanta GA; and statues of Benton, Blair, and Kenna, in Statuary Hall, Capitol; others. Address in 1918, Dedham, MA; summer, Squirrel Island, ME. Died in Boston, December 21, 1922.

DOYLE, TOM.
Sculptor. Born May 23, 1928, Jerry City, Ohio. Studied: Miami University; the Ohio State University (with Roy Lichtenstein, Stanley Twardewicz), B.F.A., 1952, M.A., 1953. Work: Brooklyn Museum; Fiberglas sculpture, City of NY, 1972; Carnegie. Exhibited: The Ohio State University, 1956; Allan Stone Gallery, NYC, 1961, 62; Dwan Gallery, NYC, 1966, 67; Cornell University; Martha Jackson Gallery, NYC, New Media—New Forms, I & II, 1960, 61; Oberlin College, 1961; Carnegie, 1961; Seattle World's Fair, 1962; Berne, 1964; Whitney Museum of American Art Annual, 1966; Los Angeles County Museum of Art; Philadelphia Museum of Art, American Sculpture of the Sixties, 1967. Awards: Ohio State Fair, 2 First and 2 Second Prizes. Taught: Brooklyn Museum

School, 1961-68; New School for Social Research, 1961-68; School of Visual Arts, NYC, 1969; associate professor of sculpture, Queens College, from 1970. Address in 1982, c/o Max Hutchinson Gallery, NYC.

DRADDY, JOHN G.
Sculptor. Born in 1833. Working in Cincinnati, 1859-60; later became a partner in the firm of Draddy and O'Brien. He executed many notable church altars including the August Daly altar, and the "Coleman Memorial" in St. Patrick's Cathedral, New York City. He died in Italy, 1904.

DRAYTON, GRACE GEBBIE WIEDERSHEIM.
Sculptor and illustrator. Born Philadelphia, PA, on October 14, 1877. Member: Fellowship Penna. Academy of Fine Arts; Alliance; Society of Illustrators; Artists Guild of the Authors' League of America. Author and illustrator of "Fido," "Kitty Puss" and other children's books. Originator of Campbell's Soup Kids. Address in 1933, 145 East 52nd St., New York, NY. Died in 1936.

DREW, CLEMENT.
Sculptor, marine painter, figurehead carver, photographer, and art dealer. Born in Boston or Kingston Mass., in 1807 or 1810. Worked in Boston from 1841 at least until 1860. Working in and around Gloucester, Mass., during the 1880's; possible living in Maine as late as 1889.

DREW, JOAN.
Sculptor and printmaker. Born in Indianapolis, IN, December 21, 1916. Studied at Mass. College of Art; Art Students League; graphics with Sternberg. Works: Rochester Memorial Art Gallery; Philadelphia Museum of Art; Lyman Allyn Museum of Art; New York Public Library; Princeton University; plus others. Exhibitions: Albright-Knox Art Gallery, 1964; Museum of Modern Art, 1957, 58, and 60; Boston Printmakers, Boston Museum of Fine Arts, 1957-68; one-woman shows, Lyman-Allyn Museum, 1959; Mayer Gallery, Cleveland, 1967; plus many others. Included in "Prize-Winning Graphics II," 1964. Address in 1970, Rye, NY.

DREYER, GAY.
Sculptor. Born in Christiansburg, VA, July 31, 1915. Studied at Art Students League, with William Zorach, 1933; Beaux-Arts Institute, with Eugene Steinttof, 1934; Baylor University, B.S., 1959; Iowa University, M.F.A., 1959. Work in Chrysler Museum, Norfolk, VA; others. Has exhibited at Penna. Academy, Philadelphia; Brooklyn Museum, NY; Smithsonian Institution; Silvermine Guild; others. Works in wood and bronze. Address in 1982, Norfolk, VA.

DREYFUSS, ALBERT.
Sculptor, painter, and writer. Born NYC, 1880. Pupil of George Grey Barnard, Harper, Twachtman, Du Mond, Pratt Institute; Art Students League of New York. Member: Salons of America; Society of Independent Artists; League of New York Artists. Work: Arsenal Park Memorial, Pittsburgh, PA. Awards: Pioneer Monument for Albion, Orlean Co., NY, 1911. Assisted in the studios of R. Hinton Perry, Tonetti, and Victor Ciani on sculpture for public buildings and monuments. Contributor of art criticism and essays to newspapers and magazines. Address

in 1929, 232 West 14th Street, New York, NY.

DRISCOLL, ELLEN.
Sculptor. Born in 1954. Studied: Wesleyan University. Exhibitions: Wesleyan University; Boston Visual Artists Union Show, 1975. Artist-in-residence, Pulpit Rock Artists Community, Woodstock, Connecticut, 1974-75.

DROUET, (BESSIE) CLARKE.
(Mrs. Henry Drouet). Sculptor and painter. Born in Portsmouth, NH, January 18, 1879. Pupil of Phillip Hale and George Bellows. Member: National Association of Women Painters and Sculptors. Address in 1933, Skywood Studio, 430 East 86th St., NYC.

DROWNE, SHEM.
Sculptor. Born in Kittery, Maine, in 1683. Made weather vanes, carved figureheads and ornamental pieces. Worked in Boston. Some of his copper weather vanes still exist. Died in 1774.

DRUGGER, MARIE R. (MRS.).
See Duggar.

DRUMMOND, (I G).
Sculptor and painter. Born in Edmonton, Alberta, Canada, April 11, 1923; US citizen. Studied: Penna. Academy of Fine Arts; University of Penna., B.F.A., 1951, M.A., 1952; also with George Harding. Work: Commissions for New York World's Fair Trade Center, 1963-64; Aeromatic Travel Corp., 1969; Art Club Camera, Grand Central Station; Ahi Ezer Synagogue, Brooklyn, 1971, many more. Exhibitions: Penna. Academy of Fine Arts, 1950; Silvermine Guild, 1964; East Hampton Gallery, NY, 1968-69; Art Image, Manhattan, 1969-70. Media: Colored concrete and wire lathe. Address in 1980, Astoria, NY.

DRUMMOND, J. B.
Sculptor. Active 1864. Patentee—bas relief of General McClellan, 1864. Possibly this is the Scottish sculptor James Drummond, Edinburgh 1816-1877.

DRYFOOS, NANCY PROSKAUER.
Sculptor. Born in New Rochelle, NY, March 25, 1918. Studied: Sarah Lawrence College, sculpture with Oronzio Maldarelli, painting with Curt Roesch; Columbia University School of Architecture, with Maldarelli, sculpture with Jose De Creeft; Art Students League. Member: Fellow, National Sculpture Society; National Society of Women Artists, NY; American Society of Contemporary Artists; Knickerbocker Art; Westchester Arts and Crafts Guild; others. Awards: Prizes, National Arts Club, NY, 1947; Painters and Sculptors Society, NJ, 1950; Village Art Center, 1950; Westchester Arts and Crafts Guild, 1950, 51; gold medal of honor, Allied Artists of America, 1958; Knickerbocker Artists, 1960; American Society of Contemporary Artists, 1970. Work: Salmagundi Club; Columbia University Library; Evanston Museum of Fine Arts; Brandeis University; Sarah Lawrence College; numerous commissions. Exhibited: Allied Artists of America, 1947-51; Audubon Artists, 1947; Syracuse Museum of Art, 1948, 51; Penna. Academy of Fine Arts, 1950; National Academy of Design, 1951; National Asso-

ciation of Women Artists, NY, 1952; Painters and Sculptors Society of NJ, 1950, 51; Knickerbocker Artists, 1951, 52; Hudson Valley Art Association, 1952; Contemporary Art, 1949-52; Brooklyn Museum; National Sculpture Society Annual, 1965-80. Address in 1982, 45 East 89th St., NYC.

Du BOIS, MARY ANN DELAFIELD.
(Mrs. Cornelius Du Bois). Sculptor and cameo-cutter (amateur). Born in NYC, November 6, 1813. Began sculpting in 1842; produced many busts, ideal figures, and cameos including Cupid and Psyche; Novice; head of the Madonna; and over thirty cameo likenesses. Worked: NYC, 1842-52. Associate Member of National Academy. Died October 27, 1888.

Du MOND, HELEN SAVIER.
Sculptor and painter. Born in Portland, OR, August 31, 1872. Pupil of Art Students League, Robert Brandegee and F. V. Du Mond in NY; Collin and Merson in Paris. Member: National Arts Club (life); Art Workers Club; Catherine L. Wolfe Art Club. Address in 1933, 27 West 67th St., NYC; summer, Lyme, CT.

Du PEN, EVERETT GEORGE.
Sculptor. Born in San Francisco, CA, June 12, 1912. Studied at University of Southern California, with Merril Gage; Louis Comfort Tiffany Fellowship, summer, 1935 and 36; Chouinard Art Institute; Yale University School of Fine Arts, B.F.A.; and with Lukens, Sample, Snowden, Fulop, Eberhard, and Archipenko. Work: Bronze sculptures, Seattle World's Fair, 1962; Seattle Art Museum; others. Awards: Tiffany scholarship, 1935-36; fellowship, European study, 1937; Saltus gold medal, National Academy of Design. Exhibited: American Academy in Rome, 1935-37; National Academy of Design; Kansas City Art Museum, 1942; City Art Museum of St. Louis, 1941, 42; San Francisco Art Association, 1943; Seattle Art Museum; Penna. Academy of Fine Arts; National Sculpture Society. Member: Fellowship, National Sculpture Society; academician National Academy of Design. Works in wood and bronze. Lectures: Modern Sculpture. Taught: Professor of Sculpture, University of Washington School of Art, Seattle, Washington, from 1945. Address in 1982, Seattle, WA.

DUBLE, LU.
Sculptor. Born Oxford, England, January 21, 1896. Studied: Art Students League; National Academy of Design; Cooper Union Art School and with Archipenko, De Creeft, Hofmann. Member: Associate of the National Academy of Design, National Sculpture Society; National Association of Women Artists; Architectural League; Audubon Artists. Awards: Guggenheim Fellowship, 1937, 38; Fellow, Institute of International Education; prize, National Association of Women Artists, 1937; Audubon Artists, 1950; National Academy of Arts and Letters, 1952; medal, Audubon Artists, 1947, gold medal, 1958. Work: Newark Museum of Art. Exhibited: Phila. Museum of Art, 1940; Carnegie Institute; Montclair Art Museum, 1941; Museum of Modern Art, 1942, 1952; Penna. Academy of Fine Art, 1942-46; Whitney Museum of American Art, 1946, 1947; National Academy of De-

sign, annually; Audubon Artists, annually; Sculptors Guild; National Association of Women Artists, annually; Marie Sterner Gallery, 1938 (one-man). Instructor at Greenwich House, NYC. Address in 1970, 17 East 9th Street, NYC. Died in 1970.

DUCHAMP, MARCEL.
Sculptor and painter. Born in Blainville, France, July 28, 1887. Studied at the Academie Julian, Paris, 1904. Came to US in 1915, staying with art patrons Louise and Walter Arensberg. In 1955 he became a US citizen. Exhibited: Montross Gallery, NYC, 1916 (four-man); Arts Club of Chicago, 1937; Rose Fried Gallery, 1952; Galerie de l'Institute, Paris, 1957; Sidney Janis Gallery, 1958, 59; La Hune, Paris, 1959; Eva de Buren Gallery, Stockholm, 1963; Walker, 1965; Tate Gallery, 1966; Galerie Rene Block, Berlin, 1971; L'Uomo e l'Arte, Milan, 1973. Retrospectives of his work include: Galeria Solaria, Milan, 1967; Paris/Moderne, 1967. Co-founder, along with Man Ray and Francis Picabia, of the DADA group in NYC, 1917. Famous for his "Ready-mades" or commonplace objects raised to the level of artistic appreciation, an example being his celebrated "Fountain," which was a urinal presented upside down in 1917 at the Society of Independent Artists. Also published one issue of *New York Dada* in 1921 and produced a film in 1925 entitled *Anemic Cinema*. Died in Neuilly, France, October 1, 1968.

DUFF, JOHN EWING.
Sculptor. Born in Lafayette, IN, December 2, 1943. Studied at San Francisco Art Institute, B.F.A., 1967; with Manuel Neri, Paul Harris, and Ron Nagle. Work in Museum of Modern Art, NY; Guggenheim and Whitney; Institute of Contemporary Art, Boston, MA. Has exhibited at Whitney Museum; Willard Gallery, 1975, 76, 77, and 78, NY; Irving Blum Gallery, Los Angeles, 1972; others. Received Theodor Award from Guggenheim Museum. Works in fiberglas and wood. Address in 1982, 5 Doyers, New York, NY.

DUFFY, RICHARD H.
Sculptor. Born New York, NY, January 22, 1881. Pupil of Art Students League of New York; Mercie in Paris. Associate, National Sculpture Society, 1914. Address in 1928, 14718 Ferndale Avenue, Jamaica, NY. Died in 1953.

DUFRENE, THOMAS.
Sculptor. Born in England. Worked in Philadelphia from 1841 to 1853, from 1849 as proprietor of an ornament works.

DUGGAR, MARIE R. (MRS.).
Sculptor. She died in St. Louis, MO, May 5, 1922. She made a specialty of bas-relief portraits of children. (Listed as Drugger, Marie R. in Mallett's.)

DUHME, H. RICHARD, JR.
Sculptor. Born in St. Louis, MO, May 31, 1914. Studied: Penna. Academy of Fine Arts, 1932-38; University of Penna., 1934; Barnes Foundation, 1940-41; Washington University, B.F.A., 1953; American School of Classical Studies, Athens, Greece. Member: Allied Artists of America; Phila. Art Alliance; Group 15; National Sculpture Society, fellow. Awards: Penna. Academy of Fine

Arts, 1935; Ware Fellow, 1938; Prix de Rome, 1939; Art Guild, St. Louis, 1948; Vassar College, 1949. Work: Fountain, Overbrook, PA; portrait memorial, Centralia, MO, Granite City, IL, St. Louis, MO. Exhibited: Penna. Academy of Fine Arts, 1938-41, 1950; Metropolitan Museum of Art, 1942; City Art Museum of St. Louis, 1936-39, 1947-52, 61; St. Louis Art Guild, 1948, 49; Cosmopolitan Club, Phila., 1940; Phila. Art Alliance, 1939-41; People's Art Center, St. Louis, 1952, 61; National Academy of Design, 1957, 60, 61. Taught: Professor of Sculpture, Washington University, St. Louis, MO, from 1947; head of sculpture department, Chautauqua Institute Summer Schools, from 1953, and Syracuse University Chautauqua Center, 1953-69. Address in 1982, St. Louis, MO.

DUMAS, VALSIN (VALSAIN).
Sculptor—marble. At New Orleans, 1841-42.

DUMLAO, GERALD.
Sculptor. Born in Portsmouth, VA, 1935. Studied: Cleveland Institute of Art, B.F.A.; Cranbrook Academy of Art, M.F.A. Exhibitions: Local and regional schools; Detroit Institute of Arts, Works by Michigan Artists, 1974-75. Address in 1975, Paw Paw, MI.

DUNBAR, ANNA (GLENNY).
(Mrs. Davis Dunbar). Sculptor. Born in Buffalo, New York, May 28, 1888. Pupil of Bourdelle in Paris. Exhibited in Buffalo, NY, 1931. Address in 1918, Buffalo, New York.

DUNBAR, ULRIC STONEWALL JACKSON
Sculptor. Born January 31, London, Ontario, Canada, in 1862, and was a pupil of Frederick A. T. Dunbar and the Art School of Toronto, Canada. He was a member of the Washington Arts Club. His awards include a bronze medal at the Columbian Exposition, Chicago, 1893; prize, Pan-American Exposition, Buffalo, 1901; prize, Atlanta Exposition, 1902; St. Louis Exposition, 1904; prize, Seattle, WA, 1906; silver medal, Panama-Pacific Exposition, San Francisco, 1915. He is represented in Washington by a bronze statue of Gov. Alexander M. Shepherd; "Singleton Monument," Oak Hill Cemetery; bust of Hendricks and Martin Van Buren, US Senate; bust of G. G. Hubbard, Hubbard Memorial Hall; statue of Col. Hammond, Atlanta, GA; Ross memorial bronze, "Grief," Norwich, CT; bronze busts of Albert Pike, Scottish Rite Temple, Washington, DC; Little Rock, AR; Dallas, TX; St. Louis, MO; and Baltimore, MD. Address in 1926, Washington, DC. Died in Washington, DC, in May 1927.

DUNCAN, FREDERICK (ALEXANDER).
Sculptor and painter. Born in Texarkana, Ark., May 11, 1881. Pupil of Art Students League of New York; George Bridgman, Howard Chandler Christy. Address in 1933, 54 West 68th St., NYC.

DUNDAS, VERDE VAN V.
Sculptor, writer, and lecturer. Born in Marlin, TX, August 31, 1865. Pupil of Lorado Taft. Member of the Chicago Municipal Art League; Chicago Art Students League; American Art Society, Philadelphia; Western Art Society. Work: "Baby Buntin," Arche Club, Chicago. Address in

1926, Chicago, IL; Paris, IL; summer, Art Institute of Chicago, IL.

DUNLAP, JAMES BOLIVER.
Sculptor, painter, lithographer, engraver, and cartoonist. Born in Indianapolis, IN, May 7, 1825. Worked: San Francisco, 1850-60; Indianapolis. Executed bust of John Sutter in marble. Drew cartoons for Indianapolis *Locomotive*. Executed portraits in both sculpture and painting. Died in Indianapolis, IN, September 4, 1864.

DUNN, EMELENE ABBEY.
Sculptor, painter, and architect. Born Rochester, NY, May 26, 1859. Pupil in sculpture, of Hiram Powers in Florence and Mundy in Rochester; in painting, of Wiles, Satterlee, Sanderson; Corcos in Florence; Duval in Paris. Supervisor, State Board of Education of Connecticut. Established NY Normal Art School, 1905; American Art Club, 1913. Address in 1929, 435 West 119th Street, New York.

DUNPHY (DUMPHY, DURPHY), RICHARD L.
Sculptor. Son of a NYC cabinet-maker. Exhibited his cameos and portrait busts at American Institute. Executed busts of Zachary Taylor, William B. Townsend, and James Webb. Awarded silver medal, American Institute. Worked: NYC, from 1856.

DUNWIDDIE, CHARLOTTE.
Sculptor and patron. Born in Strasbourg, France, in 1907. Studied: Academy of Arts, with Wilhelm Otto, Berlin; Mariano Benlluire y Gil, Madrid, Spain, and in Buenos Aires. Award: National Academy of Design, Speyer Award, 1969; Lindsey Memorial Prize, National Sculpture Society, 1970; and 15 gold medals; Pen & Brush Club, 1958. Collections: Marine Corps Museum, Washington, DC; Church of the Good Shepherd, Lima, Peru; Throne Room of the Cardinal's Palace, Buenos Aires; Bank of Poland, Buenos Aires; Church of Santa Maria, Cochubamba, Bolivia. Exhibited: Salon Bellas Artes, Buenos Aires, 1940-45; Allied Artists of America, 1956-72; National Sculpture Society, 1958-72; National Academy of Design, 1959-80. Was president of Pen and Brush Club, 1966-70; vice-president, National Sculpture Society, from 1979. Address in 1982, 35 East Ninth St., NYC.

DUQUEMY, JOHN (JEAN) D.
Sculptor and carver. At San Francisco, 1858-60.

DURIG, ERNEST.
Sculptor. Active in Washington, DC, 1934. (Mallett's)

DUSENBERY, WALTER.
Sculptor and ceramist. Born in Alameda, CA, 1939. Studied at San Francisco Art Institute, 1961; ceramics with Marguerite Wildenhain, 1962-66; California College of Arts and Crafts, M.F.A., 1971. Work in Carnegie Institute; Guggenheim Museum; Metropolitan Museum of Art. Has exhibited at Guggenheim Museum; Metropolitan Museum of Art; International Sculpture Conference, Washington, DC; others. Address in 1982, 216 Lafayette St., NYC.

D'USSEAU, LEON.
Sculptor and painter. Born in Los Angeles, Calif., in 1918. Exhibited: Metropolitan Museum of Art, 1942; Audubon

Artists, 1945; Palace of Legion of Honor, 1941; California Watercolor Society, 1946; Los Angeles Museum of Art, 1937-40. Address in 1953, Hollywood, Calif.

DUTRA, RANDY.
Sculptor and painter. Studied: Art Students League, Figure with Thomas Fogarty; Sculpture with Jose De Creeft; Drawing and Painting with Robert Lougheed, New Mexico; Painting in Color with Catherine Hagen; Drawing and Painting with Clarence Tillenius, Canada. Exhibited: National Cowboy Hall of Fame; Salmagundi Club; Game Con. International, San Antonio; Adobe Art Festival; Sportsman Edge, NY. Awards: Adobe Art Fest., 1979 third place in sculpture; Adobe Art Festival 1980, first place in sculpture; Valley Artists 1977, first place in graphics. Collections: Clarence Tillenius, Jan Thomas, Harley Brown, Catherine Hagen. Media: Painting, oil; sculpture, bronze. Member of Society of Animal Artists. Address in 1983, Castro Valley, California.

DUTZLER, FRANZ.
Woodcarver. Born in Sierning, Austria, 1940. Studied art in Austria. Emigrated to Australia in 1960; traveled to New Zealand; settled in US. Employed throughout as a chef, pursuing fishing in his free time. Specialty is game fish carved from painted wood, usually combination of kiln-dried alder and eastern maple, with painted details. Represented by the Carson Gallery of Western American Art, Denver, CO; Eddie Bauer Store. Address since 1975, Sisters, OR.

DUVENECK, FRANK.
Sculptor, painter, etcher, and teacher. He was born at Covington, KY, in 1848, and received his early training at a monastery near Pittsburgh. He also studied in Munich under Diez. He was made a National Academician in 1906, and was a member of the Society of American Artists of NY, Cincinnati Art Club, and the National Institute of Arts and Letters. Taught at Art Students League, 1898-99, and Academy of Fine Arts, Cincinnati. Represented at the Cincinnati Museum Association; Art Association of Indianapolis; Pennsylvania Academy of Fine Arts, Philadelphia; National Gallery of Art, Washington, DC. Awarded medal, Columbian Exposition, Chicago, 1893; silver medal, Pan-American Exposition, Buffalo, 1901; honorable mention, Paris Salon, 1895. Address in 1910, Art Academy of Cincinnati, h. Covington, KY. Died in 1919 in Ohio.

DWIGHT, ED.
Sculptor. Born in Kansas City, KS, about 1933. Studied at Arizona State University, B.S. aeronautical engineering, 1957; University of Denver. Was Air Force experimental test pilot and first Black astronaut trainee; later worked for IBM. Has executed commissions including bust of a Black politician, series of Blacks in the West ("Black Frontier Spirit in the American West"); also sculpted series "The Evolution of Jazz" and many other pieces. Specialty is statues and statuettes of Blacks in the Old West. Medium is bronze. Reviewed in *Southwest Art*, November 1977; *Artists of the Rockies*, winter 1982. Represented by Von Graybill Gallery, Paradise Valley, AZ;

Leslie B. DeMille Gallery, Laguna Beach, CA. Address in 1982, Denver, CO.

DWIGHT, N. W.
Sculptor. At Fall River, Massachusetts, 1860.

DYKAAR, MOSES WAINER.
Sculptor. Born in Vilna, Russia, 1884. Died in New York, 1933. (Mallett's)

DYKSTRA, FLORENCE.
Sculptor. Work includes "Homage to Jim Hughes," Dutch elm wood, exhibited at National Association of Women Artists Annual, NYC, 1983. Member: National Association of Women Artists. Address in 1983, 195 Tenth Avenue, NYC.

E

EAKINS, THOMAS.
Sculptor and painter. Born in Philadelphia, Penna., July 25, 1844. Pupil of Penna. Academy of Fine Arts; Ecole des Beaux-Arts under Gerome, Bonnat, and Dumont in Paris. Work: reliefs for Trenton Battle monument; horses of Grant and Lincoln on the Soldiers' and Sailors' monument, Brooklyn; assisted in modelling figures of prophets adorning Witherspoon Building. Awards: Medal, Columbian Exposition, Chicago, 1893; honorable mention, Paris Exposition 1900; gold medal, Pan-American Exposition 1901; gold medal, St. Louis Exposition 1904; Temple gold medal, Penna. Academy of Fine Arts 1904; Proctor prize, National Academy of Design 1905. Member: National Academy of Design. Professor of painting and director of schools, Penna. Academy of Fine Arts. Address in 1910, 1729 Mt. Vernon Street, Philadelphia, Penna. Died June 25, 1916, Philadelphia.

EARLE, WINTHROP.
Sculptor. Born in Yonkers, New York, 1870. Member: Art Students League, New York. Died in New York City, March 2, 1902.

EARLEY, JAMES FARRINGTON.
Sculptor. Born in Birmingham, England, September 27, 1856. American citizen, 1882. Pupil of Royal Academy. Papal medal, Leo XIII; silver medal, St. Louis Exposition 1904. Member Washington Architectural Club; Society of Washington Artists. Address in 1910, rear 175 East S St.; h. 1348 T St., NW, Washington, DC.

EARNSHAW, J. B.
Sculptor. Active 1862. Patentee—design for a monument, 1862.

EAST, NATHANIEL S., JR.
Sculptor and designer. Born in Delaware Co., PA, March 21, 1936. Studied at Phila. College of Art; with Herman Cohen. In collections of Glassboro College, NJ; University City Arts League, Phila.; Phila. School System; Bell Telephone Company, Phila. Exhibited at Allentown, PA; Antonio Souza Gallery, Mexico City, 1969; Grabar Gallery, Phila., 1968; National Forum of Professional Artists, Phila.; etc. Received National Ornamental & Miscellaneous Metals Association awards, 1978, 80. Member: University City Arts League (vice-president, 1965-66); National Forum of Professional Artists; etc. Author and teacher. Works in pre-used metal objects. Address in 1982, Hatfield, PA.

EASTERDAY, SYBIL UNIS.
Sculptor. Born in San Jose, California, in 1876. Studied with Juan Buckingham Wandesforde, Hayward, California, c. 1892; with Arthur Mathews and Douglas Tilden at Mark Hopkins Institute of Art, San Francisco, mid-1890's. Had studio in San Francisco c. 1897-1903. Worked in Mexico City, 1903-05, on portrait commissions. Her works include portrait of Porfirio Diaz, President of Mexico, 1903; plaster panel of "Memory Unveiling the Past;" "Despair;" "Reverie." Active for 10-year period; much celebrated in local and national press. Little of her work has survived, except through photographs. Died in Tunitas Glen, San Mateo Co., California, in 1961.

EBERHARD, ROBERT GEORGE.
Sculptor, craftsman, lecturer, museum curator, and teacher. Born Geneva, Switzerland, June 28, 1884. Pupil of MacNeil at Art Students League, Mercie, Carlier, Peter, Rodin at Ecole des Beaux-Arts, Lycee Montaigne, Paris; Pratt Institute Art School; Yale University, BFA, MA. Member: Societe des Artistes Francais; Artistes du Cher; New Haven Paint and Clay Club; National Sculpture Society. Head of Department of Sculpture at Yale University. Work: War Memorial tablets, White Plains (NY) High School; flagstaff base, Public School No. 9, Brooklyn; war memorial, Rosedale, NY. Received Lissignol prize, Geneva, Switzerland; silver medal, Artistes du Cher, Vierzon, France; honorable mention, Paris Salon. Exhibited at National Sculpture Society, 1923. Positions: Curator at Yale University Gallery of Fine Art and taught at Yale, from 1952. Address in 1953, Newcastle, ME.

EBERLE, ABASTENIA ST. LEGER.
Sculptor. She was born in Webster City, IA, April 6, 1878. Pupil of Art Students League of New York; George Grey Barnard. Member: Associate National Academy of Design; National Sculpture Society; All. Artists of America American Federation of Arts. Awards: Bronze medal, St. Louis Exposition, 1904; Barnett prize, National Academy of Design 1910; bronze medal, P.-P. Exposition, San Francisco, 1915; prize, Garden Club of America, 1929; honorable mention, Allied Artists, 1930; Lindsay Morris Sterling prize, National Sculpture Society, 1931. Work: "Girl on Roller Skates" and "Mowgli," Metropolitan Museum, New York; "Windy Doorstep," Worcester Art Museum; Peabody Art Institute; Baltimore; Newark Museum, and Carnegie Institute, Pittsburgh; "Little Mother," Chicago Art Institute; "The Dancer," Venice, Italy, and Twentieth Century Club, Buffalo, NY; "Rag Time," Toledo Art Museum; "Hurdy Gurdy," Detroit Institute; general excellence trophy, "Iron May," Pacific and Asiatic Fleet. Address in 1933, 204½ West 13th Street, New York, NY; summer, Green Farms, CT. Died February 26, 1942, in New York City.

EBEY, MARJORIE.
Sculptor. Member St. Louis Art Guild. Address in 1910, St. Louis, MO.

ECKHARDT, EDRIS.
Sculptor, lecturer, and educator. Born in Cleveland, Ohio, January 28, 1906. Studied at Cleveland School of Art; and with Alexander Blazys. Member: American Ceramic Society. Awards: Prizes, Cleveland Museum of Art, 1935-37, 43-45; National Ceramic Exhibition, Syracuse Museum of Fine Art, 1933; Butler Art Institute, 1946. Work: Mall, Cleveland, Ohio; ceramics, Cleveland Public Library and School; Cleveland Museum of Art; Akron Public School; Queens (NY) Library; Ohio State University; Philadelphia Art Alliance; Columbus Public School; Cleveland Board of Education. Exhibited: Syracuse Museum of Fine Art, 1933-41; Paris Exposition, 1936; International Ceramic Exhibition, Scandinavian countries, 1939, 40; New York World's Fair, 1939; Golden Gate Expositions, 1939; College Art Association of America traveling exhibition, 1933-36; Cleveland Museum of Art 1933-46; Toledo, Ohio, 1939, 40; Butler Art Institute 1946; Wichita Art Association, 1946; Akron, Ohio, 1937; Phila. Art Association, 1944. Address in 1953, Cleveland, Ohio.

ECKHART, WILLIAM.
Sculptor. Born in Germany in 1835. Worked in New York City, 1860.

ECKLEY, SOPHIA MAY TUCKERMAN (MRS.).
Sculptor. Born c. 1825. Died in 1874. Exhibited: Boston Athenaeum, 1864-67.

ECKSTEIN, FREDERICK.
Sculptor and drawing master. Born c. 1775, probably in Berlin. Studied at the Academy in Berlin. Son of Johann Eckstein; moved to US in 1794. Worked: Philadelphia, 1794-1817; Harmony, Pennsylvania; Wheeling, West Virginia; Cincinnati, 1823-30, 1838-40; Kentucky. Johann and Frederick co-founded Pennsylvania Academy. Frederick taught Hiram Powers, Shobal Clevenger. Died February 10, 1852, Cincinnati.

ECKSTEIN, JOHANN.
Sculptor, modeler in wax, portrait and historical painter, and engraver. Probably born in Mecklenburg, Germany, c. 1736. Historical painter and sculptor at Prussian Court, c. 1772 to 1794. Executed a death mask and plaster bust of Frederick the Great in 1786. Exhibited at the Royal Academy (London) and Berlin Academy. Emigrated to the US in 1794, settling in Philadelphia. Worked there as a limner and "statuary" with his son, Frederick Eckstein. An organizer of the Columbian Society of Artists (1795), the Penna. Academy (1805), and the Society of Artists (1810). Exhibited a design for an equestrian statue of Washington in Roman costume, Society of Artists, 1811-12. Died in Havana, Cuba, June 27, 1817/1818.

ECKSTEIN, JOHN.
Sculptor and painter. Born in Germany, 1750. Died in Philadelphia, PA, c. 1817-22. (Mallett's)

EDDY, SARAH JAMES.
Sculptor. Born in Boston, 1851. Exhibited portrait bust of Samuel S. Fleisher, at the Penna. Academy of Fine Arts, Philadelphia, 1914. Address in 1926, Bristol Ferry, RI.

EDGERLY, GLADYS C.
Sculptor. Member: Fellowship Penna. Academy of Fine Arts. Address in 1926, c/o Art Alliance, 1823 Walnut Street; The Lenox, 13th and Spruce Streets, Philadelphia, PA.

EDMOND, ELIZABETH.
Sculptor. Born 1887, in Portland, ME. Exhibited at the Penna. Academy of Fine Arts, Philadelphia, 1914. Died June 22, 1918, in Pasadena, Calif.

EDSTROM, DAVID.
Sculptor, writer, lecturer, and teacher. Born Hvetlanda, Sweden, March 27, 1873. Pupil of Borjison, Royal Academy, Stockholm; Injalbert in Paris. Member: Los Angeles Painters and Sculptors; South Calif. Sculptors Club; Scandinavian Artists of NY; Calif. Painters and Sculptors Club. Award: Silver medal, World's Fair, St. Louis, 1904. Work: "Soldiers' Monument," Ottumwa, Iowa; "Isis" and "Nepthys," Masonic Temple, Washington, DC; War memorial relief, Montreal, Canada; Statue of Judge G. F. Moore, Scottish Rite Temple, Dallas, Texas; "Cry of Poverty," "Caliban," "Portrait of Baron Beck-Frus" and "Portrait of Dr. Romdahl" in Gothenburg Museum, Sweden; reliefs in the Faehrens Gallery, Stockholm; "Portrait of the Crown Prince of Sweden," and "Portrait of the Princess Patricia of Connaught," in the Royal Palace, Stockholm; Statue of "Gen. P. Cochran," Dallas, Texas; Statue, M. H. Whittier, Los Angeles; Strickland Memorial, Dallas, Texas; "The Hunchback," "Caliban," "February," "Peasant," "Old Italian Soldier," "Two Souls," "Grotesque," "Ernest Thiel," "Prometheus," "Athlete," National Museum, Stockholm. Address in 1933, Los Angeles, Calif. Died in 1938.

EDWARDS, LONNIE JOE.
Sculptor. A native of West Texas; active in Lubbock in 1972. Educated at Texas Tech. Work in West Texas Museum. Specialty, Western and animal subjects. Works include "Indian Hunter," "Owl," "Dove," "Water Bird."

EECKHOUT, JAN (DR.).
Modeler in wax. Executed wax portrait of Dr. Abraham Chovet of Philadelphia, 1784.

EGAS, CAMILO.
Sculptor, painter, etcher, lithographer, and teacher. Born in Quito, Ecuador, December 10, 1899. Studied at Academia de las Bellas Artes, Ecuador; Royal Institute des Beaux-Arts, Rome; San Fernando Academia de Bellas Artes, Madrid. Awards: Fellowships to Rome and Paris from Ecuador; prize, International Exhibition, Quito. Work: Museum of Modern Art; Newark Museum of Art; IBM; National Museum, Ecuador; murals, New York World's Fair, 1939; New School for Social Research, NY; Jijon Library, Quito. Exhibited: Salon d'Automne, Salon de Tuileries, Salon des Independentes, all in Paris; Galeria Nacional de Rome; Salon del Retiro, Madrid. Position: Director, Art Department, New School for Social Research, NYC. Address in 1953, 248 West 14th St., NYC; h. Orwigsburg, PA. Died in 1962.

EGELSON, POLLY.
Sculptor. Studied: Maryland Institute of Art; Radcliffe

College. Awards: New England Ceramic League, 1964; Attleboro Art Museum, 1975. Exhibitions: Highland Gallery, Carmel, California; Copley Society, 1974; Cambridge Art Association, Massachusetts, 1975.

EGGENHOFER, NICK.
Sculptor, painter, and illustrator. Born Gauting, Southern Bavaria, Germany 1897; came to US (New York City) in 1913. Studied at Cooper Union; apprenticeship at the American Lithography Company. Member: Cowboy Artists of America, National Academy of Western Art. Painted "Making Friends" in 1923, reproduced on cover, *Western Story Magazine*, 1923. Illustrated for many books and magazines. Produced series of bronzes of scale model Western vehicles he had made. Specialty is Western subjects, wagon-train era. Lived in Milford, NJ; later moved to Cody, Wyoming. Living there in 1976.

EGNER, JOHN.
Sculptor. Born in Philadelphia, PA, 1940. Studied: Franklin and Marshall College; Philadelphia Museum College of Art, B.F.A.; Brooklyn Museum Art School; Yale University, M.F.A. Exhibitions: Albion College (three-person), 1968; Vanderlip Gallery, Philadelphia, 1968; Willis Gallery, Detroit, 1971-72; Eastern Michigan University, 1972; All Michigan II, The Flint Institute of Arts, 1973; Detroit Bank and Trust Artists Invitational, 1974; University of Michigan Invitational, 1974; Detroit Artists Market, 1974; Detroit Institute of Arts, Works by Michigan Artists, 1974-75. Commissions: North Wall, Park Shelton Hotel, commissioned by Detroit Renaissance, 1974. Address in 1975, Detroit, MI.

EGRI, TED.
Sculptor and painter. Born in NYC, May 22, 1913. Studied at Master Institute Roerich Museum, dipl., 1931-34; Duncan Phillips Memorial Gallery Art School, 1942; Hans Hofmann School of Art, New York, and Provincetown, MA, 1948. Work in Museum of New Mexico, Santa Fe; others. Has exhibited at Colorado Springs Fine Arts Center; Penna. Academy of Fine Arts Annual; Shidoni 6th and 7th Annual Outdoor Show. Received awards from Museum of New Mexico, top award for sculpture and honorable mention for drawing. Member: Artists Equity Association; Taos Art Association. Address in 1982, Taos, NM.

EHRICH, WILLIAM.
Sculptor. Born in Koenigsberg, Germany, July 12, 1897. Studied at State Art School of Koenigsberg; with Erich Schmidt-Kestner, Stanislaus Cauer, and Franz Thryne. Exhibited: Finger Lakes Exhibition, Rochester, NY; Albright Art Gallery; Syracuse Museum of Fine Arts. Award: Honorable mention, wood sculpture, Buffalo Society of Artists, 1932; prizes, Albright Art Gallery, 1935, 38, 40, 41, 45; Rochester Memorial Art Gallery. Member: Buffalo Society of Artists. Address in 1953, Carnegie Hall; University of Rochester; h. Rochester, NY.

EHRMAN, HYMAN M.
Sculptor. Born in Russia, February 2, 1884. Studied in Russia and at the Penna. Academy of Fine Arts. Work: Plaques of Mayor Baker, Chief of Police, L. V. Jenkins, Gov. Junius L. Meier, Portland, Oregon. Member: Oregon Society of Artists. Address in 1933, 739 S. W. Grant St., Portland, Oregon.

EICHENBAUM, AUDREY.
Sculptor. Address in 1935, Chicago, Ill. (Mallett's)

EIDE, PALMER.
Sculptor, painter, educator, and craftsman. Born in Sioux Falls, Minnehaha County, SD, July 5, 1906. Studied at Augustana College, BA; Art Institute of Chicago; Harvard University; Yale University; Cranbrook Academy of Art; St. Olaf College, DFA. Member: College Art Association of America; American Oriental Society. Awards: Scholarships, Harvard University, 1936-37; Fellow, Yale University, 1940, 41; Painting, Sioux City Art Center, 1966; Governor's Award in Arts for Creative Achievement, South Dakota, 1976. Work: City Hall Broadcasting Station KSOO, Sioux Falls, SD; Trinity Lutheran Church, Rapid City, SD; mural, University of South Dakota, etc. Position: Professor of Painting, Augustana College, Sioux Falls, SD, 1931-71. Exhibited: Sioux City Art Center, 1961, 62, and 66; Fine Arts in Service of Church, Seattle, WA, 1963; Lee Fine Arts Center, University of South Dakota, 1977; Dahl Fine Arts Center, Rapid City, SD, 1977; others. Address in 1982, Sioux Falls, SD.

EINO, (EINO ANTTI ROMPPANEN).
Sculptor. Born in Mynamaki, Finland, February 6, 1940; US citizen. Has exhibited at one-man shows, International Design Center, Los Angeles; Palm Springs Desert Museum, CA; National Endowment for the Arts, Century City, CA; others. Works in marble. Address in 1982, Malibu, CA.

ELDER, DAVID MORTON.
Sculptor. Born in Windsor, Ontario, Canada, July 3, 1936; US citizen. Studied at Wittenberg University, B.A., 1957; Ohio State University Graduate School, M.A., 1961. Work at Denver Art Museum, Colorado; Long Beach Art Museum, California. Has exhibited at Long Beach Museum of Art; California College of Arts and Crafts, Oakland; San Francisco Centennial Show, De Young Museum. Received first prize, 4th Annual, Long Beach Museum. Works in bronze and polyester resin. Address in 1982, Northridge, CA.

ELDREDGE, MARY AGNES.
Sculptor. Born in Hartford, Conn., January 21, 1942. Studied at Vassar College, with Concetta Scaravaglione and Juan Nickford, BA; Pius XII Institute, Florence, Italy, with Josef Gudics, MFA. Works: Dartmouth College Collection. Commissions: Cemetery monument, Mt. Calvary Children's Plot, Portland, Ore., 1971; exterior copper relief, Our Lady of Mt. Carmel Church, Staten Island, 1972; Sts. Mary and John, St. Paul Church, Nassau, Bahamas, 1973-74; four copper sculptures, St. Joseph Church, Rosenburg, Ore., 1974; St. Therese, St. Vincent Ferrer Church, NY, 1975; Ambry, Shrine of the most Blessed Sacrament, Washington, DC, 1981-82; plus others. Exhibitions: Mostra dell' Arte Religiosa per Pasqua, Florence, 1965; National Arts Club Religious Art Exhibition, NY, 1966; Academy Artists Association Na-

tional Exhibition, Springfield, Mass., 1967; Modern Art and the Religious Experience, Fifth Avenue Presbyterian Church, NY, 1968; 6th Biennial National Religious Art Exhibition, Cranbrook Academy of Art, 1969. Awards: Therese Richard Memorial Prize, National Arts Club, 1966; Academy of Artists Association Award, 1967. Member: Southern Vt. Artists, Inc. Media: Copper and stone. Address in 1982, Springfield, VT.

ELISCU, FRANK.
Sculptor, lecturer, and teacher. Born in NYC, July 13, 1912. Studied with Rudolph Evans and Paul Fjelde. Commissions: War memorial, Cornell Medical College; Presidential Eagle, Oval Office, White House; inaugural medal, President Ford, Vice President Rockefeller, plus others. Exhibited: Penna. Academy of Fine Arts; Conn. Academy of Fine Arts; Cleveland Museum of Art; Detroit Institute of Art; plus others. Member: Fellowship National Sculpture Society (president 1967-70); National Academy of Design (academician); Architectural League of New York. Awards: Prize, Architectural League of New York, 1955, Silver Medal, 1958; Henry Hering Award, 1960; and others. Address in 1982, Sarasota, FL.

ELLENBERG, MAGGIE.
Sculptor. Work includes "Links," American wonderstone, exhibited at National Association of Women Artists Annual, NYC, 1983. Member: National Association of Women Artists. Address in 1983, 799 Park Avenue, NYC.

ELLER, JAMES.
Sculptor. Born in Hollywood, CA, 1943. Group exhibitions: Pop Art USA, Oakland Art Museum, 1963; Collage and Assemblage in Southern California, The Los Angeles Institute of Contemporary Art, 1975; San Francisco Museum of Modern Art, 1976; National Collection of Fine Arts, Smithsonian, 1977.

ELLERHUSEN, ULRIC HENRY.
Sculptor and teacher. Born in Germany, April 7, 1879; came to America at age of 15. Pupil of Art Institute of Chicago; Lorado Taft; Art Students League of NY; Karl Bitter. Member: National Sculpture Society 1912; NY Architectural League 1914; Beaux-Arts Institute of Design (honorary), 1916; Allied Artists of America; American Federation of Arts; Associate National Academy of Design, 1932. Exhibited at National Sculpture Society, 1923. Awards: 1st prize in competition for medal for St. Louis Art League; medal of honor for sculpture, NY Architectural League, 1929; Allied Artists of America, 1934. Work: "Contemplation," "Wonderment," "Meditation" and "Frieze of Garland Bearers," exterior decorations, Fine Arts Building San Fran.; Schwab Memorial Fountain, Yale University Campus, New Haven, Conn.; medal for St. Louis Art League; Penna. Memorial medal to employees of the Penna. Rail Road in military service; peace monument and allegorical portraits of "Confucius," "Columbus," "Pocahontas," and "Life of Douglass," Elmwood Park, East Orange, NJ; 3 reliefs illustrating F. Douglass Memorial Home, Wash., DC; Edward Austin Abbey II, Memorial, University of Penna.; portrait of Very Rev. Walter G. Moran, St. Vin-

cent Ferrer Church, NY; Communion Rail, Church of St. Gregory the Great, NY; portrait of Prof. Alexander Smith, University of Chicago; St. Michael Relief, St. Mary's College, Notre Dame, Ind.; "The March of Religion," South Front Chapel, University of Chicago; also "Morning," "Evening," "Prophet," "Priest," "Learning," "Science," portraits of "Bach," "Wilson," Roosevelt;" Exterior of Christ Church, Cranbrook, Mich.; buttress finial statues of Gutenberg, Pasteur, W. Wright, Renan, Pere Marquette, Phillips Brooks, Bishop Williams, Bishop Page, Dr. Samuel Marquis; "They came and stood at the Cross," (John and Mary); Church of the Heavenly Rest, NY, Symbolism, main entrance, "Moses" and "St. John Baptist;" others. Address in 1953, Towaco, NJ. Died in 1957.

ELLERY, RICHARD VANDERFORD.
Sculptor and painter. Born in Salem, Mass., October 22, 1909. Studied at Mass. School of Art. Work: "Portrait of Judge Joseph Quinn," Law Library, Court House, Salem, Mass. Address in 1933, Danvers, Mass.

ELLFELDT, WALTER CHARLES.
Sculptor. Born in Kansas City, Missouri, October 20, 1909. Studied with Wallace Rosenbauer. Award: Honorable mention, Annual Mid-Western Exhibition, Kansas City Art Institute, 1933. Member: Phi Sigma Lambda. Address in 1933, Kansas City, Missouri.

ELLICOTT, HENRY JACKSON.
Sculptor. Born in Anne Arundel County, MD, 1848. Studied drawing at the National Academy of Design; also studied under Brumidi, Powell, and Leutze. Died in Washington, DC, February 11, 1901.

ELLIOTT, RONNIE.
Sculptor, painter, etcher, and lithographer. Born in NYC, December 16, 1916. Studied at NY University; Hunter College; Art Students League; and with William Zorach, Alexander Brook, Hans Hofmann, Francis Luna. Member: Art League of America. Exhibited: Penna. Academy of Fine Arts, 1933, 34, 39; Honolulu Academy of Art, 1936; Golden Gate Exposition, 1939; New York World's Fair, 1939; Carnegie Institute, 1941; Corcoran Gallery of Art, 1939; National Academy of Design, 1941; Bennington College, 1943; San Francisco Museum of Art, 1945, 46; Western College, Oxford, OH, 1945; Marquie Gallery, 1942, 44 (one-man); Art of this Century, 1943-45; Metropolitan Museum of Art, 1942; Museum Non-Objective Painting, 1946, 47; Norlyst Gallery, 1947; Carlebach Gallery, 1947; Museum of Modern Art, 1948; Galerie Creuze, Paris, 1948; Realites Nouvelles, Paris, 1948-51, Polo Gallery, Washington, DC, 1976; Andre Zarre Gallery, NYC, 1977; Nardin Gallery, NYC, 1979. Work: Museum of Modern Art; Whitney Museum; Carnegie Institute; Cornell University; and others. Awards: Wellesley College Purchase Award, Jewett Arts Center, 1970. Address in 1982, 68 East Seventh Street, New York City.

ELLIOTT, THOMAS.
Sculptor. Born in Kalamazoo, MI, 1952. Studied: Western Michigan University, B.F.A. Exhibitions: Kalan Steers

Gallery; Kalamazoo area shows; Detroit Institute of Arts, Works by Michigan Artists, 1974-75. Awards: Southwestern Michigan Area Show, Kalamazoo, 1974. Address in 1975, 302 Stuart Avenue, Kalamazoo, MI.

ELLIS, HARVEY.
Sculptor and painter. Born in Rochester, New York, 1852. President, Rochester Society of Arts and Crafts. Member: New York Water Color Club. Died in Syracuse, New York, January 2, 1904.

ELLIS, JOSEPH BAILEY.
Sculptor and teacher. Born North Scituate, Mass., May 24, 1890. Pupil of Albert H. Munsell, Bela Pratt; Peter and Injalbert in Paris. Member: Copley Society; Boston Architectural Club; Pittsburgh Art Association; Salma. Club. Address in 1933, College of Fine Arts, Carnegie Institute of Technology; h. Pittsburgh, PA; summer, Boothbay, Maine. Died January 24, 1950.

ELLIS, SALATHIEL.
Sculptor, cameo portraitist, and designer of medals. Born in Vermont or Toronto, Canada, 1860. Began his career as a cameo-cutter in St. Lawrence Co., NY. Worked in NYC 1842 to at least 1864. Executed medals for the US Mint; in 1864 contributed two medallions to the Metropolitan Fair.

ELLIS, VERNON.
Sculptor, painter, etcher, writer, and teacher. Born in Columbia, PA, December 5, 1885. Pupil of Chase. Address in 1918, Plainfield, MA. Died in 1944.

ELLISON, ROBERT W.
Sculptor. Born in Detroit, MI, December 13, 1946. Studied at Michigan State University, B.F.A., 1969, M.F.A., 1971. Has exhibited at Detroit Museum of Art; 21st Annual All California Show, Laguna Beach Museum of Art; Richmond Art Center, CA; others. Received first place, 21st Annual All California Show, 1975. Works in welded steel. Address in 1982, Penngrove CA.

ELLSWORTH, CHERYL (LAWTHER).
Sculptor. Born in Dubuque, Iowa, in 1911. Studied at University of Wisconsin. Has exhibited in New York and Penna.

ELMENDORF, STELLA.
See Stella E. Tylor.

ELSNER, LARRY EDWARD.
Sculptor and educator. Born in Gooding, ID, 1930. Studied at Utah State University, B.S.; Columbia University, M.F.A. Has exhibited at Salt Lake Art Center; Everson Museum, Syracuse, NY; Smithsonian Institution Show, Sculpture, Washington, DC; others. Received Ford Foundation Sculpture Purchase Award, 1963. Teaching at Utah State University, from 1960, professor of sculpture. Works in wood and ceramics. Address in 1982, Logan, UT.

ELWELL, FRANCIS (or FRANK) EDWIN.
Sculptor. Born in Concord, Mass., June 15, 1858. He was a pupil of Daniel Chester French; Falguiere and Ecole des Beaux-Arts in Paris. His works include "Dickens and Little Nell," in Philadelphia; "The Flag" at Vicksburg, Miss.; equestrian statue of General Hancock at Gettysburg, Penna.; and "New Life," cemetery, Lowell, MA; "Greece" and "Rome," New York Custom House; "Lincoln Monument," Orange, NJ; "Egypt Awaking," Paris; "The New Life," Penna. Academy, Philadelphia; others. Awards: gold medal, Philadelphia Art Club, 1891 and 97; silver medal, Pan-Am. Exposition, Buffalo, 1901; medal, Columbian Exposition, Chicago, 1893. Received a silver medal for architecture from the King of Belgium. Died in Darien Conn., January 23, 1922.

ELWELL, JOHN H.
Sculptor, painter, illustrator, etcher, and writer. Born in Marblehead, Mass., March 10, 1878. Pupil of Vesper L. George, Reuben Carpenter, Evening Art School Boston. Member: Boston Art Club. Address in 1926, Boston, Mass.; h. Newton Highlands, Mass.; summer, Marblehead, Mass.

ELWELL (or ELLWELL), ROBERT FARRINGTON.
Sculptor, painter and illustrator. Born near Boston, MA, 1874. Self-taught as an artist. Worked as newspaper artist in Boston about 1890; in 1896 became ranch manager, a job he held for 25 years, for Colonel Cody. Sketches earned him commissions for Western illustrations. Painted for *Harper's, Century, American,* other 1930's magazines. Specialty was Western subjects. Primarily painter and illustrator. Died in Phoenix, Arizona, in 1962.

EMANUEL, HERZL.
Sculptor. Born in Scranton, PA, 1914. Studied at Rochester Memorial Art Gallery; Academie Scandinave under Despiau, 1931; Academie Grande Chaumiere under Robert Wlerick; and under Ossip Zadkine in Paris. Works: "Savage Head" (painted plaster), 1939; "Spain" (bronze), 1938.

EMBLER, A. H.
Sculptor. Worked: New York City. Exhibited: National Academy, 1858, bas-relief portraits.

EMERSON, SYBILL DAVIS.
Sculptor, painter, decorator. Born in Worcester, Massachusetts, 1892. Exhibited: Salon d'Automne, 1928. Awards: First prize, San Francisco Art Association, 1924.

EMERY, IRENE.
Sculptor. Born in Grand Rapids, Mich., February 1, 1900. Studied with Alexander Archipenko and Emil Zettler. Address in 1933, Chicago, Ill.; summer, Grand Rapids, Mich.

EMERY, LIN.
Sculptor and kinetic artist. Born in NYC. Studied: Studio of Ossip Zadkine, Paris; Sculpture Center, NYC. Awards: First National Bank of Atlanta, Georgia, 1969; Humanities Center, Univ. of South Carolina, 1972; South Central Bell Headquarters, 1972. Collections: New Orleans Civic Center, Louisiana; Pensacola Art Center, Florida; Huntington Galleries, Huntington, West Virginia. Exhibited: Penna. Academy of Fine Arts Annual, Phila., 1960, 64; Far East Tour, International House and US Information

Service, three countries, 1962; Sculpture: 1900-65, De-Waters Art Museum, 1965; International Sculpture Conference Exhibit, DC, 1980; and many others. Commissioned works: Aquamobile, University of SC, Columbia, 1970-72; aquamobile, Fidelity National Bank, Oklahoma City, 1971; magnetmobile, Birmingham, AL, 1972; others. Member: Sculptors Guild, NY; Contemporary Arts Center, New Orleans, (board member). Media: Various metals and kinetics. Address in 1983, New Orleans, LA.

EMMES, HENRY.
Sculptor. He worked about 1740-57 in Boston. Specialty was gravestone portraits.

EMMET, JOHN PATTEN.
Sculptor and painter (amateur). Born in Dublin, April 8, 1797; came to US in 1804. Worked as doctor in South Carolina; chemistry professor in Virginia. Died August 13, 1842, New York City.

EMPIE, HAL H.
Sculptor, painter, cartoonist, and illustrator. Born in Safford, AZ, March 26, 1909. Studied with Frederic Taubes. Member: El Paso Sketch Club; Arizona Artists Guild. Work: Panels, Methodist Church, Duncan, Ariz. Exhibited: Museum of Modern Art; Pepsi-Cola, 1944, 45; Calif. Water Color Society, 1945; El Paso, TX. Contributor, illustrator and cartoonist for Western magazines. Position: Instructor, Cloudcroft, New Mexico, Art Colony. Address in 1953, Duncan, AZ.

ENGEL, GEORGE.
Sculptor. Born in Queens, NY, 1953. Studied: Pratt Institute, Brooklyn, 1971-75; also under Michael Aviano, 1973-76. Exhibited: Leslie-Lohman Gallery, Soho, NYC; Cartier's main windows, 1978; Salmagundi Show, Sardi's; National Sculpture Society; National Academy of Art, NYC. Represented: Leonarda di Mauro Gallery, NYC; Leslie-Lohman Gallery, NYC; Portraits Incorporated, NYC; Stanley and Schenck Gallery, Atlanta, GA. Work: "Portrait of a Young Man," 1979; "Negress," "Portrait of a Negress;" "Nude on a Beach," 1977; "Quentin Crisp," 1981; "James Coco," 1983. Address in 1984, 232 West 124th St., NYC.

ENGLAND, PAUL GRADY.
Sculptor, painter, and writer. Born in Hugo, OK, January 12, 1918. Studied at Carnegie Institute, BA, 1940; University of Tulsa, MA, 1959; Art Students League, with George Grosz, William Zorach, Jose De Creeft. Member: Artist Equity Association; Art Students League. Exhibited: ACA Gallery, 1945, 46; Penna. Academy of Fine Arts, 1947, 52; Contemporary Art Gallery, 1944-46; Riverside Museum, 1946; one-man: Le Centre d'Art, Port-au-Prince, Haiti, 1947; RoKo Gallery, 1948; Galerie Creuze, Paris, 1949; Bodley Gallery, NY, 1950; Hugo Gallery, 1951; Grand Central Moderns, NYC, 1955; Philbrook Art Center, Tulsa, 1971; St. Mary's College, MD, 1972. Awards: Grand Awards, Philbrook Art Center, 1957 and 63; Graphics Award, Joslyn Museum of Art, 1957; Award of Excellence, Smithtown Arts Council, LI, 1981. Position: Associate professor of painting, Hofstra

University, 1959-81; professor, from 1981. Address in 1982, 359 Soundview Drive, Rocky Point, NY.

ENGMAN, ROBERT.
Sculptor. Born 1927, in Belmont, Mass. Studied: RI School of Design, 1948-52, BFA; Yale University, with Josef Albers, Jose de Rivera, 1952-1954, MFA. Work: Franchard Corporation; Museum of Modern Art; Revere; Wellesley College; Yale University. Exhibited: The Stable Gallery, 1960, 62; MIT, 1966; Kanegis Gallery, Boston 1967; Institute of Contemporary Art, Boston; Museum of Modern Art; Sao Paulo, 1961; Guggenheim, 1962; Whitney Museum, 1965; Los Angeles County Museum of Art, American Sculpture of the Sixties, 1967. Awards: National Academy of Design, Samuel F. B. Morse Fellowship, 1963-64. Taught at Yale University, 1954; University of Penna., 1963. Address in 1970, Durham, CT.

ENNIS, GEORGIA LEAYCROFT.
(Mrs. G. P. Ennis). Sculptor and painter. Born in Wading River, Long Island, NY. Pupil of Chase and Hayes Miller. Address in 1926, 58 West 57th Street, NYC; summer, Eastport, Maine.

ENQUIST, MARY B.
Sculptor. Member: Washington Water Color Club. Address in 1929, Washington, DC.

ENTE, LILY.
Sculptor, painter, printmaker. Born in Ukraine, Russia, May 20, 1905. Works mostly in black and white marble. Exhibitions: Claude Bernard Gallerie, Paris, France; Great Burlington Gallery, London, England; Whitney Museum of American Art; International Exhibition 84 Artists, Bundy Art Gallery, Waitsfield, VT; Riverside Museum, New York; Stable Gallery, New York; University of Illinois. Collections: Phoenix Art Museum; Riverside Museum; Safad Museum, Israel. Member: National Association of Women Artists; Artists Equity Association; Brooklyn Society of Artists. Address in 1982, 400 Riverside Drive, New York, NY.

ENTERS, ANGNA.
Sculptor, painter, illustrator, cartoonist, and writer. Born in NYC, April 28, 1907. Studied in US, Europe, Greece, Egypt, Near East. Awards: Guggenheim Fellow, 1934, 35. Work: Metropolitan Museum of Art; Honolulu Academy of Art; mural, Penthouse Theatre, University of Washington. Exhibited: Newhouse Gallery, 1933-45; Warren Gallery, London, England; Metropolitan Museum of Art, 1943; Honolulu Academy of Art; Rochester Memorial Art Gallery; Worcester Museum of Art; Minneapolis Institute of Art; Detroit Institute of Art; Rhode Island School of Design; San Francisco Museum of Art; Wadsworth Atheneum; Renaissance Society, University Chicago; Baltimore Museum of Art; Bloomington (Ill.) Art Museum; Colorado Springs Fine Art Center; Denver Art Museum; Albany Institute of History and Art; Pasadena Art Institute; Santa Barbara Museum of Art; Addison Gallery of American Art; Los Angeles Museum of Art, 1945; Art Institute of Chicago, 1939-41, 49; Museum of Fine Art of Houston, 1950; Brook Art Gallery, London,

England, 1950; Museum of Modern Art, 1933, 44. Author and illustrator, "First Person Plural," 1937; "Love Possessed Juana," 1939; "Silly Girl," 1944; illustrated, "Best American Short Stories of 1945." Contributor to: Art and theatre publications, on painting and arts. Represented American Theatre, International Berlin Art Festival, 1951. Address in 1953, c/o Newhouse Galleries, 15 East 57th St.; h. 113 West 57th St., NYC.

EPPING, FRANC.
Sculptor. Born in Providence, RI, in 1910. Studied at Otis Art Institute, Los Angeles; Corcoran Gallery of Art, Wash., DC; Academy of Fine Arts, Munich, Germany; also with Joseph Wackerle and Bernhard Bleeker. Works: Washington College; Nebraska Art Association; Berea College; High Museum of Art, Atlanta, Georgia; Public Buildings Administration, Wash., DC; US Post Office, Alabama City, Alabama; Oakmont, Penn. Awards: Academy of Fine Arts, Munich, Germany, 1933; Conn. Academy of Fine Arts, 1954; Silvermine Guild, 1955.

EPSTEIN, BEATRICE.
Sculptor. Work includes "Android," mixed media. Member: National Association of Women Artists. Address in 1983, 112 W. 81 Street, NYC.

EPSTEIN, BETTY O.
Sculptor. Work includes "Cast a Shadow," coco-bolo. Member: National Association of Women Artists. Address in 1983, 39 Gramercy Park N., NYC.

EPSTEIN, JACOB.
Sculptor. Born in New York City, 1880. Work: Oscar Wilde monument, Pere Lachaise, Paris; figures in London Medical Association Building. Address in 1916, care of Medical Association, London, England. Died in 1959.

ERBA, GASPAR.
Sculptor, plaster modeler. At San Francisco, from 1856.

ERESBY, ELOISE L. BREESE DE.
(Lady Willoughby de Eresby). Sculptor. Born in New York. Member: National Arts Club; New York Municipal Art Society; Associate, National Sculpture Society.

ERICSON, MAURITZ A.
Sculptor. Born in 1836. Died in Pelham, New York, October 24, 1912.

ERIKSEN, GARY.
Sculptor. Born in Jackson, Michigan, September 11, 1943. Studied: Oberlin College, AB, 1966; Kent State Univ., MA, 1968; Univ. of Chicago, 1971-73; Accademia delle Belle Arti di Roma, Italy, 1973-77; Mechanics Institute, NYC, 1979-81; assistant to Steve Daley; foundry of American Academy in Rome, 1974. Work: Medals, National Gallery, Budapest; medals, Smithsonian Institution; Cooper-Hewitt, NYC; American Numismatic Society, NYC; others, including commissions. Exhibitions: National Gallery, Budapest, 1977; National Sculpture Society, NYC, 1978; Salma. Club, NYC, 1982; Palazzo Medici Riccardi, Florence, 1983; Cooper-Hewitt, 1983; American Medallic Sculpture Association, NYC, 1983; others. Awards: First prize, Salma. Club, 1982; Fountains project grant, NYS Council on the Arts, 1982.

Member: American Medallic Sculpture Assoc., Co-founder and pres.; NY Artists' Equity Assn.; Federation Internationale de la Medaille. Media: Bronze, terra cotta. Address in 1983, 280 Mott St., NYC.

ERSKINE, HAROLD (PERRY).
Sculptor. Born Racine, Wis., June 5, 1879. Pupil of Ecole des Beaux-Arts, Paris; Sherry E. Fry; Colorado University School of Fine Arts. Member: Beaux Arts Society and Century Club, New York. Work: Portrait bust, Carl Akeley, American Museum Natural History, NY; Walter J. Travis Memorial, Garden City Golf Club, NY; War memorial, St. Anthony Club, NYC; Wilton Merle-Smith Memorial, Central Presbyterian Church, NYC; Founders Memorial, National Chi Psi Fraternity, Ann Arbor, Mich.; numerous garden sculptures. Address in 1933, 251 East 61st Street, New York, NY; summer, Roxbury, Conn. Died January 6, 1951.

ESHERICK, WHARTON HARRIS.
Sculptor, painter, craftsman, designer, and wood engraver. Born Phila., PA, July 15, 1887. Studied at Phila. Museum School of Industrial Art; Penna. Academy of Fine Art; and student of Chase, Beaux, and Anshutz. Member: Artists Equity Association; Phila. Alliance; Phila. Art Club. Awards: Prize, Penna. Academy of Fine Arts, 1951; one of eleven winners in an International Sculpture Competition, awarded two prizes for "The Unknown Political Prisoner;" gold medal, Architectural League, 1954; Phila. Museum School of Art, 1957. Work: Penna. Academy of Fine Arts; Whitney Museum of Amer. Art; Phila. Museum of Art; University Penna.; Hedgerow Theatre, Moylan, PA. Exhibited: World's Fair NY, 1939; 20th Century Sculpture Show, 1952-53; Museum of Modern Art, 1953; Addison Gallery of Amer. Art, Andover, MA, 1964; Phila. Museum of Art, 1949; Penna. Academy of Fine Art, 1951, 52; Whitney Museum of Amer. Art, 1952; Phila. Art Alliance, 1952; others. Address in 1970, Paoli, PA. Died in 1970.

ESTERN, NEIL.
Sculptor. Born in NYC, April 18, 1926. Studied at Temple University, B.F.A. and B.S. (education), 1947. Work in Brooklyn Museum; portrait bust of John F. Kennedy, Kennedy Memorial, Grand Army Plaza, Brooklyn; others. Received Samuel F. B. Morse Medal. Address in 1982, Brooklyn NY.

ETTL, ALEX J.
Sculptor. Born Fort Lee, NJ, December 12, 1898. Pupil of his father, John Ettl, and Robert Aitken. Studied: National Academy of Design; Columbia University; City College of New York. Member: Fellow, National Academy of Design. Work: "Katrina Trask Memorial," Yaddo, Saratoga Springs, NY; Wolf and Jacobs Memorial, Friars' Club, New York City; marble bench historical site, Hackensack, NJ; sculpture, Pennsylvania Building, Philadelphia, PA; Elsie the Borden Cow, and numerous industries in U.S. Address in 1933, 304 West 42nd Street, NYC; h. Princeton, NJ.

ETTL, JOHN.
Sculptor. Born Budapest, Hungary, August 1, 1872. Stud-

ied in Budapest, Paris, Munich, and Vienna. Work: "Abraham Lincoln," State Arsenal, New York; "War Memorial," East Rutherford, NJ; sculpture in Palace of Justice, Berne, Switzerland; Soldiers Monument, Haverstraw; "Chief Oratam," Bergen County Historical Society; sculpture, Pennsylvania Building, Philadelphia, PA. Exhibited National Sculpture Society, 1923. Address in 1933, 227 West 13th Street, NYC; h. Port Washington, NY. Died in 1940.

EVANS, DICK.
Sculptor and educator. Born in Roswell, NM, July 10, 1941. Studied at Texas Technical University, Lubbock, 1959-62; University of Utah, Salt Lake City, BFA, 1964, MFA, 1966. Work at Smithsonian Institution, Washington, DC; University of New Mexico Art Museum; Milwaukee Art Museum, WI; others. Has exhibited at Renwick Gallery, Smithsonian Institution, Washington, DC, 1980. Address in 1982, Milwaukee, WI.

EVANS, RUDULPH.
Sculptor. Born Wash., DC, February 1, 1878. Pupil of Falguiere and Rodin; studied at Corcoran Art Gallery, Wash., DC; Art Students League of New York; Academie Julien and Ecole des Beaux-Arts, Paris. Member: Associate National Academy of Design, 1919; National Academy, 1929; Paris Art Assoc., All. Artists of America; National Sculpture Society; National Institute of Arts and Letters, 1926. Awards: Bronze medal, Paris Salon, 1914; Watrous gold medal, National Academy of Design, 1920; Legion of Honor, Paris; Crown of Italy, Rome. Work: Marble portrait, Gen. Bolivar, Bureau American Republics, Wash.; statue James Pierce, NY; bronze portrait, John Greenleaf Whittier, Hall of Fame, NY; Jean Webster McKinney Memorial, Greenwich, Conn.; Corcoran Gallery; Kiernan Memorial, Green Bay, Wis.; Woolley Memorial, Detroit, Mich.; bronze portrait, Joseph French Johnson, New York University. Decorated by King Victor Emanuel for Exhibition in Rome. Statue of "The Golden Hour," acquired by French Government for Luxembourg; replica of same in Metropolitan Museum, NY. Exhibited extensively in U.S. and abroad. Address in 1953, Washington, DC. Died in 1960.

EVERETT, ELIZABETH (RINEHART).
Sculptor, painter, illustrator, etcher, and craftsman. Born Toledo, Ohio. Studied: Pratt Institute Art School, Brooklyn, NY; University of Washington, Seattle, BA; also pupil of Walter Isaacs. Exhibited: Marshall Field, Chicago, IL, 1946. Awards: Sweepstake prize, 1926; first prize, 1927, 1928, Western Washington Fair, 1920; Women Painters of Washington, 1933. Member: Women Painters of Washington, (President); Seattle Photographic Society. Address in 1953, Seattle, Washington.

EVERETT, EUGENIA.
Sculptor. Born in Loveland, Colorado, in 1908. In California 1932-71. Studied at Otis Art Institute, Los Angeles. Taught at Ventura College, California, and Sedona Arts Center, Arizona. Works include monumental sculpture, Civic Auditorium, Oxnard, California; sculpture group, St. Daniel the Prophet Catholic Church, Scottsdale, Arizona. Exhibited at Golden Gate International Exposition, San Francisco, 1939; Los Angeles County Museum of Art. Received first prize, California Art Club, 1932, 46; purchase prize, Los Angeles County Fair, 1939; first prize, Ventura Art Show, California, 1970.

EVERETT, HERBERT EDWARD.
Sculptor and teacher. Born Worcester, Mass. Pupil of Boston Museum School; Julian Academy in Paris; Penna. Academy of Fine Arts. Member: Phila. Water Color Club. Address in 1933, Philadelphia, PA. Died in 1935.

EVERETT, LOUISE.
Sculptor and painter. Born in Des Moines, IA, April 9, 1899. Pupil of Fursman, Hawthorne, Julia Bracken Wendt, Otis Art Institute; Fontainebleau School of Fine Arts, 1925; Julian Academy in Paris, 1926. Member: California Art Club; Laguna Beach Art Association; West Coast Arts. Awards: Second prize, West Coast Arts, 1923; marine prize, Laguna Beach Art Association, 1923; silver medal, sculpture, Pacific Southwest Exposition, 1928. Address in 1929, 980 South Manhattan Place, Los Angeles, Calif.

EVERETT, RAYMOND.
Sculptor, painter, book-plate designer and teacher. Born in Englishtown, NJ, August 10, 1885. Studied at Drexel Institute; Harvard; pupil of Howard Pyle, Joseph Lindon Smith, and Denman Ross; in Paris at the Julien Academy; in Rome. Award: Silver medal, Southern States Art League, San Antonio, 1929. Represented in Detroit Public Library; Elisabet Ney Museum, Austin, Texas; University of Colorado Museum. Member: Texas FAA; Southern States Art League; American Institute of Architects. Taught at the University of Pennsylvania and the University of Michigan; University of Texas from 1917. Specialty was Texas landscape; painted Bluebonnet series ("Texas Bluebonnets," "A March Morning," "Golden Evening"). Chiefly painter. Address in 1941, Austin, Texas.

EVERGOOD, PHILIP (HOWARD FRANCIS).
Sculptor, painter, illustrator, lecturer, writer, and teacher. Born in NYC, October 26, 1901. Pupil of Cambridge University; Slade School in London; under von Schlegell and Luks at Art Students League, NYC; Julian Academy in Paris. Awards: Prizes, Art Institute of Chicago, 1935, 46; Carnegie Institute, 1945, 50; Hallmark Award, 1950; Corcoran Gallery, 1951; gold medal, Penna. Academy of Fine Arts, 1950, 58; and others. Work: Metropolitan Museum of Art; Museum of Modern Art; Whitney; Boston Museum of Fine Arts; Los Angeles Museum of Art; Art Institute of Chicago; Brooklyn Museum; and others. Exhibited: Carnegie Institute, 1938, 39; World's Fair of New York 1939; Tate Gallery, London, 1946; etc. Illustrator for *Fortune* and *Time* magazines. Member: Art Students League of New York; Artists Equity Association; National Institute of Arts and Letters. Address in 1970, Bridgewater, CT.

EVERSLEY, FREDERICK JOHN.
Sculptor. Born in Brooklyn, NY, August 28, 1941. Studied at Carnegie Institute of Technology (electrical engineering); Instituto Allende, San Miguel de Allende, Mexico

(photography). Employed as technical consultant, Los Angeles County Museum, 1971; artist-in-residence, National Air & Space Museum, Smithsonian, 1977-80. In collections of Smithsonian; Whitney, NYC; Milwaukee Art Center; Guggenheim Museum; MIT; Oakland Art Museum. Commissions: San Francisco, Atlanta, Dallas (Hyatt-Regency), Miami International Airport, etc. Exhibited at Phyllis Kind Gallery, Chicago; Harris Gallery, NYC; Braunstein Gallery, San Francisco; Whitney, NYC; National Academy of Science, Wash., DC; Jewish Museum, NYC; Los Angeles County Museum of Art; Cornell University; San Francisco Museum of Modern Art; Indianapolis; Los Angeles Institute of Contemporary Art; Museum of Contemporary Art, Chicago; more. Awarded National Endowment for the Arts fellowship; others. Works in multicolored cast transparent plastic; stainless steel; laser light. Address in 1982, c/o Engineered Aesthetics, Venice, CA.

EWERTZ, HENRY.
Sculptor. Address in 1934, Ridley Park, PA. (Mallett's)

EYRE, LOUISA.
Sculptor. Born Newport, RI, January 16, 1872. Pupil of Augustus Saint-Gaudens, Charles Grafly, Thomas Anshutz, Kenyon Cox; also studied at Penna. Academy of Fine Arts and Art Students League of New York. Member: Philadelphia Arts and Crafts Guild of Philadelphia Museum and School of Indian Art; Philadelphia Alliance. Exhibited at National Sculpture Society, 1923; Palace Legion of Honor; Penna. Academy of Fine Arts, 1896-1945. Work: Tablet to Gen. George Sykes for Memorial Hall, West Point, NY; decorative reliefs, University Museum, Philadelphia, PA; Dennison Building, NY; Washington Cathedral, Washington, DC. Specialty was portraits and ideal works of children. Address in 1953, Franklin, NH. Died in 1953.

EYRE, WILSON.
Sculptor and architect. Awards: Silver medal, St. Louis Exposition 1904. Member: T-Square Club 1883; Arts Club of Philadelphia; Fellow, American Institute of Architects, 1893; Philadelphia Chapter, American Institute of Architects. Address in 1908, 929 Chestnut St., Philadelphia, PA.

EZEKIEL, MOSES.
Sculptor. Born Richmond, VA, October 28, 1844. Graduated VA Military Institute, 1866; studied anatomy at Medical College of VA. Moved to Cincinnati, 1868; visited Berlin, Germany, 1869, where he studied at Royal Academy of Art, and under Prof. Albert Wolf. Admitted to Society of Artists, Berlin, on the merits of his colossal bust of Washington, and was first foreigner to win the Michael Beer prize. The Jewish order, "Sons of the Covenant," commissioned him in 1874 to execute a marble group representing "Religious Liberty," for Centennial Exhibition, later in Fairmount Park, Philadelphia. Among his productions are busts of Liszt, Cardinal Hohenlohe, Eve, Homer, David, Judith; "Christ in the Tomb;" statue of Mrs. Andrew D. White for Cornell University; "Faith," Cemetery, Rome; "Madonna," for Church, Tivoli; "Apollo and Mercury," in Berlin, etc. Member of the National Sculpture Society. Received a gold medal from the Royal Art Association, Palermo; and a silver medal, St. Louis Exposition, 1904. Address in 1910, Rome, Italy; Cincinnati, OH. Died in Rome, Italy, March 27, 1917.

F

FABION, JOHN.
Sculptor and painter. Born in Vienna, Austria, October 31, 1905. Studied at Art Institute of Chicago, with Boris Anisfeld; and abroad. Member: Artists Equity Association. Awards: Prizes, Art Institute of Chicago, 1933, 36, and 60. Work: Statler Hotel, Washington, DC, and Los Angeles, Calif.; United States Naval Academy; St. Mary's Hospital, Anderson, IN; United States Post Office, Bedford, IN; monument, Chopin School, Chicago, IL. Exhibited: Art Institute of Chicago; Golden Gate Exposition, 1939; National Museum, Washington, DC; Pennsylvania Academy of Fine Arts; American Artists Exhibition, Chicago; others. Taught: Professor of Art, Art Institute of Chicago, 1946-70, professor emeritus, from 1970. Address in 1982, Chicago, IL.

FABRI, LUDOVICK.
Figure-maker. Born in Italy in 1800. Working in New York City in 1850.

FACCI, DOMENICO (AURELIO).
Sculptor, painter, teacher, and craftsman. Born in Hooversville, Penna., February 2, 1916. Studied at Roerich Academy of Art, and with Pietro Montana, Louis Slobodkin, William Zorach. Member: Artists Equity Association; Audubon Artists; Sculptors League; National Sculpture Society (fellow); others. Awards: Audubon Artists, 1956-61, and 1978; Kickerbocker Artists, 1978; and many others. Work: Florida Southern College. Exhibited: Artists Equity Association Lighthouse Exchange, 1950; Whitney Museum of American Art; National Academy of Design, First International Art Exhibition, Florida Southern College; Butler Institute of American Art; Audubon Artists, 1978. Position: Instructor of sculpture, Roerich Academy of Art, NYC. Address in 1982, 248 West 14th St.; NYC.

FAEDMAN, TANYA.
Sculptor and graphic artist. Works with organic forms in polyurethane foam and pencil.

FAGGI, ALFEO.
Sculptor. Born Florence, Italy, September 11, 1885. Pupil of Accademia Belle Arts, Florence. Member: Salons of America. Work: War Memorial "Pieta" and fourteen reliefs "Stations of the Cross," St. Thomas Church, Chicago; "The Doubting St. Thomas," Chapel at the University of Chicago; life-size figure of St. Francis, Museum of Santa Fe, NM; bronze head of Japanese poet, Art Institute of Chicago; head of Noguchi, Phillips Memorial Gallery, Washington, DC; statue of Eve, Arts Club of Chicago; bronze door, episodes in life of St. Francis, University of Chicago. Address in 1929, Woodstock, NY.

FAGNANI, JOSEPH (GUISEPPE).
Sculptor and portrait painter. Born in Naples, December 24, 1819; died in New York, May 22, 1873. He came to America in 1851, and lived in Washington and then in New York. His painting of the "Nine Muses," in the Metropolitan Museum of Art, New York, attracted much attention, as well-known American beauties had served as models. Exhibited at National Academy; Boston Atheneum; Penna. Academy.

FAHLEN, CHARLES.
Sculptor. Born in California, 1939. Studied at San Francisco State College, 1962, BA; Otis Art Institute, Los Angeles, 1965, MFA; and Slade School, London, England, 1966. Major exhibitions: Brooklyn Museum, NY, 1970; Whitney Museum of American Art, NY, 1970; 71st American Exhibition, Art Institute of Chicago, 1974; Philadelphia: Three Centuries of American Art, Philadelphia Museum of Art, 1976; many one-man shows. Work in Museum of Modern Art, NYC; Phila. Museum of Art; others. Address in 1982, c/o Droll/Kolbert Gallery Inc., 724 Fifth Avenue, NYC.

FAIRBANKS, AVARD TENNYSON.
Sculptor. Born Provo, UT, March 2, 1897. Pupil of Art Students League of New York under James E. Fraser; Beaux-Arts in Paris, under Injalbert; Grande Chaumiere and Ecole Modern, Paris; Yale University, BFA; University of Wash., MFA; University of Mich., MA and PhD; Fellow, Guggenheim Memorial Foundation, 1927. Member: National Sculpture Society; American Federation of Arts. Work: "The Indian," "The Pioneer," Salt Lake City Public Schools; monument "The Blessing of Joseph" and fountain in honor of Hawaiin motherhood, Laie, HI; "Doughboy of Idaho," Service Memorial, Oregon Agricultural College, Corvallis; "Old Oregon Trail Marker" and "War Memorial," Jefferson High School, Portland, OR; bronze doors, US National Bank, Portland, OR; "Fountain of Aphrodite," Washburne Gardens, Eugene, OR; Memorial to the Pioneer Mothers, Vancouver, WA; the Three Witnesses Memorial, Salt Lake City; Tabernacle Door for Altar, St. Mary's Cathedral, Eugene, OR; "Heat and Power," Power House, University of Oregon. Exhibitions: Paris Salon, 1914; National Academy of Design; National Sculpture Society; Pan-Pacific Exhibition, 1915; Carnegie; Art Institute of Chicago; San Francisco Museum of Art; others. Taught: University of Oregon, 1920-27; Seattle Institute of Art, 1928-29; University of Michigan, 1927-47; University of Utah from 1947; University of North Dakota, from 1965. Address in 1929, University of Oregon, Eugene, OR; address in 1976, Salt Lake City, UT.

FAIRBANKS, J. LEO.
Sculptor, painter, lecturer, teacher, and writer. Pupil of Julian Academy, Paris. Member: American Artists Pro-

fessional League; American Federation of Arts; Society of Oregon Artists; Park and Garden Sculptor Society. Designed and executed sculpture frieze on Mormon Temple, Hawaii; mural paintings, Salt Lake Temple; Library Building, Oregon State College; State War Memorial, ID; Arizona Temple and Logan Temple, Mesa, AR; mural decorations and two stained glass windows, Hall of Religion, Century of Progress Exposition, Chicago, IL. Professor of Art and Architecture, Oregon State College, Corvallis, OR. Address in 1933, Corvallis, OR.

FALKENSTEIN, CLAIRE.
Sculptor. Born in Coos Bay, OR. Studied at the University of Calif., Berkeley. Exhibited: Illinois Segno Gallery, Rome, Italy, 1958; Institute of Contemporary Art, Boston, 1959; Art for Use, Louvre, Paris, 1962; Carnegie Institute, Pittsburgh, 1964; Whitney Museum of American Art, NYC, 1964; numerous others. Commissions: A floor to ceiling stair railing for Gallery Sapzio, Milan, Italy, for Gallery Stadler, Paris, France; fountain, Wilshire Blvd., Los Angeles; stained glass windows, rectory screen and doors, St. Basil's Catholic Church, Los Angeles; numerous other fountains, murals, and gates. In collections of Baltimore; Boston Museum of Fine Arts; Guggenheim; many more. Worked copper, iron, and found objects. Address in 1982, Venice, CA.

FANE, LAWRENCE.
Sculptor. Born in Kansas City, MO, September 10, 1933. Studied at Harvard University, A.B., 1955; Boston Museum School, 1956; with George Demetrios, 1956-59. Work in Corcoran Gallery, DC; University of North Carolina Weatherspoon Gallery, Greensboro; De Cordova Museum, Boston. Has exhibited at Zabriskie Gallery, NY; others. Member of American Academy in Rome. Taught at Rhode Island School Design, Providence, 1966-69, instructor of design; teaching at Queens College, NY, from 1969, professor of sculpture. Works in steel and bronze. Address in 1982, 355 Riverside Drive NYC.

FARALLA.
Sculptor. Born in Brooklyn, NY, 1916. Came to California, 1934. Studied: California School of Fine Arts (now San Francisco Art Institute), B.F.A., 1955; San Francisco State College, 1956. One-man exhibitions: Pasadena Art Institute, CA, 1947; M. H. de Young Memorial Museum, San Francisco, 1963; San Francisco Museum of Art, 1966, 1975. Group exhibitions: Contemporary California Sculpture, Oakland Art Museum Kaiser Center, CA, 1963; White on White, De Cordova Museum, Lincoln, MA, 1965; Monotypes in California, The Oakland Museum, CA, 1972; San Francisco Museum of Modern Art, 1976; National Collection of Fine Arts, Smithsonian, 1977. Address in 1977, San Francisco, CA.

FARBER, ELFIE R. (MRS.).
Sculptor and painter. Born in Milwaukee, Wis. Studied with Carl Holty, Armin Hansen, Peter Rotier, W. Quirt, and George Dietrich. Awards: First prize for water color, 1931, honorable mention, 1932, Milwaukee Art Institute. Member: Wis. Painters and Sculptors. Address in 1933, 4217 West North Ave., Milwaukee, Wis.

FARNHAM, JESSICA SHIRLEY.
Sculptor and painter. Born in New Rochelle, NY. Studied with Lorado Taft and Charles Mulligan. Work: "Park Scene," painting, Woodlawn High School, Birmingham; medallion, Montgomery Museum of Fine Arts, Montgomery, Ala. Member: Southern States Art League; Ala. Artists' League; Birmingham Art Club. Head of Art Department, Woodlawn High School, Birmingham, Ala. Address in 1933, 45 Woodlawn Station, Birmingham; h. Citronelle, Ala.

FARNHAM, SALLY JAMES.
(Mrs. Paulding Farnham). Sculptor. Born in Ogdensburg, NY, November 26, 1876. Studied at Wells College. Work: Equestrian statue of Gen. Bolivar, New York, NY; war memorial, Fultonville, NY; statue of Sen. Clark, Corcoran; Soldiers and Sailors Monument, Ogdensburg, NY; frieze in Pan Am Bldg., Wash., DC; Vernon Castle mem., Woodlawn Cemetery, NYC. Exhibited at NSS, 1923. Died April 28, 1943, in New York City. Address in 1929, 57 West 57th St., New York, NY.

FARNUM, SUZANNE SILVERCRUYS.
(Mrs. Henry W. Farnum). Sculptor, writer, and lecturer. Born in Maeseyck, Belgium, May 29, 1898. Studied with Eberhardt, at Yale School of Fine Arts. Works: Herbert Hoover's bust, Louvain Library, Belgium, and copy to Mrs. Herbert Hoover; "Princess Josephine Charlotte of Belgium," property of Queen Elizabeth; Baptismal Font, Lutheran Church, New Haven, CT; plaque and medals of Dr. William Gillman Thompson, Reconstruction Hospital, NY; bust, Dr. Carmalt, New Haven Hospital, New Haven, CT. Awards: Beaux Arts prize, best composition of year, 1927; alumni prize, Academy of Rome, 1928. Member: National Association Women Painters and Sculptors; Paint and Clay Club. Address in 1933, 37 West 10th Street, NYC; home, 92 Cottage Street, New Haven, CT.

FARR, FRED W.
Sculptor. Born August 9, 1914, St. Petersburg, Fla. Studied: University of Oregon; Art Students League; American Artists School, NYC. Work: Ball State Teachers College; Detroit Institute; University of Illinois; Phillips; Portland (ME) Museum of Art. Rep. by P. Rosenberg and Co., NYC. Commissions for Moore-McCormack Lines Inc., SS Argentina (mural). Exhibited: The Bertha Schaefer Gallery, NYC; Museum of Modern Art; Springfield (Mass.) Museum of Fine Arts; Walker Utica; Rhode Island School of Design; Whitney Museum; Port-au-Prince (Haiti) Bicentennial Exposition; Walters Art Gallery, Baltimore; ART:USA:59; and many universities. Awards: Port-au-Prince Bicentennial Exposition, 1950, Haiti Silver Medal. Member: Artists Equity. Taught: Brooklyn Museum School; Museum of Modern Art School, 1947; Hunter College, 1954; Dalton Schools, NYC, 1950; University of Colorado; Dayton Art Institute School; University of Oregon, 1948. Address in 1970, 155 Ridge St., NYC. Died in 1973.

FASANO, CLARA.
Sculptor. Born in Castellaneta, Italy, in 1900; US citizen. Studied: Cooper Union Art School; Art Students League;

Adelphi College, Brooklyn, NY; Academy Julien and Colarossi, Paris; also in Rome with Dazzi. Awards: National Association of Women Artists, 1945, 50, 55; Audubon Artists, 1952; National Inst. of Arts and Letters, 1952; Daniel Chester French medal, National Academy of Design, 1965, and Greer prize, 1968; scholarship abroad, 1922-1923. Exhibitions: Whitney Museum of American Art, NY; Metropolitan Museum of Art; National Academy of Design; Penna. Academy of Fine Arts, Philadelphia. Collections: US Post Office, Middleport, OH; Technical High School, Brooklyn, NY; Port Richmond High School, Staten Island, NY; Metropolitan Museum of Art; Smithsonian, Wash., DC. Taught sculpture at the Industrial and Fine Arts School of New York and Adult Ed., 1946-56; Manhattanville College, 1956-66. Address in 1982, Italy.

FASNACHT, HEIDE ANN.
Sculptor. Born in Cleveland, OH, January 12, 1951. Studied at Rhode Island School of Design, B.F.A., 1973; Hunter College. Has exhibited at Los Angeles Institute of Contemporary Art; Cleveland Museum of Art; Women Sculptors' Drawings, Max Hutchinson Gallery, NY. Received award, National Endowment for the Arts, Art in Public Places; fellowships, Yaddo, 1979, and MacDowell Colony, 1981. Teaching at State University of NY, Purchase, from 1981, professor of sculpture. Works in wood and mixed media. Address in 1982, 4 White St., NYC.

FAUGHT, ELIZABETH J(EAN).
(Mrs. Ray Clinton Faught). Sculptor. Born in Richmond, Virginia, November 2, 1883. Studied at Rinehart School of Sculpture, Ephraim Keyser. Member: Maryland Institute Alumni Association; Baltimore Museum of Art. Address in 1933, "Aqua Vista," 201 Athol Gate Lane, Carroll P.O., Baltimore, Maryland.

FAULKNER, SARAH M. (SALLY).
Sculptor, painter, designer, teacher, and craftswoman. Born in Lowell, Mass., May 8, 1909. Studied at Boston Museum of Fine Arts School; Army Air Force Photo. School. Member: Lowell Art Association; Boston Photo. Society. Position: Instructor, Lowell Art Association, Lowell, Mass. Address in 1953, Lowell, Mass.

FAUR, AUREL-SEBASTIAN.
Sculptor and painter. Born in Romania, January 30, 1918. Studied at School of Beaux Arts, Bucharest, 1934-37; School of Ceramics, Sevres, France. Worked at Manufacture National de Sevres, Iser, Despiaux, Maillol. Exhibited: Salon d'Automne, Paris; Salon des Independants, Salon des Tuileries, Grandes Galeries d'Art Contemporain, all in Paris; Musee de Peinture Moderne, Wauxhall, Bruxelles. Awards: 1st prize for portrait sculpture, School of Beaux Arts, Bucharest, 1939. Collections: Simu and Dona State Museums, Bucharest. Specialty is portrait sculpture cast in bronze and alabaster. Paints on porcelain in oils and watercolor. Address in 1983, 91-41st Road, Forest Hills, New York City.

FEBLAND, HARRIET.
Sculptor and painter. Born in NYC. Studied at Pratt Institute; NY University; Art Students League; American Artists School. Work in New School Art Center, NY; Cincinnati Art Museum; others. Has exhibited at Silvermine Guild, CT; Museum of Modern Art, Paris; Women Choose Women, NY Cultural Center; others. Member of NY Artists Equity Association; Silvermine Guild of Artists; National Association of Women Artists. Works in acrylic, sculpture in steel and other metals, plexiglas, marble and wood. Address in 1982, 245 E. 63rd St., NYC.

FECHIN, NICOLAI IVANOVICH.
Sculptor and painter. Born Kazan, Russia, 1881; came to US after World War I, living first in NYC; moved to Taos, NM, in 1927. Studied at Art School of Kazan; Imperial Academy of Art in St. Petersburg, with Ilya Repin; awarded a traveling scholarship through Europe. Member Imperial Academy of Fine Arts, Russia. Work in Imperial Academy of Fine Arts (Petrograd), Kuingi Galleries (Petrograd), Museum of Kazan, Albright Art Gallery (Buffalo, NY), Art Institute of Chicago, Museum of New Mexico, Colorado Springs Fine Art Center, National Cowboy Hall of Fame, Harrison Eiteljorg Collection. Received first prize for portraits from the National Academy in 1924. Specialty was Indian figures and Southwestern subjects. Titles include "Young Indian Girl," "Old Indian," others. Died in Santa Monica, CA, in 1955.

FEIGENBAUM, HARRIET.
(Mrs. Neil Chamberlain). Sculptor. Born in NYC, May 25, 1939. Studied at Art Students League; National Academy School of Fine Arts; Columbia University. Works: Andrew Dickson White Museum, Cornell University; Colgate University Museum. Exhibitions: Hundred Acres First Sculpture Annual, NY, 1971; one-person show, Warren Benedek Gallery, 1972 and 74; New York Artists on Tour-3, Sculpture, 1973, Department of Cultural Affairs; New York Today—Works on Paper, University of Missouri, St. Louis, 1973; Whitney; Brooklyn; others. Awards: Hallgarten Traveling Fellowship, 1961; others. Address in 1982, 49 West 24th Street, NYC.

FEIN, LEONA M.
Sculptor. Work includes "Birdie the Bag Lady," ceramic, exhibited at National Association of Women Artists Annual, NYC, 1983. Member: National Association of Women Artists. Address in 1983, 245-03 62 Avenue, Douglaston, NY.

FEINBERG, NAOMI.
Sculptor. Born in USA. Solo shows: American Standard Gallery, NYC; Carol Korn Gallery, Florida. Group shows: Long Island Annual Art Exhibition; Shirley Reece Gallery, NYC; Gallery 725, NYC; Federation of Modern Painters and Sculptors, Inc., 43rd Anniversary Exhibition, 1983. Collections: Mark VII Corporation, Florida; Gemini Corporation; University of Minnesota; in US, Israel, Mexico.

FELDMAN, BELLA TABAK.
Sculptor. Born in NYC. Studied at Queens College, City University of New York, B.A.; Calif. College of Arts and Crafts; Calif. State University, San Jose, M.A. In collections of Oakland Museum, CA; Berkeley Art Museum, University of Calif; plus numerous commissions. Exhibi-

ted at Palace of the Legion of Honor, San Fran., 1961; Summer Series, San Francisco Museum, 1964; Berkeley Art Center, 1974; San Francisco Art Institute, 1975; University Calif., Santa Barbara, 1975. Awards include Calif. Museum Trustees Award, 1967; First Prize, San Fran. Women Artists, 1967. Media: Metal, paper, and resin. Address in 1982, 12 Summit Lane, Berkeley, CA.

FELL, OLIVE.
Sculptor, painter, etcher, muralist and caster of life masks. Born at Big Timber Creek at the foot of the Crazy Mountains in Montana about 1900. Studied at Wyoming University; Art Institute of Chicago and Art Students League. Work in Buffalo Bill Museum (Olive Fell Room), Cody, WY, "100 Best Prints of the Year." Specialty was Western scenes and wildlife; titles include, "Fenced Sagebrush," "The Lone Rider," "Wading Moose." Address in 1949, Four Bear Ranch, near Cody, Wyoming.

FELLOWS, FRED.
Sculptor and painter. Born in Ponca City, OK, August 15, 1934. Competed in rodeos; worked as saddlemaker and then commercial artist. Has done commissions for Winchester Firearms and Armco Steel Corp. Exhibited at Cowboy Artists of America show since 1968; Cowboy Hall of Fame; Russell Museum; Montana Historical Society; Los Angeles Co. Museum of Art; others. Awarded gold medal, Phippen award, 1975, and silver medal, 1978, Cowboy Artists of America Exhibition; Grumbacher. Member of Cowboy Artists of America. Specialty is the contemporary West. Bibliography, *Western Painting Today*, Hassrick; *Artists of the Rockies* magazine and *Print* magazine. Represented by The Peacock Galleries Limited, Jackson, WY; Flathead Lake Galleries, Bigfork, MT. Address in 1982, Bigfork, MT.

FENCI, RENZO.
Sculptor. Born in Florence, Italy, November 18, 1914; US citizen. Studied at Royal Institute of Art, Florence. Work in Permanent Gallery of Modern Art, Florence; Santa Barbara Museum of Art, CA. Has exhibited at Art Institute of Chicago; Los Angeles County Museum of Art; Santa Barbara Museum of Art; others. Received awards from California State Fair, 1947, 49, and 50; Los Angeles County Museum of Art, 1955; Santa Barbara Museum Biennial Show. Taught at Otis Art Institute, 1954-77, professor of sculpture and head of dept. Works in bronze. Address in 1982, Los Angeles, CA.

FENDER, TOM MAC.
Sculptor. Born in Tyler, TX, October 12, 1946. Studied at Baylor University, B.F.A., 1969; University of California, Los Angeles, M.A., 1975; M.F.A., 1979. Work in National Museum of Modern Art, Kyoto, Japan; others. Has exhibited at "Fiber Works: America and Japan," National Museum of Modern Art, Kyoto and Tokyo, Japan; "California," Riverside Art Center, CA; Herron Gallery, Indianapolis; others. Works in fiber materials and homemade paper. Address in 1982, Los Angeles, CA.

FENTON, BEATRICE.
Sculptor. Born Philadelphia, PA, July 12, 1887. Pupil of School of Industrial Art, Philadelphia, and Penna. Acad-

emy of Fine Arts. Member: Fellowship Penna. Academy of Fine Arts; Plastic Club; Philadelphia Art Alliance; National Association of Women Painters and Sculptors; National Sculpture Society, fellow. Exhibited at National Sculpture Society, 1923; Philadelphia Art Alliance, 1924-65; Penna. Academy of Fine Art, 1920-68; Woodmere Art Gallery, 1958-68; others. Awards: Stewardson sculpture prize, Penna. Academy of Fine Arts, 1908; Cresson Traveling Scholarship, Penna. Academy of Fine Arts, 1909-1910; honorable mention, P.-P. Exposition, San Francisco, 1915; honorable mention, Plastic Club, 1916; Widener medal, Penna. Academy of Fine Arts, 1922; Fellowship prize, Penna. Academy of Fine Arts, 1922; Shillard silver medal, Plastic Club, 1922; bronze medal, Sesqui-Centennial Exposition, Philadelphia, 1926; Owens Memorial Award, 1967; others. Represented in permanent collection, Philadelphia Art Club; Fairmount Park, Philadelphia; Charles M. Schmitz Memorial, Academy of Music; "Fairy Fountain," Wister Park, Philadelphia; Brookgreen Gardens, SC; Philadelphia Museum of Art; others. Taught sculpture at Moore Institute of Art, Science and Industry, Philadelphia, 1942-53. Address in 1982, Philadelphia, PA.

FERBER, HERBERT.
Sculptor and painter. Born April 30, 1906, NYC. Studied: City College of New York, 1923-26; Columbia University School of Dental and Oral Surgery, 1927, BS, 1930, DDS; Beaux-Arts Institute of Design, NYC, 1927-30; National Academy of Design, 1930. Work: Bennington College; Brandeis University; Albright; Cranbrook; Detroit Instute; Metropolitan Museum of Art; Museum of Modern Art; NYU; Newark Museum; Whitney Museum; Walker; Williams College; Yale University. Exhibited: The Midtown Betty Parsons Gallery, The Kootz Gallery, Andre Emmerich Gallery, all in NYC; Whitney Museum; San Francisco Museum of Art; Walker; National Academy of Design; Brooklyn Museum; Penna. Academy of Fine Arts; Corcoran; Philadelphia Art Alliance; Sculptors Guild; Golden Gate International Exposition, San Francisco; New York World's Fair, 1939; Art Institute of Chicago; Metropolitan Museum of Art; Sao Paulo; Museum of Modern Art; Brussels World's Fair, 1958; Tate; Carnegie; Documenta II, Kassel; Baltimore Museum of Art; Cranbrook; Battersea Park, London, International Sculpture Exhibition; Musee Rodin, Paris; plus numerous commissions, including B'nai Israel Synagogue, Millburn, NJ; Brandeis University; Whitney; J. F. Kennedy Federal Office Building, Boston, 1969. Awards: Beaux-Arts Institute of Design, NYC, Paris Prize, 1929; L. C. Tiffany Grant, 1930; Metropolitan Museum of Art, Artists for Victory, $1,000 Prize, 1942; Tate, International Unknown Political Prisoner Competition, 1953; Guggenheim Foundation Fellowship, 1969. Taught: University of Pennsylvania 1936-64; Columbia University School of Dental and Oral Surgery; Rutgers University, 1965-67. Rep. by Knoedler Gallery, NYC. Address in 1982, 44 MacDougal St., NYC.

FERGUSON, CATHERINE.
Sculptor. Born in Sioux City, Iowa, in 1943. Studied: Rosary College, River Forest, Illinois; Creighton Univer-

sity, Omaha, Nebraska; Arrowmont School of Crafts, Gatlinburg, Tennessee. She received awards at the Associated Artists of Omaha Show, 1970, 73. Collections: Ahmanson Law Center, Creighton University Law School, Omaha; Brenton Bank, Des Moines, Iowa. Cofounder, Old Market Craftsmen Guild.

FERGUSON, DUNCAN.
Sculptor. Born Shanghai, China, January 1, 1901. Pupil of A. H. Atkins, Robert Laurent. Member: Society of Independent Artists; Salons of America. Work: "Anatol" and "Mimi," Newark Museum, Newark, NJ; male figure, life-sized bronze, Whitney Museum of American Art, NYC. Address in 1929, 11 Minetta St., NYC; address in 1933, Cape Neddick, ME.

FERGUSON, ELEANOR M.
Sculptor. Born Hartford, June 30, 1876. Pupil of C. N. Flagg in Hartford; D. C. French, G. G. Barnard and Art Students League of New York. Member: Conn. Academy of Fine Arts. Address in 1933, 847 Prospect Ave.; 123 Vernon St., Hartford, CT.

FERGUSON, KATHLEEN ELIZABETH.
Sculptor. Born in Chicago, IL, January 31, 1945. Studied at Stephens College, Columbia, MO, 1963-64; Layton School of Art, Milwaukee, WI, B.F.A., 1969; Rhode Island School of Design, Providence, M.F.A. Has exhibited at Smithsonian Institution; San Cicero Gallery, Chicago; Virginia Museum of Fine Arts, Richmond; Whitney Museum of American Art. Address in 1982, Lexington, KY.

FERNIE, JOHN CHIPMAN.
Sculptor and teacher. Born in Hutchinson, KS, October 22, 1945. Studied at Colorado College, Colorado Springs, 1963-65; Kansas City Art Institute, Missouri, 1965-68, BFA, 1968; University of California, 1968-70, MFA, 1970. Exhibited: Whitney; University of California, Berkeley, 1970; University Art Museum, Berkeley, Calif., 1970; San Francisco Art Institute, Calif., 1970; Kansas City Art Institute, Missouri, 1974; Musee d'Art Moderne, Paris, 1973; and Van Abbemuseum, Eindhoven, Netherlands. Received National Teaching Fellowship, Oakland, Calif., 1970; others. Taught: Sculpture at the California College of Arts and Crafts, Oakland, 1970-72; Stephens College, Columbia, Missouri, 1972-74; Nova Scotia College of Art and Design, Halifax, Canada since 1975. Media: Cardboard and wood. Address in 1982, 735 College Avenue, Boulder, CO.

FERON, LOUIS.
Sculptor. Member of the National Sculpture Society. Address in 1982, Snowville, NH.

FERRANA, JOSEPH.
Figure maker. Born in Italy c. 1800. Lived and worked in Baltimore, 1860. Worked in plaster.

FERRANA, PILARENE.
Figure maker. Born in Tuscany c. 1841. Son of Joseph Ferrana. Lived and worked in Baltimore, 1860. Worked in plaster.

FERRARA, JACKIE.
Sculptor. Working mainly with fiber in the early 1970's.

FERRARA, JOE.
Sculptor and painter. Born in New Haven, CT, 1931. Studied: Pratt Institute, Brooklyn, B.F.A. Worked in NYC art studios and New Haven and Hartford agencies. Opened own commercial art studio in 1962 in Hamden, CT. Began his famous Winchester calendars in 1967. Also designs engravings for guns and gun boxes. Currently painting and sculpting Old West subjects. Paints in oil and tempera. Represented by Biltmore Galleries, Los Angeles, CA. Address in 1982, Hamden, CT.

FERRARI, FEBO.
Sculptor. Born Pallanza, Italy, December 4, 1865. Pupil of Royal Academy, Turin. Member: New Haven Paint and Clay Club. Specialty, architectural sculpture. Died in 1951? Address in 1933 Onahill Cottage, Short Beach, CT.

FERRARI, VIRGINIO LUIG.
Sculptor and educator. Born in Verona, Italy, April 11, 1937. Studied at Scuola d'Arte and Academy Cignaroli, Verona. Work in High Museum of Art, Atlanta, GA; others. Has exhibited at Art Institute of Chicago, 1968; Brooklyn Museum, 1968. Member of Arts Club of Chicago. Works in bronze and marble. Sculptor-in-residence, University of Chicago, from 1966. Taught at University of Chicago, 1967-76, assistant professor of sculpture. Address in 1982, Chicago, IL.

FERREN, JOHN.
Sculptor, painter, designer, and teacher. Born in Pendleton, OR, October 17, 1905. Studied at Sorbonne, Paris; University Florence, Italy; University Salamanca, Spain. Work: Museum of Modern Art; Wadsworth Atheneum; Phila. Museum of Art; San Fran. Museum of Art; Detroit Institute of Art; Scripps College; Museum of Non-Objective Painting, NY. Exhibited: Corcoran Gallery of Art, 1937; Penna. Academy of Fine Arts, 1937, 40, 45; Calif. Palace of the Legion of Honor, 1945, 49, 52; Detroit Institute of Art, 1946; City Art Museum, 1946; Kleemann Gallery, 1947-49; Museum New Mexico, 1950; Santa Barbara Museum of Art, 1952; San Fran. Museum of Art, 1952; Stanford University, 1952; one-man: Matisse Gallery, 1936-38; Willard Gallery, 1941; Minneapolis Institute of Art, 1936; San Fran. Museum of Art, 1937; Putzel Gallery, Hollywood, Calif., 1936. Position: Instructor, Cooper Union Art School, NYC. Address in 1953, 52 East 9th St., NYC; h. Los Angeles, Calif. Died in 1970.

FERRER, RAFAEL.
Sculptor and painter. Born in Santurce, Puerto Rico, 1933. Studied at Staunton Military Academy, Virginia, 1948-51; Syracuse University, NY, 1951-52; University of Puerto Rico, Mayaquez, 1952-54, under E. Granell. Exhibitions: University of Puerto Rico Museum, Mayaquez, 1964; Pan American Union, Washington, DC, 1966; Penna. Academy of Fine Arts, Philadelphia, 1967; Leo Castelli Gallery, NYC, 1968; Kunsthalle Berne, Switzerland, 1969; Stedelijk Museum, 1969; Museum of Modern Art, NYC, 1970; Corcoran Gallery, 1971; Whitney Museum, NYC, 1973. Taught: Philadelphia College of Art, Penna., 1967. Lived in Hollywood, Calif. and Europe. Was associated with the Surrealist Group, Paris, 1953. In 1959, took up painting professionally. Address in 1982, c/o Nancy Hoffman Gallery, 429 West Broadway, NYC.

FERSTADT, LOUIS.
Sculptor, painter, illustrator, designer, teacher, and lecturer. Born in Ukraine, Russia, October 7, 1900. Work: Walker Art Center; Whitney Museum of American Art; Tel-Aviv Museum, Palestine; Biro-Bidjan, Russia; murals, Hunter College; radio station WNYC; RCA Building, NY. Exhibited: Whitney Museum of American Art; Metropolitan Museum of Art; Museum of Modern Art; Brooklyn Museum; Carnegie Institute; National Academy of Design; Penna. Academy of Fine Arts; and in international exhibitions. Illustrator, "Peek-a-Boo," juvenile book, 1931. Position: Art Staff, *Chicago Tribune*; Art Director, Fox Features Syndicate; Art Director, Ed., Writer, comic books. Address in 1953, 147 Fourth Ave.; h. 510 West 124th St., NYC. Died in 1954.

FEUDEL, ALMA L. M. A. (MRS.).
Sculptor and painter. Born in Levenworth, Kansas, March 31, 1867. Self taught. Address in 1903, Chicago, IL.

FEUERMAN, CAROLE JEAN.
Sculptor. Work includes "City Slicker," resin, oil, exhibited at National Association of Women Artists Annual, NYC, 1983. Member: National Association of Women Artists. Address in 1983, Roslyn, NY.

FIELDS, MITCHELL.
Sculptor. Born in Belcest, Rumania, September 28, 1901. Studied at National Academy of Design; Beaux-Arts Institute of Design. Member: National Sculpture Society; Associate of the National Academy of Design. Awards: Guggenheim Fellow, 1932, 35; prize, National Academy of Design, 1929; Widener Memorial gold medal, Penna. Academy of Fine Arts, 1930; National Academy of Design, 1949, prize, 1950. Work: Brooklyn Museum; Gorki Literary Museum; Museum of Modern Western Art, Moscow. Exhibited: Museum of Modern Art; Whitney Museum of American Art; Brooklyn Museum; Metropolitan Museum of Art; National Academy of Design; Penna. Academy of Fine Arts. Died in 1966. Address in 1953, 3 Great Jones St.; h. 38 Morton St., NYC.

FIENE, PAUL
Sculptor. Exhibited in New York, 1934. (Mallet's)

FIERO, EMILIE.
Sculptor. Born in Joliet, IL. Studied at Art Institute of Chicago; in Italy and France. Pupil of Bartlett and Injalbert. Works: Calvary Episcopal Church, Gramercy Park, NYC; Eccleston, Maryland; fountains, Cleveland Museum of Art. Exhibited: Salon des Artistes Francais, 1925, 27; National Academy of Design; National Sculpture Society; Penna. Academy of Fine Arts; Architecture League. Address in 1953, NYC. Died 1974.

FILARDI, DEL.
Sculptor. Member of Society of Animal Artists; Catharine Lorillard Wolfe Club; Salma. Club. Has exhibited at National Sculpture Society; Catharine Lorillard Wolfe Club, NYC; Society of Animal Artists, NYC; "Birds of Prey," Museum of Science, Boston; Blue Herron Gallery. Address in 1983, c/o Blue Herron Gallery, Wellfleet, MA.

FILIPOWSKI, RICHARD E.
Sculptor and educator. Born in Poland, May 29, 1933; US citizen. Studied at Institute of Design, Illinois Institute of Technology, B.A., with Moholy-Nagy. Work in Addison Gallery of American Art, Andover, MA; sculptural ark, Temple B'rith Kodesh, Rochester; sculptural cross, Trinity Evangelist Lutheran, Philadelpia. Has exhibited at Institute of Contemporary Art, Boston; Fitchburg Art Museum, MA; Outdoor Sculpture Exhibition, De Cordova Museum, Lincoln, MA; others. Teaching at Mass. Institute of Technology, associate professor visual design, 1953. Works in bronze, brass, silver, steel, and aluminum. Address in 1982, Lexington, MA.

FILKOSKY, JOSEFA.
Sculptor. Born in Westmoreland City, PA, June 15, 1933. Study: Seton Hall College; Carnegie-Mellon University; Cranbrook Academy of Art; Art Institute of Chicago, Summer Sculpture Seminar. Exhibitions: Art Image in All Media, NYC, 1970; Indiana University, 1972; Bertha Schaefer Gallery, NYC, 1973 (all solos); Pittsburgh Plan for Art, 1971, 73, 75; Sculpture in the Fields, Storm King Art Center, Mountainville, NY, 1974-76; Sculpture on Shoreline Sites, Roosevelt Island, NY, 1979-80. Awards: Three Rivers Purchase Prize, 1972; Associated Artists of Pittsburgh Award, 1976. Teaching: Professor of Art, Seton Hall, from 1956. Member: Associated Artists of Pittsburgh; others. Works in aluminum, plexiglass. Address in 1983, Seton Hall College, Greensburg, PA.

FILLERUP, PETER M.
Sculptor. Born in Cody, WY, 1953. Studied at Ricks College in Rexburg, ID, 1972; Brigham Young University, Provo, UT; apprenticed to Avard Fairbanks, learned marble and foundry work in Italy; plaster casting, Salt Lake City. Work is in cultural center in Salt Lake City; Buffalo Bill Historical Center, Buffalo Bill's Memorial Museum, and Old West Trail Town. Received art award scholarship, Brigham Young University, 1976. Represented by Altermann Art Gallery, Dallas, TX; Carson's Gallery, Denver, CO. Specialty is statues and statuettes of historical Western figures. Address in 1982, Wapiti, WY.

FILTZER, HYMAN.
Sculptor. Born in Zitomir, Russia, May 27, 1901. Studied at Yale School of Fine Arts; Beaux-Arts Institute of Design; and with Gutzon Borglum, Paul Manship. Member: Fellow, National Sculpture Society. Awards: Prize, National Aeronautic Association, Washington, DC, 1922. Work: Public Schools, New York, Bronx, and Queens; Bellevue Hospital, New York; Ft. Wadsworth, New York; Russell Sage Foundation; United States Army Soldier's Trophy. Exhibited: National Academy of Design, 1926, 1936, 40; Philadelphia Museum of Art, 1940; New York World's Fair, 1939; Architectural League, 1938; Whitney Museum of American Art, 1940; Metropolitan Museum of Art, 1942; New York Historical Society, 1943; Penna. Academy of Fine Arts, 1953; others. Position: Restorer of Sculpture, Metropolitan Museum of Art, New York City, from 1945. Address in 1967, c/o Metropolitan Museum of Art, NYC; h. 1639 Fulton Ave., Bronx NY. Died in 1967.

FINE, JUD.
Sculptor. Born in Los Angeles, California, November 20, 1944. Studied at University of California, Santa Barbara; Cornell University. Taught at University of Southern California, L.A., 1977-78 and from 1979. In collections of Minneapolis Institute of Art; L.A. Co. Art Museum; Art Institute of Chicago; Yale; others. Exhibited at Ronald Feldman Fine Arts, NYC; Margo Leavin Gallery, L.A.; galleries in Pescara, Italy, and Brussels; Documenta V, Kassel, Germany; Biennale de Paris; Pasadena Museum of Modern Art, California; Institute of Contemporary Art, Boston; Laguna Beach (Calif.) Museum of Art; Yorkshire Sculpture Park, England. Received grant, L.A. Co. Art Museum; Laura Slobe memorial award, Art Institute of Chicago. Address in 1982, Los Angeles, California.

FINKE, LEONDA FROELICH.
Sculptor and draftsman. Born in Brooklyn, NY, January 23, 1922. Studied at Art Students League; Education Alliance; Brooklyn Museum Art School. Work in Norfolk Museum of Arts and Science, VA; others. Has exhibited at Penna. Academy of Fine Arts Painting and Sculpture Annual; Dallas Museum of Fine Arts; Hecksher Museum; NY Botanical Gardens. Received Medal of Honor, National Association of Women Artists, 1980; Edith H. and Richmond Proskauer Prize, National Sculpture Society; Lindsey Morris Memorial Prize, 1970, Tallix Foundry Prize, 1977, both National Sculpture Society. Member of National Association of Women Artists; Audubon Artists; fellow, National Sculpture Society; Sculptors Guild. Works in bronze, wood; ink, and silverpoint. Address in 1982, Roslyn, NY.

FINKLE, MELIK.
Sculptor. Born in Rumania in 1885. Studied at Cincinnati Art Academy. Work in Cincinnati Museum; US Post Office, Sylvania, OH; City College of NY; others. Address in 1953, NYC.

FINLEY, ELLA.
Sculptor, painter, and teacher. Born in Philadelphia. Pupil of Penna. Academy of Fine Arts. Address in 1910, Philadelphia, PA.

FINNEGAN, EDWARD.
Sculptor. Born in 1937. Sculpts in stone. Drawings are in graphite and chalk on paper. Living in New York City in 1984.

FINTA, A(LEXANDER).
Sculptor, illustrator, teacher, and writer. Born Turkeve, Hungary, June 12, 1881. Studied at Columbia University; and in Europe. Member: American Federation of Arts; Painters and Sculptors Club of Southern California. Work: Marble bust of his Eminence Cardinal Hayes, Metropolitan Museum of Art, New York; bronze portrait of Count Apponyi, National Museum of Budapest, Hungary; "Strength," granite monument, City of Rio de Janeiro, Brazil; 30-foot high marble War Monument, City of Nyitra, Czechoslovakia; 15-foot high granite War Monument, City of Maniga, Czechoslovakia; 12-foot high marble monument of Adolf Merey, City of Budapest, Hungary; monument of Honveds, City of Hatvan, Hun-

gary; Numismatic Society, NYC. Exhibited: National Museum of Fine Arts, Budapest; Metropolitan Museum of Art; Brooklyn Museum; National Academy of Design; Library of Congress; others. Sculptor for Twentieth Century Fox Film Corporation, 1944, 45. Address in 1953, Los Angeles, CA. Died in 1958 (?).

FIORATO, NOE.
Sculptor. Address in 1921, 308 West 56th Street, New York, NY.

FIORE, ANTHONY JOSEPH.
Sculptor. Born in NYC, Sept. 10, 1912. Studied at National Academy of Design. Member: Larchmont Art Society. Address in 1933, 4601 Murdock Ave., NYC.

FIORE, GEORGIA ELEANORA.
Sculptor. Born in Philadelphia, Penna. Exhibited: Salon des Artistes Francais, 1934.

FIORE, ROSARIO RUSSELL.
Sculptor. Born in NYC, January 5, 1908. Studied at National Academy of Design; Beaux Arts Institute of Fine Arts; Mech. Institute. Work includes bronze sculptures, Interior Dept., Washington, DC; White House, Washington, DC; heroic size bronze statue of Gen. George C. Marshall, Leesburg, VA; others. Has exhibited at Grand Central Art Gallery, NYC; Architecture League, NY; Corcoran Art Gallery, Washington, DC. Received National Academy Prize; Anna V. Huntington Award, National Academy. Member of National Sculpture Society. Address in 1982, Jekyll Island, GA.

FIRMIN, A(LBERT) E(DWIN).
Sculptor. Born in Mexia, Texas, March 6, 1890. Studied at Chicago Academy of Fine Arts. Address in 1933, Dallas, Texas.

FISCHER, R. M.
Sculptor. Born in NYC, March 21, 1947. Studied at C. W. Post College, Long Island University, NY, B.A., 1971; San Francisco Art Institute, California, M.F.A., 1973. Has exhibited at Functional Art, Otis Art Institute, Los Angeles, CA, 1980; Hayden Gallery, Mass. Institute of Technology, Cambridge, 1981; others. Received National Endowment for the Arts Award, 1981; others. Address in 1982, 73 W. Broadway, NYC.

FISH, GERTRUDE ELOISE.
Sculptor. Born in Roselle Park, NJ, Sept. 28, 1908. Studied with Georg Lober, Charles Grafly, and Albert Laessle. Awards: Penna. Academy of Fine Arts, 1930; Exhibitions by Women Artists, Gimbel Bros., Philadelphia, 1932. Member: Fellowship Penna. Academy of Fine Arts; Westfield Art Association. Address in 1933, 420 Chestnut St., Roselle Park; summer, Cranberry Lake, NJ.

FISHER, GEORGE HAROLD.
Sculptor, writer, craftsman, and educator. Born in Detroit, MI, September 14, 1894. Studied at Detroit School of Fine Arts; and with John Wicker. Awards: Prizes, Grosse Pointe, Michigan, 1934-36. Work: Murals, Westlake Professional Building, Los Angeles; Flint Ridge Biltmore Hotel; US Post Office, Chelsea, MI. Exhibited: Detroit Institute of Art, 1919, 1931-33; Los Angeles Museum of

Art, 1924-26; Painters and Sculptors Society, 1926, 27; California Water Color Society, 1926; California Modern Art Workers, Hollywood, 1924; San Diego Fine Art Society, 1926; Scarab Club, Detroit, MI, 1936. Address in 1953, Detroit, MI.

FISHER, KENNETH L.
Sculptor. Born in Tacoma, WA, April 28, 1944. Studied: University of Oregon, Eugene. Exhibited extensively, nationally: Henry Korn Gallery, Eugene, OR, 1970; International Art Gallery, Pittsburgh, PA, 1971; Jewish Community Center, Portland, OR, 1971; Portland Art Museum Sales Gallery, Portland, OR, 1980; Howell Street Gallery, Seattle, WA, 1981; 41st Annual, Braithwaite Fine Arts Gallery, Southern Utah State College, UT, 1982; Goldsboro's 3rd Annual Juried Exhibition, NC, 1982; Painter and Sculptors Society of NJ, 49th National, Bergen Community Museum, NJ, 1982; Louisiana Art and Arts Guild 13th Annual River Road Show, Guild Gallery, LA, 1982; Cooperstown Art Association 47th Annual, NY 1982; Galerie Triangle 3rd Annual National Exhibition, Washington, DC, 1982; Audubon Artists 41st Annual, National Arts Club, NY, 1983; Salmagundi Club, 2nd Annual Non-Member Open Juried Exhibition, Salmagundi Club, NYC, 1983; Knickerbocker Artists 33rd Annual Exhibition, Salmagundi Club, NYC, 1983; and others. Awarded: Honorable Mention, 16th Annual, Coos Art Museum, Coos Bay, OR, 1981; Honorable Mention, Terrance Gallery National Juried Exhibition, Palenville, NY, 1982; M. Grumbacher Bronze Medallion, Southport's 2nd Annual Art Exhibit, Southport NC, 1982; First and Second Place, 8th Annual, J. K. Ralston Museum, Sidney, MT, 1982; First Place, Joseph A. Cain Memorial Sculpture Purchase Award for the Del Mar College Permanent Collection, Corpus Christi, TX, 1982; Certificate of Recognition, 10th International Art Exhibition, Georgia Tech., Georgia, 1983; numerous others. Media: Bronze, aluminum, chrome and applied color. Address in 1983, Portland, OR.

FISK, MARY STELLA.
Sculptor. Member: Independent Society of Sculptors. Address in 1924, Angola, IN.

FITE, HARVEY.
Sculptor. Born in Pittsburgh, PA, Dec. 25, 1903. Studied at St. Stephen's College; Woodstock School of Painting; with Corrado Vigni, Florence, Italy. Exhibited in numerous one-man shows in Rome, Italy, Paris, and NY, 1949-51; US State Dept. traveling group shows in Europe and Africa, 1953, 54; Opus 40, Woodstock, NY, monumental landscape structure on 6½ acres of bluestone quarry; Whitney. Received Asia Foundation Grant for Cambodia, 1956. Member of Woodstock Artists Association. Taught at Bard College (professor of sculpture, 1932-69; emeritus from 1969). In collections of Whitney; Albany Institute; restoration of Mayan sculpture in Carnegie Institute, Washington, DC. Died in Saugerties, NY, in 1976.

FITE-WATERS, GEORGE.
Sculptor. Born in San Francisco, California. Exhibited: Salon, Paris, 1923.

FITZ-RANDOLPH, GRACE.
Sculptor, painter, and teacher. Born in NY. Pupil of J. Alden Weir and Augustus Saint Gaudens in New York; Benjamin-Constant, Girardot and Puech in Paris. Bronze medal, Atlanta Exposition 1895. Member Art Students League of New York; New York Woman's Art Club. Address in 1910, 3 Washington Square, South, NYC. Died in NYC, January 1917.

FIX, JOHN ROBERT.
Sculptor and silversmith. Born in Pittsburgh, PA, October 31, 1934. Studied at Rochester Institute of Technology, School of American Craftsmen, B.F.A.; Conn. College, M.A.T.; study with Lawrence G. Copeland, Hans Christianson, William A. McCloy, and Frances Felten. Has exhibited at Associated Artists of Pittsburgh Annual, Carnegie Museum, 1957-80; De Cordova Museum, Lincoln, MA, 1962; Brookfield Craft Center; others. Works in silver, gold, and pewter. Address in 1982, Groton, CT.

FJELDE, PAUL.
Sculptor and educator. Born Minneapolis, MN, Aug. 12, 1892. Studied at the Minneapolis School of Art; the Beaux-Arts Institute of Design and the Art Students League, NY; and under Lorado Taft in Chicago; Royal Academy, Copenhagen; Academie de la Grande Chaumiere, Paris. Exhibited at National Sculpture Society, 1923. Awards: Honorable mention, St. Paul Institute, 1918; American Artists Professional League; National Sculpture Society. Member: Society of Western Sculptors; Chicago Society of Artists; National Sculpture Society (fellow); National Academy of Design, Academician. Works: Lincoln monument, Christiania, Norway; J. S. Bradstreet memorial, Minneapolis Art Institute; Irwin memorial, Auburn, ME; Gjertsen memorial, Minneapolis, MN; Lincoln monument, Hillsboro, ND; Pioneers memorial, Council Bluffs, IA; Donnersberger memorial, McKinley Park, Chicago, IL; decorations for Washington School, McKeesport, PA; Brookgreen Gardens, SC. Taught: Pratt Institute from 1929; instructor at National Academy School of Fine Arts, NYC; editor of *National Sculpture Review*, 1951-55; etc. Address in 1970, Brooklyn, NY.

FLAESCHNER, JULIUS.
Sculptor. Born in Germany. Worked in Berlin in 1844 and 1860-62. Worked in NYC c. 1854-57.

FLAGELLA, VICTOR.
Sculptor. Active in NYC, 1848-51. With the firm of Sence & Flagella, 1849-50.

FLANAGAN, JEANNE E.
Sculptor. Born in Detroit, MI, 1948. Studied: Eastern Michigan University, M.F.A. candidate. Exhibited at Detroit Institute of Arts, Works by Michigan Artists, 1974-75. Address in 1975, Ann Arbor, MI.

FLANAGAN, JOHN.
Sculptor. Born Newark, NJ, in 1865. Pupil of Saint-Gaudens in NY; Chapu and Falguiere in Paris. Member: National Academy of Design 1911; National Sculpture Society 1902; NY Architectural League 1914; Conn. Academy of Fine Art; Salmagundi Club; American

Numismatic Society; Society of Illustrators; New Society of Artists. Exhibited at National Sculpture Society, 1923. Awards: Silver medal, Paris Exp., 1900; silver medal, Pan-Am. Exp., Buffalo, 1901; silver medal, St. Louis Exp., 1904; medal of honor for section medals, P.-P. Exp., San Francisco, 1915; Saltus medal, American Numismatic Society, 1921; Chevalier of Legion of Honor, 1927; Watrous gold medal, National Academy of Design, 1932. Work: Clock, Library of Congress, Washington, DC; bronze relief, "Antique Education," Free Public Library, Newark, NJ; tinted marble relief "Aphrodite," Knickerbocker Hotel, NYC; bronze memorial portrait of Samuel Pierpont Langley, Smithsonian Institution, Washington, DC; Bulkley memorial, Aetna Life Insurance Bldg., Hartford, CT; Alexander memorial medal for School Art League of NY, 1915; statue of Joseph Henry in Albany, NY. Represented in medal collections of the Luxembourg, Paris; Museum of Ghent, Belgium; Metropolitan Museum of Art and American Numismatic Society of New York; Chicago Art Institute; Carnegie Institute, Pittsburgh; Newark Art Museum; war medal for the town of Marion, MA; medal for the Garden Club of America; "Medaille de Verdun," voted by Congress, and presented by the President of the United States to the City of Verdun. Address in 1933, 116 West 65th St., NYC. Died March 28, 1952.

FLANNAGAN, JOHN.
Sculptor. Born April 7, 1895, in Fargo, ND. Studied Minneapolis Institute School, 1914-17, with R. Koehler. Work: Andover (Phillips); Cincinnati Art Museum; Cleveland Museum of Art; Detroit Institute; Harvard University; Honolulu Academy; Metropolitan Museum of Art; Vassar College; Whitney Museum; Wichita Art Museum. Exhibited: Whitney Studio Club, NYC, 1925; Weyhe Gallery, 1927, 28, 30, 31, 34, 36, 38; Arts Club of Chicago, 1934; Vassar College, 1936; Bard College, 1937; Buchholz Gallery, NYC, 1942; Museum of Modern Art; Whitney Museum; Metropolitan Museum of Art; Brooklyn Museum. Awards: Guggenheim Foundation Fellowship, 1932; Metropolitan Museum of Art, Alexander Shilling Prize, 1940. Died Jan. 6, 1942, in New York City.

FLANNERY, LOT.
Sculptor. Worked on National Capitol, 1850's.

FLATEN, ARNOLD.
Sculptor. Born in Minneapolis, Minn. Exhibited: Salon des Artistes Francais, 1932.

FLAVIN, DAN.
Sculptor and writer. Born 1933, in NYC. Studied: Cathedral College of the Immaculate Conception; US Air Force Meteorological Technician Training School; University of Maryland (Extension, Korea); New School for Social Research; Columbia University. Self-educated as an artist. Work: Eindhoven; Harvard University; Los Angeles County Museum of Art; Museum of Modern Art; Ottawa (National); Whitney Museum; Metropolitan Museum of Art; Guggenheim; Philadelphia. Exhibited: Judson Gallery, NYC; Kaymar Gallery, NYC; Green Gallery, NYC; Galerie Rudolf Zwirner, Cologne, 1966; The Kornblee Gallery, NYC, 1967; Konrad Fischer Gallery, Dusseldorf,

1969; Hartford (Wadsworth); Jewish Museum, Primary Structures, 1966; Eindhoven, Kunst-Licht-Kunst, 1966; Los Angeles County Museum of Art; Philadelphia Museum of Art, American Sculpture of the Sixties, 1967; Trenton State, Focus on Light, 1967; The Hague, Minimal Art; Documenta IV, Kassel; Whitney Museum, Light: Object and Image; UCLA, Electric Art, 1969; flourescent light, Albright-Knox, 1972; installations of flourescent light, Art Institute of Chicago, 1977, Parrish Art Museum, Southampton, NY, and National Gallery, Ottawa, 1979; plus many others and commissions for Grand Central Station, NYC, Hudson River Museum, Yonkers, Federal Building and US Courthouse, Anchorage, Kunstmuseum in Basel, Kroller Muller Museum, Eindhoven, Holland. Represented by Leo Castelli Gallery, NYC. Address in 1982, Garrison, NY.

FLEMING, H(ENRY) S(TEWART).
Sculptor, painter, illustrator, and craftsman. Born in Philadelphia, July 21, 1863. Pupil of Lefebvre and Benjamin-Constant in Paris. Member: Society of Illustrators 1901. Address in 1929, 1 Broadway, New York, NY; Eton College, Scarsdale, NY.

FLERI, JOSEPH C.
Sculptor. Born Brooklyn, NY, May 20, 1889. Member: National Sculpture Society; Architectural League of NY. Work: "Crucifixion and Twelve Apostles," Holy Cross Church, Philadelphia, PA; other sculpture in churches in Bethlehem and Northampton, PA; garden sculpture, Syosset, NY; statues at Brookgreen Gardens, SC; others. Address in 1953, 461 Sixth Avenue, NYC. Died in 1965.

FLETCHER, CALVIN.
Sculptor, painter, architect, craftsman, writer, lecturer, and teacher. Born in Provo, Utah, June 24, 1882. Pupil of Pratt Institute; Columbia University; Art Institute of Chicago; Central School Arts and Crafts in London; Colarossi and Biloul in Paris; Morse in Chicago. Works: Two murals in Latter Day Saints Temple in Logan, Utah, Utah State Collection; Utah State Agricultural College; J. H. Vanderpoel Collection, Chicago; Smoky Hill Art Club, KS. Award: First prize, Utah State Fair Association. Address in 1933, Agricultural College; h. Logan, Utah.

FLETCHER, WILLIAM BALDWIN.
Sculptor. Born in Indianapolis, IN, August 18, 1837. He was a physician and amateur sculptor. Work in Indiana State House. Died in Florida, April 25, 1907.

FLOETER, KENT.
Sculptor. Born in Saginaw, MI, October 22, 1937. Studied at Boston University, B.F.A.; Yale University, M.F.A. Work in Pangborn Foundation Collection, Hagerstown, MD; others. Has exhibited at Biennial Exhibition of Contemporary American Art, Whitney Museum of American Art, NY, 1975; Akademie der Kunst, Berlin, Germany, 1976; Louisiana Museum of Modern Art; Humlebaeck, Denmark, 1976; others. Address in 1982, c/o Mary Boone, 42 Bone St., NYC.

FLOOD, EDWARD C.
Sculptor and painter. Born in 1944. Studied at Art Institute of Chicago. Work in National Collection of Fine Arts,

Washington, DC; Art Institute of Chicago, IL. Has exhibited at Indianapolis Museum of Art, IN; Art Institute of Chicago; others. Received Cassandra Foundation Grant, 1970; National Endowment Artists Fellowship Grant, 1978; others. Works in acrylic and wood. Address in 1982, Brooklyn, NY.

FLOOD, MARY EMMA.
(Mrs. T. E. Stebbins). Sculptor. Address in 1934, Syosset, Long Island, New York. (Mallett's)

FLORIO, SALVATOR ERSENY.
Sculptor. Born in Messina, Italy, in 1890 (or 1895?). He studied at the National Academy of Design, and assisted in the studios of Hermon A. MacNeil, A. Stirling Calder and James E. Fraser. Awards: silver medal for nude figure, National Academy of Design; bronze medal for service as sculptor, Panama-Pacific International Exposition, San Francisco, CA, 1915. Works: Reliefs, Springtime; Adam and Eve; The Tribute; head of Minerva, San Francisco Museum of Art, San Francisco, CA; portrait, Rear-Admiral C. J. Peoples. Exhibited at National Sculpture Society in 1923.

FLORSHEIM, RICHARD A.
Sculptor, painter, educator, writer, printmaker and lecturer. Born in Chicago, IL, October 25, 1916. Studied at University of Chicago, and with Aaron Bohrod. Member: Chicago Soc. of Artists; Artists Equity Association. Awards: Prizes, Art Institute of Chicago, 1946, 50. Work: Musee du Jeu de Paume, Paris; Art Institute of Chicago. Exhibited: Penna. Academy of Fine Arts, 1934, 35; Los Angeles Museum of Art, 1934; San Francisco Museum of Art, 1935, 48; Art Institute of Chicago, 1940-43, 45, 47-51; Salon des Refuses, 1935; Toledo Museum of Art, 1942; Philadelphia Print Club, 1946, 48, 51; Whitney Museum of American Art, 1947; Zanesville Art Institute, 1948; Baltimore Museum of Art, 1948; Delgado Museum of Art, 1948; Chicago Society of Etchers, 1948; University of Nebraska, 1950; Milwaukee Art Institute, 1950; Akron Art Institute, 1951; Decatur Art Center, 1951; and many more. Address in 1976, Chicago, IL. Died in 1979.

FLOYD, CARL LEO.
Sculptor and environmental artist. Born in Somerset, KY, October 12, 1936. Studied at Kansas City Art Institute, B.F.A., 1964; Cranbrook Academy of Art, M.F.A., 1967. Work in Hogback Nature Park, Madison, OH; University of Vermont Art Museum, Burlington; others. Has exhibited at J. B. Speed Museum of Art, Contemporary Sculpture, Louisville, KY; Cincinnati Art Museum; others. Teaching at Cleveland Institute of Art, from 1971, instructor of sculpture. Address in 1982, Madison, OH.

FOHR, JENNY.
Sculptor and instructor. Born in NYC. Studied at Hunter College, B.A.; Alfred University; University of Colorado, M.A. Work in Norfolk Museum, VA; Long Beach Island Foundation of Arts and Science, NJ; Oakland Museum, California; Ciba-Geigy, NY. Exhibitions: Chautauqua Art Association Galleries, NY, 1960; Brooklyn Museum, 1961; National Association of Women Artists, Chateau de la Napoule, France, 1965; National Association of

Women Artists Traveling Show, India, 1966; New Jersey State Museum, Trenton, 1968; American Color Print Society Traveling Show, 1972. Awards: Medal of Honor, Painters and Sculptors Society, NJ, 1963; Samuel Mann Award, American Society of Contemporary Artists, 1971; May Granick Award, National Association of Women Artists, 1975. Address in 1982, 165 East Street, NYC.

FOLEY, MARGARET.
Sculptor and cameo portraitist. Biographers differ as to where Margaret Foley, (Margaret E. Foley) was born. Some give her birthplace as Vermont, others as New Hampshire. Largely self-taught. Worked in Boston and later went to Rome. Some of her works were exhibited at the Centennial Exposition at Philadelphia in 1876. Tuckerman wrote of her that she "achieves new and constant success in her relievos." Her medallions of William and Mary Howitt, of Longfellow, and of William Cullen Bryant, and her ideal statues of Cleopatra, of Excelsior, and of Jeremiah are considered to be the best specimens of her cameo work. The cameo portrait of William Cullen Bryant, in the New York Historical Society, is said to be cut by Margaret Foley. Exhibited at Boston Atheneum; Penna. Academy; National Academy; Centennial Exhibition, Philadelphia. She died in 1877 at Meran in the Austrian Tyrol.

FOLLETT, JEAN.
Sculptor and painter. Born in St. Paul, MN, June 5, 1917. Studied at Univ. of Minnesota; Hans Hofmann School of Art, NY; and the School of Fernand Leger, in Paris, France, 1946-51. Works: Museum of Modern Art; Whitney; "Lady with the Open-Door Stomach" (1956) and "Many Headed Creature" (1958). Exhibited: Four one-man shows at the Hansa Gallery, NY, 1951-59; Guggenheim Museum, 1954; Soho Gallery, NY, 1977, plus many more. Awards: Cash award, National Foundation of the Arts & Humanities, 1966. Her style is noted for use of 'found' objects (pieces of wood, metal, string, etc.) Paintings are distinguished by extremely thick application of paints, giving appearance of relief. Address in 1982, St. Paul, MN.

FONSSAGRIVES-PENN, LISA.
Sculptor. Born in Sweden. Studied: Music and Art History at the Sorbonne, Paris, and The Art Students League in New York.

FONTANINI, CLARE.
Sculptor and educator. Born in Rutland, VT. Studied at College of St. Catherine, A.B.; Columbia University, with Josef Albers and Oronzio Maldarelli, M.A. Commissions, Madonna and Child (cherry wood), St. Agnes and Ascension Episcopal Church, Washington, DC; others. Has exhibited at Mint Museum of Art, Charlotte, NC; Walker Art Gallery, Minneapolis; Virginia Museum of Fine Art, Richmond; Corcoran Gallery of Art, Washington, DC; Smithsonian Institution; others. Received First Prize for Sculpture, Corcoran Gallery Art Annual. Member of Artists Equity Association; Society of Washington Artists. Works in stone and wood. Address in 1982, Washington, DC.

FORA, LOUIS.
Sculptor and carver. Worked: Charleston, South Carolina, 1845-61. Executed portrait busts in marble.

FORAKIS, PETER.
Sculptor and painter. Born October 2, 1927, Hanna, Wyoming. Studied: San Francisco Art Institute, with Bud Dixon, Thomas Hardy, Nathan Oliveira, 1954-57, BA. Work: Aldrich; commissions for Williams College, Denver City Park, Univ. of Houston, Tex. Exhibited: Gallery Six, San Francisco; Spasta Gallery, San Francisco; David Anderson Gallery, NYC; Tibor de Nagy Gallery, NYC; Uiano Museum, Tokyo; San Francisco Museum of Art; Oakland Art Museum; Martha Jackson Gallery, NYC; Guggenheim, Drawings and Prints, 1964; Jewish Museum, Primary Structures, 1966; Los Angeles County Museum of Art. Taught: San Francisco Art Institute, 1958; Brooklyn Museum School, 1961-63; The Pennsylvania State Univ., 1965; Carnegie, 1965; Univ. of Rhode Island, 1966. Address in 1982, Putney, VT.

FORD, DALE.
Woodcarver and painter. Born near Visalia, CA, 1934. Educated in business; ran own commercial art shop (Dale Ford Originals). Since 1970 topics have been strictly Western; began miniature horse-drawn vehicles several years later. Commissions include large collection of horse-drawn vehicles (86 displayed at Sentry Insurance, Wisconsin). Sells to collectors. Reviewed in *Western Horseman*, *West Art*, *Southwest Art*. Represented by Period Gallery West; Hall Galleries; McCulley Gallery, Dallas, TX. Specializes in 19th century Western vehicles, some combining hardwood and steel. Address since 1980, Incline Village, near Lake Tahoe, NV.

FORD, ELIZABETH.
Sculptor. Born in Rhode Island. Exhibited: Salon d'Automne, 1924.

FORNELLI, JOSEPH.
Sculptor, painter and illustrator. Born in Chicago, IL, May 21, 1943. Studied: Art Institute of Chicago. Exhibited: Leigh Yawkey Woodson Museum, Wausau, WI; Cleveland Museum of Natural History; Reflexes and Reflection—N.A.M.E. Gallery Chicago; National Wildlife Art Show, Kansas City; Brookfield Zoo Spec. Exhibit Building, one man show. Awards: Chicago Municipal Art League's 1979 Gold Medal; 1st Place Blue Ribbon, National Wildlife Art Show; Honorable Mention, Italian American Artists in the U.S.A. Member: Chicago Municipal Art League Board Member; National Wildlife Art Collectors Society; Ducks Unlimited; Vietnam Veterans Arts Group Board Member; Society of Animal Artists. Work includes life size portrait bust, Columbus Hospital, IL; illustrations for *Main Street*, Sinclair Lewis, 1970; numerous magazine illustrations. Media: Bronze and stone; oil and watercolor. Address in 1983, Park Ridge, IL.

FORSHEY, W.
Sculptor. Worked: New Orleans, from 1847.

FORSYTH, (MARY) BRYAN.
Sculptor and painter. Born in Tucson, AZ, 1910. Studied at Maryland Institute of Art, 1929-30; Grand Central School of Art, NYC, 1931-32 (Western art with Frank Tenney Johnson). Had studio in NYC, 1937-68; did portrait commissions, commercial art, and illustrations for newspapers, magazines, books. Moved to New Mexico in 1969. Work includes bronze of Mari Sandoz (author), Nebraska Hall of Fame, commission, 1978; bronze "Victorio," New Mexico Museum of Fine Arts, 1981. Received *St. Nicholas* magazine medals for drawing, 1921, 23. Represented by Shidoni Gallery and Foundry, Tesuque, NM; Sanders Galleries, Tucson, AZ. Specialty is Southwestern subjects. Address in 1982, Pecos, NM.

FORSYTHE, VICTOR CLYDE.
Sculptor, painter, illustrator and cartoonist. Born Orange, California, 1885. Studied with Louisa MacLeod at the School of Art and Design, Los Angeles; Art Students League, pupil of DuMond. Employed as staff artist for the *New York World*; did cartoons and comic strips; painted propaganda posters. On return to California, painted scenes of Western desert, mining camps, prospectors, ghost towns. Member: Painters of the West. Work in Municipal Art Guild (Phoenix), Harmsen Collection, Earl C. Adams Collection. Died in California in 1962.

FORTINI, CHARLES.
Sculptor. At NYC, 1848.

FOSDICK, GERTRUDE CHRISTIAN.
(Mrs. J. W. Fosdick). Sculptor, painter, and writer. Born in Middlesex Co., VA, April 19, 1862. Pupil of Julian Academy in Paris under Bouguereau and Lefebvre. Member: Pen and Brush Club; North Shore Art Association; Allied Art Association; National Arts Club. Work: Stacy Memorial, Gloucester, MA. Address in 1933, 33 West 67th St., New York, NY; summer "The Nutshell," Sugar Hill, NH.

FOSHKO, JOSEF.
Sculptor. Born in Russia. Worked in US. Exhibited at Paris; Worcester Art Museum, 1933.

FOSS, FLORENCE WINSLOW.
Sculptor. Born in Dover, New Hampshire, August 29, 1882. Studied at Mt. Holyoke College; Wellesley College; University of Chicago; Radcliffe College. Awards: Springfield Art Association, 1941, 43; Society of Washington Artists, 1936. Exhibited at Penna. Academy of Fine Arts; National Academy of Design; Art Institute of Chicago; Conn. Academy of Fine Art; others. Professor of Art, Mt. Holyoke College. Address in 1953, Mt. Holyoke, South Hadley, MA.

FOSTER, ENID.
Sculptor. Born San Francisco, CA, October 28, 1896. Pupil of Chester Beach. Work: "Three Fates," Mt. View Cemetery Association, Oakland, CA; "Reuniting of Souls," Mausoleum, Oakland; memorial pool to Sarah B. Cooper, Golden Gate Park, San Francisco. Address in 1933, Piedmont, California.

FOSTER, NORMAN.
Sculptor. Address in 1935, New York. (Mallett's)

FOUST, STEVE.
Sculptor. Born in St. Louis, MO, 1947. Studied: Wayne

State University. Private collections. Exhibitions: Willis Gallery, Detroit (one-man), 1972-74; Michigan Artists Exhibition, The Detroit Institute of Arts, 1971; Detroit Bank and Trust Artists Invitational, 1974; Detroit Artists Market, 1974; Detroit Institute of Arts, Works by Michigan Artists, 1974-75. Awards: Rossetti Associates Prize, Michigan Artists Exhibition, The Detroit Institute of Arts, 1971. Commissions: Wall commissioned by New Detroit, 1973; impermanent sculpture commissioned by Detroit Adventure, 1974. Address in 1975, c/o Common Ground, Detroit, MI.

FOWLE, ISAAC.
Ship carver. In Boston, 1806-43. Apprenticed to Simeon Skillin, Jr., of Boston. Worked in Skillin's shop with Edmund Raymond until about 1822. Formed partnership with his sons John D. and William H. Fowle, 1833. Examples of his work are in the Old State House, Boston, including the figure of a woman.

FOWLE, JOHN D.
Ship carver. In Boston, 1833-1869. With his brother William H. Fowle, formed partnership with father Isaac Fowle in 1833. Work included an eagle and coat of arms of NY for the *Surprise* (1850) and a crowing cock for the *Game Cock* (1851).

FOWLE, WILLIAM H.
Ship carver. In Boston, 1833-early 1860's. In partnership with father Isaac and brother John D. Fowle. Died in Lexington, MA, soon after 1860.

FOWLER, MARY BLACKFORD.
(Mrs. Harold North). Sculptor. Born in Findlay, OH, February 20, 1892. Studied at Oberlin College, A.B.; Columbia University; Corcoran School of Art; and with George Demetrios. Member: Society Washington Artists; North Shore Art Association. Work: Memorial tablets, Springfield (Mass.) Public Library; Findlay, OH; sculptural reliefs, Federal Building, Newport News, VA. Exhibited: Institute Modern Art, Boston, 1945; North Shore Art Association; Society of Washington Artists. Co-Author: "The Picture Book of Sculpture," 1929. Address in 1953, Washington, DC.

FOWLER, MEL.
Sculptor. Born in San Antonio, TX, November 25, 1921. Studied at Southwestern University, University of Texas, University of Maryland, and Norfolk School of Art. Represented by Texas Fine Arts Permanent Collection; State Health Dept. Building, Homburg, Germany (9-foot carrara marble sculpture); others. Has exhibited at Galveston (TX) Art League; Congressional Exhibition, DC; Galerie Monika Beck, Homburg, Germany; Art Museum, Wichita Falls, TX; International Sculpture Exhibition, Massa, Italy; Mannheim, Germany; Pietrasanta, Italy; Laguna Gloria Art Museum, Austin, TX; others. Address in 1984, Liberty Hill Texas, and Italy.

FOWLER, PHILIP.
Sculptor. Member of the National Sculpture Society. Award: Therese and Edwin H. Richard Memorial Prize, National Sculpture Society, 1970. Address in 1982, Philadelphia, PA.

FOX, CECILIA, BEATRICE BICKERTON.
(See Beatrice Fox Griffith).

FOX, LINCOLN.
Sculptor. Born in Morrilton, AR, 1942. Studied: University of Texas, B.F.A.; University of Dallas, M.A.; University of Kansas, M.F.A. Began exhibiting in 1968; one-man show at Smithsonian Institution, 1975. Reviewed in *Southwest Art*, May 1980. Represented by own gallery; Shidoni Gallery and Foundry, Tesuque, NM. Specialty is bronze statues and statuettes, primarily of Indians. Address since 1971, Alto, NM.

FOX, MICHAEL DAVID.
Sculptor and instructor. Born in Cortland, NY, December 29, 1937. Studied at State University NY College, New Paltz, with Ilya Bolotowsky and Ken Green; State University NY College, Buffalo, with Robert Davidson and George Stark, B.S., 1962, M.S., 1969; Brooklyn Museum School, with Tom Doyle, Rueben Tam and Toshio Odate, 1964. Work in Brooklyn Museum. Has exhibited at Brooklyn Museum, 1964; J. B. Speed Art Museum, Louisville, KY, 1965-67; Everson Museum, Syracuse, 1968-78; Munson-Williams-Proctor Institute, Utica, 1968-80; others. Received Sculpture Award, Brooklyn Museum, 1964; others. Works in plastic, polyester resin, and acrylic. Address in 1982, Oswego, NY.

FOX, SEYMOUR.
Sculptor. Born in NYC in 1900. Studied sculpture at Yale University, New Haven, Conn., and for two months under Anton Hanak in Vienna. Works: Heads; statues; figure, Pan.

FOY, FLORVILLE.
Sculptor. Worked: New Orleans, 1841-56. Medium: Marble.

FOY, PROSPER.
Sculptor, marble cutter, gilder, gnomist, engraver. Worked: New Orleans, 1825-38.

FRAGUA, CLIFF.
Sculptor. Born in Albuquerque, NM, 1955. Studied painting, ceramics, and sculpture at Institute of American Indian Arts. Reviewed in *Southwest Art*, August 1980. Represented by Galeria Del Sol, Albuquerque, NM; Wadle Galleries, Santa Fe, NM. Specialty is Indian forms; medium is stone. Address since 1973, Jemez Pueblo, NM.

FRALEY, LAURENCE K.
Sculptor. Born in Portland, Ore., May 17, 1897. Studied with H. M. Erhman. Member: American Artists Professional League; Oregon Society of Artists. Address in 1933, Portland, Ore.

FRANCIS, MURIEL (WILKINS).
Sculptor, painter, teacher, and craftsman. Born in Longview, TX, October 25, 1893. Studied at Shreveport School of Art and Design; Kansas City Art Institute, and with Paul Mercereau, Will Stevens, Virginia Cole, Alexander Archipenko, and others. Member: Ft. Worth Art Association. Awards: Prize, Ft. Worth Art Association.

Exhibited: Texas General; Ft. Worth Art Association; Texas Fine Art Association; Southern States Art League; State of Texas traveling exhibit, 1952-53. Instructor of Art, Carswell Air Force Base, Texas. Address in 1953, Ft. Worth, TX.

FRANK, JANE SCHENTHAL.
Sculptor and painter. Born in Baltimore, MD, July 25, 1918. Studied at Parsons School, NY, 1938-39; with Hans Hofmann, Provincetown, MA, 1960; Rhinehart fellowship, Maryland Institute of Art, 1961. Work in Baltimore Museum of Art; Corcoran Gallery of Art; Smithsonian Institution; others. Has exhibited at Baltimore Museum of Art; Corcoran Gallery of Art; A Decade of Sculpture, Philadelphia Art Alliance; others. Member of Artists Equity Association. Address in 1982, Owings Mills, MD.

FRANK, MARY.
Sculptor. Born February 4, 1933, London, England. Studied: NYC, with Max Beckmann, 1950; Hans Hofmann, 1951. Work: Brandeis University; Art Institute of Chicago; Kalamazoo Institute; University of Massachusetts; Southern Illinois University; Wichita Art Museum; Worcester Art Mus. Exhibited: Stephen Radich Gallery, NYC; Boris Mirski Gallery, Boston; The Drawing Shop, NYC; The Zabriskie Gallery, NYC; MIT; Yale University; Brandeis University; Museum of Modern Art, Hans Hofmann and His Students. Awards: Ingram Merrill Foundation Grant, 1962; Longview Foundation Grant, 1964-66; National Council on the Arts, 1969. Taught: New School for Social Research. Address in 1970, 203 W. 86th St., NYC.

FRANKENSTEIN, JOHN PETER.
Sculptor and painter. Born c. 1816 in Germany. Came to Cincinnati, Ohio, in 1831; lived in Philadelphia from 1839; returned to Ohio in 1847 and Cincinnati in 1856, where he had a studio; moved to NYC c. 1874. Exhibited at Artists' Fund Society; the Apollo Association. Specialty was portraits, both in painting and sculpture. Died April 16, 1881, in New York City.

FRANKENSTEIN, MARIE M. C.
Modeller and amateur painter. Born in Germany; came to Cincinnati in 1831. Lived in Springfield, OH, where she was a teacher. Still living there in 1881.

FRANKLIN, CHARLOTTE WHITE.
Sculptor and painter. Born in Philadelphia, PA, 1923. Studied at Tyler Art School, Temple University BA, 1945, BS (education), 1946, MFA, 1947; Institute San Miguel Allende, University Guanajuato, 1957; Mexico City College, 1958; University of Madrid, 1968; and others. Awards: Fulbright Fellowship; Philadelphia Board of Education fellowship to University of Madrid and Rome; Les Beaux Arts Exhibition, Philadelphia. Work: In private collections; commissions for St. Augustine Church, Philadelphia; and others. Exhibited: Colleges, universities, libraries, US Embassy in Madrid; Penwalt Galleries, Philadelphia; William Penn Memorial Museum; others. Address in 1982, Philadelphia, PA.

FRANKLIN, DWIGHT.
Sculptor and painter. Born New York, NY, January 28, 1888. Member: American Association of Museums. Work in American Museum of Natural History; Newark Public Library; Metropolitan Museum; Children's Museum, Brooklyn; Cleveland Museum; University of Illinois; French War Museum; 21 groups, Museum of the City of New York. Specialty, miniature groups for museums, usually of historical nature. Address in 1933, c/o The Coffee House, 54 West 45th St., New York, NY.

FRANKLIN, GILBERT ALFRED.
Sculptor and educator. Born in Birmingham, England, June 6, 1919; US citizen. Studied at Rhode Island School of Design, B.F.A., 1946; National Museum of Mexico City; American Academy of Rome, fellowship, 1949. Work in Rhode Island School of Design Museum of Art; Hopkins Center Gallery, Dartmouth College, NH; Boston Museum of Fine Arts; others. Has exhibited at De Young Memorial Museum Annual of American Art, San Francisco; Whitney Museum Annual, NY; Penna. Academy; De Cordova Museum, Lincoln, MA. Received Prix de Rome, American Academy of Rome, 1948; Grand Prize, Boston Arts Festival, 1958; Providence Art Club Medal for Excellence in the Arts, 1975. Member: American Academy Alumni Association; Providence Art Club. Teaching at Rhode Island School of Design, from 1956, professor of sculpture. Position, Trustee, American Academy of Rome, 1975-80. Works in bronze and marble. Address in 1982, Providence, RI.

FRANKLIN, IONE.
Sculptor. Born in Texas. Studied at Texas State College for Women; Columbia University; Art Students League, with William Zorach and William Palmer. Works: Dallas Museum of Fine Arts. Awards: Southern States Art League, 1936, 46; Texas General Exhibition, 1941, 45. Exhibited: Southern States Art League, 1936, 42, 44, 46; Kansas City Art Institute, 1942; Texas General Exhibition, 1941, 44. Address in 1953, Commerce, TX.

FRANZONI, CARLO.
Sculptor. Born 1789 in Carrara, Italy; came to US. Represented in the capitol, Washington, DC. Died May 12, 1819, in Washington, DC.

FRANZONI, GIUSEPPE.
Sculptor. Born c. 1780 in Carrara, Italy; came to US in 1806. Represented in the Capitol, Washington, DC; also worked in Baltimore. Died April 6, 1815, in Washington, DC.

FRASER, COLIN.
Sculptor. Born in Detroit, MI, 1947. Studied: Wayne State University, B.F.A., M.F.A. candidate. Private collections. Exhibitions: Wayne State University (student shows); Michigan Artists Exhibition, The Detroit Institute of Arts, 1972; All Michigan II, The Flint Institute of Arts, 1973; Willis Gallery, Detroit, 1974; Detroit Institute of Arts, Works by Michigan Artists, 1974-75. Address in 1975, Grosse Ile, MI.

FRASER, JAMES EARLE.
Sculptor. Born Winona, MN, November 4, 1876. Pupil of Falguiere in Paris. Member: Associate, National Acad-

emy of Design 1912; Academician, National Academy of Design, 1917; National Institute of Arts and Letters; National Sculpture Society 1907; National Association of Portrait Painters; National Commission of Fine Arts; New Society of Artists; National Arts Club. Exhibited at National Sculpture Society, 1923. Awards: First prize, American Art Association of Paris, 1898; medal, Edison competition, 1906; gold medal for sculpture and gold medal for medals, P.-P. Expo., San Francisco, 1915; prize, National Arts Club, 1929. Knighted in Swedish order of Vasa. Represented by medals in Metropolitan Museum, NY; Ghent Museum and Rome; bust of Ex-President Roosevelt, Senate Chamber, Capitol, Washington; Fine Arts Academy of Buffalo; statue of Bishop Potter in Cathedral of St. John the Divine, NY; "End of the Trail," City of San Francisco; Buffalo nickel; U.S. Victory Medal; John Hay Memorial, Cleveland; "Alexander Hamilton," south entrance U.S. Treasury, Washington; "Victory Figure," Bank of Montreal; "Canadian Soldier," Bank of Montreal, Winnipeg; R. T. Lincoln sarcophagus, Arlington National Cemetery; John Ericsson Monument, Washington, DC; bronze statue of Lincoln, Jersey City, NJ. Commissioned to do figures for Arlington Memorial Bridge. Instructor, Art Students League of New York, 1906-11. Address in 1953, Westport, CT. Died in 1953.

FRASER, LAURA GARDIN.
(Mrs. James E. Fraser). Sculptor. Born Chicago, IL, September 14, 1889. Pupil of James E. Fraser and Art Students League. Member: Associate, National Academy of Design, 1924; National Academician, 1931; National Sculpture Society; National Academy of Women Painters and Sculptors. Exhibited at National Sculpture Society, 1923; National Academy of Design; and in Paris. Awards: Helen Foster Barnett prize, National Academy of Design, 1916; Shaw Memorial prize, National Academy of Design, 1919; Saltus gold medal, National Academy of Design, 1924; Saltus gold medal, American Numismatic Society, 1926; Watrous medal, National Academy of Design, 1931. Designed medal for Society of Medalists, 1930. Work: Wadsworth Atheneum; Elks Building, Chicago; Delaware Park in Buffalo, NY; New York University; Grant memorial half dollar and gold dollar; equestrian statue, Baltimore; Brookgreen Gardens, SC; heroic allegorical groups, Theodore Roosevelt Bridge, Washington, DC; many more. Address in 1953, Westport, CT. Died in 1966.

FRASER, MARY ALDRICH.
Sculptor. Born in NYC, February 22, 1884. Studied with William Ordway Partridge and Georg Lober. Works: National Cathedral, Washington, DC; St. John's Cathedral, NYC; Garden City Cathedral, Long Island, NY; St. Luke's Cathedral, Orlando, FL; and in many other cathedrals; also in private gardens. Award: Central Florida Exp., Orlando, FL. Exhibited: Argent Gallery; National Arts Club; Central Florida Exp.; others. Address in 1962, Orlando, FL; summer, Garden City, NY.

FRAUGHTON, EDWARD JAMES.
Sculptor. Born in Park City, UT, March 22, 1939. Studied: University of Utah, B.F.A., 1962; with sculptors Avard T.

Fairbanks and Justin Fairbanks. Traveled in Europe; his first monumental sculpture was cast in Italy. Exhibited: National Academy of Design, NYC, 1976-78, 1980-81; National Sculpture Society, NYC, 1974-81; San Francisco Bohemian Club, 1975-80; National Academy of Western Art, Oklahoma City, 1973-77; Whitney Museum, Cody, WY; Grand Central Galleries, NYC; Utah Museum of Fine Arts, 1980. In collections of National Cowboy Hall of Fame, Oklahoma City; Favell Museum of Western Art, Klamath Falls, OR; commissions at Prisidio Park, San Diego, CA; Brigham Young Cemetery, Salt Lake City, UT; Official Inaugural Medal, Pres. R. Reagan; others. Awards: Gold medal, "Where Trails End," National Academy of Western Art, 1973; gold medal, "The Last Farewell," National Academy of Western Art, 1975; gold medal designed by Solon Borglum, "Anasazi," National Academy of Western Art, 1977; Ellin Speyer Prize, "The Last Arrow," National Academy of Design, 1978; Tallix Foundry Prize, 1981, National Sculpture Society; San Dimas Festival of Western Arts; others. Member: National Sculpture Society; Society of Animal Artists; San Francisco Bohemian Club. Bibliography includes *Bronzes of the American West*, Broder; *National Sculpture Review*, fall, 1976, winter 1976-77; *Persimmon Hill* magazine; *Artists of the Rockies*. Represented by Kennedy Galleries, NYC; Husberg Fine Arts Galleries, Sedona, AZ. Specialty is figures and animals. Works in bronze. Address in 1983, South Jordan, UT.

FRAZEE, JOHN.
Sculptor. Born in Rahway, NJ, July 18, 1790. He was apprenticed as a youth to a country bricklayer, William Lawrence. His first work with the chisel was carving his employer's name upon the tablet of a bridge, constructed by Lawrence over Rahway River at Bridgetown, in 1808. In 1814 he formed a partnership with a former apprentice, and established a stonecutting business at New Brunswick. In 1818 he moved to New York, and with his brother William opened a marble shop in Greenwich Street. From that time until 1825 he made tombstones and mantels. His portrait bust of John Wells, old St. Paul's Church, Broadway, New York, is probably the first marble bust made in this country by a native American. A number of busts were executed by Frazee in 1834, seven of which are in the Boston Athenaeum. Died Feb. 24, 1852, in Crompton Mills, RI.

FRAZIER, BERNARD (EMERSON).
Sculptor, museum art director, craftsman, and lecturer. Born in Athol, KS, June 30, 1906. Studied at University of Kansas, BFA; National Academy of Art; Art Institute of Chicago; and with Lorado Taft. Member: National Sculpture Society; American Ceramic Society; Scarab Club. Awards: Prizes, Syracuse Museum of Fine Art, 1941; Chicago Galleries Association, 1943; Springfield Museum of Art, 1944; Kansas City, MO, 1938; Fellow, Carnegie Foundation, 1938, 39. Work: University of Kansas; Baker University, Kansas; Philbrook Art Center; State Minerals Building, Kansas; Ft. Dearborn memorial plaque, Chicago, IL; dioramas, Dyche Museum of Natural History. Exhibited: Syracuse Museum of Fine Art, 1938-41; San Francisco Museum of Art, 1939, 40; Cran-

brook Academy of Art, 1946; Art Institute of Chicago, 1941; Cincinnati Museum Association, 1941; National Academy of Design, 1939, 41; Corcoran Gallery of Art, 1941; Philadelphia Art Alliance, 1939, 41; Museum of New Mexico, Santa Fe, 1942, 46; Kansas City Art Institute, 1940, 41, 43; Springfield Museum of Art, 1944; Chicago Galleries Association, 1939, 40, 42, 43. Lectures: Sculpture; Ceramic Sculpture. Position: Sculptor in Residence, 1937-38; Instructor, 1939-44, University of Kansas; Art Director, Philbrook Art Center, Tulsa, OK, 1944-50. Address in 1953, Tulsa, OK.

FRAZIER, CHARLES.
Sculptor. Born in 1930, Morris, OK. Studied at Chouinard Art Institute, Los Angeles 1948-49 and 1952-56. Also resided in Italy. Work: La Jolla's and Los Angeles Museum, and many private collections. Exhibitions: La Jolla; Ellin Gallery, Los Angeles; Kornblee Gallery, NYC; Los Angeles County Museum; Penna. Academy of Fine Arts; Dwan Gallery, Los Angeles; Art Institute of Chicago; Pasadena Art Museum. Awards: La Jolla Art Center, 1962; Long Beach Museum of Art, 1963. Address in 1970, Los Angeles, CA.

FRAZIER, PAUL D.
Sculptor and educator. Born in Pickaway Co., OH, May 6, 1922. Studied at Ohio State University, B.F.A.; Cranbrook Academy of Art, M.F.A.; Skowhegan School of Painting and Sculpture, with Jose de Creeft; Academie de la Grande Chaumiere, with Ossip Zadkine. Work in Cranbrook Museum; Munson-Williams-Proctor Institute; others. Has exhibited at Solomon R. Guggenheim Museum; others. Received Cranbrook Foundation Medal for Sculpture, 1949; First Prize for Sculpture, Cooperstown Museum, 1957. Works in plaster. Address in 1982, Washington Depot, CT.

FRAZIER, RICHARD WILLIAMS.
Sculptor. Born in St. Louis, MO, January 5, 1922. Studied at Penna. Academy of Fine Arts with Walker Hancock, Paul Manship, and Harry Rosen; Barnes Foundation, PA. Work in Museum of the National Academy of Design and Gallatti House, NY; others. Commissions, Dolphin Fountain, Gallatti House; others. Member of National Sculpture Society, fellow; Allied Artists of America; associate, National Academy of Design. Received Tiffany Fellowship, Louis Comfort Tiffany Foundation; Dessie Grear Prize, National Academy of Design. Works in clay and stone. Address in 1982, 86 W. 12 St., NYC.

FREDERICK, FRANK FORREST.
Sculptor, painter, and worker in applied arts. Born in Methuen, MA, October 21, 1866. Pupil of Mass. Normal Art School; Royal College of Art, Stanhope Forbes and Newlyn in London; Tom Robertson in Venice; Trenton School of Industrial Arts. Member: Society of Western Artists. Professor of Art and Design, University of Illinois; Director, Trenton School of Industrial Arts. Also writer and lecturer. Address in 1925, Trenton, NJ.

FREDERICKS, MARSHALL MAYNARD.
Sculptor. Born in Rock Island, IL, January 31, 1908. Studied at John Huntington Polytechnic Institute, Cleve-

land, OH; Cleveland School of Art, Graduate, 1930; Munich, Germany; Paris, France; Copenhagen, Rome, and London; Carl Milles Studio; Cranbrook Academy of Art. Work in Detroit Institute of Arts; Cranbrook Museum of Art; Henry Ford Memorial, Dearborn, MI; Saints and Sinners Fountain, Oakland University; others. Has exhibited at Carnegie Institute; Art Institute of Chicago; Detroit Art Institute; Whitney Museum; others. Member National Academy of Design (academician); National Sculpture Society (fellow); honorary member, Michigan Society of Architects; Royal Society of Arts (fellow); International Institute of Arts and Letters (fellow). Taught at Cranbrook School, 1932-38, instructor of sculpture; Cranbrook Academy of Art, 1932-42, instructor of sculpture. Address in 1982, Birmingham, MI.

FREDERICKSON, FREDERICK LYDER.
Sculptor and painter. Born in Mandal, Norway, February 18, 1905. Studied at Art Students League, with R. Soyer, L. Kroll, Laurent; and in Norway. Work: Phila. Museum of Art. Exhibited: Penna. Academy of Fine Arts, 1937, 41; Virginia Museum of Fine Art, 1942; one-man exhibitions: Downtown Playhouse, 1936; Hudson Walker Gallery, 1937, 39; Schoneman Gallery, 1940; Marie Sterner Gallery, 1941; Marquie Gallery, 1944; and in Norway, 1939. Address in 1953, 1202 Lexington Ave., NYC.

FREE, JOHN D.
Sculptor and painter. Born in Pawhuska, OK, 1929. Initially studied pre-veterinary medicine and animal husbandry. Worked as a cowboy, in rodeos, and as a rancher. Turned to art, studying privately in Taos, NM, for four years. In collections of Gilcrease Museum, Tulsa, OK; National Cowboy Hall of Fame, Oklahoma City; others. Had one-man show at National Cowboy Hall of Fame, 1971, and National Academy of Western Art, 1973; group, Grand Central Galleries, NYC, 1973. Member of Cowboy Artists of America, 1972-75; National Academy of Western Art. Awarded second in sculpture and honorable mention, Philbrook Art Center; silver medal, National Academy of Western Art, 1979. Has own foundry. Reviewed in *Persimmon Hill, Oklahoma Today, The Oklahoma Cowman; The Cowboy in Art*, Ainsworth. Specialty is Western animals. Media: Bronze; oil, pastel, pencil. Address in 1982, Pawhuska, OK.

FREEBORNE, ZARA MALCOLM.
Sculptor and portrait painter. Born in Allentown, Penn., c. 1861. Died in Boston, Mass., 1906. Worked: Europe.

FREEMAN, BILL.
Sculptor and painter. Born in Greensboro, North Carolina, 1927. Learned painting from his mother. Worked for US Forest Service, Silver City, NM; farmed; was itinerant cowboy in Arizona, New Mexico, California, Wyoming, Massachusetts; worked for Arizona Game Department with biologists and illustrated publications. Later turned to painting and sculpture full-time. Represented by Trailside Galleries, Scottsdale, AZ. Specializes in Western wildlife, horses, landscapes. Address in 1982, Scottsdale, AZ (winters); Jackson, WY (summers).

FREEMAN, EDITH EMOGENE.
(Mrs. Edith Sherman). Sculptor and worker in applied

arts. Born in Chicago, Ill., June 16, 1876. Pupil of Art Institute of Chicago under Lorado Taft. Also a teacher. Address in 1906, Chicago, Ill.

FREEMAN, FLORENCE.
Sculptor. Born in Boston, MA, 1836. After study with Richard Greenough, she went abroad and studied with Hiram Powers. Established a studio in Rome. Executed several bas-reliefs of Dante, and many portrait busts. Also specialized in chimney pieces. She died after 1876, in Rome, Italy.

FREEMAN, H. A. L. (MRS.).
Sculptor. Wife of the artist James E. Freeman. Born in Augusta Latilla, Italy, 1826. For many years she had her studio in Rome. A "Group of Children," also the "Culprit Fay," of Drake's poem, were modelled with skill by Mrs. Freeman.

FREILICHER, HY.
Sculptor, teacher, and craftsman. Born in Northumberland, PA, April 13, 1907. Studied at College of the City of New York, B.S.; Beaux-Arts Institute of Design. Member: Sculptors Guild. Exhibited: Sculptors Guild, annually; New York World's Fair, 1939; American Federation of Arts traveling exhibition; Carnegie Institute; Brooklyn Museum; Metropolitan Museum of Art. Lectures: Sculpture History, Aesthetics, Technique. Position: Instructor of Sculpture, Abraham Lincoln High School, Brooklyn, New York. Address in 1953, 2514 Avenue M, Brooklyn, New York.

FRENCH, DANIEL CHESTER.
Sculptor. Born Exeter, NH, April 20, 1850. Pupil of Wm. Rimmer in Boston; J. Q. A. Ward in NY; Thomas Ball in Florence. Member: Associate, National Academy of Design 1900, Academician, National Academy of Design 1901; National Sculpture Society 1893; Society of American Artists 1882; NY Architectural League 1890; American Institute of Architects 1896; Academy San Luca, Rome; National Arts Club; Century Association; National Institute of Arts and Letters; American Academy of Arts and Letters; Concord Art Association. Member National Commission of Fine Arts 1910-15. Awards: Third class medal, Paris Salon, 1892; medal of honor Paris Exp., 1900; medal of honor of sculpture, NY Architectural League, 1912; medal of honor, P.-P. Exp., San Francisco, 1915; gold medal of honor, National Institute of Arts and Letters, 1918. Work: "Death and the Sculptor," memorial to Martin Milmore, Boston; "The Minute Man," Concord, MA; "Abraham Lincoln," for Lincoln, Nebraska; "Continents," New York Custom House; "Gen. Devens," equestrian statue (in collaboration with E. C. Potter), Worcester, MA; "Jurisprudence" and "Commerce," Federal Building, Cleveland; "Quadriga," State Capitol, St. Paul, MN; "Alma Mater," Columbia University, NY; Parkman Memorial, Boston; "Mourning Victory," memorial to Melvin brothers in Concord, MA, and replica and "Memory," Metropolitan Mus., NY; bust of Emerson, Art Mus., Montclair, NJ; "Spirit of Life," Trask Memorial, Saratoga, NY; "Study of a Head," Fine Arts Academy, Buffalo; "Statue of Emerson," Concord, MA;

"Lafayette Monument," Brooklyn, NY; "Lincoln" in the Lincoln Memorial, Monument to First Division, Dupont Fountain, and "The Sons of God Saw the Daughters of Men that they were Fair," Corcoran Gallery, all in Washington, DC; White Memorial Fountain, Boston, MA; War Memorial, Milton, MA; War Memorial, St. Paul's School, Concord, NH. Died Oct. 7, 1931. Address in 1929, 12 West 8th St., h. 36 Gramercy Park, NYC; summer, Glendale, MA.

FRENCH, DAVID M.
Sculptor. Born in Newmarket, New Hampshire, 1827. Executed life size statue of William Lloyd Garrison. Died in Newburyport, Mass., April 19, 1910.

FRENCH, ELIZABETH D. L.
Sculptor, painter, and writer. Born in Plymouth, Penna., June 28, 1878. Studied with Charles W. Hawthorne. Works: Papier-mache figures, life size, of historical characters in Wyoming Valley, for Wilkes-Barre Sesqui-Centennial; author of original pageants, plays, and stories for children; church decorations, Grace Church, Kingston, Penna.; decorations, Mission Room, St. Stephens Church, Wilkes-Barre, Penna. Address in 1933, 44 Reynolds St., Kingston; summer, Chase, Penna. Died in 1943.

FRENCH, JARED.
Sculptor and painter. Born in Ossining, NY, February 4, 1905. Studied at Amherst College, MA, 1921-25; Art Students League, NYC, 1925-27, under Boardman Robinson, Kimon Nicholaides. Exhibited: Julien Levy Gallery, NY, 1939; Museum of Modern Art, NYC, 1943; Edwin Hewitt Gallery, NYC, 1950, 55; Robert Isaacson Gallery, NYC, 1962; Rochester Museum, NY, 1964; New York Cultural Center, NYC, 1972; Whitney; Carnegie. Awards: National Institute of Arts and Letters Award, 1967. Modelled numerous murals under the Federal Arts Project. Member: Mural Painters Society, NY, 1936-38. In collections of Whitney; Baltimore; others. Media: Stone, cast metals; tempera. Address in 1982, Rome, Italy.

FREUND, WILLIAM F.
Sculptor and painter. Born January 20, 1916. Studied at University of Wisconsin, B.S., M.S.; University of Missouri. Member: Mid-American Artists. Awards: Fellowship and prize, Tiffany Foundation, 1940, 49; Mid-American Artists, 1950; Madison Art Salon; Milwaukee Art Institute; Missouri Valley Art; Addison Gallery of American Art, 1945, 46. Exhibited: Madison Library; Wisconsin Union; Milwaukee Art Institute; City Art Museum of St. Louis; William Rockhill Nelson Gallery; Springfield (MO) Art Museum; Joslyn Museum of Art; Mulvane Municipal Art Gallery; Denver Art Museum; National Academy of Design; St. Louis Central Library Gallery, (one-man). Position: Instructor, Stephens College, Columbia, MO, 1946-64; Southern Illinois University, 1964-81. No longer sculpting by 1982. Address in 1982, Watersmeet, MI.

FREY, ERWIN F.
Sculptor and teacher. Born Lima, OH, April 21, 1892. Pupil of C. J. Barnhorn, James Fraser, Henri Bouchard, Paul Landowski; Lima College; Cincinnati Art Academy;

Art Students League; Beaux-Arts Institute of Design; Julian Academy, Paris. Member: National Sculpture Society; Columbus Art League. Award: Honorable mention, Paris Salon, 1923; honorable mention, Art Institute of Chicago, 1925; others. Work: Beatty Memorial, Springfield, OH; Madonna and Child, Lamme Engineering Medal, Ohio State University; Fairmount Park, Philadelphia; others. Exhibited: Paris Salon, 1923; Penna. Academy of Fine Arts 1929; Art Institute of Chicago, 1928; Architectural League, 1925; National Academy of Design, 1930; Philadelphia Museum of Art, 1943, 50. Professor of Fine Arts, Ohio State University, from 1925. Address in 1953, Ohio State University; h. Columbus, OH. Died in 1968.

FREY, GRACE EGGERS.
Sculptor. Exhibited a portrait in the Cincinnati Museum in 1925. Address in 1926, Columbus, OH.

FREY, VIOLA.
Sculptor and painter. Born in Lodi, CA, August 15, 1933. Studied at Delta College, Stockton, CA; California College of Arts and Crafts, BFA; Tulane University, MFA. Works: Leslie Ceramic Collection, Berkeley, CA; Oakland Museum, CA. Exhibitions: One-woman shows, Art Institute of Chicago, 1960's and Haggin Museum, Stockton, 1971; Sculpture Exhibition, Hank Baum Gallery, San Francisco, 1975; San Fancisco Museum of Modern Art; Everson; Smithsonian; others. Teaching at California College of Arts and Crafts from 1965. Address in 1982, San Francisco, CA.

FRIBERT, CHARLES.
Sculptor. Born in Sweden. Pupil of Royal Academy in Stockholm; Ecole des Beaux-Arts and Falguiere in Paris. Awards: First prize for silver statuette given to King Oscar II. Member: Art Club of Philadelphia. Address in 1903, Philadelphia, PA.

FRIED, HOWARD LEE.
Sculptor. Born in Cleveland, OH, June 14, 1946. Studied painting at Syracuse University, New York, 1964-67; Cleveland Art Institute, Ohio, 1966; Western Reserve University, Cleveland, Ohio, abnormal psychology, 1966; San Francisco Art Institute, CA, 1967-68, under Wally Hedrick and William Allen; University of California, Davis, under Robert Arneson, Manuel Neri, and others, 1968-70. In collections of Cleveland Art Museum; Everson; Fort Worth; others. Exhibited: Reese Palley Gallery, NYC; De Saisset Art Museum, Santa Clara, CA, 1972; Kunsthalle, Duesseldorf, Germany, 1972; University of Contemporary Art, University of Penna., 1975; Everson; Joslyn; others. Awards: Augusta Hazard Award for Painting, Syracuse University, NY, 1966; Adeline Kent Award, San Francisco Art Institute, CA, 1971; National Endowment for the Arts Grant, Washington, DC, 1975. Taught: San Francisco Art Institute, CA, from 1970. Address in 1982, San Francisco, CA.

FRIED, SHEILAH.
Sculptor. Studied: University of Toledo; Kent State University; University of Notre Dame. Awards: Kodak International Photographic Competition, 1970; Toledo Area Artists, 1975. Exhibitions: Women 71, University of Illinois, 1971; Fort Wayne Museum of Art, Indiana, 1974; Mansfield Arts Center, Ohio, 1975.

FRIEDBERG, RICHARD S.
Sculptor and educator. Born in Baltimore, MD, August 10, 1943. Studied at Antioch College, B.A., 1965; Graham Foundation, fellowship, 1966; Yale University, B.F.A. and M.F.A., 1968. Has exhibited at Whitney Museum of American Art; Munson-Williams-Proctor Institute, NY; Storm King Art Center, NY; Prospect Mountain Sculpture Show, Lake George, NY; Alexander Milliken Gallery, NY; others. Received National Endowment fellowship, 1974. Works in steel and aluminum. Address in 1982, c/o Alexander F. Milliken Inc., 98 Prince St., NYC.

FRIEDENBERG, KATHLEEN M.
Sculptor and medical illustrator. Studied veterinary medicine, University of London, 1965; Studio School of Art and Design, Philadelphia, PA; watercolor painting under Domenic di Stefano; sculpture under Natalie Hodes, 1974; Wayne Art Center, under Holly Silverthorne; also under Zeno Frudakis. Work: Illustrations for *Practical Horseman* magazine; two books, *The Lame Horse* and *The Sick Horse*, Dr. James Rooney (author); various anatomical and surgical drawings for *Equine Medicine and Surgery*; sculpture works include "Old Friends" (bronze), "Hard Day's End" (bronze), "Free at Last" (bronze); numerous others. Awards: Thouron Scholarship to study orthopaedics in man and horse, University of Penna.; two 1st prizes and a silver medal from DaVinci Alliance; Coscia award for sculpture, DaVinci Alliance; Amelia prize, Woodmere. Exhibitions: Allied Artists, NYC, 1983; Chester County Art Association, Invitational Show, PA, April 1983; North American Sculpture Exhibition, Golden, CO. Member: Association of Medical Illustrators; Society of Animal Artists. Specialty, animal subjects, horses. Address in 1983, Ardmore, PA.

FRIEDENSOHN, ELIAS.
Sculptor and painter. Born December 12, 1924, NYC. Studied: Tyler School of Fine Arts, Temple University, 1942-43, with Rafael Sabatini; Queens College, with Cameron Booth, 1946-48, AB; NYU, Institute of Fine Arts; privately with Gabriel Zendel in Paris. Work: Art Institute of Chicago; Sara Roby Foundation, University of Illinois; Whitney; Walker; Minneapolis Museum of Art. Exhibited: Hewitt Gallery, NYC, 1955, 57, 59; Vassar College, 1958; Feingarten Gallery, NYC, San Francisco, Los Angeles and Chicago; Terry Dintenfass Inc., NYC, 1967; Audubon Artists Annual; Whitney Museum, Young America, 1957, Fulbright Artists, 1958, Annuals, 1958, 59, 60, 62; Art Inst. of Chicago Annuals, 1957, 59; University of Illinois, 1957, 59, 61, 63; National Arts Club Annual, NYC, 1958; Galleria Schneider, Rome, Fulbright Artists; Corcoran Annuals, 1960, 62; Smithsonian; Albright; Philadelphia Art Alliance; Syracuse University; Penna. Academy of Fine Arts Annual, 1967; Minnesota Museum, 1980; and many more. Awards: Lowe Foundation Award, 1951; Fulbright Fellowship (Italy), 1957; University of Illinois, 1957; National Arts Club Annual, NYC, Stephens Award, 1958; Guggenheim Foundation

Fellowship, 1960. Member: College Art Association. Taught: Queens College. Represented by Terry Dintenfass, NYC. Address in 1982, Leonia, NJ.

FRIEDLANDER, LEO.
Sculptor. Born NYC, 1889. Pupil of Art Students League of New York; Ecole des Beaux Arts of Paris and Brussels; American Academy in Rome. Member: National Sculpture Society; Alumni, American Academy in Rome; New York Architectural League; National Academy. Exhibited at National Sculpture Society, 1923; National Academy of Design; Architectural League; Art Institute of Chicago; others. Awards: American Academy in Rome Fellowship, 1913-16; Helen Foster Barnett Prize, National Academy of Design, 1918 and 1924; honorable mention, Art Institute of Chicago, 1920; silver medal, Sesqui-Centennial Exp., Philadelphia, 1926; medal, Architectural League, 1933. Work: Sculptures on Washington Memorial Arch, Valley Forge, PA, 1912; figures on altar of St. Thomas' Church, Frankfort, PA; colossal heads of Beethoven and Bach, Eastman School of Music, Rochester, NY; 3 colossal figures, entrance Masonic Temple, Detroit, MI; 28 allegorical life-sized bas-reliefs, National Chamber of Comerce, Wash., DC; 3 life-sized allegorical figures, Ann Arbor, University of Michigan Museum; figure, "Bacchante," Metropolitan Museum of Art; in New York City; 8 allegorical figures for Baptismal Font, Cranbrook Church, Michigan; 3 6-feet figures "The Three Wise Men," Chapel, Berkeley, CA; bronze doors and allegorical column caps, Goldman Memorial, Congregational Cemetery, Queens, NY; entire sculptures for Epworth Euclid M. E. Church, Cleveland, OH; designed the seal for the New York Building Congress; three marble reliefs, Amer. Bank and Trust Co., Phila., PA; eight marble Metopes, Lee Higginson Bank, NYC; pediment, Museum, City of New York, 1929; all sculptures for facades, Jefferson County Court House, Birmingham, AL, 1929-30; bronze relief, and two stone reliefs, main entrance, Genessee Valley Trust Co., 1929-30; all exterior figurative sculpture, Grosse Pointe Church, Grosse Pointe, MI, 1929-30. Address in 1953, White Plains, NY. Died in 1966.

FRIEDMAN, KENNETH SCOTT.
Sculptor and educator. Born in New London, Conn. Studied humanities, drama at California Western University, Point Loma, 1965; Shimer College, Mount Carroll, IL, 1965-66; San Francisco State University, 1966-71; Starr King School of the Graduate Theological Union, Berkeley, CA, 1969-70; Graduate School of Human Behavior, United States International University, San Diego, CA, 1974-76, PhD. Associated with the Fluxus artists, George Maciunas, Dick Higgins, Nam June Paik, Ben Vautier, and Alison Knowles in New York, 1966. Exhibited: Fluxus West, San Francisco, 1967, 68, 69, 71; Whitney Museum of American Art, NYC; Museum of Modern Art, Paris; National Gallery of Canada, Ottawa, Ontario, 1972; Oakland Art Museum; Joslyn; plus others. Member: Western Association of Art Museums; others. Director of Fluxus West, San Diego, CA, 1966-75. Executive director, Institute for Advanced Studies in Contemporary Art, San Diego and NYC; others. Author of *The Aesthet-*

ics, Beau Geste Press, Devon, England, 1972. Address in 1982, Institute for Advanced Studies, P.O. Box 600, Canal Street Station, NYC.

FRIEDMAN, MARK.
Sculptor. Born in NY, December 19, 1905. Studied at Beaux-Arts Institute of Design; Art Students League; Julian Academy, Paris; with Jean Bouchard, Paul Landowski. Exhibited: National Academy of Design; Sculptors Guild; Brooklyn Museum; Penna. Academy of Fine Arts; Salon des Artistes Francais, 1932; others. Member of Societe des Artistes Francais; Sculptors Guild. Awards from Beaux-Arts Institute of Design; Salon d' Automne, 1931; Salon de Printemps, Paris, 1932; others. Address in 1953, 40 W. 69th St., NYC.

FRISCH, VICTOR.
Sculptor. Born in Vienna, Austria, in 1876. Studied painting at the Academy of Fine Arts, Munich, and then sculpture under Heinrich Zuegel and Ludwig Herterich. Also worked in Auguste Rodin's studio as pupil and assistant, and for twelve years he remained with Rodin in Paris. After the war he came to the US. Works: Garden sculpture and fountain, Long Island, NY; Lucius N. Littauer monument, Gloversville, NY; Beethoven memorial, Vienna, Austria; church figures, Lyons, France; various sculptures in European museums and cemeteries; war memorial, Despair. Awards: Won competition for the Emil Verhaeren monument in Paris; gold medals in Paris, Vienna, and Munich. Membership: National Sculpture Society; NY Arch. League; Art Clubs of Vienna and Munich.

FRISHMUTH, HARRIET WHITNEY.
Sculptor. Born in Philadelphia, PA, on September 17, 1880. Studied in Paris under Rodin and Injalbert, in Berlin under Cuno von Enchtritz, and also in NY (Art Students League) under Hermon A. MacNeil and Gutzon Borglum. Exhibited at the Paris Salon in 1903; National Sculpture Society in NYC, 1923; National Academy of Design; Academy of Fine Arts, Philadelphia; others. Awards: Augustus Saint-Gaudens Prize, Art Students League; Helen Foster Barnett prize, for Girl and Dolphin fountain, National Academy of Design; MacMillin prize for sculpture, National Association of Women Painters and Sculptors; honorable mention, for the Saki Sun-dial, P.-P. International Exp., San Francisco, 1915; National Arts Club prize, for Extase, National Association of Women Painters and Sculptors, 1921; Elizabeth N. Watrous gold medal, for Fantasie, National Academy of Design, 1922. Member: National Sculpture Society, 1914; Art Alliance of America; National Association of Women Painters and Sculptors; League of American Artists; Allied Artists of America; fellow, National Academy of Design; others. Work: Joy of the Waters, Museum of Fine Arts, Dayton, OH; Metropolitan Museum of Art, NYC; Los Angeles Museum of Art; museums in New Hampshire, Georgia, New Jersey; John Herron Art Institute; Dallas Museum of Fine Arts; Brookgreen Gardens, SC. Address in 1976, Norwalk, CT. Died in 1979.

FROLICH, FINN HAAKON.
Sculptor. Born Norway, August 13, 1868. Pupil of Ernest

Barrias, Augustus Saint-Gaudens, D. C. French. Member: Southern California Sculptors Guild; Norse Studio Club; California Painters and Sculptors. Award: Silver medal, Paris Exposition, 1900; silver medal, Long Beach Exp. Work: Monuments to James Hill and Edvard Grieg, Seattle; monument to Jack London, Honolulu; Tower of Legends, Forest Lawn Cemetery, Los Angeles; monuments to R. Amundsen, Long Beach, CA; Paul Kruger, Johannesburg, South Africa. Director of Sculpture, Alaska-Yukon-Pacific Exposition, 1909; official sculptor, Pan-American Exposition, California, 1915. Director, Frolich School of Sculpture, Hollywood, CA. Address in 1933, Hollywood, CA. Died in 1947.

FROMAN, ANN.
Sculptor. Born in NYC, April 7, 1942. Studied at Fashion Institute of Technology, NY, A.A.; Palace of Fontainebleau School of Fine Art, France; National Academy School of Fine Art; Art Students League, NYC. First worked in fashion design; turned to sculpture in 1968. Traveled in Israel and Italy; influenced by Arab women and churches. Work in Congregation Emanu-El of NY; Butler Museum of Art, Youngstown, OH; Slater Museum, Norwich, CT. Has exhibited NY Artists, Brooklyn Museum; Judaica Museum, Phoenix, AZ; others. Received first prize for sculpture, Salmagundi Club, American Society of Contemporary Artists; plus numerous others. Member of American Society of Contemporary Artists; Artists Equity Association. Specializes in bronze figures, often Western subjects. Work is cast in own foundry. Titles include "Women of the West," "Women of the Bible," "Nude York," "Dancing Bronzes." Represented by Gemini Gallery, Palm Beach, FL; Shorr Goodwin Gallery, Phoenix, AZ. Address in 1982, Standfordville, NY.

FROMEN, AGNES VALBORG.
Sculptor. Born Waldermasvik, Sweden, December 27, 1868. Pupil of Art Institute of Chicago under Lorado Taft and Charles Mulligan. Member: Chicago Society of Artists; Art Institute of Chicago Alumni; Swedish American Art Association; Cordon. Exhibited at National Sculpture Society, 1923. Awards: Prize, Municipal Art League of Chicago, 1912; Swedish Exhibition, 1912; second and third prize for frieze of Illinois State Fair Building, 1914; prizes at Swedish American Exhibition, 1917, 19, 24 and 29; honorable mention, Art Institute Chicago, 1922. Work: "The Spring," Art Institute of Chicago; "Bust of Washington Irving," Washington Irving School, Bloomington, IL; memorial tablet in Hyde Park Church of Christ, Chicago; memorial fountain, Oxford, OH; fountain and greenhouse, Forest Lawn Cemetery, Omaha, NE; "Baby Jane," Museum, Goteborg, Sweden. Address in 1933, Chicago, IL.

FROST, JULIUS H.
Sculptor, painter, and teacher. Born in Newark, NJ, July 11, 1867. Self-taught. Member: Society of Independent Artists; Art League of Washington; American Federation of Arts. Address in 1933, Washington, DC. Died in 1934.

FROST, ROSAMOND.
Sculptor. Address in 1934, New York. (Mallett's)

FRUDAKIS, ANTONIO.
Sculptor. Member of the National Sculpture Society. Award: The John Spring Art Founder Award, National Sculpture Society, 1977. Address in 1982, 163 West 23rd Street, New York City.

FRUDAKIS, EVANGELOS WILLIAM.
Sculptor and instructor. Born in Rains, UT, May 13, 1921. Studied at Greenwich Workshop, NY, with Merli and Albino Cavalitto, 1935-39; Beaux Arts Institute of Design, NY, 1940-41; Penna. Academy of Fine Arts, with W. Hancock, P. Manship, E. J. Ferris, J. F. Harbeson, D. M. Robb, and W. M. Campbell; assistant to sculptors P. Manship and J. Davidson. Work in Penna. Academy of Fine Arts; National Academy of Fine Arts, NY; over-life size female figure in fountain, Philadelphia Civic Center; others. Has exhibited at Penna. Academy of Fine Arts Annual, 1941-62; National Academy of Design Annual 1948-63; Philadelphia Museum of Art; Philadelphia Art Alliance; others. Received awards from National Sculpture Society; Cresson traveling scholarship; Henry Scheidt Memorial scholarship; Louis Comfort Tiffany scholarship; American Academy of Rome, Italy, Prix de Rome fellowship; others. Member, Penna. Academy of Fine Arts; American Academy of Rome; National Sculpture Society; academician, National Academy of Design; Allied Artists of America. Teaching at National Academy of Fine Arts, NY, from 1970, instructor; Penna. Academy of Fine Arts, Philadelphia, from 1972, senior instructor. Address in 1982, Frudakis Gallery, Philadelphia, PA.

FRUDAKIS, ZENOS.
Sculptor and painter. Born in San Francisco, CA, July 7, 1951. Studied at Penna. Academy of Fine Arts, Philadelphia, 1973-76; University of Penna., Philadelphia, B.F.A., 1981. Works, Boy and Elephant (life size fountain sculpture), Burlington Mall, NJ; and others. Has exhibited at National Sculpture Society; National Academy of Design; Allied Artists of America; Salmagundi Club, NY. Received Certificate of Merit, National Academy of Design; award, National Sculpture Society; others. Member of Allied Artists of America; fellowship, Penna. Academy of Fine Arts; Penna. Art Alliance; others. Works in bronze; oil. Address in 1982, Philadelphia, PA.

FRY, SHERRY EDMUNDSON.
Sculptor. Born Creston, IA, September 29, 1879. Pupil of Art Inst. of Chicago under Taft; Verlet and MacMonnies in Paris; Academie Julien and Ecole des Beaux-Arts, Paris. Member: Associate, National Acad., 1914; National Sculpture Society 1908; NY Architectural League, 1911; National Academician, 1930. Exhibited at National Sculpture Society, 1923. Awards: Honorable mention, Paris Salon, 1906; medal, Salon, 1908; American Academy at Rome scholarship 1908-11; silver medal, P.-P. Exp., San Francisco, 1915; Watrous gold medal, National Academy of Design, 1917; honorable mention, Art Institute of Chicago, 1921; Wm. M. R. French gold medal, Art Institute of Chicago, 1922. Work: Statue, "Indian Chief," Oskaloosa, IA; "Au Soleil," fountain, Toledo Museum of Art; "The Dolphin," fountain, Mt. Kisco, NY; "The Turtle," fountain, Worcester, MA; fountain for St. George,

Staten Island, NY; Capt. Abbey, Tompkinsville, CT; pediment, H. C. Frick house, NYC; pediment, Clark Mausoleum, Los Angeles; statue of Ira Allen, University of Vermont; "Modesty," Metropolitan Museum of Art, NYC. Address in 1933, Century Club, 7 West 43rd St., NYC; Roxbury, CT. Died in 1966.

FUCHS, EMIL.

Sculptor, painter, and etcher. Born in Vienna, Austria, in 1866. He studied under Victor Tilguer and later at the Royal Academy in Vienna and Berlin, winning a travelling scholarship in 1890 which enabled him to study in Italy where he remained until 1899. From 1897 he made his residence in London, later moved to NY, where his paintings and sculpture were frequently shown. Awards: Gold medal, Munich Exp., 1896, for Mother Love, executed in Rome. Member: National Sculpture Society; NY Architectural League. Work: Monument to Prince Christian Victor, St. George's Chapel, Windsor, England; monuments to Queen Victoria at Balmoral and Sandringham, England; The Sisters, memorial in marble, Walker Art Gallery, Liverpool, England; bronze statue, La Pensierosa, Metropolitan Museum of Art, NY; marble busts, Lady Alice Montague, Ignace Paderewski, Sir Arthur Pinero; marble bas-relief, Sancta Cecilia, in a private collection, NY; bronze busts, Gari Melchers, Sir Johnston Forbes-Robertson, Sir David Murray; bas-relief, Mother and Child; Ashley Memorial, Ramsey Cathedral, England. Exhibited at National Sculpture Society, 1923. Address in 1926, 80 West 40th Street, NYC. Died in NYC in 1929.

FUGATE-WILCOX, TERRY.

Sculptor. Born in Kalamazoo, MI, November 20, 1944. Studied at Ferris Institute. Work in Guggenheim Museum and Museum of Modern Art, NY; National Gallery of Australia, Canberra; Dept. of Parks, NY. Has exhibited at Detroit Institute of Art; Dwan Gallery, NY; others. Received awards from National Endowment for the Arts; others. Address in 1982, c/o Louis K. Meisel Gallery, 141 Prince St., NYC.

FUGE, PAUL H.

Sculptor. Born in Plainfield, NJ, June 9, 1946. Studied at Yale University, B.A., 1968. Has exhibited at Museum of Modern Art, NY; Walker Art Museum, Minneapolis; Philadelphia Museum of Fine Arts; others. Taught at Yale University School of Art and Architecture, 1968-72, instructor of art; California Institute of Arts, 1971-73, visiting artist. Address in 1982, Oxford, CT.

FUHRMAN, ESTHER.

Sculptor and designer. Born in Pittsburgh, PA, Feb. 25, 1939. Studied at Penna. State Univ., 1956-57; Frick Dept. of Fine Arts, Univ. of Pittsburgh, B.A., 1960; also with Sabastiano Mineo and Hana Geber, NY. Works: Port of NY Authority; American Crafts Council, NYC; marble lobby piece, International Education and Training, Inc., NY, 1970; gemstone and bronze memorial, Temple Sinai, Pittsburgh; numerous other commissions. Exhibited at National Association of Women Artists, National Academy of Art, NY; Six Contemporary Artists, Montclair Museum of Art, NJ; Sculptors League, NY; American

Society of Contemporary Arts, Lever House, NY; others. Received Annual Exhibition Award, National Association of Women Artists, 1972 and 74. Media: Bronze with acrylics and gemstone materials. Address in 1982, Jenkintown, PA.

FULDA, E(LISABETH) RUNGIUS.

Sculptor, painter, and etcher. Born in Berlin, Germany, Aug. 16, 1879. Studied with Carl Rungius, August Gaul, and Richard Friese. Work: "Spring," mural painting, Public School No. 41, NYC; "Shoe Bill Stork" and "Mother Giraffe and Baby," paintings, Bronx Zoological Park, NYC; "Dinosaur Babies," group, American Museum of Natural History, NYC; illustrations, "Tales of Nature's Wonderland," by W. T. Hornaday. Member: National Association of Women Painters and Sculptors. Address in 1933, 157 East 116th Street, NYC.

FULLER, MARY.

(Mary Fuller McChesney). Sculptor. Born in Wichita, KS, October 20, 1922. Studied: University of California in Berkeley; California Faience Company of Berkeley. Work in San Francisco General Hospital; Children's Sculpture Garden, Community Center, Salinas, CA; others. Exhibitions: Syracuse Museum, NY; San Francisco Museum of Art; San Francisco Women's Center; Bolles and Gump's Galleries, San Francisco; others. Awarded first prize for Ceramic Sculpture, Pacific Coast Ceramic Association 1947 and 1949; Merit Award, San Francisco Art Festival, 1971; National Endowment for the Arts art critic grant, 1975. Medium: Concrete. Also noted for her writing of short stories, novels, and articles on art. Address in 1982, Petaluma, CA.

FULLER, META V. WARRICK (MRS.).

See Warrick.

FULLER, SUE.

Sculptor and printmaker. Born in Pittsburgh, PA, in 1914. Studied: Carnegie Institute; Columbia University; with Hans Hofmann, S. W. Hayter, Josef Albers, T. Tokuno. Awards: Association of Artists, Pittsburgh, 1941, 42; Northwest Printmakers, 1946; Phila Printmakers Club, 1944, 46, 49; Tiffany Foundation Fellowship, 1947; National Institute of Arts and Letters, 1950; NY State Fair, 1950; Guggenheim Fellowship, 1948. Collections: New York Public Library; Library of Congress; Harvard University Library; Carnegie Institute; Whitney Museum of American Art; Ford Foundation; Art Institute of Chicago; Museum of Modern Art; Brooklyn Museum; Metropolitan Museum of Art; National Academy of Design; Baltimore Museum of Art; Philadelphia Museum of Art; Seattle Art Museum; Guggenheim; others. Exhibited Metropolitan Museum of Art; Museum of Modern Art; Penna. Academy of Fine Arts; Butler; Corcoran; in Paris, Brazil, Germany, and more. Media: Plastic and string. Address in 1982, Southampton, NY.

FULOP, KAROLY.

Sculptor. Born in Czabadka, Hungary, in 1893. Moved to Los Angeles, California, c. 1930. Studied in Budapest, Hungary; Munich, Germany; Paris, France. Founded school of decorative art in his studio in Los Angeles in

1931. Exhibited at Babcock Galleries, NYC; Stendahl Galleries, Los Angeles; Doll and Richards Galleries, Boston; California Pacific International Exposition, San Diego; Golden Gate International Exp., San Diego; Golden Gate International Exp., San Francisco, 1939; Los Angeles County Museum of Art, 1980.

FULTON, A(GNES) FRASER.
Sculptor, painter and designer. Born Yonkers, NY, March 10, 1898. Pupil of Dow, Martin, Bement, Upjohn. Member: Yonkers Art Association. Award: Honorable mention, "House Beautiful" cover contest. Address in 1929, Teachers' College, Columbia University, New York, NY; h. Yonkers, NY.

FULTON, DOROTHY.
Sculptor, painter, and teacher. Born in Uniontown, PA, October 23, 1896. Studied at Penna. Academy of Fine Arts; Philadelphia Museum School of Industrial Art; University of Southern California; University of Penna.; University of Kansas; also pupil of Laessle, McCarter, Breckenridge, Garber, and Hale. Award: Fellowship, Penna. Academy of Fine Arts. Exhibited: Lancaster, PA, Art Association, 1937-41; Kansas City Art Institute, 1933; Penna. Academy of Fine Arts, 1935, 36-38, 40, 45; Newman Gallery, Philadelphia, 1936 (one-man); and others. Address in 1953, Lindon Hall, Lititz, PA; h. Bokeelia, Lee Co., FL.

FURMAN, DAVID STEPHEN.
Sculptor and educator. Born in Seattle, WA, August 15, 1945. Studied at University of Oregon, B.A. (ceramics), 1969; University of Washington, M.F.A. (ceramics and glassblowing), 1972. Has exhibited at Whitney Museum (ceramic sculpture); Chicago Art Institute; Los Angeles Co. Art Museum; others. Received National Endowment for the Arts Fellowship, 1975; Fulbright Fellowship, Peru, 1979. Member of World Crafts Council; American Crafts Council; Artists Equity. Teaching at Claremont Graduate School, Pitzer College, from 1973, professor of sculpture; Otis Art Institute, from 1975, instructor of clay sculpture. Works in clay and glaze. Address in 1982, Pitzer College Art Dept., Claremont, CA.

FURST, BREADING.
Sculptor. Born in New York, 1918. Exhibited in New York, 1934. (Mallett's)

G

GABA, LESTER.
Sculptor. Address in 1935, New York. (Mallett's)

GABO, NAUM.
Sculptor. Born August 5, 1890, in Briansk, Russia. Came to US in 1946. Studied: University of Munich, medical faculty, 1910, natural science, 1911; Polytechnic Engineering School, Munich, 1912. Work: Albright; Hartford (Wadsworth); Museum of Modern Art; US Rubber Co.; Whitney Museum; Yale University. Exhibited: Galerie Percier, Paris, 1924; Little Review Gallery, NYC, 1926; Arts Club of Chicago, 1934, 52; Lefevre Gallery, London, 1936; Musee du Jeu de Paume, 1937; Julien Levy Galleries, NYC, 1938; Hartford (Wadsworth), 1938, 53; Museum of the City of London, 1942; Baltimore Museum of Art, 1950; MIT, 1952; Pierre Matisse Gallery, NYC, 1953; Amsterdam (Stedelijk), circ., 1965-66; Museum of Modern Art; Whitney Museum; Art Institute of Chicago; Paris (Moderne). Awards: Tate, International Unknown Political Prisoner Competition, Second Prize, 1953; Guggenheim Foundation Fellowship, 1954; Art Institute of Chicago, Logan Medal, 1954; Royal College of Art, London, Hon. DFA, 1967. Member: American Academy of Arts and Letters, 1965. Taught at Harvard University, 1953-54; designed sets for Ballet Russe, 1926 ("La Chatte"); executed commissions for Bijenkorf Building in Rotterdam and US Rubber Co. Building, NYC. Represented by Marlborough-Gerson Gallery, NYC. Died in 1977.

GABRIEL, ROBERT A.
Sculptor. Born in Cleveland, OH, July 21, 1931. Studied at Cleveland Institute of Art; Skowhegan School of Painting and Sculpture. Has exhibited at Cleveland Museum Art Exhibition, Pittsburgh; Carnegie Institute, Pittsburgh; others. Received prize, Wichita, KS; Mary Page Traveling Scholarship, Cleveland Institute of Art. Member of Associated Artists of Pittsburgh; Pittsburgh Society of Sculptors. Address in 1982, Pittsburgh, PA.

GACH, GEORGE.
Sculptor and painter. Born in Budapest, Hungary, January 27, 1909; US citizen. Studied at Hungarian Academy of Fine Art. Has exhibited at Audubon Artists, Allied Artists, National Sculpture Society; Hammer Galleries, NY; others. Received gold medals, Hudson Valley Art Association, NY; National Sculpture Society, NYC; others. Member of Allied Artists of America; National Sculpture Society; National Art League; Hudson Valley Art Association; others. Works in bronze, wood; oil, plastic. Address in 1982, Roslyn Heights, NY.

GAENSSLEIN, OTTO ROBERT.
Sculptor and painter. Born in Chicago, IL, June 6, 1876. Pupil of A. Chatain, Carl Marr, and J. P. Laurens. Honorable mention, Paris Salon 1906. Member: Paris American Art Association; Chicago Society of Artists. Address in 1910, Paris, France.

GAER, FAY.
Sculptor and craftswoman. Born London, England, April 7, 1899. Pupil of Ralph Stackpole, Leo Lentelli. Member: Art Students League of NY. Represented in Mills College Art Gallery, Mills College, CA; Temple Emanuel, San Francisco. Address in 1933, Berkeley, CA.

GAGE, MERRELL.
Sculptor, lecturer, and teacher. Born Topeka, KS, December 26, 1892. Pupil of Art Students League of NY; Beaux Arts and Henri School of Art. Member: California Art Club; California Painters and Sculptors. Award: Gold medal, Kansas City Art Institute, 1921; gold medal and Way Side Colony prize, Pacific Southwest Exp., 1928; honorable mention, Los Angeles Museum, 1929; prize, Los Angeles Museum of Art, 1933. Works: Lincoln Memorial and Billard Memorial, owned by the State of Kansas; Police Memorial and American Legion. Memorial Fountains, Kansas City; Bar Assoc. Memorial, Jackson Co., MO; Santa Monica World Flight Memorial; Childrens Fountain, La Jolla Public Library; figures of "Agriculture" and "Industry," California State Bldg., Los Angeles; "John Brown" and "The Flutist," Malvane Museum, Topeka, KS; decorative sculpture on Edison Bldg., Los Angeles, Outdoor Theatre, Redlands, Memorial Fountain, Beverly Hills, all in California. Exhibited: Golden Gate Exposition, 1939; Los Angeles Mus. of Art, 1945 (one-man). Position: Instructor of Sculpture, University of Southern CA, from 1945. Address in 1953, Santa Monica, CA. Died in 1981.

GAGE, ROBERT MERRELL.
Sculptor. His bronze statue of Lincoln stands in the State House Grounds, Topeka. Address in 1926, Topeka, KS.

GAGLIARDI, TOMMASO.
Sculptor. Born in Rome; employed in the studio of Thomas Crawford. Moved to US in 1855. Employed as a sculptor at the US Capitol in Washington, 1855-58; executed bust of Crawford. In Italy c. 1860-70. After 1870 he traveled to Japan; founded a school of sculpture in the Royal Academy at Tokyo. Later went to India and there executed numerous portrait busts. Died in Italy in 1895.

GAGLIARDI & GIAMPAOLI.
Sculptors. Tommaso Gagliardi and Dominicus Giampaoli. Worked in Washington, DC, in 1860.

GAGNON, CHARLES EUGENE.
Sculptor and consultant. Born in Minneapolis, MN, February 24, 1934. Studied at University of Minn., A.A., 1956, B.S., 1958, and M.Ed., 1960; Minneapolis School of Art, 1959; with Berthold Schiwetz, Florence, Italy, 1964-65, and with Jacques Lipchitz, 1968. Has exhibited at

National Academy Galleries, NY; National Arts Club, NY; Walker Art Center Biennial, Minneapolis; Minneapolis Art Institute; others. Works in bronze. Address in 1982, Rochester, MN.

GAINES, NATALIE EVELYN.
Sculptor. Born in Detroit, Michigan. Studied at Detroit Society for Arts and Crafts; Greason School, Detroit. Awards: Crespi Gallery, 1958; Temple Emanu-El, NY, 1959.

GALE, DON.
Sculptor. Member of the National Sculpture Society. Address in 1982, Santa Monica, CA.

GALEN, ELAINE.
Sculptor and painter. Born in NYC, July 12, 1928. Studied at Philadelphia Museum School of Art, dipl., 1950; University of Penna., B.A., 1951; Art Students League, 1955-59; NY University, M.A., 1963; major study with Morris Kantor. Works: Philadelphia Museum of Art; Museum Rigaud, France; Rey Collection, Perpignan, France; Atelier 45. Commissions: Images from the Wind (portfolio, also co-auth.), NY, 1962 and Mythic Encounters (litho suite), Chicago, 1974, Ed DuGrenier. Exhibitions: Whitney Museum of American Art Annual, NY, 1961; Brooklyn Museum International, 1963; NJ State Arts Council, 1970; one-woman show, Penna. Academy of Fine Arts, Peale House, 1972; State Museum of Illinois, 1974; numerous one-woman shows and others. Awards: Chautauqua Institute First Prize for Painting, 1963; National Print Award, Hunterdon Center, NJ, 1970; American Iron and Steel Institute. Award for Design Excellence, 1972; plus others. Media: Stainless steel; oil and pencil-ink. Address in 1982, c/o Zriny Hayes Gallery, Chicago, IL.

GALEPPI, ALEXANDER.
Sculptor, engraver, and art dealer. At New Orleans, 1849, 1852-56.

GALLO, FRANK.
Sculptor. Born in 1933 in Toledo, OH. Earned B.F.A. from Toledo Museum School, 1954; M.F.A. from University of Iowa, 1959. Taught at University of Illinois since 1960. Received awards from Des Moines Art Center; Contemporary Arts Center, Cincinnati, OH; Guggenheim fellowship, 1966. Exhibited at Toledo Museum of Art, 1955; Gillman Galleries of NYC and Chicago; Penna. Academy of Fine Art; Whitney; Art Institute of Chicago; Louisiana State University; Puch Gallery, NYC; Time, Inc. In collections of Museum of Modern Art; Colorado State University; Baltimore Museum of Art; Princeton; and many private collections. Address in 1982, Dept. of Art, University of Illinois, Urbana, IL.

GALT, ALEXANDER.
Sculptor. Born June 26, 1827, in Norfolk, VA. He studied abroad. Among his works are many portrait busts; bust of Jefferson Davis was executed from actual measurements. Died January 19, 1863, in Richmond, VA.

GAMBLE, JOHN M.
Sculptor and painter. Born in Morristown, NJ, Nov. 25, 1863. Studied at San Francisco School of Design; and in

Paris, with Laurens, Constant. Member: San Francisco Art Association; Santa Barbara Community Art Association; American Federation of Arts; Foundation of Western Art. Awards: Medal, Alaska-Yukon-Pacific Exp., 1909. Work: Auckland (N.Z.) Museum of Art. Address in 1953, Santa Barbara, CA.

GANDOLA, PAUL MARIO.
Sculptor, architect, and craftsman. Born Besano, Italy, August 15, 1889. Pupil of Milan Academy of Fine Art. Member: Cleveland Society of Artists; Cleveland Sculptors Society. Address in 1933, 12208-10 Euclid Avenue; care of The Cleveland Society of Artists, Cleveland, OH.

GANIERE, GEORGE ETIENNE.
Sculptor and teacher. Born Chicago, IL, April 26, 1865. Pupil of Art Institute of Chicago. Member: Chicago Society of Artists; Alumni Art Institute of Chicago. Exhibited at National Sculpture Society, 1923. Award: Shaffer prize, Art Institute of Chicago, 1909. Work: "Baby Head" in John Vanderpoel Memorial Collection; "Lincoln" at Lincoln Memorial School, Webster City, IA, and at Burlington, Wis.; "Lincoln Fountain," Lincoln Highway, Chicago, IL; "Gen. Anthony Wayne," equestrian statue Fort Wayne, IN; "Lincoln" and "Douglas," Chicago Historical Society; "Lincoln," IL Historical Society; "Lincoln," Grand Army Memorial Hall, Chicago; "Hately Memorial," Highland Park, IL; "Lincoln Memorial," Starved Rock, State Park, IL; "Dr. Frank W. Gunsaulus Memorial," Chicago; "Head of Lincoln," "Meditation," Milwaukee Art Institute; "The Debator," Omaha Society of Fine Arts; "Head of Lincoln," Morgan Park, IL; "Tecumseh," "Little Turtle," Chicago Historical Society; "The Toilers," "Awakening Soul" and ideal figure, "Innocence," Fine Arts Gallery, De Land, FL. Former instructor and head, Sculpture Department, Chicago Art Inst. Director and instructor, Department of Sculpture, Stetson University, De Land, Fla. Died in 1935. Address in 1933, De Land, FL.

GANINE, PETER.
Sculptor. Born in Tiflis, Russia, October 11, 1900. Studied at Corcoran School of Art; and in Russia. Member: California Art Club; Society for Sanity in Art. Awards: Prizes, Corcoran Gallery of Art, 1932; California Art Club, 1934, 36; San Diego Fine Art Society, 1938; Ebell Salon, 1939, 45; Syracuse Museum of Fine Art, 1940; Los Angeles Museum of Art, 1945. Work: Syracuse Museum of Fine Art; San Diego Fine Art Society. Exhibited: Golden Gate Exp., 1939; San Diego Fine Art Society; Los Angeles Museum of Art; Syracuse Museum of Fine Art. Address in 1953, Hollywood, CA.

GANSER, IVAN LAURENCE.
Sculptor. Born in Eugene City, Oregon, June 10, 1906. Pupil of Wallace Rosenbauer, Lloyd Ney, and Ross Braught. Address in 1953, Kansas City, Missouri.

GARBEILLE, PHILIP.
Sculptor. Active 1848. Patentee—bust of Zachary Taylor, 1848. Worked in New Orleans; later in Mexico.

GARCIA, ROBERT ARTHUR.
Sculptor. Born in Casa Blanca, French Morocco, in 1952.

Studied film making, was assistant camera man, Los Angeles; studied sculpture at Institute of American Indian Arts, Santa Fe; apprenticed to Allan Houser, 1977. Sculpts figures in various media, primarily in stone. Represented by Parke Gallery, Vail, CO; Seth's Canyon Road Gallery, Santa Fe, NM. Address in 1982, Los Cerrillos, NM.

GARDIN, LAURA.
(Mrs. James E. Fraser). Sculptor. Born in Chicago, IL, 1889. Pupil of James E. Fraser. Member: National Sculptors Society; National Academy of Women Painters and Sculptors. Awards: Helen Foster Barnett prize, National Academy of Design, 1916; Shaw memorial prize, National Academy of Design, 1919. Address in 1926, 3 MacDougal Alley, NYC. See also Fraser, Laura Gardin.

GARDNER, ELIZABETH RANDOLPH.
Sculptor. Address in 1934, New York. (Mallett's)

GARDNER, MABEL.
Sculptor. Born in Providence, Rhode Island. Exhibited: Paris, France.

GARIBALDI, MRS. PIETRO A. (LUCINDA).
Sculptor. Born in Maine, c. 1822. Statuary maker, with her husband, in Boston, 1850.

GARIBALDI, PIETRO A.
Sculptor. Born in Italy, in 1818. Statuary maker in Boston in 1850-51. Assisted in his work by his wife. Later established the firm of Garibaldi & Cordano.

GARLICK, THEODATUS.
Sculptor, wax portraitist. Born in Vermont, 1805. Died in Bedford, Ohio, 1884. Worked: Cleveland, Ohio; Youngstown, Ohio.

GARRETT, CLARA PFEIFER.
(Mrs. Edmund A. Garrett). Sculptor. Born Pittsburgh, PA, July 26, 1882. Pupil of St. Louis School of Fine Arts; Ecole des Beaux-Arts; Mercie and Bourdelle in Paris. Awards: Bronze medal, Louisiana Purchase Exp., St. Louis, 1904; honorable mention, National Sculpture Society, 1905; sculpture prize, Artists' Guild of St. Louis, 1915; St. Louis Art League Prize, 1916. Work: "Boy Teasing Turtle," Metropolitan Museum, New York City; "McKinley," City of St. Louis; "Children at Play," 50-ft. frieze, Eugene Field School, St. Louis. Address in 1933, Beverly Hills, CA.

GARRISON, ROBERT.
Sculptor. Born Fort Dodge, IA, May 30, 1895. Pupil of Pennsylvania Academy of the Fine Arts; Gutzon Borglum. Work: 2 Bronze Mountain Lions for State Office Building of Denver, Colorado; two seal fountains, Voorhees Memorial; Daly Memorial; Fairmount Cemetery; Athena, Morey High School; Overseas Memorial Tablet, Post Office, Denver; Mosher Memorial, Rochester, NY; sculpture on Riverside Baptist Church, New York City; terra cotta decorations on South Side High School, National Jewish Infirmary, and Midland Building, Denver, CO; sculpture on Boston Ave. M.E. Church, Tulsa, OK; three panels, RKO Building, Rockefeller Center, NYC. Address in 1933, Chappell House, Denver, CO; 125 West 55th St., New York, NY. Died in 1945.

GARSTIN, ELIZABETH WILLIAMS.
Sculptor. Born New Haven, January 12, 1897. Studied: Eberhard; Yale Art School. Member: New Haven Paint and Clay Club; American Federation of Art. Address in 1933, New Haven, CT; summer, Salisbury, CT.

GARVEY, HENRY.
Sculptor. Exhibited: Cleveland, 1857. Worked in plaster.

GASPARRO, FRANK.
Sculptor and instructor. Born in Philadelphia, PA, August 26, 1909. Studied at Penna. Academy of Fine Arts, and with Charles Grafly. Member: Society of Medalists, Fellow, Penna. Academy of Fine Arts. Awards: Cresson traveling scholarship, Penna. Academy of Fine Arts, 1930, 31. Work: Philadelphia Museum of Art; Harrisburg Museum of Art; Allentown Art Museum. Exhibited: Philadelphia Museum of Art, 1940; Penna. Academy of Fine Arts, 1946; medals at French Mint, Paris, France, 1950; Spanish International Medallic Art Exhibition, Madrid, 1952. Instructor of Sculpture, Fleisher Art Memorial, Philadelphia, PA; Sculptor-Engraver, US Mint, Philadelphia, PA, from 1942. Awards: Order of Merit, Italian Republic, 1973; Percy Owens Award, Outstanding Artist, PA, 1979; Citation for Superior Performance of the US Treasury, 1977. Address in 1983, Havertown, PA.

GASSETTE, GRACE.
Sculptor and painter. Born in Chicago, IL. Pupil of Mary Cassatt. Address in 1910, Paris, France.

GATES, HARRY IRVING.
Sculptor and educator. Born in Elgin, IL, December 8, 1934. Studied at University of Illinois, B.F.A., 1958, M.F.A., 1960. Work in Corcoran Gallery Art, Washington, DC; National Collection of Fine Art, Washington, DC; Baltimore Museum of Fine Art. Has exhibited at Baltimore Museum of Fine Art; National Collection of Fine Art; Corcoran; Museum of Contemporary Crafts, NY; others. Teaching sculpture at George Washington University, from 1964. Address in 1982, Frederick, MD.

GAULOIS, HELENE.
Sculptor. Exhibited in New York, 1934. (Mallett's)

GAUTREAU, J. B.
Sculptor. At New Orleans, 1830-32.

GAY, RUTH A.
Sculptor. Born in Ontario, Canada, November 30, 1911. Studied at Syracuse University; Art Students League; with Alexander Brook, Henry Varnum Poor and Charles Cutler. Exhibited: Riverside Museum; Grand Central Art Gallery; Whitney Museum, 1938; others. Awards: Albright Art Gallery; Western New York Exhibition, 1948, 49. Taught art at MacMurray College, Jacksonville, IL, 1938-46. Address in 1953, Niagara Falls, NY.

GAYLORD, FRANK CHALFANT.
Sculptor and designer. Born in Clarksburg, WV, March 9, 1925. Studied at Carnegie Institute of Technology College of Fine Arts; Tyler School of Fine Arts, Temple University, B.F.A. Has exhibited at National Sculpture Society Annual Exhibition, 1965 and 79. Associate member of

the National Sculpture Society. Works in granite. Address in 1982, Barre, Vermont.

GEBER, HANA.
Sculptor and instructor. Born in Praha, Czech., February 14, 1910. US citizen. Studied at Teachers College, Prague; Art Students League; Sculpture Center, NY. Works: Yeshiva University Museum; Jewish Museum, NY; Rose Art Museum, Brandeis University; Museum Ethnography and Folklore, Ramat-Aviv, Israel; Lowe Art Museum, University of Miami. Commission: Wedding altar, Temple Emanuel, Yonkers, NY; memorial, Verona High School, NJ; statue, Riverdale Temple, Bronx; statue, Temple Sinai of LI, NY; silver wallpiece, Free Westchester Synagogue; plus others. Exhibitions: One-woman shows, Montclair Art Museum, Union American Hebrew Congregations, NY; Sculpture Center, NY; American Jewish History Society, Waltham and Boston, MA; and Penna. Academy of Fine Arts, Philadelphia; plus others. Awards: Memorial Foundation of Jewish Culture Fellowship, 1969; Gold Medal, National Association of Women Artists; First Prize, American Society of Contemporary Artists; plus others. Media: Silver and bronze. Address in 1982, 168 West 225th Street, NYC.

GEBHARDT, C. KEITH.
Sculptor, painter, designer, lecturer, writer, and illustrator. Born in Cheboygan, MI, August 14, 1899. Studied at University of Michigan; Art Institute of Chicago. Work: Murals, paintings, sculpture, Milwaukee Public Museum. Director of Winnipeg School of Art, Canada, 1924-29; Associate Artist, 1932-40, Chief Artist, 1940-53, Milwaukee Public Museum, Milwaukee, WI. Address in 1953, Milwaukee, WI.

GEBHARDT, HAROLD.
Sculptor and teacher. Born in Milwaukee, WI, August 21, 1907. Studied at Layton School of Art. Awards: Prizes and medals, Wisconsin University, 1936; Wisconsin Painters and Sculptors, 1937; Milwaukee Art Institute, 1937; Los Angeles Museum of Art, 1946, 50. Work: Milwaukee Public Library; State Teachers College, Milwaukee. Exhibited: Los Angeles Museum of Art, 1939-46, 50; Art Institute of Chicago; Milwaukee Art Institute; University of Wisconsin; University of Minnesota; Santa Barbara Museum of Art; Scripps College; California State Fair; Los Angeles County Fair; Chaffey College; Pasadena Art Institute; Greek Theatre, Los Angeles. Instructor of Sculpture, Occidental College and Los Angeles County Art Institute, Los Angeles, CA. Media: Stone, wood; acrylic. Address in 1983, Sylmar, CA.

GEE, YUN.
Sculptor, painter, and teacher. Born in Canton, China, Feb. 22, 1906. Studied with Chu and at California School of Fine Arts. Works: Altar Piece, "The Last Supper," St. Peter's Lutheran Church, NY. Member: Society of Independent Artists. Inventor of the Lunar Tube. Address in 1953, NYC.

GEES, J. F. S.
Sculptor and engraver. At New Orleans, 1818. Worked in marble, wood, and wax.

GEHR, JAMES L.
Sculptor and designer. Born in Green Bay, WI, Dec. 8, 1906. Studied at Layton School of Art; Goodyear Technical Institute; Frank Lloyd Wright Fellow, Taliesin, Spring Green, WI. Member: National Sculpture Society; Wisconsin Painters and Sculptors; Seven Arts Society, Milwaukee, WI. Awards: Prizes, Milwaukee Art Institute, 1938, 40. Work: Animal sculpture groups, Milwaukee, WI, parks; Milwaukee Public Museum. Exhibited: Howard University, 1941; Seven Arts Society, annually; Wisconsin Painters and Sculptors, annually. Lectures: Animal Sculpture. Address in 1953, Cedarburg, WI.

GEIS, WILLIAM R. III.
Sculptor. Born in Salina, Kansas, in 1940. Moved to California in 1955. Studied at California School of Fine Arts (San Francisco Art Institute). Taught there 1965-67, 70-72, and from 73; Sacramento State; University of Kentucky. Exhibited at Bolles Gallery, San Francisco; San Francisco Art Institute; Quay Gallery, San Francisco; Nancy Hoffman Gallery, NYC; Oakland Art Museum; Los Angeles Co. Museum of Art; Whitney; others.

GEISSBUHLER, ARNOLD.
Sculptor and teacher. Born in Delemont, Switzerland, August 9, 1897. Studied at Julian Academy, Grande Chaumiere, Paris; Zurich, Switzerland. Apprenticed with Otto Munch in Zurich, Switzerland, 1914-19. Member: Sculptors Guild, NY. Work: Art Museum, Berne, Switzerland; Fogg Museum of Art; war memorial, Somloire, France; architectural sculpture, Switzerland, France, USA. Exhibited: New York World's Fair, 1939; Salon des Tuileries, Paris, France; Philadelphia Museum of Art; Institute of Contemporary Arts, Washington, DC; Whitney Museum of American Art; Metropolitan Museum of Art; one-man shows include Guild Farnsworth Museum of Art; Dennis (MA) Art Center, and others in the US and abroad. Awards: Bronze Medal for Figure, Academy Julian, Paris, 1919; Outstanding Award, Art USA, 1958; Cambridge Centennial Award, Cambridge Art Association. Taught drawing and sculpture, NY School of Design, 1929-30; Stuart School of Design, Boston, 1936-42; Wellesley College, Wellesley, MA, from 1937. Medium: Bronze. Address in 1982, Dennis, MA.

GEIST, SIDNEY.
Sculptor and art critic. Born in Paterson, NJ, April 11, 1914. Studied at St. Stephen's College, Annandale-on-Hudson, NY; Art Students League; Academie de la Grande Chaumiere, Paris. Work: Bard College, Annandale-on-Hudson, NY. Has exhibited at Salon Jeune Sculpture, Paris, 1950; American Artists Annual, Chicago, 1962; and many in NY and Paris. Received Olivetti Award, Silvermine Guild; Guggenheim Fellowship, 1975-76. Taught sculpture at Pratt Institute, 1961-65; teaching sculpture, New York Studio School, from 1964; teaching sculpture at Vassar College, 1967-75, from 1976. Works in wood and stone. Address in 1982, 11 Bleecker St., NYC.

GELERT, JOHANNES SOPHUS.
Sculptor. Born in Denmark, 1852; came to the United

States in 1887. He was a member of the National Sculpture Society. Represented: Haymarket Monument, Chicago; Gen. Grant in Galena, IL; in the Art Institute, Chicago, and museums in Denmark. Died in New York City, November 4, 1923.

GELLER, TODROS.
Sculptor, etcher, engraver, block printer, writer. Born in Vinnitza, Russia, July 1, 1889. Work: "Yiddish Motivs," seven wood cuts, Buckingham Collection, Art Institute of Chicago; "Yiddish Motivs" and "Palestine," book of wood cuts, Chicago Public Library, Detroit Public Library, Milwaukee Public Library, and Hebrew Union College, Jewish Museum, Cincinnati, OH. Member: Chicago Society of Artists; Chicago No-Jury Society of Artists; Around the Palette. Address in 1933, Chicago, Ill.

GENDROT, FELIX ALBERT.
Sculptor and painter. Born in Cambridge, MA, April 28, 1866. Studied: Mass. Normal Art School, Boston; Julian Academy in Paris under Laurens and Constant; sculpture with Puech and Verlet. Member: Boston Art Club; American Art Association of Paris; Copley Society; American Federation of Arts. Address in 1933, Roxbury, MA.

GENTILE, GLORIA IRENE.
Sculptor and designer. Born in NYC. Studied at Cooper Union, NY, 1947-50; Yale University, 1951-54, B.F.A. and M.F.A.; studied with Josef Albers, Will Barnet, Abraham Rattner, Marsicano, Stuart Davis, Buckminster Fuller, Philip Johnson, Frederick Kiesler, Louis Kahn, Frank Lloyd Wright, and Alvin Lustig. Exhibitions: One-person shows, Harbrace Gallery, 1967; Aleksandra Kierekieska Gallery, 1968; Art Directors Club Gallery, 1968; Young and Rubican Gallery, NY, 1968; and Ogilvy and Mather Inc. Gallery, 1968. Media: Bronze, ball joints. Address in 1982, 333 East 46th Street, NYC.

GENTILINI, JOSEPH.
Sculptor. At Boston, 1848-49.

GEORGE, DAN.
Sculptor. Born in Lake George, NY, July 5, 1943. Studied: State University NY, Albany; Art Students League, 1968-73; Academie v Schonekunsten, Antwerp, 1970-71; Henry Schenckenberg Merit Scholar. Work: Hyde Collection, Glens Falls, NY; Manhattan Laboratory Museum, NYC; Sculpture Space, Utica, NY. Commissions: Stewart-Scott Association, Poughkeepsie, NY; site project, Lake George, NY. Exhibitions: Lowe Art Gallery, Syracuse, NY, 1978; Prospect Mtn. Sculpture Show, Lake George, 1979; Usden Gallery, Bennington College, VT, 1979; Sculpture at Columbia Plaza, Washington, DC, 1980; and others. Awards: Grant, NYS Council on the Arts, 1978; Collaborations in Art, Science & Technology, 1978. Media: Cast metals. Address in 1982, 64 W. 21st St., NYC.

GEORGE, MARGARET.
Sculptor and painter. Member: Denver Art Association. Address in 1918, Denver, CO.

GEORGE, RICHARD F.
Sculptor. Born in Boston, MA (or San Francisco, CA), in

1865. Member National Arts Club; Salmagundi Club, 1902. Address in 1910, 72 Washington Square, S., NYC. Died in Brooklyn, NY, September 28, 1912.

GERHARDT, KARL.
Sculptor. Born in Boston, Massachusetts, 1853. Exhibited: Paris Salon. Represented by various statues in Hartford, Connecticut; Brooklyn, New York; Pennsylvania. Died in 1940.

GERLACH, GUSTAVE.
Sculptor. Pupil of Karl Bitter, and sculptor of the colossal personification of "Minnesota." Active in 1900.

GEROWITZ, JUDY.
Sculptor. Born in Chicago, Illinois, in 1939. Exhibited at the Rolf Nelson Gallery, Los Angeles, California, 1966. Noted work: "Ten Part Cylinder," (fiberglas, ten units), 1966.

GERRISH, WOODBURY.
Sculptor. Ship-figurehead carver who worked in Portsmouth, NH, 1844-64. His head of Benjamin Franklin is displayed at the US Naval Academy, Annapolis, MD.

GERSHOY, EUGENIE.
Sculptor and painter. Born in Krivoi Rog, Russia, January 1, 1901. Became a US citizen. Studied at Art Students League, with Calder; California School of Fine Arts; and in Europe with Sloan, Miller, and Robinson, 1921-22. Works: Art Institute of Chicago; Metropolitan Museum of Art; Whitney Museum of American Art; Biggs Memorial Hospital; Astoria Public Library, NY. Awards: St. Gaudens medal; Red Cross National Competition, 1941; Metropolitan Museum of Art, 1943; Rotunda Gallery, San Fran., 1950; Fellowship, Yaddo Foundation, 1951. Exhibited: Whitney Museum of American Art Annual and Biennial Exhibits, NY, from 1931; 15 Young American Sculptors and 20th Century Portraits, Museum of Modern Art, 1942; San Fran. Museum, CA, 1948-65; Women Artists of America, Newark Museum, NJ, 1964; Invitationals, Phila. Museum of Art, PA, 1940, 42; Artists for Victory, Metropolitan Museum of Art, NY, 1942; one-woman shows were held at the Brooklyn Museum, Baltimore Museum, Dallas Museum, Wichita Museum, Delgado Museum, and others. Also taught painting and drawing at New Orleans Art School, 1940-41; at the San Francisco Unified School, 1946-65; and ceramic sculpture at the California School of Fine Art, San Francisco, 1956-57. Commissions: Polychromed papier mache sculptures, Cafe Society, NY, 1942; San Francisco Art Commission, CA, 1965; papier mache portrait sculptures, Chelsea Hotel, NYC, 1967-77. Address in 1982, Hotel Chelsea 222 West 23rd Street, NYC.

GESSNER, DEBBIE.
Sculptor. Born in Portland, OR, 1954; moved to Arizona in 1963. Began career in art in 1973. Has exhibited at George Phippen Show, 1977; O'Brien's Art Emporium, Scottsdale, AZ; Bern, Switzerland (solo); Trailside Galleries, Scottsdale, AZ. Awarded second place, George Phippen Show. Specializes in Indians and horses. Works in bronze. Address since 1978, Philadelphia, PA.

GETZ, DOROTHY.
Sculptor. Born in Grand Junction, Iowa, September 7, 1901. Studied at Ohio State University, B.A., 1923, M.A., 1932; Academy Belle Arti, Perugia, Italy, summers 1962, 63, 65. Works: Columbus Gallery Fine Arts, Ohio; Akron Institute of American Art, Ohio; Sassaferato, Italy. Exhibitions: Ceramic National, Syracuse, NY, 1952 and 54; Five Ohio Ceramic and Sculpture Shows, Akron, 1955-64; Drawing and Small Sculpture Annual, Ball State University Art Gallery, 1956, 58, and 59. Awards: Salvi Prize, 4th Piccolo Europa, Sassaferato, Italy, 1963; Purchase Prize, Ohio Ceramic and Sculpture Show, Akron Institute of American Art, 1964; Purchase Prize, Columbus Gallery Fine Arts, 1966.

GEVELOT, NICHOLAS.
Sculptor. Worked on US Capitol, Washington, 1820's; elsewhere as late as 1850, where he executed bas-relief, W. Penn's Treaty. Other later works include busts of Lafayette and Hamilton; equestrian statue of G. Washington, 1834.

GEYER, HENRY CHRISTIAN.
Sculptor. Stonecutter and plaster caster, active in Boston 1768-70. Work included human and animal likenesses.

GHIGLIERI, LORENZO E.
Sculptor and painter. Born in Los Angeles, CA, 1931. Received scholarship from Los Angeles Art Directors Club, 1948; served as naval artist during Korean War; worked in commercial art in Chicago and NYC. Turned to sculpture in 1974. Work includes ship's portrait for official presentation to Great Britain, 1953; life-size bronze of an eagle; life-size bronze of Abraham Lincoln; 4 by 12 foot bronze, "Genesis of Love;" statuette presented by Oregon to Pres. Reagan. Reviewed in *Southwest Art*, November 1979. Specializes in dramatic Eskimo and Indian figures; wildlife. Address since 1956, near Portland, OR.

GIACOMANTONIO, ARCHIMEDES A.
Sculptor and painter. Born in Jersey City, NJ, Jan. 17, 1906. Studied at DaVinci Art School, NY, 1925; with Onorio Ruotolo, 1925-26; with Vincenzo Gemito, 1926-29; Royal Academy of Art, Rome, 1929. Work at Jersey City Museum, NJ; Columbus Monument, Jersey City, NJ; Columbus Monument, Hazelton, PA. Has exhibited at Academy of Fine Arts, Rome, Italy; Equitable Galleries, Allied Artists and National Sculpture Society, NYC, 1936-81; Theodore Roosevelt, Metropolitan Museum, NY; National Academy of Design, NY. Received medal, Montclaire Art Museum, 1936; gold medal, National Academy of Design, 1980; gold medal, National Sculpture Society, 1981; Linsey Morris Memorial, Allied Artists, 1981. Member: Allied Artists of America; National Sculpture Society; American Artists Professional League; National Academy of Design; Lotus Club, NY. Address in 1982, c/o Jock Manton, 42 West 67th St., NYC.

GIAMBERTONE, PAUL.
Sculptor. Born in Italy; US citizen. Studied at Beaux Arts Institute of Design, NY, with Gaetano Cecere; Education Alliance, NY, with Chaim Gross. Work in Safad Museum, Israel; Philothea Museum, London, Ontario. Has exhibited at National Arts Club, NY; Silvermine Guild Artists, New Canaan, CT; Salmagundi Club; others. Member: Artists Equity Association of NY; Sculptors League. Works in welded and cast bronze. Address in 1982, 121 E. 23rd St. NYC.

GIAMBRUNI, TIO.
Sculptor. Born August 30, 1925, San Francisco, Calif. Studied: University of California, Berkeley, with Glenn Wessels, John Haley, Jacques Schnier, Richard O'Hanlon, BA, MA. Has exhibited at Richmond Art Center, 1960; Barrios Art Gallery, Sacramento, 1963; Berkeley Gallery, 1963, 64, 66; Stanford University, "Some Points of View for '62," 1962; Museum of Contemporary Crafts, Creative Casting, 1963; New Orleans Delgado, Bay Area Artists, 1963; New School for Social Research, The Artist's Reality, 1964. Commission for Golden Gate Redevelopment Project, San Francisco. Awards: San Francisco Museum of Art, Patrons of Music and Art Award, 1959. Living in California in 1970. Died in 1971.

GIAMMARTINI, ACHILLE.
Sculptor. Born in Pittsburgh, PA, 1861. Died in Atlanta, GA, 1929. (Mallett's)

GIAMPAOLI, DOMINICUS.
Sculptor. Partner of Gagliardi & Giampaoli in Washington, DC, in 1860.

GIANAKOS, CRISTOS.
Sculptor. Born in NYC, January 4, 1934. Studied at School of Visual Arts, graduate certificate. Work: Museum of Modern Art, NY; Moderna Museet, Stockholm; others. Exhibited: Whitney Museum of American Art, NY; Milwaukee Art Center; San Francisco Museum of Art; Museum of Modern Art, NY. Received Creative Artists Public Service Grant, 1976-77 and 1979-80; National Endowment for the Arts Award, 1980. Instructor at School of Visual Arts, from 1965. Address in 1982, 93 Mercer St., NYC.

GIANAKOS, STEVE.
Sculptor and painter. Born in NYC, 1938. Studied at Pratt Institute, Brooklyn, NY. Has exhibited at Guggenheim Museum, NY; Contemporary Greek-American Artists, Brooklyn Museum, NY; Fischbach Gallery, NY; Droll-Kolbert Gallery, NY; Contemporary Arts Museum, Houston, TX. Address in 1982, c/o Droll/Kolbert Gallery Inc., NYC.

GIANELLI, FROSTINO.
Sculptor. Born in Tuscany, living in Philadelphia in 1860. Worked in plaster.

GIANNINI, JOSEPH.
Sculptor. Set up a terra cotta and marble factory. At Cincinnati, 1856-60.

GIBRAN, KAHLIL GEORGE.
Sculptor. Born in Boston, MA, November 29, 1922. Studied at Boston Museum School, 1940-43, painting with Karl Zerbe. Work in Chrysler Collection, Virginia Museum, Norfolk; Penna. Academy of Fine Art, Philadelphia; others. Has exhibited at Whitney Museum of

American Art Annual; Cambridge Art Association; Boston Athenaeum, 1981; others. Received George Widener Medal, Penna. Academy of Fine Arts, 1958; John S. Guggenheim Fellowship, 1959-61; National Institute of Arts and Letters Award and Fellowship, 1961. Member of National Sculpture Society; New England Sculpture Society; Cambridge Art Association; Provincetown Art Association; others. Works in steel. Address in 1982, Boston, MA.

GIBSON, RICHARD P.
Sculptor. Exhibited a statue, of "Clitoly," at the American Inst. in 1856. Worked out of New York City, from 1856-1858.

GICHNER, JOANNA E.
Sculptor. Born in Baltimore in 1899. Pupil of Grafly. Address in 1926, 1516 Madison Ave., Baltimore, MD.

GIL, MICHELE ACCOLTI.
Sculptor. Born in Conversano, Italy, Dec. 2, 1876. Pupil of Academy of Naples under Dorsi; of Rivalta and Zocchi in Florence. Came to America in 1903. Address in 1903, 357 West 15th St., NYC.

GILBERT, SHARON.
Sculptor. Born in New York City in 1944. Studied: The Cooper Union; The Skowhegan School of Painting and Sculpture; Brooklyn Museum. Exhibitions: Columbia University, New York, 1971; State University of New York at Albany, 1972; Whitney Museum, Art Resources Center, New York, 1974.

GILBERTSON, BORIS.
Sculptor. Born in Evanston, IL, May 7, 1907. Studied at Art Institute of Chicago. Awards: Prizes, Art Institute of Chicago, 1933, 43. Work: Sculpture reliefs, US Post Office, Fond du Lac, Janesville, WI; Dept. Interior Bldg., Washington, DC; memorial, Dubois, WY. Exhibited: Penna. Academy of Fine Arts, 1943, 44; Corcoran Gallery of Art, 1937; Whitney Museum of American Art, 1936; Art Institute of Chicago. Address in 1953, Cornucopia, WI.

GILBERTSON, WARREN ANTHONY.
Sculptor and teacher. Born in Watertown, Wis., Aug. 7, 1910. Address in 1933, Chicago, IL; Santa Fe, NM.

GILES, W. A.
Sculptor. Active 1866. Patentee—bust and clock-case, 1866.

GILHOOLY, DAVID JAMES, III.
Sculptor. Born in Auburn, CA, April 15, 1943. Studied at University of California, Davis, B.A., 1965, M.A., 1967. Work in Australia National Gallery, Canberra; Oakland Museum, CA; National Gallery, Ottawa, Ontario; Stedelijk Museum, Amsterdam; others. Has exhibited at Institute of Contemporary Art, Boston; Montreal Museum of Art; Whitney Museum of American Art Sculpture Annual; Wadsworth Atheneum, Hartford, CT; San Francisco Museum of Art; others. Member of Royal Canadian Academy. Works in clay and wood. Address in 1982, Davis, CA.

GILL, SUE MAY WESCOTT (MRS.).
Sculptor and painter. Born in Sabinal, TX. Pupil of Penna. Academy of Fine Arts, 1920-26; Julian Academy, Paris. Member: Philadelphia Alliance; Penna. Academy of Fine Arts; National Association of Women Painters and Sculptors; Ten Philadelphia Painters. Awards: Cresson Traveling Scholarship, Penna. Academy of Fine Arts, 1922; first Toppan prize, Penna. Academy of Fine Arts, 1923; honorable men., Ogunquit Art Center, 1931; Penman Memorial prize, National Association of Women Painters and Sculptors, 1932; Fellowship prize, Penna. Academy of Fine Arts, 1933. Represented in The Little Gallery, Cedar Rapids, IA. Specialty, portraits and flowers. Instructor, Summer School, Syracuse University, NY. Address in 1982, Wynnewood, PA.

GILLESPIE, JOSEPH.
Sculptor. Born in Lincoln, IL, 1871. Address in 1903, Chicago, IL.

GILLESPIE, T.
Sculptor. At Charleston, South Carolina, 1828.

GILLIES, MARY ANN.
Sculptor. Born in Grand Rapids, Michigan, in 1935. Studied: Michigan State University; Columbia University; Perugia, Italy. Exhibitions: Women's Interart Center, New York City; Community Church Gallery, New York City; Buffalo State University, New York.

GILLMORE, EDWINA S.
Sculptor. Address in 1934, Great Neck, Long Island, New York. (Mallett's)

GILMAN, BETTY.
Sculptor. Work includes "Solar Penetration," Italian alabaster, exhibited at National Association of Women Artists, NYC, 1983. Member: National Association of Women Artists. Address in 1983, 60 East End Avenue, NYC.

GINNEVER, CHARLES.
Sculptor. Born in San Mateo, CA, August 28, 1931. Studied with Zadkine and Hayter, Europe, 1953-55; California School of Fine Arts, San Francisco, B.F.A., 1957; Cornell University, M.F.A., 1959. Work in Wadsworth Atheneum, Hartford, CT; Hirshhorn Museum, Washington, DC; Storm King Art Center, Mountainville, NY; others. Has exhibited at Paula Cooper Gallery, NY; Max Hutchinson Gallery, NYC; Long Beach Museum of Art; Storm King Art Center; others. Received Guggenheim Fellowship, 1974; National Endowment Art Grant, 1975. Works in steel. Address in 1982, Putney, VT.

GIRONA, JULIO.
Sculptor. Born December 29, 1914, in Manzanillo, Cuba. Came to US in 1941. Studied: Escuela San Alejandro, Havana, 1930-34; Academie Ranson, Paris, 1935-36; Art Students' League, 1950-56, with Morris Kantor. Work: Argentina Nacional; Havana Nacional; Newark Museum; Recklinghausen; Trenton. Represented by Bertha Schaefer Gallery, NYC. Exhibited: Colegio de Arquitectos, Havana, 1934; Havana Nacional, 1947, 54; Artists' Gallery, NYC, 1953; The Bertha Schaefer Gallery, 1956,

59, 61, 63; Galerie Gunar, Dusseldorf, 1958; Werkkunstschule, Krefeld, Germany, 1963; Venice Biennial; Baltimore Museum of Art, 1956, 59, 60; Brooklyn Museum, 1959; Albright, 1959, 60; Argentina Nacional; Metropolitan Museum of Art; Houston Museum of Fine Arts; San Francisco Museum of Art; Newark Museum; Denver Art Mus.; Mus. of Modern Art; others. Awards: Newark Museum, First Prize; Havana Nacional. Address in 1970, Teaneck, NJ.

GIRONDA, R.
Sculptor and architect. Born in Brooklyn, NY, December 3, 1936. Studied at Pratt Institute, B.F.A.; National Academy of Design; Metropolitan College, B.S., 1972; Art Students League. Has exhibited at Silvermine Guild, New Canaan, CT, 1963; National Academy of Design Galleries, 1972-75; Brooklyn Museum Show, 1973-75; Caravan House, NY, 1974; others. Received first prize, Brooklyn Museum. Member of National Academy of Design; American Institute of Architecture. Media: Brass and stainless steel. Address in 1982, Brooklyn, NY.

GISCH, WILLIAM S.
Sculptor, painter, illustrator, engraver, educator, lithographer, and blockprinter. Address in 1933, Cleveland, OH.

GLASCO, JOSEPH M.
Sculptor and painter. Born in Pauls Valley, OK, January 19, 1925. Studied at University of Texas, 1941-42; with Rico Lebrun, 1946; in Mexico City, 1947; Art Students League, NY, 1948. Work in Metropolitan Museum of Art and Museum of Modern Art; Hirshhorn Museum; Whitney Museum of American Art. Exhibited: Catherine Viviano Gallery, NY; Gimpel and Weitzenhoffer Gallery, NYC; Museum of Modern Art; Whitney Museum of American Art; Metropolitan Museum of Art; Guggenheim Museum; Art Institute of Chicago, IL; Corcoran Gallery of Art; Dallas Museum of Fine Arts; Los Angeles Co. Museum of Fine Arts; others. Member of National Society of Literature and the Arts. Address in 1982, Galveston, TX.

GLASS, BILL.
Sculptor. Cherokee, born in Tahlequah, OK, 1950; raised on southwestern reservations. Studied business at Central State College, with a few art classes; researched ancient symbolism at the Tahlequah Archaeological Society; studied at Institute of American Indian Art, Santa Fe. Directed Cherokee Arts and Crafts program. Works in clay and bronze; special subject is "strong Indian women." Reviewed in *Artists of the Rockies*, fall 1979. Has exhibited at Sloan-McKinney Galleries, Tulsa, OK. Address in 1982, Locust Grove, OK.

GLASSON, LLOYD.
Sculptor and educator. Born in Chicago, IL, January 31, 1931. Studied at Art Institute of Chicago, B.F.A., 1957; Tulane University, M.F.A., 1959. Work in New Britain Museum of American Art, CT; Wichita Art Museum. Exhibited: Dorsky Gallery, NY, 1966 and 74; John Slade Ely House, New Haven, CT. Received first prizes, Art Association Regional, Delgado Museum. Member of

Sculptors Guild; Associate of National Academy of Design. Taught at University of Hartford, West Hartford, CT, from 1964, sculpture and drawing. Media: Bronze and ceramic. Address in 1982, Portland, CT.

GLEASON, WILLIAM B.
Sculptor. One of Boston's leading figurehead and ornamental carvers of the mid-19th century. Began career in 1845 in partnership with his father Samuel W. and brother Benjamin A. Gleason. Gleason was credited with many figureheads, one of the most famous being his "Minnehaha," reproduced in Pickney. He continued to work until the 1870's.

GLEASON, ADELE SCHULENBERG.
(Mrs. Charles K. Gleeson). Sculptor. Born in St. Louis, MO, January 18, 1883. Studied with George J. Zolnay; St Louis School of Fine Arts; Grafly; and in Berlin. Member: St. Louis Art Guild. Address in 1926, Kirkwood, MO.

GLEESON, JOSEPH MICHAEL.
Sculptor, painter, and illustrator. Born Dracut, Mass., February 8, 1861. Pupil of Bouguereau, Dagnan-Bouveret, Robert-Fleury in Paris. Member: Society of Illustrators. Specialty, animals. Address in 1906, 54 East 59th Street, New York, NY; h. Newfoundland, NJ.

GLEN, ROBERT.
Sculptor. Studied: Taxidermy under Coroman Tonas; Denver, Night School, Anatomy and Art. Member: Society of Animal Artists; London Zoological Society. Private Collections: H.M. Queen Elizabeth II; Late President Jomo Kenyatta. Specialties: African wildlife and humans in relationship with animals. Address in 1983, Nairobi, Kenya.

GLENNY, ALICE RUSSELL.
(Mrs. John Glenny). Sculptor and painter. Born Detroit, MI, 1858. Pupil of Chase in New York; Boulanger in Paris. Member: Buffalo Society of Artists; Art Students League of Buffalo; National Academy of Women Painters and Sculptors. Award: Prize for mural decoration, Buffalo Historical Society. Address in 1929, Raymond House, W. London, England; Buffalo, NY.

GLENNY, ANNA.
Sculptor. Born in 1888. Address in 1934, Buffalo, New York. (Mallett's)

GLICENSTEIN, ENOCH HENDRYK (ENRICO?).
Sculptor and painter. Born in Tourkeck, Russia, May 24, 1870. Studied at the Academy of Fine Arts, Munich, where he received the Prix de Rome, in 1895 and 96; l'Ecole des Beaux-Arts, Lodz, Poland, 1887. Established a residence there for several years. In 1910 he became professor at the Academy of Art, Warsaw. Moved to US in 1926. Works: Melancholy, Staedel Museum, Frankfort, Germany; Cain and Abel; statue, Jeramiah, Newark Museum, NJ; Wanderer, and Quirinal Palace, Rome, Italy; Maternity; Awakening; Messiah; Orpheus; Solitaria; Crucifixion; Serenata; Hyperion; Beggar; Musicians; San Francisco; busts of Hirzsenberg, and Daughter of d'Annunzio, National Museum, Cracow, Poland; Lord Bal-

four, Hebrew University, Jerusalem, Palestine; Prof. Orestano; Galriele d'Annunzio; Artist's Son; Count Strogonoff; portraits of Prof. Mommsen, Son, and Daughter; Dr. Ludwig Mond, Mme. E. W.; half figure, Sibilla; statue, Stornello, Kunsthalle, Bremen, Germany; head, Artist's Conception of St. Peter; St. Francis; bust, Beppe Ciardi; statue, St. Francis. Exhibited: Salon de la Societe Nationale, 1906; memorial exhibition, Petit Palais, Paris, 1949. Awards: Silver medal, Lemberg, Poland, 1893; first prize, 1894, and Prix de Rome, 1895, 1896, Academy of Fine Arts, Munich, Germany; first and second prize, Warsaw, Poland, 1897; gold medal, International Exposition, Paris, 1900; gold medal, Munich, 1905. Membership: Sztuka in Cracow, Poland; Societe Nationale des Beaux-Arts, Paris. Died in NYC, December 30, 1942.

GLICKMAN, ARTHUR.
Sculptor. Born in NYC, April 29, 1923. Studied with Issac Soyer, 1953; National Academy of Design, with Jean D. Marco and Evangelos Frudakis, 1964-68; New School for Social Research, with Bruno Luccesi, 1969. Has exhibited at Allied Artists of America, National Academy Gallery, NY, 1970, 74, 78, 80, and 81; National Academy of Design, National Academy Gallery, NY; National Sculpture Society; others. Member of Allied Artists of America; Sculptors Association of NJ. Media: Bonded bronze on plexiglas. Address in 1982, Teaneck, NJ.

GLICKMAN, MAURICE.
Sculptor, painter, teacher, writer, and lecturer. Born in Jassy, Romania, January 6, 1906. Studied at Art Students League; and abroad. Member: Sculptors Guild; Audubon Artists. Awards: Guggenheim Fellow, 1934. Work: Dept. Interior, Washington, DC; Binghamton Museum of Art; Howard University; James Monroe High School, NY; US Post Office, Ashburn, GA; South River, NJ; Northampton, PA; bas-reliefs for public buildings. Exhibited: Whitney Museum of American Art, 1937-51; Penna. Academy of Fine Art, 1939-41; Philadelphia Museum of Art, 1940; Museum of Modern Art, 1935; New York World's Fair, 1939; Morton Gallery, 1931 (one-man); Women's Club, University of North Carolina, 1941 (one-man). Contributor to: Art magazines with articles on sculpture and architecture. Position: Director, The School for Art Studies, NYC. Address in 1982, 165 East 66th St., NYC.

GLINSKY, VINCENT.
Sculptor, painter, etcher, lithographer, and teacher. Born in Russia, December 18, 1895. Studied at Columbia University; City College, NY. Exhibited: National Academy of Design, 1920, 23, 24, 44, 47-52; Architectural League, 1926, 44, 46, 50; Salon des Tuileries, Paris; Museum of Modern Art, 1930; Brooklyn Museum, 1930, 38; Museum Modern Art, 1942; Philadelphia Museum of Art, 1940, 49; Art Institute of Chicago, 1930, 32, 35, 38; Carnegie Institute, 1941; Penna. Academy of Fine Art, 1931, 39, 43, 45-52; Argent Gallery, 1950-52; others. Awards: Prizes, medals, Penna. Academy of Fine Arts, 1935, 48; Guggenheim Fellow, 1935-36; grant, American Academy of Arts and Letters and National Institute of Arts and Letters, 1945. Taught: Instructor at Brooklyn College,

Brooklyn, NY, from 1949; NY University, 1950-75. Address in 1970, 9 Patchin Place, NYC. Died in 1975.

GLINTENKAMP, HENDRICK.
Sculptor, painter, and illustrator. Born Augusta, NJ, Sept. 10, 1887. Pupil of Robert Henri; National Academy of Design. Work: Series of twelve woodblock prints, Victoria and Albert Museum, London, England; group of seven woodblock prints, Public Library, New York; group of three woodblock prints, Baltimore Museum of Art, Baltimore, MD. Address in 1933, Amenia, NY. Died in 1946.

GLOVER, ROBERT LEON.
Sculptor and painter. Born in Upland, CA, May 20, 1936. Studied at Chouinard Art Institute, 1957; Los Angeles Co. Art Institute, M.F.A., 1960. Has exhibited at San Francisco Museum of Fine Arts; Los Angeles Co. Museum; Everson Museum of Fine Arts; Pasadena Museum of Modern Art; others. Taught at Otis Art Institute, 1964-79; assistant professor of design and intermedia, ceramics and sculpture. Address in 1982, c/o SPACE Gallery, Los Angeles, CA.

GODDARD, RALPH BARTLETT.
Sculptor. Born Meadville, PA, June 18, 1861. Pupil of National Academy of Design and Art Students League of New York; Dampt in Paris. Member: National Sculpture Society, 1899. Work: Statuettes of Carlyle and of Tennyson, and bronze portrait medallions, Metropolitan Museum, New York; "Premiere Epreuve," Detroit Institute; Statue of Gutenberg, Hoe Building, New York. Address in 1933, New York City; and Madison, CT. Died April 25, 1936.

GODFREY, E.
Sculptor. At Salem, Mass., 1792.

GODWIN, FRANCES BRYANT.
Sculptor. Born in Newport, Rhode Island, in 1892. Studied at the Art Students League of NY, under James Earle Fraser and George Bridgman, and at the Colarossi Academie in Paris with M. Poisson; and also for a short time with A. Phimister Proctor in Rome. Works: Head, E. M.; horse, Cock Robin. Membership: National Arts Club. Her work has been chiefly animal sculptures, and more especially, horses.

GOELLER, E. SHATWELL (MISS).
Sculptor and painter. Born in San Francisco, CA, July 30, 1887. Pupil of Armin Fansen and Frank Van Sloun. Member: San Francisco Art Club. Address in 1918, San Francisco, CA.

GOETHE, JOSEPH ALEXANDER.
Sculptor, painter, engraver, craftsman, and writer. Born in Ft. Wayne, IN, March 1, 1912. Studied at Dayton Art Institute. Member: Santa Monica Art Guild. Awards: Fellow, Huntington Hartford Foundation, 1952. Work: Virginia Museum of Fine Arts; Evansville Public Museum; Washington County Museum of Fine Art, Hagerstown, MD; Brooks Memorial Museum; sculpture, figures, Langston Terrace Housing Project, Washington, DC; USS "Pres. Monroe;" USS "African Meteor." Exhibi-

ted: Cincinnati Mus. Assoc., 1935, 36; Art Inst. of Chicago, 1934; National Academy of Design, 1943; Hoosier Salon; Chicago Society of Independent Artists; Washington Art Club; Philadelphia Museum of Art and many one-man exhibitions. Author: "Handbook of Commercial Woods," 1938. Address in 1953, Santa Monica, CA.

GOFF, THOMAS JEFFERSON.
Sculptor and medalist. Born in Bristol, RI, December 22, 1907. Studied at Rhode Island School of Design, 1930-34; with Louise A. Atkins, Hugo O. E. Carlborg, and William A. Heath. Work in US Naval Museum, Washington, DC; Smithsonian Institution; Newport News Museum, VA; US Naval War College Museum, Newport, RI; plus bronze seals; others. Has exhibited at National Sculpture Society; Bristol Art Museum; others. Member: Society of Medalists, Danbury, CT; Orders and Medals Society of America. Works in wax, modeling clay, plaster, bronze, and die steel. Address in 1982, Bristol, RI.

GOITEIN, OLGA.
Sculptor. Born in Vienna, Austria. Studied at Boston Museum of Fine Arts School; Brooklyn Museum School of Art; Scuola Rossi, Paris. Works: Bezalel Museum, Jerusalem. Awards: Brooklyn Society of Art, 1949, 51; New Haven Paint and Clay Club, 1949, 51, 52. Address in 1953, Orange, CT.

GOLD, MARTHA B.
Sculptor. Born in NYC, September 20, 1938. Studied at University of Rochester; Barnard College, Columbia University, B.A.; Columbia University, M.A.; National Academy School of Fine Arts. Has exhibited at National Academy of Design, NY; North American Sculpture Annual, Foothills Art Center, Golden, CO; Allied Artists of America, American Academy Institute of Arts and Letters; National Sculpture Society Annual. Received awards from Audubon Artists; National Sculpture Society; Allied Artists of America. Member of Allied Artists of America. Works in bronze. Address in 1982, c/o National Academy of Design, NYC.

GOLDBECK, WALTER DEAN.
Sculptor, painter, and etcher. Born in St. Louis, MO, 1882. Award: Cahn honorable mention, Art Institute of Chicago, 1911. Died in 1925.

GOLDE, R. P.
Sculptor. Born in Germany. Came to US in 1884. Pupil of Prof. Schilling in Dresden. Address in 1910, 41 West 21st St., NYC.

GOLDFINGER, ELIOT.
Sculptor. Born in NYC, August 14, 1950. Studied: Pratt Institute, B.F.A., 1974; National Academy School, NY, 1977-78. Work: Museum of Natural History; Bust of Mayor John Lindsay, Mayor Abe Beame, Mayor Robert Wagner, Mayor Ed Koch, all in Museum City of NY; others. Exhibited: Allied Artists of America, NY; National Academy of Design, NY; Salmagundi Club, NY; National Sculpture Society; others. Awards: Gloria Medal, National Sculpture Society; Elliot Liskin Prize, Salmagundi Club; Debellis Prize, Salmagundi Club. Member: National Sculpture Society; Salmagundi Club. Media: Plas-

tillene and bronze. Address in 1982, 370 Columbus Ave., NYC.

GOLDNER, JANET.
Sculptor. Born in Washington, DC, 1952. Study: Asgard School, Denmark, 1971; Penland School, NC, 1972; Experiment in International Living, VT; independent study of arts in West Africa, 1973; Antioch College, B.A. Art, 1974; NYU, M.A. Sculpture, 1981. Work: Terry Gallery, Sudbury, MA; Rockrose Development Corp., NYC; many private collections and commissions. Outdoor sculpture: Austerlitz, NY, 1981; Bethesda, MD, 1981, 82; Wilton, CT, 1982. One-person shows: Stamford Museum, CT, 1977, 80; Washington Square E. Gallery, NYC, 1978, 80; Phoenix Gallery, NYC, 1983. Exhibitions: Concord Art Association, MA, 1975; Worcester Craft Center, MA; Bell Gallery, Greenwich, CT, 1977; Phoenix Gallery, NYC, 1981, 82; Cable Artists, NYC, 1982. Award: Millay Colony for the Arts, NY; Ossabow Island Project, GA; VA Center for the Creative Arts, Sweet Briar; Yaddo, Saratoga Springs, NY. Media: Fibers, wire mesh, copper, wire, metal, found objects. Address in 1983, 77 Bleeker St., NYC.

GOLDTHWAITE, ANNE.
Sculptor, painter, etcher, and lithographer. Born c. 1875. Studied: National Academy of Design in NY and at the Academie Moderne in Paris. Collections: Metropolitan Museum of Art, NY; Whitney Museum of American Art, NY; Rhode Island School of Design; National Collection of Fine Arts, Washington, DC. Commissions: Over two hundred prints; fired clay sculpture; murals for the state of Alabama. Member: President, New York Society of Women Artists, 1937-38. Taught: New York Art Students League for more than twenty-three years. Specialty: Southern scenes, portraits, still lifes, and landscapes. Address in 1933, Montgomery, AL. Died in 1944.

GOLUBIC, THEODORE.
Sculptor and designer. Born in Lorain, OH, December 9, 1928. Studied at Miami University, B.F.A.; Art Students League; with Jon Corbino; Notre Dame, M.F.A.; assistant to Ivan Mestrovic. Has exhibited at National Academy of Design, NY; Detroit Institute of Arts; Penna. Academy of Fine Arts, Philadelphia; Ball State University; National Sculpture Society. Address in 1982, Phoenix, AZ.

GONZALES, CARLOTTA.
(Mrs. Richard Lahey). Sculptor, painter, teacher, and illustrator. Born in Wilmington, NC, April 3, 1910. Studied at Penna. Academy of Fine Arts, with Laessle; National Academy of Design, with Aitken; Art Students League, with Laurent, Karfiol. Member: Society of Independent Artists; Ogunquit Museum of Art. Exhibited: Corcoran Gallery of Art, 1939, 50, 51; Montclair Art Museum, 1952; National Academy of Design, 1931. Illustrated, "Stars in the Heavens;" "USA and State Seals." Position: Staff artist, National Geographic Magazine, Washington, DC, from 1943. Address in 1982, Vienna, VA.

GONZALEZ, XAVIER.
Sculptor and painter. Born in Almeria, Spain, February 15, 1898. Became a US citizen. Studied at Art Institute of

Chicago, 1921-23; studied at museums in Europe, 1937-38, worked in Paris, where he came in contact with art world; assistant to the Spanish painter, Jose Arpa. Awards: St. Boltoph Club of Boston, Dana and Dawson medals, a Guggenheim Fellowship, 1949; Ford Foundation Grant, 1965; gold medal and the 79th Artist Annual Award, National Art Club of NY, 1978; plus others. Member: American Watercolor Society; American National Academy; National Association of Mural Painters (president), 1968. Taught: Newcomb College for Women of Tulane University, New Orleans, LA, 1930-42; art instructor at the Brooklyn Museum, 1945; lecturer at the National College Association, 1946; Western Reserve University, 1953-54; Summer School of Art, Wellfleet, MA; lecturer at the Metropolitan Museum of Art, NY; instructor at Art Students League. Has done mural commissions in Alabama, Texas, and Louisiana. Address in 1982, 222 Central Park South, NYC.

GOO, BENJAMIN.
Sculptor and painter. Born in Honolulu, HI, July 12, 1922. Studied at State University of Iowa, B.F.A., 1953; Cranbrook Academy of Art, M.F.A., 1954; Brera Academy of Fine Art, School of Marino Marini, Milan, Italy, 1954-55. Work: Roswell Museum and Art Center, NM; Phoenix Art Museum, AZ; others. Has exhibited at Silvermine Guild Artists, New Canaan, CT; Penna. Academy of Fine Arts; Detroit Institute of Art; San Francisco Museum of Art; Museum of Contemporary Crafts, NY; others. Teaching at Arizona State University, from 1955, professor of art. Works in metals and stone. Address in 1982, Tempe, AZ.

GOODACRE, GLENNA.
Sculptor and painter. Born in Lubbock, Texas, August 28, 1939. Studied at Colorado College, B.A.; Art Students League. Works: Texas Technical Museum, Lubbock; Presbyterian Hospital, Denver, CO; Diamond M. Foundation Museum, Snyder, TX. Commission: Bronze bust of Dr. W. C. Holden, Texas Technical University, 1972; bronze of Dan Blocker, City Center, Odonnell, TX, 1973; bronze of J. Evetts Haley, Haley Library, Midland, TX, 1973; bronze of C. T. McLaughlin, Diamond M. Foundation, 1973; bronze relief of Dr. Kenneth Allen, Presbyterian Hospital, Denver, CO, 1975. Exhibitions: Catharine Lorillard Wolfe Art Club, NY, 1972; Texas Fine Arts National Show, Austin, 1973; West Texas National Watercolor Show, Museum Texas Technical University, 1973; Allied Artists of America, NY, 1974; National Academy of Design, NY, 1975. Awards: Catharine Lorillard Wolfe Art Club Cash Award for Oil Portrait, NY, 1972; Allied Artists of America. Award for Sculpture, NY, 1974. Media: Oil, pastel, watercolor; bronze. Address in 1982, Boulder, CO.

GOODE, JOE (or JOSE BUENO).
Sculptor and painter. Born in Oklahoma City, OK, 1937; went to California in 1958. Studied: Chouinard Art Institute, Los Angeles, 1959-61. One-man exhibitions: Dilexi Gallery, San Francisco, 1962; The Fine Arts Patrons of Newport Harbor, Pavilion Gallery, Balboa, CA, 1968; Fort Worth Art Center Museum, TX, 1972. Group exhibitions: Six More, Los Angeles County Museum of Art,

1963; Ten From Los Angeles, Seattle Art Museum Pavilion, Washington, 1966; Surrealism is Alive and Well in the West, Baxter Art Gallery, California Institute of Technology, Pasadena, 1972; American Pop Art, Whitney Museum of American Art, NY, 1974. Address in 1977, Hollywood, CA.

GOODELMAN, AARON J.
Sculptor, illustrator, etcher, lecturer, and teacher. Born in Russia, April 1, 1890. Pupil of G. T. Brewster; J. Injalbert. Member: Plastic Club; Society of Independent Artists. Awards: Bronze medal, Society of Beaux Arts Architecture, 1914, 1915, 1916. Work: Portrait bust of Ansky, Classic Theatre; "The Golem," Gabel's Theatre; "Sholem Alachem," Sholem Alachem Folks' Institute; "Relief," Hospital for Joint Diseases, all in New York. Illustrated for *Kinter Journal* and *Kinter Land*. Taught: Chairman of Art Dept., instructor of sculpture, Jefferson School for Social Science, NYC, 1946-52. Address in 1953, NYC. Died in 1978.

GOODMAN, ESTELLE.
Sculptor. Born in NYC. Studied at Barnard College, B.A. Work: Norfolk Museum Art, VA; also private collections in US and England. Exhibitions: Allied Artists; Audubon Artists; Fordham University; Union College; Pace College; others. Awards: Prizes, Painters and Sculptors of NJ, 1963 and 67; Yonkers Art Association; Vermont Art Center; plus others.

GOODNIGHT, VERYL.
Sculptor and painter. Born in Denver, CO, 1947. Largely self-taught. Opened own studio in 1967. Works published: Represented in "Brush With The West" by Dale Burke. Two limited edition lithographs entitled "Pronghorn" and "New Leader In Ten Minutes." Sculpture-28 different castings—limited editions. Exhibited: Driscol Gallery, Denver; Fenn Gallery, Santa Fe; Trailside Galleries, Scottsdale and Jackson, WY; Collector's Covey, Dallas, TX; New York Game Conservation, San Antonio; Northwest Rendezvous group, Helena, MT; Peking, China, show. Awards: Two Gold Medal Awards Wildlife Artists International 1978 and 1979; 1980 Allied Artists of America (Pietro & Alfreda Montana Award). Member: Society of Animal Artists; Allied Artists of America. Media: Bronze; oil. Specialties: North American Wildlife and waterfowl; horses. Reviewed in *Southwest Art*, July 1977; *Art West*, December 1980. Address in 1983, Englewood (Denver), CO.

GOODRICH, ALICE D.
Sculptor. Born in 1881. Died in Brooklyn, New York, September 30, 1920. (Mallett's)

GOODSTEIN, BARBARA.
Sculptor. Studied: Tyler School of Art, 1967; Plymouth College of Art and Design, England, 1968-69; University of Guadalajara, MX, 1969; NY Studio School, 1971-72; Pennsylvania State University, 1966, B.A.; Queens College, City University of NY, 1974, M.F.A. Exhibitions: Queens College, NYC; NY University; Tyler Faculty Show; International Festival of Women Artists, Copenhagen, Denmark; Anti-War Art Show, San Francisco; Bo-

wery Gallery, NYC; others. Awarded: Fellowship, Pennsylvania State University, 1965; Scholarship, New York Studio School, 1971-72; Graduate Assistantship, Queens College, 1973-74; Merrill Foundation Grant for Sculpture, 1979; Yaddo Artists Colony Residency; Cummington Art Community Residency, 1983. Taught: Tyler School of Art, Temple University, 1976-77; instructor, Philadelphia College of Art, modeling, 1978-81; instructor, University of Vermont, modeling, 1981-82; also held numerous workshops and lectures from 1974-80 on various topics. Noted work includes "One Pose-Two Views," fired clay; "Back to Back #1-5," a series of reliefs. Works chiefly in clay and plaster. Address in 1984, Woodside, NY.

GOODWIN, FRANCES M.
Sculptor. Born in Newcastle, IN. She studied art in Indianapolis, IN, and later at the Chicago Art Institute, where she became interested in modeling. Later abandoned her intention of becoming a painter in order to study sculpture. She studied at the Art Students League, New York, with D. C. French as instructor. Except as stated she was self-taught. Among her works are: Statue representing Indiana, for Columbian Exposition; bronze bust of Capt. Everett, Riverhead Cemetery, New York; marble bust of Schuyler Colfax, Senate gallery; bust of Robert Dale Owen for the State House at Indianapolis, IN. Died 1929 in Newcastle, IN.

GOODYEAR, JOHN L.
Sculptor, painter, and kinetic artist. Born October 22, 1930, in Los Angles, CA. Studied: University of Michigan (with Richard Wilt, Chet LaMore, Gerome Kamrowski), B.Design, 1952, M.Design, 1954. Work: Museum of Modern Art; NYU; Newark Museum; Chrysler; Whitney Museum; Corcoran; Guggenheim. Exhibited: The Amel Gallery, NYC, 1964-66; Museum of Modern Art, The Responsive Eye, 1965; Harvard University, 1965; Whitney Museum, Art of the US, 1966; Walker and Milwaukee, Light Motion Space, 1967; Albright; Whitney Museum; Newark Museum, 1969; MIT. Awards: Graham Foundation Fellowship, 1962, and 1970; MIT fellow, 1970-71. Address in 1982, Art Dept., Rutgers University, NJ.

GORBUTT, JOHN D(ETWILER) JR.
Sculptor and painter. Born in Troy, Kansas, October 20, 1904. Studied with V. Helen Anderson. Work: "Portrait of Justice E. R. Sloan," property of the State of Kansas. Award: Kansas Free Fair, 1932. Member: Topeka Artist Guild. Address in 1933, Topeka, Kansas.

GORDIN, SIDNEY.
Sculptor. Born October 24, 1918, in Cheliabinsk, Russia. Studied: Cooper Union, 1937-41, with Morris Kantor, Wallace Harrison, Leo Katz. Work: Art Institute of Chicago; Newark Museum; Chrysler; Southern Illinois University; Whitney Museum. Exhibited: Grace Borgenicht Gallery Inc., 1953, 55, 58, 60, 61; New School for Social Research, 1957; Dilexi Gallery, San Francisco, 1959, 63, 65; de Young, 1962; Los Angeles County Museum of Art, 1963; Metropolitan Museum of Art, 1951; Whitney Museum of American Art Annuals, 1952-57; Museum of Modern Art; Art Institute of Chicago; Penna. Academy of Fine Arts; Brooklyn Museum; Newark Museum; San Francisco Museum of Art; Tulsa (Philbrook). Taught: Pratt Institute, 1953-58; Brooklyn College, 1955-58; New School for Social Research, 1956-58; Sarah Lawrence College, 1957-58; University of California, Berkeley from 1958. Commissions for Temple Israel, Tulsa, OK, 1959; Envoy Towers, 300 East 46 Street, NYC, 1960. Address in 1982, c/o Anglim Gallery, San Francisco, CA.

GORDON, BERNARD.
Sculptor. Member: Fellowship Penna. Academy of Fine Arts. Address in 1924, c/o The Penna. Academy of Fine Arts, Philadelphia, PA.

GORDON, ELIZABETH.
Sculptor. Born in St. Louis, MO, in 1913. Studied: The Lenox School; sculpture with Walter Russell, Edmondo Quattrocchi. Awards: Brooklyn War Memorial Competition, 1945; Catherine L. Wolfe Art Club, 1951, 1958; Pen and Brush Club, 1954; National Academy of Design, 1956; gold medal, Hudson Valley Art Association, 1956; Pen and Brush Club, 1957. Collections: The Lenox School, NY; Aircraft Carrier "U.S.S. Forrestal;" James L. Collins Parochial School, TX; Woodstock Cemetery; Kensico Cemetery, NY; James Forrestal Research Center, Princeton University.

GORDON, JOHN S.
Sculptor and educator. Born in Milwaukee, WI, November 16, 1946. Studied at Antioch College, B.A., 1970; Claremont Graduate School, M.F.A., 1973. Has exhibited at Whitney Museum of American Art; Long Beach Museum of Art; Los Angeles Institute of Contemporary Art; San Francisco Art Institute Gallery; others. Received awards from National Endowment for the Arts; others. Works in steel and wood. Address in 1982, Inglewood, CA.

GORDON, LEON.
Sculptor. Born in Bonsor, Russia, 1888. Pupil of Art Institute of Chicago; Art Students League, NYC; Julian Academy; Kunst Academy, Vienna. Member: Salmagundi Club; Society of Artists. Address in 1933, 80 West 40th Street, NYC.

GORDON, WINIFRED.
Sculptor. Award: Therese and Edwin H. Richard Memorial Prize, 1969 (Honorable Mention), National Sculpture Society.

GORI, OTTAVIANO.
Sculptor. Worked: NYC, 1841-59; San Francisco, from 1861. Exhibited: American Institute, 1842. Media: Marble and alabaster.

GORIG, MYRA.
Sculptor. Born in New York City in 1943. Studied: Fashion Institute of Technology; The Art Students League, New York City; Munich Germany Art University. Exhibitions: Croquis Gallery, New York City; Erotic Art Gallery, New York City. Awarded a prize in the Munich Art Academy Exhibition.

GORSKI, BELLE SILVERA (MRS.).
Sculptor and painter. Born in Erie, Penn., 1877. Worked: Chicago.

GORSKI, DANIEL ALEXANDER.
Sculptor and painter. Born in Cleveland, OH, October 26, 1939. Studied at Cleveland Institute of Art, dipl.; Yale University School of Art and Architecture, with Jack Tworkow and Al Held, B.F.A., 1962 and M.F.A., 1964. Work at Yale University. Has exhibited Primary Structures, Jewish Museum, NY; Aldrich Museum, Ridgefield, CT; Baltimore Museum of Art; Sculpture Outdoors, Temple University; others. Received Horelick Award, Baltimore Museum; Ford Foundation Grant. Address in 1982, Seven Valleys, PA.

GOSSELIN, LUCIEN H.
Sculptor. Born Whitefield, NH, Jan. 2, 1883. Pupil of Verlet, Bouchard, Landowski, and Mercie. Member: Societe Libre des Artistes Francais. Award: Honorable mention, French Artists Salon, 1913. Address in 1933, Paris, France; h. Manchester, NH.

GOTO, JOSEPH.
Sculptor. Born January 7, 1920, in Hilo, Hawaii. Studied: Chicago Art Institute School; Roosevelt University. Work: Art Institute of Chicago; Indiana University; Museum of Modern Art; University of Michigan; Union Carbide Corp. Exhibited: Allan Frumkin Gallery, NYC and Chicago, 1962; Stephen Radich Gallery, NYC 1964, 65, 67; Art Institute of Chicago; Carnegie Institute; University of Illinois; Speed Art Museum, Louisville; Whitney Museum; Rhode Island School of Design; and many more. Awards: Art Institute of Chicago, 1957; Graham Foundation Fellowship, 1957; John H. Whitney Fellowship; Art Institute of Chicago, Watson F. Blair Prize; Art Institute of Chicago, Logan Prize; Art Institute of Chicago, Palmer Prize; J. S. Guggenheim Fellowship, 1969. Address in 1982, Providence, RI.

GOTT, JOHN.
Sculptor. Born in 1785. Worked: Albany, NY; NYC. Noted work: Bust of General Fremont. Exhibited: American Institute, 1856. Died in 1860.

GOTTHOLD, ROZEL.
Sculptor, painter, craftsman, and writer. Born in New Orleans, LA, January 26, 1886. Inventor of palm baskets. Address in 1921, New Orleans, LA.

GOULD, JANET.
Sculptor. Born in Roumania, June 5, 1899. Studied with A. Finta, Charles Neilson. Member: League of Present-Day Artists; Creative Arts; NY Ceramic Arts. Awards: Prizes, Asbury Park Art Association, 1940; Springfield Museum of Art, 1950. Exhibited: National Academy of Design, 1940, 42, 44; Asbury Park Art Association, 1940; Cincinnati Museum, 1943; Hartford, CT, 1942; Art Institute of Chicago, 1943, 47; Riverside Museum, 1944, 48; Ferargil Gallery, 1946; Barbizon Plaza (one-woman); Penna. Academy, 1946, 47; Audubon Artists, 1945; Irvington Free Library, 1946; Springfield Art Museum, 1948, 50; Fairmont Art Association, 1949. Address in 1953, 315 West 36th St.; h. 235 West 22nd St., NYC.

GOULD, STEPHEN.
Sculptor and collector. Born in NYC, December 25, 1909. Studied at New School for Social Research, with Manola Pascal. Has exhibited at National Exhibition of Professional Artists, NY; Salmagundi Club; National Society of Arts and Letters Exhibition, Metropolitan Museum of Art, NY, 1979. Member of Royal Society of Arts; National Society of Arts and Letters; Artists Equity Association; Salmagundi Club. Works in clay. Address in 1982, Tamarac, FL.

GOULD, THOMAS RIDGEWAY.
Sculptor. Born in Boston, Nov. 5, 1818. He studied with Seth Cheney. His two colossal heads of "Christ" and "Satan" were exhibited at the Boston Athenaeum in 1863. His most celebrated statue was the "West Wind;" among his portrait busts are those of Emerson, Seth Cheney, and the elder Booth. Opened studio in Florence in 1868 where lived most of his life. He died Nov. 26, 1881, in Florence, Italy.

GOULET, LORRIE.
(Lorrie J. de Creeft). Sculptor and teacher. Born in Riverdale, NY, Aug. 17, 1925. Studied at Inwood Pottery Studios, 1932-36, with Amiee Voorhees; Black Mountain College, NC, with Joseph Albers; sculpture with Jose de Creeft, 1943-44. In collections of Hirshhorn, Washington, DC; NJ State Museum; others. Commissions for NY Public Library; Bronx Municipal Hospital; Bronx Police and Fire Station. Exhibited at Clay Club Sculpture Center, NYC, 1948, 55; American Federation of Arts, 1963; World Trade Fairs, Algiers, Barcelona, Zagreb, 1964; Contemporary Gallery, NYC, 1959, 62, 66, 68; Kennedy Galleries, NYC, 1971, 73-75, 78, 80; many more. Taught at Museum of Modern Art, 1957-64; New School for Social Research, 1961-75; Art Students League, 1981; others. Awards: First Sculpture Prize, Norton Gallery, 1949, 50, and Westchester Art Society, 1964; Soltan Engel Memorial Award, Audubon Artists, 1967. Member of Sculptors Guild; Audubon Artists; founding member, Visual Artists and Galleries Association; National Commission on Art Education; others. Works in wood, stone, ceramics. Represented by Kennedy Galleries, NYC. Address in 1982, 241 West 20th St., NYC.

GRABACH, JOHN R.
Sculptor and painter. Born in Newark, NJ, March 2, 1886. Pupil of Art Students League of NY. Member: League of NYA; Society of Independent Artists; Audubon Artists; Philadelphia Water Color Club. Exhibited: Corcoran Gallery of Art., 1931, 33, 35, 41; Art Institute of Chicago; Montclair Art Museum. Position: Instructor of Art, Newark School of Fine and Industrial Art. Died in 1981. Address in 1953, Irvington, NJ.

GRAFLY, CHARLES.
Sculptor. Born Dec. 3, 1862, in Philadelphia, PA. Pupil of Penna. Academy of Fine Arts, and Chapu and Dampt, Paris. Member of International Jury of Awards, St. Louis Exp., 1904; Municipal Art Jury, Philadelphia National Academy, 1906; National Institute of Arts and Letters; National Sculpture Society; Architectural League; Philadelphia Art Club; Penna. Academy of Fine Arts. Repre-

sented in permanent collections of Penna. Academy of Fine Arts; Detroit Art Museum; St. Louis Museum; Carnegie Institute, Pittsburgh; Boston Museum. Executed a large number of notable pieces in busts, life size; colossal figures, portrait, and ideal figures, groups, largely in bronze. Received awards at Paris Salon, 1891; Penna. Academy of Fine Art, 1892; Columbian Exp., Chicago, 1893; Atlanta Exp., 1895; Penna. Academy of Fine Arts, 1899; International Exp., Paris, 1900; Pan-Am. Exp., Buffalo, 1901; Buenos Aires Exp., 1910; Philadelphia Water Color Club, 1916; George D. Widener gold medal, 1913; Watrous gold medal, National Academy, 1918; and Palmer Gold Medal, Art Institute of Chicago, 1921. Exhibited at National Sculpture Society, 1923. Address in 1926, Philadelphia, PA. Died May 5, 1929, in Philadelphia, PA.

GRAHAM, CECILIA BANCROFT.
Sculptor. Born San Francisco, CA, March 2, 1905. Pupil of Louis de Jean, Oskar Thiede, Nicolo D'Antino. Address in 1929, Berkeley, CA; summer, Stateline, Lake Tahoe, CA.

GRAHAM, JOHN D.
Sculptor and painter. Born Kiev, Russia, Dec. 27, 1891. Pupil of John Sloan. Work: Sixteen paintings, Phillips Memorial Gallery, Washington, DC; painting, Spencer Kellog collection, New York; five paintings, Ben Hecht collection, New York. Author: "System and Dialectics of Art," 1937. Address in 1953, NYC. Died in 1961.

GRAHAM, PAYSON (MISS).
Sculptor and illustrator. She was a member of Art Students League of New York. Address in 1926, 251 West 81st St., New York.

GRAHAM, ROBERT.
Sculptor. Born August 19, 1938, in Mexico City, Mexico. US citizen. Studied: San Jose State College; San Francisco Art Institute, 1963-64, MFA. Work: Cologne; Pasadena Art Museum; Whitney Museum; Museum of Modern Art; plus many more. Exhibited: Nicholas Wilder Gallery, LA, 1964, 65, 69; Thelen Gallery, Essen, West Germany, 1967; The Kornblee Gallery, 1968, 69; Whitney Museum, 1967, 69; Washington Univ. (St. Louis), Here and Now, 1969; Walker Art Center travel exhibition, 1981; Robert Miller Gallery, NYC, 1982. Address in 1982, Venice, CA.

GRAHAM, WALTER.
Sculptor and painter. Born in Toledo, IL, Nov. 17, 1903; raised in Chicago. Studied at Chicago Academy of Fine Arts; Chicago Art Institute; privately. Illustrated for Street and Smith Publishers; painted cover art for magazines (*Western Story, Western Life, Appaloosa News*, etc.). Owner of Nugent Graham Studios (commercial art), 1939-50. Turned to fine art full-time in 1950. Work in Central Washington Museum, Wenatchee; Favell Museum, Oregon; murals for ships, State of Alaska; others. Exhibited at Russell Museum, Great Falls, MT; Society of Animal Artists Exhibition, Columbus (OH) Gallery; Art Institute of Chicago; others. Awarded first prize, Chicago Galleries; gold medal, Palette and Chisel Academy, Chi-

cago; honorable mention, Seattle Art Director's Club. Member of Society of Animal Artists. Specialty is animals and Western historical subjects. Works in bronze; oil, watercolor. Bibliography, *Western Painting Today*. Address in 1982, Wenatchee, WA.

GRAND, THOMAS.
Sculptor. At New Orleans, 1818.

GRANDEE, JOE RUIZ.
Sculptor and painter. Born in Dallas, TX, Nov. 19, 1929. Studied at Aunspaugh School of Art, Dallas. Operated ranch; turned full-time to art in 1956. Represented in the White House, Washington, DC; Montana State Historical Society; commissions include wedding portrait of Linda Bird and Chuck Robb, portrait of Texas Ranger for Richard Nixon, and others. Has exhibited at Amon Carter Museum, Ft. Worth, TX; El Paso (TX) Museum of Fine Arts; US Capitol (first comprehensive exhibition of a Western artist); and many more. Selected first Official Artist of Texas; also awarded Franklin Mint gold medal in Western art, and many others. Specialty is Old West subjects. Has illustrated a number of books; biography is *The West Still Lives*, by Schultz. Represented by Corpus Christi Art Gallery, Corpus Christi, TX; One Main Gallery, Dallas, TX. Address in 1982, Arlington, TX.

GRANDY, WINFRED MILTON.
Sculptor. Born in Preston, CT, Sept. 20, 1899. Studied with Burdick, Yale School of the Fine Arts. Awards: Honorable mention, University of Tennessee, Knoxville, TN, 1931; first prize, garden figure, Mass. Agricultural/Horticultural Show, 1932. Address in 1933, New Haven, CT; summer, "The Studio," Short Beach, CT.

GRANLUND, PAUL THEODORE.
Sculptor and educator. Born October 6, 1925, Minneapolis, MN. Studied: Gustavus Adolphus College, 1952, BA; University of Minnesota; Cranbrook Academy of Art, 1954, MFA. Work: Cranbrook Acad. of Art; Minneapolis Institute; Virginia Museum of Fine Arts; Walker; plus others. Exhibited: Minneapolis Institute, 1959; Walker, 1956; Allan Frumkin Gallery, Chicago, 1959, 66, 68, NYC, 1960, 63; Esther Robles Gallery, 1962, Los Angeles; California Palace, 1962; American Academy, Rome, 1959; University of Illinois, 1961; Cincinnati Art Museum, 1961; Corcoran, 1961; Albright, 1962; Minneapolis School of Art, Art of Two Cities, 1965; plus more. Awards: Cranbrook, George A. Booth Scholarship, 1953; Fulbright Fellowship, 1954; Guggenheim Foundation Fellowship, 1957, 58. Taught: Cranbrook Academy of Art, 1954; Minneapolis Institute School, 1955-71; University of California, summer, 1959. Address in 1982, c/o Gustavus Adolphus College, St. Peter, MN.

GRANT, J. JEFFREY.
Sculptor and painter. Born in Aberdeen, Scotland, April 19, 1883. Studied in Aberdeen; Munich, Germany. Work in Springfield Museum of Art; Municipal Art League, Chicago; others. Exhibited at National Academy of Design; Corcoran; Pennsylvania Academy of Fine Arts; Art Institute of Chicago. Won awards at Art Institute of Chicago; Palette and Chisel Academy. Member of Associa-

tion of Chicago Painters and Sculptors; Palette and Chisel Academy; Chicago Art Club; others. Listed as painter in 1953. Address in 1934 and 1953, Chicago, IL.

GRANT, JAMES.
Sculptor. Born in Los Angeles, CA, 1924. Studied at University of Southern California, B.Ed., 1945, M.F.A., 1950; Jepson Art Institute, Los Angeles, 1947-49. Work in San Francisco Museum of Art; Pasadena Art Museum, CA; others. Has exhibited at Los Angeles Co. Museum of Art; Museum of Modern Art, NY; de Young Memorial Museum, San Francisco, CA; Hansen Gallery, San Francisco; many more. Address in 1982, c/o Hansen-Fuller Gallery, San Francisco, CA.

GRASSI, ANDREA.
Sculptor. Born in Massa Carrara, Italy, 1938. Studied: Accademia di Belle Arti, Carrara, Italy; also the Academie des Beaux-Arts, Paris, France. Collections: Musee d'Art Moderne, Paris; Roswell Museum, Roswell, NM; the Musee de Cholet, Cholet, France; also private collections throughout Europe and US. Exhibited: Zabriskie Gallery, NYC, 1963, (group show); Collective Exhibition of the Galleries of Lisbon, Portugal, 1971; Galerie L. 55, Paris, 1973; Musee de Tesse, Le Mans, France, 1974; IE Gallery, Copenhagen, Denmark, 1977; Roswell Museum, Roswell, NM, 1978; Opening Gallery, NYC, 1979; Rizzoli Gallery, NYC, 1982; Sculture nella citta, Forte dei Marmi, Italy; permanent outdoor sculpture show, Forte dei Marmi, Italy. Address in 1984, 118 St. Marks Place, NYC.

GRAUSMAN, PHILIP.
Sculptor. Born in NYC, July 16, 1935. Studied at Syracuse University, B.A., 1957; Skowhegan School of Painting and Sculpture, summers 1956 and 57; Cranbrook Academy of Art, M.F.A., 1959; Art Students League, with Jose de Creeft, 1959. Work in Brooklyn Museum; Wadsworth Atheneum, Hartford; Akron Art Institute, OH; Baltimore Museum of Art; Munson-Williams-Proctor Institute, Utica; Jewish Museum, NYC. Has exhibited at Penna. Academy of Fine Arts; Grace Borgenicht Gallery, NY; Whitney Museum of American Art; Yale University Art Gallery; Wadsworth Atheneum; Museum of Modern Art, NY; others. Received gold medal sculpture, Audubon Artists, 1958; Louis Comfort Tiffany Foundation grant; National Institute of Arts and Letters Grant, 1961; Ford Foundation Purchase Grant, 1961; Steel Memorial Prize, Penna Academy, 1962; Prix de Rome Fellowship, 1962-65. Taught at Cooper Union, 1965-67, instructor of design; Pratt Institute, 1956-69, instructor of design and drawing; Yale University, 1973-76, visiting assistant professor. Works in cast metal. Address in 1982, c/o Grace Borgenicht Gallery, NYC.

GRAVES, BRADFORD.
Sculptor and educator. Born in Dallas, TX, July 26, 1939. Studied at School of Visual Arts; New School for Social Research, with Seymour Lipton; Goddard College, B.A. and M.A. Work in NJ State Museum, Trenton; Corcoran Gallery, Washington, DC; Weatherspoon Art Gallery, University of North Carolina; plus highway sculpture. Has exhibited at Storm King Art Center, Mountainville,

NY; NJ State Museum, Trenton; Whitney Counterweight, NY; others. Works in stone sculpture and stone earthworks. Address in 1982, c/o Patricia Hamilton, 20 W. 57th St., NYC.

GRAVES, NANCY STEVENSON.
Sculptor and painter. Born in Pittsfield, MA, Dec. 23, 1940. Studied at Vassar College, Poughkeepsie, NY, 1958-61, BA; School of Art and Architecture, Yale University, New Haven, CT, 1961-64, BFA, MFA, 1964. In 1966, travelled to Florence, Italy; studied sculpture. Began her filming career in 1969 in NYC. Exhibited: Graham Gallery, NYC, 1968; Whitney Museum, NYC, 1969; National Gallery of Canada, Ottawa, 1970; Gallery Reese Palley, NYC; New Galerie der Stadt Aachen, Germany (for film); Vassar College, Poughkeepsie, NY; Museum of Modern Art, NYC; Yale University, New Haven, CT; Pratt Institute, NYC, all in 1971; Institute of Contemporary Art, University of Penna., Philadelphia, (films) 1972; Albright-Knox Art Gallery, Buffalo, 1974. Group shows include The School of Visual Arts, NYC, 1971; Corcoran Gallery of Art, Washington, DC, 1971; American Women Artists Kunsthause, Hamburg, West Germany; Indianapolis Museum of Art, 1972; Documenta V, New Galerie, Kassel, Germany, 1972; Stadtischen Kunsthalle, Dusseldorf, West Germany; and Louisiana Museum, Vancouver Art Gallery, British Columbia, Canada, 1977. Awards: Fulbright-Hayes Grant in painting, Paris, 1965; Vassar College Fellowship, 1971; National Endowment for the Arts Grant, 1972. Works with fetish assemblage sculpture using acrylic, fur, feathers, and metal. Address in 1982, 69 Wooster Street, NYC.

GREEN, DAVID OLIVER.
Sculptor and educator. Born in Enid, OK, June 29, 1908. Studied at American Academy of Art; National Academy of Art. Work in Los Angeles Co. Museum of Natural History, CA. Has exhibited at Los Angeles Co. Museum Art Annual; Tucson Art Center, AZ; Laguna Beach Art Gallery, CA; others. Taught at Otis Art Institute, 1947-73, assistant professor of sculpture. Received first prize for sculpture, Laguna Beach Art Association; Pasadena Society of Artists. Member of International Institute of Arts and Letters; Pasadena Society of Artists; Society of Italic Handwriting; Society of Calligraphy, Los Angeles. Works in stone and wood. Address in 1982, Altadena, CA.

GREEN, GEORGE THURMAN.
Sculptor and painter. Born in Paris, TX, May 10, 1942. Studied at Texas Technological University, B.A., 1965; University of Dallas, M.A., 1968; Kansas City Art Institute, MO. Work in Oklahoma Art Center Museum, Oklahoma City; Dallas Museum of Fine Art; theater set design, Dallas Theater Center, National Endowment for the Arts. Has exhibited at Dallas Museum of Fine Art; Walker Art Center; Minneapolis; Whitney Museum of American Art; Indianapolis Museum of Art. Received Texas Annual Painting and Sculpture Cash Award, James and Lillian Clark Foundation, 1971; Endowment for Theater Art, National Endowment for the Arts; National Endowment for the Arts Grant. Address in 1982, Dallas, TX.

GREEN, JASHA.
Sculptor and painter. Born in Boston, MA, May 1, 1927. Studied at Boston Museum School, 1941, 46-47; with F. Leger, Paris, France, 1948-50. Work in Guggenheim Museum, NY; Brooklyn Museum; Philadelphia Museum of Art; Kansas City Art Institute, MO; Denver Art Museum. Has exhibited at Albrecht Museum, St. Joseph, MO; Everson Museum, Syracuse, NY; Chrysler Museum, Norfolk; Oklahoma Museum, Oklahoma City; others. Works in steel sculpture; oil painting. Address in 1982, 117 E. 18th St., NYC.

GREEN, JASPER.
Sculptor, woodcarver, and artist-correspondent. Born January 31, 1829, at Columbia, PA. Worked for *Harper's Weekly* during the Civil War. Died in Philadelphia, in March 2, 1910.

GREEN, TOM.
Sculptor and instructor. Born in Newark, NJ, May 27, 1942. Studied at University of Maryland, B.A., 1967, M.A. (painting), 1969. Has exhibited at Philadelphia Art Alliance; Corcoran Gallery of Art; Whitney Museum of Art. Teaching at Corcoran School of Art, from 1969, assistant professor of sculpture and drawing. Address in 1982, Corcoran School of Art, Washington, DC.

GREENAMYER, GEORGE MOSSMAN.
Sculptor and educator. Born in Cleveland, OH, July 13, 1939. Studied at Philadelphia College of Art, B.F.A.; University of Kansas, M.F.A. Has exhibited at Institute of Contemporary Art, Boston; De Cordova Museum, Lincoln, MA; Mass. Institute of Technology; others. Received New England Exhibition Award, Silvermine Guild of Artists; Center Advanced Visual Studies Research Fellowship, Mass. Institute of Technology. Member of Boston Visual Artists Union; New England Sculptors Association. Works in steel and aluminum. Address in 1982, Marshfield, MA.

GREENBAUM, DOROTHEA SCHWARCZ.
Sculptor and graphic artist. Born in NYC, June 17, 1893. Studied: NY School of Fine and Applied Art; Art Students League. Member: Sculptors Guild; National Association of Women Artists; Audubon Artists. Works: Whitney Museum of Amercian Art; Lawrence Museum, Williamstown, MA; Oberlin College; Fitchburg, Mass. Art Center; Huntington Museum; Brookgreen Gardens, SC; Newark Museum of Art; Baltimore Museum of Art; Museum of Moscow, Russia; Puerto Rico; Ogunquit Museum of Art. Awards: Penna. Academy of Fine Art, 1941; Society of Washington Artists, 1941; International Business Machines, 1941; Audubon Artists, 1954; Grant, Am. Academy of Arts and Letters, 1947; National Association of Women Artists, 1952, 54. She has had 28 one-woman shows. Address in 1983, Princeton, NJ.

GREENE, GERTRUDE.
Sculptor. Born in Brooklyn, NY, May 24, 1911. Studied at the Leonardo da Vinci Art School in NYC, 1924-26. Moved to Vienna for a year after marrying painter Balcomb Greene in 1926; later to Paris until 1931; then permanently in NYC. She began making relief construc-

tions in 1935. Exhibited: Painters and Sculptors Guild and the Federation of Modern Painters and Sculptors; Whitney Museum Painting Annual, 1980; Metropolitan Museum of Modern Art; one-woman exhibits included the Grace Borgenicht Gallery, NYC, 1951; Bertha Schaefer Gallery, NYC, 1955, 57-58; American Abstract Artists, 1937-44, a group which she helped found; Whitney Museum of American Art, 1951, Museum of Modern Art, 1951; Carnegie Institute, 1952. Address in 1953, NYC. Died in NYC, Nov. 25, 1956.

GREENE, MARIE ZOE.
Sculptor. Born in 1911. Studied: Radcliffe College; New Bauhaus, Chicago; in France; in Italy. Award: Gold medal, Cannes, France, 1969. Collections: Roosevelt University, Chicago; Southwest Missouri State College; Radcliffe College.

GREENE, MARY SHEPHARD.
(See Mary Shepard Greene Blumenschein).

GREENLEAF, HELEN.
Sculptor and teacher. Born in Riverside, IL, June 3, 1885. Pupil of School of Boston Museum of Fine Arts. Member: Conn. Academy of Fine Arts. Address in 1916, 64 South Main St., Wallingford, CT; summer, Center Harbor, NH.

GREENLEAF, KENNETH LEE.
Sculptor and critic. Born in Damariscotta, ME, August 10, 1945. Work in Whitney Museum of American Art, NY; Houston Museum of Fine Arts, TX; New School for Social Research, NY; Mint Museum of Art, Charlotte, NC; others. Has exhibited at Whitney Museum; Tibor de Nagy Galleries, NY; Kelly Gallery, Chicago; B. R. Kornblatt Gallery, Baltimore, MD; Barridoff Galleries, Portland, ME. Address in 1982, Richmond, ME.

GREENLY, COLIN.
Sculptor. Born January 21, 1928, London, England. US citizen. Studied: Harvard University, AB, 1948; American University (with Robert Gates); Columbia University (with Oronzio Maldarelli, Peppino Mangravite). Work: Corcoran; Des Moines; Museum of Modern Art; National Collection of Fine Arts, Washington, DC; National Gallery; Albright-Knox. Exhibited: Jefferson Place Gallery, Washington, DC, 1958, 1960, 63, 65; The Bertha Schaefer Gallery, NYC, 1964, 66, 68; Corcoran, 1968; Museum of Modern Art; De Cordova; Flint Institute; Whitney. Awards: Corcoran, 1956; The Corcoran School of Art, National Playground Sculpture Competition, First Prize, 1967; National Council on the Arts Grant, 1967; Creative Artists Public Service Fellow, 1978. Address in 1982, Campbell Hall, NY.

GREENOUGH, HORATIO.
Sculptor. Born September 6, 1805, in Boston, MA. Modeled miniature figures from chalk and plaster, from 1817; later formally studied painting, drawing, stonecutting and clay modeling with local instructors; Harvard graduate, 1825; sculpture in Italy, 1824-26, under the patronage of Washington Allston. Some of his works include bust of John Quincy Adams from life; Chief Justice John Marshall; "Chanting Cherubs," which was

commissioned by James Fenimore Cooper; "The Child and the Angel;" colossal statue of "Washington," 1833-41 placed originally in the Capitol Rotunda for a short time, later moved in front of the Capitol, presently in the Smithsonian Institution; "The Rescue." Publications: *Aesthetics in Washington*, 1851, *Travels, Observations and Experience of a Yankee Stonecutter*, 1852, the latter under the pseudonym of Horace Bender. Formulated the theory of functionalism. Died in Somerville, MA, in 1852.

GREENOUGH, RICHARD SALTONSTALL.
Sculptor. Born in Jamaica Plain, MA, April 27, 1819. He was a younger brother of Horatio Greenough and worked for some years in Paris. Had a studio in Newport, RI. His statue of Benjamin Franklin is in City Hall Square, NY; and his "Boy and Eagle" is in the Boston Athenaeum. He died on April 23, 1904, in Rome, Itlay.

GREENSTEIN, BENJAMIN.
Sculptor. Born in London, England, March 18, 1901. Pupil of George Bellows and Robert Henri. Address in 1918, 123 West 115th St., NY.

GREENWOOD, GERTRUDE B.
Sculptor. Studied at the Mass. Normal Art School, in Boston, under Raymond Porter and Cyrus E. Dallin, and also at the school of the Museum of Fine Arts, under Frederick Allen, Richard H. Recchia, and George Demetrois. In 1929, she worked on a large coat-of-arms and head, for a garden. Works: Jean's First Winter; Study of a Scotchman. Address in 1935, Lawrence, KS.

GREER, JEFFERSON E. (JAMES E.?).
Sculptor, painter, and muralist. Born in Chicago, IL, 1905. Studied at University of Wisconsin; Chicago Academy of Fine Art; Loyton Art Institute in Milwaukee. Settled on a Texas ranch in 1925. Assisted in fresco murals, El Paso School of Mines; in 1934 assisted Gutzon Borglum at Mount Rushmore; made Post Office decorations for the Federal Works Administration in Prairie du Chien. Address in 1948, Bristol, RI.

GREER, RUSSELL ULYSSES.
Woodcarver. Born in Minnesota, 1922; family moved to Montana. Studied art at home through Famous Artists School. Carves figures of Indians; works in cottonwood. Represented by Husberg Fine Arts Gallery, Sedona, AZ. Address since 1968, Bend, OR.

GREEVES, RICHARD V.
Sculptor. Born in St. Louis, MO, 1925. Exhibited in Peking, China, show. Won gold medal, 1976, 79, silver medal, 1978, Prix de West, 1977, all at National Academy of Western Art. Member of National Academy of Western Art. Specialty is Indians. Works in bronze. Reviewed in *Southwest Art*, summer 1975. Operates own gallery. Address since 1951, Fort Washakie, WY, (Wind River Indian Reservation).

GREGORY, ANGELA.
Sculptor and educator. Born in New Orleans, LA, on October 13, 1903. Studied: NY State College of Ceramics, Alfred, NY; Newcomb College of Tulane University; Parsons School in Paris and Italy; Grande Chaumiere, Paris;

with Antoine Bourdelle; Charles Keck, NY. Awards: Scholarship Newcomb College; Southern States Art League, 1930, 1931; Louisiana Painters and Sculptors, 1929; St. Mary's Dominican College Distinguished Award Medal, 1977. Collections: International Business Machines; Delgado Museum of Art; Louisiana State Museum; Criminal Courthouse, New Orleans; Louisiana State University; Louisiana Library; La Tour Caree, Septmonts, France; Louisiana National Bank, Baton Rouge; Charity Hospital, New Orleans; Silver-Burdette Publishing Co., NY; Louisiana State University, Baton Rouge; St. Gabriel Church, St. Gabriel, LA; McDonogh monument, Civic Center, 1938; Bienville monument, 1955, New Orleans, LA. Artist-in-Residence, Newcomb College, Tulane University, LA, 1940-41; sculptor-in-residence, St. Mary's Dominican College, 1962-75; professor of art, 1975-76, emeritus professor, from 1976. Address in 1982, New Orleans, LA.

GREGORY, ELIOT.
Sculptor and traveling portrait painter. Born in New York, 1854. Exhibited: Paris Salon. Died in Paris, 1915.

GREGORY, JOHN.
Sculptor. Born London, England, May 17, 1879. Arrived in United States c. 1891. Pupil of Art Students League of NY; Beaux-Arts, Paris; American Academy, Rome; studied under J. Massey Rind, Geo. Grey Barnard, Hermon A. MacNeil, G. Borglum, Herbert Adams, Mercie. Member: Beaux-Arts Institute of Design (hon.); National Sculpture Society; NY Architectural League; American Federation of Arts. Awards: America Academy in Rome Fellowship, 1912-15; NY Architectural League medal in Sculpture, 1921; honorable mention, Art Institute of Chicago, 1921; medal, Concord Art Association, 1926. Work: "Philomela," Metropolitan Museum; "Launcelot and Sir Ector," Corcoran Gallery, Washington, DC; decorative flooring relief, Cunard Bldg., NYC; War memorials, Suresnes, Paris, France; numerous garden sculptures. Exhibited at National Sculpture Society, 1923. Address in 1953, NYC. Died in 1958.

GREGORY, KATHARINE V. R.
(Mrs. John Gregory). Sculptor and teacher. Born in Colorado Springs, CO, Sept. 1, 1897. Studied with Bourdelle and J. M. Lawson. Member: National Association of Women Painters and Sculptors; Society of Independent Artists. Award: Bryant prize for sculpture, National Association of Women Painters and Sculptors, 1933. Address in 1933, 222 East 71st St., NYC.

GREGORY, WAYLANDE.
Sculptor, designer, writer, and lecturer. Born in Baxter Springs, KS, June 13, 1905. Studied: Kansas State Teachers College; University of Chicago; Kansas City Art Institute; and in Europe. Member: National Sculpture Society; Society of Designer-Craftsman. Awards: Alfred University, 1939; Paris Exp., 1937; Syracuse Museum Fine Arts, 1933, 1937, 1940; prize, Architectural League, 1936; Cleveland Museum of Art 1929, 1931. Work: Sculpture, District Bldg., Washington, DC; fountain, Roosevelt Park, NJ; Syracuse Museum of Fine Arts; Cranbrook Museum; City Art Museum, St. Louis; others.

Exhibited: Whitney Museum of American Art; Museum of Modern Art; Art Institute of Chicago; Montclair Art Museum; Worcester (MA) Museum of Art; City Art Museum, St. Louis; Richmond Academy, Arts and Sciences; San Diego, CA; many one-man shows in leading museums, and in Europe. Contributor to art magazines. Lecturer on ceramic art, etc. Address in 1953, Mountain Top Studios, Bound Brook, NJ. Died in 1971.

GRESSEL, MICHAEL L.
Sculptor. Born in Wurzburg, Germany, September 20, 1902; US citizen. Study: Art School, Bavaria, with Arthur Schleglmeunig; Beaux Arts Institute of Design, NYC. Work: Metropolitan Museum of Art, NY; Bruckner Museum, Albion, MI; National Theatre & Academy, NYC; National Theatre, Washington, DC. Commission: Ivory relief portrait for Gen. Eisenhower, 1962; emblem, Harvard University; Legend of Sleepy Hollow, Monument, Tarrytown, NY; and others. Exhibitions: Hudson Valley Art Association, White Plains, NY, 1946-72; Allied Artists of America; National Academy of Design, 1971; National Sculpture Society, NY, 1972; and others. Awards: Gold Medal, Hudson Valley Art Association, 1972; others. Member: Hudson Valley Art Association, director from 1952; National Sculpture Society. Address in 1982, Armonk, NY.

GREY, ESTELLE (ASHBY).
Sculptor and painter. Born in Scranton, PA, December 8, 1917. Studied at Traphagan School of Fashion; Art Students League. Works: Randolph Macon Womens' College; Butler Institute of American Art. Exhibitions: Fish University; Riverside Museum, 1960; Kaymar Gallery, 1968-72; Tirca Karlis Gallery, 1970-74. Media: Terra cotta, metal; oil.

GRIEGER, WALTER SCOTT.
Sculptor. Born in Biloxi, MS, August 27, 1946. Studied at Chouinard Art Institute; Otis Art Institute; San Fernando Valley State College, B.A. Work in Whitney Museum of American Art, NY. Has exhibited at Museum of Modern Art; Whitney Museum of American Art; Los Angeles Co. Museum of Art; Sidney Janis Gallery, NY; others. Address in 1982, Los Angeles, CA.

GRIESBACH, DAVID.
Sculptor. Born in Evans City, Penn. Studied at the Otis Art Institute in Los Angeles, Calif., under Julia Bracken Wendt. Works: Bust, Thomas Jefferson, Jefferson High School, Los Angeles, Calif.; Sun-dial; Head of a Mexican Boy; portraits and smaller works. Active in 1929.

GRIEVES, BOB.
Sculptor. Born in Henry County, OH, 1922. Studied nights at Chicago Art Institute. Employed on cattle ranch in Nebraska, in Chicago stockyards, later at own sign business. Has worked in ceramic sculpture; works in bronze. Specialty is statuettes of mountain men in the early West. Reviewed in *Southwest Art*, December 1980. Represented by El Prado Gallery of Art. Address in 1982, Detroit, MI.

GRIFFITH, BEATRICE FOX.
(Mrs. Charles F. Griffith). Sculptor and craftswoman. Born Hoylake, Cheshire, England, Aug. 6, 1890. Pupil of Grafly and Guisseppe Donato; Penna. Academy of Fine Arts. Member: Philadelphia Alliance; National Association of Women Painters and Sculptors; Fellowship Penna. Academy of Fine Arts; Plastic Club. Work: Marble portrait of Edith Wynne Mathison, Bennett School, Millbrook, NY; marble portrait, President Ewing, Lahore Union College, Lahore, India; bronze portrait of Herbert Burke, Valley Forge Historical Society, Valley Forge Memorial Chapel; 75th Anniversary medal for Women's Medical College, Philadelphia; National Society of Colonial Dames of America medal for Sesqui-Centennial Exp., Philadelphia, 1926; bronze trophy, "Swan Dive," National A.A.U. Swimming Trophy, 1927; illuminated manuscripts for Board of Education, Philadelphia, Art Alliance, Philadelphia, and Valley Forge Historical Society. Address in 1929, "Lynhurst," Ardmore, PA.

GRIFFITH, J. MILO.
Sculptor. Exhibited: Royal Academy, 1883. Work: Earliest public work was done for Llandaff Cathedral. Designer of a silver shield presented by South Wales to the Prince and Princess of Wales, 1888. Exhibited: Royal Academy, 1883. Taught: Professor of Art in a college in San Francisco. Died in 1897.

GRIGGS, BRIGITIA.
Sculptor. Born in Bad Wildungen, West Germany, in 1945. Studied: With Max Steiner in West Germany, University of Alabama in Huntsville, Alabama. Collections in Japan, Canada, Germany, and the United States.

GRIGNOLA, JOHN.
Sculptor. Born in Italy, 1861. Died in New York, 1912. (Mallett's)

GRIGOR, MARGARET CHRISTIAN.
Sculptor. Born in Forres, Scotland, March 2, 1912; US citizen. Studied at Mt. Holyoke College, B.A.; Penna. Academy of Fine Art. Works: Mt. Holyoke College, South Hadley, MA; Smithsonian Institute, Washington, DC; Medallic Art Co., Danbury, CT. Commissions: American Medalists Association Medal, 1948; Alaska-Hawaii Medal, Society of Medalists, 1965; Alexander Hamilton Medal, Hall of Fame of Great Americans, NY University, 1971; designed American Revolution Bicentennial Medal for 1975, 74. Exhibitions: National Sculpture Society, Annual, 1969, 72, 74, and National Academy of Design, NY, 1973. Awards: Lindsay Morris Memorial Prize, National Sculpture Society, 1969; Semi-finalist, Bicentennial Coin Competition, 1974. Media: Plasteline plaster. Address in 1976, Steilacoom, WA. Died 1981.

GRIMES, FRANCES.
Sculptor. Born Braceville, OH, January 25, 1869. Pupil of Pratt Institute in Brooklyn; assistant to Herbert Adams and Augustus Saint-Gaudens. Member: National Sculpture Society, 1912; National Association of Women Painters and Sculptors; American Federation of Arts. Awards: Silver medal for medals, P.-P. Exp., San Francisco, 1915; McMillin sculpture prize, National Association of Women Painters and Sculptors, 1916. Work: Overmantel, Washington Irving High School, New York City; "Girl

by Pool" and "Boy with Duck," Toledo Museum of Art; bust of Charlotte Cushman and Emma Willard, Hall of Fame; bust of Bishop Potter, Grace Church, NYC. Exhibited at National Sculpture Society, 1923. Address in 1953, 229 East 48th St., New York, NY. Died in 1963.

GRIPPE, PETER J.
Sculptor and printmaker. Born August 8, 1912, Buffalo, NY. Studied: Albright Art School; Buffalo Fine Arts Academy, with E. Wilcox, Edwin Dickinson, William Ehrich; Atelier 17, NYC. Work: Andover (Phillips); Brandeis University; Brooklyn Museum; Albright; Library of Congress; Metropolitan Museum of Art; Museum of Modern Art; New York Public Library; National Gallery; Philadelphia Museum of Art; The Print Club, Philadelphia; Tel Aviv; Toledo Museum of Art; Whitney Museum; Walker. Exhibited: The Willard Gallery, The Peridot Gallery, Lee Nordness Gallery, all in NYC; Metropolitan Museum of Art; Whitney Museum of American Art Annuals, for many years; Federation of Modern Painters and Sculptors; American Abstract Artists Annuals; Carnegie; Brooklyn Museum; Detroit Institute; Art Institute of Chicago; American Federation of Arts; Mus. of Modern Art; Penna. Academy of Fine Arts; University of Illinois; Art: USA:59, NYC, 1959; Print Council of America, NYC, American Prints Today, circ., 1959-62; Institute of Contemporary Art, Boston; Smithsonian, Drawings by Sculptors; Boston Athenaeum; plus many more. Awards: Brooklyn Museum, 1947; Metropolitan Museum of Art, $500 First Prize, 1952; The Print Club, Philadelphia, Charles M. Lea Prize, 1953; National Council for United States Art, $1,000 Sculpture Award, 1955; Boston Arts Festival, First Prize for Sculpture, 1955; Rhode Island Arts Festival, Sculpture Award, 1961; Guggenheim Foundation Fellowship, 1964. Taught: Black Mountain College, 1948; Pratt Institute, 1949-50; Smith College, 1951-52; Atelier 17, NYC, 1951-52; Brandeis Univ., from 1953. Address in 1982, Orient, NY.

GRONBORG, ERIK.
Sculptor and ceramist. Born in Copenhagen, Denmark, November 12, 1931; US citizen. Studied at University of California, Berkeley, B.A., 1962, M.A., 1963. Work at Oakland Art Museum, CA; Everson Museum of Art, Syracuse; Museum of Art, Basel, Switzerland. Has exhibited at Museum of Modern Art, Paris, France; Museum of Contemporary Crafts, NY; Everson Museum of Art, Syracuse; others. Taught at Reed College, Portland, OR, 1965-69, assistant professor of ceramics and sculpture. Address in 1982, Solana Beach, CA.

GROOMS, RED.
Sculptor. Born in Nashville, TN, June, 1937, under the name Charles Roger Grooms. Studied at the Art Institute of Chicago; Peabody College for Teachers, Nashville, TN; Hans Hofmann School, NYC; and the New School for Social Research. Became involved in non-verbal spontaneous theatrical presentations called "Happenings," with Claes Oldenberg, Jim Dine, and Allan Kaprow, NYC. One of his better known "happenings" was entitled "Burning Building," 1959. Permanent works of his were assemblages of groups of objects, which in turn made

environments such as his "Loft on 26th Street," 1965-66, at the Hirschhorn Museum. Collections of his works are at Rutgers University and the Art Institute of Chicago. Exhibited: Art Institute of Chicago, 1966; Museum of Modern Art, NYC, 1966; Guggenheim Museum, NYC, 1972; one-man shows were held at Ft. Worth Art Musuem, in Texas, 1976; University of Miami, 1980. Coauthored a book with Allan Kaprow. Address in 1982, Marlborough Gallery Inc., 40 West 57th St., NYC.

GROPPI, PEDRO.
Sculptor. Born in Italy. Lived in Boston in June, 1860. Medium: plaster.

GROSS, ALICE (ALICE GROSS FISH).
Sculptor. Born in NYC. Studied with Ruth Yates. Work in Berkshire Museum, Pittsfield, MA. Has exhibited at Audubon Artists; National Academy of Design, NY, 1968; Allied Artists of America, 1969; Knickerbocker Artists, National Arts Club, NY. Member of Silvermine Guild of Artists; Audubon Artists; Allied Artists of America; Knickerbocker Artists. Address in 1982, 16 Sutton Pl., NYC.

GROSS, CHAIM.
Sculptor. Born March 17, 1904, in Kolomea, East Austria. Came to USA in 1921. Studied: Kunstgewerbe Schule; Educational Alliance, NYC; Beaux-Arts Institute of Design, with Elie Nadelman; Art Students League, with Robert Laurent. Work: Ain Harod; Addison Gallery, Andover, MA; Baltimore Museum of Art; Bezalel Museum; Boston Museum of Fine Art; Brooklyn Museum; Art Institute of Chicago; Jewish Museum; Metropolitan Museum of Art; Museum of Modern Art; Penna. Academy of Fine Art; Philadelphia Museum of Art; Queens College; Reed College; Rutgers University; Smith College; Tel-Aviv; Whitney Museum; Walker; Worcester Art Museum; Butler; and many others, including commissions for Main P.O., Wash., DC; FTC Bldg., Washington DC; Hadassah Hospital, Jerusalem; Temple Shaaray Tefila, NYC; and others. Exhibited: Boyer Gallery, Philadelphia, 1935; Boyer Gallery, NYC, 1937; A.A.A. Gallery, NYC, 1942, 1969; Youngstown (Butler); Jewish Museum; Duveen-Graham Gallery, NYC; Whitney Museum; Sculptors Guild Annuals; Penna. Academy of Fine Arts; Amer. Federation of Arts; American Painting and Sculpture, Moscow, 1959; Museum of Modern Art; Smithsonian; New York World's Fair, 1964-65. Awards: L. C. Tiffany Grant, 1933; Paris World's Fair, 1937, Silver Medal; Museum of Modern Art, Artists for Victory, $3,000 Second Prize, 1942; Boston Arts Festival, Third Prize for Sculpture, 1954; Penna. Academy of Fine Art, Honorable Mention, 1954; Audubon Artists, Prize for Sculpture, 1955; National Institute of Arts and Letters Grant, 1956, and Award of Merit Medal, 1963. Member: Sculptors Guild (President); Artists Equity; Federation of Modern Painters and Sculptors; National Institute of Arts and Letters. Taught: Educational Alliance, NYC; New School for Social Research. Address in 1983, 526 LaGuardia Place, New York City.

GROSS, JULIET WHITE.
(Mrs. John Lewis Gross). Sculptor, painter, draughtsman,

and writer. Born Philadelphia, Pennsylvania. Pupil of Philadelphia School of Design; Penna. Academy of Fine Arts; Edouard Leon in Paris. Member: Fellowship, Penna. Academy of Fine Arts; National Association of Women Painters and Sculptors; Philadelphia Alliance. Awards: Mary Smith prize, Penna. Academy of Fine Arts, 1919; Fellowship Penna. Academy of Fine Arts prize, 1920; gold medal, Plastic Club, 1925; honorable mention (Societe des Artistes Francais), Paris Salon, 1926. Address in 1929, Sellersville, PA.

GROSSBERG, JAKE.
Sculptor and educator. Born in Luban, Poland, February 13, 1932; US citizen. Studied at Columbia University, M.A.; Brooklyn College, M.F.A. Work in Riverside Museum Collection; Chrysler Museum, Provincetown; others. Has exhibited at Brooklyn Museum, NY; Museum of Modern Art, NY; Philadelphia Art Alliance; others. Teaching at Bard College, Annandale-on-Hudson, NY, from 1969, professor of fine arts. Works in steel. Address in 1982, c/o Frank Marino Gallery, NYC.

GROSSEN, FRANCOISE.
Sculptor and instructor. Born in Neuchatel, Switzerland, August 19, 1943. Studied at School of Architecture, Polytech University, Lausanne, Switzerland; School of Arts and Crafts, Basel, Switzerland; University of California, Los Angeles, M.A. with B. Kester. Has exhibited Wall Hangings, Museum of Modern Art, NY; Hadler Galleries, NY; National Museum of Modern Art, Tokyo and Kyoto, Japan; Soft-art, Weich, Plastisch, Kunsthaus, Zurich; others. Teaching, New School for Social Research, NY. Works in fiber. Address in 1982, 135 Greene St., NYC.

GROSSMAN, ISIDORE.
Sculptor, craftsman, and teacher. Born in NYC, Feb. 23, 1908. Member: Art League of America. Exhibited: Carnegie Institute, 1939; Penna. Academy of Fine Art, 1939-46; NY World's Fair, 1939; New School for Social Research, 1939, 40; Municipal Art Gallery, 1940; Fairmount Park, PA, 1940. Address in 1953, 604 East 9th St.; h. 389 East 10th St., NYC.

GROSSMAN, MILTON H.
Sculptor. Born in British Columbia, Canada, March 2, 1908. Work: "Portrait of Sam L. Warner," Warner Brothers Theatre, Buffalo, NY. Award: Honorable mention, Albright Art Gallery, Buffalo, NY. Member: Buffalo Society of Artists. Address in 1933, Buffalo, NY.

GROSSMAN, NANCY.
Sculptor and painter. Born in NYC, April 28, 1940. Studied at Pratt Institute. Work in Whitney Museum of American Art, NY; others. Has exhibited at Corcoran Gallery of Art; Whitney Museum of American Art Sculpture Annual; Figure Sculpture, Fogg Art Museum; others. Received Guggenheim Memorial Foundation Fellowship, 1965; American Academy of Arts and Letters/ National Institute of Arts and Letters Award, 1974. Address in 1982, 105 Eldridge St., NYC.

GROSVENOR, ROBERT.
Sculptor. Born 1937, in New York City. Studied: Ecole des Beaux-Arts, Dijon, 1956; Ecole Nationale des Arts De-

coratifs, 1957-59; Universita di Perugia, 1958. Work: Lannan Foundation; MIT; Museum of Modern Art; New York University; Aldrich; Whitney Museum; Walker. Exhibited: Dwan Gallery, NYC, 1966; Park Place Gallery, NYC, 1962-66; NY University, 1967; New York World's Fair, 1964-65; Jewish Museum; Albright; The Hague, Minimal Art, 1968; Whitney Museum of American Art Sculpture Annual, 1968-69; Walker. Awards: National Council on the Arts, 1969. Taught: School of Visual Arts, NYC. Address in 1982, c/o Paula Cooper Gallery, NYC.

GROSVENOR, THELMA CUDLIPP.
(Mrs. Charles S. Whitman). Sculptor, painter, and illustrator. Born in Richmond VA, October 14, 1892. Studied in England; and with Kenneth Hayes Miller, Art Students League, NY. Member: New York Society of Women Artists. Exhibited: Penna. Academy of Fine Arts; Corcoran Gallery of Art; Toledo Museum of Art; Art Institute of Chicago; Whitney Museum of American Art; Newport Art Association; National Academy of Design; Virginia Museum of Fine Art; Rhode Island School of Design; College Art Association of America traveling exhibition. Member: Newport Art Association, NY State Women Artists. Illustrated covers for *Vanity Fair*, *Town and Country*, *Saturday Evening Post*, *Harper's*, *Century*, and *McClures*. Lectures: "Pre-Columbian Sculpture." Address in 1953, 455 East 57th St., NYC.

GROTH, BRUNO.
Sculptor. Born in Stolp, Germany, December 14, 1905; US citizen. Studied at Otis Art Institute, Los Angeles. Work in Joseph H. Hirshhorn Collection, NY; fountain pieces, Cities of Fresno and Crescent City, CA; others. Has exhibited at De Young Museum, San Francisco; Brussels World's Fair; Santa Barbara Museum of Art; Museum of Contemporary Crafts, NY; others. Works in welded steel and bronze. Address in 1982, Cornville, AZ.

GROVE, EDWARD RYNEAL.
Sculptor and painter. Born in Martinsburg, WV, Aug. 14, 1912. Studied at National School of Art, Washington, DC, 1933; Corcoran School of Art, Washington, DC, with Schuler and Weisz, 1934-40; also with Robert Brackman, Noank, CT, 1946. Work in Smithsonian Institution; Corcoran Gallery of Art; Washington Cathedral, DC; Museum of Medallic Art, Poland. Has exhibited at Watercolor Annual, Penna. Academy of Fine Arts, Philadelphia; National Sculpture Society, Lever House, NY; others. Sculptor-engraver of US Mint, Philadelphia, 1962-65. Member of the National Sculpture Society; Artists Equity Association; National Academy of Design. Awards: Lindsey Morris Memorial Prize, 1967, Mrs. Louis Bennett Prize, 1971, both from National Sculpture Society; American Numismatic Association. Works in clay, bronze, silver; oils, watercolor. Address in 1982, West Palm Beach, FL.

GROVE, JEAN DONNER.
Sculptor. Born in Washington, DC, May 15, 1912. Studied at Hill School of Sculpture; Corcoran School of Art; Catholic University of America; Wilson Teachers College, B.S., 1939; Cornell University; Philadelphia Museum of Art; travel study in Europe; also with Clara Hill, Hans

Schuler, Heinz Warneke, and Fritz Janschka. Work in Rosenwald Collection, Philadelphia, PA; others. Has exhibited at Corcoran Gallery of Art, Washington, DC; Penna. Academy of Fine Arts Annual, Philadelphia; National Academy of Design; others. Received Competition Prize for Design of Artists Equity Association Philadelphia Award; Tallix Foundry Award, National Sculpture Society; others. Member of National Sculpture Society; Artists Equity Association; Philadelphia Art Alliance; associate member of National Academy of Design, NY; others. Works in stone, wood, clay, bronze, and plastics. Address in 1982, West Palm Beach, FL.

GROW, RONALD.
Sculptor. Born 1934 in Wooster, OH. Studied at University of Colorado; earned M.A. at UCLA. Taught at University of Mexico since 1962. Work: In private collections. Exhibitions: California State Fair, 1961; Long Beach Museum of Art; University of New Mexico; Scripps College; Syracuse University; Downey Museum of Art, CA; UCLA; Brandeis University. Awards: Sculpture, California State Fair, 1961; Long Beach Museum of Art and Los Angeles and Vicinity Exhibitions, both 1962.

GRUB, HENRY.
Sculptor and painter. Born in Baltimore, MD, 1884. Pupil of Maynard, Ward, and Bridgman. Member: New York Society of Independent Artists. Address in 1926, 53 Greenwich Ave., New York.

GRUBER, AARONEL DEROY.
Sculptor and kinetic artist. Born in Pittsburgh, PA. Studied at Carnegie Institute of Technology. Work in Smithsonian Institution, Washington, DC; Rose Art Museum, Brandeis University; Butler Institute of American Art; De Cordova Museum, Lincoln, MA; plus sculpture commissions. Has exhibited at De Cordova Museum, Lincoln, MA; Biennal International de la Petite Sculpture, Budapest Museum, Hungary; Everson Museum, Syracuse, NY; others. Received six sculpture awards, Western Penna. Society of Sculptors. Works in lucite and plexiglas. Address in 1982, Pittsburgh, PA.

GRUENFELD, CASPER.
Sculptor. Address in 1903, Chicago, IL.

GRUPPE, KARL HEINRICH.
Sculptor and painter. Born Rochester, NY, March 18, 1893. Son of Charles Gruppe, the painter. Lived in Holland as a child; returned to US as adult. Pupil of Karl Bitter; studied at Royal Academy of Antwerp and Art Students League, NY. Member: National Sculpture Society (assoc.); NY Architectural League (assoc.). Award: Saint-Gaudens prize, 1912, Art Students League; Avery prize, 1920, NY Architectural League; Helen Foster Barnett prize, 1926. Work: Final figure, Italian towers, P.-P. Exp., San Francisco, 1915; Memorial Tablet, City Club, NY; Memorial Tablet, Princeton Charter Club; Portrait Bust, Dean of Adelphi College, Brooklyn, NY, 1929. Exhibited at National Sculpture Society, 1923; Annual Exhibition, National Sculpture Society, 1977. Address in 1982, Southold, NY. Died in 1982.

GRYGUTIS, BARBARA.
Sculptor and ceramist. Born in Hartford, CT, November 7, 1946. Studied: University of Arizona, Tucson, AZ, B.F.A., 1968, M.F.A., 1971; travel-study in Japan. Awards: Tucson Art Center, AZ, 1968, 1970, 1971, 1975. Exhibition: University of Arizona Museum of Art, 1971; Graphic Arts Gallery, Tucson, AZ, 1972; Harlan Gallery, Tucson, 1975; Renwick Gallery, Smithsonian; Museum of Contemporary Crafts, NYC, 1976; Everson Museum, Syracuse, NY, 1976. Commissions: Union Bank Branch Office, Tucson; La Placita Shopping Center, Tucson. Media: Clay and glass. Address in 1982, Tucson, AZ.

GSCHWIND, WILLIAM E.
Sculptor. Address in 1934, Toledo, Ohio. (Mallett's)

GUACCERO, I. VINCENT.
Sculptor, painter, educator, designer, and craftsman. Born in Italy. Studied at Teachers College, Columbia University, B.S., M.A. Member: Eastern Art Association; Society for Advancement of Education; American Association Univ. Professors. Lectures: Art Education. Position: Assistant Professor of Fine Arts and Art Education, Louisiana State University, Baton Rouge, LA; Chairman, Southeastern Area Art Commission for International School Art Program; Associate Council member, Commission on Art Education. Address in 1953, Baton Rouge, LA.

GUCK, EDNA.
Sculptor and painter. Born in NYC, March 17, 1904. Studied at Art Students League, and in Paris, France. Work: Seattle Art Museum; Brooklyn Museum; Queens College; National Hospital for Speech Disorders; Halloran Hospital; New York Public School; New York Housing Projects. Awards: Prize, Essex Art Association, 1951. Exhibited: Riggs-Sargent, Mexico, D.F., 1952; Essex Art Association, 1950-51; Carlebach Gallery, 1950; Centre d'Art, Haiti, 1949; Bonestell Gallery, 1939-46; Am-British Art Center, 1942; AID, 1941; Metropolitan Museum of Art, 1941; New York World's Fair, 1939; New School for Social Research, 1940; Ferargil Gallery, 1939; NY Society of Women Artists, 1935-38; Newark Museum of Art, 1936; Newton Gallery, 1935; Jersey City Museum, 1935; Providence Art Association, 1930; Salon d'Automne, Paris, 1928. Position: Instructor at River Edge Adult Education, NJ, 1951-52; Jewish Community Center of the Rockaways, NY, 1951-52. Address in 1953, 433 West 18th St., NYC.

GUDEBROD, LOUIS ALBERT.
Sculptor. Born Middletown, CT, September 20, 1872. Pupil of Yale Art School; Art Students League of NY, under Mary Lawrence and Augustus Saint-Gaudens; Dampt in Paris. Member: National Sculpture Society 1902; New York Architectural League, 1902; Conn. Academy of Fine Arts; New Haven Paint and Clay Club; Lyme Art Association. Awards: Silver medal, Charleston Exp., 1902; gold medal, Panama-Pacific Exp., San Francisco, CA, 1915. Assistant to Saint-Gaudens in Paris. Director of Sculpture, Charleston Exp., 1902. Work: Anderson Prison Monument for New York State at Andersonville, GA; "Henry Clay Work Memorial," Hartford, CT; portrait memorials in Bristol and Meriden public libraries; Weaver High School, Hartford; Grace Hospi-

tal, New Haven; Mayflower tablet in State Capitol, Hartford. Address in 1933, Meriden, CT.

GUERNSEY, ELEANOR LOUISE.
Sculptor. Born in Terre Haute, IN, 1878. Pupil of Art Institute of Chicago. Member: Art Students League of Chicago; Indian Sculptors' Society. Address in 1926, James Milliken University, Decatur, IL.

GUEST, GEORGE.
Sculptor. Born in Buckinghamshire, England. Pupil of Edith Woodman Burroughs; Norwich Academy; Bela L. Pratt in Boston. Address in 1916, St. Botolph Studios, Boston, MA; summer, Groton, MA.

GUGLIELMO, VICTOR.
Sculptor. Born in Italy. He assisted Frank Happersburger in his work in San Francisco. Address in 1926, San Francisco, CA.

GUILD, EMMA CADWALADER (MRS.).
See Cadwalader-Guild.

GUINZBURG, FREDERIC VICTOR.
Sculptor, craftsman, lecturer, and teacher. Born New York City, June 18, 1897. Pupil of J. Myers and Victor David Brenner at Art Students League; Ernesto Grazzeri in Rome; and School of American Sculpture. Member: National Sculpture Society (assoc.); NY Architectural League. Award: Honorable mention, Concord Art Association, 1924; bronze medal, Sesqui-Centennial Exp., Philadelphia, 1926. Exhibited at National Sculpture Society, 1923. Address in 1929, 21 West 89th St., New York, NY; Chiselhurst Studio, Chappaqua, Westchester Co., NY. Died in 1978.

GUION, DAVID.
Sculptor. Worked out of Cincinnati, Ohio c. 1830-40. First teacher of Shobal Vail Clevenger, sculpture.

GUION, SUSAN.
Sculptor and landscape painter. Worked: Cincinnati, c. 1830-40. Exhibited at National Academy of Design, 1859.

GUMMER, DON.
Sculptor. Born in Louisville, KY, 1946. Studied at John Herron Art Institute, Indianapolis, 1964-66; School Museum of Fine Arts, Boston, 1966-70; Yale University School of Fine Arts, New Haven, B.F.A., 1971, M.F.A., 1973. Work, outdoor installations, Dag Hammerskjold Plaza, NYC; others. Has exhibited at Albright-Knox Art Gallery, Buffalo; Joe and Emily Lowe Art Gallery, Syracuse University, NY; Akron Art Museum, OH; Aldrich Museum of Contemporary Art, Ridgefield, CT; Chicago Arts Club; others. Received grant, National Endowment for the Arts; grant, Tiffany Foundation. Works in wood and stone. Address c/o Sperone Westwater Fischer, 142 Greene St., NYC.

GUNDLACH, HELEN FUCHS.
(Mrs. E. Q.). Sculptor, painter, and illustrator. Born in Buffalo, NY, Feb. 9, 1890. Studied with John Carlson, Charles Rosen, and Walter Everette. Award: Fellowship prize, Buffalo Society of Artists, 1923. Member: Buffalo Society of Artists; Art Dept., League of American Pen Women. Address in 1933, Ebenezer, NY.

GUSSOW, ROY.
Sculptor and environmental artist. Born November 12, 1918, Brooklyn, NY. Studied: NY State Institute of Applied Agriculture (Farmingdale), 1938; Institute of Design, Chicago, with Lazlo Moholy-Nagy, Alexander Archipenko. Work: Atlanta Art Association; Brooklyn Museum; California Academy of Science; Museum of Modern Art; University of North Carolina; North Carolina Museum of Art, Raleigh; Whitney Museum; Guggenheim. Represented by Borgenicht Gallery, NYC. Exhibited: Design Associates Gallery, Greensboro, NC, 1952; Penna. State University, 1959; Grace Borgenicht Gallery Inc., NYC, 1964; Art Inst. of Chicago; Omaha (Joslyn); Denver Art Museum; San Francisco Museum of Art; Metropolitan Museum of Art; Penna. Academy of Fine Arts; Whitney Museum. Awards: Penna. Academy of Fine Arts, Honorable Mention, 1958; Ford Foundation, 1960, 62; National Gold Medal Exhibition for the Building Arts, NYC, 1962. Taught: Colorado Springs Fine Arts Center, 1949-51; North Carolina State College, 1951-62; Pratt Institute, 1962-68. Commissions: US Commerce Department Trade Fair, circ. Bankok and Tokyo, 1956 (American Pavilion); San Francisco Museum of Science and Industry, 1962; Phoenix-Mutual Building, Hartford, CT, 1963 (8-ft. stainless steel sculpture commissioned by Max Abramovitz); Tulsa Civic Center, 1968; Xerox Corp., 1968; others. Address in 1983, 4040 24th Street, Long Island City, NY.

GUSTAFSON, FRANK G.
Sculptor. Born in Sweden, November 8, 1863. Pupil of Art Institute of Chicago. Address in 1918, Chicago Art Institute; h. Chicago, IL; summer, Oden, MI.

GUTKIN, PETER.
Sculptor. Born in Brooklyn, NY, 1944. Studied at Tyler School of Art, Temple University, B.F.A., 1966; San Francisco Art Institute, M.F.A., 1968. Work in Oakland Museum, CA; Portland Museum of Art, OR; San Francisco Museum of Modern Art; and others. Has exhibited at Whitney Museum of Art, NY; San Francisco Museum of Art; Krannert Art Museum, Champaign, IL; San Diego Museum of Art; others. Received National Endowment for the Humanities and Art Award; Purchase Prize, San Francisco Art Festival. Address in 1982, San Francisco, CA.

GUY, JAMES M.
Sculptor and painter. Born February 10, 1910, in Middletown, Conn. Studied: Hartford Art School, with Albertus Jones, Kimon Nicolaides. Work: Wadsworth; Guggenheim; MIT; Society of the Four Arts. Represented by Chas. Egan Gallery, NYC. Exhibited: Boyer Gallery, NYC, 1939, 40; Ferargil Galleries, NYC, 1941, 42, 44; Carlebach Gallery, NYC, 1949, 50; Paris World's Fair, 1937; New York World's Fair, 1939; Golden Gate International Exposition, San Francisco, 1939; Whitney Annuals; Museum of Modern Art; Metropolitan Museum of Art; Art Institute of Chicago. Address in 1982, Moodus, CT.

H

HAACKE, HANS CHRISTOPH.
Sculptor. Born in Cologne, Germany, August 12, 1936. Studied at Staatliche Werkakademie, Kassel, Germany, M.F.A.; Atelier 17, Paris, with S. W. Hayter; Tyler School of Art, Philadelphia. Work in Museum of Modern Art, NY; Kaiser Wilhelm Museum, Krefeld, Germany; Moderna Museet, Stockholm; others. Has exhibited at Museum of Modern Art, Oxford; Paul Maenz Gallery, Cologne, Germany; John Weber Gallery, NY; many more. Received Fulbright Fellowship, 1961; Guggenheim Fellowship, 1973; National Endowment for the Arts Fellowship, 1978. Teaching at Cooper Union, from 1967, professor of art. Address in 1982, c/o John Weber Gallery, NYC.

HAAG, CHARLES (CARL) OSCAR.
Sculptor. Born Norrkoping, Sweden, 1867. Pupil of Junghaenel Ziegler and Injalbert. Awards: Bronze and silver medal, first prize, Swedish-American Exhibition. Work: "Cornerstone of the Castle" in Winnetka; "Accord," Metropolitan Museum, New York; series of fountains, among them the "American Fountain," at Johnstown, PA. Sculptor of symbolic and poetic art and series of figures and groups in wood called "the spirits from the woods;" series of stones called the "stoneworld." Address in 1933, Winnetka, Illinois. Died in 1934.

HAAS, HELEN.
(Mrs. Ruffin Haas de Langley). Sculptor. Born in NYC, 1904. Studied with Antoine Bourdelle, France. Works: Luxembourg Museum, Paris; Port Sunlight Museum, London; NY Mus. of Natural History. Exhibited: Salon Des Tuileries, Paris; Salon D'Antomne, Grand Palais, Paris; a one-woman show was held at the Charpentie Gallery, Paris, Jacques Seligman Gallery, New York and Knoedler Gallery, London; and a special exhibit for the Armed Forces, in London, 1942-43. Address in 1982, 28 East 73rd Street, NYC.

HABER, IRA JOEL.
Sculptor and writer. Born in NY, February 24, 1947. Work in Guggenheim Museum, NY; Hirshhorn Museum, Washington, DC; Albright-Knox Art Gallery, Buffalo, NY. Has exhibited at Museum of Modern Art, NY; Whitney Museum Annual Sculpture Exhibition, NY; Fischbach Gallery, NY; University of California, Santa Barbara; Albright-Knox Art Gallery; Institute of Contemporary Art, Philadelphia. Received National Endowment for the Arts Fellowship, 1974-75 and 77-78. Taught at Fordham University, 1971-74, instructor of sculpture. Address in 1982, 105 W. 27th St., NYC.

HABERGRITZ, GEORGE JOSEPH.
Sculptor and painter. Born in NYC, June 16, 1909. Study:

National Academy of Design; Cooper Union, graduate; Academie Grande Chaumiere. Work: Butler Museum, Youngstown, OH; Safad Museum, Israel; Jewish Museum, London; Purdue Univ.; Wilberforce Univ. Exhibition: Albright Museum, Painting Annual, Buffalo, NY, 1938-40; American Watercolor Society Annual, 1947-49; National Association Painters in Casein, 1947-74; National Academy of Design, 1948-51; others in US and Bogata, Colombia. Awards: Gold medal, drawing, National Academy of Design, 1938; Grumbacher awards, National Society of Painters in Casein, 1968, 70, 72, 74. Teaching: Director, School of Continuing Art Education, from 1968; lecturer in Africa, South Pacific, India, from 1957; Art Students League, Instructor in Painting, 1960-64; Workshop Prof. Artists, from 1967; others. Member: National Society of Painters in Casein. Media: Oil, wood, metal, collage, found material. Address in 1982, 150 Waverly Place, NYC.

HACKET, JAMES M.
Sculptor. Born in Vermont. At Vergennes, Vermont, 1850.

HACKLIN, ALLAN DAVE.
Sculptor and painter. Born on Feb. 11, 1943. Studied at Pratt Institute, Brooklyn, NY, 1959-65. Exhibited: Allan Stone Gallery, NYC, 1967; Galerie Mueller, Stuttgart, West Germany; Galerie Rudolph Zwirner, Cologne, West Germany; Galerie Neuendorf, Hamburg, West Germany, 1969; Betty Parsons Gallery, NYC, 1969, 71; New Gallery, Cleveland, OH, 1970; Kunsthalle, Darmstadt, West Germany, 1971; Indianapolis Mus. of Art, IN, 1972; Parsons-Truman Gallery, NYC, 1975. Awards: National Endowment for the Arts, 1975, 80. Taught: Pratt Institute, 1969-70; California Institute of Arts, 1970-77; Cooper Union, 1977-80; Rhode Island School of Design, 1979-82. Address in 1982, Jefferson, NY.

HADFIELD, TED LEE.
Sculptor. Born 1950. Studied: Colorado State University, Fort Collins, CO, B.F.A., 1978; Cranbrook Academy of Art, Bloomfield Hills, M.F.A., 1980. Exhibitions: Rocky Mountain Invitational, Aspen, CO, 1978; Marietta Crafts National, Marietta College, Marietta, OH, 1979; Midwest Craft Exhibition, Rochester Art Center, Rochester, MN, 1979; Michigan Ceramics, Pewabic Pottery, Detroit, 1979, 80; Detroit Ceramics, Detroit Artists Market, 1980; Westwood Clay National, Otis Parsons Gallery, Los Angeles, CA, 1908; 8th Annual Invitational, Eastern Michigan University, Ypsilanti, 1982; Michigan Artists, The Detroit Institute of Arts, 1982. Current position: Co-owner, "Artpack & Transport." Address in 1982, Southfield, MI.

HADLIN, W.
Sculptor. Working in America c. 1850. Medium: wax.

HADZI, DIMITRI.

Sculptor and printmaker. Born March 21, 1921, in NYC. Studied: Polytechnic Institute of Brooklyn; Cooper Union; Polytechnion, Athens; Museo Artistico Industriale, Rome; Brooklyn Museum School. Work: Albright; MIT; Museum of Modern Art; New School for Social Research; Princeton University; Rhode Island School of Design; Guggenheim; Whitney; Yale University; Fogg Art Museum; Hirshhorn. Commissions for MIT, Lincoln Center, JFK Office Bldg. (Boston). Exhibited: Galleria Schneider, Rome, 1958, 60; Seiferheld Gallery, NYC, 1959; Galeria Van der Loo, Munich, 1961; Stephen Radich Gallery, 1961; Gallery Hella Nebelung, Dusseldorf, 1962; MIT, 1963; Felix Landau Gallery, 1969; Middleheim Park, Antwerp, International Outdoor Sculpture Exhibition, 1957, 59; Carnegie, 1958, 61; Museum of Modern Art; Claude Bernard, Paris, Aspects of American Sculpture, 1960; Whitney Annuals; Boston Arts Festival, 1961; XXXI Venice Biennial, 1962; Seattle World's Fair, 1962; Battersea Park, London, International Sculpture Exhibition, 1963; New York World's Fair, 1964-65; Musee Rodin, Paris, 1966. Awards: Fulbright Fellowship (Greece), 1950; L. C. Tiffany Grant, 1955; Guggenheim Foundation Fellowship, 1957; National Inst. of Arts and Letters, 1962. Address in 1983, Cambridge, MA.

HAFNER, CHARLES ANDREW.

Sculptor. Born in Omaha, NE, October 28, 1888. Pupil of Edmund C. Tarbell, F. W. Benson, Philip Hale at School of Museum of Fine Arts, Boston; James Earle Fraser, Art Students League, NY; Solon Borglum, Edward McCartan, Beaux-Arts Institute of Design. Member: NY Architectural Lg.; Allied Artists of Amer.; Artist Fellowship, Inc.; Numismatic Society of NY; National Sculpture Society. Works: Terra cotta pediment, Rivoli Theatre, NY; marble fountain "The Dance," Albee Theatre, Brooklyn, NY; Peter Pan Fountain (bronze), Paramount Theatre, NY; three medals, Numismatic Museum, NY; Rockefeller Center, NYC. Address in 1953, 112 W. 54th St., NYC.

HAGAN, JAMES GARRISON.

Sculptor and instructor. Born in Pittsburgh, PA, July 11, 1936. Studied at Carnegie-Mellon University, B.F.A.; Iowa State University; University of Pittsburgh, MA. Work at National Gallery of Art, Washington, DC; others. Has exhibited at Zabriskie Gallery, NYC; Nassau Co. Museum, NY; Wood Works, Wadsworth Atheneum, Hartford, CT; others. Teaching at University of Virginia, Charlottesville, from 1963, associate professor of sculpture. Works in wood. Address in 1982, Charlottesville, VA.

HAGEL, FRANK D.

Sculptor and painter. Born in Kalispell, MT. Studied at Art Center College of Design, Los Angeles. Worked in Detroit as an illustrator. (Prior to art studies tried ranching, rodeoing, logging, construction.) Returned to Montana in 1972. Specialty is historical Northwest subjects, trappers, mountain men, Indians, wildlife. Sketches and photographs big game during hunting season; works from these in studio. Also sculpts medals and paints murals.

Work sold at Kalispell Auction. Reviewed in *Southwest Art*, October 1977. Represented by Ponderosa Gallery, Kalispell, MT; Settlers West Galleries, Tucson, AZ. Address in 1982, Kalispell, MT.

HAGEN, JOAN B.

Sculptor. Studied: Vassar College, Poughkeepsie, NY; Art Barn, Greenwich, CT; Silvermine, New Canaan; Art Life Studio, NYC. Works: six sculptures reproduced for national distribution through Alva Museum replicas. Exhibited: Hudson Valley Art Association; Audubon Artists; and local groups. Awards: Greenwich Art Society Award. Member: Stone Sculpture Society, NYC; Society of Animal Artists, NYC. Medium: Stone. Address in 1983, Greenwich, Conn.

HAGUE, MORTON.

Sculptor. Born in Brooklyn, New York, March 2, 1894. Studied with Wilcoxson and Fromen. Address in 1933, Chicago, IL; h. Morgan Park, Ill.

HAGUE, RAOUL.

Sculptor. Born in Constantinople, Turkey, 1905. Came to US in 1921. Studied at the University of Iowa, 1921; Chicago, and NY, 1926-27; Art Students League, 1927-28; and the Courtauld Institute, London, 1950-51. Exhibited: Museum of Modern Art, 1933, 56; Whitney Museum of American Art, 1945-48, 52, 57, and 58. Awards: Ford Foundation Grant, 1961; Mark Rothko, 1962. Address in 1982, Woodstock, NY.

HAHN, NANCY COONSMAN (MRS.).

Sculptor. Born St. Louis, MO, August 28, 1892. Pupil of Zolnay, Eberle and Grafly; Washington University; St. Louis School of Fine Arts. Member: St. Louis Artists Guild; North Shore Art League, Winnetka, IL. Work: Missouri State Memorial, presented by the State to the French Government; Kinkaid Memorial Fountain and bench ends, Daughters of America Colonists Fountain, Forest Park, City of St. Louis; "Maidenhood" and Reedy Memorial, St. Louis Art Museum; H. H. Culver Memorial, Culver, IN; Barclay Memorial, New London, MO; Doughboy War Memorial, Memphis, TN; Dawson Fountain figures, Winnetka, IL; "Maidenhood," Cleveland Museum of Art; others. Awards: Medal, St. Louis School of Fine Arts. Exhibited: Penna. Academy of Fine Arts, 1916, 18, 20-24; Architectural League, 1916-18, 20; National Academy of Design, 1916, 18; Pan-Pacific Exp., 1915; Albright, Buffalo; Corcoran; Art Institute of Chicago, 1916-18, 20, 22, 24, 44, 46, 48, 49; others. Address in 1953, Winnetka, IL.

HALE, (MARY POWELL) HELME.

(Mrs. William Hale). Sculptor, painter, and teacher. Born Kingston, RI, April 12, 1862. Pupil of Art Students League of NY; Rhode Island School of Design; Chase; Saint-Gaudens; Duveneck; Knowlton. Member: Alumni Association Rhode Island School of Design; North Shore Art Association; American Artists Professional League; American Federation of Arts. Address in 1933, Gloucester, MA.

HALE, NATHAN CABOT.

Sculptor and writer. Born July 5, 1925, in Los Angeles,

CA. Studied: Chouinard Art Inst., Los Angeles, 1945; Art Students League, 1945-50; Santa Monica City College, 1952. Work: Indianapolis (Herron); Los Angeles County Museum of Art; sculpture commission, St. Anthony of Padua, East Northport, NY; set designs. Exhibited: Felix Landau Gallery, 1957; Washington Irving Gallery, NYC, 1960; Feingarten Gallery, NYC and Chicago, 1961; The Midtown Galleries, NYC, 1964, 68; Hazleton Artist League, 1966; NYU, 1967; Los Angeles County Museum of Art; Hirschl & Adler Galleries, Inc., NYC, Continuing Traditions of Realism in American Art, 1962; Corcoran; Albright; United States Government, Art in the Embassies, 1965-66; National Art Museum of Sport, NYC, 1969; and many more. Awards: Los Angeles County Museum of Art, Purchase Prize for Sculpture, 1953. Member: New York Architectural League; Municipal Art Society of New York. Taught: Los Angeles City Art Education and Recreation Program, 1956-57; Pratt Institute, 1963-64; Art Students League, 1966-72. Address in 1982, Amenia, NY.

HALEY, JOHN CHARLES.
Sculptor and painter. Born in Minneapolis, MN, September 21, 1905. Studied with Cameron Booth, Minneapolis; and Hans Hofmann, Munich and Capri. Work in Metropolitan Museum of Art, NY; San Francisco Museum of Art; others. Has exhibited at San Francisco Art Association Annual; Chicago Art Institute; Oil Painting, 51 and Drawing, 52, Metropolitan Museum of Art, NY; 149th Annual Painting and Sculpture, Penna. Academy of Fine Arts; M. H. De Young Memorial Museum, San Francisco. Received six painting and sculpture awards, San Francisco Art Association, 1936-56; Watercolor Award, California Watercolor Society; Painting Award, Richmond Art Center. Teaching at University of California at Berkeley, from 1930. Works in all media in painting and sculpture. Address in 1982, Richmond, CA.

HALEY, ROBERT DUANE.
Sculptor and painter. Born Lambertville, NJ, January 6, 1892. Pupil of Kenneth Hayes Miller, George Bridgman, Robert Tolman and John C. Johansen. Address in 1929, Greenwich CT; Bridgeport, CT.

HALKIN, THEODORE.
Sculptor and painter. Born in Chicago, IL, March 2, 1924. Studied at Art Institute of Chicago, B.F.A., 1950; Southern Illinois University, M.S. (art), 1952. Work in Art Institute of Chicago; Butler Institute of American Art. Has exhibited at Corcoran Gallery; American Painting and Sculpture Annual, Penna. Academy of Fine Arts; Detroit Institute of Arts; Allan Frumkin Galleries, NY and Chicago; others. Received Purchase Prize, Butler Institute; Chicago and Vicinity Show First Prize for Sculpture, Art Institute of Chicago; others. Teaching at Art Institute of Chicago, associate professor of art. Address in 1982, c/o Phyllis Kind Gallery, Chicago, IL.

HALKO, JOE.
Sculptor and painter. Born near Great Falls, MT, August 11, 1940. Studied at College of Great Falls, biology; art briefly in NYC. Worked in taxidermy; turned to art full-time in 1976. Exhibited at C. M. Russell Museum Art Show and Auction, Great Falls, 1973, 75, 77-79; Cowboy Hall of Fame, Solon Borglum Invitational, OK, 1976; Society of Animal Artists, NYC, 1978; others. Received awards at Spokane Art Exhibit, Washington State Historical Society; Russell Auction (best sculpture); others. Member of Society of Animal Artists; Northwest Rendezvous Group. Reviewed in Art West, March 1980. Represented by Fowler's Gallery; Settlers West Gallery, Tucson, AZ. Specializes in North American wildlife. Media: Bronze; acrylic, oil. Address in 1982, Great Falls, MT.

HALL, FRANCES DEVEREUX JONES.
(Mrs. Frances Devereux Jones Hall). Sculptor and painter. Born New Orleans, LA. Pupil of Sophie Newcomb College, New Orleans; Henry McCarter, Howard Pyle, Charles Grafly. Member: Philadelphia Alliance; National Association of Women Painters and Sculptors, New York. Instructor of modelling, Springside School, Chestnut Hill, Philadelphia. Address in 1933, Philadelphia, PA.

HALL, JAMES.
Sculptor. Active in Charleston, South Carolina, 1803. His work has been located in both North Carolina (Wilmington) and South Carolina (Georgetown). Specialty was gravestones. Died in 1823.

HALL, MICHAEL DAVID.
Sculptor and educator. Born in Upland, CA, May 20, 1941. Studied at Western Washington State College, 1958-60; University of North Carolina, B.A., 1962; University of Iowa, 1962; University of Washington, M.F.A. (sculpture), 1964. Has exhibited at Whitney Museum of American Art Annual Sculpture Exhibition, NY, 1968 and 1973; Hammarskjold Plaza, NY, 1972; Detroit Institute of Arts, 1977; Walker Art Center, Minneapolis, 1977; others. Received Guggenheim Foundation Fellowship, 1973; National Endowment for the Arts Fellowship, 1974. Teaching at Cranbrook Academy of Art, from 1970, resident sculptor. Works in steel and aluminum. Address in 1982, c/o Cranbrook Academy of Art, Bloomfield Hills, MI.

HALL, PARKER L.
Sculptor, painter, and craftsman. Born in Denver, Colorado, September 15, 1898. Award: Honorable mention, California Palace of Legion of Honor, 1931. Member: San Francisco Art Association; Bohemian Club. Address in 1933, San Francisco, CA; h. Berkeley, CA.

HALL, SUSAN.
Sculptor. Member: National Association of Women Painters and Sculptors, New York. Address in 1929, 130 West 57th Street, New York, NY.

HALL, THOMAS VICTOR.
Sculptor, painter, illustrator, and teacher. Born Rising Sun, IN, May 30, 1879. Pupil of Nowottny, Meakin, Duveneck, Art Academy, Cincinnati. Member: Salmagundi Club; KitKat Club; Cincinnati Art Club; Artists Fellowship. Address in 1933, Salmagundi Club, NYC; summer, Peekskill, NY.

HALLER, ARLENE.
Sculptor. Born in Newark, NJ, Feb. 17, 1935. Study:

Newark State, 1957; self-taught in art. Exhibition: Newark (NJ) Museum; National Academy of Design, NYC; Silvermine Guild, New Canaan, CT; Catherine Lorillard Wolfe Art Club, NYC; Allied Artists of America; National Arts Club; Rutgers University (solo); and others. Awards: American Association of University Women; Catherine Lorillard Wolfe Art Club, Excalibur award & Harriet Frishmuth award for traditional sculpture. Address in 1983, North Plainfield, NJ.

HALLER, G. J.
Sculptor. Active 1865. Patentee—bust of Lincoln, 1865.

HALLSTHAMMAR, CARL.
Sculptor. Born in 1897. Address in 1934, Chicago, IL. (Mallett's)

HAMANN, CHARLES F.
Sculptor. Member of National Sculpture Society. Active in 1926. Address in 1910, East 37th St., Flatbush, NY.

HAMAR, IRENE.
Sculptor. Born in Brazil, May 23, 1915. Came to US in 1941. Eighteen one-woman shows in South America, Europe and US, including show at Petit Palais, Paris, 1953. Works in permanent collections of The Metropolitan Museum of Art (NYC), The William Rockhill Nelson Museum of Art (Kansas City, MO), Museu de Bellas Artes (Buenos Aires), Museu de Bellas Artes (Rio de Janeiro), Ministere de l'Education (Rio de Janiero), Museu de Arte, Museu de Arte Moderna (both Sao Paulo), Ministere de l'Education (The Hague), Fodor Mus. of Amsterdam, also numerous private collections. Works include 14 foot sculpture, Univ. of Brazil, Rio de Janeiro. Home and studio in 1962, 125 E. 81st St., NYC.

HAMILTON, EVERETT.
Sculptor. Born in Philadelphia, PA. Address in 1927, Paris. (Mallett's)

HAMILTON, JOHN B.
Sculptor and painter. Exhibited in New York, 1934. (Mallett's)

HAMLIN, GENEVIEVE KARR.
Sculptor and teacher. Born in New York City, July 1, 1896. Pupil of Abastenia St. L. Eberle, and Henry Dropsy in Paris; also studied at Vassar College. Member: National Association of Women Painters and Sculptors; American Numismatic Society; Sculptors Guild; National Association of Women Artists. Work: Portrait Medallion of Theodore Roosevelt, Tsing Hua College, Peking, China; medals for Exposition of Women's Arts and Industries, Antique and Decorative Arts League, American Art Dealers Association. Exhibited at Penna. Academy of Fine Arts, 1923-38; National Academy of Design, 1923-38; Art Institute of Chicago, 1926; NY World's Fair, 1939; Rehn Gallery; others. Speciality, small sculpture; portrait heads in the round and relief, animal studies. Address in 1953, 58 West 57th St., NYC.

HAMMARGREN, FRITZ EMANUEL.
Sculptor. Born Orebro, Sweden, April 7, 1892. Pupil of Bourdelle in Paris, and Art School, Gothenborg, Sweden.

Member: Scandinavian-American Art Club and National Sculpture Society. Work: "Leda and the Swan," fountain, and monument to Dr. N. A. Wilson, Orebro, Sweden; portrait, A. P. Waller, John Morton Memorial Building, Philadelphia; "Torso," in marble, Brooklyn Museum, Brooklyn, NY; numerous figures, fountains, and small sculptures. Awards: Honorable mention, Conn. Academy of Fine Arts, 1927; honorable mention, Montclair Art Museum, 1932. Address in 1933, Leonia, NJ.

HAMMER, TRYGVE.
Sculptor, craftsman, and draftsman. Born Arendal, Norway, September 6, 1878. Pupil of Skeibrok, MacNeil, Calder and Solon Borglum. Member: National Sculpture Society; Society of Independent Artists; Brooklyn Society of Modern Art; Scandinavian-American Art; Architectural League of NY; Philadelphia Art Alliance. Work: Roosevelt Commons Memorial, Tenafly, NJ; memorial window, Crescent Athletic Club, Brooklyn, NY; head of a baby, Newark Museum; head of a man, Brooklyn Museum; "Good Shephard" mem. tablet, Zion Lutheran Church, Brooklyn, NY; Humphrey Memorial Tablet, Stevens Institute, Hoboken, NJ. Exhibited at National Sculpture Society, 1923. Died 1947. Address in 1933, Douglaston, Long Island, NY.

HAMMOND, EDITH.
Sculptor, painter, and teacher. Born in Omaha, NE. Pupil of Fursman, Polasek, Vanderpoel, Clute, Mulligan. Member: Alumni Art Institute of Chicago; Chicago Art Students League. Work: Painting in civic art collection, Chicago Municipal Pier. Taught: Assistant instructor, Summer School of Painting, Saugatuck, MI. Address in 1918, Chicago, IL.

HAMMOND, HARMONY.
Sculptor and painter. Born in Chicago, IL, February 8, 1944. Studied at Junior School of the Art Institute of Chicago, 1960-61; Milliken University, Decatur, IL, 1961-63; University of Minnesota, MN, 1963-67; Alliance Francaise, Paris, Summers of 1967, 69. Exhibited: Bottega Gallery, Minneapolis, 1964; Walker Art Center, Minneapolis, 1964; Minneapolis Institute of Arts, Minneapolis, 1965; Sarah Lawrence College, 1972; New Gallery, Cleveland, OH, 1973; New York Cultural Center, NYC, 1973; Vassar College Art Gallery, Poughkeepsie, NY, 1975; one-woman shows include Lerner-Heller Gallery, 1979, 81, Herter Gallery, Amherst College, 1981; retrospective, Glen Hanson Gallery, Minneapolis, 1981; Denver Art Museum, 1981; Haag Gementemuseum, The Hague, 1980; many others. Taught: Painting and drawing at the Art Institute, Chicago, 1973; private studio seminar for Women Artists, NYC, 1973; Richmond College; City University, NYC, 1975. Published articles, "More on Woman's Art: An Exchange," *Art in America*, November, 1976; and "Feminist Abstract Painting—A Political Viewpoint," *Heresies*, December, 1977; and "A Sense Touch: Women Identified Sexuality in Womens Art," *Heresies*, Spring, 1981; and others. Address in 1982, 129 West 22nd Street, NYC.

HAMMOND, JANE NYE.
Sculptor. Born in New York, 1857. Exhibited: Chicago

Exposition, 1893; Buffalo Exposition, 1901. Died in Providence, RI, October 23, 1901.

HAMOUDA, AMY.
Sculptor. Born in Edinburg, IN. Studied at Boston Museum School, under Karl Zerbe; Ohio State University, B.F.A.; Institute Allende, University of Guanajuato, under David Alfaro Siqueiros, M.F.A.; Ecole de la Grande Chaumiere, Paris; State University of NY, Buffalo, M.A., 1978. Has exhibited at Albright-Knox Art Gallery, Buffalo; Brooklyn Museum; Cork Gallery, Avery Fisher Hall, Lincoln Center, NY; others. Received grant for sculpture, NY State Council on the Arts, Creative Artists Public Service. Address in 1982, Buffalo, NY.

HAMPTON, BILL.
Sculptor, painter, and illustrator. Born in Simi Valley, CA, 1925. Worked in the Walt Disney Studio. Specialty, cowboys and horses in ranch scenes, flesh tones of Indian children. Has illustrated for magazines. Address in 1976, Apple Valley, CA.

HAMPTON, JAMES.
Sculptor. Born in Elloree, South Carolina, April 8, 1909. Self-taught. His only known work is entitled "Throne of the Third Heaven of the Nations Millenium General Assembly," which was begun in 1950. The piece, left unfinished at the time of his death, was said to be inspired by his mystical visions and religious convictions in the Second Coming of Christ. Died in Washington, DC, Nov. 4, 1964.

HAMPTON, JOHN WADE.
Sculptor and painter. Born in NYC, 1918. Work in Cowboy Hall of Fame. Won gold medal in sculpture, Cowboy Artists of America Show, 1977, 79-81. Co-founder of Cowboy Artists of America. Illustrations published in *Arizona Highways* and *Western Horseman*, others. Specializes in Old West subjects. Sculpts in bronze. Reviewed in *Southwest Art*, May 1974; *Art West*, November 1980. Address in 1982, Scottsdale, AZ.

HAMPTON, LUCILLE CHARLOTTE.
Sculptor and medalist. Born in Brooklyn, NY, July 22, 1922. Studied: Columbia Bible College, SC, 1948-50; Brooklyn College, NY, 1950-57; New York University, NYC, 1965-66. Commissions: The American Breed, 1971, commissioned by Dr. Alton Ochsner, New Orleans and the Bronc-5 Minutes to Midnight, 1974; The Sidewinder, 1971, commissioned by Donald C. Cook, New York and Adam & Eve, 1972-73; Bicentennial Special (4 animals), commissioned by Robert Lewis White, Winston-Salem, NC, 1975. Exhibitions: Hudson Valley Art Association, 1970, 71, 73; Allied Artists of America, NYC, 1971, 72; Catharine Lorillard Wolfe Art Club, NY, 1972-81; American Artists Professional League, Lever House, NY, 1973 and 74; Pen Women of America NY, 1975; National Academy of Design, NYC, 1975, 80; one-woman shows include Gateway Art Gallery, Palm Beach, FL, 1979; Lance Industries, 1975-80. Awards: John Newington Award, Hudson Valley Art Association, 1970, 71; Council of American Artists Societies Award, 1972, 74; Huntington Award, 1973; cash award, Ameri-can Artists Professional League, 1973, 74, 78, 80, 81, 82; Anna Hyatt Huntington Horse Head Trophy, 1975, and Brenner Gold Medal Award, 1976, both Catharine Lorillard Wolfe Art Club, NYC. Memberships: Catharine Lorillard Wolfe Art Club, NYC; American Artists Professional League, NYC, fellow, director, 1982; Royal Society of Arts, London, England, fellow; Montana Historical Society; American Cowgirl Artists Association. Teaching: Tutored students in sculpture and foundry techniques. Publications: Article in *Southwest Art*, Nov., 1978; The Chilmark Collection, Lance, 1981; listed in *Bronzes of the American West*, Broder. Technique: Sculpts in wax or clay, utilizing foundry procedures. Specialty is American West and religious subjects. Address in 1984, 1763 Second Avenue, Suite 17-N, NYC.

HAMROL, LLOYD.
Sculptor. Born in San Francisco, CA, September 25, 1937. Studied at University of California, CA, 1959, B.A., 1963, M.A., under Adolf Gottlieb. Exhibited: Whitney Museum of American Art, NYC, 1966; Los Angeles Co. Museum of Art, 1967; Museum of Contemporary Art, Chicago, 1973; Fort Worth Art Museum, TX, 1977; La Jolla Museum of Art, CA, 1968; San Diego Museum of Art, CA, 1980; and others. Awards: Individual Artists Fellowship Grant, National Endowment for the Arts, 1974; Individual Artists Fellowship Grant, National Endowment for the Arts, 1980. Published article "Two Artists/Two Attitudes" in *Criteria, A Review of the Arts*, 1974. Taught: California Institute of the Arts, Valencia, 1970-74; University of California, San Diego, 1977-78; University of California, Los Angeles, 1978-79. Works in stone and wood. Address in 1982, Venice, CA.

HANBURY, UNA.
Sculptor. Born in Kent, England, 1909; came to US, (Washington, DC) 1944. Studied at Polytechnic School of Art; Royal Academy School of Art; Academie de la Grande Chaumiere, Academie Julian, Paris; with Frank Calderon, March Brothers, Jacob Epstein. In collections of National Portrait Gallery, Washington, DC; Smithsonian Institution (auditorium), Wash., DC; numerous commissions including Julius Rudel, Kennedy Center, DC. Exhibited at National Sculpture Society, Lever House, NYC; National Portrait Gallery, Washington, DC; others. Awarded numerous prizes including Landseer prize and gold medal, Royal Academy of Art. Past member of Society of Animal Artists and National Sculpture Society. Sculpts portraits and horses in bronze. Reviewed in *Bronzes of the American West* by Broder; *Artists of the Rockies*, summer 1979; *Southwest Art*, August 1980. Represented by Munson Gallery, Santa Fe, NM; Carson Gallery, Denver, CO. Address since 1970, Santa Fe, NM.

HANCOCK, WALKER (KIRTLAND).
Sculptor. Born in St. Louis, MO, June 28, 1901. Study: St. Louis School of Fine Arts with Victor Holm; Washington University, St. Louis, 1918-20, honorary DFA, 1942; University of Wisconsin, 1920; Penna. Academy of Fine Arts, 1921-25; American Academy in Rome. Work: Penna. Academy of Fine Arts; Corcoran Gallery, National Gallery of Art, and National Portrait Gallery, Wash-

ington, DC; and many others. Commissions: Eisenhower Inaugural Medals; Penna. Railroad War Memorial, Penna. Railroad Station, Philadelphia; Army and Navy Medal; portrait statues of Douglas MacArthur, US Military Academy; John Paul Jones, Fairmount Park, Philadelphia; James Madison, Library of Congress, Madison Building; Booth Tarkington & Robert Frost, National Portrait Gallery; Field Service Memorial, Blerancourt, France; bronze bas-relief of Edwin A. Ulrich, The Edwin A. Ulrich Museum, Wichita (KS) State University; and many others. Exhibitions: National and international museums and galleries, and at National Sculpture Society, NY. Positions: Resident Sculptor, American Academy, Rome, 1956-57, 1962-63; Sculptor in Charge, Stone Mt. Memorial, GA, 1964; Head, Department of Sculpture, Penna. Academy of Fine Arts, 1929-68. Awards: Widener gold medal, Penna. Academy of Fine Arts; Fellowship prize, Penna. Academy of Fine Arts, 1931; sculpture, National Academy of Design, 1949; J. Sanford Saltus medal, American Numismatic Society, 1953; Thomas H. Proctor prize, National Academy of Design, 1959; Medal of Achievement, National Sculpture Society, 1968; Medal of Honor, 1981; and many others. Member: Exec. Comm., American Academy in Rome; National Collection of Fine Arts Commission; Academician, National Academy of Design; Fellow, National Sculpture Society; National Institute of Arts and Letters; Architectural League of NY; Benjamin Franklin Fellow, Royal Society of Arts. Media: Bronze, stone. Address in 1982, Gloucester, MA.

HANDLEY, MONTAGUE.
Sculptor. His work includes busts of "Diana," "Bacchus," and "Flora."

HANLEY, HARRIET CLARK.
Sculptor. Born St. Louis, MO. Work: Monument to George B. Wright, Fergus Falls, MN. Address in 1933, Minneapolis, MN.

HANNAFORD, ALICE IDE.
(Mrs. Foster Hannaford). Sculptor. Born Baltimore, MD, August 28, 1888. Pupil of Fraser and Art Students League of NY. Work: "Wigwam Dance," Brooklyn Institute Museum. Address in 1933, Winnetka, IL.

HANNAN, JOHN J.
Sculptor or stonecutter. Born in Ireland. Working in New York City in 1860.

HANNELL, V. M. S.
Sculptor and painter. Born in Negaunee, MI, Jan. 22, 1896. Studied at Art Inst. Chicago and Academy of Fine Arts, Obo, Finland. Work: "The Virgin," St. Joseph's Church, Woods Hole, MA. Member: Chicago No-Jury Society of Artists. Address in 1933, Chicago, IL; summer, Furnessville, Chesterton, IN.

HANSEN, EJNAR.
Sculptor, painter, lithographer, and teacher. Born in Copenhagen, Denmark, Jan 9, 1884. Studied at Royal Academy of Fine Art, Copenhagen, Denmark. Member: California Water Color Society; California Art Club; Pasadena Society of Artists. Awards: Prizes, Los Angeles Mus.

of Art, 1927, 45, 46; Federation Western Art, 1934; San Diego Fine Art Society, 1941; Los Angeles Art Club, 1941; Pasadena Art Inst., 1943; California Water Color Society, 1944; Pasadena Society of Artists, 1947, 51; State Art College, 1948, 49; National Orange Show, 1951; Laguna Beach Art Association, 1951, 52; Newport Beach Union High School, 1952; Palos Verdes Annual, 1952. Work: Los Angeles Mus. of Art; San Diego Fine Art Society; Pasadena Art Inst.; Pomona, California Municipal College; California State Fair College; National Orange Show; Springville, UT, College; Santa Paula, California, Municipal College; NY Public Library; mural, US Post Office, Lovelock NV. Exhibited: NY World's Fair, 1939; Golden Gate Exp., 1939; Corcoran Gallery of Art, 1943; Cincinnati Museum Association, 1945; Art Institute of Chicago, 1945, 46; Los Angeles Mus. of Art; National Academy of Design, 1946; Pasadena Art Institute. Position: Instructor, Los Angeles County Art Institute; Instructor, Art, John Muir College and Pasadena School of Fine Art, Pasadena, CA. Address in 1953, Pasadena, CA.

HANSEN, JAMES LEE.
Sculptor. Born June 13, 1925, Tacoma, Wash. Studied: Portland (Ore.) Museum School. Work: Univ. of Oregon; Portland (Ore.) Art Museum; San Francisco Museum of Art; Seattle Art Museum; plus many commissions in Oregon, Washington, California. Exhibited: Kraushaar Galleries, 1952; Dilexi Gallery, San Francisco; The Morris Gallery, NYC, 1951; Fountain Gallery, 1966, 69; Portland, Ore. Art Museum; Santa Barbara Museum of Art; San Francisco Museum of Art; Seattle Art Museum; Whitney Museum; The Morris Gallery, NYC, 1961; State of Washington Governor's Invitational, circ., 1964-69. Awards: San Francisco Museum of Art, 1952, 60; Seattle Art Museum, 1952; San Francisco Museum of Art, American Trust Co. Award, 1956; Seattle Art Museum, 1958; Fellow of the International Institute of Arts and Letters. Address in 1982, Battle Ground, WA.

HANSEN, OSCAR J.W.F. (OSKAR III).
Sculptor. Born in 1892 to Oskar II and Josephine Maximiliana in the then dual Kingdoms of Norway and Sweden. Came to U.S. in 1910. His works are in many private and public collections, including Brooklyn Museum; American Numismatic Museum; Art Museum of Milan; Lake Forest Public Library; Rand Tower, Minneapolis; Art Institute of Rio de Janeiro; Dayton Art Institute; Chicago Zoological Park, Brookfield; and many others. His works include colossal granite "Liberty," Yorktown, VA; colossal bronze "Winged Figures of the Republic," Hoover Dam; reliefs in concrete, Hoover Dam; colossal "Wings," created in 1929 in Chicago, later displayed in Navy Museum (Washington, DC), and Brooklyn Museum; Hinsdale (Ill.) War Memorial; turquoise Stallion's Head, Smithsonian Gem Collection; bronze "Excelsior," wedding gift of people of Norway to King Olav V and Princess Martha; portrait busts of Joseph Conrad, Elijah Paris Lovejoy, David Lloyd George, Wilbur and Orville Wright, others; "Holy Figures of Christendom," faceted and sculptured from Morganite Beryl crystal, exhibited at National Museum of the Smithsonian; 4,535 carat Beryllium crystal depicting flaming Buddhist nun;

"Brooding Image of God," faceted in 507(1/2) carat Morganite. Elected fellow, International Institute of Arts and Letters; eulogized by U.S. Congress in 1961 for his inspired sculpture. Author of *Beyond the Cherubim* and books on astronomy, biology, theology, and the arts. Died in Charlottesville, VA, in 1971.

HANSON, DUANE.
Sculptor and educator. Born in Alexandria, MN, January 17, 1925. Studied at Macalester College, B.A.; University of Minn.; Cranbrook Academy of Art, M.F.A. Work in Whitney Museum; Wadsworth Atheneum; Milwaukee Art Museum; others. Has exhibited at Whitney Museum of American Art Sculpture Annual; Museum of Contemporary Art, Chicago; Virginia Museum of Fine Arts, Richmond; Corcoran Gallery of Art; others. Works in mixed media, polyvinyl-acetate. Address in 1982, Davie, FL.

HANSON, JO.
Sculptor. Born in Carbondale, IL. Studied at San Francisco State University, M.A. (art), 1973; University of Illinois, M.A. (education). Work in San Francisco Museum of Modern Art; others. Has exhibited at Corcoran Gallery of Art; San Francisco Museum of Modern Art; Penna. Academy of Fine Art; Otis Art Institute, Los Angeles. Received National Endowment for the Arts artist fellowship grant, 1977; National Endowment for the Arts, 1979. Member of Artists Equity Association. Address in 1982, San Francisco, CA.

HANSON, LAWRENCE.
Sculptor and educator. Born in Winona, MN, July 28, 1936. Studied at University of Minn., B.A., 1959, M.F.A., 1962; University of California, Santa Barbara, with Stan Reiffel, 1969. Work in Walker Art Center, Minneapolis; La Jolla Museum of Contemporary Art; Seattle Art Museum; C. M. Russell Museum, Great Falls, MT; and others. Has exhibited at Modern Art Pavillion, Seattle Art Museum; Walker Art Center; others. Teaching at Western Washington University, from 1963, sculpture and contemporary art. Member of Western Association of Art Museums; American Museum Association; Washington Art Consortium. Address in 1982, Dept. of Art, Western Washington University, Bellingham, WA.

HANSON, NILS EDWIN.
Sculptor. Address in 1934, Cleveland, Ohio. (Mallett's)

HAOZOUS, BOB.
Sculptor. Born in Los Angeles, CA, 1943. Son of Apache sculptor Allan Houser. Studied at Utah State University; California College of Arts and Crafts, B.F.A., 1970. His work is in public collections, has been exhibited, and has won awards. Specialty is cowboys and Indians, in various materials including cast stainless steel. Represented by Heydt/Bair Gallery, Santa Fe, NM. Address in 1982, Santa Fe, NM.

HAPPERSBERGER, FRANK.
Sculptor. Born in San Francisco, 1859. Exhibited: Societe des Artistes, 1882.

HARBAUGH, MARJORIE WARVELLE (MRS.).
Sculptor. Born in Chicago, IL, July 28, 1897. Studied at Milwaukee-Downer College, B.S.; Univ. of Wisconsin, M.S.; and with Mabel Frame, William Varnum, Franz Aust. Member: Wisconsin Society of Applied Arts Work: Univ. of Wisconsin; Oriental Consistory Library, Chicago, IL; Hudson Memorial Garden, Hudson, OH. Exhibited: Massillon Mus. of Art, 1945; Milwaukee Art Institute. Address in 1953, Hudson, OH.

HARDIE, FERNANDO.
Sculptor. Born in Tuscany, 1837. Employed by his father, Lorenzo Hardi, Sr., in Philadelphia, 1860. Medium: plaster.

HARDIE, LORENZO JR.
Sculptor. Born in Tuscany, 1834. Employed by his father, Lorenzo Hardie, Sr. Active in Philadelphia in 1860. Medium: plaster.

HARDIE, LORENZO SR.
Sculptor. Born in Tuscany, 1818. Employed numerous artists, including his sons, Fernando and Lorenzo Hardie, Jr., Francesco Barsotte, Frostino Gianelli, Michael Belli, Domenica Belli, Anato Belli, Angelo Mathedi, Lorenzo Pero, Giovanni March. Active in Philadelphia in 1860. Medium: Plaster.

HARDIN, ADLAI S.
Sculptor. Born in Minneapolis, MN, September 23, 1901. Studied: Art Institute of Chicago; Princeton University, A.B. Member: Associate, National Academy of Design; National Sculpture Society. Awards: Prizes, Architectural League, 1941; National Sculpture Society, 1950; medal, National Academy of Design, 1945. Work: Penna. Academy of Fine Arts; IBM; Moravian Church, Bethlehem, PA. Exhibited: National Academy of Design; Penna. Academy of Fine Arts, annually. Address in 1982, Darien, CT.

HARDING, HARVEY A.
Sculptor and painter. Worked: New Orleans, 1836, 1856-59.

HARDY, THOMAS (AUSTIN).
Sculptor. Born in Redmond, OR, November 30, 1921. Studied at Oregon State University, 1938-40; University of Oregon, B.A., 1942, with Archipenko, summer 1951, M.F.A., 1952. Work in Whitney Museum of American Art; Seattle Art Museum; duck fountain, University of Oregon; others. Has exhibited at Museum of Modern Art Sculpture Exhibition; Whitney Museum of American Art Sculpture Annual; others. Received award for Color Lithography, Society of American Graphic Artists, 1952; Seattle Art Museum Northwest Annual Sculpture Award, 1955. Member of Portland Art Museum; Contemporary Crafts Association. Works in welded bronze, brush and ink. Represented by Kraushaar Galleries, NYC. Address in 1982, Portland, OR.

HARE, DAVID.
Sculptor. Born March 10, 1917, in NYC. Studied in New York, Arizona, Colorado (majored in experimental color photography). Work: Brandeis University; Albright; Carnegie; Wadsworth; Metropolitan Mus. of Art; Museum of Modern Art; San Francisco Museum of Art;

Guggenheim; Whitney Museum; Washington University; Yale University. Published portfolio of color photos on American Indian, with C. Whissler of American Museum of Natural History (1940). Exhibited: Hudson D. Walker Gallery, NYC, 1939; Julien Levy Galleries, NYC, 1946; The Kootz Gallery, NYC, 1946, 48, 51, 52, 56, 58, 59; San Francisco Museum of Art; Staempfli Gallery, 1969; Philadelphia Museum of Art, 1969; I & IV Sao Paulo Biennials, 1951, 57; Museum of Modern Art; Musee Rodin, Paris, International Sculpture, 1956; Brussels World's Fair, 1958; Art Institute of Chicago, 1961; Seattle World's Fair, 1962; Whitney Museum of American Art. Address in 1982, New York City.

HARE, JEANNETTE R.
Sculptor. Born Antwerp, Belgium, August 24, 1898. Pupil of C. C. Rumsey, A. S. Calder, H. Frishmuth. Member: National Association of Women Painters and Sculptors. Address in 1933, Forest Hills, Long Island, NY; summer, Ogunquit, ME.

HARGRAVE (HARGREAVE), THOMAS.
Sculptor and stonecutter. Worked: Philadelphia 1837-after 1860. Medium: Marble.

HARKAVY, MINNA R.
Sculptor. Born in Estonia, 1895. Studied at Art Students League; Hunter College; in Paris with Antoine Bourdelle. Awards: National Association of Women Artists, 1940-1941; National Exhibition of American Science, Metropolitan Museum of Art, 1951; Project award, United States Treasury. Collections: Whitney Museum of American Art; Museum of Modern Art; Musee Municipal, St. Denis, France; Museum of Western Art, Russia; Tel-Aviv, Ain Harod Museum, Israel; United States Post Office, Winchendon, MA. Exhibited: San Francisco Museum of Art; Art Institute of Chicago; Penna. Academy of Fine Arts; others. Address in 1982, 2109 Broadway, New York City.

HARLEY, CHARLES RICHARD.
Sculptor. Born in Philadelphia in 1864. Educated at Spring Garden Institute; Penna. Academy of Fine Arts; in Paris at Ecole Nationale des Arts Decorative, Academie Julien, Ecole des Beaux Arts, and under Dampt and Aube; also in NY under St. Gaudens and Martiny; and in Rome and Florence. Professionally engaged as sculptor since 1895. Medal, Buffalo Exposition, 1901. Address in 1926, 709 West 169th Street, New York.

HARMON, ELOISE (NORSTAD).
Sculptor. Born in St. Paul, MN, Aug. 28, 1923. Studied at Hunter College; Art Students League; Alfred Univ.; also with Maija Grotell, Albert Jacobson, and Norman La Liberte. Commission: Mural, Inn at the Landing, Kansas City, 1968; mural, NY Apt., 1970; murals, Park Sheraton Hotel, NY, 1970; Fountain, El Conquistador Hotel, PR, 1970; altar cross, Our Redeemer Lutheran Church, NY, 1972. Exhibitions: Cranbrook Art Show, Detroit, 1969; Episcopal Church Center, Chicago, 1971; New England Exhibition, New Canaan, CT, 1972. Awards: International Award, American Institute Decorators, 1970. Medium: Clay. Address in 1982, Pleasantville, NY.

HARMON, LILY.
Sculptor and painter. Born in New Haven, CT, November 19, 1912. Studied at Yale School of Art; Academie Colarossi, Paris; Art Students League. Work in Whitney Museum; Butler Art Institute; Tel Aviv Museum, Israel; Hirshhorn Museum; others. Has exhibited at Metropolitan Museum of Art; Carnegie Institute; International Salon, Palace of Fine Arts, Mexico City; others. Member of Artists Equity; National Academy of Design. Teaching at National Academy of Design, from 1974, oil painting. Address in 1982, 151 Central Park W., NYC.

HARNEY, CHARLES Y.
Sculptor. Died in New York, 1912. (Mallett's)

HARNISCH, ALBERT E.
Sculptor. Born in Philadelphia, 1843. Studied at Penna. Academy of Fine Arts; and in Italy. Lived in Rome for eight years. Pupil of Jos. A. Bailly. He executed the Calhoun Monument and the Barclay family group. He made a specialty of portrait busts. Exhibited at Penna. Academy of Fine Arts, 1859-69.

HAROLD & RANDOLPH.
Ship carvers. Worked in Baltimore; carved the *Scotia* figurehead in 1839.

HAROOTIAN, KHOREN DER.
Sculptor and painter. Born in Armenia, April 2, 1909; US citizen. Studied at Worcester Art Museum, MA. Work in Metropolitan Museum of Art; Whitney Museum of Art; Bezalel Museum, Israel; sculpture, Fairmount Park Association, Philadelphia; bronze monument, Armenian Bicentennial Committee, Fairmount Park, Philadelphia. Has exhibited at Whitney Museum; Penna. Academy of Fine Arts; Fairmount Park International Exhibition, Philadelphia Museum; Brussels World's Fair, Belgium; others. Received George D. Widener Medal, Penna. Academy of Fine Arts, 1954; American Academy of Arts and Letters and National Institute of Arts and Letters Award and Citation, 1954; Silver Medal, Gruppo Donatello, Florence, Italy, 1962. Works in bronze, marble, and watercolor. Address in 1982, Orangeburg, NY.

HARPER, LILLIE HYDE.
Sculptor and craftswoman. Address in 1933, c/o National Arts Club, 15 Gramercy Park, NYC.

HARR, PAMELA.
Sculptor. Born in Palo Alto, CA, 1944. Studied at Oregon State University, B.S. physical therapy, 1966; bronze-casting course, 1973. Initially worked for Department of Agriculture as an illustrator; turned to sculpture in 1973. Specialty is people in a Western setting, including pioneer women. Member of Women Artists of the American West. Reviewed in *Southwest Art*, February, 1979. Represented by Bridger Foundry and Gallery, Bozeman, MT. Address since 1977, Bozeman, MT.

HARRAH, JUNE.
(June Harrah Lord). Sculptor. Member of the National Sculpture Society. Address in 1982, North Salem, New York.

HARRIS, BELLE C.
See Belle C. Harriss.

HARRIS, BETTY.
Sculptor. Address in 1935, Madison, Wisconsin. (Mallett's)

HARRIS, GEORGE ALBERT.
Sculptor and painter. Born in San Francisco, CA, January 24, 1913. Studied at California School of Fine Arts. Work in San Francisco Museum of Art. Exhibited at National Academy of Design; Art Institute of Chicago; others. By 1953 no longer listed as sculptor. Address in 1953, California.

HARRIS, JULIAN HOKE.
Sculptor and educator. Born in Carrollton, GA, August 22, 1906. Studied at Georgia Institute Technology, B.S.; Penna. Academy of Fine Arts. Member: National Sculpture Society; American Institute of Architects; Atlanta Art Association; Southern States Art League, 1939; Tri-County Exh., Atlanta, 1940; IBM, 1942; Association Georgia Art, 1951. Work: designed and executed sculpture on 24 public buildings and 21 memorial and portrait commissions including: Stone Mountain Confederate Memorial; Georgia State Office Building, Atlanta; Coca-Cola Bottling Comp., Atlanta; Atlanta Constitution Building; New Georgia State Prison, Reidsville; Upson County Hospital, Thomaston, GA; Uncle Remus Library, Atlanta; Grant Park Zoo; 24 commemorative medallions including official inaugural medallion for Pres. Jimmy Carter, commemorative medals and medallions for Rich's, Atlanta; Mandeville Mills, Carrollton, GA. Position: Professor, Department of Architecture, Georgia Institute Technology; Professor, Atlanta (GA) Art Institute. Address in 1982, Atlanta, GA.

HARRIS, MARGIE COLEMAN.
Sculptor, painter, educator, etcher, writer, and lecturer. Born in Washington, DC, March 30, 1891. Studied at Carnegie Inst.; Univ. of Pittsburgh; Univ. of Chicago; Penna. State College. Member: Eastern Art Association; National Education Assoc.; Associated Artists of Pittsburgh; All. Artists Johnstown; Penna. Art Educ. Association; Philadelphia Print Club; NJ Painters and Sculptors; New Orleans Art Association; Ligonier Valley Art League; Johnstown Art League; Cambria County Art Association. Awards: Prizes, Ebensburg Fair, 1935; All. Artists Johnstown, 1933-37; 51, 52; Garden Club, 1938-1945. Work: Cambria Library; Veteran's Hospital, Aspinwall, Bethlehem, PA; State Teachers College, Indiana, PA. Exhibited: Indiana, PA, 1944-46; Associated Artists of Pittsburgh, 1924-53; All. Artists, Johnstown, 1933-53; Ebensburg, PA, 1932-41; Philadelphia Print Club, 1950-52; Irvington Print Club, 1950-52; NJ Painters and Sculptors Society, 1952; Norton Gallery of Art, 1952; Puzzletown Guild, 1950-52. Position: Instructor of Art, Penna. State College, 1919-38; teacher and lecturer at Art Institute, Johnstown, PA, 1935-53; State Teachers College, 1939; treasurer, Penna. Art Education Association, 1952, 53. Address in 1953, Johnstown, PA.

HARRIS, MARGO LIEBES.
Sculptor. Born in Frankfurt, Germany, in 1925. Studied in Germany and Italy; Art Students League, with William

Zorach. Works: in private collections. Exhibited: Whitney Museum of American Art; Portland Museum of Fine Arts; Detroit Art Institute; Sculpture Center, NY; Boston Arts Festival; plus others. Address in 1976, 300 East 74th Street, NYC.

HARRIS, PAUL.
Sculptor. Born 1925, in Orlando, FL. Studied with Jay Karen Winslow, Orlando, Florida; Chouinard Art Institute; New School for Social Research (with Johannes Molzahn); University of New Mexico; Hans Hofmann School. Exhibited: Poindexter Gallery, 1961, 63, 66; New School for Social Research; University of New Mexico; Los Angeles County Museum of Art, 1967; IX Sao Paulo Biennial, 1967; Museum of Modern Art; shows in Vienna, Cologne, Belgrade, Baden-Baden, Geneva, Brussels, Milan. Awarded Resident of MacDowell Colony, 1977, and Guggenheim Fellowship, 1979. Represented by Poindexter Gallery, NYC. Taught: University of New Mexico; Knox College; New Paltz State College; Montclair State College; California Art Institute. Address in 1982, Bolinas, California.

HARRIS, REGINALD G. (MRS.).
See Davenport, Jane.

HARRIS, ROY M.
Sculptor. Born in Ogden, UT, 1928; grew up in northern Idaho. Studied at Weber State College; Utah State University, B.S.; holds doctorate in animal genetics. Taught animal science at California Polytechnic State University; worked in cattle and ranching business. Began sculpting in 1974. Creates bronzes in editions of ten to twenty. Specialty, cowboys and range animals. Represented by Copenhagen Galleri, Solvang, CA. Address since 1954, San Luis Obispo, CA.

HARRISS (or HARRIS), BELLE C.
(Mrs. Richard T.) Sculptor. Born in Brenham, Texas. Represented in Brooklyn Museum, Brooklyn, NY. Address in 1933, 22 Charles St.; h. 1158 Fifth Ave., NYC.

HARRITON, DAVID M.
Sculptor, painter, designer, craftsman, and lecturer. Born in Romania, April 1, 1895. Studied at National Academy of Design; Art Students League. Member: Society of Designer-Craftsmen (Pres.). Awards: Medal, Paris Exp., 1937. Work: Glass ceiling, Clark Memorial, Vincennes, IN; Worcester War Memorial; Federal Reserve Bldg., Washington, DC; US Bureau Shipping, NYC. Exhibited: Society Designer-Craftsmen, annually. Lectures: Carved glass. Address in 1953, 511 East 72nd St.; h. 137-58 75th Rd., Kew Gardens Hills, NY.

HARSHMAN, ARTHUR L.
Sculptor, designer, and painter. Born in Dunkirk, IN, December 29, 1910. Member: Industrial Designers Institute; Indiana Art Society; Indianapolis Art Association; Indiana Society of Printmakers. Work: Museum of Modern Art; Ball State Teachers College Gallery, Muncie, Ind. Exhibited: Library of Congress, 1946; Laguna Beach Art Association, 1947, 48; Mint Museum of Art, 1946, 47; Industrial Designers Institute, Good Design Exhibition,

Chicago, 1950; Industrial Designers Institute, NY, 1951; Indiana Artists, 1947-49; Tri-State Print Exhib., 1946; Ohio Art, 1949. Position: Head, Design Control Department, Indiana Glass Co., from 1937. Address in 1953, Dunkirk, IN.

HART, FREDERICK E.
Sculptor. Member of the National Sculpture Society. Address in 1982, Washington, DC.

HART, JAMES JR.
Sculptor. Located: NYC, 1858.

HART, JOEL TANNER.
Sculptor. Born February 10, 1810, in Clark County, KY. He went abroad for study and spent much of his life in Florence, Italy. He executed several statues of Henry Clay, 1846-48 and busts of many prominent men. Associated with Shobal Vail Clevenger after 1831. Died in Florence, Italy, March 2, 1877.

HARTLEY, JOAN.
Sculptor. Address in 1934, New York. (Mallett's)

HARTLEY, JONATHAN SCOTT.
Sculptor. Born in Albany, NY, September 23, 1845. He studied in New England and later in Paris and Italy. His first teacher was Erastus D. Palmer, one of the early American sculptors. He married the daughter of the painter George Inness. Exhibited at London, 1884, 1889; Buffalo Exposition, 1901; National Academy, 1901. He was elected to the National Academy in 1891. Died in New York City on December 6, 1912.

HARTLEY, JOSEPH.
Sculptor. Born in Albany, New York, May 19, 1842. Member: Salmagundi Club. Address in 1921, 1442 Minford Place, New York, NY.

HARTWIG, CLEO.
Sculptor. Born in Webberville, MI, October 20, 1911. Studied: West Michigan University, AB, Honorary MA, Honorary DFA. Also studied at the Art Institute of Chicago; The International School of Art. Works represented in "Contemporary American Sculpture" by C. Ludwig Brumme; "Sculpture in Modern America" by Jacques Schnier; "Interior Design & Decoration" by Janet K. Smith; others. Exhibited: Metropolitan Museum; Whitney Museum; Denver Museum; Philadelphia Museum; National Institute of Arts and Letters; others. Awards: National Academy of Design 1979; National Sculpture Society, 1969, 76, 78, 80; others from National Association of Women Artists; Audubon Artists; etc. Member: Audubon Artists; National Association of Women Artists; Society of Animal Artists, NYC; Sculptors Guild; National Sculpture Society (Fellow); National Academy of Design (Academician). Taught: Cooper Union 1945-46, part time at the Montclair Art Museum, NJ, 1945-71. Media: bronze, stone, wood, and terracotta. Address in 1983, 9 Patchin Place, New York, NY.

HARVEY, (WILLIAM) ANDRE.
Sculptor. Born in Hollywood, FL, October 9, 1941. Studied at University of Virginia, B.A.; additional study with Michael Anasse, Valauris, France; and Charles Parks,

Hockessin, Delaware. Work in Delaware Art Museum; White House, Washington, DC; others. Has exhibited at National Sculpture Society, NY; Delaware Art Museum, Wilmington; others. Member of the National Sculpture Society. Works in bronze. Address in 1982, Rockland, DE.

HARVEY, CHARLES Y.
Sculptor. Born in 1869. Died in New York, January 27, 1912. (Mallett's)

HARVEY, ELI.
Sculptor, painter, and craftsman. Born Ogden, OH, September 23, 1860. Pupil of Cincinnati Academy under Leutz, Noble, and Rebisso; Julian Academy in Paris under Lefebvre, Constant and Doucet; Delecluse Academy under Delance and Callot, and Fremiet at the Jardin des Plantes Paris Zoo. Member: National Sculpture Society, 1902; New York Architectural League, 1903; American Art Association of Paris; American Society of Animal Painters and Sculptors; Allied Artists of Amer.; Society National des Beaux Arts; California Art Club; Laguna Beach Art Association; American Federation of Arts. Awards: First class gold medal for painting, Paris-Province Exp., 1900; Wanamaker prize for sculpture, American Art Association of Paris, 1900; bronze medal for sculpture, Pan-Am. Exp., Buffalo, 1901; bronze medal, St. Louis Exp., 1904; bronze medal, P.-P. Exp., San Francisco, 1915. Work: "Maternal Caress" and American bald eagle for honor roll, Metropolitan Museum, NY; sculpture for Lion House, New York Zoo; recumbent lions for Eaton Mausoleum; portrait of "Dinah," gorilla, for New York Zoological Society; medal commemorating entry of the U.S. into the war, for American Numismatic Society; Eagles for the Victory Arch, New York; American Elk for BPOE; sculpture for the Evangeline Blashfield Memorial Fountain; Brown Bear Mascot for Brown University, Providence; represented in museums of St. Louis, Liverpool, Newark, Cincinnati; American Museum of Natural History, and Metropolitan Museum of Art, New York; Brookgreen Gardens, SC. Exhibited at National Sculpture Society, 1923; and Paris Salons, 1895, 1899. Died February 10, 1957, in Calif. Address in 1933, Alhambra, California.

HARVEY (JONES), GERALD.
Sculptor and painter. Born in San Antonio, TX, 1933. Studied fine art at North Texas State University; and privately. Influenced by French and American Impressionists. His shows have sold out for up to $1,000,000. Specialty is the West of the present and the past. Paints in oil. Represented by Texas Art Gallery. Bibliography, Southwest Art, summer 1976; Artists of the Rockies, spring, 1979; The Cowboy in Art, Ainsworth; Western Painting Today, Hassrick. Address in 1982, Cedar Park, TX.

HARWOOD, SABRA B.
Sculptor. Born Brookline, MA, January 18, 1895. Pupil of Bela Pratt and Charles Grafly. Member: Copley Society. Address in 1933, Boston, MA.

HASELTINE, ELISABETH.
(Mrs. Frederick C. Hibbard). Sculptor. Born in Portland, OR, September 25, 1894. Studied at University of Chi-

cago; Art Institute Chicago; with Polasek, Bourdelle, and Mestrovic. Work: Interior sculpture, Norton Memorial Hall, Chautauqua, NY; sculpture, Illinois State Museum, Springfield. Awards: French Traveling Fellowship, Art Institute of Chicago, 1925; first prize, sculpture, 1930, third prize, 1932, Chicago Galleries Association. Member: Association of Chicago Painters and Sculptors; Chicago Gallery Association; Cordon Club. Instructor in art, University of Chicago. Address in 1933, Chicago, IL.

HASELTINE, HERBERT.
Sculptor. Born in Rome, Italy, April 10, 1877. Pupil of Aime Morot; studied at Royal Academy, Munich, and Julian Academy, Paris. Work: "British Champion Animals," Field Museum, Chicago, IL; Metropolitan Museum of Art; Whitney Museum; Brooklyn Museum; Addison Gallery, Andover, MA; National Gallery of Art, Washington, DC; Virginia Museum of Fine Arts; Tate, London; Rhode Island School of Design; equestrian monuments in connection with architectural work by Sir Edwin Luylens, R.A., at Jamnagar, Kathiawar, India. Address in 1953, 200 Central Park South, New York City. Died in 1962.

HASELTINE, JAMES HENRY.
Sculptor. Born Philadelphia, November 2, 1833. He studied in Philadelphia under Joseph Bailly; in Paris and Rome. Served in the United States Army in Civil War. He executed statue of "America Honoring Her Fallen Brave," owned by Philadelphia Union League Club. He also did portraits of Longfellow, Read, General Sheridan and General Merritt. Exhibited at Penna. Academy of Fine Arts, 1855, and later. Died in Rome, Italy, November 9, 1907.

HASELTINE, WILLIAM STANLEY.
Sculptor. Born June 11, 1835, in Philadelphia. Studied in Philadelphia under Webster. Elected an Academician of National Academy of Design, 1861. He had a studio in Rome, and exhibited at the "Centennial," in Philadelphia, 1876. Died February 3, 1900, in Rome, Italy. Brother of J. H. Haseltine.

HASKEY, GEORGE.
Sculptor and painter. Born in Windber, PA, Oct. 24, 1903. Studied at Carnegie Inst.; and with Emile Walters, Samuel Rosenberg, Hobart Nichols. Awards: Prizes, All. Artists, Pittsburgh, 1933, 34, 35, 38; Art Lg., N. Kensington, PA, 1940; Fellow, Tiffany Foundation, 1935. Work: Latrobe (PA) H.S. Exhibited: All. Artists Johnstown, 1933-43; Tiffany Foundation, 1935, 36; Carnegie Inst., 1937-44; Munson-Williams-Proctor Inst., 1946. Address in 1953, Watertown, NY.

HASKIN, DONALD MARCUS.
Sculptor. Born in St. Paul, Minn., July 28, 1920. Studied at University of Minnesota, with Tovish; Cranbrook Academy. Taught at University of California at Berkeley, 1963-65; University of Arizona at Tucson, from 1965. At Berkeley helped establish foundry which provided first opportunity for Bay Area sculptors to cast in bronze locally. In collections of Yuma (AZ) Art Association; Bernicia Art Museum, California; commissions in bronze and

stainless steel for Tucson. Exhibited at Contemporary Crafts Museum, NYC, 1961; San Francisco Museum of Art, 1962; Tucson Museum of Art, 1975; others. Address in 1982, Tucson, Arizona.

HASTINGS, DANIEL.
Sculptor. In Mass., c. 1775. Work includes portrait on slate of John Holyoke, Newton, Mass., done in 1775. Specialty was gravestones.

HASTINGS, WILLIAM GRANVILLE.
Sculptor. Born in England c. 1868. Died in Mount Vernon, NY, June 13, 1902. (Mallett's)

HASWELL, ERNEST BRUCE.
Sculptor, writer, lecturer, and teacher. Born in Hardinsburg, KY, July 25, 1889. Pupil of Barnhorn (at Cincinnati Art Academy), Meakin, Dubois, Victor Rousseau; Academie Royale des Beaux Arts, Brussels, Belgium. Member: Cincinnati MacDowell Society; Cincinnati Art Club; Crafters' Guild. Work: "Spinoza," bas-relief, Hebrew Union College and Spinoza House, The Hague; "Northcott Memorial," Springfield, IL; Cincinnati Museum, Cincinnati MacDowell Society, Rookwood Pottery; St. Coleman's Church, Cleveland; war memorial, Bond Hill, OH; war memorial, Avondale (OH) School; portraits of Generals Greene, St. Clair, and Wayne, Greensville, OH; Nippert Memorial, University of Cincinnati Stadium; Jacob Burnett Memorial, Cincinnati; Moorman Memorial, Louisville, KY; Holmes Memorial, Cincinnati, OH; Brookgreen Gardens, SC. Exhibited at National Sculpture Soc. in 1923. Contributor to "International Studio," "Art and Archaeology," "Craftsman" magazines. Associate Professor, College of Applied Arts, University of Cincinnati, Ohio. Died in 1965. Address in 1953, Cincinnati, OH.

HATCHETT, DUAYNE.
Sculptor. Born May 12, 1925, in Shawnee, OK. Studied: Univ. of Oklahoma with John O'Neil, BFA and MFA. Work: Carnegie; Columbus; Dallas Museum of Fine Arts; Aldrich; Whitney Museum; Rochester Memorial Mus. Exhibited: Haydon Calhoun Gallery, Dallas; Oklahoma; Tulsa (Philbrook); Bryson Gallery, Columbus, Ohio; Royal Marks Gallery, NYC, 1966, 68, 69; New York World's Fair, 1964-65; Whitney Museum; Los Angeles County Museum of Art, American Sculpture of the Sixties, 1967; Carnegie, 1967; HemisFair '68, San Antonio, 1968; Albright. Works in metal. Address in 1982, Buffalo, NY.

HAUPERS, CLEMENT (BERNARD).
Sculptor, painter, lecturer, and teacher. Born in St. Paul, MN, March 1, 1900. Studied at Minneapolis School of Art; and with L'Hote, Bourdelle, Jacovleff, in Paris. Member: Minnesota Art Association. Awards: Prizes, Minn. State Fair, 1925; Minneapolis Institute of Art, 1928. Work: Brooklyn Museum; New York Public Library; Philadelphia Museum of Art; Minneapolis Institute of Art; San Diego Society of Fine Art; Dallas Museum of Fine Art. Exhibited: Art Institute of Chicago; New York World's Fair, 1939; Milwaukee Art Institute; Minnesota State Fair; Minneapolis Institute of Art; Walker Art Cen-

ter. Position: Supt., Fine Art Department, Minn. State Fair, 1930-41; Instructor, St. Paul School of Art, 1931-36; State Director, Regional Director, Assistant to National Director, Federal Art Project, 1935-42; Instructor, St. Paul Art Center, St. Paul, Minn., from 1945. Address in 1953, Rutledge, MN.

HAUPT, CHARLOTTE.
Sculptor and teacher. Born in Pittsburgh, PA, November 2, 1898. Studied at University of Cincinnati, B.A.; Cincinnati Art Academy, with Clement Burnhorn; and in Europe. Member: Cincinnati Professional Art Association. Work: Cincinnati Museum Association. Exhibited: Cincinnati Museum Association, annually, 1944, one-woman; Pittsburgh Garden Center, 1934; Ephraim, WI, 1945. Lectures: Appreciation of Sculpture. Address in 1953, Cincinnati, OH.

HAUSER, ALONZO.
Sculptor and educator. Born in La Crosse, WI, January 30, 1909. Studied at Layton School of Art; Univ. of Wisconsin; Art Students League, with William Zorach. Member: An American Group; Sculptors Guild; Minnesota Art Association; Minnesota Sculptors Guild. Awards: Prizes, Wisconsin Painters and Sculptors, 1940-42; IBM, 1941; Minnesota Regional Sculpture Award, 1946. Work: IBM; St. Paul's Church, St. Paul, MN; Milwaukee Art Inst.; Walker Art Center; reliefs, US Post Office, Park Rapids, MN. Exhibited: Whitney Museum of American Art; Brooklyn Mus.; NY World's Fair, 1939; Sculptors Guild; Minn. Regional Sculpture Exhibition; one-man exhibition; ACA Gallery, 1936; Layton Art Gallery, 1942; Walker Art Center, 1946; St. Paul Gallery of Art, 1946; Las Cruces Community Art Center, NM, 1975. Position: Instructor of Sculpture, Layton School of Art, 1940-42; Carleton College, 1944-45; Head of Art Dept., Macalester College, St. Paul, MN, 1945-49. Address in 1982, Mesilla Park, NM.

HAWKINS, BENJAMIN F.
Sculptor. Born in St. Louis, MO, June 17, 1896. Pupil of Victor Holm, Leo Lentelli, Lee Lawrie. Member: National Sculpture Society. Work: "Minerva," University of Michigan, Ann Arbor; sculptural detail, Washington Hall, United States Military Academy, West Point, NY; figures, high school, Little Rock, AR; Brookgreen Gardens, SC. Address in 1982, Pleasantville, NY.

HAWKS, RACHEL MARSHALL.
(Mrs. Arthur L. Hawks). Sculptor and teacher. Born Port Deposit, MD, March 20, 1879. Pupil of Maryland Institute, Rinehart School of Sculpture under Ephraim Keyser, Charles Pike. Member: Handicraft Club of Baltimore; Maryland Institute Alumni. Work: Bust of Dr. Basil Gildersleeve, Johns Hopkins University, Baltimore; numerous garden sculptures—"Boy and Dragon Fly," "Boy and Dolphins," etc. in Administration Building, Maryland Casualty Co., Baltimore. Specialty, mural decorations in relief. Exhibited at National Sculpture Society, 1923. Address in 1953, Ruxton, Baltimore Co., MD.

HAWLEY, JAMES J.
Sculptor. Born 1871. Died in NYC, December 11, 1899. (Mallett's)

HAWORTH, JANN.
Sculptor and painter. Working with dolls and assemblage figures. She has exhibited at the Sidney Janis Gallery, New York City.

HAWS, MARION.
Sculptor and painter. Born in Vernal, UT, 1947. Studied art at Brigham Young University, 1969-74 (with William Whitaker). Painting full-time since 1976. Painting subjects are rural landscapes; sculpture concentrates on the Old West. Represented by Four Seasons Gallery, Jackson, WY; Husberg Fine Arts Gallery, Sedona, AZ. Address in 1982, Newton, Cache Valley, UT.

HAWTHORNE, EDITH G.
Sculptor, painter, craftsman, writer, and teacher. Born in Copenhagen, Denmark, Aug. 29, 1874. Studied with Chase. Member: Laguna Beach Art Association. Address in 1933, San Francisco, California.

HAY, GENEVIEVE LEE.
Sculptor and teacher. Born in Cleveland, OH, September 12, 1881. Pupil of Henri; Cooper Union; Art Students League of New York. Member: MacDowell Club. Died in Flemington, NJ, April 7, 1918. Address in 1918, 356 West 22nd St., NYC.

HAYASHI, JOY.
Sculptor. Working mainly with primary forms.

HAYDON, HAROLD EMERSON.
Sculptor, painter, illustrator, educator, lecturer, and writer. Born in Fort William, Canada, April 22, 1909. Studied at Univ. of Chicago, Ph.D., M.A.; Art Institute of Chicago. Member: Artists Equity Association; American Association Univ. Professors. Awards: Prize, University of Chicago, 1945. Work: Mural, Pickering College, Newmarket, Ontario, Canada. Exhibited: Art Institute of Chicago, 1937, 38, 44, 45, 46-50; others. Illustrator, many educational books, monographs, etc. Taught: Instructor, Assistant Professor of Art, University of Chicago, IL, 1944-48; Associate Professor, 1944-75; visiting lecturer, murals, University of Chicago, 1975-81. Address in 1983, Chicago, IL.

HAYES, DAVID VINCENT.
Sculptor. Born March 15, 1931, in Hartford, CT. Earned A.B. at University of Notre Dame (1951), and MFA from Indiana (1955), with David Smith. Taught at Harvard University. Awards: Fulbright research grant, 1961; Guggenheim Fellowship, 1961; National Inst. of Arts and Letters award. Exhibited at Smithsonian; Guggenheim; Willard Gallery, NYC; Wadsworth; Musee Rodin (American Center). In collections of Dallas Museum; Guggenheim; Addison Gallery; Museum of Modern Art, NY; Brooklyn Museum; Houston Museum of Fine Arts; and private collectors. Address in 1982, Conventry, CT.

HAYES, LOUISA.
Sculptor, painter, and craftsman. Born in Buffalo, NY, January 15, 1881. Pupil of Robert Reid and Albright Art School. Member: American Society of Sculptors; Buffalo Guild of Allied Arts. Address in 1918, Buffalo, NY; sum-

mer, "Shoreoaks," care of Ridgeway, Ontario, Canada.

HAYNES, C. YOUNGLOVE.
Sculptor. At Philadelphia, 1850. Noted work: Bas-relief portrait of Henry Clay.

HAYNES, VERNITA CAROLYN.
Sculptor and commercial artist. Born in Hartford, CT. Studied sculpture with Henry Kries, Hartford Art School, 1934-35, Naum Michel Los, NYC, 1932-40. Staff artist for Aetna Ins. Co., Hartford, CT, from 1925; sculptor of bronze bust of Francis S. Murphy at Murphy Terminal, Bradley Field Airport, Windsor Locks, CT; designed, modeled in low relief, official bank seal for the Society for Savings, Hartford, 1955. Exhibited in group shows in Hartford, Meriden, Torrington, CT, Springfield, MA, NYC. Recipient 1st prize Torrington Artists, 1954; best in show prize, Conn. Classic Arts, Inc., 1959. Member: Hartford C. of C. (mem. fire prevention com. 1959), Hartford Society of Women Painters, Arts and Crafts Association of Meriden, Inc., Torrington Artists, Society of Conn. Craftsmen, and Conn. Classic Arts, Inc. Address in 1962, 22 Kenyon St., Hartford. Office: 55 Elm St., Hartford. Studio: 219 Sisson Ave., Hartford.

HAYS, AUSTIN.
Sculptor. Born in NYC in 1869; was the son of William J. Hays, member of National Academy of Design, and brother of William J. Hays, the landscape painter. Was a clerk in the Chemical National Bank, but later went to Paris and studied art for six years under Mercie and Puech. Much of his work was exhibited in the Petit Salon in Paris and the National Academy of Design, NYC. He was a member of the Salmagundi Club. Died at his country home in the White Mountains, July 24, 1915.

HAYS, ELAH HALE.
Sculptor. Born in Madisonville, TX, in 1896. She moved to San Francisco, California, in 1913. Studied at University of California at Berkeley; under Vaclav Vytlacil, 1938, and Antonio Prieto, 1946. Taught at California College of Arts and Crafts, Oakland, 1943-73. Works include bas-reliefs, facade of Giannini Hall, University of California, Berkeley; bas-reliefs, John McLaren Elementary School, San Francisco; drinking fountain, First Congregational Church, Berkeley. Exhibited at University of California, Berkeley; Oakland (California) Art Gallery; San Francisco Museum of Art; San Francisco Art Association Annuals; San Francisco Society of Women Artists; others.

HAYWARD, F. HAROLD.
Sculptor, illustrator, painter, and teacher. Born in Romeo, MI, June 30, 1867. Pupil of Whistler, Laurens, and Benjamin-Constant in Paris. Address in 1910, Mt. Clemens, MI.

HAZAK, ELIE.
Sculptor. Born in Ismir, Turkey, 1945; raised in Jerusalem. Studied art in Jerusalem, privately and at school. Came to US; was employed in a foundry, studied art. Specialty is statuettes of Old West subjects; works in bronze. Sells mostly to private individuals. Reviewed in *Southwest Art*, June 1980. Address since 1969, Thousand Oaks, CA.

HAZEN, FANNIE WILHELMINA.
(Mrs. B. F. Ledford). Sculptor and painter. Born Murphy's Gulch, CA, August 27, 1877. Pupil of Hopkins Institute, San Francisco, and Academie Moderne, Paris. Address in 1933, Los Angeles, CA; summer, Los Gatos, CA.

HEAD, SAMUEL.
Sculptor and marble cutter. Located: New Orleans, 1852-53.

HEALY, ANNE LAURA.
Sculptor and educator. Born in NYC, October 1, 1939. Studied at Queens College, NY, B.A., 1962. Work in Museum of Contemporary Crafts, NY; NY Culture Center; others. Has exhibited at Brooklyn Museum, NY; American Academy and Institute of Arts and Letters; others. Received award for sculpture, Association of American University Women. Represented by Zabriskie Gallery, NYC. Address in 1982, City University of NY Art Dept., NYC.

HEBALD, MILTON ELTING.
Sculptor and printmaker. Born May 24, 1917, NYC. Studied: Art Students League with Ann Goldwaithe, 1927-28; National Academy of Design, with Gordon Samstag, 1931-32; Master Institute of United Arts, Inc., NYC, 1931-34; Beaux-Arts Institute of Design, NYC, 1932-35. Work: Bezalel Museum, Calcutta; Museum of Modern Art; Museum of the City of New York; Penna. Academy of Fine Arts; Phila. Museum of Art; Tel Aviv; Virginia Museum of Fine Arts; Whitney Mus.; Yale Univ.; and commissions, including bronze fountain at 333 E. 79th St., NYC; bronze frieze at Pan-Am Terminal Kennedy Airport; bronze group, Central Park, NYC; James Joyce Monument, Zurich; and others. Exhibited: ACA Gallery (Prize show), NYC, 1937, 40; Grand Central Moderns, NYC, 1949, 52; Galleria Schneider, Rome, 1957, 63; Lee Nordness Gallery, NYC, 1959-61, 63, 66; Penthouse Gallery, San Francisco, 1966; Gallery of Modern Art, 1966, 68; Virginia Museum of Fine Arts, 1967; Kovler Gallery, Chicago, 1967-68; London Arts; Cincinnati Art Museum; Sculptors Guild; Whitney Museum Annuals, 1937-63; Penna. Academy of Fine Arts, 1938-64; Arte Figurativo, Rome, 1964, 67; Carnegie, 1965. Awards: ACA Gallery Competition Prize, 1937; Brooklyn Museum, First Prize, 1950; Prix de Rome, 1955-59. Taught: Brooklyn Museum School, 1946-51; Cooper Union, 1946-53; Univ. of Minnesota, 1949; Skowhegan School, summers, 1950-52; Long Beach State College, summer, 1968. Address in 1982, Bracciano, Italy.

HEBB, MATHILDE M.
Sculptor. Born in Baltimore, Maryland, in 1911. Studied at Maryland Institute; Rinehart School of Sculpture; Goucher College. Works: Sculpture figures and fountains, Baltimore, Maryland parks. Awards: Maryland Institute, 1934; Rinehart School of Sculpture, 1935; traveling scholarship, Rinehart School of Fine Arts, 1936; Baltimore Museum of Art, 1936. Address in 1953, Cockeysville, MD.

HEBER, CARL AUGUSTUS.
Sculptor. Born Stuttgart, Germany, April 15, 1875. Pupil

of Art Institute of Chicago; Academie Julian, and Ecole des Beaux Arts, Paris. Member: National Sculpture Society 1904; Philadelphia Alliance. Awards: Bronze medal, St. Louis Exposition, 1904; bronze medal, P.-P. Expos., San Francisco, 1915; prize, American Institute of Architects and T Square joint exhibition, Philadelphia. Work: "Pastoral," St. Louis Museum Fine Arts; "Champlain Memorial," Crown Point, NY; "Champlain Statue," Plattsburg, NY; "Schiller Monument," Rochester, NY; "Benjamin Franklin," Princeton University; statue "Valor," New York City; Everette Memorial, Goshen, NY; Soldiers and Sailors Monument, Geneva, IL; World War Memorial, Wausau, WI; "Roman Epic Poetry," Brooklyn Museum; "Herald of the Dawn" erected at Batavia, NY. Exhibited at National Sculpture Society, 1923. Died 1956. Address in 1953, Philadelphia, PA.

HEERS, WENDEL.
Sculptor. Born in Minnesota, 1924. Studied: University of Minnesota; Minneapolis School of Art; School of Vision, Salzburg, Austria. Private collections. Exhibitions: Michigan Artists Exhibition, The Detroit Institute of Arts, 1972; All Michigan II, The Flint Institute of Arts, 1973; works by Michigan Artists, Detroit Institute of Arts, 1974-75. Awards: Juror's Citation, All Michigan II, The Flint Institute of Arts, 1973. Address in 1975, Ann Arbor, MI.

HEIDEL, EDITH OGDEN.
Sculptor and writer. Born St. Paul, MN. Pupil of Augustus Saint-Gaudens. Member: Washington Art Club. Address in 1929, Washington, DC.

HEIKKA, EARLE ERIK.
Sculptor. Born of Finnish parents in Belt, Montana, in 1910. Early models were in wood, leather, cloth, papier-mache, plaster and metal. Subjects were primarily pack trains, stagecoaches, mounted cowboys and Indians in action. Works are in collections of Museum of Native Cultures, Spokane, Washington; C. M. Russell Museum, Great Falls, Montana; National Cowboy Hall of Fame, Oklahoma City; many more. His "Bringing in Nanooksoah," measuring 10" by 30", executed in German silver, is in the Harmsen Collection of American Western Art. Lived near Great Falls, Montana, from 1934. Died in 1941.

HEINZMANN, SAMILLA LOVE JAMESON.
(Mrs. Heinzmann). Sculptor, painter, illustrator, and cartoonist. Born in Indianapolis, IN, April 22, 1881. Pupil of Chicago Art Institute; Detroit Fine Arts Academy; Carnegie Institute of Technology; De Lug in Vienna. Work: Thomas Paine Memorial Tablet, NYC; Henry Hudson Tablet, Amsterdam, Holland. Member: Society of Independent Artists; Institute of Arts and Sciences. Address in 1953, The Willow Bridge Studio, Princess Bay, Staten Island, NY.

HEIZER, MICHAEL.
Sculptor and painter. Born in Berkeley, California, in 1944. Studied at San Francisco Art Institute, 1962-66. Went to NYC in 1966. Exhibited at galleries in Dusseldorf, Frankfurt, Cologne, Essen, Munich, West Germany; Innsbruck, Austria; and Turin, Italy; Dwan Gallery, NYC; Detroit Institute of Art; Ace Gallery, Los Angeles; Xavier Fourcade Inc., NYC; Whitney Annuals, NYC; Stedelijk Museum, Amsterdam; Kunsthalle, Bern, Switzerland; Guggenheim; Documenta VI, Kassel, Germany; Hirshhorn; Art Institute of Chicago; others. Creates giant works such as earth projects using desert space and the interplay of natural forces.

HELD, CHARLES.
Sculptor. Awarded honorable mention, Exposition Universelle, Paris, 1889.

HELENE, SISTER.
Sculptor, painter, teacher, writer, and craftswoman. Born in Alameda, CA. Studied at Siena Heights College, A.B.; Art Institute of Chicago; Claremont Graduate Art Seminar; Cranbrook Academy of Art, M.F.A.; and abroad. Member: American Artists Professional League; Stained Glass Association of America; American Federation of Arts; College Art Association of America. Work: Bronze doors, figures, stained glass and murals for churches. Exhibited: Institute of Modern Art, Boston, 1944; Detroit Institute of Art, 1939, 42, 45; Catholic Art Association, 1938-42; Cranbrook Museum; Des Moines Art Center; Springfield Museum of Art; Saginaw Museum of Art; Sioux City Art Center. Contributor to Catholic Art Quarterly; Stained Glass Quarterly; American Apostolate, research film strip for metal designers. Position: Director, Studio Angelico, Adrian, MI, from 1935; Comm. of the Arts, Association American College, 1945-52, Faculty Advisor, from 1952. Address in 1953, Adrian, MI.

HELLER, EUGENIE M.
Sculptor, painter, cartoonist, and lithographer. Born in Rushville, IL. Pupil of J. Alden Weir in New York; Aman-Jean, Grasset and Whistler in Paris. Represented by woodcuts in the Art Gallery, Lindsborg, KS; Illinois State Art Gallery, Springfield; Grosvenor Library, Buffalo, NY; Brooklyn Museum. Address in 1933, Brooklyn, NY.

HELMAN, PHOEBE.
Sculptor. Born in NYC, Oct. 29, 1929. Studied at Washington Univ., with Paul Burlin, B.F.A.; Art Students League; also with Raphael Soyer. Work: Hampton Inst. Museum, VA; Ciba-Geigy, NY; Fox, Flynn, Melamed, NY; Friedlich, Fearon, and Strohmeier, NY. Commission: Steel wall piece, commission by Milan Stoeger, NY, 1973; steel wall piece, commission by Muriel Mannings, NY, 1973. Exhibitions: One-woman show, Max Hutchinson Gallery, 1974; Sculpture Now, Inc. Gallery 1, 1974; plastics, State Univ. NY Potsdam, 1975. Media: Laminite and wood; steel. Address in 1982, 217 East 23rd Street, NYC.

HELMUTH, JESSIE L.
Sculptor and painter. Born in Chicago, IL, July 20, 1892. Pupil of Mulligan, Crunelle, Polasek, and Charles Schroeder. Address in 1918, Chicago, IL.

HEMENWAY, ALICE SPAULDING (MRS.).
Sculptor, painter, teacher, and lecturer. Born in Dedham, MA, April 9, 1866. Studied at Mass. School of Art; Rhode Island School of Design; and abroad. Member: Tampa Civic Art Club; American Federation of Arts; Florida

Federation of Arts. Awards: Medal, Mass. School of Art. Work: Tampa Art Institute; Hillsboro Masonic Lodge, Children's Home, YWCA, Public School, all in Tampa, FL; Boston Art Club. Exhibited: Paris Salon; Rhode Island School of Design; Tampa Art Institute; Tampa Civic Art Club; Boston Art Club (one-woman). Address in 1953, Tampa, FL.

HEMENWAY, AUDREY.
Sculptor. Born in New York City, in 1930. Studied: Hunter College, M.A., B.F.A.; privately with Willem de Kooning. Awards: National Endowment for the Arts, Short-term Activities Fellowship-Grant, 1973. Exhibitions: Williams College, 1972; SUNY Museum at Albany, 1972; O. K. Harris Gallery, 1970; Katz Gallery, 1970.

HEMENWAY, CHARLES.
Sculptor. Born early in the 19th century. Trained at Tingley's stoneyard in Providence. Executed a number of portrait busts as well as cemetery monuments. Died in 1887.

HENDERSON, JOHN R.
Sculptor, painter, and printmaker. Active in Denver, Colorado, 1893-98. Charter member of the Artists Club. Work in Denver Public Library (sketches and woodblocks). Head modeled in relief exhibited in 1898.

HENDLEY, JOHN WALTER.
Sculptor. Born in Virginia in 1826. Modeler at the Smithsonian Institution, Washington, DC. Died in Washington, July 3, 1899.

HENNEMAN, VALENTIN.
Sculptor, painter, etcher, lecturer, and teacher. Born Oost-Camp, Belgium, July 7, 1861. Studied in Belgium, Germany, Italy, France. Work: "The Decline of Illiteracy in Belgium," "The Shepherd," "Storm in the North Sea," "Moonlight on the Atlantic," owned by the Belgian Government; "Liniken Bay," Museum of Bruges; "View at Southport," City Hall, Bruges; portrait of Baron L. de Bu de Westvoorde, City Hall Oost-Camp. Three hundred portraits of noted Belgians. Known as the "Snow Sculptor." Instructor, in portrait, Bangor Society of Art. Died 1930. Address in 1929, Bangor, ME; summer, Boothbay Harbor, ME.

HENRICH, JEAN MacKAY.
See MacKay, Jean V.

HENRY, ALBERT P.
Sculptor. Born Versailles, KY, in 1836. His first art work, as a boy, was a carving from marble of an Indian girl holding a dove while a wolf creeps up to snatch the bird from her grasp. He modeled small portrait busts and cast them in iron for door stoppers. At the beginning of the Civil War, young Henry recruited a company of the Fifteenth Kentucky Cavalry. He was captured and taken to Libby Prison. While in prison he devoted much of his time to carving oxen bones used for making soup. He smuggled some from the prison including "The Prisoner's Dream," showing the interior of a cell, an armed sentry at the door, while the prisoner is sleeping on the floor. Following the close of the war he was appointed

consul at Anconia, Italy. Prior to his leaving the US he had executed his bust of Henry Clay, now in the Capitol at Washington, and a bust of Abraham Lincoln from life, now in the Custom House, in Louisville, KY. He studied in Florence, Italy under Powers and Joel T. Hart. His most ambitious work was an ideal bust of Genevieve. He also made one of Senator Guthrie, of Kentucky, and a bust of Senator Garrett Davis. Died November 6, 1872.

HEPBURN, CORNELIA.
Sculptor. Member: National Association of Women Painters and Sculptors. Address in 1924, 630 Park Ave., NYC.

HEPWORTH, BARBARA.
Sculptor. Born in Wakefield, Yorkshire, England, in 1903. Studied at Leeds School of Art and at the Royal College of Art in London, spent three years in Italy studying carving under Ardini. Exhibitions: London, 1928; XXV Venice Biennale, 1950; Whitechapel Art Gallery, London, 1954; and at the V Sao Paulo Biennial, 1959; numerous open air international sculpture exhibitions in London, 1949-57. Awards: Second prize in the international sculpture competition for the work entitled "The Unknown Political Prisoner;" and the sculpture prize at Sao Paulo in 1959. Works are represented in the Museum of Modern Art, NY; Kroller-Mueller Museum, Holland; Tate Gallery, London; and many others. Commissions: Festival of Britain, 1951; "Vertical Forms" for the Technical College at Hatfield, and "Meridian," for the State House in London.

HERBERT, BARBARA.
Sculptor. Born in New York. Exhibited: Salon des Artistes Francais, c. 1926. Awards: Honorable mention, Salon des Artistes Francais, 1930.

HERBERT, JAMES DRUMMOND
Sculptor, painter and advertising art director. Born New York, December 26, 1896. Studied at Columbia University; Art Students League; Julian Academy, Paris. Pupil of Bridgman, DuMond, Hayes Miller, Lentelli. Member: Art Students League of NY; National Arts Club; Society of Illustrators; National Sculpture Society. Exhibited at National Academy of Design; Penna. Academy of Fine Arts; Art Institute of Chicago; Architectural League; Art Directors Club. Address in 1953, 53 East 10 Street, New York, NY. Died 1970.

HERING, ELSIE WARD.
Sculptor. Born August 29, 1872, in Howard County, MO. Studied in Denver, CO, and at Art Students League. Pupil of Augustus Saint-Gaudens. She and her husband became his assistants. Member: Denver Art Club and National Sculpture Society. Exhibited at National Sculpture Society, 1923. Work: Schermerhorn memorial font in Chapel of Our Savior, Denver, CO; W.C.T.U. drinking fountain, St. Louis Museum. Received awards at SC Exposition, 1902; Louisiana Purchase Exposition, St. Louis, 1904. Specialty was portraits, busts and reliefs. Died in NY, January 12, 1923.

HERING, HENRY.
Sculptor. Born NYC, February 15, 1874. Pupil of Augustus Saint-Gaudens, 1900-07; studied at Cooper Union, 1888-91; with Philip Martiny, 1891-97; at Art Students

League, 1894-98; at Ecole des Beaux-Arts and Colarossi Academy, Paris, 1900-01. Member: New York Architectural League 1910; National Sculpture Society 1913; Amer. Federation of Arts. Awards: Silver medal for medals and bronze medal for sculpture, P.-P. Exposition, San Francisco 1915. Work: Civil War Memorial, Yale Univ., New Haven; Robert Collyer Memorial, Church of Messiah, NYC; sculpture on Field Museum of Natural History, Chicago; the two South Pylon groups, "Defense" and "Regeneration," Michigan Avenue Bridge, Chicago; "Pro Patria," Indiana State War Memorial; sculpture, Industrial Arts Building, Chicago; Federal Reserve Banks at Dallas, Kansas City, Chicago, Cleveland, Pittsburgh, and Clarksburg, West VA. Exhibited at National Sculpture Society, 1923. Address in 1933, Waldorf Building, 10 West 33d Street; h. Hotel White, 37th Street and Lexington Avenue, New York, NY. Died January 17, 1949, in New York City.

HERMS, GEORGE.
Sculptor. Born in Woodland, California, in 1935. Studied at College of Engineering, University of California at Berkeley; primarily self-taught in art. Taught at University of California at Irvine and California State at Fullerton. Exhibited at Hermosa Beach, Los Angeles; Rolf Nelson Gallery, Molly Barnes Gallery, Nicholas Wilder Gallery, all in Los Angeles; Museum of Modern Art; Whitney; Dallas Museum of Fine Arts; San Francisco Museum of Modern Art; San Diego Museum of Art; other galleries and museums in California.

HERRING, MABEL C.
Sculptor. Exhibited: Exposition Universelle, Paris, 1900.

HERRON, JASON (MISS).
Sculptor. Born in Denver, Colorado, September 11, 1900. Studied at Stanford Univ., BA; Otis Art Institute; University of Southern California, with Merrell Gage and F. Tolles Chamberlin at Los Angeles Co. Art Institute. Works: Los Angeles Museum of Art; Browning Museum, London, England; South Pasadena High School; Belmont School, Los Angeles; Santa Monica, CA. High School. Awards: Los Angeles Co. Fair, 1934; Los Angeles Art Association; Society for Sanity in Art, 1945; California Art Club, 1946. California Palace of Legion of Honor, San Francisco; National Academy of Design, NY; Corcoran Gallery of Art, Washington, DC; Art Institute of Chicago; plus numerous others. Address in 1976, Ventura, CA.

HERRON, RONALD M.
Sculptor and painter. Born in Havre, MT, 1943; raised in Kalispell, MT. Long acquainted with wildlife, ranching, and Indians. Specialty is subjects of Montana life. Works in bronze, including miniatures, statuettes, and large pieces. Painting, "Medicine Bundle," can be seen at entrance to gallery at Mt. Rushmore. Represented by Montana Gallery and Book Shoppe, Helena, MT. Address in 1982, Helena, MT.

HERSCHLER, DAVID.
Sculptor. Born in Brooklyn NY, March 1, 1940. Studied at Accademia Belli Arte, Perugia, Italy, 1960; University of Rome, 1960; Cornell University, B.Arch., 1962; Clare-

mont Graduate School, M.F.A., 1967. Work in Joseph H. Hirshhorn Foundation, Washington, DC; La Jolla Museum of Art; Storm King Art Center, Mountainville, NY; others. Works in stainless steel and gold. Address in 1982, c/o Ankrum Gallery, Santa Barbara, CA.

HERSHMAN, LYNN LESTER.
Sculptor. Born in CA, June 17, 1941. Studied at Case Western Reserve Univ., Cleveland, OH, 1963, BA; at California College of Arts and Crafts, Oakland; at Univ. of California, Los Angeles; at Ohio Univ., Athens, OH; Otis Art Institute, Los Angeles; Cleveland Inst. of Art, OH; California State Univ., San Francisco, 1972, M.A. Exhibited: Butler Art Institute of American Art, Youngstown, OH; National Sculpture Exhibit, San Diego Mus. of Art, Santa Barbara, CA, 1972; Richmond Art Center, Richmond, CA, 1970; William Sawyer Gallery, San Francisco, CA, 1970; University of Art Museum, Berkeley, CA, 1972; Musee Nationale d'Art Moderne, Centre National d'Art et de Culture George Pompidou, Paris, 1979; San Francisco Museum of Modern Art, 1980. Has written numerous articles, including "The Newer Art," *Studio International* (London), May, 1972; "Toadal Orgasm," in *City Magazine*, Vol. 1, No. 5, 1973; "Mainlining the Hard Stuff vs. Cold Turkey Hedonism" in Bronx Museum catalogue, January, 1975; others. Address in 1982, 3007 Jackson, San Francisco, CA.

HERZ, ELISE.
Sculptor. Work includes "Janes," aluminum. Member: National Association of Women Artists. Exhibited at 94th Annual Exhibition, National Association of Women Artists. Address in 1983, Larchmont, NY.

HERZ, NORA (EVELYN).
Sculptor. Born in Hipperholme, England, May 13, 1910. Studied: Pratt Institute Art School; Sculpture Center; and in Germany. Awards: Village Art Center, 1949, 1951; Montclair Art Museum, 1956; Pen and Brush Club, 1956; Hunterdon County Art Center, 1957; Bamberger Company, 1957, 1958. Collections: Bavarian National Museum, Munich, Germany; Athens, GA. Exhibited: Audubon; National Academy of Design; Penna. Academy of Fine Arts; Metropolitan Museum of Art; Architectural League; Sculpture Center; National Sculpture Society; others. Address in 1953, 2 West 15th Street; h. 224 Sullivan Street, New York City.

HERZEL, PAUL.
Sculptor, painter, and illustrator. Born Germany, August 28, 1876. Pupil of St. Louis School of Fine Arts; Beaux-Arts Institute of Design, NY. Member: National Sculpture Society (Associate); American Federation of Arts. Awards: Mrs. H. P. Whitney "Struggle" prize, 1915; Barnett prize, National Academy of Design, 1915; prize, Garden Club of America, 1929. Exhibited at National Sculpture Society, 1923. Address in 1933, Brooklyn, New York.

HESKETH.
Sculptor. Born in Maine. Studied at Wellesley College, B.A., with John Flannagan. Member: Artists Equity Association. Work: Ferargil Gallery; Egan Gallery. Exhibited:

Detroit Institute of Art, 1946; City Art Museum of St. Paul, 1946; Philadelphia Museum of Art, 1940; Carnegie Institute, 1941; Art Inst. of Chicago, 1942, 43; Penna. Academy of Fine Arts, 1943; Metropolitan Museum of Art, 1943; De Motte Gallery; Egan Gallery; J. B. Neumann Gallery; one-man exhibitions: San Francisco Museum of Art, 1943; Seattle Art Museum, 1943; Ferargil Gallery, 1942, 43, 45; Cosmopolitan Club, Philadelphia, PA, 1946; Whitney Museum of American Art; Addison Gallery of American Art. Address in 1982, Bluehills Studio, RD 1, Kempton, PA.

HESNESS, GERD.

Sculptor. Born in NYC, May 5, 1952. Studied at Fashion Institute of Technology, NY, A.A. (fine arts), 1975; National Academy of Design, NY; Frudakis Academy of Fine Arts, Philadelphia, PA. Has exhibited at National Sculpture Society, NY; National Academy of Design, NY; Salmagundi Club, NY; others. Received Walter Lantz Youth Prize, National Sculpture Society, 1980; Helen Foster Barnett Prize, National Academy of Design Annual Exhibition, 1980; Marguerite Hexter Prize, Allied Artists of America Annual Exhibition, 1980. Member of Allied Artists of America. Works in bronze. Address in 1982, Frudakis Gallery, Philadelphia, PA.

HESS, EMIL JOHN.

Sculptor and painter. Born in Willock, PA, Sept. 25, 1913. Studied at Duquesne Univ.; Art Inst. of Pittsburgh; Art Students League; Brooklyn Museum Art School. Work: Penna. State Mus.; Mus. of Modern Art. Exhibited: National Academy of Design, 1950; Penna. State Mus., 1950; Art Students League, 1947-50; Brooklyn Mus., 1951; one-man: Betty Parsons Gallery, 1951, 52, 68, 70. Member: Life member, Art Students League; American Federation of Arts; International Platform Assoc. Media: Metal; oil. Address in 1982, 130 West Tenth St., NYC.

HESS, GEORGE.

Sculptor. Born in Pfungstadt, Germany, September 28, 1832. Studied sculpture in Munich, Germany. Worked: NYC. Medium: Stone.

HESSE, EVA.

Sculptor. Born in Hamburg, Germany, Jan. 11, 1936. Studied: Cooper Union, NY; Yale University, B.F.A. Exhibited: Boston Museum, 1961; Wadsworth Atheneum, 1961; Castelli "Warehouse" Exhibition, 1968; Whitney Museum, 1968, 69; Museum of Modern Art, 1969; Galerie Ricke, Cologne, West Germany, one-woman, 1969; others. Taught: Instructor, School of Visual Art, NYC. Making sculpture and hangings with fiber, plastic, rubber, metal, during the 1960's. Died in 1970.

HIBBARD, ELISABETH HASELTINE.

Sculptor. Born in Portland, Oregon, in 1894. Studied at Portland, Oregon Art School; University of Chicago; Art Institute of Chicago; Grande Chaumiere, Paris; also with Polasek, Bourdelle, Navellier, and deCreeft. Works: University of Chicago; Norton Memorial Hall, Chautauqua, NY; Jackson Park, Chicago. Exhibited: Art Institute of Chicago, 1924-31, 35-40, 43, 44; Women's Art Salon,

Chicago, 1943-45; others. Awards: Art Institute of Chicago, 1925; Chicago Galleries Assoc., 1929, 30, 32; National Association of Women Artists, 1937. Address in 1953, Chicago, IL.

HIBBARD, EVERETT.

Sculptor and painter. Studied: Oklahoma, Detroit, Boston and New York City. Works Published: 8 Lithographs in color (in edition of 250); 5 Lithographs in Black and White (in editions of 25). Exhibited: Tulsa Oklahoma Gallery, Santa Fe, New Mexico; Albuquerque NM; Sports Arts, New Orleans; Plainfield, Chatham and Ridgewood, NJ; Ellenville, NY; and Collectors Cabinet, New York City. Awards: Southwestern Art Association, Tulsa Oklahoma, Washington University, Topeka Kansas, Sumerset County College NJ, Ridgewood, Fairlawn and Bergen County Art Guilds, NJ. Member: Society of Animal Artists, NYC. Taught: Philbrook Art Center, Tulsa, Oklahoma. Media: Stone; oil and watercolor. Address in 1983, Midland Park, NJ.

HIBBARD, FREDERICK CLEVELAND.

Sculptor. Born Canton, MO, June 15, 1881. Pupil of John Vanderpoel and Lorado Taft; Art Institute of Chicago; Illinois Institute of Technology; University of Missouri. Member: Chicago Soc. of Artists; Cliff Dwellers; Chicago Painters and Sculptors; American Federation of Arts. Awards: Honorable mention, Art Institute of Chicago, 1913; Shaffer prize, Art Institute of Chicago, 1914; gold medal, Kansas City Art Institute, 1924. Work: "Mark Twain," Hannibal, MO; "Gen. James Shields," Carrollton, MO; "The Virginian," Winchester, VA; "U.D.C. Shiloh Memorial," Shiloh National Park, TN; "General Grant," Vicksburg, MS; "Dr. G. V. Black," Lincoln Park, Chicago, IL; "Volney Rogers," Youngstown, Ohio; "Gen. H. W. Lawton," Fort Wayne, IN; "Soldier and Sailor," Pittsburgh; "Doughboy," McConnellsville, OH; "Tom Sawyer" and "Hucklebury Finn," Hannibal, MO; "Champ Clark," Bowling Green, MO; "Fountains," Stevens Hotel, Chicago. Represented in Vanderpoel Collection, Chicago; University of Chicago; Illinois Institute of Technology; Butler Art Institute; others. Exhibited at National Sculpture Society, 1923; Art Institute of Chicago, 1903, 04, 08, 11-13, 16, 18, 19, 24, 33-35, 39, 40, 43; Pan-Pacific Expo., 1915; Baltimore Museum of Art, 1923; Penna. Academy of Fine Arts, 1904; Kansas City Art Institute, 1924; others. Vice President Municipal Art League, Chicago. Address in 1953, 923 East 60th Street, h. 6209 Ellis Avenue, Chicago, IL.

HIBBEN, HELENE.

Sculptor. Born Indianapolis, November 18, 1882. Pupil of William Forsyth at Herron Art Institute; Lorado Taft at Art Institute of Chicago; James Earle Fraser at Art Students League of New York. Member: New York Society of Craftsmen; Indianapolis Art Association. Address in 1933, Indianapolis, IN.

HICKEY, ROSE VAN VRANKEN.

Sculptor. Born in Passaic, NJ, May 15, 1919. Studied: Pomona College; Art Students League; University of Iowa; and with Bridgman, Humbert Albrizio, Mauricio Lasansky, Zorach and Laurent. Awards: Los Angeles Mu-

seum of Art, 1944; Oakland Art Gallery, 1945, 46; Pasadena Art Institute 1945, 51; Joslyn Museum of Art, 1950; Walker Art Center, 1951; Des Moines Art Center, first prize, sculpture, 1953; National Association of Women Artists, 1952; portrait award for sculpture, Catharine Lorillard Wolfe National Art Exhibition, New York City, 1969; Salma. Club, 1980, 82, 83; others. Represented in Des Moines Art Center; Coventry Cathedral, England; Laguna Gloria Museum, Austin, TX; others. Exhibited at Pasadena Art Museum, 1946; National Association of Women Artists Annual, National Academy, 1951-79; Stedelijk Museum, Amsterdam, 1956-57; Audubon Artists Annual, National Academy, 1965; Salmagundi Club Annual, NYC, 1978, 79; many others. Address in 1982, Houston, TX.

HICKEY, WILLIAM.
Sculptor and stonecutter. Active in New York City, 1849-52. Received diploma for statuary at the American Institute in 1849.

HIGGINS, (GEORGE) EDWARD.
Sculptor. Born 1930, in Gaffney, SC. Studied art at age of twelve under Morris Graves; attended Munich Preparatory School; travelled and painted independently throughout Europe in mid 1930's; studied with Hans Hoffman in New York; University of North Carolina, 1954, BA. Work: Albright; Art Institute of Chicago; Dallas Museum of Fine Arts; Museum of Modern Art; Guggenheim; Whitney Museum; and commissions, including Cameron Building, NYC; NYS Theatre at Lincoln Center, NYC. Exhibited: Leo Castelli Inc., NYC, 1960, 63, 66; Richard Feigen Gallery, NYC, 1964; Minneapolis Institute, 1964; Museum of Modern Art; Claude Bernard, Paris; Whitney Museum; Houston Museum of Fine Arts; Art Institute of Chicago; Carnegie; Seattle World's Fair, 1962; Guggenheim; American Federation of Arts; Tate; Gulbenkian International; 1964 New York World's Fair, 1964-65; Documenta IV, Kassel, 1968; plus many more. Awards: L. C. Tiffany Grant, 1962; Flint Institute, I Flint Invitational, 1966. Taught: Parsons School of design, 1962-63; Philadelphia Museum School, 1963. Address in 1982, Easton, PA.

HIGGINS, EUGENE.
Sculptor, painter, and etcher. Born in Kansas City, MO, February 1874. Pupil of Laurens, Benjamin Constant, Gerome and Ecole des Beaux-Arts, in Paris. Work: "The Little Mother," Carnegie Inst., Pittsburgh; "Tired Out," "Man and the Setting Sun," Milwaukee Inst.; etchings in NY Public Library and Brooklyn Museum; Congressional Library, Washington, DC. Member: Associate National Academy of Design; League of American Artists; NY Water Color Club; Brooklyn Society of Etchers. Exhibited: National Academy of Design; Carnegie Institute; Penna. Academy of Fine Arts; Art Institute of Chicago. Died in 1958. Address in 1953, West 22nd St., NYC.

HIGGS, FLORENCE BESSOM.
(Mrs. George W. Higgs). Sculptor. Born in Marblehead, MA, November 30, 1905. Exhibited sculpture in group shows at Baltimore Museum of Art, Richmond Museum of Art, Corcoran Gallery Art, Philadelphia Museum Art,

Syracuse Museum of Art, John Herron Art Museum, Indianapolis; others. Founder of The Artists Mart in Georgetown, DC, from 1951. Taught art at Mrs. Cooks Private School, 1943-49. Sculptors Group (treasurer from 1953). Address in 1962, Arlington, VA. Office: Washington, DC.

HILDEBRANDT, WILLIAM ALBERT, JR.
Sculptor, painter, teacher, and illustrator. Born in Philadelphia, PA, October 1, 1917. Studied at Tyler School of Fine Arts, Temple University, B.F.A., B.S. in Education, M.F.A.; Philadelphia Mus. School of Industrial Art. Member: Philadelphia Art Teachers Association; Penna. State Education Association; National Education Association. Awards: Prizes, Temple University Alumn. Award, 1948; Tyler Art School Alumn., 1950; Philadelphia Art Teachers Association, 1949, 50. Exhibited: Penna. Academy of Fine Arts, 1941; Temple University, 1946 (one-man); Woodmere Gallery, 1943-46; Philadelphia Art Teachers Association, 1946-52; Ragan Gallery, 1946; DaVinci All., 1948-52; Friends Central School, 1950-52. Positions: Art Supv., Sharon Hill, PA, 1939-44; Art Supv., Tyler School of Art, 1944-47; Art Consultant, Franklin Institute Lab for Research and Development, from 1947; Art, Winston Publishing Co., from 1952. Illustrated *Echoes from Mount Olympus*, 1970; author of *Aunt in the Middle Years*, 1980. Media: Oil, multiple media. Address in 1983, PA.

HILL, CAROLINE.
Sculptor and painter. Born in Boston, Mass. Exhibited: Tuileries, Paris, 1929.

HILL, CLARA.
Sculptor. Born in MA. Pupil of Augustus Saint-Gaudens; Julian Academy under Puech and Colarossi Academy under Injalbert, in Paris. Member: Society Washington Artists; American Federation of Arts. Award: Grand prize, Seattle Exp., 1909. Represented in Trinity College, Washington, DC; Army Medical Museum, Washington, DC; Woman's Medical College, Philadelphia. Address in 1933, c/o the Arts Club, Washington, DC; h. Washington, DC. Died in Washington, DC, 1935.

HILL, J. H.
Sculptor and engraver. At Burlington, Vermont, 1849.

HILL, JESSIE F.
Sculptor. Member: California Art Club. Address in 1928, Hollywood, CA.

HILL, WILLIAM LEE.
Sculptor and painter. Born in Star Valley, WY, 1922. Studied at Brigham Young University, English literature and education, 1949. Specialty is animals and people of the West. Paints in oil in Impressionist style. Prints published by Western Profiles Publishing Co.; represented by Zantmann Art Gallery, Palm Desert, CA; Myer's Gallery, Park City, UT. Reviewed in *Southwest Art*, December 1979. Address in 1982, Mendon, UT.

HILTON, HEATHER.
Sculptor. Born in Albany, New York, in 1945. Studied: Mary Washington College of the University of Virginia; Virginia Commonwealth University. Awarded the

Warner Communications award by the National Sculpture Society, 1974. Exhibitions: The Virginia Museum of Fine Arts, 1969; The Mint Museum of Art, 1972; The High Museum of Art, Atlanta, Georgia, 1972.

HINCHMAN, MARGARETTA S.
Sculptor, painter, lithographer, and illustrator. Born in Philadelphia, PA. Pupil of Howard Pyle and Kenyon Cox. Member: American Federation of Arts; Plastic Club; Philadelphia Arts and Crafts Guild; Philadelphia Alliance; Fellowship Penna. Academy of Fine Arts; Print Club; Philadelphia Water Color Club; Washington Water Color Club; Mural Painters; La Musee des Arts Decoratifs and Union Centrale des Arts Decoratifs, Paris. Award: Silver medal, Plastic Club, Philadelphia, 1927. Address in 1953, Washington, CT.

HINCKLEY.
Sculptor. One of his earliest works, entitled "Reclining Boy," was shown in Cleveland (Ohio) in September 1851.

HINES, NORMAN.
Sculptor. Born in Pawtucket, Rhode Island, April 8, 1926. Self-taught. Apprenticed with the former Irons & Russell Co., Providence, RI. Began sculpting full time in 1960. Exhibited twice at the National Sculpture Society in NYC. Has produced over seventy medals and commemorative seals: Pope Pius XII Portrait Plaque, Vatican; John F. Kennedy Inaugural Portrait Plaque, Young Democrats of RI; 100th Anniversary of Memorial Day Medal, Franklin Mint; St. Joseph Medal, Franklin Mint; Portrait Busts of John F. Kennedy, Lyndon B. Johnson, both for the New York World's Fair; Seals for the Depts. of Interior, Justice, Treasury, and the US Park Ranger Badge and Seal. Media: Clay, plaster, bronze, and pewter. Address in 1984, Attleboro, MA.

HINMAN, CHARLES B.
Sculptor and painter. Born December 29, 1932, Syracuse, NY. Studied: Syracuse Univ., BFA, 1955; Art Students League, with Morris Kantor, 1955-56. Work: Albright; Detroit Institute; Flint Institute; Los Angeles County Museum of Art; Museum of Modern Art; Nagaoka, Japan; Aldrich; Whitney Museum. Played professional baseball, 1954-55, with Milwaukee Braves. Exhibited: Richard Feigen Gallery, NYC and Chicago; Tokyo Gallery, 1966; Lincoln Center, 1969; Riverside Museum; Whitney Museum; Art Institute of Chicago; San Francisco Museum of Art; Nagaoka, Japan; VI International Art Biennial, San Marino (Europe), 1967; Carnegie; Jewish Museum; Herron; Aldrich. Awards: Syracuse Univ., Augusta Hazard Fellowship, 1955-56; Nagaoka, Japan, First Prize, 1965; Flint Institute, First Prize, 1966; Torcuato di Tella, Buenos Aires, Special Mention, 1967. Taught: Staten Island Academy, 1960-62; Woodmere Academy, 1962-64; Aspen Institute Artist-in-Residence; Cornell Univ. Address in 1982, 231 Bowery, NYC.

HINTON, CHARLES LOUIS.
Painter, illustrator, and sculptor. Born Ithaca, NY, October 18, 1869. Pupil of National Academy of Design under Will H. Low; Gerome and Bouguereau, in Paris; Ecole des Beaux-Arts, Paris, under Gumer. Exhibited at Na-

tional Sculpture Society, 1923. Member: Associate, National Academy of Design, 1916; Mural Painters; National Sculpture Society; Artists' Fellowship; Century Club; NY Architectural League, 1911. Award: Traveling scholarship, National Academy of Design, 1893; honorable mention, Pan-Am. Exposition, Buffalo, 1901; others. Work: Mural decoration in court house, Wilkes Barre, PA; Cleveland Museum of Art; Smithsonian Inst. Illustrated "Emmy Lou," etc. Died in 1950. Address in 1933, Bronxville, NY.

HINTON, ERWALD STUART.
Sculptor. Born in New York, January 3, 1866. Worked in Chicago. Address in 1910, Chicago, IL.

HINTON, MRS. HOWARD.
Sculptor. Pupil of Lant Thompson. Born in 1834; died in New York City, December 19, 1921.

HIPP, WILLIAM EMSLEY III.
Sculptor. Born on June 27, 1952; raised in Davidson, NC. Studied: University of North Carolina, Charlotte, B.A., 1974. Works: "Sam Ervin" and "Paul Green," both at University of North Carolina; "William H. Bobbit," North Carolina Supreme Court Building, Raleigh, NC; "Albert Coates," North Carolina Institute of Government, Chapel Hill, North Carolina; others. Exhibited: North Carolina Museum of Art. Teaching: Visiting artist, South Carolina Arts Commission, 1975. Works in bronze; work cast at Joel Meisner Foundry, Long Island, NY. Address in 1984, Chapel Hill, NC.

HIRAMOTO, MASAJI.
Sculptor and painter. Born Fukui, Japan, Dec. 8, 1888. Pupil of Penna. Museum; Columbia University. Member: Society of Independent Artists; Japanese Art Society; Salons of America; Salon D'Automne, Societe Nationale des Beaux-Arts, Paris. Work: "The Daibutsu," Columbia University. Address in 1933, Suite 1601, 165 Broadway, New York, NY; h. Paris, France.

HIRSCH, WILLARD NEWMAN.
Sculptor. Born in Charleston, SC, November 19, 1905. Studied at College of Charleston; Beaux-Arts Institute of Design; National Academy of Design. Member: Artists Equity Association; South Carolina Art Guild. Awards: Prizes, South Carolina Art Guild, 1951. Work: Lincoln Hospital, NY; IBM; Columbia (SC) Museum of Art; Clemson College; relief, National Guard Armory, Mullins, SC. Exhibited: Syracuse Museum of Fine Arts, 1948; National Academy of Design, 1935, 42; Penna. Academy of Fine Art, 1942; Whitney Museum of American Art, 1950; Wichita Art Association, 1949; South Carolina Art, Gibbes Art Gallery, 1947-52, one-man; Columbia Museum of Art, 1952; Gibbes Art Gallery, 1943, 45, 46, 51. Member: Charleston Artists Guild; South Carolina Artists Guild (past pres.) Position: Instructor of Sculpture, Gibbes Art Gallery, Furman University, Greensville, SC; Ext. Div., University South Carolina, Columbia, SC. Address in 1982, 2 Queen St., Charleston, SC.

HIRST, CLAUDE RAGUET.
Sculptor and painter. Born in Cincinnati, OH, 1855. Studied: Cincinnati Art Academy with Nobel; and in NY. Her

husband was the landscape painter, William Fitler. Exhibited: National Academy of Design, 1884. William Harnett's influence is seen in her similar still-lifes of books, pipes, and tobacco jars. She also worked in watercolor. Member: National Academy of Women Painters and Sculptors; New York Watercolor Club. Address in 1933, NYC. Died in 1942.

HITCHCOCK, DAVID HOWARD.
Sculptor, landscape painter, and illustrator. Born Hawaii, May 15, 1861. Pupil of Virgil Williams; Bouguereau and Ferrier in Paris. Member: Salmagundi Club 1904; Honolulu Art Society. Died in 1943. Address in 1933, Laniakeal; h. Honolulu, Hawaii.

HOARD, MARGARET.
Sculptor. Born in Iowa in 1880. Pupil, Art Students League of NY. Member: L'Union Internationale des Beaux-Arts et des Lettres, Paris, 1914; Art Students League of New York; National Association of Women Painters and Sculptors. Award: Honorable mention, P.-P. Exposition, San Francisco, 1915. Represented in Metropolitan Museum of Art, New York, NY. Address in 1933, Mt. Vernon, New York. Died in 1944.

HOBBS, (CARL) FREDRIC.
Sculptor and filmmaker. Born in Philadelphia, PA, December 30, 1931. Studied at Cornell University, B.A.; Academy of San Fernando Belles Artes, Madrid, Spain. Work in Museum of Modern Art, NY; Metropolitan Museum of Art; Oakland Museum of Art; others. Has exhibited at Penna. Academy of Fine Arts; National Fine Arts Collection, Smithsonian Institution; California Palace Legion of Honor, San Francisco; San Francisco Museum of Modern Art; others. Works in steel supported fiberglas and latex acrylic. Address in 1982, Los Altos, CA.

HOBBS, LOUISE ALLEN (MRS.).
Sculptor. Born in Lowell, MA. Pupil of Rhode Island School of Design in Providence; School of Boston Museum of Fine Arts. Address in 1916, 9 Copley Studios, Boston, MA.

HOBSON, KATHERINE THAYER.
(Mrs. Hobson-Kraus). Sculptor. Born in Denver, Colorado, on April 11, 1889. Studied at Art Students League; also in Europe; sculpture with Walter Sintenis, Dresden, Germany. Works: University of Konigsberg and Gottingen; Univ. Library, Gottingen; St. James Church, NYC; Bahnhofsplatz, Gottingen; School of Technology, Dresden. Membership: National Sculpture Society; Hudson Valley Art Association; Pen and Brush Club; Allied Artists of America; others. Address in 1982, NYC. Died in 1982.

HODGE, LYDIA HERRICK
Sculptor. Member: Oregon Society of Artists; American Artists Professional League; National Association Women Painters and Sculptors. Address in 1933, 1825 Fairmount Blvd., Eugene, Oregon.

HODGELL, ROBERT OVERMAN.
Sculptor, painter, etcher, engraver, lithographer, and serigrapher. Born in Mankato, KS, July 14, 1922. Studied at Univ. of Wisconsin, B.S., M.S.; Dartmouth College; State Univ. of Iowa. Member: Society of American Graphic Artists; Art Association Mus.; National Ser. Society; Mid-Am. Arts; Madison Art Association. Work: Joslyn Art Mus.; Dartmouth College; Wisconsin Union; Topeka Art Guild; Kansas State Teachers College; Kansas State College. Exhibited: Mississippi Art Assoc., 1947; Albany Print Club, 1947, 51; Society of American Graphic Artists, 1947, 50-52; Washington Water Color Club, 1948; Northwest Printmakers, 1949; Philadelphia Print Club, 1950; Portland Society of Artists, 1950; Butler Art Inst. 1951; Terry Art Inst., 1952; Bradley Univ., 1952; National Ser. Society, 1952; Library of Congress, 1948, 52; Western Arts, 1948-52; Kansas Painters, 1949-51; Mid-Am. Arts, 1950, 51; Walker Art Center, 1951; Wisconsin Salon, 1942; Kansas Free Fair, 1935-43, 47; Six States Exhibition, 1943, 44, 46, 47; Topeka Art Guild, 1947, 49, 50; Madison Art Association, 1948-52; Pell College, 1950, and others. Illustrated "The Lee Papers," 1948; "Soil Conservation," 1948. Position: Instructor, Des Moines Art Center, Des Moines, Iowa, from 1949. Address in 1953, Des Moines Art Center; h. Des Moines, IA.

HODGES, HAROLD.
Sculptor. Address in 1934, Hagerstown, MD. (Mallett's)

HOE, MABEL KENT.
Sculptor and painter. Born in Cranford, NJ, January 27, 1880. Studied at Art Students League; and with Archipenko, Arthur Lee, Bridgman, Miller, Nicolaides. Member: National Association of Women Artists; Asbury Park Society of Fine Arts. Awards: Prize, National Association of Women Artists, 1936. Exhibited: National Association of Women Artists; Montclair Art Museum; American Artists Professional League; and in Asbury Park, Spring Lake, Newark, NJ. Address in 1953, Cranford, NJ.

HOFFMAN, ANDREA.
Sculptor. Born in Los Angeles, CA, January 3, 1946. Studied at University of California, Riverside, A.B., 1967; San Diego State University, MA, 1974; University Southern California, Ph.D. cand., 1975; Tommasi Bronze Foundry, Italy; study with Robert Maclean, Benedict Cippolini and Jacques Lipchitz. Works: Chiostro di S. Lazzaro, Camaiore, Italy. Commission: Two Brothers (bronze), Dante Tedeschi, Carrara, Italy, 1973; marble cardinal, Hoover High School, San Diego, 1975. Exhibitions: International Sculpture Section, National Marble Show, Carrara, Italy, 1972; Ai Frati, 5th Annual International Exhibition, Camaiore, Italy, 1972. Awards: Annual Gift Purchase Prize, Artists Equity Association, San Diego, 1975. Positions: Internist, Los Angeles Co. Museum and J. Paul Getty Museum, 1975-76; written numerous articles for *Art Week*, *San Diego Magazine*, and *LA Times*, from 1978. Media: Marble and bronze. Address in 1982, Del Mar, CA.

HOFFMAN, EDWARD FENNO, III.
Sculptor. Born in Philadelphia, PA, October 20, 1916. Studied at Penna. Academy of Fine Arts. Member: Fellow, Penna. Academy of Fine Arts. Awards: Cresson traveling scholarship, 1948; Tiffany Foundation grant, 1950; National Academy of Design, 1951. Work: Brook-

green Gardens, SC; war memorial, Penna. Hospital, and Lansdowne, PA; St. Alban's Church, Newtown Square, PA. Exhibited: Penna. Academy of Fine Arts, 1947; National Academy of Design, 1951, 52; Philadelphia Sculpture Exhibition, 1952; Woodmere Art Gallery, 1947, 49; National Sculpture Society Annual, NYC, 1972, 79. Member: National Academy of Design; National Sculpture Society; Allied Artists. Address in 1983, Wayne, PA.

HOFFMAN, FRANK B.
Sculptor, painter, and illustrator. Born in Chicago, IL, August 28, 1888. Studied with Wellington Reynolds, Leon Gaspard, John Singer Sargeant. Exhibited: Art Institute of Chicago; Harwood Gallery, Taos, NM. Position: Art, Brown and Bigelow Calendar Co., St. Paul, MN, from 1940. Address in 1953, Taos, MN.

HOFFMAN, MALVINA CORNELL.
(Mrs. Samuel Bonaries Grimson). Sculptor and painter. Born NYC, June 15, 1887. Pupil of Rodin in Paris; Gutzon Borglum, Herbert Adams and J. W. Alexander in NY. Member: Associate National Academy of Design, 1925; National Institute of Social Sciences; Three Arts Club, NY (hon); National Academy of Women Painters and Sculptors; Alliance; Painters and Sculptors Gallery of Art; National Sculpture Society. Awards: Honorable mention, Paris, 1911; first prize, "Russian Dancers" exhibit, Paris, 1911; honorable mention, for sculpture, P.-P. Exp., San Francisco, 1915; Shaw memorial prize, National Academy of Design, 1917; Widener gold medal, Penna. Academy of Fine Arts, 1920; Barnett prize, National Academy of Design, 1921; Elizabeth Watrous gold medal, National Academy of Design, 1924; Joan of Arc gold medal, National Assoc. of Women Painters and Sculptors, 1925; hon. mention, Concord Art Association, 1925. Exhibited at National Sculpture Society, 1923. Work: "Russian Bacchanale," Luxembourg Museum; "Bill," Jeu de Paume, annex, Luxembourg Museum, Paris; "Head of Modern Crusader," Metropolitan Museum of Art; "Ivan Mestrovic," "Martinique Woman," "Senegalese Soldier," Brooklyn Museum; "Pavlowa Mask," Carnegie Institute, Pittsburgh; "Pavlowa Gavotte," Museum of Art, Stockholm; "The Sacrifice," Cathedral of St. John the Divine, NY; "Gervais Elwes," Queen's Hall, London; "Ignace Paderewski," (the artist), Academy of Rome; "John Keats," University of Pittsburgh, Pittsburgh, PA; "Anna Pavlowa," mask, Corcoran Gallery of Art, Washington, DC; "Ignace Paderewski" (the Statesman), portrait, purchased for permanent exhibition in US. Represented at American Museum of Natural History; Detroit Museum of Art; Cleveland Museum; heroic size stone group, entrance Bush House, London. Decorated with Palmes Academique, France, 1920; Royal Order of St. Sava, III, Yugoslavia, 1921. Address in 1953, 157 East 35th Street, h. 120 East 34th Street, New York, NY. Died in 1966.

HOFFMAN, MAXIMILIAN A.
Sculptor and painter. Born in Trier, Germany, February 6, 1887. Pupil of Milwaukee Art Students League; Royal Academy, Munich. Member: Chicago Society of Artists; Society of Western Sculptors. Address in 1918, 4 East Ohio St., Chicago, IL. Died July 1, 1922.

HOFFMAN, WILMER.
Sculptor. Born Catonsville, MD, August 1, 1889. Studied at Princeton University; Rinehart School of Sculpture; Penna. Academy of Fine Arts. Pupil of Charles Grafly, Ephraim Keyser, and Albert Laessle. Member: Fellowship Pennsylvania Academy of Fine Arts; Guild of South Carolina Artists. Award: Cresson traveling scholarship, Pennsylvania Academy of Fine Arts, 1922, 1924; gold and silver medals, Paris Expo., 1937. Work: French Government Foreign Art Collection, Paris; Baltimore Museum of Art. Exhibited: Salon d'Automne, Salon des Tuileries, Paris; New York World's Fair, 1939; one-man shows in Paris, Amsterdam, London, Charleston, NYC. Died May 21, 1954. Address in 1953, Charleston, SC.

HOFFMANN, MARGARETA.
Sculptor. Address in 1935, Cleveland, Ohio. (Mallett's)

HOFMAN, RUTH ERB.
(Mrs. Burton A.). Sculptor, painter, and educator. Born in Buffalo, NY, April 13, 1902. Studied at Wellesley College, B.A.; Child-Walker School of Fine Arts and Crafts; and with Arthur Lee, Agnes Abbot, Edwin Dickinson, Charles Burchfield. Member: The Patteran. Awards: Prizes, Carnegie Inst., 1941; Terry Art Inst., 1952; Albright Art Gallery, 1939, 40, 46. Work: Sculpture, Northwestern Univ. Hall of Fame. Exhibited: Carnegie Inst., 1941, 43, 44; Metropolitan Mus. of Art (AV), 1942; Art Inst. of Chicago, 1943; Riverside Mus., 1939, 42; American Federation of Arts traveling exhib., 1939; Albright Art Gallery, 1934-52; Terry Art Inst., 1952. Address in 1953, Buffalo, NY.

HOFMANN, ETHEL N.
Sculptor. Born in New York City, in 1915. Studied: Brooklyn College, New York; Cornell University; University of Miami, Florida. Exhibitions: Merritt College, Oakland, California, 1972; California College of Arts and Crafts, 1973; University of California, Extension-San Francisco, 1974.

HOFMANN, HANS.
Sculptor, painter, and educator. Born March 21, 1880, Weissenberg, Bavaria, Germany. Studied: Gymnasium, Munich; Academie de la Grande Chaumiere, 1904; lived and studied in Paris, 1903-14, under the patronage of Phillip Freudenberg; associated with Henri Matisse, Pablo Picasso, Georges Braque, and Robert Delamay. One-man exhibitions: Paul Cassier Gallery, Berlin, 1910; California Palace, 1931; New Orleans/Delgado, 1940; Art of This Century, NYC, 1944; Betty Parsons Gallery, 1946, 47; The Kootz Gallery, NYC, 1947, 49, 50-55, 57, 58, 60-64, 66; Richard Gray Gallery, Chicago, 1978; Metropolitan Museum of Art, "Hans Hofmann as Teacher," 1979; numerous others. Awards: J. Henry Schiedt Memorial Prize, Penna. Academy of Fine Arts, 1952; medal, Art Institute of Chicago, 1953; honorable mention, 1963; honorary degree, University of California, 1964; others. Taught: Opened his first school in Munich, 1915-32; summer sessions at Ragusa, 1924, Capri, 1925-27; Saint-Tropez, 1928, 29; Chouinard Art Institute, Los Angeles, CA, 1930; University of California, Berkeley, 1930; Art Students League, 1932-33; established his own school in

NYC, in 1933-58. Author: Search for the Real and Other Essays, 1948. Died February 17, 1966.

HOFSTED, JOLYON GENE.
Sculptor and educator. Born in San Antonio, TX, October 21, 1942. Studied at California College of Arts and Crafts, Oakland; Brooklyn Museum Art School, NY. Work in Museum of Modern Art, Kyoto, Japan; Brooklyn Museum; Museum of Contemporary Crafts, NY; others. Has exhibited at Brooklyn Museum; others. Taught at Brooklyn Museum Art School, 1963-71, art; director, 1970-73; Haystack Mountain School of Crafts, ME, 1966 and 1968, ceramics; teaching at Queens College, City University of NY, from 1966, art. Address in 1982, Shady, NY.

HOLDEN, HAROLD.
Sculptor and painter. Born in Enid, OK, 1941. Studied at Oklahoma State University; Texas Academy of Art, graduated 1962. Initially employed in commercial art; art director, Horseman magazine. Began painting full-time in 1973. Awarded first prize, painting and sculpture, Texas Cowboy Artist show. Sells his work in Sedona, AZ, Tulsa, OK, Houston, Fort Worth, and San Angelo, TX. Specialty is contemporary cowboys in a traditional setting. Address in 1982, Kremlin (near Enid), OK.

HOLDER, PEGGY.
Sculptor. Active in Paris, France, 1928-33. (Mallett's)

HOLEN, NORMAN DEAN.
Sculptor and educator. Born in Cavalier, ND, September 16, 1937. Studied at Concordia College, B.A., 1959; State University of Iowa, M.F.A., 1962; University of Minn., Minneapolis, 1972. Has exhibited at Minneapolis Institute of Art; National Gallery, Washington, DC; others. Received bronze medal, National Sculpture Society. Member of the National Sculpture Society. Works in welded steel and terra cotta. Address in 1982, Minneapolis, MN.

HOLLINGWORTH, KEITH WILLIAM.
Sculptor. Born in Providence, Rhode Island, April 21, 1937. Studied at the Rhode Island School of Design, Providence, 1955-59; Mills College, Oakland, CA, 1962-64. Exhibited: University of Mass., Amherst, 1965; St. Peter's Episcopal Church, NYC, 1968; Whitney Museum of American Art, NYC, 1966; Herron Art Institute, Indianapolis, IN, 1972; one-man shows, Art Institute of Chicago, 1970, Paula Cooper Gallery, 1971, 72; others. Also involved as a technical assistant in Dance-theater Productions, NY, in conjunction with Robert Rauschenberg, John Giorno, Deborah Hay, Les Levine, Yvonne Rainer, Joan Jonas, Steve Reich, Trisha Brown, Julie Judd, and Judy Padow, 1967-68. Participated in theater pieces and productions at University of Mass., Amherst; Windham Chicago, IL; and Univ. of Minnesota, Minneapolis, Chicago, IL; and University of Minnesota, Minneapolis since 1967. Taught: Ohio University, Athens, 1964-65; University of Mass., Amherst, 1965-67; Drexel University, Philadelphia, 1969-71; Pace College, NY, 1972-73; and Queens College, Flushing, NY, 1973-74; guest artist, University of Maine, Orono, 1974. Address in 1982, Chester, MA.

HOLLISTER, ANTOINETTE B.
Sculptor. Born Chicago, IL, August 19, 1873. Pupil of Art Institute of Chicago; Injalbert and Rodin in Paris. Member: South West Sculptors; Chicago Society of Artists. Awards: Honorable mention for sculpture, P.-P. Exposition, San Francisco, 1915; Shaffer prize for sculpture, Art Institute of Chicago, Chicago, 1919. Address in 1929, The All-Arts Studios, Greenwich, CT.

HOLM, VICTOR S.
Sculptor and teacher. Born Copenhagen, Denmark, December 6, 1876. Pupil of Art Institute of Chicago under Lorado Taft; Philip Martiny in NY. Member: National Sculpture Society, 1913; St. Louis Art Guild; St. Louis Art League; 2 x 4 Society of St. Louis; Municipal Art Com.; Alumni Art Inst. of Chicago; St. Louis Architecture Club (hon.); Ethical Culture Society; Societe Francaise (hon.). Awards: Silver medal, MO State Fair, 1913; Carleton prize ($100), St. Louis Art Guild, 1914, 16, 17; honorable mention, P.-P. Exp., San Francisco, 1915; St. Louis Artists' League prize ($300), 1922; silver medal, Midwestern Artists, Kansas City, 1926. Work: Parker Memorial, State Univ. Library, Rolla, MO; Ives Memorial, City Art Museum, St. Louis; Barnes Memorial, Barnes Hospital, St. Louis; Missouri State Monument at Vicksburg, MS; Gov. Carlin Monument, Carrollton, IL; Washington Fischel Monument, Bellefontaine, St. Louis, MO; "Boy With Father's Sword," St. Louis Public Library; decorations of exterior of St. Pius' Church, St. Louis; Waterloo, IA, High School; Ft. Dodge High School; "Col. Drieux" monument, New Orleans; Washington University War Memorial, St. Louis; Nelson Memorial Fountain, Le Claire, IL; Musicians Memorial Fountain, Forest Park, St. Louis; Dr. Beaumont Memorial, Beaumont High School, St. Louis; Wayman Crow Memorial, City Art Museum, St. Louis; World War Monument, Maplewood, MO; Emile Zola Memorial, WMHA, St. Louis; Claude Monet Medal for Two-By-Four Society, St. Louis; Geo. W. Niedringhaus Memorial, Granite City, IL; Festus Wade Memorial, Missouri State Capitol Bldg., Jefferson City, MO; "Spirit of St. Louis," Gold Medal given by American Society of Mechanical Engineers for Aviation; Long Memorial, Long Public School, Statue of Geo. Washington, Masonic Temple, two heroic statues, Continental Life Insurance Building, Heroic Bear, Municipal Auditorium, all in St. Louis, MO; Shaw Gold Medal for Horticulture given by MO Botanical Gardens. Exhibited at National Sculpture Society, 1923. Address in 1933, School of Fine Arts, Washington University, St. Louis, MO. Died in 1935.

HOLMES, DAVID VALENTINE.
Sculptor and painter. Born in Newark, NY, November 27, 1945. Studied at Temple University Abroad, Tyler School, Rome, Italy, 1966-67; Tyler School of Art, Temple University, Philadelphia, PA, B.F.A., 1968; University of Wisconsin, Madison, M.F.A., 1972. Work in Milwaukee Art Museum; Kohler Arts Center, Sheboygan, WI. Has exhibited at Chicago Art Institute; Kohler Arts Center, WI; American Craft Museum, NY; Smithsonian, Washington, DC; others. Received National Endowment for the Arts Fellowship, others. Works in wood and acrylic. Address in 1982, Racine, WI.

HOLMES, MARJORIE DAINGERFIELD.
Sculptor. Born in NYC. Studied with Borglum, Young, Amateis, Lober. Work: Portrait bust of Dr. Bailey K. Ashford, purchased by Government of Puerto Rico for School of Tropical Medicine, San Juan. Member: National Arts Club. Address in 1933, Gainsborough Studios, 222 Central Park South, NYC; summer, "Westglow," Blowing Rock, NC.

HOLMES, RUTH ATKINSON.
Sculptor and painter. Born in Hazelhurst, MS. Studied at Miss. State College Women; Tulane Univ. LA; Miss. College and Southwest Jr. College. Works: Univ. of LA, Alexandria and Baton Rouge; Miss. State College Women, Columbus; Miss. State Univ., Starkville. Commission: Mural (with Bess Dawson), Church of God, McComb, MS; mural (with Bess Dawson and Halcyone Barnes), Progressive Bank, Summit, MS; mural (with Bess Dawson and Halcyone Barnes), First National Bank, McComb, 1972. Exhibitions: One-woman shows, Ahda Artzt, NY, 1964, Mary Chilton Gallery, Memphis, TN, 1966, Brooks Memorial Gallery and Mus., Memphis, 1969, Univ. Louisiana, Alexandria, 1969, and Bryant Gallery, Jackson, MS, 1971. Awards: First Prize Pastel, Chautauqua Art Association, NY, 1962; First Prize, Miss. Art Association National Oil Show, Jackson, 1966; First Prize, La Font Workshop, S Cent Bell Tel. Co., Pascagoula, MS, 1968. Member: Miss. Art Colony; LeFonte Art Colony; and Miss. Art Association (board member). Address in 1982, P.O. Box 543, McComb, MS.

HOLSCHUH, (GEORGE) FRED.
Sculptor. Born in Beerfelden, Germany, November 19, 1902; US citizen. Studied at Penna. Academy of Fine Arts; University of Penna.; also with Bauhaus founder, Walter Gropius. Work at Addison Gallery, NY; Brookgreen Gardens, SC; monument, Yugoslav Order of St. Francis, Washington, DC; others. Has exhibited at Penna. Academy of Fine Arts; National Academy of Design, NY; Regional Sculpture Show, Smithsonian Institution, Washington, DC. Received Stimson Prize in Sculpture, Penna. Academy of Fine Arts, 1935; European Traveling Scholars, 1935, 36; Southern Sculptors National Show. Member: Association of Southern Sculptors. Works in wood and copper. Address in 1982, Tallahassee, FL.

HOLSMAN, ELIZABETH TUTTLE.
Sculptor and painter. Born Brownville, NE, Sept. 25, 1873. Pupil of Art Institute of Chicago. Member: Chicago Society of Artists; Chicago Art Club; Chicago Galleries Association. Award: Silver medal, St. Paul Institute, 1916. Work: "Still Waters," Omaha Society of Fine Arts; "Portrait of David Rankin," bronze bas-relief, and "Portrait of Joseph Addison Thompson," Tarkio College, Tarkio, MO; bronze bas-relief of Dean Reese, Law School, University of Nebraska, Lincoln, NE; war memorial bas-relief "Lieut. Alexander McCornick" in US Destroyer "The McCornick;" war memorial "Victory" with honor roll in Harrison Technical High School, Chicago. Address in 1933, Chicago, IL; summer, Lotus Island, Lauderdale Lakes, WI.

HOLT, CHARLOTTE SINCLAIR.
Sculptor and illustrator. Born in Springfield, MA, June 11, 1914. Student of Mass. Normal Art School, Boston Museum of Fine Arts, 1929-32, Child-Walker School of Fine Arts and Crafts, 1932-34, Boston University College of Liberal Arts, 1933-34, College of Medicine, 1934-35; postgrad in medicine art, University of Illinois College of Medicine, 1935-37; studied portrait painting with Bernard Keyes, Boston, sculpture with Malvina Hoffman, NYC. Staff medicine illustrator, Illinois Dept. of Public Health, Bureau of Health Education, from 1935; free lance illustrator and sculptor, from 1935; instructor, University of Illinois College of Medicine, 1937-45. Permanent lay exhibit, Museum of Science and Industry. Recipient Beaux Arts gold medal, stained glass design and interior decorating, 1934-35. Member: Association of Medicine Illustrators. Address and Studio in 1962, River Forest, IL.

HOLT, NANCY LOUISE.
Sculptor and film maker. Born in Worcester, Mass., April 5, 1938. Studied at Jackson College; Tufts University, B.S. Comn: Landscape sculptures, University of Mont., 1972, Univ. of RI, 1972 and Artpark, Lewiston, NY, 1974. Exhibitions: Interventions in the Landscapes, Mass. Institute of Technology, 1974; Painting and Sculpture Today, Indianapolis Museum, 1974; Collectors Video, Los Angeles Co. Museum, 1974; Response to the Environment, Rutgers University, 1975; Video 1975, Corcoran Museum, Washington, DC; Mass. Institute of Technology, 1981; Whitney Biennial, 1979 and 81. Awards: National Endowment for the Arts Grant, 1975; CAPS Grant, 1975. Address in 1982, 799 Greenwich Street, NYC.

HOLT, WINIFRED.
Sculptor. Born in New York. Pupil of Trentanove and Augustus Saint Gaudens; also studied in Italy. Address in 1910, 44 East 78th St., NYC; and Lyceum Club, London, England.

HOLVEY, SAMUEL BOYER.
Sculptor and designer. Born in Wilkes Barre, PA, July 20, 1935. Studied at Syracuse University; American University. Represented by commission, bas-relief mural, WY Valley Country Club, Wilkes Barre, PA, 1962. Exhibited at Corcoran Area Show, Washington, DC; Annual Washington Area Sculpture Show; Am. Genius, Corcoran Gallery, etc. Taught design and graphic design, Corcoran School of Art, DC, 1965-80; University of MD, 1967-78. Works in metal direct contruction, lumia. Address in 1982, Bethesda, MD.

HOLZER, J. A.
Sculptor and mural painter. Born in Berne, Switzerland, in 1858. Pupil of Fournier and Bernard in Paris. His mural, "Homer," is at Princeton University, Princeton, NJ. Address in 1926, 182 East 72d Street, New York, NY.

HOLZHAUER, EMIL EUGEN.
Sculptor and painter. Born Schwabisch Gmund, Germany, Jan. 21, 1887. Pupil of Robert Henri, Homer Boss. Member: Society of Independent Artists; Audubon Art-

ists; Georgia Art Association; Southern States Art League. Awards: Art Institute of Chicago, 1930; North Carolina Exhibition, 1942; Southern States Art League, 1946; Carnegie grant, 1946, 49; Georgia Art Association, 1952; others. Work: Albany Institute of History and Art; Art Institute of Chicago; Newark Museum; Whitney Museum, NYC; Syracuse Museum of Fine Arts; High Museum of Art; others. Exhibited: Art Institute of Chicago, 1927-35, 37, 43; Penna. Academy of Fine Arts, 1928, 32; Corcoran, 1930, 34, 51; Carnegie, 1930; Brooklyn Museum, 1929, 33; Albright; Whitney, 1933, 34; many others. By 1953 no longer listed as sculptor in American Art Annuals. Professor of Art, Wesleyan College, Macon, GA, from 1942. Address in 1953, Wesleyan College; h. 656 College St., Macon, GA.

HONIG, GEORGE H.
Sculptor and portrait painter. Born Rockport, IN, 1881. Pupil of National Academy of Design and H. A. MacNeil in New York. Member: Evansville Society of Fine Arts and Hist. Awards: Suydam bronze medal, National Academy of Design, 1914; Suydam silver medal, National Academy of Design, 1915. Work: Spanish-American war memorial at Salina, KS; "The Spirit of 1861" and "The Spirit of 1916," on Vanderburg County Soldiers' and Sailors' Coliseum, Evansville, IN; "The Hiker," Fairview Park, Denver, CO; portrait of Cleo Baxter Davis in Court House, Bowling Green, KY; portrait in bronze of J. B. Gresham for War Mothers of America, Evansville, IN; Service Star and Legion Memorial, Evansville, IN; Judge Thomas Towles, Sr., Memorial, Henderson, KY; Abraham Lincoln Trail Markers (portrait) Grand View, IN; six memorials of Transylvania Company, Henderson, KY; replicas in Transylvania University, Lexington, KY, and Univ. of North Carolina, Chapel Hill, NC; Rotary Hall of Fame Memorial, Fine Arts Society, Evansville; Portrait Crowder Memorial, Evansville, Indiana; war memorials in Elks House, Princeton, NJ, Evansville, IN, and Mt. Vernon, IN, in Eagles Home at Anderson and Richmond, IN; in Masonic Temple, Evansville, IN; in Court House at Bloomington, IL, and Evansville, IN; soldier group, Joliet, Ill.; fountain and bronze goups, Shelbyville, IN; Capello memorial, Evansville, IN; World War memorials at Evansville and Connelton, IN; bronze portrait, Rescue Mission. Address in 1933, Evansville, IN.

HOOD, ETHEL PAINTER.
Sculptor. Born in Baltimore, MD, April 9, 1908. Studied: Art Students League; Julian Academy, Paris. Awards: Gold medal, Catherine L. Wolfe Art Club, 1954; Society of Washington Artists, 1939. Collections: Radio City and French Building, Rockefeller Center, New York City; St. Francis of the Curbs, Brookgreen Gardens, SC. Exhibited at Baltimore Museum of Art; Corcoran; National Academy of Design, NYC; Whitney; Penna. Academy of Fine Arts; Corcoran Gallery of Art, Washington, DC; others. Member: Fellowship National Sculpture Society; National Association of Women Artists. Address in 1982, 15 E. 61st Street, NYC.

HOOKER, MARGARET HUNTINGTON.
Sculptor, painter, and illustrator. Born in Rochester, NY,

June 10, 1869. Studied at Art Students League and Metropolitan Schools of NY; also in Paris and London. Taught art in Normal School, Cortland, NY, 1893-94; illustrated for *New York Tribune*, 1897; later taught arts and crafts in Paris. Sculpture includes marble bas relief (the American Naturalist Edgar Burroughs?), exhibited at Apollo Gallery, Poughkeepsie, NY, 1974. Address in 1915, Rochester, NY; living in Paris in 1926.

HOOPER, GRACE.
Sculptor and painter. Born in Boston, Mass., 1850. Work: Boston, Mass.

HOPE, JOHN W.
Sculptor. Exhibited at National Academy of Design in 1925. Specialty, animals. Address in 1926, 65 Gun Hill Road, NY.

HOPKINS, MARK.
Sculptor. Born in Williamstown, MA, February 9, 1881. Pupil of Frederick MacMonnies. Member Societe des Artistes Francais; Union Internationale des Beaux-Arts. Died in 1935 in Paris, France. Address in 1910, Givernypar-Vernon, Eure, France; and Williamstown, MA.

HOPPIN, THOMAS FREDERICK.
Sculptor, painter, and etcher. Born August 15, 1816, Providence, RI. Brother of Augustus Hoppin. Studied in Philadelphia and later in Paris under Delaroche. On his return to this country he opened his studio in New York and worked in that city during the late 1830's. He lived in Providence, RI, 1841-72. He produced statues in plaster, stained glass designs, and many etchings and illustrations of American life and history. The American Art Union in 1848 and 1850 published two of his etchings. Exhibited at National Academy of Design; Art-Union; Boston Athenaeum; American Institute. Honorary member of National Academy of Design, New York. Died January 21, 1872, in Providence, RI.

HOPTNER, RICHARD.
Sculptor. Born in Philadelphia, PA, April 3, 1921. Studied at University of Penna., 1951-57; Cranbrook Academy of Art, scholarship, 1960. Has exhibited at Philadelphia Museum of Art; Penna. Academy of Fine Arts; others. Received sculpture grant, Louis Comfort Tiffany Foundation. Works in teakwood and rare woods. Address in 1982, Philadelphia, PA.

HORCHERT, JOSEPH A.
Sculptor. Born Hechingen, Germany, May 4, 1874. Studied in Staedel Art Institute, Frankfurt am Main, and Royal Academie, Munich, Germany. Member: St. Louis Art League; St. Louis Art Guild. Award: Prize for Fountain, St. Louis Art League. Work: Guggenheim Memorial Fountain, St. Louis; figures on the Friedrich Bridge, Berlin; high altar, Sacrament Church, St. Louis, MO; memorial tablet, College of Pharmacy, St. Louis; pediments, high school, Jersey City, NJ, and Preparatory Seminary, St. Louis; memorial tablet, Westminster College, Fulton, MO; portraits of Founders of Lindenwood College, St. Charles, MO. Address in 1933, St. Louis, MO.

HORD, DONALD.
Sculptor. Born in Prentice, Wisconsin, February 26, 1902.

Pupil of Santa Barbara School of the Arts; University of Mexico; Penna. Academy of Fine Arts; Beaux-Arts Institute of Design. Member: National Sculpture Society; National Academy; National Institute of Arts and Letters. Work: Bronze, "El Cacique," San Diego Fine Arts Gallery, San Diego, CA; San Francisco Museum of Art; fountain, Balboa Park, San Diego; San Diego Civic Center; others. Exhibited: Museum of Modern Art, NYC, 1942; Metropolitan Museum of Art, 1942, 51; American-British exhibition, 1944. Awards: Medal, San Diego Expo., 1935, 36; National Institute of Arts and Letters, 1948; Guggenheim Fellowship, 1945, 47. Address in 1953, San Diego. Died in 1966.

HORN, MILTON.
Sculptor. Born Ukraine, Russia, September 1, 1906. Pupil of Henry Hudson Kitson, Boston; Beaux-Arts Institute of Design, New York; Educational Alliance, NYC. Work: Ceiling, Hotel Savoy-Plaza, New York; Brookgreen Gardens, SC; National Museum of Fine Arts, Washington, DC; National Academy of Design, NYC; numerous commissions including WVA University Medical Center; B'nai Israel Temple, Charleston, WVA; Central Water Filtration Plant, Chicago; others. Awards received from American Institute of Architects and National Sculpture Society. Exhibited: New York World's Fair, 1939; Penna. Academy of Fine Arts, 1936; Brooklyn Museum, 1930; Metropolitan Museum of Art, 1942, and 51; Philadelphia Museum of Fine Arts, 1949; National Institute of Arts and Letters, 1953, 55, 77; many others. Artist in residence, Olivet College, 1939-49, Michigan. Address in 1953, Olivet College, Michigan. Living in Chicago in 1982.

HORNBOSTEL, RUTH.
Sculptor. Exhibited in Paris, 1933. (Mallett's)

HORNE, MURIEL LORRAINE.
Sculptor, painter, and illustrator. Born in South Orange, NJ, Jan. 25, 1904. Pupil of Pratt Inst., NYC. Address in 1924, Newark, NJ.

HOROWITZ, IDA.
Sculptor. Uses fibers to make sculpture for walls.

HOROWITZ, NATHAN.
Sculptor. Born in Grand Rapids, 1947. Studied: Cranbrook Academy of Art, M.F.A. Exhibitions: National and state exhibitions; works by Michigan Artists, Detroit Institute of Arts, 1974-75. Awards: First prize, Port Huron International. Commissions: Kappey-Nemar Corp.; City of Grand Rapids. Address in 1975, Grand Rapids, MI.

HORTER, FEDERICK FORMES.
Sculptor. Born in Tremont, NY, November 1, 1869. Pupil of Cooper Union in NY. Address in 1910, Weehawken, NJ.

HORWITT, WILL.
Sculptor. Born in NYC, January 8, 1934. Studied at Art Institute of Chicago, 1952-54. Work in Boston Museum of Fine Arts; Wadsworth Atheneum, Hartford, CT; Albright-Knox Art Gallery, Buffalo; Guggenheim Museum; others. Has exhibited at Stephen Radich Gallery,

NY; Tanglewood, MA; Whitney Museum of American Art; others. Received Guggenheim Fellowship, 1965; Louis Comfort Tiffany Foundation Purchase Grant, 1968-69. Address in 1982, 60 Beach St., NYC.

HOSMER, HARRIET GOODHUE.
Sculptor. Born Watertown, MA, October 9, 1830. Educated at Lenox, and studied drawing and modeling in Boston, and anatomy at the Medical College, St. Louis; 1852-59 in Rome under John Gibson, the English sculptor. Executed many ideal figures, among the most popular being a statue of "Puck," her "Beatrice Cenci," which is in the St. Louis public library, "Zenobia," "Sleeping Faun," and a statue of Thomas H. Benton cast in bronze for Lafayette Park, St. Louis. She was also noted for her writing both in prose and poetry. Died in Watertown MA, February 21, 1908.

HOUGH, WALTER (DR.).
Sculptor, writer, and lecturer. Born in Morgantown, WV, April 23, 1859. Pupil of E. F. Andrews and W. H. Holmes. Member: Washington Water Color Club and American Federation of Arts. Address in 1933, National Museum, Washington, DC.

HOUSE, JAMES (CHARLES), JR.
Sculptor and educator. Born in Benton Harbor, MI, Jan. 19, 1902. Studied at University of Michigan; Penna. Academy of Fine Arts; University of Penna., BS in Education. Work: Sculpture, Whitney Mus. of American Art. Exhibited: Penna. Academy of Fine Arts, 1939, 40, 42, 45, 46; Dallas Museum of Fine Art, 1936; Brooklyn Museum, 1932; Whitney Museum of American Art, 1934, 36; Philadelphia Museum of Art, 1933, 40, 50; Carnegie Institute, 1941; NY Municipal Exhibition, 1936; Metropolitan Museum of Art (AV), 1942; Museum of Modern Art, 1942; Detroit Institute of Art, 1932, 35, 38-40; Kansas City Art Institute, 1935. Award: John Frederick Lewis first prize for caricature, Philadelphia Water Color Club, 1925. Author: "Fifty Drawings," 1930. Illustrations in *The New Yorker*, *Life*, *Collier's*, and numerous newspapers. Position: Assistant Professor, Modeling and Drawing, University of Pennsylvania, Philadelphia, PA, 1927-72, emeritus associate professor, 1972-75, visiting critic, 1976, 77, and 79; associate professor of Philadelphia Mus. of Art Eve. Class, 1949-50; sculpture critic. Address in 1982, Media, PA.

HOUSER, ALLAN C.
Sculptor and painter. Born in Apache, OK, June 30, 1914. Studied at Indian Art School, Santa Fe, NM, with Dorothy Dunn, Olaf Nordmark. Work: Murals, Dulce, NM; Dept. Interior Bldg., Wash., DC; Ft. Sill Indian School, OK; Southwestern Museum, Los Angeles, CA; State Museum, Santa Fe. Exhibited: National Gallery of Art, Wash., DC, 1953; Chicago Indian Center, 1953; Art Institute of Chicago, 1953; Southern Plains Indians Museum, 1971; Gallery Wall, Phoenix, AZ, 1975-78; Outdoor Sculpture Shows, Shidoni Foundry, Santa Fe, 1976-77; Gov's Gallery, State Capital, Santa Fe, 1977; Jamison Gallery, Santa Fe, 1977; American Indian and Cowboy Exhibition, San Dimas, CA, 1978; Wagner Gallery, Austin, TX, 1978. Awards: Gold medal in bronze,

silver medal in stone and silver medal in other metal, Heard Museum of Sculpture I Show, 1973; Best of Show and First Place in Sculpture American Indian and Cowboy Show, San Dimas, CA, 1978. Taught: Instructor of art, Intermountain Indian School, Bringham City, UT; head Dept. of Sculpture, Institute of American Indian Arts, Santa Fe; Lake Forest College, Chicago, 1978; University of Washington, 1978; artist-in-residence, Dartmouth College, Hanover, NH, 1979. Address in 1982, Los Angeles, CA.

HOUSKEEPER, BARBARA.
Sculptor and painter. Born in Ft. Wayne, IN, Aug. 25, 1922. Studied at Knox College, IL; Rhode Island School Design; Art Institute of Chicago. Works: Illinois Bell and Telephone, Chicago; Gould Foundation, Rolling Meadows, IL; Insurance Co., Long Grove; Mercury Rec., Chicago. Commissions: Large sculptures, Exec. Office Condecor Mfg., Mundelein, IL, 1972, Mr. and Mrs. William Goldstandt Collection, Glencoe, IL, 1972, Mr. and Mrs. Leonard Sax Collections, Northfield, IL, 1972 and Reception Hall, Kemper Insurance Co. Home Office, Long Grove, IL, 1974; Memorial Sculpture, American Bar Association, Chicago, 1975. Exhibitions: New Horizons in Art (wide regional annual), since 1966; Theme Ecology Invitational, University Wisconsin Gallery, Madison, 1970; Springfield State Museum All Summer Show, 1973; one-person show, Michael Wyman Gallery, Chicago, 1973 and 76; 1st Chicago Sculpture Invitational, Federal Building, Chicago, 1974. Awards: First Prize, Painting, New Horizons in Art Annual, 1969 and First Prize, Painting, 1970; Second Prize, Sculpture, Old Orchard Festival Annual, 1973. Media: Acrylic sheet, stainless steel. Address in 1982, El Granada, CA.

HOUSTON, (PATRICK) CODY.
Sculptor. Born in Mooresville, NC, 1941. Studied at Montana State University, biological sciences 1969. Previously worked summers as Forest Service trail crew foreman; later employed as stock inspector, Montana Livestock Commission. Worked at Ace Powell Art Foundry, Kalispell, MT. Began sculpting full-time in 1976. Exhibited at Russell Show (awarded best of show in sculpture); Western Experience Sale (award received). Specialty is figures, wildlife, and ranch scenes. Works in bronze. Represented by Sierra Galleries, Orinda, CA; Biltmore Galleries, Los Angeles, CA. Address since 1976, Augusta, MT.

HOUSTON, RUSSELL A.
Sculptor and architect. Born in Morgantown, West Virginia, September 28, 1914. Studied at Corcoran School of Art; Univ. of Hawaii; and with Robert Laurent. Member: Society of Washington Artists; Art Guild of Washington; Maryland Sculptors Guild; Washington Sculptors Group; Association Fed. of Architecture. Awards: Prizes, Corcoran School of Art, 1940, 41; Society of Washington Artists, 1940, 41, 48, 49; Association Fed. Architecture, 1939, 40, 47, 48 (4); Corcoran Gallery of Art 1947; Baltimore Museum of Art, 1947, 48. Work: Design medal for New York World's Fair, 1939; American Legion medal; sculpture, Officer's Club, Washington, DC; St.

Paul's Church, Washington, DC; Carlton Hotel, Pittsburgh, PA. Exhibited: Penna. Academy of Fine Art, 1946; Corcoran Gallery of Art, 1943 (one-man); Morgantown, West Virginia, 1938 (one-man); Society of Washington Artists, 1939-44, 48, 49; Association Fed. of Architecture, 1939, 42, 46, 47, 48; US National Museum, 1940, 48-52; Honolulu Academy of Art, 1945 (one-man); Washington Art Club, 1947-49; Home Builder's Exp., Washington, DC, 1948, 49; Virginia Museum of Fine Art, 1951; Playhouse, Washington, DC (one-man). Position: Sculpture, Architecture, Mills, Petticord and Mills Association, Washington, DC. Address in 1953, Kensington, MD.

HOVANNES, JOHN.
Sculptor and teacher. Born in Smyrna, NY, December 31, 1900. Studied at Rhode Island School of Design; Beaux-Arts Institute of Design. Member: Sculptors Guild; Audubon Artists; Westchester Arts and Crafts Guild. Awards: Guggenheim Fellow, 1940; Eugene Meyer award, 1941; Wings for Victory competition, 1942. Work: Newark Museum. Exhibited: Penna. Academy of Fine Arts, 1942, 43, 45, 46; Art Institute of Chicago, 1942, 43; Metropolitan Museum of Art (AV), 1942; National Academy of Design, 1943; Riverside Mus., 1943; Whitney Museum of American Art, 1942-46; Nebraska Art Association, 1945; New York World's Fair, 1939; Sculptors Guild, annually; Robinson Gallery, 1941 (one-man). Position: Instructor, Cooper Union Art School, 1945, 46; Art Students League, NYC, 1945, 46. Address in 1953, 126-30 East 59th St.; h. 140 East 58th St., NYC. Died in 1973.

HOVELL, JOSEPH.
Sculptor and teacher. Born in Kiev, Russia, October 28, 1897. Studied at Russian Imperial Art School; Cooper Union Art School, with Brewster; National Academy of Design, with Robert Aitken. Work: New York Museum of Science and Industry; US Government; Nordacs Club; Carnegie Hall Gallery; Yeshiva College; White House, Washington, DC. Commissions: Portrait busts, bas-reliefs of numerous important persons in private collections; plaques and busts, Carnegie Hall, NY. Exhibited: Bronx Art Guild, 1927; Community House, NY, 1928, 33; National Academy of Design, 1929, 31; Brooklyn Museum, 1930; Roerich Museum, 1932; Carnegie Hall, 1934, 35, 36; All. Artists of Am., 1935; Grand Central Palace, 1937; Jewish Museum, NY, 1949, 50; Medallic Art, 1952. Address in 1982, 130 West 57th St., NYC.

HOVENDEN, MARTHA.
Sculptor. Born Plymouth Meeting, PA, May 8, 1884. Pupil of Charles Grafly, H. A. MacNeil. Member: Fellowship Penna. Academy of Fine Arts; Plastic Club; Washington Art Club. Exhibited at Pennsylvania Academy of Fine Arts in 1924. Died 1941. Address in 1933, Plymouth Meeting, PA.

HOWARD, CECIL DE BLAQUIERE.
Sculptor. Born in Canada, April 2, 1888. At the age of thirteen he started working at the Art School, Buffalo, NY, were he studied under James E. Fraser. In 1905 he entered the Academie Julien, Paris, and exhibited at the Salon the following year. Also exhibited in NYC at National Sculpture Society. Member: Societe Nationale des

Beaux-Arts, associe, 1912; National Academy of Design, NY; National Institute of Arts and Letters; National Sculpture Society; Salon d'Automne; Salon de Tuileries. Works: Two war monuments in France, one at Hautot-sur-Mer and one at Ouville-la-Riviere, both towns on the Normandy coast; Whitney; Brooklyn Museum; Albright, Buffalo; Museum of Modern Art, Paris. Most of his work consists of nude figures of various sizes, but he also did many portrait busts and animal studies. Often worked directly in stone and marble. Died in 1956. Address in 1953, 40 West 57th St., NYC.

HOWARD, LINDA.
Sculptor. Born in Evanston, IL, October 22, 1934. Studied: University of Denver, Denver, CO; Hunter College, SUNY, New York City; Chicago Art Institute, 1953-55. Awards: Creative Artists Public Service Grant, 1975; North Jersey Cultural Council, 1974; New England Artists, 1970. Exhibitions: Silvermine Guild, CT, 1971; Philadelphia Civic Center Museum, 1974; Sculpture Now Gallery, New York City, 1975, 78; Art Institute of Chicago, 1980; many others. Represented by sculpture for 1980 Winter Olympics, Lake Placid; Springfield Art Museum; others. Address in 1982, 11 Worth St., New York, NY.

HOWARD, ROBERT A.
Sculptor. Born April 5, 1922, Sapulpa, Okla. Studied: Phillips University; University of Tulsa, BA, MA, 1949 and privately with Ossip Zadkine, Paris, France. Work: University of North Carolina; NC Museum of Art, Raleigh. Exhibited: Person Hall Art Gallery, Chapel Hill, NC, 1951; Charlotte Mint, 1954; Greenville (NC) Library, 1959; Royal Marks Gallery, NYC, 1967, 68; Penna. Academy of Fine Arts; Detroit Institute; Whitney Museum; New York World's Fair, 1964-65; Los Angeles County Museum of Art, American Sculpture of the Sixties. Address in 1982, Chapel Hill, NC.

HOWARD, ROBERT BOARDMAN.
Sculptor. Born in New York, September 20, 1896. He attended the California School of Arts and Crafts, studying drawing under P. W. Wahl and painting under X. Martinex. In 1916 he entered the Art Students League, studying under Kenneth Hayes Miller. In 1918 he went to France, and after World War I studied alone in Paris for two years and elsewhere in Europe. In collections of San Francisco Museum of Modern Art; Oakland Museum, California; commissions for San Francisco Stock Exchange (sculpture murals), Golden Gate Park in San Francisco (fountain), IBM Research Center in San Jose, others. Exhibited at National Sculpture Society, 1923; Corcoran, 1937; Carnegie, 1941; Whitney Annuals, 1948-55; Metropolitan Museum of Art, 1951; San Francisco Museum of Modern Art, 1976; San Francisco Art Institute; plus many more. Instructor, sculpture, at San Francisco Art Institute, 1945-54, and Mills College, 1946. Address in 1982, San Francisco, Calif.

HOWELLS, ALICE IMOGEN.
Sculptor, painter, and craftsman. Born Pittsburgh, PA. Pupil of Art Students League of NY; Robert Henri, William Chase. Member: Art Centre of the Oranges;

Catherine Lorillard Wolfe Art Club; Provincetown Art Association. Award: Silver medal, Panama-Pacific Exposition, San Francisco, 1915. Address in 1933, East Orange, NJ; summer, Provincetown, MA. Died in 1937.

HOWLAND, EDITH.
Sculptor. Born March 29, 1863, in Auburn, NY. Studied at Vassar College, Poughkeepsie, NY. Pupil of Gustave Michel in Paris, and of Augustus Saint-Gaudens; also studied at Art Students League under Daniel C. French. Member: Art Students League of New York; National Assoc. of Women Painters and Sculptors; National Sculpture Society. Award: Honorable mention, Paris Salon, 1913. Represented in Metropolitan Museum by marble group "Between Yesterday and Tomorrow;" also in Brooklyn Museum. Exhibited at the National Sculpture Society, 1923. Address in 1933, Catskill-on-Hudson, NY. Died September 8, 1949.

HOXIE, VINNIE REAM.
Sculptor. Born in Madison, WI, on September 25, 1847. She studied under Bonnat in Paris and with Majolilin in Rome. Her statues of Abraham Lincoln, in the rotunda of the Capitol, Washington, DC, and Admiral Farragut, standing in Farragut Square, Washington, were executed under commissions from Congress. Among her other works were many portrait busts and medallions of prominent Americans and foreigners, and a number of ideal statues. Died in Washington, DC, November 2, 1914.

HOYT, HETTIE J.
Sculptor and painter. Born Harvard, IL. Pupil of Carl Marr, F.W. Heine, Fred Grant. Member: American Artists Professional League. Work: "Fleur de Lis and Lillies," D. A. R. Continental Hall, Washington, DC; "Chrysanthemums," Woman's Club, Milwaukee; "Zinnias," College Woman's Club, Milwaukee. Specialty, still life and flowers. Address in 1933, Stamford, CT.

HSIAO, CHIN.
Sculptor and painter. Born in Shanghai, China, January 30, 1935. Study: Taipei Normal College; with Li Chun-Sen, Taipei, Taiwan. Work: Museum of Modern Art, The Metropolitan Museum, NYC; National Gallery of Modern Art, Rome; Philadelphia Museum of Art; others. Exhibitions: Carnegie; 7th Biennial Sao Paulo, 1963; 4th Salon, Galeries-Pilotes, Lausanne, Switzerland, and Paris; plus others. Awards: City of Capo d'Orlando, Italy, prize. Media: Metal construction; acrylic, ink. Living in NYC in 1970. Address in 1982, Milano, Italy.

HUBARD, WILLIAM JAMES.
Sculptor, portraitist, and silhouettist. Born in Whitchurch, Shropshire, England, August 20, 1807. Immigrated, 1824. Originally worked on silhouettes as a child; gave it up for oil painting. Settled in Glouster County, VA; later Richmond. Became interested in sculpture in 1850's. Constructed a bronze foundry in Richmond, which was later converted to ammunition production during the Civil War. Hubard was killed at the foundry in an accidental explosion. Worked: NYC; Boston; Philadelphia; Baltimore; Gloucester County, VA; Richmond, from 1841. Exhibited: National Academy, 1834. Work held:

Corcoran Gallery, Washington. Died in Richmond, VA, Feb. 15, 1862.

HUBBARD, BESS BIGHAM.
Sculptor. Born in Fort Worth, TX, February 18, 1896. Studied at Chicago Academy of Fine Arts; and with Boardman Robinson, Xavier Gonzalez, Alexandre Hogue, Octavio Medellin, Ernest Freed, and William Zorach. Works: Colorado Springs Fine Arts Center; Dallas Museum of Fine Arts; Texas Fine Arts Association; Elizabet Ney Museum. Awards: Dallas, Texas, 1944; Museum of Fine Arts, Abilene, Texas, 1949-1951; Fort Worth Art Association, 1950. Address in 1953, Lubbock, TX.

HUBBELL, STEPHEN J.
Sculptor and painter. Born in Pasadena, CA, 1933. Briefly trained in technical illustration; worked for Lockheed Aircraft and as commercial artist. Member of American Indian and Cowboy Artists. Awarded gold medal at American Indian and Cowboy Artists show, 1980. Specializes in ranching and packing subjects in Trinity County, CA. Illustrated *Appaloosa Breed Characteristics*. Address since 1971, Weaverville, CA.

HUBER, DAN.
Sculptor. Born in Yankton, SD, 1941. Worked with horses, competed in rodeos. Began sculpting professionally in 1973. Specialty is historic and contemporary Western scenes. Works in bronze. Awarded best of show, sculpture, C. M. Russell Auction, 1974. Reviewed in *Art West*, fall 1978. Represented by Husberg Fine Arts Gallery, Sedona, AZ; Trail's End Gallery, Portland, OR. Address in 1982, Milwaukie, OR.

HUDSON, JON BARLOW.
Sculptor. Born in Billings, MT, December 17, 1945. Studied at California Institute of Arts, with Allen Raprow, Paul Brach and Lloyd Harnroll, B.F.A., 1971, M.F.A., 1972; Stuttgart State Art Academy, West Germany, with Rudolph Hoflehner, 1969; Dayton Art Institute, with Charles Ginnever, Bob Koepnick, and Ann Tabatchnick, B.F.A., 1975. Has exhibited at Dayton Art Institute Museum, OH; J. B. Speed Art Museum, Louisville, KY; others. Member of Artists Equity; Center Visual Arts. Works in stainless steel and metals. Represented by Condeso/Lawler Gallery, NYC; Tamara B. Thomas Fine Arts, Los Angeles, CA. Address in 1982, Yellow Springs, OH.

HUDSON, ROBERT H.
Sculptor and painter. Born September 8, 1938, in Salt Lake City, UT. Studied: San Francisco Art Institute, BFA, 1962, MFA, 1963. Work: Los Angeles County Museum of Art; Oakland Art Museum; San Francisco Museum of Art; Stedelijk Museum, Amsterdam. Represented by Allan Frumkin Gallery, NYC; Hansen-Fuller Gallery, San Francisco. Exhibited: Richmond (CA) Art Center, 1961; Batman Gallery, San Francisco, 1961; Bolles Gallery, San Francisco, 1962; San Francisco Art Institute, 1965; Allan Frumkin Gallery, Chicago, 1964, 68, NYC, 1965; Nicholas Wilder Gallery, Los Angeles, 1967; San Francisco Museum of Art; Whitney Museum; Los Angeles County Museum of Art; Art Institute of

Chicago; Walker. Awards: Richmond (CA) Art Cent., 1959; San Francisco Art Festival, 1961; San Francisco Museum of Art, 1963; San Jose State College, 1964; San Francisco Museum of Art, Nealie Sullivan Award, 1965; Guggenheim Fellowship. Address in 1982, Cotati, CA.

HUDSPETH, ROBERT NORMAN.
Sculptor (and painter?). Born in Canada, 1862. Address in 1934, Concord, Mass. (Mallett's)

HUELSE, CARL.
Sculptor. Exhibited at Annual Exhibition of National Academy of Design, New York, 1925. Address in 1926, Philadelphia, PA.

HUETER, JAMES WARREN.
Sculptor and painter. Born in San Francisco, CA, 1925. Studied at Pomona College, B.A.; Claremont Graduate School, M.F.A., with Henry Lee McFee, Albert Stewart, and Millard Sheets. Has exhibited at Pasadena Art Museum; Los Angeles Co. Museum; Denver Museum of Art; Butler Institute of American Art; others. Received first prize and purchase award for painting, Pasadena Art Museum; first prize for sculpture, Los Angeles Co. Museum. Taught at Mt. San Antonio College Eve. Div., Walnut, CA, 1951-80, painting and drawing; Pomona College, 1959-60, sculpture. Works in wood and oil. Address in 1982, Claremont, CA.

HUFF, WILLIAM GORDON.
Sculptor and painter. Born Fresno, CA, February 3, 1903. Pupil of B. Bufano, Edgar Walter, Arthur Lee. Awards: Second sculpture award, Palace of Fine Art, San Francisco, 1922; first sculpture prize, CA Society of Fine Arts, San Francisco, 1923. Work: Civil War Monument, Bennington, VT; Prof. Fay Memorial, Tufts College, MA; Francis Marion Smith Memorial, Oakland, CA; Chief Solano Monument, Solano Co., CA. Address in 1933, Berkeley, CA; summer, Rock Tavern, NY.

HUGHES, ROBERT BALL (or BALL ROBERT).
Sculptor. Born January 19, 1806, in London, England, where he studied with Edward Hodges Baily of the School of Flaxman; received the silver medal of the Royal Academy. He came to the United States in 1829 and settled first in New York and later in Dorchester, MA. He modeled the groups "Little Nell," "Uncle Toby and the Widow Wadman," preserved in plaster at the Boston Athenaeum. His life-size high-relief of Bishop Hobart of New York is in the vestry of Trinity Church, New York. Executed full-length statue of Alexander Hamilton for Merchants' Exchange; wax bust of Charles Wilkes, President of Bank of New York, New York Historical Society, 1830; John Watts, bronze version at Metropolitan Museum of Art; others. Exhibited at National Academy of Design; Boston Athenaeum; Artists' Fund Society, Philadelphia. Honorary professional member of National Academy of Design, 1831. He died March 5, 1868, in Dorchester, MA.

HULBERT, CHARLES ALLEN.
Sculptor and painter. Born in Mackinaw Island, MI. Pupil of Penna. Academy of Fine Arts; John Ward Stimson in NY; Metropolitan Museum Art School, and Artist-

Artisan Institute in NYC. Work: "The Old Trunk," Public Library, Erie, PA; "Portrait of Sec. Edward Lazansky," the Capitol, Albany, NY. Address in 1933, South Egremont, MA.

HULSE, MARION JORDAN GILMORE.
Sculptor, painter, designer, and illustrator. Born in Ottumwa, Iowa. Studied at Boston Museum of Fine Art School; Art Students League; University of Kentucky; American Academy of Art. Work: Murals, US Post Office, Corning, Corydon, Iowa. Exhibited: Iowa State Fair; Ottumwa Art Center; Iowa State College. Address in 1953, Minneapolis, MN.

HUMES, RALPH HAMILTON.
Sculptor. Born Philadelphia, December 25, 1902. Pupil of Albert Laessle and Charles Grafly at Penna. Academy of Fine Arts; Rinehart School of Sculpture. Member: National Sculpture Society; Conn. Academy of Fine Arts; New Haven Paint and Clay Club; National Academy (Associate); others. Awards: Cresson Traveling Scholarship, Penna. Academy of Fine Arts, 1929, 30; prizes, National Academy of Design, 1932, 37; New Haven Paint and Clay Club, 1932, 36; fellowship, Penna. Academy of Fine Arts, 1937; others. Exhibited: Penna. Academy of Fine Arts, 1930-34, 37; National Academy of Design, 1932, 33, 35, 37, 40, 45; National Sculpture Society Shows; Art Institute of Chicago; many others. Represented in Brookgreen Gardens, SC; fountain, Coral Gables, FL; Penna. Academy of Fine Arts; commissions. Address in 1980, Leesburg, FL. Died in 1981.

HUMPHREYS, ALBERT.
Sculptor and painter. Born near Cincinnati, OH. Pupil of Gerome and Alexander Harrison in Paris. Represented by paintings in Detroit Institute of Art and Boston Public Library. Represented by sculpture in National Gallery of Art, Washington, DC, and Children's Fountain, South Manchester, CT. Address in 1922, 96 Fifth Avenue, New York. Died in 1922.

HUMPHRIES, CHARLES HARRY.
Sculptor. Born in England, 1867. Member: National Sculpture Society, 1908; Society of Independent Artists. Exhibited: NY Academy of Design; Philadelphia Academy of Fine Arts. Work: "Indian Appeal to Manitou," "Indian Sundial." Address in 1933, 214 East 45th Street, NYC. Died in 1934.

HUNT, BRYAN.
Sculptor. Born in Terre Haute, IN, June 7, 1947. Studied at Otis Art Institute, 1969-72. Work in Solomon R. Guggenheim Museum, Museum of Modern Art, Whitney Museum of American Art, all in NYC; Yale Art Gallery, New Haven, CT; Stedelijk Museum, Amsterdam. Has exhibited at Guggenheim Museum; Stedelijk Museum, Amsterdam; Whitney Museum of American Art; Museum of Modern Art; The Venice Biennalle, Italy. Works in construction and bronze. Address in 1982, 31 Great Jones St., NYC.

HUNT, CLYDE DU VERNET.
Sculptor. Born in Scotland in 1861. Student of Mass. Institute of Technology, Boston. Represented in Metro-

politan Museum of Art, New York, by marble statue, "Nirvana." Exhibited at National Sculpture Society, 1923. Member: National Sculpture Society. Address in 1926, Weathersfield, VT. Died in 1941.

HUNT, ESTHER.
Sculptor and painter. Born Grand Island, NE, August 30, 1885. Pupil of Chase. Member: Laguna Beach Art Association. Award: Gold medal for sculpture, Pan-Pacific Exposition, San Diego, 1915. Address in 1933, 142 East 18th Street, New York, NY.

HUNT, KARI.
(Mrs. Douglas Melvin Hunt). Sculptor and writer. Born in Orange, NJ, January 29, 1920. Studied at Mt. Holyoke College, 1937-39; Cornell University; University of Buffalo; and with Doane Powell. Sculptress of ethnological masks in sculpture; sculpts and casts bronzes, ceramics of ancient and primitive masks in bronze, ceramics of ancient and primitive masks found in museums, from photographs; also records original copies of masks that are becoming extinct in Bali, Java, Ceylon, South Pacific, China, etc. Work: Doane Powell Collection of portrait masks. Made masks for CBS television, 1954, ABC-TV, 1954-55, doing heads and masks of television stars and for ads. Address and studio in 1982, Glen Gardner, NJ.

HUNT, RICHARD HOWARD.
Sculptor. Born September 12, 1935, Chicago, Ill. Studied: University of Illinois; The University of Chicago; Art Institute of Chicago School, 1959, BA. Ed. Work: Bezalel Museum; Albright; Art Institute of Chicago; Cleveland Museum of Art; Museum of Modern Art; Milwaukee; Whitney. Exhibited: The Alan Gallery, NYC, 1958, 1960, 63; Stewart Richard Gallery, San Antonio, 1960, 64; Felix Landau Gallery; Cleveland Museum of Art; Milwaukee; Museum of Modern Art; Whitney Museum; Yale University; Newark Museum; Carnegie; Seattle World's Fair, 1962; Hemis Fair '68, San Antonio, Texas, 1968; Brooklyn Museum; and others. Awards: Art Institute of Chicago, James Nelson Raymond Traveling Fellowship, 1957; Guggenheim Foundation Fellowship, 1962; Art Institute of Chicago, Logan Prize. Taught: University of Illinois, 1960-62; Art Institute of Chicago School, 1960-61; Yale University, 1964; Chouinard Art Institute, Los Angeles, 1964-65. Media: Various metals. Address in 1982, Chicago, IL.

HUNT, WAYNE.
Sculptor and poet. Born Bear Valley, WI, 1904. Member of Cowboy Artists of America. Specialty is cowboy genre. Works in bronze. Address in 1974, Cornville, AZ.

HUNT, WILLIAM MORRIS.
Sculptor, painter, cameo portraitist, and teacher. Born in Brattleboro, VT, March 31, 1824. Studied in Rome, Italy, under Henry Kirke Brown; later at Duesseldorf; Paris under Pradier. Influenced deeply by work of Thomas Couture in Paris. Returned to Boston where he taught art; noted for bringing attention to emerging art trends in Paris and Barbizon, France, in latter half of 19th Century. Sculpture works were few. Works: "The Horses of Anahita" (or "The Flight of Night"), 1846, one of two large

murals for the State Capitol at Albany, New York, 1878; work also in Metropolitan Museum, NYC; and Washington, DC. Died at Appledore, one of the Isles of Shoals, off New Hampshire coast, September 8, 1879.

HUNTER, DAVID.
Sculptor. Born in England, August 1865. Pupil of Art Institute of Chicago and John Gelert in Chicago. Second prize, Architectural Club, Chicago; first prize for relief at Springfield, IL. Member Palette and Chisel Club; Chicago Architectural Club. Address in 1910, Northwestern Terra Cotta Co., Chicago, IL. Died 1927 in New York.

HUNTER, LEONARD LEGRANDE, III.
Sculptor and educator. Born in Washington, DC, July 3, 1940. Studied at University of Miami, B.A.; Graduate School of Architecture, University of Penna.; University of California, Berkeley, M.F.A. Work in Hopkins Center, Dartmouth College. Has exhibited at New Orleans Museum of Art, 1973; Whitney Museum of American Art, 1975; Film Festival of the Americas, Virgin Islands, 1977; others. Address in 1982, Lexington, KY.

HUNTINGTON, ANNA VAUGHN HYATT.
(Mrs. Archer M.) Sculptor. Born Cambridge, MA, March 10, 1876. Studied: Art Students League, NY, under H. MacNeil and Borglum; H. H. Kitson in Boston; self-study of wild animals at the Bronx Zoo. Exhibited: National Sculpture Society, 1923. Member: Associate (1916) and Academician, National Acad. of Design, NY (1923); National Sculpture Society, 1905; American Federation of Arts; American Academy of Arts and Letters; board member, Brookgreen Gardens, SC. Awards: Honorable men., Paris Salon, 1910; silver medal, P.-P. Exp., San Francisco, 1915; purple rosette from French Gov., 1915; gold medal, Plastic Club, 1916; Saltus medal, National Academy of Design, 1920, 1922; Legion of Honor, 1922; gold medal, National Academy of Design, 1958; Grand Cross of Alfonso the Twelfth, Spanish Gov.; many others. Work: "Lion," (bronze) erected at Dayton, OH; "Joan of Arc," for which she was awarded honorable mention at the Paris Salon, unveiled NYC, 1915; Gloucester, MA; Blois, France; Cathedral of St. John the Divine, NY; bronze elephants, Carnegie Institute; other pieces held in collection of Brookgreen Gardens, SC: "Jaguar," (bronze), 1907; "Great Dane," (granite), 1922; "Diana of the Chase," (bronze), 1922; "Youth Taming the Wild," (limestone), 1927; "El Cid Campeador," 1934; "Mother," (bronze), 1953; "Wrong Number," (bronze), 1967; numerous others. Specialty, animal sculpture, garden sculpture, and fountains. Address in 1970, Bethel, CT. Died on October 4, 1973.

HUNTINGTON, CLARA.
Sculptor. Born Oneonta, NY, February 2, 1878. Pupil of Arturo Dazzi in Rome. Member: National Association of Women Painters and Sculptors. Work: Portrait bas-relief of H. E. Huntington, Henry E. Huntington Library and Art Gallery, San Marino, CA; decorative bas-relief, Berkeley Women's Club, California. Address in 1933, Los Gatos, CA; Forti Di Marmi, (Lucca) Italy.

HUNTINGTON, JIM.
Sculptor. Born in Elkhart, IN, January 13, 1941. Studied at Indiana University, Bloomington, 1958-59; El Camino College, 1959-60. Work in Addison Gallery of American Art, Andover, MA; Brandeis University; Whitney Museum of American Art; Storm King Art Center, Mountainville, NY; others. Has exhibited at Corcoran Gallery of Art; Whitney Museum of American Art; Mass. Institute of Technology; Max Hutchinson Gallery, NY. Received National Endowment for the Arts Fellowship, 1980-81. Works in stone, metal, and wood. Address in 1982, Brooklyn, NY.

HUNTINGTON, ROBERT LESLIE.
Sculptor. Born in Yonkers, NY, 1890. Studied and practiced civil engineering. After his war service, he studied at the Beaux-Arts Institute of Design, NY, under Leo Lentelli and Edward McCartan, 1920-25. Works: The Mask; statue, Dawn; Doughboy's Head; Let's Go; figure, sculpture, for architectural decoration.

HUNTOON, MARY.
Sculptor, painter, etcher, and teacher. Born Topeka, November 29, 1896. Pupil of Joseph Pennell and Henri, Art Students League; and studied in Paris. Exhibited: Brooklyn Society of Artists, 1930; Salon d'Automne, 1929; Women Painters of America, 1936-38; others. Member: National League of American Pen Women; Prairie Water Color Painters. Address in 1953, Paris, France; summer, Topeka, KS.

HUOT, ROBERT.
Sculptor, painter, and filmmaker. Born September 16, 1935, Staten Island, NY. Studied: Wagner College, BS; Hunter College. Work: Paula Cooper, NYC; Doberman Collection, Munster, Germany; Museum of Modern Art. Exhibited: Stephen Radich Gallery, NYC, 1964, 1965-67; Galerie Schmela, 1968; Paula Cooper Gallery, NYC, 1969; Vassar College, Poughkeepsie, NY, 1964; Guggenheim, Systematic Painting, 1966; IV Internat. Young Artists Exhibit, America-Japan, Tokyo, 1967; American Federation of Arts, 1967; Museum of Modern Art, The Art of the Real, 1968; Albright-Knox. Awards: National Council on the Arts. Taught: Hunter College, 1963-81. Represented by Filmmakers Coop, NYC; Max Hetzler, Stuttgart. Address in 1982, New Berlin, NY.

HURST, RALPH N.
Sculptor and educator. Born in Decatur, IN, September 4, 1918. Studied at Indiana University, Bloomington, B.S. and M.F.A.; Ogunquit School of Painting and Sculpture, ME, with Robert Laurent. Work in Evansville Museum of Arts and Science, IN; Columbus Museum of Arts and Crafts, GA; others. Has exhibited at Metropolitan Museum, NY, American Sculpture, 1951; National Liturgical Art Exhibition, San Francisco, 1960; High Museum, Atlanta, GA, 1967. Member of Artists Equity Association; National Art Education Association; Southeastern Sculptors Association. Works in alabaster and wood. Address in 1982, Tallahassee, FL.

HUTCHINS, MAUDE PHELPS McVEIGH.
Sculptor. Born New York City, February 4, 1899. Pupil of Robert G. Eberhard; Yale School of Fine Arts. Exhibited: Grand Central Art Galleries; Univ. of Chicago; others. Member: New Haven Painters and Sculptors Society; National Academy of Women Painters and Sculptors. Award: Floyd Warren prize, Beaux-Arts Institute of Design, New York, 1925. Address in 1953, Chicago, IL.

HUTCHINSON, ALLEN.
Sculptor. Born in England January 8, 1855. Pupil of Jules Dalou. Works: "King Kalakana," Hawaiian types and figures and busts of Hawaiian notables, etc., Bishop Museum, Honolulu; "Sir Alfred Stephen," National Art Gallery, Sydney, Australia; busts of Robert Louis Stevenson, Honolulu Academy of Arts and the Stevenson Society of America, Saranac Lake, NY; Auckland Art Museum, New Zealand. Address in 1929, 25 Dongan Place, New York, NY.

HUTCHINSON, JOSEPH SHIELDS.
Sculptor, painter, educator, and museum director. Born in Mt. Pleasant, PA, October 15, 1912. Studied at Ohio State University, B.F.A., M.F.A.; Western Reserve University; and with James Hopkins, Edward Frey. Member: American Association University Prof. Awards: Prize, Columbus (OH) Art League, 1937. Work: Sculpture, Ohio Wesleyan University. Position: Instructor, Dept. of Fine Arts, Ohio State University, Columbus, OH, 1935-37; Assistant Professor, Ohio Wesleyan University of Dalaware, OH, 1937-40; former director, Mints Museum of Art, Charlotte, NC. Address in 1953, Charlotte, NC.

HYATT, ANNA VAUGHN.
(Mrs. Archer M. Huntington.) See Huntington, Anna Hyatt Vaughn.

HYATT, HARRIET RANDOLPH.
See Mrs. Mayor.

HYDE, (ETHEL) CONDICT.
(Mrs. Hugh M. Hyde). Sculptor. Born in Morristown, NJ, 1925. Student of private schools; B.A., Barnard College, 1947; Cranbrook Academy of Art, 1947, 48; Art Students League, 1947, 48; University of New Mexico, 1944-45; Beaux Art, Paris, 1949. Established Spook Farm Gallery of Contemporary Painting and Sculpture, Inc., 1956, director, from 1956. Bronze bust of W. V. Griffin in permanent collection, English Speaking Union, NYC. Member: advance gifts com. American Red Cross, Community Chest; trustee, Bernardsville Library, 1952-58; Metropolitan Museum of Art, Museum of Modern Art, Kappa Kappa Gamma. Address in 1962, Spook Hollow Road. Office: Spook Farm Gallery, Far Hills, NJ.

HYDE, DOUG.
Sculptor. Nez Perce and Assiniboine Indian, born in Hemiston, OR, 1946. Studied at Institute of American Indian Art, Santa Fe, with sculptor Allan Houser, 1963-66; Art Institute of Los Angeles, 1966-67; trained as tombstone cutter, Nez Perce Reservation. Later taught and did graduate work at the Institute of American Indian Art. Own studio since 1974. Specialty is Indian figures and animals; works in stone. Noted work: "Calling on the Bird People," (Colorado alabaster). Reviewed in *Artists of the Rockies*, spring 1975; *Southwest Art*, July 1978. Represented by Artistic Gallery, Scottsdale, AZ; Fenn Galleries Ltd, Santa Fe. Address since 1971, Santa Fe, NM.

HYDE, EDWARD.
Sculptor. Worked: Brooklyn, New York, 1859.

HYDE, MARIE A. H.
Sculptor, painter, illustrator, writer, and craftswoman. Born in Sidney, OH, October 12, 1882. Studied at Cleveland School of Art; Art Students League; National Academy of Design; and with William Chase, Frank Parsons. Awards: Prize, Cleveland School of Art, 1905. Work: Metropolitan Museum of Art; Southwest Museum of Los Angeles, CA; Museum of New Mexico, Santa Fe. Illustrator, technical handbooks, Lockheed-Connors-Joyce, 1943-46. Author, illustrator, and craftswoman, national magazines and art publications. Address in 1953, Arizona Studios, 508 West 114th St., NYC.

HYNES, BARBARA JO.
Sculptor and painter. Born in Springfield, OH. Studied at the Dayton Art Institute, also in Chicago, Washington, DC, NYC, and New Orleans; University of Dayton, BA, BFA; graduate work at Wright State University. Exhibited: The All Ohio Painting and Sculpting Show; The All Ohio Graphic Show; and St. Mary's, Maryland, Graphic Art Exhibits. Awards: Working in art with retarded children. Member: Dayton Art Institute, Ohio Historical Society, and the Early American Society. Taught: Art and art history at numerous high schools.

I

IANNELLI, ALFONSO.
Sculptor, painter, craftsman, writer, lecturer, and teacher. Born Andretta, Italy, February 17, 1888. Studied: Newark Technical School; Art Students League; pupil of Gutzon Borglum; George B. Bridgman; William St. John Harper. Represented by sculpture in Sioux City Court House, Sioux City, IA; design and sculpture, Immaculata High School, Chicago; Midway Gardens, Chicago; St. Francis Xavier Church, Kansas City, MO; Church of St. Thomas the Apostle, Chicago; "Youth," Art Institute of Chicago; sculpture and stained glass, St. Thomas Aquinas High School, Racine, WI; St. Patrick's Church, Racine, WI. Exhibited: Art Institute of Chicago, 1921, 25 (one-man), 1948-52; National Sculpture Society; Grand Central Gallery. Member: Cliff Dwellers. Awards: honorary degree, M.F.A., Art Institute of Chicago, 1928; St.-Gaudens prize in sculpture. Address in 1953, Park Ridge, IL.

IARDELLA (or JARDELLA), ANDREW B.
Sculptor. Worked: Philadelphia, 1803-31. Exhibited: Bust of Alexander Hamilton, Penna. Academy, 1811.

IARDELLA, FRANCISCO.
Sculptor. Born in Carrara, Italy, 1793; to US in 1816. Died in Washington, January 23, 1831. Worked on US Capitol, Washington.

IARDELLA (or JARDELLA), GIUSEPPE.
Sculptor. Born in Italy. Worked: Philadelphia, 1790's-1803.

IDE, ALICE STEELE.
See Mrs. Foster Hannaford.

IHRIG, CLARA LOUISE.
Sculptor, painter, and illustrator. Born Oakland, Pittsburgh, PA, October 31, 1893. Pupil of Sparks, Zeller, and Sotter. Member: Asso. Artists of Pittsburgh. Address in 1933, Pittsburgh, PA.

ILES, TERRY (JOHNSON).
Sculptor. Member of the National Sculpture Society. Address in 1982, Sun Lakes, Arizona.

ILLAVA, KARL.
Sculptor. Pupil of Gutzon Borglum. Member: National Sculpture Society; Architectural League of New York (associate). Work: War Memorial, 66th St. and Fifth Ave., New York; War Memorial, Gloversville, NY; memorial to Dr. Henry Franenthal, foyer, Joint Disease Hospital, NYC; memorial to Veterans of All Wars, Whitestone, NY; others. Address in 1934, Bronxville, NY.

INDIANA, ROBERT.
Sculptor and painter. Born in New Castle, IN, September 13, 1928. Studied at John Herron School of Art; Munson-Williams-Proctor Institute; Art Institute of Chicago, B.F.A.; Skowhegan School of Painting and Sculpture; University of Edinburgh and Edinburgh College of Art, Scotland; others. Work in Museum of Modern Art; Whitney Museum of American Art; Carnegie Institute of Arts; Stedelijk Museum, Amsterdam; others. Has exhibited at Museum of Modern Art, NY; Tate Gallery, London; Whitney Museum of American Art; Virginia Museum of Fine Arts, Richmond; Corcoran Gallery of Art; others. Works in oil and steel. Address in 1982, c/o Star of Hope, Vinalhaven, ME.

INDICK, JANET.
Sculptor. Born in Bronx, NY, March 3, 1932. Studied at Hunter College, with Robert Motherwell and Dong Kingman, B.A. (art), 1953; The New School, with Gregorio Prestopino and Richard Pousette-Dart, 1961. Work in Bergen Community Museum of Art and Science, Paramus, NJ; steel sculpture, The Jewish Center, Teaneck, NJ; sculpture (brass), Tree of Life Temple Beth Rishon, Wyckoff, NJ; includes "Small Gallery," stainless steel and wood. Has exhibited at 94th Annual Exhibition of National Association of Women Artists, 1983. Awards: National Association of Women Artists, sculpture prize, 1974; National Association of Painters and Sculptors, sculpture prize, 1978, 80; others. Member of National Association of Women Artists. Address in 1983, Teaneck, NJ.

INGELS, FRANK LEE.
Sculptor. Born in Tomara, Nebraska, in 1886. Address in 1934, Los Angeles, CA. (Mallett's)

INGELS, KATHLEEN BEVERLEY.
Sculptor. Member: Chicago Society of Artists. Address in 1919, Chicago, IL.

INGHAM-SMITH, ELIZABETH.
Sculptor and painter. Born in Easton, Pennsylvania. Pupil of Pennsylvania Academy of the Fine Arts, Philadelphia; Henry B. Snell; Whistler in Paris; Alex Jameson in London. Member: Philadelphia Water Color Club; Washington Water Color Club; New York Water Color Club. Address in 1934, Old Inn, North Shirley, MA.

INGRAHAM, NATALIE (MRS.).
Sculptor. Born in New York. Pupil of Millet de Marcilly. Address in 1910, Paris, France.

INNES, CHARLES.
Sculptor. At New York City, 1854-56. Exhibited: Busts of Huges, Brady, and Fremont, American Institute, 1856.

INSLEE, CHARLES T.
Sculptor. Worked: New York City, during 1859, 60.

INSLEY, WILL.

Sculptor and painter. Born October 15, 1929, Indianapolis, Ind. Studied: Amherst College, BA, 1951; Harvard University Graduate School of Design, M. Architecture, 1955. Work: Brandeis University; Colby College; University of North Carolina. Exhibited: Amherst College, 1951; The Stable Gallery, 1965-68; Walker, 1968; Albright; Cornell University; Whitney; Riverside Museum; Guggenheim; VI International Art Biennial, San Marino (Europe), 1967; Aldrich; New Delhi, First World Triennial, 1968; Museum of Modern Art, 71; Museum of Contemporary Art, Chicago, 1976. Awards: National Foundation on the Arts, 1966; Guggenheim Foundation Fellowship, 1969. Taught: Oberlin College Artist-in-Residence, 1966; University of North Carolina, 1967-68; Cornell University, 1969; School of Visual Arts, NYC, 1969-78. Represented by Max Protech Gallery, NYC. Address in 1982, 231 Bowery, NYC.

INVERARITY, ROBERT BRUCE.

Sculptor, painter, illustrator, etcher, lithographer, block painter, craftsman, lecturer, teacher, and writer. Born in Seattle, Wash., July 5, 1909. Studied: University of Washington, B.A., 1946; Fremont University, M.F.A., 1947, PhD, 1948, and with Kazue Yamagishi, Blanding Sloan, and Mark Tobey. Work at University of Washington, two mosaics; Washington State Museum, six panels. Exhibited at one-man shows and numerous group exhibitions. Director, Philadelphia Maritime Museum, 1969-76; Museum of International Folk Art, 1949-54; Adirondack Museum, 1954-65. Taught: University of Washington, 1933-37. Author and illustrator of "Block Printing and Stenciling," "The Rainbow Book" (Art of Batik), yearly article in "Puppetry, A Yearbook of Marionettes." Address in 1982, La Jolla, CA.

IREDELL, RUSSELL.

Sculptor, painter, etcher, illustrator, and designer. Born February 28, 1889. Studied: Penna. Academy of Fine Arts, and with Henry McCarter, Cecilia Beaux, Daniel Garber. Member: Laguna Beach Art Association. Awards: Cresson Traveling scholarship, Penna. Academy of Fine Arts. Work: many private portrait commissions. Exhibited: Laguna Beach Art Association, 1943-46, and later; Festival of Art, Laguna Beach; Pasadena, La Jolla, Coronado, Santa Ana, Huntington Beach, San Francisco, Palm Springs, all in Calif.; Nassau; Lake Forrest, Ill.; and others. Author, illustrator, "Drawing the Figure." Address in 1953, Laguna Beach, Calif. Died in 1959.

IRELAND, PATRICK.

Sculptor. Born in Ballaghaderrin, Ireland, 1934. Has exhibited at Los Angeles Co. Museum of Art; Corcoran Gallery of Art; Seattle Art Museum; Fogg Art Museum; others. Address in 1982, 15 W. 67th St., NYC.

IRVIN, MELITA.

Sculptor. Born in Port Hope, Ontario, Canada. Exhibited predominantly in the Chicago area.

IRVIN, SISTER MARY FRANCIS.

Sculptor, painter, teacher, and engraver. Born in Canton, Ohio, October 4, 1914. Studied: Seton Hill College; Carnegie Institute, B.F.A.; Art Institute of Chicago; Cranbrook Academy of Art, M.F.A. Member: Associated Artists of Pittsburgh; Greensburg Art Club; College Art Association of America, New York; Catholic Art Association. Awards: Associated Artists of Pittsburgh, 1944; Greensburg Art Club, 1944, 45, 55, 57. Work: Carnegie Institute; St. Charles Borromeo Church, Twin Rocks, PA. Exhibited: Library of Congress, 1944; Associated Artists of Pittsburgh, 1943-46, 54, 57; Carnegie Institute, 1944, 56; Greensburg Art Club, 1944-52, 54, 57, 59-64; Pittsburgh Playhouse, 1950, 53; Allegheny Art League, 1951. Taught: Professor of Art, Seton Hill College, Greensburg, PA. Address in 1970, Greensburg, PA.

IRVING, ELENA.

Sculptor. Born in New York City in 1931. Studied: Fashion Institute of Technology, New York City; Universidad Iberoamericana, Mexico; The Art Institute, Milan; Ceramic Sculpture, Queens College, New York City. Collections: Museum of Modern Art, Mexico City; Trebor Collection, Oklahoma Art Center, Oklahoma City; Sao Paulo Contemporary Art Museum, Sao Paulo, Brazil; Universidad de Navarra, Pamplona, Spain.

IRVING, JOAN.

Sculptor and painter. Born in Riverside, Calif., March 12, 1916. Studied: Riverside City Col., with Richard Allman, 1933-35; Art Center School, Los Angeles, Calif.; with Edward Kaminski and Barse Miller, 1935-37. Awards: Festival of Art, Laguna Beach, 1951; Calif. Watercolor Society, 1951; National Orange Show, 1951; Watercolor West, 1975. Membership: American Watercolor Society; life fellow, Royal Society of Arts; honorary life member, Watercolor West; honorary life member, San Diego Watercolor Society. Collections: Metropolitan Museum of Art; Newport Harbor School Collection. Exhibited: American Water Color Society, National Academy, New York City; Calif. Watercolor Society, Los Angeles County Museum of Arts, 1950, 51, 52, 53, and 55. Address in 1982, Del Mars, Calif.

IRWIN, ROBERT.

Sculptor and environmental artist. Born 1928, in Long Beach, Calif. Studied: Otis Art Institute, 1948-50; Jepson Art Institute, Los Angeles, 1951; Chouinard Art Institute, L.A, 1951-53. Work: Fort Worth; Los Angeles County Museum of Art; Pasadena Art Museum; Whitney Museum; Art Institute of Chicago; Museum of Modern Art; Walker. Exhibited: Felix Landau Gallery, Ferrus Gallery, Los Angeles; Pasadena Art Museum, 1960; The Pace Gallery, 1966, 68, 69; Los Angeles County Museum of Art; Jewish Museum, 1968; Whitney Museum; San Francisco Museum of Art; Museum of Modern Art; VIII Sao Paulo Biennial, 1965; Vancouver, 1968; Documenta IV, Kassel, 1968; Walker, 1968; Stedelijk; Fogg. Taught: Chouinard Art Institute, 1957-58; UCLA, 1962; University of California, Irvine, 1968-69. Address in 1982, Los Angeles, Calif.

ISAACS, BETTY LEWIS.

Sculptor. Born in Hobart, Tasmania, Sept. 2, 1894. Studied at Cooper Union Art School; Art Students League; Alfred University; Kunstgewerbe Schule, private study at Warsaw (Poland) and in Vienna(Austria). Exhibited:

National Alliance of Art in Industry, Audubon Artists, National Association of Women Artists, Brooklyn, Society of Artists, Cooper Union, Ferargil Galleries, Argent Galleries, etc. Works: Cooper Union Museum; Church of St. Anselm, Tokyo, Japan. Awards: National Association of Women Artists, 1955, 57, 60. Taught: Cooper Union Art School, Greenwich House, NYC, 1930-36. Address in 1970, 21 E. 10th St., NYC. Died in 1971.

ISELIN, LEWIS.
Sculptor. Born in New Rochelle, New York, June 22, 1913. Studied: Harvard University; Art Students League, 1934-38, with Mahonri Young, John Stuart Curry, George Bridgman and Gleb Derujunshy; Guggenheim Fellowship, 1952. Member: Century Association. Awards: prize, National Academy of Design, 1938; Penna. State College, 1950; Guggenheim Fellow, 1951-52. Work: American Military Cemetery, Suresnes, Paris, France (Memorial, figure, reliefs); Fogg Art Museum, Cambridge, MA; Columbus Gallery of Fine Arts, OH; Rockland Art Museum, ME. Exhibited: National Academy of Design, 1938, 43; Penna. Academy of Fine Arts, 1940-60; Museum of Modern Art, 1942; World's Fair, New York, 1939; Metropolitan Museum of Art, 1945; Whitney Museum of Art, 1940-60; Penna. State College, 1950. Medium: Bronze. Address in 1982, Camden, Maine.

ISELLA, LOUISA.
Sculptor. Born in Buenos Aires, Brazil. Exhibited and awards: Honorable mention, Salon des Artistes Francais, 1908.

ISERMAN, HAINO.
Sculptor. Born 1829. Died in Chicago, Ill., January 5, 1899. (Mallet's)

ISNARD, JEAN JACQUES.
Sculptor and engraver. Worked in New Orleans from 1818-46. Medium, marble.

ISPANKY, LASZLO.
Sculptor and designer. Born in Budapest, Hungary, November 3, 1919. Studied at Budapest Fine Arts Academy; Cranbrook Academy of Art, Bloomfield Hills, MI. Work in Vatican Museum, Rome, Italy; Buckingham Palace, London; bust of Eugene Ormandy, Philadelphia Philharmonic; sculpture, Basketball Hall of Fame, Springfield, MA; George Washington at Prayer sculpture, Valley Forge, PA; others. Has exhibited at National Sculpture Society, NY; NJ State Museum, Trenton; others. Works in bronze and porcelain. Address in 1982, Hopewell, NJ.

ITALIANO, JOAN MYLEN.
Sculptor and educator. Born in Worcester, MA. Studied: Siena Heights College, Adrian, MI, PhB; Studio Angelico, M.F.A.; Barry College, Miami, FL. Awards: Toledo Annual, 1950; Best of Show, Artists' Guild Show, Palm Beach, 1955; Palm Beach Art League, 1955, 1956. Collections: The Navy Base Chapel, Key West, FL; The Holy Ghost Seminary, Ann Arbor, MI; St. Thomas Aquinas High School, Chicago, IL; Mary Manning Walsh Home, NYC. Exhibited: Detroit Institute of Art, 1950 and 56; Fitchburg Art Museum; others. Media: Metal, wood, clay, and enamel. Member: International Sculpture Cen-

ter; Southern Association of Sculptors. Taught: Instructor of sculpture, Barry College, Miami, FL, 1956-58; associate professor of sculpture and ceramics, College of the Holy Cross, 1969, chairman of the fine arts dept., 1977-80. Address in 1982, West Boylston, MA.

IVES, CHAUNCEY BRADLEY.
Sculptor. Born December 14, 1810, in Hamden, Connecticut. Worked in NYC, 1840-44. Had a studio for seven years in Florence; later settled in Rome, with many visits to the US. His best known statues are "Pandora," "Rebecca," "Bacchante," and his statues of Roger Sherman and Jonathan Trumbull are in the Capitol at Washington, DC. Largely a portrait sculptor. Died Aug. 2, 1894, in Rome.

IVES, J. J.
Sculptor. Exhibited: Bust of General Scott, National Academy, 1850.

IVONE, ARTHUR.
Sculptor. Born Naples, Italy, May 29, 1894. Pupil of Achille D'Orsi Mossuti, Naples; Ettene Ferrari, Rome; C. J. Barnhorn, Cincinnati Art Academy. Member: Cincinnati Art Association. Work: Ohio State War Memorial; Springfield (Ohio) Museum; panels, Birmingham, AL; others. Stephen C. Foster Memorial bronze bust, Music Hall, Cincinnati, OH. Address in 1953, Cincinnati, OH.

IZUKA, KUNIO.
Sculptor. Born in Tokyo, Japan, March 2, 1939. Studied at Otis Art Institute of Los Angeles; Art Students League. Work in Otis Art Institute of Los Angeles; Museum of Modern Art, Tokyo, Japan; Museum of Modern Art, Kyoto, Japan; sculpture, Warner Communications, Los Angeles; others. Has exhibited at Museum of Modern Art, Rio de Janeiro and Milan; others. Received purchase prize, Otis Art Institute of Los Angeles. Member of Sculptors Guild; Japanese Artist Association, NY. Works in metal. Address in 1982, 80 Amsterdam Ave., NYC.

J

JACKSON, HARRY ANDREW.
Sculptor and painter. Born in Chicago, IL, April 18, 1924. Studied at the Art Institute, 1931-38, with Ed Grigware in Cody, WY, 1938-42, with Hans Hoffman at the Brooklyn Museum Art School, 1946-48. Exhibited: National Collection of Fine Arts, Wash., DC, 1964; National Academy of Design, NYC, 1964, 65, 67, 68, and 70; National Cowboy Hall of Fame, Oklahoma City, 1966 and 70-72; a retrospective of works was held at the Buffalo Bill Historical Center, Cody, WY, 1981. Awards: Samuel Finley Breese Morse Gold Medal from the National Academy of Design, 1968, and the silver medal, from the National Cowboy Hall of Fame, 1971. Member: Cowboy Artists of America; National Sculpture Society; fellow, American Artists Professional League; Bohemian Club; National Academy of Western Art; and the National Academy of Design (associate). He was official combat artist for the US Marine Corps, 1944-45; the youngest combat artist in World War II. He is the author of a volume entitled *Lost Wax Bronze Casting*, 1972. Subject matter of his works draws upon the life of the American West and his own experience as a cowboy. Address in 1982, Cody, WY.

JACKSON, HAZEL BRILL.
Sculptor. Born Philadelphia, PA, December 15, 1894. Studied: School of the Museum of Fine Arts, Boston; Scuola Rosatti, Florence, Italy; also under Bela Pratt, Charles Grafly; Angelo Zanelli in Rome. Exhibitions: National Academy of Design; National Academy of Rome; National Academy, Firenze, Italy: Corcoran Gallery. Member: Circolo Artisco of Rome; L. C. Tiffany Foundation; fellow, National Sculpture Society; Boston Society of Sculptors. Works: Vassar College; Calgary Museum, Canada; bronzes, Wellesley College; "The Starling" and "The Pelican," Concord, MA, Art Museum. Address in 1982, Twin Oaks, 83 Balmville Rd., Newburgh, NY.

JACKSON, JOHN ADAMS.
Sculptor and artist (crayon). Born in Bath, Maine, November 5, 1825. Pupil of D. C. Johnston, Boston; Suisse, Paris. Worked: Boston; NYC; Italy, 1860-79. Died in Italy, August 30, 1879.

JACKSON, MAY HOWARD (MRS.).
Sculptor. Born Philadelphia, PA, May 12, 1877. Pupil of Penna. Academy of Fine Art. Member: Society of Independent Artists. Award: Harmon, sculpture, 1928. Work: "William P. Price," St. Thomas' Church, Phila.; "Paul Lawrence Dunbar," Dunbar High School, Washington, DC; William H. Lewis, ex-Asst. Attorney General; Kelly Miller, Howard University, Washington, DC. Address in 1929, Washington, DC. Died 1931 in Washington, DC.

JACKSON, SANDRA.
Sculptor. Works include boxes using the assemblage technique.

JACKSON, SARAH.
Sculptor and graphic artist. Born in Detroit, Mich., November 13, 1924. Studied at Wayne State University, B.A., 1946, M.A., 1948. Works: Joseph H. Hirshhorn Collection, Washington, DC; National Gallery Canada, Ottawa; Montreal Museum of Fine Arts; Montreal Museum of Contemporary Arts; Art Gallery Ontario, Toronto. Commissions: Dancer (bronze), Cloverdale Shopping Center, Toronto, 1966; Metamorphosis (bronze) and Mindscape (bronze hanging), Student Union Building, Dalhousie University; plastic and bronze, sculpture, Mt. Sinai Hospital, Toronto. Exhibitions: Montreal Museum of Fine Arts; Ontario Graphic Artists; Gadatsy Gallery, Toronto; Mt. St. Vincent University; one-woman show, St. Mary's University; plus many others. Awards: Sculpture Award, Winnipeg Art Gallery; Ontario Arts Council Grant, 1974. Media: Bronze, plastic, drawings. Address in 1982, Halifax, Canada.

JACOB, NED.
Sculptor and painter. Born in Elizabethton, Tenn., November 15, 1938. Self-taught as an artist; private studies with Robert Gilbert, Robert Lougheed, and Bettina Steinke. Lived in New Jersey in teens; worked as ranch hand in Montana; lived on Blackfoot Indian reservation. Later moved to studio in Taos; Denver in 1965. Work in National Cowboy Hall of Fame; Harmsen Collection; Denver Art Museum; Whitney; Indianapolis Museum of Art; Albrecht. Exhibitions: One-man shows, National Cowboy Hall of Fame and Western Heritage Center, Oklahoma City, 1966; Boise Gallery of Art, Idaho, 1975; Whitney Gallery of Western Art, 1976; others. Member of Cowboy Artists of America, 1967; Salmagundi Club; National Academy of Western Art. Specialty, Western subjects in traditional style. Address in 1982, Denver, Colorado.

JACOBS, DAVID (THEODORE).
Sculptor. Born March 1, 1932, in Niagara Falls, NY. Studied: Orange Coast College, 1951-53, A.A.; Los Angeles State College of Applied Arts and Sciences, 1953-57, A.B., M.A. Work: Hofstra University; The Ohio State University; Otterbein College; Guggenheim; Virginia Museum of Fine Arts. Exhibited: The Kornblee Gallery, 1963-65; Emily Lowe Gallery, Hempstead, NY, 1964; Museum of Modern Art; Guggenheim; San Francisco Museum of Art; Dayton Art Institute; Vassar College; Herron; Art Institute of Chicago; Milwaukee, Directions I: Options, circa, 1968. Taught: The Ohio State University, 1957-62; Hofstra University, from 1962; Huntington Township Art

League, Huntington, NY, 1963-64; City College of New York, 1977-79. Media: Aluminum, rubber. Address in 1982, Hofstra University, Hempstead, NY.

JACOBS, HAROLD.
Sculptor and painter. Born in NYC, October 29, 1932. Studied at Cooper Union, 1953; New York University; New School for Social Research; Sorbonne, Fulbright scholar, 1961. Work in Whitney Museum of American Art; Portland Art Museum, OR; Penna. Academy of Fine Arts. Works in mixed media; inflatable structures. Address in 1982, Philadelphia, PA.

JACOBS, LEONEBEL.
Sculptor, portrait painter, and teacher. Born Tacoma, Washington. Pupil of Brush, Hawthorne. Member: National Association of Women Artists; American Watercolor Society; Pen and Brush Club; American Federation of Arts. Work: Portraits of Mrs. Calvin Coolidge, Sir John Lavery, Mrs. William B. Meloney, Prince de Ligne, Dean Hubert E. Hauks, Gutzon Borglum, Dr. Frances Carter Wood. Author of *Portraits of Thirty Authors*. Address in 1953, 322 East 57th Street, NYC.

JACOBS, MICHEL.
Sculptor, portrait painter, writer, and teacher. Born Montreal, Canada, September 10, 1877. Studied: Ecole des Beaux-Arts, Paris; pupil of Laurens in Paris; E. M. Ward at National Academy of Design; and in Berlin, Germany. Member: Salma. Club; Society of Independent Artists; Art Fellowship; Artists Guild of the Authors' League of America. Exhibited at National Sculpture Society, 1923; National Academy of Design; Allied Artists of America; Paris Salon; Montreal Museum of Art; Washington Society of Artists. Work: "Portrait of Champ Clark," in the Capitol, Washington; 26 portraits in Barone de Hirsch Institute, Montreal, Canada; Medal for "Military Order of World War;" bas-relief at National Portrait Gallery, Washington, DC. Author of "The Art of Color" (1946), "The Art of Composition" and "The Study of Color." Director of the Metropolitan Art School. Address in 1953, Rumson, NJ.

JACOBSON, DONALD.
Sculptor. Born in Chicago, IL, 1952. Studied: Herron Art Institute, B.F.A. Exhibitions: Shows in Indiana, Illinois, and Michigan; Works by Michigan Artists, Detroit Institute of Arts, 1974-75. Awards: Best Sculpture, Indianapolis 500 Show. Address in 1975, Battle Creek, MI.

JACOBSON, URSULA MERCEDES
Sculptor and painter. Born in Milwaukee, WI, March 26, 1927. Wife of Art Jacobson, who is also a painter. Studied: University of Wisconsin-Milwaukee, B.S., 1948; Western Reserve University; Cleveland Museum and School of Art; University of Wisconsin-Madison, M.S., 1950, graduate study, 1950-51. Awards: Wisconsin Designer Craftsmen, Milwaukee, 1948; Weatherspoon Annual, NC, 1967; Phoenix Art Museum, 1974. Exhibitions: Yares Gallery, AZ, 1965; Bolles Gallery, San Francisco, 1966; Four Corners Biennial, Phoenix Art Museum, 1971-75; Palace of the Legion of Honor, San Francisco. Address in 1982, Phoenix, AZ.

JACOBSON, YOLANDE.
(Mrs. J. Craig Sheppard). Sculptor. Born in Norman, OK, May 28, 1921. Studied at University of Okla., B.F.A.; also in Norway, France, and Mexico. Works: Gilcrease Museum of Art, Tulsa, Okla.; Jacobsen Museum Art, Norman; State History Society, Reno, Nev.; History Museum, Carson City, Nev. Commissions: Sen. Patrick McCarran (bronze statue), Statuary Hall, Washington, DC, 1961; president's portrait bust, University Nev., Reno, 1962; bronze sculpt., Governor's Mansion, Carson City, 1965. Exhibitions: Denver Museum of Art, 1941; Okla. Annual, Tulsa, 1942-45; Mid-West Annual, Kansas City, 1951; Oakland Museum Art, 1956; Silver Centennial, Virginia City, Nev., 1961. Awards: Mid-West Annual, Kansas City, 1941; Denver Museum Art, 1941; Silver Centennial, Virginia City, 1961. Media: Bronze, wood. Address in 1982, Reno, NV.

JACOBSSON, STEN WILHELM JOHN.
Sculptor, painter, teacher, and craftsman. Born in Stockholm, Sweden, March 28, 1899. Studied: with Carl Milles; in Germany, Sweden, US, France. Awards: First Prize in Sculpture and First Prize in Medalist Competition, US Government; Prize, Barbeur Memorial Competititon, Detroit, Mich. Work: murals, First Swedish Baptist Church, NY; First Lutheran Church, Arlington, NJ; Metropolitan Museum of Art; Detroit Institute of Art; Sculptor, United States Post Office, Forest Hills, New York. Instructor of sculpture, painting, and design, Wayne State University; instructor, Detroit Country Day School; Henry For Art School; Cranbrook Academy of Arts. Membership: Society of Medalists. Address in 1982, Detroit, MI.

JACQUARD, (JERALD WAYNE JACKARD).
Sculptor and educator. Born in Lansing, MI, February 1, 1937. Studied at Michigan State University, B.A. and M.A. Work in Museum of American Art, Andover, MA; Detroit Institute of Art, MI; Kalamazoo Institute of Art, MI. Has exhibited at Detroit Institute of Art; Indianapolis Museum; others. Received Fulbright Scholarship, 1963; Guggenheim Fellowship, 1973; National Endowment for the Arts, 1980; others. Taught at University of Illinois, 1966-75, sculpture; teaching at Indiana University, from 1975, sculpture. Works in steel. Address in 1982, Bloomington, IN.

JAEGERS, ALBERT.
Sculptor. Born in Elberfeld, Germany, in 1868. He came to Cincinnati, OH, while a boy and was apprenticed to his father, a wood-carver, who was engaged in ecclesiastical work. Studied: Sculpture at the Cincinnati Art Academy under Louis J. Rebisso, and architecture in the office of Lucien Plymton. Studied in the art centers of Europe. Member: New York Architectural League; National Institute of Arts and Letters; National Sculpture Society. Works: Statues, New York Custom House and Fine Arts Building, St. Louis, MO; commissions for Pan-American Exposition, Buffalo, NY, and Louisiana Purchase Exposition, St. Louis, MO; monument to General von Steuben, Wash., DC, 1910, replica presented by US Government to Germany, 1911; marble monument to the Founders of

Germantown, PA, 1920. Exhibited at National Sculpture Society, 1923. Awarded bronze medal, St. Louis Exposition, 1904. Died in Suffern, NY, 1925.

JAEGERS, AUGUSTINE.
Sculptor. Born Barmen, Germany, March 31, 1878. Brought to America in 1882. Pupil of Art Students League of New York; National Academy of Design; Ecole des Beaux-Arts in Paris, under Mercie. Member: National Sculpture Society, 1909. Awards: Collaborative and Avery prize, Architectural League of New York, 1909. Work: Sculpture on arches in Court of Four Seasons, San Francisco Exposition, 1915; Frey and Lopez Memorial, New York. Address in 1933, 3225 30th Street, Long Island City, NY.

JAFFE, NORA.
Sculptor and painter. Born in Urbana, OH, February 25, 1928. Studied at Dayton Art Institute, OH; also with Samuel Adler and David Hare, NY. Work in Brooklyn Museum, NY; Penna. Academy of Fine Arts, Philadelphia; others. Has exhibited at Museum of Modern Art, NY; Baltimore Museum of Art; Penna. Academy of Fine Arts; Vassar College, Poughkeepsie, NY. Received MacDowell Colony Residency, 1969-70; others. Works in plaster, wood; and oil. Address in 1982, 285 Central Park W., NYC.

JAGENS, WILLIAM.
Sculptor. Born: Vermont, c. 1818. Living at Berkshire, VT, September 1850.

JAMES, ALFRED EVERETT.
Sculptor, painter, etcher, designer, teacher, and craftsman. Born in Edgewood, RI, April 17, 1908. Studied: RI School of Design; Thurn School of Modern Art; and with Hans Hofmann. Member: Scarab Club. Awards: Prizes, West Palm Beach Army Exchange, 1943; Montgomery Museum of Fine Arts, 1945, 47, 50. Work: Birmingham Museum of Art; murals, Providence Public Library. Exhibited: U.S. Army Exchange, West Palm Beach, Fla., 1943; High Museum of Art, 1950; Montgomery Museum of Fine Arts, from 1940, 43, 45, 47, 50. Taught: Instructor of Art, Alabama Polytechnic Institute, Auburn, Alabama, 1937-46. Address in 1953, Auburn, AL.

JAMES, AUSTIN.
Sculptor. Born Philadelphia, PA, March 12, 1855. Pupil of California School of Fine Arts; Bufano; Stackpole; Mora. Member: Carmel Art Association; Los Angeles Painters and Sculptors; Pasadena Art Institute. Address in 1934, Pasadena, CA; summer, Pebble Beach, CA.

JAMES, EVA GERTRUDE (MRS.).
Sculptor, painter, craftsman, writer, and teacher. Born Morgan County, IN, July 18, 1871. Studied in Indiana University; St. John's Academy; and with Robert E. Burke. Member: Indiana Art Club; Hoosier Salon. Award: Prizes, Indiana State Fair, 1924 and 1925. Exhibited: Soc. of Indiana Artists; Indiana State Fair, Brazil, IN. Address in 1953, Brazil, IN.

JAMES, ROY WALTER.
Sculptor, painter, writer, and teacher. Born Gardena, CA,

September 23, 1897. Self taught. Member: California Art Club; Laguna Beach Art Association; Long Beach Art Association; Artists Guild of the Authors' League of America. Work: "Sentinel by the Sea," Long Beach Public Library; "Sunset," Long Beach High School; "Old Baldy," Public Library, Covina; "Light the Crown of Beauty," High School, Covina, CA. Exhibited: Oakland Art Gallery; Palace of the Legion of Honor; Los Angeles Museum of Art. Contributor to various art periodicals and newspapers. Address in 1953, Los Angeles, CA.

JAMES, S. C.
Sculptor. Worked in Cincinnati in 1849.

JAMESON, SAMILLA LOVE.
See Samilla Love Jameson Heinzmann.

JANET, HENRY.
Sculptor. Worked: New Orleans, 1856.

JANOWSKY, BELA.
Sculptor and instructor. Born in Budapest, Hungary, in 1900. Studied: Ontario College of Art; Penna. Academy of Fine Arts; Cleveland School of Art; Beaux-Arts Institute of Design; and with Alexander Blazys and Charles Grafly. Commissions: Bronze reliefs, US Department of Commerce Building, Washington, DC; bronze 150th anniversary plaque of New York Naval Shipyard, Naval Historical Museum, Washington, DC; Royal Society of Canada. Exhibited: Ontario Society of Artists; Allied Artists of America Annual, from 1939; National Academy of Design; National Sculpture Society; Penna. Academy of Fine Arts; Chicago Art Institute. Member: Modelers and Sculptors League of America; Allied Artists of America; National Sculpture Society. Award: Allied Artists of America, Lindsey Morris Memorial Prize, 1951 and 64. Taught: Instructor of sculpture, Craft Students League. Address in 1982, 52 W. 57th St., NYC.

JANTO, PHYLLIS.
Sculptor. Born in Philadelphia, PA, April 20, 1932. Studied: Moore Institute of Art, Philadelphia, 1952-54; Hunter College, BFA, 1962; Pratt Inst., MFA, 1965. Work in private collections. Exhibitions: Pratt Institute, 1965 (solo); Lowe Gallery, Hudson Guild, NYC, 1975 (solo); Atlantic Gallery, NYC, 1983 (solo), 1981, 83 (group); Brooklyn Museum, 1974, 75; Lincoln Center, 1975; Bowdoin College, Maine, 1980; Nexus Gallery, Philadelphia, 1983; Port of History Museum, Philadelphia, 1983; many other galleries in NYC, Washington, DC, and Maine. Awards: Scholarship to Sculpture Center; Wm. Graf Scholarship for Graduate Study (Hunter College); grant, National Endowment for the Arts, 1980. Member: Artists' Equity Association; Women's Caucus for the Arts; Atlantic Gallery. Medium: Wood. Address in 1983, 48 West 20th St., NYC; summer, Washington, ME.

JARVIS, JOHN WESLEY.
Sculptor, portraitist, engraver, and miniaturist. Born in South Shields, England, 1780. Emigrated with family c. 1785; settled in Philadelphia. Apprenticed to Edward Savage. Later taught Henry Inman and John Quidor. Worked: New York City, 1802-10, painting portraits and miniatures in conjunction with Joseph Wood; Baltimore,

1810-13; New York City, 1813-40; New Orleans; Richmond, VA; Washington. Died in New York City, January 12, 1840.

JEANFIL, HENRI (JACQUES).
Sculptor, painter, etcher, and lecturer. Born in North Tonawanda, NY, June 8, 1909. Studied with D. Campagna, Richardson, K. Green, and F. Bach. Work: "La Ballet Russe," "Valkyries," "Street Scene, Sicily," "Les Muses," paintings, "Old Log Cabin," etching, Buffalo School of Fine Arts. Member: Buffalo Society of Artists; Boston Art Club; Penna. Academy of Fine Arts; National Sculpture Society. Address in 1933, 642 Oliver St.; Jeanfil Studios, 350 Gibson St., Buffalo; summer, North Rushford Lake, NY.

JEGART, RUDOLF.
Sculptor. Address in 1935, Madison, Wisconsin. (Mallett's)

JEHU, JOHN M.
Sculptor. Work: "Princess and Frog," statuette, Cincinnati Museum. Address in 1918, 154 West 55th St., NYC.

JENCKS, PENELOPE.
Sculptor and instructor. Born in Baltimore, MD. Studied with Hans Hofmann; Skowhegan School of Painting and Sculpture; Boston University, B.F.A. Works: MacDowell Colony Collection. Exhibitions: National Institute of Arts and Letters, NY, 1966; Young Talent, Mass. Council of Arts and Humanities, Boston, 1968; 21 Alumni, Boston University, 1969; 14 Aspects of Realism, Boston Visual Artist Union, 1974; Living American Artists and the Figure, Museum of Art, Penna. State University, 1974. Awards: Colonist, MacDowell Colony 1975. Medium: Terra-cotta. Address in 1976, Newton, MA.

JENKINS, F. LYNN.
Sculptor. Born in Devonshire, England, 1870. He studied at the Royal Academy Schools in London, Paris, and Rome. Member: Royal Society of British Sculptors; National Sculpture Society; New York Architectural League. Works: Portrait busts, King Edward; VII; Sec'y Mellon; John McFadden; George J. Gould; and many others; decorative sculptures, Lloyd's Registry of British Shipping; United Kingdom Provident Institute; public libraries, Town Halls and other public and private buildings in London and elsewhere; garden decorations and fountains, Luton Hoo and Knowsley, England; fountains and pedestal sculpture, Chestnut Hill, PA; statuette, Diana, Metropolitan Museum of Art, New York, and numerous others. Exhibited at National Sculpture Society 1923. Died in New York 1927.

JENNEWEIN, CARL PAUL.
Sculptor. Born on December 2, 1890, in Stuttgart, Germany. In US since 1907. Studied at Art Students League, with Buhler and Lauter, 1907-09, with Clinton Peters, 1910. Opened his studio in 1921. Member: National Sculpture Society; New York Architectural League; (hon.) American Institute of Architects; American Academy in Rome Alumni. Awards: Collaborative prize for sculpture and Avery prize, New York Architectural League, 1915; American Academy in Rome Fellowship in sculp-

ture, 1916-19; honorable mention, Art Institute of Chicago 1921; Medal of Honor, Architectural League of New York, 1972; Benjamin Clinedinst Memorial Medal for Achievement, Exceptional Artistic Merit in Sculpture, 1967; American Numismatic Association Art Award, 1970; Daniel Chester French Award Medal, 1972 and 150th Anniversary Gold Medal, 1975; numerous others. Represented in Metropolitan Museum of Art; Corcoran Gallery, Washington; Penna. Academy of Fine Arts, Baltimore Museum of Art; Darlington memorial fountain, Wash., DC; frieze, Eastman School of Music, Rochester, NY; Dante Tablet, Ravenna, Italy; Philadelphia Museum of Art; Barre, VT, war memorial; Lincoln Life Insurance Building, Ft. Wayne, IN; portrait of G. B. McClellan, Caruso Memorial, Metropolitan Opera House; Cunard Building decoration and in the Woolworth Building, NY; Plymouth, MA, memorial fountain; Levi tomb, Mt. Pleasant, NY; Providence War Memorial; mural decorations, Church of the Ascension, Kingston, NY. Exhibited at National Sculpture Society, 1923. Address in 1976, 538 Van Nest Avenue, Bronx, NY. Died in 1978.

JENNINGS, DOROTHY (MRS.).
Sculptor and painter. Born in St. Louis, MO, on November 19, 1894. Pupil of Nancy Hahn, Victor Holm, G. Goetsch, W. Ludwig, F. Conway, and W. Wuerpel. Member: St. Louis Art League; St. Louis Independent Artists. Award: Prize for sculpture, St. Louis Artists Guild, 1928. Address in 1934, St. Louis, MO.

JENNINGS, FRANCIS A.
Sculptor, painter, and teacher. Born in Wilmington, Delaware, February 27, 1910. Studied: Wilmington Academy of Art; Fleischer Memorial School of Art; Philadelphia Graphic Sketch C. Work: Mural, Delaware Industrial School for Boys. Exhibited: Penna. Academy of Fine Arts, 1939, 42, 43; Whitney, 1962; Wilmington Art Center, 1935-37, 1939-43; Pyramid Club, Philadelphia, 1950-52; Ellen Donovan Gallery, Philadelphia, 1952, (one-man); Baltimore Museum of Art, MD, 1963; four shows, Makler Gallery, Phila. and Rose Fried Gallery, NYC, 1960-66; Ward Nasse Gallery, NYC, 1977; Landmark Gallery, 1977; others. Taught: Lecturer, National Art Teachers Association Conv., April, 1969. Address in 1982, 55 Greene Street, New York City.

JENSEN, HANK.
Sculptor. Born in Pittsburgh, PA, April 29, 1930. Studied at Carnegie Mellon University; Pratt Institute; with Hans Hofmann. Work in Hirshhorn Museum, Washington, DC; stage construction for dance theater piece, Nikolais Dance Co., NY. Received Fulbright Grant to Florence, 1964-65; others. Works in steel and wood. Address in 1982, Bennington, VT.

JENSEN, LEO (VERNON).
Sculptor and painter. Born in Montevideo, MN, July 10, 1926. Studied at Walker Art Center, scholar, 1946-48. Work in New Britain Museum of American Art, Connecticut; Phillip Morris, NY; bronze musicians, United Artists Corp., NY; and others. Has exhibited at New Britain Museum, Far Gallery, NY; Arras Gallery, NY; Butler Institute of American Art, Ohio; Milwaukee Art

Center. Received first prize for wood carving, Silvermine Guild Artists Annual; first prize for sculpture, John Slade Ely House Invitational. Works in bronze, wood; acrylic, watercolor. Address in 1982, Ivoryton, CT.

JESTER, RALPH.
Sculptor. Address in 1934, New York. (Mallett's)

JEWETT, MAUDE SHERWOOD.
(Mrs. Edward H. Jewett). Sculptor. Born in Englewood, NJ, on June 6, 1873. Pupil of Art Students League of New York. Member: National Association of Women Painters and Sculptors; Alliance; American Federation of Arts; American Artists Professional League. Exhibited at National Sculpture Society, 1923. Work: Fountain in Cleveland Museum; Soldiers and Sailors War Memorial, East Hampton, LI, NY. Specialty: Sun-dials, portrait statuettes. Was living in New York City in 1926. Address in 1933, Easthampton, Long Island, NY. Died in Southampton, LI, April 17, 1953.

JEWETT, WILLIAM DANBAR.
Sculptor. Born in England, Worked: US.

JEYNES, PAUL.
Sculptor. Born in Millburn, NJ. Studied: Yale University, 1949; also studied with Frank Eliscu, 1974-75. Work: Numerous Private collections, plus commissions. Exhibited: Abercrombie and Fitch, NYC; Sculpture Center, NYC Caravan House, NYC; Audubon Artists; Cincinnati Zoo International Wildlife Art Show, 1983. Awards: 1st prize ($2,500), Cincinnati Zoo International Wildlife Art Show, 1983. Member: Board of Directors, Art Founder's Guild of America, Inc. Editor of "The Artist's Foundry" for modern art, Foundry, Long Island City, NY. Medium: Bronze. Address in 1983, 305 East 70th St., New York, NY.

JIMENEZ, LUIS ALFONSO JR.
Sculptor. Born in El Paso, TX, July 30, 1940. Started sculpture career as an assistant to his father in El Paso, TX, 1946-58. Later studied at the University of Texas, Austin, 1960-64; Ciudad Universitaria, Mexico City, 1964, BS (art). Assistant to Semore Lipton, NYC, from 1966-67. Work: Long Beach Museum, CA; New Orleans Museum, LA; National Collection of Fine Arts, Washington, DC. Exhibited: Graham Gallery, NYC, 1969, 70; David Stuart Galleries, Los Angeles, 1969; Bienville Gallery, Orleans, 1973; Whitney Museum, NYC, 1979; Fogg Art Museum, 1971; Yale University of Art Museum, Hartford, Conn., 1975; Contemporary Arts Museum, Houston, TX, 1975; New Mexico Museum of Fine Arts, Santa Fe, 1978. Awards: Personal grant fellowship from the National Endowment for the Arts, 1977. Media: Fiberglas, neon; colored pencil, lithographs. Address in 1982, El Paso, TX.

JIROUCH, FRANK LUIS.
Sculptor and painter. Born in Cleveland, OH, on March 3, 1878. Studied: Cleveland School of Art; Penna. Academy of Fine Arts; Julian Academy, Paris, France; pupil of Matzen, Ludikie, Grafly, Garber, Pearson, Landowski, Bouchard. Member: National Sculpture Society; Cleveland Society of Artists; Fellowship Pennna. Academy of

Fine Arts. Work: Bronze relief in Church of Lady of Lourdes; "Diana of Ephesus," Union National Bank; Stone pediment, United Savings and Trust Bank; Chapman Memorial, Cleveland Ball Park; Altar of Sacrifice, Cleveland; Spanish War Monument, Columbus, OH; "Day and Night," Wade Park, Cleveland; Maine Memorial Tablet, Havana, Cuba; "Portrait of Victor Herbert," bronze, 1905. Exhibited: Penna. Academy of Fine Arts, Paris Salon; Art Institute of Chicago; Architectural League; Los Angeles Museum of Art. Address in 1953, Cleveland Heights, OH. Died in 1970.

JJ, (JEAN JACQUES DE LA VERRIERE).
Sculptor and goldsmith. Born in Paris, France, March 8, 1932; US citizen. Studied at Ecole National Art Decoratif, B.Ph., Paris, France, 1949; Escuela de Artes Suntuarias, Barcelona, Spain, 1951; London Central School, England, 1957; Pratt Institute, with Prof. Albert, M.F.A., 1975; Hunter College, M.A. (art history), 1979. Work in Metropolitan Museum, NY; Museum of Modern Art, NY. Has exhibited at Cooper Union Museum, Jewelry as an Art; others. Taught at Pratt Institute, 1972-75, sculpture and electroforming. Member: New York Craftsmen; American Crafts Council; American Goldsmith Association. Works in gold, precious and semi-precious stones, precious woods, ivory, turtle shell, and coral. Address in 1982, 99 MacDougal St., NYC.

JOHANSEN, MELVIN.
Sculptor. Born in Oakland, California, in 1915. Initially apprentice taxidermist, Snow Museum of Natural History, Oakland; learned diorama preparation and animal anatomy there. Sketches and photographs of wildlife in Mexico, Canada, Western US have appeared on sports calendars, magazines of natural history; motion pictures have been used in Disney and nature films. "Birds in Flight" was title of solo exhibition at museums in California and Nevada. In 1972, turned full-time to bronze sculpture. Specialty is wildlife. Exhibits at the Sportsman's Edge, NYC; The May Galleries, Scottsdale, AZ, and Jackson, WY. Address since 1981, Merlin, Oregon.

JOHANSON, PATRICIA.
Landscape-sculptor and architect. Born in NYC, September 8, 1940. Studied: Bennington College; Hunter College; City College School of Architecture; Brooklyn Museum Art School; Art Students League. Awards: Guggenheim Fellowship, 1970-71; first prize, Environmental Design Competition, Montclair State College, 1974; Artists Fellowship, National Endowment for the Arts, 1975. Work in Detroit Institute of Art; Metropolitan Museum of Art; Museum of Modern Art; gardens, *House and Garden*, 1969; Cyrus Field, 1970-75; Con Edison Indian Point Visitors Center, 1972; projects for Columbus East High School, Columbus, IN, 1973. Exhibited: Museum of Modern Art, 1968-69, 79; Penna. Academy of Fine Arts, 1975; Brooklyn Museum, 1977, 80; Newark Museum, 1979; others. Represented by Rosa Esman Gallery, NYC. Address in 1982, Buskirk, NY.

JOHNS, JASPER.
Sculptor and painter. Born in Augusta, GA, May 15, 1930; grew up in Allendale and Sumpter. Studied at University

of South Carolina, 1947-48. Represented in Wadsworth Atheneum; Whitney; Albright-Knox; Museum of Modern Art, New York and Paris. Works: "The Critic Sees," 1961; "Double White Map," 1965, which sold at an auction in NY for $240,000, highest price ever paid at that time for a 20th century American piece of art; "Book," 1957 and "Drawer," 1957, which are examples of the attachment of objects to paintings. Exhibited: Retrospective, San Francisco Museum of Modern Art, 1978; Museum of Modern Art, NY, 1968, 70, and 72; The Second Breakthrough, 1959-64; Univ. of California, Irvine, 1969; Museum of Contemporary Art, Chicago, 1971-72; Seattle Art Museum, Wash., 1973; Art Institute of Chicago, 1974; numerous other group and one-man shows, some of which were held at the Gallery d'Arte del Noviglio, in Milan, 1959, the Gabrie Rive Droite in Paris, and the Whitechapel Gallery, London, 1964. Executed numerous sculpted objects consisting of mass produced objects such as beer cans, flashlights, and lightbulbs. He was drafted into the Army in 1949. Address in 1982, c/o Leo Castelli, 420 W. Broadway, NYC.

JOHNSON, ADELAIDE (MRS.).
Sculptor. Born Plymouth, IL, 1860. Studied with Monteverde and Fabi Altini in Rome. Work: Portrait bust of Susan B. Anthony, Metropolitan Museum, NY; portrait bust of Hiram W. Thomas, Chicago Historical Society; largest work was the "Memorial to the Pioneers of the Women's Suffrage Movement," presented by the Women of the US to the Joint Committee on the Lib., February 15, 1921. It is now placed in the Crypt on the first floor of the Capitol beneath the Dome; the work consists of a group setting of Elizabeth Cady Stanton, Susan B. Anthony, and Lucretia Mott in Carrara. Address in 1933, 230 Maryland Avenue, NYC, Washington, DC. Died in 1949.

JOHNSON, BELLE.
Sculptor. Exhibited at Penna. Academy of Fine Arts, Philadelphia, in 1925. Address in 1926, 200 Claremont Ave., NY.

JOHNSON, BURT W.
Sculptor and teacher. Born April 25, Flint, OH, in 1890, and was a pupil of Louis Saint-Gaudens, J. E. Fraser, Robert Aitken, and George Bridgman. He was a member of the Laguna Beach Artists' Association and the New York Architectural League. He is represented by "Spanish Music Fountain" and "Greek Tablet" at Pomona College, Claremont, CA; panel "Christ" at St. Francis Hospital, La Crosse, WI; memorial fountain, Huntington Park, CA; Pomona Valley memorial monument, Pomona; Dimick statue, West Palm Beach, CA; memorial statue, Woodside, NY; Anna I. Young memorial panel, Agnes Scott College, Decatur, GA; World War Memorial Panel, College Park, Atlanta, GA; four heroic architectural figures and two heroic panels on facade of building, fountain "High Note," two copies of "Kneeling Cynthia," "Little Sculptor Boy" and "Pottery" in lobby, Fine Arts Bldg., Los Angeles, CA. Address in 1926, 86 Grove St., Flushing, NY; summer Claremont, CA. Died in Claremont, CA, March 27, 1927

JOHNSON, CLETUS MERLIN.
Sculptor and painter. Born in Elizabeth, NJ, November 19, 1941. Studied at Bard College; Parsons School of Design; School of Visual Arts. Has exhibited at Art Institute of Chicago; Whitney Museum; Museum of Modern Art, NY; Leo Castelli Gallery, NYC. Address in 1982, Garnerville, NY.

JOHNSON, DANIEL LA RUE.
Sculptor. Born in Los Angeles, 1938. Studied: Chouinard Art Institute, B.F.A.; with Alberto Giacometti in Paris. One-man exhibitions: Pasadena Community Center, CA, 1953; Chouinard Art Institute, 1956; Rolf Nelson Gallery, Los Angeles, 1964. Group exhibitions: Pasadena Art Museum, CA, 1962; Boxes, Dwan Gallery, Los Angeles, 1964; The Negro in American Art, UCLA Art Galleries, University of California, Los Angeles, 1966; Dimensions of Black, La Jolla Museum of Art, CA, 1966; San Francisco Museum of Modern Art, 1976; National Collection of Fine Arts, Smithsonian Institution, 1977. Address in 1977, Los Angeles, CA.

JOHNSON, DONALD M.
Sculptor. Address in 1934, East Orange, NJ. (Mallett's)

JOHNSON, GRACE MOTT.
Sculptor. Born New York City, July 28, 1882. Pupil of Gutzon Borglum and H. A. MacNeil Art Students League. Also studied in Paris. Member: National Academy of Women Painters and Sculptors; Grand Central Gallery; National Sculpture Society; Society Independent Artists; Society of Animal Painters and Sculptors. Awards: McMillin Sculpture prize, National Academy of Women Painters and Sculptors, 1917, Joan of Arc medal, 1927, prizes, 1935, 36. Exhibited at the National Sculpture Society, 1933. Specialty, animals. Work: New York Public Library; Public Library, Pleasantville, New York. In collections of Whitney and Brookgreen Gardens. Address in 1953, Pleasantville, NY.

JOHNSON, IRENE CHARLESWORTH.
Sculptor. Born Gering, NE, September 27, 1888. Pupil of Zolnay. Work in Nashville Museum of Art. Member: Southern States Art League; Nashville Art Association. Awards: Second prize for sculpture, All Southern Exhibition, 1921; first prize for sculpture, Southern States Art League, 1925. Address in 1953, Nashville, Tenn.

JOHNSON, J. THEODORE.
Sculptor and painter. Born in Oregon, IL, November 7, 1902. Studied: Art Institute of Chicago; and with Andre L'Hote, Aristide Maillol, in Paris, France. Awards: Lathrop European Scholarship, 1925; med. prizes, Art Institute of Chicago, 1928, 31; Chicago Galleries Association, 1929; Guggenheim Fellow, 1929; Minneapolis Institute of Art, 1943, 44; Minneapolis State Fair, 1944. Work: Art Institute of Chicago; Toledo Museum of Art; Vanderpoel Collection; IBM Collection; Minneapolis Institute of Art; University of Chicago; Field Museum; murals, Garden City, LI, NY; Oak Park, Ill.; Morgan Park, Ill.; Western Illinois State Teachers College. Exhibited: Corcoran Gallery of Art, 1928, 30, 37; Carnegie Institute, 1929, 30; Penna. Academy of Fine Arts, 1929, 37; Art Institute of

Chicago, 1928-30, 32, 40; National Academy of Design, 1936; Golden Gate Exposition, 1939; Toronto, Canada, 1940; National Gallery, Canada, 1940; Montreal Art Association, 1941; Brooklyn Museum, 1932; Minneapolis Institute of Art, 1938-44; San Francisco Museum of Art, 1946; Minn. State Fair, 1941-44; Whitney Museum of American Art; etc. Taught: Instructor, Head of Department, Minneapolis School of Art, 1938-45; Associate Professor, San Jose College, San Jose, California, from 1945. Address in 1953, Art Department, San Jose State College; h. Cupertino, Calif.

JOHNSON, LESTER.
Sculptor and painter. Born in Detroit, MI, September 28, 1937. Studied: Wayne State University; University of Michigan, B.F.A., M.F.A. Exhibitions: Michigan Artists Exhibition, The Detroit Institute of Arts, 1964-66, 70, 72; Michigan Watercolor Society, 1965-67, 71; Butler Institute, Youngstown, OH, 1966; Springfield Art Museum, MO ("Watercolor USA"), 1966; Detroit Artists Market ("Seven Black Artists"), 1969; Gallery 7, Detroit (one-man), 1970; California National Watercolor Society, Laguna Beach, 1970; The Whitney Museum of American Art, NY ("Contemporary Black Artists in America"), 1971, 73; Carnegie Institute, Pittsburgh, 1971-72; Cranbrook Academy of Art, 1972; The Whitney Museum of American Art, NY, 1973; The Flint Institute of Arts (one-man), 1973; Works by Michigan Artists (sculpture), The Detroit Institute of Arts, 1974-75. Collections: The Detroit Institute of Arts; The Flint Institute of Arts; Sonnenblich-Goldman, NY. Awards: John S. Newberry Prize, Michigan Artists Exhibition, The Detroit Institute of Arts; Mrs. Albert Kahn Award Museum Purchase, 1964; Harlem Gallery Square, 1969, 71, 72; 1st Prize in Painting, Michigan State Fair, 1969, 73. Address in 1975, Detroit, MI.

JOHNSON, NEOLA.
Sculptor, painter, illustrator, and teacher. Born Chicago, IL. Pupil of Anthony Angarola and Cameron Booth. Member: Gary Pen and Pencil Club. Address in 1929, 1300 West Fifth Ave., Gary, IN; summer, Lindstrom, MN.

JOHNSON, SARGENT CLAUDE.
Sculptor. Born in Boston, Mass., October 7, 1889. Studied at Califorina School of Fine Arts; and with Stackpole, Bufano. Work: "Esther," terra cotta head, Fine Arts Gallery of San Diego; San Francisco Museum of Art; porcelain enamels, Richmond (CA) City Hall. Awards: Gold medal, California Legion of Honor, 1925; Kahn prize, 1927, bronze medal, 1929, prize of $150, 1933, Harmon Foundation; first prize, sculpture, California Legion of Honor, 1931, Odgen prize, 1933. Member: San Francisco Art Association. Taught: Instructor of sculpture, Mills College, Oakland, CA. Address in 1953, San Francisco, California. Died in 1967.

JOHNSON, STANLEY QUENTIN.
Sculptor. Born in Murray, Utah, in 1939. Became company artist in National Guard; later studied sculpture with Avard Fairbanks at University of Utah; also studied commercial illustration. Began sculpting full-time in 1978. Specialty is Indian legend subjects. Works in

bronze; casts in own foundry. Represented by his own gallery. Address since 1977, Mapleton, Utah.

JOHNSON, W. PARKE.
Sculptor and painter. Member: Artists Guild of the Authors' League of America, New York. Address in 1928, 147 West 23rd Street; 1133 Broadway, NYC.

JOHNSON, WILLIAM E. (BILL).
Sculptor and painter. Born in Charleston, IL, in 1925. Studied at Western State College, with Harvey Dunn, summer 1947; Trinidad State Junior College, Colorado, with A. R. Mitchell, 1947-49; Art Students League, New York City with Frank J. Reilly, 1949, 50; Art Center School of Design, Los Angeles, graduated 1954. Worked as commercial artist in New York City, 1954-65; head, dept. of art, Trinidad State Junior College, Colorado, from 1965. Specialty is Old West subjects; paints in oil, sculpts in bronze. Exhibits at El Prado Gallery of Art. Address since 1965, Trinidad, CO.

JOHNSTON, BARRY WOODS.
Sculptor. Born in Florence, AL. Studied at Georgia Institute of Technology, B.S., 1969; Art Students League, with Joseph De Creeft; Penna. Academy of Fine Arts, with Walker Hancock, Harry Rosen, and Tony Greenwood; National Academy of Fine Arts, with Michael Lantz; also studied in Italy, with Enzo Cardini and Madame Simi. Has exhibited at National Sculpture Society Annual Group Show, NY, 1980 and 1981; others. Received Stewardson Award, Penna. Academy of Fine Arts; Honorable Mention, National Academy of Design; others. Member: National Sculpture Society. Works in clay and bronze. Address in 1982, Washington, DC.

JOHNSTON (JOHNSON), JOHN R.
Sculptor and painter. Born in Ohio, during the 1820's. Worked: Cincinnati, 1842-53; Baltimore, 1857-72.

JOHNSTON, RANDOLPH W.
Sculptor and etcher. Born in Toronto, Canada, February 23, 1904. Studied: Ontario College of Art; University of Toronto; Central School of Art and Crafts, London; Royal Canadian Academy. Member: Clay Club; Society of Gold. Awards: prize, Springfield (Mass.) Art League, 1937. Work: mem. tablets, Toronto and Montreal, Canada; reliefs, Smith College; member panels, Eagle Brook School; University Nebraska. Exhibited: Royal Canadian Academy, 1925, 26; National Gallery, Ottawa, 1927; Society of Independent Artists, 1942; AV, 1942; Audubon Art, 1945; Clay Club, 1944 (one-man), 1945; Springfield Art League, 1937, 38; Whitney Museum of Art, 1949; Smith College, 1948-51; Pittsfield Art League, 1936; George Walter Vincent Smith Art Gallery, 1945 (one-man). Author, illustrator, "The Country Craft Book," 1937; illustrated "The Golden Fleece of California." Contributor to art magazines. Taught: Assistant Professor, Smith College, Northampton, Mass., from 1940. Address in 1953, Bahamas.

JOHNSTON, SCOTT.
Sculptor, painter, and illustrator. Born in Sac City, IA, December 5, 1903. Studied at Art Institute Chicago, with Alfonso Iannelli. Address in 1933, 224 East Ontario St., Chicago, Ill.

JOHNSTON, WINANT P.

Sculptor, painter, and writer. Born in NYC, July 2, 1890. Pupil of Charles Grafly. Member: Independent Society of Sculptors. Address in 1926, Washington, DC.

JONAS, LOUIS PAUL.

Sculptor. Born in Budapest, Hungary, July 17, 1894. Studied with Carl E. Akeley. Work: "Indian Elephant Group," "The Last Stand," American Museum of Natural History; group in bronze, City of Denver, Colo.; Memorial Fountain for Humane Society, New Rochelle, NY. Member: New Rochelle Art Association; New York Architectural League; American Association of Museums; Museum Association of Great Britain. Address in 1933, 62 Flandreau Ave., New Rochelle, NY.

JONES, ANTHONY W.

Sculptor and carver. Worked: New York City, 1818-61. Exhibited: Bust of General James Tallmadge, American Institute Fair, 1844. Died in 1868.

JONES, CARTER RUTHVEN.

Sculptor. Born in Mount Kisco, NY, March 6, 1945. Studied at School of Visual Arts, with Edward Giobbi, 1964-65; Boston Museum School, dipl., 1969. Has exhibited at Equitable Gallery, NY. Received Youth Award, National Sculpture Society; others. Member of National Sculpture Society. Works in clay and plaster. Address in 1982, 215 East 80th St., NYC.

JONES, COVELLE.

Sculptor. Born in Bremond, Texas, in 1940. Studied at Tarleton State University, BS art education; North Texas State University, MA. Has exhibited at Western Heritage Show; Texas Ranger Hall of Fame. Has worked on commission. Reviewed in *Southwest Art*, April 1978. Represented by Corpus Christi Art Gallery, Corpus Christi, TX; Cross Galleries, Fort Worth, TX. Specialty is Western figures; works in bronze; work signed "Covelle." Address in 1982, Waco, Texas.

JONES, (CHARLES) DEXTER (WEATHERBEE), III.

Sculptor and designer. Born in Ardmore, PA, December 17, 1926. Studied at Penna. Academy of Fine Arts, Philadelphia, 1947-49; Charles Rudy and Walker Hancock, 1951-52; Accademia della Belle Arti, Florence, Italy, 1955-56. Work at National Academy of Design; Woodmere Art Gallery; Penna. Academy of Fine Arts; Smithsonian Institution; others. Has exhibited at Penna. Academy of Fine Arts; National Academy of Design, NY; National Sculpture Society, NY; Philadelphia Museum of Art; Allied Artists of America, NY; Penna. Society of Architects; others. Received Helen Foster Barnett Prize, National Academy of Design; John Gregory Award, Therese and Edwin Richard Prize, Mrs. Louis Bennett Prize, all National Sculpture Society. Member: National Sculpture Society, fellow; American Institute of Architects; Allied Artists of America; National Arts Club; others. Works in bronze and stone. Address in 1982, Philadelphia, PA.

JONES, ELIZABETH A. B.

Sculptor and medalist. Born in Montclair, NJ, May 31, 1935. Studied at Vassar College, B.A., 1957; Art Students League, 1958-60; Scuola Arte Medaglia, The Mint, Rome, Italy, 1962-64; Academy Brasileira Belas Artes, Rio de Janeiro, honorary diploma, 1967. Works: Creighton University. Commissions: Portrait of Albert Schweitzer, Franklin Mint, Penna., 1966; gold sculptures with precious stone, Govn't. Italy, 1968; portrait of Picasso, commissioned by Stefano Johnson, Milan, Italy, 1972; Gold Medal Award for Archeol., University Museum, University Penna., 1972; Holy Year Jubilaeum; gold portrait medallion, Pope John Paul II, gift of State to the Pope by Italy, 1979; many others. Exhibited: Tiffany & Co., NY, Houston, Los Angeles, Chicago, and San Francisco, 1966-68; Montclair Art Museum, NJ, 1967; many international medallic art shows, Rome, Madrid, Paris, Athens, Prague, and Cologne; Smithsonian Institution and National Sculpture Society, NY, 1972; USIS Consulate, Rome, Italy, 1973. Awards: Outstanding Sculptor of the Year, American Numismatic Association, Colorado Springs, CO, 1972; Louis Bennet Award, National Sculpture Society, 1978. Media: Wax, plaster, silver and gold. Address in 1982, Philadelphia, PA.

JONES, EMERY.

Carver of ship figureheads. Worked: Newcastle, South Freeport, ME, 1856-60. Sculpted figure of Samuel Skolfield, which is reproduced in Pinckney.

JONES, FRANCES DEVEREUX.

See Hall, Frances Devereux Jones.

JONES, GLADYS MOON.

(Mrs. Harry LeRoy Jones). Sculptor and writer. Born Colfax, IL, December 28, 1892. LL.B., Northwestern University, 1921; student at Corcoran School of Art, 1952-54; studied sculpture under Innocenti, in Florence, Italy; MFA, Catholic University of America, 1958. Admitted to Ill. bar, 1922; editorial staff Science Service, 1927, Sunday Features for National Education Association, 1928; published five articles, *Ladies Home Journal*,1928-29; founder of All States Publicity News Bur., 1929; expert consultant Administration Export Control, 1941-42; information specialist Bd. Econ. Warfare, 1942-44; analyst Foreign Econ. Administration, 1944-45; sales representative Woman's National News Service, 1946. Taught sculpture and ceramics, YWCA Adult Educ. Program, 1959-60. Exhibited in artists' group shows in Washington, Corcoran Area shows. Address in 1962, 1310 34th St. Studio: 3316 P St. Rear, Washington.

JONES, HOWARD W.

Sculptor. Born June 20, 1922, Ilion, NY. Studied: Toledo University; Syracuse University, BFA Cum Laude, 1948; Columbia University; Cranbrook. Work: Albright; Kansas City (Nelson); Milwaukee Art Institute; Aldrich; St. Louis Art Museum; Walker. Exhibited: Mitchell Gallery, Woodstock, NY; Fairmont Gallery, St. Louis, 1961; Kansas City (Nelson); The Howard Wise Gallery, NYC; Worcester Art Museum; Walker and Milwaukee, Light, Motion, Space, 1967; Whitney Museum, Light: Object and Image, 1968; Jewish Museum, Superlimited, 1969; Aldrich Boston and Newark Museum of Fine Arts, NJ, 1969 and 70; Wadsworth Atheneum, Forbes Foundation

Museum, NJ. Awards: *Art in America* (Magazine), New Talent, 1966; Graham Foundation Fellowship and Grant, 1966-67; Syracuse University, Roswell S. Hill Prize; Syracuse University, four-year scholarship; National Endowment for the Arts Fellowship and Grant, 1977. Taught at Yale University, 1967; Washington University, St. Louis, from 1957. Rep. by Howard Wise Gallery, NYC. Address in 1980, St. Louis, MO.

JONES, MARY KLAUDER.
(Mrs. Thomas Jones). Sculptor. Member: Fellowship Penna. Academy of Fine Arts. Address in 1934, Palma, Mollorca Island (Spain). (Mallett's)

JONES, PATTY SUE.
Sculptor, painter, and weaver. Born in New Orleans, Louisiana, August 18, 1949. Studied: Auburn University, Alabama; University of California at Los Angeles; University of Washington. She was Artist-in-Residence in Yuma, 1974-76, member of the Director's Council, 1976-77. Exhibited: Tucson Museum of Art, Arizona, 1975; Occidental College, Los Angeles, 1981; Los Angeles Institute of Contemporary Art, 1981; and numerous others. Commissions: Paintings for Regent Hotels International, Beverly Hills, CA; tapestry, Fluor Corporation, Irvine, California, 1978; others. Awards: Purchase Award, 10th Annual Southwestern, 1975. Address in 1982, Los Angeles, CA.

JONES, THOMAS DOW.
Sculptor and medallionist. Born December 11, 1811, in Oneida Co., NY. Little is known of him except from letters written by him in October and November, 1857, to Honorable Lewis Cass and Capt. Meigs. The letters refer to a bust of the Honorable Lewis Cass executed nine years previous to this time. They also refer to a bust of Honorable John C. Breckenridge, on which Jones was then engaged, and to the fact that he himself was a western sculptor. Moved to Ohio in 1830's. Worked in Cincinnati as stonemason; 1842, began sculpting portrait busts. In November, 1857, he resided in Cincinnati, OH. Also worked in Boston, NYC, Detroit, and Nashville. He was elected an Associate Member of the National Academy in 1853. Best known works include: bust of Lincoln, 1861; Salmon P. Chase, 1876. Died in Columbus, OH, February 27, 1881.

JONES, THOMAS HUDSON.
Sculptor. Born Buffalo, NY, July 24, 1892. Studied: Albright Art Gallery; Carnegie Institute; Boston Museum Fine Art School; American Academy, Rome, Italy. Award: Prix-de-Rome, 1919-22. Work: "Gen. U. S. Grant," Hall of Fame, NY; portrait figure "Dr. Moore," Park in Rochester, NY; medal, Columbia University, NY; Skinner Memorial Relief, Holyoke, MA; Munger Relief, Birmingham, AL; figure, "Christ," St. Matthews Church, Washington, DC; Eno Memorial, Trinity College, Hartford, CT; Trowbridge Portrait, American Academy, Rome, Italy; William Rutherford Mead Portrait, NYC; Meldrum Memorial Relief, Library, Houston, Tex.; Morton Memorial, Burlington, Wisconsin; awarded sculpture for Tomb of Unknown Soldier, Arlington National Cemetery. Executed many medals including: World War II; The Free-

dom Medal; Women's Army Corps; For Humane Service (German Airlift); and others. Taught: Instructor of Sculpture, Albright Art Gallery; Columbia University. Address in 1970, Washington, DC.

JONES, WILLIAM.
Sculptor. Born in South Carolina, c. 1815. Worked: New York City, 1850.

JONSON, JON MAGNUS.
Sculptor. Born in Upham, ND, December 18, 1893. Studied with Albin Polasek and Lorado Taft. Work: Sculpture for International House, Chicago. Award: Garden sculpture prize, Hoosier Salon, 1931. Address in 1933, Frankfort, Ind.

JOPLING, FREDERIC WAISTEL.
Sculptor, painter, illustrator, and etcher. Born in Kensington, London, England, April 23, 1860. Studied at Art Students League of New York; pupil of Walter Shirlaw; Sartain; Penfold; Chase. Member: Print Makers' Society of Calif. Represented in the National Gallery of Canada at Ottawa. Address in 1926, The Men's Hotel, Buffalo, NY.

JORDAN, FREDD ELMER.
Sculptor and craftsman. Born Bedford, IN, November 25, 1884. Award: Prize ($200), Hoosier Salon, Chicago, 1928. Address in 1934, 559 Hendrie Street, Detroit, MI.

JORGENSEN, JORGEN.
Sculptor, painter, and etcher. Born in Denmark, December 6, 1871. Member: American Artists' Professional League; Society of Independent Artists; Newark Outdoor Sketch Club. Etchings in the Newark Museum. Address in 1933, 10 Fernwood Road, Maplewood, NJ.

JOSEPH, ADELYN L.
Sculptor, painter, craftsman, and writer. Born in Chicago, June 16, 1895. Pupil of Mulligan, Grafly, and Polasek. Member: Chicago Society of Artists; Society of Women Sculptors; Chicago Artists' Guild. Address in 1928, 1311 East 53rd Street, Chicago, IL.

JOSEPH, JOAN A.
Sculptor. Pupil of Mulligan, Crunelle, and Polasek. Member: Chicago Society of Artists; Society of Independent Artists. Exhibited "The Art Student" at the Academy of Fine Arts, Philadelphia, 1924. Address in 1926, 4320 Drexel Boulevard, Chicago, IL; Green Lake, WI.

JOSSET, RAOUL (JEAN).
Sculptor. Born Tours, France, December 9, 1900. Studied with Injalbert and Bourdelle. Work: Fifteen war memorials in France; "Colossal Christ of Jussy," Aisne, France; two Indians carved on pylons, George Rogers Clark Memorial, Vincennes, Ind.; at Century of Progress Exposition, Chicago, Ill., figure of executive over main entrance and four bas-reliefs inside Federal Building, three statues and finial on Agricultural Building. Awards: Medals, Salon of Paris, 1922 and 1923. Address in 1953, 139 West 54th Street, NYC. Died in 1957.

JOURNEAY, HELEN.
Sculptor. Address in 1935, Odenton, MD. (Mallett's)

JOUVENAL, JACQUES.
Sculptor-portraits. Born in Germany, March 18, 1829.

Worked: NYC, 1853-55; Washington, 1855-1905. Work held: US Capitol. Died in Washington, March 8, 1905.

JOVINE, MARCEL.
Sculptor and medalist. Born in Naples, Italy, July 26, 1921; US citizen. Studied at University of Naples, Italy, B.S.; Royal Academy, Turin, Italy, B.S., 1941; also studied with Brunetto Buracchini, Siena, Italy. Work in Museum of Racing, Saratoga, NY; Winter Olympic medal, Switzerland, 1980; others. Has exhibited at National Sculpture Society. Received awards from National Sculpture Society. Member of National Sculpture Society. Works in mixed metals. Address in 1982, Closter, NJ.

JUDD, DONALD CLARENCE.
Sculptor. Born June 3, 1928, Excelsior Springs, MO. Studied: College of William and Mary, 1948-49; Columbia University, BS, 1949-53, Museum of Fine Arts; Art Students League, with Johnson, Stewart Klonis, Robert Beverly Hale, Louis Bouche, Will Barnet. Work: Art Institute of Chicago; Detroit Institute; Los Angeles County Museum of Art; Museum of Modern Art; Pasadena Art Museum; St. Louis City; Whitney Museum; Walker; Albright-Knox. Exhibited: Leo Castelli, NYC; Whitney Museum; Ileana Sonnabend Gallery, Paris; VIII Sao Paulo Biennial, 1965; Stockholm Nat'l., 1965; Walker; Los Angeles County Museum of Art; Detroit Institute; Wash. Gallery of Modern Art; Guggenheim; Museum of Modern Art; Jewish Museum; others. Awards: Swedish Institute Grant, 1965; U.S. Government Grant, 1967 and 76; Guggenheim Foundation Fellowship, 1968. Taught: Allen Stevenson School, 1957-61; Hunter College, 1966; Yale University, 1967. Address in 1982, c/o Leo Castelli Gallery, NYC.

JUDD, NEALE M.
Sculptor. Member: Washington Water Color Club. Address in 1928, National Museum, Washington, DC.

JUDSON, SYLVIA SHAW.
Sculptor. Born in Chicago, IL, June 30, 1897. Studied at Art Institute of Chicago with Albin Polasek; Grande Chaumiere, Paris, France, with Antoine Bourdelle. Works: Art Institute of Chicago; National Academy of Design; Phila. Museum of Art; Springfield Museum of Art; Davenport, Iowa; Dayton Art Institute. Awards: Art Institute of Chicago, 1929; Carr prize, 1947; International Sculpture Show, Philadelphia, 1949; Municipal Art League, 1957; Lake Forest College, 1952; Chicago Chapter of American Institute of Architects, 1956, Garden Clubs of America, 1956. Exhibited: Art Institute of Chicago, 1938; Arden Gal., NYC, 1940; and the Sculpture Center, NYC, 1957; International Sculpture Exhibition, Philadelphia Museum; American Shows, Art Institute of Chicago, Museum of Modern Art, NYC, and the Whitney Museum of American Art, NY. Also taught sculpture at the American University, Cairo, Egypt, 1963; Vice President of the women's board for the Art Institute of Chicago, 1953-54. Address in 1976, Lake Forest, Ill. Died in 1978.

JUNDHENK, OSCAR.
Sculptor. Pupil of Royal Academy, Berlin. Address in

1910, 321 Helen St., Cincinnati, OH.

JUNGWIRTH, LEONARD D.
Sculptor, etcher, and lecturer. Born in Detroit, Michigan, October 18, 1903. Studied: University of Detroit, Bachelor of Architecture, England; Wayne University, MFA, and in Germany. Member: Michigan Academy School of Arts and Letters. Work: Detroit Institute of Art; Kalamazoo Institute of Art; Richard Memorial, Detroit; Grosse Pointe (Michigan) Church; reliefs, Michigan State College, Grand Haven (Michigan) High School; St. Thomas Aquinas Chapel, East Lansing, Michigan. Exhibited: Detroit Institute of Art, annually; Flint Institute of Art, 1951. Lectures on Techniques of Sculpture. Taught: Instructor, Wayne University, 1936-40; Associate Professor, Michigan State College, East Lansing, Michigan, from 1940. Address in 1953, East Lansing, Michigan. Died 1964.

JUNJEL, BARTHOL.
Sculptor—marble, stone. Worked: New Orleans, 1850-51.

JUNJEL & BARRET.
Marble and stone partners in sculpture. Worked: New Orleans, 1850-51. The team was Barthol Junjel and Anthony Barret.

JUNKIN, MARION MONTAGUE (MR.)
Sculptor, painter, and etcher. Born in Chunju, Korea, August 23, 1905. Studied: Washington and Lee Universities, BA, 1927; Art Students League, 1927-30; and with Randolph Johnston, George Luks, George Bridgmen, Edward McCarten. Awards: Prize, Virginia Mus. of Fine Arts, 1946; Butler Institute of American Art, 1946; Richmond Academy of Fine Arts; others. Work: Virginia Museum of Fine Arts; IBM. Exhibited: Art Institute of Chicago; Penna. Academy of Fine Arts, 1933; Corcoran Gallery of Art, 1935; Virgina Museum of Fine Arts, 1942, 44; Carnegie Institute; Whitney Museum of American Art; World's Fair, New York 1939; IBM; Pepsi-Cola, 1946; Butler Institute of American Art, 1946; Tennessee annual exhibition. Taught: Professor, Head of Art Department, Vanderbilt University, Nashville, Tenn., 1941-46. Died 1977.

JURECKA, CYRIL.
Sculptor. Born Moravia, Czechoslovakia on July 4, 1884. Pupil of Academy of Fine Arts, Prague. Member: California Art Club. Died in 1960. Address in 1934, Claremont, CA.

JUST, WILLIAM.
French sculptor. Born in 1820. Worked in New York City in 1850.

JUSZKO, JEAN (or JENO).
Sculptor. Born in Ungvar, Hungary, Nov. 26, 1880. Studied: Nat'l. Sch. of Ceramics, Hungary; Ecole des Beaux-Arts, Paris. Member: Nat'l. Sculpture Soc.; Salma. C.; Amer. Numismatic Soc.; NY Arch. Lg. Work: Monument of Archbishop Samy, Santa Fe, NM. Exhibited at Nat'l. Sculpture Soc., 1923; Annual Exhib., Nat'l. Acad. Design, NY, 1925. Address in 1935, NYC. Died 1954.

K

KAGY, SHEFFIELD HAROLD.
Sculptor, painter, and educator. Primarily painter. Born in Cleveland, OH, October 22, 1907. Studied at Cleveland School of Art; Corcoran School of Art; John Huntington Polytechnic Institute, Cleveland; and with Henry Keller, P. Travis, Oley Nordmark, Ernest Fiene, others. Member: Artists Guild of Washington; Society of Washington Artists; Landscape Club, Washington, DC; Washington Printmakers. Awards: Prizes, White Sulphur Springs, WV, 1936; Cleveland Museum of Art, 1933, 35; medal, Wash. Landscape Club, 1950. Work: Murals, US Post Office, Walterboro, SC; Luray, VA; map, Presidential Yacht "Williamsburg." Exhibited: Art Institute of Chicago, 1934; Whitney Museum of American Art; Penna. Academy of Fine Arts; PMG; American Federation of Arts; National Museum, Washington, DC; Cleveland Museum of Art; Corcoran Gallery of Art; Palm Beach Art Center; Norfolk Museum of Art; New York World's Fair, 1939; Golden Gate Exposition, 1939. Position: Instructor, National School of Art, Washington, DC, 1946-56. Address in 1982, Washington, DC.

KAHAN, SOL B.
Sculptor. Born in Zitomir, Russia, December 23, 1886. Studied at Art Students League, with Robert Laurent. Exhibited: National Academy of Design; Whitney Museum of American Art; College Art Association of America; Brooklyn Museum; Architectural League. Address in 1953, 1717 Bryant Ave., Bronx, NY.

KAHILL, VICTOR.
Sculptor. Exhibited "A Study," at the Penna. Academy of Fine Arts, Philadelphia, 1924. Member: Penna. Academy of Fine Arts. Address in 1926, 3610 Spring Garden St., Philadelphia.

KAHN, ISAAC.
Sculptor and painter. Born Cincinnati, August 16, 1882. Pupil of Duveneck and Lindsay. Member: Cincinnati Art Club; Ceramic Society. Address in 1929, 4609 Eastern Avenue; h. 327 Kemper Lane Apts., Cincinnati, Ohio.

KAIN, FRANCIS.
Sculptor and marble cutter. Born c. 1786. Worked: NYC, 1811-39. Died in Eastchester, NY, 1844.

KAIN, JAMES.
Sculptor and marble cutter. Worked: NYC, 1827-38; New Orleans, 1829, 1832. Died in NYC, 1838.

KAINZ, LUISE.
Sculptor, etcher, engraver, and teacher. Born in NYC, May 3, 1902. Studied at Teachers College, Columbia University; Munich Academy of Fine and Applied Arts. Exhibited: Weyhe Gallery; National Arts Club; Brooklyn Society of Etchers; Dudensing Gallery. Contributor to *Design* magazine. Position: Chairman of the Art Department, Bay Ridge High School, Brooklyn, NY. Address in 1953, 208 East 15th St., NYC.

KAISER, DIANE.
Sculptor. Born in Brooklyn, NY, May 27, 1946. Studied at Syracuse University, semester in Florence; Brandeis University; Columbia University (graduate); Art Students League; others. Has exhibited at SOHO 20 Gallery, NYC; Museum of Fine Arts, Springfield, MA; Rose Art Museum, Waltham, MA; Aldrich, Ridgefield, CT; Flint Institute of Art, AMI; Parsons-Dreyfuss Gallery, NYC; A.I.R. Gallery, NYC; Fourteen Sculptors Gallery, NYC; many more. Received MacDowell Colony Fellowship, 1973; Finalist, Betty Brazil Memorial Grant in Sculpture. Also teaches sculpture, lectures, has served as administrator, art reviewer. Address in 1984, 225 West 106th Street, NYC; summer, Northampton, MA.

KAISH, LUISE MEYERS.
Sculptor. Born September 8, 1925, Atlanta, GA. Studied: Syracuse University, with Ivan Mestrovic, BFA; Museum of Fine Arts; Escuela de Pintura y Escultura, Mexico City, with Alfredo Zalce, J. G. Galvan. Work: High Museum; Jewish Museum; University of Miami; University of Rochester; St. Paul Gallery; Syracuse University; Whitney Museum; plus numerous commissions, including Jewish Museum, Temple Beth Shalom, Wilmington, DE, Temple Israel in Westport, CT, and corporations. Exhibited: Sculpture Center, NYC, 1955, also 1958; Staempfli Gallery, NYC, 1968; Metropolitan Museum of Art; Whitney Museum; Museum of Modern Art; National Academy of Design; Sculptors Guild; Albright; American Academy of Arts and Letters; Newark Museum. Awards: Guggenheim Foundation Fellowship; L. C. Tiffany Grant; Audubon Artists, Medal; Ball State Teachers College, purchase prize; Lowe Foundation Award; National Association of Women Artists; University of Rochester; Syracuse (Everson). Member: Sculptors Guild; Audubon Artists. Address in 1982, 610 West End Avenue, NYC.

KALDENBERG, FREDERICK ROBERT.
Sculptor. Born in New York in 1855. Self-taught in art. Took up carving in meerschaum at ten years of age, and at fourteen commenced ivory carving, being the first native American to do this work. Some of his productions were in the possession of the late Russian Emperor, the King of Belgium and the Presidents of Venezuela and Mexico, and among the relics of General U. S. Grant; also in the gallery of George W. Vanderbilt, the Smithsonian Institution, and the palace of Li Hung Chang, etc. Member of National Sculpture Society; New York Architectural League; New York Society of Craftsmen. Awarded

bronze medal, American Institute, 1869; gold medal, Cincinnati, 1884. Died in NYC, October, 1923.

KALISH, MAX.
Sculptor. Born Poland, March 1, 1891. Pupil of Matzen, Adams, Calder, Injalbert. Member: American Federation of Arts; National Academy (Associate); National Sculpture Society. Awards: First prize for sculpture, Cleveland Museum of Art, 1924 and 1925. Work: "Laborer at Rest" and "Torso," Cleveland Museum of Art; also represented in Amherst College, Mass.; National Gallery, Washington, DC; Newark, NJ, Museum. Died in 1945.

KALLEM, HERBERT.
Sculptor. Born in Philadelphia, PA, November 14, 1909. Studied at National Academy of Design; Pratt Institute; Hans Hofmann School of Fine Arts. Work in Whitney Museum of American Art, NY; Wadsworth Atheneum, Hartford, CT; Chrysler Museum, Provincetown, MA; others. Has exhibited at Whitney Museum of American Art; Carnegie Institute; others. Member of Sculptors Guild; Audubon Artists. Taught at School of Visual Arts and NY University, sculpture. Address in 1982, 45 W. 28th St., NYC.

KALLMAN, KERMAH.
Sculptor. Born in Sweden, April 11, 1905. Studied with Aaron Goodelman, Saul Berman. Member: Audubon Artists; New York Society of Women Artists; National Association of Women Artists; Artists Equity Association. Exhibited: Am-British Art Center; Riverside Museum; National Academy of Design; ACA Gallery; Bonestell Gallery; Peikin Gallery; Chappelier Gallery; Norlyst Gallery; National Arts Club; Argent Gallery; American Academy of Arts and Letters; Contemporary Art Gallery; DeMotte Gallery; Laurel Gallery; Penna. Academy of Fine Arts, 1947, 49, 52. Position: Director, New York Society of Women Artists, NYC, 1943, 50-51. Address in 1953, 161 East 88th St., NYC.

KALLWEIT, HELMUT G.
Sculptor. Born in Germany, September 18, 1906. Member: League Present-Day Art. Exhibited: Riverside Museum; Argent Gallery; Burliuk Gallery; RoKo Gallery; Contemporary Art Gallery; ACA Gallery. Address in 1953, 115 West 104th St., NYC; summer, Shinnecock Hills, LI, NY.

KAMENSKY, THEODORE.
Sculptor. Born in St. Petersburg, Russia, 1836. Pupil of St. Petersburg Academy. Came to US in 1872. Member: St. Petersburg Academy of Fine Arts 1863. Awards: Medals at London International Exposition and Vienna Exposition. Work: Crowning statue and two reliefs for Capitol, Topeka, KS; "The Little Sculptor" and "The Widow and Child," St. Petersburg Academy. Address in 1913, Clearwater, FL. Died in Florida, 1913.

KAMMERER, HERBERT LEWIS.
Sculptor. Born in NYC, July 11, 1915. Studied at Yale University, B.F.A.; American Academy in Rome; National Academy of Design; Art Students League; apprentice to Charles Keck and C. Paul Jennewein; assistant to Paul Manship. Member: National Sculpture Society;

American Academy in Rome. Work: Medals, memorial tablets and portraits of prominent persons. Exhibited: National Academy of Design, 1942, 49, 51, 52; Penna. Academy of Fine Arts, 1941, 47-49, and from 52; Palazzio Venezia, Rome, 1950, 51; and many more. Awards: George D. Widener Gold Medal, Penna. Academy of Design Annual, 1948; Prix d'Rome, American Academy Rome, 1949; Grant in Sculpture, National Institute of Arts and Letters, 1952, Fulbright, 1949-51. Professor of sculpture, SUNY, New Paltz, NY, from 1962. Address in 1982, New Paltz, NY.

KANE, BILL (WILLIAM DAVID).
Sculptor. Born in Holden, MA, February 18, 1951. Studied at University of Mass., Amherst, B.A., 1973; San Francisco State University, CA, 1978. Work in San Francisco Museum of Modern Art; Crocker Art Museum, Sacramento. Has exhibited at National Museum of Art, Kyoto and Tokyo, Japan; others. Works in neon and plexiglas. Address in 1982, San Francisco, CA.

KANE, MARGARET BRASSLER.
Sculptor. Born in East Orange, NJ, May 25, 1909. Studied: Syracuse University; Art Students League; and with John Hovannes. Awards: National Association of Women Artists, 1942, 1951; New York Architectural League, 1944. Exhibited at Art Institute of Chicago; Metropolitan Museum; Whitney; Pennsylvania Academy of Fine Arts; others. Collections: US Maritime Commission; Limited Editions Lamp Company. Address in 1982, Cos Cob, CT.

KANGAS, GENE.
Sculptor and writer. Born in Painesville, OH, May 22, 1944. Studied at Miami University, B.F.A.; Bowling Green University, M.F.A.; University of Kentucky, sculpture seminar. Work in Butler Institute of American Art, OH; Cuyahoga Co. Justice Center, Cleveland, OH. Has exhibited at American Crafts Council, NY; Royal Marks Gallery, NY; Ohio Sculpture Invitational, Dayton; others. Received Fulbright-Hays Scholarship, 1968; first prize in sculpture, Cleveland Museum of Art. Address in 1982, Painesville, OH.

KAPETAN, MICHAEL R.
Sculptor. Born in Ypsilanti, MI, 1946. Studied: Harvard University, B.A. Private collections. Exhibited at The Detroit Institute of Arts, Works by Michigan Artists, 1974-75. Address in 1975, 315 Fourth, Rochester, MI.

KAPFENBERGER, JOSEPH.
Sculptor. Address in 1934, New York. (Mallett's)

KAPLAN, MURIEL.
Sculptor. Work includes "Paul Mocsanyi," terra cotta, exhibited at 94th Annual Exhibition of National Association of Women Artists, NYC, 1983. Member: National Association of Women Artists. Address in 1983, Palm Beach, FL.

KAPOUSOUZ, VASILEOS.
Sculptor. Member of the National Sculpture Society. Address in 1982, San Diego, CA.

KARABERI, MARIANTHE.
Sculptor. Born in Boston, MA. Studied at Penna. Acad-

emy of Fine Arts; University of Penna.; Barnes Foundation; Art Students League; and with John Hovannes, Antonio Salemme, and Heinz Warnecke. Award: Corcoran Gallery of Art, 1957.

KARAWINA, ERICA.
(Mrs. Sidney C. Hsiao). Sculptor, painter, stained glass artist, designer, and lithographer. Born in Wittenberg, Germany, January 25, 1904. Studied in France and with Charles J. Connick, Frederick W. Allen. Work: Addison Gallery of American Art; Los Angeles Museum of Art; Biro-Bidjan Museum, Russia; Museum of Modern Art; Les Archives International de la Danse, Paris, France; Metropolitan Museum of Art; Boston Museum of Fine Art; Worcester Museum of Art; stained glass in churches in San Francisco, CA; Denver, CO; Chicago, IL; Cincinnati, OH; New York, NY; Paris, France. Exhibited: Boston Art Club; Society of Independent Artists, Boston; Penna. Academy of Fine Arts; Rockefeller Center, NY, 1937; New York World's Fair, 1939; Oklahoma Art Center; Grand Rapids Art Gallery, 1940; one-man exhibitions: Grace Horne Gallery, Boston; University of New Hampshire, Durham, NH, 1937; Lancaster (PA) Art Club, 1937; Wadsworth Atheneum, 1938; Texas State College, 1939. Commissions: Crux Gemmata (glass in concrete), Manoa Valley Church, Honolulu, HI, 1967; six windows of sculptured glass, St. Anthony's Church, Oahu, HI, 1968; translucent glass mosaic murals, Hawaii State Office Bldg., Honolulu, HI, 1975; others. Address in 1982, Honolulu, HI.

KARESH, ANN BAMBERGER.
Sculptor and painter. Born in Bamberg, Germany; US citizen. Studied at Willesden Technical College, London, England; Hornsey College of Art, London. Represented at Gibbes Art Gallery, Charleston, SC; Home Federal Savings and Loan Association Collections, SC; Jewish Community Center Collections, Charleston; Columbia Museum of Art, SC. Exhibitions include Watercolor USA, National Watercolor Exhibition, 1962; 23rd Annual Contemporary American Painting, Palm Beach, Florida, 1962; Directors Choice, 10 South Carolina Artists Traveling Exhibition, 1965; Contemporary Artists, South Carolina Invitational, 1970-71; one-woman show, Columbia Museum of Art, 1972, and B'nai B'rith Museum, Washington, DC, 1975; plus others. Awards: First Prize in Painting, South Carolina Artists Annual, 1963; Best in Enamel, SC Craftsmen, 1968, Best in Metal, 1970. Media: Metal, wood; and acrylic. Address in 1976, Charleston, SC.

KARFUNKLE, DAVID.
Sculptor, painter, and etcher. Born in Austria, June 10, 1880. Pupil of National Academy of Design, New York, with Francis Jones, Edgar Ward; Royal Academy, Munich, Germany; and with Bourdelle, in Paris. Work: Newark Museum; Cleveland Museum of Art; murals, Grace Church, Jamaica, Long Island, New York. Exhibited: Carnegie Institute; Penna. Academy of Fine Art; Art Institute of Chicago; National Academy of Design; others abroad. By 1953 no longer listed as a sculptor. Address in 1953, 20 East 14th Street, New York City.

KARL, MABEL FAIRFAX (SMITH)(MRS.).
Sculptor, etcher, and blockprinter. Born in Glendale, Oregon, June 27, 1901. Studied with Leo Lentelli, Joseph Pennel, George Bridgman, and Archibald Dawson. Work: "Fawn" drypoint, Fine Arts Gallery, San Diego, Calif.; Calif. Trophy, sculpture, US Marines, San Diego; "Woodrow Wilson" and "Memorial," bronze reliefs, Wilson Memorial High School, San Diego. Awards: Honorable mention for sculpture, Museum of Fine Arts, Houston, 1932; honorable mention for sculpture, Fine Arts Gallery, San Diego, 1933. Member: Art Students League of New York; Artists Guild; Fine Arts Society San Diego; American Federation of Arts. Address in 1933, 4119 Voltaire Ave., Ocean Beach, Calif.; 1207 Willard St., Houston, Texas.

KARPEL, ELI.
Sculptor and instructor. Born in NYC, October 25, 1916. Studied at City College of New York, B.A.; University of California, Los Angeles, MA; University of Southern California; Ohio State University; with Chaim Gross. Work in Hirshhorn Museum, Washington, DC; Storm King Mountain Museum, Mountainville, NY. Has exhibited at Southern California Exhibition, Long Beach Museum of Art; others. Works in bronze and other materials. Address in 1982, Santa Monica, CA.

KASKEY, RAYMOND JOHN.
Sculptor and architect. Born in Pittsburgh, PA, February 22, 1943. Studied at Carnegie Mellon University, B.A. (architecture), 1967; Yale University, School of Art and Architecture, also sculpture with Erwin Haver, 1969. Work in Museum of Modern Art, NY. Has exhibited at Salon des Realites Nouvelles, Parc Floral Museum, Paris; National Sculpture Society Annual, NY, 1980 and 1981. Member of National Sculpture Society. Received Mrs. Lindsey Bennett Prize, National Sculpture Society, 1982. Works in bronze. Address in 1982, Washington, DC.

KASSLER, MARGEURITE.
(Mrs. Bennett). Sculptor. Born in Tacoma, Washington, 1895. Address in 1935, Denver, CO. (Mallett's)

KASSOY, HORTENSE.
Sculptor and painter. Born in Brooklyn, NY, on February 14, 1917. Studied: Pratt Institute; Columbia University; University of Colorado; Columbia University Teachers College, with Oronzo Maldarelli, B.S. and M.A.; American Artists School, with Chaim Gross. She was awarded a prize at Painter's Day at the New York World's Fair; sculpture award, American Society of Contemporary Artists. Exhibitions: Toledo Museum, Ohio, 1947; A.C.A. Gallery, 1940, 1954; National Academy of Design; Brooklyn Museum, 1974; Lincoln Center, 1975; International Sculpture Exhibition, Forte dei Marmi, Italy, 1976, and Pietrasanta, Italy, 1976; others. Member of Artists Equity; others. Media: Wood, marble, batik, watercolor. Address in 1982, 130 Gale Place, Bronx, New York.

KATCHAMAKOFF, ATANAS.
Sculptor, painter, and craftsman. Born in Leskovetz, Bulgaria, January 18, 1898. Studied at Fine Arts Academy, Sofia, Bulgaria. Work: "Zany Gintcheff, Bulgarian Poet,"

City of Leskovetz, and Fountain, Big Garden, Sofia, Bulgaria; architectural sculptures for Deutsche Bank, Berlin, Germany. Awards: First prize, Academy of Fine Arts, Sofia, Bulgaria, 1919 and 1920; first prize for statue, "Grief," International Sculpture Exhibition, Berlin, Germany, 1920; first prize for "Egyptian Thought," International Sculpture Exhibition, Venice, Italy, 1921; first prize, "Madonna and Child," Calif. State Fair, 1929; first prize ($1,500), for "Indian Woman with Papoose," Art Alliance of America, 1931; prize, 13th annual Los Angeles Exhibition, 1932. Address in 1933, Palm Springs, Calif.

KATZ, EUNICE.
Sculptor and painter. Born in Denver, Colo., January 29, 1914. Studied at Art Students League, with Harry Sternberg; Sculpture Center, with Dorothea Denslow; also with Angelo di Benedetto, Frederick Taubes, Donald Pierce, and Edgar Britton. Works: US State Department Art for Embassies Prog., Washington, DC; Temple Emanuel Collections, Denver, Colo.; Hillel House, Boulder; Children's Hospital, Pittsburgh, Penna.; four figure sculpture (bronze), Beth Israel Hospital, 1970; others. Exhibitions include Allied Artists of America, National Academy, 1949-66; National Society of Painters and Sculptors, NJ, 1964; one-woman shows, Pietrantonio Gallery, NY, 1965; others. Awards: Award of Merit, Rocky Mountain Liturgical Arts, 1958; Patron's Award, Art Museum New Mexico Biennial, 1966; First Place Award, American Association of University Women, 1966. Media: Bronze and Oil. Address in 1982, Denver, CO.

KATZEN, LILA PELL.
Sculptor and educator. Born in NYC. Studied: The Art Students League, NYC; Cooper Union, NY; also with Hans Hoffman, NYC, and Provincetown, MA. Awards: Goodyear Fellow, Foxcroft School, Virginia; Creative Arts Award, The American Association of University Women; Corcoran Gallery of Art, Washington, DC, 1959; Fellowship, Tiffany Foundation, 1964. In collections of Smithsonian; Everson, Syracuse, NY; National Gallery of Art, Washington, DC; others. Exhibited: Biennial of Contemporary Painting and Sculpture, Whitney Museum of Art, NYC, 1973; Baltimore Museum, 1975; Fordham University, Lincoln Center, 1978; University of N.C., Chapel Hill, 1979; Metropolitan Museum Art Center, Coral Gables, Florida, 1980; others. Taught: Maryland Institute College of Art, from 1962. Media: Steel and other metals, concrete. Address in 1982, 345 Broadway, New York, NY.

KAUBA, CARL.
Sculptor. Born in Vienna, Austria, in 1865. Studied at Vienna academies under Carl Waschmann, Stefan Schwartz. Although he probably never visited US, collectors rank him in a class with Remington and Russell as one of the great portrayers of American Western subjects. Executed his detailed, small to medium size bronzes in Vienna studio from photos, illustrations and artifacts sent from US. Work exported to US 1895-1912; not fully appreciated until 1950's. In Harmsen Collection of American Western Art. Died in 1922.

KAUFFMAN, (CAMILLE) ANDRENE.
Sculptor, painter, and educator. Born in Chicago, IL, April 19, 1905. Studied at Art Institute of Chicago, B.F.A.; University of Chicago, M.F.A.; and with Andre L'Hote. Member: Chicago Society of Artists; American Association University Prof. Awards: European scholarship, Art Institute of Chicago, 1926. Work: Murals and sculptures, public building; murals, US Post Office, Ida Grove, Iowa; medal, Rockford (IL) College; mural, Science Building, Rockford College. Exhibited: Art Institute of Chicago, annually; Whitney Museum of American Art, 1934; Brooklyn Museum, 1934; Chicago Society of Artists, 1926-46. Position: Instructor, Art Institute of Chicago, Chicago, IL, 1927-67, chairman, division of fine arts, 1963-66, emeritus prof., from 1967; Prof., Rockford (IL) College, from 1943. By 1976, no longer listed as a sculptor. Address in 1982, Elmhurst, IL.

KAUFFMAN, (ROBERT) CRAIG.
Sculptor. Born March 31, 1932, Eagle Rock, Calif. Studied: University of Southern California, 1950-52; UCLA, BA, MA, 1952-56. Work: University of Arizona; Albright; Los Angeles County Museum of Art; Museum of Modern Art; Pasadena Art Museum; Aldrich; Whitney Museum. Represented by Pace Gallery, NYC, and Irvine Blum Gallery, L.A. Exhibited: Felix Landau Gallery, L.A.; Dilexi Gallery, San Francisco; Ferus Gallery, Los Angeles; The Pace Gallery, NYC; San Francisco Museum of Art; UCLA, California Painters Under 35, 1959; Seattle Art Museum; Detroit Institute; Museum of Modern Art, The 1960's; Guggenheim; V Paris Biennial, 1967. Address in 1982, 31-33 Mercer Street, NYC.

KAUFMAN, JEAN FRANCOIS.
Sculptor, painter, etcher, and writer. Born Uznach, Switzerland, October 31, 1870. (Naturalized citizen of the United States). Pupil of Gerome, Ecole Nationale des Beaux-Arts, Paris. Award: Hon. mention, Paris Salon, 1927. Works: "Portrait Hon. Asa Bird Gardner," War Department, Washington, DC; decorations in Monumental Church, Richmond, VA; monumental bronze bust, Poughkeepsie, NY. Address in 1929, 94 West Houston St., New York, NY.

KAUFMAN, MICO.
Sculptor. Born in Romania, January 3, 1924; US citizen. Studied at Academy of Fine Arts, Rome and Florence, Italy, 1947-51. Has exhibited at New England Sculpture Society; National Sculpture Society, NY; Audubon Artists; Allied Artists of America; others. Member: National Sculpture Society; New England Sculpture Association. Works in bronze and stainless steel. Address in 1982, North Tewksbury, MA.

KAWAMURA, GOZO.
Sculptor. Born Japan, August 15, 1886. Pupil of MacMonnies, and studied in Paris at Ecole des Beaux-Arts; also studied in studios of Kitson in Boston, Remington in NY, A. A. Weinman, J. E. Fraser, and others. Member: American Numismatic Artists. Work: Memorial tablet of World War I, American Jersey Cattle Club; "Portrait of Prince Katcho," Japanese Imperial Family; ideal type of cow and bull for Holstein-Friesian Association of America, to be

placed in every college of agriculture in the United States. Exhibited at National Sculpture Society, 1923. Address in 1933, 96 Fifth Avenue; 5 West 16th Street, NYC. Died in 1950.

KAZ, NATHANIEL.
Sculptor. Born in NYC, March 9, 1917. Studied at the Art Students League with George Bridgeman, Samuel Cashwan, Wm. Zorach. Work: "Danse Espagnole" (bronze), 1955; in collections of Brooklyn Museum; Whitney; Metropolitan Museum of Art; others. Exhibited: Downtown Gallery, NYC, 1939; Chicago Art Institute, 1937, 38; New York World's Fair, 1939; Penna. Academy of the Fine Arts, Phila.. 1953; Whitney Museum of American Art, NY; American Museum of NaturalHistory, NY; Sculptors Guild Exhibition, 1954; Metropolitan Museum; Whitney; others. Member: Sculptors Guild; The Woodstock Society of Artists; and the Brooklyn Society of Artists; others. Awards: First prize, Detroit Art Institute, 1929. Address in 1983, 160 West 73 Street, NYC.

KEANE, RICHARD.
Sculptor and painter. Studied: BFA, MFA School of the Art Institute of Chicago. Illustrated *The Serengeti Lion, Mountain Sheep and Goats, Golden Shadows, Flying Hooves, The Tiger, Its Life in the Wild* all by Dr. George Shaller; many illustrations for latest edition of *Encyclopedia Britannica*; others. Exhibited: Chicago and Vicinity show; one man show in the gallery of The Art Institute of Chicago, IL; Union League Club, and numerous local galleries. Awards: James Ryerson Traveling Fellowship. Member: Society of Animal Artists, NYC. Teaching: Art Institute of Chicago, presently. Media: oil, watercolor, acrylic and graphics; bronze and terracotta. Address in 1983, Flossmoor, Ill.

KEARFOTT, ROBERT RYLAND.
Sculptor, painter, and illustrator. Born in Martinsville, VA, December 12, 1890. Studied at University of Virginia, B.A.; Art Students League; and with Bridgman, Miller, Hawthorne. Member: Salma. Club; Artists Guild; Studio Guild. Work: Cover designs, advertising illustrations for national magazines. Address in 1953, Mamaroneck, NY.

KEARL, STANLEY BRANDON.
Sculptor. Born December 23, 1913, Waterbury, Conn. Studied: Yale University, 1941, BFA, 1942, MFA; State University of Iowa, 1948, Ph.D., also studied in Rome. Work: Marbach Galerie; University of Minnesota; Rome (Nazionale); Stockholm (National); Sweden (Goteborg). Exhibited: L'Obelisco, Rome, 1950; Galerie d'Art Moderne, Basel, 1951; Samlaren Gallery, Stockholm, 1951; Marbach Galerie, Berne, 1952; Beaux Arts Gallery, London, 1956; Galleria Selecta, Rome, 1957; Obelisk Gallery, Washington, DC, 1958; Wakefield Gallery, NYC, 1961; D'Arcy Gallery, NYC, 1962; Grand Central Moderns, NYC, 1965, 68; XXVI Venice Biennial, 1952; Penna. Academy of Fine Art; Museum of Modern Art; Whitney Museum Annual, 1962; Hudson River Museum, Yonkers, NY. Awards: Fulbright Exchange Professor to Rome University, Italy, 1949-50; Institute of Contemporary Arts, Florence, Italy, 1952; Connecticut Academy Sculpture Prize, 1959; Silvermine Guild Association Annual

award, 1967. Taught: Pratt Institute, 1967. Address in 1982, Scarsdale, NY.

KEARNEY, JOHN (W).
Sculptor and art administrator. Born in Omaha, NE, August 31, 1924. Studied at Cranbrook Academy of Art, Bloomfield Hills, MI, 1945-48; University Stranieri, Perugia. Work in Norfolk Art Museum, VA; Edwin A. Ulrich Museum of Art, Wichita, KS; others. Has exhibited at Corcoran Biennial, Washington, DC; Painting and Sculpture Today, John Herron Museum, Indianapolis; ACA Galleries Biennial, NY; Art Institute of Chicago; Ulrich Museum, KS; and others. Received Fulbright Award, 1963-64; others. Works in bronze and steel. Address in 1982, Chicago, IL.

KEARNS, JAMES JOSEPH.
Sculptor and painter. Born in Scranton, PA, August 7, 1924. Studied at Art Institute of Chicago, B.F.A, 1951. Work in Museum of Modern Art; Whitney Museum of American Art, NY; National Collection of Fine Arts, Smithsonian Institution; others. Has exhibited at National Institute of Arts and Letters; Whitney Museum of American Art Annual; Penna. Academy of Fine Arts; others. Received National Institute of Arts and Letters Grant. Teaching at School of Visual Arts, from 1960, drawing, painting, and sculpture. Works in bronze and fiberglas. Address in 1982, Dover, NJ.

KECK, CHARLES.
Sculptor. Born NYC, September 9, 1875. Pupil of National Academy of Design; Art Students League of New York; Philip Martiny; Augustus Saint-Gaudens; American Academy in Rome; studied further in Greece, Florence, and Paris. Member: Associate, National Academy of Design; National Sculpture Society, 1906; New York Architectural League, 1909; Numismatic Society; Allied Artists of America; American Federation of Arts; Alumni Association, American Academy in Rome. Award: Rinehart Scholarship to Rome, 1901-05; gold medal, Architectural League of New York, 1926. Work: "Stonewall Jackson," Charlottesville, VA; "Booker T. Washington," Tuskegee, AL; George Washington Monument, Palermo Park, Buenos Aires; Sloane Tablet, Robert College, Constantinople; Lewis and Clark Monument, Charlottesville, VA; Citizen Soldier, Irvington, NJ; Mohammed Statue, Institute of Arts and Sciences, Brooklyn, NY; Soldiers' Memorial, Brooklyn; "George F. Johnson," Binghamton, NY; "George Rogers Clark," Springfield, Ohio; Liberty Monument, Ticonderoga, NY; Memorial Tablet and Friendship Panel, Yale University Club, NYC; Soldiers' Memorial, Harrisonburg, VA; War Memorial, Montclair, NJ; Columbia University Pylons (2) Science and Letters, NYC; Wrenn Tablet—Tennis Champion, Forest Hills Stadium, LI; Mitchell Monument, Scranton, PA; Pittsburgh Soldiers' Monument, Pittsburgh; Swope Memorial, Kansas City, MO; Soldiers' Monument, Lynchburg, VA; Souvenir Gold Dollar, San Francisco Exposition; Souvenir Half Dollar Sesqui-Centennial Exposition, and United States Steamship "Maine" Memorial Tablets, for United States Government; sculpture on the New York State Education Building, Albany, NY; Manchester

Bridge, Pittsburgh; Pittsburgh City Hall; Wilmington City Hall; Oakland City Hall; busts of Patrick Henry, James Madison, Hall of Fame, NY; statue of Lincoln, Wabash, IN. Address in 1933, 40 W. 10th Street, NYC. Died in 1951.

KEEN, WILLIAM C.
Sculptor. In NYC, 1855-57.

KEENE, MAXINE M.
Sculptor and educator. Born in Cleveland, OH, April 7, 1939. Studied at Kent State University, B.F.A., Cranbrook Academy of Art, Bloomfield Hills, Mich., M.F.A. Works: Ball State University Gallery Art, Muncie, Ind.; bronze bas-reliefs, American United Life, Muncie, 1970, and Doctors Accounting Serv. Co., Indianapolis, Ind., 1971. Exhibited: Mid States Art Exhibition, Evansville Museum Art, Ind., 1969; 150 Years of Indiana Art Invitational, Anderson Fine Arts Center, 1969; Presenting Seven Sculptors, Sculptors Gallery, Washington, DC, 1970; 23rd Annual Ceramic and Sculpture Show, Butler Institute of American Art, Youngstown, Ohio, 1970; 53rd Annual May Show, Cleveland Museum of Art, 1972. Awards: Contemporary Artists Society Award and Morris-Goodman Talbot Gallery Award, Herron Museum of Art. Member: College Art Association of American; Muncie Art Association. Medium: Bronze. Address in 1976, Art Department, Ball State University, Muncie, IN.

KEENEY, ANNA.
Sculptor. Born in Falls City, OR, 1898. Pupil of Avard Fairbanks, Harry P. Camden. Work: "Fallen Aviator," First National Bank, Condon, Ore.; "Eve," University of Ore. Address in 1933, University of Oregon; h. 1380 Beech, Eugene, Ore.; summer, Olex, Ore.

KEHM, BIMEL.
Sculptor, designer, and writer. Born in Dayton, OH, February 4, 1907. Studied at University of Illinois; Julian Academy, Paris, France; Yale School of Fine Art; Beaux-Arts Institute of Design. Member: Architectural League. Work: Brooklyn (NY) Technical High School. Exhibited: Architectural League; National Academy of Design; Allied Artists of America. Contributor to: *House and Garden*, *Architectural Forum* magazines. Address in 1953, New Canaan, CT.

KELLER, GEORGE A.
Sculptor. Exhibited in Davenport, IA, 1935. (Mallett's)

KELLER, GERMAINE.
Sculptor. Born in Detroit, MI, 1938. Studied: University of Michigan, B.F.A.; Wayne State University, M.A., M.F.A. candidate. Exhibited at Detroit Institute of Arts, Works by Michigan Artists, 1974-75. Address in 1975, Garden City, MI.

KELLEY, MAY McCLURE.
(Mrs. William Fitch Kelley). Sculptor and painter. Pupil of Cincinnati Art School, Herbert Vos, Charles W. Hawthorne, Brenda Putnam, G. J. Zolnay, Jo Davidson, Antoine Bourdelle. Member: Washington Art Club; Society of Washington Artists. Works: Bas-relief portrait,

Grace Coolidge, The White House; "Adoration," Woman's Universal Alliance, Washington, DC. Address in 1933, 2207 Massachusetts Ave., Washington, DC; Knole, Rockville Pike, MD.

KELLNER, MARY.
Sculptor. Born in NYC, June 16, 1900. Studied at Ogunquit School of Art; Clay Club, and with Robert Laurent, Chaim Gross. Member: National Association of Women Artists; Brooklyn Society of Artists; Art League, Guilford, CT; Artists Equity Association; Meriden Arts and Crafts; Silvermine Guild of Artists. Awards: Prizes, Brooklyn Society of Artists, 1949, 51; Silvermine Guild of Artists, 1952. Work: Bezabel National Museum, Israel. Exhibited: National Association of Women Artists, 1946-52; ACA Gallery, 1948 (one-man); Brooklyn Museum, 1945-48, 50, 52; Artists of America, 1945; Audubon Artists, 1947; Meriden Arts and Crafts, 1949-52; Argent Gallery; New York Historical Society; Silvermine Guild Artists, 1952; Riverside Museum, 1950. Address in 1953, 105 Lincoln Rd., Brooklyn NY; summer, Stony Creek, CT.

KELLY, EDNA.
Sculptor. Born Bolivar, NY, July 23, 1890. Pupil of Cincinnati Art Academy, Ella Buchanan. Member: Calif. Art Club; Long Beach Art Association; Laguna Beach Art Club. Awards: Prize, Pomona-Los Angeles County Fair, 1927; medal and award, Panama Pacific Exposition, Long Beach, 1928. Address in 1929, 1539 North Edgemont, Hollywood, CA; h. 112 East Broadway, Long Beach, CA.

KELLY, ELLSWORTH.
Sculptor and painter. Born in Newburgh, NY, May 31, 1923. Studied at Pratt Institute, 1941-42; Boston Museum School, 1946-48; Ecole des Beaux-Arts, 1948-49. Exhibited: Betty Parsons Gallery, NYC, many; Museum of Modern Art, NY; Paintings, Sculpture, and Drawings by Ellsworth Kelly, Washington Gallery of Modern Art, 1963; Venice Biennale International Art, 1966; NY Painting and Sculpture, 1940-1970, Metropolitan Museum of Art, NY, 1969; Recent Painting and Sculpture, Stedelijk Museum, Amsterdam, Holland, 1979-80; Guggenheim; Whitney; many more. Numerous sculpture commissions, including the lobby of the Transportation Building, Philadelphia, in 1956; a wall sculpture for New York World's Fair, New York Pavilion, 1964; mural, UNESCO, in Paris, 1969; mural, Central Trust Company, Cincinnati, OH, 1981. Represented in Whitney; Guggenheim; Metropolitan; Carnegie; Museum of Modern Art; others. Noted for his hard-edge, multi-paneled modular paintings also.

KELLY, JAMES EDWARD.
Sculptor. Born in NY, July 30, 1855. Pupil of National Academy of Design and Art Students League of New York; Theodore Robinson and Carl Hirschberg. Work: "Monmouth Battle Monument;" equestrian Gen. Sherman; "Col. Roosevelt at San Juan Hill;" etc. Represented by Southington, CT, war memorial; Monmouth Battle Monument. Illustrated for *Scribner's*; *Harper's*; *St. Nicolas*, until 1881; since then exclusively sculptor. One of the founders of New York Art Students League. Address in

1929, 318 West 57th St., NYC. Died in NY, 1933.

KELLY, LEE.
Sculptor. Born in McCall, Idaho, May 24, 1932. Studied at Museum of Art School, Portland, OR. Work at Portland Art Museum; Seattle Art Museum; others. Has exhibited at Denver Museum Annual Invitational; West Coast Now, Portland Art Museum. Received Seattle Art Museum Purchase Award; Ford Foundation Purchase Award; others. Taught art at Reed College, Portland, OR, 1976-80. Works in metal. Address in 1982, Oregon City, OR.

KELSEY, MURIEL CHAMBERLIN.
Sculptor. Born in Milford, New Hampshire. Studied at University of New Hampshire, BS, 1919; Columbia University; New School for Social Research, 1934; also with Dorothea Denslow, Sculpture Center, NYC. Works: Brookgreen Gardens, South Carolina. Member: American Association of U. Women, Mental Health Society, Sculpture Center NY, Art League Manatee County, Fla., Association Fla. Sculptors. Award: Sarasota Festival of Arts, 1953; others. Exhibited: Sculpture Center of New York, from 1934; Audubon Artist, NYC, 1958-62; Harmon Gallery, Naples, FL, from 1964; National Academy of Design; and others. She has also taught as an assistant in the zoology labs at the University of New Hampshire and Vermont. Works in stone. Address in 1982, c/o Oehischlaeger Galleries, 107 East Oak Street, Chicago, IL.

KELSEY, T. D.
Sculptor. Born in Shelley, Idaho, in 1940; raised near Bozeman, Montana. Saddle bronc rider for many years. Studied pre-med at Montana State University; flew for United Air Lines; acquired own ranch. Began modelling as a hobby; has concentrated on art since 1979. Work includes three bronzes commissioned by Professional Rodeo Cowboys' Hall of Fame in Colorado; life size bronze, Museum of Longhorn Breeders Association of America, Forth Worth, Texas. Specialty is Western cattle, saddle bronc and team roping. Works in bronze. Reviewed in *Artists of the Rockies*, fall 1981. Represented by Saks Gallery, Denver, CO; Peppertree Fine Art, Inc., Calabasas, CA. Address since 1972, Kiowa, Colorado.

KEMEYS, EDWARD.
Sculptor. Born in Savannah, GA, in 1843. He studied in New York and later in Paris. He made a specialty of the wild animals of the American continent. His "Fight between Buffalo and Wolves" was exhibited in the Salon of 1878. Among his works: "Panther and Deer," "Coyote and Raven;" he also made the colossal head of a buffalo for the Pacific Railroad station at St. Louis. A collection of some fifty of his small bronzes is at the National Gallery in Washington, DC. He died at Georgetown Heights, Washington, DC, in 1907.

KEMEYS, LAURA S. (MRS.).
Sculptor. Born in Cumberland Co., NJ. Pupil of Art Institute of Chicago under Edward Kemeys and Lorado Taft. Member: Washington Society of Artists. Address in 1916, 3122 P St., Washington, DC.

KEMPF, TUD.
Sculptor and craftsman. Address in 1933, Chicago, IL.

KENDAL, ELISABETH.
Sculptor, painter, and illustrator. Born in Gerrish Island, Maine, September 22, 1896. Pupil of Yale School of the Fine Arts. Address in 1924, 58 Trumbull St., New Haven, CT.

KENDALL, (WILLIAM) SERGEANT.
Sculptor and painter. Born Spuyten Duyvil, NY, January 20, 1869. Pupil of Art Students League of New York; Eakins in Phila.; Ecole des Beaux-Arts and Merson in Paris. Member: Society of American Artists, 1898; Associate, National Academy of Design 1901; Academician, National Academy of Design 1905; National Institute of Arts and Letters; New York Water Color Club; Conn. Academy of Fine Arts; Century Association; New Haven Paint and Clay Club. Dean, School of Fine Arts of Yale University, 1913 to 1922. Awards: Honorable mention, Paris Salon, 1891; medal, Columbian Exposition, Chicago, 1893; Lippincott prize, Penna. Academy of Fine Arts, 1894; honorable mention, Tennessee Centennial Exposition, Nashville, 1897; second prize, Worcester Museum, 1900; bronze medal, Paris Exposition, 1900; bronze medal, Carnegie Institute, Pittsburgh, 1900; second prize, Worcester Museum, 1901; silver medal for painting, bronze medal for drawing and honorable mention for sculpture, Pan-American Exposition, Buffalo, 1901; Shaw prize, Society of American Artists 1901; Shaw Fund Purchase, Society of American Artists 1903; gold medal, St. Louis Exposition, 1904; Isidor medal, National Academy 1908; Harris prize, Art Institute of Chicago 1908; Palmer gold medal, Art Institute of Chicago 1910; gold medal for painting and silver medal for sculpture, P.-P. Exposition, San Francisco, 1915; Butler prize, Art Institute of Chicago, 1918; gold medal, Miss. Art Association, 1926; Isidor medal, National Academy of Design, 1927. Work: "Beatrice," Pennsylvania Academy, Phila.; "The Seer," and "Psyche," Metropolitan Museum, New York; "An Interlude," National Gallery, Washington; "Narcissa," Corcoran Gallery, Washington; "Crosslights," Detroit Institute of Arts; "Intermezzio," RI School of Design, Providence, and many private collections. Address in 1929, Hot Springs, VA. Died 1938.

KENNEDY, SYBIL.
Sculptor. Born in Quebec, Canada, August 13, 1899. Studied at Montreal Art School and with Alexander Archipenko. Works: National Gallery, Canada; Montreal Museum of Fine Arts. Awards: Huntington prize, National Association of Women Artists, 1941; Amelia Peabody prize, 1948. Exhibited: National Academy of Design; Art Institute of Chicago; Weyhe Gallery (solo), NYC, 1949; others. Address in 1953, 55 East 86th Street, NYC.

KENNEY, BENJAMIN HARRIS.
Sculptor. At work in 1850's.

KENNY, LISA A.
Sculptor, painter, and primarily graphic artist. Born in Mineola, NY. Studied with Thomas Henry Kenny. Work: Museum of Modern Art, Miami, Fla.; Madison Art Center, Wisc.; Print Collection, Philadelphia Public Library; Wooster College Museum of Art, Ohio; Nassau Commu-

nity College Firehouse Gallery, Garden City, NY. Exhibitions: Graphics 1971, Miami Museum Modern Art. Address in 1982, San Diego, CA.

KENT, ADALINE.
(Mrs. Robert B. Howard). Sculptor. Born Kentfield, California, August 7, 1900. Studied at Vassar College; California School of Fine Arts; Grande Chaumiere, Paris; also with Ralph Stackpole, Antoine Bourdelle. Works: Stanford University; Mills College; San Francisco Museum of Art. Awards: San Francisco Museum of Art, 1937; West Coast Ceramics, 1945, 1958; San Francisco Art Council, 1952; Lafayette sculpture prize, 1955. Exhibited at World's Fair New York, 1939; California Palace of the Legion of Honor; Art Institute of Chicago; Museum of Modern Art. Address in 1953, San Francisco.

KENT, CAROLINE.
Sculptor. Born in 1934. She has worked with assemblage, montage, photo images, and real objects.

KEPALAS, (ELENA KEPALAITE).
Sculptor and painter. Born in Vilnius, Lithuania; US citizen. Studied at Ont. College of Art, Toronto; Brooklyn Museum School of Art. Works: Penna. Academy of Fine Art, Philadelphia; University of Mass. Art Gallery, Amherst; Library and Museum of Performing Arts, Lincoln Center, NY; Lithuanian Museum, Adelaide, Australia; Museum of Modern Art Lending Service, NY. Exhibitions: Penna. Academy of Fine Art, Philadelphia, 1968; Silvermine Guild Artists Annual, New Canaan, Conn., 1969; Jersey City Museum, NJ, 1969-71; Phoenix Gal., NY, many one-woman shows, Brooklyn Museum, NY, 1964. Media: Wax and metal. Address in 1982, c/o Phoenix Gallery, 30 West 57th Street, NYC.

KEPNER, RITA M.
Sculptor and writer. Born in Binghamton, NY, November 15, 1944. Studied: Elmira College, NY; Harpur College, State University of New York, Binghamton. Awards: Harpur College, 1966; Waterbury Arts Council Arts Festival, Connecticut, 1967; study-travel grant to Poland, 1975; others. Exhibitions: Seattle Art Museum, Washington, 1975; Master Works in Wood, Portland Museum of Art, OR, 1976; Zalaegerszeg City Musuem, Hungary, 1977; Bialystok Museum, Poland, 1977; Zoliborg Museum, Warsaw, Poland, 1981; and many earlier shows. Member: Accademia Italia Pelle Art e Del Lavaro; International Association of Art; International Artists Cooperation; Artists Equity Association; Polonia Cultural Soc. (liaison, from 1976). Works in stone and wood. Address in 1982, Seattle, WA.

KEPPLER, GEORGE.
Sculptor. Born in Germany, January 22, 1856. He came to America, and lived in Providence, RI. Studied in Baden and Berlin. Address in 1926, 56 Wesleyan Avenue, Providence, RI.

KERRIGAN, MAURIE.
Sculptor. Born in Jersey City, NJ, April 28, 1951. Studied at Moore College of Art, Philadelphia, PA, B.F.A., 1973; Art Institute of Chicago, M.F.A., 1977; Whitney Museum

of American Art, 1977. Work in Philadelphia Museum of Art; Phillips Collection, Smithsonian Institution. Has exhibited at Art Institute of Chicago; Academy of Fine Art, Philadelphia, PA; others. Member of Womens Caucus Art; Alumni Association, Art Institute of Chicago. Works in portable frescoes, wood. Address in 1982, Philadelphia, PA.

KETTLEWELL, NEIL M.
Sculptor. Born in Evanston, Illinois, in 1938. Studied at University of Michigan, PhD physiological psychology, 1968. Associate Professor, psychology, University of Montana; began sculpture as second career in 1977. Self-taught in art. Specialty is wildlife. Works in bronze. Reviewed in *Art West*, November 1979. Represented by Husberg Fine Arts, Sedona, AZ. Address since 1969, Missoula, Montana.

KEY, RAE.
(Mrs. Edmund Key, Jr.). Sculptor and painter. Born in Marshall, Texas. Self-taught. Member: Southern States Art League. Address in 1933, 109 East Crockett St., Marshall, Texas.

KEY-OBERG, ELLEN B.
Sculptor. Born in Marion, Alabama, April 11, 1905. Studied at Cooper Union Art School. Works: University of Wisconsin; Norfolk Musuem, Virginia. Awards: Audubon Artists, 1944; National Association of Women Artists, 1949. Exhibited at National Academy of Design, NY; Pennsylvania Academy of Fine Arts; Whitney. Taught sculpture and painting, Chapin School, 1937-70; sculpture workshop, Newark (NJ) Museum, 1955-65. Address in 1982, LaJolla, CA.

KEYES, BESSIE P.
Sculptor. Born in 1872. Elected to the National Academy in 1921.

KEYSER, EPHRAIM.
Sculptor and teacher. Born in Baltimore, October 6, 1850. Pupil of Royal Academies in Munich and Berlin. Member: National Sculpture Society 1907; Charcoal Club of Baltimore; American Federation of Arts. Awards: Silver medal, Munich Academy; first class medal, New Orleans Exposition, 1885. Work: Major General Baron de Kalb, Annapolis, MD; memorial to President Chester A. Arthur, Rural Cemetery, Albany, NY; "Psyche," life size marble, Cincinnati Art Museum; "Bust of Sidney Lanier," Johns Hopkins University. Instructor Rinehart School for Sculpture, Maryland Institute. Address in 1929, 20 Overhill Road, Roland, Park, Baltimore, MD. Died in 1937.

KEYSER, ERNEST WISE.
Sculptor and painter. Born Baltimore, MD, December 10, 1876. Pupil of Maryland Institute Art School in Baltimore; Art Students League of New York; Julian Academy in Paris; Augustus Saint-Gaudens. Member: National Sculpture Society 1902; Paris Allied Artists of America; New York Architecture League 1908. Award: Gold medal, New York Society of Architecture, 1923. Work: "Enoch Pratt Memorial," Baltimore; Adm. Schley statue,

Annapolis; "Sir Galahad" for Harper memorial, Ottawa, Canada; fountain, Newark Museum; memorial at Troy, OH. Exhibited at National Sculpture Society, 1923. Address in 1929, 59 West 12th St.; 249 West 74th St., New York, NY. Address in 1953, Atlantic Beach, FL. Died in 1959.

KIENHOLZ, EDWARD.

Sculptor and assemblagist. Born 1927, in Fairfield, Wash. Studied: Eastern Washington College of Education. Founder of the Now Gallery, Los Angeles. Work: Los Angeles County Museum of Art; Museum of Modern Art; Whitney Museum. Exhibited: Ferus Gallery, Los Angeles; Pasadena Art Museum; Dwan Gallery, Los Angeles; Dwan Gallery, NYC; Guggenheim; Museum of Modern Art, The Art of Assemblage; others. Address in 1970, c/o Eugenia Butler Gallery, L.A.

KIESLER, FREDERICK JOHN.

Sculptor and architect. Born on September 22, 1896, in Vienna, Austria. Came to US in 1926 and became a US citizen in 1936. Studied architecture at the Institute of Technology and the Academy of Fine Arts in Vienna. Designed Vienna's International Exhibition of New Theater Technique, 1924, and also the Austrian Theater Exhibit at the Paris World's Fair, 1925. As a registered architect he later designed and built the Art of the Century Gallery, NY, in 1940; Galerie Maeght, Paris, 1947; World House Galleries, NYC, 1957; and Kamer Gallery, NYC, 1959. During the late 30's and 40's associated with the Surrealists and designed the International Surrealist Exhibition in Paris, 1947. Some works include his wood construction entitled "Galaxy," 1947-48 (second version 1951); "Universal Theater," commissioned in 1961; and the "Shrine of the Book," a sanctuary in Jerusalem, 1965. In collection of Museum of Modern Art. Exhibited at Museum of Modern Art; Leo Castelli Inc., NYC, 1961, 62; The Howard Wise Gallery, NYC, 1969; Andre Emmerich Gallery, NYC, 1979, 1980; Guggenheim; Whitney; others. Noted for environmental sculpture, integrating plastic arts into an environmental context. Scenic director of the Julliard School of Music, 1933-57; director of the Columbia University School of Architecture's Laboratory for Design Correlation, 1936-42. Died in NYC, December 27, 1965.

KILENYI, JULIO.

Sculptor and medalist. Born in Arad, Hungary, February 21, 1885. Studied: Royal Academy of Art School, Budapest, Hungary; and in France and Germany. Designer of distinguished service medal of the US Navy Dept.; Lindbergh medal of St. Louis; Commander Byrd North Pole medal; Thomas A. Edison medallion for Edison Pioneers; General Pershing medallion for American Legion; Judge E. H. Gary for US Steel Corporation; medal for 150th anniversary Battle of Bunker Hill; and many more. Represented in the Metropolitan Museum of Art and Numismatic Museum, NY; Cleveland Museum of Art; Boston Museum of Fine Arts; Mass. Historical Museum; and others. Member: National Sculpture Society; Architectural League of New York; American Numismatic Society; Audubon Artists; Allied Artists of America; and

others. Exhibited at National Sculpture Society, 1923; National Academy of Design; Albright Art Gallery; Penna. Academy of Fine Arts. Address in 1953, 1 West 67th St., NYC. Died in 1959.

KILPATRICK, DeREID GALLATIN.

Sculptor and painter. Born Uniontown, September 21, 1884. Pupil of Lucien Simon, Rene Prinex, Emil Menard, Antoine Bourdelle, Raphael Collin. Studied in Paris. Work: Statue of Young George Washington, Lincoln Highway at Waterford, PA; statue of Colonel William Crawford, Connellsville, PA; bas reliefs, Methodist Episcopal Church, Greensburg, PA; old portraits, Court House, Uniontown, PA. Address in 1929, c/o Dr. A. G. Morgan, 45 Prospect Place, NYC; h. care of Dr. J. J. Kilpatrick, Bellefonte, PA; summer, The White Swan Hotel, Uniontown, PA.

KIMBALL, ISABEL MOORE.

Sculptor. Born Wentworth, Mitchell Co., IA. Studied: Pratt Institute Art School, Brooklyn, New York; also a pupil of Herbert Adams. Member: Society of Painters of New York; National Association of Women Painters and Sculptors; Brooklyn Society of Arts; Painters and Sculptors; American Federation of Arts. Work: "Wenonah" Fountain in Central Park, Winona, Minn.; gold medal, YMCA swimming and life saving; Richards memorial tablet, Vassar College; Barrett memorial, Historical Society, Des Moines, Iowa; war memorial tablet for Essex, Conn.; war memorial tablet, Mountainville, NY; Burnett memorial tablet, Central High School, Kalamazoo, Mich.; Brooklyn Botanical Gardens; Riceville, IA. Address in 1953, Elgin, IL.

KIMMELMAN, HAROLD.

Sculptor. Born in Philadelphia, PA, February 20, 1923. Studied at Cape School of Art, Provincetown, MA; Penna. Academy of Fine Arts, Philadelphia. Has exhibited at Penna. Academy of Fine Arts; others. Received May Audubon Prize for sculpting. Member of Artists Equity Association; fellowship, Penna. Academy of Fine Arts. Works in stainless steel and bronze. Address in 1982, Philadelphia, PA.

KING, DAISY B.

Sculptor and painter. Born in Washington, DC, September 8, 1875. Studied at Corcoran School of Art, with E. F. Andrew; Boston Museum of Fine Arts School, with Bela Pratt; and with H. J. Ellicott. Awards: Medal, Corcoran School of Art. Work: St. Paul's Church, Stockbridge, MA; mural, Gurley Mem. Church, Washington, DC; and many portraits. Exhibited: Architectural League; National Academy of Design; Society of Independent Artists. Address in 1953, 39 Gramercy Park, NYC.

KING, JOHN CROOKSHANKS.

Sculptor. Born October 11, 1806, in Kilwinning, Ayrshire, Scotland. Came to United States in 1829. Worked as machinist in New Orleans, Louisville, and Cincinnati until 1833. Met Hiram Powers in Cincinnati. After 1840, moved to Boston. Executed marble busts and cameo likenesses. Among his best known busts are: "Daniel Webster," "John Quincy Adams," "Louis Agassiz" and

"Emerson." Died in Boston, April 22, 1882.

KING, MARION PERMELIA.
Sculptor. Born Ashtabula, Ohio, October 7, 1894. Pupil of Charles Grafly. Member: Cleveland School of Art Alumni; Fellowship Penna. Academy of Fine Arts; Allied Artists of America; Society of Independent Artists; American Federation of Arts. Awards: Cresson Traveling Scholarship, Penna. Academy of Fine Arts, 1923-25; Stimson Prize, 1925. Address in 1929, 14 Sherman St., Ashtabula, Ohio.

KING, ROY E.
Sculptor. Born in Richmond, VA, November 22, 1903. Studied at Beaux-Arts Institute of Design; and with Bridgman, Lawrie, Jennewein. Member: National Sculpture Society. Work: Sculpture, busts, figures, panels, College of City of New York; United States Post Office, Bloomsburg, PA; US Military Academy, West Point, NY; Honolulu, Hilo, Schofield, St. Andrew's Cathedral, all in Hawaii. Address in 1953, 2850 Kalihi St., Honolulu, HI.

KING, S. CECILIA COTTER.
(Mrs. W. A. King). Sculptor and painter. Born in Tipperary, Ireland, October 30, 1874. Pupil of Cincinnati Art Academy, under Sharp, Meakin, and Nowottny in painting and Rebisso in sculpture. Associate member, Society of Western Artists. Address in 1910, 147 Bead Ave., Central Park, Buffalo, NY.

KING, VIRGINIA MORRIS.
(Mrs. Sylvan King). Sculptor. Born in Norfolk, VA, October 16, 1879. Pupil of Solon Borglum and of Harriet Frishmuth. Awards: Florence K. Sloane prize and Elsie Stegman prize, Norfolk Society of Artists, 1921. Member: Norfolk Society of Artists. Address in 1926, Keokuk St., Chevy Chase, Washington, DC; summer, 596 Mowbray Arch, Norfolk, VA.

KING, WILLIAM DICKEY.
Sculptor. Born February 25, 1925, Jacksonville, Florida. Studied: University of Florida, 1942-44; Cooper Union, 1945-48, with Milton Hebald, John Hovannes; Brooklyn Museum School, 1948-49; Central School of Arts and Crafts, London, 1952; others. Taught at Brooklyn Museum School, 1953-60; Berkeley; Art Students League 1968-69. Awards: Cooper Union 1948 & 64; Fulbright, 1949; others. Exhibited at Philadelphia Museum of Art; Museum of Modern Art; Guggenheim; Cooper Union; Whitney; Terry Dintenfass, NYC, and many others. In collections of Addison; Syracuse University; Cornell; Bankers Trust in NYC; mural commission, *SS United States*; others. Address in 1982, 17 E. 96th Street, New York, NY.

KINGSLEY, NORMAN WILLIAM.
Sculptor, portrait painter, engraver, and dentist. Born in St. Lawrence Co. NY, October 26, 1829. Practiced dentistry in Elmira and Troy, NY; moved to NYC in 1852. Member: Lotos Club. Work includes a bust of Whitelaw Reid at the Lotos Club, NYC. He exhibited at the National Academy, 1859-80. Address in 1909, Warren Point, NJ.

KINGTON, L(OUIS) BRENT.
Sculptor and educator. Born in Topeka, KS, July 26, 1934. Studied at University of Kansas, B.F.A., 1957; Cranbrook Academy of Art, M.F.A., 1961. Work at Museum of Contemporary Crafts, NY; St. Paul Art Center, MN; Krannert Art Museum, University of Illinois; others. Has exhibited at North American Goldsmiths, Smithsonian, Washington, DC; Cranbrook Museum of Art, Bloomfield Hills, MI; Museum of Contemporary Art, Chicago; Victoria and Albert Museum, London. Member of Society of North American Goldsmiths; Artists-Blacksmiths Association of North America. Teaching at Southern Illinois University, Carbondale, from 1961, metal smithing. Works in metals. Address in 1982, Carbondale, IL.

KINMONT, ROBERT.
Sculptor. Born in Los Angeles, CA, 1937. Studied: Japanese calligraphy, Sumi-e, and oil painting privately in Los Angeles; San Francisco Art Institute, B.F.A., 1970; University of California, Davis, M.F.A., 1971. Lived in Seattle, Washington, 1962-64; moved to San Francisco, 1965. Exhibitions: Gallery Reese Palley (solo), San Francisco, 1971; Slant Step Show, Berkeley Gallery, San Francisco, 1966; Idea-Document, Paula Cooper Gallery, NY, 1969; Extraordinary Realities, Whitney Museum of American Art, NY, 1973; San Francisco Art Institute, 1974; Word Works, Too, Art Gallery, San Jose State University, CA, 1975; San Francisco Museum of Modern Art, 1976; National Collection of Fine Arts, Smithsonian, 1977. Address in 1977, Bishop, CA.

KINNEY, BENJAMIN HARRIS.
Sculptor and marble cutter. Born February 7, 1821, in Mass.; raised in Sunderland, VT. Became established in Worcester MA, after 1843, with a sojourn in Rutland, VT, in 1850. His bust of Isaiah Thomas is owned in Worcester, Mass. Also represented at American Antiquarian Society. Died December 1888, in Worcester.

KINZINGER, ALICE FISH.
Sculptor, painter, educator, and craftswoman. Born in Grand Rapids, MI, November 6, 1899. Studied at University of Michigan, A.B.; Art Institute of Chicago; Baylor University, M.A.; and with Hans Hofmann. Member: Texas Fine Arts Association. Work: Francis Parker School, Chicago, IL; murals, Pub. School, Grand Rapids, MI. Exhibited: Minneapolis Institute of Art; Grand Rapids Art League; West Texas Exhibition, Ft. Worth, TX. Position: Instructor, Baylor University, Waco, TX, 1935-46. Address in 1953, 1621 South 9th Street, Waco, TX.

KIPP, LYMAN.
Sculptor. Born December 24, 1929, Dobbs Ferry, NY. Studied Pratt Institute, 1950-54; Cranbrook Academy of Art, 1952-53. Work: Albright; Univ. of California; Cranbrook; Dartmouth College; MIT; Univ. of Michigan; South Mall, Albany; Whitney Museum. Exhibited: Cranbrook; Betty Parsons Gallery, NYC; RI School of Design; Whitney Museum Annuals, 1956, 60, 62, 66, 68; Claude Bernard, Paris; Art Institute of Chicago; Carnegie; Jewish Museum; Musee Cantonal des Beaux-Arts, Lausanne, II Salon International de Galeries Pilotes, 1966; Los Angeles County Museum of Art; Museum of Modern Art.

Awards: Guggenheim Foundation Fellowship, 1965; Fulbright Grant, 1966; others. Member: American Association of University Professors. Taught: Harvey School, Hawthorne, NY; Cranbrook Academy of Art; Bennington College, 1960-63; Hunter College, 1964-67; Herbert Lehman College, 1966-75; Dartmouth College, 1969. Address in 1982, Somers, NY.

KIRCHMAYER, JOHN.
Sculptor and carver. Born in Bavaria, 1860. Died in Mass., 1930. (Mallett's)

KIRCHNER, EVA LUCILLE (EO).
Sculptor, ceramist, designer, educator, and lecturer. Born in Rich Hill, MO, September 25, 1901. Studied at Denver Art Academy; Denver University; University of Chicago; Columbia University; University South Calif.; Alfred University. Member: Colorado Society of Ceramists; 15 Colorado Artists. Exhibited: Denver Art Museum (one-woman). Work: Sculpture and panels, City and County Building, Denver, CO; garden sculpture, St. Anne's Orphanage, Denver. Position: Instructor, Museum of Art School, Denver Art Museum, Denver, CO. Address in 1953, 2921 East 14th Ave., Denver, CO.

KIRK, FRANK C.
Sculptor and painter. Born in Zitomir, Russia, May 11, 1889. Studied at Penna. Academy of Fine Arts, with Hugh Breckenridge, Daniel Garber, Cecilia Beaux, Philip Hale; and in Paris. Member: National Academy of Design; Conn. Academy of Fine Arts; Society of Wash. Artists; Artists Equity Association; Audubon Artists; Boston Art Club; Allied Artists of America; Wash. Art Club; North Shore Art Assn; Copley Society, Boston; Springfield Art League. Awards: Fellowship, Penna. Academy of Fine Arts; Cresson traveling scholarship, Penna. Academy of Fine Arts; prizes, Conn. Academy of Fine Art, 1934, 39, 51; Ogunquit Art Center, 1935; Allied Artists of America, 1943, 45; Springfield Art League, 1943; North Shore Art Association, 1947, 48, 51. Work: Museum Western Art, Moscow, Russia; State Museum, Trenton, NJ; Binghamton Museum of Art; Cayuga Museum of History and Art; Phila. Museum of Art; Biro-Bidjan Museum, Russia. Exhibited nationally. Address in 1953, 38 Union Sq., NYC. Died in 1963.

KIRK, JEROME.
Sculptor. Born in Detroit, MI, April 3, 1923. Studied at Mass. Institute of Technology, B.S. Work in San Francisco Museum of Modern Art; Phoenix Art Museum; Storm King Art Center, Mountainville, NY. Has exhibited at De Young Museum Collectors Show; Krannert Art Museum, Champaign, IL; Storm King Art Center; Indianapolis Museum of Art; others. Address in 1982, Oakland, CA.

KIRMSE, MARGUERITE.
Sculptor, painter, illustrator, and etcher. Born Bournemouth, England, December 14, 1885. Pupil of Frank Calderon. Member: Phila. Painters Club; Springfield Art Association. Illustrated "Bob, Son of Battle," by Ollivant. Address in 1929, 231 East 48th St., New York, NY; summer, Bridgewater, Conn. Died in 1954.

KIRPAL, ELSA.
See Elsa Kirpal Peterson.

KIRSCHENBAUM, BERNARD EDWIN.
Sculptor. Born in NYC, September 3, 1924. Studied at Cornell University; Chicago Institute of Design, B.A. Work at Storm King Art Center, Mountainville, NY. Has exhibited at Central Park (Sculpture in Environment), NY; Newark Museum, NJ; Indianpolis Museum of Art; Corcoran Gallery of Art; Storm King Art Center. Received Guggenheim Fellowship, Sculpture. Address in 1982, 180 Park Row, NYC.

KIRSTEN, RICHARD CHARLES.
Sculptor, graphic artist, and painter. Primarily painter and graphics. Born in Chicago, IL, April 16, 1920. Studied at Art Institute of Chicago; University of Wash.; and in Japan. Member: American Federation of Arts; Northwest Water Color Society; Northwest Printmakers; Artists Equity Association. Awards: Prizes, Seattle Art Museum, 1949, 50; Music and Art Foundation, 1951; Northwest Water Color Society, 1952. Exhibited: Seattle Art Museum, 1945, 47-52; Western Wash. Fair, 1949-51; Music and Art Foundation, 1949-52; Pacific Northwest exhibition, Spokane, Wash., 1949-51; Northwest Printmakers, 1950, 51; Buffalo Print Club, 1951; Artists Equity Association (Seattle Chptr.) 1952; one-man: Seattle Art Museum, 1943; Studio Gallery, 1949, Millard Pollard Association, 1952, Hathaway House, 1952, all in Seattle. In collections of Metropolitan Museum; Seattle Art Museum; Tokyo Museum of Modern Art. Position: Specialist (Artist) US Navy, Chicago, 1944-46; artist, Kirsten Pipe Co., 1946-48; Ed. Art, Seattle Post-Intelligencer, from 1948. Address in 1982, Seattle, WA.

KISCH, GLORIA.
Sculptor. Born in NYC, November 14, 1941. Studied at Sarah Lawrence College, B.A., 1963; Boston Museum School, 1964-65; Otis Art Institute, Los Angeles, B.F.A. and M.F.A., 1969. Works: Palm Springs Desert Museum, Calif.; Downey Museum of Art, Calif.; Otis Art Institute, Los Angeles: Milwaukee Art Museum. Denver Art Museum. Exhibitions: One-woman shows, Suzanne Saxe Gallery, San Fran., 1973, Newport Harbor Art Museum, Newport Beach, Calif., 1974; Cirrus Gallery, Los Angeles, 1974 and 75 and Wade Stevenson Gallery, Paris, 1975; Milwaukee Art Museum, 1981; others. Address in 1982, 620 Broadway, NYC.

KISELEWSKI, JOSEPH.
Sculptor. Born Browerville, MN, February 16, 1901. Studied at Minneapolis School of Art, 1918-21; National Academy of Design, 1921-23; Beaux-Arts Institute of Design, NY, 1923-25; American Academy in Rome; Academie Julian, Paris. Member: National Academy of Design; National Sculpture Society; Architectural League; American Academy in Rome. Awards: Prix de Rome, 1926-29; Watrous gold medal; prize, Beaux-Arts, Paris; and others. Work: Statue, Milwaukee, WI; groups, Bronx County Court House, NY; fountain at Huntington Museum, SC; pediment, Commerce Building, Washington, DC; George Rogers Clark memorial, Vincennes, IN; plaques, Capital Building, Washingtion, DC, Covington, KY, John Peter Zanger School, NY; reliefs, General Accounting Building, Washington, DC; statue, Harold Vanderbilt, Nashville, TN; statue, Moses, Syracuse Univer-

sity Law School; others. Address in 1982, Browerville, MN.

KISLOV, RICHARD.
Sculptor. Member of the National Sculpture Society. Address in 1982, N. Muskegon, MI.

KISSEL, WILLIAM THORN, JR.
Sculptor. Born in NYC, February 6, 1920. Studied at Harvard University, B.A., 1944; Penna. Academy of Fine Arts, 1951-53; Barnes Foundation, Merion, PA, graduate, 1953; Rinehart Graduate School of Sculpture, graduate, 1958, with Sidney Waugh, Cecil Howard, and Bruce Moore. Has exhibited at American Artists Professional League Grand National, Lever House, NY; National Academy of Design Exhibitions; National Sculpture Society Exhibitions. Received Speyer Awards, National Academy of Design; American Artists Professional League Award. Member of National Sculpture Society; fellow, American Artists Professional League; fellow, Penna. Academy of Fine Arts; Municipal Art Society of NY. Works in bronze and marble. Address in 1982, Owings Mills, MD.

KITSON, HENRY HUDSON.
Sculptor. Born Huddersfield, England, April 9, 1865. Pupil of Ecole des Beaux-Arts in Paris under Bonnaissieux. Member: Copley Society, 1899; Boston Society of Arts and Crafts; Boston Art Club; Eclectics. Awards: Three gold medals, Mass. Charitable Mechanics' Association, New York, 1886; bronze medal, Paris Exposition, 1889; medal, Columbian Exposition, Chicago, 1893; decoration from King of Rumania; medal, Paris Exposition, 1900. Work: "The Minute Man," Lexington, Mass.; Cedar Rapids, Iowa; Dyer Memorial Fountain, Providence; W. M. Hunt Memorial, Boston; "Music of the Sea," Boston Museum; "Viscount James Bryce," bronze bust, National Gallery, Washington, DC; National Gallery, London, England; Newark Museum; "Admiral Selfridge," Vicksburg, Miss.; "Roger Conant" statue, Salem, Mass.; "Patrick A. Collins Monument," "Robert Burns Monument," "Henry B. Endicott Memorial," "Gov. Banks Monument," Boston, Mass.; "Farragut Statue;" "Lt. Gen. Stephen D. Lee," "Gen. Martin L. Smith," "Iowa State Memorial," Vicksburg, Miss.; "Thomas A. Doyle statue," Providence, RI; "Walt Whitman," bust, London, England; "Elizabeth, Queen of Roumania (Carmen Sylva)," "Carol, King of Roumania," Bucharest, Roumania; "Christ," Drexel Memorial Chapel, Philadelphia, PA; "Haynes Memorial," Newark, NJ. Address in 1929, 4 Harcourt St., Boston, Mass. Died in 1947.

KITSON, SAMUEL JAMES.
Sculptor. Born in England in 1848, he came to America in 1878, having studied in Italy. He produced such work as the "Sheridan Monument" and the portrait of Gov. Greenhalge in the State House at Boston. He died in New York in 1906.

KITSON, THEO ALICE RUGGLES.
(Mrs. H. H. Kitson). Sculptor. Born Brookline, Mass., 1871. Pupil of H. H. Kitson in Boston; Dagnan-Bouveret

in Paris. Member: Copley Society; National Sculpture Society. Awards: Hon. mention, Paris Salon, 1890; two medals, Mass. Charitable Mechanics' Association; bronze medal, St. Louis Exposition, 1904. Work: "Minute Man of '76," Framingham, Mass.; soldier monuments at Goshen, NY; Walden, NY; Vicksburg, MS; Minneapolis, MN; Pasadena, CA; Providence, RI; Little Falls, RI; Ashburnham, MA; North Andover, MA; North Attleboro, MA; Sharon, MA; Topsfield, MA; Spanish War monuments at Schenectady, NY, and Lynn, MA; World War memorials, Dorchester, MA; Brookline, MA; Francestown, NH; Equestrian Statue of Victory, Hingham, MA; portrait statue of "Gen. Kosciuszko," Public Gardens, Boston, MA; memorial statue, Mt. Auburn, Cambridge, MA. Address in 1929, Framingham, MA.

KITTELSON, JOHN HENRY.
Sculptor and painter. Born in Arlington, SD, 1930. Self-taught as a sculptor. Worked as a saddlemaker; as a cowboy in South Dakota, Montana, Nebraska, Wyoming, and Colorado. Began painting in oil about 1956. In 1970 he began sculpting in bronze. Member of Cowboy Artists of America. Reviewed in *Arizona Living* 10/26/73. Specialty is Western subjects in traditional style. Works in wood, bronze, ceramics. Address in 1976, Fort Collins, Colorado.

KLASS, DAVID.
Sculptor. Born in Washington, DC, 1941. Studied: Pratt Institute, School of Arch., 1959-62, Art School, B.F.A., 1962-66; under Theodore Roszak, 1966-68; Columbia College of Physicians and Surgeons, 1973-74. Exhibitions: Riverside Museum, NYC, 1962; National Academy of Design Annual, NYC, 1971; NJ Painters and Sculptors Society, Jersey City, NJ, 1971, 72, 73, 74, 75; First Street Gallery, NYC, 1977; National Sculpture Society Annual, NYC, 1981; Salmagundi Annual, NYC, 1983; others. Awards: New Jersey Painters and Sculptors Society, Honorable Mention, 1975; National Academy of Design, Helen Foster Barnett Prize, 1976; Salmagundi Annual, The Phillip Isenberg Award, 1983. Membership: President of Society of Artists and Anatomists. Taught: Pratt Institute, 1968-69; University of Bridgeport, CT, 1971; Educational Alliance Art School, NYC, 1972-75; Bennington College, VT, 1978; Parsons School of Design, NYC, 1978-79; Sculpture Center School, NYC, 1983; private classes in anatomy, from 1974. Noted for his Judaic sculptures such as the Rochester Holocaust Memorial, Rochester, NY. Other noted works include "Spirit of Dance" and "Pegasus." Media: Metals. Address in 1984, 136 West 24th Street, NYC.

KLASSEN, JOHN P.
Sculptor, painter, educator, and craftsman. Born in Ukraine, Russia, April 8, 1888. Studied at Ohio State University; and in Germany. Member: Columbus Art League. Awards: Prize, Columbus Gallery of Fine Art, 1945. Exhibited: Syracuse Museum of Fine Art, 1939; Columbus Gallery of Fine Art, 1939-46. Lectures: Mennonite Art. Position: Prof. of Art, Bluffton College, Bluffton, OH, 1924-46. Address in 1953, Bluffton, OH.

KLASSTORNER, SAMUEL.
Sculptor and teacher. Born Russia, February 25, 1895. Pupil of Art Institute of Chicago. Member: Chicago Painters and Sculptors; Chicago Society of Art. Awards: Adams Foreign Traveling Fellowship, Art Institute of Chicago; Englewood Woman's Club prize, 1921, from Chicago Society of Art; Frank G. Logan medal and $200, Chicago Society of Art; honorable mention, Painters and Sculptors, 1923, Art Institute of Chicago. Address in 1933, Chicago, Ill.

KLAUDER, ELFRIEDA.
Sculptor. Member: Fellowship of Penna. Academy of Fine Arts. Address in 1924, 400 Gowen Ave., Germantown, Philadelphia, PA.

KLAUDER, MARY.
Sculptor. Exhibited "A Study" at the Penna. Academy of the Fine Art, Philadelphia, 1914. Address in 1926, Bala, Penna.

KLAVANS, MINNIE.
Sculptor and painter. Born in Garrett Park, MD, May 10, 1915. Studied at Wilson Teachers College, B.S. Ed., 1935; private instructor in silversmithing, 1951-55; painting with Laura Douglas, 1958-60; American University 1960-64; with Luciano Penay, 1965-70; Corcoran Gallery of Art, plastics with Ed McGowin, 1970-71. Represented in National Collection of Fine Arts, Smithsonian Institution, White House, Corcoran Gallery of Art and National Endowment for the Arts, all in Wash., DC; Museum of Contemporary Art, Madrid, Spain; Baltimore Museum of Art, MD. Exhibited at Corcoran Gallery of Art, 1965 and 67; Baltimore Museum of Art, MD, 1967 and 72; Cisneros Gallery, NY, 1967; Museum of Modern Art, Bilbao, Spain, 1969; Chrysler Museum of Art, Norfolk, VA, 1972. Awards: First Prize for silversmithing, Smithsonian Institution, 1953 and 55; Spec. Award, Baltimore Museum of Art, 1967. Member: Artists Equity Association. Address in 1982, Washington, DC.

KLAVUN, BETTY.
Sculptor. Born in Boston, MA. One-man shows: Bertha Schaefer Gallery, 1968-71-72; Ingber Galleries; Bridge Gallery, 1965; J. Walter Thompson, 1968. Group shows: American Academy of Arts and Letters; Art Park; Storm King, Mountainville, NY; Sculptor's Guild, 1973-74-75; Monmouth Museum of Arts and Sciences; Sculpture in the Park, 1974; New Jersey; City of NY; Cultural Affairs, 1974; Annuals of Federation of Modern Painters and Sculptors, NYC. Collections: GAME Children's Museum; Children's Psychiatric Center; General Theological Seminary; City of Scottsdale, AZ; Mayo Foundation; Ciba Geigy collection.

KLEIN, FRANK ANTHONY.
Sculptor and craftsman. Born in Trier, Germany, June 23, 1890. Studied in Germany, with Van de Velde, Grasseger, Sobry. Member: Allied Artists of America. Work: Statues, portraits, memorials, monuments: Court St., Brooklyn, NY; St. Nicolas Cemetery, Passaic, NJ; St. Catherine of Siena Church, NY; Brooklyn Technical High School; Richmond Hill, NY; St. Stephens Church, Arlington, NJ;

Our Lady of Angels Church, Brooklyn, NY; also work in ceramics. Exhibited: Architecture League; National Sculpture Society; Whitney Museum of American Art; Brooklyn Museum; Penna. Academy of Fine Arts; New York Historical Society. Contributor: Articles and illustrations, newspapers and magazines. Address in 1953, 1244 East 45th St., Brooklyn, NY.

KLEINSMITH, GENE (EUGENE DENNIS).
Sculptor and writer. Born in Madison, WI, February 22, 1941. Studied at Augustana College, Sioux Falls, SD, with Palmer Eide and Ogden Dalyrymple, B.A. (art), 1963; Colorado State University, Fort Collins, with William C. Alexander and Clara Hatton, 1966; Northern Arizona University, Flagstaff, with Dr. Donald Bendel and Dr. Peter Jacobs, M.A. (art), 1969. Work at Walker Art Center, Minneapolis; Los Angeles Co. Museum; others. Has exhibited Clay and Fiber, Minneapolis Institute of Art; American Bicentennial Exhibition, Paris, France; National Endowment Traveling Exhibition, southern California; others. Member: American Crafts Council; Los Angeles Co. Art Museum Association; others. Works in stoneware and metal assemblages. Address in 1982, Apple Valley, CA.

KLINE, ALMA.
Sculptor. Born in Nyack, NY. Studied at Radcliffe Col., A.B.; also sculpture with Jose DeCreeft. Works in Norfolk Museum of Arts and Science, VA; St. Lawrence University, NY. Exhibited at Women's Int. Art Club, London, 1955; National Association of Women Artists, Museum Bellas Artes, Buenos Aires, 1963; ten one-woman shows, Travel Art Guild, 1964; one-woman show, Thomson Gallery, NY, 1969; Society of Animal Artists, Natural History Museum, Smithsonian Institution, 1971; Academy of Natural Science, Phila. Awarded Grumbacher Purchase Award, Audubon Artists, 1960; Medal of Honor, Knickerbocker Artists, 1964; Patrons of Art Award, Painters and Sculptors Society, NJ, 1969. Member of Society of Animal Artists; National Association of Women Artists; others. Media: Wood and stone. Address in 1982, 225 East 74th Street, NYC.

KLING, BERTHA.
Sculptor. Born in Philadelphia, PA, August 8, 1910. Studied at Boston Museum of Fine Arts School; Fontainebleau School of Fine Art, France; Penna. Academy of Fine Art. Member: Philadelphia Art Alliance. Awards: Fellowship, Penna. Academy of Fine Arts; Hunt traveling scholarship, Boston, 1933; prizes, RI Chronicle, 1936; Penna. Academy of Fine Arts, 1940. Exhibited: New York World's Fair, 1939; Penna. Academy of Fine Art, 1935, 36, 38, 43; National Sculpture Society, 1935, 38, 40, 42; Philadelphia Art Alliance, 1935-45; Newport Art Assn., 1938, 39, 40; Providence Art Club, 1935-39, 41. Lectures: Techniques of Sculpture and Bronze Casting. Address in 1953, 1676 Margaret St., Philadelphia, PA.

KLINGHOFFER, SHIRLEY.
Sculptor. Work includes "Round In Circles," marplex, exhibited at National Association of Women Artists, NYC, 1983. Member: National Association of Women Artists. Address in 1983, Westfield, NJ.

KLOTZ-REILLY, SUZANNE RUTH.
Sculptor and painter. Born in Shawno, WI, October 15, 1944. Studied at Washington University; Kansas City Art Institute; University of Missouri; others. In collections of Minnesota Museum of Art, Saint Paul, 1973; Abilene Fine Arts Museum, 1973; Oklahoma Art Center, Oklahoma City, 1974; others. Exhibited: Dallas Museum of Fine Arts, TX, 1973; Phoenix Art Museum, 1981; Mira Costa College, Oceanside, Calif., 1982; Minnesota Museum of Art; others. Address in 1982, c/o Lambert Miller Gal., 24 North Second Street, Phoenix, AZ.

KNAPP, SADIE MAGNET.
Sculptor and painter. Born in NYC, July 18, 1909. Studied at New York Training School for Teachers, lic.; City College of New York; Brooklyn Museum Art School; Atelier 17; Sculpture Center. Works: Georgia Museum Art, Athens; Norfolk Museum Art, VA; Riverside Museum, NY; others. Exhibitions: Corcoran Gallery Art, Washington, DC; Baltimore Museum; Penna. Academy of Fine Art, Philadelphia; Butler Institute of Art, Youngstown, Ohio; plus others in Canada, England, France, Switzerland, Argentina, Mexico, Japan, India, Scotland and Italy. Received Awards for Painting, Baltimore Museum, 1956, 58, and 61; Award for Painting, Silvermine Guild Artists, 1965; Grumbacher Award for Painting, National Academy of Design, 1968; Cramer Prize, 1980. Member: National Association of Women Artists; National Society of Painters in Casein and Acrylics; Artists Equity Association; others. Address in 1982, West Palm Beach, FL.

KNAPP, TOM.
Sculptor. Born in Gillette, Wyoming, September 28, 1925. Studied at California College of Arts and Crafts, Oakland, California; Art Center School of Design, Los Angeles. Initially worked as animation artist, Mountain Bell Telephone, Albuquerque, New Mexico. Turned to sculpture full-time in 1969. Work in Whitney Gallery of Western Art, Cody, Wyoming; Indianapolis Museum of Art; and commissions. Awarded best of show (bronze), Sacramento Indian Art Show, 1974; first place (Indian art), Great Western Exhibition Center, Los Angeles, 1974; first place (bronze), San Diego Indian Art Show, 1974. Specialty is subjects of the modern Western scene. Works in bronze, which he casts himself. Reviewed in *New Mexico Magazine*; *Art West*. Represented by Fowler's Gallery. Address since 1971, Ruidoso Downs, New Mexico, where he owns Buckhorn Bronze Foundry.

KNAPP, WILLI.
Sculptor, painter, and etcher. Born in Hofeld, Germany, April 4, 1901. Studied at Art Institute Chicago. Awards: First prize, Wis. State Exhibition, 1929 and 1930; sculpture prize, Milwaukee Art Institute, 1930; prize, applied art, Wis. Applied Art Association, 1931; medal, Milwaukee Art Institute, 1932, second prize, applied arts, 1932, first prize, applied arts, 1933. Represented in State Teachers College, Milwaukee, Wis. Address in 1933, 419 East Townsend St., Milwaukee, Wis.

KNEELAND, HORACE.
Sculptor. Born c. 1808 in New York City. Worked in New York City 1839-51. Exhibited: National Academy; American Art Union. Work possibly includes bas-relief of a "Trotting Horse," owned in Washington, DC. Died c. 1860.

KNIGHT, CHARLES R(OBERT).
Sculptor, painter, and illustrator. Born Brooklyn, NY, October 21, 1874. Studied: Art Students League; Brooklyn Polytechnic Institute. Pupil of Brush and DuMond. Work: Mural decorations of prehistoric animals and men, American Museum of Natural History, New York; Los Angeles Museum; Field Museum, Chicago. Specialty, animals and birds, modern and fossil. Member: New York Archicture League, 1912. Address in 1953, 24 West 59th Street, New York City. Died in NYC, April 1953. By 1953, no longer listed as a sculptor.

KNOCHE, LUCILLE (MORLEY).
Sculptor, painter, and designer. Primarily designer. Born in Mt. Vernon, NY, March 23, 1899. Studied at Art Institute of Chicago; Illinois Institute of Technology, and in Germany. Member: Inter-Society Color Council; American Society for Aesthetics; Industrial Designers Institute. Awards: All American Packaging award, 1942. Work: San Fran. Museum of Art; Typographical Art Society, Chicago; New York World's Fair. Exhibited: Industrial Designers Institute traveling exhibition. Co-editor, *Descriptive Color Names Dictionary*, 1950. Contributor to *Better Homes and Gardens*, *Good Housekeeping*, *Forum*, *Interior Design*, and other national magazines. Arranged exhibitions for Fashion Group, Chicago; Marshall-Fields; Container Corp. America; Inter-Society Color Council. Positions: Color and Fabric Stylist, Montgomery Ward Co., NY; Color Technician, Montgomery Ward, Chicago, 1942-46, Butler Bros., 1946-48, Sears Roebuck Co., 1953. Address in 1953, Chicago, IL.

KNOLLENBERG, MARY T.
Sculptor. Born in Great Neck, NY, 1904. Studied at School of American Sculpture, with Mahonri Young; Grande Chaumiere, with Bourdelle, Paris, France; Corcoran School of Art with Warneke. Award: Guggenheim fellowship, 1933.

KNOWLTON, GRACE FARRAR.
Sculptor. Born in Buffalo, NY, March 15, 1932. Studied at Smith College, B.A.; Corcoran School of Art; American University; painting with Kenneth Noland and Vatclav Vytlacil; drawing and sculpture with Lothar Brabanski; welding steel with Martin Chirino. Work: J. Patrick Lannan Museum, Palm Beach, Fla.; Lloyds of London, Washington, DC; Newark Museum, NJ; Storm King Art Center, Mountainville, NY. Exhibitions include one-woman shows at Hinckley and Brohel Gallery, Washington, DC, 1969, Spectrum Gallery, NY, 1971, Henri Gallery, Washington, DC, 1973, Razor Gallery, NY, 1974. Also exhibited at Parsons-Dreyfuss Gallery, NYC. Member: American Federation of Art. Address in 1982, Sneden's Landing, Palisades, NY.

KOBLICK, FREDA.
Sculptor. Born in San Francisco, Calif. Studied at San Francisco City College; San Francisco State College; Plastic Indust. Technical Institute, plastic engineer, 1943.

Commissions: Cast acrylic doors, Sheraton Dallas Hotel, Texas, 1961; prismatic construct of acrylic, Anshen and Allen, Int. Building, San Francisco, 1963; cast acrylic relief, Rohm and Haas Co., Independence Hall, Phila., 1964; cast acrylic fountain, Robert Royston, City of Vallejo, Calif., 1966; San Francisco International Airport. Exhibitions: Museum of Contemporary Crafts, NY, 1968; Fountain Art Gallery, Portland, 1971; Pierres de Fantasie, Oakland Museum, Calif.; others. Awards: Louis Comfort Tiffany Foundation Grant in Aid, 1969; Guggenheim Foundation Fellowship, 1970-71. Member: Artists Equity Association; Plastics Institute of Great Britain. Works in plastic. Address in 1982, San Francisco, CA.

KOELPIN, WILLIAM J.
Sculptor and painter. Self-taught. Work: Wildlife World, Colorado; Ward Foundation, MD; limited edition sporting art prints; numerous private collections. Exhibited: Leigh-Yawkey-Woodson Museum, Smithsonian Institution, Birmingham Museum of Fine Art, Cleveland Museum of Natural History, Colorado Museum of Natural History, Los Angeles Museum of Natural History. Awards: "Best in World," World Championship in Wildfowl Carving, Salisbury MD; numerous Best of Show awards in national and international carving competitions. Member: Society of Animal Artists, NYC. Teaching: Private and night school courses; seminars and lectures. Media: Oil, watercolor, wood. Address in 1983, Hartland, Wisconsin.

KOENIG, ELIZABETH.
Sculptor. Studied: Wellesley College; Yale University; The Art Students League, New York City; American University, Washington, DC; Corcoran School of Art, Washington, DC. Exhibitions: National Bureau of Standards, 1966; Rockville Civic Center, Municipal Gallery, 1968; Montgomery County Art Association, 1971.

KOEPNICK, ROBERT CHARLES.
Sculptor and teacher. Born in Dayton, OH, July 8, 1907. Studied at Dayton Art Institute; Cranbrook Academy of Art; and with Carl Milles. Member: Dayton Society of Painters and Sculptors. Awards: Prizes, College Art Association of America, 1931; National Academy of Design, 1940, 41; National Catholic Welfare Competition, 1942; National Gallery of Art, 1945. Work: Sculpture, County Court House, St. Paul's Church, Parker Cooperative School, Roosevelt High School, all in Dayton, OH. Exhibited: Penna. Academy of Fine Art, 1936-38, 40; National Academy of Design; Art Institute of Chicago, 1937; Syracuse Museum of Fine Art, 1938; Cincinnati Museum Association, 1935-37, 39, 40; Dayton Society Painters and Sculptors, 1937-45; Metropolitan Museum of Art, NYC. Position: Head, Sculpture and Ceramic Department, School of Dayton Art Inst., Dayton, OH, 1936-41, 46-74, emeritus prof., from 1974. Address in 1982, Lebanon, OH.

KOHLER, ROSE.
Sculptor and painter. Born Chicago, Ill. Pupil of Cincinnati Academy under Duveneck and Barnhorn. Member: Cincinnati Woman's Art Club; American Artists Professional League. Died in 1947. Address in 1929, 2 West 88th St., New York, NY.

KOHLMANN, RENA TUCKER.
See Magee, Rena Tucker Kohlmann.

KOHN, BEATRIZ.
Sculptor. Work includes "Comadre," bronze, exhibited at National Association of Women Artists, NYC, 1983. Member: National Association of Women Artists. Address in 1983, 2255 Broadway, NYC.

KOHN, GABRIEL.
Sculptor. Born 1910, in Phila., PA. Studied: Cooper Union, 1929; Beaux-Arts Institute of Design, NYC, 1930-34; Zadkine School of Sculpture, Paris, 1946. Work: Albright; Cranbrook; Museum of Modern Art; Ringling; Whitney Museum. Exhibited: Atelier Mannucci, Rome, 1948; Galleria Zodiaco, Rome, 1950; Cranbrook, 1953; Leo Castelli Inc., NYC, 1959; Otto Gerson Gallery, NYC, 1963; Salon de la Jeune Sculpture, Paris, 1950; Los Angeles County Museum of Art; Metropolitan Museum of Art, National Sculpture Exhibit; Penna. Academy of Fine Arts; Whitney Museum; Museum of Modern Art; Claude Bernard, Paris, Aspects of Am. Sculpture; New School for Social Research; Seattle World's Fair, 1962. Awards: Augustus Saint-Gaudens Medal from Cooper Union, 1925; Beaux-Arts Institute of Design, NYC, 14 awards in sculpture, 1929-32, and a silver medal, 1932; Cranbrook, George A. Booth Scholarship, 1952; Tate, International Unknown Political Prisoner Competition, 1953; Ford Foundation Grant, 1960. Address in 1970, N. Hollywood, CA. Died in 1975.

KOHUS, FRANK.
Sculptor. Member of the National Sculpture Society. Address in 1921, 710 Clark Street, Cincinnati, Ohio.

KOLCHIN, ELLEN.
Sculptor. Work includes "Cat and Bird Pair," stone, exhibited at National Association of Women Artists, NYC, 1983. Member: National Association of Women Artists. Address in 1983, 440 Riverside Drive, NYC.

KOLIN, SACHA.
Sculptor and painter. Born in Paris, France, May 9, 1911. Studied at School of Applied Arts, Academy of Fine Art, Vienna; Studio Naoum Aronson and Societe Nationale des Beaux-Arts in Paris. Work in Smithsonian National Galleries; Everson Museum (commission); others. Member: Artists Equity Association; League Present-Day Artists. Awards: Prizes, Societe Nationale des Beaux-Arts, Paris, 1934, 35. Exhibited: Vienna, Austria, 1934; Paris, France, 1934-36; Mercury Gallery, NY, 1938-41; New York World's Fair, 1939; ACA Gallery; Whitney Museum of American Art; Burliuk Gallery; Contemporary Art Gallery; ANTA Theatre; Everson; Brooklyn Museum; Salon des Realites Nouvelles, Paris, others. Sculpted in metal, wood, and formica. Address in 1953, 777 West End Ave., NYC. Died in 1981.

KOLLER, E. LEONARD.
Sculptor, illustrator, writer, lecturer, and teacher. Born Hanover, PA, December 8, 1877. Studied under Pyle, Morse and Willett. Member: Eastern Art Association;

American Federation of Arts. Work: "Soldiers Memorial Monument," near Gettysburg battlefield, and memorial windows in Pittsburgh and Philadelphia. Author of text books on design, illustration and lettering. Address in 1933, 633 Jefferson Ave., Scranton, PA.

KOLLOCK, MARY.
Sculptor, landscape, still life and portrait painter. Born in Norfolk, VA, in 1840 (the *Artists Year Book* says August 20, 1832); lived in NYC. Studied at Penna. Academy; the Art Students League; and in Paris. Exhibited at the Penna. Academy from 1864; and at the National Academy from 1866. Died on January 12, 1911, in NYC.

KONI, NICOLAUS.
Sculptor and lecturer. Born in Hungary, May 6, 1911; US citizen. Study: Academy of Fine Art, Vienna; Masters School, Paris; Masters School, Florence, Italy. Work: Oklahoma Art Center, Oklahoma City; Forrestal Building; Metropolitan Opera House; Kennedy Center, Washington, DC; many others. Exhibitions: Whitney, NYC; Birmingham (AL) Museum of Fine Art; Parrish Art Museum, South Hampton, NY; Milch Galleries, NYC; International Sculpture Expo, Paris; many others. Awards: First prize in Art, Parrish Art Museum. Member: National Sculpture Society; Quilleis Art Society. Media: Wood, marble, bronze, jade, gold. Living in New York City in 1970. Address in 1982, Palm Beach, Florida.

KONRATY, LOLA.
Sculptor and painter. Born in Riga, Russia, February 24, 1900. Studied abroad and with Serge Soudeikine, William Ehrich. Work: Rochester Memorial Art Gallery. Exhibited: Buffalo, NY; Syracuse Museum of Fine Art; Rochester Memorial Art Gallery, 1935-46. Address in 1953, Pittsford, NY.

KONTI, ISIDORE.
Sculptor. Born Vienna, Austria, July 9, 1862. Pupil of Imperial Academy in Vienna under Helmer and Kundmann. Came to US in 1890. Member: Associate, National Academy of Design, 1908, Academician, 1909; National Arts Club; Yonkers Art Association; League of American Artists; National Sculpture Society, 1897; New York Architectural League, 1901; Salma. Club, 1904; Allied Artists of America; American Federation of Arts. Award: Gold medal, St. Louis Exposition, 1904. Work: "Genius of Immortality," Metropolitan Museum of NY, and Detroit Institute; "Illusion," owned by the Italian government; "South America," group for Bureau of American Republics Building, Washington, DC; medal "Landing of Jews in America," Minneapolis Institute; "Orpheus," Peabody Institute, Baltimore, MD; monument of Kit Carson and Lt. Beal, National Museum of Art, Washington; statues of Justinian and Alfred the Great, Court House, Cleveland; three fountains, Audubon and City Park, New Orleans; "Rev. Morgan Dix," Trinity Church, NY; memorial to heroes of World War, Yonkers, NY; "The Despotic Age," St. Louis Museum and Corcoran Gallery; memorial, St. John's Cathedral, NYC; "Dancer," Museum, Newark, NJ; Lincoln and Hudson-Fulton Memorials, Yonkers, NY; McKinley Memorial, Philadelphia; fountain figure,

NYC. Address in 1933, 314 Riverdale Ave., Yonkers, NY. Died in 1938.

KONZAL, JOSEPH.
Sculptor. Born Milwaukee, WI, in 1905. Studied: Art Students League, with Weber, Kuhn, Laurent, 1926-30; Layton School of Art, 1927; Beaux-Arts Institute of Design, NYC, 1928-30. Work: New School for Social Research; Storm King Art Center, Mountainville, NY; Tate; Whitney Museum. Exhibited: Eighth St. Playhouse, NYC, 1938; Contemporary Arts Gallery, NYC; The Bertha Schaefer Gallery, NYC; Art Institute of Chicago; Museum of Modern Art; New York World's Fair, 1939; Brooklyn Museum, 1950, 52, 54, 56, 58, 60; Penna. Academy of Fine Arts, 1953-54, 58, 64; Federation of Modern Painters and Sculptors Annuals; Sculptors Guild Annuals; Silvermine Guild Annuals, 1954-63; Whitney Museum Annuals, 1960, 62, 63, 64, 66, 68; Carnegie; Newark Museum; New York World's Fair, 1964-65; Boston Museum; Aldrich Museum; others. Awards: Brooklyn Museum Biennial, 2 First Prizes; Guggenheim Fellow. Member: Sculptors Guild; Federation of Modern Painters and Sculptors. Taught at Brooklyn Museum School; Adelphi University; Newark Public School of Fine and Industrial Art; Queens College. Address in 1982, 360 West 21st Street, NYC.

KOPTA, EMRY.
Sculptor. Address in 1934, Phoenix, Arizona. (Mallet's)

KORAS, GEORGE.
Sculptor. Born in Florina, Greece, April 1, 1925; US citizen. Studied at School of Fine Arts, Athens, Greece; studied in Paris and Rome, 1955; Art Students League, 1957; with Jacques Lipchitz, 1955-59. Work in W. P. Chrysler Collection; Provincetown (MA) Museum; Norfolk (VA) Museum; National Museum of Athens, Greece, plus commissions for Board of Education, Queens and Bronx, NY. Exhibitions include Panhellenios Zapeion, Athens, Greece; Brooklyn Museum; Penna. Academy of Fine Arts; Silvermine Guild Artists; Consulate General of Greece. Awards: Brooklyn Museum; Penna. Academy of Fine Arts; Hofstra University. Teaching at SUNY Stony Brook, from 1966. Member of Audubon Artists, director of sculpture, 1963-66, 68-71. Works in bronze. Address in 1982, Flushing, NY.

KORBEL, MARIO J.
Sculptor. Born Osik, Czechoslavakia, March 22, 1882. Came to U.S. at age 18, returned to Europe to study in Paris and Munich. Later established a studio in Prague. Member: Chicago Society of Artists; National Sculpture Society. Award: Shaffer prize, Art Institute of Chicago, 1910; Goodman Prize ($500), Grand Central Galleries, 1929. Work: Dancing group, Cleveland Museum; "Andante," Metropolitan Museum of Art; "Minerva," University of Havana, Cuba; marble bust in Chicago Art Institute; McPhee Memorial monument, Denver. Also in collections of the Vatican; Cranbrook Academy of Art; National Gallery of Canada; Whitney, and many private collections. Exhibited at National Sculpture Society, 1923. Died in 1954. Address in 1933, 54 West 74th St., New York, NY.

KORMAN, BARBARA.
Sculptor and instructor. Born in NYC, April 8, 1938. Studied at Art Students League; New York State College; ceramics, Alfred University, B.F.A., 1959, grad. fel., 1959-60, M.F.A. Exhibitions: Rochester Memorial Art Gallery, NY, 1959; Albright-Knox Art Gallery, Buffalo, NY, 1960; Hartford Museum Gallery Shop, Conn., 1961; Hudson River Museum, Yonkers, NY, 1973-74; National Academy of Design, NY, 1973-75. Metropolitan Museum; others. Awards: House of Heydenryk Prize for Sculpture, 1974. Member: Nat'l. Assn. of Women Artists; Hudson River Artists Committee; International Soc. of Artists. Address in 1982, 357 East 201st Street, NYC.

KORMENDI, ELIZABETH.
Sculptor and painter. Born in Budapest, Hungary. Studied in Europe. Member of Society of Fine Art, Budapest. Works: Museum of City of Budapest; Immaculate Conception Church, East Chicago, Illinois; Boys' Town; Our Lady of the Lake Church, Wawasee, Indiana; St. Catherine's Church, St. Peter's Church, Oshkosh, Wisconsin. Exhibited at Milwaukee Art Institute; Herron Art Institute; and abroad. Address in 1953, South Bend, IN.

KORMENDI, EUGENE (JENO).
Sculptor and teacher. Born in Budapest, Hungary, October 12, 1889. Studied at Art Academy of Budapest; and in Paris. Member: Society of Fine Art, Budapest; Society Four Arts, Palm Beach, FL; Audubon Artists. Awards: Society Four Arts, Palm Beach, 1945; Hoosier Salon, 1946; medal, Barcelona Institute Exposition. Work: Heeres Museum, Vienna; Budapest Museum; memorials, monuments, statues, Valparaiso, IN; University of Notre Dame; Mt. Mary College, Milwaukee; Boys Town, NE; Washington, DC; Ft. Wayne, IN; and many works abroad. Exhibited: One-man exhibition: Milwaukee Art Institute, 1940, 45; Norton Gallery, 1944; Renaissance Society, University Chicago, 1941; Oak Park Art League, 1941; Herron Art Institute, 1943; also, Hoosier Salon, 1946; Audubon Artists, 1946; Art Institute of Chicago, 1946; and abroad. Position: Artist in Residence, University Notre Dame, South Bend, IN, from 1941. Address in 1953, 1009 West Washington Ave., South Bend, IN. Died in 1959.

KORNEMAN AND JUNGBLUTH.
Sculptors. Active 1869. Patentees—statuette, 1869.

KOS, PAUL JOSEPH.
Sculptor. Born in Rock Springs, Wyoming, December 23, 1942. Went to California in 1962. Studied at San Francisco Art Institute. Taught at University of Santa Clara, California, 1969-77; San Francisco Art Institute, from 1978. In collections of Fort Worth (Texas) Art Museum; San Francisco Museum of Modern Art; Winery Lake, Napa, California; others. Exhibited at Richmond Art Center, California; Reese Palley Gallery, San Francisco and NYC; de Young Mus., San Francisco; Leo Castelli Gallery, NYC; Everson, Syracuse; University of Nevada; Museum of Conceptual Art, San Francisco; La Jolla Museum of Contemporary Art; Los Angeles County Museum of Art; Whitney; Paris Biennale; San Francisco Museum of Modern Art; others. National Endowment Fellow, 1974 and

76. Also works in video art. Address in 1982, San Francisco, California.

KOSCIELNY, MARGARET.
Sculptor and painter. Born in Tallahassee, Fla., August 13, 1940. Studied at Texas Woman's University, with Toni Lasalle; University of Georgia, B.A. (art history) and M.F.A., with Irving Marantz, Jus. Schwartz and Charles Morgan. Commission: plexiglas sculpture, John Portman, Atlanta, Georgia, 1969 and 70; plexiglas sculpture, Maurice D. Alpert, Int. City Corp., Atlanta, 1972 and 75; Omni, Norfolk, VA, 1975; Atlanta Airport. Exhibitions: Fla. State Fair, Tampa, 1965; American Drawing 1968, Philadelphia, 1968; Drawing USA, St. Paul, Minn., 1969; Cummer Gallery, Jacksonville, 1972; Art Celebration, Jacksonville, 1973 and 74; others. Medium: Plexiglas. Address in 1982, Jacksonville, FL.

KOTTLER, HOWARD WILLIAM.
Sculptor and educator. Born in Cleveland, OH, March 5, 1930. Studied at Ohio State University, B.A., 1952, M.A., 1956, Ph.D., 1964; Cranbrook Academy of Art, Bloomfield Hills, Michigan, M.F.A, 1957. Work at Victoria and Albert Museum, London, England; National Museum of Modern Art, Kyoto; Cleveland Museum of Art; Museum of Contemporary Crafts, NY; others. Exhibited at San Francisco Museum of Art; Long Beach Museum, CA; Everson Museum of Art, Syracuse; Denver Art Museum, CO. Received US Government Fulbright Grant, 1957; National Endowment for the Arts; others. Member of American Craftsman's Council. Works in clay. Address in 1982, Seattle, WA.

KOWAL, DENNIS J.
Sculptor and writer. Born in Chicago, Ill., September 9, 1937. Studied at Art Institute of Chicago; University of Ill., Chicago; Southern Ill. University. Work in Gillette Corp., Boston; Brockton Art Center; MBTA Station, Prudential Auditorium, Boston; monuments, Milton Academy, Mass.; commissions for numerous corporations, banks, etc. Has exhibited at 66th Chicago Artists Annual, Art Institute of Chicago; Robert Freidus Gallery, NYC; Mead Art Museum, Amherst College, Mass.; Gilbert Gallery Ltd., Chicago; many others. Member: Boston Visual Artists Union; New England Sculptors Association, Boston; others. Author: *Casting Sculpture*; *Artists Speak*, New York Graphic Society. Address in 1982, Cohasset, MA.

KOWNATZKI, HANS.
Sculptor and painter. Born Koenigsberg, Germany, November 26, 1866. Pupil of Neide, Knorr, Koner and Lefebvre in Paris. Award: First prize for sculpture, Society of Washington Artists, Washington, DC, 1929. Member: Society of Independent Artists. Address in 1933, Peconic, Long Island, NY. Died in 1939.

KRAMER, REUBEN ROBERT.
Sculptor and teacher. Born in Baltimore, MD, October 9, 1909. Studied: Rinehart School of Sculpture; American Academy in Rome, F.A.A.R., and in London and Paris. Member: Artists Equity Association; Alumn., American Academy in Rome. Awards: Rinehart traveling scholar-

ship, 1931, 1933; Prix de Rome, 1934; Brooklyn Museum of Art, 1940, 1946, 1948, 1949, 1951, 1952; Peale Museum, 1949; Maryland Sculptors Guild, 1947; National Institute of Arts and Letters Grant, 1964; others. Work: Brooklyn Musem of Art; IBM College; Martinet College; USPO, St. Albans, WV; relief, St. Mary's Seminary, Alexandria, VA. Work: Baltimore Museum; Corcoran; Portland (OR) Art Museum; others, including 8 1/2 ft. statue of Justice Thurgood Marshall (commission). Exhibited: Philadelphia Museum of Art, 1940, 1949; Penna. Academy of Fine Arts, 1949-52; Brooklyn Museum of Art, 1940, 1941, 1943-1952; American Academy in Rome; Grand Central Gallery. Taught: Instructor, Baltimore City College and American University, Washington, DC; Director, Evening and Saturday School, Baltimore Art Center, MD, 1953. Works in bronze. Address in 1982, Baltimore, MD.

KRASNOW, PETER.
Sculptor and painter. Born in the Ukraine, Russia, c. 1887-90; in Los Angeles, California, from 1922. Studied at Art Institute of Chicago until 1916. Exhibited at Whitney Studio Club, NYC, 1922; Los Angeles Co. Museum, 1922, 27; Stendahl Art Gallery, Los Angeles; California Palace of Legion of Honor, San Francisco, 1931; Galerie Pierre, Paris, 1934; Pasadena Art Institute, California, 1954; California-Pacific International Exposition, San Diego, 1935; Museum of Modern Art, Sao Paulo, Brazil; Los Angeles Institute of Contemporary Art; San Francisco Museum of Modern Art; Rutgers University, NJ; many others in California. Carved directly in wood. Died in Los Angeles in 1979.

KRATINA, JOS(EPH) M.
Sculptor and teacher. Born Prague, February 26, 1872. Pupil at L'Ecole des Beaux Arts and Julian Academy in Paris. Member: Art Alliance of America; Brooklyn Society of Artists. Address in 1933, 109 Berkeley Place, Brooklyn, NY; summer, Mt. Tremper, NY.

KRATINA, K. GEORGE.
Sculptor. Born in NYC, February 12, 1910. Studied at Syracuse University, B.S. and M.S.; Yale University B.F.A. Work includes wood statues, St. Paul's Cathedral, Los Angeles; steel sculpture, Adath Israel Temple, Merion, PA; others. Received Prix de Rome, 1938; others. Member of National Sculpture Society (fellow). Address in 1982, Old Chatham, NY.

KRAU, (ERSILIA) ZILI.
Sculptor and painter. Born in Sat Chinez, Romania; US citizen. Studied at Graphic Sketch Club, Philadelphia, 1928-30; National Academy of Design, with Leon Kroll, 1930-32; others. Exhibited at Philadelphia Academy of Fine Arts; Montreal Museum of Fine Arts; Philadelphia Museum of Art (sculpture), 1975; others. Works in wood, plaster; oil, pastel. Address in 1982, Cinnaminson, NJ.

KRAUS, ADOLPH F.
Sculptor. Born in Zeulenroda, Germany, August 5, 1850. Settled in America in 1881. Works: Theodore Parker and "Crispus Attucks" monuments; winged figures of "Victory," Machinery Hall, Columbian Exposition, Chi-

cago, 1893. Award: Grand Prize of Rome. Died in Danvers, MA, November 7, 1901.

KRAUS, ROBERT.
Sculptor. Deceased. He was the sculptor for the Crispus Attucks monument.

KRAUS, ROMUALD.
Sculptor and teacher. Born in Itzkany, Austria, February 7, 1891. Studied in Europe, with Langer, Kleimsch, Wackerle. Awards: Prize, Golden Gate Exp., 1939. Work: Sculpture, Court House, Newark, NJ; Howard University; Evander Childs High School, Bronx, NY; Newark Museum; Court House, Covington, KY; US Post Office, Ridgewood, NJ; Williamstown, NY. Exhibited: Metropolitan Museum of Art; Cincinnati Museum Association, 1946; Penna. Academy of Fine Arts, 1935, 36; Golden Gate Exp., 1939. Position: Instructor, Art Center, Louisville, KY; Cincinnati Museum Association, Cincinnati, OH. Address in 1953, Cincinnati, OH.

KREBS, ROCKNE.
Sculptor. Born in Kansas City, MO, December 24, 1938. Studied at Kansas University, Lawrence, B.F.A., 1961. Work in Phillips Collection; Smithsonian Institution; Corcoran Gallery of Art; Hirshhorn Museum and Sculpture Garden; Philadelphia Museum of Art. Has exhibited at Corcoran Gallery of Art; Whitney Museum of American Art; Art Institute of Chicago; Albright-Knox, Buffalo, NY; Los Angeles Co. Museum of Art; Walker Art Center, Minneapolis, MN; others. Received first prize, sculpture, Corcoran Gallery of Art, 1965; J. S. Guggenheim Fellowship, 1972; others. Address in 1982, Washington, DC.

KREBS, ROSE K.
Ceramic Sculptor. Born in Germany. Studied at Bauhaus, Germany; Ceramic Workshop; Art Students League; and with William Zorach. Work: Ceramic vases for Mercedes-Benz showrooms, NY; Cooper Union Museum. Awards: Pen and Brush Club, 1958.

KREIS, HENRY.
Sculptor. Born in Essen, Germany, 1899; came to US in 1923. Studied under Paul Wackerle in Munich at the State School of Applied Art. Studied also with Paul Manship at the Beaux-Arts Institute of Design, NYC. Works: "Indian Summer" (brownstone), 1937; Medal of the Wise and Foolish Virgins (bronze), 1947. Died in Essex, CT, in 1963.

KRENTZIN, EARL.
Sculptor and silversmith. Born in Detroit, Michigan, December 28, 1929. Graduated from Cass Technical High School, 1948; Wayne State University, BFA, 1952; Cranbrook Academy, Michigan, MFA, 1954; Royal College of Art, London, 1957-58. In collections of Detroit Institute of Art, MI; Cranbrook Galleries, MI; St. Paul (MI) Art Center; Jewish Museum, NYC; others, including commissions. Exhibited at Museum of Contemporary Crafts, NYC, 1963, 65; one-man shows, Kennedy Galleries, NYC, 1968-75, Detroit Institute of Art, 1978, Oshkosh Museum, 1982. Awarded prize at Detroit Institute of Arts, 1952; Fulbright Fellowship, 1957-58; Tiffany Grant, 1966; Wichita Arts Center, Kansas, 1966. Works in

fiber, clay, metal, silver. Represented by Kennedy Galleries, NYC. Address in 1982, Grosse Pointe, Michigan.

KRETSCHMAN, EDWARD A.
Sculptor and teacher. Born in Germany, Aug. 27, 1849. Came to the US in 1856. Pupil of J. A. Bailey and Geo. Starkey. Diploma, American Institute, 1875. Address in 1910, Philadelphia, PA.

KREZNAR, RICHARD J.
Sculptor and painter. Born in Milwaukee, WI, May 1, 1940. Studied at University of Wisconsin, B.F.A.; Brooklyn College, M.F.A.; Institute Allende, Mexico. Work in Walker Art Center, Minneapolis; Milwaukee Art Center, WI; others. Has exhibited at Penna. Academy of Fine Arts; Butler Institute of American Art, Youngstown, OH; Milwaukee Art Center; others. Received Ford Foundation Purchase Award; prizes, Milwaukee Art Center. Taught studio art courses, Brooklyn College, 1964-73, and as assistant professor from 1974-79; sculpture, Skowhegan School of Painting and Sculpture, 1978; sculpture, Philadelphia College of Art, from 1980. Address in 1982, 284 Lafayette St., NYC.

KRIENSKY, MORRIS E.
Sculptor, painter, illustrator, and designer. Primarily painter. Born in Glasgow, Scotland, July 27, 1917. Studied at Professional Design School; Art Students League; Boston Museum of Fine Arts School; and with Alma O. Le Brecht. Member: American Watercolor Society. Work: M. Knoedler and Co.; Pushkin Museum, Moscow; others. Exhibited: American Watercolor Society, 1946; Dept. Interior, Washington, DC; White House, Washington, DC; Art Institute of Chicago; Hackley Art Gallery; Wilmington Society of Fine Art; Dartmouth College; M. Knoedler and Co.; National Academy of Design; others. Address in 1982, 463 West St., NYC.

KRIPAL, NICK.
Sculptor. Born in 1953. Studied: Kearney State College, Kearney, NE, B.F.A., 1975, M.F.A., 1977; Southern Illinois University, Edwardsville, M.F.A., 1979. Exhibitions: Super Mud Student Invitational Exhibition, Penna. State University, State College, 1978; Annual Mid-States Crafts Exhibition, Evansville Museum of Arts and Science, Evansville, IN, 1978, 1979; Carol Shapiro Gallery, St. Louis, MO, 1980; Michigan Ceramics, Pewabic Pottery, Detroit, 1980; Art from Craft Materials, Detroit Focus Gallery, 1981; Tea Pots USA, Southern Illinois University, Edwardsville, 1981; Michigan Artists 1980-81, The Detroit Institute of Arts, 1982. Awards: National Works on or of Paper and Clay Exhibition, Memphis State University, Memphis, TN, 1978, Second Prize; Pensacola National Crafts Exhibition, Pensacola Junior College, Pensacola, FL, 1979, Purchase Award; Michigan Fine Arts Competition, Birmingham-Bloomfield Art Association, 1982, Third Prize. Currently Assistant Professor of Art, Central Michigan University, Mt. Pleasant, MI. Address in 1982, Mt. Pleasant, MI.

KRUGER, LOUISE.
Sculptor and designer. Born in Los Angeles, CA, in 1924. Studied: Scripps College, CA; Art Students League; also

with Capt. Sundquist, shipbuilder; F. Guastini, Pistoia, Italy; Chief Opoku Dwumfour, Kumasi, Ghana. Collections: Museum of Modern Art; New York Library Print Collection; Modern Museum, Sao Paulo; Brooklyn Museum. Exhibitions: Metropolitan Museum; Whitney; Museum of Modern Art; Art Institute of Chicago; Kunsthaus, Zurich. Works in wood, bronze. Address in 1982, 30 East Second Street, New York City.

KRUGMAN, IRENE.
Sculptor. Born in NYC. Studied at Kansas City Art Institute; New York University; New School for Social Research, with Yasuo Kuniyoshi. Work in NJ State Museum, Trenton; Newark Museum, NJ; others. Has exhibited at Brooklyn Museum, NY; Riverside Museum, NY; Summit Art Center, NJ; others. Works in wire and plaster. Address in 1982, Morristown, NJ.

KRUPKA, JOSEPH.
Sculptor. Born in Czechoslovakia Jan. 1, 1880. Pupil of Hermon MacNeil. Member: NY Architectural League 1914 (assoc.). Address in 1916, 510 East 77th St., NYC; summer Greycourt, NY.

KUCHARYSON, PAUL.
Sculptor, etcher, engraver, craftsman, designer, and illustrator. Chiefly graphic artist. Born in Utica, NY, July 2, 1914. Studied at John Huntington Institute of Art; Cleveland School of Art. Awards: Prizes, New York World's Fair, 1939; Cleveland Museum of Art; Dayton, OH; Oakland, CA. Position: Artist, Inter-Collegiate Press, Kansas City, MO, from 1946. Address in 1953, Kansas City, MO.

KUEMMEL, CORNELIA A.
Sculptor, painter, and teacher. Born Glasgow, Howard Co., MO. Pupil of St. Louis School of Fine Arts, under John Fry and E. Wuerpel. Member: St. Louis Art Guild. Died in 1937. Address in 1933, Pritchett College, Glasgow, MO.

KUFFLER, SUZANNE.
Sculptor. Working with language-based images and assemblage during the early 1970's.

KUHN, ROBERT J.
Sculptor. Exhibited at National Academy of Design, 1925. Address in 1929, Richmond Hill, NY.

KUHNE, HEDVIG (HARRIETT).
Sculptor and painter. Born in Berlin, Germany. Student of Art Institute of Chicago, Chicago Academy of Fine Arts, Atelier Alexander Archipenko. Exhibited at Chicago Woman's Club Tudor Gallery, 1937; Hackley Gallery of Art; Fremont (MI) Foundation, 1954; Art Institute of Chicago; Marshall Field and Co. Gallery; Corcoran Gallery Washington, DC; Detroit Institute of Arts; Grand Rapids Gallery of Art. Director of Browngate Studio Summer School of Painting, from 1944. Received art directors prize, Art Institute of Chicago, 1942, Metropolitan Museum, 1942. Fellow, International Institute of Arts and Letters. Address in 1962, Browngate Studio, Hart, Mich.

KUNTZE, EDWARD J.
Sculptor and etcher. Born in Pomerania, Germany, 1826;

came to the US in 1852. Worked in Philadelphia in the mid-1850's; in NYC from 1857. Resided in London from 1860 to 1863. Associate of the National Academy, 1869-70. Died in NY, 1870.

KURHAJEC, JOSEPH A.
Sculptor. Born in Racine, WI, October 13, 1938. Studied at University of Wisconsin, B.S., 1960; M.F.A., 1962. Work in New School for Social Research, NY; Museum of Modern Art, NY; Chicago Art Institute; Walker Art Center, Minneapolis. Has exhibited at Sculpture Annual, Whitney Museum of American Art; Guggenheim Museum, NY. Address in 1982, c/o Allan Stone Gallery, NYC.

KURTZ, BENJAMIN TURNER.
Sculptor. Born in Baltimore, MD, January 2, 1899. Pupil of Charles Grafly, Albert Laessle. Member: Fellowship Penna. Academy of Fine Arts; National Sculpture Society; Philadelphia Art Alliance; others. Work: Public Library, Fort Worth, TX; Curtis Institute Museum, Philadelphia; Public Library, Camden, ME; Brookgreen Gardens, SC; Johns Hopkins Hospital, Baltimore; Peale Museum, Baltimore; Hochild Kohn Department Store, Baltimore; fountain, Norton Gallery, West Palm Beach, Florida; Baltimore Museum of Art; National Gallery; others. Awards: Cresson traveling scholarship, Penna. of Fine Arts, 1922; bronze medal, Sesqui-Centennial Exposition, Philadelphia, 1926; Spalding prize ($1,000), Art Institute of Chicago, 1926; others. Address in 1953, Baltimore, MD.

KUSAMA, YAYOI.
Sculptor. Born in Tokyo, Japan, March 22, 1941. US citizen. Studied at the Kyoto Arts and Crafts School, Japan, 1959. Has exhibited at DeCordova Museum, Boston, 1960; Stadt Museum, Schloss Morsbroish, Leverkusen, Germany, 1961; Whitney Museum, 1962; Institute of Contemporary Art, 1964; Chrysler Museum, 1965; Ginza, Tokyo, 1975 and 76. In collections of Chrysler Museum, Provincetown, MA; Stedelijk Museum, Amsterdam. Working with assemblage in the 1960's. Address in 1982, Tokyo, Japan.

KUSSOY, BERNICE (HELEN).
Sculptor. Born in Brooklyn, NY, 1934. Studied at Art Students League; Cooper Union; Western Reserve Univ., B.S.; Cleveland Inst. Art, M.F.A. Work in Butler Inst. of American Art, Youngstown, OH; Kalamazoo Art Inst., MI; Univ. of California, Santa Barbara; Mex-Am. Inst. Cult. Relations, Mexico City; Bundy Art Gal., Waitsfield, VT; Brancusi Marble Co., Los Angeles; Temple Beth Israel, Pomona, CA. Exhibitions include Laguna Beach Art Assn., 1964; Otis Art Inst., Los Angeles, 1964; Mexico City, 1965; Judah L. Magnes Jewish Mus. of the West, Berkeley, CA, 1968; plus others. Awards from Butler Inst. of American Art, 1958 and Cincinnati Mus. Assn. Prizes, 1958. Works in welded or bronzed metals and found objects. Address in 1976, San Francisco, CA.

L

LA FONTAINE, GLEN.
Sculptor. Cree Indian, born in Seattle, Washington, in 1950; raised in Bellecourt, North Dakota, Turtle Mountain Reservation. Studied at Institute of American Indian Arts, Santa Fe, New Mexico; influenced by sculptor Allan Houser; The Center of the Eye Film School; Rhode Island School of Design; with silversmith Charles Loloma, 1971; grant to tour Mexico, 1972. Worked on Colville Indian Reservation, eastern Washington. Has exhibited at Heard Museum, invitational, 1975; Amon Carter Museum, solo, 1976; 4 pieces in European tour. Mural of Plains culture is at Daybreak Star Arts Center in Fort Lawton, Washington. Specialty is designs and Indian concepts of Plains horse culture. Works in molded paper, clay and ceramic tile. Reviewed in *Southwest Art*, February 1982. Represented by Westwood Galleries, Portland, OR. Address in 1982, Portland, Oregon.

LA FORD, (CAROL) GRENDE.
Sculptor and painter. Born in Grangeville, Idaho, in 1955. Self-taught. Has raised and trained Appaloosa horses. Specialty is wildlife and horses. Works on scratchboard and in oil. Represented at Favell Museum; Hells Gate Park. Member of Women Artists of the American West. Owns Grende La Ford Western Art Studio. Address in 1982, Clarkston, Washington.

LAATSCH, GARY.
Sculptor. Born in 1956. Studied: Cranbrook Academy of Arts, Bloomfield Hills, B.F.A., 1978; School of the Art Institute of Chicago, IL, M.F.A., 1981. Exhibitions: Flint Annual Exhibition, Flint Institute of Arts, 1975, 77, 79; Hartland Annual Exhibition, Hartland, 1975-80; Saginaw Annual Art Exhibition, Saginaw Art Museum, 1976, 77, 79, 81; Annual Mid-Michigan Exhibition, Midland Center for the Arts, 1976-82; Private Parts in Public Places, Cranbrook Academy of Art Museum, Bloomfield Hills, MI, 1978; 6/6, Artemesia Gallery, Chicago, IL, 1979; 78th Annual Artists of Chicago and Vicinity, Art Institute of Chicago, IL, 1981; Michigan Fine Arts Competition, Birmingham-Bloomfield Art Association, 1982; Michigan Artists 1980-81, The Detroit Institute of Arts, 1982. Awards: Annual Mid-Michigan Exhibition, Midland Center for the Arts, 1977, Purchase Award, 1980, Best of Show; Flint Annual Exhibition, Flint Institute of Arts, 1977, Sculpture Award, 1977, 79; Creative Artists Grant, Michigan Council for the Arts, 1982; H. Wurlitzer Foundation of New Mexico, 1982. Address in 1982, Saginaw, MI.

LABORDE, MISS C. A. B.
Sculptor. Born New Haven, Conn. Pupil of Laporte-Blairsy. Address in 1913, Paris, France.

LaCHAISE, GASTON.
Sculptor. Born in Paris, March 19, 1882. Came to US in 1906. Pupil of Bernard Palissy; Ecole des Beaux Arts under Gabriel Jules Thomas, also a sculptor. Worked with Lalique; H. H. Kitson in Boston. Work: "Seagull," National Coast Guard Memorial; decoration frieze, American Telephone and Telegraph Bldg., NY; Cleveland Museum of Art; Newark Museum; Penna. Museum; Morgan Memorial Museum, Hartford, CT; Phillips Memorial Gallery, Wash.; Smith College Art Museum, Northampton, MA; Whitney Museum of Art, NY; Toledo Art Museum; Wichita Art Museum; Rockefeller Center and many private collections. Exhibitions held at Joslyn Museum of Art, Brummer Gallery, NYC; Phila. Art Association; Brooklyn Museum; Weyhe Gallery, NYC; Museum of Modern Art; R. Schoelkopf Gallery, NYC; Wadsworth Atheneum; others. Published *Gaston Lachaise: Sixteen Reproductions in Collotype*, with introduction by A. E. Gallatin. Address in 1933, 58 West 8th St., NYC. Died in NYC, October 19, 1935.

LACHENMAYER, PAUL N.
Sculptor. Gold medal, Art Club of Philadelphia 1898. Address in 1910, Philadelphia, PA.

LADD, ANNA COLEMAN.
(Mrs. Maynard Ladd). Sculptor. Born Bryn Mawr, PA, July 15, 1878. Studied in Paris and Rome. Member: Concord Art Assn.; National Sculpture Society, 1915 (assoc.); Boston Guild of Artists; North Shore Art Association; American Federation Arts; Art Institute Chicago; National Academy of Design. Award: Hon. mention, P.-P. Exp., San Francisco, 1915. Work: Bronzes in Boston Art Museum; bronze medal, "The Spirit of Serbia," Rhode Island School of Design; "Bronze Lady," Gardner collection, Boston; "Wind and Spray," Borghese Collection, Rome; Boston Public Gardens Fountain; "Fountain of Youth," Torresdale, PA; Soldiers' Memorials, Hamilton and Manchester, MA, Beverly Farms, South Bend, Brookline, and Grand Rapids; fountains in Boston Public Library gardens. Founded American Red Cross Studio of Portrait Masks, France, 1917-19. Exhibited: National Sculpture Society, 1923. Address in 1933, Boston, MA; summer, Beverly Farms, MA. Died in 1939.

LAESSLE, ALBERT.
Sculptor. Born Phila., March 28, 1877. Pupil of Spring Garden Inst., Drexel Institute, Penna. Academy of Fine Arts, C. Grafly, and studied in Paris. Member: Associate, National Academy Design; National Sculpture Society, 1913; Fellowship Penna. Acad. of Fine Arts; National Institute of Arts and Letters; Philadelphia Alliance; American Numismatic Society; New Society Artists of New York; Societe des Amis de la Medaille d'Art, Brus-

sels; Society Animal Painters and Sculptors, NY. Awards: Stewardson prize, 1902, and Cresson traveling scholarship, Penna. Academy of Fine Arts, 1904; bronze medal, Buenos Aires, 1910; Penna. Academy of Fine Arts Fellowship prize ($100), 1915; gold medal, P.-P. Exp., San Fran., 1915; first sculpture prize, Americanization through Art, Philadelphia, 1916; Widener gold medal, Penna. Academy of Fine Arts, 1918; honorable mention, Art Institute Chicago, 1920; gold medal, Fellowship, Penna. Academy of Fine Arts; gold medal, Sesqui-Centennial Exp., Philadelphia, 1926; prize ($300), best outdoor decorative group, Philadelphia Art Alliance, 1928; James E. McClees prize, 1928; Saltus medal, American Numismatic Society, 1951. Work: "Turtle and Lizards," "Blue Eyed Lizard," and "Chanticleer," Penna. Academy, Philadelphia; "Heron and Fish," Carnegie Inst., Pittsburgh; 3 small bronzes, "An Outcast," "Locust and Pine Cone," "Frog and Katydid," Peabody Institute, Baltimore; "Victory" and "Turning Turtle," Metropolitan Museum, NY; "The Bronze Turkey," Philadelphia Art Club; "Penguins," Philadelphia Zoological Gardens; "Billy," Rittenhouse Square, Philadelphia; "Hunter and First Step," Concord Art Association, Concord, MA; "Dancing Goat," "Pan," "Billy," "Duck," "Turtle," "Frogs" for fountain, Camden, NJ. Exhibited: National Sculpture Society, 1923. Instructor Penna. Academy of Fine Arts Country School, Chester Springs, PA. Address in 1953, Miami, FL. Died in 1954.

LAESSLE, MARY P. MIDDLETON.
(Mrs. Albert Laessle). Sculptor. Born in Philadelphia, PA, May 1, 1870. Member: Fellowship, Penna. Academy of Fine Arts. Address in 1910, Germantown, PA.

LaFARGE, JOHN.
Sculptor, landscape and figure painter, decorator, and glass painter. Born March 31, 1835, in New York. Pupil of Couture in Paris and William M. Hunt. Member: Society of American Artists, 1877; National Arts Club; Mural Painters (hon. pres.); National Academy, 1869; National Institute of Arts and Letters; American Inst. of Architects; and Century Association. The year 1876 marked an artistic shift from flower studies and landscapes to stained glass and murals. Awarded gold medal, Pan-Am. Exp., Buffalo, 1901; diploma and medal of honor, St. Louis Exp., 1904; medal of honor, Architectural League of NY, 1909. Represented in Metropolitan Museum, NY, and Boston Museum of Fine Arts. (See *American Painting and Its Tradition*, by John C. Van Dyke.) Address in 1910, 51 West 10th Street, NYC. Died in Providence, RI, Nov. 14, 1910.

LaFAVOR, WILL.
Sculptor. Born in Frankfort, NY, 1861. Exhibited "Herr Meisner," at the Penna. Academy of the Fine Arts, Philadelphia, 1914. Address in 1929, Washington Park Field House, Pittsburgh, PA.

LAFON, DEE J.
Sculptor and painter. Born in Ogden, UT, April 23, 1929. Studied at Weber State Col.; Univ. of Utah, B.F.A., 1960, M.F.A., 1962; also with Francis de Erdley, Phil Paradise, and Marguerite Wildenhain. Work: Utah State Fine Art Collection, Salt Lake City; Oklahoma Art Ctr., Oklahoma City; Philbrook Art Mus., Tulsa, OK.; Univ. of Oklahoma, Norman; Dillard Collection, Univ. of North Carolina, Greensboro. Comn: Wood sculpture, Univ. of Oklahoma, 1972; copper fountain, E Cent State Col., 1972. Exhibitions: Watercolor USA, Springfield, MO, 1968; National Oil Painting Exhib., Jackson, MS., 1968; Am. Drawing Bienniale, Norfolk, VA, 1969; International Miniature Prints Show, Pratt Graphic Ctr., NY, 1970; Midwest Bienniale, Omaha, NE, 1972. Awards: Eight State Exhib., Purchase Award, 1970; Hon. Mention, Midwest Bienniale, 1972; Tulsa Regional Painting and Drawing Award, 1972. Media: Paintings usually in oil; sculpture in multi-media. Address in 1982, Ada, OK.

LAGANA, FILIPPO.
Sculptor. Born in Italy, April 27, 1896. Pupil of Beaux-Arts Inst. of Design. Member: Darien G. of Seven Arts; Silvermine Guild of Artists. Work: Portrait, "Clarence Roe," Pennsylvania Mus. of Art, Philadelphia. Address in 1934, Darien, CT. Died in 1963.

LAGER, FANNIE.
Sculptor and collector. Born in NYC, November 14, 1911. Studied at Brooklyn College, painting with Nancy Ranson, 1939-41; Brooklyn Museum Art School, painting with Isaac Soyer, 1942-70, and sculpture with Toshio Odate, Barney Hodes, and Lee Ackerman, 1974-81; Sculpture Center, sculpture with Shulamith Brumer, 1971-73. Has exhibited at Brooklyn Museum, NY; Salmagundi Club, NY; Knickerbocker Artists 29th Annual National Arts Club, NY. Works in wood and stone. Address in 1982, Brooklyn, NY.

LAIRD, E. RUTH.
Sculptor. Born in Houston, TX, March 21, 1921. Studied at Cranbrook Academy of Art, Bloomfield Hills, MI, with Maija Grotell, summer 1951 and 1953-55. Work in Museum of Contemporary Crafts, NY; Everson Museum, Syracuse, NY; Cranbrook Museum, MI. Has exhibited at Laguna Gloria Museum, Austin, TX; Museum of Fine Arts, Houston; others. Taught ceramic sculpture at Museum of Fine Arts School, Houston, 1958-68. Works in clay and stone. Address in 1982, Fredericksburg, TX.

LAISNER, GEORGE ALOIS.
Sculptor, painter, craftsman, educator, and lecturer. Born in Czechoslovakia, May 5, 1914. Studied at Art Inst. of Chicago, B.A.E.; Univ. of Chicago, B.A.E.; and with Chapin, Polasek, Anisfeld. Member: Northwest Art Assn. Awards: Prizes, Puyallup, Washington, 1939; Seattle Art Mus., 1943, 44; San Francisco Mus. of Art, 1943. Work: Seattle Art Mus.; San Francisco Mus. of Art; Northwest Printmakers. Exhibited: Art Inst. of Chicago, 1937, 40, 46; Library of Congress, 1943; Seattle Art Mus., 1940-45; Northwest Printmakers, 1938-45; Golden Gate Exp., 1939; San Francisco Mus. of Art, 1939, 41, 44; San Francisco Art Assn., 1940-44; Oakland Art Gal., 1940-45. Position: Instructor of Art, 1937-41, Professor of Fine Art, 1942-46, State Col. of Washington, Pullman, Washington. Address in 1953, Pullman, WA.

LALONDE, JOSEPH WILFRID.
Sculptor and painter. Born Minneapolis, Minn., March

19, 1897. Pupil of Gustave Goetsch, F. Luis Mora, F. V. Du Mond, Stanislas Stickgold. Award: First painting prize, Minn. State Art Soc. 1923. Work: Mural of Joan of Arc and St. Louis, St. Louis Church, St. Paul, MN; over altar, St. Adelbert's Church, St. Paul. Address in 1933, 53 Greenwich Ave., New York, NY; h. St. Paul, MN.

LAMB, ELLA CONDIE.

(Mrs. Charles R. Lamb). Sculptor, painter, illustrator, and craftsman. Born New York. Pupil of Wm. M. Chase and C. Y. Turner in New York; Hubert Herkomer in England; Collins and Courtois in Paris. Work: National Arts Club; mosaic frieze, Sage Chapel, Cornell Univ., Ithaca, NY; murals, Flower Library, Watertown, NY; mosaic raredos, St. Mary's Church, Wayne, PA; others. Member: Mural Painters; National Arts Club. Awards: Dodge prize, National Academy of Design, 1889; honorable mention, Columbia Exp., Chicago, 1893; medal, Atlanta Exp., 1895; honorable mention, Pan-Am. Exp., Buffalo, 1901. Represented in collection of the National Arts Club. Specialty mural decorations, stained glass and portraits. Living in Cresskill, NJ, in 1933. Died in 1936.

LAMBERT, CHARLES.

Stonecutter. Born in Kirk Deighton, Yorkshire, England, August 30, 1816; moved to Nauvoo, IL, 1844; settled in Utah in 1849. Joined Mormons, 1843. Carved sun-face capitals of the Nauvoo Temple of the Latter Day Saints, Nauvoo, IL, about 1844. Died in Salt Lake City on May 2, 1892.

LAMIS, LEROY.

Sculptor and teacher. Born Sept. 27, 1925, in Eddyville, IA. Earned B.A. from New Mexico Highlands Univ., 1953; MA, Columbia Univ. 1956. Taught at Cornell College (IA) 1956-60 and Indiana State Univ. from 1961. Awarded residency, Dartmouth, 1970, and received awards from Des Moines Art Center (1958) and NYS Council on Arts. Work in Albright-Knox Museum; Whitney; Hirshhorn; others. Exhibited at Clarke College (1957 and 1961); State Univ. of Iowa; Albright-Knox; Denver Art Museum; Museum of Modern Art; Smithsonian Institution; La Jolla; Whitney Museum; Ball State Teachers Club, IN; Scripps Club; and others. In collections of Whitney; Albright-Knox; Staempfli Collection; Hirshhorn Collection and many private collections. Media: Plastics. Address in 1982, Terre Haute, IN.

LAMONT, FRANCES KENT (MRS.).

Sculptor. Pupil of Solon Borglum and Mahonri Young. Represented in Cleveland Museum of Art; memorial to the wars of America, New Canaan, CT; Spanish-American war memorial, New Rochelle, NY; Metropolitan Museum of Art; Denver Art Museum; Cranbrook Museum of Art; Albright Art Gallery; others. Exhibited: Salon des Tuileries, Paris, 1937-39; Whitney, 1941-51; Philadelphia Museum of Art, 1940-49; Penna. Academy of Fine Arts, 1940, 48, 49; Allied Artists of America, 1958, 59, 60; one man: George W. V. Smith Museum, 1950; Denver Art Museum, 1952; traveling exhibition, 1952-53; Albright, 1953. Awards: Allied Artists of America, 1958; National Sculpture Society, 1969. Member: National Sculpture Society. Address in 1970, 21 West 10th Street, NYC. Died in 1975.

LAMSON, JOSEPH.

Carver. Specialty was tombstones. Active in Charlestown, MA, early in the 18th century. Work included representations of faces and figures.

LANDER, LOUISA.

Portrait sculptor. Born in Salem, MA, September 1, 1826. Began her art career by modeling likenesses of members of her family; went to Rome, 1855, and studied under Thomas Crawford. Studio in Washington, DC, after 1855. Among her first notable works were figures of marble, "Today" and "Galatea." Among her later works are: A bust of Governor Gore, of MA; bust of Hawthorne; statues of "Virginia Dare;" "Undine;" "Virginia;" "Evangeline;" "Elizabeth;" "The Exile of Siberia;" "Ceres Mourning for Proserpine;" "A Sylph Alighting;" "The Captive Pioneer;" also many portrait busts. Address in 1923, 1608 19th St., Washington, DC. Died November 14, 1923.

LANDIS, LILY.

Sculptor. Born in NYC. Studied at Sorbonne, France; Art Students League; also with Jose De Creeft. Exhibited group shows at Sculptors Guild; Audubon Artists; National Academy of Design; Art Institute Chicago; Corcoran Gallery; Sculpture Center; Penna. Academy of Fine Arts; Whitney Museum of American Art; and others. Works: Noma Electric Company; David Doniger Company; Hirsch & Company; and also many private collections. Address in 1983, 400 E. 57th St., NYC.

LANDSMAN, STANLEY.

Sculptor. Born January 23, 1930, NYC. Studied: Univ. of New Mexico, with Randall Davey, Adja Yunkers, Agnes Martin, BFA, 1947-50, 1954-55. Work: Museum of Modern Art; Paris (Moderne); Aldrich; Whitney Museum; Walker. Exhibited: Richard Feigen Gallery, NYC; Richard Feigen Gallery, Los Angeles, 1965; Leo Castelli Inc., NYC, 1966; Museum of Modern Art, The 1960's; Aldrich; New Delhi, First World Triennial, 1968; Cleveland Museum of Art; Whitney Museum, Light: Object and Image, and Sculpture Annual; UCLA, Electric Art. Taught: Adelphi College; School of Visual Arts, NYC; Pratt Institute; Artist-in-Residence, Aspen Institute and Univ. of Wisconsin. Address in 1982, 45 Downing St., NYC.

LANE, KATHARINE WARD.

Sculptor. Born Boston, MA, Feb. 22, 1899. Pupil of Anna Hyatt Huntington, Charles Grafly, Brenda Putnam. Member: Guild Boston Artists; National Association of Women Painters and Sculptors; North Shore Art Association; Boston Sculptors Society; National Sculpture Society. Awards: Bronze medal, Sesqui-Centennial Exposition, Philadelphia, 1926; Widener Memorial gold medal, Penna. Academy of Fine Arts, 1927; Joan of Arc gold medal, National Association Women Painters and Sculptors, 1928, and Anna Hyatt Huntington prize, 1931; Paris Salon, France, 1928; Grover prize, North Shore Art Association, 1929; Speyer prize, National Academy of

Design, 1931; Barnett prize, 1932. Works: Museum of Fine Arts, Boston, MA; Reading Museum, PA; entrance doors and brick carvings, Harvard University, MA. Address in 1933, Boston, MA; summer, Manchester, MA.

LANE, MARION JEAN ARRONS.
Sculptor, painter, and teacher. Studied: Brooklyn Museum Art School, with Manifred Schwartz and Reuben Tam; The Art Students League, NYC, with Morris Kantor; Pratt Institute, William Paterson College, NJ, B.A.; Rutgers University, M.F.A. Exhibitions: Brooklyn Museum; Montclair Museum; Edward Williams College, 1971; Kraushaar Gallery, NYC, 1975; Pleiades Gallery, NY, 1976, 77. Awards: Brooklyn Museum, 1958; Montclair Museum, 1960, 1964; Atlantic City Annual, 1963. Taught: Instructor, drawing and painting, Riverdell Adult School, Oradell, NY, 1961-71; Edward Williams College, 1972; Bergen Community College, 1980-81. Life member, Art Students League. Address in 1976, Ridgewood, NJ.

LANG, CHARLES M.
Sculptor, painter, illustrator, craftsman, and teacher. Born Albany, NY, Aug. 26, 1860. Pupil of Julius Benzur, Prof. Lofftz; studied in Venice and London. Member: Salmagundi Club. Work: "Gov. David B. Hill," "Gov. Roswell P. Flower," Albany, NY; "Hugo Flagg Cook," Capitol, Albany; Judges Parker and Houghton, Court House, Albany; bust of James Ten Eyck, Masonic Temple, Albany; "Gen. Joseph B. Carr," "Cuett" and "Warren," Troy, NY; "Morgan J. O'Brien," Manhattan Club, New York City; "Bishop Rooker," "Gen. C. P. Easton," "Prof. Robinson," Albany High School, Ithaca, NY. Address in 1933, Miller Bldg. Studio, 1931 Broadway; 47 Fifth Ave., New York, NY. Died in 1934.

LANGE, KATHARINE GRUENER.
(Mrs. Oscar J. Lange). Sculptor. Born in Cleveland, OH, Nov. 26, 1903. Studied at Smith College, B.A., 1924; Cleveland Institute of Art, 1933. Works: Cleveland Museum of Art; Republic Steel Corporation, Cleveland. Exhibited: Architectural League; Whitney; Metropolitan Museum of Art; Cleveland Museum of Art; others. Awards: Cleveland Museum of Art, 1936, 1937, 1940-43, 1945, 1946, 1948-50, 1952, 1953-55, 1957. Member: Cleveland Institute of Art; Cleveland Art Association. Address in 1962, Shaker Heights 22, OH.

LANGENBAHN, AUGUST A.
Sculptor. Born in Germany, August 28, 1831. Came to US c. 1852; settled in Buffalo, NY c. 1885. Works held: Buffalo Historical Society; Buffalo Public Library; Buffalo Museum; NY Historical Society. Died in Buffalo, NY, June 7, 1907.

LANGLAIS, BERNARD.
Sculptor and painter. Born July 23, 1921, Old Town, ME. Studied: The Corcoran School of Art, with Ben Shahn; Skowhegan School, with Henry V. Poor; Brooklyn Museum School, with Max Beckmann; Academie de La Grande Chaumiere; Academy of Art, Oslo. Work: Philadelphia Museum of Art; Art Institute of Chicago; Colby College; University of Maine; The Olsen Foundation

Inc.; Provincetown (Chrysler); Whitney Museum. Exhibited: Leo Castelli Inc., New York City; Allan Stone Gallery, NYC, 1962; Makler Gallery, Philadelphia, 1966; Portland (ME) Museum of Art; ART:USA:58 and ART:USA:59, New York City, 1958, 59; Yale University, Best of Contemporary Painting from New York Galleries, 1960; Boston Arts Festival; Martha Jackson Gallery, NYC; Art Institute of Chicago Annuals; Whitney Museum Annuals; San Francisco Museum of Art, 1962; Houston Museum of Fine Arts; Museum of Modern Art, The Art of Assemblage, 1961; Carnegie; others. Awards: Scholarship, Corcoran Gallery; Fulbright Fellowship (Norway), 1954-55, 56; Purchase Award, National Academy of Arts and Letters, 1969; Guggenheim Fellowship, 1972; Ford Foundation. Medium: Wood. Address in 1976, Cushing, ME.

LANGLEY, SARAH.
(Mrs. Earl Mendenhall). Sculptor, painter, illustrator, writer, and teacher. Born Texas, July 12, 1885. Pupil Penna. Academy of Fine Arts. Member: Fellowship Penna. Academy of Fine Arts. Works: "Jewels," Penna. Academy of the Fine Arts. Address in 1933, Philadelphia, PA; summer, Forest Inn, Eagles Mere Park, PA.

LANGS, MARY METCALF.
Sculptor. Born in Burford, Ontario, Canada, March 12, 1887. Studied sculpture with Bourdelle, Despiau, Gimond in Paris. Awards: Albright Art Gallery, 1938, 41, 45, 50. One man shows Schenectady and Niagara Falls, NY; exhibited Salon de Printemps, Paris, Salon d'Autumn, Paris, National Academy of Design, Penna. Academy of Fine Arts, Audubon Artists, NYC, Artists Western NY, Buffalo, and others. Member: Patteran Society; Artists Equity; International Institute of Arts and Letters (life fellow). Address in 1962, Niagara Falls, NY.

LANGTON, BERENICE FRANCES.
(Mrs. Daniel W. Langton). Sculptor. Born in Erie Co., PA, September 2, 1878. Pupil of Augustus Saint-Gaudens in NY; Rodin in Paris. Member: Pen and Brush Club; National Assn. of Women Painters and Sculptors. Exhibited at National Sculpture Soc., 1923; Metropolitan Mus. of Art, 1942; Penna. Acad. of Fine Arts; National Acad. of Design; Salon des Beaux-Arts, and Salon des Tuileries, Paris, France; Penn and Brush Club. Awards: Bronze medal, St. Louis Exp., 1904; Helen Foster Barnett prize for sculpture, National Assn. of Women Painters and Sculptors, 1915; medal, Pen and Brush Club, 1948. Works: Lawrence memorial, New London, CT; Rathborne tablet, NY Athletic Assn., Travers Island, NY; Triton fountain, Oakdene, Bernardsville, NJ; varicolored marble fountain, Cleveland, OH; swan fountain, Hempstead, LI; marble Sun-dial, Morristown, NJ. Exhibited: Metropolitan Museum of Art, 1942; Penna. Acad. of Fine Arts; Walters Gallery, Baltimore, MD; Salon des Beaux-Arts, Salon des Tuileries, Paris, France. She executed numerous small marbles, bronzes, and portrait medals. Address in 1953, 122 East 27th Street, NYC. Died in 1959.

LANKES, JULIUS J.
Sculptor, painter, illustrator, etcher, artist, craftsman, and

writer. Born in Buffalo, NY, August 31, 1884. Studied: Art Students league, Buffalo, NY; Boston Museum of Fine Arts School; pupil of Mary B. W. Coxe; Ernest Fosbery; Philip Hale; W. M. Paxton. Member: Associate of the National Academy; Society of American Graphic Artists; Print Makers' Society of California. Represented in permanent print collections of the Boston, NY, and Newark Public Libraries; Metropolitan, Brooklyn Museums; Carnegie Institute, Pittsburgh; Library of Congress, Washington, DC; British Museum. Exhibited: Carnegie; Corcoran; Albright; Baltimore Museum of Art; Rochester Memorial Art Gallery; Richmond Academy of Fine Arts. Illustrations for "New Hampshire," by Robert Frost. Address in 1953, Durham, NC. Died in 1960.

LANSING, WINIFRED J.
Sculptor. Born in Rochester, NY, in 1911. Studied at Brooklyn Museum Art Center; Art Students League. Works: Rochester Memorial Art Gallery; Rochester Public Library. Address in 1983, Highland, NY.

LANTZ, MICHAEL.
Sculptor. Born in New Rochelle, NY, April 6, 1908. Studied at the National Acad. of Design, 1924-26; under Lee Lawrie, 1926-35; and at the Beaux-Arts Inst. of Design, 1928-31. Exhibited: Philadelphia Mus. of Art, PA, 1940 and 48; National Sculpture Soc.; National Acad. of Design; and the Lever House, NY. Member: National Sculpture Soc. (president, from 1970-73, chairman of honors and awards committee); National Acad. of Design (council member, 1970 to present, 1st vice president, 1975 to present); American Acad. of Achievement (board of governors); and the Fine Arts Fed. of NY (vice president, 1970). Taught: Professor of Sculpture in adult education in New Rochelle, 1936-38; Instructor at the National Acad. of Design, from 1965-present. Commissioned works: Sculptural Outlines for the Architect's Building in Albany, NY, 1968; Thomas Jefferson Bicentennial Medal, US Mint, 1976; New Rochelle Bicentennial Medal, 1976; a four foot bronze eagle for the Peoples Bank for Savings, 1977; and others. Published numerous articles in the National Sculpture Review. Address in 1982, New Rochelle, NY.

LARA, ARMOND.
Sculptor, painter, and collagist. Born in Denver, Colorado, in 1939. Studied at Colorado Institute of Art, architecture; Glendale College, BA art 1962. Became Arts Advisor to Bellvue, Washington; Art Director in Redmond, 1975; selected Artist in the City of Seattle, 1977. Preferred medium is handmade paper. Represented by Heydt/Bair Gallery, Santa Fe, NM; W. A. Taylor Gallery, Houston, TX. Address since 1981, Santa Fe, New Mexico.

LARMANDE (or LARMONDO) LEO J.
Sculptor. At NYC, 1854-56. See Larmande & Bourlier.

LARMANDE & BOURLIER.
Sculptors. Active in NYC, 1854-56; Leo J. Larmande and Alfred J. B. Bourlier.

LARSEN, MORTEN.
Sculptor, painter, and wood carver. Born in Saal Sogan, Jutland, Denmark, in 1858 or 1859. Later lived in California. Studied at Industrial Art School and Royal Academy, probably in Denmark. Exhibited at Mechanics' Institute of Industrial Exhibitions, San Francisco, 1890's. Executed "Deer in the Forest" (1893), sculpted in high relief. His work departed from the academic tradition and was inspired more by the European folk-art traditions. His pieces were among the few landscape-inspired sculptures of the period.

LASCARI, HILDA K.
Sculptor. Born in Sweden, 1886. Member: National Sculpture Society. Address in 1934, New York. Died in 1937. (Mallett's)

LASKE, LYLE F.
Sculptor and educator. Born in Green Bay, WI, May 10, 1937. Studied at University of Wisconsin, Platteville, B.S., 1959; University of Wisconsin, Madison, M.S., 1961 and M.F.A., 1965; University of Minnesota, 1968. Has exhibited at Walker Art Center, Minneapolis; Artists of Central NY, Everson Museum of Art, Syracuse; American Woodcarvers, Craft Center, Worchester, MA; Handmade Furniture, American Craft Museum, NY; others. Works in wood and bronze. Address in 1982, Art Dept., Moorhead State University, Moorhead, MN.

LASSAW, IBRAM.
Sculptor. Born May 4, 1913, in Alexandria, Egypt; US citizen. Studied with Dorothea H. Denslow at Sculpture Center, NYC (1926-30); at Beaux-Arts Institute and City College, NYC. Founder of American Abstract Artists. Exhibitions include those at Kootz Gallery (many since 1951); MIT; Duke University; Museum of Modern Art; Carnegie; Art Institute of Chicago; Philadelphia Art Alliance; Albright-Knox; Seattle World's Fair (1962); University of Illinois; Two Hundred Years of American Sculpture, and Recent Acquisitions, Whitney Museum of American Art, NYC; numerous others. Taught: Instructor of sculpture, American University, 1950; artist-in-residence, Duke University, 1962-63; visiting artist, University of California, Berkeley, 1965-66; adjunct faculty, Southampton College, from 1966; visiting professor, Brandeis University, Waltham, NY, 1972; Mt. Holyoke College, 1978. In collections of Harvard University; Washington University; Newark Museum; Wadsworth Atheneum; Baltimore Museum; Cornell University; Whitney Museum; Museum of Modern Art, NY and Rio de Janeiro, Brazil; Kneses Tifereth Israel Synagogue, Port Chester, NY; Beth El Temples of Providence and Springfield; Carnegie; Albright; and others. Address in 1982, East Hampton, NY.

LATHROP, ELINOR L.
Sculptor and painter. Born in Hartford, CT, Sept. 26, 1899. Pupil of Hale, Logan, Calder, Mora, and Jones. Member: Hartford Art Society. Address in 1926, West Hartford, CT; summer, Old Lyme, CT.

LATHROP, GERTRUDE KATHERINE.
Sculptor. Born Albany, NY, Dec. 24, 1896. Studied: Art Students Lg., School of American Sculpture. Pupil of Solon Borglum and Charles Grafly. Sister of illustrator Dorothy Pulis Lathrop; mother was painter. In collec-

tions of Brookgreen Gardens; National Collection of Fine Arts, Washington, DC; Albany Public Library; Houston Public Library; Smithsonian Institution, Washington, DC. Exhibited: National Sculpture Society, 1923; Albany Institute of History and Art, 1957, 66; Woodmere Art Gallery, Philadelphia, 1963. Member: Society of Animal Painters and Sculptors; National Academy of Design; National Institute of Arts and Letters; National Association of Women Painters and Sculptors; National Sculpture Society (Assoc.). Awards: Hon. mention, Art Institute of Chicago, 1924; Helen Foster Barnett prize, National Academy of Design, 1928, and Saltus Gold Med. for Merit, 1970; Medal of Honor, Allied Artists of America, 1964; Silver Medal, Pen and Brush Club, 1967; others. Address in 1982, Falls Village, CT.

LAUBER, JOSEPH.
Sculptor, mural painter, etcher, craftsman, and teacher. Born Meschede, Westphalia, Germany, Aug. 31, 1855; came to US at age of nine. Pupil of Karl Muller, Shirlaw and Chase; worked with La Farge. Member: Mural Painters; NY Architectural Lg., 1889; Artists' Fellowship, Inc. (President); Salmagundi Club, 1902. Awards: Hon. mention for mosaics and glass, Columbian Exp., Chicago, 1893; gold and bronze medals for mosaic and mural designs, Atlanta, 1895; medals, for etchings and mural work, Midwinter Fair, California. Specialty, stained glass, mosaics and murals. Work: Paintings—sixteen symbolic figures, Appellate Court, NY; portrait of ex-speaker Pennington, House of Representatives, Wash., DC; windows in Church of the Ascension, NY; Trinity Lutheran Church, Lancaster, PA; painting of Christ, Euclid Ave. Baptist Church, Cleveland, Ohio. Instructor of art at Columbia Univ., NY. Address in 1933, 371 West 120th St., New York. Died Oct. 19, 1948.

LAUCK, ANTHONY JOSEPH.
Sculptor and educator. Born in Indianapolis, IN, December 30, 1908. Studied at John Herron Art School, Indianapolis; Corcoran School of Art, Washington, DC; also with Oronzio Maldarelli, Ivan Mestrovic, Carl Milles, Hugo Robus, and Heinz Warneke. Work in Penna. Academy of Fine Arts; Corcoran Gallery of Art; Butler Institute of Fine Arts; Indianapolis Museum of Art; others. Has exhibited at Fairmount Park Art Association International Exhibition, Philadelphia; Penna. Academy of Fine Arts; Audubon Artists, National Academy of Arts, NY; others. Received awards from Fairmount Park Art Association, 1948; Penna. Academy of Art, 1953; Indianapolis Museum of Art, 1954. Taught drawing and sculpture at University of Notre Dame, 1950-73. Works in wood and stone. Represented by Bodley Gallery, NYC. Address in 1982, Notre Dame, IN.

LAUCK, JOHN.
Sculptor. Exhibited a marble bas-relief at the American Institute in 1856. Otherwise known as barber and saloon keeper. Active in NYC, 1855-57.

LAUDER, JAMES.
Sculptor. Born in NJ, c. 1825. Worked: NYC, 1846-61.

LAUNITZ, ROBERT EBERHARD SCHMIDT VON DER.
Sculptor. Born in Riga, Latvia, Nov. 4, 1806. Studied sculpture under Thorwaldsen in Rome. In 1828 he came to America; worked in marble shop of John Frazee, later formed a partnership with Frazee, 1831, in NY, and was elected a member of the National Academy in 1833. Mainly a sculptor of mantels and gravestones. Also among his productions are the Pulaski monument in Savannah, GA; the Battle monument in Frankfort, KY; the monument to General George H. Thomas in Troy, NY. Taught many American sculptors, including Thomas Crawford. Died in NYC, Dec. 13, 1870.

LAURENT, ROBERT.
Sculptor and educator. Born Concarneau, France, June 29, 1890. Came to US 1902. Pupil of Hamilton Easter Field; Maurice Sterne; Frank Burty; British Academy in Rome. Member: Artists Equity Assn.; New England Sculptors Association; Salons of America; Modern Artists of America; Brooklyn Society of Modern Artists; National Sculpture Society; Audubon Artists. Awards: Logan medal, prize, Art Institute of Chicago, 1924, 38; Fairmount Park (Philadelphia), International Sculpture Competition, 1935 (monument); Brooklyn Museum, 1942; Herron Institute, five 1st prizes; Audubon Artists, 1945; medal of honor and prize, 1967; many others. Received commission from Radio City Music Hall, NYC; and others. Represented in Art Institute of Chicago; Newark Museum; Brooklyn Museum; Vassar College; Whitney Museum; Museum of Modern Art; Penna. Academy of Fine Arts; Wadsworth Atheneum; Metropolitan Museum of Art; Whitney; Brooklyn Museum; others. Exhibited at Daniel Gallery, Salons of America, Whitney, Metropolitan Museum of Art, all in NYC; Art Institute of Chicago; Brooklyn; Corcoran; Penna. Academy of Fine Arts; John Herron Art Institute; and many more. Director of Ogunquit (ME) School of Painting and Sculpture. Taught: Art Students League; Vassar; Goucher; Corcoran School of Art; Indiana University, Bloomington, IN, from 1942, Emeritus, from 1960. Address in 1970, Indiana University, Bloomington, IN; h. Cape Neddick, ME. Died in Cape Neddick, ME, April 20, 1970.

LAURIE, LEE. O.
(See Lawrie, Lee O.).

LAURIE-WALLACE, JOHN.
Sculptor, painter, illustrator, lecturer, and teacher. Born Garvagh, Ireland, July 29, 1863. Pupil of Thomas Eakins; Penna. Academy of Fine Arts; Art Institute of Chicago. Member: Omaha Artists Guild, President; Chicago Society of Artists. Work: Joslyn Memorial; Lincoln Art Gallery. Address in 1953, Omaha, NE.

LAUTZ, WILLIAM.
Sculptor. Born in Unstadt, Germany, on April 20, 1838, and came to the US in 1854. Since that time he was a resident of Buffalo. He was an actor and for sixteen years confined himself entirely to Shakespearean roles. He then found expression in sculpture and modeling, and

some of his work is in the Buffalo Historical Society Building. Died in Buffalo, NY, June 24, 1915.

LAVATELLI, CARLA.

Sculptor and weaver. Born in Rome, Italy, Aug. 21, 1929; US citizen. Studied at National Gallery, Rome, Italy; Phillips Collection, Washington, DC; Stanford Univ. New Law Bldg.; H. E. Leone, Pres. Repub. Italy; Freidburgh Univ., Germany. Commission: Lobby Spingold Theater, Brandeis Univ., 1969; New Bldg. Upjohn Pharmaceuticals, Kalamazoo, MI, 1970; portrait group of S.A.S. Ranier, III, Prince of Monaco and his family, 1971; Imperial Majesties Shah and Shahbanou Iran, 1974; Kasser Found., NJ, commissions by Mr. and Mrs. A. Kasser and Mr. and Mrs. S. Mouchary, 1974-75. Exhibitions: Spoleto, Palazzo Collicola, Italy, 1966; Palazzo della Quadriennale, 1967; one-woman shows, Hakone Mus., Japan, 1972-73 and Phillips Collection, Washington, DC, 1974; San Francisco Mus. Art, 1975-76. Media: Stone, bronze, stainless steel, paper, white and black yarns. Address in 1982, 140 Thompson Street, NYC.

LAWRENCE, RUTH.

(Mrs. James C.). Sculptor, craftsman, writer, lecturer, educator, and museum director. Born in Clarksfield, Ohio, June 9, 1890. Studied: Ohio State University; Akron University; University of Minnesota; and in Italy. Member: College Art Association of America; Western Art Association; American Museum Directors Association; Sculptors Guild; American Society for Aesthetics. Work: University of Minnesota; Walker Art Center. Contributor to art magazines and educational journals. Taught: Instructor, 1934, Curator, Gallery of Art, 1934-40; Director of University Gallery, Assistant Professor, University of Minnesota, Minneapolis, from 1940. Address in 1953, 310 Northrop Auditorium; h. Minneapolis, Minn.

LAWRIE (or LAURIE), LEE O.

Sculptor. Born Rixford, Germany, October 16, 1877. Pupil of Saint Gaudens and Martiny. Instructor in sculpture, Harvard Univ., 1910-12; Yale Univ., 1908-18. Member: Associate of National Academy of Design; National Institute of Arts and Letters; National Sculpture Society; National Arts Club; New York Architectural League; Century Association; (hon.) American Institute of Architecture. Award: Gold medal, American Inst. of Architecture, 1921 and 1927; hon. award, Southern California Chapter, American Institute of Architecture, 1926; medal, Architectural League, 1931. Work: Decorations in US Military Academy, West Point; Church of St. Vincent Ferrer, and reredos of St. Thomas' Church, NY; Harkness Memorial Tower and Archway, Yale Univ.; sculpture for National Academy of Sciences, Washington, DC; sculpture for Nebraska State Capitol; small marble head of woman, Metropolitan Museum of Art, NY; Los Angeles Public Library; Bok Carillon Tower, FL; Goodhue Memorial, NY; memorial, Octagon House Garden, Washington, DC; peace memorial, Gettysburg, PA; others. Exhibited at National Sculpture Society, 1923. Address in 1953, Locust Lane Farm, Easton, MD. Died in 1963.

LAWSON, JOHN DONALD (MRS.).

Sculptor. Member: National Academy of Women Painters and Sculptors. Address in 1928, Saugatuck, CT.

LAWSON, KATHARINE STEWART (MRS.).

Sculptor. Born in Indianapolis, IN, May 9, 1885. Pupil of Lorado Taft, Hermon A. MacNeil. Award: Shaw prize, National Academy of Design, 1921. Member: National Association of Women Painters and Sculptors; Independent Society of Sculptors. Address in 1933, Saugatuck, CT; "Lone Pine Studio," Westport, CT.

LAWSON, LOUISE.

Sculptor. Died April 4, 1899.

LAWSON-PEACEY, JESS M. (MRS.).

Sculptor. Born Edinburgh, Scotland, February 18, 1885. Studied at College of Art, Edinburgh, and the Royal College of Art, London. Member: British Institute; Associate Royal College of Art, London; Art Alliance of America; National Sculpture Society; National Association of Women Painters and Sculptors; ARBS, London. Awards: Helen Foster Barnett prize, National Academy Design, 1918; Widener gold medal, Penna. Academy of Fine Arts, 1919; medal, International Exp., Paris, 1926; McClees prize, Penna. Academy of Fine Arts, 1927. Exhibited at National Sculpture Society, 1923. Address in 1933, 114 East 71st St., NYC. Died in 1965.

LAY, PATRICIA ANNE.

Sculptor. Born in New Haven, CT, August 14, 1941. Studied at Rochester Institute of Technology, M.F.A.; Pratt Institute, B.S. Works: New Jersey State Museum, Trenton. Exhibitions: 25th Ceramic National, Everson Museum of Art, Syracuse, NY, 1968-69; Warren Benedek Gallery, NY, 1973; one-person show, New Jersey State Museum, 1974; Contemporary Reflections, Aldrich Museum, Ridgefield, CT, 1975; Whitney Museum of American Art Biennial, 1975. Media: Fired clay, metal, wood. Address in 1982, Department of Art, Montclair State College, Upper Montclair, NJ.

LAYBOURNE-JENSEN (LARS PETER).

Sculptor and painter. Born in Copenhagen, Denmark, in 1888. Pupil of Danish Academy. Member: Society of Independent Artists. Address in 1926, Roselle Park, NJ.

LAZAREE (or LAZZAREE), JOSEPH.

Sculptor. Worked: New York City, 1843-50. Died c. 1850.

LAZZARI, PIETRO.

Sculptor, painter, lithographer, illustrator, and etcher. Born in Rome, Italy, May 15, 1898; US citizen. Studied: Ornamental School of Rome. Member: National Society of Mural Painters; Art Guild of Washington; Washington Watercolor Society; Artists Equity Association. Awards: Prize, Ornamental School, Rome; Fulbright Scholarship; Baltimore Museum Lord Prize. Work: Art Institute of Chicago; Whitney; National Collection of Fine Arts, Washington, DC; San Francisco Museum of Art; others, including many commissions. Exhibited: Metropolitan Museum of Art, 1942; Whitney Museum of Art, 1934; Art Institute of Chicago, 1943; National Academy of Design, 1944, 45; Contemporary Art Gallery, 1939; Whyte Gallery, 1943; Crosby Gallery, 1945; Paris, France, 1945; Corcoran; National Collection of Fine Arts, 1970. Taught: Instructor, sculpture and drawing, American University, Washington, DC, from 1948-50; Corcoran School of Art, 1965-69. Media: Concrete, bronze; oil.

Address in 1976, Washington, DC. Died in 1979.

LE VA, BARRY.
Sculptor. Born in 1941, Long Beach, CA. Studied at the Otis Art Institute in Los Angeles, CA, 1964-67. Exhibited his first one man show at the Minneapolis School of Art, 1969; Bykert Gallery, NYC; Whitney Museum, Anti-Illusion Show; University Museum in Columbus, OH, 1969; La Jolla Museum, CA, 1970; Galerie Ricke, Cologne, West Germany; the Nigel Greenwood Gallery, London; and Galleria Toselli, Milan, Italy. Taught art at the Minneapolis College of Art and Design, 1968, and Princeton University, NJ, 1973-74. Work has gone through numerous changes. Some of his pieces are known as "distributions" which utilize such media as flour and cement powder distributed over various surfaces. Another group is his "Velocity Pieces," one example involving Le Va's construction and destruction of four walls and the recorded sounds of his movements. Other modes include the use of rods and slices of wooden dowels on the floor such as his "12 to 3: End Touch-Ends Cut."

LE WITT, SOL.
Sculptor. Born 1928, in Hartford, Conn. Studied: Syracuse University, B.F.A., 1949. Work: Museum of Modern Art; Stedelijk; Albright-Knox; and German museums. Exhibited: Dwan Gallery, NYC and Los Angeles; Galerie Bischofberger, Zurich, 1968; Galerie Heiner Friedrich, Munich, 1968; Konrad Fischer Gallery, Dusseldorf, 1968; Whitney Sculpture Annual; Los Angeles County Museum of Art; Philadelphia Museum of Art; Aldrich; Munich (Modern); New Art; USA, 1968; Stadtische Kunsthalle, Dusseldorf, 1969; Guggenheim; Museum of Modern Art; Walker; Wadsworth Atheneum; La Jolla Museum. Taught: Museum of Modern Art School, 1964-67; Cooper Union, 1967. Address in 1982, 117 Hester St., NYC.

LEACH, LOUIS LAWRENCE.
Sculptor. Born in Taunton, Mass., May 4, 1885. Studied: Mass. School of Art; and with Cyrus Dallin. Work: Monuments, memorials, bas-reliefs, Taunton, Mass.; Mass. State House; Garden City, NY; Brighton, Mass.; Sioux City, Iowa; Tufts College; Tufts Medical School, Boston. Address in 1953, Taunton, Mass. Died in 1957.

LEAF, JUNE.
Sculptor and painter. Born in Chicago, IL, 1929. Studied at the Art Institute of Chicago; Paris. Exhibited: Whitney Museum of American Art, NY, 1970; Cranbrook Academy Art Museum, Michigan, 1974; Boston University Art Gallery, MA, 1975; Museum of Contemporary Art, Chicago, IL, 1978; Katherine Nash Gallery, Minneapolis, 1981. Works in all media. Address in 1982, c/o Young Hoffmann Gallery, Chicago, IL.

LEAVES, ANN.
Sculptor. Member of the National Sculpture Society. Address in 1982, Acton, Mass.

LEBLANC, WILLIAM.
Sculptor. Active in New Orleans, 1849-51.

LEBRUN, RICO (FREDERICO).
Sculptor, painter, printmaker, and teacher. Born in Naples, Italy, Dec. 10, 1900. Studied: Academy of Arts and National Technical Institute, Naples; Beaux-Arts Academy, also in Naples. After moving to US in 1924, returned frequently to Italy to study Renaissance and Baroque masters. Lived in Springfield, IL, 1924; moved to NYC in 1925, where he became a successful advertising artist; taught at Art Students Lg. Settled in California in 1938. Represented in Los Angeles Museum of Art; Metropolitan Museum of Art; Museum of Modern Art; Munson-Williams-Proctor Institute; Boston Museum of Fine Arts; Rhode Island School of Design; Whitney; others. Has exhibited at City Art Museum of St. Louis, 1945; Los Angeles Museum of Art, 1945, 48-51; Carnegie Institute, 1945; Whitney, 1948-50, 52; Art Institute of Chicago, 1947, 48, 51; Metropolitan Museum of Art, 1950; Penna. Academy of Fine Arts, 1951, 52; others. Awards include prizes, Art Institute of Chicago; Guggenheim Fellowship; Metropolitan Museum of Art; American Academy of Arts and Letters. Member of Artists Equity Association. Highly influential artist on West Coast. Also taught in Mexico at Escuela de Bellas Artes, San Miguel de Allende; in Italy at American Academy, Rome. Represented by Kennedy Galleries, NYC. Address in 1953, Los Angeles, CA. Died in 1964.

LECONTE, A.
Sculptor. Active 1865. Patentee—medallion of Lincoln 1865.

LEDERER, ESTELLE MacGILL.
Sculptor, painter, lecturer, and teacher. Born in Cleveland, Ohio, April 7, 1892. Address in 1933, Studio 5, New Haven, CT; summer, Estelle MacGill Lederer Art Colony, Pine Orchard, CT.

LEE, ARTHUR.
Sculptor. Born Trondheim, Norway, May 4, 1881. Studied at Art Students League; Ecole des Beaux-Arts, Paris; and in London and Rome. Awards: Guggenheim Fellowship; American Academy of Arts and Letters grant; honorable mention for sculpture, P.-P. International Exp., San Francisco, 1915; Widener Memorial gold medal at Penna. Academy of Fine Arts in 1924. Work: "Eureka," torso, Cooper Union, NY; "Volupte," torso, Metropolitan Museum, NY; Whitney Museum of American Art; Brooklyn Museum; Valentine Museum, Richmond, VA. Exhibited at National Sculpture Society, 1923; Art Institute of Chicago; others. Taught: Instructor, Greenwich House, NYC. Address in 1953, 1947 Broadway; h. 160 Waverly Pl., NYC. Died in 1961.

LEEBER, SHARON CORGAN.
Sculptor. Born in St. Johns, MI, Oct. 1, 1940. Studied at Univ. Wyoming; National Open Univ., Washington, DC; Trinity Univ. Works: Shreveport Mus., LA; Del Mar College; Las Cumbres, Acapulco, Mexico; 2001 Club, Dallas, TX. Comn: Six welded steel pieces, Stemmons Inn, Dallas, TX, 1972; large welded male, Incarnate Word College, San Antonio, TX, 1977; four welded figures, Fryburger Collection, San Antonio, 1975. Exhibitions: Texas Fine Arts National, Austin, 1969;

one-woman retrospective show, Elizabet Ney Mus., Austin, 1971; Texas Sculpture and Painting, Dallas, 1971; Okla. Painting and Sculpture, Oklahoma City, 1971; Texas Ann. Erotic Show, San Antonio, 1971 and 72. Awards: Purchase Award, Shreveport Mus., 1969; Purchase Award, Del Mar Coll. Member: National Sculptors' Assn.; Artists Equity Assn.; Texas Fine Arts Assn. Media: Steel, glass, aluminum, marble. Address in 1982, Dallas, TX.

LEEPER, DORIS MARIE.
Sculptor and painter. Born in Charlotte, NC, April 4, 1929. Studied: Duke University, B.A. in Art History, 1951; self-taught as an artist. Collections: National Collection of Fine Arts, Washington, DC; 180 Beacon Collection, Boston; Chase Manhattan Bank; Wadsworth Atheneum, Hartford, CT; Columbus Museum of Art, OH; Reserve Insurance, Orlando, FL; Bank of NY; Jacksonville Art Museum, Florida. Exhibited: Contemporary Women Artists, National Arts Club, NY, 1970; Mississippi Museum of Art, Jackson, 1979; High Museum of Art, Atlanta, 1975; Museum of Arts and Science, Daytona Beach, 1980. Awarded an individual grant from the National Endowment for the Arts, 1972; Artist in Residence Fellowship, Rockefeller Foundation, 1977, others. Media: Oil; fiberglas, metal, and concrete. Address in 1982, New Smyrna, FL.

LEFTWICH, BILL.
Sculptor and painter. Born in Duncan, Oklahoma, in 1923. Studied at Dallas Institute of Fine Art, with Olin Travis; San Antonio Academy of Art, with Hugo Pohl; sculpting, in England, 1945. Has worked as a cowboy, park ranger, smelter; served in cavalry in World War II. Has written and illustrated books; painted magazine covers. Specialty is Indian, cowboy, Mexican, and military subjects. Sculpts in bronze. Member of Texas Cowboy Artists Association; The Company of Military Historians; Western Writers of America. Represented by Big Bend Art Gallery, Alpine, TX; La Casa Gallery, Abilene, TX. Address in 1982, Fort Davis, Texas.

LeGALIENNE, GWENN.
Sculptor, painter, and engraver. Born in Paris, 1900. Exhibited: Salon d'Automne; Tuileries.

LEHMAN, HAROLD.
Sculptor, painter, and teacher. Born in New York City, October 2, 1913. Studied: Otis Art Institute; and with Fettelson, Siqueiros. Member: Art League of America; Woodstock Art Assn. Awards: Prizes, Los Angeles Museum of Art, 1933; Municipal Art Gallery, NY, 1937. Work: Newark Museum; Museum of Modern Art; murals, Rikers Island, NY; United States Post Office; Renovo, PA. Exhibited: World's Fair, New York, 1939; Whitney Museum of Art, 1940; Museum of Modern Art, 1943; National Academy of Design, 1943; Woodstock Art Association, 1942-45; National Gallery of Art, 1943. Taught: Instructor, YMCA, New York, NY, 1947-50. Address in 1953, 46 West 21st Street, New York, NY.

LEIFERMAN, SILVIA W.
Sculptor and painter. Born in Chicago, IL. Studied at Univ. of Chicago, 1960-61; extensive study in Chicago, IL, Provincetown, MA, Mexico, Rome, Italy, and Madrid, Spain. Works: Miami Museum of Modern Art, Florida; Lowe Art Museum, Univ. of Miami; Roosevelt Univ., Chicago; in collections of Jack Benny and Gov. Haydon Burns; also in private collections throughout the world. Exhibitions: International Platform Assn., 1967; Artists Equity Show, Crystal House, Miami Beach, 1968; Lowe Art Museum; Beau Art Gallery, Univ. of Miami; one-woman shows, Hollywood Museum Art, Florida, 1968 and Miami Museum of Modern Art, 1972; plus others. Member of American Federation of Arts; others. Positions: Co-founder and vice pres., Silvia and Irwin Leiferman Foundation; pres., Active Accessories by Silvia, Chicago, from 1964. Media: Oil, acrylics; hot wax. Address in 1982, Bal Harbour, FL.

LEIGH, HARRY E.
Sculptor and painter. Born in Buffalo, NY, November 7, 1931. Studied at Albright Art School, dipl., 1952; State University of New York, Buffalo, B.A., 1953; Columbia University, M.A., 1959; painting with Richard Pousette-Dart, 1956-60. Work in Virginia Museum of Fine Art, Richmond; others. Has exhibited at Albright-Knox Art Gallery, Buffalo; Everson Museum, Syracuse; Brata Gallery, NY; OK Harris Gallery, NY; Rockland Center of Arts, Nyack, NY. Received MacDowell fellowship, artist-in-residence, 1968, 69, 70, 72, 74, and 75; Yaddo fellowship, artist-in-residence, 1972, 79, and 80; others. Works in wood and bricks. Address in 1982, Suffern, NY.

LEIGH, WILLIAM ROBINSON.
Sculptor, painter, illustrator, writer, lecturer, and teacher. Born in Berkeley County, West VA, September 23, 1866. Studied: Maryland Institute, with Hugh Newell; Royal Academy, Munich, with Raupp, Gysis, Loefftz. Member: Allied Artists of America; Salmagundi Club; Author's League. Awards: Medal, Royal Academy, Munich; Appalachian Exp., Knoxville, TN, 1911. Work: Frank Phillips Museum, Bartlesville, OK; African Hall, American Museum of Natural History; and in Munich. Exhibited: Babcock Gallery; Grand Central Art Gallery, 1939, 41, 44; Gumps Gallery, San Fran., CA, 1944; Washington County Museum of Fine Arts, 1950, 52; Maryland Institute, Baltimore, 1950. Author, illustrator, "Frontiers of Enchantment," 1938; and other books. Contributor to: Scribners, Natural History magazine, Colliers. Lectures: Art; Africa. Painter of backgrounds for African Hall, American Museum of Natural History, NYC. Address in 1953, 1680 Broadway; h., 200 West 57th St., NYC. Died in 1955.

LEKAKIS, MICHAEL NICHOLAS.
Sculptor. Born March 1, 1907, NYC. Self-taught. Work: Dayton Art Museum; Greece (National); Hartford (Wadsworth); Museum of Modern Art; Portland (OR) Art Museum; Guggenheim; Seattle Art Museum; Tel Aviv; Whitney Museum. Exhibited: Philadelphia Museum of Art, 1977; Artists' Gallery, NYC, 1941; The Bertha Schaefer Gallery, New York City; Dayton Art Museum; Whitney Annuals, 1948-52, 1958, 60, 62; Guggenheim, Sculpture and Drawings, 1958; Cleveland Museum of

Art, 1961; Boston Arts Festival, 1961; Wadsworth Atheneum; Seattle World's Fair, 1962; Museum of Modern Art. Address in 1982, 345 West 29th Street, New York City.

LEKBERG, BARBARA HULT.
Sculptor. Born in Portland, OR, March 19, 1925. Studied at the University of Iowa, B.F.A. 1946, M.A., 1948; and with Humbert Albrizio. Works: Knoxville (Tennessee) Art Center; Socony Building, NY; Des Moines Art Center; Beldon-Stratford Hotel, Chicago. Exhibitions: Penna. Academy of Fine Arts Annual, Philadelphia, 1950-62; San Francisco Museum of Art, 1952; Whitney, 1953, 57; New Talent, American Federation of Arts, Traveling Show, 1959-60; Recent Sculpture USA, Museum of Modern Art, NYC, 1959; one-woman shows, Sculpture Center, NY, 1959, 65, 71, 75, 77, and 82; traveling solo show, Birmingham Museum of Art, SC, 1973; and others. Awards: American Institute of Arts and Letters, 1956; Guggenheim fellowship, 1957, 59. Taught at the College of New Rochelle, 1980-82; and the Philadelphia College of Art, 1981-82. Address in 1983, Mamaroneck, NY.

LELAND, ELIZABETH.
(Mrs. Ernest E. Morenon). Sculptor. Born in Brookline, MA, April 6, 1905. Studied at Julian Acad., Paris, 1926-27; Ecole Nationale Superieur des Beaux Arts, Paris, 1927, 28, 30, 32; Fontainebleau School of Fine Arts, France, 1927, 1928. Exhibitions: One-man show, Jr. League, Boston, Brookline, Mass., 1934; group shows, Independent Artists, Boston; Penna. Acad. of Fine Arts; Merrimack Valley Art Assn. Awards: Honorable mention Jr. League regional show, New Haven; 2nd prize national show, San Francisco, 1934. Member: Social Science Club, Newton; National Society of Colonial Dames of America. Director of Merrimack Valley Artists, 1935-38. Address in 1962, Newton, MA; Studio: Boston, MA; summer, Sandwich, MA.

LEMON, DAVID.
Sculptor. Born in San Diego, California, in 1945. Began showing sculpture and won scholarships in late teens. Worked in a printing plant; took classes in illustration; modeled in spare time. Work shown at Texas Trails Gallery, San Antonio, TX. Reviewed by *Southwest Art*, August 1981. Specialty is figures of the Old West. Works in bronze. Address in 1982, Sandy, Utah.

LEMON, FRANK.
Sculptor. Born in Washington, DC, Nov. 10, 1867. Pupil of Corcoran School of Art. Awarded diploma, Pan-American Exp., Buffalo, 1910, for work in National Museum exhibit. Member of NY Architectural League, 1902. Address in 1918, East Point, GA.

LENGHI, MOSES G.
Sculptor. At NYC, 1848-49. Exhibited: American Institute, 1849. Medium: Marble.

LENTELLI, LEO.
Sculptor and painter. Born in Bologna, Italy, Oct. 29, 1879; came to US in 1903. Works: Saviour and sixteen angels, reredos, Cathedral of St. John the Divine, NY; group over entrance of Mission Branch Library, San Francisco, CA; five figures, facade, San Francisco Public Library; decorations, Orpheum Theatre, St. Louis, MO; decoration, Sixteenth Street Bridge, Pittsburgh, PA; panel, Corning Free Academy, Corning, NY; flagpole base and panels for Mothers House, Rice Memorial playfield, Pelham, NY; six equestrian figures and sculptural decorations, Panama-Pacific International Exp., San Francisco, CA; groups, Sullivan Gates, Denver, CO; panels, entrance doorway and top of tower, Straus Bank Building, NY; lunette, Steinway Piano Building, NY; group, Sesquicentennial Exp., Philadelphia, PA; fountain, Breakers Hotel, Palm Beach, FL; Diana, Leda, Park Central Hotel, NY; R. E. Lee, Charlottesville, VA (with H. M. Shrady); Cardinal Gibbons, Washington, DC; Brookgreen Gardens. Awards: Henry O. Avery prize, NY Architectural Lg., 1911, 21; collaborative and Avery prize, NY Architectural Lg., 1913; purchase prize, San Francisco Art Assn., 1916; gold medal, NY Architectural Lg., 1922; Elizabeth N. Watrous gold medal, National Academy of Design, 1927. Membership: National Sculpture Society; NY Architectural League; National Academy of Design. Taught: California School of Fine Arts, San Francisco, 1913-18; instructor, Art Students Lg., NYC. Address in 1953, 51 West 10th Street, NYC. Died in 1962.

LENZ, ALFRED (DAVID).
Sculptor. Born Fond du Lac, WI, May 20, 1872. Began studying as a jeweler's apprentice; then studied engraving, chasing, metal founding, all operations necessary to produce an object of art in metal. Specialty, bronze statuettes. Member of National Scultpure Society, Art Workers Club. Exhibited at National Sculpture Society, 1923. Works include "Pavlowa," Metropolitan Museum of Art; "Star Dust" and "Senorita Hootch," Cleveland Museum of Art; "Senorita Hootch," Newark Museum of Art. Address in 1925, Flushing, Long Island, NY. Died in Havana, Cuba, Feb. 16, 1926.

LENZ, OSCAR.
Sculptor. Born in Providence, RI, in 1874. Studied under Saint Gaudens in New York and under Saulievre in Paris. After his return to this country, he executed the Colonial Group at Charleston, SC, and some of the groups in the Pennsylvania Railroad Station in New York. Died June 25, 1912.

LEON, DENNIS.
Sculptor and educator. Born in London, England, July 27, 1933; US citizen. Studied at Temple University, B.Sc. (education), 1956; Tyler School of Art, M.F.A., 1957. Has exhibited at Penna. Academy of Fine Arts; Philadelphia Museum of Art; San Francisco Museum of Modern Art. Received Guggenheim Fellowship, 1967; National Institute of Arts and Letters Award, 1967; MacDowell Fellowship, 1981; others. Taught sculpture at Philadelphia College of Art, 1960-72; sculpture at California College of Arts and Crafts, from 1972. Address in 1982, Berkeley, CA.

LEONARD, LEONARD SCHWARTZ.
Sculptor. Born in Cincinnati, Ohio, 1923. Awarded Guggenheim grant, 1949, for study in Paris.

LEOPOLD, SOPHIA.
Sculptor. Work includes "Odette," alabaster, exhibited at 94th Annual Exhibition of National Association of Women Artists, NYC, 1983. Member: National Association of Women Artists. Address in 1983, 200 E. 57 Street, NYC.

LEPPER, ROBERT LEWIS.
Sculptor and educator. Born in Aspinwall, PA, September 10, 1906. Studied at Carnegie Institute of Technology, B.A.; Harvard University Graduate School of Business Administration, cert. Work in Butler Museum of American Art, Youngstown, OH; Carnegie Museum of Art; Museum of Modern Art, NY; Stedelijk Museum, Amsterdam. Received medal, Penna. Society of Architects; Purchase Award, Carnegie Museum. Taught design at Carnegie-Mellon University, 1930-75. Address in 1982, Pittsburgh, PA.

LERNER, MARILYN.
Sculptor. Working in the early 1970's in wood and rubber making what she terms "funky" wall constructions.

LEROUX, L.
Sculptor and wood carver. Active in New Orleans, LA, 1834.

LESHER, MARIE PALMISANO.
Sculptor. Born in Reading, PA, September 20, 1919. Studied: The Art Students League, NYC; Berte Fashion Studio in Phila.; Museum of Fine Arts School and Univ. of Houston, TX. Awards: International Exhibition, Berwick, Penna., 1970; Beaumont Art Museum, 1971-1973; Del Mar Coll., Corpus Christi, TX, 1972; Texas Fine Arts Assn., 1973; Prix de Paris, 1978; others. Collections: Carver Museum, Tuskegee, AL; Art Guild, Shreveport, LA; Laguna Gloria Art Museum, Austin, TX. Exhibited: 7th Annual Eight State Exhibition, Oklahoma Art Center, 1965; Butler Inst. of American Art, Youngstown, OH, 1970; Catharine Lorillard Wolfe Art Club Annual, NYC, 1973, 79, 81; National Sculpture Soc. 40th and 41st Annuals, NYC, 1973, 74; 14th Biennial, Joslyn Mus. of Art, Omaha, NE, 1976; many others. Member: Artists Equity, NY and Philadelphia; Texas Soc. of Sculptors International. Taught sculpture at Sculptors Workshop, Houston, 1972-73. Media: Bronze, clay, and wood. Address in 1982, Houston, TX.

LESLEY, FLORENCE CARROLL.
Sculptor. Born in Philadelphia. Pupil Art Students League of NY under Saint Gaudens; Julian Academy in Paris, under Puech and Verlet. Member Art Students League of NY. Address in 1910, Chambersburg, PA.

LEVENTHAL, RUTH LEE.
Sculptor and painter. Born in NYC, October 5, 1923. Studied at Art Students League; National Academy Design; also with John Terken, Robert Tompkins, Maxim Bugester, and Frank Eliscu. Works: Federation of Jewish Philanthropies, NY; YMHA and YWHA, Brooklyn; Riverside Memorial Chapel, NY. Commission: Three paintings, NY World's Fair, 1964-65; sculpture, Riverside Memorial Chapel, 1970, six sculptures, 1972; portrait of Golda Meir, private commissions, 1972. Exhibitions: Six shows, National Academy of Design, NY; NY World's Fair, 1964-65; five shows, National Arts Club, NY; one-woman shows, Kottler Galleries, NY, 1970, and Temple Sinai, Roslyn, Long Island, 1971; Sculptured Gold Jewelry, Bergdorf-Goodman, NY, 1972. Awards: Catharine Lorillard Wolfe Art Club Gold Medal, 1970, 73, 81; National Academy Design, 1978; Gold Medal, National Arts Club, 1973; Salmagundi Award, 1975, 76, 78, 79, and 81; plus others. Member: Royal Society of Arts, fellow; National Society of Arts and Letters; Catharine Lorillard Wolfe Art Club; Allied Artists of America; plus others. Co-authored 2 books titled *Take One of My Pills*, 1965; and *Our Romance is Over*, 1966. Address in 1982, 425 East 58th Street, NYC.

LEVEY, JEFFREY KING.
Sculptor and painter. Born in NYC, Sept. 25, 1908. Studied with Ivan Olinsky, David Karfunkle, Daniel Garber. Member: National Arts Club; MacDowell Colony. Address in 1933, 67 West 52nd St., NYC; summer, MacDowell Colony, Peterboro, NH.

LEVI, JOSEF.
Sculptor and painter. Born February 17, 1938, NYC. Studied: University of Connecticut, with Walter Meigs, BA; Columbia University. Work: Albright; Des Moines; Louisville (Speed); Museum of Modern Art; Aldrich. Exhibited: The Stable Gallery; Arts Club of Chicago; Louisville (Speed); Walker, Light Motion Space, 1967; Museum of Modern Art, The 1960's; Flint Institute; Herron; Whitney Museum; Aldrich; Nelson Atkins Gallery, Kansas City. Received Purchase Award, University of Illinois, Urbana, 1966. Address in 1982, 171 West 71st Street, NYC.

LEVI, LINDA.
Sculptor. Born in 1935. Noted for her work with plastic constructions.

LEVINE, LES.
Sculptor and video artist. Born in Dublin, Ireland, October 6, 1935; US citizen. Studied at Central School of Arts and Crafts, London, England. Work at National Gallery of Canada, Ottawa; Metropolitan Museum of Art, NY; Whitney Museum of American Art, NY; Museum of Modern Art, NY; others. Has exhibited at Documenta, Kassel, West Germany; Philadelphia Museum of Art; others. Received first prize for The Star Machine, Sculpture Biennale, Art Gallery of Ontario; National Endowment for the Arts Fellowship, 1974 and 80; others. Works in gold; multimedia. Address in 1982, 20 E. 20th St., NYC.

LEVINE, MARILYN ANNE.
Sculptor and educator. Born in Medicine Hat, Alta, Canada, Dec. 22, 1935. Studied at Univ. of California, Berkeley, M.A., 1970, M.F.A., 1971. Works: Montreal Mus. Fine Arts; National Mus. of Modern Art, Kyoto and Tokyo; Utah Mus. of Fine Arts, Salt Lake City; William Rockhill Nelson Gal. of Art, Kansas City; Univ. Art Mus., Berkeley; San Francisco Mus. of Modern Art. Exhibitions: One-man shows, Hansen-Fuller Gal., San Francisco, 1971, 75; and O. K. Harris Gal., NY, 1974, 76, 79,

81; Sharp Focus Realism, Sidney Janis Gal., NY, 1972; Canada Trajectories, Mus. Art Modern, Paris, 1973; Retrospective, Norman McKenzie Art Gal., Regina, Canada, 1974. Teaching: Assistant professor of sculpture and ceramics, Univ. Utah, from 1973. Awards: Gold Medal, XXVII Concorso Internationale della Ceramica Arte, 1969; Canadian Council on Arts Grant, 1969 and 1973; Ceramics International Medal, 1973; National Endowment for the Arts Fellowship, 1976, 80. Medium: Clay. Address in 1982, Oakland, CA.

LEVINE, SAUL.
Sculptor and painter. Born in NYC, June 11, 1915. Studied at Syracuse University; Yale University, B.F.A.; Corcoran Art School, with Heinz Warneke. Awards: Prize, Art Institute of Chicago, 1943. Work: Brooklyn Museum; murals, US Post Office, Ipswich, MA; South Hadley, MA. Exhibited: Penna. Academy of Fine Arts, 1946; Pepsi-Cola, 1944; Whitney Museum of American Art, 1943; Art Institute of Chicago, 1943; New York World's Fair, 1939; Carnegie Institute, 1940; Virginia Museum of Fine Arts, 1946; Artists Guild of Washington, 1945; Soc. of Washington Artists, 1946. Address in 1953, Washington, DC.

LEVINSON, MON.
Sculptor and painter. Born in NYC, Jan. 6, 1926. Studied economics at the Univ. of Penna., Philadelphia, 1943-44, 1946-48. Self-taught in the field of art. Work: Whitney; Hirshhorn; commission for Mus. of Modern Art; others. Exhibited: Kornblee Gal., NYC, 1961, 63-66, 68; Franklin Siden Gal., Detroit, 1965-67, 69; Mus. of Modern Art, 1963; Sidney Janis Gal., NYC, 1964; Obelisk Gal., Boston, 1968; Storm King Arts Center, Mountainville, NY, 1972 and 75; Whitney Mus., NYC, 1970, 73; Rosa Esman Gal., NYC, 1976, 77; 55 Mercer St. Gal., 1980; Getler Pall Gal., NY, 1981; and numerous others. Awards: Astor Foundation Grant, NYC, 1967; Fulbright Award for Sculpture, Washington, DC, 1970, 71, 74; Cassandra Foundation Award, NYC, 1972; National Endowment for the Arts Fellowship, 1976. Taught: Visiting artist at C. W. Post Coll., 1970-72 and 76-77. Address in 1982, 309 West Broadway, NYC.

LEVITAN, ISRAEL (JACK).
Sculptor and teacher. Born June 13, 1912, in Lawrence, Mass. Studied: Chicago Art Inst. School; with Amedee Ozenfant and Hans Hofmann, NY; Ossip Zadkine, Paris; Ramamurtis S. Mishra. Work: Interchurch Center, NYC, head of Ben Gurion, commissioned by Maurice Dershowitz; bronze of Moses' hands, commissioned by Murray Reiter. Exhibited: Weyhe Gal., NYC, 1953; Barone Gal., NYC; Univ. of California, Berkeley; Grand Central Moderns, NYC; Whitney Mus. Annuals; Penna. Acad. of Fine Arts; Paris (Moderne); San Francisco Mus. of Art; Brooklyn Mus.; Philadelphia Mus. of Art; Claude Bernard, Paris. Exhibited: Mus. of Modern Art, Paris, NY, and Tokyo; Whitney; Penna. Acad. of Fine Arts; Detroit Inst. of Art; Brooklyn Mus.; Weyhe Gal.; others. Awards: MacDowell Colony Fellowship, 1956; Guild Hall, First Prize, Sculpture, 1958. Member: American Abstract Artists, 1954-57. Taught: Cooper Union, 1959; Brooklyn Mus. School, 1955-59; New York Univ. 1968; Univ., of Califor-

nia, Berkeley, 1962; Philadelphia Mus. Coll. of Art, 1967-68; Florida Humanistics Inst., Largo, from 1975; and privately. Address in 1982, Largo, FL.

LEVY, BEATRICE I.
(Mrs. Maurice D. Levy). Sculptor. Born in NYC, July 28, 1918. Studied at Art Students Lg., NYC, 1945. Exhibitions: One-man show ACA Gal., 1954; group shows, Audubon Artists, 1952, 56, 58; National Acad. of Design, 1952; National Assn. of Women Artists annuals; Long Island Art Lg., 1955, 56; Brooklyn Mus., 1958; Silvermine Guild Artists, 1959; Jersey City Mus. Awards: Rose Metzger Memorial prize, National Assn. of Women Artists, 1957, other prizes. Member: Art Students Lg.; Artists Equity Assn.; National Assn. of Women Artists. Address in 1962, Great Neck, Long Island, NY.

LEVY, JOSEPHINE.
Sculptor. Exhibition: Woodstock, NY, 1934. (Mallett's)

LEVY, MARGARET WASSERMAN.
Sculptor. Born on December 13, 1899; US citizen. Studied at Wellesley College, B.A., 1922; Bryn Mawr College, 1923; Philadelphia School of Occupational Therapy, 1923-24; Stella Elkins Tyler School of Art; Penna. Academy of Art. Work in Penna. Academy of Fine Arts; Philadelphia Museum of Fine Arts. Has exhibited at Detroit Institute of Arts; Penna. Academy of Fine Arts; Philadelphia Museum of Art; National Academy of Design 138th, NY, 1963 and 1981; others. Member of Artists Equity, Philadelphia; Philadelphia Art Alliance. Address in 1982, Philadelphia, PA.

LEWIS, CAROLE.
Sculptor and painter. Studied: Painting, George Jo Mess, Indianapolis, Indiana; drawing, Gustev Rehberger, Art Students League; sculpture, Hara Geber Workshop, NY. Work: "November Bird," terra cotta, unique. Exhibited: Extensively in group shows, with the Sculptors League, National Association of Women Artists; Bronx Museum; Hudson River Museum; Audubon Artists; and in New York Galleries. Awards: Charles H. Lexitt Prize; National Association of Women Artists, 1981; Elizabeth Erlanger Memorial Award; American Society of Contemporary Artists, 1981; Mary and Gustave Kellner Award. Member: Society of Animal Artists; National Association of Women Artists. Teaching: Assistant teacher at the Hara Geber Workshop, Marble Hill, New York, for 5 years. Media: bronze and terracotta. Specialty: Cats. Address in 1983, 368 West 246th St., Riverdale, Bronx, New York.

LEWIS, EDMONIA.
Sculptor. Born near Albany, NY, July 4th, 1843/45. She was part Indian by birth. Her work shows considerable ideality and talent, and her chief patronage was from abroad. Exhibited in Boston in 1865. She also executed portrait busts of Henry W. Longfellow, Charles Summer, John Brown, and Abraham Lincoln.

LEWIS, GOLDA.
Sculptor, painter, and papermaker. Born in NYC. Studied with Vaclav Vytacil, Hans Hofmann, and Jack Tworkov; woodblock with Seong Moy, papermaking with Douglass Howell, and sculpture with Robert Laurent. Works:

Ciba-Geigy Chemical Comp., Ardsley, NY; Madden Corporation, NY; Hercules Powder Comp., Wilmington, DE; Foundations of Paper Hist., Haarlem, Holland; Cheney Pulp & Paper Comp., Franklin, OH; plus other public and private collections. Exhibitions: Landmark Gal., NY, 1973; Women Choose Women, NY Cultural Center Museum 1973; Weatherspoon Art Gal., Univ. of North Carolina, Greensboro, 1974; Kresge Art Center Gal., Michigan State Univ., 1974; Museum of Modern Art, NY, 1976; one-woman shows, Alonzo Gal., NY, 1974, Peter M. David Gal., Minneapolis, 1974, and Benedicta Arts Center Gal., College of St. Benedict (Minn.), 1974; plus many others. Awards: NY State Council Arts Grant, 1971. Media: Terra cotta and paper. Address in 1982, 31 Union Square West, NYC.

LEWIS, MARY.
Sculptor and illustrator. Born in Portland, Oregon, June 18, 1926. Studied at Univ. of Oregon, 1945-50, B.S. (sculpture), 1949; Oregon Div. American Association Univ. Women Mabel Merwin fellowship, 1950, Syracuse Univ., with Ivan Mestrovic, technical assistant to Mestrovic, 1951-53, M.F.A., 1953. Works: In private collections. Comn: Four-ft mahogany and hammered copper bird and 28 inch Carrara marble skunk cabbage, commissioned by Joseph Stein and Waterbury Club, Conn., 1964; small stone carving, Prouty Garden, Children's Hospital Medical Center, Boston, 1965; Madonna and Child (maple relief from half round log 20 by 30 inches), St. Louis de Montfort Sem. Chapel, Litchfield, CT, 1966. Exhibitions: Artists of Oregon, Portland Museum Art, 1951 and 69; 12th and 14th Annual New England Exhibs., Silvermine Guild Artists, New Canaan, CT, 1961 and 63; 62nd and 63rd Annual Exhibs., New Haven Paint and Clay Club, John Slade Ely Center, New Haven, 1963 and 64. Awards: Tiffany Travel Scholar, 1953; Fulbright Lecturer, 1958-59; Associate, National College Arts, Pakistan, 1959. Co-Author of *The Little Yellow Dinosaur*, 1971; illustrated *In the Beginning—The Bible Story of Creation, Adam and Eve, Cain and Abel*; others. Media: Most sculpture media; ink, watercolor. Address in 1982, Rainier, OR.

LEWIS, WAYNE.
Sculptor. Born in Washington, DC, in 1947. Studied at Corcoran Gallery School of Art in 1957 and later; also studied art in high school and college. Illustrated for a publishing company; moved to Washington, where began sculpting full-time. Specialty is subjects of the old American West; works in bronze. Represented by Old Town Art Gallery, Oak Harbor, WA; Gainsborough Gallery, Calgary, Alberta, Canada. Address since 1979, Oak Harbor, Washington.

LEY, MARY HELEN.
Sculptor, painter, and teacher. Born in Leadville, Colo., April, 1886. Studied with Sterba and Dudley Crafts Watson. Member: Colo. Art League; Hoosier Salon. Address in 1933, 606 East Wayne St., Ft. Wayne, Ind.

LIBERMAN, ALEXANDER.
Sculptor and painter. Born 1912 in Kiev, Russia. Studied with Andre L'Hote (in Paris), 1929-31; arch. with August Perret; Ecole des Beaux Arts, Paris 1930-32; Rhode Is-

land School of Design, DFA (hon.), 1980. U.S. citizen, 1946. Art Director of *Vogue* magazine 1943; Art Director of Conde Nast Publ., USA and Europe, 1944; Editorial Director of same, 1962. Exhibited at Mus. of Modern Art, 1960, 62, 64, 65, 67-69; Bennington College; Guggenheim and Whitney Museum, NYC; Los Angeles County Museum, Corcoran Gallery of Art; Wash., DC; Tokyo Biennial (1962); Phila. Museum of Art, 1969; Milwaukee Art Center and NY World's Fair (1964); Emmerich Gallery, NYC, 1967-69, 73, 74, 78-81. Award: Chevalier, Legion of Honor, France. In collections of Art Institute of Chicago; Smith College; Whitney Museum; Addison Gallery; Chase Manhattan Bank; Albright-Knox; Yale Univ.; Washington Gallery of Modern Art; Museum of Modern Art; Tate Gallery, London. Living at 173 E. 70th St., NYC, in 1982.

LIBHART (LIEBHART), JOHN JAY.
Modeller in clay, portrait, miniature, landscape, historical, and still life painter. Born in York County, PA, 1806; raised and lived in Marietta, on the Susquehanna. Studied painting with Arthur Armstrong. Active in Marietta, Harrisburg, Lebanon, Lancaster, and other central Pennsylvania towns. Died after 1860.

LICHTENAUER, JOSEPH MORTIMER.
Sculptor and painter. Born in NYC, May 11, 1876. Studied at Art Students League; Julian Academy, Paris; and with Mowbray, Merson. Member: National Society of Mural Painters; Architectural League; Silvermine Guild of Artists; Salmagundi Club; Art Fellowship; American Artists Professional League. Awards: Medal, Architectural League, 1903, 05; Paris Salon, 1937. Work: Smithsonian Institution; Metropolitan Museum of Art; Brooklyn Museum; American Academy of Arts and Letters; ceiling, Shubert Theatre, NY; triptychs, US Army. Exhibited: National Society of Mural Painters, annually; National Academy of Design, 1945; Salmagundi Club; Silvermine Guild of Artists; Argent Gallery, 1946 (one-man). Address in 1953, Westport, CT.

LICHTENSTEIN, ROY.
Sculptor and painter. Born in NYC, October 27, 1923. Studied at Ohio State University, Columbus, BFA, 1946, MFA, 1949; Art Students League, NYC, under Reginald Marsh. Work: Albright-Knox; Art Institute of Chicago; Museum of Modern Art; Whitney; Walker. Exhibited: Carlebach Gallery, NYC, 1951; John Heller Gallery, NYC, 1952-54; Ferus Gallery, Los Angeles; Galleria II Punto, Turin, 1964; Leo Castelli Gallery, NYC; Art Institute of Chicago; Guggenheim Museum, NYC; Gallery of Modern Art, Wash.; Whitney; Institute of Contemporary Arts, London, 1963; Detroit Institute of Arts, 1973; Museum of Modern Art, NYC, 1974; Blum-Helman Gallery, NY, 1981; others. Taught: Instructor of art at Ohio State University, 1946-51; State University of New York, College at Oswego, 1957-60; Rutgers University, 1960-63. Many articles, including "What is Pop Art?," in *Art News*, NYC, November 1966; Metamorphoses: l'Ecole de NY," in Quadram, Paris, March 1966; "Le Classicism du Hot Dog," in La Quinzaine Litteraire, Paris, January 1968; plus other interviews with the artist. Address in 1982, Southampton, NY.

LIDOV, ARTHUR HERSCHEL.
Sculptor, painter, designer, and illustrator. Born in Chicago, IL, June 24, 1917. Studied at Univ. of Chicago, BA, 1936, studied art history, 1938-39. Awards: Prizes, Univ. of Chicago, 1933; Art Dir. Club, Chicago, 1946; Art Dir. Club, NY, 1948; Art Dir. Club, Detroit, 1952; American Institute of Graphic Arts Award, 1963. Work: Public School, Chicago; US Post Office, Chillicothe, IL; Monsanto Chemical Co.; Coca-Cola Co.; Wright Aeronautics; Radio Corp. Am.; Reynolds Aluminum Corp.; Lederle Pharmaceutical Co.; NY Central RR; US Playing Cards; US Army; Schenley Distillers; National Distilleries; Chase National Bank, and many other leading US firms. Exhibited: Univ. of Chicago, 1933; Art Institute of Chicago, 1933, 34; National Acad. of Design, 1946-48; Milwaukee Art Inst., 1945; national traveling exh., Fortune magazine, 1948; Art Dir. Club, Chicago, 1946, NY, 47, 49, 50, Detroit, 52; Mus. of Modern Art. Contributor illus. to national magazines. Living in Poughquag, NY, in 1982.

LIEBERMAN, LOUIS (KARL).
Sculptor. Born in Brooklyn, NY, May 7, 1944. Studied: Brooklyn Museum Art School, with Isaac Soyer, 1961-64; Brooklyn College, B.A., 1962; Rhode Island School of Design, with Richard Merkin, B.F.A., 1969. Exhibitions: Vancouver Art Gallery, Vancouver, B.C., Canada, 1969; James Yu Gallery, NYC, 1973, 74; Renneth Gallery, West Hampton Beach, NY, 1979; John Davis Gallery, Akron, OH, 1983; Columbus Museum of Art Collectors Gallery, OH, 1984; (all solo exhibitions). Group exhibitions: Gary Mansion Gallery, Rhode Island School of Design, Providence, 1970; Aldrich Museum of Contemporary Art, Ridgefield, CT, 1973, 74; M. Knoedler & Co., NYC, 1976; Getler/Pall Gallery, NYC, 1980, 81; Cleveland Institute of Art, 1982; Metropolitan Museum of Art, NYC, 1983; others. Collections: Metropolitan Museum of Art, NYC; Philadelphia Museum of Art, PA; Aldrich Museum of Contemporary Art, Ridgefield, CT; Staten Island Museum, Richmond, NY; others. Awards: Creative Artists Public Service Foundation of the New York State Council on the Arts, for graphics, 1980-81, for sculpture, 1972; National Endowment for the Arts, Visual Arts Fellowship, 1972. Teaching: Adjunct lecturer in drawing, Brooklyn College, NY, 1971-78; adjunct lecturer sculpture, design, Lehman College, Bronx, NY, 1972-75; others. Member: International Sculpture Center, NYC. Address in 1984, 16 Greene St., NYC.

LIGGET, JANE STEWART
Sculptor, painter, and teacher. Born in Atlantic City, NJ, Sept. 4, 1893. Studied at Penna. Academy of Fine Arts, with Beatrice Fenton; and in Paris, France. Member: National Association of Women Artists; American Artists Professional League; Philadelphia Art Alliance; American Federation of Arts. Awards: Fellow, Penna. Academy of Fine Arts; Cresson traveling scholarship, Penna. Academy of Fine Arts, 1915. Exhibited: Woodmere Art Gallery, 1941-45; Penna. Academy of Fine Arts, 1941-46; Allied Artists of America, 1943; Philadelphia Art Alliance, 1942-46; National Association of Women Artists, 1942. Position: Instructor, sculpture, Valley Forge Gen-

eral Hospital, Phoenixville, PA, 1944-45. Address in 1953, Merion, PA; studio in Philadelphia, PA.

LIGHT, ALVIN B.
Sculptor. Born in Concord, NH, in 1931. Grew up in Stockton, Calif., prior to moving to San Francisco in 1951. Studied at Calif. School of Fine Arts, San Francisco, 1951-53, 56-59, 61. Taught at San Francisco Art Institute, 1962-80. Exhibited at Dilexi Gallery in San Francisco and Los Angeles; de Young Museum, San Francisco; San Francisco Art Institute; San Francisco Museum of Modern Art; Whitney, NYC; Oakland Art Museum; L.A. Co. Museum of Art; and others. Executed monumental sculptures in wood. Died in San Francisco, California, in 1980.

LIMERICK, JAMES ARTHUR.
Sculptor and painter. Born in Philadelphia, Pennsylvania, 1870.

LIMONE, FRANK.
Sculptor. Born in Brooklyn, NY, August 14, 1938. Studied at St. Louis University, B.A., 1969; Tyler School of Art, Philadelphia, M.F.A., 1972. Work in Walker Art Center, Minneapolis; High Museum of Art, Atlanta, GA; others. Has exhibited at Des Moines Art Center; Walker Art Center, Minneapolis; others. Received Mid-Career Sculpture Grant, National Endowment for the Arts, 1981. Address in 1982, Des Moines, IA.

LINCOLN, DONALD A.
Sculptor and woodcarver. Born in Grinnell, Iowa, in 1920. Self-taught in art. Worked in graphic arts in Sacramento, California, 1955-75. Turned to sculpture full-time in 1975. Specialty is wild animals in their natural surroundings; also life size figures of Indian women, carved wood doors, pen and ink wildlife drawings. Works in bronze, wood, stone. Awarded Best of Show, Kalispell Art Show and Auction, 1981, for "The Honey Bucket," a wood sculpture. Represented by The Sagebrush Gallery, Medicine Lodge, KS; Rosemary's Galleries, Boise, ID. Has own studio and gallery. Address since 1975, Rollins, Montana.

LINDBORG, CARL.
Sculptor and painter. Born in Philadelphia, PA, Nov. 27, 1903. Studied at Philadelphia Museum School of Industrial Art; Penna. Academy of Fine Arts; Julian Academy, Paris, and with Andre L'Hote. Awards: Fellow, Penna. Academy of Fine Arts; medal, Philadelphia Art Club, 1937. Work: Penna. Academy of Fine Arts; Friends Central School Gallery; Allentown Museum. Exhibited: Corcoran Gallery of Art, 1931; Penna. Academy of Fine Arts; Whitney Museum of American Art; Friends Central School Gallery, annually; Fellow, Penna. Academy of Fine Arts; Philadelphia Museum of Art; Philadelphia Art Club; Philadelphia Art Alliance; Am-Swedish Museum, Philadelphia, PA; Military Preparatory School and College; Wellons Gallery, NY, 1952. Address in 1953, Newtown Square, PA.

LINDER, HENRY.
Sculptor. Born Sept. 26, 1854, in Brooklyn, NY. Pupil of

Professor Knabl. Exhibitor at the National Sculpture Society of numerous busts; also the sitting figures "Music" and "Spring." Awarded bronze medal, St. Louis Exp., 1904. Member of National Sculpture Society; National Society of Craftsmen. Died Jan. 7, 1910, in Brooklyn, NY.

LINDER, JEAN.
Sculptor. Born in Berkeley, CA, in 1939. Studied: University of California at Berkeley; San Francisco Art Institute. Exhibitions: Oakland Museum, 1962; Richmond Museum, 1963; Whitney Museum of American Art, 1966, 1970; 55 Mercer, NYC, 1972. Collections: San Francisco Museum, CA; Rose Art Museum of Brandeis University; Trenton State Museum, NJ.

LINDING, HERMAN M.
Sculptor, painter, and craftsman. Born in Sweden, June 1, 1880. Pupil of Callmander, Carl Wilhelmson, and of Colarossi. Member: Society of Independent Artists; Whitney Studio Club; Alliance. Address in 1926, Grant's Corners, Ossining, NY; 154 East 64th St., New York, NY.

LINDQUIST, MARK.
Sculptor and craftsman. Born in Oakland, CA, May 16, 1949. Studied at New England College, B.A., 1971; Pratt Institute. Work in Metropolitan Museum of Art, NY; National Museum of American Art, Washington. Has exhibited at De Cordova Museum, Lincoln, MA; Florence Duhl Gallery, NY, 1976; American Woodcarvers, Rockefeller Center, NY; New Handmade Furniture, American Craft Museum, NY. Received MacDowell Colony fellowship, New Hampshire, 1979. Works in wood; photography. Address in 1982, Henniker, NH.

LINGEN, PENELOPE.
Sculptor and miniature painter. Member: Southern States Art League. Address in 1928, Houston, TX.

LINGREN, ROD.
Sculptor. Born in Santa Barbara, CA, in 1931. Took classes in printmaking; learned casting and finishing as dental technician; studied sculpture. Travelled in Europe, Near East, India. Specialty is Western subjects in miniature and medium size bronzes. Represented by Husberg Fine Arts Gallery, Sedona, AZ. Address since 1977, Alpine, CA.

LINK, B. LILLIAN.
Sculptor. Born New York, 1880. Pupil of Mrs. Charles Sprague-Smith, George Grey Barnard and Herbert Adams. Member: MacDowell Club; Alliance; National Association of Women Painters and Sculptors. Awards: Avery prize, NY Architectural League, 1907; sculpture prize, NY Woman's Art Club, 1912. Address in 1934, Boston, MA; 260 West 76th St., NYC.

LINN, STEVEN ALLEN.
Sculptor. Born in Chicago, IL, May 3, 1943. Studied at University of Illinois, B.S. (floriculture and ornamental horticulture). Has exhibited at Flint Institute of Fine Arts; Indianapolis Museum of Art; Whitney Museum of American Art; Corcoran Art Museum; others. Received Ward Sculpture Prize, Berkshire Museum, 1968; Rome Prize, American Academy in Rome, 1975; MacDowell Colony Fellowship, 1980. Address in 1982, 101 Crosby St., NYC.

LINTON, FRANK B. A.
Sculptor and painter. Born in Philadelphia, PA, February 26, 1871. Pupil of Thomas Eakins in Philadelphia; Gerome, Benjamin-Constant, Bouguereau, Bonnat and Laurens in Paris. Member: Internationale Union des Beaux-Arts et des Lettres, Paris; Philadelphia Art Club. Awards: Medaille de Bronze, Paris Salons, 1927; "Officier d'Academie," French Government, 1928. Represented in Johns Hopkins University, Baltimore, MD; Girard College, Hahnemann College, College of Physicians, and the Baldwin Locomotive Works, all in Philadelphia; "La derniere retouche," owned by the French Government. Address in 1933, Philadelphia, PA.

LINTON, MRS. ROLAND.
Sculptor. Born in NYC, February 21, 1904. Studied at Brooklyn Academy; Art Students League, 1919-1920; also with R. Laurent, and J. De Creeft. Works: Daphne, Mother and Child, Magdalena; International Business Machines; Harry Kriendler, Harold Hedges. Exhibitions in leading museum and galleries in US. Awards: International Business Machines, 1946, 47; National Association of Women Artists, 1947; Long Island Art Festival; gold medal of honor, Audubon Artists, 1946; Sculpture House award, Painters and Sculptors Society of NJ; 1st prize sculpture, 1958. Member: NY Society of Women Artists (president), National Association of Women Artists (assistant gallery director), Dutchess County Art Association, Audubon Artists. Address in 1962, 880 Fifth Ave., NYC.

LION, HENRY.
Sculptor. Born in Fresno, CA, Aug. 11, 1900. Studied at Otis Art Institute and with S. MacDonald-Wright. Work: "The Pioneer," bronze fountain; De Anga Memorial; "Felipe De Neve, Founder of Los Angeles," bronze; bronze doors and chandelier panels, City Hall; all the property of the City of Los Angeles. Exhibited: Los Angeles Co. Fair; Painters and Sculptors Society; Pacific Southwest Exp.; Golden Gate Exp., 1939, San Francisco; one-man, Los Angeles Museum of Art, 1937, 45. Author of "Sculpture for Beginners." Awards: Sculpture award, Los Angeles Co. Fair, 1922, 33, 34, 39; $1,000 prize for fountain design, 1923; prizes, Otis Art Institute, 1923, 40, 41; National Sculpture Competition, 1923; purchase prize, Los Angeles Woman's Club, 1925; sculpture award, Pacific Southwest Exp., Long Beach California, 1928; Ebel Salon, 1937, 42; California Art Club, 1938. Member: California Art Club. Address in 1953, Los Angeles, CA.

LIONNI, LEO.
Sculptor and painter. Born in Amsterdam, Holland, May 5, 1910; US citizen. Studied at University of Genoa, Italy, Ph.D. Work in Philadelphia Museum of Art; Museum of Modern Art and Metropolitan Museum of Art, NYC. Has exhibited at Museum of Modern Art, NYC; Staempfli Gallery, NYC; others. Was art director for *Fortune* from 1948-60. Works in bronze; oil. Address in 1982, c/o Staempfli Gallery, NYC.

LIPCHITZ, JACQUES.
Sculptor. Born in Druskieniki, Lithuania, August 22, 1891. Came to US in 1941. Studied: Ecole Beaux-Arts,

Paris, 1909-11, with Jean Antonine Ingalbert & Dr. Richet; Academy Julien, Paris, with Raoul Verlet; Academie Colarossi, Paris; Columbia University, Hon. LHD, 1968. Work: Museum Modern Art, Paris; Museum Grenoble, France; Museum of Modern Art, Guggenheim, and Metropolitan Museum Art, NYC; Albright-Knox Art Gallery, Buffalo, NY; Philadelphia Museum of Art; Tate; Tel Aviv; and many others. Commissions: Five bas-reliefs, Barnes Foundation, Merion, PA, 1922; "Prometheus," Paris World's Fair, 1937; sculpture, Fairmount Park Association, Philadelphia, 1958; Presidential Scholars Medallion, 1964; others. Exhibitions: Brummer Gallery, NYC, 1935; Paris World's Fair, 1937; Buchholz Gallery NYC, 1942, 43, 46, 48, 51; Galerie Maeght, Paris, 1946; retrospectives, at Museum of Modern Art, 1972; Walker Art Center, 1954; Malborough Gallery, 1968; Cleveland Museum of Art 1954, 72; Rijks Museum; Paris/Moderne Museum; Tate; Albright-Knox; Whitney; Museum of Modern Art; Art Institute of Chicago; Joslyn Museum, Omaha; many others. Awards: sculptures, Academy Julien, Paris, 1909; gold medal, Paris World's Fair, 1937; Widener gold medal, Penna. Academy of Fine Arts, 1952; Gold Medal, sculpture, American Academy of Arts and Letters and National Institute of Arts & Letters, 1966. Among his many noted works; "Prometheus," 1937; "Rape of Europa," 1938; "Peace on Earth," 1969. Member: American Academy of Arts and Letters; National Institute of Arts and Letters. Address in 1970, Fine Arts Associates, 44 Walker St., NYC; h. Hastings-on-Hudson, NY. Died in 1973.

LIPINSKY de ORLOV, LINO SIGISMONDO.
Sculptor, painter, etcher, and conservator. Born in Rome, Italy, January 14, 1908. Studied at British Academy of Arts; Lipinsky Art Academy, Rome; Accademia Belle Arti, Rome. Member: Society of American Graphic Artists; Audubon Artists; Chicago Society of Etchers; Calcografia Romana, Rome, Italy; others. Awards: Medal, Rome, Italy, 1928, 31; Paris Salon, 1937; Budapest, Hungary, 1936; prizes, Chicago Society of Etchers, 1941; Society of American Graphic Artists, 1942; Library of Congress, 1942; Detroit Institute of Art, 1943; Kosciuszko Foundation, 1948; Westchester Co. Historical Society, 1979; others. Work: Severance Music Hall, Cleveland, OH; St. Patrick's Cathedral, NY; Boston Symphony Hall; NY Public Library; Library of Congress; Detroit Institute of Art; Cranbrook Academy of Art; Metropolitan Museum of Art; Vassar College; Florida State University; Yale University; Radcliffe Music Bldg.; many churches in US and abroad. Exhibited: Los Angeles Museum of Art, 1927, 28, 32; Art Institute of Chicago, 1934; Chicago Society of Etchers; Society of American Graphic Artists; Grand Central Art Gallery; Library of Congress; National Academy of Design; Cleveland Museum of Art; Detroit Institute of Art; Albany Institute of History and Art; one-man: Vose Gallery; Symphony Hall, Boston; Jr. League, Boston; Knoedler Gallery; Audubon Artists; Carnegie Institute; Mills College, Oakland, CA; Albright Art Gallery; and abroad. Co-author: "Anatomy for Artists," 1931; author: "Pocket Anatomy in Color for Artists,"

1947. Curator, John Jay Homestead, Katonah, from 1967. Media are primarily oil and etching. Address in 1982, Katonah, NY.

LIPMAN, STAN.
Sculptor and instructor. Born in Lancaster, PA, March 18, 1931. Studied at Temple University, Millersville State College, B.S. (education); University of Southern California. Work at Smithsonian Fine Arts Gallery, Washington, DC; Los Angeles Co. Art Museum. Has exhibited at NY School of Design; Los Angeles Co. Art Museum; Philadelphia Museum of Art; others. Received Los Angeles Co. Art Museum Award, 1972. Works in steel and bronze. Address in 1982, Lancaster, PA.

LIPMAN-WULF, PETER.
Sculptor and printmaker. Born in Berlin, Germany, April 27, 1905; US citizen. Studied at State Academy of Fine Arts, Berlin, with Ludwig Gies. Work in Metropolitan Museum of Art; Whitney Museum of American Art; National Gallery of Art, Washington, DC; British Museum, London; bronze busts of Bruno Walter and Karl Bohm, Metropolitan Opera, NY; bronze bust of Pablo Casals, Corcoran Gallery of Art, Washington, DC; others. Has exhibited at Penna. Academy of Fine Arts; Whitney Museum of American Art; Jewish Museum, NY; Guild Hall, East Hampton, NY; others. Received Guggenheim Fellowship, 1949-50; Olivetti Award, Silvermine Guild Artists, 1962. Member of Guild Hall, East Hampton, NY; Silvermine Guild Artists. Taught as professor of sculpture, Adelphi University, from 1961. Address in 1982, Sag Harbor, NY.

LIPOFSKY, MARVIN BENTLY.
Sculptor and glass artist. Born in Barrington, IL, Sept. 1, 1938. Studied: Industrial Design at the University of Illinois, Urbana, BFA, 1957-61; sculpture at the University of Wisconsin, Madison, 1962-64, MS, MFA. Exhibited: Stedelijk Museum, Amsterdam, Holland, 1970; Gallery Marronnier, Kyoto, Japan, 1978; Florence Duhl Gallery, NYC, 1979. Member: International Committee Artists in Glass; Glass Art Society. Commissions: Twin glass, metal, and plastic panels for the Metro Media Bldg., Los Angeles, CA, 1969. Work: Corning Museum; Stedelijk, Amsterdam; Museum of Contemporary Crafts, NYC; Oakland Art Museum, California; others. Awarded National Endowment for the Arts fellowship, 1974 and 76; Purchase Awards, Toledo Museum of Art, 1968; Northern Illinois University, 1969. Address in 1982, Berkeley, CA.

LIPPOLD, RICHARD.
Sculptor. Born May 3, 1915, Milwaukee, WI. Studied: The University of Chicago; Chicago Art Institute School, 1933-37, BFA (industrial design), University of Michigan. Work: Addison, Andover, MA; Detroit Institute of Art; Wadsworth; Metropolitan Museum of Art; Museum of Modern Art; Newark Museum; Utica; Virginia Museum of Fine Arts; Whitney Museum; and commissions, including Metropolitan Museum of Art; Four Seasons Restaurant, NYC; Chateau Mouton Rothschild, Pauillac, France; Pan-Am Bldg., Lincoln Center. Exhibited: The

Willard Gallery, NYC, 1947, 48, 50, 52, 68; Museum of Modern Art; Philadelphia Museum of Art; Tate; Whitney Museum; France (National); Brooklyn Museum, Sculpture in Silver; Newark Museum, Abstract Art; Art Institute of Chicago. Awards: Tate, International Unknown Political Prisoner Competititon, Third Prize, 1953; Brandeis University, Creative Arts Award, 1958; American Institute of Architects, Fine Arts Medal, 1970; Municipal Art Society of NY, Citation, 1963; Architects League of NY, Silver Medal, 1960; elected to the National Institute of Arts and Letters 1963. Taught: Layton School of Art, Milwaukee, 1940-41; University of Michigan, 1941-44; Goddard College, 1945-47; Trenton Junior College (Head of Art Dept.), 1947-52; Queens College, 1947-48; Black Mountain College, 1948; Hunter College, 1952-65. Address in 1982, Locust Valley, NY.

LIPTON, SEYMOUR.
Sculptor. Born November 6, 1903, in NYC. Studied: City College of New York, 1921-22; Columbia Univ., 1923-27. Work: Brooklyn Museum; Albright; Cornell Univ.; Des Moines; Detroit Institute; Metropolitan Museum Art; Museum of Modern Art; Univ. of Massachusetts; Univ. of Michigan; New School for Social Research; Phillips Gallery, Washington, DC; Santa Barbara Museum of Art; South Mall, Albany; Tel Aviv; Toronto; Utica; Whitney Museum; Yale Univ.; Hirshhorn; many commissions, including IBM, Yorktown Heights, NY; Inland Steel Bldg., Chicago; Dulles International Airport, DC; Lincoln Center, NYC; Milwaukee Center for Performing Arts. Exhibited: Whitney Museum Annuals; IV Sao Paulo Biennial, 1957; XXIX Venice Biennial, 1958; Carnegie, 1958, 61; Brussels World's Fair, 1958; Seattle World's Fair, 1962; New York World's Fair, 1964-65; Art Institute of Chicago, 1966; Museum of Modern Art, Dada, Surrealism and Their Heritage, 1968; Penna. Academy of Fine Arts Annual, 1968; Smithsonian, 1968; Museum of Modern Art, The New American Painting and Sculpture, 1969; MIT; numerous galleries. Awards: Prizes, Art Institute of Chicago, first prize, 1957; IV Sao Paulo Biennial, Top Acquisition Prize, 1957; National Institute of Arts and Letters, 1958; Guggenheim Foundation, 1960; New School for Social Research, 1960; Ford Foundation Grant, 1962; awards, Architectural League, 1961, 63; Penna. Academy of Fine Arts, Widener Memorial Gold Medal, 1968. Taught: Cooper Union, 1942-44; Newark State Teachers College, 1944-45; Yale Univ., 1957-59; New School for Social Research, 1940-64. Represented by Marlborough Gallery, NYC. Address in 1982, 302 W. 98th St., NYC.

LITTLE, EDITH TADD (MRS.).
Sculptor, painter, illustrator, architect, craftsman, writer, lecturer, and teacher. Born Philadelphia, June 27, 1882. Studied: Penna. Academy of Fine Arts; pupil of Chase, Beaux, Grafly. Member: Fellowship Penna. Academy of Fine Arts; Florida Association of Architects. Former chairman of art, Florida Federation of Women's Clubs. Chairman of Fine Arts, Puiellas Co. Federation of Women's Clubs. Address in 1933, Florida Art School; h. St. Petersburg, FL.

LITTLE CHIEF, BARTHELL.
Sculptor and painter. Born in Lawton, OK, October 14, 1941. Work in Southwestern Museum of Los Angeles, CA; Southern Plains Museum, Anadarko, OK; Oklahoma Historical Society, Oklahoma City. Has exhibited at Philbrook Art Museum, Tulsa, OK; Morris Museum, Morristown, NJ. Works in tempera, gouache; terra-cotta, bronze. Address in 1982, Anadarko, OK.

LITTLEFIELD, BROTHERS.
Ship carvers. Active in Portland, ME, 1858-70's. The brothers were Charles H. and Francis A., sons of Nahum Littlefield. Executed figurehead of the *Ocean King*, 1874.

LITTLEFIELD, NAHUM.
Ship carver. Active in Portland, ME, in 1830's. Father of Charles and Francis Littlefield.

LITTLEJOHN, MARGARET (MARTIN).
Sculptor, painter, illustrator, and teacher. Born in Jefferson, Texas, Dec. 12, 1887. Pupil of Paxton, Hale, Chase, and Carlson. Member: Ft. Worth Art Association. Address in 1919, Ft. Worth, Texas. (Other listings show her only as a painter.)

LITTLETON, HARVEY K.
Sculptor and educator. Born in Corning, NY, June 14, 1922. Studied at University of Michigan; Brighton School of Art, England; Cranbrook Academy of Art, M.F.A. Work in Toledo Museum of Art, OH; Victoria and Albert Museum, London; Museum of Modern Art, NY; Metropolitan Museum of Art, NY; others. Has exhibited at Bellevire Museum, Artist Produced Glass, Zurich, Switzerland; Contemporary Art Glass Gallery, NY; others. Received Toledo Museum Art Research Grant, 1962; Louis Comfort Tiffany Foundation Grant, 1970-71; Corning Glass Works, 1974. Member of American Crafts Council (fellow); honorary member of National Council of Education in Ceramic Arts; honorary member of Glass Art Society. Taught art at University of Wisconsin, Madison, from 1951. Works in glass. Address in 1982, Spruce Pine, NC.

LIVEZEY, WILLIAM E.
Sculptor, painter, and illustrator. Born near Unionville, MO, April 12, 1876. Illustrated "The Days of Long Ago," by W. E. Comstock, etc. Address in 1921, 538 South Dearborn Street; h. 2320 Cleveland Avenue, Chicago, Ill.

LIVINGSTONE, M. L.
Sculptor. Active 1860. Patentee—medallion of Washington Irving, 1860.

LLOYD, CAROLINE ALMA (NEE GOODMAN).
Sculptor. Born in Ft. Wayne, IN, March 7, 1875. Studied voice and piano in Chicago and Denver, 1894-97; and in Berlin 1909-10; also taught voice. Later studied drawing and miniature painting in Paris; studied sculpture there after 1929. From 1929 to 1939 she exhibited regularly at the Salon d'Automne, the Tuileries, the Salon des Beaux-Arts, and other galleries in Paris; also exhibited at New York World's Fair, 1939; Golden Gate International Exp., San Francisco. Received medal for sculpture, Paris International Exp., 1937; French Government purchased

work for exhibit at Musee Jeu de Paume, 1939. Associate member of Societe Nationale des Beaux-Arts, Paris. Died in Los Angeles, CA, December 30, 1945.

LO MEDICO, THOMAS GAETANO.
Sculptor and designer. Born in NYC, July 11, 1904. Studied at the Beaux-Arts Institute of Design. Exhibited at the Metropolitan Museum of Art; the Whitney Museum of American Art; Penna. Academy of Art; National Academy of Design; plus numerous others. Awards: J. Stanford Saltus Medal, from the Numismatic Society, 1956; Mrs. Louis Bennet Prize and the Lindsey Morris Memorial Prize from the National Sculpture Society. Member: American Numismatic Society; National Sculpture Society, fellow; National Academy of Design; and the New York Architectural League. Taught: Instructor at the National Academy of Design School of Fine Arts, NY. Address in 1982, Tappan, NY.

LOBER, GEORG JOHN.
Sculptor. Born Chicago, IL, November 7, 1892. Pupil of Calder, Borglum, and Longman, National Academy of Design, Columbia College, and Beaux Arts Institute. Member: NY Architectural League; National Sculpture Society; Conn. Academy of Fine Arts; Salmagundi Club; Allied Artists of America; National Arts Club; Academician, National Academy of Design; others. Awards: Avery collaborative prize, NY Architectural League, 1911; honorable mention, Art Institute of Chicago, 1918, 1920; first prize, Conn. Academy of Fine Arts, 1924; prize, Art Centre of the Oranges, 1926; medal, prizes, National Arts Club; National Sculpture Society, 1952. Represented in Corcoran Gallery, Washington, DC, and Montclair Museum, Montclair, NJ. Work: Permanent Exhibition Medals, Numismatic Museum, NY; Bronze statue "Eve," Metropolitan Museum, NY; Byzantine Madonna in silver, Brooklyn Museum, NY; Eleanor T. Woods, "Peace Memorial," Norfolk, VA; nineteen Lincoln Memorial Tablets, State of Illinois; John Wells James Memorial, MA; "Mother's Memorial," 71st Regiment Armory, NYC; Caleb Thomas Winchester Memorial, Wesleyan College, Middletown, CT; marble Baptistry, First Baptist Church, Plainfield, NJ; St. Peter and St. Paul Church of Our Lady of Consolation, Pawtucket, RI; Memorial, Central Park, NYC, to honor NYC employees; bronze portrait, Frank Bacon, Golden Gate Museum, San Francisco, CA; also important portraits. Exhibited at National Sculpture Society, 1923; National Academy of Design, annually; Penna. Academy of Fine Arts; Allied Artists of America; National Arts Club; Montclair Art Museum; others. Address in 1953, 33 West 67th Street, NYC. Died in 1961.

LOCHRIE, ELIZABETH DAVEY.
Sculptor and painter. Born in Deer Lodge, MT, July 1, 1890. Studied at Pratt Inst. Art School, B.A.; Stanford Univ.; and with Winold Reiss, Dorothy Puccinelli, Nicholas Brewer, Victor Arnitoff. Member: Life fellow, International Inst. of Arts and Letters; Montana Inst. of Arts; American Artists Professional League; Northwest Association of Arts. Work: Murals, US Post Office, Burley, ID; Dillon, MT; St. Anthony, ID; State Hospital, Ga-

len, MT; bronze panels, Finlen Hotel, Butte, MT; Ford Motor Co. Collection; IBM Collection; bronze bas-relief portrait, James Finlen, Fort Lauderdale, 1970. Exhibited: Association of American Artists, 1939-45; NY World's Fair, 1939; Baltimore Art Association, 1945; Northwest Art Association, 1944-46; Rhodes Gallery, Tacoma, WA, 1940; Findlay Gallery, 1945; Montana Art Association; Arthur Newton Gallery, 1951 (one-man); Town Hall Gallery, NY, 1952 (one-man); Bozeman (MT) College; one-woman, State History Gallery, Helena, MT, 1944, 73; Arthur Newton Gallery, NY, 1959; Whitney Museum of Art, Cody, WY, 1968. Lectures: Art in Montana; War Art; etc. Address in 1980, Ojai, CA. Died in 1981.

LOCKPEZ, INVERNE.
Sculptor. Born in Havana, Cuba, in 1941. Studied: The National Academy of San Alejandro, Havana; Atelier of Lolo Soldeville, Paris. Living and working in NYC since 1966. Grants: Cintas Foundation, NY, 1970-1971; NYS Council on the Arts, 1973. Commissions: Latin-American Theater, NY, 1969; Sculpture, NYC Public Arts Council, McKenna Square, 1972.

LOCKS, SEYMOUR.
Sculptor and painter. Born in Chicago, IL, 1919. Moved to California, 1931. Studied: San Jose State College, CA, A.B.; Stanford University, Stanford, CA, M.A., 1946. One-man exhibitions: Lucien Labaudt Gallery, San Francisco, 1955, 57; San Francisco Museum of Art, 1960 (with William Wiley); San Francisco Art Institute, 1974. Group exhibitions: From San Francisco—A New Language in Painting, Kaufmann Art Gallery, YM-YWHA, NY, 1954; The Art of Assemblage, The Museum of Modern Art, NY, 1961; A Period of Exploration, San Francisco, 1945-50, The Oakland Museum, CA, 1973; San Francisco Museum of Modern Art, 1976; National Collection Fine Arts, Smithsonian, 1977. Address in 1977, San Francisco, CA.

LODBERG, AGNES C. L.
Sculptor, painter, craftswoman, writer, and teacher. Born in Denmark, April 8, 1875; came to America in 1906. Pupil of the Royal Academy of Fine Arts, Copenhagen, Denmark. Work: Portrait medallion of President Wilson owned by American Numismatic Society; Christian X, King of Denmark; portrait bust of Admiral F. E. Chadwick, University Library, Morgantown, W.Va. Member: Scandinavian American Society, NY. Address in 1919, Newport, Rhode Island.

LOEFFLER, MORITZ.
Sculptor. Address in 1934, Bloomfield, NJ. Died in 1935. (Mallett's)

LOEHER, ALOIS.
Sculptor. Born in Paderborn, Germany. Worked: NYC, 1883; Milwaukee, 1889. Works held: Chicago Art Institute. Died at Silver Springs, Maryland, 1904.

LOERCHER, ELSIE A.
Sculptor. Address in 1934, New York. (Mallett's)

LOGAN, JUAN LEON.
Sculptor. Born in Nashville, TN, August 16, 1946. Studied at Howard University; Clark College. Work in Museum

of African Art, Washington, DC; Mint Museum of Art, Charlotte; others. Has exhibited at Carnegie Institute, Pittsburgh; National Exhibition/Black Artist, NJ State Museum, Trenton; Mint Museum of Art, Charlotte. Received award from Santa Fe Festival of the Arts, NM; others. Member of Southern Association of Sculptors Inc.; National Conference of Artists. Works in wood and steel. Address in 1982, Belmont, NC.

LOMBARD, JAMES.
Sculptor. Born in Baldwin, ME, June 26, 1865. Carved his first works in wood while at school in Baldwin, ME. Later moved to Bridgton, ME, where he farmed and made furniture and weathervanes during the 1880's. Noted for his silhouettes of hens and roosters in pine. Died in Bridgton, ME, Feb. 27, 1920.

LONE WOLF.
(Hart Meriam Schultz). Sculptor, painter, illustrator, and commercial artist. Born on the Blackfoot Reservation, Montana, 1882. Studied at Indian schools; Los Angeles Art Students League in 1910; in Chicago 1914-15; encouraged by Thomas Moran. Work in Harmsen Collection, University of Nebraska Art Gallery, Santa Fe Railroad (Chicago). Illustrated books of his father, James Willard Schultz. Specialty was Western subjects, including statuettes of horses, buffalo, deer. Style in the school of Remington and Russell. Died probably in Tucson, Arizona, about 1965.

LONG, ELLIS BARCOFT.
Sculptor and painter. Born in Baltimore, MD, October 30, 1874. Pupil of Andre Castaigne and of E. S. Whiteman in Baltimore; of Cox, Mowbray, Saint Gaudens, and D. C. French in New York. Member: Charcoal Club. Address in 1926, 127 Baltimore, MD.

LONG, FRANK WEATHERS.
Sculptor, painter, engraver, and jeweler. Born in Knoxville, TN, May 7, 1906. Studied at Art Institute of Chicago; Penna. Academy of Fine Arts; New Mexico State Teachers College; Julian Academy in Paris. Work: IBM Collection, NY; Smithsonian Institution; Berea College Collection; US Post Office, Berea, Morehead, Louisville, KY; Drumright, OK; Hagerstown, MD; others. Exhibited: World's Fair, NY, 1939; Golden Gate Exp., San Francisco, 1939; American Federation of Arts traveling exhibition; one-man, Speed Memorial Museum, 1940; Berea College, 1938-40; Ashland (KY) Art Association, 1939; University of New Mexico Gallery, 1968; Museum of Albuquerque, 1979. Member of Southern Highlanders Handicraft Guild; Albuquerque Chapter of New Mexico Designer-Craftsmen (president 1969). Position: Director, Alaska Office of Indian Arts and Crafts Board, Juneau, AK, 1951-57. Media: Gem material; metal. Address in 1953, Berea, KY.

LONG, HUBERT.
Sculptor. Born in Sydney, Australia, February 2, 1907; US citizen. Studied at Newark School of Fine and Industrial Art, NJ. Work in Guild Hall Museum Collection, East Hampton, NY; Phoenix Art Museum, AZ; others. Has exhibited at Andrew Crispo Gallery, NY, 1974 and 76;

Guild Hall, East Hampton, NY, 1976; Indianapolis Museum; others. Works in wood. Address in 1982, East Hampton, NY.

LONG, TED.
Sculptor and painter. Born near North Platte, Nebraska, in 1933. Self-taught in art. Did commercial art work, including cartoons of rodeo performances. Received commission to execute sculpture of Standing Bull for Nebraska Hall of Fame. Has exhibited at invitational shows, including Cheyenne Frontier Days. Specialty is historical Plains Indians, Western scenes. Paints in oil; sculpts in bronze. Represented by Copenhagen Galleri, Solvang, CA; Overland Trails Galleries, Scottsdale, AZ, and Jackson Hole, WY. Address in 1982, North Platte, Nebraska.

LONGLEY, BERNIQUE.
Sculptor and painter. Born in Moline, IL, in 1923. Studied: Art Institute of Chicago; with Francis Chapin and Edouard Chassaing; Bryon Lathrop traveling fellowship, 1945; Institute de Allende, Mexico, 1971; Santa Fe School of Arts and Crafts, 1975. Collections: Museum of New Mexico; Dallas Art Museum; mural, La Fonda Del Sol Restaurant, NY; mural, Alexander Girard Home, Santa Fe. Exhibitions: Art Institute of Chicago; New Mexico Museum of Fine Arts; Santa Fe Festival of Arts, 1977-81; Denver Art Museum; one-woman: San Francisco Museum of Art; Van Dieman-Lilienfeld Gallery, NY; Denver Art Museum; others. Awards: Lathrop traveling scholarship, Art Institute of Chicago, 1945, honorable mention, 1948; Museum of New Mexico, purchase prize, 1953, honorable mention, 1965; honorable mention, Denver Museum of Art Regional Sculpture Show, 1948; Mexico State Fair. Address in 1982, Santa Fe, NM.

LONGMAN, (MARY) EVELYN BEATRICE.
(Mrs. N. H. Batchelder). Sculptor. Born Winchester, OH, Nov. 21, 1874. Pupil of Art Institute of Chicago under Taft; French in NY; Olivet College, M.A. Member: National Sculpture Society 1906; Associate of the National Academy of Design 1909; Academician, National Academy of Design, 1919; American Numismatic Society; Concord Art Association; Conn. Academy of Fine Arts; American Federation of Arts; National Arts Club. Awards: Silver medal, St. Louis Exp., 1904; silver medal, P.-P. Exp., San Francisco, 1915; Shaw memorial prize, National Academy of Design, 1918 and 1926, Watrous gold medal, 1924; W.M.R. French gold medal, Art Institute of Chicago, 1920; Widener gold medal, Penna. Academy of Fine Arts, 1921; Flagg prize, Conn. Academy of Fine Arts, 1926. Work: Bronze doors of Chapel, US Naval Academy, Annapolis; bronze door of Library, Wellesley College, Wellesley, MA; Ryle memorial, Public Library, Paterson, NJ; "Torso," bust of Henry Bacon, and "Victory," Metropolitan Museum, NY; "Victory," and "Electricity," Toledo Museum; Allison monument, Des Moines, IA; "Electricity," American Telephone and Telegraph Bldg., NY; centennial monument, Chicago; Naugatuck War Memorial, Naugatuck, CT; Theodore C. Williams Memorial, All Souls' Church, NY; Spanish War Memorial, Hartford, CT; also represented in Metropoli-

tan Museum of Art; Wadsworth Atheneum; Chicago Institute; City Art Museum, St. Louis; Cincinnati Museum of Art; Cleveland Museum; Herron Art Institute, Indianapolis. Exhibited at National Sculpture Society, 1923. Address in 1953, Osterville, MA. Died in 1954.

LONGWORTH, BERTIE CORTLAND (MRS.).
Sculptor. Pupil of Beaudel in Paris. Address in 1906, 12 Rue Campaigne-Premiere, Paris, France.

LOPEZ, CHARLES ALBERT.
Sculptor. Born in Matamoras, Mexico, Oct. 19, 1869. He came to New York when a youth and studied with Ward of New York, afterwards at the Ecole des Beaux Arts in Paris. Awarded first prize for McKinley Monument, Philadelphia. He was elected in 1906 as an Associate of the National Academy. Died the same year in NYC on May 18.

LOPEZ, RHODA LE BLANC.
Sculptor and educator. Born in Detroit, Michigan, March 16, 1912. Studied at Detroit Art Academy, Wayne State Univ.; Cranbrook Academy of Art, with Maija Crotell. Works: Detroit Institute of Arts; Univ. of Wisconsin, Madison; Scripps College, Claremont, CA. Commissions: Figure of Christ (incised in concrete), Claremont Lutheran Church, 1967; two sculpted brick fireplaces, 1969, and one high relief fireplace, 1970, Sim Bruce Richards; baptismal fountain, Univ. City Lutheran Church, 1970; wall fountain, Medical Center, Dr. Larry Fine, 1971; memorial wall, Unitarian Church, San Diego, 1977-78. Exhibitions: Syracuse National, 1949-55; Michigan Craftsmen Annual, 1949-58; five shows, Scripps Invitational, 1953-66; Allied Craftsmen Annual, San Diego, 1960-72; Design 8-11, Pasadena, 1965, 68, and 71. Member: Allied Craftsmen (president, 1965-68); African Art Society; others. Medium: Clay. Address in 1982, San Diego, CA.

LORD-WOOD, E. RUSSELL.
Sculptor. Member: Fellowship, Penna. Academy of Fine Arts. Address in 1924, Folcroft, PA.

LORENSEN, CARL.
Sculptor. Born in Klakring, Denmark, in 1864. He was a pupil of Kroyer, studying at the Copenhagen Academy. Went to Chicago in 1890 and did a number of sculptures for the World's Fair. He was a regular exhibitor at the Art Institute of Chicago and Field Museum, Chicago. Died January 17, 1916, in Chicago, IL.

LORENZANI, ARTHUR EMANUELE.
Sculptor and teacher. Born Carrara, Italy, Feb. 12, 1886. Came to the US in 1913. Pupil of Academia Belle Arti, Carrara, 1904; Rome Prize and three year pension. Member: National Sculpture Society; NY Architectural League; Allied Artists of America. Exhibited at National Academy of Design; Penna. Academy of Fine Arts; Albright-Knox Gallery; National Sculpture Society, 1923. Commissions: John F. Kennedy (bronze portrait), M. Labetti Post Veterans of Foreign Wars, Staten Island, 1964. Award: $200 prize at International Exp., Parma, Italy; Mrs. H. P. Whitney Prize for War competition; Special Silver Medal, National Sculpture Society, 1968. Specialty,

portraits and home and garden fountains. Media: Bronze, marble. Address in 1982, Staten Island, NY.

LOS, NAUM MICHEL.
Sculptor and teacher. Born Novomoskovsk, Russia, Oct. 19, 1882. Studied: Royal Academy of Fine Arts, Berlin, Germany; Univ. of Lausanne, Switzerland; pupil of Paul Du Bois and Victor Rousseau. Work: Bust of Oscar Browning, Kings College, Cambridge, England; bronze portrait bust and portrait plaquette, Pres. of French Institute in US, Museum of French Art, NY; other portrait busts in Rome and US. Exhibited: Golden Gate Exp., 1939, San Francisco; National Academy of Design; National Sculpture Society; Penna. Academy of Fine Arts. Taught: Instructor of sculpture, drawing, painting, and anatomy, Naum Los School of Art, NYC, in 1953. Address in 1953, 22 East 60th Street, NYC.

LOSTINE, HENRY.
Sculptor. Born in Prussia in 1814. Working in New Orleans in June 1860.

LOTHROP, KRISTIN CURTIS.
Sculptor. Born in Tucson, AZ, Feb. 8, 1930. Study: Bennington College, BA; sculpture with George Demetrios, 4 years. Exhibitions: Hudson Valley Art Association, 1968; National Sculpture Society, 1967-71; National Academy of Design, 1968-71; Allied Artists of America, 1969. Awards: Mrs. Louis Bennett Award, National Sculpture Society, 1967; Thomas R. Proctor Award, National Academy of Design, 1968; Daniel Chester French Award, 1970. Member: New England Sculptors Association; National Sculpture Society. Media: Bronze, wood, and stone. Address in 1982, Manchester, MA.

LOTTA, L.
Sculptor and portraitist. Active in New Orleans, 1842.

LOVE, HARRELL L.
Sculptor and painter. Born in Wynne, Arkansas, in 1940. Studied at University of Arkansas, BS art, 1961; Wayne State University, Detroit; University of New Mexico; Memphis Academy of Art; University of Oklahoma. Taught art at Wiley College, Marshall, Texas; University of Arkansas; also worked as commercial artist. Specialty is Indian and wildlife figures. Sculpts in wood and stone. Represented by own Touch of Love Gallery. Address since 1978, Santa Fe, New Mexico.

LOVE, JIM.
Sculptor. Born in Amarillo, TX, 1927. Has exhibited at Dallas Museum of Contemporary Art; Museum of Modern Art, NY; Museum of Fine Arts, Houston; Whitney Museum of American Art, NY; others. Address in 1982, Houston, TX.

LOVELAND, JOHN WINTHROP.
Sculptor and painter. Born West Pittston, PA, Oct. 1, 1866. Pupil of Swain Art School, New Bedford, MA, under Harry Neyland. Member: Washington Society of Artists. Address in 1933, Wardman Park Hotel, Washington, DC; summer, Nantucket, MA.

LOVET-LORSKI, BORIS.
Sculptor. Born in Lithuania, December 25, 1894. Studied:

Academy of Art, St. Petersburg, Russia. Member: Academician, National Academy; fellow, National Sculpture Society; Lotos Club. Awarded: Knight of the Legion of Honor, 1948. Work: British Museum, London; Metropolitan Museum of Art; Dumbarton Oaks; San Diego Fine Arts Association; Los Angeles Museum of Art; Seattle Art Museum; San Francisco Museum of Art; sculpture and mosaics for Chapel of American War Memorial, Manila, Philippines; bronze head of Gen. DeGaulle, for City Hall, Paris, France, 1959-60; heroic size bronze head of John Foster Dulles, for Washington International Airport; others. Had exhibited at Salon d'Automne; Tuileries; also one-man in NYC, London, Manila, Philadelphia, and Caracas. Address in 1970, 131 East 69th Street, NYC. Died in 1973.

LOWE, J. MICHAEL.
Sculptor and educator. Born in Cincinnati, OH, August 18, 1942. Studied at Ohio University, B.F.A.; Cornell University, M.F.A. Work in Butler Institute of American Art, Youngstown, OH; Tyler Museum of Art, TX; others. Has exhibited at Butler Institute of American Art Annual; Artists of Central NY, Munson-Williams-Proctor Institute, Utica, NY; others. Received Inez D'Amanda Barnell Award for Sculpture, Rochester Memorial Art Gallery, 1966; Purchase Awards, Tyler Museum of Art, 1970; Butler Institute of American Art, 1972. Works in welded metal. Address in 1982, Dept. of Fine Arts, St. Lawrence University, Canton, NY.

LOWELL, SHELLEY.
Sculptor and painter. Born in 1946. Studied: Pratt Institute, Brooklyn, NY. Exhibitions: The Erotic Art Gallery, NYC; International Museum of Erotic Art, San Francisco, CA; The Bronx Museum of Art, Bronx, NY, 1975. In the collection of Memorial Sloan-Kettering Cancer Center, NYC.

LUBART, HENRIETTE D'ARLIN.
Sculptor and educator. Born in Beirut, Lebanon, December 3, 1915; US citizen. Studied at Columbia University, NY, M.A., 1942, Ph.D., 1953; Art Students League, with William Zorach and Jose De Creeft. Work in Institute for the Study of Man, NY; Israel Art Collection, Jaffa; others. Has exhibited at National Association of Women Artists, NY; Silvermine Guild Artists, New Canaan, CT; others. Received gold medals, Knickerbocker Artists, 1962 and Artists Equity Association. Taught at Vassar College, 1944-53, assistant professor. Works in wood and stone. Address in 1982, 44 W. 77th St., NYC.

LUCAS, ALBERT PIKE.
Sculptor and painter. Born Jersey City, NJ, in 1862. Pupil of Hebert, Boulanger, Dagnan-Bouveret and Courtois in Paris. Member: Academician, National Academy Design, 1927; Societe Nationale des Beaux-Arts, Paris; National Arts Club; Lotos Club; Allied Artists of America; Salmagundi Club; National Sculpture Society; Fine Arts Federation of NY; Society of Painters of NY. Awards: Honorable mention, Paris Exp., 1900; bronze medal, Pan-Am. Exp., Buffalo, 1901; Isidor prize, Allied Artists of America, 1931. Work: "October Breezes," National Gallery, Washington; "Ecstasy," marble bust, Metropoli-

tan Museum, NY. Address in 1933, 1947 Broadway, NYC. Died in 1945.

LUCCEARINI, ANDREW.
Statue moulder. Born in Italy in 1828. Living with his brother John Luccearini in Washington, DC, June 1860.

LUCCEARINI, JOHN.
Statue moulder. Born in Italy in 1830. Living with his brother Andrew Luccearini in Washington DC, June 1860.

LUCCHESI, BRUNO.
Sculptor. Born in Lucca, Italy, July 31, 1926; US citizen. Studied at Institute Arte, Lucca, M.F.A., 1953. Work in Penna. Academy of Fine Arts; Dallas Museum of Fine Arts; Hirshhorn Museum; Whitney Museum of American Art, NY; others. Has exhibited at Whitney Museum of American Art; Penna. Academy of Fine Arts; Corcoran Gallery of Art; Brooklyn Museum, NY. Member of Sculptors Guild; Artists Equity Association; National Academy of Design; National Sculpture Society. Received Watrous Gold Medal, National Academy of Design, 1961; Gold Medal, National Arts Club, 1963; S. F. B. Morse Medal, National Academy of Design, 1965; others. Teaching at New School for Social Research, from 1962, instructor. Address in 1982, 14 Stuyvesant Street, NYC.

LUCKER, PAUL.
Sculptor. Exhibition: New York, 1935. (Mallett's)

LUDTKE, LAWRENCE MONROE.
Sculptor. Born in Houston, TX, October 18, 1929. Studied at University of Houston, B.S.; Coppini Academy of Fine Art, San Antonio, with Waldine Tauch. Work includes bronze bust, St. Lukes Hospital, Houston; bronze bas relief, Rice University, Houston. Member of National Sculpture Society, fellow. Works in bronze and marble. Address in 1982, Houston, TX.

LUDWIG, EVA.
Sculptor. Born in Berlin, Germany, May 25, 1923; US citizen. Studied at Greenwich House of Pottery, 1958-62, with Lu Duble; Sculptor's Workshop, 1964, with Harold Castor; Craft Students League, 1968, wood sculpture with Domenico Facci; Queens College, 1980-81. Exhibitions: Contemporary Liturgical Art, Philadelphia, 1963; Own Your Own, Denver Art Museum, 1968; Rochester Festival Religious Art, NY, 1971; Cooperstown Art Association Annual, NY, 1971, 73, and 74; Nonmemorial Exhibition, National Sculpture Society, NY, 1972. Awards: Best in Wood, Woodstock Guild Craftsmen, 1969, Bert Wangler Memorial Award, 1972; First Prize in Sculpture, Cooperstown Art Association, 1971. Media: Wood and clay. Address in 1982, Flushing, NY.

LUINI, COSTANZO.
Sculptor and craftsman. Born Milan, Italy, August 31, 1886. Pupil of Aitken and MacCartan. Member: New York Architectural League; American Federation of Arts; Boston Society of Arts and Crafts; Art League of Nassau Co. Works: Medals, Walter Scott, T. Edison, T. Vail, Societe des Femmes de France of NY; Gen. Pershing; Wall Tablet for US Naval Academy. Exhibited: National Acad-

emy of Design, Annual Exhibition, 1925. Address in 1933, Elmhurst, Long Island, NY.

LUISI, JERRY.
Sculptor and instructor. Born in Minneapolis, MN, October 7, 1939. Studied at National Academy of Design; Art Students League. Work in National Academy of Design, NY; others. Has exhibited at National Academy of Design; Allied Artists of America; National Sculpture Society; Salmagundi Club; others. Received Greenshields Foundation Grant, 1972 and 75; Anna Hyatt Huntington Award, Hudson Valley Art Association, 1980; John Gregory Award, National Sculpture Society, 1980; others. Member of National Sculpture Society; life member of Art Students League; Artists Equity Association. Teaching sculpture at Fashion Institute of Technology, from 1972, and at National Academy of Design, from 1979. Address in 1982, 37 E. 28th St., NYC.

LUKE, WILLIAM.
Figurehead carver. Born in Portsmouth, VA, 1790. Active in 1822. A noted work is his figure of "Tamanend." Reportedly worked in the Gosport Navy Yard and carved for many Navy ships.

LUKEMAN, (HENRY) AUGUSTUS.
Sculptor. Born Richmond, VA, Jan. 28, 1872. Pupil of Launt Thompson and D. C. French in NY; Ecole des Beaux-Arts in Paris, under Falguiere. Member: Associate, National Academy of Design, 1909; NY Architectural League, 1898; National Sculpture Society, 1898. Award: Bronze medal, St. Louis Exp., 1904. Work: "McKinley," Adams, MA, and Dayton, OH; "Manu," Appellate Court, NY; four figures, Royal Bank Bldg., Montreal; four figures, Brooklyn Institute Museum; Columbus Custom House; "Professor Joseph Henry," Princeton University; "Kit Carson," Trinidad, CO; Straus Memorial, NY, 1915; US Grant Memorial, San Diego, CA; Soldiers' monument, Somerville, MA; statue, "Franklin Pierce," Concord, NH; "Women of the Confederacy," monument, Raleigh, NC; "Gen. Wm. Shepard," Westfield, MA; "Honor Roll," Prospect Park, Brooklyn, NY; "Soldiers' Memorial," Red Hook Park, Brooklyn, NY; Equestrian Statue, Francis Asbury, WA; Francis Asbury, Drew Seminary, Madison, NJ; General Gregg, Reading, PA; War Memorial, Pittsfield, MA; Masonic War Memorial, Elizabeth, PA; War Memorial, Wilmington, DE; Statues of Sen. James George and Jefferson Davis for Statuary Hall, Capitol, Washington; Stone Mountain Confederate Memorial, GA. Exhibited at National Sculpture Society, 1923. Address in 1933, 160 West 86th St., NYC; summer, Stockbridge, MA. Died in NY, 1935.

LUKIN, SVEN.
Sculptor and painter. Born February 14, 1934, in Riga, Latvia. Studied architecture at University of Penna. Awarded Guggenheim fellowship, (1966). Exhibited at Nexus Gallery (Boston), 1959; Stedelijk Museum, Amsterdam, Holland, 1966; Betty Parsons Gallery, Martha Jackson Gallery, Whitney Museum, Guggenheim Museum (NYC); Dwan Gallery (LA). In collections of Los Angeles County Museum; Albright-Knox Gallery, Buffalo, NY; University of Texas; Allentown (PA) Art Mu-

seum; Whitney, NYC; and Larry Aldrich Museum, Ridgefield, CT. Address in 1982, 807 Ave. of the Americas, NYC.

LUKITS, THEODORE NIKOLAI.
Sculptor and painter. Studied: Art Institute of Chicago; St. Louis School of Fine Art. Member: International Art Club, Los Angeles; American Institute Fine Arts Society, CA; Laguna Beach Art Association; Riverside (CA) Art Association; Los Angeles Art Association; California Art Club; Society for Sanity in Art; American Artists Professional League. Awards: Brand Memorial Prize, 1918; Bryan Lathrop scholarship, 1919; prizes, Art Institute of Chicago, 1926, 27, 29; Los Angeles Museum of Art, 1937; medals, Painters and Sculptors of Los Angeles, 1942. Restored masterpiece (El Greco), 1925, at the Santa Barbara, CA, Mission. Position: President and Director of Lukits Academy of Fine Arts, Los Angeles. Address in 1953, Los Angeles, CA.

LUMPKINS, WILLIAM THOMAS.
Sculptor, painter, designer, and craftsman. Born in Marlow, OK, April 8, 1909. Studied at Univ. of New Mexico; Colorado State College; Univ. of California at Los Angeles; Texas Christian Univ. Work: Murals, Native Market, Santa Fe, NM; designed school, trade, and industrial buildings, in Southwest. Exhibited: Palace of Legion of Honor, 1934; Southwest Annual, 1934-40, 46; Chappell House, Denver, CO, 1938; NY World's Fair, 1939; Paris Salon; Memphis, TN, 1945. Author, illustrator, "Modern Pueblo Homes." Address in 1953, Santa Fe, NM.

LUNDEEN, GEORGE W.
Sculptor. Born in Holdrege, Nebraska, in 1948. Studied art at Hastings College; University of Illinois, MFA sculpture; in Italy on Fulbright-Hays grant. Taught briefly in Nebraska; artist in residence, Texas A & M. Has exhibited at National Sculpture Society; National Academy of Design, New York City. Member of National Sculpture Society. Specialty is statuettes of people; works in bronze and terra-cotta. Reviewed in *Artists of the Rockies*, spring 1981. Represented by Driscol Gallery, Denver, CO; O'Brien's Art Emporium, Scottsdale, AZ. Address in 1982, Loveland, Colorado.

LUNG, ROWENA CLEMENT.
Sculptor and painter. Born in Tacoma, WA, March 27, 1905. Pupil of Parshall, Herter, Cooper, Armstrong, Cadorin, and Fletcher. Member: Society of Independent Artists; Tacoma Civic Art Association; Women Artists of Washington; others. Represented in State Historical Building, College of Puget Sound, and Lowell School, Tacoma, WA. Director of Armstrong School of Art. Taught: Professor of art, College of Puget Sound, Tacoma, WA. Address in 1933, Tacoma, WA; summer, Vashon Island, WA.

LUPORI, PETER JOHN.
Sculptor and educator. Born in Pittsburgh, PA, December 12, 1918. Studied at Carnegie-Mellon University, B.F.A., 1942; University of Minnesota, M.S. (education), 1947; with Joseph Bailey Ellis and John Rood. Work in Walker

Art Center, Minneapolis; Holy Childhood Church, St. Paul, MN; others. Has exhibited at Carnegie Institute of Art; Walker Art Center; Minneapolis Institute of Arts; St. Paul Museum of Art; others. Received 2nd award in sculpture, Prix de Rome, NY, 1941; Carnegie Institute Prize for Sculpture, Associated Artists of Pittsburgh, 1949; 2nd prize sculpture, Local Artists Exhibition, Minneapolis Institute of Arts, 1953. Member of Artists Equity Association; Society of Minnesota Sculptors. Works in ceramic, wood, and welded metal sculpture. Address in 1982, c/o Dept. of Art, College of St. Catherine, St. Paul, MN.

LUPTON, FRANCES PLATT TOWNSEND (MRS.).
Sculptor, miniaturist, and landscape painter. According to Dunlap, in his "History of the Arts," a Mrs. Lupton modeled and presented a bust of Governor Throop to the National Academy of Design. Also exhibited at the National Academy of Design in 1828, 29, and 31.

LUSH, VIVIAN.
(Mrs. Vivian Lush Piccirilli). Sculptor. Born in NYC, August 3, 1911. Studied: Leonardo da Vinci Art School; National Academy of Design; Art Students League; also with Attilio Piccirilli, Charles Keck, and Robert Aitken. Award: National Association of Women Artists. Collections: Riverside Church, NY; Rockefeller Center, NY; Port Richmond High School; Unity Hospital, Brooklyn, NY; Roosevelt High School, Bronx, NY; Children's Wing, Public Library, Trinidad, British West Indies. Member: National Association of Women Artists. Address in 1953, Bronx, NY.

LUTHER, JESSIE.
Sculptor, painter, craftsman, writer, lecturer, and teacher. Born Providence, RI, Nov. 3, 1860. Pupil of S. R. Burleigh; Paul Bartlett and Raphael Collin in Paris. Member: Providence Art Club; Boston Society of Arts and Crafts; Providence Handicraft Club; Philadelphia Arts and Crafts Guild; Boston Weavers Guild. Address in 1929, East Providence, RI; h. Providence, RI.

LUTOMSKI, JAMES W.
Sculptor. Born in 1944. Studied: Wayne State University, Detroit, B.F.A., 1973, M.F.A., 1977. Exhibitions: Fibers and Clay, Troy Art Gallery, Troy, 1977; Art of Three, Troy Art Gallery, Troy, 1978; Fall Exhibition, Detroit Artists Market, 1980; Six Artists in a New Space, Detroit Focus Gallery, 1980; Macomb County Community College, Warren, 1980, 81; Art from Craft Material, Detroit Focus Gallery, 1981; Michigan Ceramics, Detroit Artists Market, 1981; Michigan Artists 1980-81; The Detroit Institute of Arts, 1982. Address in 1982, Detroit, MI.

LUTTIKHUIZEN, ESTHER.
Sculptor and painter. Born in 1951. Studied: Hope College, Holland, B.A., 1973; Haystack Mountain School of Crafts, Deer Isle, ME, 1976. Exhibitions: Marietta Crafts National, Marietta College, Marietta, OH, 1977; The Doll, Renwick Gallery of the National Museum of American Art, Smithsonian Institution, Washington, DC, 1978; Dolls and Doll Houses, New Jersey State Museum, Tren-

ton, 1978; Women Artists Invitational, Douglass College, New Brunswick, NJ, 1979; Marietta National, Marietta College, Marietta, OH, 1980; Michigan Artists 1980-81, The Detroit Institute of Arts, 1982. Awards: American Handicrafts Exhibition, Monmouth Museum, Monmouth, NJ, 1977, First Prize; Individual Fellowship, New Jersey State Council on the Arts, 1978. Address in 1982, Grand Rapids, MI.

LUTZ, MARJORIE BRUNHOFF.
Sculptor. Born in Cincinnati, OH, January 25, 1933. Studied at Sculpture Center, NY; Art Students League, with Sidney Simon; Duke University. Work in Southern Vermont Art Center, Manchester. Has exhibited at Southern Vermont Art Center, Manchester; Knickerbocker Show, Salmagundi Club, NY; Allied Artists Show, National Arts Club, NY; others. Member of American Society of Contemporary Artists; Organization of Independent Artists; Screen Directors' Guild. Works in wood and stone. Address in 1982, 203 East 72nd St., NYC.

LUTZ, WINIFRED ANN.
Sculptor and environmental artist. Born in Brooklyn, NY, May 6, 1942. Studied at Cleveland Institute of Art, B.F.A., 1965; Atelier 17, with Stanley William Hayter, 1965; Cranbrook Academy of Art, M.F.A., 1968. Work in Cleveland Museum of Art; Albright-Knox Art Gallery; Chicago Art Institute; Crocker Gallery, Sacramento. Has exhibited at Santa Barbara Museum of Art, Handmade Paper Objects, CA; Handmade Paper, Prints, and Unique Works, Museum of Modern Art, NY; others. Member: American Crafts Council; Artists Equity; others. Teaching sculpture at Yale School of Art, from 1975. Works in wood; handmade paper. Address in 1982, New Haven, CT.

LUX, GWEN (CREIGHTON).
(Gwen Lux Creighton). Sculptor. Born in Chicago, IL. Studied: Maryland Institute of Arts; Boston Museum of Fine Arts School; later in Paris; and with Ivan Mestrovic, in Yugoslavia. Awards: Guggenheim fellowship, 1933; Detroit Institute of Art, 1945, 1956; National Lithograph prize, 1947; National Association of Women Artists, 1947; Audubon Artists, 1954; Architectural League, 1958; others. Collections: Association of American Artists; Radio City, NY; McGraw-Hill Building, Chicago; University of Arkansas; Victoria Theatre, NY; Bristol Tenn. Hospital; Steamship "United States;" Texas Petroleum Club, Dallas; Northland Shopping Center, Detroit; General Wingate School, Brooklyn; General Motors Research Center, Detroit; Socony Building, NYC; R. H. Macy-Roosevelt Field, NY; Public School 19, NYC; Aviation Trades High School, Long Island, NY; Detroit Museum; Country Day School, Lake Placid, NY. Member: Hawaii Artists and Sculptors League. Exhibited: Whitney, 1935; Detroit Museum, 1948; Pomeroy Galleries, San Francisco, 1968; Contemporary Arts Center, Honolulu, 1970; Downtown Gallery, Honolulu, 1976; others. Media: Concrete, various metals, polyester resin. Address in 1982, Honolulu, HI.

LYE, LEN.
Sculptor. Born July 5, 1901, in Christchurch, New Zealand. Came to US in 1948. Studied: Wellington Tech-

nical College; Canterbury College of Fine Arts. Began work in kinetic construction in 1920's. Work: Albright; Art Institute of Chicago; Whitney Museum. Exhibited: London Film Society, 1928; Museum of Modern Art, Motion Sculpture, 1961, and Albright, 1965; Stedelijk, Art in Motion, 1961-62; Whitney Museum Annual, 1962; The Howard Wise Gallery, NYC, On The Move, 1963. Taught: City College of New York (film technique); NYU. Received international awards for experimental films, Brussels, Belgium, 1958; National Endowment for the Arts Grant, 1979. Address in 1982, 41 Bethune St., NYC.

LYFORD, CABOT.
Sculptor and painter. Born in Sayre, PA, May 22, 1925. Studied at Skowhegan School of Art, summer 1947; Cornell University, B.F.A., 1950; Sculpture Center, NY, 1950-51. Work in Addison Gallery of American Art, Andover, MA; Wichita Museum, Kansas; Harbor Sculpture (black granite), Portsmouth, NH; others. Has exhibited at Payson Museum, Portland, ME; Addison Gallery, Andover, MA; Fitchburg Art Museum; others. Teaching sculpture at Phillips Exeter Academy, NH, from 1963. Works in stone and metal; watercolor. Address in 1982, Exeter, NH.

LYNCH, GERALD FRANCIS.
Sculptor and draftsman. Born in Philadelphia, PA, January 26, 1944. Studied at Maryknoll Seminary College, B.A., 1961-65; Philadelphia College of Art, 1966 and 69. Has exhibited at Allied Artists of America Annuals, National Academy of Design, NY; Philadelphia Art Alliance, PA; Salmagundi Club, NY; others. Received gold medal (sculpture), Allied Artists of America; others. Member of Allied Artists of America; Artists Equity; Ocean City Art Center. Works in marble, wood; chalk, ink. Address in 1982, Villas, NJ.

LYNN-JENKINS, FRANK.
Sculptor. Born in Torquay, England, in 1870, and was a pupil of Lambeth School of Modeling and the Royal Academy of Art in London. His awards included a silver medal at the International Paris Exposition in 1900. He is represented by a marble Madonna and Child at the Metropolitan Museum of Art in NY. Died in NYC, September 1, 1927.

LYON, ALFRED B.
Sculptor. Member: Indiana Society of Sculptors. Address in 1925, Indianapolis, IN.

LYON, EDWIN.
Sculptor. Worked: Natchez, Mississippi. Exhibited: Penna. Academy, 1848, 1853.

M

MacCLINTOCK, DORCAS.
Sculptor. Born in New York City. Self-taught. Studied as a biologist at Smith College and University of Wyoming. Exhibitions: Group shows, Slater Museum, Norwich, CT; Grand Central Galleries, Columbus, OH; Gallery of Fine Arts; Owens Gallery, Oklahoma City, OK; Foot of Main Gallery, Essex, CT; New Haven Library. Awards: Science Book Award, New York Academy of Science 1974, for *A Natural History of Giraffes*. Member: Society of Animal Artists, American Society of Mammalogists; Society of Vertebrate Paleontology; Sigma X. Expeditions: East Africa, 1970. Specialties: Hoofed mammals and carnivores. Author of numerous animal natural history books. Media: Plaster mold from plastilene model; casts from a latex compound. Address in 1983, Hamden, CT.

MacCUISTON, JACQUES (JAX) (MISS).
Sculptor. Born in Texarkana, Texas, October 19, 1906. Studied with Haakon Frolich and George Demont Otis. Award: Sixth Annual Allied Arts exchange, Dallas Public Art Gallery, 1933. Address in 1933, 5122 Gaston Ave., Dallas, Texas.

MacDONALD, HAROLD L.
Sculptor, painter, illustrator, and teacher. Born in Monitowoc, Wis., May 13, 1861. Pupil of Boulanger and Lefebvre in Paris. Member: Society of Washington Artists. Address in 1921, Purcellville, VA.

MacDONALD, JAMES WILSON ALEXANDER.
Sculptor, painter, writer, and lecturer. Born in Steubenville, OH, August 25, 1824. Was in the publishing business in St. Louis, but from his thirtieth year he devoted himself to art. He made the first portrait bust cut in marble west of the Mississippi, that of Senator James T. Benton of Missouri. After the Civil War he came to NY, and his bust of Charles O'Connor is in the Appellate Court, and that of James T. Brady in the Law Library; his bronze statue of Fitz-Greene Halleck is in Central Park, and his Washington Irving in Prospect Park, Brooklyn. Died in Yonkers, NY, August 14, 1908.

MacHARG, KATHERINE.
Sculptor, painter, designer, and teacher. Born in Biwabik, Minn., October 5, 1908. Studied: Pratt Institute Art School; Penna. Academy of Fine Arts; University of Arizona; Duluth State Teachers College. Member: Minn. Sculpture Group; American Federation of Arts. Awards: Penna. Academy of Fine Arts. Exhibited: Chester Springs traveling exh.; Minn. State Fair, 1940; Duluth Arrowhead Exh. Contributor to *School Arts Magazine*. Address in 1953, 205 Superior Street; h. Duluth, Minn.

MACHEN, W. H.
Sculptor. Active 1865. Patentee—monument to the memory of Abraham Lincoln, 1865.

MACHLIN, SHELDON (MERRITT).
Sculptor. Born September 6, 1918, in NYC. Studied: NYU; Art Students League; New York School of Fine and Applied Art; School of Modern Photography. Work: Metropolitan Museum of Art; Museum of Modern Art; Milwaukee; New York Cultural Center; Aldrich; Svenska Handelsbanken; Virginia Museum Fine Arts; Whitney Museum. Exhibited: Bolles Gallery, NYC and San Francisco; The Bertha Schaefer Gallery, NYC; Museum of Modern Art; Virginia Museum of Fine Arts; Whitney Museum Sculpture Annual, 1964, 66, 68; Trenton, Focus on Light, 1967; La Jolla Museum, 1969; Brooklyn Museum, 1969; others. Address in 1970, Brooklyn, NY. Died in 1975.

MacINTOSH, WILLIAM W.
Sculptor. Born in West Philadelphia, PA. Pupil of Penna. Academy of Fine Arts, under Eakins, Schussele, Poore, Chase, Cecilia Beaux, and Camille Piton. Specialty: medals. Address in 1918, 1822 Chestnut St., Philadelphia, PA.

MACK, RODGER ALLEN.
Sculptor and educator. Born in Barberton, OH, November 8, 1938. Studied at Cleveland Institute of Art, B.F.A., 1961; Cranbrook Academy of Art, Bloomfield Hills, MI, M.F.A., 1963; Academia Belle Arti, Florence, Italy, Fulbright grant, 1963-64. Work in Albrecht Museum of Art, St. Joseph, MO; Munson-Williams-Proctor Institute, Utica, NY; others. Has exhibited at Krasner Gallery, NY; Everson Region, Everson Museum of Art, Syracuse, NY; Rochester Institute of Technology; others. Received National Endowment for the Arts Award; Ford Foundation Grant, 1980-81. Teaching sculpture at Syracuse University, from 1968. Works in bronze and stone. Address in 1982, Syracuse, NY.

MACKAY, FRANCES I.
Sculptor. Born in Baltimore, MD, in 1906. Studied at the Maryland Institute, Baltimore, under J. Maxwell Miller, and at the Penna. Academy of Fine Arts, under Albert Laessle. Works: Bust, Carl; relief, Helen; figure, Terino; Diane. Awards: Rinehart traveling scholarship, 1926.

MacKAY, JEAN V.
(Mrs. Jean MacKay Henrich). Sculptor, teacher, lecturer, and engraver. Born Halifax, N.S., Canada, September 19, 1909. Studied: Antioch College, B.A.; Art Institute of Chicago; Art Institute of Buffalo, NY; and abroad. Member: Buffalo Print Club; The Patteran. Work: Library of Congress; Veterans Memorial, Geneva, NY. Exhibited: Penna. Academy of Fine Arts, 1942; Butler Art Institute, 1941; Seattle Art Museum, 1942; San Francisco Museum of Art, 1942; Denver Art Museum, 1942; Albright Art Gallery, 1936-46. Taught: Instructor of Sculpture, Art Institute of Buffalo, NY, 1937-43, 1944-46. Address in 1953, 155 St. James Pl., Buffalo, NY.

MacKENZIE, RODERICK D.

Sculptor, painter, illustrator, etcher, writer, lecturer, and teacher. Born London, England, April 30, 1865. Pupil of the School of the Museum of Fine Arts, Boston; Constant, Laurens, Jules Lefebvre, Chapu and the Ecole Nationale des Beaux-Arts in Paris. Member: Royal Society of Arts, London; American Federation of Art. Award: Curzon gold medal, India. Work: "State Entry Delhi, Durbar, 1903," Museum at Calcutta; "The Chitor Elephants," gate to Fort, Delhi, India; "Afghans" and "Beluchis;" series of night pictures of steel works, Birmingham, AL; eight murals and bas-relief panels, Rotunda and Dome, State Capitol, Montgomery, AL. Address in 1933, The Art Studio, Mobile, AL.

MacKINSTRY, ELIZABETH (CONKLING).

Sculptor, illustrator, and teacher. Born in Scranton, PA, March 31, 1879. Pupil of Arthur Dow and Pratt Institute in New York; Gerome in Paris. Address in 1918, 1118 Elmwood Ave.; h. 1046 Elmwood Ave., Buffalo, NY.

MacLEAN-SMITH, ELIZABETH.

Sculptor and lecturer. Born in Springfield, Mass., February 18, 1916. Studied at Wellesley College, A.B.; Belgian-Am. Educ. Found. traveling fel., Belg., 1937; Boston Museum School, with Federick Warren Allen and Sturdivant traveling fel., Mexico, 1941. Work: Museum Fine Arts, Boston; Museum Fine Arts, Springfield, Mass.; Williams College, Williamstown, Mass. Commissions: Polyester murals, Dini's Sea Grill, Boston, 1962-70; fountain and garden sculptures and portraits in private collections. Exhibitions: New England Sculptor's Association, Prudential Center, Boston, 1968 and 70; one-woman shows, G. W. V. Smith Museum, Springfield, 1950, Tufts College, Medford, Mass., 1952, Crane Museum, Pittsfield, Mass., 1956 and McIver-Ready Gallery, Boston, 1968. Media: Wood, stone, and clay. Taught: Instructor of Sculpture, Boston Museum School, 1940-53; Bradford Jr. College. Served as president for five terms, New England Sculptor's Association. Address in 1982, Charlestown, MA.

MacLEARY, BONNIE.

Sculptor. Born San Antonio, Texas, 1898. Pupil of New York School of Art; Julian Academy, Paris; James E. Fraser; Frank Du Mond Art Students League of New York. Member: National Sculpture Society; Associate of the National Academy of Design; National Academy of Women Painters and Sculptors; National Arts Club of NY; Allied Artists of America; American Artists Professional League. Work: "Aspiration," Metropolitan Museum of Art, New York; "Ouch!" Children's Museum, Brooklyn, NY; Munos Rivera Monument, Rio Piedras, Puerto Rico; World's War Memorial Monument, San Juan, Puerto Rico. Exhibited: National Academy of Design; National Association of Women Artists; Penna. Academy of Fine Arts; Architectural League; Allied Artists of America. Received award, Women's Art and Industrial Exhibition, 1928, 29. Address in 1953, New York City. Died in 1971.

MacLEOD, YAN (MISS).

Sculptor. Born in 1889. Address in 1935, Paris, France. Died in 1978. (Mallett's)

MacMONNIES, FREDERICK WILLIAM.

Sculptor and painter. Born Brooklyn, NY, September 28, 1863. Pupil of National Academy of Design; Art Students League of New York; Augustus Saint-Gaudens; Falguiere, Ecole des Beaux Arts and Mercie in Paris. Member: Society of American Artists 1891; Associate National Academy of Design 1901; National Academy of Design 1906; New York Architectural League 1892; National Institute of Arts and Letters; National Arts Club, NY. Awards: second class medal, Paris Salon, 1891; medal, Columbian Expo., Chicago, 1893; first class gold medal, Antwerp, 1894; medal, Phila. Art Club, 1895; medal, Atlanta Exp., 1895; grand prize of honor, Paris Expo., 1900; medal, Munich; first prize, Boston Art Club; Honorable mention for painting, Paris Salon, 1901; gold medal for sculpture, Pan-Am. Expo., Buffalo, 1901; Chevalier of the Legion of Honor, 1896; Chevalier Order of St. Michael of Bavaria. Work: "Army" and "Navy" and "Horse Tamers," "J. S. T. Stranahan," "General Slocum," Brooklyn, NY; "Bacchante," Metropolitan Museum of Art, New York, and Luxembourg, Paris; "Victory," West Point, NY; "Sir Henry Vane," Boston Public Library; central bronze door and statue of "Shakespeare," Library of Congress, "Gen. McClellan," Washington, DC; "Pioneer Monument," Denver; "Pan of Rohalion," Fine Arts Academy, Buffalo, NY; "Nathan Hale," Civic Virtue," fountain, New York; "Washington at Princeton," Princeton, NJ; Lindbergh Medal for Society of Medalists. Exhibited at National Sculpture Society, 1923. Address in 1933, 20 West 10th Street, New York, NY; Giverny-par-Vernon, Eure, France. Died in 1937.

MacMURRAY, M.

Sculptor. Address in 1919, 12521 Lake Shore Blvd., Cleveland, OH.

MacNEIL, CAROL BROOKS.

(Mrs. H. A. MacNeil). Sculptor. Born in Chicago, IL, January 15, 1871. Pupil of Art Institute of Chicago under Lorado Taft; MacMonnies and Injalbert in Paris. Member: National Sculpture Society, 1907; National Association of Women Painters and Sculptors. Exhibited: National Sculpture Society, 1923. Awards: Honorable mention, Paris Exp., 1900; bronze medal, St. Louis Exp., 1904. Executed busts, statuettes, fountains. Address in 1933, College Point, LI, NY. Died in 1944.

MacNEIL, HERMON ATKINS.

Sculptor. Born Everett, MA, February 27, 1866. Pupil of Mass. Normal Art School in Boston; Chapu at Julien Acad. and Falguiere at Ecole des Beaux-Arts in Paris. Member: National Sculpture Society, 1897; Associate, National Academy of Design, 1905; National Academy of Design, 1906; Society of American Artists, 1901; New York Architectural Lg., 1902; Century Assn.; New York Municipal Art Society; National Academy of Arts and Letters; American Federation of Arts. Exhibited at National Sculpture Soc., 1923. Awards from: Columbian Expo., Chicago, 1893; Atlanta Expo., 1895; Paris Expo., 1900; Pan-Am. Expo., Buffalo, 1901; Charleston Expo., 1902; St. Louis Expo., 1904; Jewish Settlement in

America; P.-P. Expo., San Francisco, 1915; medal of honor for sculpture, NY Architectural League, 1917. Designer of Pan-Am. medal of award; New York Architectural League medal of honor; US Government quarter dollar. Sculptures at City Park, Portland, Oregon; Albany, NY; State Capitol at Hartford, Conn. In collections of: Metropolitan Museum of Art; Corcoran; Art Institute of Chicago; Montclair (NJ) Art Museum; Northwestern University; Cornell; Hall of Fame, New York University. Taught at Cornell University, Art Institute of Chicago, Pratt, American Academy in Rome. Address in 1953, College Point, LI, NY.

MACOMBER, ALLISON R.
Sculptor. Born in Taunton, MA, July 15, 1916. Studied at Mass. College of Art; and with Cyrus E. Dallin, Raymond Porter, and Sir Henry Kitson. Works: Edith C. Baker School, Brookline, MA; Reany Memorial Library, St. Johnsville, NY; State Teachers College, Lowell, MA; University of Mississippi; Notre Dame University; US Marine Corps.; Anaconda Copper Mines; St. Mary's Cathedral, Trenton, NJ; Buffalo Medical Society; Boston Gridiron Club; Dartmouth College; Moline Illinois Historical Society; Providence Water Commission; Jordan Hospital, Plymouth, Mass.; Boston University; Memorial Stadium, University of Rhode Island; rotunda, Howard State Hospital, Providence, Rhode Island; Masonic Lodge, Rhode Island; Masonic Lodge, Taunton, England; New Church of the Sacred Heart, Taftville, Conn.; Chenery Library, Boston University. Exhibited: Penna. Academy of Fine Arts, from 1938; National Sculpture Society Annual, 1940; Smithsonian Traveling Exhibition, 1960-62. Award: Utopian Club, 1960; International Silver Competition Award, 1960; others. Taught as artist in residence at Boston College, from 1963. Address in 1976, Mulberry Cottage, Segreganset, MA. Died in 1979.

MADISON, DAVE.
Sculptor. Born in Paw Paw, MI, 1951. Studied: Michigan State University, B.A. Exhibitions: Western Michigan University (Student Show), 1972; Michigan State University (Student Show), 1974; The Detroit Institute of Arts (Works by Michigan Artists), 1974-75. Address in 1975, Paw Paw, MI.

MADSEN, LOREN WAKEFIELD.
Sculptor. Born in Oakland, CA, March 29, 1943. Studied at Reed College, Portland, OR, 1961-63; University of California, Los Angeles, B.A., 1966, M.A., 1970. Work in Walker Art Center, Minneapolis; Museum of Modern Art, NY; Georges Pompidou Center, Paris; Hirshhorn Museum, Washington, DC. Has exhibited at Los Angeles Co. Museum of Art; Museum of Modern Art, NY; Walker Art Center; The Biennale of Sculpture, Sydney, Australia; others. Received New Talent Award, Modern and Contemporary Art Council, Los Angeles Co. Museum of Art; fellowship-grant, National Endowment for the Arts. Works in brick and lumber. Address in 1982, 428 Broome St., NYC.

MAENE, EDWARD.
Sculptor. Born in 1852. Died in Philadelphia, Penna., 1931. (Mallett's)

MAGEE, RENA TUCKER KOHLMAN.
(Mrs. Franklin Magee). Sculptor, painter, and writer. Born Indianapolis, IN, November 29, 1880. Pupil of Joseph De Camp, H. Siddons Mowbray, Charles H. Woodbury, and George Gray Barnard. Member: National Sculpture Society; Independent Society of Sculptors. Director of Exhibitions, Milch Galleries. Contributor to various magazines on topics of art. Address in 1953, New York, NY.

MAGNER, DAVID.
Sculptor or carver. Born in Massachusetts c. 1835. At Boston, 1860.

MAGONIGLE, H. VAN BUREN.
Sculptor, architect, painter, and writer. Born Bergen Heights, NJ, October 17, 1867. Offices of Vaux & Radford; Charles C. Haight; McKim, Mead & White. Member: Associate National Academy of Design; Fellow, American Institute of Architects; New York Architectural League (pres.); Alumni American Academy in Rome (past Pres.); National Sculpture Society (vice-pres.); Salma. Club; American Federation of Arts; Society Beaux-Arts; New York Chapter American Institute of Architects (Pres.). Awards: Gold medal, New York Architectural League, 1889; Rotch Traveling Scholarship, 1894. Work: McKinley National Memorial, Canton, OH; National Maine monument, and Firemen's Memorial, both in New York City; Liberty Memorial, Kansas City, MO; Arsenal Technical Schools, Indianapolis. Author of *The Nature, Practice and History of Art; The Renaissance*, etc. Address in 1933, 101 Park Avenue; h. 829 Park Avenue, New York, NY.

MAGRAGH, GEORGE.
Wood carver. Born in Philadelphia. Exhibited: Pennsylvania Academy of Fine Arts, 1811 and 1813.

MAHLKE, ERNEST D.
Sculptor and educator. Born in Madison, WI, September 15, 1930. Studied at University of Wisconsin, B.S. and M.S.; Institute Allende, University of Guanajuato, Mexico, M.F.A. Has exhibited at Smithsonian Institution, Traveling Exhibitions; Cooperstown Art Association National Annual; Munson-Williams-Proctor Institute, Utica, NY; others. Member of American Craftsmen's Council. Teaching sculpture at State University of NY at Oneonta, from 1962. Works in wood and metal sculpture. Address in 1982, Oneonta, NY.

MAHON, JOSEPHINE.
Sculptor, painter, craftsman, writer, and teacher. Born Caldwell, NJ, October 31, 1881. Pupil of Charles W. Hawthorne, Richard Hayley Lever; New York School of Fine and Applied Arts; Pratt Institute; Columbia University. Member: American Artists' Professional League; Catharine Lorillard Wolfe Art Club. Address in 1933, Bloomfield Avenue, West Caldwell, NJ; summer, "Wateredge," Nantucket, MA.

MAHONEY, JOHN H.
Sculptor. Member: Independent Society of Sculptors. Address in 1925, 909 Lexington Ave., Indianapolis, IN.

MAIER-KRIEG, EUGEN.
Sculptor and painter. Born in Germany. Address in 1934, Los Angeles, CA. (Mallett's)

MAKARENKO, ZACHARY PHILIPP.
Sculptor and painter. Born in North Caucasus, Russia, February 20, 1900; US citizen. Study: State University Academy of Fine Arts, Kiev; in Germany and Italy. Work: Public & private collections worldwide. Exhibition: Angelicum, Regional Ital. IV Relig. Exhibition, Milan, 1947; USA Relig. Exhibition, Burr Gallery, NYC, 1958; American Artists Professional League Grand National, NYC, 1966; National Academy of Design Galleries, NYC, 1971; others. Awards: American Artists Professional League, 1966; Medal of Honor, Painter and Sculptor Society Exhibition, Jersey City (NJ) Museum, 1971; Allied Artists of America Gold Medal of Honor, for sculpture, National Academy of Design Galleries, 1971; others. Member: Fellow, American Artists Professional League. Address in 1980, North Bergen, NJ.

MALDARELLI, LAWRENCE.
Sculptor. Member: National Sculpture Society. Address in 1928, 159 Sixth Ave., NYC.

MALDARELLI, ORONZIO.
Sculptor. Born September 9, 1892, Naples, Italy. Came to USA, 1900. Studied: Cooper Union, 1906-08; National Academy of Design, 1908, with Leon Kroll, Ivan Olinsky, Hermon McNeil; Beaux-Arts Institute of Design, NYC, 1912, with Solon Borglum, Jo Davidson, John Gregory, Elie Nadelman. Work: Art Institute of Chicago; Dallas Museum of Fine Arts; Fairmount Park Association; Met. Museum of Art; Newark Museum; Ogunquit; Penna. Academy of Fine Arts; Sara Roby Foundation; Utica; Va. Museum Fine Arts; Whitney; commission for St. Patrick's Cathedral, NYC. Exhibited: National Academy of Design, 1922, 23, 58, 62, 63; California Palace, 1930; Art Institute of Chicago, 1935, 36, 40, 42, 57; Whitney Museum, 1936, 56, 62; Univ. of Minnesota, 1937; Society of Independent Artists, NYC, 1941; Penna. Academy of Fine Arts, 1943; Sao Paulo, 1951; Museum of Modern Art, 1953; Univ. of Illinois, 1953, 55; Hartford (Wadsworth), 1957. Awards: Fairmount Park Association, Philadelphia, First Prize, Sculpture, 1930; J. S. Guggenheim Fellowship, 1931-33; Art Institute of Chicago, Logan Medal, 1941; National Institute of Arts and Letters Grant, 1948; Penna. Academy of Fine Arts, Widener Memorial Gold Medal, 1951; Architectural League of New York, Silver Medal of Honor, 1954, 56. Member: National Institute of Arts and Letters; National Academy of Design; Architectural League of New York; National Sculpture Society; Artists Equity Association. Taught at Sarah Lawrence College, 1933-61; professor of sculpture, Columbia University, NYC. Address in 1953, 8 West 13th Street, NYC. Died in NYC January 4, 1963.

MALICK, EVA KRISTINA DALBERG.
See Eva Kristina Dalberg.

MALIK, MARLENE.
Sculptor. Born in 1940. Studied: The Art Institute of Chicago; Roosevelt University, Chicago; University of Rhode Island. Exhibitions: Deron Gallery, Chicago, 1960; Helme House Gallery, 1970; URI Group Show, 1973; HERA Women's Cooperative Gallery, Wakefield, Rhode Island, 1975. She is noted for her "First Memory" sculptures.

MALLARY, ROBERT.
Sculptor. Born December 2, 1917, in Toledo, OH. Studied with John Emmett Garrity and at Escuela de las Artes del Libro, Mexico City. Taught at University of New Mexico, Pratt, and Amherst. Exhibited at Allan Stone Gallery, 1961-2; Seattle World's Fair, 1962; Museum of Modern Art Sao Paulo Biennial, Brazil, 1963 and Institute of Contemporary Art, London, 1968. In collections of Museum of Modern Art; Albright-Knox; Houston's Museum of Fine Arts; Smith College; Brandeis; Whitney; LA County Museum; and Berkeley. Address in 1982, Conway, MA.

MALLORY, RONALD.
Sculptor. Born June 17, 1935, in Philadelphia, PA. Studied: Univ. of Colorado, 1951; University of Florida, B.Arch., 1952; School of Fine Arts, Rio de Janeiro (with Roberto Burle Marx), 1956; Academie Julian, Paris, 1958. Work: University of California at Berkeley; Museum of Modern Art; Munich (Modern); Aldrich; Whitney Museum; and others. Exhibited: The Stable Gallery, 1966, 67; Esther Robles Gallery, 1968; Palais des Beaux-Arts, Brussels, 1965; Houston (Contemporary); Carnegie; Flint Institute; Worcester Art Museum; UCLA, Electric Art, 1969; Torcuato di Tella, Buenos Aires, 1969; Museum of Modern Art; Whitney. Address in 1982, c/o Galeria Bonino Ltd., NYC.

MALMSTROM, MARGIT.
Sculptor. Born in Stockholm, Sweden, in 1943. Studied: Bard College, sculpture with Harvey Fite; in NYC with sculptor Bruno Lucchesi; later as a scholarship student at the National Academy of Design. Work has been exhibited since 1977 in numerous galleries in NYC. Awards: Helen Foster Barnett Prize from the National Academy show in 1978. Taught: Sculpture at Barrett House, Dutchess County Art Association, Poughkeepsie, NY; The Chelsea School of Fine Art, NYC; The Sculpture Center, NYC, currently. Has also conducted demonstrations and workshop classes at Sculpture Associates, NYC. Co-author, with Bruno Lucchesi, of three books on sculpture technique: *Terracotta: The Technique of Fired Clay Sculpture*; *Modeling the Head in Clay*; and *Modeling the Figure in Clay*. Address in 1984, 36 West 21st Street, NYC.

MANATT, WILLIAM WHITNEY.
Sculptor. Born in Granville, OH, March 2, 1875. Pupil of Broutos of Athens; Saint Gaudens at Art Students League of NY. Address in 1915, Berkeley, CA.

MANCA, ALBINO.
Sculptor. Born in Tertenia, Sardinia, Italy, January 1, 1898. Studied: Royal Academy of Fine Art, Rome, Italy, with Ferrari, Zannelli. Member: National Sculpture Soci-

ety (fellow), National Academy of Design; American Artists Professional League; All. Artists of America. Awards: Prizes, Royal Acad. of Fine Art, Rome, Italy, 1926, 27; Montclair Art Museum, 1941; American Artists Professional League, 1941; All. Artists of America, 1943; prizes, National Academy of Design, 1964, 66; Smithsonian Inst., 1965. Work: Monument, Cagliari, Sardinia; The Gate of Life, entrance gate, Queens Zoo, 1968; Brookgreen Gardens, SC; Henry Hering Memorial Medal, 1959; sculpture, Fairmount Park Association, Phila., PA; commemorative medals in numismatics collections of Smithsonian Institution, American Numismatic Society, Metropolitan Museum of Art. Exhibited: American Artists Professional League, 1941; Newark Museum, 1941; Montclair Art Museum, 1941; Allied Artists of America, 1943; Museum of Modern Art (AV), 1942; Italian Salon, Rockefeller Center, NY, 1940 (one-man); World's Fair, New York, 1939. Address in 1980, 131 West 11th Street, New York, NY.

MANCINI, JOHN.
Sculptor. Worked: New York City, 1841-57.

MANDEL, HOWARD.
Sculptor, painter, and illustrator. Born in Bayside, NY, February, 24, 1917. Studied: Pratt Institute Art School, Brooklyn; New York Sculpture Center; Art Students League; Atelier Fernand Leger, Paris; Atelier Andre L'Hote, Paris; Ecole Beaux Arts, Sorbonne, France. Member: Audubon Artists; Clay Club; Woodstock Art Association. Awards: Tiffany Fellow, 1939, 49; Fulbright Scholarship to Paris, 1951, 52. Work: Whitney; Butler Institute, Youngstown, OH; Norfolk Museum of Arts and Science, VA; Lexington, KY; Marine Hospital, Ft. Stanton, N.M.; mural, Arthur Studios, NY. Exhibited: American Watercolor Society of New York, 1937-40; New York Watercolor Club, 1937-40; Toledo Museum of Art, 1941; Utah State Institute of Fine Arts, 1941; Clay Club, 1940-46; Philadelphia Museum of Art, 1940-42; Woodstock Art Association, 1946; Vendome Gallery, 1942; Whitney, 1948-59; Metropolitan Museum of Art, 1950; National Institute of Arts and Letters, 1955, 61. Illustrated many national magazines. Address in 1982, 285 Central Park West, NYC.

MANGER, BARBARA.
Sculptor. Used materials of all types to make floor and wall pieces.

MANGER, HEINRICH (HENRY).
Sculptor. Born in 1833. Active in Philadelphia c. 1862 to 1871. Exhibited a bust of Lincoln at the Pennsylvania Academy, 1865-67.

MANGUM, WILLIAM (GOODSON).
Sculptor and painter. Born in Kinston, NC. Study: Corcoran School of Art, Washington, DC; Art Students League; University of NC, Chapel Hill. Work: Carl Sandburg Memorial, Flat Rock, NC; "Lamp of Learning" Monument, Greensboro, NC; NC Museums; private collections, including R. Phillip Hanes. Exhibitions: Isaac Delgado Museum; Galerie Paula Insel Exhibition and Bodley Gallery National, NYC; NC Museum of Art;

Museum of Art, Springfield, Mass.; Virginia Museum of Fine Art; Southeast Center of Contemporary Art, Winston-Salem, NC. Awards: Virginia Museum of Fine Art; Delgado Museum Award, NC Museum of Art. Member: Southern Association of Sculptors. Teaching: Sculpture and art history at Salem College, from 1982. Address in 1982, Salem College, Winston-Salem, NC.

MANHOLD, JOHN HENRY.
Sculptor. Born in Rochester, NY, August 20, 1919. Studied at University of Rochester, B.A.; Washington University, St. Louis, M.A.; New School, with Chaim Gross and Manolo Pasqual; also with Ward Mount. Work in City of West Orange, NJ; Memorial Sloan-Kettering Hospital, NY; others. Has exhibited at Allied Artists of America; Audubon Artists of America; Grover M. Hermann Fine Arts Center, OH; National Sculpture Society; others. Member of American Artists Professional League (fellow); Painters and Sculptors Society, NJ; National Arts Club; Knickerbocker Artists. Awards: Second prize, Partons Award, Painters and Sculptors Society of NJ, 1971; John Subkis Award, National Arts Club, 1971; others. Work in marble and bronze. Address in 1982, Chatham, NJ.

MANKOWSKI, BRUNO.
Sculptor and medalist. Born in Germany, October 30, 1902. US citizen. Studied art at the Munich Art School and State Art Sch., Berlin, Beaux-Arts Institute, NY. Exhibited: National Academy of Design Annual, 1940-78; Penna. Academy of Fine Arts Annual, 1947-54; National Sculpture Society Annual, 1947-78; American Academy of Arts and Letters, 1949-50; Allied Artists of America Annual, 1952-77. Awards: Daniel Chester French Award, Allied Artists of America, 1964; Herbert Adams Memorial Medal, 1972, and gold medal, at the Bicentennial Exhibition, 1978; National Sculpture Society; Gold Medal from the American Numismatic Association, Colorado Springs, 1980. Member: National Academy of Design, 1971-73; fellow, National Sculpture Society (counsel member, 1953-58, 71-78, chairman of the exhibit committee, 1956-58); a life fellow of the American Numismatic Society. Commissions: Sculptured panel, by US Government Society of Fine Arts, Chesterfield, SC, 1939; memorial plaque, Macombs Junior High School, NY, 1949; numerous designs for Steuben Glass, Corning, NY, 1954-55. Address in 1982, Debary, FL.

MANLEY, F.
Sculptor. Active mid-19th century. Made portrait busts in NY.

MANN, JEAN.
Sculptor. Exhibitions: Stamford Museum; Jorgensen Museum at Storrs; Belardo Gallery, New York City. Awards: New Haven Paint and Clay Club; Villary Art Ctr., New York City; the John P. Kebabian prize for sculpture.

MANN, MARGERY.
Sculptor. Born in Cleveland, OH, May 12, 1919. Studied: Goucher College, Baltimore, BA, 1939; University of Chicago, 1939-41. Noted for her Pop Art food-sculptures

during the 1960's. By 1976, working mostly as a photographer. Address in 1976, Davis, CA.

MANNING, DIANE.
Sculptor. Noted for boxes in plastic and aluminum.

MANNING, HILDA SCUDDER.
Sculptor. Born in Boston, MA. Studied at Mass. School of Art, Boston, with Cyrus Dallin; with Felix Benneteau, Paris. Has exhibited at Paris Spring Salon; Corcoran Gallery, Washington, DC; Delgado Museum, New Orleans; others. Member of National Sculpture Society; Pen and Brush. Works in bronze and terra cotta. Address in 1982, Bronxville, NY.

MANNING, ROSALIE H.
Sculptor. Born in Boston, Mass. Studied at the California School of Fine Arts, San Francisco, in 1916, under Leo Lentelli. Won a scholarship at the Art Students League of NY, and studied sculpture under Solon Borglum, and drawing under Louis Mora. In 1917 studied at the school of the Museum of Fine Arts, Boston, under Charles Grafly. From 1919 to 20 she studied at the Piccirilli Brothers studio with Attilio Piccirilli. From 1920 to 25 studied drawing with Mahonri Young. Works: Love Group; Jersey Bull; fountain, Rain in the Face, private estate, San Francisco, CA; Shorthorn Bull, Blackhawk Ranch, CA; R. C. H.; Police Dog, Greg; Himalayan Tahr; Contented Duckling.

MANOIR, IRVING (K).
Sculptor, painter, craftsman, lithographer, blockprinter, lecturer, teacher, and writer. Born in Chicago, IL, April 28, 1891. Pupil of H. M. Wollcot, Art Institute of Chicago, Chicago Academy of Fine Arts, Penna. Academy of Fine Arts, and studied abroad. Award: Prize of $500, Speed Memorial Museum, Louisville, KY, 1931; Laguna Beach Art Association, 1925. Work: "Fairytale Land of New Mexico," Speed Memorial Museum, Louisville, KY; "Still Life," Milwaukee Art Institute, Milwaukee, WI; "Decortive Birds," Brooks Memorial Art Museum, Memphis, TN; "Where D. H. Lawrence Lived in Taos," and "Decorative Trees," Commission for the Encouragement of Local Art, Art Institute of Chicago, Chicago, IL. Exhibited: Corcoran; Penna. Academy of Fine Arts; Art Institute of Chicago; Los Angeles Museum of Art; Laguna Beach Art Association; City Art Museum of St. Louis; others. Address in 1953, Corona del Mar, CA.

MANOR, FLORENCE.
Sculptor. Born in Santa Cruz, CA, October 29, 1881. Award: Gold medal, Alaska-Yukon-Pacific Exposition, 1909. Address in 1916, 2529 Union Street, h. 2245 Green Street, San Francisco, CA.

MANSHIP, PAUL HOWARD.
Sculptor. Born December 25, 1885, St. Paul, Minn. Studied at St. Paul School of Art; Penna. Academy of Fine Arts; Art Students League; American Academy in Rome. Work: American Academy in Rome; Addison Gallery, Andover MA; Art Institute of Chicago; Cochran Memorial Park; Detroit Institute; Harvard University; League of Nations; Metropolitan Museum of Art; Minneapolis Institute; New York Coliseum; Pratt Institute; Rockefeller Center; St. Louis; Corcoran; Luxembourg, Paris; Fairmount Park, Phila. Exhibited: Architectural League of New York, 1912; Amer. Federation of Arts, 1914; 37 Leicester Gallery, London, 1921; Phila. Museum of Art, 1926; Tate, 1935; Century Association, 1935; Va. Museum of Fine Arts, 1936; Arden Gallery, NYC, 1941; American Academy of Arts and Letters, 1945; Walker, 1948; St. Paul Gallery, 1967; Smithsonian, 1958; Penna. Academy Fine Arts; National Academy of Design; Whitney Museum; Metropolitan Museum of Art; National Sculpture Society; many others in US and abroad. Member: Associate, National Academy of Design, 1914; National Academy of Design, 1916; National Sculpture Society, 1912; American Institute of Arts and Letters, 1918; Chevalier, Legion d'Honneur, 1929; Century Association; National Arts Club. Awards: American Academy in Rome scholarship, 1909-12; Barnett prize, National Academy of Design, 1913; Widener gold medal, Penna. Academy of Fine Arts, 1914; gold medal, P.-P. Exp., San Fran. 1915; Barnett prize, National Academy of Design, 1917; gold medal, American Institute of Architects, 1921; medal, American Numismatic Society, 1924; gold medal, Phila. Art Assn., 1925; gold medal, Sesqui-Centennial Expo., Phila., 1926; Legion of Honor, 1929; National Sculpture Society, 1943; National Institute of Arts and Letters, gold medal, 1945. Address in 1953, 319 East 72 St., NYC; Lanesville, Gloucester, MA. Died February 1, 1966, in NYC.

MANUEL, BOCCINI.
Sculptor, painter, and etcher. Born Pieve di Teco, Italy, September 10, 1890. Pupil of Andri Favory, Andre Derain. Member: Art Students League of New York; Society of Independent Artists; Salon d'Art Francais Independent, Paris; Chicago No-Jury Society of Artists; Salons of America. Address in 1933, 485 Madison Avenue; h. 470 Midland Avenue, Rye, NY.

MANUEL, DAVE.
Sculptor and painter. Born in Walla Walla, Washington, in 1940. Self-taught in art. Received Grumbacher and *Parent Magazine* award in 1949; best of show bronze awards in Washington, Oregon, Nevada, yearly since 1978. Paintings of Marcus Whitman story were used in government film for Whitman Mission Museum, Walla Walla. Other work includes John Wayne statues, Frontier Museum, Temecula, California (comn.), also owned by Wayne Family and U. S. Repeating Arms Co. Specialty is figures and wildlife of historical West; paints in oil, sculpts in bronze. Collector of Indian artifacts, housed in own museum. Member Western Artists of America. Address since 1977, Joseph, Oregon.

MAPLES, THOMAS.
Sculptor. Born in England, c. 1803; came to US c. 1850. Worked: Philadelphia, 1850-70's.

MAPLESDEN, GWENDOLINE ELVA.
Sculptor, painter, illustrator, writer, lecturer, and teacher. Born Secunderabad, India, September 3, 1890. Pupil of Daniel Garber, Geo. Bridgman, Vincent Du Mond. Member: National Academy of Women Painters and Sculpters; Fellowship, Penna. Academy of Fine Arts; Alliance;

NYSC; Art Students League of NY; American Artists Professional League; National Arts Club, NY; American Federation of Arts. Author of *A Comparison Between Eastern and Western Ideals of Art*. Address in 1933, 523 West 121st Street; h. 435 West 119th Street, New York, NY; summer, Suffield, CT.

MARAFFI, LUIGI.
Sculptor and craftsman. Born Aversa, Italy, Dec. 4, 1891. Pupil of Grafly. Member: Graphic Sketch Club, Phila.; Fellowship, Penna. Academy of Fine Arts. Awards: Stewardson prize and two Cresson Scholarships, Penna. Academy of Fine Arts. Work: Bronze portrait of Edward T. Stotesbury, Drexel Bank, Philadelphia. Address in 1933, 1311 Christian St., Philadelphia, Penna.

MARANS, MOISSAYE (MR.).
Sculptor. Born in Chisinau, Roumania, October 11, 1902. U.S. citizen. Studied: Technical Institute, Bucharest; University Jassy, Roumania; Cooper Union Institute, New York, with Brewster; National Academy of Design, with Aitken; Penna. Academy of Fine Arts, with Grafly; Cincinnati Academy of Fine Arts; Beaux-Arts Institute of Design, NY; New York University. Member: National Academy of Design; Architectural League of New York; Audubon Artists; National Sculpture Society; American Artists Professional League. Awards: Prizes, Penna. Academy of Fine Arts, 1928; United States Post Office competition, York, PA, 1941; American Federation of Arts traveling exhibition, 1951; Football Coach of the Year Plaque Competition, 1946; 1953 Medal for Reflection, Architectural League of New York, 1953; medal, National Academy of Design, 1967. Work: Norfolk Museum of Fine Arts; Smithsonian Institution, Museum of Natural History, Wash., DC; Brooklyn Botanical Gardens; West Baden (Ind.) College; United States Post Office, Boyertown, PA; Chagrin Falls, Ohio. Exhibited: National Academy of Design; Los Angeles Museum of Art; Corcoran Gallery of Art; World's Fair, New York, 1939; Whitney Museum of American Art; Philadelphia Mus. of Art; Penna. Academy of Fine Arts; National Sculpture Society; American Federation of Arts traveling exhibition; Brooklyn Museum; Jewish Museum, NY. Media: Wood and stone. Address in 1976, 93 Court Street, Brooklyn, NY. Died in 1977.

MARCHAND, JOHN NORVAL.
Sculptor, painter, and illustrator. Born in Leavenworth, KS, 1875. Studied at the Harwood Art School, St. Paul, Minn.; at the Munich Academy, 1897-99. Worked as staff artist, *New York World*; as a book and magazine illustrator in New York City. Illustrated *Girl of the Golden West*; *Arizona: A Romance of the Great Southwest*; many other books and magazines. Executed portrait bust of Charles M. Russell, 1905. Specialty was Western subjects. Member of Society of Illustrators. Work in Earl C. Adams Collection, Anschutz Collection, Harmsen Collection. Died in Westport, CT, in 1921.

MARCHESCHI, (LOUIS) CORK.
Sculptor and teacher. Born in San Mateo, CA, April 5, 1945. Studied at the College of San Mateo, CA, 1963-66; Calif. State College, Hayward, 1966-68; Graduate School, Calif. College of Arts and Crafts, Oakland, 1969-70, MFA, 1970; also with Mel Ramos and Paul Harris. Became involved in Experiments in Art and Technology, San Francisco and Berkeley, 1968-69. Exhibited: Egor Meade Gallery, San Francisco, 1968; Museum of Art, Oakland, CA, 1970; Louis K. Meisel Gallery, NYC, 1973; Galerie M. Bochum Weitmar, West Germany, 1974; Ulrich Museum, Wichita, KS, 1975; Hanson-Cowles Gallery, Minneapolis, MN, 1977; Tubingen Museum, Germany, 1978; numerous others. Awarded Minn. State Arts Coun. Grant, 1975; and Bush Foundation Grant, 1978. Taught: Minneapolis College of Art and Design, from 1970. Author of several books and articles, including *Heat, Light, and Motion*, 1974, *Neon*, 1975. Address in 1982, Minneapolis, MN.

MARCHINO, FREDERICK.
Sculptor. At New York City, 1850.

MARGOULIES, BERTA (O'HARE).
(Berta Margoulies O'Hare). Sculptor. Born in Lovitz, Poland, September 7, 1907; US citizen. Studied at Hunter College; Art Students League; Academies Colarossi and Julien, Paris; Ecole des Beaux-Arts, Paris. Works: Willamette University, Salem, OR; Des Moines Art Institute, Iowa; College, City of New York; Washington, DC; Monticello, AR; US Post Office, Canton, NY; Whitney; Metropolitan Museum of Art; several US government commissions. Exhibitions: Whitney; Metropolitan Museum of Art; Penna. Academy of Fine Arts; Art Institute of Chicago; National Academy of Design; Corcoran, others. Awards: Avery Prize for Sculpture; New York Architectural League, 1937; American Academy of Arts and Letters, 1944; Guggenheim fellowship, 1946; Society of Four Arts, 1947; Penna. Academy of Fine Arts, 1951; Montclair Art Museum, 1952, 53. Founding member of Sculptors' Guild and Artists Equity. Address in 1982, Flanders, NJ.

MARGULIES, ISIDORE.
Sculptor and kinetic artist. Born in Vienna, Austria, April 1, 1921. Studied at Cooper Union Art School, NY, 1940-42; State University of NY, Stony Brook, B.A. (liberal arts), 1973; C. W. Post College, M.A.A., 1975; with Robert White, James Kleege, and Alfred Van Loan. Work in Brookgreen Gardens, SC. Has exhibited at National Academy of Design, NY; National Sculpture Society; Nelson Rockefeller Collection, 1980-81. Member of National Sculpture Society. Received gold medal, National Sculpture Society, 1980; Council of American Artists Award, National Sculpture Society, 1979. Address in 1982, Plainview, NY.

MARGULIES, PAULINE.
Sculptor. Born in New York, September 1, 1895. Studied with Fraser, Brewster, and Eberle. Address in 1919, Cooper Hall, 20 East Seventh Street, New York City.

MARINSKY, HARRY.
Sculptor, painter, designer, and illustrator. Born in London, England, May 8, 1909. Studied: Rhode Island School of Design; Pratt Institute Art School, Brooklyn. Member: Artists Equity Association, NY; Silvermine Guild of Art.

Awards: Prizes, Art Directors Club, 1945; Silvermine Guild Sculpture Award, 1956. Commissions: Large bronze bird for scent and touch garden, Stamford Museum, CT, 1960; bronze figures, Harlequin Plaza, Denver, CO, 1981. Exhibited: Art Institute of Chicago, 1947; Museum of Modern Art, 1943; Madison Square Garden, NY, 1946 (one-man); Rhode Island Museum of Art, 1940-42; Montross Gallery, 1941; Am-British Art Center, 1943-45; Eggleston Gallery, 1951 (one-man); Rolly-Michaux Galleries, Boston and NY; National Home Furnishing Show, 1952. Illustrated, "Mexico in Your Pocket," 1936; "Judy at the Zoo," 1945, and other books. Contributor to national magazines. Media: Bronze; watercolor. Address in 1982, Pietrasanta (Lucca) Italy.

MARIONI, TOM.
Sculptor, environmental artist, and museum director. Born in Cincinnati, OH, May 21, 1937. Moved to San Fran., CA, in 1959. Studied at Cincinnati Conservatory of Music, 1954; Cincinnati Art Academy, 1955-59. Curator, Richmond (CA) Art Center, 1968-71; founder and director, Museum of Conceptual Art, San Fran., from 1970; editor, *Visions* magazine, from 1975. In collections of Oakland Museum and Richmond Art Center, CA; Student Cultural Center, Belgrade, Yugoslavia; City of San Fran.; plus commissions. Exhibited at Columbus, GA; Richmond (CA) Art Center; Oakland (CA) Museum; Whitechapel Gallery, London; de Young, San Fran.; L.A. Institute of Contemporary Art; San Fran. Museum of Modern Art; and many galleries including those in San Fran., L.A., Bologna (Italy), Vienna (Austria), Bern (Switzerland), and Edinburgh (Scotland). Has published extensively. Awarded National Endowment for the Arts award, 1976-79; Guggenheim Grant, 1980. Address in 1982, San Fran., Calif.

MARISOL, ESCOBAR.
Sculptor. Born May 22, 1930, Paris, France. Studied: Art Students League, 1950, with Yasuo Kuniyoshi; Hofmann School, 1951-54; Academie des Beaux-Arts, Paris, 1949; New School for Social Research, 1951-54; Moore College of Art, Philadelphia,.hon. degree, 1970. Work: Arts Club of Chicago; Brandeis University; Albright; Museum of Modern Art; Whitney Museum; and others. Exhibited: Leo Castelli Inc., NYC 1957; Arts Club of Chicago, 1965; Sidney Janis Gallery, 1966, 67; Festival of Two Worlds, Spoleto, 1958; Dallas Museum of Fine Arts; Art Institute of Chicago; Carnegie; University of Illinois, 1961; American Federation of Art, Wit and Whimsey in 20th Century Art, circa, 1962-63; Whitney Museum Annuals, 1962, 64, 66; Museum of Modern Art; Tate, Painting and Sculpture of a Decade, 1954-64; The Hague, New Realism; Los Angeles County Museum of Art, American Sculpture of the Sixties, 1967; Houston Festival of Arts, 1967; and many more. Contributor to *Pop Art*; *The Art of Assemblage*; others. Address in 1982, c/o Sidney Janis Gallery, NYC.

MARK, PHYLLIS.
Sculptor. Born in NYC. Studied: Ohio State University; New School for Social Research; sculpture with Seymour Lipton. Exhibitions: Drew University, 1969; Morris Museum, NJ, 1970; The Hudson River Museum, 1971-72; Women Choose Women, New York Cultural Center, 1973; Institute Contemporary Art, Los Angeles and Boston; Brooklyn Museum; Albright-Knox; many more. Collections: Dickerson-White Museum, Cornell University; The RCA Corporate Collection; Syracuse University; Corcoran. Works with motorized or wind propelled sculpture, metal, Dacron sails. Address in 1982, 803 Greenwich St., New York City.

MARKELL, ISABELLA BANKS.
Sculptor, painter, and etcher. Born in Superior, WI, December 17, 1891. Studied: Fontainebleau, FR, 1930; Maryland Inst.; Penna. Academy of Fine Arts; Ecole des Beaux-Arts, Paris, France; also with Farnsworth. Member: Society of American Graphic Artists, NY; Pen and Brush Club; Miami Art Association; others. Awards: Prize, Southern States Art League, 1945; prizes, National Association of Women Artists, 1956, 58-60, 64; three gold medals, American Artists Professional League, 1960, prize, 1964; many others. Work: New York Historical Society; Museum City of New York; Northwest Printmakers; Metropolitan Museum of Art; many others. Exhibited: Newark Museum; Northwest Printmakers; Phila. Print Club; Baltimore Museum of Art; Birmingham Art Museum; High Museum of Art; Allied Artists of America; New York Historical Society; American Watercolor Society of New York; Society of American Graphic Artists, NY; Museum, City of New York; De-Motte Gallery; Argent Gallery; Library of Congress; Calif. Palace of the Legion of Honor; Laguna Beach Art Association; New Haven Paint and Clay Club; Ringling Museum of Art; Irvington Art Museum; Toronto Art Gallery; Miami Beach, FL; New Jersey Painters and Sculptors Society. Address in 1982, 10 Gracie Square, NYC.

MARKS, GEORGE.
Sculptor and painter. Born in Conrad, Iowa, in 1923. Studied at University of Iowa, BFA, 1950. Worked as a commercial artist. Specialty is the West of today. Member of Cowboy Artists of America since 1966. Has exhibited at Cowboy Artists of America shows; Peking, China, show, 1981. Awarded silver medals, Cowboy Artists of America. Bibliography includes *The Cowboy in Art*, Ainsworth; *Bronzes of the American West*, Broder; *Western Painting Today*, Hassrick. Represented by Galeria del Sol, Albuquerque, NM. Address since 1965, Albuquerque, New Mexico.

MARKS, ISSAC.
Sculptor. Born in Lithuania, July 17, 1859. Self-taught. Address in 1933, 202 East 154th St., Harvey, Ill.

MARLOW, HENRY.
Sculptor. Born in Liverpool, England, 1838. Died in New Rochelle, NY, December 28, 1911. (Mallett's)

MAROZZI, ELI RAPHAEL.
Sculptor and instructor. Born in Montegallo, Italy, August 13, 1913; US citizen. Studied at University of Washington, B.A.; University of Hawaii, M.A.; also with Mark Tobey. Work in St. Andrew's Cathedral, Honolulu; stone

figure portrait, Vedanta Society of Sacramento, CA; stone Madonna and Child, St. Philomena Church, Honolulu; others. Has exhibited at Seattle Art Museum Annual; Hawaii Painters' and Sculptors' League, Honolulu; others. Taught art at Honolulu Academy of Arts, 1950-55. Works in marble and synthetic stone. Address in 1982, Honolulu, HI.

MARRON, EUGENIE MARIE.
Sculptor, painter, and teacher. Born in Jersey City, NJ, November 22, 1901. Studied: Columbia University, B. of Science, M.A.; and with Alexander Archipenko, Rudolph Belling, Fernand Leger. Member: National Association of Women Artists, New York. Awards: prizes, American Artists Professional League, 1944; Montclair Art Museum, 1944; Montclair Art Association, 1944. Exhibited: one-man exhibition; Montross Gallery; Charles Morgan Gallery; Lilienfeld Gallery; Montclair Art Museum. Address in 1953, 152 West 57th Street, New York, NY.

MARSHALL, MacLEAN.
Sculptor. Born in New York City, May 2, 1912. Studied: Art Students League; University Virginia; Child-Walker School of Design; Yale University School of Fine Arts, and with George Bridgman, Kimon Nicolaides, George Demetrios. Awards: prize, National Arts Club, New York, 1935; Telfair Academy, 1941. Member: Association of Georgia Artists; National Arts Club, New York; North Shore Art Association. Work: Telfair Academy of Art. Exhibited: National Arts Club, New York; Penna. Academy of Fine Arts; Telfair Academy of Art; Savannah Museum of Art; Grand Central Art Gallery. Address in 1953, Rome, GA.

MARSHALL, RACHEL.
See Mrs. Arthur L. Hawks.

MARSHALL, W. M.
Sculptor. Active 1868. Patentee—medallion of General Grant, 1868.

MARTIGNY, PHILIPPE.
Sculptor. Born in Alsace, France, 1859. Spent his boyhood in France working in various studios. Came to America in the early eighties, and became a pupil of St. Gaudens. Executed many groups for World's Fair, Chicago; several pieces for Congressional Library, Washington, etc. Address in 1898, 50 Washington Sq., E., NYC.

MARTIN, KNOX.
Sculptor and painter. Born in Barranquilla, Colombia, February 12, 1923. Brought to US when a child; became a US citizen. Studied at the Art Students League, after World War II, for four years. Exhibited: Santa Barbara Museum of Art, CA, in 1964; Yale University Art Gallery, 1966; Whitney Museum of American Art, 1972; National Gallery, Yugoslavia, 1981; Ingber Gallery, NYC, 1981; and others. Awards: Creative Artists Public Service, 1978; Balloonist Award, Mat Wiedekehr, St. Paul, MN, 1972; National Endowment for the Arts, 1972. Commissions of his work include a nineteen story wall painting, for City Walls, Inc., NY; wall painting, Mercor, Inc., at the Merritt Complex in Ft. Lauderdale, FL, 1972; wall painting, Houston and Mac Dougal Streets, NYC, 1979; and

another wall painting for Nieman Marcus, White Plains, NY, 1980. Represented in Museum of Modern Art, NY; Whitney; Corcoran; others. Address in 1982, 128 Ft. Washington Avenue, NYC.

MARTIN, MARVIN B.
Sculptor and etcher. Born in Fort Worth, TX, July 28, 1907. Studied: Kansas City Art Institute. Member: American Artist Prof. League; Denver Art Guild. Awards: prizes, Missouri State Fair, 1927, 32. Work: Fairmount Cemetery, Guldman Memorial, National Home for Jewish Children, CO. Historical Society, Kirkland School of Art, Rosehill Cemetery, Police Building, all of Denver, CO; High School, Art Museum, Boulder, CO; U.S. Dept. Interior monument, Ignacio, CO; Univ. of Colorado; Kent School for Girls, Denver, CO. Exhibited: Missouri State Fair, 1927, 33; Kansas City Art Institute, 1933, 35, 38, 39; Denver Art Museum, 1933, 35, 36, 1938-41, one-man exh., 1935, 44; Cincinnati Museum Assoc., 1935; Univ. of Colo., 1937 (one-man); Architectural League, 1938; World's Fair, NY, 1939; Univ. of Illinois Faculty Exh., 1945, 46, traveling exh., 1945. Taught: Instructor of Sculpture, Denver Univ., 1935-38; Univ. of IL., Urbana, IL., from 1944. Address in 1953, Champaign, IL.

MARTINELLI, EZIO.
Sculptor and painter. Born November 27, 1913, West Hoboken, NJ. Studied: Academy of Fine Arts, Bologne, Italy, 1931; National Academy of Design, 1932-36; Barnes Foundation, Merion, PA, 1940; with Leon Kroll, Gifford Beal, Robert Aitken (sculpture), Ivan Olinsky. Work: Brooklyn Museum; Art Institute of Chicago; University of Illinois; Memphis (Brooks); Newark Museum; Phila. Museum of Art; Guggenheim; Seattle Art Museum; United Nations; Whitney Museum; University of Wisconsin; 30-ft. sculpture, Gen. Assembly Building, UN (commission). Exhibited: The Willard Gallery, NYC, 1946, 47, 52, 55, 64, 66; Art Institute of Chicago; Penna. Academy of Fine Arts; Brooklyn Museum; Whitney Museum Annuals, 1948, 61, 62, 66; Walker, 1956; American Federation of Art, Major Work in Minor Scale; Va. Museum of Fine Arts; Carnegie; National Inst. of Arts and Letters; Claude Bernard, Paris, Aspects of American Sculpture, 1960; Newark Museum, Survey of American Sculpture; Gallery of Modern Art, NYC; De Cordova. Awards: L. C. Tiffany Grant, 1936, 64; Guggenheim Foundation Fellowship, 1956-62; National Academy of Design, President's Award; Ford Foundation, 1963; National Institute of Arts and Letters Award, 1966. Appointed to the Jury of Selection, John Simon Guggenheim Memorial Foundation, 1963. Taught: Pennsylvania School of Industrial Art, Philadelphia, 1946-49; Philadelphia Museum School, 1946-49; Sarah Lawrence College, 1947-75; Parsons School of Design; American Academy, Rome, Artist-in-Residence, 1964-65 (appointed Trustee, 1966); Skowhegan School of Painting and Sculpture, summer, 1969. Address in 1980, Saugerties, NY.

MARTINEZ, JUAN H.
Sculptor. Born in Albuquerque, New Mexico, in 1927. Self-taught in art, enrolled briefly at Los Angeles Art Center. Built own foundry and did own casting. Specialty

is Western subjects; works in bronze. Member of American Indian and Cowboy Artists. Exhibits at Overland Trail, Scottsdale, AZ; Son Silver West, Sedona, AZ. Address in 1982, Pico Rivera, California.

MARTINI, STANISLAO.
Sculptor. Born in 1837. Died in Boston, MA, 1915. (Mallett's)

MARTINO, EVA E.
Sculptor and painter. Born in Philadelphia, Penna. Studied at Gwynedd Mercy College; Montgomery Co. Community College; also with Giovanni Martino. Member of Artists Equity Association; National Forum of Professional Artists. Exhibitions: Reading Museum, Penna., 1962; National Academy of Design, NY, 1965; Penna. Academy of Fine Arts, Philadelphia, 1966; Edinboro Teacher's College, Penna., 1967; Butler Institute of American Art, Youngstown, Ohio, 1970; Audubon Artists, 1978. Awards: Bronze Medal, Da Vinci Alliance, 1953; First Prize, Plymouth Meeting Hall, 1967; Third Prize, Philadelphia Sketch Club, 1972; Second Prize, Greater Norristown Art League, 1976. Media: Oil and Wood. Address in 1982, Blue Bell, PA.

MARTINO, MICHEL.
Sculptor. Born Alvignano, Casserta, Italy, February 22, 1889. Pupil of Lee Lawrie and H. Kitson. Award: English Fellowship prize of Yale University for study abroad. Work: "Landing of Pilgrims," "Battle of Lexington," Strong School, New Haven; White Plains High School Memorial Tablet; commemorative medal, American Public Health Society; Memorial Flagstaff, Brooklyn, NY; Spanish War memorial, New Haven; pediment for St. Anne Church, Hartford, CT. Address in 1929, 211 Clay Street, New Haven, CT; h. 14 Myron Street, Norris Cove, CT.

MARTINSEN, MONA.
Sculptor. Born in New York. Address in 1908, 15 Rue Bourgois, Paris, France.

MARTINY, PHILIP.
Sculptor. Born in Alsace, France, May 10, 1858, and came to America about 1876. He was a pupil of Augustus Saint-Gaudens and of Francois and Eugene Dock in France. Member: Associate Member of the National Academy of Design, 1902; Society of American Artists, 1891; New York Architectural League. He is represented by the World War Monument in Greenwich Village; McKinley Monument, Springfield, MA; statue of past Vice-President Garret A. Hobart, Paterson, NJ; sculpture on the Agricultural and Fine Arts Buildings at the World's Fair, Chicago; Soldiers' and Sailors' Monument, City Hall, Jersey City, NJ; in NYC by sculpture in the Hall of Records, doors for St. Bartholomew's Church, and two groups in the Chamber of Commerce. Address in 1926, Warburton Avenue, Bayside, L.I., NY. Died in NYC, June 26, 1927.

MARTZ, NEAL.
Sculptor. Award: Therese and Edwin H. Richard Memorial Prize, 1979, National Sculpture Society.

MARYAN, HAZEL SINAIKO.
Sculptor, painter, and teacher. Born in Madison, Wis., May 15, 1905. Studied: University of Wisconsin, B.S.; Art Institute of Chicago; and with E. Chassaing, A. Polasek, A. Archipenko, E. Simone. Member: Chicago Art Club; Artists Equity Association, New York. Exhibited: Art Institute of Chicago, 1930-32, 1937-41; Wis. Salon, 1932-65; Chicago No-Jury Exh., 1933, 34; Artists Equity Association, 1952, 65; Waterloo, Iowa Annual, 1965; others. Address in 1970, Madison, WI.

MARZOLLO, CLAUDIO.
Sculptor. Born in Milan, Italy, July 13, 1938; US citizen. Studied at Columbia College, B.A. Work in Windsor Art Gallery, Ontario; Museum of Science and Industry, Chicago; Ft. Wayne Museum of Art, IN; others. Has exhibited at Everson Museum, Syracuse, NY; Toledo Museum of Art; National Academy of Science, Washington, DC; Whitney Museum of American Art, NY; Akron Art Institute, OH; others. Works in plexiglas and aluminum with various light sources, filters, and motors. Address in 1982, Cold Spring, NY.

MASON, C. D.
Sculptor. Born in France in 1830, and came to the US when thirty years old. First work was on the old Vanderbilt mansion; he did some carvings on the Soldiers' and Sailors' Monument and the Angels of Art at the entrance to Greenwood Cemetery. He also worked on the Garden City Cathedral and in the Philadelphia and Chicago Expositions. Died in Mineola, LI, NY, July, 1915.

MASON, DORIS BELLE.
Sculptor. Born in Green River, Wyoming, in 1896. Studied at University of Idaho; University of Iowa; University of Southern California. Works: Spokane Art Association; Mt. Home Idaho Congregational Church. Awards: Iowa State Fair, 1937, 1938.

MASON, FRED.
Sculptor. Born in El Monte, CA, 1938. Studied: Immaculate Heart College, Los Angeles, 1955-58. Group exhibitions: Directions in Collage: California, Pasadena Art Museum, CA, 1962; The Contained Object, Los Angeles County Museum of Art, 1966; Assemblage in California, Art Gallery, University of California, Irvine, 1968; Collage and Assemblage in Southern California, The Los Angeles Institute of Contemporary Art, 1975; The Modern Era, San Francisco Museum of Modern Art, 1976, and National Collection of Fine Arts, Smithsonian, 1977. Address in 1977, Venice, CA.

MASON, JOHN.
Sculptor. Born in Madrid, NE, March 30, 1927; raised in Nevada. Studied art at the Otis Art Institute, Los Angeles, CA, 1949-52; and the Chouinard Art Institute, Los Angeles, CA, 1953-54. Associated with sculptors Peter Voulkos and Kenneth Price during 1950's. Exhibitions: Several one-man including Pasadena Art Museum, CA, 1960 and 74; Whitney Museum of Modern Art, 1964, 73, and 76; Retrospective, Los Angeles Co. Museum of Art, 1966; National Museum of Modern Art, Kyoto, Japan, 1971; the now defunct Ferus Gallery, Los Angeles, CA,

since 1961. Awards: Ford Foundation Award, 67th American Exhibit, Art Institute of Chicago, 1964; University of Calif. Award; Creative Arts Institute, 1969-70. Commissions include the ceramic relief at Palm Springs Spa, Calif.; another ceramic relief for the Tishman Building in Los Angeles, CA, 1961; and ceramic doors for Sterling Holloway in South Laguna, CA. Noted for his monumental wall reliefs and free standing unglazed sculpture. Taught: Pomona College, Claremont, CA; University of Calif., Irvine, 1967-73; Hunter College, NY, from 1974. Address in 1982, 1521 South Central Ave., Los Angeles, CA.

MASON, MARY STODDERT.
Sculptor. Born in Jackson, TN. Principal works, "Pilgrim Mother," "The Spirit of the New Era," and "Woman Triumphant." Address in 1926, Elmsford, Westchester County, NY. Died in 1934.

MASSABO, JUSTIN.
Sculptor. Born in France in 1829. Listed as being in New York City in September of 1850.

MASSEE, CLARISSA DAVENPORT.
Sculptor and teacher. Pupil of Injalbert and Bourdelle in Paris. Address in 1909, Paris, France; Williston, North Dakota.

MASSON, RAYMOND.
Sculptor. Address in 1898, 27 Tremont Row, Boston, Mass.

MASTERSON, JAMES W.
Sculptor, painter, illustrator, and writer. Born in Hoard, Wisconsin, 1894. Studied at the Chicago Academy of Fine Art; Art Institute of Chicago; San Jose Art School (Calif.). Work in Montana schools, banks, library; author and illustrator, *It Happened in Montana*. Instructor at Custer County Junior College. Received a fellowship in 1962. Specialty is Montana subjects. Died in 1970 in Miles City, Montana.

MATHEDI, ANGELO.
Sculptor. Born in Tuscany in 1836. In Philadelphia in 1860. Resided with and was presumably employed by Lorenzo Hardie. Medium: plaster.

MATHEWS, SAMUEL.
Sculptor and scagliola artist. Worked: New York City, 1846-51.

MATHIE, GOLDIE (RALSTON).
Sculptor and painter. Born in Massillon, Ohio, August 18, 1884. Studied: with Miriam Cramer, Bernice Langton, Sister Matilda. Member: Akron Woman's Art League; Barberton Group A.; Barberton Women's Club; Composers and Authors Association of America. Awards: prizes, Canton, Ohio, 1943, 47. Exhibited: National Academy of Design, 1948; Miniature Painters, Sculptors and Gravers, Washington DC; Riverside Museum, NY; Newport Art Association; also in Canton, Massillon, Akron, Barberton, Ohio. One-man; Ashland, KY. Address in 1953, West Barberton, Ohio.

MATHIESEN, PAT.
Sculptor. Born in Hollywood, California. Studied art in San Francisco. Has sculpted Alaskan wildlife; produced bronze series of Apache, Hopi, Mandan, Navajo Indian figures; since 1978 has been sculpting Crow Indian and horse figures. Works in polychromed bronze. Reviewed in *Southwest Art*, March 1981. Work shown at O'Brien's Art Emporium, Scottsdale, Arizona, since 1966. Represented by The May Gallery, Scottsdale, AZ, and Jackson Hole, WY; In the Spirit Gallery, Kansas City, KS. Address since 1978, West Yellowstone, MT.

MATTA, D.
Sculptor. Awards: Chautauqua, New York; Hollywood Circle Exhibitions, Florida. Exhibitions: Hemingway Gallery, New York City; Sheldon Swope Museum, Indiana, 1967; Keuka College, New York. Collections: Bell Telephone Company, Chicago; Edinboro State College, Pennsylvania; Fontbonne College, New Orleans.

MATTEI, MATTIS.
Sculptor. At Buffalo, New York, 1855.

MATTESON, IRA.
Sculptor and draftsman. Born in Hamden, CT, June 26, 1917. Studied at Art Students League, with Arthur Lee, 1937-42, also with William Zorach, 1946-51; National Academy, with John Flanagan, 1946-47. Work in Akron Art Institute, OH; Cleveland Museum of Art; Chrysler Museum, Provincetown, MA; others. Received Prix de Rome, American Academy of Rome, 1953-55, Louis Comfort Tiffany, 1956 and 60; others. Teaching at School of Art, Kent State University, Kent, from 1968. Works in wood and metal. Address in 1982, Kent, OH.

MATTHEWS, ANNA LOU.
Sculptor, painter, teacher, and illustrator. Born Chicago, IL. Pupil of Taft and Vanderpoel at Art Institute of Chicago; Chicago Art Academy; Ecole des Beaux-Arts and under Simon, Max Bohm, and Garrido in Paris; Brangwyn in London. Member: Association of Chicago Painters and Sculptors. Awards: Honorable mention, 1913; second sculpture prize, MN State Art Comm., 1914; Rosenwald prize, Art Institute of Chicago, 1921; Harry A. Frank prize, Art Institute of Chicago, 1929; Municipal Art League, Chicago, 1932. Represented in St. Paul Institute of Art; Juvenile Court Room; murals, Walter Scott School, Rosenwald Collection, and City of Chicago Collection, Chicago, IL. Address in 1933, Green Bay, WI; summer, Big Suamico, WI.

MATTHEWS, ELIZABETH ST. JOHN (MRS.).
Sculptor. Born in Philadelphia, January 25, 1876. She studied with J. Liberty Tadd in Philadelphia, with Leon Girardet in Paris and with Olin L. Warner in New York. She sculpted a bust of President Taft. Died in New York, April 27, 1911.

MATTHEWS, HARRIETT.
Sculptor. Born in Kansas City, MO, June 21, 1940. Studied at Sullins Jr. College, Briston, VA, AFA; University GA, BFA and MFA; with Leonard DeLonga. Works: University GA Art Museum; Colby College Art Museum. Commission: Designed awards for the Maine Arts and Humanities Comn., 1969. Exhibitions: University Okla. Art Museum, 1965; Colby College Art Museum, 1975;

one-woman shows, Vanderbilt University Museum, 1974 and College Atlantic, 1975; New England Women, DeCordova Museum, Lincoln, Mass., 1975; 76 Maine Artists, Maine State Museum, 1976; others. Taught: University of Oklahoma, 1964-65; Colby College, 1966-75; associate professor, from 1975. Media: Welded steel. Address in 1982, Clinton, ME.

MATTHEWS, LESTER NATHAN.
Sculptor, painter, craftsman, and designer. Born in Pittsburgh, PA, August 8, 1911. Studied: Calif. College of Arts and Crafts; with Sargent Johnson, M. Beckford Young, Worth Ryder. Member: San Francisco Art Association. Awards: prize, San Francisco Art Association, 1939; American Academy in Rome, 1942. Work: Stockton (Calif.) Jr. College; Peter Burnett High School, San Jose, Calif.; Salinas (Calif.) Jr. College; Ft. Ord, Calif. Exhibited: Art Institute of Chicago; Oakland Art Gallery; San Francisco Museum of Art; Golden Gate Exposition, San Francisco, 1939; Sacramento Art Center; Los Angeles Museum of Art, 1946-48. Address in 1953, 1220 Third Ave., Los Angeles, CA.

MATUSZAK, JOHN.
Sculptor. Born in Grand Rapids, MI, 1953. Exhibited at The Detroit Institute of Arts, Michigan Focus, 1974. Address in 1975, Grand Rapids, MI.

MATZEN, HERMAN N.
Sculptor and teacher. Born in Denmark, July 15, 1861. Pupil of Munich and Berlin Academies of Fine Arts. Member: National Sculpture Society; National Arts Club, NY; Cleveland Society of Artists. Awards: Second medal, Berlin, 1895; first medal, Berlin Exp., 1896. Work: "War" and "Peace," Indianapolis Soldiers and Sailors Monument; "Schiller Monument," Detroit; "Law" and "Justice," Akron (OH) County Court House; "Wagner Monument," Cleveland; Burke Mausoleum; "Moses" and "Gregory," Cleveland Court House; "Cain and Abel," Lake County Court House; Tom L. Johnson monument, Cleveland Public Square; Holden Mausoleum and L. E. Holden Memorial, Plain Dealer Building; Thomas White Memorial, Cleveland; Holden Memorial Tablet, Harvard University, Cambridge; Haserot Monument, Cleveland; Hatch Memorial, Western Reserve University, Cleveland. Address in 1933, 5005 Euclid Avenue; h. 2423 Woodmere Drive, Cleveland, OH. Died in 1938.

MATZKIN, MEYER.
Sculptor. Born in Russia, November 25, 1880. Address in 1921, 110 Tremont Street, Boston, Mass; 29 Homestead Street, Roxbury, Mass.

MAUCH, MAX.
Sculptor. Born Vienna, Austria, February 6, 1864. In New York City, from 1891 and in Chicago, from 1893. Worked with Bitter and Bell. He exhibited at the National Sculpture Society, New York. He died in Chicago, February 13, 1905.

MAUNSBACH, GEORGE ERIC.
Sculptor and painter. Born in Helsingborg, Sweden, January 5, 1890. Studied: Stockholm Academy with Anders Zorn; Royal Academy, with Sargent; Boston Museum of Fine Arts School, with Pape. Member: American Artists Professional League; Scandinavian-American Art. Work: port., Columbia University; Maywood College, Scranton, PA; World War Collection, Washington DC; American Society of Composers, Authors and Publishers, NY; Lincoln and Benjamin Franklin Hotels, NY; Court House, Easton, PA; Ft. Dix, NJ; Symphony Hall, Detroit; Library of Congress; Cavalry Armory, Brooklyn, NY; Ft. Jay; Ft. Slocum; Camp Upton; Lawrence University; Supreme Court, Schenectady and Louisville, NY; etc. Exhibited: Brooklyn Museum; Art Institute of Chicago; National Academy of Design; Penna. Academy of Fine Arts; Paris Salon; Newport Art Association; etc. Lectures: "The Art of Portrait Painting." Address in 1953, 939 Eighth Avenue; h. 58 West 57th Street, New York, NY. Died in 1969.

MAURY, MATTHEW FONTAINE.
Sculptor. Active, 1931. (Mallett's)

MAVROUDIS, DEMETRIOS.
Sculptor and educator. Born in Thasos, Greece, November 18, 1937. Studied at Jersey City State College, B.A.; Teachers College, Columbia University, M.A. and Ed.D. Has exhibited at Albright-Knox Art Gallery, Buffalo, NY; UN; Delaware Art Museum, Wilmington; Storm King Art Center, Mountainville, NY; Philadelphia Art Alliance; Alaska State Museum. Member of American Foundrymen's Society; National Art Education Association. Taught in NYC and, currently, University of Richmond, VA, from 1974. Works in cast metal and wood. Address in 1982, Richmond, VA.

MAXWELL, CORALEE DeLONG.
Sculptor. Born in Ohio, September 13, 1878. Pupil of Herman Matzen. Member: National Sculpture Society; Cleveland Woman's Art Club; Cleveland Art Center; American Federation of Arts. Work: Fountain, Newark, OH. Award: Honorable mention, Cleveland Museum of Art, 1926; first prize, Bernards Gallery, NY, 1928. Address in 1933, Cleveland, OH. Died in 1937.

MAY, BEULAH.
Sculptor. Born Hiawatha, KS, June 26, 1883. Pupil of Lorado Taft, William Chase, Charles Grafly. Member: Calif. Art Club; West Coast Arts, Inc.; California Sculptors Guild. Address in 1933, Santa Ana, CA.

MAYCALL, JOHN.
Sculptor. Born in Massachusetts, c. 1842. At Boston, 1860.

MAYER, CASPER.
Sculptor. Born in Bavaria, December 24, 1871. Pupil of J. Q. A. Ward, schools of Cooper Union, National Academy of Design in New York. Award: Silver medal, St. Louis Exp., 1904. Maker of anthropological groups for American Museum of Natural History and State Museum, Albany. Member: National Sculpture Society. Address in 1929, American Museum of Natural History, New York, NY; h. 24 Carver Street, Astoria, L.I., NY. Died in NY, 1931.

MAYER, EDWARD ALBERT.
Sculptor and educator. Born in Union, NJ, October 30, 1942. Studied at Brown University, Providence, Rhode Island, B.A., 1964; University of Wisconsin, Madison, M.F.A., 1966. Work in Milwaukee Art Center, WI; Rose Art Museum, Waltham, MA. Has exhibited at Kunsthalle Darmstadt, West Germany; Rose Art Museum, Waltham, MA; architectural sculpture, Los Angeles Institute of Contemporary Art, CA; Dayton Art Institute, OH. Received Regional Fellowship, National Endowment for the Arts, 1978; Fellowship, Ohio Arts Council, 1978, 79, and 81; National Fellowship, National Endowment for the Arts, 1979. Address in 1982, Athens, OH.

MAYER, HARRIET HYATT (MRS.).
Sculptor and teacher. Born in Salem, MA, April 25, 1868. Pupil of Cowles Art School; Henry Kitson and Dennis Bunker in Boston. Silver medal, Atlanta Exp., 1895. Address in 1910, Annisquam, MA; winter, Princeton, NJ.

MAYER, LOUIS.
Sculptor and painter. Born Milwaukee, WI, Nov. 26, 1869. Pupil of Max Thedy in Weimar; Paul Hoecker in Munich; Constant and Laurens in Paris. Member: Salma. Club; Wisconsin Painters and Sculptors. Awards: Bronze medal for sculpture, St. Paul Art Institute, 1915; silver medal, P.-P. Exp., San Fran., 1915; hon. mention, sculpture, Art Institute of Chicago, 1919; special mention, Milwaukee Art Institute, 1922. Work: State historical collections at Des Moines, IA, and Madison, WI; Public Library, Burlington, IA; Springer Collection, National Museum, Washington, DC; Milwaukee Art Institute; busts of Lincoln, Emerson and Whitman, Community Church, Theodore Roosevelt, Roosevelt House, Eugene V. Debs, Rand School of Social Science, New York City; bust of George F. Greer, and relief tablet to American Labor, National McKinley Birthplace Memorial, Niles, OH. Exhibited at National Sculpture Society, 1923; National Academy of Design; Penna. Academy of Fine Arts; Copley Society, Boston; Art Institute of Chicago; Milwaukee Art Institute. Address in 1953, Hopewell Junction, NY.

MAYNARD, RICHARD FIELD.
Sculptor, painter, and writer. Born in Chicago, IL, April 23, 1875. Studied: Cornell University; Harvard University; Art Students League; New York School of Art; and with William Chase, Irving Wiles, Joseph De Camp, and Robert Blum. Member: New York Society of Painters; Allied Artists of America; Art Society, Old Greenwich; Authors League of America; American Watercolor Society of New York. Exhibited: New York Watercolor Club; National Academy of Design; American Watercolor Society; National Arts Club, NY; Phila. Watercolor Club; Corcoran Gallery of Art; Art Institute of Chicago. Contributor: short stories to national magazines. Address in 1953, Old Greenwich, Conn.

MAYNARD, VALERIE.
Sculptor, muralist, and lecturer. Born in NYC, August 22, 1937. Studied at Goddard College. Work: Johnson Pub., Chicago; Riksutstallningar, Stockholm, Sweden; Arnot Museum, Elmira, NY; National Lawyers Guild, NY; IBM Corp., White Plains, NY. Commissions: Ceramic mural (with Bennington Potters, Vt. and Architectural Renewal Com. Harlem, Inc., NY), comn by J. P. Resnick & Son, 1975; monument for Harlem Park Plaza, A. Phillip Randolph Park, NY, 1975. Exhibitions: Millenium, Phila. Museum of Art, 1973; Herbert F. Johnson Museum, Cornell University, 1974; Riksutstallningar, Stockholm, 1975; Sojourn Gallery 1199, NY, 1975; Arnot Museum, 1975. Awards: CAPS Grants, New York Council Arts, 1972 and 74. Media: Sculpture; graphics. Address in 1980, 463 West Street, NYC.

MAYOR, HARRIET R. HYATT (MRS.).
(Mrs. Mayor). Sculptor, painter, and teacher. Born Salem, MA, April 25, 1868. Pupil of Henry H. Kitson and Dennis Bunker at Cowles Art School in Boston. Member: American Federation of Arts; Boston Art Club. Award: Silver medal, Atlanta Exp., 1895. Work: Memorial tablet, Princeton University; tablet, Carnegie Institute, Washington, DC; tablet to Alpheus Hyatt, Woods Hole, MA; historical tablet, Gloucester, MA; bust of Rear Admiral Goldsboro, Annapolis; statue, Mariner's Park, Newport News, VA. Exhibited at National Sculpture Society, 1923. Address in 1933, Annisquam, MA; winter, Princeton, NJ.

MAYORGA, GABRIEL HUMBERTO.
Sculptor and painter. Born in Colombia, S. Am., March 24, 1911; US citizen. Studied: National Academy of Design, painting with Leon Kroll, Ivan Olinsky, etching with Aerobach-Levi, sculpture with Robert Aitkin; Art Students League, with Brackman; Grand Central Art School, NYC, with Harvey Dunn. Work: West Point Museum; Institute Ingenieros, Bogota, Colombia; Art Gallery of Barbizon Plaza, NYC, 1955; plus many painting and portrait commissions from 1955. Exhibitions: Institute Ingenieros, Bogota, Colombia; Art Gallery of Barbizon Plaza, NYC; Mayorga Art Gallery; International Expos, Paris; International Art Show, NYC. Art Positions: Instructor, Pan-American Art School, NYC; Art Director, Mannequins by Mayorga Inc., NYC; others. Media: Oil, watercolor; epoxy plastic, polyester plastic. Address in 1982, 331 W. 11 Street, New York, NY.

MAYS, PAUL KIRTLAND.
Sculptor and painter. Born in Cheswick, PA, October 4, 1887. Studied: Carnegie Institute; Art Students League; Grande Chaumiere, Paris; pupil of Hawthorne, Johansen, Chase, Tack, Fraser; Massey in London; Ertz at the Academie Delecluse. Specialty, decorative screens and mural panels. Work: murals, The White House, Wash., DC; US Post Office, Norristown, PA. Exhibited: Corcoran Gallery; Whitney; Grand Central Art Gallery; Penna. Academy of Fine Arts; Philadelphia Museum of Art; Dutchess County, NY; Carmel Art Association; others. Member: National Society of Mural Painters; Carmel Art Association. Address in 1953, Carmel, Calif. Died in 1961.

MAZUR, WLADYSLAW.
Sculptor. Born in Poland, 1871. Pupil of Academy of Fine Arts at Vienna. Address in 1935, Cincinnati, OH. (Mallett's)

MAZZONE, DOMENICO

Sculptor and painter. Born in Rutigliano, Italy, May 16, 1927. Work: Museum of Foggia, Italy; monument in Rutigliano, Italy; monument in Barletta, Italy; bronze plaque in S. Fara Temple, Bari, Italy; UN Building, NYC. Exhibited: National Exhibition of Marble, Carrara, Italy; National Exhibition, San Remo, Italy; Gubbio, Italy; Silvermine, CT; Italian Club Exhibition, UN Building, NYC, 1967. Awards: Silver Medal, Carrara Exhibition; Gold Medal, Exhibition International Viareggio; Bronze Medal of Copernicus, 1972. Address in 1983, Jersey City, NJ.

Mc LEARY.

Sculptor. Exhibited: National Association of Women Painters and Sculptors, 1924.

McCAHILL, AGNES McGUIRE.

(Mrs. Daniel Wm. McCahill). Sculptor and painter. Born in New York. Pupil of Herbert Adams and Augustus Saint-Gaudens. Member Art Students League of New York; New York Woman's Art Club. Address in 1910, 145 West 55th St.; h. 120 East 82nd St., NYC.

McCANN, LEONARD.

Sculptor and painter. Born in Burley, Idaho, in 1939. Studied at Rocky Mountain School of Art, commercial art degree, 1969. Assistant Dir. of the School, briefly; worked for sculptor Ken Bunn, learning modeling and foundry processes; Assistant Curator, Sculpture, Denver Museum of Natural History. Turned to sculpture full-time in 1975. Specialty is statuettes of historical Western cavalry and Indians. Member of Northwest Rendezvous Group. Reviewed in *Art West*, May 1981. Represented by Artists' Union Gallery, Bozeman, MT; Gallery Select, Seattle WA. Address since 1952, Aurora (near Denver), Colorado.

McCANN, MINNA (MRS.).

Sculptor. Address in 1924, 510 St. Peter, Jackson Square, New Orleans, LA.

McCARTAN, EDWARD.

Sculptor. Born Albany, NY, August 16, 1879. Pupil of Art Students League of New York; Ecole des Beaux-Arts in Paris; Pratt Institute, and with Herbert Adams, George Gray Barnard, Hermon MacNeil. Member: Associate of the National Academy of Design; National Academy of Design, 1925; National Sculpture Society, 1912; New York Architectural League; Beaux-Arts Institute Design; American Federation of Arts; National Institute Arts and Letters; Concord Art Association (Pres.); American Academy of Arts and Letters; American Institute of Architects. Exhibited at National Sculpture Society, 1923. Awards: Barnett prize for sculpture, National Academy of Design, 1912; Widener gold medal, Penna. Academy of Fine Arts, 1916, prize, 1931; medal of honor for sculpture, NY Architectural League, 1923; gold medal of honor, Concord Art Association; Pratt Prize, Grand Central Gallery, 1931; gold medal of honor, Allied Artists of America, 1933. Work: Fogg Museum of Art; Brookgreen Gardens, SC; Fine Arts Academy, Buffalo; Metropolitan Museum, New York; City Art Museum, St. Louis; Albright Gallery,

Buffalo. Address in 1953, 225 East 67th Street, NYC.

McCARTY, LEA FRANKLIN.

Sculptor, painter, and author. Born probably California, 1905. Studied at the Chouinard Art School in Los Angeles; privately in California. Work includes sculpture, Jack London Square (Oakland); busts, Wyatt Earp plaque (Tombstone); portrait series, "Gunslingers of the Old West." Specialty in painting was gunmen and portraits; in sculpture executed statues and busts of Western subjects, in bronze. Address in 1958, Santa Rosa, Calif.

McCAUSLIN, WILLIAM C.

Sculptor and painter. Born in Steubenville, OH, 1860. Died in Washington, DC, 1929. (Mallett's)

McCHESNEY, CLARA T.

Sculptor and painter. Born in Bronsville, CA. Active, 1907. (Mallett's)

McCLURE, CAROLINE SUMNER.

(Mrs. G. G. McClure). Sculptor and writer. Born St. Louis, MO. Pupil of Lorado Taft, Hermon MacNeil. Member: National Arts Club. Work: Figure of Victory for dome of the Missouri Building, St. Louis Exposition, 1904. Address in 1933, 640 Riverside Drive, New York, NY.

McCLURE, MAUD QUINBY.

Sculptor. Born in Mt. Morris, IL, October 4, 1884. Pupil of Art Institute of Chicago and Lorado Taft in Chicago. Member: Alumni, Art Institute of Chicago; Chicago Art Club. Address in 1925, Eagle's Nest Camp, Oregon, IL.

McCLURE, THOMAS F.

Sculptor and educator. Born in Pawnee City, NE, April 17, 1920. Studied at University of Nebraska, B.F.A., 1941; Washington State College, 1941; Cranbrook Academy of Art, M.F.A., 1947. Work in Seattle Art Museum; Syracuse Museum of Fine Arts, NY; Detroit Institute of Arts; others. Has exhibited at Penna. Academy of Fine Arts Annual; Contemporary Sculpture 1961, Cincinnati Art Museum and John Herron Art Institute. Received prize in sculpture, 12th National Ceramics Annual, Syracuse; Founders Prize in Sculpture, 45th Michigan Artists Annual, Detroit, 1954. Taught sculpture at University of Michigan, 1949-79. Works in metal. Address in 1982, Prescott, AZ.

McCORMACK, NANCY.

Sculptor. (See Cox-McCormack.)

McCRACKEN, JOHN HARVEY.

Sculptor and painter. Born in Berkeley, Calif., December 9, 1934. Studied at Calif. College of Arts and Crafts, Oakland, BFA, 62, graduate work, 1962-65. Taught at University of Calif. at Irvine, 1965-66; UCLA, 1966-68; School of Visual Arts, NYC, 1968-69; Hunter College, from 1971; University of Nevada at Reno and Las Vegas; University of Calif. at Santa Barbara, from 1975. In collections of Museum of Modern Art, Whitney, Guggenheim, all in NYC; L.A. Co. Museum of Art; others. Exhibited at Nicholas Wilder Gallery, L.A.; Robert Elkon Gallery, NYC; Ileana Sonnabend Gallery, Paris and NYC; Art Gallery of Ontario, Toronto; Jewish Museum, Whitney, Guggenheim, Museum of Modern Art, all in NYC;

L.A. Co. Museum of Art; Van Abbemuseum, Eindhoven, Holland; San Fran. Museum of Modern Art; Art Institute of Chicago; others. Received National Endowment for the Arts Award, 1968. Works in fiberglas and wood. Address in 1982, c/o Nicholas Wilder Gallery, L.A.; CA.

McCRACKEN, PHILIP.
Sculptor. Born in Bellingham, WA, November 14, 1928. Studied at University of Washington, B.A.; sculpture with Henry Moore, England, 1954. Work in Detroit Institute of Art; Museum of Art, Victoria, B.C.; United Nations Association, NY; others. Has exhibited at Seattle Art Museum; Victoria Museum, B.C., 1964; La Jolla Museum of Art, CA; Anchorage Museum of Art; Corcoran Gallery of Art; Whitney Museum of American Art, NY; others. Address in 1982, Anacortes, WA.

McCREERY, JAMES LINDSAY.
Sculptor and illustrator. Born in Berkeley, CA. Address in 1934, Berkeley, CA. (Mallett's)

McDERMOTT, WILLIAM LUTHER.
Sculptor, painter, designer, craftsman, educator, and lecturer. Born in New Eagle, PA, February 21, 1906. Studied: Carnegie Institute, B.A.; University Pittsburgh, M.A.; Herron Art Institute; and with Joseph Ellis, J. P. Thorley, Frederick Nyquist. Member: Pittsburgh Society of Sculptors; Pittsburgh Art Association; American Artists Professional League; American Association of University Professors. Work: SS. Peter and Paul Church, St. Joseph Art School, De Paul Institute, all in Pittsburgh; Providence Normal School, PA; Mary Washington College, Fredericksburg, VA. Exhibited: Assoc. Artists of Pittsburgh, 1932-37; Pittsburgh Society of Sculpture, 1934-37; Virginia Museum of Fine Arts, Richmond. Lectures: Art Appreciation; Architecture and Sculpture. Taught: Professor of Art, Mary Washington College, Fredericksburg, VA, 1941-46. Address in 1953, Fredericksburg, VA.

McDUFFIE, JANE.
See Thurston, Jane McDuffie.

McELROY, NANCY LYNN.
Sculptor and designer. Born in New London, Conn., July 23, 1951. Studied at Calif. State University, San Diego; University Calif., Davis; with Roy DeForest. Works: Archive Sohm, Markgroningen, Germany; Vancouver Art Gallery, BC. Commissions: Soft zipper sculpture, comn by Terry Arnold, San Diego, 1974; woven textile designs, Sammlung Maurer, Fluxus Arch, Budapest, Hungary, 1975. Exhibitions: Henry Art Gallery, University Wash., Seattle, 1972; Joslyn Art Museum, Omaha, NE, 1973. Address in 1976, Davis, CA.

McGARY, DAVID.
Sculptor. Born in Cody, Wyoming, in 1958. Studied with Harry Jackson in Italy. Opened studio and foundry near Ruidoso, New Mexico, on return from Italy. Specialty is statuettes of Plains Indians subjects; works in bronze. Represented by Dewey-Kofron Gallery, Santa Fe, NM; Wagner Gallery, Austin, TX. Address in 1982, Alto, New Mexico.

McGOWIN, ED.
Sculptor and painter. Born in Hattiesburg, MS, June 2, 1938. Studied at Mississippi Southern College, B.S.; University of Alabama, M.A. Work in Corcoran Gallery of Art; National Collection of Fine Arts, Washington, DC; Whitney Museum of American Art, NY; Indianapolis Museum of Art; others. Has exhibited at Whitney Annual American Sculpture; Corcoran Gallery; National Collection of Fine Arts; others. Address in 1982, 96 Grand St., NYC.

McGRATH, BEATRICE (WILLARD).
Sculptor. Born in Dodge City, Kansas, November 28, 1896. Studied at Cleveland School of Art and with Herman N. Matzen. Award: Third prize, Garden Club Competition, Cleveland, Ohio, 1925. Member: Sculptors' Society of Cleveland. Address in 1933, 40 Wall St., New Haven, Conn.

McGREW, RALPH BROWNELL.
Sculptor, painter, and writer. Born in Columbus, Ohio, 1916. Studied with Lester Bonar at Alhambra, California (high school); Otis Art Institute, Los Angeles, with Ralph Holmes; also with Edouard Vysekal and E. R. Shrader. Worked as movie set decorator before turning to fine arts. Former member Cowboy Artists of America, American Institute of Fine Art, National Academy of Western Art. Work in Anschutz Collection, Cowboy Hall of Fame, University of Santa Clara, Read Mullan Gallery of Western Art, Museum of Northern Arizona. Specialty is Indian subjects rendered in a style of poetic realism. Address in 1976, Guemado, New Mexico.

McINTIRE, SAMUEL FIELD.
Carver. Born in Salem, Mass., in 1780. Son of Samuel McIntire. Worked with his father; succeeded to the business in 1811. Died on September 27, 1819.

McINTIRE, SAMUEL.
Sculptor and architect. Born in Salem, MA, in 1757. Apprenticed to his father's building trade, where he later began making decorative wood carvings. Working in that capacity for a wealthy Salem merchant, Elias Hasket Derby, by the 1790's. Performed decorative work for a number of Derby's ships, such as the Mount Vernon, 1798. Known primarily as architect; proposed a design for the US Capitol; but was rejected. In sculpture, he carved numerous eagles and reliefs, occasional portrait busts, such as his busts of John Winthrop and Voltaire. Other works include four ornamental gateways for the Salem Common, 1802, including a relief medallion of George Washington. Many works have been attributed to McIntire, but few have been documented to his studio. Died in Boston, February 6, 1811.

McINTOSH, JOSEPH H.
Sculptor. Address in 1934, New York. (Mallett's)

McKAYE, H.E., S.J. McKAYE.
Sculptor. Active 1867. Patentees—three statuettes, 1867.

McKEE, KATHERINE LOUISE.
(Mrs. Frank Kelsey). Sculptor, painter, designer, commercial artist, and craftsman. Studied: Teachers College, Co-

lumbia University, B.S., A.M.; Cleveland School of Art; Escuela de Pintura y Escultura, Mexico City. Awards: prizes, Cleveland Museum of Art, 1934, 37, 1938-41, 1946-48; American Fine Art Gallery, NY, 1931; Butler Art Institute, 1943. Work: Cleveland Museum of Art; Cleveland Municipal Collection. Exhibited: National Association of Women Artists, New York, 1931-33, 44; World's Fair New York, 1939; Weatherspoon Gallery, North Carolina, 1944, 48; Syracuse Museum of Fine Arts, 1947, 48; Art Center, New York, 1930; Phila. Art Alliance, 1947, 49; Butler Art Institute, 1939, 43, 45, 46, 48; Wichita Art Association, 1946-48; Cleveland, 1936; New York Society of Ceramic Art, 1945; Cleveland Museum of Art traveling exh., 1940, 41, 48; Kearney Memorial Exhibition, Milwaukee, 1946; Ohio Valley Exhibition, 1946. Address in 1953, Berkeley, Calif.

McKELLAR, ARCHIBALD.
Sculptor. Born Paisley, Scotland, October 23, 1844. Worked for the Monumental Bronze Company, of NY, as its sculptor, and at the time of his death was superintendent of its works at Bridgeport and a director of the company. Works: Bronze statue of James A. Garfield, Wilmington, DE; "Defense of the Flag," which has been copied nearly 1,000 times. Died in Bridgeport, Conn., July 4, 1901.

McKENZIE, ROBERT TAIT.
Sculptor, writer, and lecturer. Born Almonte, Ontario, Canada, May 26, 1867. Member: Phila. Sketch Club; Fellowship Penna. Academy of Fine Arts; Century Association; Phila. Art Club; American Federation of Arts; National Sculpture Society; Phila. Alliance. Exhibited at National Sculpture Society, 1923. Awards: Silver medal, St. Louis Exp., 1904; King's medal, Sweden, 1912; honorable mention, P.-P. Exp., San Fran., 1915. Work: "Sprinter," Fitz William Museum, Cambridge, England; "College Athlete," Ashmoleam Museum, Oxford, England; "Juggler" and "Competitor," Metropolitan Museum, NY; "Competitor," Candian National Gallery, Ottawa; "Onslaught," a group, and "Relay," statuette, Art Gallery, Montreal, CN; "The Plunger and the Ice Bird;" statuettes "Boy Scout" and "Blighty" and "Capt. Guy Drummond," memorial statue, Canadian War Museum, Ottawa, Canada; portraits in low relief of F. K. Huger and Crawford W. Long, University of GA; Dr. W. W. Keen, Brown Univ., Providence; "The Youthful Benjamin Franklin," bronze statue, University of PA campus; and Newark Museum, "Portrait of Weir Mitchell," and medals for Franklin Inst. Phila., University of Buffalo, Achilles Club, London; "Baron Tweedmouth" and "Lady Tweedmouth," Guisachan, Scotland; fountain with panel in high relief, "Laughing Children," Athletic Park Playground, Philadelphia; statues, "Provost Edgar F. Smith" and "Rev. George Whitefield," Triangle of the University of PA dormitories, 1919; "Norton Downs, Aviator," St. Paul's School; Victory Memorial, Cambridge, England; memorial statue, Col. George Harold Baker, Parliament Bldgs., Ottawa, CN; "William Cooper Proctor," and "Dean West," Princeton, NJ; "Flying Sphere," St. Louis Art Museum; Scottish-American War Memorial, Edinburgh, Scotland; General Wolfe, Greenwich, England.

Address in 1933, 2014 Pine Street, Philadelphia, PA; summer, Almonte, Ont. Died in 1938.

McKILLOP, EDGAR ALEXANDER.
Sculptor. Born in Balfour, North Carolina, June 8, 1878. Self-taught. Carved numerous objects in wood, such as clock housings, musical instruments, victrolas, knives, and furniture. Only four of his works are known today, despite the volume of his work. Died in Balfour, North Carolina, August 4, 1950.

McKINSTRY, GRACE E.
Sculptor, portrait painter, and teacher. Born Fredonia, NY. Pupil of Art Students League of NY; Art Institute of Chicago; Julian and Colarossi Academies; also with Raphael Collin in Paris. Member: American Artists Professional League; American Federation of Arts; National Arts Club. Work: Portraits in the Capitol, St. Paul, MN; Lake Erie College, Painesville, OH; Charleston College, Northfield, MN; Shattuck School, Faribault, MN; Army and Navy Club, Washington, DC; Woman's Club, Minneapolis; Cornell University; Beloit (WI) College; Pomona College, CA, etc. Address in 1933, Pen and Brush Club, New York, NY.

McKNIGHT, ROBERT J.
Sculptor and industrial designer. Born in Bayside, LI, NY, February 26, 1905. Studied: Yale College, Ph. B.; Yale School Fine Arts, BFA, and with H. Bouchard, Paris; Carl Milles. Awards: Lake Forest Scholarship, 1930; Prix de Rome, 1932; gold medal, Electronic Magazine (for indst. des.), 1952. Work: Brookgreen Gardens, SC. Exhibited: Phila. Museum of Art; Carnegie Institute; Grand Central Art Guild; Robinson Gallery, NY; Brooks Mem. Art Gallery, Springfield Art Academy, 1946-52. Lectures: History of Art; Design. Positions: Director, Memphis Academy of Art, 1936-41; Instructor of Design, Southwestern University, 1941-42; Army Aviation Engineers, 1942-45; Instructor Sculpture, Ceramics, Interior Decoration, Wittenberg College, Springfield, Ohio, 1948-51. Address in 1953, 648 East High St.; h. 1577 McKinley Ave., Springfield, Ohio.

McLAUGHLIN, J. W.
Sculptor. Active 1865. Patentee—monument, 1865.

McLAUGHLIN, NANCY.
Sculptor and painter. Born in Western Montana in 1932. Studied art in high school and at Montana State University. Specialty is Blackfoot Indian women, tribal legends. She has also painted Blackfoot children; illustrated book about the Blackfoot; painted Pacific Northwest Makah Indians. She sculpts in bronze. Member of American Artists of the Rockies; Western Artists of America. Reviewed in *Southwest Art*, February 1975. Represented by Select Gallery. Address in 1982, Newport, Washington.

McLEARY, BONNIE.
See MacLeary, Bonnie.

McMILLEN, MICHAEL CHALMERS.
Sculptor and environmental artist. Born in Los Angeles, CA, April 6, 1946. Studied at San Fernando Valley State College, CA; California State University, Northridge, BA; UCLA, MA, MFA. Exhibited at California Institute of

Technology; L.A. County Museum of Art; Whitney; Sydney, Australia; L.A. Institute of Contemporary Art; Newport Harbor Museum, Newport Beach, CA; Fort Worth, TX; Walker, Minneapolis; San Diego; other California galleries. Awarded University of California fellowship, L.A. Art Council, 1976; travel grant, Biennale of Sydney, Australia Council, 1972; National Endowment for the Arts fellowship, 1978. Address in 1982, Santa Monica, California.

McMURRY, LEONARD.
Sculptor. Born in Texas Panhandle, 1913. Studied at Washington University, St. Louis; sculpture under Carl C. Mose; also with Ivan Mestrovic. Work includes monument, "Eighty Niner," Oklahoma City; portrait busts at National Cowboy Hall of Fame; Indian Hall of Fame, Anadarko, Oklahoma; portrait busts of main characters of Battle of Little Big Horn. Address in 1975, Oklahoma City, Oklahoma.

McMURTY, EDWARD A.
Sculptor. Address in 1919, 2342 Lincoln Ave., Chicago, IL.

McNEELY, STEPHEN THOMAS.
Sculptor and painter. Born in East Orange, NJ, November 17, 1909. Studied at the National Academy of Design; Beaux-Arts Institute of Design; also with Robert Aitken and Leon Kroll. Work: Newark Museum; Newark Public Library; Caldwell (NJ) Public Library. Exhibited: Corcoran Gallery, 1941; Carnegie, 1941; Penna. Academy of Fine Arts, 1942; National Academy of Design, 1942; Metropolitan Museum of Art, 1943. Awarded prize, National Academy of Design, 1942. Address in 1953, 538 East 83rd Street, NYC.

McVEY, LEZA S.
Ceramic sculptor and weaver. Born in Cleveland, OH, May 1, 1907. Studied at Cleveland School of Art; Colorado Fine Art Center; Cranbrook Academy of Art. Works: Smithsonian Institution; Syracuse Museum of Fine Arts; Cleveland Museum of Art; General Motors, Detroit, Michigan; Butler Institute of American Art. Awards: Syracuse Museum of Fine Arts, 1950, 51; Michigan Arts and Crafts, 1951; Cleveland Museum of Art, 1954-67; Butler Institute of American Art, 1958. Exhibited: Syracuse Museum and National Circuit, 1945-69; Smithsonian Institution, 1951-61; International Cong. Contemporary Ceramics, Ostend, Belgium, 1960; one-woman shows were held at the Cleveland Institute of Art, 1965; Albright-Knox Art Gallery, 1965; and the Penna. Academy, Pomona, CA. Medium: Clay. Address in 1982, 18 Pepper Ridge Road, Cleveland, OH.

McVEY, WILLIAM M.
Sculptor, lecturer, and teacher. Born in Boston, MA, July 12, 1905. Studied at Rice University; Cleveland Institute of Art; Academies Colarossi, Grande Chaumiere, and Scandinave, Paris, 1929-31; and with Despiau. Awards: Cleveland May Shows; Purchase Award, Butler Institute of American Art, Youngstown, OH, 1967, and Everson Museum, Syracuse, NY, 1951, 52. Member: Cleveland Sculptors' Club; College Art Assoc. of America; fellowship, National Sculpture Society; Assoc. National Academy of Art. Exhibited at Grand Salon d'Automne; Penna. Academy of Fine Arts; Cleveland May Shows. Taught: Cleveland Museum, 1932; Houston Museum, 1936-38; University of Texas, 1939-53; head sculpture dept., Cleveland Institute of Art, 1953-46; Cranbrook Academy, 1946-53. Media: Stone, bronze. Represented in Houston Art Museum, Houston, TX; Canton McKinley High School, Canton, OH; Cleveland Museum of Art; Smithsonian Institution; Ariana Museum, Geneva, Switz. Address in 1982, Cleveland, OH.

MEADE (or MEAD), LARKIN GOLDSMITH.
Sculptor. Born in Chesterfield, New Hampshire, on January 3, 1835. He studied under Henry Kirke Brown from 1983-55. Worked in Brattleboro, VT, for a few years; later in Italy as a artist-correspondent for *Harper's Weekly* in 1861-62. His statue of Ethan Allen is in Washington, DC, and his statue of Abraham Lincoln is in Springfield, IL. In 1878 he resided in Washington, DC, and assisted the commission in the completion of the Washington Monument; designed sculptural decorations for Agricultural Building at Columbian Exposition. Address in 1910, Florence, Italy; and c/o W. M. Mead(e), 160 Fifth Avenue, NYC. He died in Florence, Italy, on October 15, 1910.

MEADMORE, CLEMENT L.
Sculptor. Born in Melbourne, Australia, February 9, 1929. Studied at Royal Melbourne Institute of Technology. Work in Art Institute of Chicago; National Gallery of Australia; J. B. Speed Museum, KY; large outdoor sculptures, Columbia University, NY State, Albany; others. Has exhibited at Guggenheim International, NY; Aldrich Museum, Ridgefield, CT; Rockefeller Collection, Museum of Modern Art; Whitney Museum of American Art, NY; others. Works in steel and bronze. Address in 1982, 800 W. End Ave., NYC.

MEAGHER, MARION T.
Sculptor, painter, and teacher. Born in New York City. Pupil of National Academy of Design, of Chase, Beckwith, and R. Swain Gifford in New York; he also studied in Paris and Antwerp. Artist of the Dept. of Anthropology, American Museum of Natural History, and New York Ophthalmic College. Address in 1933, 939 Eighth Avenue, New York, NY; summer, Fisher's Island, NY.

MEANS, ELLIOT (ANDERSON).
Sculptor and illustrator. Born in Stamford, Texas, March 10, 1905. Studied at School of the Museum of Fine Arts, Boston. Work: Government Printing Building, Wash., DC; Welfare Island, NY; US Post Office, Suffern, NY; Dexter, ME. Exhibited: National Academy of Design, 1933, 35-37, 40, 41, 44. Illustrated *The Children's Story Bible*; other books and book jackets. Address in 1953, 200 East 16 St., NYC.

MEARS, HELEN FARNSWORTH.
Sculptor. Born in Oshkosh, WI, in 1876. Studied in New York and Paris. First success, "Genius of Wisconsin," exhibited at Chicago Exp., 1893; executed "The Fountain of Life," 1904; marble statue of Frances E. Willard, 1905, which was placed in the Capitol, Washington; portrait

bust of George Rogers Clark; also bust of William L. G. Morton, M.D., placed in Smithsonian Institution; portrait reliefs of Augustus St. Gaudens, Louis Collier Wilcox, and Edward A. McDowell. Awarded $500 prize from Milwaukee Women's Club, Columbian Expo., Chicago, 1893; silver medal, St. Louis Expo., 1904. Member of National Sculpture Society. Address in 1910, 253 West 42nd Street, NYC. She died in NYC on February 17, 1916.

MECKLEM, HANNAH.
(Mrs. Austin M. Mecklem). Address in 1934, Woodstock, New York. (Mallett's)

MEDRICH, LIBBY E.
Sculptor. Born in Hartford, CT. Studied at New York University, 1931; Vassar College, 1949 and 54; Silvermine Guild School, 1951; Art Students League, 1952-55; White Plains Co. Center, 1957 and 58; also with John Hovannes, Clara Fasano, Helen Beling, Domenico Facci, George Koras, Harold Castor, Albert Jacobson, and others. Has exhibited at Prix de Paris, Galerie Raymond Duncan, Paris; Metropolitan Museum of Art; Hudson River Museum; Lever House, American Society of Contemporary Artists; others. Received third prize, Salmagundi Club; others. Member of Artists Equity Association of NY; Mamaroneck Artists Guild; American Society of Contemporary Artists; others. Works in bronze and polyester resin. Address in 1982, Larchmont, NY.

MEEHAN, JOSEPH.
Sculptor. Born in Italy in 1824. Listed as living in New York City in August of 1850.

MEGE, VIOLETTE (CLARISSE).
Sculptor and painter. Born in French Algiers, March 19, 1889. Pupil of Georges Rochegrosse, Ecole Nationale des Beaux Arts, Academie Julien, J. P. Laurens and Humbert, in Paris. Member: Societe des Artistes Francais; Society of Independent Artists. Awarded fellowship of French Government. Address in 1926, 119 West 87th Street, New York, NY.

MEIER, SIGRID.
Sculptor and weaver. Born in Switzerland in 1933. Studied: Philadelphia College of Art; Haystack Mountain School, Deer Isle, Maine; Wallingford Community Art Center, Pennsylvania. Awards: Civic Center Museum, Philadelphia, 1970; Philadelphia Guild of Handweavers, 1969, 70, 72. She is represented in the collection of The Wilmington Museum of Fine Arts, Wilmington, Delaware.

MEIZNER, PAULA.
Sculptor. Born in Belchatow, Poland; US citizen. Studied at Westchester Workshop, White Plains, NY. Has exhibited at Aldrich Museum, Ridgefield, CT; New Britain Museum of American Art, CT; Sculpture in the Fields, Storm King Art Center, Mountainville, NY; others. Received Charles N. Whinston Memorial Award, National Association of Women Artists, NY; others. Member of Audubon Artists; Silvermine Guild Artists; National Association of Women Artists. Works in fieldstone and aluminum. Address in 1982, New Rochelle, NY.

MELCHERS, JULIUS THEODORE.
Sculptor, wood carver, and teacher. Born in Prussia, 1830. Came to US after 1848. Worked in Detroit, from 1855. Media were wood and stone. Died in 1903.

MELCHERT, JAMES FREDERICK.
Sculptor and educator. Born in New Bremen, OH, December 2, 1930. Studied: Princeton University, A.B., 1952; University of Chicago, M.F.A., 1957; Montana State University, Missoula, 1958, 59 (summers); University of California, Berkeley, M.A., 1961; ceramics with Peter Voulkos. Moved to Berkeley, CA, 1959. One-man exhibitions: Richmond Art Center, CA, 1961; San Francisco Art Institute, 1970; San Francisco Museum of Art, 1975; Contemporary American Sculpture, Whitney Museum of American Art, NY. Group exhibitions: Abstract Expressionist Ceramics, Art Gallery, University of California, Irvine, 1966; Documenta 5, Kassel, Germany, 1972; Public Sculpture/Urban Environment, The Oakland Museum, CA, 1974; The Modern Era, San Francisco Museum of Modern Art, 1976, and Smithsonian National Collection of Fine Arts, 1977. Work at San Francisco Museum of Art; Museum of Modern Art, Kyoto, Japan; Victoria and Albert Museum, London; Oakland Museum of Art, CA; Stedelijk Museum, Amsterdam. Received Louis Comfort Tiffany Foundation Grant; Nealie Sullivan Award, San Francisco Art Institute; National Foundation Arts Grant. Teaching sculpture at University of California, Berkeley, from 1964. Works in clay. Living in Oakland, CA, in 1977. Address in 1982, National Endowment for the Arts, Washington, DC.

MELICOV, DINA.
Sculptor. Born in Russia, January 12, 1905. Studied at Iranian Institute; Columbia University. Works: US Post Office, Northumberland, Penna. Exhibited: World's Fair, New York, 1939; Penna. Academy of Fine Arts, 1946; Whitney; Brooklyn Museum; National Academy of Design; Argent Gallery; ACA Gallery; Sculptor's Guild. Awards: National Association of Women Artists; European travelling scholarship, Educational Alliance Art School, NYC; and others. Member: National Association of Women Artists, NYC; and the Sculptors Guild. Address in 1953, 939 8th Avenue, NYC.

MELIODON, JULES ANDRE.
Sculptor and teacher. Born Paris, France, June 1, 1867. Pupil of Falguiere, Fremiet, Barrau, and Message in Paris. Member: New York Architectural League; Societe des Artistes Francais; Societe des Professeurs Francais en Amerique; Alliance. Awards: Hon. mention, Paris Salon, 1902; Diploma of Officer of Academy, 1898; Diploma of Officer of Public Instruction, 1904; Master Craftsman, Phila. Building Congress, 1932. Work: "The Explorer Lesueur," Museum of Natural History, Paris; decorative sculpture on the reconstructed Sorbonne, Paris; Bahai's Vase (with Tiffany and L. Bourgeois, architect); Soldiers Monument, Bloomingdale, NJ; Roxy Theatre (in cooperation), New York City; bronze doors, Administration Building; statuary panels, Board of Education, New Naval Hospital, Philadelphia. Instructor at University of Pennsylvania. Address in 1933, 1840 So. Bancroft St.,

Philadelphia, PA; summer, Lincoln Park, NJ.

MELLON, ELEANOR M.
Sculptor. Born Narberth, PA, August 18, 1894. Pupil of V. D. Salvatore, Edward McCartan, A. A. Weinman, Robert Aitken, Charles Grafly, Harriet Frishmuth. Member: National Sculpture Society, American Federation of Arts. Exhibited at National Sculpture Society, 1921, 29, 43; Penna. Academy of Fine Arts; National Academy of Design; Art Institute of Chicago; Allied Artists of America; National Assoc. of Women Artists; Society of Wash. Artists; American Artists Professional League; North Shore Art Assoc.; Met. Museum of Art, 1942; NY Jr. League. Awards: Prizes, National Academy of Design, 1927; NY Jr. League, 1942; medal, Society of Wash. Artists, 1931; hon. mention, National Assoc. of Women Painters and Sculptors, 1932; American Artists Professional League, 1945. Position: Member Council, National Sculpture Society; Secretary, 1936-40, 45; Board of Directors, Architectural League; Municipal Art Society, 2nd V. Pres., 1942-44. Address in 1953, 22 E. 60th, St., NYC. Died in 1979.

MELLON, MARC.
Sculptor. Award: C. Percival Dietsch Sculpture Prize, 1981, National Sculpture Society.

MELLOR, GEORGE EDWARD.
Sculptor and educator. Born in Bronxville, NY, September 13, 1928. Studied at Oberlin College, A.B. (fine arts), 1954; Atelier Zadkine, 1952-53; Tyler School of Fine Arts, M.F.A., 1965. Work in National Collection of Fine Arts, Smithsonian Institution; others. Has exhibited at Regional Exhibition, Penna. Academy of Fine Arts; Rhode Island School of Design; others. Address in 1982, Onset, MA.

MELVILLE, FRANK
Sculptor and etcher. Born in Brooklyn, December 28, 1832. Pupil of Henry K. Brown. Member: California Society of Etchers; Chicago Society of Etchers. Work: Library of Congress, Washington, DC; NY Public Library; Brooklyn Institute Museum; Walker Gallery, Liverpool, England. Address in 1916, 6 Montague Terrace, Brooklyn, NYC.

MENCHILLI, GEORGE G.
Sculptor. Born in Italy, 1800. Listed as living in Louisville, KY, in 1850. He employed his sons Achille and Francisco and his daughter Nicodema in his shop. Specialty was busts. Worked in plaster.

MENCONI, FRANK G.
Sculptor and designer. Born in Tuscany, Italy, April 24, 1884. He was educated abroad until his sixteenth year, when his parents immigrated to the United States. He was best known for his design of the Monumental Victory Arch, New York, for the home coming of American soldiers of the World War, and the Boston Memorial to Mrs. Mary Baker Eddy, founder of Christian Science. Several years ago he revived an ancient art known as "Graffito," a process of engraving on cement in colors, which was used on several public buildings in Washington, DC. Died in Union City, NJ, April 24, 1928.

MENCONI, RALPH JOSEPH.
Sculptor. Born in Union City, NJ, June 17, 1915. Studied: Yale University, B.F.A.; Hamilton College; National Academy of Design; Tiffany Foundation. Member: National Sculpture Society; Municipal Art Soc. (Dir.). Awards: Speyer award, National Academy of Design, 1941; Tiffany Foundation grant, 1947; National Jefferson Expansion Memorial (in collaboration with Caleb Hornbostel), 1947; Jefferson Comp., 1948. Work: Brookgreen Gardens, SC; St. Rose of Lima, Short Hills, NJ; St. Joseph's Catholic Church, Camden, NJ; medals, plaques, National Book Award; New York Univ. Law Center; Kenyon College; *Reader's Digest*; General Electric; Buckley School; Grenfell Assn., and many portrait commissions. Exhibited: National Academy of Design; National Sculpture Society; Medallic Art Co., 1950; International Comp., Imperial Palace, Addis Ababa; Government of Portugal, International Competition. Address in 1970, West 154 55th St., NYC, h. Old School Lane, Pleasantville, NY. Died in 1972.

MENDENHALL, EARL (MRS.).
See Langley, Sarah.

MENEELEY, EDWARD.
Sculptor and painter. Born in Wilkes Barre, PA, December 18, 1927. Studied at Murray Art School, Wilkes Barre, 1952-56; School of Visual Arts, NYC, 1957-58; privately with Jack Tworkov, NYC, 1958-59. Work: Museum of Modern Art; Whitney; Chrysler Museum; Metropolitan Museum of Art. Exhibited: Donovan Gallery, Phila., 1952-54; Parma Gallery, NYC, 1962; Frederick Teuscher Gallery, NYC, 1966; Whitney Museum, NYC, 1969; Museum of Modern Art, NYC, 1970; Victoria and Albert Museum, London, 1971; one-man exhibitions include the Susan Caldwell Gallery, NYC, 1976; a retrospective at the Frank Marino Gallery, NYC, 1978; many others. Awards: Grant from the National Endowment for the Arts, Washington, DC, 1971; Arts Council Grant, London, 1971. Taught: St. Louis, MO, 1979; Art Students League, NYC, 1974, 79. Address in 1982, 201 Second Ave., NYC.

MENGARINI, FAUSTA VITTORIA.
Sculptor and teacher. Born in Rome, Italy, April 18, 1893. Studied with Edoardo Gjoia, Royal Academy of Arts, Rome. Work: War Memorial, and heroic size figures on Palace of Justice, Royal Italian Government, Rome, Italy; baptismal font, Montclair, NJ; Monumental Lighthouse, Massaua, Eritrea, Africa (Royal Italian Government). Awards: Nanna Matthews Bryant prize for sculpture, National Academy of Women Painters and Sculptors, 1931; honorable mention, Int. Fair, Tampa, Fla., 1931. Member: National Academy of Women Painters and Sculptors. Address in 1933, 256 West 55th St.; h. 31 East 30th St., NYC; summer, c/o A. Tamburini, Rome, Italy.

MERCER, GENEVA.
Sculptor. Born Jefferson, Marengo Co., AL, January 27, 1889. Studied in Italy; also a pupil of G. Moretti. Exhibited: National Academy of Design; Gore Mansion, Boston, 1942; Penna. Academy of Fine Arts; Institute of Modern Art, Boston; Copley Society, Boston; others.

Member of the Alabama Art League; Institute of Modern Art, Boston; Pitts. Art Association; Copley Society, Boston. Work: "Rev. James L. Robertson," "Soldiers' Memorial," Bronxville (NY) Reformed Church; memorial to Florence McComb, Osceola School, Pittsburgh, PA; Museum of Fine Arts, Montgomery, AL; Alabama Memorial Building; numerous memorials in schools and churches. Awards: Philadelphia Art Week, 1925; San Remo, Italy, 1934; Mass. Horticultural Society, 1941. Address in 1953, Boston, MA.

MERCER, HENRY CHAPMAN.
Sculptor and worker in applied arts. Born in Doylestown, PA, June 24, 1856. Studied art at Harvard. Curator (1894-97) Prehistoric Archaeology, University of Pennsylvania. Grand prize for pottery, St. Louis Exp. 1904. Member Boston Society of Arts and Crafts; Daedalus Association of Crafts, Phila.; Designers' and Artisans' Club, Baltimore; Detroit Association of Crafts. Specialty: Pottery and color-printing. Address in 1910, Moravian Pottery; h. "Aldie," Doylestown, PA.

MERCER, WILLIAM ROBERT, JR.
Sculptor. Born in Doylestown, PA, 1862. Address in 1898, Doylestown, PA.

MERRILD, KNUD.
Sculptor, painter, writer, and block painter. Born in Odum, Denmark, May 10, 1894. Studied at Royal Academy of Fine Arts, Copenhagen, Denmark. Works: "Deer and Tiger" (sketch for fresco), "Man and Horse" and "Leaping Deer" (silk embroidery), Museum of Art and Industry, Copenhagen, Denmark; mural decorations in hotels and buildings in Los Angeles, Studio Theatre Auditorium, Hollywood, California; Museum of Modern Art; Philadelphia Museum of Art; Los Angeles Museum of Art; San Diego Fine Arts Society; Pomona Gallery, Los Angeles, CA. Exhibited: Brooklyn Museum, 1936, 39, 43; Museum of Modern Art, 1936, 42; Golden Gate Expo., 1939; Art Institute of Chicago, 1940; Whitney, 1941; American Federation of Arts, 1942; Los Angeles Museum of Art, 1934-44; San Francisco Museum of Art, (one-man) 1937; others. Author of *A Poet and Two Painters*, London, 1938, NY, 1939. Address in 1953, 2610 South Robertson Blvd., Los Angeles, California.

MESEROLE, WILLIAM HARRISON.
Sculptor. Born in Brooklyn, New York, December 28, 1893. Pupil of MacNeil. Address in 1918, 730 Rugby Rd., Brooklyn, NYC.

MESSO, DOMINICK.
Sculptor. Born in France in 1827. Was living in Philadelphia in August of 1860.

MESTROVIC, IVAN.
Sculptor, painter, and teacher. Born in the Slavonian village of Vrpolje, Yugoslavia, August 15, 1883. Studied with Otto Koenig in Vienna, 1899; four years at the Academy of Fine Arts in Vienna, 1900-04; with E. Hellmer, H. Bitterlich, Otto Wagner. Spent student years studying the styles of Rodin and the Vienna Secession, the results of which centered on a series of sculptures commissioned for the Kossovo Monument, a project never completed. Works: "The Crucifixion," 1917 (wood); "Lamentation," 1915; "Ashbaugh Madonna," 1917 (walnut); "Virgin and Child," 1919-22; "Amour and Psyche," 1918 (stone); "Distant Chords," 1918 (bronze); "The Raising of Lazarus," 1940 (walnut); "Study for the Monument of Marko Marulic," (plaster); "Woman with a Harp," 1924 (marble); "Woman with a Lute," 1924 (marble); "Waiting," 1929 (marble); "St. Luke the Evangelist, 1928 (bronze);" "Indian with Bow," 1926 (bronze); Mestrovic Family Memorial Chapel," 1926-31/1936-38 (stone); "Pieta," 1942 (marble); "Study of Moses," 1953 (plaster). Represented in Belgrade (National); Brooklyn Museum; Albright; Art Institute of Chicago; Detroit Institute; Snite Museum of Art; Congregation of the Holy Cross; Syracuse University; University of Minnesota Museum of Art; San Diego Fine Arts Museum; Wichita Art Museum; Louisiana Arts and Science Center, Baton Rouge; University of Notre Dame; and Mestrovic Gallery. Exhibited in Prague, Munich, Paris, Vienna, Zagreb, and the Victoria and Albert Museum, 1915; one-man show at the Metropolitan Museum of Art. Taught: Syracuse University, 1947-55 and University of Notre Dame, 1955-1962. Member of American Academy of Arts and Letters, 1953. Died January 17, 1962, in Notre Dame, IN.

METCALF, JAMES.
Sculptor. Born March 11, 1925, in NYC. Studied: Dayton Art Institute School; Penna. Academy of Fine Arts, 1944-46; Central School of Arts and Crafts, London, 1950-53. Work: Univ. of Arizona; Museum 20 Jahrhunderts; New York Hilton Hotel; Yale Univ. Exhibited: Galerie Furstenberg, Paris, 1959; Galerie Europe, Paris, 1963; Albert Loeb Gallery, NYC, 1964; Dayton Art Institute, 1946; Cincinnati Art Museum; III Biennial of Spanish-American Art, Barcelona; V Sao Paulo Biennial; Exposition Internationale de la Sculpture, Paris, 1961; Un Demi-Siecle de la Sculpture, Paris, 1962; Actualite de la Sculpture, Paris, 1963; Documenta III, Kassel, 1964. Awards: Copley Foundation Grant, 1957; Clark Foundation Grant. Address in 1976, Yellow Springs, Ohio.

METZ, GERRY MICHAEL.
Sculptor and painter. Born in Chicago, July 22, 1943. Studied at Wright Junior College and the School of Professional Art. In collections of Mt. Whitney Museum of Western Art, California; Favell Museum of Western Art, Klamath Falls, Oregon. Has exhibited at Death Valley Western Art Show, California, 1973-79; George Phippen Memorial Western Art Show, Prescott, Arizona, 1975-81; others. Received awards in watercolor, Death Valley Western Art Show; in mixed media and watercolor, George Phippen Show; others. Director, Village Art School, Skokie, Illinois, 1968-72; taught at Phoenix Art Museum, 1973-76. Specialty is Old West subjects. Works primarily in watercolor and oils; sculpts in bronze. Reviewed in *The Western Horseman*, June 1980; *Southwest Art*, December 1980. Represented by The May Gallery, Scottsdale, AZ; Casa Dolores Gallery, Carmel-by-the-Sea, CA. Address since 1971, Scottsdale, Arizona.

METZGER, EVELYN BORCHARD.
Sculptor and painter. Born in NYC, June 8, 1911. Studied

at Vassar College, A.B., 1932, with C. K. Chatterton; Art Students League, with George Bridgman and Rafael Soyer; also George Grosz, sculpture with Sally Farnham, Guzman de Rojas in Bolivia and Demetrio Urruchua in Arg. Works: Fine Arts Gallery of San Diego, Balboa Park, Calif.; Ariz. State Museum, Tucson; Lyman Allyn Museum, New London, Conn.; University Mo-Columbia; Butler Institute American Art, Youngstown, Ohio; also in over 40 museums including Art in the Embassies Prog. Exhibitions: One-woman shows, Galeria Muller, Buenos Aires, 1950, Gallerie Mex-Am. Cultural Institute, Mexico City, 1967; Van Diemen-Lilienfeld Gallery, NY, 1966. Member: Amer. Federation of Arts; Artists Equity Association; others. Media: Oil, enamel, acrylics, and mixed media. Address in 1982, 815 Park Ave., NYC.

MEYENBERG, JOHN CARLISLE.
Sculptor and craftsman. Born Tell City, IN, February 4, 1860. Pupil of Cincinnati Art Academy under Thomas S. Noble, L. F. Rebisso; Beaux-Arts in Paris under Jules Thomas. Member: Cincinnati Art Club. Work: "Egbert Memorial," Fort Thomas, KY; "Pediment," Covington (KY) Carnegie Library; "Aunt Lou Memorial," Linden Grove Cemetery; Theodore F. Hallam, bust, Court House, Covington, KY; "Nancy Hanks," Lincoln Park entrance, State of Indiana; "Benn Pitman Memorial," Cincinnati Public Library. Exhibited at National Sculpture Society, 1923. Address in 1929, Tell City, IN.

MEYER, ALVIN (WILLIAM) (CARL).
Sculptor. Born Bartlett, IL, December 31, 1892. Pupil of MD Institute; Penna. Academy of Fine Arts under Charles Grafly; Rinehart School of Sculpture in Baltimore, MD; American Academy in Rome. Member: Charcoal Club. Work: Peabody Institute, Maryland Institute, Baltimore; Chicago Daily News Building; Chicago Board of Trade; Archives Building, Springfield, IL; Natural History Building, Urbana, IL. Award: Cresson Traveling Scholarship, Penna. Academy of Fine Arts; Rinehart Traveling Scholarship from the Peabody Institute; Prize of Rome, American Academy in Rome, 1923. Exhibited at National Sculpture Society, 1923. Address in 1953, Chicago, IL.

MEYER, ENNO.
Sculptor, painter, illustrator, and etcher. Born Cincinnati, OH, August 16, 1874. Pupil of Duveneck. Member: Cincinnati Art Club. Specialty is animals. Address in 1929, Milford, OH.

MEYER, FRED (ROBERT).
Sculptor and painter. Born in Oshkosh, WI. Studied at University of Wisconsin; Harvard Graduate School of Business Administration; Cranbrook Academy of Art, B.F.A. and M.F.A. Work in NY State Theatre, Lincoln Center for the Performing Arts; Everson Museum, Syracuse, NY; Munson, Williams, Proctor Institute, Utica, NY; two bronze sculptural groups, Lazarus Mall, Columbus, OH; others. Has exhibited at Midtown Galleries, NY; Philadelphia Art Alliance; Everson Museum, Syracuse; 156th Annual, National Academy of Design; others. Teaching at Rochester Institute of Technology, from 1955.

Awarded Ford Foundation Fellowship, 1955. Works in bronze, terra cotta; gouache. Address in 1982, Scottsville, NY.

MEYER, SEYMOUR W.
Sculptor. Born in Brooklyn, NY. Studied with Louise Nevelson. Work in Museum of Modern Art, Rio de Janeiro, Brazil; Tel-Aviv Museum; Temple Beth-El, Great Neck, NY; others. Has exhibited at Metropolitan Museum of Art, NY; Lester Gallery, Los Angeles, CA; Royal Academy, London; Engel Gallery, Jerusalem; others. Member of Guggenheim Museum; American Federation of the Arts; Museum of Modern Art, NYC; Sculptors League of New York. Works in bronze. Address in 1982, Great Neck, NY.

MEYER, URSULA.
Sculptor and photographer. Born in Hannover, Germany. Studied at the New School for Social Research, BA, 1960; Columbia University Teachers College, MA, 1962. Exhibited: Amel Gallery, 1964 and 68, Hunter College, 1969, Lehman College, 1971, City University of NY, 1974; Finch College Museum, 1967; Brooklyn Museum, 1968; others. Work: Brooklyn Museum; Finch College Museum; Aldrich Museum; others. Awards: Estelle Goodman Award for Best Sculpture, National Design Center, 1966; City University of New York Research Grant, Lehman College, 1970. Member: Women's Interart Center; Women in Arts. Taught: Assistant professor at Hunter College, 1966-68; associate professor of sculpture, Lehman College, from 1968. Media: Metal. Address in 1982, Lehman College, City University of New York, West, NYC.

MEYNELL, LOUIS.
Sculptor and painter. Born in Cherryfield, ME, Sept. 22, 1868. Pupil of Otto Grundmann, F. H. Tompkins, and School of Boston Museum of Fine Arts (graduate, 1888). Address in 1910, 41 Commonwealth Ave., Chestnut Hill, MA.

MEYNER, WALTER.
Sculptor, painter, and writer. Born in Philadelphia, PA, February 12, 1867. Pupil of Penna. Academy of Fine Arts. Member: Salma. Club; Fellowship, Penna. Academy of Fine Arts; Society of Independent Artists; Allied Artists of Amer. Address in 1933, 150 Nassau St., NYC.

MEZZARA, JOSEPH.
Sculptor. Born in NYC. Exhibited: Paris Salon, 1852, 1875. Works held: Chambery Museum, France.

MEZZARA, PIETRO.
Sculptor and stonecutter. Born in Italy c. 1823. In San Francisco c. 1856-78. Work: Statue of Lincoln, Lincoln Grammar School, San Francisco, 1865-66; statues and pediments, State Capitol, Sacramento, California, c. 1873; "Charity," Masonic Temple, San Francisco; "Romulus and Remus," Mechanics' Pavilion facade. Exhibited at Mechanics' Institute Industrial Exhibitions, San Francisco, 1857-78; San Francisco Art Association, 1872, 75. Received gold medals, Mechanics' Institute, San Francisco, 1865, 69, 71. Member of San Francisco Art Association. Considered San Francisco's first resident sculptor of

note. Executed cameos, medallions, and portrait busts for city's social elite. Responsible for acquiring from the Louvre plaster casts of antique sculpture for San Francisco Art Association's School of Design. These influenced California's first generation of sculptors in the 1880's. Died in Paris in 1883.

MICHAEL, D. D. (MRS.).
See Wolfe, Natalie.

MICHELSON, LEO (LEIBA).
Sculptor; portrait, figure, and landscape painter; engraver. Born in 1887. Exhibited: Paris; NY; Baltimore; Berlin; Lisbon; Russia. Works held: Baltimore Museum; Paris Museum of Modern Art; Riga (Russia) Museum; San Diego Museum; Tel-Aviv, Israel; Jerusalem, Israel.

MICHELSON-BAGLEY, HENRIETTA.
Sculptor and painter. Born in Kansas City, MO. Studied at Long Beach Jr. College, Calif.; Univ. Mex., Mexico City; Univ. MO, B.A.; Univ. Caracas, Venezuela; also with Andre L'Hote, Paris, and Edwiggi Poggi, Florence; Art Students League, with Morris Kantor, George Grosz, and V. Vytlacil; also studied theater, dance, and voice. Commissions: Sets for fourteen plays, including *The Tragedy of Thomas Andros*, Circle Repertory Theatre Co., NY, 1973, and set for e. e. cummings play, *Him*, Circle Repertory Theatre Co., 1974. Exhibitions: Sao Paulo Biennial, Brazil, 1963; New England Annual, Silvermine Guild, New Canaan, Conn., 1966 and 68; Drawings, Paintings, and Theater Images, Artists Space, NY, 1975; Heard Museum of Indian Arts and Crafts, Phoenix, AZ, 1979; others. Art Students League; Ten Uptown; Actors Equity Association. Media: Wood, clay; pastel, and acrylic. Address in 1982, 306 West 81st Street, NYC.

MICHNICK, DAVID.
Sculptor. Born in Gorinka, Ukraine, in 1892. Studied at the Art School of Odessa, at the Art Institute of Chicago, under Albin Polasek, and at the Beaux-Arts Institute of Design, NY. Works: Garden figure, private estate, Albany, NY; Nymph, private estate, Chicago, IL; overmantel, private residence, Forest Hills, LI; memorial panel, Isadora Duncan; statues—Disarmament; Attic; Quiet Water. Awards: Medals, Beaux-Arts Institute of Design, NY.

MICKELSON, ARLENE JO.
Sculptor and intaglio printmaker. Born in Seattle, Washington, in 1938. Studied art at University of Washington two years; later studied bronze casting and intaglio printing. Specialty is art and mythology of the Pacific Northwest Coast Indians. Member of American Artists of the Rockies. Represented by Trails West Gallery of Fine Arts; Trails End Gallery, Portland, OR. Address in 1982, Issaquah, Washington.

MIDDLEBROOK, DAVID A.
Sculptor and educator. Born in Jackson, MI, May 1, 1944. Studied at Albion College, B.A., 1966; University of Iowa, with Jerry Rothman, Paul Soldner, and Stuart Eddie, M.A., 1969, with Don Reitz, Byron Burford, and Hans Braeder, M.F.A., 1970. Work in San Jose Museum of Art, Oakland Museum of Art and San Francisco Museum of Art, CA; San Francisco Museum of Modern Art. Has exhibited at Everson Museum of Art, Nine California Artists, Syracuse, NY; Smithsonian Museum, traveling, Washington, DC, 1978-80; Sculpture Now, San Francisco Museum of Modern Art; Los Angeles Co. Museum of Art; others. Received National Endowment for the Arts artist grant, 1977; others. Member of College Art Association; American Crafts Council; others. Address in 1982, Los Gatos, CA.

MIDDLETON, MARY P.
See Laessle, Mary P. Middleton.

MIDENER, WALTER.
Sculptor, craftsman, and teacher. Born in Germany, October 11, 1912. Studied: Vereinigten Staats Schulen Fine and Applied Art; Berlin Academy, 1932-36; Wayne State University, M.A., 1950. Member: Michigan Sculpture Society; Michigan Academy of Arts and Letters. Awards: Tiffany grant, 1940; Honolulu, HI, 1943; prize, Detroit Institute of Art, 1950; Scarab Club Gold Medal, 1960. Work: Whitney Museum of American Art; Flint Institute of Art; Detroit Institute of Art. Exhibited: Penna. Academy of Fine Arts, 1941, 48, 51, 59; Philadelphia Museum of Art, 1949; Whitney Museum of American Art, 1950, 51, 64; Metropolitan Museum of Art, 1951; Museum of Modern Art, 1950; Cranbrook Academy of Art, 1950; John Herron Art Institute, 1951; Detroit Institute of Art, 1946-51. Taught: Head of sculpture dept., Art School, Society of Arts and Crafts, Detroit, MI, 1946-66, assistant director, 1958-61, acting and associate director, 1961-67, dean of faculty, 1967-68; director, Center for Creative Studies, College of Art and Design, 1968-76, pres., 1976-77, pres. emer. and prof. sculpture, 1977-79. Media: Metal, wood, and clay. Address in 1982, East Jordan, MI.

MIELZINER, LEO.
Sculptor, painter, illustrator, etcher, writer, and lecturer. Born New York City, December 8, 1869. Pupil of Cincinnati Art Academy; Ecole des Beaux-Arts, Julian Academy, Colarossi Academy, Paris; Kroyer in Denmark. Member: Boston Art Club; Cincinnati Art Club; Salma. Club. Work: "Portrait of John Bassett Moore," Kent Hall, Columbia University, New York; University of Delaware and State Department, Washington, DC; "Portrait of Nathan Abbott," "Portrait of Harlan Fiske Stone," Kent Hall, Columbia University, NY; "Portrait of Solomon Schechter," Jewish Theological Seminary, NY; "Portrait of Moses Mielziner," Hebrew Union College, Cincinnati; "Portrait of Woodrow Wilson," Democratic Club, NY; "Portrait of Elizabeth Milbank Anderson," Barnard College, NY; miniature, "Mother and Child," Boston Art Museum; lithograph, "Boy in Fur Cap," Brooklyn Art Museum; silverpoint, "Arabesque," Worcester Art Museum, Worcester, MA; "Portrait of Louis Loeb," Metropolitan Museum of Art, NY; "Portrait of Isaac M. Wise," Cincinnati Art Museum; portraits of General Pershing, Woodrow Wilson, Theodore Roosevelt, New York Public Library. Address in 1933, 47 Fifth Avenue, Washington Square, New York, NY; summer, Head O'Pamet North, Truro, MA. Died in 1935.

MIESTCHANINOFF, OSCAR.
Sculptor. Born in Vitebsk, Russia, 1884. Naturalized citizen of US in 1949. Initially self-taught; later attended Odessa School of Fine Arts in Russia and the Ecole des Beaux-Arts in Paris. Exhibited many times in Paris until 1944 when he moved to NYC. One-man exhibits in NY, Wildenstein Galleries, Los Angeles Co. Museum, 1955. Died in NYC, 1956.

MIGNERY, HERB.
Sculptor and painter. Born in Bartlett, Nebraska, in 1937. Drew cartoons in college; later worked in sign painting and commercial art. Turned to sculpture full-time in own studio, 1974. Specialty is Western figures. Sculpts in bronze; paints in various media. Represented by Folger Ranch Gallery, Midland, TX. Published by Cornhusker Press, Hastings, NE. Address in 1982, Hastings, Nebraska.

MIKKELSON, GWENDOLEN HATHORNE.
Sculptor. Member: Society of Independent Artists. Address in 1925, Route 2, Danbury, Conn.

MILES, EMILY WINTHROP.
Sculptor. Born in NYC. Studied under Abastenia St. L. Eberle, Daniel C. French, Brenda Putnam, Harriet W. Frishmuth. Works: Bust, R. F. S. Awards: Prize, Stockbridge Art Exhibition, MA, 1928. Membership: National Association of Women Painters and Sculptors. Died in 1962.

MILES, MAUD MAPLE (MRS.).
Sculptor, painter, and teacher. Born in Chariton, IA, February 11, 1871. Pupil of Art Institute of Chicago; Arthur Dow in New York. Address in 1910, 524 West 140th St., NYC.

MILIGAN, MARTHA.
Sculptor. Address in 1935, Cleveland, Ohio. (Mallett's)

MILIONE, LOUIS G., SR.
Sculptor and teacher. Born Padua, Italy, February 22, 1884. Studied: Spring Garden Institute; pupil of Charles Grafly, Herman Deigendesch, Porter, Alexander Calder, and William Chase; Phila. School of Industrial Art, and Penna. Academy of Fine Art. Member: Fellowship, Penna. Academy of Fine Arts; American Federation of Art; Alliance. Awards: Stewardson prize, 1904; Cresson Scholarship, Penna. Academy of Fine Arts, 1907, prize, 1904. Exhibited at National Sculpture Society, 1923; National Academy of Design, 1910-30; Sculpture Society, 1940-43; Penna. Academy of Fine Arts, 1910-36; Philadelphia Museum of Art; others. Work: "Brig. Gen. Kirby Smith," Vicksburg, MI; and in Church of the Redeemer, Bryn Mawr; Germantown High Sch., Phila.; Fairmount Park, PA; Philadelphia Academy of Music; various memorials, reliefs, and busts. Specialized in sculpture in stone. Address in 1953, Havertown, PA.

MILLER, BURR (CHURCHILL).
Sculptor. Born in Wilkes-Barre, PA, April 3, 1904. Studied: Yale University, Ph.B.; Yale School of Fine Arts, with Robert Eberhard; in Paris, with Bouchard; and with Jose De Creeft and Paul W. Bartlett. Work: Bishop Museum,

Honolulu. Exhibited: Penna. Academy of Fine Arts, 1930, 39; National Academy of Design, 1931, 32, 35, 36, 46; Society of Independent Artists, 1938-42; Golden Gate Exposition, 1939; World's Fair, NY, 1939; Whitney, 1940; Conn. Academy of Fine Arts, 1933, 34, 36, 37; Anderson Gallery, 1939 (one-man). Member of National Sculpture Society; Federation of Modern Painters and Sculptors; Conn. Academy of Fine Arts. Received honorable mention, Paris Salon 1907. Address in 1953, 17 MacDougal Alley; h. Gramercy Park, NYC.

MILLER, DONALD RICHARD.
Sculptor and medalist. Born in Erie, PA, June 30, 1925. Studied at Dayton Art Institute, 1947-52; Pratt Institute, 1955-57; Art Students League, 1958-61; also with Ulysses A. Ricci, 1956-60. Work in Dayton Art Institute, OH; Medallic Art Co., NY; Division of Numismatics, Smithsonian Institution; two bronze reliefs, Cincinnati Zoo; Philadelphia Zoo; Washington Cathedral; others. Has exhibited at Allied Artists of America, from 1963; National Academy of Design, 1967-74; National Sculpture Society, from 1967; Society of Animal Artists, from 1968; others. Received Mrs. Louis Bennett Prize, National Sculpture Society. Teaching sculpture at Fashion Institute of Technology, from 1972. Member of National Sculpture Society (fellow); Society of Animal Artists; American Artists Professional League (fellow); Allied Artists of America; Audubon Artists. Address in 1982, Warwick, NY.

MILLER, EDGAR.
Sculptor. Born in 1899. Exhibited: Chicago, 1933. (Mallett's)

MILLER, F. W.
Sculptor. Member: Lotos Club. Address in 1909, 41 East 30th Street, New York, NY.

MILLER (or MILER), GEORGE M.
Sculptor and modeler. Born in Scotland; came to US towards the latter part of the eighteenth century. At Phila., 1798, and from 1813; at Baltimore, c. 1810-12. He made busts of C. W. Peale, Bishop White, Commodore Bainbridge, Mrs. Madison, Mrs. Jerome Bonaparte, Jefferson, Washington and in 1798, of George Washington. He was a member of the Penna. Academy of Fine Arts exhibiting there from 1813-15, and the Columbian Society of Arts. He died in 1819.

MILLER, GEORGE WASHINGTON.
Sculptor. Exhibited: Paris, 1933. (Mallett's)

MILLER, (RICHARD) GUY.
Sculptor. Born in Pittsburgh, PA. Studied at City and Guilds of London Art Council, with Ennis Fripps, 1958; Art Students League, NY, with Will Barnet, Robert Hale; Pratt Institute, Brooklyn, NY, with Calvin Albert, M.F.A., 1965. Work in Pratt Institute, Brooklyn; stainless steel wall sculpture, New School, NY; others. Has exhibited at Guild Hall, East Hampton, NY; Heckscher Mus., Huntington, NY, 1975 and 81; Betty Parsons Gallery, NY, 1979, 80, and 81; others. Tiffany Foundation grant, 1966; MacDowell Colony Foundation fellowship, 1968; others. Member of Art Students League, NY. Works in stainless

steel; lucite. Address in 1982, 25 Minetta Lane, NYC.

MILLER, HARRIETTE G.

Sculptor and painter. Born Cleveland, OH. Member: American Woman's Association; National Association of Women Painters and Sculptors; Alliance; Grand Central Art Galleries. Represented in Whitney Museum, NYC; Corcoran Gallery, Washington, DC; and Grand Central Art Galleries. Address in 1933, Whimsy Farm, Arlington, VT; 17 rue de la Tour, Paris, France.

MILLER, HELEN ADELE LERCH.

Sculptor. Exhibited Chicago, 1934. (Mallett's)

MILLER, JOSEPH MAXWELL.

Sculptor. Born Baltimore, MD, December 23, 1877. Pupil of Maryland Institute School of Art and Design, Rinehart School of Sculpture and Charcoal Club in Baltimore; Julian Academy in Paris under Verlet. Awards: Gold medal of honor, Maryland Institute School of Art and Design, 1897; Rinehart scholarship to Paris, 1901-05; honorable mention, Paris Salon, 1902; silver medal, St. Louis Exp., 1904; Officier d'Academie, 1912; honorable mention for medals, P.-P. Exp., San Francisco, 1915. Work: "Cardinal Gibbons," Penna. Academy of Fine Arts, and Metropolitan Museum, NY; "Ishmael," St. Louis Museum; "Separation of Orpheus and Eurydice," Peabody Institute, Baltimore; "Bust of Lady," Walters Gallery, Baltimore; monuments to French soldiers, Annapolis, MD; "School Children," Baltimore, MD; "Daniel Coit Gilmore Memorial," Johns Hopkins University, Baltimore. Exhibited at National Sculpture Society, 1923. Address in 1929, Baltimore, MD. Died in 1933, in Baltimore, MD.

MILLER, JOSEPH PINDYCK.

Sculptor. Born in NYC in 1938. Study: Student apprentice to Alexander Archipenko, Woodstock, NY; Middlebury College, VT, BA, 1960; Brooklyn Museum School of Art, NY, 1960-61; Silvermine Guild School of Art, New Canaan, CT, 1960-61. US Army Illustrator, from 1961-63. One-man shows: Katonah (NY) Gallery, 1967; Sculpture 1972-1978, SUNY, Albany, 1978; Recent Steel Sculpture and Selected Work of the 70's, Bethel (CT) Gallery, 1979; Recent Sculpture & Wall Reliefs & Selected Work of 70's, Vassar College, Poughkeepsie, NY, 1981. Exhibition: Katonah (NY) Gallery, 1966-78; Rose Fried Gallery, NYC, 1968; Phoenix Gallery, NYC, 1971; Gruenebaum Gallery, NYC, 1975; 28th Annual New England Exhibition, Silvermine Guild, CT, 1977; others. Address in 1983, Brewster, NY.

MILLER, R.

Sculptor. Active 1866. Patentee—cemetery monument, 1866.

MILLER, RICHARD McDERMOTT.

Sculptor. Born April 30, 1922, in New Philadelphia, Ohio. Studied: Cleveland Institute of Art, 1940-42, 1949-51, grad., 51. Work: Butler; Columbia, SC, Museum of Art; Massillon Museum; University of Nebraska; Whitney Museum; Canton Art Institute; Hirshhorn Museum, Washington, DC; University of Houston. Exhibited: Peridot Gallery, 1964, 66, 67, 69, Feingarten, Los Angeles,

1966; Duke University, 1967; Raleigh (NC) Museum of Art, 1967; Cleveland Museum of Art, 1968; Alwin Gallery, London, 1968; Whitney; National Institute of Arts and Letters; Baltimore Museum of Art; Butler, Sculpture Annual, 1970; Penna. Academy of Fine Arts, 1981; others. Awards: May Page Scholarship, Cleveland Institute of Art, 1951; Butler purchase prize, 1970; gold medals, National Academy of Design, 1974 and 81; Sculpture Award, American Academy and Institute of Arts and Letters, 1978. Taught at Queens College, NYC, from 1967. Address in 1983, 53 Mercer St., NYC.

MILLER, ROSE SHECHET.

Sculptor. Studied: Boston Museum of Fine Arts; Massachusetts College of Art. Awards: Brockton Art Association, 1965; Newport, RI, Art Assoc., 1974; National Community Art Program, Washington, DC, 1974. Exhibitions: Eastern States Exposition, 1964; Boston Visual Artists' Union Gallery, 1975; M.I.T. Faculty Club, 1975.

MILLER, VEL.

Sculptor and painter. Born in Nekossa, WI, January 22, 1936. Studied at Valley College, Los Angeles; Art Students League of Los Angeles, with Hal Reed, Max Turner. Taught at Art Students League, Los Angeles, and Long Beach State College. Work in La Galeria, Sedona, Arizona; Barry Goldwater Collection, Scottsdale, Arizona; others. Exhibited at Nebraskaland Invitational, North Platte, Nebraska; Peterson Gallery, Beverley Hills, California; La Galeria, Sedona, Arizona; others. Won gold medal, sculpture, California Art Club; bronze medal, watercolor, George Phippen Memorial, Prescott, Arizona; others. Specialty is Western subjects, as seen through the eyes of a woman. Sculpts in bronze; paints in oils and watercolor. Reviewed in *Southwest Art*, November 1976; *Artists of The Rockies*, summer 1981. Represented by Overland Trail Galleries, Scottsdale, AZ. Address in 1982, near Atascadero, CA.

MILLER, WILLIAM.

Sculptor. Born in Providence, Rhode Island. He executed a series of large medallions of distinguished native citizens, civil and military.

MILLES, CARL.

Sculptor and teacher. Born in Lagga, Sweden, 1875. Apprenticed to cabinet-maker in Stockholm in 1892. Studied at the Technical School, Stockholm; Ecole des Beaux-Arts, Paris. Became an assistant to Rodin in Paris. Taught at Royal Academy in Stockholm, Cranbrook Academy of Art in Michigan. Became a US citizen in 1945. Work: monuments, memorials, and figures, Whitney Museum of American Art; Cranbrook Academy of Art; City Hall, St. Paul, Minn.; Art Institute of Chicago; Tate Gallery, London; heroic figures, fountains, etc., in many cities in Sweden. Member: National Institute of Arts and Letters; National Sculpture Society. Awarded prize, Golden Gate Exposition, 1939. Address in 1953, Cranbrook Academy of Art, Bloomfield Hills, Mich. Died in Lidingo, Sweden, 1955.

MILLIS, CHARLOTTE (MELISSA).

Sculptor. Born in Palo Alto, Calif., Dec. 23, 1906. Studied

at University of Chicago, Ph.B.; Art Institute of Chicago, B.F.A.; Carnegie Art Center, University of Oregon. Works: International Business Machines collection; Church of the Redeemer, Chicago, IL. Exhibited: Art Institute of Chicago, 1935, 46-50; New York World's Fair, NYC, 1939; Oakland Art Gallery, 1942; Minneapolis Institute of Art, 1935-37, 39, 41, 42, 44; St. Paul Gallery, 1941-45; Syracuse Museum of Fine Art, 1950; and many others. Taught art at Macalester College, St. Paul, MN, 1944-45; and was assistant professor of art at George Williams College, Chicago, IL, from 1950. Member: Artists Equity Association; Renaissance Society; Midwest Sculptors and Potters. Awards: Minneapolis Institute of Art, 1935, 36, 41, 44; Minnesota State Fair, 1942; Walker Art Center, 1944. Address in 1953, 5315 South Drexel Avenue; h. 5744 Kenwood Avenue, Chicago, IL.

MILLMORE, JOSEPH.
Sculptor. Born in Ireland in 1842. Brother of Martin Millmore. He worked with his brother on the memorial to the Union dead in Mount Auburn Cemetery, Cambridge, MA. He died in Geneva, Switzerland, 1886.

MILLMORE, MARTIN.
Sculptor. Born in Ireland, 1845. He entered the studio of Thomas Ball in Charlestown in 1860. He soon took a studio and modeled busts of Longfellow and Sumner, and also executed marble statues for Horticultural Hall, Boston. Millmore executed a bust of George Ticknor for the Public Library, Boston; also busts of C.O. Whitmore, General Thayer, and an ideal bust of "Miranda." He died in Roxbury, MA, 1883.

MILLS, AGNES.
Sculptor and printmaker. Born in NYC. Studied at Cooper Union Art School, graduate; Pratt Institute, BFA; New York University School of Architecture; Art Students League; Design Lab.; American Artists School; and with Raphael Soyer, Yasuo Kuniyoshi, and Ruth Leaf. Works: Hunterdon Co. Museum, Clinton, NJ; University Maine, Amherst; Washington Society Painters, Sculptors, and Printmakers; California School Arts and Crafts, Oakland; C. W. Post College. Exhibitions: Audubon Annual, National Academy of Design, 1970 and 71; Butler Institute of American Art Annual, 1971-72; Penna. Academy of Art Annuals, 1973; Okla. Art Museum Annual Printmaking Exhibition, 1973 and 74; Seattle Art Museum Annual, 1974. Awards: First Prize in Printmaking, Washington Miniature Prints and Sculpture, 1970; Purchase Prize, Hunterdon Co. Art Museum, 1972; Purchase Award, Nassau Community College, 1974. Media: Etching in color, colograph; acrylics, welded steel.

MILLS, CLARK.
Sculptor. Born near Syracuse, NY, December 13, 1810/15. He lived in Charleston, SC, where he discovered a method of taking casts from the living face. He executed busts of a number of eminent South Carolinians. He designed the Jackson monuments in Washington and New Orleans; a scene in the battle of Princeton with a statue of Washington which was dedicated in Washington, DC, on February 22, 1860; also was commissioned to cast a bronze of Crawford's "Freedom" for the U.S. Capitol Dome. He died January 12, 1883, in Washington, DC.

MILLS, DODIE.
Sculptor. Born in St. Louis, MO, November 2, 1906. Studied: Art Students League; and with Charles Nielsen. Exhibited: Morgan Gallery; Bonestell Gallery; Tricker Gallery; Roerich Museum. Address in 1953, 38 West 57th Street, New York, NY.

MILLS, F.
Sculptor. Active 1865. Patentee—bust of Lincoln, 1865.

MILLS, J. HARRISON.
Sculptor, painter, and poet. Born in Buffalo, New York, 1842. His early life was spent in Denver, CO. He was long a member of the New York Water Color Club. Works held at Buffalo Academy of Fine Arts. Died in Buffalo, NY, October 25, 1916.

MILLS, THEODORE AUGUSTUS.
Sculptor. Born in Charleston, SC, in 1839. Eldest son of Clark and Eliza S. Mills. During his boyhood he pursued modeling as an amusement, without regular instruction, until 1860, when he entered the Royal Art Academy of Munich as a pupil. Received a prize for his composition "Penelope Presenting the Bow of Ulysses to the Suitors" at the Acad. Returned to United States and commenced work in the studio of his father, Clark Mills, then engaged in making a model for a proposed memorial in Washington to President Lincoln; was afterwards employed by the National Museum, Washington, and later at the Carnegie Institute, Pittsburgh. Noted for his Indian groups. He died December 1916, Pittsburgh, PA.

MILLS, THEOPHILUS.
Sculptor. Born in Charleston, SC, c. 1842. Second son of Clark Mills. Living in Washington, DC, in 1860.

MILLS, LOREN STURDEVANT (STURDY).
Sculptor and designer. Born in Atkinson, Nebraska, January 8, 1915. Studied: Minneapolis School of Art; Kansas City Art Institute; University of Nebraska. Exhibited: Syracuse Museum of Fine Arts, 1940; Minneapolis Institute of Art, 1935; St. Paul Artists, 1935; Kansas City Art Institute, 1938-40; Nelson Gallery of Art, 1941; Missouri State Fair, 1938-41; Philbrook Art Center, 1940; Nebraska Art Museum, 1946; Lincoln Art Guild, 1946; Joslyn Art Museum, 1950. Taught: Instructor of Sculpture and Ceramics, Kansas City Art Institute, Kansas City, MO, 1938-40. Address in 1953, Lincoln, Neb.

MILROY, HARRY C.
Sculptor. Member: Independent Society of Sculptors. Address in 1924, Delphi, IN.

MIM, ADRIENNE C. (ADRIENNE CLAIRE SCHWARTZ).
Sculptor and painter. Born in Brooklyn, NY, February 4, 1931. Studied at Brooklyn Museum Art School and Brooklyn College, NY, 1950; Hofstra University, 1965. Work at Guild Hall, East Hampton, NY; Sculpturesites, Amagansette, NY. One-man shows: Fordham at Lincoln Center—Robert Moses Plaza; Phoenix II Gallery; Guild Hall. Group shows: Heckscher Mus., Huntington, NY; Brooklyn Museum; Parrish Museum, Southampton, NY;

Pace University. Received Fellowship, MacDowell Colony; Helen B. Ellis Memorial Prize, National Association of Women Artists, 1980; Silver Medal, Audubon Artists, 1980. Member of Federation of Modern Painters and Sculptors; National Association of Women Artists; Sculptors Guild. Works in fiberglas, steel; oil, mixed media. Address in 1982, East Hampton, NY.

MIMNAUGH, (MARY THERESA) TERRY.
Sculptor and painter. Born in Renton, Washington, in 1954. Studied art in high school and college; also self-taught; apprenticed to cowboy-artist-foundryman. Won commission to model Jeannette Rankin. Sculpts statuettes and heroic figures in bronze. Represented by Sherwood Gallery, Great Falls, MT; Ponderosa Gallery, Kalispell, MT. Address in 1982, Renton, Washington.

MINAZZOLI, EDWARD A.
Sculptor. Born Momo, Italy, August 16, 1887. Pupil of Art Students League of NY; Niehaus, Fraser, Bartlett; Antonin-Mercie at Ecole des Beaux Arts in Paris. Member: American Art Association of Paris; American Federation of Arts. Awards: Chevalier Order of Donilo, 1918; Chevalier of the Crown of Italy, 1922; hon. mention, Paris Salon, 1929, and medal, 1932; Officier d'Academie, 1932. Works: Groups, "Apparition N.D. de Lourdes" and "St. Theresa of Lisieux," at Cathedral of Chatillon, Loire, France; group, Fountain Garden, Poughkeepsie, NY; statue, West New York. Many notable portrait busts. Address in 1933, 18 Bld. Edgar Quinet; h. 17 bis Rue Campagne Premiere, Paris XIV, France; 60 19th Street, West New York, NJ.

MINER-COBURN, JEAN P.
Sculptor. Born in Menasha, WI. Pupil of Art Institute of Chicago. Member: Palette Club. Address in 1898, 6329 Stewart Ave., Chicago, IL.

MINER-WICKES, LINDA.
Sculptor. Born in Albuquerque, New Mexico, in 1941; raised in Santa Fe, New Mexico. Studied with painter Josef Bakos and at California College of Arts and Crafts. Lived in Europe and Colorado before returning to Santa Fe. Worked at Shidoni Foundry, Tesuque, NM. Specialty is stylized bronze and concrete fountains. Exhibits at Von Grabill Gallery, Paradise Valley, AZ; Shidoni, Tesuque, NM. Address since 1972, Santa Fe, New Mexico.

MINISCI, BRENDA (EILEEN).
Sculptor and ceramist. Born in Gowanda, NY, June 15, 1939. Studied at Rhode Island School of Design, Rome, Italy, 1960-61, Providence, B.F.A., 1961; Cranbrook Academy of Art, Bloomfield Hills, MI, M.F.A., 1964; Provincetown Fine Arts Workshop, with Harry Hollander. Work in Everson Museum, Syracuse, NY; Fitchburg Art Museum, MA; fiberglas fountain sculpture and clear cast polyester resin sculpture, University of Mass., Amherst; others. Exhibited at Cranbrook Art Museum, Bloomfield Hills; Museum of Contemporary Crafts, NY; Smithsonian Institution; Everson Museum, Syracuse; Seven Sculptors, Boston City Hall Galleries, Mass.; others. Received award for sculpture, Providence Rhode Island Art Club; purchase prize for sculpture,

Berkshire Museum, North Adams College; others. Taught ceramics and sculpture at University of Mass., Amherst, 1967-71; teaching ceramics and sculpture at Williston-Northampton School, Easthampton, Mass., from 1971. Address in 1982, North Hatfield, MA.

MINTICH, MARY RINGELBERG.
Sculptor and craftsman. Born in Detroit, MI. Studied: Albion College; Indiana University, B.A.; Queens College; University of Tenn.; University of North Carolina at Greensboro, M.F.A. Exhibited: Arts Showcase '79, Mint Museum; Green Hill Gallery, 1980; Greenville Museum, 1981; Rowan Gallery, 1981; others. Awards: Mint Museum, Charlotte, NC, 1971; Purchase Awards, Ceramics National and 8th Regional Piedmont Crafts Exhibition; honorable mention, Springs Mill Travelling Exhibition, 1976. Collections: Everson Museum, Syracuse, NY; Mint Museum of Art, Charlotte, NC; Sea Islands Development Corp. Member: Visual Arts Coalition; Mint Museum (advisory committee). Taught: Sacred Heart College, 1967-73; Penland School of Crafts, 1972; associate professor of sculpture, design, and metals, Winthrop College, from 1972. Address in 1982, Belmont, NC.

MIRALDA, ANTONI.
Sculptor. Born in Barcelona, Spain, October 2, 1942. Studied at School of Textile Engineers, Tarrasa, 1956-61; Cours de Methode Comparee des Arts Plastiques; Centre International d'Etudes Pedagogiques, Sevres, France, 1962-64. Work in Moderna Museet, Stockholm; National Center for Art and Culture, Paris; others. Has exhibited at Museum of Modern Art, Paris; Museum of Contemporary Crafts, NY; Metropolitan Museum of Art, NY; Documenta 6, Kassel, Germany; Contemporary Arts Museum, Houston. Address in 1982, 24 Harrison St., NYC.

MIRANDA, FERNANDO.
Sculptor. Exhibited at National Sculpture Society, New York.

MIRKO, (MIRKO BASALDELLA).
Sculptor. Born 1910 in Undine, Italy. Studied in Venice, Florence, and Rome. Director of Design Workshop at Harvard University since 1957. Received awards from Sao Paulo Museum; the Carrara sculpture prize; and gold medal from Republic of Italy. Exhibited at Galleria La Cometa (Rome), 1935; Comet Gallery, NYC (1947, 1949); RI School of Design; Institute of Contemporary Art (Boston); University of Illinois; many other international galleries.

MISERENDINO, VINCENZO.
Sculptor. Born in Italy, January 29, 1876. Pupil of Loiacolo. Address in 1925, 1947 Broadway, New York City.

MISH, CHARLOTTE (ROBERTA).
Sculptor, painter, illustrator, craftswoman, writer, and teacher. Born Lebanon, PA, August 17, 1903. Pupil of W. L. Judson, F. Tadema, F. Vincent DuMond, Art Students League of NY; College of Fine Arts, University of Southern California. Member: Portland Art Association; Ore-

gon Society of Artists. Work: Music Box Theatre, Seattle. Address in 1933, Portland, OR.

MISS, MARY.
Sculptor. Born in NYC, May 27, 1944. Studied at the University of Calif., Santa Barbara, BA, 1966; Rinehart School of Sculpture, Maryland Art Institute, Baltimore, MFA, 1968. Exhibited: Whitney Museum of American Art Sculpture Annual, NYC, 1970; Larry Aldrich Museum, Ridgefield, CT, 1971; Allen Memorial Art Museum, Oberlin College, OH, 1973; Whitney Museum Painting and Sculpture Biennial, NYC, 1973; one-woman shows held at the Salvatore Ala Gallery, Milan, Italy, 1975. Awards: New York State Council on the Arts CAPS Grant, 1973 and 76; Nat. Endowment Awards, 1974, 75. Taught: Instructor at the School of Visual Arts, NYC, 1972; visiting artist at Pratt Institute, Brooklyn, NYC, 1973; Hunter College, NYC, 1972-75; Sarah Lawrence College, Bronxville, NY, from 1976. Address in 1982, Canal St. Station, NYC.

MITCHAM, GEORGIA WHITMAN.
Sculptor. Born in Providence, RI, July 4, 1910. Studied at Slade School of Art, University of London; with Naum M. Los, NY. Works: American Museum of Natural History, NY; Smithsonian Institution, Washington, DC; Bennington Museum, VT; Norwich University, Northfield, VT; Harvard University, Cambridge, Mass. Commissions: Two champion Angus Bulls, commissioned by Gifford Cochrane, North Salem, NY; bas-relief of dinosaur, American Museum of Natural History; plus others. Exhibitons: One-man shows, Studio Guild, NY, 1938, Southern Vermont Art Center, Manchester, 1969 and Bennington Museum, 1972, 73; Child's Gallery, Boston, 1964. Awards: First for Sculpture, North. Vt. Artists, 1963, Saratoga Art Festival, NY, 1964, and Norwich Show, Northfield, VT, 1975. Member of Southern Vermont Art Center and National League of American Pen Women. Media: Aluminum, lead, and iron. Address in 1980, Middlebury, VT.

MITCHELL, BENJAMIN T.
Sculptor. Born Jan. 12, 1816, in Muncy, PA; he settled in Nauvoo, IL, in 1841; moved to Utah in 1848. Cut the first capital for the Mormon Temple at Nauvoo, Ill., about 1844. Died in Salt Lake City on March 9, 1880.

MITCHELL, EVA BLANCHE.
Sculptor. Born in Williamsport, PA, April 1, 1872. Pupil of Lorado Taft. Address in 1921, Harlan Road, Riverside, Ill.

MITCHELL, GEORGE BERTRAND.
Sculptor, painter, writer, and lecturer. Born in East Bridgewater, MA, April 18, 1872. Studied: Cowles Art School, Boston; Julian Academy, Ecole des Beaux-Arts, Paris, France. Work: Agricultural Dept., State of Conn.; Marine Historical Association, Mystic, Conn.; Lyman Allyn Museum. Exhibited: American Watercolor Society, 1945, 46; Salmagundi Club, 1917-51; others. Awards: Honorable mention, Paris, Salon, 1890. Member: American Watercolor Society; Salma. Club; Mystic Art Association; Rutherford Art Association; American Artists Professional League; Marine Historical Assoc. Address in 1953, Mystic, CT; h. Rutherford, NJ.

MITCHELL, GLADYS VINSON (MRS.).
Sculptor and painter. Born in Albuquerque, NM, March 1, 1894. Pupil of Boyer Gonzales and E.G. Eisenlohr. Member: Chicago Artists' Guild. Award: Silver medal, Woman's Forum, Dallas Art Association, 1916. Work: "Snow Composition," Museum of Santa Fe; represented in collection of Houston Artists' League. Address in 1924, 139 South Elmwood Ave., Oak Park, IL.

MITCHELL, GURNSEY.
Sculptor. He was a graduate of the Ecole des Beaux Arts in Paris. Worked and exhibited in Paris, where he won honorable mention in 1890. Among his best known works are the statue of Martin B. Anderson, former president of the University of Rochester; "Aurora;" "The Young Botanist;" and "David and Goliath." Died in Rochester, NY, August 1, 1921.

M'KENZIE, J.
Sculptor and carver. At Charleston, South Carolina, 1846.

MOCHARNIUK, NICHOLAS (NIMO).
Sculptor, designer, and craftsman. Born in Philadelphia, PA, May 11, 1917. Studied: Girard College, Phila., PA. Member: League of Present-Day Artists; Woodstock Art Association. Awards: Prize, Springfield Mus. of Art, 1945. Work: Springfield (MO) Museum of Art. Exhibited: Marquie Gallery, 1943-46 (all one-man); Allied Artists of America, 1945; Audubon Artists, 1945; League of Present-Day Artists, 1946. Address in 1953, 318 Canal Street, New York, NY; h. Butternut Hill Farm, Gilboa, NY.

MOCHI, UGO.
Sculptor and painter. Born in Florence, Italy, in 1889. US citizen. Studied: Academy of Fine Arts, in Florence, 1899; scholarship to the Art Academy, in Berlin, Germany, 1910; sculpture with August Gaul. Exhibited sculpture in London, 1922, where Queen Mary purchased his works for the Royal Collection at Windsor Castle; New York Museum of Science and Industry; Columbia University; College of New Rochelle; Albany Institute of History and Art (one-man), 1974; others. Exhibitions of outline art included Windsor Castle; Berlin Museum of Natural History; Metropolitan Museum of Art; and the Museum of Natural History, New York City. Awards: Award for museum work, New York Zoological Society, 1969; first prize for graphics, Federation of Westchester Art Clubs, 1952, and Beaux-Arts, White Plains, NY, 1971. Member: New York Society of Animal Artists (ranking officer); New York Zoological Society; Audubon Artists.Address in 1976, New Rochelle, NY. Died 1977.

MODEL, ELISABETH DITTMANN.
Sculptor and painter. Born in Bayreuth, Bavaria, in 1903. Became a US citizen. Studied at College of Art, and with Walter Thor and Cericioli, Munich, Bavaria; Academy of Art, Amsterdam, Holland; and in Paris with Kogan. Works: Corcoran Gallery of Art; Wadsworth Atheneum; Jewish Mus., NY; Rykspreuteu Cabinet, Amsterdam, Holland; Washington. Exhibitions: One-woman shows in Europe, NYC, Washington; Museum of Fine Arts, Phila.; Museum of Fine Arts, Boston; Brooklyn Museum;

Stedelijk Museum, Amsterdam, Holland; plus many others. Awards: National Association of Women Artists, 1950, 51, 52; Brooklyn Society of Art, 1953, 54. Member: Federation of Modern Painters and Sculptors (corr. sec.). Taught: Private lessons in Amsterdam, Holland, 1930-38 and in NYC, 1942-48. Address in 1982, 340 W. 72nd St., NYC.

MODJESKA, FELICIE M.
(Mrs. Ralph Modjeska). Sculptor. Born in Cracow, Austrian-Poland, February 2, 1869. Pupil of Taft, Mulligan, and Polasek. Address in 1918, 1216 Astor St., Chicago, IL; summer, 220 Michigan Ave., Chicago, IL.

MOELLER, HENRY NICHOLAS.
Sculptor and painter. Born New York City, January 5, 1883. Pupil of Hinton, Curran, MacNeil, Aitken. Work: Memorial tablet to Elisha Kent Kane in the Grand Lodge of Masons of Cuba. Address in 1933, 140 West 88th Street, New York, NY.

MOFFITT, JOHN M.
Sculptor. Born in England in 1837. He came to the United States as a youth. He designed the figures that represent the four ages of man at the entrance to Greenwood Cemetery, the reredos in the Packer Memorial Church, and many altars in the principal churches of New York. He died in 1887.

MOHOLY-NAGY, LAZLO.
Sculptor, painter, and photographer. Born July 20, 1895, Bacsbarsod, Hungary; came to US in 1937. Studied: Univ. of Budapest, 1913-14, LLB. Work: Art Inst. of Chicago; Dayton Art Inst.; Detroit Inst.; Los Angeles Co. Museum of Art; Museum of Modern Art; San Fran. Museum of Art; Guggenheim. Exhibited: Stedelijk; Hamburg; Mannheim; Cologne; Budapest (National); Stockholm (National); The London Gallery, London, 1937; Harvard Univ., 1950; Zurich, 1953; Kunst Kabinett Klihm, 1956, 59, 62, 66; Kleemann Gallery, NYC, 1957; Dusseldorf, 1961; Guggenheim; Art Inst. of Chicago; Whitney Museum; Yale Univ.; Museum of Modern Art, The Machine as Seen at the End of the Mechanical Age, 1968, and others. Taught: Staatliche Bauhaus, Berlin, 1922; founding collaborator, with Gyorgy Kepes and Robert Wolff, of the Inst. of Design, Chicago, 1938-42; director of the New Bauhaus, Chicago. Designed for State Opera and the Piscator Theatre, Berlin, 1928. Died November 24, 1946, Chicago, IL.

MOIR, ROBERT.
Sculptor, painter, and teacher. Born in Chicago, Ill., January 7, 1917. Studied: Art Institute of Chicago; Columbia University; NYU; Art Students League. Work: Honolulu Academy of Art; Whitney Museum; Rittenhouse Savoy, Philadelphia, PA. Exhibited: Art Institute of Chicago, 1940, 41, 48; Whitney Museum, 1951-55, 56; Metropolitan Museum of Art, 1951, 52; Sculpture Center, NY, 1951 (one-man); Sculptor's Guild, Lever House, NY, 1959, 60. Member: New Sculpture Group; Sculptors Guild. Address in 1980, 400 East 93rd Street, New York, NY.

MOLIN, C. GUNNAR.
Sculptor, painter, and etcher. Born in Stockholm, Sweden.

Pupil of Art Students League of New York. Member: Scandinavian-American Artists; American Artists Professional League. Address in 1933, 180 State St., Brooklyn, NY.

MOLINE, BOB.
Sculptor and painter. Comanche Indian, born in Amarillo, TX, in 1938. Worked in saddle making, designed own hand-tooling patterns. Turned to art full-time in 1973. Has won numerous gold medals in shows of his work. Specialty is contemporary Indians and cowboys. Paints in acrylic watercolor. Founded Ten in Texas (XIT), an artists' group. Reviewed in *The Cattleman*, October 1981. Represented by Signature Gallery and Trailside Galleries, Scottsdale, AZ. Address since 1961, Fort Worth, TX.

MONAGHAN, WILLIAM SCOTT.
Sculptor and painter. Born in Philadelphia, PA, November 1, 1944. Studied at Yale University, B.A.; Harvard Graduate School of Design, M.A. Work in Addison Gallery of American Art, Andover, MA; Aldrich Museum of Contemporary Art, Ridgefield, CT; sculpture, Boston 200 Bicentennial Art Collection. Has exhibited at Sculptors' Workshop Show, Addison Gallery of American Art; Institute of Contemporary Art, Boston; Soho Center for Visual Artists, NY; others. Works in metal, cloth, and paint. Address in 1982, 165 Perry St., NYC.

MONNIER, FRANCE X.
Sculptor. Born in Belfort, France, 1831. Worked: New York City; Detroit. Died in Detroit, April 5, 1912.

MONRAD, MARGARET.
Sculptor and teacher. Born in New Zealand, June 10, 1879. Pupil of Royal American Federation of Arts, Copenhagen; sculpture in Italy. Member: National Association of Women Painters and Sculptors; New Haven Paint and Clay Club; Plainfield Art Association. Teaching: Instructor, Industrial and Fine Arts Department, Hampton Institute, Virginia. Address in 1933, Hampton Institute, VA; 166 Putnam Avenue, Hamden, New Haven, CT.

MONSSEAU (MONCEAU), P. H.
Sculptor. Worked: New Orleans, 1838-1860's.

MONTANA, PIETRO.
Sculptor and painter. Born Alcamo, Italy, June 29, 1890. US citizen. Studied at Cooper Union Art School and the Mechanics Institute; pupil of George T. Brewster. Member: Fellow, National Sculpture Society, NY; National Academy of Design; Allied Artists of America (treasurer, 12 years); Artist's Fellowship (treasurer, 4 years); Hudson Valley Art Association; Architectural League of New York. Represented in Georgia Museum of Art, Athens; American Numismatic Society, NY; Brookgreen Gardens, SC; others. Work: "Doughboy Monument," NY; War Monument, Heisser Square, Brooklyn; "The Dawn of Glory," Highland Park, Brooklyn; "Mark Twain and Washington Irving," memorial tablet, New York City; "The Minute Man," East Providence, RI; "Mother Davison," Governor's Island, NY; War Memorial, Sicily, Italy; "Weisserberger Memorial," City Cemetery, Alliance, Ohio; Stations of the Cross, Fordham University, NY,

1947-52. Exhibited at National Academy of Design Annual, NY, 1921, 31; Allied Artists of America Annual, NY, from 1932; Hudson Valley Art Association, White Plains, NY, from 1937; National Sculpture Society, from 1923. Awards: Elizabeth M. Watrous gold medal, National Academy of Design, 1931; National Sculpture Society, 1962; Hudson Valley Art Association, 1962. Teaching: Instructor of sculpture, Master Institute of Arts, New York City, 1931-34; Fordham University, 1947-52. Address in 1976, Rome, Italy. Died in 1978.

MONTGOMERY, MAURINE.
(Mrs. T. Harrison Gibbs). Born in Wyanet, Ill., June 25, 1906. Studied with Carl Milles; private study, sculpture, Cranbrook Art Academy, Bloomfield Hills, Mich., 1932-36; in Italy, 2 yrs. Exhibitions: Group shows, Penna. Art Academy; Chicago Art Institute; executed sculptured mural, "The Letter," in US Post Office, Homewood, Ill. Member: Phila. Art Alliance; Art Center, and Amateur Musical Club, Peoria, Ill.; Alpha Phi. Address in 1962, 3905 Lynnwood Place, Peoria, Ill.; 1430 County Line Road, Rosemont, PA.

MOORE, E. BRUCE.
Sculptor. Born Bern, Kansas, August 5, 1905. Pupil of Penna. Academy of Fine Arts, with Charles Grafly, Albert Laessle. Member: Academician, National Academy of Design; National Sculpture Society; Fellowship Penna. Academy of Fine Arts; Wichita Art Guild. Award: Widener gold medal, Penna. Academy of Fine Arts, 1929, Cresson traveling scholarship, 1925, 26; Guggenheim Fellowship, 1929-30, 30-31; prizes, National Academy of Design, 1935, 37; grant, National Inst. of Arts and Letters, 1943; Henry Hering Memorial Medal, National Sculpture Society, 1968; others. Work: Whitney; Penna. Academy of Fine Arts; Brookgreen Gardens, SC; American Academy in Rome; two bronze tigers, Princeton Univ.; portrait busts of Col. Thomas Fitch and Henry Wallenstein, Wichita Consistory; portrait bust of Dr. A. H. Fabrique, Wichita Medical Society; "Feline," High School, Wichita; sculptural designs and terra cotta decorations on high school, Wichita. Exhibited: Whitney Museum, 1942; National Institute of Arts and Letters, 1943; Virginia Museum of Fine Arts, 1958; Mostra Art Mod., Comaiore, Italy, 1968; others. Address in 1976, Washington, DC. Died in 1980.

MOORE, LON W. R.
Sculptor. Address in 1898, 126 Athenaeum Building, Chicago, IL.

MOORE, LOU WALL (MRS.).
Sculptor. Member: Chicago Society of Artists. Award: Bronze medal, St. Louis Exposition, 1904. Address in 1926, 5476 Ridgewood Court, Chicago, IL.

MOORE, MARTHA.
(Mrs. Charles H. Rathbone, Jr.). Sculptor. Born New Britain, CT, December 30, 1902. Pupil of Archipenko and Heinz Warneke. Member: National Arts Club; Society of Independent Artists. Address in 1933, 75 Central Park West, New York, NY.

MOORE, MARY E.
Sculptor. Born in Taunton, MA. Studied at the school of the Boston Museum of Fine Arts, and was a pupil of Bela L. Pratt, Charles Grafly, and Frederick W. Allen. Works: Dudley Buck, Church of the Holy Trinity, Brooklyn, NY; W. W. Bond, Public Library, Hartford, CT; Rev. Charles F. Hoffman, Trinity College, Hartford, CT; relief, Charles M. Eliot; wall fountains, Huntington, LI, and Chesnut Hill, MA; Iris fountain, Shrewsbury, MA; shell bird-bath; fountain figure; bust H. T. Greene. Awards: Fairmount Park Art Association prize, Penn. Academy of Fine Arts, 1928; gold medal, Penn. Horticultural Society, Philadelphia Art Alliance, 1928; medal, Concord Art Association, 1928. Membership: Guild of Boston Artists; Boston Society of Sculptors.

MOORE, MAUD ISABELL.
Sculptor. Address in 1898, 1403 Sherman Avenue, Evanston, IL.

MOORE, VIRGINIA LEE.
Sculptor and printmaker. Native of Cleveland, OH. Studied at the Cleveland Institute of Art, BFA; and Western Reserve University, BA in education; also studied at Wittenberg University. Member: James Ward Art League, Champaign County Arts Council, Western Ohio Watercolor Society, Ohio Watercolor Society. Numerous private showings of her art.

MOORE, WILLIAM A.
Sculptor and painter. Born in Glendale, CA, in 1936. Studied at Art Center College of Design, Los Angeles, 1956-58. Technical illustrator in missiles and aircraft industry; formed own graphic art and industrial design business; corporate art director. Turned to painting full-time in 1978. Specialty is subjects showing the history of early man and the wilderness. Sculpts in bronze. Represented by Riata Gallery, Virginia City, NV; Artists Co-op Gallery, Reno, NV. Address since 1968, Reno, NV.

MOQUIN, RICHARD ATTILIO.
Sculptor. Born in San Francisco, CA, July 1, 1934. Studied at City College of San Francisco, A.A.; San Francisco State College, B.A. and M.A., with Seymour Locks. Work in Oakland Museum; San Francisco Museum of Art; others. Has exhibited at Ceramic National, Everson Museum, Syracuse, NY; M. H. De Young Museum Show, San Francisco; Stanford University Sculpture Invitational; others. Received an award from M. H. De Young Museum, 1970; others. Teaching sculpture at City College of San Francisco, from 1969. Works in clay and plastic. Address in 1982, Kentfield, CA.

MORA, DOMINGO.
Sculptor. Born in Catalonia, Spain. Studied in Barcelona and Madrid. Member of National Sculpture Society. Worked in Montevideo, Uruguay, where he is represented in museums. Exhibited at National Sculpture Society, NY. Address in 1910, Mountain View, Santa Clara, CA. Died in San Francisco, July 24, 1911.

MORA, JOSEPH JACINTO.
Sculptor. Born Montevideo, Uruguay, October 22, 1876. Pupil of Domingo Mora; J. DeCamp; J. C. Beckwith. Member: National Sculpture Society. Work: "Cervantes Monument," San Francisco, CA; "Doughboy," San

Raphael, CA; "Bret Harte Memorial," Bohemian Club, San Francisco, CA; "Junipero Serro Sarcophagus," Mission, San Carlos, Carmel, CA; heroic pediments, Don Lee Building and Stock Exchange, San Francisco, CA, Pacific Mutual Building, Los Angeles; heroic figures, Scottish Rite Temple, San Jose, CA; four heroic bronzes, Ponca City, OK. Address in 1933, Pebble Beach, CA; h. Carmel, CA.

MORAHAN, EUGENE.
Sculptor. Born Brooklyn, NY, August 29, 1869. Pupil of Augustus Saint-Gaudens. Member: Painters and Sculptors; Santa Monica Art Association; National Sculpture Society. Work: Alfred Gwynne Vanderbilt memorial fountain, Newport, RI; Elks Memorial, Buffalo; Soldiers and Sailors Memorial, Carroll Park, Brooklyn, NY; Cuddy Memorial, St. Barnabas' Church, Bexhill, England; Gen. Samuel Welch Monument, Buffalo, NY. Address in 1933, Santa Monica, CA.

MORAN, BETTIE J.
Sculptor and painter. Born in Wellington, Texas, in 1925. Has exhibited at Museum of New Mexico since 1949. Oil painting published in 1982 New Mexico art calendar. Sculpts in bronze; paints in oils and acrylic. Style is traditional, non-objective, and abstract. Represented by Lundeen Gallery, Las Cruces, NM; Mountain Road Gallery, Albuquerque, NM. Address since 1968, Albuquerque, New Mexico.

MORANI, SALVATORE.
Sculptor. Address in 1919, 705 Walnut St., Philadelphia, PA.

MORCOS, MAHER NAGUIB.
Sculptor and painter. Born near Cairo, Egypt, February 23, 1946. Illustrating textbooks by age 15, he studied at Cairo University, degree in architecture and degree in art (anatomy). Came to US in 1972. Executed bust, Egyptian President Nasser, Ministry of Education, Cairo; mural, Valley National Bank, Scottsdale, AZ; other commissions. Has exhibited at Charles Russell Museum, Great Falls, MT; American Institute of Contemporary Art, San Dimas, CA; George Phippen Show, Prescott, AZ; others. Specialty is romantic Old West. Works in bronze; oil and watercolor. Member of American Indian and Cowboy Artists. Reviewed in *Southwest Art*, April 1978. Represented by Eagle Art Gallery, La Jolla, CA; and Circle Galleries, NYC. Address in 1982, San Diego, California.

MORE, THOMAS.
Ship carver. Active in Portsmouth, NH, in 1707; in Kittery, ME, in 1720; later lived in Boston with his son Samuel, also a carver. Executed lion figurehead while in Kittery.

MORENON, ERNEST E.
Sculptor. Member: National Sculpture Society. Address in 1982, Newton, MA.

MORETTI, GIUSEPPE.
Sculptor. Born in Italy, 1859. Came to New York and exhibited at the National Sculpture Society. Died in 1935.

MORGAN, ARTHUR C.
Sculptor, painter, designer, teacher, and writer. Born in Riverton Plantation, Ascension Parish, LA, August 3, 1904. Studied with Borglum, Korbel, McCarten, Beaux Arts Institute of Design. Work: Southwestern Institute of Art; bust of "Dr. James Monroe Smith," Louisiana State University, and bust of "Dr. George A. Sexton," Centenary College, Shreveport, LA; architectural bronzes and stone carvings, US Post Office and Court House, Alexandria, LA; heroic figure, Chief Justice Edward Douglass White, US Capitol, Wash., DC; A. J. Hodges Commemorative Bust, Hodges Gardens, Many, LA; "Don Quixote and Sancho Panza," "Thais," "Nymph and Faun," and "Satyr," Gorham Co., NYC. Exhibited: Louisiana State University, 1927, Southwestern Institute of Art, 1938; LA State Exhibition, 1940, 50; Philbrook Art Center, 1952 (all one-man). Director of Fine Arts, instructor of sculpture, painting, drawing, and art history, Centenary College, Shreveport LA; director, Southwestern Insitute of Art, Shreveport, LA, 1934-74. Media: Bronze, marble. Member: National Arts Club; Dartmouth House Club; Society of Medalists; New Orleans Art Association; American Federation of Arts. Address in 1953, 657 Jordan Street, Shreveport, LA.

MORGAN, D.
Sculptor. Active 1838. Exhibited: National Academy of Design, New York.

MORGAN, FRANCES MALLORY.
Sculptor. Born in Memphis, Tenn. Studied at Art Students League; National Academy of Design; Penna. Academy of Fine Arts; also with John Hovannes and Alexander Archipenko. Works: Brooks Memorial Art Gallery, Memphis; IBM Corp. Commissions: Neely Grant (bronze), Mrs. Neely Grant, Memphis, 1934; Sen. Gilbert Hitchcock, 1945, and bronze fountain, 1949, Mrs. Gilbert Hitchcock, Washington, DC; bronze fountain, Vance Norfleet, Memphis, 1952; many portraits of children. Exhibitions: World's Fair, New York, 1939-40; Whitney Museum of American Art, NY, 1940; Metropolitan Museum of Art, NY, 1942; Philadelphia Art Alliance, 1946; Penna. Academy of Fine Arts, 1947. Awards: Anna Hyatt Huntington Award for Olympia, 1941; Prize for Peace Again, 1944, National Association Women Artists; Award for Fish, Audubon Artists, 1961. Media: Clay, stone, wood. Address in 1983, 50 Mendota Ave., Rye, NY.

MORGAN, HELEN BOSART.
(Mrs. Edwin M. Wagstaff). Sculptor. Born in Springfield, OH, October 17, 1902. Studied at Art Inst. of Chicago, 1952-53; Wittenberg College, A.B., 1923; Dayton Art Inst., 1940-42. Exhibitions: Group shows, Springfield Art Assn.; Dayton Art Inst., 1960; Columbus Gallery, 1960; Cin. (OH) Museum Art; Butler Art Inst.; Nat'l. Academy of Design; Allied Artists of America; Nat. Assn. Women Artists; Syracuse Mus.; Wichita Art Assoc.; Newman Brown Gallery, Chicago, 1953; Cincinnati Museum of Art; many others. Awards: Springfield Co. Fair, 1951; Dayton Art Inst., 1945, 46, 48; Springfield Art Exhib., 1946-48, 52, 54, 60, 71; Clark Co. Fair, 1951; Ohio State Fair, 1952; 2nd prize in sculpture, Columbus Art League,

1960; 2nd prize sculpture, Ohio Religious Exhib., 1960. Member: Fellow, Internat. Inst. Arts and Letters; National Assn. Women Artists; Dayton Art Inst.; Assn. Univ. Women; Artists Equity Assn.; Columbus Art League. Media: Bronze, plastic. Address in 1982, Springfield, OH.

MORGAN, JANE.
Sculptor and painter. Born in 1832. Died in Livingston, New York, 1899.

MORGAN, ROBERT F.
Sculptor, painter, and museum curator. Born Helena, Montana, 1929. Studied art in Helena High School, with Mable Bjork; later with Jack Beauchamp at Carroll College. Employed as commercial artist; later curator, museum of Montana Historical Society. Specialty is wildlife, particularly birds, ducks, geese. Address in 1969, Helena, Montana.

MORIGI, ROGER.
Sculptor. Born in Bisyschio, Italy, October 4, 1907; US citizen. Studied at Brera University, Malin, Italy, degree, 1927. Work in Washington National Cathedral; Supreme Court, DC; Post Office, Washington, DC; Rockefeller Church, Bronx. Position, master carver, Washington National Cathedral, 1955-78. Address in 1982, Hyattsville, MD.

MORIN, THOMAS EDWARD.
Sculptor and educator. Born September 22, 1934, Malone, NY. Studied: Massachusetts College of Art, with Lawrence Kupferman, 1952-56, BS.Ed.; Cranbrook Academy of Art, 1956-57, M.F.A.; Academy of Fine Arts, Florence, Italy, 1960-61; Brown University, basic metall. certificate, 1966, plastics technol. certificate, 1967. Work: Ogunquit, ME; New York University, Oneonta; Brown University; Virginia Museum of Fine Arts. Exhibited: Margaret Brown Gallery, Boston, 1954; Gallery Four, Detroit, Kanegis Gallery, Boston; Silvermine Guild; The Kornblee Gallery, NYC; De Cordova; Boston Arts Festival; Penna. Academy of Fine Arts; Detroit Institute Annuals; Whitney Museum Annual; Houston Museum of Fine Arts; Audubon Artists Annual; RI School of Design Museum of Art; Wadsworth Atheneum, Eleven New England Sculptors. Awards: Fulbright Fellowship, 1960; Silvermine Guild, First Prize and Best in Show, 1960; Rhode Island Arts Festival, First Prize 1960; Rhode Island Art Festival, First Prize; New Haven Art Festival, First Prize, 1966. Taught: Cranbrook Academy of Art, 1957-58; Silvermine Guild, 1958-60; Rhode Island School of Design, from 1961. Address in 1982, Johnston, RI.

MORLEY, RUTH KILLICK.
Sculptor, craftsman, and teacher. Born in London, England, June 8, 1888. Studied with Jean Dampt; Bourdelle. Member: Alliance. Address in 1933, 234 West 15th St., NYC.

MORRELL, WILLETT H.
Shipcarver. Working in New York City from 1842 to 51. Exhibited a full size wood carving of a woman at the American Institute, with artist Winter Lindmark, 1842.

MORRIS, DAVID.
Sculptor. Born in Wales in 1817. Listed as living in Philadelphia in August of 1850. Medium: Plaster.

MORRIS, GEORGE FORD.
Sculptor, painter, illustrator, lecturer, writer, and critic. Born in St. Joseph, MO. Studied: Art Institute of Chicago; Julian Academy, Paris, France. Contributor: illustrations for *Scribner's, Century* magazines. Specializes in painting famous horses, their owners and riders. Address in 1953, Fordacre, Shrewsbury, NJ.

MORRIS, GEORGE LOVETTE KINGSLAND.
Sculptor, painter, writer, lecturer, teacher, and designer. Born in New York, November 14, 1905/06. Studied: Yale University, B.A.; Art Students League; Academie Moderne, Paris, France. Member: American Abstract Artists; Federation of Modern Painters and Sculptors. Awards: Berkshire Museum, 1964; Temple Gold Medal, Penna. Academy of Fine Arts, 1967. Work: Metropolitan Museum of Art; Penna. Academy of Fine Arts; Phila. Museum of Art; Whitney Museum; U.S. State Department; Berkshire Museum; Yale School of Fine Arts; Encyclopedia Britannica Collection; New Art Circle, NY. Exhibited: Whitney Museum, 1938-46; Penna. Academy of Fine Arts, 1945, 46; Carnegie Institute, 1944-58; American Abstract Artists, 1936-58; Federation of Modern Painters and Sculptors, 1941-58; Virginia Museum of Fine Arts, 1946; Berkshire Museum, 1935, 38, 45; Century Association, NY, 1965; Corcoran Gallery, 1965. Contributor to: *Partisan Review*, with articles on abstract art. Position: Advisory Committee, Museum of Modern Art, New York, NY, 1933-40. Address in 1953, 340 East 72nd Street, New York, NY. Died in 1975.

MORRIS, HILDA.
Sculptor and painter. Born in NYC, in 1911. Studied at Art Students League; Cooper Union Art School. Works: Memorial Art Gallery, University of Rochester; Reed College, Portland, OR; Munson-Williams-Proctor Institute; Seattle Art Museum; Portland Oregon Art Museum; San Francisco Museum of Art; Walter Chrysler Collection, Virgina Museum. Exhibited: Metropolitan Museum of Art, 1951; 3rd Pacific Coast Biennial, Santa Barbara Museum of Art, 1960; Northwest Art Today, Seattle World's Fair, 1962; Brooklyn Museum, 1964; San Francisco Museum of Art. Received Ford Foundation Fellowship, 1960. Address in 1982, Portland, OR.

MORRIS, PAUL WINTERS.
Sculptor. Born in Du Quoin, IL, November 12, 1865. He studied with Saint-Gaudens and under D. C. French in New York. He died in New York, November 16, 1916.

MORRIS, REGINA STAHL.
Sculptor. Born in Westport, Connecticut, in 1945; raised in Sarasota, Florida. Studied art with her father, Ben Stahl; bronze sculpture at Shortridge School of Equine Art. Traveled in Canada, Mexico, Europe, widely in US, visiting museums. Specialty is statuettes of horses; has also sculpted other animals. Works in bronze. Represented by her Godolphin Farms. Address in 1982, Bradyville, Tennessee.

MORRIS, ROBERT.
Sculptor. Born February 9, 1931, in Kansas City, MO. Studied: Kansas City Jr. College; Kansas City Art Institute, 1948-50; University of Kansas City; San Francisco Art Institute; Reed College, 1953-55; Hunter College, M.A., 1966. Work: National Gallery, Melbourne; Dallas Museum of Fine Art; Whitney; Tate; Modern Museum, Stockholm. Exhibited: Dilexi Gallery, San Francisco; Green Gallery, NYC; Dwan Gallery, Los Angeles; Leo Castelli Inc., NYC; Ileana Sonnabend Gallery, Paris; Sonnabend Gallery, Paris; Wadsworth Atheneum; Whitney Museum; Jewish Museum, Primary Structures; Art Institute of Chicago; Walker; Detroit Institute, Color, Image and Form; Los Angeles Co. Museum of Art and Phila. Museum of Art, American Sculpture of the 60's; Museum of Modern Art, The 1960's; Torcuato di Tella, Buenos Aires; Eindhoven; Guggenheim, Guggenheim International; Albright; The Hague, Minimal Art; Foundation Maeght; Corcoran Gallery; Stedelijk Museum; Smithsonian Institution; others. Awards: National Council on the Arts; Art Institute of Chicago, 1966; Guggenheim, 1967, fellowship, 1969; Torcuato di Tella, Buenos Aires, 1967; Sculpture Award, Society of Four Arts, 1975. Address in 1982, c/o Castelli Gallery, NYC.

MORRIS, VIRGINIA LEIGH.
Sculptor. Born Norfolk, VA, October 16, 1899. Pupil of Solon Borglum, Harriet Frishmuth; Yale School of Fine Arts. Member: Norfolk Society of Artists; Society of Washington Artists; Washington Art Club; Southern States Art League. Awards: Florence K. Sloane prize, 1921 and 1926, and Elsie Stegman prize, 1921, Norfolk Society of Artists. Address in 1933, 596 Mowbray Arch, Norfolk, VA.

MORRISON, MARK.
Sculptor. Born in King Fisher, Okla., January 1, 1900. Studied: University of Missouri; Art Students League, and with John Flanagan, Jose De Creeft, William Zorach. Member: Sculptor Guild; Architectural League; Audubon Artists. Awards: prize, National Academy of Design, 1950. Exhibited: Metropolitan Museum of Art, 1942, 51; National Academy of Design, 1949, 50; Penna. Academy of Fine Arts, 1949, 50; Fairmount Park, Phila., 1949; Whitney Museum of American Art, 1949, 50; Nebraska Fine Arts Association, 1946; Newark Museum, 1944; Wilmington Society of Fine Arts, 1946; Audubon Artists, 1947-50; Sculptor Guild, 1950, 51; New Britain, Conn., 1947. Address in 1953, 8 West 13th Street, New York, NY.

MORRISON, MARY COPLES.
Sculptor. Born in Petersburg, VA, December 20, 1908. Studied with M. Miller and Hans Schuler. Address in 1933, Sixteenth St., N. W., Washington, DC.

MORSE, JEAN H.
Sculptor. Born in Derby, CT, September 7, 1876. Pupil of Yale Art School, Chase, Woodbury. Member: New Haven Paint and Clay Club; Northern Valley, NJ, Art Association; American Federation of Arts. Address in 1933, Englewood, NJ; summer, Cotuit, MA.

MORSE, SAMUEL FINLEY BREESE.
Sculptor, figure and portrait painter, and inventor. Born in Charlestown, MA, April 27, 1791. He graduated from Yale in 1810; became a pupil of Washington Allston whom he accompanied the following year to London, where he studied under Benjamim West. Returned to America in 1815 and painted portraits in Boston, MA; Concord, NH; and Charleston, SC. Settled in New York in 1823, where, in 1826, he became one of the original founders of the National Academy of Design and its first Pres., serving from 1827-45 and again, 1861-62. Among his most important paintings is the full-length portrait of Lafayette in the New York City Hall, and the large picture of the old "House of Representatives by Candle Light," now in the Corcoran Gallery of Art, in Wash., DC. His model of a "Dying Hercules" was awarded a gold medal. From 1839 until his death he devoted his time to perfecting the invention of the telegraph. Died in NYC, April 2, 1872.

MORTIMER, GEORGE D. (T., F.).
Sculptor. Worked: New York City. Exhibited: National Academy, 1838-42; Apollo Association, 1838-42.

MORTIMER, MARY ELEANOR.
Sculptor. Address in 1919, Tuxedo Park, New York.

MORTIMER, NORMAN J.
Sculptor. Born in San Francisco, California, May 16, 1901. Address in 1933, New Hope, Penna.

MORTON, KATHERINE GIBSON.
Sculptor and painter. Born in New York, NY, November 14, 1895. Studied: with Boardman Robinson, Jonas Lie, Jerry Farnsworth. Work: Brookgreen Gardens, SC. Exhibited: National Academy of Design, 1941; Southern Vermont Artists, 1936-39; Norton Gallery, West Palm Beach, FL, 1944-46; Society of Four Arts, 1943-46; Tricker Gallery, 1939; one-woman exhibitions: Arden Gallery, 1935; Ferargil Gallery, 1936; Worth Avenue Gallery, Palm Beach, Fla., 1946. Illustrated, special pamphlets, American Museum of Natural History, New York, NY, Address in 1953, Madison, Conn.

MOSE, CARL C.
Sculptor and teacher. Born Copenhagen, Denmark, February 17, 1903. Studied: Art Institute of Chicago; Art Students League; Beaux-Arts Institute of Design; pupil of Lorado Taft, Albin Polasek, Leo Lentelli. Member: Society of Washington Artists; American Federation of Arts; St. Louis Art Guild; 2 x 4 Club; National Sculpture Society; National Society of Arts and Letters. Work: Corcoran Gallery; Minn. State Historical Society; Ft. Sumter, NC; Meridian Hill Park, Wash., DC; US Post Office, Maplewood, MO, and Salina, KS; figures of Apostles for the Washington Cathedral, Mt. St. Albans, Wash., DC; medal for the American Medical Association; decorations on Y.M.C.A., Chicago, IL; eighteen decorative panels, exterior Potomac Electrical Power Company Building; others. Exhibited: Art Institute of Chicago, 1918-38; National Academy of Design; Royal Academy, Copenhagen, Denmark; one-man: Corcoran Gallery; Minneapolis Institute of Art; Society of Washington Artists; Chicago Galleries Association; St. Louis Art Guild; Museum of Fine Arts, Houston. Awards: Prizes, Minneapolis Insti-

tute of Art; St. Louis Art Guild, 1947, 49, 52; medal, Society of Washington Artists; others. Address in 1953, 4527 Olive Street; h. Maryland Avenue, St. Louis, MO.

MOSELSIO, SIMON.
Sculptor, painter, and educator. Born in Russia, December 17, 1890. Studied: Kunstgewerbe Schule; Royal Academy of Fine Arts, Berlin, Germany. Member: National Sculpture Society; Arch. League. Awards: med., Paris International Exposition. Work: Whitney Museum; University of Georgia; IBM; Bennington Historical Museum; Weyhe Gallery. Exhibited: World's Fair, New York 1939; Whitney Museum, 1934, 35, 39, 1940-43, 45, 46, 50; Art Inst. of Chicago; Penna. Academy of Fine Arts; Weyhe Gallery (one-man); Fleming Museum of Art; Salons of America, 1925, 26; New York Art Center, 1926 (one-man); Brooklyn Museum, 1930; Research Inst. Theatre, Saratoga Springs, NY; Library of Congress, 1949; Philadelphia Museum of Art, 1940; Worcester Museum of Art, 1943, 51; Buchholz Gallery, 1941, 43, 45; Albany Inst. History and Art; etc. Taught: Instructor of Sculptor and Art, Bennington College, Bennington, VT, from 1933; Director Corp. of Yaddo. Address in 1953, Old Bennington, VT. Died in 1963.

MOSMAN, MELZAR HUNT.
Sculptor. Born 1845. Died in Chicopee, Mass., January 11, 1926.

MOSMAN, WARREN TOWLE.
Sculptor and teacher. Born in Bridgeport, Conn., July 18, 1908. Studied: Yale School of Fine Arts, BFA; American Academy in Rome, F.A.A.R. Member: National Sculpture Society; American Institute of Architects. Taught: Art Consultant, Ellerbe & Co., Architects & Engineers, St. Paul, Minn. Address in 1953, E 505 First National Bank Bldg., St. Paul, Minn.; h. Hopkins, Minn.

MOSS, JOE (FRANCIS).
Sculptor and painter. Born in Kincheloe, WV, January 26, 1933. Studied at West Virginia University, A.B., 1951, M.A., 1960. Has exhibited at Members Exhibition, Museum of Modern Art, NY; J. B. Speed Museum, Louisville, KY; Leading Contemporary Sculptors Exhibition, Sculpture Now, NY; others. Received sculpture award, Appalachian Corridors Exhibition, Charleston, 1970. Works in plastic and metal. Address in 1982, Newark, DE.

MOTT-SMITH, MAY.
(Mrs. Small). Sculptor, miniature painter, and craftswoman. Born Honolulu, HI, March, 17, 1879. Pupil of Colarossi Academy; Van Der Weyden; Spicer-Simson; Robert Aitken. Member: California Art Club; Society of Independent Artists; California Society of Miniature Painters; California Sculptors Society; National Academy of Women Painters and Sculptors; American Numismatic Society; American Federation of Arts. Awards: Bronze medal for small relief, Panama-California Exp., San Diego, 1915; silver medal for jewelry, P.-P. Exp., San Francisco, 1915. Exhibited at National Sculpture Society, 1923. Address in 1933, c/o Harriman National Bank, New York City. Died in 1952.

MOTTO, JOSEPH C.
Sculptor. Born in Cleveland, OH, March 6, 1892. Pupil of Matzen, MacNeal, and Heber. Member: Cleveland Society of Artists; Cleveland Society of Sculptors. Award: First prize, Cleveland Museum of Art, 1922. Work: Shakespeare bust, City of Cleveland; bust of "Prof. Wilson," Western Reserve University, Cleveland; "Matzen" bust, Cleveland School of Art; "Lincoln" bust, Hawken School, South Euclid. Address in 1933, Hawken School, South Euclid, OH; h. 1536 East 41st Street, Cleveland, OH.

MOUGEL, MAX.
Sculptor and etcher. Born in New York, NY, April 21, 1895. Work: Brooklyn Museum; Library of Congress; U.S. Government Buildings. Exhibited: American Museum of Natural History; Society of American Graphic Artists, 1936, 1938-40, 44; Conn. Academy of Fine Arts, 1936; Penna. Academy of Fine Arts, 1936; Phila. Print Club, 1940; Alden Gallery, 1940; Library of Congress, 1944; Carnegie Institute, 1944; Corcoran Gallery of Art, 1944-46; National Maritime Exhibition, 1945. Illustrator, architectural and travel magazines. Address in 1953, 574 C Minneford Avenue, City Island, New York, NY.

MOUNIER, LOUIS.
Sculptor, painter, and teacher. Born in France, December 21, 1852. Pupil of F. Sanzel in Paris (sculpture); F. Rondel in New York (painting). Address in 1910, Louisia Lodge, Vineland, NJ.

MOUNT, WARD.
(Pauline Ward). Sculptor and painter. Born in Batavia, NY. Studied at NYU; Art Students League; private study with G. Gardner, K.H. Miller, A.P. Lucas, J.P. Pollia. Works: Designed bronze medal of honor for Painters and Sculptors Society NJ, 1947; designed and executed The Bell of America, for Bell Association, 1950; Roosevelt Museum, Hyde Park, NY; Museum of Modern Art; Hudson River Museum; Delgado Museum. Exhibitions: Irvington Public Library; Delgado Museum; Hudson River Museum; Montclair Art Museum; Los Angeles Museum; Trenton State Museum; Jersey City Museum; National Academy of Design, 1944; Library of Congress; National Sculpture Society, 1945-48; New York Architectural League; New York Public Library; Municipal Art Gallery; Allied Artists of America; Riverside Museum; National Arts Club; Grand Central Palace; Academy of Allied Artists; NY Historical Museum; New Jersey Gallery; Fine Arts Building, NYC; Audubon Artists, 1940-42; Penna. Academy of Fine Arts, 1949; Springfield Museum of Fine Arts; Smithsonian Institution, 1951; Carlebach Gallery; Terry Art Institute; rep. in many collections including the Late Pres. Franklin D. Roosevelt, Hon. C.B. Howard of Canada, G. Timken Fry, B.U. Gimbel; others. Awards: 1st prize for oil painting, Jersey City Museum, 1941; 1st prize for sculpture, Painters and Sculptors Society, 1943, 51; 1st prize sculpture, ann. state exhbn., Montclair Art Museum, 1945; 1st prize sculpture; NJ Artists, 1945; 1st prize sculpture, Asbury Park Society of Fine Arts, 1946; purchase prize Jersey City Museum, 1946; first sculpture prize, Kearney Museum,

NJ, 1947; gold medal, Jersey J. Woman of Achievement, 1971. Member: Founder, pres., Painters and Sculptors Society of NJ; faculty, Academy of Allied Arts; Fellow, International Institute of Arts and Letters; Royal Society of Artists, London, England; New York Society of Painters; Artists Equity Association, NY; founding member, Audubon Artists. Head of oil painting and sculpture department, New Jersey State Teachers College; founder, former director of art classes, Jersey City Medical Center, 1948-49; director, Ward Mount Art Classes, Jersey City, from 1939. Address in 1982, Jersey City, NJ.

MOWBRAY-CLARKE, JOHN FREDERICK.
Sculptor. Born Jamaica, West Indies, August 4, 1869. Pupil of Lambeth School, London. Member: American Painters and Sculptors. Represented in Metropolitan Museum, New York; Newark (NJ) Museum; British Museum, London. Address in 1933, "The Brocken," Pomona, Rockland Co., NY. Died 1953.

MOWNIHAN, FRED.
Sculptor. Member: National Sculpture Society. Address in 1898, 145 West 55th St., New York City.

MOYERS, WILLIAM.
Sculptor and painter. Born in Atlanta, Georgia, December 11, 1916. Studied fine arts at Adams State College; Otis Art Institute, Los Angeles. Worked as a cowboy; in art at Walt Disney Studios; in New York City as an illustrator. Turned to fine art full-time around 1962. In collections of Gilcrease Institute, Tulsa, Oklahoma; National Cowboy Hall of Fame, Oklahoma City. Has exhibited in Cowboy Artists of America Shows since 1968; National Cowboy Hall of Fame, solo, Oklahoma City; Peking, China, Show; others. Received gold and silver medals, sculpture, Cowboy Artists of America Shows; others. Member of Cowboy Artists of America. Specialty is Western life; works in oils, watercolor, bronze. Bibliography includes *Southwest Art*, March 1980; *Cowboy in Art*, Ainsworth; *Western Americana*; *Bronzes of the American West*, Broder. Represented by Taos Art Gallery, Taos, NM; Trailside Galleries, Scottsdale, AZ. Address in 1982, Albuquerque, New Mexico.

MOYNIHAN, FREDERICK.
Sculptor. Born in 1843 on Island of Guernsey, Great Britain. Student of the Royal Academy, London. Made a specialty of military figures of the Civil War period. Died January 9, 1910, in New York City.

MOZIER, JOSEPH.
Sculptor. Born in Burlington, VT, August 12, 1812. He studied sculpture for several years in Florence, and then went to Rome, where he spent the greater part of his professional career. Among his best works are "Esther," the "Wept of Wish-ton-Wish," "Tacite," "Truth," the "White Lady of Avenel," "The Peri," "Pocahontas," "Prodigal Son," "Rizpah," and "Il Penseroso" in marble; the last was transferred from the Capitol in 1888 to the National Gallery, Washington, DC; works also at Museum of Fine Arts, Philadelphia. Died in Faido, Switzerland, on October 3, 1870.

MUCCIOLI, ANNA MARIA.
Sculptor and painter. Born in Detroit, Mich., April 23, 1922. Studied at Soc. Arts and Crafts; with Sarkis Sarkisian, Charles Culver, and Hay Holland. Exhibitions: Butler Institute, Youngstown, Ohio, 1969; Birmingham Museum, Ala., 1970; National Academy Galleries, NY, 1971; Carrol Reece Museum, Tenn., 1974; one-woman show, Liggett Sch., 1974. Awards: Detroit Windsor Int. Second Place Award, 1969; honorable mention, Mich. Watercolor Society, 1970; Third Place, Scarab Club, 1971, honorable men., Silver Medal Exhibition, 1976, 79. Member: Watercolor Society of Alabama; Michigan Watercolor Society; Women's Caucus of Art. Media: Bronze, stone; watercolor. Address in 1982, c/o Muccioli Studio Gallery, Detroit, MI.

MUELKE, ROBERT.
Sculptor, craftsman, illustrator and designer. Born in Buffalo, NY, April 3, 1921. Studied: Pratt Institute Art School; Art Institute, Buffalo. Member: Industrial Designers Institute. Exhibited: Albright Art Gallery, 1942. Position: Industry and Architectural Design, 1943-46, with Raymond Loewy, General Electric, Barnes and Reinecke, and others. Own design practice, from 1945. Address in 1953, Milford, Conn.

MUELLER, AUGUSTUS MAX JOHANNES.
Sculptor. Born in Meiningen, Germany, June 8, 1847. Pupil of the Royal Academies of Berlin and Munich. Address in 1910, 926 West College Ave.; h. 2314 Poplar St., Philadelphia, PA.

MUELLER OR MILLER, CHARLES.
Sculptor. Born in Germany, about 1820. Worked in New York City from about 1856 into the 1860's. Exhibited at the National Academy; the American Institute. Worked in bronze and marble.

MUELLER, HENRIETTA WATERS.
Sculptor and painter. Born in Pittsburgh, PA, April 13, 1915. Studied: Northwestern Univ.; Art Institute of Chicago, with Helen Gardner, BFA, 1938; Art Students League; Univ. of Wyoming, M.A., 1948, M.Ed., 1960; Univ. of Colo., with Wendell Black; and with Will Barnet, Ilya Bolotowsky, John Opper, and George McNeil. Awards: Mary Griffiths Marshall Memorial fellowship, Alpha Chi Omega, 1952; Tri-State Exhibition, 1958; Cummington fellowship, 1954, Wilson Daly Prize, John Herron Art Institute, Indianapolis, 1952; Purchase Award, Univ. Wyoming Art Museum, 1973. Collections: NY Public Library; Joslyn Art Museum; Henry Gallery, Univ. of Wash.; Nelson Gallery of Art; Woman's College, Univ. of North Carolina. Exhibited at Phila. Museum; San Fran. Museum of Art; Met. Museum of Art; Pioneer Museum, Stockton, CA, 1971; others. Member: Wyoming Artists' Assn.; Artists Equity Assn.; Laramie Art Guild. Media: Oil, watercolor, acrylic; steel and aluminium. Address in 1982, Laramie, WY.

MUIR, WILLIAM H.
Sculptor. Address in 1934, Pelham, New York. Died in 1965. (Mallett's)

MULLER, CHARLES.

Sculptor. Active 1856-68. Patentee—statuette, Burton as Captain Cuttler, 1856; four figures, 1868; figure and base, 1868.

MULLER, OLGA POPOFF (MRS.).

Sculptor. Born New York City, December 1, 1883. Studied in Russia, Munich, and Paris. Member: National Association of Women Painters and Sculptors, NY. Awards: Cahn honorable mention, Art Institute of Chicago, 1911; McMillin prize, National Association of Women Painters and Sculptors, NY, 1914; med. of honor, Paris Exhibition of Women's Works; bronze meds., P.-P. Exp., San Francisco, 1915; honorable mention, National Association of Women Painters and Sculptors, 1925. Address in 1933, Flushing, NY.

MULLIGAN, CHARLES J.

Sculptor. Born in Riverdale, Ireland, September 28, 1866. He came to America as a boy and worked with a stone cutter near Chicago. Studied at Chicago Art Institute, under Taft, and later under Falguiere, at the Ecole des Beaux-Arts in Paris. Among his statues are "The Three Sisters," at Springfield, Illinois; Lincoln, known as "The Rail Splitter," and a statue of Col. Finnerty. Member of Society of Western Artists; Palette and Chisel Club (hon.). Address in 1910, Chicago, IL. He died March 25, 1916, in Chicago, IL.

MULLIGAN, GEORGE.

Sculptor. Address in 1919, 1521 East 61st St., Chicago, IL.

MULLIN, CHARLES EDWARD.

Sculptor, painter, etcher, and serigrapher. Born in Chicago, Ill., July 6, 1885. Studied: Chicago Academy of Fine Arts, with Wellington J. Reynolds; Art Institute of Chicago. Member: South Side Art Association; Ridge Art Association, Chicago. Awards: prizes, Chicago, Ill., 1929, 30. Work: Chicago Public School. Exhibited: National Academy of Design, 1944, 45; Library of Congress, 1944, 45; Laguna Beach Art Association, 1945; Philadelphia Print Club, 1946; Los Angeles Museum of Art; Kansas City Art Institute; Baltimore Museum of Art; Springfield Museum of Art; Art Institute of Chicago, 1920, 28, 29, 30, 1932-34, 37. Address in 1953, Orland Park, Ill.

MULRONEY, REGINA WINIFRED.

Sculptor, illustrator, writer, and teacher. Born New York City, December 4, 1895. Pupil of Art Students League of New York; San Francisco Art School. Member: Catherine Lorillard Wolfe Club; Louis Comfort Tiffany Foundation; Phila. Alliance; Phila. Society of Artists; National Association of Women Artists; League of American Pen Women, 1934. Awards: Catherine Lorillard Wolfe prize for sculpture, 1929, League of American Pen Women, 1934. Position: Director, R. W. Mulroney School of Art, San Francisco, CA. Address in 1953, San Francisco, CA.

MUNDHENK, AUGUST.

Sculptor. Born 1848. Conducted an art foundry in Cincinnati for over thirty years. Died in Cincinnati, Ohio, April 1, 1922.

MUNDHENK, OSCAR.

Sculptor. Address in 1908, 321 Helen St., Cincinnati, Ohio. Died in 1956.

MUNDT, ERNEST KARL.

Sculptor, writer, lecturer, and educator. Born in Bleicherode, Germany, October 30, 1905. US citizen. Studied: at Berlin Institute of Technology, dipl. architecture, 1930; Univ. of Calif., Ph.D., 1961. Member: College Art Association of America; San Fran. Art Association; Artists Equity Association. Work: San Fran. Museum of Art. Exhibited: Whitney Museum, 1951; Metropolitan Museum of Art, 1950; Detroit Institute of Art, 1944; Nierendorf Gallery, 1945, 46; San Fran. Museum of Art, 1946; Calif. Palace of the Legion Honor, 1949. Author, illustrator, "A Primer of Visual Art," 1950; "Art Form and Society," 1952. Contributor to *Arts and Architecture, College Art Journal, Art Quarterly* magazines. Taught: Instructor, Brooklyn College, 1945-46; Calif. School of Fine Arts, 1947-50, Director, 1950-55; assistant prof., Calif. State Univ., San Fran., 1955-76, emeritus prof., from 1976. Award: Gold Medal of Honor, Amer. Inst. of Architects, 1956. Address in 1982, San Fran., CA.

MUNDY, ETHEL FRANCES.

Sculptor. Born in Syracuse, NY. Studied: Art Students League; Fontainebleau School of Art, France; Rochester Mechanics Institute; and with Amy M. Sacker, Boston, Twachtman, Beckwith. Work: Syracuse Museum of Fine Arts; Frick Gallery, NY; J. B. Speed Memorial Museum; Louisville Kentucky Museum of Art. She discovered a new composition for use in wax portraiture and revived the art of wax portraiture which was known in Europe for 500 years before being lost in the 18th century. Member of ARMS, London; National Association of Women Artists; American Federation of Arts, NY; Society of Fontainebleau Artists. Exhibited: National Association of Women Artists; Carnegie Institute; Corcoran Gallery; Philadelphia Watercolor Club; Syracuse Museum of Fine Arts; Denver Art Museum; Brooklyn Museum; Louisville Museum of Art; Montclair Art Museum; Royal Society of Miniature Painters. Address in 1953, Syracuse, NY.

MUNDY, JOHNSON MARCHANT.

Sculptor and portraitist. Born May 13, 1831, New Brunswick, NJ. Served as apprentice to H. K. Brown for seven years. Later opened a studio in Rochester, NY, before moving to Tarrytown. Work: Statue, Washington Irving. Died in Tarrytown, NY, 1897.

MUNGER, ANNE WELLS

(Mrs. W. L. C. Munger). Sculptor, painter, teacher, and craftswoman. Born in Springfield, MA, July 17, 1862. Pupil of Philip Hale, Woodbury and DeCamp in Boston; Brush in New York. Member: Provincetown Art Association; Southern States Art League; Gulf Coast Art Association; Miss. Art Association. Award: Prize for pastel, Gulf Coast Art Association, 1932. Address in 1933, Pass Christian, MS; summer, South Wellfleet, MA.

MUNK, JOHN.

Sculptor. Member of National Sculpture Society. Address in 1910, 94 Weirfield Street, Brooklyn, New York.

MUNO, RICHARD CARL.

Sculptor and art director. Born in Arapaho, OK, July 2, 1939. Studied at Oklahoma State University School of

Technical Training, certified commercial artist. Work in Diamond M Museum, Snyder, TX; trophy, National Cowboy Hall of Fame, Oklahoma City; sculpture, Colt Firearms, Hartford; others. Has exhibited at Philbrook Mus. Art Exhibition, Tulsa, OK; Oklahoma Museum of Art Five State Salon, Oklahoma City; Solon Borglum Memorial Sculpture Exhibition, National Cowboy Hall of Fame, Oklahoma City. Preparator, Gilcrease Institute of American History and Art, Tulsa, 1960-64; curator, National Cowboy Hall of Fame, Oklahoma City, 1965-69; art director, 1970-77, dep. director, 1977-78, managing director, from 1978. Address in 1982, National Cowboy Hall of Fame, Oklahoma City, OK.

MURPHEY, MIMI.
Sculptor. Born in Dallas, Texas, January 13, 1912. Studied at Southern Methodist University, 1929-30; Dallas Art Institute, 1930-32; Art Students League; and with Eugenie Shonnard. Work: Museum of New Mexico, Santa Fe. Awards: Texas State Fair, 1933, 47; American Artists Professional League, 1937; New Mexico State Fair, 1944, 48, 49; So. States Art League, 1944-46; Fiesta Exhibition, Santa Fe, 1957; Allied Albuquerque Artists, 1951; purchase award, Museum of New Mexico, 1958. Exhibitions: New Jersey Museum; Brooklyn Museum Sculpture Center, NY; Dallas Museum; Denver Museum. Member: Clay Club, NY; New Mexico Art League; Gem and Mineral Club. Address in 1962, 2913 Santa Cruz Ave. S.E., Albuquerque, NM.

MURPHY, MICHAEL THOMAS.
Sculptor. Born in Bantry, County Cork, Ireland, November 24, 1867. Apprenticed as marble carver in Cork; studied in School of Art, Cork, and later at Royal College of Art, London; also in Paris and Italy. Came to United States in 1912. Specialized in portraits and figure subjects in relief. Exhibited at Art Institute of Chicago, 1918. Principal works: Busts of Most Rev. George W. Mundelein and of Dr. John B. Murphy, of Chicago; "Aaron Blessing the Israelites," 4th Presbyterian Church, Lincoln Parkway, Chicago; heroic size figures representing an athlete and a student, University of Michigan, Ann Arbor; etc. Member: Western Society of Sculptors; Art Workers' Guild, Artists' Annuity Fund, London; Chicago Society of Artists. Address in 1926, 4 E. Ohio Street; h. 5739 Harper Avenue, Chicago, IL.

MURPHY, MINNIE B. HALL.
(Mrs. Edward Roberts Murphy). Sculptor, painter, writer, lecturer, and teacher. Born Denver, CO, May 2, 1863. Pupil of Art Students League of New York; Art Institute of Chicago; Henry Read in Denver. Member: National Arts Club; Denver Art Club. Address in 1929, 805 Gaylord Street, Denver, CO.

MURPHY, PETER.
Sculptor. Born in Ireland, c. 1825. Immigrated before 1846. At San Francisco, 1860. Worked in marble.

MURRAY, ELLA I.
Sculptor. Address in 1934, Plainfield, New Jersey. (Mallett's)

MURRAY, RAI.
(Mrs. Leonard Somers). Sculptor. Born in New Orleans, LA, December 29, 1903. Studied at H. Sophie Newcomb College, 1926; student sculpture, New Orleans Art School, 1935-36. Exhibitions: One-man shows at Delgado Museum; Arts and Crafts Club, Houston; H. Sophie Newcomb Gallery; Jazz collection in New Orleans Public Library; garden sculpture in prominent gardens in New Orleans; copper and brass fountain for patio of new building of New Orleans Public Library. Awards: New Orleans Art Association; sculpture prizes, New Orleans Art School, 1936. Member: LA Landmark Society; New Orleans Jazz Club; New Orleans Art Association; New Orleans Jr. League; Kappa Kappa Gamma. Address in 1962, 3723 Carondelet St., New Orleans, LA.

MURRAY, RICHARD DEIBEL.
Sculptor and painter. Born in Youngstown, OH, December 25, 1921. Studied: University of Notre Dame, B.S., 1942; Georgetown University, MD, 1946; University of Penna., 1953. Work: American College of Surgeons; Mill Creek Park, and Youngstown Symphony Center. Exhibitions: Butler Art Institute, Youngstown; Kottler Galleries, NY; Canton Art Institute, Canton, OH; Galerie Int., NY, 1972; others. Awards: F. Punnell Award, Youngstown, OH, 1966; Citation, City of Youngstown, OH; others. Address in 1982, Youngstown, OH.

MURRAY, ROBERT (GRAY).
Sculptor and painter. Born March 2, 1936, Vancouver, B.C., Canada. Studied: University of Saskatchewan with Arthur McKay, Roy Kiyooka, Kenneth Lochhead, R. Simmons, 1956-58; Emma Lake Artist's Workshops, University of Saskatchewan, with Will Barnet, 1957, Barnett Newman, 1959, John Ferren, 1960, Clement Greenberg, 1962, Jack Shadbolt. Traveled in Mexico, Canada. Work: Metropolitan Museum of Art; Walker Art Center; Hirshhorn Museum; Montreal Museum of Fine Arts; Ottawa (National); Aldrich; Toronto; Whitney Museum; and others. Exhibited: Betty Parsons Gallery, NYC; Jewish Museum; Ottawa (National); Whitney Museum; Toronto; Musee Cantonal des Beaux-Arts, Lausanne, Switzerland; Los Angeles County Museum of Art; Hayward Gallery; Walker Art Center; Phila. Museum of Art; Guggenheim; Paris (Moderne); Tibor de Nagy Gallery, NY; Washington Square Gallery; others. Awards: Canada Arts Council Scholarship, 1960, Grant, 1969; second prize, X Sao Paulo Biennial, Brazil, 1969; National Endowment Grant, 1969; National Council on the Arts, 1968. Media: Steel, aluminum. Address in 1982, 66 Grand Street, NYC.

MURRAY, SAMUEL.
Sculptor and teacher. Born Philadelphia, PA, June 12, 1870. Pupil of Thomas Eakins. Awards: Diploma, Columbian Exposition, Chicago, 1893; gold medal, Art Club of Philadelphia, 1894; honorable mention, Pan-Am. Exposition, Buffalo, 1901; silver medal, St. Louis Exposition, 1904. Work: "Prophets," Witherspoon Building, Philadelphia; "Com. Barry," "Joseph Leidy," and J. H. Windrim portrait, Smith Memorial, Fairmount Park,

Philadelphia; Pennsylvania State Monument, Gettysburg, PA; Corby statue, Notre Dame University, Notre Dame, IN; portrait, Dr. J. C. Wilson, Jefferson Medical College, Philadelphia; Bishop Shanahan Memorial, St. Patrick's Cathedral; statue, Admiral George W. Melville, League Island Park, Philadelphila. Represented in Whitney Museum; Penna. Museum of Art; Metropolitan Museum of Art; University of Penna., Philadelphia. Address in 1933, 3326 Lancaster Avenue; Philadelphia, PA.

MUSE, AARON.
Sculptor. Born in Italy in 1830. Was in New York City in 1850.

MUSSELMAN-CARR, MYRA V.
Sculptor. Born in Georgetown, KY, November 27, 1880. Studied with Bourdelle; Art Students League of NY; Cincinnati Art School. Work: Fountain, Kansas City; Roslyn, LI, NY; tablet, Pittsburgh, Penna.; fountain, Bronxville, NY. Member: Woodstock Art Association. Address in 1933, Woodstock, Ulster Co., NY.

MYER, RICHARD A.
Sculptor. Born in NYC in 1927. Painted murals in Japan with Army Special Services; studied art at Brigham Young University, BA, 1952; with William Zorach and at Sculpture Center, New York City. Head designer, Classic Bronze, California. Specialty is statuettes of Western, Indian, and historical subjects. Works in bronze. Member of American Indian and Cowboy Artists. Reviewed in *Southwest Art*, July 1976. Represented by Trailside Gallery and O'Brien's Art Emporium, Scottsdale, AZ. Address since 1971, Glenora, CA.

MYERS, ETHEL.
(Mrs. Jerome). Sculptor and lecturer. Born in Brooklyn, NY, August 23, 1881. Studied at Hunter College; Columbia University; and with William M. Chase, Robert Henri, and Kenneth Hayes Miller. Member: NY Ceramic Soc. Exhibited: National Academy of Design; Corcoran Gallery of Art; Penna. Academy of Fine Arts; Art Institute of Chicago; Whitney Museum of American Art; Brooklyn Museum; and others. Specialty, small sculpture and drawing. Address in 1953, Carnegie Hall, West 57th Street; NYC; h. Carmel, NY. Died in 1960.

MYERS, FORREST WARDEN.
Sculptor. Born in Long Beach, CA, February 14, 1941. Studied at San Francisco Art Institute. Work in Whitney Museum of American Art, NY; Hirshhorn Museum, Washington, DC; Storm King Art Center, Mountainville, NY; Walker Art Center, Milwaukee; others. Has exhibited at California School of Fine Arts, San Francisco; Jewish Museum; Philadelphia Museum of Art; Los Angeles Co. Museum; Whitney Museum of American Art; others. Received Guggenheim Fellowship, 1973; Creative Artists Public Service Progress Grant, 1977; National Endowment for the Arts, 1978; others. Address in 1982, 238 Park Ave. S., NYC.

MYERS, LEGH.
Sculptor. Born in Ventnor, NJ, November 11, 1916. Studied at Penna. State University, 1935-36; Lehigh University, 1936-39; also with J. Wallace Kelly, 1952-54. Has

exhibited at Knickerbocker Artists Annual, National Arts Club, NY, 1957-81; Audubon Artists Annual, National Academy of Design, NY, 1960-81; Sculptors Guild Annual Memorial Show, Lever House, NY, 1971-81; others. Member of Sculptors Guild; Audubon Artists; Knickerbocker Artists; Artists Equity Association of New York. Won awards Audubon Artists Shows. Works in marble and wood. Address in 1982, Margate, NJ.

N

NADELMAN, ELIE.
Sculptor and etcher. Born Warsaw, Poland, February 23, 1885. Studied at Art Academy, Warsaw, 1901; Academie Colarossi, Paris, 1904. Came to US in 1914. Member: National Sculpture Society; New York Architectural League; Modern Artists Association; Salons of America; Society of Independent Artists; New Society Artists; Beaux-Arts Institute of Design; Municipal Art Society; American Federation of Arts. Exhibited in Paris at Gallery Drouant, Gallery Bernheim-Jeune, Salon d'Automne, etc.; in New York City at Scott and Fowles Gallery, Knoedler, Museum of Modern Art, Photo-Secession; Carnegie. In collection of Museum of Modern Art; Newark (NJ) Museum; Whitney. Address in 1934, Riverdale-on-Hudson, NY. Died in 1964.

NADZOV, ALEXIS.
Sculptor and designer. Born Valparaiso, Chile, 1907. Illustrated many books. Exhibited: Paris, 1933.

NAGEL, WALTER.
Sculptor. Born in Saginaw, MI, 1940. Studied: Central Michigan University, B.S., M.A. Private collections. Exhibitions: Shows in Michigan and Indiana; The Detroit Institute of Arts, Michigan Focus, 1974-75. Awards: Numerous awards in local shows. Address in 1975, Saginaw, MI.

NAHL, PERHAM W.
Sculptor, painter, lecturer, and teacher. Born in San Francisco, January 11, 1869. Studied in San Francisco, Paris, and Munich. Member: California Society of Etchers; San Francisco Art Association. Represented in the Palace of Fine Arts, San Francisco; Municipal Art Gallery, Oakland; University of California. Professor of Art, University of California.

NAKIAN, REUBEN.
Sculptor. Born August 10, 1897, College Point, NY. Studied: Robert Henri School, with Homer Boss, A. S. Baylinson; Art Students League, 1912; apprenticed to Paul Manship, 1917-20, and Gaston Lachaise. Awards: Guggenheim Foundation Fellowship, 1930; Ford Foundation Grant, 1959 ($10,000); Sao Paulo, 1960; Rhode Island School of Design, 1979. Exhibited: The Downtown Gallery, NYC; Charles Egan Gallery, NYC; Sao Paulo, 1961; Los Angeles County Museum of Art, 1962; Washington Gallery of Modern Art; Felix Landau Gallery, LA; Museum of Modern Art; Salons of America, NYC, 1922; Whitney Studio Club, NYC; Art Institute of Chicago; Penna. Academy of Fine Art; XXXIV Venice Biennial, 1968; along with others. Collections: Museum of Modern Art; NYU; Whitney; Art Inst. of Chicago; Hirshhorn. Taught: Newark Fine Arts and Industrial Arts

College; Pratt Institute, 1949. Address in 1982, Stamford CT.

NAMINGHA, DAN.
Sculptor, painter, and printmaker. Born on Hopi Reservation (Keams Canyon), Arizona, in 1950. Studied at University of Kansas; Institute of American Indian Arts, Santa Fe, New Mexico; Academy of Art, Chicago. Work in US Department of Interior Arts Collection, Washington, DC; Museum of American Indian Arts and Culture, Chicago; Heard Museum, Phoenix, Arizona; mural (commission), Phoenix Airport; others. Has exhibited at Museum of Northern Arizona, Flagstaff; California Academy of Science, San Francisco; Carnegie Museum, Pittsburgh; American Museum of Natural History, New York City; Smithsonian Institution; Field Museum, Chicago; others. Specialty is subjects inspired by his Hopi-Tewa heritage; semi-abstract. Paints in acrylic. Reviewed in *American Artist Magazine*, 1979; *Southwest Art*, April, 1973 and June, 1981. Represented by The Gallery Wall, Scottsdale, AZ. Address in 1982, San Juan Pueblo on Hopi Reservation, Arizona.

NARANJO, MICHAEL A.
Sculptor. Tewa Indian, born in Santa Clara Pueblo, New Mexico, in 1944. Studied at Highlands University, New Mexico; later studied sculpture in Taos, New Mexico. Specialty is statuettes and larger figures of Tewa Indian subjects. Works in bronze. Reviewed in *Southwest Art*, April 1977. Has own gallery. Address in 1982, Espanola, New Mexico.

NASH, KATHERINE E.
Sculptor and educator. Born in Minneapolis, MN, in 1910. Studied: Univ. of Minn.; Minneapolis School of Art; Walker Art Center; Univ. of New Mexico, computer graphics. Awards: National Delta Phi Delta Competition, 1932; Minnesota State Fair, 1941, 1942, 1944; Minneapolis Inst. of Art, 1944; Swedish-American Exhibition, 1948; Lincoln Art Guild, 1950; Nebraska State Fair, 1951, 1952; Joslyn Art Museum, 1954; Nebraska Art Association, 1955; Walker Art Center, 1951; Sioux City, 1952. Collections: Univ. Medical Building, Omaha; Buffalo, Minnesota, Court House; Walker Art Center; Lincoln (NE) Art Guild; Nebraska Art Association; Kansas State College; Concordia College; Minneapolis Public Library; Joslyn Art Museum; Omaha Association of Art. Memberships: Honorable member, Artist Equity Association, 1957-61; Sculptors Guild. Address in 1982, Excelsior, MN.

NAUMAN, BRUCE.
Sculptor. Born in Ft. Wayne, IN, Dec. 6, 1941. Studied at the Univ. of Wisconsin, 1960-64, BA, mathematics; also with Italo Scanga; Robert Arneson, Manuel Neri, Wil-

liam T. Wiley, Frank Owen, and Stephan Kaltenbach; graduate study in art at the Univ. of California. Executed works in painting and performance pieces in conjunction with rubber and fiberglas sculptures. Some of his sculpture uses parts of artist's body as molds, such as his "From Hand to Mouth," 1965. Makes use of fluorescent lighting and work scripts, as in "Window or Wall Sign," 1967. Exhibited: American Sculpture of the Sixties, Los Angeles Co. Museum of Art, California, 1967, Corcoran, Washington, DC, 1969; Whitney Museum of Art, NY, 1969; Guggenheim Museum, NY, 1969; Art and Image in Recent Art, Art Inst., Chicago, 1974; Body Works, Museum of Contemporary Art, Chicago, 1975; Drawing Now, Museum of Modern Art, NY, 1975; 200 Years of American Sculpture, Whitney Museum, NY, 1976; A View of a Decade, Museum of Contemporary Art, Chicago, 1977; Words Words, Museum Bochum, West Germany, 1979; plus many others. Address in 1982, c/o Leo Castelli Gallery, 420 West Broadway, NYC.

NAYLOR, JOHN GEOFFREY.
Sculptor and educator. Born in Morecambe, England, August 28, 1928; US citizen. Studied at Leeds College of Art, national diploma in design; Hornsey College of Art, A.T.D.; University of Illinois, M.F.A. Work at Smithsonian Institution; National Collection of Art, Washington, DC; water sculpture, University of Florida, Gainesville; others. Has exhibited at Gallery of Contemporary Art, Winston-Salem, NC; Hirshhorn Museum and Sculpture Gardens, Washington, DC. Received Fulbright Travel Grant, 1954; National Foundation for the Arts Award, 1967. Teaching sculpture at University of Florida, from 1969. Works in brass and stainless steel. Address in 1982, Gainesville, FL.

NEAL, GRACE PRUDEN.
Sculptor and painter. Born in St. Paul, MN, May 11, 1876. Studied at Chicago Art Institute; Art Students League, NY; Grand Chaumiere, Paris, 1906-07. Works: Bronze relief, Corcoran Memorial Park, St. Paul; bronze group of symbolic figures presented to Great Britain, in London, 1924. Exhibitions: Corcoran Gallery, 1945; Smithsonian Institution, 1946; National Academy of Design, NY; Penna. Academy of Fine Arts, Philadelphia; Carnegie Institute, Pittsburgh; New York Architectural League; S. Coast art show, Ringling Museum, Sarasota, 1961; others. Award: First prize sculpture, Minn. State Art Society, 1903, 04, 05. Member: Order Eastern Star. Taught: Instructor of art department, Minn. State University, 1908-11; one-woman shows include Clearwater Art Group, Florida, 1952; Florida Gulf Coast Art Center; Chamber of Commerce, Clearwarer, 1954; Art Club of St. Petersburg, 1955; Tampa Art Institute, 1956. Address in 1962, Dunedin, FL.

NEANDROSS, SIGURD.
Sculptor. Born Stavanger, Norway, September 16, 1871; came to America at age of 10; US citizen, 1894. Pupil of Cooper Union evening classes in New York; P. S. Kroyer and Stefan Sinding in Copenhagen. Member: National Sculpture Society. Exhibited at National Sculpture Society, 1923. Award: Honorable mention, collaborative competition, New York Architectural League, 1915. Works include statues at Pottsville, PA, and Peekskill, NY. Address in 1933, Ridgefield, NJ. Died in 1958.

NEBEKER, BILL.
Sculptor. Born near Twin Falls, Idaho, in 1942. Studied geology at University of Arizona; Northern Arizona University at Flagstaff; worked at Phippen Ranch foundry. Exhibited at Phippen Art Show; won gold medal, sculpture. Executed statuette of John Wayne from movie "The Searchers," signed by Wayne. Specialty is statuettes of the modern cowboy. Works in bronze. Elected member, Cowboy Artists of America. Reviewed in *Southwest Art*, October, 1981. Represented by Trailside Gallery, Scottsdale, AZ; De Mille Gallery, Laguna Beach, CA. Address since 1950, Prescott, AZ.

NEBEL, BERTHOLD.
Sculptor. Born in Basel, Switzerland in 1889. Studied sculpture at Mechanics Institute and Art Students League. Member: National Sculpture Society (assoc.); Associate National Academy, 1932. Award: Fellowship, American Academy at Rome, 1914-17; Virginia War Memorial Comp., 1926. Exhibited at National Sculpture Society, 1923. Work: Sculpture, U.S. Capitol, Washington, DC; Hartford State Capitol Building; others. Address in 1934, New York City. Died in 1964.

NED.
Carver. Black artist working in Charleston, SC, 1859. Known to have executed carvings on a hearse.

NEEDHAM, CHARLES AUSTIN.
Sculptor, landscape painter, illustrator and craftsman. Born Buffalo, NY, October 30, 1844. Pupil of August Will and Art Students League of New York. Member: New York Watercolor Club; American Water Color Society; Salmagundi Club, 1903. Awards: Medal and hon. mention, Atlanta Exp., 1895; hon. mention, New York State Fair, Syracuse, 1898; bronze medal, Paris Exp., 1900; silver medal, Charleston Exp., 1902; bronze medal, St. Louis Exp., 1904. Address in 1921, 145 East 23d St.; h. 218 East 19th St., NYC.

NEIDER, GUSTAVE.
Sculptor. Born in Bavaria in 1817. Active in Baltimore, 1860.

NEILSON, M. P.
Sculptor. Active in 1915 in Westbury, NY. (Mallett's)

NELDER, A.
Sculptor. At New Orleans, 1846-56.

NELL, ANTONIA (TONY).
Sculptor, painter, and illustrator. Born in Washington, DC. Studied: Denver School of Art; and with George Bellows. Member: American Watercolor Society of New York; National Association of Women Artists; Baltimore Watercolor Club. Awards: Prizes, New York Watercolor Club; Baltimore Watercolor Club, 1921; National Association of Women Artists, 1936. Work: Whitney Museum of American Art; Vassar College, Poughkeepsie, NY; Metropolitan Museum of Art; Ellis Island, New York. Exhibited: Art Institute of Chicago; National Academy of

Design; Baltimore Watercolor Club; World's Fair, New York, 1939; Golden Gate Exposition, San Francisco, Calif., 1939; Penna. Academy of Fine Arts; and abroad. Illustrated national magazines. Address in 1953, 58 West 57th Street; h. 2 Riverview Terrace, New York, NY.

NELSON, CAREY BOONE.
Sculptor. Born in Lexington, MO. Studied at Wellesley College, B.A.; Northwestern University; University of Missouri; Wagner College, M.S.Ed.; Art Students League, with John Hovannes, Arturo Lorenzani, and John Terken. Work, portrait of Daniel Boone, American Revolution Bicentennial, Missouri State Capitol; bronze of Le Marquis de Lafayette, American Revolution Bicentennial, Lafayette Co., MO; bas-relief, US Navy; others. Has exhibited at Allied Artists of America, National Academy of Design Galleries; International Art Exchange, Monte Carlo, Monaco, Paris, and Cannes; American Artists Professional League Grand National; others. Received first place, sculpture, Salmagundi Exhibition; others. Member of Catharine Lorillard Wolfe Art Club; Nat. Lg. of American Pen Women; life fellowship, American Artists Professional League; Society of Illustrators; fellow, Royal Society of Arts. Works in bronze and marble. Address in 1982, Staten Island, NY.

NERI, MANUEL.
Sculptor and painter. Born in Sanger, California, April 12, 1930. Studied at University of California, Berkeley; California College of Arts and Crafts, Oakland, 1952-53, 55-57; assistant to Peter Voulkos, Archie Bray Foundation, Helena, Montana, summer 1953; California School of Fine Arts, San Francisco, 1957-59. Also studied with Elmer Bischoff. Taught at California School of Fine Arts, 1959-64; University of California at Davis, from 1964. In collections of Oakland Museum; Museum of Art, San Francisco; others. Exhibited at Dilexi Gallery and Quay Gallery, San Francisco; Oakland Museum; Seattle Art Museum; Whitney, NYC; Sydney, Australia; San Francisco Museum of Modern Art; Everson, Syracuse; many others. Received sculpture prize, San Francisco Art Institute 82nd Annual; National Endowment for the Arts Grant; National Art Foundation award; Guggenheim Fellowship. Has also exhibited and published drawings. Address in 1982, c/o Gallery Paule Anglin, San Francisco, California.

NEUBERT, GEORGE WALTER.
Sculptor and curator. Born in Minneapolis, MN, October 24, 1942. Studied at Hardin-Simmons University, B.S., 1965; San Francisco Art Institute, 1967; Mills College, M.F.A., 1969. Work in Oakland Museum, CA; Richmond Art Center, CA. Has exhibited at Contemporary Sculpture, San Francisco Art Institute; Invisible Painting and Sculpture, Richmond Art Center; others. Address in 1982, Oakland Museum, Oakland, CA.

NEVELSON, LOUISE.
Sculptor and printmaker. Born in Kiev, Russia, September 23, 1900. Studied in US, Europe and Central America; Art Students League, 1928-30; with Hans Hofmann, Munich, 1931; assistant to Diego Rivera, 1932-33. Collections: Museum of Fine Arts, Houston; Farnsworth

Museum, Rockland, Maine; Brandeis University; Birmingham Museum of Art; Whitney Museum of American Art, Museum of Modern Art, St. Peter's Church, New York University, Queens College, all in NYC; Carnegie Institute; Riverside Museum, New York City; University of Nebraska; Brooklyn (NY) Museum. Exhibited: Brooklyn Museum; Nierendorf Gallery; Grand Central Moderns Gallery; Whitney; Museum of Modern Art; many others. She has been called "the most distinguished woman sculptor in America and one of the great sculptors of the world." Her wooden assemblage sculpture is usually painted black. Other media include stone, plaster, terra cotta, metals; other colors are white and gold. Address in 1983, 29 Spring St., NYC.

NEVELSON, MIKE.
Sculptor. Born in NYC, February 23, 1922. Studied at NYC; self-taught in art. Works: Colby College; Wadsworth Atheneum; Slater; Whitney; Butler. Exhibitions: Roko Gallery, NYC; Carl Siembab Gallery, Boston; Staempfli Gallery, NYC; The Amel Gallery, NYC; Grand Central Moderns, NYC, 1967; Boston Arts Festival; Carnegie; Whitney; Houston Museum of Fine Arts. Award: Silvermine Guild, 1966. Taught: Wooster Community Art Center, Danbury, CT, 1965-68; Brookfield (CT) Craft Center, 1968. Address in 1982, Fairfield, CT.

NEVILLE, JAMES.
Sculptor and carver. Media: Marble and wood. Active in Charleston, South Carolina, 1822.

NEVIN, BLANCHE.
Sculptor. Born in 1838 in Mercersburg, Penna. Studied art in Philadelphia, and later in Italy. Pupil of J. A. Bailly. She executed many portrait busts, and her statue of Peter Muhlenberg was erected in the Capitol in Washington, DC. She died April 21, 1925, in Lancaster, PA.

NEVIN, JOSEPHINE WELLES (MRS.).
Sculptor. Born in Chicago. Died in Saranac Lake, NY, 1929. (Mallett's)

NEWELL, GORDON B.
Sculptor. Born in Petaluma, California, in 1905. Studied at Occidental College, Los Angeles; University of California at Berkeley; apprenticed to Ralph Stackpole, Pacific Coast Stock Exchange, San Francisco, 1929-32. Taught at Occidental; Chouinard Art Institute, Los Angeles, 1935-36; Sculpture Center, Monterey, California, c. 1965-72. Works include relief panel, "Banjo Player," Occidental College, Los Angeles, 1933; "Valley Landing," Fresno Mall, California, 1965; "Haupt Pools," White House Mall, Washington, DC, 1968; "Eagle," Public Library, Lompoc, California, 1981-82. Exhibited at California-Pacific International Exposition, San Diego, 1935; Feingarten Gallery, NYC; Rutgers University, NJ, 1979. Continued in the cut-direct stonework aesthetic of Stackpole; works in granite. His work in the 1930's made a significant contribution to modern California idiom.

NEWLIN, SARA JULIA.
(Mrs. Donald MacGregor). Sculptor, painter, illustrator, and teacher. Born in Pennsylvania. Pupil of Wm. M. Chase, Ben Gilman, Cecilia Beaux, and Henry Thouron.

Awards: Bronze medal, American Art Society, 1902. Member: Fellowship Penna. Academy of Fine Arts; Plastic Club. Address in 1903, 1416 Arch St., Philadelphia, PA; in 1933, Princeton, NJ.

NEWMAN, ALLEN GEORGE.
Sculptor. Born NY, August 28, 1875. Pupil of J. Q. A. Ward and National Academy of Design. Member: Associate National Academy of Design, 1926; National Sculpture Society, 1907; Beaux-Arts Institute; National Arts Club; Numismatic Society; American Federation Arts. Award: National Arts Club prize ($500) for design for "Valor Medal." Work: Marble figures; "Day and Night," Harriman Bank, NY; Henry Hudson Monument, NY; "The Hiker," Providence, RI; "Gate City Guard Peace Monument" and portrait on "Joel Chandler Harris Monument," Atlanta, GA; statue of "Governor Oates," Montgomery, AL; "Gen. Philip Sheridan Monument," Scranton, PA; "Doughboy Monument," Pittsburgh, PA. Exhibited at National Sculpture Society, 1923. Address in 1929, 1947 Broadway; h. 263 West 71st St., New York, NY; summer, Marbletown, NY. Died in 1940.

NEWMAN, BARNETT.
Sculptor and painter. Born in NYC, Jan. 29, 1905. Studied at the Art Students League under John Sloan; Duncan Smith, Adolf Gottlieb and William Von Schlegell; also at Cornell Univ., 1922-26; City College of NY, BA, 1927. Works: Noted for his "zip" paintings in which a single stripe cuts vertically through a monochrome field, creating his first one in 1950, entitled "Onement I." Also in 1950, he executed his first vertical strip sculpture, the two-strip "Here I," in plaster, cast in bronze in 1962. Other of Newman's sculptures of the same type are "Here II," 1965, three steel strips, each on a trapezoidal base on a platform and "Here III," 1966. His largest sculpture was titled "Broken Obelisk," 1967, Houston, TX. Exhibited: Betty Parsons Gallery, 1950, 51; Bennington College, 1958; French and Co., Inc., NYC, 1959; Allan Stone Gallery, 1962; Irving Blum Gallery, Los Angeles, 1970; Kammerkunsthalle, Berlin, 1970; Univ. of Washington, 1971; plus many others. Taught: Substitute in NYC public schools, 1931-39; Univ. of Saskatchewan, 1959; Univ. of Penna., 1962-64. Co-founded a school called the "Subject of the Artist," along with William Baziotes, Robert Motherwell, and Mark Rothko. Died in NYC, July 4, 1970.

NEWMAN, BLOSSOM.
Sculptor. Studied: Pratt Institute, Brooklyn, New York; University of Hartford Art School, Connecticut; Museum School, Boston, Massachusetts; Karlsruhe, Germany. Awards: Lowell Art, 1967; Sudbury Art, 1965. Exhibitions: Boston Center for Adult Education, 1974; Copley Society, Boston, 1974; Manchester Art Association, Massachusetts, 1974.

NEWMAN, ISIDORA.
Sculptor, painter, illustrator, craftswoman, writer, and lecturer. Born New Orleans, LA, April 23, 1878. Author of "Fairy Flowers." Address in 1929, 2 West 89th St.; h. 285 Central Park West, New York, NY.

NEWMARK, MARILYN (MEISELMAN).
(Marilyn Newmark Meiselman). Sculptor. Born in NYC, July 20, 1928. Studied at Adelphi College; Alfred Univ.; also with Paul Brown, Garden City, NY. Commissions: Hacking Home Trophy, Prof. Horseman's Association, 1971; Hobson Perpetual Trophy, Liberty Bell Race Track, Penna., 1972; American Gold Cup Medallion Award, Appaloosa Horse Club Medallion Award, 1974; Triple Crown, commission by Sam Lehrman, 1975; plus others. Exhibitions: Allied Artists of Amer., NY, 1970-74; National Sculpture Society, NY, 1970-73 and 75; National Art Museum of Sports, NY, 1971; James Ford Bell Museum of Natural History, Minneapolis, MN, 1971; National Academy of Design, NY, 1971, 72, 74, and 75. Awards: Anna Hyatt Huntington Gold Medal Award, Catharine Lorillard Wolfe Art Club, 1973; American Artists Professional League Gold Medal Award, 1974; Ellen P. Speyer Award; National Academy of Design, 1974; plus others. Medium: Bronze. Address in 1982, East Hills, NY.

NEWTON, ASHTON.
Sculptor and painter. Born in USA. Group shows: Several in Philadelphia and NY, including 43rd Anniversary Exhibition, Federation of Modern Painters and Sculptors, Inc., NYC, 1983. Collections: Numerous paintings and mobiles in private collections.

NEY, ELIZABETH.
Sculptor. Born in 1833 in Westphalia, Germany, and patronized by the "mad king" Ludwig II of Bavaria. She left her home for political reasons, and settled in Texas in 1873. Executed a fine memorial to General Albert Sidney Johnson for the cemetery at Austin, Texas. Died June 30, 1907, in Austin, TX.

NEYLAND, HARRY.
Sculptor and painter. Born McKean, Erie Co., PA, in 1877. Pupil of New York Art Students League, and of schools in Paris. Works: Memorial tablets, Whaling Enshrined, Inc.; "Surf and Sunlight," Hudson Motor Car Co.; "The Wanderer," Pratt Institute, Brooklyn, New York; "Furled Sails;" "The Huntress of the North," Country Club, New Bedford, MA. Illustrations for "Cap'n George Fred," pub. by Doubleday, Doran and Co. Address in 1933, New Bedford, MA; h. So. Dartmounth, MA.

NIBLACK, PAT.
Sculptor and painter. Born in Wichita Falls, Texas, in 1924. Studied at Texas State College for Women; Philbrook Art Center. Specializes in children and Indians; does portrait sculpture on commission, life size and heroic. Works in bronze. Exhibits at Margaret Jamison Presents. Represented by Munson's, Santa Fe, NM; Gallery of the Southwest, Houston, TX. Address since 1969, Santa Fe, New Mexico.

NICHOLS, MARY PLUMB (MRS.).
Sculptor. Born in Vernon, OH, July 15, 1836. Pupil of Preston Powers. Medal and diploma, Columbian Exp., Chicago, 1893. Member Denver Art Club. Address in 1910, Denver, CO.

NICHOLS, PEGGY (MARTIN).
Sculptor and painter. Born in Atchison, Kansas, in 1884.

Pupil of Cecilia Beaux and Chase. Member: California Art Club. Address in 1926, Los Angeles, California.

NICHOLSON, ISABEL LEDCREIGH.
Sculptor and painter. Born St. Louis, MO, March 28, 1890. Pupil of Tarbell; Richard Brooks; Lee Randolph; Ruth Ball; Bohnen and Loup in Lausanne. Member: National Association Women Painters and Sculptors; San Diego Society Fine Arts; Carmel Society Arts and Crafts; American Federation of Arts. Address in 1929, Studio Building; h. La Playa Hotel, Carmel, CA.

NICKERSON, RUTH (JENNIE RUTH GREACEN).
Sculptor and teacher. Born in Appleton, WI, Nov. 23, 1905. Studied with Ahron Ben-Smuel, NYC; National Academy of Design; and at the Simcoe College Inst., Ontario, Canada. Exhibitions: National Academy of Design, NYC, from 1932; Whitney Museum of American Art, NYC, 1934; Museum of Modern Art, NY, 1939; Artists for Victory, at the Metropolitan Museum of Art, NYC, 1942; Audubon Artists, 1981. Taught: Instructor in sculpture at the Roerich Museum, NYC, 1934-35; Westchester Art Workshop, 1945-47 and 48-69; instructor of modelling and sculpture, National Academy of Design School, NY, 1980-81. Commissions: Numerous portraits for private collectors, from 1932; "Learning," a stone group, for the Federal Art Project, Brooklyn, 1934; "Tympanum," for the Federal Government, New Brunswick Post Office, NJ, 1936; and numerous others. Major medium is stone. Address in 1982, White Plains, NY.

NICKERSON, REUBEN.
Sculptor. Born in Massachusetts in 1834. Active in Boston, June, 1860.

NICKFORD, JUAN.
Sculptor and educator. Born in Havana, Cuba, August 8, 1925; US citizen. Studied at Academy of Art, Havana, M.F.A., 1946; School of Architecture, University of Havana. Work: Welded metal sculpture, Socony Oil Bldg., NY; screens, Grace Line, SS Santa Rosa; outdoor sculpture, Tappan Town Society, NY; others. Has exhibited at Whitney Museum of American Art Annual, 1950-57; Museum of Modern Art, NY; Los Angeles Co. Museum of Art; The Sculpture Gallery, Palo Alto, CA; Sculptor's Guild, NY; others. Received honorable mention, Penna. Academy of Fine Arts; bronze medal, NY State Exposition. Trustee, Sculpture Center of NY, from 1970. Teaching sculpture at City College of NY, from 1970. Works in metal and mixed media. Address in 1982, Tappan, NY.

NICKSON, LIA.
Sculptor and educator. Born in Chapel Hill, North Carolina. Studied at Albion College, 1940-42; A.B., University of North Carolina, 1944; Art Students League, NY, 1944-46; Grande Chaumiere, Paris, 1948; Jepson Art Institute, Los Angeles. Exhibitions: North Carolina Art Annual, 1952; Artists Equity Gallery, Los Angeles, 1952; Museum NM, Santa Fe, 1955-56, 60; Roswell Museum School, 1954, 55, 56; National Traveling Exhibit, Santa Fe Museum. Awards: Purchase prize, Roswell Museum, 1956;

Santa Fe Museum Biennial, 1958. Member: Artists Equity, Pi Beta Phi. Address in 1962, North Haledon, NJ.

NICODEMUS, CHESTER ROLAND.
Sculptor, craftsman, and teacher. Born in Barberton, OH, August 17, 1901. Studied: Penna. State College; Cleveland School of Art; Univ. of Dayton; Ohio State Univ. Member: National Sculpture Society; Columbus Art League. Work: Tablet, Wilbur Wright High School, Dayton, OH; Columbus Gallery of Fine Arts; Unitarian Church, Columbus, OH; Butler Inst. Medal; others. Exhibited: Syracuse Museum of Fine Arts, 1933-38, 40, 41; Columbus Art League, 1930-46, 63; Butler Inst. of American Art, Youngstown, OH, 1965. Taught: Instructor of Sculpture, Dayton Art Inst., 1925-30; Instructor, Sculpture and Pottery, Columbus Art School, Columbus, Ohio, 1930-43. Address in 1982, Columbus, OH.

NICOLOSI, JOSEPH.
Sculptor, painter, etcher, architect, writer, lecturer, and teacher. Born Sicily, August 4, 1893. Came to US in 1912. Pupil of Beaux-Arts Institute, Solon Borglum, Edward McCarten. Member: National Sculpture Society; New York Architectural League. Awards: Two bronze medals, 1917, 1919; five second-place medals, Beaux-Arts Institute. Work: Dr. M. B. Heyman, Manhattan State Hospital; New Brighton, Penna., War Memorial; World War Memorial, Morristown, NJ. Address in 1953, Los Angeles, Calif. Died in 1961.

NIEHAUS, CHARLES HENRY.
Sculptor. Born Cincinnati, OH, January 24, 1855. Pupil of McMicken School in Cincinnati; Royal Academy in Munich and Rome. Member: Associate National Academy of Design, 1902; National Academy of Design, 1906; New York Architectural Lg., 1895; National Sculpture Society, 1893; Salmagundi Club, 1908; National Institute Art League. Awards: Gold medal, Pan-Am. Exp., Buffalo, 1901; gold medal, Charleston Exp., 1902; gold medal, St. Louis Exp., 1904. Work: "Dr. Hahnemann" and "John Paul Jones," Washington, DC; "Garfield," Cincinnati, OH; Astor Memorial doors, Trinity Church, NY; "Caestus" and "The Scraper," Metropolitan Museum, New York; "Francis Scott Key," Baltimore; Soldiers and Sailors monuments, Hoboken, Newark and Hackensack, NJ; statues of Clay and McDowell, Statuary Hall, Capitol, Washington. Exhibited at National Sculpture Society, 1923. Address in 1933, Eagle Crest Studio, Grantwood, NJ. Died June 19, 1935.

NIIZUMA, MINORU.
Sculptor. Born in Tokyo, Japan, September 29, 1930. Studied at Tokyo University of Art, B.F.A. Work in Museum of Modern Art, NY; National Museum of Modern Art, Tokyo; Albright-Knox Gallery, Buffalo; Guggenheim Museum, NY; Hirshhorn Museum and Sculpture Garden, Washington, DC; others. Has exhibited at Museum of Modern Art; Whitney Museum of American Art; Howard Wise Gallery, NY; Contemporary Sculpture Center, Tokyo; others. Member of Modern Art Association of Japan (permanent juror); Sculptors Guild. Taught sculpture at Brooklyn Museum Art School, 1964-69; teaching at Columbia University, from 1972. Address in 1982, 463 West St., NYC.

NILSEN, MARGIT.
Sculptor. Address in 1934, NY. (Mallett's)

NIMMO, LOUISE EVERETT.
(Mrs. Ray E.). Sculptor and painter. Born Des Moines, IA, April 9, 1899. Pupil of Fursman, Charles W. Hawthorne, Julia Bracken Wendt, Otis Art Inst., Fontainebleau School of Fine Arts, Julian Academy, and Chouinard School of Art. Member: California Art Club; Women Painters of the West; Laguna Beach Art Association. Awards: Marine prize, Laguna Beach Art Association, 1923; silver medal for sculpture, Pacific Southwest Exp., Long Beach, CA, 1928; purchase prize, Beverley Hills Women's Club, 1933. Work: "Geraniums Red and Delphinium Blue," Smouse Opportunity School, Des Moines, IA; "Decorative Cactus," mural decoration, California Art Club, Los Angeles. Address in 1933, Los Angeles, CA.

NISON, MARGARET LAWSON.
Sculptor. Address in 1934, NY. (Mallett's)

NISWONGER, ILSE.
Sculptor. Born in Metz, France, in 1900. Studied at Art Students League with Archipenko, Hofmann, and Belling. Works: Sculpture in churches in the following: Westport, Fairfield, New Haven, New Canaan, West Hartford, Norwalk, and Bolton, CT; Harrisburg and Pittsburgh, PA; Brooklyn, NY; Glendora, CA; Moncton, Canada; Baraboo, Wisconsin; Don Bosco School, Paterson, NJ.

NIVOLA, CONSTANTINO.
Sculptor. Born in Orani, Sardinia, July 5, 1911. Came to US in 1939. Studied at Instituto Superiore d'Arte, Monaz, Italy, with Marino Marini, Marcello Nizzoli, 1930-36, M.A., 1936. Works: Museum of Modern Art; Whitney; Hirshhorn; Philadelphia Museum of Art; plus numerous commissions including murals in Olivetti Showroom, NYC, gardens at 1025 Fifth Ave., NYC, sculpture at Yale Univ., sculpture for 19th Olympiad, Mexico City. Exhibitions: Tibor de Nagy Gallery, NYC; The Peridot Gallery, NYC; The Bertha Shaefer Gallery, NYC; NY Architectural League; American Federation of Arts; Brooklyn Museum; Rome National Art Quadrennial, 1950; Riverside Museum; Whitney; Carnegie; Museum of Contemporary Crafts; National Gold Medal Exhibition of the Bldg. Arts, NYC; Museum of Modern Art. Awards: Philadelphia Decorators Club Award, 1959; Municipal Art Society of NY, Certificate of Merit, 1962; NY Architectural League, Silver Medal of Honor in Sculpture, 1962; Regional Exhibition of Figurative Art, Cagliari, Italy, Gold Medal; Federation of Graphic Arts, diploma; American Institute of Architecture, Fine Arts Medal, 1968. Member: NY Architectural League; National Institute of Arts and Letters. Taught: Director, Design Workshop of Harvard Univ. Graduate School, 1954-57; Columbia Univ., 1961-63. Art Director, *Interiors* magazine, 1941-45. Address in 1982, East Hampton, NY.

NIX, PATRICIA (LEA).
Sculptor and painter. US citizen. Studied at NY University; New School for Social Research, with Anthony Toney; Art Students League. Work in Smithsonian Institution, Washington, DC; Museum of the Southwest, Midland, TX; others. Has exhibited at Artists of the 70's, Avery Fisher Hall, Lincoln Center, NY; National Academy of Design Annual, NY; Heckscher Museum, Huntington, NY; others. Received awards from National Arts Club Annual; Texas Fine Arts Citations; others. Member of National Arts Club; NY Artists Equity; associate member of Audubon Artists. Works in wood, found objects; mixed media. Address in 1982, Lamesa, TX.

NOBACK, GUSTAVE JOSEPH.
Sculptor, etcher, and lecturer. Born in New York, NY, May 29, 1890. Studied: Cornell University, B.S.; University of Minnesota, M.A., Ph.D.; and with W. C. Baker, Heinz Warneke, Wheeler Williams. Member: National Arts Club, New York; American Artists Professional League. Work: New York University; China Institute of America. Exhibited: Architectural League, 1938; Penna. Academy of Fine Arts, 1940, 42, 46; National Academy of Design, 1945, 46; Allied Artists of America, 1941-45; Clay Club, 1934, 35; Asbury Park Society of Fine Arts, 1939, 40; Montclair Art Museum, 1945; National Arts Club, 1944-46; Minneapolis Sculpture Exh., 1945. Lectures: Human Anatomy in Art. Taught: Professor of Anatomy, New York University, New York, NY, 1924-45. Address in 1953, 15 Gramercy Park, New York, NY; h. Forest Hills, NY.

NOBEL, BERTHOLD.
Sculptor. Award: Fellowship, American Academy at Rome, 1914-17. Address in 1918, American Academy in Rome, Porta San Pancrazio, Rome, Italy.

NOBLE, WILLIAM CLARK.
Sculptor and painter. Born Gardiner, ME, February 10, 1858. Pupil of Pierce, Greenough, and Taft in London. Member: National Sculpture Society; National Arts Club. Work: Walters' Memorial, W. E. Channing and Soldiers and Sailors Monument, Newport, RI; memorial to Bishop Phillips Brooks in Church of the Incarnation, NY; portrait bust of Gen. Potter, Chamber of Commerce, NY; Challenge statue and General Christ statue, Antietam, MD; Gov. Curtin, Bellefonte, PA; jewelled crucifix in Church of St. Mary the Virgin; "Mother's Memorial," and "Major Pierre Charles L'Enfant Memorial," Washington, DC. Designed gold and silver money for Guatamala, 1925, and for Panama, 1930, 31. Address in 1929, Washington, DC. Died in 1938.

NOCQUET, PAUL-ANGE.
Sculptor and painter. Born in Brussels, Belgium, April 1, 1877. He came to America in 1903. Pupil of Lambeaux, Antonin Mercie, and Gerome in Paris. His bronze "American Football" brought him recognition; it was presented to Columbia Univ. Awards: First grand prize for sculpture, Rome, Belgium, 1900; silver medal, St. Louis Exp. 1904. Member: Associate, Champs de Mars, Paris, 1902; Societe Nationale des Beaux-Arts, Paris; Society "Les Arts Reunis," Paris; Ste. Sillon, Brussels. Address in 1906, 55 East 59th St., NYC. Died in 1906.

NOE, JERRY LEE.
Sculptor and educator. Born in Harlan Co., KY, September 27, 1940. Studied at University of Kentucky, B.A.; Art Institute of Chicago, M.F.A. Has exhibited at Sculpture 70, Art Institute of Chicago; Gimpel-Wietzenhoffer Gallery, NY; National Sculpture Traveling Exhibition, 1973-75; Aldrich Museum of Art, Ridgefield, CT; others. Received Ford Foundation Scholarship, Art Institute of Chicago, 1969-70; first place award, Southern Association of Sculptors, 1973; National Endowment for the Arts grant, 1977; others. Member of Southern Association of Sculptors; Southeastern Center of Contemporary Art. Taught sculpture at Art Institute of Chicago, 1969-71; teaching sculpture at University of North Carolina, Chapel Hill, from 1971. Works in neon, mixed media. Address in 1982, c/o Dept. of Art, University of North Carolina, Chapel Hill, NC.

NOGUCHI, ISAMU.
Sculptor. Born Nov. 17, 1904, in Los Angeles, CA. Studied at Columbia University (premedical); with Gutzon Borglum; Leonardo da Vinci Art School, NYC; East Side Art School, NYC; with Constantin Brancusi, Paris, 1927-29; Onorio Ruotolo and Brancus; Designed stage sets for Martha Graham Dance Co. Received commissions in NYC, Boston, Fort Worth, TX, Paris, Jerusalem. In collections of Brooklyn; Albright-Knox; Art Institute of Chicago; Metropolitan Museum of Art; Museum of Modern Art; Whitney; Tate; many others. Awards: Guggenheim Fellowship; Bollingen plus others. Exhibited at Penna. Academy of Fine Arts in 1926; Schoen Gallery, Sterner Gallery, Demotte Gallery, Harriman Gallery, all in NYC; Albright-Knox; San Francisco Museum of Art; Whitney; others. Received Guggenheim Foundation Fellowship, 1927; Logan Medal, Art Institute of Chicago; Bollingen Found. Fellowship. Address in 1937, Long Island City, NY.

NORDHAUSEN, A(UGUST) HENRY.
Sculptor, painter, and teacher. Born Hoboken, NJ, Jan. 25, 1901. Pupil of Hugo von Habermann and Howard Giles. Member: Salmagundi Club; Springfield Art League; New Haven Paint and Clay Club. Awards: First prize for portrait, 1930, and hon. mention, 1931, Springfield Art League; hon. mention, New Haven Paint and Clay Club, 1931; fellowships at Tiffany Foundation, Oyster Bay, NY, Trask Foundation, Saratoga Springs, NY, and MacDowell Assoc., Peterborough, NH. Address in 1933, 46 East 9th Street, NYC.

NORMAN, EMILE.
Sculptor and painter. Born in El Monte, CA, April 22, 1918. Work: San Francisco Museum of Art; Oakland Art Museum. Commissions: Mosaic window & marble relief, Masonic Memorial Temple, San Francisco; horse in wood, Crown Zellerbach Building, San Francisco; bronze of "St. Francis and Wood Inlay Mural," Bank of CA, San Francisco. Exhibitions: Religious Art Show, de Young Museum, San Francisco, 1953; Society of Contemporary Art Annual, Art Institute of Chicago, 1960; design & aesthetics in wood, Lowe Art Center, Syracuse University, 1967; and others. Member: Carmel Art Association;

National Society of Mural Painters. Media: Oil, acrylic; wood, precious metals. Address in 1982, Carmel, CA.

NORRIS, ETHELBERT.
Sculptor. Born c. 1829, Maryland. At Cincinnati, 1850.

NORRIS & KAIN.
Sculptors. Edward Norris and Francis Kain. Working in New York City, 1811-18.

NORTHRUP, GEORGE O.
Sculptor. Born in Detroit Lakes, Minnesota, in 1940. Studied liberal arts and business in college. Worked as a welder, plumber, restaurant manager, and conducted raft trips on Snake River. Learned metal casting; works in bronze. Specialty is wildlife statuettes. Exhibits with Society of Animal Artists. Member, Society of Animal Artists. Represented by Trailside Galleries, Scottsdale, AZ. Address since 1967, Moose, Wyoming.

NORTON, ANN W.
Sculptor. Studied at National Academy of Design; Art Students League; Cooper Union Art School; and with Leon Kroll, John Hovannes, Charles Rudy and Charles Keck. Awards: Carnegie fellowship for European study, 1932, 1935; Society of Four Arts, Palm Beach, Florida, 1944, 45; Lowe Gallery, 1952; Norton Gallery, 1943-45. Died in 1982.

NORTON, ELIZABETH.
Sculptor, painter, and block printer. Born Chicago, IL, December 16, 1887. Pupil of Art Institute of Chicago; Art Students League of New York; National Academy of Design. Exhibited: Golden Gate Exp., San Fran., CA, 1939; California Society of Etchers, annually; National Academy of Design, 1941; Prairie Print Museum, 1949-51; one-woman, California State Library, 1942; Stanford University, 1950. Member: Alliance; California Print Makers Society; Palo Alto Art Club; San Francisco Society Women Artists; American Federation of Arts Club; Library of Congress and Smithsonian Institution, Washington, DC; Public Library, Springfield, Mass. Address in 1953, 353 Lowell Avenue, Palo Alto, CA.

NORVELL, PATSY.
Sculptor and environmental artist. Born in Greenville, SC, July 13, 1949. Studied at Bennington College, VT, B.A.; also with Peter Voulkas and David Smith; San Francisco Art Institute, post graduate study; Hunter College, M.A. Exhibited at Institute for Art and Urban Resources, Queens, 1976; Nassau County Museum, Roslyn, NY, 1977; one-woman shows held at AIR Gallery, 1973, 75, 78, 80, 82; Vassar College Art Gallery and Barrett House in Poughkeepsie, NY; Zabriski Gallery, 1981; others. Received grant from the National Endowment for the Arts, 1976-77. Taught sculpture and drawing at Rutgers University, Newark, NY, 1969-70; Montclair State College, Upper Montclair, NJ, 1970-74; Columbia University, NYC, 1977; Queens College, NYC, 1977-78; and Hunter College, NY, from 1978. Uses assorted media, including glass, plexiglas, mirrors, tape, and string, to form wall pieces. Address in 1982, 78 Greene Street, NYC.

NOSWORTHY, FLORENCE PEARL ENGLAND.
(Mrs. Alfred Nosworthy). Sculptor, painter, and illustrator. Born in Milwaukee, WI. Pupil of Boston Museum of Fine Arts, under Tarbell and Benson; Cowles Art School in Boston; Art Students League of NY, under Cox and Barse. Address in 1933, Hampton, CT. Listed only as an illustrator after 1933.

NOTARO, ANTHONY.
Sculptor. Born in Italy, January 10, 1915; US citizen. Study: Rinehart School of Sculpture, MD Institute, Baltimore, 1935-39 with Wm. Simpson, Herbert Adams; also with Malvina Hoffman. Collections: The Hall of Fame for Great Americans; Student Center, Seton Hall University; National Commemorative Society; and many others. Commissions: Wrestling group, Council American Artists Society; Figure of "Winter," National Sculpture Society; portrait, Jimmy Carter; football players, Allied Artists of America; others. Exhibition: National Academy of Design; National Sculpture Society; Lever House; Allied Artists of America; Italian Cultural Center, Chicago; and many others. Awards: Bicentennial Exhibition, National Sculpture Society; Hudson Valley Art Association; plus many others. Member: Fellow, National Sculpture Society; American APL; Allied Artists of America. Address in 1982, Mendham, NJ.

NOTKIN, RICHARD T.
Sculptor and ceramist. Born in Chicago, IL, October 26, 1948. Studied at Kansas City Art Institute, with Dale Eldred and Ken Ferguson, B.F.A., 1970; University of California, Davis, with Robert Arneson, M.F.A., 1973. Work in Stedelijk Museum, Amsterdam, Holland; Smithsonian Institution, Washington, DC. Has exhibited at Whitney Museum of American Art, NY; Quay Gallery, San Francisco; Renwick Gallery, Smithsonian Institution; Seattle Art Museum; others. Received Western States Art Foundation fellowship, 1976; National Endowment for the Arts fellowship, 1979 and 81. Member of National Council of Education of Ceramic Arts; American Crafts Council. Work in ceramics, porcelain; mixed media, terra cotta. Represented by Alan Frumkin Gallery, 50 W. 57th St., NYC. Address in 1982, Myrtle Point, OR.

NOVANI, GUILIO.
Sculptor. Born Massa-Carrara, Italy, June 11, 1889. Pupil of Academy of Massa-Carrara and Beaux-Arts Institute in New York. Executed busts and medallions. Exhibited at National Sculpture Society, 1923. Address in 1929, 1347 Intervale Ave.; 126 East 75th St., New York, NY.

NOVELLI, JAMES.
Sculptor. Born in Sulmona, province of Aquila, Italy, in 1885. He came to NY in 1890. He returned to Italy in 1903 and studied under Julio Monteverde, Ettore Ferrari, and Silvio Sbricoli. He graduated at the Royal Academy of Rome in 1908. Awards: Hon. men., International Exposition, Paris, 1906. Member: National Sculpture Society, NY. Work: Motherhood group, and "Rock of Ages," Durham, NC; bronze crucifix, Holy Name Cemetery, Jersey City, NJ; bronze doors, Sigman mausoleum, and Schmuck mausoleum, Woodlawn Cemetery, NY; bronze door, Bigham mausoleum, Hawthorne, NY; bronze door, LaGioia mausoleum, Calvary Cemetery, NY; war memorials, Saratoga Park, Brooklyn, NY, and Pershing Field, Jersey City, NJ; Rowan panel, bronze, Woodlawn Cemetery, New York; Lamattina Guerriero memorial, of bronze and granite, Calvary Cemetery, NY; bronze busts; portrait reliefs in bronze and terra cotta. Exhibited at National Sculpture Society, 1923.

NUHFER, OLIVE HARRIETTE.
Sculptor, painter, teacher, designer, and writer. Born in Pittsburgh, PA, August 16, 1907. Studied: University of Oklahoma, B.F.A.; Carnegie Institute. Member: Associated Artists of Pittsburgh. Work: Murals, United States Post Office, Westerville, Ohio; altar mural, St. John's Church, Norman, Oklahoma. Exhibited: Associated Artists of Pittsburgh. Address in 1953, Pittsburgh, PA.

NUSS, JOANNE.
Sculptor. Born on May 2, 1951. Studied drawing at Valparaiso University, IN, 1969-70; lithography and painting at University of Kansas, Lawrence, 1970-71; design and architecture at the University of Copenhagen, Denmark, 1974; B.A., graduate study, at Fort Hays State University, Hays, KS, 1975; travelled extensively throughout Europe and northwest Africa, studying various metal techniques, also teaching drawing. Commissions include various indoor sculptures for private collections in St. Louis and Kansas City, MO, also in Denver, CO. Exhibited: Second International Sculpture Fair, Boston, MA; Bette Moses Gallery (one-woman), Great Bend, KS, 1980, 82; Mulvane Art Center, Washburn University, Topeka, KS; The Batz Gallery, Kansas City; Spiva Art Center, Joplin, MO; Art Exp., San Francisco, CA; The Birger Sandzen Memorial Gallery, Lindsborg, KS, 1981; Women's Conference, University of Missouri, 1982; Fort Hays State University, Hays, KS, 1984. Awards: Best 3-Dimensional Work, from Kansas Artists and Craftsmen Association Annual Exhibition; cash award, from the Wichita Art Association, Wichita, KS, March, 1983. Member: Kansas City Artists Coalition, from 1980; Kansas Sculptor's Association, from 1982; International Sculpture Center, from 1982; American Craft Council, from 1980; The Smithsonian Associates, from 1980. Specializes in bronze casting, using lost wax and sand cast methods. Address in 1983, Kansas City, MO.

OAKLEY, VIOLET.

Sculptor, painter, illustrator, and writer. Born in Jersey City, NJ, 1874. Studied at Art Students League; Penna. Academy of Fine Arts; Drexel Institute; in Paris; and with Howard Pyle. Member: Academician of National Academy of Design; Philadelphia Art Alliance; American Institute of Architects (hon.); Philadelphia Water Color Club. Awards: Hon. degree, D. Litt., Delaware College, Newark, DE; medal, Penna. Academy of Fine Arts, 1905; St. Louis Exp., 1904; Pan-Pacific Exp., 1915; Architectural League, 1916; prizes, Penna. Academy of Fine Arts, 1922, 32, 40. Work: All Angels Church, NY; Penna. State Capitol; mural panels, Cuyahoga Co. Court House, Cleveland, OH; USO Officer's Club, Philadelphia; Penna. Academy of Fine Arts; portraits, Victoria and Albert Museum, London; Vassar College; Fleischer Memorial, Philadelphia; League of Nation's Library. Exhibited: National Academy of Design; Architectural League; Penna. Academy of Fine Arts; Corcoran Gallery of Art; Philadelphia Art Alliance; Woodmere Art Gallery; Yale University; and extensively in Europe. Author, illustrator, "The Holy Experiment," 1922; "Law Triumphant," 1932; and other books. Address in 1953, Philadelphia, PA. Died in 1960.

OBERHARDT, WILLIAM.

Sculptor, painter, lithographer, and illustrator. Born Guttenberg, NJ, 1882. Studied at National Academy of Design, 1897-1900; Munich Academy of Fine Art, 1900-03, the pupil of Marr and Herterich. Member of National Academy (graphics) 1945; Society of Illustrators. Work in New York Public Library; Library of Congress; War Department; Commission of Fine Arts. Specialty was portraits, including hundreds of celebrities from 1908 to 1956; lithograph subjects included cowboys. Died probably in Pelham, New York, in 1958.

O'BRIEN, DANIEL.

Sculptor. Active in Cincinnati in 1860, where he worked with John G. Draddy.

O'BRIEN, JOHN.

Sculptor. Born in Ireland in 1834. Executed monument to Commodore Perry at Cleveland, OH. Lived in Galveston, TX, from 1882 until he died on Dec. 20, 1904.

O'BRIEN, SEUMAS.

Sculptor and writer. Born in Glenbrook, Co. Cork, Ireland, in 1880. Instructor in art, Cork School of Art, Mt. St. Joseph's Monastery (Cork); Queenstown Technical School; Metropolitan School of Art (Dublin) until 1912; Abbey Theatre dramatist and lecturer, 1913-17; exhibited at Royal Hibernian Academy. Awarded silver medal (sculpture) by Board of Education, London, 1912. Came

to US in 1913. Address in 1926, 117 W. 90th St., NYC.

O'BRIEN, THOMAS.

Sculptor. Born in Ireland, 1834. Died in Galveston, TX, 1904. See also O'Brien, John. (Mallett's)

O'CONNOR, ANDREW.

Sculptor. Born in Lanarkshire, Scotland, April 18, 1846; came to America at the age of five. Pupil of C. H. Heminway in Providence, RI; studied in Rome. Address in 1910, Holden, MA.

O'CONNOR, ANDREW, JR.

Sculptor. Born Worcester, MA, June 7, 1874. Pupil of his father; also of Daniel Chester French. Member: Associate National Academy of Design, 1919; National Institute Artists League. Awards: Bronze medal, Pan-Am. Exp., Buffalo, 1901; gold medal, Paris Salon, 1906; silver medal, Barcelona, Spain, 1907. Work: Central Porch, St. Bartholomew's Church, NY; Liscurn Memorial, Arlington; Thomas Memorial, Tarrytown; "Inspiration," St. Louis; "Justice," Newark; "Lawton," Ind'pls.; "Wallace," Washington, DC; "1898," Worcester; "Lincoln," Springfield; "Roosevelt Memorial," Glen View, IL; "Lafayette," Baltimore; "Justice," The Hague; "1917," Boston; statues in the Luxembourg; Musee des Arts Decoratifs, Paris; bust of Lincoln at Metropolitan Museum of Art; "Adam and Eve," marble, Corcoran Gallery of Art, Washington, DC. Exhibited at National Sculpture Society, 1923. Died June 9, 1941. Address in 1929, Paxton, MA.

OCVIRK, OTTO G.

Sculptor and printmaker. Born in Detroit, MI, November 13, 1922. Studied at State University of Iowa, B.F.A. and M.F.A. Work in Dayton Art Institute, OH; Detroit Institute of Art, MI; others. Has exhibited at Walker Art Center, Minneapolis, MN; Northwest Printmakers, Seattle, WA; others. Received awards for sculpture exhibition, Walker Art Center, Minneapolis; others. Works in stone; intaglio. Address in 1982, Bowling Green, OH.

O'DONOVAN, WILLIAM RUDOLPH.

Sculptor. Born in Preston County, VA, in 1844. Self-taught in art. He established a studio in New York and executed many important portrait busts and bas-reliefs. Works: Wm. Page, National Academy, which was presented to the National Academy of Design; Arthur Quartly, National Academy; Thomas Eakins, National Academy; Edmund Clarence Stedman; busts of Walt Whitman and Gen. Joseph Wheeler; equestrian statues of Lincoln and Grant for Soldiers' and Sailors' Arch, Prospect Park, Brooklyn; reliefs for Oriskany battle monument; statue of Archbishop Hughes, St. John's College, Fordham; memorial tablet to Bayard Taylor, Cornell University; a

statue to the captors of Major Andre, Tarrytown, NY. O'Donovan was one of the four founders of the famous Title Club; also a member of the Hudson-Fulton Commission. Elected Associate Member of the National Academy, 1878. Member: Society of American Sculptors; Architectural League. Died in 1920.

OERTEL, JOHANNES ADAM SIMON.
Sculptor, engraver, and painter. Born in Furth, near Nuremberg, Germany, Nov. 3, 1823. Oertel was apprenticed to J. M. E. Muller, a well-known engraver of Nuremberg; but as a result of the German revolution of 1848 he came to America and settled in Newark, NJ. He at first tried painting and then resorted to engraving, doing much work for the banknote companies. He finally attained success with his pictures of army life done from studies made in Virginia during the Civil War. He was rector of a number of churches at various times and was professor in an art school in St. Louis for two years. All of this time he was busy painting, especially in the line of Christian art, and carving church decorations. About 1857 he assisted in decorating the Capitol at Washington, DC. Died Dec. 9, 1909, in Vienna, VA.

OFFNER, ELLIOT.
Sculptor and printmaker. Born in Brooklyn, NY, July 12, 1931. Studied at Cooper Union; Yale University, B.F.A. and M.F.A, with Josef Albers and Rico Lebrun. Work in Brooklyn Museum; De Cordova Museum, Lincoln, MA; Metropolitan Museum of Art, NY; bronze sculpture, Kehilleth Israel, Brookline, MA; sculptures, Holocaust Memorial bronze, Cathedral of St. John The Divine, NY; others. Has exhibited at International Exhibition of Liturgical Art at Eucharistic Congress, Penna. Academy of Fine Arts; De Cordova Museum; Slater Memorial Museum, Norwich, CT; Boston Atheneum; others. Received Tiffany Foundation grants, 1964 and 65; National Council on the Arts and Humanities grant, 1967; others. Taught art at Smith College, 1960-74, humanities from 1974. Address in 1982, Northampton, MA.

OGDEN, EDITH HOPE.
Sculptor. Born in St. Paul, MN. Pupil of Art Students League in NY, under Augustus Saint Gaudens. Awarded a prize, design for bronze tablet for steamship *St. Paul*. Address in 1910, 130 Bowdoin St., Boston, MA.

OGINZ, RICHARD.
Sculptor and instructor. Born in Philadelphia, PA, February 7, 1944. Studied at Tyler School of Art, Temple University, B.F.A., 1966; University of Wis-Madison, M.A., M.F.A., 1968. Work in Los Angeles Co. Museum of Art, CA; Arts Council of Great Britain, London; others. Received Annual Purchase Award, Los Angeles Co. Museum of Art. Teaching sculpture at Otis Art Institute, Parsons School of Design, Los Angeles, from 1976. Works in bronze and aluminum. Address in 1982, Los Angeles, CA.

O'HANLON, HARRY.
Sculptor and painter. Born in Edmonton, Alberta, Canada, in 1915; lived in Montana. Began painting portraits of Blackfoot Indians in 1956. In mid 1960's he turned to

sculpture. Specialty is Blackfoot subjects, including hunting, camp life, religious practices. Sculpts in bronze. Work is in museums in England and Canada (Glenbow-Alberta Institute of Calgary); created "Trailing the Buffalo Hunters," given by Blackfeet to English monarchy, 1977. Reviewed in *Art West*, spring, 1979. Represented by Gainsborough Gallery, Calgary, Alberta, Canada. Address in 1982, High River, Alberta, Canada.

O'HANLON, RICHARD E.
Sculptor and painter. Born in Long Beach, CA, October 7, 1906. Studied at California College of Arts and Crafts, 1926-27; California School of Fine Arts, 1930-1933; also in Europe, India, Japan, and Mexico. Works: Addison Gallery, Andover, MA; Baltimore Museum of Art; University of California, Davis; Denver Art Museum; San Francisco Museum of Art; Smith College; Whitney; Walker; Worcester Art Museum. Exhibitions: The Willard Gallery, NYC; San Francisco Museum of Art; Carnegie; Baltimore Museum of Art; Santa Barbara Museum of Art, 1969. Taught: Univ. of California, 1948-74; emeritus professor from 1974. Address in 1982, Mill Valley, CA.

O'HARA, DOROTHEA WARREN.
Sculptor. Born Malta Bend, MO. Pupil of Royal College of Art, London; School of Design, Munich. Exhibited: Paris Salon; Metropolitan Museum of Art; Harlow Gallery; Grand Central Art Gallery; Pen and Brush Club; and in London, Stockholm, and Tokyo. Member: National Arts Club; Pen and Brush Club; Silvermine Guild of Artists; Darien Guild of Artists. Awards: Medal, Pan-Pacific Exposition, 1915. Work: Large carved white bowl, Metropolitan Museum of Art, New York, NY. Address in 1970, Darien, CT.

O'KELLY, STEPHEN J.
Sculptor. Born in Dublin, Ireland, 1850. Died October 21, 1898.

OLAND, CHARLES.
Sculptor. Born in Italy in 1800. Working in NYC in 1850.

OLBRES, ZEIGMUND ANTHONY (ZYGMON DOLBRYS).
Sculptor, painter, designer, and craftsman. Born in Clinton, MA, April 1, 1915. Studied at Worcester Art School; Boston Museum of Fine Arts School. Work: Murals, Casablanca, French Morocco; Caserta, Italy. Exhibited: NY World's Fair, 1939; Army Art Exhibition, Algeria, North Africa. Address in 1953, Clinton, MA.

OLDENBURG, CLAES THURE.
Sculptor. Born in Stockholm, Sweden, January 28, 1929. Study: Yale University; Art Institute of Chicago. Work: Albright-Knox Art Gallery Buffalo; Museum of Modern Art; Art Gallery of Ontario, Toronto; Art Institute of Chicago; Whitney; many others. Commissions: Oberlin College, OH; City of St. Louis, MO, 1971; Yale University, 1974; Walker Art Center, MN, 1974; Hirshhorn Museum, Washington, DC, 1975; others. Exhibitions: Metropolitan Museum of Art, NYC; Museum of Modern Art, NYC; Pasadena Art Museum, CA; Kunsthalle, Tubingen, Germany; Expo '70, Osaka, Japan; Seattle Art Museum; Whitney Museum; and many others in US, Amsterdam,

Baden-Baden, London, Stockholm, Denmark, Paris, New Delhi, etc. Address in 1982, 556 Broome St., NYC.

OLEJARZ, HAROLD.
Sculptor. Studied at Brooklyn College, BA 1975; Pratt Institute, MFA 1977. Represented in various corporate collections. Has exhibited at the Brooklyn Museum; Gallery 10, Washington, DC; Nexus, Philadelphia; Landmark Gallery, NYC; Silvermine Guild; 14 Sculptors Gallery, NYC (group and solo); Pratt Institute (solo); others. Address in 1984, Tenafly, NJ.

OLITSKI, JULES.
(Known also as Jules Demikov). Sculptor and painter. Born in Snovsk, Soviet Union, March 27, 1922. Emigrated to US in 1924 with his family; became a US citizen in 1946. Studied at the Beaux-Arts Institute, NYC, 1940-42; National Academy of Design, NYC, 1940-42; Zadkine School of Sculpture, Paris, 1949; Academie de la Grande Chaumiere, Paris, 1950-51; NY Univ., NYC, 1951-1953. Exhibited: Galerie Huit, Paris, 1950; Alexander Iolas Gallery, NY, 1959, 60, 69; Poindexter Gallery, NYC, 1961, 62; New Gallery, Bennington College, VT, 1963; Whitney Mus. of American Art, 1962, 64, 67, 72; Los Angeles Co. Museum of Art, 1964; and others. Awards: Second Prize for Painting, Pittsburgh International Painting and Sculpture, 1961; First Prize for Painting, Corcoran Gallery of Art, 1967. Taught: State University of NY, College at New Paltz, 1954-55; C. W. Post College, Long Island Univ., 1956-63; Bennington College, 1963-67. Wrote "Painting in Color," catalogue of 33rd Biennial of Art (Venice), 1966; and "On Sculpture," in the Metropolitan Museum of Art Bulletin, NYC, April, 1969. Address in 1982, Meredith, NH.

OLIVER, L.
Sculptor. Active 1859. Exhibited at the National Academy of Design, NY, in 1859 (plaster medallion).

OLNEY, DANIEL G.
Sculptor. Address in 1935, Washington, DC. (Mallett's)

OLSEN, CHRIS E.
Sculptor, painter, craftsman, architect, museum preparator, and lecturer. Born in Copenhagen, Denmark, April 8, 1880. Studied at Allen's Art School, Perth Amboy, NJ; Mechanics Institute, and with Peter Eggers. Member: Scandinavian-Am. Artists. Awards: Prize, Mechanics Institute. Work: American Museum of Natural History Hall of Ocean Life; Boston Museum of Science, Science Hall; and in many other museums and colleges in the US. Exhibited: National Academy of Design; High Museum of Art; Scandinavian-Am. Artists; American Museum of Natural History; Staten Island Museum of Art and Science; Arnot Art Gallery. Arranged numerous marine exhibitions in museums. Specialized in undersea painting. Contributor to scientific entomological publications. Position: Artist, Modeler, American Museum of Natural History, NYC, 1916-52. Address in 1953, West Nyack, NY.

OLSON, CARL GUSTAF THEODORE.
Sculptor, painter, craftsman, and teacher. Born Sweden, June 7, 1875. Pupil of Peter Roos. Member: Copley Society. Address in 1929, Belmont, MA.

OLSON, HERBERT VINCENT (HERB OLSEN).
Sculptor, painter, illustrator, designer, teacher, and lecturer. Born in Chicago, IL, July 12, 1905. Studied at Art Institute of Chicago. Member: Philadelphia Water Color Club. Awards: Prizes, Swedish-Am. Exh., Detroit, 1941, 42; Chicago Free Lance Art Exh., 1939, 40. Exhibited: Penna Academy of Fine Arts, 1942, 43; Art Institute of Chicago, 1939, 40; Rockford, IL, 1946; Bloomington, IL, 1946; Racine, WI, 1946; one-man exh.: O'Brien Gallery, Findlay Gallery, Chicago Galleries Association, all in Chicago. Position: Instructor of illustration, Chicago Professional School of Art, 1938-40; American Academy of Art, Chicago, IL, from 1940. Died in 1973. Address in 1953, Glenview, IL.

OLSON, JOSEPH OLAF.
Sculptor, painter, etcher, craftsman, writer, and lecturer. Born Buffalo, Minn., January 28, 1894. Pupil of F. Tadema, George Bellows. Exhibited: One-man shows, Corcoran Gallery, Washington, DC; Carnegie Institute, Pittsburgh; Chicago Art Institute. Member: Salmagundi Club; Painters and Sculptors Gallery Association; New York Water Color Club. Work: "Pyrenees Mountains," Baltimore Museum. Address in 1982, Mystic, CT.

OLSON, MERLE.
Sculptor and painter. Born in Snowflake, Arizona, 1910. Studied briefly at art school and by correspondence course. Specialty is Montana landscapes and Indian portraits. Address in 1974, Big Fork, Montana.

OLSSON, AXEL ELIAS.
Sculptor. Born in Sweden, April 17, 1857. Pupil of Stockholm Academy of Fine Arts. Address in 1910, Chicago, IL.

OLSTOWSKI, FRANCISZEK.
Sculptor, painter, illustrator, and teacher. Born Zaborowo, Poland, March 25, 1901. Pupil of his father. Member: NY Painters and Sculptors; Buffalo Society of Artists; Chicago No-Jury Society of Artists; Society of Independent Artists; Salons of America; Alliance. Work: "Abraham Lincoln," Newspaper Men's Club, NYC; "Don Basco Group," Salesian School, New Rochelle, NY; "Madonna Christiana," St. Mary's Church, NYC; "The Great America," Foreign Affairs Bldg., Warsaw, Poland; "John E. Kellerd as Mephisto," Theatre League, Buffalo; "Marguerite Olstowski," Gardner Dancing School, Toledo, OH; lion heads, Courthouse, Hackensack, NJ. Address in 1933, Matawan, NJ.

O'NEILL, AGNES.
Sculptor. Address in 1898, Art Academy of Cincinnati.

OPERTI, ALBERT (JASPER LUDWIG ROCCABIGILERA).
Sculptor, painter, and illustrator. Born in Turin, Italy, March 17, 1852. Studied abroad. Works: "Rescue of the Greely Party" and "Farthest North;" paintings for Army and Navy Dept., Washington; mural decoration in Museum of Natural History, NY; "The Last Franklin Search," American Geographic Society, NY; etc. Awards: Medals

and diplomas as official artist, US Government exhibits, Chicago and San Fran. Expositions. Member: Palette Club; Tile Club. Scenic artist in New York theatres; illustrator of books on arctic subjects, having made two voyages to the arctic regions with Rear Admiral Peary. Address in 1924, American Museum of Natural History, West 77th St., NYC.

OPPENHEIM, DENNIS A.
Sculptor. Born in Mason City, WA, September 6, 1938. Moved to California in 1940. Studied at California College of Arts and Crafts, Oakland; Stanford University, California. Taught at Yale; Art Institute of Chicago School; SUNY Stony Brook; Pratt Institute; Calif. College of Arts and Crafts; others. In collections of Museum of Modern Art; Oakland Art Museum; Stedelijk, Amsterdam; Tate, London; commissions in Tobago, West Indies, and Aspen, Colorado. Exhibited at John Gibson Gallery, NYC (many times); Museum of Modern Art; Reese Palley Gallery, San Francisco; Tate; Sonnabend Gallery, NYC; Sonnabend Gallery, NYC; Stedelijk; Cranbrook Academy of Art; Whitney annuals and biennials; MIT; Museum of Contemporary Art, Chicago; New Museum, NYC; and many others, including galleries and museums in Dusseldorf, Montreal, Basel, Bern, Turin, Kassel, Venice, Jerusalem, Paris, Stockholm, Stuttgart. Received Newhouse Foundation Grant, Stanford Univ., 1965; John Simon Guggenheim Foundation Fellowship, 1971-72; National Endowment for the Arts Grant for Sculpture, 1974. Address in 1982, 54 Franklin Street, NYC.

ORB, OVAN (JOHN CARBONE).
Sculptor, painter, lecturer, and teacher. Born in Cranston, RI, March 2, 1911. Studied at Rhode Island School of Design; Beaux-Arts Institute of Design; and with Leo Lentelli, Edward McCartan, Ossip Zadkine. Member: Rhode Island Abstract Artists; Providence Art Club; A. and W. Union, Rhode Island. Awards: Prize, Rhode Island School of Design, 1928; Rhode Island College Education, 1941. Work: Sculpture, Technical High School Library, Providence, RI; Roger Williams Park, Jamestown, RI; Rhode Island School of Design. Exhibited: Providence Art Club, 1937-41; Rhode Island School of Design, 1927-43; Brown Univ., 1941; Rhode Island College Education, 1940; Contemporary Art Gallery, 1944. Lectures: Sculpture. Address in 1953, 35 West 20th St., NYC; h. Providence, RI.

ORMOND, M. GEORGIA.
Sculptor. Member: National Association of Women Painters and Sculptors. Address in 1934, Toledo, OH.

ORR, JANICE.
Sculptor. Born in 1934. Studied: Carleton College; Northwestern University; University of Wisconsin; Cranbrook Academy of Art. Awards: Franklin Siden Gallery Award, Detroit Art Museum; Michigan Biennial of Artists and Craftsmen; Tidewater Artists Biennial. Collections: Virginia National Bank, Norfolk, Virginia; University of South Carolina.

ORTIZ, RAFAEL MONTANEZ.
Sculptor and educator. Born in NYC, January 30, 1934.

Studied at Brooklyn Museum Art School; Art Students League; Pratt Institute, B.S. and M.F.A.; Columbia University. Work in Museum of Modern Art, NY; Whitney Museum of American Art, NY; Syracuse Museum of Contemporary Art, NY. Has exhibited at Museum of Modern Art, NY; Whitney Museum of American Art, NY; Everson Museum, Syracuse, NY; San Antonio Museum, TX; Palacia de Mineria, Mexico City; others. Received John Hay Whitney Fellowship Grant, 1965. Teaching art at Rutgers, from 1972. Works in mixed media. Address in 1982, Highland Park, NJ.

ORTLIEB, ROBERT EUGENE.
Sculptor and graphic artist. Born in San Diego, CA, July 4, 1925. Studied at University of Southern California, with Merrell Gage, Francis de Erdely, and Glen Lucens, B.F.A. and M.F.A. Work in California Palace of Legion of Honor Museum, San Francisco; Laguna Beach Art Museum; wood head of Christ, Congregation, First Presbyterian Church, Culver City, CA; others. Has exhibited sculpture at Los Angeles Co. Museum, California; sculpture, Western States Exhibition, Denver Art Museum, CO; Dallas Museum of Fine Arts; Long Beach Museum of Art, CA; others. Taught sculpture at Riverside Art Center, University of California, 1962-75; others. Works in stone, wood carving, bronze, and plexiglas. Address in 1982, Garden Grove, CA.

ORTMAYER, CONSTANCE.
Sculptor and educator. Born in NYC on July 19, 1902. Studied: Royal Academy of Fine Arts, and Royal Academy of Master School, Vienna, Austria. Exhibited: Vienna Secession, 1932; National Association of Women Painters and Sculptors, NY, 1935; Allied Arts, Brooklyn Museum, 1936; National Sculpture Society, Whitney Museum American Art, NYC, 1940; Penna. Academy of Fine Arts, 1941. Awards: National Academy of Design, 1935; Whitney Museum of American Art, 1940; Florida Federation of Art, 1948; Rollins College, 1947. Collections: Brookgreen Gardens, South Carolina; American Numismatic Society, NY; US Post Office, Arcadia, Florida; US Post Office, Scottsboro, Alabama. Teaching: Professor of sculpture, Rollins College, from 1937 (also chairman of art dept.); emeritus professor from 1968. Address in 1980, Morristown, TN.

ORZE, JOSEPH JOHN.
Sculptor and art administrator. Born in Exeter, PA, December 11, 1932. Studied at Syracuse University, B.F.A., 1955, M.S., 1956; George Peabody College, Ed.D., 1970. Work in Munson, Williams, Proctor Institute, Utica, NY; others. Has exhibited at J. B. Speed Art Museum, Louisville, KY; Wadsworth Atheneum, Hartford; Everson Museum of Fine Art, Syracuse; others. Received purchase award for sculpture, Munson, Williams, Proctor Institute; first prize in sculpture, New England Arts Festival, Waterbury, CT. Member of College Art Association; National Art Education Association. Address in 1982, Worcester State College, Worcester, MA.

OSBORNE, LILLIE.
(Mrs. Lithgow Osborne). Sculptor. Born Aalholm, Denmark, March 8, 1887. Studied in Copenhagen, Rome,

Paris. Specialty, portrait-statuettes of children and animals. Address in 1933, Auburn, NY.

O'SHAUGHNESSY, THOMAS A.
Sculptor, painter, illustrator, etcher, and teacher. Address in 1933, Chicago, Ill.

OSMER, JACK.
Sculptor. Born in Prescott, Arizona, in 1932. Self-taught except for one year of art in high school. Began own casting in 1965; expanded foundry to do custom casting. Turned to sculpture full-time in 1976. Specialty is bronze statuettes of Western saddles and Indian dancers. In collections of Museum of Science and Industry, Washington; Cowboy Hall of Fame; Rodeo Hall of Fame; President Reagan; Smithsonian Institution (research notes for saddle statuettes). Member of American Indian and Cowboy Artists, Prescott, AZ. Reviewed in *Artists of the Rockies*, Fall 1977. Represented by House of Bronze Fine Arts. Address in 1982, Prescott, Arizona.

OSSORIO, ALFONSO A.
Sculptor and painter. Born August 2, 1916, in Manila, Phillipines. Studied at Harvard (1938); and Rhode Island School of Design (1938-9). Lives in US. Commissions: Murals, Church of St. Joseph, Victorias, Negros, Phillipines, 1950-51 and Washington Square Village, New York City, 1954; large circular assemblage, New York Hilton Hotel, 1964. Exhibited: Wakefield Gallery (NYC), (1941-61); Galerie Paul Facchetti, Paris (1951); Betty Parsons Gallery, Cordier and Warren, Museum of Modern Art, and Whitney Museum (all in NYC); Documenta, Kassel, Germany, 1964; plus numerous others. In private collections, and in those of the Guggenheim; Philadelphia Museum of Art; New York University; Whitney and Museum of Modern Art. Address in 1982, Wainscott, NY.

OSTERMILLER, DANIEL.
Sculptor. Studied at Univ. of Kansas, maj. in Art. Exhibition: North American Sculpture Exhibition; Nature Conservancy; National Audubon Society, Wyoming State Museum. Permanent Collection: Wyoming State Museum, Wildlife World, and private collections. Expeditions: Rhodesia, British Columbia, Alaska, and the Rocky Mountain regions. Member: Soc. of Animal Artists; Foundation for North American Wild Sheep; sponsor member of Ducks Unlimited. Medium: Bronze. Address in 1983, Loveland, CO.

OSTNER, CHARLES HINKLEY.
Sculptor and carver. Working in San Francisco, 1856-59.

OSTROWITZ, JUDITH MAURA.
Sculptor and art administrator. Born in Brooklyn, NY, February 25, 1953. Studied at School of Visual Arts, 1974, studied photography; Pratt Institute, B.F.A (painting and printmaking); with Joseph Stapleton, Charles Shucker, and Jack Sonenberg; New School for Social Research, M.A. (anthropology), 1979. Has exhibited at Brooklyn Museum; Wards Island Sculpture Garden, Organization of Independent Artists, NY; Sculpture Center Gallery, NY. Works in multimedia. Address in 1982, 170 Thompson, NYC.

OSZE, ANDREW E.
Sculptor. Born in Nagykanizsa, Hungary, January 14, 1909; US citizen. Studied at Academy of Art, Budapest; Academy D'Ungheria, Rome, fellowship, 1947-49. Work in Denver Art Museum; Museum of Budapest; fountain, Rome; T. S. Eliot relief, St. Louis; others. Has exhibited at Far Gallery, NY; De Young Museum, San Francisco; Denver Art Museum; others. Member of College Art Association of America. Works in stone, bronze, and wood. Address in 1982, Vero Beach, FL.

OTIS, SAMUEL DAVIS.
Sculptor and illustrator. Address in 1933, Norwalk, CT.

OTT, PETERPAUL.
Sculptor and teacher. Born in Pilsen, Czechoslovakia, June 4, 1895. Pupil of Karl Albiker and Alexander Archipenko. Awards: First prize 1919, first mention, 1920, state medal, 1921, Dresden Academy of Art, Germany, gold medal, Kunstverein, Chemnitz, Saxony, 1922; first prizes, National Small Sculpture Competitions, 1930 and 1931; second prize at "90 & 9," Chicago, IL, 1932. Work: War memorials: Infantry Regiment 35, Regiment Hall, Pilsen, Czechoslovakia; Student Society, Academy of Art, Dresden; Church of the City of Pinow, Silesia; College Hall of Honor, College of the City of Aue, Saxony; College Hall, College of the City of Schoenberg, Saxony; metal emblem, Infantry Regiment 35, Pilsen, Czechoslovakia; medal; Schaffen and Koennen der Deutschen Frau, Chemnitz, Germany, "Torso," male, and "Torso," female, Gorham Bronze Company Collection, NYC; plaque of Rear Admiral Byrd, Antarctic Ship, Century of Progress Exposition, Chicago, Ill.; bust of Arthur J. Morris, Original Morris Plan Bank, Norfolk, VA; entire sculptural interior decoration, St. George Playhouse, Brooklyn, NY; entire exterior decoration, Greater New York Savings Bank, Brooklyn, NY; entire interior and exterior decoration, Post Office Building, Oak Park, IL. Address in 1933, Evanston, IL.

OTTIANO, JOHN WILLIAM.
Sculptor and jeweler. Born in Medford, MA, July 23, 1926. Study: Mass. College of Art; Boston University; Penna. State University. Work: University of Western Illinois, IL; The Pennsylvania State University; Glassboro State College, NJ; private collections. Commissions for Glassboro State College and NJ Art Education Association. Exhibition: The Penna. Academy of Fine Arts, PA; The Speed Art Museum, KY; National Academy Galleries, NYC; and others. Teaching: Glassboro State College, NJ; and others. Member: American Association of University Professors; New Jersey Art Education Association; New Jersey Designer-Craftsmen Association; Artists Equity Association; National Art Education Association. Media: Bronze, gold, silver. Address in 1982, Pitman, NJ.

OTTINGER, KENNETH.
Sculptor. Born in Greenville, SC, in 1945; raised in St. Louis, MO, and Los Angeles. Studied at Art Center College of Design, BFA, 1968. Taught at Art Center College of Design; artist-in-residence, University of South Dakota. Specialty is statuettes of Western figures. Works in

bronze, with applied colored patinas. Reviewed in *Artists of the Rockies*, fall 1980. Represented by Hamburg Art Gallery, Sedona, AZ; The Peacock Galleries Ltd, Scottsdale, AZ. Address since 1979, Sedona, AZ.

OUBRE, HAYWARD LOUIS.
Sculptor and educator. Born in New Orleans, LA. Studied at Dillard University, B.A.; University of Iowa, M.F.A.; also with Hale Woodruff, Nancy E. Prophet, James Lechay, Mauricio Lasansky, and Humbert Albrizio. Work in University of Iowa Gallery, Iowa City; Atlanta University Gallery, GA; wire sculpture, Winston-Salem State University Library. Has exhibited at Joslyn Memorial Museum, Omaha, NE; Northwest Printmakers, Seattle Art Museum, WA; Ball State Annual Exhibition, Muncie, IN; others. Member of Southeastern Art Association; National Conference of Artists. Has researched and copyrighted color charts. Address in 1982, Winston-Salem, NC.

OVERLAND, CORA L. (MRS.).
Sculptor. Address in 1924, Scituate, MA.

OWEN, BILL.
Sculptor and painter. Born in Gila Bend, Arizona, January 23, 1942. Self-taught. In collections of Whitney Gallery, Buffalo Bill Historical Center, Cody, Wyoming; Phoenix Art Museum. Has exhibited with Cowboy Artists of America, Phoenix, Arizona; Texas Art Gallery, Dallas; Trailside Gallery, Scottsdale, Arizona; 1981 Peking, China show; others. Received Franklin Mint Gold Medal for Western art; Gold Medal for drawing; Silver Medal, Cowboy Artists of America Exhibition; others. Member of Cowboy Artists of America. Reviewed in *Art West*, November 1979. Work published by Salt Creek Graphics. Specialty is the modern working cowboy. Paints in oil; sculpts in wax, clay, bronze. Address in 1982, Flagstaff, Arizona.

OWEN, MICHAEL G., JR.
Sculptor, painter, illustrator, and craftsman. Born in Dallas, Texas, May 2, 1915. Studied at Dallas Art Institute. Member: Society of Washington Artists. Work: Sculpture, Southern Methodist University, Dallas, Texas. Exhibited: Kansas City Art Institute, 1938; Society of Washington Artists, 1944; Times-Herald Art Fair, 1944; Baltimore Museum of Art, 1945. Address in 1953, Greenbelt, MD.

OXMAN, MARK.
Sculptor and educator. Born in NYC, March 9, 1940. Studied at Aldelphi University, Long Island, NY, 1958-61; Penna. Academy of Fine Arts, Philadelphia, 1961-65; Skowhegan School, 1965-67. Has exhibited at Outdoor Sculpture Series, Portland School of Art, 1974; Franz Bader Gallery, Washington, DC, 1978; 21st Area Show Sculpture, Corcoran Museum, Washington, DC, 1978; others. Teaching sculpture at American University, Washington, DC, from 1976. Works in bronze. Address in 1982, Silver Spring, MD.

OZERSKY, J. W.
Sculptor. Born in Russia in 1890. Studied in NY at the Beaux-Arts Institute of Design under A. A. Weinmann

and Jo Davidson, and also at the National Academy of Design. Works: Dormir.

P

PACKARD, DAVID.
Sculptor. Born in Albany, NY, May 29, 1928. Studied at Penna. Academy of Fine Arts, with Walker Hancock, 1946-48; Syracuse University, with Ivan Mestrovic, 1951-56, B.F.A. Works: Milwaukee; Syracuse University. Exhibitions: Main St. Gallery, Chicago; Penna. Academy of Fine Arts; Audubon Artists; Ravinia Festival, Highland Park, IL; New Horizons in Sculpture, Chicago; Ball State Teachers College, Drawings and Sculpture Annual. Awards: Copley Foundation Grant, 1962; New Horizons in Sculpture, First Prize ($2,000), Chicago, 1962; Wisconsin Painters and Sculptors Annual, cash award, 1965; U. of Illinois summer fellowship, 1966. Taught: Layton School of Art, 1964-65; U. of Illinois, 1965-67; and privately. Died Feb. 2, 1968, Chicago, IL.

PACKER, FRANCIS HERMAN.
Sculptor. Born in 1873. Pupil of Martiny and Saint Gaudens. Member: National Sculpture Society, 1905. Sculptor of "Nebraska." Address in 1929, Rockville Center, LI, NY. Died in 1957.

PACKER, GITA.
Sculptor. Born in Jones County, TX, in 1922. Studied journalism at Hardin-Simmons University; later took ceramic sculpture class; otherwise self-taught in art. Worked as journalist before turning to sculpture. Specialty is statuettes of animals of the West; works in bronze. Exhibits in major invitational shows. Member, Women Artists of the American West. Reviewed in *Southwest Art*, April 1979. Represented by Hobe Sound Gallery, Hobe Sound, FL; Cross Gallery, Fort Worth, TX. Address in 1982, Fort Worth, TX.

PADDOCK, WILLARD DRYDEN.
Sculptor and painter. Born Brooklyn, NY, October 23, 1873. Pupil of Herbert Adams in New York; Pratt Institute in Brooklyn; Courtois and Girardot in Paris. Member: Associate National Academy; New York Architectural League; Salma. Club, 1904; MacD. Club; National Sculpture Society, 1915; Artist Aid Society; Allied Artists of America; Washington Art Club; Century Association. Works: Orr and Jessup relief, New York Chamber of Commerce; The Whittier and Grant memorials, Saginaw, Mich.; George Seward memorial; Noah Webster memorial, Amherst College, MA; Alfred Noble memorial, Engineering Societies Building, New York City; Edward C. Mershon memorial fountain; numerous busts, figures, fountains, sun-dials and statuettes. Exhibited at National Sculpture Society, 1923. Address in 1953, South Kent, Connecticut. Died in 1956.

PADELFORD, MORGAN.
Sculptor, painter, and teacher. Born in Seattle, Washington, October 10, 1902. Pupil of Hopkinson, Isaacs, etc. Member: Seattle Art Institute; Northwest Print Maker's Society. Award: First prize, oil, Northwest Artists Exh., 1923. Work: Symbolic bas-relief in cast stone, Chamber of Commerce Building; four portraits, University of Washington, Seattle, Wash. Address in 1933, Claremont, CA; home, 4710 20th Street, N.E., Seattle, WA.

PADOVANO, ANTHONY JOHN.
Sculptor and draftsman. Born in NYC, July 10, 1933. Studied at Brooklyn Museum School; Pratt Institute, with Alexander Kostellow; Columbia University, with Oronzio Maldarelli, 1957, BFA; Carnegie Institute of Technology. Works: American Academy, Rome; Silvermine Guild; Whitney; Herron; Storm King Art Center, NY; plus commissions, including sculpture in the Park, NYC; World Trade Center; Port Authority NY and NJ. Exhibitions: DeCordova; Richard Feigen Gallery, NYC; The Bertha Schaefer Gallery, NYC; Carnegie; American Academy, Rome; Whitney; Baltimore Museum of Art. Awards: Prix de Rome, 1960-62; III International Exhibition of Figurative Art, Rome, First Prize, 1962; Silvermine Guild, Olivetti Prize for Sculpture, 1963, 64; Guggenheim Foundation Fellowship, 1964; Ford Foundation, 1964. Member: Silvermine Guild; American Association of Univ. Professors; Sculptors Guild. Address in 1982, Putnam Valley, NY.

PAEFF, BASHKA WAXMAN.
(Mrs. Bashka Paeff Waxman.) Sculptor and teacher. Born Minsk, Russia, August 12, 1893. Pupil of Bela Pratt; Massachusetts Normal Art School; School of Boston Museum of Fine Arts. Member: Boston Guild of Artists; Detroit Society of Arts and Crafts; Boston Society of Arts and Crafts; MacDowell Colony; fellow, National Sculpture Society. Work: Mass. Chaplains' War Memorial, Hall of Fame, State House, Boston; World War Memorial, State of Maine, Kittery, ME; bronze bas-relief of "Dr. Elmer E. Southard," Harvard Medical Library; John E. Warren Memorial bronze fountain, Westbrook, ME; Julius Rosenwald fountain, Ravina, Ill.; bronze bas-relief of "Dr. E. Fernald," Fernald State School, Waverly, Mass.; "Boy and Bird" fountain, Stoughton, Mass.; "Judge Manly B. Allen" for City of Birmingham, Alabama; bronze bas-relief, "Ellen H. Richards," Mass. Institute of Technology; bronze bas-relief, C. H. Hovey Co., Boston, Mass; life-size bas-relief of Justice Oliver Wendell Holmes, Harvard Law Library; bronze relief of Dr. Martin Luther King, Jr., Boston University; also in Boston Museum of Fine Arts; and other collections. Exhibited at National Academy of Design; National Sculpture Society; and others. Address in 1976, Cambridge, MA. Died in 1979.

PAGE, H. C.
Marble cutter, carver, and engraver. Worked in Charleston, SC, 1830.

PAGUETTE, M.
Sculptor. Address in 1934, New York. (Mallett's)

PAIN, LOUISE (CAROLYN).
Sculptor. Born in Chicago, Ill., July 14, 1908. Pupil of Emil Robert Zettler. Award: Chicago Woman's Aid prize, Thirty-seventh Annual Exh. by Artists of Chicago and Vicinity, Art Institute of Chicago, 1933. Address in 1933, 6837 Oleander Parkway, Chicago, Ill.

PAINE, RICHARD G.
Sculptor. Born in Charleston, SC, February 15, 1875. Pupil of Amateis and Kemeys. Address in 1926, East Falls Church, VA.

PAINE, ROBERT.
Sculptor. Award: Hon. mention, P.-P. Exp., San Francisco, 1915. Address in 1916, Mountain Road, West Hoboken, NJ.

PAINE, T. O.
Sculptor. Born in Maine about 1825. Was living in Bangor, Maine, in 1850 and in Boston, Massachusetts, in 1852.

PALANSKY, ABRAHAM.
Sculptor and painter. Born in Lodz, Poland, July 1, 1890. Studied at Art Inst. of Chicago. Member: Los Angeles Water Color Soc.; No-Jury Soc., Chicago. Awards: Prize, Art Inst. of Chicago, 1941, 45; Pasadena Art Inst., 1952. Exhibited: Nat. Art Week, Chicago, 1940; Art Inst. of Chicago, 1940-45, 49; Illinois State Mus., 1940; No-Jury Soc., 1941, 42; Los Angeles Mus. of Art, 1944 (one-man), 1943, 45, 48, 49, 52; Oakland Art Gal., 1944; San Fran. Mus. of Art, 1944; Riverside (CA) Mus., 1946, 48; Madonna Festival, Los Angeles, 1949; Chicago Bd. Jewish Edu., 1950; Pasadena Art Inst., 1947-50; Greek Theatre, Los Angeles, 1946, 47, 48, and 51. Address in 1953, Los Angeles CA.

PALAU, FLEUR.
Sculptor. Born September 5, 1953. Studied: National Academy of Design, New York City, with Gaetano Cecere, Adolph Block, Charles Salerno, 1972-77; privately with sculptor Jurio Vivarelli, Pistoia, Italy, 1978; with Rino Giannini, University of Carrara, Italy, 1980-81. Work: In private collections in US and Italy; contractor working for sculptor Harry Jackson, Camaiore, Italy, 1979-80; subcontractor, terra-cotta bas-relief for Toronto subway, 1981-82; free-lance, small sculptures for Austin Productions, Inc., NYC, 1983. Exhibitions: National Academy Galleries 52nd Annual, NYC, 1977; Allied Artists and Audubon Artists, National Academy Galleries, NYC; Museum of Modern Art-Annual Exhibition, Forte dei Marmi, Italy, 1981, 82; Versilia Show of Foreign Artists Living Abroad, Pietrasanta, Italy (catalogue published), 1982; Pen and Brush Club Annual Sculpture Exhibition, 1983; Salmagundi Club Annual Sculpture Exhibition, 1983. Awards: Helen Smith prize, 1972, Certificate of Merit, 1973, Ralph Weiler prize, 1975, Catherine Lorillard Wolfe prize, 1976, all at National Academy of

Design, NYC. Media: Clay, bronze, and marble. Address in 1983, Northport, NY.

PALLENLIEF, ANDREW.
Sculptor. Born in Switzerland in 1824. Working in San Francisco in July 1860.

PALMER, E. V.
See Elizabeth Palmer Bradfield.

PALMER, ERASTUS DOW.
Sculptor. Born April 2, 1817, in Pompey, Onondaga County, NY. He first executed cameo portraits and later undertook sculpture. Did cameo-cutting in Utica, NY; later modeling in clay. Moved to Albany in 1846 where he had a studio for more than 25 years. All his knowledge was acquired in America, and it was not until he had become famous that he visited Europe. Exhibited: National Academy, 1851. Member: National Academy. Among his best known works are "The Indian Girl;" "White Captive;" "Morning and Evening;" also known for his portrait busts, reliefs, and memorials. One of his pupils was Launt Thompson. He died in Albany, NY, March 9, 1904.

PALMER, HERMAN.
Sculptor, painter, illustrator and etcher. Born Farmingham, Utah, March 17, 1894. Pupil of Mahonri Young. Member: NY Water Color Club. Illustrated "Hidden Heroes of the Rockies." Address in 1929, 961 Madison Ave., New York, NY.

PALMER, JESSIE (MRS. CARL E.).
Sculptor, painter, and teacher. Born in Lawrence, TX, October 19, 1882. Studied at Dallas Technical College; Broadmoor Art Academy; and with John Carlson. Member: Southern States Art League; Texas Fine Arts Association; Amarillo Art Association. Awards: Medal, Dallas Woman's Forum, 1924; prize, Texas-Oklahoma Fair, 1926, 27. Work: Travis School, Dallas, TX; Dallas Woman's Forum. Exhibited: Southern States Art League, 1928, 34, 44, 45; TX Fine Art Association, 1930-40; Elisabet Ney Museum, 1935 (one-man); Texas State Fair, 1934; Frank Reaugh Art Exhibition, 1925-46; Dallas Art Association, 1940. Position: Sec., Frank Reaugh Art Club, Dallas, TX, 1944-46. Address in 1953, Dallas, TX.

PALMER, MARGARET LONGYEAR.
Sculptor, craftsman, and teacher. Born Detroit, Aug. 19, 1897. Pupil of John Wilson. Member: Detroit Society of Arts and Crafts; Detroit Society of Women Painters. Award: First prize, Mich. State Fair, 1921. Address in 1933, 2 McKinley Pl., Grosse Pointe Farm, Mich.; 8103 Agnes Ave., Detroit, Mich.; summer, Huron Mountain Club, Huron Mountain, Mich.

PALTENGHI, A.
Sculptor. Worked at New Orleans, 1854-56; San Francisco, 1856-60.

PAOLO, CARTAINO S.
Sculptor. Born in Italy in 1882. Pupil of American Academy in Rome. Work: Bust of Ex-Gov. MacCall in Boston State House; Cardinal O'Connell in Boston Cathedral; marble memorial in Cathedral of St. John the Divine,

New York. Address in 1926, 80 Washington Square, New York City.

PAPASIAN, JACK CHARLES.
Sculptor and artist. Born in Olympia, Greece, June 27, 1878. Pupil of Antonio Dal Zotto of Venice and Ettore Ferrari of Rome. Member: National Sculpture Society. Work: "The Golden Age of Greece," property of the Greek Government. Address in 1933, 243 East 24th St.; h. 93 Lexington Avenue, NYC. Died in 1957.

PARADISE, PHILIP HERSCHEL.
Sculptor, painter, illustrator, graphic artist and teacher. Born in Ontario, Oregon, 1905. Studied at Chouinard Art Institute, Los Angeles; with F. Tolles Chamberlain, Rico Lebrun, and Leon Kroll. Taught at Chouinard 1932-40; film art director at Paramount Studios, 1941-48; lecturer at University of Texas at El Paso and Scripps College; director of the Cambria Summer Art School. Illustrated for magazines including *Fortune*, *Westways*, *True*. Work in Library of Congress, Penna. Academy of Fine Arts, Cornell University, Spokane Art Association. Member, National Academy (aquarellist). Specialty includes Western subjects. Address in 1976, Cambria, California.

PARAMINO, JOHN FRANCIS.
Sculptor and writer. Born Boston, December 25, 1888. Pupil of Augustus Saint-Gaudens and Bela L. Pratt; Boston Museum of Fine Arts School. Member: Boston Guild of Artists; Copley Society, Boston. Awards: Medal, MA Horticultural Society, 1929. Work: Sculpture, bas-reliefs, memorials, monuments, busts: State House, Boston, MA; World War II Memorial, Four Freedoms Memorial, Boston; A. Platt Andrew Memorial, Gloucester, MA; Plymouth, MA; Hall of Fame, New York University; Boston Commons; Cambridge, MA; Boston University Law School; Harvard University; others. Publications: "Sculpture as a Medium of Expression," 1945. Address in 1953, Wellesley Hills, MA.

PARDUCCI, RUDOLPH.
Sculptor. Active 1932. (Mallett's)

PARIS, HAROLD PERSICO.
Sculptor. Born in Edgemere, NY, Aug. 16, 1925. Studied at Atelier 17, NYC, 1949; Creative Graphic Workshop, NYC, 1951-52; Academy of Fine Arts, Munich, 1953-56. Works: Calif. Palace; Univ. of Calif.; Art Institute of Chicago; Lib. of Congress; Mus. of Modern Art; Memphis (Brooks); NY Pub. Lib.; Oakland Art Mus.; Ottawa (Nat'l.); Phila. Mus. of Art; San Fran. Mus. of Art; Whitney. Exhibitions: Argent Gal., NYC; Phila. Art Alliance; Village Art Center, NYC; Wittenborn Gal., NYC; Pratt Graphic Art Center; Paul Kantor Gal., Beverly Hills, CA; Bolles Gal., 1962 (two-man, with Angelo Ippolito); Hansen Gallery, San Fran.; Reed Col.; Sally Judd Gal., Portland, OR; Met. Mus. of Art; Boston Mus. Fine Art; Vienna Sezession; The Hague; Amerika Haus, Munich; Calif. Palace; Baltimore Mus. of Art; Smithsonian; Delgado; Pasadena Art Mus.; Brooklyn Mus.; Penna. Academy of Fine Arts; Galerie Kunst der Gegenwart, Salzburg; Mus. of Modern Art; Philadelphia Museum of Art; San Francisco Museum of Art; III Biennial of

Spanish-American Art, Barcelona,1955; Salon de la Jeune Sculpture, Paris; France (National); San Francisco Art Institute; New School for Social Research; M. Knoedler & Co., Art Across America; Los Angeles County Mus. of Art. Awards: L. C. Tiffany Grant, 1949; Guggenheim Foundation Fellowship, 1953; Fulbright Fellowship (Germany), 1953; Univ. of California, Creative Arts Award and Institute Fellowship, 1967-68. Address in 1970, Oakland, Calif.

PARK, MADELINE F.
Sculptor. Born in Mt. Kisco, NY, July 19, 1891. Studied at Art Students League; also with Proctor, Naum Los, and Lawrence T. Stevens. Awards: American Women's Association, 1933, 40; Hudson Valley Art Association, 1933, 1940. Specialized in wild and domestic animal sculpture. Exhibited: Paris Salon; National Academy of Design; Pennsylvania Academy of Fine Arts; Art Institute of Chicago; San Francisco Museum of Art; Whitney; Metropolitan Museum of Art; Speed Memorial Museum; Arnot Art Gallery; many more. Member: National Sculpture Society; National Association of Women Artists; Allied Artists of America; others. Address in 1953, Katonah, NY. Died in 1960.

PARK, RICHARD HAMILTON.
Sculptor. Born in NY, 1832. Active in Florence, Italy, 1890. (Mallett's)

PARK, RICHARD HENRY.
Sculptor. Born in NYC, 1832. Worked in Florence, Italy, in 1890. In collections of the Metropolitan Museum of Art, NYC. Died after 1890.

PARKER, CHARLES.
Sculptor. Member: Boston Art Club. Address in 1910, 711 Boylston St., Boston, MA.

PARKER, EDYTHE STODDARD.
Sculptor. Born in Winnetka, IL. Pupil of Art Institute of Chicago. Member Art Students League of Chicago. Address in 1910, Winnetka, IL.

PARKER, HARRY HANLEY.
Sculptor and mural painter. Born in Philadelphia on November 29, 1869. Studied at Penna. Academy of Fine Arts. Member: Fellowship Pennsylvania Academy of Fine Arts; Philadelphia Sketch Club; T Sq. Club. Died March 16, 1917, in Philadelphia.

PARKER, JOHN F.
Sculptor and painter. Born in NYC, May 10, 1884. Pupil of Henri in NY; studied in England and with Laurens and Steinlen in Paris. Member: Artists Guild of America; Alliance; Salma. Club. Award: Whitney prize, Labor Competition. Directed pageant of the City History Club, NY, 1916; Westfield 200th Anniversary pageant, etc. Represented in National Gallery, Washington; Valley Forge Museum of American History. Address in 1926, 401 Convent Ave., NYC.

PARKER, LIFE, JR.
Sculptor, portrait painter, marble and stone engraver. Born c. 1822. Active 1837. Employed by Major Benjamin Day in Lowell, MA, between 1837 and 1847.

PARKMAN, EMILY C.
Sculptor. Self-taught; some courses at Bennington College and Cleveland Institute of Art. Exhibitions: Leigh Yawkey Woodson Bird Art Show, 1980; Cleveland Museum of Natural History; and the Columbus Museum of Arts and Science, Columbus, GA. Member: Soc. of Animal Artists. Specialties: All kinds of animals. Media: Bronze, stone, wood. Address in 1983, Cleveland Heights, OH.

PARKS, CHARLES CROPPER.
Sculptor. Born in Onancock, VA, June 27, 1922. Study: Penna. Academy of Fine Arts. Work: Commissions for H. B. du Pont, Wilmington, DE; Byrnes Foundation, Columbia, SC; Brandywine River Museum; Mystic Seaport Museum; Equitable Building, NYC. Exhibitions: Nat. Sculpture Society Annual, 1962-77; National Academy of Design, 1965-77; and others. Awards: Wemys Foundation Travel Grant, Greece, 1965; American Artists Professional League, gold medal, 1970; National Sculpture Society, gold medal, 1971; others. Mem. of Advisory Committee John F. Kennedy Center, from 1968; Fellow National Sculpture Society; Allied Artists of America; National Academy of Design; Del. State Arts Council. Address in 1982, Wilmington, DE.

PARKS, CHRISTOPHER.
Sculptor. Former member of the National Sculpture Society. Awards: C. Percival Dietsch Sculpture Prize, 1972, John Gregory Award, 1975, Hexter Prize, 1975, all National Sculpture Society, NYC.

PARKS, ERIC VERNON.
Sculptor. Member of the National Sculpture Society. Awards: Council of American Artist Societies' Award, 1974, National Sculpture Society, NYC, and Walter Lantz Youth Award, 1976. Address in 1982, Unionville, PA.

PARNELL, EILEEN.
Sculptor. Born in Belfast, Ireland, in 1902. Studied under A. A. Archipenko in NY for one year. Her specialty is ceramics and small decorative sculpture. Works: Horse, Sceptre.

PARSONS, DAVID GOODE.
Sculptor, painter, illustrator, teacher, and lecturer. Born in Gary, IN, March, 2, 1911. Studied at Art Institute of Chicago; University of Wisconsin, B.S. in Art Education, M.S. in Art Education. Member: Wis. Painters and Sculptors; Wis. Art Fed. Awards: Prizes, Wis. Salon, 1938, 44, 45; Wis. Painters and Sculptors, 1941; Virginia Museum of Fine Arts, 1943; Hoosier Salon, 1939. Exhibited: Art Institute of Chicago, 1935-40, 46; Penna. Academy of Fine Arts, 1940, 46; NY World's Fair, 1939; Grand Rapids Art Gal., 1939; Carnegie Institute, 1940; Wis. Salon, 1934-41, 43, 45; Wis. Painters and Sculptors, 1933, 36-41; Virginia Museum of Fine Arts, 1943; Hoosier Salon, 1935, 38, 39; University of Wis., 1940; Houston Museum of Fine Arts, 1953, 54; Joslyn Art Mus., Omaha, 1967; others. Lectures: Contemporary American Sculpture. Position: Surgical Artist for Plastic Surgery, US Army, 1944-47; professor of sculpture and drawing, Rice University, from 1953. Address in 1982, Houston, TX.

PARSONS, DAVID T.
Sculptor. Exhibited: Manchester, VT, 1934. (Mallett's)

PARSONS, EDITH GILMAN.
Sculptor. Address in 1934, New York. (Mallett's)

PARSONS, EDITH BARRETTO STEVENS.
Sculptor. Born Houston, VA, July 4, 1878. Pupil of Art Students League of New York under French and Barnard. Member: National Association of Women Painters and Sculptors; National Sculpture Society. Work: Memorial fountain to John Galloway, Public Park, Memphis; figures for Liberal Arts Bldg., St. Louis; memorial monument, St. Paul; "Duck Girl," Metropolitan Museum; Monument to Soldiers of World War, Summit, NJ. Address in 1933, 13 Van Dam St., New York, NY; Summer, Quogue, LI, NY. Died in 1956.

PARTON, RALF.
Sculptor and educator. Born in NYC, July 2, 1932. Studied at Albright Art School, Buffalo, diploma, 1953; NY State University, Buffalo, B.S. (art education), 1954; Columbia University, M.A. (art), 1955. Work: steel sculpture, Beth Shalom Synagogue, Modesto, CA; others. Has exhibited at San Francisco Museum of Art, San Francisco, CA. Works in bronze and steel. Address in 1982, Turlock, CA.

PARTRIDGE, WILLIAM ORDWAY.
Sculptor and writer. Born Paris, France, April 11, 1861. Studied in New York, Paris, Florence and Rome. Member: Lotos Club; New York Architectural League. Work: Equestrian statue of Gen. Grant, Union League Club, Brooklyn; statue of Alexander Hamilton, Brooklyn; "Shakespeare," Lincoln Park, Chicago; "Pocahontas," Jamestown, VA; "Nathan Hale," St. Paul, Minn.; font, Cathedral of St. Peter and St. Paul, Washington, DC; Schermerhorn Memorial, Columbia University, New York. Author: "Art for America," "The Song of Life of a Sculptor," "The Technique of Sculpture," Whittier, Boston Public Library. Address in 1929, Cosmos Club, Washington, DC. Died in 1930.

PASCUAL, MANOLO.
Sculptor and instructor. Born in Bilbao, Spain, April 15, 1902; US citizen. Studied at Academy of Fine Arts, San Fernando, Madrid, Spain, M.A. Work in Museum of Fine Arts, Santo Domingo; Emily Lowe Gallery, Coral Gables, Miami University, FL; sculpture, Government of Santo Domingo; others. Has exhibited at International Art, Paris; Royal Academy of Fine Arts, Madrid; National Academy of Fine Arts, Santo Domingo; Hofstra University, NY; others. Taught sculpture at National Academy of Fine Arts, Santo Domingo, 1940-50; teaching sculpture at New School for Social Research, NY, from 1951. Works in iron and stone. Address in 1982, Jamaica, NY.

PASHIGIAN, HELEN.
Sculptor. Working in the 1970's using acrylic spheres as form.

PASSUNTINO, PETER ZACCARIA.
Sculptor and printmaker. Born in Chicago, IL, Feb. 18, 1936. Studied at Art Inst. of Chicago, scholarships, 1954-

58; Oxbow School of Painting, summer, 1958; Inst. of Art and Archeology, Paris, 1963. Exhibited: Corcoran Museum, Wash., DC; Knowlton Gal., NY, 1976; Gal. K, Wash., DC, 1976; Joseph Gal., NY; Gal. 187, Englewood, NJ; Art Latitude, NJ, 1979; and numerous others. Awards: Fulbright Fellowship, 1963-64; and a Guggenheim Award, 1971. In collections of Walter P. Chrysler Mus.; Hirshhorn; Norfolk (VA) Mus. Address in 1982, 530 La Guardia Place, NYC.

PATERSON, ANTHONY R.
Sculptor and educator. Born in Albany, NY, December 17, 1934. Studied at School of Museum of Fine Arts, Boston; with Harold Tovish, Ernest Morenon, Peter Abate; La Grande Chaumiere School of Drawing, Paris; Mass. Institute of Technology, welding; University of Guadalajara, Mexico. Work in School of Museum of Fine Arts, Boston; Kalamazoo Institute of Arts, MI. Has exhibited at American Federation of Arts Travelling Exhibition; Small Sculpture and Drawing, Ball State University; others. Received Alumni Travelling Fellowship, Boston Museum of Fine Arts, 1969; MacDowell Colony Fellowship, NH, 1971; Faculty Research Fellowship, State University of NY, 1970-73. Member of American Federation of Arts; Artists Equity. Taught sculpture at School of Museum of Fine Arts, Boston, 1962-65; teaching sculpture at State University of NY, Buffalo, from 1968. Works in bronze. Address in 1982, Buffalo, NY.

PATIGIAN, HAIG.
Sculptor. Born in Armenia, January 22, 1876. Self-taught; criticism from Marquet in Paris. Member: National Sculpture Society; Societe des Artistes Francais; National Institute of Arts and Letters; Jury of Awards, Panama-Pacific International Exposition, San Francisco, 1915. Work: "Ancient History," Bohemian Club, and "Gen. Funston," City Hall, San Francisco; monument to Dr. Rowell, Fresno, California; marble bust, Helen Wills, California Palace of Legion of Honor; bust of John Keith, Memorial Museum, San Francisco; pediment for Metropolitan Life Building, San Francisco; allegoric figures and tympanum for Memorial Museum; "Gen. Pershing" monument, and "Lincoln" monument, San Francisco; bronze bust, Herbert Hoover, White House; many statuettes, bas-reliefs, busts, and figures. Address in 1933, 3055 Webster St., San Francisco, California. Died in 1950.

PATON, A. R.
Sculptor and wax portraitist. Probably Amelia R. Paton of Dunfermline, Scotland. Executed a bust of an American, but not known to have visited the US.

PATTERSON, CURTIS RAY.
Sculptor and instructor. Born in Shreveport, LA, November 11, 1944. Studied at Grambling State University, B.S., 1967; Georgia State University, M.V.A., 1975. Has exhibited at High Museum of Art, Atlanta, GA; others. Member of Black Artists of Atlanta. Teaching sculpture at Atlanta College of Art, from 1976. Address in 1982, Atlanta, GA.

PATTI, P.
Sculptor. Born in Italy in 1810. In NYC, June 1860.

PATTI, TOM.
Sculptor. Studied at Pratt Institute School of Art and Design, B.I.D., 1967, Graduate School of Art and Design, M.I.D., 1969; New School for Social Research, with Roudolph Arheim, 1969. Work in Metropolitan Museum of Art and Museum of Modern Art, NY; Kunstmuseum Dusseldorf, West Germany; Victoria and Albert Museum, London. Has exhibited at Museum of Modern Art, NY; Corning Museum of Glass; others. Received awards from National Endowment for the Arts, 1979; first prize, Glaskunst 81, Kassel, West Germany. Address in 1982, Plainfield, MA.

PATTISON, ABBOTT.
Sculptor and painter. Born in Chicago, Illinois, May 15, 1916. Studied at Yale College and Yale School of Fine Arts. In collections of Whitney; Israel State Museum; Art Institute of Chicago; San Francisco Museum; others. Exhibited at Art Institute of Chicago, 1940-69; Metropolitan Museum of Art; Whitney; Sculpture Center, NYC; others. Taught at Art Institute of Chicago, 1946-52; Skowhegan; sculptor in residence, Univ. of Georgia. Address in 1982, Winnetka, Illinois.

PAULDING, JOHN.
Sculptor. Born Dark County, Ohio, April 5, 1883. Pupil of Art Institute of Chicago. Member: Alumni, Art Institute of Chicago; Chicago Gallery of Art; Cliff Dwellers; Chicago Painters and Sculptors. Address in 1933, 1600 Monroe Building, 104 South Michigan Avenue, Chicago, Ill.; h. Park Ridge, Ill. Died in 1935.

PAULLEY, DAVID GORDON.
Sculptor and painter. Born in Midwest, Wyoming, in 1931. Studied painting with Pawel Kontney, Denver; correspondence course; otherwise self-taught in art. In collections of Buffalo Bill Historical Center, Cody, Wyoming; Wyoming State Museum; others. Has exhibited at Wyoming State Museum; Saks Art Gallery, Denver; Thorne Gallery, Scottsdale, Arizona. Specialty is Western subjects of past and present. Prefers painting in oil; also works in watercolor, pen and ink; sculpts in bronze. Represented by Wild Goose Gallery, Cheyenne, Wyoming. Address in 1982, Cheyenne, Wyoming.

PAULUS, CHRISTOPHER DANIEL.
Sculptor, painter, illustrator, and teacher. Born in Wuertemburg, Germany, April 11, 1848. Pupil of Ernst Kaehnel in Dresden. Address in 1908, 1110 Main St., Newton, KS.

PAUSCH, EDUARD LUDWIG ALBERT.
Sculptor. Born in Copenhagen, Denmark, Sept. 30, 1850. Pupil of Carl Conrads and Karl Gerhart in Hartford; Domenico Mora in NY. Address in 1910, corner Delaware and Delavan Aves., Buffalo, NY; and Westerly, RI.

PAVAL, PHILIP.
Sculptor, painter, craftsman, and lecturer. Born in Nykobing Falster, Denmark, April 20, 1899. Studied at Borger School; Tech. School of Design, Denmark. Member: Calif. Art Club; Painters and Sculptors Club, Los Angeles Mus. of Art Assn.; Scandinavian-Am. Art Assn.; Sociedade Brasileira de Belas Artes, Brazil; other organizations abroad and in South America. Awards: Many awards in local and national exhibitions. Work: Met.

Mus. of Art; Los Angeles Mus. of Art; Philbrook Art Center; Wichita Art Assn.; Newark Mus.; Pasadena Art Inst.; Devi Palace, Vizianagaram, So. India; Presidential Palace, Quito Ecuador; Le Grand Palais, Paris, France; Buckingham Palace, London; and others. Exhibited: Golden Gate Exp., 1939; Wichita Art Assn.; Santa Barbara Mus. of Art; Los Angeles Mus. of Art; Calif. Palace of Legion of Honor; Philbrook Art Center; Newark Museum; and many others. Address in 1953, Hollywood, CA.

PAXSON, MARTHA KELSO DUNING.
Sculptor, painter, and teacher. Born in Philadelphia, PA, 1875. Pupil of Wm. Sartain and Elliott Daingerfield. Address in 1908, 2108 Bellevue St., Philadelphia, PA.

PAXTON (or PAXSON), ETHEL.
Sculptor, painter, illustrator, blockprinter, lecturer, teacher, and writer. Born in Meriden, CT, March 23, 1885. Pupil of Cecilia Beaux, Chase, Poore. Member: Nat. Assn. of Women Painters and Sculptors; Catherine Lorillard Wolfe Art Club; New Haven Paint and Clay Club; Am. Artists Professional League; Nassau County Art League. Work: Two decorations in American Embassy, Rio de Janeiro, Brazil; also articles and lectures on Modern Art, Art Appreciation, Life in Brazil, etc. Exhibited at National Academy of Design; National Association of Women Artists; American Water Color Society; others. Address in 1953, NYC.

PAYNE, GEORGE KIMPTON.
Sculptor, painter, illustrator, designer, and craftsman. Primarily designer and illustrator. Born Springville, NY, May 23, 1911. Studied at Art Students League, with George Bridgman, Allen Lewis, Thomas Benton. Contributor to: *New Yorker* magazine. Position: Scientific Artist, Nat. Zoo Park, Wash., DC, 1936; Advertising Artist, 1937-43; USNR Terrain Map Model Maker, 1943-45; Supv. Displays, Woodward and Lothrop, Washington, DC, 1946-50; Asst. Mgr. for Displays, from 1950. Address in 1953, Arlington, VA.

PAYNE, KEN.
Sculptor. Born in Lincoln County, New Mexico, about 1937. Self-taught in art. A pilot, he turned to painting in 1975 and sculpture two years later. Specialty is statuettes of cowboys. Works in bronze; does own casting. His work has been purchased by New Mexico State Fair. Represented by Leslie B. DeMille Gallery, Laguna Beach, CA. Address since 1973, Nogal, New Mexico.

PEABODY, AMELIA.
Sculptor. Born Marblehead Neck, MA, July 3, 1890. Pupil of Boston Museum of Fine Arts School; Charles Grafly; Archipenko School of Art. Exhibited: Penna. Academy of Fine Arts; World's Fair, NYC, 1939; Art Institute of Chicago; Boston Museum of Fine Arts, 1950, 51; National Academy of Design, 1952; others. Member: Copley Society; Boston Sculpture Society; Marblehead Art Association; American Federation of Arts; National Sculpture Society; National Association of Women Artists; etc. Work: "End of an Era," marble, Museum of Fine Arts,

Boston, Mass; portraits, medals, garden and architectural sculpture in bronze, stone, and pottery. Address in 1929, Fenway Studios, 30 Ipswich Street; h. 120 Commonwealth Avenue, Boston, Mass.; summer, Dublin, NH. Address in 1982, Boston, MA.

PEABODY, EVELYN.
Sculptor. Exhibited at the Penna. Academy of the Fine Arts, Philadelphia, 1924. Address in 1926, 1620 Summer St., Philadelphia.

PEABODY, MARIAN LAWRENCE.
Sculptor and painter. Born in Boston, Mass., May 16, 1875. Pupil of Hale, Benson, Tarbell, Allen, Recchia. Work: Portrait head, Lawrence College, Appleton, Wis.; portrait head, Groton School, Groton, Mass.; portrait, Episcopal Theological School, Cambridge, Mass.; portrait, Univ. of Kansas, Lawrence, Kan. Address in 1933, 27 Mechanic St., Roxbury; h. 302 Berkeley St., Boston, Mass.; summer, Devon, Bar Harbor, ME.

PEABODY, RUTH EATON.
Sculptor, painter and teacher. Born Highland Park, IL. Pupil of Art Institute of Chicago. Member: Calif. Art Club; Laguna Beach Art Association; San Diego Artists Guild. Awards: Gold medal, West Coast Artists, Los Angeles, 1926; third prize, Calif. State Fair, Sacramento, 1926; first prize, Laguna Beach Art Association, 1927; first prize, 1928 and 1930, Riverside Co. Fair; special water color prize, 1928, P. F. O'Rourke prize ($500), 1929, and Evelyn N. Lawson water color purchase prize, 1931, Fine Arts Gal., San Diego; hon. mention, Pasadena Art Inst., 1930; hon. mention, Calif. Art Club, 1930, first prize, 1931, Hatfield gold medal, 1932; second prize, Los Angeles Co. Fair, 1931; second prize, Sacramento State Fair, 1932. Work: Kerr Memorial, bronze fountain, Laguna Beach; oil and water color, Fine Arts Gallery, San Diego, Calif. Exhibited at Penna. Academy of Fine Arts; Art Institute of Chicago; Golden Gate Expo.; San Francisco, 1939; others. Address in 1953, 2160 Coast Blvd., South, Laguna Beach, Calif.

PEACEY, JESS.
See Lawson-Peacey.

PEANO, FELIX ACHILLES.
Sculptor. Born in Parma, Italy, June 9, 1863. Studied at Albertina Academy of Art, Turin; University of Turin; Paris and Rome. Lived in Oakland, CA; in Los Angeles from 1902. First important sculptor to arrive in the Los Angeles area. Known primarily for architectural sculpture and small bronzes. Combined figurative and floral imagery. Works include sculpture for bridges in Venice, CA; gardens and sculpture at house in Hawthorne, CA; bronze "Door of Life." Died in Hawthorne, CA, Jan. 10, 1949.

PEARSON, ANTON.
Sculptor, painter, and craftsman. Born in Lund, Sweden, May 23, 1892. Studied at Bethany College; in Sweden; and with Birger Sandzen. Member: Smoky Hill Art Association. Contributor to: *Kansas Magazine*. Lectures: Woodcarving and Hobbies. Address in 1953, Lindsborg, KS.

PEARSON, EDWIN.
Sculptor. Born near Yuma, Colorado, December 20, 1889. Pupil of Art Institute of Chicago with Harry Walcott; Munich Royal Academy; Hermann Hahn. Work: Bust of William Shakespeare, Munich Theater Museum and State Library, Weimar, loaned by Shakespeare Society; portrait of Professor Franz Jacobi, Clara Zeigler Museum, Munich. Exhibited: Penna. Academy of Fine Arts; Art Institute of Chicago. Address in 1953, Hyde Park, New York.

PEARSON, JAMES E.
Sculptor, educator, and author. Born in Woodstock, IL, December 12, 1939. Studied: BS and MS in Educ. at Northern Illinois University; studied art in England, Germany, France, Italy, Russia, Japan, Canada, etc. Exhibited: Carnegie Institute; Dept. of the Interior; Norfolk Museum of Arts & Sciences; Brooks Mem. Gallery; Burpee Art Gallery; Illinois State Museum; The Art Association of Newport; Palais des Beaux Arts, Charleroi, Belgium; Palais de la Scala, Monte Carlo, Monaco; others. Works: Permanent collection, Northern Ill. Univ.; DeKalb, IL; over 200 private collections. Member: Soc. of Animal Artists; Centro Studi e Scambi Internazionali; Col. Art Assn.; Ill. Art Educ. Assn.; Ill. Craftsmen's Council; The American Federation of Arts. Address in 1983, Ringwood, IL.

PECK, JUDITH.
Sculptor and educator. Born in NYC, December 31, 1930. Studied at Adelphi College, B.A.; Art Students League; Sculpture Center, NY; Columbia University, M.A. and Ed.M. Work in Yale University; monuments, Temple Beth El, Spring Valley, NY, others. Has exhibited at Baltimore Museum of Art; Detroit Institute of Arts; Penna. Academy of Fine Arts; National Academy Galleries, NY; Barzansky Galleries, NY; Reyn Gallery, NY; others. Member of Art Students League; Women's Caucus on Art; American Association of Artists/Therapists. Works in wax and fiberglas. Address in 1982, Mahwah, NJ.

PEDDLE, CAROLINE.
See Mrs. Ball.

PEDERSON, MOLLY FAY.
Sculptor and painter. Born in Waco, Texas, April 26, 1941. Studied privately with Carl Cogar, Las Cruces, New Mexico; James Woodruff, Houston; Mary Berry, McKinney, Texas; Ramon Froman, Dallas, Texas; Ken Gore, Mass.; Stewart Matthews, Arnold Vail, and H. E. Fain, Dallas. Exhibitions: Richardson Civic Arts Society Annual, Texas, 1968-70; Artists Market, Dallas, 1968-72; Bond's Alley Art and Craft Show, Hillsboro, Texas, 1969-70; Texas Fine Arts Asn. Exhib., Dallas, 1970; Temple Emanu-El Annual Brotherhood Art Festival, Dallas, 1970-72. Media: Brass, copper; oil, and acrylic. Address in 1980, Richardson, TX.

PEDRETTI, HUMBERTO (or HUMBERTA).
Sculptor. Exhibited at Penna. Academy of Fine Arts, Philadelphia, 1926. Address in 1926, Hollywood, Calif.

PEII, AHMAD OSNI.
Sculptor and craftsman. Born in Palembang, Indonesia, September 7, 1930. Studied at Craft Students League; New School for Social Research, scholarship, 1966; Education Alliance; Haystack Mountain School of Arts and Crafts. Work in New England Center of Contemporary Arts, Brooklyn, CT; others. Has exhibited at American Craft Council Gallery, NY; Brooklyn Museum; Yonkers Museum, NY; Silvermine Guild, CT; Wadsworth Atheneum, Hartford, CT; others. Received best sculpture award, Artist-Craftsmen of New York Annual Show; others. Works in bronze and concrete. Address in 1982, c/o Renata Shapiro, 60 Sutton Place S., NYC.

PEIRCE, ALZIRA.
Sculptor and painter. Born in New York City, January 31, 1908. Pupil of Bourdelle and Boardman Robinson. Work includes murals, US Post Office, Ellsworth, South Portland, ME. Exhibited at Penna. Academy of Fine Arts; Carnegie; Federation of Modern Painters and Sculptors. Address in 1933, 225 Cedar St., Bangor, ME. Living in New York City in 1953.

PEIXOTTO, GEORGE DA MADURO.
Sculptor, painter, architect, and mural decorator. Born in Cleveland, OH. Pupil of Meissonier and Munkacsy. Awards: Silver medal, Royal Academy, Dresden. Member: Societe des Artistes Francais. Specialty, mural decoration. Address in 1906, 48 Park Place, NYC, and 36 bis Avenue de l'Opera, Paris, France.

PELBY, MRS.
Wax modeler. Exhibited collection of scriptural wax statuary in NYC, 1848; in Boston, 1849; in Philadelphia, 1851.

PELL, ELLA FERRIS.
Sculptor, painter and illustrator. Born St. Louis, MO, January 18, 1846. Pupil of Cooper Union in New York under Rimmer; Laurens, Ferdinand Humbert and Gaston St. Pierre in Paris. Work: "Salome" painting owned by Boston Art Club; "Andromeda" heroic statue. Address in 1929, Beacon, NY.

PELLEGRINI, ERNEST G.
Sculptor. Born in Verona, Italy, August 18, 1889. Studied: Academy of Verona. Member: Boston Sculpture Society; Copley Society; North Shore Art Association; National Sculpture Society. Work: Reredos, St. Luke's Cathedral, Portland, ME; panels and triptychs in churches in Cambridge, Boston, Brighton, Lenox, MA; NYC; Washington, DC; Chicago; Portland, ME; St. Michael and All Angels Church, Cincinnati, OH. Exhibited: North Shore Art Association; Pennsylania Academy of Fine Arts; Detroit Institute of Art; others. Address in 1953, Boston, Mass. Died in 1955.

PENNING, TOMAS.
Sculptor. Exhibited: Woodstock, NY, 1934. (Mallett's)

PEPLOE, FITZGERALD CORNWALL.
Sculptor. Born in England, 1861. Died in Purchase, NY, January 30, 1906.

PEPPER, BEVERLY.
Sculptor and painter. Born in Brooklyn, NY, December 20, 1924. Studied at Pratt Institute; Art Students League;

and in Paris under Andre L'hote and Fernand Leger. Exhibited: Albright-Knox Art Gallery, 1968; San Francisco Museum of Art, CA, 1976; Seattle Museum of Contemporary Art, 1977; Princeton Art Museum, 1978; Andre Emmerich Gallery, 1979; International Sculpture Conference, Washington, DC, 1980; Smithsonian Institution, Washington, DC, 1980; "Excaliber" (painted steel), for the San Diego Federal Courthouse, CA, 1974; "Thel" (site sculpture), for Dartmouth College, 1977; others. Awards: Best Art in Steel, Iron and Steel Institute, 1970; two grants from the National Endowment for the Arts, 1975, 79; and a General Services Administration Grant, 1975. Used primary forms and large geometric metal forms for her sculpture in the 1960's and early 1970's. Address in 1982, Torre Gentile DiTodi, Italy.

PERATEE, SEBASTIAN.
Image maker. Worked in NYC in 1819.

PERELLI, ACHILLE.
Sculptor and painter. Born in Milan, Italy, in 1822. Studied at the Academy of Arts, Milan. Moved to US and settled at New Orleans. Was Louisiana's first sculptor in bronze. Painting subjects were fish and game. Died in New Orleans, Oct. 9, 1891.

PERELLI, CESAR.
Sculptor. Associated with Achille Perelli, New Orleans, 1853.

PERERA, GINO.
Sculptor and painter. Born in Siena, Italy, August 2, 1872. Pupil of Royal Academy, Rome; School of Boston Museum; H. D. Murphy, Birge Harrison, and Ochtman. Member: Boston Art Club; St. Botolph Club; Copley Society of Boston; Salma. Club. Address in 1933, 382 Commonwealth Ave., Boston, MA.

PEREZ, FRANCISCO.
Sculptor. Born in New York City, Aug. 24, 1934. Work: Private collections, including H. F. Guggenheim, J. P. Morgan; many public collections. Exhibitions: Loeb Student Center, NYU, NY; Brooklyn Museum, NY; Museum of Fine Arts, MA; and others. Address in 1970, Patchogue, NY.

PERHACS, LES.
Sculptor. Born in North Hollywood, California, in 1940. Studied at Chouinard Art Institute; Pratt Institute; Art Center; University of Southern California. Worked making models and designs for toys. Has own studio, shop, and foundry. Specialty is wildlife of the Pacific Northwest. Works in bronze; some pieces with 24-karat gold applied. Reviewed in *American Artist*, August 1979; *Southwest Art*, March 1980. Represented by Meinhard Gallery, Houston, TX; Carson Gallery, Denver, CO. Address since 1968, near Puget Sound, Washington.

PERILLO, GREGORY.
Sculptor, painter, and printmaker. Born in Greenwich Village, New York City, in 1929. Studied at Pratt Institute; School of Visual Arts; Art Students League; with W. R. Leigh. Worked as cartoonist for U. S. State Department. Has toured Indian reservations and the West. Specialty is the American Indian; occasional cowboy subjects. Sculpts in bronze. Has produced limited edition lithographs, plaques, plates, figures. Exhibits at Kachina Gallery, Santa Fe, NM. Address in 1982, Staten Island.

PERKINS, LUCY FAIRFIELD.
Sculptor. Born in Mineola, LI, NY. Pupil of Augustus Saint Gaudens. Address in 1910, 103 West 42nd St., NYC.

PERL, A.
Sculptor. In New Orleans, LA, 1857.

PERLESS, ROBERT.
Sculptor. Born in NYC, April 23, 1938. Studied at University of Miami, Coral Gables, FL. Work in Whitney Museum of American Art, NY; Aldrich Museum of Contemporary Art, Ridgefield, CT; Chrysler Museum at Norfolk, VA; Everson Museum, Syracuse, NY; Oklahoma Art Center, Oklahoma City. Has exhibited at Bodley Gallery, NY; Whitney Museum of American Art, NY; Houston Gallery, TX; Aldrich Museum of Contemporary Art. Address in 1982, Greenwich, CT.

PERLMAN, JOEL LEONARD.
Sculptor and teacher. Born in NYC, June 12, 1943. Studied: Cornell Univ., Ithaca, NY, 1961-65; Central School of Art and Design, London, 1964-66; University of California, Berkeley, 1967. Exhibited: Axiom Gallery, London, 1969; Bennington College, VT, 1970; Andre Emmerich Gallery, NY, 1973, 76, 78, 80; Whitney, 1973; Aldrich Museum Contemporary Art, 1973; Roy Boyd Gallery, Los Angeles, 1978, 80, 81; others. Awards: Crown Zellerbach Foundation Grant, San Francisco, 1968; Housing and Urban Development Award for Sculpture, Washington, DC, 1972; Guggenheim fellowship, 1974; Nat. Endowment for the Arts Grant, 1979. Taught: Winchester Col., England, 1968, 69; Bennington College, VT, 1969-72; artist-in-residence, Middlebury College, VT, 1972; The School of Visual Arts, NYC, from 1973; Fordham Univ., Lincoln Center Campus, NYC, from 1974. Also wrote "Notebook," an article in the Feb., 1969, *Art and Artists*. Address in 1982, c/o Emmerich Gallery, 44 East 57th St., NYC.

PERO, LORENZO.
Image maker. Born in Tuscany, 1837. In Philadelphia in 1860, working and living with Lorenzo Hardie. Medium: Plaster.

PERRY, CHARLES O.
Sculptor. Born in Helena, MT, October 18, 1929. Studied at Yale University, B.A. (architecture). Work in Art Institute of Chicago; Oakland Museum, CA; San Francisco Museum of Art, CA; Museum of Modern Art, NY; de Young Museum, San Francisco. Has exhibited at Milwaukee Art Center, WI; Chicago Museum of Contemporary Art; Whitney Museum of American Art, NY; Hopkins Art Center, Dartmouth. Works in metal. Address in 1982, Norwalk, CT.

PERRY, CLARA GREENLEAF.
Sculptor, painter, and lecturer. Born Long Branch, NJ, August 22, 1871. Pupil of Robert Henri. Member: Copley Society; National Academy of Design; Women Painters

and Sculptors; Washington Art Club. Address in 1933, care of Mrs. David Perry, The Wyoming, Washington, DC; summer, Chavaniac-Lafayette, Haute Loire, France.

PERRY, EMILIE S.
Sculptor and medical illustrator. Born New Ipswich, NH, December 18, 1873. Pupil of School of the Boston Museum; Mass. Normal Art School; Max Broedel. Member: Ann Arbor Art Association. Work: Panel in bas relief, The Women's Club, Hollywood; panel, Hollywood Library; bust of Prof. Gordon, College of Garvanza, Los Angeles. Address in 1929, Ann Arbor, MI. Died in 1929.

PERRY, JOHN D.
Sculptor. Born in Swanton, VA, in 1845. He lived in New York, 1869-70, but passed the rest of his professional life in Italy and Boston. He made many portrait busts, and his statuette of Sumner was highly praised.

PERRY, MAEBLE CLAIRE.
Sculptor. Born in Idaho, Febuary 11, 1902. Pupil of Albin Polasek. Award: Alliance, 1931. Work: "Jeff," Art Institute of Chicago. Address in 1933, 1142 Maple Ave., Evanston, Illinois.

PERRY, OSWALD.
Sculptor. He exhibited in Chicago and Cincinnati. Active in Cincinnati, Ohio, in 1925.

PERRY, ROLAND HINTON.
Sculptor and portrait painter. Born in New York, Jan. 25, 1870. Pupil of Gerome, Delance, Callot, Chapu and Puech in Paris; Ecole des Beaux-Arts, Academie Julien, Paris; Art Students League, NY. Member: National Sculpture Society; American Federation of Arts. Work: "Fountain of Neptune," Library of Congress, Washington; Langdon doors, Buffalo Historical Society; frieze, New Amsterdam Theatre, New York; "Pennsylvania" on dome of Capitol, Harrisburg; "Gen. Greene" and "Gen. Wadsworth" at Gettysburg; "New York State Memorial," Andersonville; "Gen. Curtis," Ogdensburg; "Gen. Castleman," Louisville; "New York Monument," Chattanooga; "Benjamin Rush Monument," and Lions, Connecticut Ave. Bridge, Washington; monument to 38th Infantry, Syracuse, NY. Exhibited at National Sculpture Society in 1923. Address in 1933, 51 West 10th St., New York, NY. Died October 27, 1941.

PERRY, WALTER SCOTT.
Sculptor, painter, teacher, writer and lecturer. Born Stoneham, Mass. Pupil of Langerfeldt, Higgins and Pierre Millet; Mass. Normal Art School; studied abroad. Member: National Arts Club; Alliance; Eastern AA; Western Art Association; Rembrandt Club. Supervisor of drawing and art education, public schools, Fall River, Mass., 1875-79; and Worcester, Mass., 1879-87. Director, School of Fine and Applied Arts, Pratt Institute, since its organization, from 1887 to 1928. Author of *Egypt the Land of the Temple Builders*; *With Azir Girges in Egypt*; textbooks on art education; lecturer on architecture, sculpture, painting and decoration. Address in 1929, 56 Cambridge Pl., Brooklyn, New York, NY; summer, Elmcroft, Stoneham, Mass.

PERSICO, E. LUIGI.
Sculptor, miniature and portrait painter. Born in Naples, 1791. Came to America in 1818. At Lancaster, Harrisburg, and Philadelphia, PA, 1819, 20. At Philadelphia, 1824-25. Executed sculpture for the US Capitol at Washington, including colossal "War" and "Peace" for the east portico. Project completed in 1834. Exhibited at the Boston Athenaeum and the Artists' Fund Society of Philadelphia, 1834-55. Later settled in Europe; died in 1860 at Marseilles.

PETERSEN, CHRISTIAN.
Sculptor. Born in Dybbol, North Slesvig, Denmark, February 25, 1885. Pupil of Newark Tech. School, Art Students League of New York, RI School of Design, and H. H. Kitson. Member: Attleboro Chapter, American. Federation of Artists; Chicago Galleries Association; East Orange Art Association. Work: "Battery D Memorial," New Bedford, MA; "Spanish War Memorial," Newport, RI; "Rev. John W. Moore," St. John's College, Brooklyn, NY; "Governor George W. Clarke" and "Henry C. Wallace, Secretary of Agriculture," State of Iowa; "Niels Bukh," Bukh's School, Ollerup, Denmark. Address in 1933, Buchanan St., Belvidere, Ill.

PETERSON, AUDREY MOUNT.
Sculptor and painter. Born in Salt Lake City, Utah, May 11, 1914. Studied at Univ. Utah; Univ. Chicago; Art Inst. Chicago; also with Edward A. F. Everett, Millard Sheets, Donald Yacoe, Richards Reuben, Eijnar Hansen, and Leonard Edmondson. Works: Art League Gallery, Great Falls, Mont. Exhibitions: Denver Art Museum Biennial, Colo., 1958; Laguna Beach Art Assn., Calif., 1959; Chaffey Community Art Assn., Calif., 1962; Watercolor USA, Springfield Art Museum, MO, 1964 and 71; Gallery Rene Borel, Deauville, France, 1971. Awards: Honorable Mention, National Watercolor Society, Los Angeles, 1958; First Prize, National Orange Show, San Bernardino, 1959; Purchase Prize, Art League, Great Falls, 1969. Primarily painter. Address in 1976, Altadena, CA.

PETERSON, ELSA KIRPAL.
(Mrs. R. M. Tower Peterson). Sculptor. Born in New York, NY, June 16, 1891. Pupil of Edith Woodman Burroughs, J. E. Fraser; Hans Schwegerle in Munich. Member: Art Alliance of America; Students League of NY. Address in 1933, 67 Hillside Ave.; h. 140 Barclay St., Flushing, NY.

PETERSON, GEORGE D.
Sculptor. Born in Wilmington, Delaware, 1862. Specialty, animals.

PETICOLAS, SHERRY.
Sculptor. Born in Waterloo, IA, 1904. Address in 1934, Los Angeles, CA. (Mallett's)

PETTRICH, FERDINAND (or FRIEDRICH) AUGUST.
Sculptor. Born at Dresden, Germany, December 3, 1798. Came to US in 1835. Residing in Rio de Janeiro, Brazil, in 1847; Court Sculptor to Emperor Dom Pedro II. Probably in Philadelphia, 1850. Works include bronze statue of Washington, New York Customs House, plaster replica at National Museum, Washington, DC; tomb, Laurel Hill

Cemetery, Phila.; marble portrait of Hoel Poinsett, Secretary of War, National Museum; portraits of Henry Clay and Martin Van Buren; others. Honorary professional member of National Academy of Design, NYC, 1838-60. Exhibited at Pennsylvania Academy, 1843-1870.

PFEIFER, MARIA CLARA.
Sculptor and painter. Born in St. Louis, MO. Pupil of St. Louis School of Fine Arts, under R. P. Bringhurst; Ecole des Beaux-Arts, Marqueste and Bourdelle in Paris. Awards: First prize, St. Louis School of Fine Arts; bronze medal, St. Louis Exp. 1904. Member: St. Louis Guild of Painters and Sculptors; A. Women's A. A. of Paris. Address in 1906, 1820 Locust St., St. Louis, MO; 10 Rue Campagne -Premiere, Paris.

PHELAN, ELIZABETH SIMON.
Sculptor. Born in St. Louis, MO, Dec. 9, 1896. Studied at Columbia, 1919-21; Washington University, 1939, 40. Exhibitions: One-man shows Art Mart, Clayton, MO, 1953; John Burroughs School, 1959; two-man shows, St. Louis Artists' Guild, 1955; Bernandy Architectural Office, 1952; Art Mart, Clayton, MO, 1958; group shows, 3d Sculpture Internat., Phila., 1949; National Academy of Design, 1948; Penna. Academy of Fine Arts, 1951. Awards: First prize, St. Louis Artists' Guild, 1948, 55; 2d prize, 1950, 51; purchase prize for wood sculpture, Mid-American Annual Exhib., 1952; Martha Love prize, St. Louis City Art Museum, 1952; prize for sculpture, St. Louis Church Federation, 1957. Member: St. Louis Artists' Guild; Missourians. Address in 1962, St. Louis, MO.

PHELAN, LINN LOVEJOY.
Sculptor, craftsman, designer, and teacher. Born in Rochester, NY, August 25, 1906. Studied at Rochester Inst. Tech.; Ohio State Univ., B.F.A.; Alfred Univ., MS (Educ.), 1955. Award: Prize, Arts and Crafts Festival, Abingdon, VA, 1950; NY State Fair awards, 1975. Work: Convalescent Hospital for Children, Rochester, NY; Cranbrook Acad. of Art; Dartmouth College. Exhibited: Phila. Art All., 1937-42, 45, 52; Syracuse Museum of Fine Arts, 1932-36, 42, 46, 47, 51; Columbus Gallery of Fine Art, 1931-33; NY Soc. Ceramic Art, 1934, 36; Rochester Mem. Art Gal., 1929, 30, 32, 35, 38, 47-52; Wichita Art Assn., 1946; Dartmouth Col., 1945; Albright-Knox, Buffalo, 1951; others. Contributor to *Design, Craft Horizons* magazines. Position: Owner, "Linwood Pottery," Almond, NY; Ceramic Instr., School for American Craftsmen, Alfred, NY, 1944-50; Art Supv., Alfred-Almond Central School, Almond, NY, 1950-67; lecturer, Alfred Univ., 1967-72. Address in 1982, Almond, NY.

PHELPS, RUSTY.
Sculptor. Born in Colorado Springs, Colorado, in 1936. Raised and worked in farming and ranching. Largely self-taught in art. Work selected for show at Cowboy Hall of Fame, 1975. Has won many awards. Specialty is Western figures. Sculpts in bronze. Member of Professional Artists of the Rockies. Exhibits at The Garden of the Gods Gallery, Colorado Springs; Kansas Gallery of Fine Arts, Topeka. Address since about 1952, Peyton, Colorado.

PHILBIN, CLARA.
Sculptor. Member: Cincinnati Woman's Art Club. Address in 1928, 2126 Auburn Ave., Cincinnati, OH.

PHILIP, WILLIAM H.
Sculptor. At New York City, 1858-59.

PHILLIPS, BLANCHE.
Sculptor. Born in Mt. Union, Penn., in 1908. Studied at Cooper Union Art School; Art Students League; Stienhofs Institute of Design; California School of Fine Arts; also with Zadkine, and Hofmann. Works: Whitney Museum of American Art.

PHILLIPS, DAVID.
Sculptor. Born in Detroit, MI, 1950. Studied: Wayne State University, B.F.A. Exhibited at The Detroit Institute of Arts, Michigan Focus, 1974-75. Address in 1975, Troy, MI.

PHILLIPS, GORDON.
Sculptor and painter. Born in Boone, North Carolina, September 9, 1927. Studied at Corcoran School of Art, Washington, DC. Taught there. Worked as free lance illustrator and art director. Later turned full-time to painting. Has exhibited at Franklin Mint, PA. Awarded gold medals, Distinguished Western Art, Franklin Mint, 1973, 74. Specialty is Western Americana. Paints in oil and watercolor. Represented by Kennedy Galleries, New York City. Address in 1982, Crofton, Maryland; spends summers in the West.

PHILLIPS, HELEN.
Sculptor. Born in Fresno, CA, 1913. Studied sculpture at the Art School of CA, under Ralph Stackpole from 1931-36. Later went to study in Paris until outbreak of World War II; returned to US until 1950. Exhibited at the Paris School, the Salon de la Jeune Sculpture and the Salon de Mai. Awards: French Award for her entry for the monument "The Unknown Political Prisoner." Media: clay, plaster, wood, stone, and metal.

PHILLIPS, MELITA AHL.
Sculptor and painter. Born in Newark, NJ, May 20, 1904. Studied at Parsons School of Design, 1924; Art Students League; also with Howard Giles, Felicie Waldo Howell; sculpture with Henry Mitchell. Work: Bear sculpture, Library, Belair, MD; others. Has exhibited at Annual Exhibition, Catharine Lorillard Wolfe Art Club, National Academy of Design, NY; Annual Exhibition, Hudson Valley Art Association, Westchester, NY; Memorial Show, Lever House, NY; others. Received first prize for White Polar Bear, National Arts Club, 1977; others. Member of National Arts Club, NY; Hudson Valley Art Association; National League of American Pen Women Diamond State Branch, DE. Works in stone, bronze; watercolor, and oil. Address in 1982, Elkton, MD.

PHIPPEN, GEORGE.
Sculptor and painter. Born in Iowa, 1916. Studied briefly with Henry Balink, Santa Fe; otherwise self-taught in art. Worked in commercial art and illustration before turning to oil painting and sculpture. Specialty was Western subjects, chiefly cowboy scenes. Has sculpture in Phoenix Art Museum. Was first president of Cowboy Artists of America. Died in Skull Valley, Arizona, 1966. Studio became public art gallery.

PIAI, PIETRO.
Sculptor. Born in Vittorio, Treviso, Italy, March 31, 1857. Pupil of Stella at Vittorio; Academy in Turin under C. Tabacchi. Address in 1903, 131 Houston St., NY.

PIATTI, ANTHONY.
Sculptor. Worked in NYC, 1849-57. Exhibited at the National Academy of Design, NY, in 1850.

PIATTI, EMILIO F.
Sculptor. Born in NYC December 18, 1859. Pupil of his father, Patrizio Piatti, and also of Cooper Union. Assistant to Saint-Gaudens. Works include "Grief" for the Mausoleum of George Westcott, a statue of General Spinola, and a bust of Bertha Galland. Died in Englewood, NJ, Aug. 22, 1909.

PIATTI, PATRIZIO.
Sculptor. Born near Milan, Italy, 1824. Came to America and settled in NY in 1850. Address in 1903, 229 West 23rd St., NY.

PIAZZONI, GOTTARDO F. P.
Sculptor, painter, and etcher. Born Intragna, Switzerland, April 14, 1872. Pupil of San Francisco Art Assn. School of Fine Arts; Julian Academy and Ecole des Beaux-Arts, Paris. Member: San Francisco Art Association; California Society of Etchers; Bohemian Club; Club Beaux Arts San Francisco; American Federation of Arts. Represented in the Walter Collection, San Francisco Art Association; California Palace of the Legion of Honor; Golden Gate Park Museum, San Francisco; Oakland (Calif.) Art Gallery; Municipal Gallery, Phoenix, Ariz.; Mills College Art Gallery, Oakland, Calif. Address in 1933, 446 Lake St., San Francisco, Calif. Died in 1945.

PICARD, LIL.
Sculptor and painter. Born in Landau, Germany; US citizen. Studied at College of Strassbourg, Alsace-Loraine; in Vienna, Austria, and Berlin, Germany; Art Students League, with Jevza Modell. Works: Schniewind Collection, Nevege, Germany; Hahn Collection, Cologne, Germany. Exhibitions: Parnass Gallery, Wuppethal, Germany, 1962; Insel Gallery, Hamburg, Germany, 1963; Smolin Gallery, NY, 1965; Kunsthalle, Baden-Baden, Germany; Stedelijk Museum, Holland; plus others. Address in 1980, 40 E. Ninth St., NYC.

PICCHI, FREDERICK.
Sculptor. In New Orleans, 1860-61.

PICCIRILLI, ATTILIO.
Sculptor. Born Massa, Italy, May 16, 1866. Pupil of Accademia San Luca, Rome. Came to US 1888. Member: Associate, National Academy of Design, 1909; New York Architectural League, 1902; Allied Artists of America. Awards: Bronze medal, Pan-Am. Exposition, Buffalo, 1901; silver medal, St. Louis Exposition, 1904; hon. mention, Paris Salon, 1912; gold medal, P.-P. Exposition, San Francisco, 1915; Widener gold medal, Penna. Academy of Fine Arts, 1917; Saltus gold medal, National Academy of Design, 1926. Work: "Maine Memorial," New York; "MacDonough Monument," New Orleans; "Dancing

Faun" and "Head of a Boy," Fine Arts Academy, Buffalo; pediment, Frick House, NYC; bust of Jefferson, Virginia Capitol. Exhibited at National Sculpture Society, 1923. Address in 1933, 467 East 142d St., New York, NY. Died in 1945.

PICCIRILLI, BRUNO.
Sculptor. Born in NYC, March 30, 1903. Studied at the National Academy of Design, and at the Beaux-Arts Institute of Design, NY; American Academy in Rome. Works: Fountain figure, Pan; head, Mimi; bust, Modern Amazon; portrait medallion; statuette, Orpheus; and at Riverside Church, NYC; Brookgreen Gardens, S.C.; Mount Carmel School, Poughkeepsie, NY; others. Exhibited at National Academy of Design, 1930-32; Architectural League, 1945; Albany Institute of History and Art; others. Member of National Sculpture Society; Architectural League; Dutchess County Art Association. Instructor of sculpture, Beaux-Arts Institute of Design, NYC. Died in 1976.

PICCIRILLI, FERRUCCIO M.
Sculptor. Address in 1924, 467 East 142nd St., NYC.

PICCIRILLI, FURIO.
Sculptor. Born Massa, Italy, March 14, 1868. Pupil of Accademia San Luca, Rome. Came to US 1888. Member: Associate, National Academy of Design; New York Architectural League, 1914 (assoc.). Awards: Hon. mention, Pan-Am. Exposition, Buffalo, 1901; silver medal, St. Louis Exposition, 1904; silver medal, P.-P. Exposition, San Francisco, 1915. Exhibited at National Sculpture Society, 1923. Address in 1933, 467 East 142d St.; h. 1 Beach Terrace, Bronx, New York, NY. Died in 1949.

PICCIRILLI, GUISEPPE.
Sculptor. Born in Rome, Italy, 1843. Settled in NYC in 1888 and opened a studio there. Assisted by his sons, he executed marble decorations for the New York Customs House, Chamber of Commerce, County Court House and Stock Exchange Buildings, all in NYC. Died in New York City, January 20, 1910.

PICCIRILLI, HORACE.
Sculptor. Born in Massa, Italy, in 1872. Studied in NYC under Roine. Award: Speyer Memorial prize ($300), National Academy of Design, 1926. Works: Interior decorations on the Frick house, New York City; decorations in marble, stone, and majolica on the Clark house, New York City; models for the exterior decorations of the New Court House, NYC. Exhibited at National Sculpture Society, 1923. Address in 1933, 467 East 142nd St., New York, NY.

PICCIRILLI, MASO.
Sculptor. Address in 1929, 467 East 142nd St., New York, NY.

PICCIRILLI, ORAZIO.
Sculptor. Address in 1929, 467 East 142nd St., New York, NY.

PICCOLI, GIROLAMO.
Sculptor. Born Palermo, Sicily, May 9, 1902. Pupil of

Wisconsin School of Art, Frank Vittor, Lorado Taft. Awards: Milwaukee Art Institute medal, 1922; hon. mention, Wisconsin Painters and Sculptors, 1924. Work: Sculpture on the Eagles Club Bldg., Milwaukee; fountain, "Boy With Duck," Lake Park, Milwaukee. Taught: Instructor of Sculpture, Layton School of Art, Milwaukee. Address in 1933, 216 East 17th St., New York City.

PICKENS, ALTON.
Sculptor, painter, and instructor. Born in Seattle, WA, January 19, 1917. Study: Reed College, Portland, OR, 1936-38, influenced there by calligrapher and printer Lloyd J. Reynolds; Portland Art Museum, one semester; New School for Social Research, NYC, 1939, with Seymour Lipton, sculpture; solitary study at Museum of Modern Art and Metropolitan Museum of Art. Work: Museum of Modern Art; Hirshhorn Museum & Sculpture Garden, Wash. DC; numerous private collections. One-man exhibitions: ACA Gallery, NY, 1956, 60; Indiana University Art Museum, 1956; Vassar College Art Gallery, 1956, 61, 77. Group: Metropolitan Museum of Art, NYC, 1942; Museum of Modern Art, 1943, 46; Art Institute of Chicago, 1945, 46, 51, 54; Carnegie Institute, 1945, 46, 47; Whitney Museum, 1946, 48, 49, 50, 55; John Herron Art Museum, Indianapolis, 1947, 49; Institute of Contemporary Arts, London, 1950; Corcoran Gallery, Wash. DC, 1951; Bienal du Museu de Arte Moderna, Sao Paulo, 1951, 53; Galerie "Kunst der Gegenwart," Salzburg, 1952; ACA Gallery, NY, 1964; Rutgers University Art Gallery, 1977; Phila. Art Museum; Penna. Academy of Fine Arts; National Institute of Arts and Letters; and many more. Teaching: Professor art, Vassar College, from 1956. Bibliog.: Books, reviews, exhibition catalogues. Media: Oils, pen and ink, woodcut, lithograph, etching, aquatint, charcoal, pastel, watercolor; bronze. Address in 1982, Art Department, Vassar College, Poughkeepsie, NY.

PIENE, OTTO.
Sculptor and painter. Born in Laasphe, Westphalia, Germany, April 18, 1928. Studied at Blocherer Art School and Academy of Fine Arts, Munich, 1948-50; Dusseldorf Art Academy, West Germany, 1950-53; University of Cologne, West Germany, 1953-57. Work in Albright-Knox Art Gallery, Buffalo, NY; Museum of Modern Art, NY; Carnegie Institute International Museum of Art, Pittsburgh, PA; others. Has exhibited at Corcoran Gallery of Art, Washington, DC; Earth, Air, Fire, Water: Elements of Art, Museum of Fine Arts, Boston, MA; Center for Advanced Visual Studies, Mass. Institute of Technology, Cambridge; others. Director, Center for Advanced Visual Studies, Mass. Institute of Technology, Cambridge. Address in 1982, c/o Mass. Institute of Technology, Cambridge, MA.

PIERCE, DIANE.
Sculptor and painter. Studied at Cleveland Institute of Art; Western Reserve University. Exhibited: National Audubon Society, 1977, 79, 80; National Wild Turkey Federation, 1977; Cleveland Museum of Natural History, 1978; Nation Wildlife Fed., 1980; Game Conservation International Convention and Show, TX, 1979; Salisbury

Wildfowl Festival, MD, 1976, 77, 79; Easton Waterfowl Festival, MD, 1977, 78, 79; Soc. of Animal Artists, NYC, 75, 76, 78, 79. Awards: Sculpture, Catherine Lorillard Wolfe Art Club, NYC, 1978; OK, 1979; painting, Nat. Wildlife Show, MO, 1978; Tulsa Wildlife Art Show, OK, 1979; Midwest Wildlife Art Show, MO, 1978; Indiana State Waterfowl Stamp Contest, 1979; Long Island Waterfowl Stamp Contest, 1980. Member: Society of Animal Artists; International Platform Assn.; Salmagundi Club. Specialty: Birds. Media: Bronze; oil, watercolor, scratchboard, and pastel. Address in 1983, Mentor, OH.

PIERCE, JAMES SMITH.
Sculptor and art historian. Born in Brooklyn, NY, April 26, 1930. Studied at Oberlin College, A.B., 1952; Harvard University, Ph.D., 1962. Has exhibited at Ball State University Art Gallery; Hirshhorn Museum; Smithsonian Institution, Washington, DC; La Jolla Museum of Contemporary Art, CA; Seattle Art Museum, WA; others. Member of College Art Association; Society of Architectural Historians. Works in earth and rock. Address in 1982, Dept. of Art, University of Kentucky, Lexington, KY.

PIERCE, ROWENA ELIZABETH.
Sculptor. Member: Providence Art Club. Address in 1921, 328 Broadway, Providence, RI.

PIET, JOHN FRANCES.
Sculptor. Born in Detroit, MI, February 23, 1946. Studied at Detroit Society of Arts and Crafts, B.F.A., 1973; Wayne State University, M.F.A., 1975. Exhibitions: All Michigan I and II, The Flint Institute of Arts, 1971, 73; Willis Gallery, Detroit, 1973, 74 (one-man); Detroit Artists Market, 1974; Environmental Sculpture Symposium, Wright State University, Dayton, OH, 1974; Detroit Institute of Arts, 1980; Museum of Contemporary Art, Chicago, 1981; Cranbrook Academy of Art, West Bloomfield, MI, 1980. Awards: 1969-72, Ford Foundation Grants; National Endowment for the Arts, Art Fellow, 1973; New Detroit Inc. grant for sculpture at Pingree City Park; Impermanent Sculpture grant, Michigan Council for the Arts; National Endowment for the Arts Grant, Oakland University Festival, 1981. Works in steel. Address in 1982, Detroit, MI.

PIETRO, CARTAINO Di SCIARRINO.
Sculptor. Born in Palermo, Italy, Dec. 25, 1886. Mainly self-taught, but studied for a time in Rome. Member: Boston Arts Club. Awards: Hon. men., P.-P. Exp., San Fran., 1915. Represented by statues of John Burroughs and Charles S. Sargent, American Museum of Natural History, NYC; marble fountain for Hackensack, NJ, Court House; bust of Elihu Root for Hamilton Col., and in Pan-American Union, Washington, D.C.; bust of John Muir, University of Wisconsin, Madison, WI; bust of W. H. Taft, Hague Peace Palace, Hague, Holland; bust of General William Booth, Memorial College, Philadelphia. Died in Pelham, NY, Oct. 9, 1918.

PIETZ, ADAM.
Sculptor and medalist. Born Offenbach, Germany, July 19, 1873. Studied at Penna. Academy of Fine Arts; Art

Institute of Chicago; and in Germany. Member: Phila. Sketch Club; Fellow Penna. Academy of Fine Arts; American Numismatic Society; NY Numismatic Society. Work in Chicago Art Institute; Memorial Hall, Philadelphia; Navy Yard, Phila.; Huston Club, University of Penna.; Phila. Sketch Club; National Museum, Washington; Vanderpoel Memorial Collection, Chicago; British Museum and American Numismatic Society. Exhibited at National Sculpture Society, 1923. Award: Bronze medal, Madrid, Spain, 1951. Position: Assistant Engraver, US Mint, 1927-46, retired. Address in 1953, Drexel Hill, PA.

PIKE, CHARLES J.
Sculptor. Member of New York Architectural Lg., 1902. Address in 1910, 151 West 23rd St., NYC.

PILLARS, CHARLES ADRIAN.
Sculptor. Born Rantoul, Ill., July 4, 1870. Pupil of Taft, French, and Potter; Art Institute of Chicago. Work: Memorial group to Florida's dead in the World War, Jacksonville; Bryan Memorial, Battleship Florida; Memorial Flag Staff Standard, St. Augustine; statue of Gen. Kirby Smith and statue of Dr. John Gorrie, United States Capitol, Washington, DC; statue, W. B. Barnett, Barnett National Bank, Jacksonville, Fla. Address in 1933, Sarasota, Fla. Died in 1937.

PINARDI, ENRICO VITTORIO.
Sculptor and painter. Born in Cambridge, MA, February 11, 1934. Apprenticed with Pelligrini and Cascieri, five years; studied at Boston Architectural Center; School of Museum of Fine Arts, Boston; Mass. College of Art, B.S. (education); Rhode Island School of Design, M.F.A. Work in Worcester Art Museum, De Cordova Museum, Lincoln, and Boston Institute of Contemporary Art, all in MA; others. Has exhibited at De Cordova Museum; Boston University; others. Teaching sculpture at Worcester Art Museum School, 1963-67. Works in wood. Address in 1982, Hyde Park, MA.

PINEDA, MARIANNA (or MARIANA).
Sculptor. Born in Evanston, IL, May 10, 1925. Studied at Bennington Col.; Univ. of Calif., Berkeley; privately with George Stanley in Los Angeles (sculpture); Cranbrook Acad. of Art, with Carl Milles; privately with Raymond Puccinelli in San Fran., with Oronzio Maldarelli in NY, and Ossip Zadkine in Paris; scholarship, Radcliffe Institute for Indp. Study, 1962-64. Works: Addison Gal., Andover, MA; Boston Mus. of Fine Arts; Bowdoin Col.; Dartmouth College; Wadsworth Atheneum; Harvard University; Walker; Williams College. Exhibitions: Walker; The Swetzoff Gallery, Boston; De Cordova; Museum of Modern Art; Albright; Whitney; Metropolitan Museum of Art; Art Institute of Chicago; Boston Arts Festival; NY World's Fair, 1964-65. Awards: Albright, 1948; Walker; Boston Arts Fest., 1957, 60. Address in 1982, Boston, MA.

PINKNEY, ELLIOTT.
Sculptor, painter, and printmaker. Born in Brunswick, GA, January 9, 1934. Study: Woodbury University, Los Angeles, BA; Art Instruction Inc., Minneapolis. Work:

Murals in Watts Towers Arts Center, Los Angeles; Church of God in Christ, Los Angeles; other work in private and institutional collections. Commissions: Watts Community Housing Corp.; Los Angeles Dept. of Parks & Recreation; Watts Alcoholic Rehabilitation Center; etc. Exhibited: Black Artists Invitational, LA County Museum of Art, 1972; Environmental Billboard Art, LA, 1973; Merabash Museum, NJ, 1975; Watts Towers Arts Center Gallery, LA, 1977; Compton (CA) College Gallery, 1981; Calif. Black Printmakers, 1983; many more. Member: Int'l. Soc. of Artists; Bunker Hill Art League. Award: Latham Found. Int'l. Poster Award; Theatre Guild Amer. Theatre Society & Council of Living Theatre Award; California Arts Council Grant. Primarily painter and printmaker. Address in 1983, Compton, CA.

PINTO, JODY.
Sculptor. Born in NYC, April 8, 1942. Studied: Penna. Academy of the Fine Arts, 1964-68, Cresson fellowship, 1967, 68; Philadelphia College of Art, 1971-73, B.F.A. Exhibited: Artpark, Lewiston, NY, 1975; Nexus Gallery, Philadelphia, 1976; Whitney Museum, NYC; Bard College, Annandale, NY, 1984; Philadelphia Museum of Art; Penna. Academy of Fine Arts. One-man exhibitions, Hal Bromm, NYC, 1978, 79, 80, 83; 112 Greene Street Gallery, NYC; Richard Demarco Gallery, Edinburgh, Scotland. Works: Philadelphia Museum of Art; Penna. Academy of Fine Arts; Whitney; Art Institute of Chicago; Wildlife Preserve, Cape May, NJ, 1974; "Finger Span: For Climber's Rock," Fairmount Park, Philadelphia, 1984; "Landmarks," Bard College, Annandale-on-Hudson, NY, 1984; many others. Awards: National Endowment for the Arts Grant, 1979-80; Penna. Council on the Arts Grant, 1980-81; NJ Council on the Arts Grant, 1980-81; Hazlett Memorial Award, PA, 1983. Taught: University of Guelph, Canada, 1977; Penna. Academy of Fine Arts, from 1980; Rhode Island School of Design, from 1980. Works in industrial materials (building). Address in 1982, 28 W. 69th St., NYC.

PIPER, GEORGE H.
Sculptor and painter. Member: Chicago Society of Artists. Address in 1906, 12 Tree Studio Bldg., Chicago, IL.

PIPPENGER, ROBERT.
Sculptor, designer, and craftsman. Born Nappanee, Ind., April 26, 1912. Studied: John Herron Art School, B.F.A. Awards: Prix de Rome, 1938; fellow, American Academy in Rome. Work: Sculpture, Plymouth (Ind.) Library; Brookgreen Gardens, SC. Exhibited: Grand Central Art Galleries, 1937-39; Penna. Academy of Fine Arts, 1941; New Jersey State Museum, Trenton, 1945. Address in 1953, New Hope, PA.

PISANI, F. AND C. (BROTHERS).
Sculptors. At San Francisco, 1860.

PITKIN, CAROLINE W.
Sculptor, painter, craftsman, and teacher. Born New York City, June 12, 1858. Pupil of Chase, DuMond, Harrison, Woodbury, Brenner. Member: Pen and Brush Club of New York; Alliance; National Academy of Women Painters and Sculptors. Address in 1933, 550 West 157th St., New York, NY. Died before 1940.

PITMAN, THEODORE B.
Sculptor, painter, illustrator, and maker of museum dioramas. Born in 1892. Studied at Harvard. Works include "Custer" for *The Frontier Trail* (commission); "Custer" for *Firearms in the Custer Battle*. Died in 1956.

PITTMAN, KITTY BUTNER (MRS. JAMES T.).
Sculptor, painter, and teacher. Born in Philadelphia, PA, Dec. 20, 1914. Studied at Oglethorpe Univ.; and with Fritz Zimmer, Robert Dean, Maurice Seiglar. Member: Atlanta Art Exhibitors. Exhibited: Southern States Art League, 1935-40; Assoc. Georgia Artists, 1933-36, 38, 40; Atlanta Studio Club, 1932-40; Atlanta Art Assn., 1936, 38; Atlanta Art Exhibitors, 1940-42; Chicago North Shore Art League, 1937. Address in 1953, Atlanta, GA.

PLASSMAN, ERNST.
Sculptor. Born June 14, 1823, in Westphalia, Germany. Studied in Germany and Paris. He came to New York in 1853 where the following year he opened "Plassman's School of Art," which he carried on until his death. He executed many models, carvings and sculptures; his statue of Franklin is in Printing-House Square, NY, and his figure of "Tammany" is on Tammany Hall, NY. Also a woodcarver. Author of *Modern Gothic Ornaments*, 1875; *Designs for Furniture*, 1877. He died in New York City on November 28, 1877.

PLATT, ELEANOR.
Sculptor. Born in Woodbridge, NJ, May 6, 1910. Studied at Art Students League; also under Arthur Lee. Noted work: "Louis D. Brandeis" (bronze) head, in collection of Met. Museum of Art. Also represented at Boston Museum of Fine Arts; Supreme Court Building, Wash., DC; Brooklyn; New York Bar Association; Museum of the City of NY; others. Executed awards medals, bas-reliefs, plaques, busts. Awards: Chaloner Scholarship, 1939-41; Grant, American Academy of Arts and Letters, 1944; Guggenheim Fellowship, 1945. Living in Santa Barbara, CA, in 1953. Address in 1970, 50 West 77th St., NYC. Died in 1974.

PLUNGUIAN, GINA.
Sculptor, painter, and educator. Studied at Ecole des Beaux Arts, Montreal; Dayton Art Inst. Works: Bronze portrait of Albert Einstein in Tel-Aviv Museum, Israel; others. Exhibitions: Sculpture, New Burlington Gallery, London, Eng., 1955; Stedelijk Museum, Amsterdam; Zaal Gallery, Antwerp; Les Maison des Arts, Schaarbeek, Belg., 1956; Argent Gallery, NYC; National Association of Women Artists; others. Awards: Watercolor prize, Hunter Gallery, 1954; first prize sculpt., 1955; oil painting prize, Del. Art Center, 1958; Hatch Meml. sculpt. prize, National Association of Women Artists, 1960. Member: Artists Equity Association; National Association of Women Artists; Associated Artists of NJ; Knickerbocker Artists; Coll. Art Association of America; Del. Art Council. Taught at Delaware Art Center, Wilmington, from 1957. Address in 1962, 461 W. Chestnut Hill Rd., Newark, Delaware.

PODESTA, STEPHEN.
Plaster image maker. Born in Italy, 1810. Living in Boston in 1860; in Massachusetts from at least 1843.

PODOLSKY, HENRY.
Sculptor. Exhibited "The Old Rabbi" at the Penna. Academy of Fine Arts, Philadelphia, 1921. Address in 1926, 1335 Greenmount Ave., Baltimore, MD.

POGANY, (WILLIAM ANDREW) "WILLY."
Sculptor, painter, illustrator, etcher, and craftsman. Primarily painter and designer. Born in Hungary, Aug. 24, 1882. Studied in Budapest. Member: Salma. Club; Architectural League; Royal Society of Arts, London. Awards: Gold medals, Leipsig, and Budapest Exposition; gold medal, Panama-Pacific Exp., San Francisco, 1915. Work: Twelve paintings, Hungarian National Gallery, Budapest; mural paintings for Heckscher Foundation and Peoples House, NY. Stage design for Broadway productions and Metropolitan Opera Co. Address in 1953, 1 West 67th St., NYC.

POGZEBA, WOLFGANG H.
Sculptor, painter, photographer, and architect. Born in Munich, Germany, July, 7, 1936. Came to US with parents in 1948; settled in Denver, CO, in 1950. Studied at Colo. Sch. of Mines at Golden; Sch. of Architecture, Univ. of Colo.; Univ. of Mexico, Mexico City; Kunstakademie, Munich; Ecole des Beaux-Arts, Paris. Works: Harmsen Collection of Western American Art; Denver Art Museum; Indianapolis Museum of Fine Art; Russell Museum, Great Falls, Montana. Exhibited: Montana Historical Soc.; Fine Arts Mus., San Diego; Marion Koogler McNay Art Inst., San Antonio, Texas; Amon Carter Mus., Ft. Worth, Texas; State Mus. of Wyoming; others. Awards: Mus. of NM; Salt Lake City Art Ctr.; Annual Bookbinders Western Book Show. Casts his own bronzes; also works in steel and fiberglas. Subjects are Western and others. Address in 1982, Taos, NM.

POIDIMANI, GINO.
Sculptor and teacher. Born in Rosolini, Italy, Jan. 2, 1910. Studied at Royal School of Art, Siracuse, Italy; Royal Liceo Artistico of Rome; Royal Acad. of Fine Arts, Rome. Member: Int. Artistic Assn., Rome; Artistic and Cultural Club, Siracuse, Italy; Nat. Sculpture Soc.; Allied Artists of America. Awards: Gov. scholarship to Royal Acad. of Fine Art, Rome; gold medal for sculpture, Tripoli, 1929. Work: Statues, bas-reliefs, Cathedral of Messina, Rome; St. Joseph's Catholic Church, Rosolini, Italy; Monumental Cemetery, Milan, and others; numerous portrait busts in private collections. Exhibited: Florence, 1942; San Remo prize exhibition, 1937, 39, 40; Venice Biennale, 1941; Rome, 1947 (one-man); Audubon Artists, 1947, 50-52; Penna. Acad. of Fine Arts, 1948; Fairmount Park, Phila., 1949; Nat. Sculpture Society, 1951, 52; Argent Gal., 1951; Allied Artists of America, 1951. Address in 1953, 121 Bank St., NYC.

POINTER, AUGUSTA L.
Sculptor. Born Durango, Colorado, May 10, 1898. Pupil of Henry Hering. Award: Avery prize, Architectural League of New York, 1928. Address in 1933, care of Henry Hering, 10 West 33rd St., New York, NY; h. Lincoln Park, NJ.

POLASEK, ALBIN.

Sculptor and teacher. Born in Frenstat, Czechoslovakia, February 14, 1879. Pupil of Charles Grafly at Penna. Academy of Fine Arts; American Academy in Rome. Member: Associate, National Academy of Design; National Sculpture Society, 1914 (associate); NY Architectural League; Southwest Society; Chicago Society of Artists; Cliff Dwellers; American Federation of Arts; Alumni Association of the Fellowship of the American Academy in Rome. Awards: Prix de Rome, American Academy in Rome, 1910; hon. mention, Paris Salon, 1913; Widener gold medal, Penna. Academy of Fine Arts, 1914; silver medal, P.-P. Exp., San Francisco, 1915; Logan medal ($1,500), Art Institute of Chicago, 1917; Hearst prize, Art Institute of Chicago, 1917; medal, Milwaukee Art Institute, 1917; Shaffer prize, Art Institute of Chicago, 1917; Logan medal ($500), Art Institute of Chicago, 1922; silver medal, Chicago Society of Artists, 1922; Fairmount Park Art Association prize ($500) at Penna. Academy of Fine Arts, 1925; Chicago Galleries Assn., 1937. Work: "Fantasy," Metropolitan Museum, NY; "F. D. Millet" bust, Pennsylvania Academy of Fine Arts, Philadelphia; "Sower," "Unfettered," busts of Charles Hawthorne, Charles L. Hutchinson, Frank G. Logan, Chicago Art Institute; "Aspiration," Detroit Institute of Art; Richard Yates Memorial, Springfield, Ill.; J. G. Batterson Memorial, Hartford, Conn.; Theodore Thomas Memorial, Chicago; Woodrow Wilson Memorial, Prague, Czechoslovakia, 1928, for which artist received order of the White Lion, awarded by the Government. Head of Sculpture Department, Chicago Art Institute. Address in 1953, Winter Park, FL. Died in 1965.

POLISZCZUK, OREST STEPHAN.

Sculptor and educator. Born in Lviv, Ukraine, January 7, 1942; US citizen. Studied at University of Maryland, B.A., 1966, M.A., 1968. Work, sculpture (steel), St. Stephan's Lutheran Church, White Oak, MD; others. Has exhibited at Baltimore Museum of Art; Sculptors Guild, NY; Ukrainian-Canadian Art Foundation, Toronto; others. Received an award for Young Sculptors Competition, Sculptors Guild, NY; others. Member of Southern Sculptors Association; Artists Equity Association, MD. Works in chrome-plated welded steel; gouache, oils. Address in 1982, Columbia, MD.

POLITI, LEO.

Sculptor, painter, illustrator, and cartoonist. Born in Fresno, CA, 1908. Studied at the Art Institute in Milan, national scholarship, in 1924. Murals in University of Fresno theater. Was art editor, Viking Press. Illustrated *Little Pancho*, 1938; weekly *Jack and Jill*, 1939. Address in 1972, Los Angeles, CA (?).

POLITINSKY, (FLORA) AUGUSTA.

Sculptor and painter. Born in Paterson, NJ. Studied at Am. Art School, NY; National Academy Design; Newark Museum; Art Students League. Exhibitions: National Academy School, Gotham Painters, NY, 1960; Paterson Mus., 1963; Ahda Artzt Gallery, NY, 1967-69; Burr Artists, Jersey City Mus., 1969; Empire Savings, Hannover Trust, NY, 1971. Awards: Best in Show, Gotham Painters,

1965; Hon. Men., Composers, Auth., Artists of America, 1972. Media: Watercolor, casein, oil; papier mache, copper, and aluminum wire. Address in 1976, Paterson, NJ.

POLK, FRANK FREDERICK.

Sculptor. Born in Louisville, Kentucky, September 1, 1908. Self-taught in art, except for some study with Hughlette Wheeler, George Phippen, and J. R. Williams. Worked as a cowboy, in rodeos, on ranches, as stunt man in cowboy films. Work in Colorado Springs Fine Arts Center; private collections. Has exhibited at Cowboy Artists of America Show, Cowboy Hall of Fame, Oklahoma City; Phoenix Art Museum; Kennedy Galleries, New York City; others. Won Golden Spur Award, bronze, National Rodeo Cowboy's Association; silver medal, George Phippen Memorial Annual Art Show, Prescott, Arizona. Member of Cowboy Artists of America. Specialty is statuettes of cowboys from 1918 to the present. Works in bronze. Bibliography includes *Bronzes of the American West*, Broder. Address in 1982, Mayer, Arizona.

POLLACK, REGINALD MURRAY.

Sculptor and painter. Born in Middle Village, Long Island, NY, July 29, 1924. Studied with Moses Soyer, Boardman Robinson, Wallace Harrison; Academie de la Grande Chaumiere, Paris. Awards: Maurice Fromke scholarship, Spain, 1951; Prix Neumann, Paris, 1952; Prix des Peintres Etrangers-Laureate, Paris, 1958; Ingram-Merrill Foundation grants in painting, 1964, 70-71. Work: Mint Mus. of Art; Whitney; Mus. of Modern Art; Brooklyn; Tel Aviv; many others. Exhibited: Salon de Mai, 1949, 51, Salon d'Automne, 1949, 50, 52, both in Paris, France; Joslyn Art Mus., 1951, Peridot Gal., NY, 1949-69; Felix Landau Gal., Los Angeles, 1977; many others. Taught: Yale, Cooper Union, UCLA, and elsewhere. Has written and illustrated numerous books. Address in 1953, Paris, France; address in 1982, Great Falls, VA.

POLLAK, VIRGINIA MORRIS.

Sculptor, educator, and museum consultant. Born in Norfolk, VA, October 16, 1898. Studied at Yale; Art Students League, NYC; Harriet Whitney Frishmuth Studio; Borglum School of American Sculpture; and abroad. Awards: Elsie Stegman prize; Florence K. Sloan award; Distinguished Service award; Presidential citation for work, World War II. Member: American Federation of Arts; Society American Archaelogy; Federated Garden Club of NY. Co-founder, Alva Studios, museum sculpture reproductions. Address in 1962, 502 Park Ave., NYC. Died c. 1968.

POLLAND, DON.

Sculptor. Born in Los Angeles in 1932. Has worked in various capacities including farmer, commercial artist, tool designer, and art director. Studied modeling and foundry technique on his own. In collections of Whitney Gallery, Cody, Wyoming; Favell Museum, Oregon; C. M. Russell Gallery; Montana Historical Society. Exhibited at Peking, China, show. Specialty is miniature Western figures. Works in bronze; some polychromed. Reviewed in *Southwest Art*, October 1975. Represented by Trailside

Galleries, Scottsdale, AZ. Address in 1982, Prescott, Arizona.

POLLIA, JOSEPH P.
Sculptor and painter. Born in Italy, 1893. Studied Boston Museum of Fine Arts School. Member: Conn. Academy of Fine Arts; National Sculpture Society. Work: Statues, memorials, figures, monuments, VA; courthouse, Elizabeth, NJ; Sheridan Sq., NYC; others in White Plains, Gloversville, Lake Placid, Tarrytown, Troy, all in NY; many others. Address in 1953, 1947 Broadway, New York, NY. Died in 1954.

POLLOCK, COURTENAY.
Sculptor, who exhibited at the Penna. Academy of the Fine Arts, Philadelphia, 1915. Address in 1926, "The Schuyler," 57 West 45th St., New York City.

POMEROY, LAURA SKEEL (MRS.).
(Laura Skeel Hofmann). Sculptor. Born in NY, 1833; grew up in Poughkeepsie. She executed a bust of Matthew Vassar, which still stands in Vassar College. Died in the Bronx, NYC, August 23, 1911.

POND, THEODORE HANFORD.
Sculptor and painter. Born in Beirut, Syria, September 22, 1873. Pupil of Herbert Adams, Du Mond, and Pratt Inst. in NY; also studied in Paris and London. Member: Boston Society of Arts and Crafts; Detroit Arts and Crafts; Providence Art Club; New York Architectural League 1902. Director, Dept. of Applied and Fine Arts at Mechanics Inst., Rochester, NY. Address in 1910, Maryland Institute, School of Art and Design, Baltimore, MD.

POOLE, EARL LINCOLN.
Sculptor, painter, illustrator, lecturer, educator, and museum director. Born in Haddonfield, NJ, October 30, 1891. Studied at Philadelphia Mus. School of Industrial Art; Penna. Acad. of Fine Arts; Univ. of Penna. Member: Reading Teachers Assn.; Penna. State Edu. Assn.; Nat. Edu. Assn.; Art Assn. Mus. Awards: Fellowship, Penna. Acad. of Fine. Arts; hon. degree, Sc. D., Franklin and Marshall Col., 1948. Work: Univ. of Michigan; sculpture, Reading Mus. Park, Reading, PA. Exhibited: Penna. Acad. of Fine Arts; Univ. of Michigan; Lib. of Congress; Los Angeles Mus. of Art; Harrisburg (PA) Art Assn.; City Art Mus. of St. Louis; Am. Mus. of Natural Hist. Illustrator, "Birds of Virginia," 1913; "Mammals of Eastern North America," 1943; and other books. Lectures: Symbolism in Art. Position: Dir. of Art Edu., Reading School District, 1916-39; Asst. Dir., 1926-39, Dir., 1939-57, Reading (PA) Publ. Mus. Died in 1972. Address in 1970, West Reading, PA.

POOR, HENRY WARREN.
Sculptor, painter, and teacher. Born in Boston, MA, January 10, 1863. Graduate of Mass. Normal Art School; studied in Paris. Member: Boston Art Club. Address in 1925, 23 Oakland Street, Medford, MA.

POPE, ALEXANDER.
Sculptor and painter. Born in Boston in 1849. Member: Copley Society, 1893; Boston Art Club. Published "Upland Game Birds and Water Fowl of the United States."

At the beginning of his career he painted and modeled animals; after 1912 he was chiefly a portrait painter. He died in September 1924, in Hingham, Mass.

POPE, WILLIAM FREDERICK.
Sculptor. Born in Fitchburg, Mass., in 1865. He lived for a time in Boston, Mass. He died in Paris or Boston, Mass., October 22, 1906.

PORTANOVA, JOSEPH DOMENICO.
Portrait sculptor and designer. Born in Boston, Massachusetts, May 16, 1909. Studied with Cyrus Dallin. In collections of Smithsonian; California Institute of Technology; Orthopaedic Hospital, Los Angeles; Los Angeles Memorial Coliseum; others. Exhibited at Los Angeles Co. Museum of Art; Laguna Beach Art Association; National Academy of Design; others. Member of California Art Club; American Institute of Fine Arts. Worked in bronze. Address in 1976, Pacific Palisades, CA. Died in 1979.

PORTER, BRUCE.
Sculptor, mural painter, and writer. Born San Francisco, February 23, 1865. Studied in England and France. Member: American Painters and Sculptors. Award: Chevalier Legion of Honor of France. Work: Designed "Stevenson Memorial," San Francisco; stained glass and mural paintings in churches and public buildings of California; gardens—"Filoli" and "New Place." Author: "The Arts in California," etc. Address in 1933, Santa Barbara, Calif.

PORTER, JAMES TANK.
Sculptor. Born Tientsin, China, October 17, 1883. Studied: Pomona College, BA; Art Students League with George Bridgman, Gutzon Borglum; pupil of Robert Aitken. Member: Art Students League of NY; San Diego Friends of Art. Work: "Portrait bust of James W. Porter," "Portrait relief of my Mother," owned by Beloit College, Wis.; portrait of Prof. Chester Lyman, Yale University; Ellen B. Scripps testimonial, La Jolla; "Portrait bust of Pres. James A. Blaisdell," Pomona College, Calif.; "Portrait of a Young Man," San Diego Fine Arts Gallery; "Portrait bust of the late Bishop Bashfold," M.E. Church of North China, Peking. Exhibited: National Academy of Design; Penna. Academy of Fine Arts; San Diego Fine Art Society, 1923-41. Address in 1953, La Mesa, Calif.

PORTER, RAYMOND AVERILL.
Sculptor. Born Hermon, NY, February 18, 1883. Member: Boston Society of Arts and Crafts; Copley Society. Work: Memorial to President Tyler, Richmond, VA; statue, "The Green Mountain Boy," Rutland, VT; Victory Memorial, Salem, Mass.; World War Memorial, Commonwealth Armory, Boston, Mass. Address in 1933, Massachusetts Normal Art School, Boston; h. Dana Hill Apts., 331 Harvard St., Cambridge, Mass. Died April 2, 1949.

PORTMANN, FRIEDA BERTHA ANNE.
Sculptor and painter. Born in Tacoma, Wash. Studied with Fernand Leger, Glenn Lukens, Clifford Still, Norman Lewis Rice, Peter Camfferman, Edward DuPenn, Julius Heller, Hayter, Lasansky and H. Matsumoto. Works: Univ. Southern Calif., Los Angeles; Art Inst. Chicago; Calif. Col. Fine Arts, Oakland; Sacajawea (wooden

garden sculpture), Seattle; Beer and Skittles (mural), private home, Seattle; Pioneer Teacher (oil), Pioneer Asn., Seattle; Lily Madonna (ceramics), Garden, Cath. School, Seattle; numerous portraits in oil. Exhibitions: Prints, Boston Mus. Arts; Paintings, Prints, Sculpture, and Crafts, Seattle Art Mus.; Sculpture, Denver Mus. Art; Painting and Print, Oakland Mus. Art; Paintings, Argent Gallery, NY. Media: Leather, weaving, and ceramics. Address in 1976, Seattle Washington.

PORTNOFF, ALEXANDER.
Sculptor, painter, and teacher. Born in Russia in 1887. Pupil of Charles Grafly; Penna. Academy of Fine Arts. Member: Fellowship, Penna. Academy of Fine Arts; American Federation of Arts; Phila. Alliance. Awards: Cresson European Scholarship, Penna. Academy of Fine Arts, 1912, 13; hon. mention, P.-P. Exp., San Francisco, 1915. Exhibited: National Sculpture Society. Represented in Milwaukee Art Institute; Brooklyn Museum, Voks Museum, Moscow; and in private collections. Address in 1933, 718 Locust St., Philadelphia, PA; High Point, Long Beach Island, NJ. Died in 1949.

PORZIO, LEE.
Sculptor. Working in Arizona since 1953 with her artist/husband, Allen Ditson. Mostly architectural and commercial commissions. Collections: Valley National Bank, Tempe, Arizona; IMC Magnetics Company, Tempe, Arizona; Phoenix Municipal Building, Phoenix, Arizona.

POSEY, LESLIE THOMAS.
Sculptor. Born in Harshaw, Wisconsin, January 20, 1900. Pupil of E. Clausen, H. Schuetze, Fred Koenig; also at Pennsylvania Academy of Fine Arts, with Albert Laessle; Art Institute of Chicago, with Albin Polasek; Wisconsin School of Fine and Applied Arts. Award: Medal, Milwaukee Art Inst., 1923; others. Work: "The Frontiersman," Women's Alliance, Merrill, WI; "Beethoven," Wildwood Park, Wisconsin; decorative cast stone, Church of the Redeemer, Sarasota, FL; garden figure, National Council of Garden Clubs; others. Exhibited at Milwaukee Art Institute; Chicago Art Institute; Hoosier Salon; others. Works in stone and bronze. Address in 1924, 810 East Main St., Merrill, WI; address in 1982, Sarasota, FL.

POST, ANNE. B.
Sculptor and graphic artist. Born in St. Louis, MO. Studied at Bennington Col., B.A. (fine arts); with Simon Moselsio, Stephen Hirsch, and Edwin Park; in Europe. Works: Israel Museum, Jerusalem; Norfolk Museum, VA; Art Dept. Museum, Wellesley Col.; Dept. Fine Arts Museum, Univ. Chicago; Dept. Visual Art Museum, Bennington Col. Exhibitions: Toledo Museum Art; St. Louis Mus. Art; Contemp. Art Exhib., New York World's Fair; New York Univ.; J. B. Neumann Gallery, NY. Media: Wood and stone. Address in 1982, 29 Washington Square, West, NYC.

POSTGATE, MARGARET J.
Painter and sculptor. Born Chicago, Ill. Pupil of Art Institute of Chicago; Art Students League; Robert Ryland, Mahonri Young. Member: College Art Association; Illinois Academy of Fine Arts. Awards: Second prize, 1924,

3rd prize, 1927, 1st prize, 1928, National Small Sculpture Competition, New York; medal, murals, Beaux-Arts, 1924; Harper's Sketch Contest, 1931. Address in 1933, 388 Park Pl., Brooklyn, NY.

POTTER, BESSIE O.
(See Vonnoh, Bessie O. Potter.)

POTTER, EDWARD CLARK.
Sculptor. Born in New London, Conn., on November 26, 1857. Studied sculpture under Mercie and Fremo, Paris. Collaborated with D. C. French in sculpture for Chicago Exposition, 1892-93; executed equestrian statues of Grant at Philadelphia, 1894; one of Washington, at Paris, 1898; Hooker, at Boston, 1904; Derens, at Worcester, Mass., 1905; Slocum, at Gettysburg; De Soto, at St. Louis Exposition, 1904; also statues in Fulton Library, Washington. Elected to National Academy of Design, 1906. Member: National Institute of Arts and Letters; National Sculpture Society; Architectural League. Died in 1923, in New London.

POTTER, LOUIS (or LEWIS) McCLELLAN.
Sculptor and etcher. Born in Troy, NY, November 14, 1873. Pupil of Luc Olivier Merson, Jean Dampt, and Charles Flagg. Member: NY Municipal Art Society. "The Snake Charmer" attracted favorable comment at the Pan-American Exposition, while his busts "A Tunisian Jewess" and "A Young Bedouin" were highly praised. Address in 1910, 18 East 23d St., NYC. Died in Seattle, WA, in 1912.

POTTER, NATHAN DUMONT.
Sculptor and painter. Born Enfield, Mass., April 30, 1893. Son of Edward Clark Potter, sculptor. Pupil of D. C. French and E. C. Potter. Work: World War Memorial Column, Westfield, NJ; Equestrian Statue, William Jackson Palmer, Colorado Springs, Colo. Address in 1933, Lyme Conn. Died in 1934.

POTTS, DON.
Sculptor and lecturer. Born in San Francisco, CA, October 5, 1936. He studied at San Jose State College, B.A., M.A., 1965; University of Iowa, 1963. Work in Joslyn Art Museum, Omaha; La Jolla Museum of Art, CA; Oakland Museum, CA; San Francisco Museum of Art; others. Has exhibited at Denver Art Museum; Walker Art Center, Minneapolis; Whitney Museum of American Art, NY; Museum of Modern Art, NY; San Francisco Museum of Modern Art, CA; Stedelijk Museum, Amsterdam; others. Received National Endowment for the Arts Fellowship Grant, 1970; Louis Comfort Tiffany Foundation Grant, 1973-74; others. Address in 1982, c/o Hansen Fuller Goldeen Gallery, San Francico, CA.

POUCHER, ELIZABETH MORRIS.
Sculptor. Born in Yonkers, NY. Studied at Vassar College, A.B.; New York University; Columbia University; Art Students League; Academie de la Grande Chaumiere; Ecole Animalier; and with Alexander Archipenko; Anhdre L'Hote. Work at Smithsonian Institution, Washington, DC; Taylor Art Gallery, Vassar College, Poughkeepsie, NY; Museum of the City of NY; others. Has exhibited at Hudson Valley Art Association, White

Plains, NY; Pen and Brush, NY; National Sculpture Society Exhibitions; others. Received gold medal, Hudson Valley Art Association, 1958; Pen and Brush, gold, bronze, silver medals; others. Member, National Sculpture Society; Allied Artists of America; Pen and Brush; Hudson Valley Art Association. Address in 1982, Bronxville, NY.

POUPELET, JANE.
Sculptor. Member: National Association of Women Painters and Sculptors. Address in 1924, 30 rue Dutot, Paris, France. Died in 1932.

POUSETTE-DART, NATHANIEL J.
Sculptor, painter, etcher, teacher, and lecturer. Born St. Paul, Minn., September 7, 1886. Pupil of St. Paul Art School; Henri and MacNeil in New York; Penna. Academy of Fine Arts. Member: Artists' Society, St. Paul Inst.; Gargoyle Club. Awards: Cresson Scholarships, 1909 and 1910; Toppan prize, 1910, all at Penna. Academy of Fine Arts; hon. mention for painting and second prize for etching, 1913; third prize for painting and first prize for etching, 1914; all from Minnesota State Art Society; hon. mention for painting, St. Paul Inst., 1915; first prize for painting, Minnesota State Art Society, 1916. Director of art department at St. Catherine's College, St. Paul, Minn.; St. Benedict's College, St. Joseph, Minn.; and Minnesota College, Minneapolis, Minn. Address in 1921, Valhalla, NY.

POWELL, DAVE.
Sculptor and painter. Born in Kalispell, Montana, in 1954. Has worked making molds and plaster patterns for the Western sculptor R. Scriver; costume and prop design for films, including "Grizzly Adams;" film consultation, including NBC; then studied with Western painter R. Lougheed. Specialty is Old West figures. Represented by Wounded Knee Gallery, Santa Monica, CA; Wood River Gallery, Sun Valley, ID. Address since 1977, Santa Fe, New Mexico.

POWELL, DOANE.
Sculptor and mask maker. Address in 1934, NY. (Mallett's)

POWELL, J.
Sculptor. Active 1865-66. Patentee—medallion of Lincoln, 1865; medallion of Grant, 1866.

POWELL, LESLIE J.
Sculptor, painter, teacher, designer, and lithographer. Born in Fort Sill, OK, March 16, 1906. Studied at Univ. of Okla.; Chicago Acad. of Fine Arts; Art Students Lg.; NY Univ.; Columbia Univ., B.F.A., M.A. Work: Univ. Arizona; Columbia Univ.; Lehigh Univ.; Univ. of Okla.; Brooklyn Mus.; Matthews Mus. of Theatre Arts; Cooper Union Mus.; Newark Mus. of Art. Exhibited: New Orleans Arts and Crafts, 1926, 31, 45; Delgado Mus. of Art, 1927; Morgan Gal., NY, 1939, 40; Lehigh Univ., 1943; Carlebach Gal., NY, 1948; Monmouth (IL) Col., 1949; Norlyst Gal., 1949; Third St. Gal., Los Angeles, 1950; Avery Lib., Columbia Univ., 1950; Mercersburg (PA) Art Gal., 1951; Galerie Raymond Duncan, Paris, 1966; Springfield (MA) Mus., 1964, 65; Audubon, 1969;

Philbrook Art Center, 1957; many other galleries. Address in 1970, 39½ Washington Sq. S., NYC.

POWERS, HIRAM.
Sculptor. Born in Woodstock, VT, July 29, 1805. Raised in Cincinnati, OH. Initiated his studies by modelling figures for a wax museum in Cincinnati. Modelled wax figures of Dante's *Inferno*. In 1834, made several portrait busts in Wash., DC. Nicholas Longworth, patron of Powers, sent him to Florence, Italy, in 1837 to study sculpture; he remained there until his death. Works during the Italian period include "Greek Slave," 1843; "The Fisher Boy," 1848; "California," 1950; and other portrait busts and ideal figures. Other works are statues of Adams, Jackson, Webster, Calhoun, Longfellow, Gen. Sheridan. Exhibited at the Crystal Palace Exhibition, London, 1851; National Academy of Design; works also exhibited at Metropolitan Museum, and Cincinnati Art Museum, posthumously. In collections of Metropolitan Mus.; de Young Mus., San Francisco; other museums and private collections. Member: National Academy of Design. Worked in marble. Died in Florence, Italy, June 27, 1873.

POWERS, LONGWORTH.
Sculptor. Son of Hiram Powers. Resided in Florence, Italy, for many years and died there in 1904.

POWERS, PRESTON.
Sculptor and portrait painter. Son of Hiram Powers. Born in Florence in 1843. He practiced his profession in Boston, Mass., Washington, DC, and in Portland, ME. His life-bust of Whittier is in the library at Haverhill, Mass.

POWRIE, ROBERT.
Sculptor and painter. Born 1843. His chief work is the memorial to General John Gibbons in Arlington Cemetery. Died December 13, 1922.

PRAHAR, RENEE.
Sculptor. Born in New York City, October 9, 1880. She studied in Paris with Bourdelle, and Injalbert, at the Beaux Arts. Exhibited: The Salon, Paris; National Sculpture Society, NYC, 1923. Honors: Prize for sculpture, National Association of Women Painters and Sculptors, 1922. Works: Impression; Jaguars (unfinished); bronze, A Russian Dancer, Metropolitan Museum of Art, New York City. Member: National Association of Women Painters and Sculptors. Address in 1933, 309 4th Street, New York, NY. Died in 1962.

PRASUHN, JOHN G.
Sculptor. Born near Versailles, Ohio, Dec. 25, 1877. Pupil of Mulligan, Taft, Art Institute of Chicago. Member: Ind. Art Club; Indianapolis Art Association. Award: Mildred Veronese Beatty prize, 1927. Work: Bronze tablet, Northern Ill. State Normal School, De Kalb; bronze bust of "Dr. F. W. Gunsaulus," Field Museum of Natural History; marble music group, Lincoln Park Band Stand, Chicago; two lions on Columbus Memorial Fountain, Washington, DC. Publication: Author of article "Cement," in *Scientific American*, 1912. Address in 1933, 1310 Hiatt St., Field Museum of Natural History, Dept. of Anthropology, Indianapolis, Ind.

PRATT, BELA LYON.
Sculptor. Born in Norwich, Conn., on December 11, 1867. Studied with Saint-Gaudens, Chase and Cox in New York, and in Paris with Falguiere. Represented by statue of Nathan Hale at Yale University; "The Seasons" in the Congressional Library, Washington; and many war monuments and memorials. Died in Boston, May 18, 1917.

PRATT, DUDLEY.
Sculptor, educator, and writer. Born in Paris, France, June 14, 1897. Studied: Yale Univ.; Boston Mus. of Fine Arts Sch.; Grande Chaumiere, Paris; and with E. A. Bourdelle, Charles Grafly. Member: Artists Equity Assn. (Pres. Seattle Chptr.). Work: Seattle Art Mus.; IBM Coll.; architectural sculpture, Civic Auditorium, Henry Art Gal., Doctors Hosp., Univ. of Wash. Medical Sch., all in Seattle, WA; Women's Gymnasium, Social Science Bldg., Univ. of Wash.; Hoquiam (WA) City Hall; Bellingham City Hall; Wash. State Col. Lib., etc. Exhibited: Seattle Art Mus., 1929-41, 1935 (one-man); Oakland Art Gal., 1940; NY World's Fair, 1939; Sculpture Ctr., NY, 1957-69; Penna. Acad. of Fine Art; Detroit Inst. of Art, 1958; others. Lectures: History of Sculpture. Position: Asst., Assoc. Prof. of Sculpture, Univ. of WA, Seattle, WA, 1925-42; Ed.-in-Chief, handbooks, 1942-47,, Boeing Aircraft Co., Seattle, WA. Died in 1975. Address in 1953, Seattle, WA; in 1970, San Miguel de Allende, MX.

PRATT, GEORGE DUPONT.
Sculptor and patron. Born in New York City. Positions: Trustee of the Metropolitan Museum of Art, 1922-35; Trustee of the American Museum of Natural History; Trustee of American Association of Museums and Vice President of Board of Directors of Pratt Institute. Work: "Mountain Goat" (bronze), 1914, at Metropolitan Museum of Art. Died in 1935.

PRATT, HELEN L.
(Mrs. Bela L. Pratt). Sculptor. Born in Boston, MA, May 8, 1870. Pupil of School of the Boston Museum of Fine Arts. Address in 1915, 30 Lakeville Place, Jamaica Plain, MA.

PRATT, VIRGINIA CLAFLIN (MRS. DUDLEY).
Sculptor and teacher. Born in Littleton, MA, June 1, 1902. Studied: Boston Museum of Fine Arts School; Grande Chaumiere, Paris. Work: Numerous portrait heads. Exhibited: Seattle Art Museum. Position: Head of Art Dept., Helen Bush School, Seattle, Washington, 1926-38. Address in 1953, Seattle, WA.

PRAZEN, JOHN F.
Sculptor. Born in Price, Utah, in 1939. Learned metal working in his father's forge. Became president of this business, Pioneer Welding, in Salt Lake City. His specialty is busts of American Indians. He works with welded metal; uses several processes and a variety of metals such as brass, copper, steel, stainless steel and silicon bronze overlay. Reviewed in *Southwest Art*, August 1979. Represented by Voris Gallery, Salt Lake City. Address in 1982, Salt Lake City, Utah.

PRAZEN, RICHARD.
Sculptor. Self-taught; worked in a bronze foundry. Exhibi-

tions: Don Palmers World Art Tours, Denver and Las Vegas; Utah Arts Festival; Park City Arts Festivals; Charles Russell Museum; Springville Art Museum; Salt Lake Hilton Hotel; Many Horse Gallery, Hollywood, CA. Commissions: Hogle Zoo; Idaho State Univ.; Skaggs Drug Center and Alpha-Beta Supermarkets; Utah Power and Light; Northwest Alaskan Pipeline Co.; Northeastern Nevada Museum; Anheiser Busch; many corporate collections. Member: Artists in Action; Soc. of Animal Artists; American Welding Soc. Prizes: Best In Shows and two Second Best, Utah State Fair. Media: Bronze, welded mixed metals; limited edition bronzes. Specialty is birds and western subjects. Address in 1983, Taylorsville, UT.

PREMINGER, MARY GARDNER.
Sculptor and painter. Born in Grand Rapids, MI. Studied at Kansas City Art Museum; Academie des Beaux Arts, Paris; University of California, Los Angeles, with Fritz Faiss. Work in Collectors Gallery, Museum of Modern Art, NY; monumental steel sculpture, Westminister Mall, CA; functional sculptures, Golden Gate Park, San Francisco; others. Has exhibited at Fresno Museum of Fine Art; Los Angeles Co. Museum, CA; M. H. De Young Memorial Museum, San Francisco; Museum of Modern Art, NY; Corcoran Gallery, Washington, DC. Works in bronze, steel; oil acrylic. Address in 1982, Malibu, CA.

PRENDERGAST, CHARLES E.
Sculptor, painter, and teacher. Born Boston, Mass., May 27, 1868. Member: Copley Society; Society of Indp. Artists; Mural Painters; New Society of Artists; others. Represented: Barnes Foundation, Philadelphia; Phillips Memorial Gallery, Washington, DC; International House, NYC; Addison Museum of American Art, Andover, MA. Address in 1933, 219 West 14th St.; 50 Washington Sq., New York, NY. Died in 1948.

PRESCOTT, KATHARINE T.
Sculptor. Born at Biddeford, ME. Pupil of E. Boyd, Boston, and of F. E. Elwell, New York. Member: Boston Art Students' Association; Copley Society, Boston. Exhibited at Art Institute, Chicago; National Sculpture Society; National Academy of Design, New York; Penna. Academy of Fine Arts, Philadelphia; Boston Art Club. Address in 1926, 59 5th Ave., New York.

PRESCOTT, PRESTON L.
Sculptor, teacher, and designer. Born in Ocheydan, Iowa, Aug. 10, 1898. Studied at Minneapolis Inst. of Art; Otis Art Inst.; Art Students League; and with Gutzon Borglum, David Edstrom. Member: Calif. Art Club; Laguna Beach Art Assn. Awards: Prizes, Calif. Art Club, 1935, 36; Laguna Beach Art Assn., 1936; Los Angeles Chamber of Commerce, 1927-29. Work: Sculpture portraits, Calif. State Bldg., Los Angeles; memorial, Arcadia, Calif. Exhibited: Met. Mus. of Art (AV), 1942; Los Angeles Museum of Art, 1937; Calif. Art Club, 1935, 36; Ebell Salon, 1935-37; Stendahl Gallery, Los Angeles, 1937; Laguna Beach Art Assn., 1936-38. Position: Instr. sculpture, Sheridan Memorial School of Art, Ben Lomond, Calif., 1953. Address in 1953, Santa Cruz County, CA.

PRESTINI, JAMES LIBERO.
Sculptor and designer. Born in Waterford, CT, January 13,

1908. Studied at Yale University, B.S., 1930, School of Education, 1932; University of Stockholm, 1938, with Carl Malmsten; Institute of Design, Chicago, 1939, with L. Moholy-Nagy; also studied in Italy, 1953-56. Work in Smithsonian Institution, Washington, DC; San Francisco Museum of Art; Brooklyn Museum, NY; others. Has exhibited at San Francisco Museum of Art; Art Institute of Chicago; Museum of Modern Art, NY; Metropolitan Museum of Art, NY; others. Received Guggenheim Fellowship for Sculpture, 1972-73; others. Works in steel, aluminum, and wood. Address in 1982, Berkeley, CA.

PREZZI, WILMA A. M.

Sculptor, portrait and creative painter, and muralist. Born in Astoria, LI, NY, Sept. 2, 1915. Studied at State Edn. Dept., Teachers Coll., 1940; Philathea Coll., London, Ont., 1954; Ph.D. (hon.), St. Andrew's Ecumenical Univ., London, Eng., 1957; and Metropolitan Art School, 1932. Works: Reproduced in many publications, dailies, magazines, art and news periodicals US and abroad; Messiah, 1954; heroic mural 24 ft., Boston; St. Gregory's Seminary, Cincinnati; portraits of prominent persons; numerous portraits of sports figures under Prezzi-Kilenyi Assn. Exhibitions: Rockhill-Nelson-Atkins Museum, Kansas City, MO, 1944; Museum of Arts and Sciences, Norfolk, VA, 1944; Gallery C.T. Loo, 1949; Knoedler Gallery, NYC, 1945; Southampton Museum, 1945; Carnegie Inst., 1946-47; China Inst. in Am., 1947; Studio Gallery, NYC, 1941; Allied Artists of America, 1944, 45, 46; Arthur Harlow Galleries Water Colors, 1948; NY Arch. Lg. Mem. Shows, 1950, 51. Adam Mickiewicz Museum, Warsaw (Poland) Centennial Internat., 1956-57. Received numerous international awards; gold medal, International Fine Arts Council; Architectural League of NY; others. Member of International Institute of Arts and Letters; International Fine Arts Council; American International Academy; others. Taught: Costume Design at School of Industrial Arts, NYC, 1943-44; also fashion designer. Address in 1962, Hotel des Artistes, 1 W. 67th St., New York City.

PRICE, CHESTER B.

Sculptor and etcher. Address in 1924, 137 East 45th St., NYC.

PRICE, CLAYTON S.

Woodcarver and painter. Born in Bedford, IA, 1874. Studied: St. Louis School of Fine Art, Missouri, 1905-06. Visited San Francisco, 1915; lived in Monterey, CA, 1918-1929; moved to Portland, OR, 1929. One-man shows: Beaux Arts Galerie, San Francisco, 1925; Portland Art Museum, Oregon, 1942, 51; The Fine Arts Patrons of Newport Harbor, Pavilion Gallery, Balboa, CA, 1967. Group exhibitions: Frontiers of American Art, M. H. de Young Memorial Museum, San Francisco, 1939; Romantic Painting in America, The Museum of Modern Art, NY, 1943; Fourteen Americans, The Museum of Modern Art, NY, 1946; San Francisco Museum of Modern Art, 1976; and Smithsonian, 1977. In collections of Portland Art Museum, Oregon; Hirshhorn Museum and Sculpture Garden, Washington, DC. Sculpture includes miniature woodcarvings of animals and farm workers. Died in 1950, Portland, OR.

PRICE, HENRY.

Sculptor. Awards: Bronze medal, St. Louis Exp., 1904. Address in 1906, London, England.

PRICE, KENNETH.

Sculptor and printmaker. Born in Los Angeles, CA, Feb. 16, 1935. Studied at Chouinard Art Inst., 1953-54; Univ. of California, Los Angeles, 1955; Univ. of Southern California, BFA, 1956; Otis Art Inst., 1957-58; NY State College of Ceramics at Alfred Univ., MFA, 1958. Associated with sculptor-ceramist Peter Voulkas. Exhibited: First one-man exhibit, Ferus Gal., Los Angeles, 1960; two-man shows, 1966, and American Sculpture of the Sixties, 1967, Los Angeles Co. Museum of Art; Ten from Los Angeles, Seattle Art Museum, 1966; Whitney Museum of American Art, NY, 1972; Museum of Modern Art, NY, 1971; Philadelphia Museum of Art, 1972; others. Awards: Tamarind Fel., 1968-69. Address in 1982, Taos, New Mexico.

PRIOR, CHARLES M.

Sculptor, illustrator, etcher, and teacher. Born in NY, December 15, 1865. Pupil of National Academy of Design under Edgar M. Ward. Awards: Tiffany gold medal, 1884. Specialty, etching on silver. Member: Soc. of Independent Artists; Eastern Arts Assn.; American Artists Professional Lg.; American Federation of Arts. Address in 1908, 24 East 21st St., NYC; address in 1933, 571 West 139th St., NYC.

PROCTOR, ALEXANDER PHIMISTER.

Sculptor and painter. Born Bozanquit, Ont., Canada, September 27, 1862. Pupil of National Academy of Design and Art Students League in New York; Puech and Injalbert in Paris. Member: Associate, National Academy of Design 1901, Academician, National Academy 1904; Society of American Artists 1895; American Water Color Society; NY Architectural League 1899; National Sculpture Society 1893; National Institute of Arts and Letters; Artists Aid Society; Century Association; National Arts Club; American Society of Animal Painters and Sculptors. Awards: Medal, Columbian Exp., Chicago, 1893; Rinehart scholarship to Paris, 1896-1900; gold medal, Paris Exp., 1900; gold medal for sculpture and bronze medal for painting, St. Louis Exp., 1904; NY Architectural League medal, 1911; gold medal, P.-P. Exp., San Fran., 1915. Specialty, Western subjects. Exhibited at National Sculpture Society, 1923. Work: "Panthers," Prospect Park, Brooklyn, NY; "Puma," "Fawn," "Dog with Bone," and "Fate," Metropolitan Museum, NY; "Indian Warrior," Brooklyn Museum; "Tigers," Princeton University; Buffaloes and Tigers on bridges, Washington, DC; "Moose," Carnegie Institute, Pittsburgh "Pioneer," Univ. of Oregon, Eugene; Lions, McKinley monument, Buffalo; "Circuit Rider," State House, Salem, Ore.; equestrian statue of Col. Roosevelt, Portland, Ore., and Minot, NH; "Bronco Buster" and "On War Trail," Civic Center, Denver, Colo.; heroic Indian fountain, Lake George, NY; "Pioneer Mother," Kansas City, KS; bronze tablet markers for Pony Express Trail. Address in 1933, New York City. Died in 1950.

PROCTOR, GIFFORD MacGREGOR.
Sculptor. Born in NYC, February 5, 1912. Studied at Yale U., BFA; American Academy in Rome, Prix de Rome fellowship; apprenticed to his father, Phimister Proctor. Work includes heroic granite eagles, Federal Office Building, New Orleans, 1940; portrait statues, National Capitol Building, Washington, DC; medals, portrait busts, garden and decorative sculpture; other commissions. Member of National Sculpture Society. Works in bronze. Living in Rome in 1935; address in 1976, Palo Alto, CA.

PROCTOR, JUDITH.
Sculptor. Studied: University of Alabama in Tuscaloosa and Huntsville. Exhibitions: Birmingham Scrap Metal Sculpture Exhibit, 1964; Scottsboro Art Council, 1973.

PROPHET, ELIZABETH.
Wood sculptor. Studied at Rhode Island School of Design.

PROPHET, NANCY ELIZABETH.
Sculptor. Born in Orctic Center, RI, March 19, 1890. Pupil of RI School of Design (grad.); L'Ecole des Beaux Arts. Member: Newport Art Assn.; College Art Assn. Awards: Otto H. Kahn prize, exhibition of work of Negro Artists, 1929; Greenough prize, Newport Art Assn., 1932. Work: "Silence" and "Discontent," Museum of the Rhode Island School of Design, Providence; "Congolais," Whitney Museum of American Art, New York. Address in 1933, 147 rue Broca, Paris, France.

PROSPER.
Sculptor, marble cutter, engraver, and teacher. Worked in New Orleans in 1825 and 1837.

PROTIN & MARCHINO.
Sculptors and carvers. Worked in NYC, 1850. Victor Protin and Frederick Marchino.

PRUITT, A. KELLY.
Sculptor, painter, illustrator, and author. Born in Waxahachie, Texas, 1924. Worked as cowboy. Self-taught in art. Work in Museum of New Mexico, Diamond M Museum (Snyder, Texas). Specialty is Western subjects; sculpts in bronze. Author and illustrator of articles in *Cattleman*, *Paint Horse* magazines. Bibliography includes autobiography and movie, "A Lamp Out of the Old West." Address in 1976, Presidio, Texas.

PRUITT, LYNN.
Sculptor. Born in Washington, DC, May 24, 1937. She is mostly self-taught. Has exhibited at Montgomery College, MD; Prince George's Community College, MD; Alexandria City Hall; Corcoran Gallery of Art, Washington, DC; Smithsonian Institution, Washington, DC; Baltimore Museum; National Audubon Society, Chevy Chase, MD. Collections: Naval Academy, Annapolis, Maryland. Awards from the National Institute of Health, Bethesda, MD, 1968, 69, 70, 71, 73. Member of Washington Womens Arts Center; American Crafts Council. Works in plaster casts, steel, wood, leather, and plexiglas. Address in 1982, Rockville, MD.

PUCCINELLI, RAYMOND (RAIMONDO).
Sculptor and graphic artist. Born in San Francisco, California, May 5, 1904. In California 1904-48. Studio in Florence, Italy, from 1960. Studied at California School of Fine Arts, San Francisco, 1919; Rudolph Schaeffer School of Design, San Francisco, 1924-27; with woodcarvers, stone cutters and master plasterers in Italy and France, 1927-28; assistant to J. Vieira, San Francisco, 1928. Taught at Mills College, 1938-47; Berkeley (Univ. of California), 1942-47; Queen's College, NYC, 1948-51; Rinehart School of Sculpture, Baltimore, 1958-60. In collections of Columbia University Music Library; Fresno (Calif.) Mall; Stadt Theatre Museum, Schleswig, Germany; City of San Francisco Hospital; Duke University; museums and galleries throughout Germany; Hirshhorn, Washington, DC; Jerusalem Music Center; numerous commissions. Exhibited at Oakland Art Gallery, California; California Palace of Legion of Honor, San Francisco, 1939, 46; San Francisco Museum of Art; de Young, San Francisco; Institute of Arts and Letters, NYC; Galleria Schneider, Rome; galleries in Milan, Paris, and Florence; California-Pacific International Exposition, San Diego; 1939 NY World's Fair; Golden Gate International Exposition, San Francisco; Philadelphia Museum; Detroit Institute of Art; Grand Palais, Paris; Salon d'Automne, 1978-82; Whitney; Corcoran; and others. Received many awards, including sculpture prize, San Francisco Museum of Art and L.A. Co. Museum of Art; gold medal, Florence, Italy. Works in granite, porphyry, bronze, polished diorite, terra-cotta, etc. Lives in Florence, Italy.

PUGLIESE, CARL J.
Sculptor and illustrator. Born in New York City in 1918. Studied at School of Visual Arts, New York City. Specialty is statuettes of historical Western subjects, including Indian and military figures. Works in bronze. In collections of West Point Museum of the US Military Academy. Has exhibited at Western Heritage Sale, Houston, Texas; National Sculpture Society; Grand Central Art Galleries, New York City; Grizzly Tree Gallery, Gunnison, CO. Won award at Society of American Historical Artists show, 1982. Member: Society of American Historical Artists (founding); Historical Arms Society of New York; fellow, Company of Military Historians. Illustrated many books, including *Confederate Edged Weapons*, *Classic Bowie Knives*, *Literary Places: New England and New York*. Has lectured on American illustration. Address in 1982, Yonkers, New York.

PURCELL, JOHN WALLACE.
Sculptor, craftsman, teacher, and writer. Born in New Rochelle, NY, January 3, 1901. Studied at Cornell Univ., A.B.; Art Institute of Chicago. Awards: Medal, 1946, Ryerson traveling scholarship, 1930; Art Inst. of Chicago; prize, Evanston and North Shore Artists, 1935, 39. Work: Art Institute of Chicago. Exhibited: NY World's Fair, 1939; Art Institute of Chicago, 1933-46; Evanston and North Shore Artists, 1933-46. Position: Instr. Sculpture, Art Institute of Chicago, 1925-44; Evanston (Illinois) Art Center, 1944-46. Address in 1953, Evanston, Illinois.

PURDY, H. P. W.
Sculptor. Active 1865. Patentee—composition in alto relievo, 1865.

PURRINGTON, HENRY J.
Ship carver, musician, and amateur actor. Born in Mattapoisett, MA, 1825. Employed at New Bedford, Massachusetts, 1848-1900. Still living in the 1920's.

PURVES, AUSTIN, JR.
Sculptor, mural painter, craftsman, and educator. Born in Chestnut Hill, PA, Dec. 31, 1900. Studied at Penna. Academy of Fine Arts; Julian Academy, Am. Conservatory, Fontainebleau, France. Member: Arch. Lg.; Nat. Soc. of Mural Painters; Century Assn. Work: Illuminated Litany Service, St. Paul's Church, Phila., PA; coats-of-arms, St. Michael's Church, Jersey City, NJ; reredos, St. Paul's Church, Duluth, MN; Grace Church, Honesdale, PA; mosaic ceiling, Bricken Bldg., NY; memorial, Wash., DC; fresco, St. Michael's Church, Torresdale, PA; sculpture, map, design, S.S. *America*; other work, Firestone Mem. Lib., Princeton Univ.; Am. Battle Monuments Comm.; S.S. *United States*; Fed. Reserve Bank of Boston; Washington Hall Barracks Complex, West Point, NY; others. Position: Pres., Nat. Soc. of Mural Painters; Adv. Bd., Cooper Union Art School, NYC, Dir., 1931-38; taught at Yale Sch. of Fine Arts, Nat. Academy of Design, Bennington Col., (1940-42). Address in 1970, Litchfield, CT.

PURYEAR, MARTIN.
Sculptor. Born in Washington, DC, May 23, 1941. Studied at Catholic University of America, B.A.; Royal Academy of Art, Stockholm; Yale School of Art and Architecture, M.F.A. Work at Corcoran Gallery of Art, Washington, DC; Guggenheim Museum, NY. Has exhibited at Corcoran Gallery, Washington, DC; Guggenheim Museum; Whitney Biennial Exhibition; others. Works in wood and related materials. Address in 1982, Washington, DC.

PUTNAM, ARTHUR.
Sculptor. Born Waveland, Mississippi, September 6, 1873. Member: National Sculpture Society 1913. Award: Gold medal, P.-P. Exp., San Francisco, 1915. Work: "Snarling Jaguar," Metropolitan Museum, New York. Address in 1929, care of Bohemian Club, San Francisco, California; care of American Express Company, Paris, France. Died in 1930.

PUTNAM, BRENDA.
Sculptor and teacher. Born Minneapolis, Minn., June 3, 1890. Studied: Boston Art Museum School under E. C. Messer; Art Students League; also pupil of Bela Pratt, J. E. Fraser, Mary Moore and Charles Grafly. Member: National Sculpture Society; National Academy of Design; National Association of Women Painters and Sculptors; American Federation of Arts; others. Awards: Hon. mention, Chicago Art Institute, 1917; Helen Foster Barnett prize, National Academy of Design, 1922, 29; Widener medal, Penna. Academy of Fine Arts, 1923; Avery prize, New York Architectural League, 1924. Represented in Dallas Museum, Dallas, Texas; Hispanic Museum, New York; Rock Creek Cemetery, Washington, DC; Brookgreen Gardens, SC; private estates. Exhibited at National Sculpture Society, 1923. Publications: Author and illustrator, "The Sculptor's Way," 1939; "Animal X-Rays," 1947. Address in 1953, Wilton, Conn. Died in 1975.

PUTNAM, JACK D.
Sculptor and taxidermist. Born in Edgewater, Colorado, in 1925. Self-taught in art. Trained as zoological preparator; became curator of Denver Museum of Natural History. Turned to sculpture full-time in 1975. Specialty is wildlife. Works in bronze, life size and miniature; some work in gold. In museum collections. Reviewed in *Art West*, November 1981. Represented by Cosmopolitan Fine Art Gallery, Denver, CO; Stremmel Gallery, Reno, Nevada. Address since 1978, Franktown, Colorado.

Q

QUATTROCHI, EDMONDO.
Sculptor. Member of the National Sculpture Society. Awards: Therese and Edwin H. Richard Memorial Prize, 1966, Lindsey Morris Memorial Prize, 1948, all National Sculpture Society. Died 1966.

QUEBY (or QUELY), JOHN.
Sculptor. Born in Florida, 1808. Worked in NYC in 1850.

QUEST, CHARLES FRANCIS.
Sculptor, painter, illustrator, and teacher. Born Troy, NY, June 6, 1904. Studied: Washington Univ. School of Fine Art; Europe; also a pupil of Fred Carpenter, Edmund Wuerpel. Member: St. Louis Artists Guild; St. Louis Artists' League. Awards: Edward Mallinckrodt watercolor prize, St. Louis Artists Guild, 1924; Letticia Parker Williams prize, St. Louis Artists Guild, 1926, 1929; George Warren Brown prize, St. Louis Artists Guild, 1928; Black and White prize, St. Louis Artists' League, 1928; National Print Exhibition, Library of Congress; Society of American Graphic Artists, 1971; others. Work: Mural decoration, Hotel Chase, St. Louis. Teaching: Inst. of Arts, St. Louis Public Schools, MO, 1929-44; professor of art, Washington University School of Fine Arts, 1944-71; emeritus professor, from 1971. Address in 1980, 200 Hillswick Rd., Tryon, NC.

QUINER, JOANNA.
Portrait sculptor. Born in 1801. Worked in Beverly, Massachusetts. Exhibited at Boston Athenaeum, 1846-48. Died in 1873.

QUINN, BRIAN GRANT.
Sculptor. Born in Wahoo, NE, October 21, 1950. Studied at Nebraska Wesleyan University, with Maynard Whitney, B.A.E.; Arizona State University, with Benn Goo, M.F.A. Work at Tucson Art Museum, AZ; others. Has exhibited at Southwest Invitational, Yuma Arts Center; Arizona Biennial, Tucson Art Museum; others. Artist-in-Residence, National Endowment for the Arts; others. Member of Southern Association of Sculptors. Address in 1982, Phoenix, AZ.

QUINN, EDMOND THOMAS.
Sculptor and painter. Born in Philadelphia, PA. Pupil of Eakins in Philadelphia; Injalbert in Paris. Elected Associate Member of the National Academy; National Sculpture Society, 1907; New York Architectural League; National Institute Artists League. Exhibited at National Sculpture Society, 1923. Award: Silver medal, P.-P. Exposition, San Francisco, 1915. Work: Statue, "John Howard," Williamsport, PA; statue, "Zoroaster," Brooklyn Institute of Arts and Sciences; reliefs on "Kings' Mountain (SC) Battle Monument;" bust of Edgar Allan Poe, Fordham University, NYC; "Nymph," statuette, Metropolitan Museum, NYC; statue of Major General John E. Pemberton, Vicksburg (MS) National Military Park; statue of Edwin Booth as "Hamlet," Gramercy Park, New York; bust of Professor Hooper, Brooklyn Museum. Address in 1926, 207 East 61st St., NYC. Died in 1929.

QUINN, STEPHEN C.
Sculptor and painter. Studied at Ridgewood School of Fine Arts and Design. Work at American Museum of Natural History involves research, design, and fabrication of museum exhibits (painting, illustrations, murals, dioramas, sculpture, taxidermy, models). Member: Society of Animal Artists. Collections: Models and paintings on permanent display at American Museum of Natural History. Taught: Animal drawing and animal anatomy at the American Museum of Natural History. Publications: Harper and Row's *Complete Field Guide To North American Wildlife; New York Times Magazine; Animal Kingdom Magazine.* Media: Bronze; oil, watercolor. Specialty: Birds. Address in 1983, Ridgefield Park, NJ.

QUISGARD, LIZ WHITNEY.
Sculptor and painter. Born in Philadelphia, PA, October 23, 1929. Studied at Maryland Institute College of Art, dipl., 1949, B.F.A. (summa cum laude), 1966; also with Morris Louis, 1957-60; Rinehart School Sculpture, M.F.A., 1966. Works: Univ. of Arizona, Ghallager Memorial Collection, Tucson; Lever House, NY; Univ. of Baltimore, MD; Johns Hopkins Univ.; Hampton School, Towson, MD; William Fell School, Baltimore, MD, 1978. Exhibitions: Corcoran Biennial American Painting, Corcoran Gallery Art, Washington, DC, 1963; Univ. of Colorado Show, 1963; American Painting and Sculpture Annual, Penna. Academy of Fine Art, Philadelphia, 1964; Art Institute of Chicago Annual, 1965; one-woman shows, Jefferson Place Gallery, Washington, DC, 1961, Emmerich Gallery, NY, 1962, Univ. of Maryland, 1969, Gallery 707, Los Angeles, 1974, South Houston Gallery, NY, 1974; and Arts and Science Center, Nashua, NH, 1975. Awards: Artists Prize, Baltimore Museum Regional Exhibition, 1958; Rinehart Fel., Maryland Institute, 1964-66; Best in Show, Loyola College, 1966. Teaching: Instructor in painting and color theory, Maryland Institute, Baltimore, from 1965.

R

RAAB, GEORGE.
Sculptor, block painter, and teacher. Born Sheboygan, WI, Feb. 26, 1866. Pupil of Richard Lorenz in Milwaukee; C. Smith in Weimar; Courtois in Paris. Member: Milwaukee Art Society; Wisconsin Painters and Sculptors. Award: Medal, Milwaukee Art Institute, 1917. Work: "The Lone Pine," St. Paul Institute; "The Veil of Snow" and "Mother," Milwaukee Art Institute. Educational Director of Decatur Institute of Art. Address in 1933, Art Institute, Decatur, IL.

RAB, SHIRLEE.
Sculptor and jeweler. Study: Traphagen School of Design, NYC; New School for Social Research, NYC; Philadelphia Museum of Art; Moore College of Art—jewelry major; Philadelphia College of Art; Fleisher Art Memorial; Cheltenham Township Art Center; Rutgers University (spec. prog. for selected artists); Princeton Atelier -masters course, bronze casting; summer study, Florence, Italy. Work: In private collections. Exhibited throughout US since 1962; Trenton (NJ) State Museum; National Academy of Design, NYC; Philadelphia Art Alliance; Squibb Gallery, Princeton, NJ. Awards: National Academy of Design, NYC; New School, NYC; Chestnut Hill Academy; Atlantic City Inauguration Exhibition; Fleisher Art Memorial; others. Currently designing jewelry; teaching sculpture Cherry Hill, Moorestown, Phila.

RABILLON, LEONCE.
Sculptor and teacher. Born in Baltimore, MD, 1814. Executed two portrait busts for the Peabody Institute, Baltimore, in the early 1870's. Died in 1886.

RABOFF, FRAN.
Sculptor. Noted for her organic forms made with cast and laminated plastic.

RAEMISCH, WALDEMAR.
Sculptor and teacher. Born in Berlin, Germany, August 19, 1888. Studied: In Germany. Member: National Sculpture Society; Providence Art Club. Awards: Medal, Penna. Academy of Fine Arts, 1946. Work: Cranbrook Academy of Art; Fogg Museum of Art; Providence Art Museum. Exhibited: Art Institute of Chicago, 1942; Penna. Academy of Fine Arts, 1946; Phillips Academy, Andover, Mass., 1941; Worcester Museum of Art, 1942; Buchholz Gallery, 1941, 45. Taught: Instructor of Sculpture, Rhode Island School of Design, Providence, RI, from 1939. Address in 1953, 52 Boylston Avenue, Providence, RI. Died in 1955.

RAIMONDI, JOHN RICHARD.
Sculptor. Born in Boston, MA, May 29, 1948. Studied at Mass. College of Art, B.F.A., 1973. Work at National Museum of American Art, Washington, DC; Milwaukee Art Museum, WI; Oklahoma Museum of Art, Oklahoma City; others. Has exhibited at Art for Architectural Spaces, Art Gallery, Baltimore; New Accessions, Smithsonian Institution, Washington, DC; others. Address in 1982, East Boston, MA.

RALSTON, JAMES KENNETH.
Sculptor, painter, illustrator, muralist, and author. Born in Choteau, MT, 1896. Studied at Art Institute of Chicago. Worked as cowpuncher and rancher, as well as commercial artist. Works: Jefferson National Expansion Memorial (St. Louis), Custer Battlefield National Monument, Montana Historical Society, Whitney Gallery (Cody, WY), others. Works include painting titled "After the Battle;" bronze statues, "Buffalo Bill" and "Cow and Calf" for Montana Historical Society, Helena; Custer Battlefield National Munument, 1964. Has exhibited at Charles M. Russell Gallery (Great Falls), Montana Historical Society, Galeries Lafayette (Paris), others. Specialty is historical Western subjects; primarily painter and illustrator. Address in 1982, Billings, MT.

RAMON, ADOLPHO.
Sculptor. Pupil of Mrs. Harry Payne Whitney. Address in 1919, 2 Mac Dougal Alley, NYC.

RAMSEY, EDITH.
Sculptor. Address in 1934, Brooklyn, NY. (Mallett's)

RAMSEY, LEWIS A.
Sculptor, landscape and portrait painter, and muralist. Born in Bridgeport, IL, 1873; settled in Utah. Studied with John Hafen; at Art Institute of Chicago; Julien Academy, Paris, under Bouguereau and Laurens from 1897-1903; and under Douglas Volk. Work can be seen in Latter-Day Saints temples and public buildings, Utah. Worked in Boston and NYC as a calligrapher and photo retoucher. Taught at Latter-Day Saints University from 1903-05. In the early 1930s he moved to Hollywood where he painted portraits of movie stars for art cards. Died there in 1941.

RANDALL, DARLEY (MRS.).
See Talbot, Grace Helen.

RANDALL, (LILLIAN) PAULA.
Sculptor and designer. Born in Plato, MN, Dec. 21, 1895. Studied at Minneapolis Institute of Arts; Univ. of Southern California; Otis Art Institute, Los Angeles. Works: Western Div., National Audubon Society, Sacramento, CA; Official Tournament of Roses, Pasadena, CA. Exhibitions: All California Exhibition, Laguna Beach Art Museum, California, 1964; Univ. of Taiwan, Formosa, 1964; Brandeis Univ. Exhibition, Granada Hills, CA, 1967; Form and the Inner Eye Tactile Show, California State Univ., Los Angeles and Pierce College, San Fernando,

CA, 1972; one-person show, Galerie Vallombreuse, Biarritz, France, 1975. Awards: Laguna Beach Art Museum Award, All California Show, 1964; Special Achievement Award, All California Exhibition, Indio, 1966; Pasadena Society Artists Special Award, 1971. Media: Wood, stone, plastics, welded metals. Address in 1982, Sierra Madre, CA.

RANDELL, RICHARD K.
Sculptor. Born in Minneapolis, MN, in 1929. Work: Minneapolis Institute; Univ. of Minnesota; St. Paul Gallery; Walker. Exhibitions: Minneapolis Institute; Royal Marks Gallery, NYC; Detroit Institute; Art Institute of Chicago; Museum of Contemporary Crafts, 1963; M. Knoedler & Co., Art Across America; NY World's Fair, 1964-65; Los Angeles County Museum of Art; Herron. Awards: Walker Biennial, 1956, 62, 66; Minneapolis Institute, first prize and purchase prize, 1957, honorable mention, 1959; St. Paul Gallery, 1961. Taught: Assistant to John Rood, Minneapolis, 1954-57; Hamline Univ., 1954-61; Macalaster College, 1961; Univ. of Minnesota, 1961-65; Sacramento State College, 1966. Address in 1970, c/o Royal Marks Gallery, NYC.

RANDOLPH, GRACE FITZ.
Sculptor, teacher, and painter. Born in NY. Pupil of J. Alden Weir, Augustus Saint Gaudens, NY; Benjamin-Constant, Girardot and Puech in Paris. Award: Bronze medal, Atlanta, 1895. Member: Art Students League; Sec. NY Woman's Art Club. Address in 1903, 3 Washington Square North, NY.

RANDOLPH, INNES.
Portrait sculptor. Born Oct. 25, 1837. Lived and worked in Baltimore. About 1873 executed a bust of George Peabody, founder of the Peabody Institute in Baltimore. Died April 28, 1887.

RANDOLPH, JAMES THOMPSON.
Portrait sculptor and wood carver. Born in Bound Brook, NJ, 1817. Lived and worked in Baltimore. With firm of Harold & Randolph, ship carvers, 1839; headed firm of Randolph & Seward, ship carvers, 1853-60. Executed a bust of John T. Randolph, 1858; the McDonough Monument in Greenmount Cemetery, 1865. Died in 1874.

RANKIN, ELLEN HOUSER.
Sculptor. Born in Atlanta, IL, 1853. Pupil of Art Inst. of Chicago and Fehr School, Munich. Address in 1898, Chicago, IL.

RANKINE, V. V.
Sculptor and painter. Born in Boston, MA. Studied at Amedee Ozenfant School, NY; Black Mt. College, with Albers and De Kooning. Work in National Museum of American Art, Washington, DC; Corcoran Gallery of Art, Washington, DC; Oklahoma City Museum; Guild Hall Museum, East Hampton, NY; others. Has exhibited at Betty Parsons Gallery, NY, 1966-81; Corcoran Biennial, 1967-68; others. Works in plexiglas; acrylic on wood. Address in 1982, Washington, DC.

RANNUS, A. W.
Sculptor. Member: Society of Independent Artists. Address in 1924, 900 Sixth Ave., NYC.

RAPHAEL, MICHI.
Sculptor. Studied: Pratt Institute, Brooklyn, New York; New School, New York. Exhibitions: Sunrise Gallery, Charleston, West Virginia; Mainstream 73 and 75, Marietta College, Marietta, Ohio; Union Carbide Galleries, New York City. Collections: Hoffman La Roche Drug Company, Nutley, New Jersey; First National Bank & Trust, Tulsa, Oklahoma; American Steel Products, Syosset, Long Island, New York.

RASCOVICH, ROBERT B.
Sculptor and water color painter. Worked in Chicago. Died in 1905.

RASKIND, PHILIS.
Sculptor and instructor. Born in NYC. Studied at Art Students League; National Academy School of Fine Arts, 1973. Work: Peace Medal US and North Vietnam, private commission, NY; theatre masks for NYC Opera; others. Has exhibited at Catherine Lorillard Wolfe Art Club, National Arts Club, NY, 1972-79; National Sculpture Society, NY, 1972-80; National Academy of Fine Arts, 1976-78; others. Received gold medal, Pen and Brush Club; bronze medal, Catherine Lorillard Wolfe Art Club. Member: Catherine Lorillard Wolfe Art Club; National Art League; International Society of Artists; Artists Equity Association. Works in clay and wood. Address in 1982, 37 East 28th St., NYC.

RATHBONE, EDITH K.
Sculptor. Member: Society of Independent Artists. Address in 1924, Hotel Wellington, 7th Ave. and 55th St., NYC.

RATHBONE, MRS. CHARLES H. JR.
See Martha Moore.

RATTEY, HARVEY L.
Sculptor. Born near Chinook, Montana, in 1939. Ranch foreman for many years. Specialty is statuettes of Indian and cowboy life, rodeo subjects, wildlife. Works in bronze. Runs Bridger Foundry and Gallery with his wife, sculptor Pamela Harr. Address since 1972, Bozeman, Montana.

RAUL, HARRY LEWIS.
Sculptor, designer, lecturer, and writer. Born Easton, PA, in 1883. Pupil of NY School of Art; F. E. Elwell; Art Students League of NY under F. V. Du Mond; Penna. Academy of Fine Arts under Grafly. Member: Art Centre of the Oranges (pres.); Mystic Society of Artists; American Federation of Arts. Work: "Green Memorial Statue," Easton, PA; "Monument to Martyrs of the Maine" (Hail, Martyrs' statue), Northampton Co., PA; "Soldiers' Monument" (Old Glory Statue), W. Chester, PA; "Portrait, Ex-Mayor Rudolph Blankenburg," Philadelphia; Englewood, NJ, World War Memorial ("America, 1917-1918" statue); Manton B. Metcalf memorial, Rosedale Cemetery, Orange, NJ; ("Faith, Hope and Charity," bronze group); Wilson Borough, Penn. World War monument; "The Face of Lincoln," Lincoln Trust Co. Bldg., Scranton, PA; Julia-Dykman Andrus memorial group, Yonkers, NY; Herbermann memorial, Sea Girt, NJ; Williams-Coolidge memorial, Easton, PA; Herbermann memorial, Jersey

City, NJ; War Mothers memorial, Philadelphia, PA. Author, "The Celtic Cross for Modern Usage." Exhibited at National Sculpture Society, 1923. Address in 1953, Washington, DC.

RAUSCHENBERG, ROBERT.
Sculptor, painter, and photographer. Born in Port Arthur, TX, Oct. 22, 1925. Studied briefly at the Univ. at Austin, TX (pharmacy); Kansas City Art Institute and the School of Design, 1946-47; Academie Julian, Paris, 1947; studied under Josef Albers at Black Mountain College, NC, 1948-49; Art Students League, 1949-50, under Morris Kantor and Vaclav Vytlacil. Returned to Black Mountain College in 1952 and became associated with performance musician John Cage and dancer-choreographer Merce Cunningham. Exhibited at Museum of Modern Art, 1968; Milwaukee Art Center, 1968; Whitney, NYC, annuals 1969, 70, 73; Guggenheim; Copenhagen; Baltimore; Munich; Tate, London; Pompidou Center, Paris; numerous other group and solo shows in US and abroad. Received Grand Prix d'Honneur, 13th International Exhibition of Graphic Art, Ljubljana, Yugos.; gold medal, Oslo; Officer of the Order of Arts and Letters, France; others. In collections of Albright-Knox, Buffalo; Whitney; White Museum, Cornell Univ.; Tate; Museum of Modern Art; many others. Among the many types of execution, the artist designed sets, costumes, and lighting for Cunningham's Dance Company for over ten years. Address in 1982, c/o Leo Castelli Gallery, 420 West Broadway, NYC.

RAUSCHNER, HENRY.
Wax miniaturist. Advertised in Charleston, SC, in November, 1810 and April, 1811. Possibly same as John Christian Rauschner.

RAUSCHNER, JOHN CHRISTIAN.
Wax portraitist. Born in Frankfurt, Germany, 1760. In NYC 1799-1808; travelled and worked from Massachusetts to Virginia or farther south. In Philadelphia, 1801, 1810-11; in Boston and Salem, MA, 1809-10. Work at NY Historical Society; Maryland Historical Society.

RAY, CHRISTOPHER T.
Sculptor and craftsman. Born in Albany, NY, May 7, 1937. Studied at Penna. Academy of Fine Arts, 1960; studied with Howard Keyser, master blacksmith, 1964-66. Work: sculptured gates, Penn's Landing Sq., Philadelphia; sculptured gate/bas-relief, Chestnut St. Park, Philadelphia; others. Has exhibited at Smithsonian Institution, Washington, DC; American Craft Show, Philadelphia Museum of Art; Sculpture Outdoors, Temple University, Ambler, PA; Penna. Academy of Fine Arts Fellows Show, Philadelphia; Animal Art, Smithsonian Institution; others. Member of Artists' Equity Association; Penna. Academy of Fine Arts, Fellow; Artists-Blacksmiths Association of North America; American Crafts Council. Address in 1982, Philadelphia, PA.

RAY, MAN.
Sculptor and painter. Born in Philadelphia, PA, Aug. 27, 1890; grew up in NYC. Studied at National Academy of Design; Art Students League; and Ferrer Art Center, NYC. Early career involved with painting, photography, and mixed media. First sculptures produced in 1920's in bronze, entitled "By Itself I" and "By Itself II;" later turned toward sculpture with "found" objects, an early example being a nineteen inch high wood skyscraper held in a C-clamp, titled "NY 17," and others such as his "Cadeau," an iron with nails protruding outward from its bottom. Founded, in collaboration with Marcel Duchamp and Katherine S. Dreier, the Societe Anonyme, a society involved with the collection of modern art in the US. Published, in conjunction with Duchamp, the first and only issue of *New York Dada* in 1921. Later travelled to Paris. Member: Parisian Dada Group. In 1923, he made his first film and exhibited in the first Surrealist exhibition held at the Galerie Pierre, Paris, 1925. Other exhibitions include one-man shows and retrospectives at the Los Angeles County Museum in 1966 and the NY Cultural Center, 1975; numerous galleries in Paris, London, Cologne, California, NYC; also exhibited at Brooklyn Museum; Museum of Modern Art; Whitney; Yale Univ. In collection of Museum of Modern Art. Address in 1971, Paris, France. Died in 1976.

RAY, ROBERT DONALD.
Sculptor, painter, printmaker, and gallery owner. Born in Denver, CO, Oct. 2, 1924. Studied at Drake University in Des Moines, IA; University of Southern California; the Centro Estudios Universitarios in Mexico City, with Justino Fernandez. Traveled in Europe; received grant from the Wurlitzer Foundation to Taos in 1954. Work in Baltimore Museum of Art; Brooklyn Museum; Denver Art Museum; Museum of New Mexico; Columbia Museum of Art (South Carolina). Has exhibited at Denver Art Museum; print exhibition, Library of Congress; Museum of New Mexico; California Palace of Legion of Honor; others. Awarded first prize, sculpture, Museum of New Mexico; others. Recently exploring light in glass sculpture. Address in 1982, Taos, NM.

RAYMOND, JEAN.
Sculptor. Address in 1935, NY. (Mallett's)

RAYMOND, LEONE EVELYN.
Sculptor. Born in Duluth, Minnesota, March 20, 1908. Studied at Minneapolis School of Art; also studied with Charles S. Wells. Works: Bas-reliefs, International Falls, Minnesota Stadium; Sebeka, Minnesota High School; Farmer's Exchange Building, St. Paul; Hall of Statuary, Washington, DC; Lutheran Church of the Good Shepherd, Minneapolis; Church of St. Joseph, Hopkins, Minnesota; interior of St. George's Episcopal Church, St. Louis Park, Minnesota. Awards: Minnesota State Fair, 1941, 43, 44; Minneapolis Institute of Art, 1944; Walker Art Center, 1944, 45.

RAYNOR, GRACE HORTON.
Sculptor. Born New York, NY, Sept. 20, 1884. Member: Art Workers Club. Work: Plaque, Public Library, Glen Ridge, NJ; fountain, Cherry Valley Club, Long Island. Specialty, portrait statuettes and heads.

REA, JAMES EDWARD.

Sculptor, painter, designer, lecturer, teacher, and illustrator. Born in Forsyth, Montana, January 14, 1910. Studied: St. Paul School of Art; American Academy of Art, Chicago; University of Minnesota, B.S.; University of Redlands; Claremont College. Member: Twin City Puppetry Guild. Awards: Prizes, Minn. State Fair, 1933, 34. Work: Custer State Park Museum, S.D.; Hotel Lenox, Duluth, MN; Lowry Medical Building, St. Paul, MN; Harding High School, St. Paul. Exhibited: Grumbacher Exhibition, 1935; Minn. State Fair; Minneapolis Institute of Art, 1932-42. Lectures: History of Art. Address in 1953, San Bernardino, CA.

REA, JOHN LOWRA.

Sculptor, writer, and teacher. Born Beekmantown, NY, Jan. 29, 1882. Pupil of H. A. MacNeil; J. E. Fraser, F. V. Du Mond. Work: Bronze tablet to George H. Hudson, State Normal School, Plattsburgh, NY. Address in 1933, Plattsburg, Clinton Co., NY.

READ, MARK WOODWARD.

Sculptor. Born in 1950. Studied: Center for Creative Studies, Detroit, B.F.A., 1976; Cranbrook Academy of Art, Bloomfield Hills, M.F.A., 1978. Exhibitions: Statements in Sterling, Lever House, NY, 1976, 77, 78; Michigan Silversmith's Guild Exhibition, Detroit Bank and Trust, 1978; Young Americans-Metal, American Craft Museum, NY, 1978; Michigan Metalsmiths Invitational, Rental Gallery, Detroit Institute of Art, 1980; Michigan Artists 1980-81, The Detroit Institute of Arts, 1982. Awards: Statements in Sterling, Lever House, NY, 1977, Third Prize; Artists in the Schools Program, Michigan Council for the Arts, 1982. Address in 1982, Farmington Hills, MI.

READ, THOMAS BUCHANAN.

Sculptor, international portrait and historical painter, illustrator, and poet. Born in Chester County, PA, March 12, 1822; moved to Cincinnati; also lived in Boston, Philadelphia, and in Italy (Rome and Florence). Painted signs, itinerant portraits, and canal boats and played female parts in a theatrical troupe. Employed by Shobal Vail Clevenger as a stonecutter in Cincinnati. Nicholas Longworth provided him a studio in Cincinnati. Works include portrait bust of General Sheridan and painting of General Harrison. Represented in Peabody Institute (Baltimore), Pennsylvania Academy of Fine Art; Cincinnati Art Museum; Smithsonian Institution. Moved to Philadelphia in 1846. Leading American poet in 1855. Member: Colony of American Artists in Rome. Specialty, Indian and historical subjects. Died in NYC, May 11, 1872.

REAM, VINNIE (MRS. HOXIE).

Sculptor. Born in Madison, WI, on Sept. 25, 1847. Studied sculpture under Clark Mills and Luigi Majoli. Work: Several busts of congressmen, including bust of Pres. Abraham Lincoln from life. $10,000 commission from Congress in Aug. 1866 to make a full-size marble statue of Lincoln for Capitol Rotunda. Other busts included Gustave Dore and Pere Hyacinthe. Died in Washington, DC, on Nov. 20, 1914.

REBECK, STEVEN AUGUSTUS.

Sculptor. Born Cleveland, OH, May 25, 1891. Pupil of Karl Bitter, Carl Heber, Cleveland School of Art; National Academy Design, NY; Beaux-Arts Institute of Design, NY. Member: Cleveland Sculpture Society; Cleveland Society of Artists; National Sculpture Society (associate). Awards: Medal for portrait bust, Cleveland Museum of Art, 1922; award for sculpture, Cleveland Museum, 1923. Work: "Shakespeare," Cleveland, OH; Soldiers' Memorial, Alliance, OH; heroic statue, Sphinx, Civil Court House, St. Louis, MO. Exhibited at National Sculpture Society, 1923. Address 1953, Cleveland Heights, OH. Died in 1975.

REBER, MICK.

Sculptor and painter. Born in St. George, UT, June 6, 1942. Studied at Brigham Young University, B.F.A. and M.F.A. Work: paintings, 20th Century Fox; sculptural park, City of Las Vegas, NV; sculptural playground, Clark Co. School District, Las Vegas. Has exhibited at San Francisco Museum of Modern Art; Denver Art Museum; Seattle Art Museum. Taught painting and sculpture at Ft. Lewis College, Durango, Co., 1968-76. Work in wood, steel, and acrylic. Address in 1982, Las Vegas, NV.

REBISSO, LOUIS T.

Sculptor. Born 1837 in Genoa, Italy. Settled in Boston in 1857. He taught modeling for years in the Art Academy of Cincinnati. His equestrian statue of Gen'l. McPherson is in Washington and his Gen'l. Grant is in Chicago. Associated with Thomas Dow Jones. Died May 3, 1899, in Cincinnati, OH.

RECCHIA, RICHARD HENRY.

Sculptor. Born Quincy, MA, Nov. 20, 1885. Studied: Boston Museum of Fine Arts School; and in Paris and Italy. Member: National Sculpture Society; Boston Guild of Artists; Copley Society; Boston Sculptors Society (Founder); Boston Art Club; North Shore Art Association; Gloucester Society of Artists; Rockport Art Association. Awards: Bronze medal, P.-P. Exp., San Francisco, 1915; National Sculpture Society, 1939; International Exp., Bologna, Italy, 1931; National Academy of Design, 1944. Work: Bas-relief portrait of Gov. Curtis Guild, Boston State house; "Architecture," figure panel on Boston Museum; Red Cross panel in Musee de l'Armee, Gallery Foch, Paris; Memorial to Gov. Oliver Ames, North Eastman, MA; Sam Walter Foss Memorial panel, John Hay Library, Brown University, RI; Phi-Beta-Kappa tablet, Harvard University; "Disaster Relief" model, American Red Cross Museum, Washington, DC; George E. Davenport portrait tablet, and William Hoffman, portrait tablet, Brown University, Providence, RI; "Youth," J. B. Speed Memorial Museum, Louisville, KY. Exhibited at National Sculpture Society, 1923. Address in 1929, Boston, MA.

REDER, BERNARD.

Sculptor and painter. Born in Czernowitz, Bukovina, Austria, June 29, 1897. Came to US in 1943. Studied at Academy of Fine Arts, Prague, 1919, with Peter Bromse, Jan Stursa. Works: Baltimore Museum of Art; Brooklyn Museum; Art Institute of Chicago; Harvard Univ.; Jewish Museum; Metropolitan Museum of Art; Museum of

Modern Art; NY Public Library; National Gallery; Philadelphia Museum of Art; Sao Paulo. Exhibitions: Manes Gallery, Prague, 1935; Galerie de Berri, Paris, 1940; Lyceum Gallery, Havana, 1942; Weyhe Gallery, 1943; Philadelphia Alliance; Tel-Aviv; Grace Borgenicht Gallery Inc., NYC; Art Institute of Chicago; The Contemporaries, NYC; Palazzo Torrigiani, Florence, Italy; World House Galleries, NYC; Whitney; Philadelphia Museum of Art; Museum of Modern Art. Awards: International architectural competition to house the monument to Christopher Columbus in Santo Domingo, 1927; Ford Foundation Grant, Program in Humanities and the Arts ($10,000), 1960. Died Sept. 7, 1963, NYC.

REDMAN, MIKAEL.
Sculptor. Born in Flagstaff, Arizona, in 1941. Studied music at Northern Arizona University. Specialty is Indian figures in miniature; works in precious metals and jewels; some bronze. Does not show. Reviewed in *Southwest Art*, December 1973; *Art West*, November 1979. Represented by his Mikael Redman Studio. Address in 1982, Scottsdale, Arizona.

REED, EARL H.
Sculptor and etcher. Born Geneva, IL, July 5, 1863. Self-taught. Member: Chicago Society of Artists. Work: Toledo Museum of Art; Library of Congress, Washington, DC; Chicago Art Institute; NY Public Library; St. Louis Art Museum; Milwaukee Art Institute. Author: "Etcher: A Practical Treatise;" "The Voices of the Dunes and Other Etchings;" "The Dune Country;" "Sketches in Jacobia;" "Sketches in Duneland;" "Tales of a Vanishing River;" and "The Silver Arrow." Address in 1929, Chicago, IL.

REED, HELEN.
Sculptor and painter. She began her professional career in Boston by drawing portraits in crayon. Later she went to Florence where she studied sculpture under Preston Powers, sending to America bas-reliefs in marble which have been exhibited at the Boston Art Club and in NY.

REED, WILLIAM G.
Sculptor and painter. Studied brush work-painting under "Shou" in Tsing Tao, China, 1945-47; studied oil, watercolor, sculpture, ceramic, and design under Arne Randall, Nan Wiley, and Opal Fleckenstien, 1948-55. Awards: US Military poster design (North China Occupation Forces); State of Oregon Recreational Billboard Design; Brunswick Corp. Building Front "Neon Sign Design of the Year;" $35,000 grant for prehistoric man-wildlife (State of Idaho). Member Society of Animal Artists. Permanent collections: Herret Museum, Twin Falls, ID; Idaho Cattleman's Association, Boise, ID; others. Expeditions: Five-year study (Mule Deer), NV; one-year study Rocky Mtn. Bighorn (Salmon River Area). Specialties: Flora, fauna, portrait, symbolistic. Media: Wood, terracotta, steel, and silver; oil, watercolor, acrylic, graphics. Address in 1983, St. Maries, ID.

REGAT, JEAN-JACQUES ALBERT.
Sculptor and muralist. Born in Paris, France, September 12, 1945. Studied at University of Alaska, B.A.; Societe

des Beaux Arts, France. Has exhibited at Heritage Northwest Gallery, Juneau, AK; Erdon Gallery, Houston, TX; Rendezvous Gallery, Anchorage, AK. Works in stone, wood, and bronze. Address in 1982, c/o Regat Studio, Anchorage, AK.

REGAT, MARY E.
Sculptor and muralist. Born in Duluth, MN, Nov. 12, 1943. Studied at Univ. of Alaska. Works: Anchorage Fine Arts Museum, Alaska; Pfeils Prof. Travel Agency, Anchorage; Post Oak Towers Bldg., Alaska Interstate Corp., Houston, Texas; Anchorage Natural Gas. Exhibitions: All Alaska Juried Art Show, Anchorage; one-woman shows, Color Center Gallery, 1970 and 71 and Artique Gallery, 1972-75; Alaska State Museum, Juneau, 1973; plus others; Heritage Northwest Gallery Juneau, 1973-74. Awards: Sculpture Award, Design I, 1971; Purchase Award, Anchorage Fine Arts Museum, 1971. Media: Stone, wood; and oil. Address in 1982, Regat Studio, Anchorage, AK.

REGINATO, PETER.
Sculptor. Born in Dallas, TX, August 19, 1945. Studied at San Francisco Art Institute, 1963-66. Work in Houston Museum of Fine Arts; Storm King Art Center, Mountainville, NY; others. Has exhibited at Whitney Museum of American Art; Aldrich Museum, Ridgefield, CT; Modern Sculpture in Houston Collections, Museum of Fine Arts, Houston; Hayward Gallery, London, England, 1975; others. Received John Simon Guggenheim Memorial Foundation fellowship; Purchase Award, Hirshhorn Museum, Washington, DC. Works in welded steel. Address in 1982, 60 Greene St., NYC.

REIBACK, EARL M.
Sculptor and kinetic artist. Born in NYC, May 30, 1943. Studied at Lehigh University, B.A. and B.S. (engineering physics); Mass. Institute of Technology, M.S. (nuclear engineering). Work in Whitney Museum of American Art; Philadelphia Museum of Art; Milwaukee Art Center; Wichita Art Museum, KS; others. Has exhibited at Milwaukee Art Center, WI; Brooklyn Museum, NY; Metropolitan Museum of Art, NY; Philadelphia Museum of Art; Albright-Knox Art Gallery, Buffalo, NY; Long Beach Museum of Contemporary Art, CA; others. Address in 1982, 20 E. Ninth St., NYC.

REIBEL, BERTRAM.
Sculptor and wood engraver. Born in New York, NY, June 14, 1901. Studied: Art Institute of Chicago, and with Alexander Archipenko. Member: Artists Equity Association; Am-Jewish Art Club. Exhibited: National Academy of Design; International Print Makers; Penna. Academy of Fine Arts; Metropolitan Museum of Art; Cincinnati Museum Association; Oakland Art Gallery; Northwest Print Makers; Art Institute of Chicago; Kansas City Art Institute; Detroit Institute of Art; Southern Print Makers; Buffalo Print Club; Denver Art Museum; Philadelphia Print Club; San Francisco Museum of Art; Library of Congress. Address in 1982, Chappaqua, NY.

REIBER, R(ICHARD) H.
Sculptor, painter, etcher, designer, lecturer and teacher.

Born in Crafton, PA, October 2, 1912. Studied: Cornell University; and with Kenneth Washburn, Olaf Brauner, Walter Stone. Member: Pittsburgh Art Association; Pittsburgh Architectural Club; Pittsburgh Print Club. Lectures: "Process of Etching." Address in 1953, 434 Fifth Avenue; h. Pittsburgh, PA.

REID, PEGGY.
Sculptor and painter. Born Liverpool, England, June 7, 1910. Pupil of Robert J. Kuhn. Address in 1933, Westford, NY; Skowhegan, ME.

REIF, (F.) DAVID.
Sculptor and educator. Born in Cincinnati, OH, December 14, 1941. Studied at University of Cincinnati, 1960-63; School of Art Institute of Chicago, B.F.A., 1968; Yale University, with James Rosati, Robert Morris, and Al Held, M.F.A., 1970. Has exhibited at Laguna Gloria Art Museum, Austin, TX; Joslyn Art Museum, Omaha, NE; Dorsky Gallery, NY; others. Received third prize, Southern Association of Sculptors; best sculpture award, Joslyn Art Museum, Omaha; others. Member of Southern Association of Sculptors; International Sculpture Center, Washington, DC. Represented by Dorsky Galleries Ltd., NYC. Address in 1982, Laramie, WY.

REIMANN, WILLIAM P.
Sculptor and educator. Born in Minneapolis, MN, November 29, 1935. Studied at Yale University, B.A., 1957; B.F.A., 1959, M.F.A., 1961; with Josef Albers, Rico Lebrun, Robert M. Engman, James Rosati, Gilbert Franklin, Seymour Lipton, Gabor Peterdi, Neil Welliver, and Bernard Chaet. Work in Museum of Modern Art; Whitney Museum of American Art; Boston Museum of Fine Arts. Has exhibited at Galerie Chalette, NY, 1961-68; Whitney Museum of American Art; Carnegie Institute; others. Teaching at Harvard University, from 1964. Works in plexiglas, stainless steel, pencil. Address in 1982, Cambridge, MA.

REINA, SALVATORE.
Sculptor. Born Santo Stefano, Girgenti, Italy, April 8, 1896. Pupil of Beaux-Arts Institute of Design, NY. Work: "Memory," Lake View Cemetery, East Hampton, CT; "Crucifix," Gate of Heavenly Rest Cemetery, NY. Member: Salons of America. Address in 1933, 128 East 23rd Street, New York, NY; h. South Beach, Staten Island, NY.

REINDEL, EDNA.
Sculptor. Born in Detroit, MI, in 1900. Studied: Pratt Institute Art School. Awards: Art Directors Club, 1935; fellowship, Tiffany Foundation, 1926, 1932; Beverly Hills Art Festival, 1939. Collections: Metropolitan Museum of Art; Dallas Museum of Fine Arts; Whitney Museum of American Arts; Ball State Teachers College; Canajoharie Art Gallery; *Life Magazine* Collection; New Britain Art Institute; Labor Building, Washington, DC; Fairfield Court, Stamford, CT; Governor's House, St. Croix, Virgin Islands; US Post Office, Swainsboro, Georgia. Address in 1953, Santa Monica, CA.

REINHART, STEWART.
Sculptor, painter, and etcher. Born in Baltimore in 1897. Pupil of Edward Berge and Maxwell Miller. Address in 1926, 45 Washington Square, New York, NY.

REINHART, WILLIAM H.
See Rinehart, William Henry.

REISS, HENRIETTE.
Sculptor, painter, designer, lecturer, and teacher. Born in Liverpool, England, May 5, 1890. Studied: In Switzerland, Germany, England, and with Schildknecht in Germany. Member: Artists Equity Association. Exhibited: Metropolitan Museum of Art; Whitney Museum of American Art; Art Institute of Chicago; Boston Museum of Fine Arts; Brooklyn Museum; Cleveland Museum of Art; American Museum of Natural History; Newark Museum; Philadelphia Museum of Art; City Art Museum of St. Louis; American Federation of Arts, New York: Carnegie Institute; Dayton Art Institute; Cincinnati Museum Association; Baltimore Museum of Art; American Design Gallery; Anderson Gallery; Grand Central Palace; Rochester Memorial Art Gallery; American Women's Association; one-woman: Toledo Museum of Art; Cleveland Museum of Art; University of Nebraska; University of Kentucky; University of Delaware; Hackley Art Gallery; Fashion and Industrial Exhibition; extensively in Europe. Contributor to national magazines. Taught special classes in design for supervisors, public and high school teachers of Board of Education, New York, NY; instructor, Fashion Institute of Technology, Textile Design Department, New York, NY, 1953. Address in 1953, 10 Fifth Avenue, New York, NY.

REISS, ROLAND.
Sculptor. Born in Chicago, Illinois, in 1929. Went to California in 1941. Studied at University of California at Los Angeles. Taught at University of Colorado, 1957-71; Claremont (California) Graduate School, from 1971. Exhibited at Los Angeles Co. Museum of Art; Ace Gallery, Venice, California; Whitney, NYC; San Francisco Museum of Modern Art; Fort Worth (Texas) Art Museum; Hirshhorn Museum and Sculpture Garden, Washington, DC; Documenta VII, Kassel, Germany; Los Angeles Institute of Contemporary Art; others.

REISTER, DOROTHY WINNER.
Sculptor. Born in Pittsburgh, PA, Nov., 1916. Studied at William and Mary College, 1935; A.B., Carnegie Institute of Technology, 1939; Univ. of Pittsburgh, 1940-42; M.A., Syracuse Univ., 1956. Exhibitions: Carnegie Institute; Metropolitan Museum, NYC; Rochester, NY; Memorial Gallery. Awards: Received several sculpture awards. Member: Association of Artists; Ceramic Guild; Museum Association; NY State Craftsmen Council Cultural Agys. Taught art at Carnegie Technical and Syracuse Univ., 1949-57; lecturer, from 1945. Author: *Design for Flower Arrangers*, 1960; also articles in field. Address in 1962, Cazenovia, NY; office, Syracuse, NY.

REMINGTON, FREDERIC SACKRIDER.
Sculptor, painter, etcher, and illustrator. Born in Canton, NY, Oct. 4, 1861. Studied one year at Yale Art School, under John Henry Niemeyer, 1871, but otherwise was self-taught. Owing to ill health he went West and, after clerking in a general store, became a cowboy and later

stockman on a ranch. From the knowledge he gained in these connections and from his own experiences sprang the inspiration for his remarkably vivid and faithful portrayal of the life on the Western plains and in the mining camps for which he became so justly renowned. His first commission, executed in the early eighties, was an Indian picture based on "Geronimo's Campaign." He produced a large number of oil paintings, about fifteen bronzes, and was the author of several books. In 1888, *The Century* published his illustrated edition of *Teddy Roosevelt's Ranch Life and the Hunting Trail*. Travelled with Roosevelt's Roughriders to Cuba in 1898 as artist-correspondent. He received a silver medal for sculpture at the Exp. in 1889; he was an associate member of the National Academy of Design, and a member of the National Institute of Arts and Letters. In collections of Amon Carter Museum, TX; Whitney Gallery of Western Art; Remington Art Memorial, Ogdensburg, NY. Died Dec. 26, 1909, in Ridgefield, CT.

REMSEN, HELEN Q.
Sculptor. Born in Algona, IA, March 9, 1897. Studied: University of Iowa; Northwestern University; Grand Central School of Art; also studied with Georg Lober and John Hovannes. Awards: Society of Four Arts, Palm Beach, Florida, 1942; Norton Gallery of Art, 1944; Dallas Museum of Fine Arts, 1944; Florida Federation of Art, 1941, 1942, 1944; National Sculpture Exhibition, Sarasota, 1953; Smithsonian Institution, 1954; New Orleans Art Association, 1955, 1957; National Sculpture Society, 1961. Work: Jungle Gardens, Sarasota; St. Boniface Church, Sarasota; Three Marys (marble) dedicated in 1964; memorial sculpture, Algona, Iowa Public Library, dedicated June, 1969; and others. Address in 1970, Sarasota, FL.

REMUS, PETER.
Sculptor. Born in France in 1824. Living in Pittsburgh, PA, in Sept. 1850.

RENEZETTI, AURELIUS.
Sculptor. Executed a portrait bust of the late N. W. Ayer. Address in 1926, Philadelphia, PA.

RENIER, JOSEPH EMILE.
Sculptor. Born on August 19, 1887. Studied at Art Students League; American Academy in Rome; also with Victor Rousseau and Adolf Weinman. Work: Brookgreen Gardens, SC; Mattatuck Museum, Waterbury, CT; medal for Medallic Art Society; Ross Memorial medal, for American Tuberculosis Association, 1952; triptych, Citizens Commission for the Army and Navy, 1945; bronze war memorial plaque, Ozone Park, NY, 1947; others. Has exhibited at Penna. Academy of Fine Art; New Haven Paint and Clay Club. Member: National Sculpture Society and associate of the National Academy. Award: Prize, Garden Club of America, 1929. Taught: Associate Professor, Life Drawing, Yale University, 1927-41. Address in 1953, NYC. Died in 1966.

RENIERS, PETER.
Sculptor. Executed small bust of Elisha Kent Kane (1820-1857). The piece is signed and dated Philadelphia, 1857.

RENNELS, FREDERIC M.
Sculptor. Born in Sioux City, IA, 1942. Studied: Eastern Illinois University, B.A.; Stanford University; Cranbrook Academy of Art, M.F.A. Private collections. Exhibitions: Spectrum Gallery, NY, (one-person), 1972; Michigan Artists Exhibition, The Detroit Institute of Arts, 1970; The Art Institute of Chicago (Chicago Vicinity Show), 1972; Razor Gallery, NY (one-person), 1973; Michigan Focus, The Detroit Institute of Fine Art, 1974-75. Awards: Cranbrook Founders Award, 1970. Address in 1975, Elgin, IL.

RENO, JIM.
Sculptor. Born in Wheeling, West Virginia, in 1929; lived in New Castle, Indiana. Studied at John Herron Art Institute, Indianapolis. Moved to Texas and trained cutting horses until turning to sculpture full-time. Has sculpted thoroughbred Secretariat (commission); equestrian statue, Texas A & M; figure statue and "The Brand Inspector," Fort Worth, Texas; also represented in National Museum of Racing. Has exhibited at National Academy of Design; Pennsylvania Academy of Fine Arts; the White House. Specialty is contemporary Western subjects in monuments and statuettes. Works in bronze. Reviewed in *Southwest Art*, September 1975. Represented by Meredith Long & Company in Houston, Texas. Address since 1952, Simonton, Texas.

RENWICK, WILLIAM WHETTEN.
Sculptor and painter. Born in Lenox, MA, 1864. Died in Short Hills, NJ, 1933. (Mallett's)

REVEREND, T. OR J.
Sculptor. Born in Philadelphia. Exhibited at the Penna. Academy in 1859.

REYNERSON, JUNE.
Sculptor, painter, and craftsman. Born Mound City, KS, February 21, 1891. Pupil of Pratt Inst. and Columbia University. Member: Western Art Association; Pen and Brush Club; Hoosier Salon; Art Section, Women's Dept. Club, Terre Haute. Position: Professor Emeritus of Art, Indiana State Teachers College, Terre Haute, IN. Address in 1953, Terre Haute, IN.

RHEAD, LOIS WHITCOMB.
Sculptor and craftsman. Born Chicago, IL, Jan. 16, 1897. Pupil of F. H. Rhead; L. V. Solon. Exhibited: National Association of Women Painters and Sculptors, NYC, 1924. Member: National Association Women Painters and Sculptors; American Ceramic Society. Address in 1929, E. Liverpool, OH; summer, Santa Barbara, CA.

RHIND, JOHN MASSEY.
Sculptor. Born Edinburgh, Scotland, July 9, 1860. Pupil of his father, John Rhind, R.S.A.; Dalou in Paris; came to US in 1889. Member: National Sculpture Society, 1893; NY Architectural League, 1894; NY Municipal Art Society; National Arts Club; Salma. Club; Allied Artists of America; Brooklyn Society of Artists. Awards: Scholarship, $2,000, Scottish Academy; national scholarship, South Kensington, London; gold medal, St. Louis Exp., 1904. Work: Astor door, Trinity Church, NY; equestrian, "George Washington," Newark, NJ; Pittsburgh; "Stephen Girard," Philadelphia; "Peter Stuyvesant," Jer-

sey City; "Robert Burns," Pittsburgh; McKinley Memorial, Niles, OH; "Apollo," "Minerva," "J. G. Butler, Jr.," "Wisdom," "Authority," Butler Art Institute, Youngstown, OH; numerous decorations for federal and municipal buildings. Member: National Sculpture Society; NY Architectural League, 1894; National Arts Club. Address in 1933, 208 East 20th St., h. 34 Gramercy Park, NYC. Died in 1936.

RHODEN, JOHN W.
Sculptor. Born in Birmingham, AL, in 1918. Studied under Hugo Robus, William Zorach, and Oronzio Maldarelli at Columbia University School of Painting and Sculpture; also with Richmond Barthe in 1938. Exhibited: Metropolitan Museum of Art; Penna. Academy of Fine Arts; Audubon Annual; American Academy of Art; National Academy of Design; numerous others. Awards: Rockefeller Grant, 1959; Guggenheim Fellowship, 1961; others. Commissions: Monumental Abstraction, for the Metropolitan Hospital, 1968; Monumental Bronze for Bellvue Hospital, NYC, 1975; Monumental Sculpture for the Afro-American Museum, Philadelphia, PA, 1976; and others. Address in 1982, Brooklyn, NY.

RICCI, ULYSSES ANTHONY.
Sculptor. Born in NYC, May 2, 1888. Studied: Art Students League; also with James Earle Fraser. Work: Medals, American Numismatic Society; sculpture, Plattsburg, NY; Dept. of Commerce Bldg., Washington, DC; and others. Exhibited: Penna. Academy of Fine Arts; Metropolitan Museum of Art, 1942; and others. Member: National Sculpture Society, 1914. Address in 1953, New York, NY. Died in 1960.

RICE, ANTHONY HOPKINS.
Sculptor and painter. Born in Angeles Pampanga, Philippine Islands, July 21, 1948. Studied at Virginia Commonwealth University, Richmond, B.F.A., 1970; University of North Carolina, Chapel Hill, M.F.A., 1972. Work in High Museum of Art, Atlanta, GA; Smithsonian Institution; others. Has exhibited at Corcoran Gallery, Washington, DC; St. Petersburg Museum of Art, FL; High Museum; Smithsonian; others. Teaching at Wesleyan College, Macon, GA, from 1972. Works in steel and wood. Address in 1982, c/o Wesleyan College, Macon, GA.

RICE, JACQUELYN IONE.
Sculptor. Born in 1931. Working in the early 1970's with funky ceramic sculpture.

RICE, MARGHUERITE SMITH.
(Mrs. Fred Jonas Rice). Sculptor. Born St. Paul, MN, June 11, 1898. Pupil of Edward Pausch. Work: Portrait bust, Bishop Charles Harry Brent, memorial in Phillipines. Member: Buffalo Society of Artists; Guild Allied Artists. Address in 1933, Buffalo, NY.

RICE, WILLIAM CLARKE.
Sculptor and painter. Born in Brooklyn, NY, April 19, 1875. Pupil of George de F. Brush. Graduate of NY City College, 1897. Also painted mural decorations, including those at Park Central Hotel, NYC. Taught art and design in NYC schools. Member of Architectural League and National Society of Mural Painters. Address in 1926, 145

East 23d Street, NYC. Died in NYC, Feb. 13, 1928.

RICH, FRANCES L.
Sculptor and draftsman. Born in Spokane, WA, on Jan. 8, 1910. Studied: Smith College; Cranbrook Academy of Art; Claremont College; Columbia University; with Malvina Hoffman, Carl Milles, Millard Sheets, and Alexander Jacovleff. Collections: Army and Navy Nurse Memorial, Arlington National Cemetery; Purdue University; Wayside Chapel of St. Francis, Grace Cathedral, San Francisco; Mt. Angel Abbey, St. Benedict, OR; Hall of Fame, Ponca City, OK; Smith College; St. Peters Church, Redwood City, CA; University of California, Berkeley; Madonna House, Combermere, Ontario, Canada; Carl Milles Museum Garden, Stockholm; University of Oklahoma; science medal, Dr. Jonas Salk. Medium: Bronze. Address in 1980, Palm Desert, CA.

RICHARD, BETTI.
Sculptor. Born in NYC on March 16, 1916. Studied: Art Students League with Mahonri Young, Paul Manship. Awards: National Academy of Design, 1947; Pen and Brush Club, 1951; gold medal, Allied Artists of America, 1956; National Sculpture Society, 1960. Collections: Doors, Oscar Smith Mausoleum; Church of the Immaculate Conception, NY; Pieta Skouras Memorial, NY; Bellingrath Gardens, Mobile, AL; monument to race horse "Omaha" at Ak-Sar-Ben Track, Omaha; figure, Austrian Legation, Tokyo; figure, Sacred Heart Rectory, Roslindale, MA; House of Theology, Centerville, OH; statue, St. Francis of Assisi Church, NY; busts at Metropolitan Opera House, Lincoln Center, NYC. Exhibited at Allied Artists of America annuals; National Academy of Design; National Sculpture Society. Member: National Sculpture Society (secretary, from 1971); Architectural League of NY; Allied Artists of America; Audubon Artists. Works in bronze, stone, and wood. Address in 1980, 131 E 66th St., NYC.

RICHARDS, DAVID.
Sculptor. Born in North Wales, 1829; came to US and settled in Utica, NY. Works: "President Grant," "General Harding," "The Confederate Soldier," at Savannah, GA; "Love" and "Boy Gathering Shells." Died in Utica, NY, November 28, 1897.

RICHARDS, LEE GREENE.
Sculptor, painter, and illustrator. Born Salt Lake City, July 27, 1878. Pupil of J. T. Harwood, Laurens, and Bonnat. Member: Salon d'Automne; Paris Allied Artists of America; Utah Society of Artists; National Art Club. Award: Honorable mention, Paris Salon, 1904. Address in 1933, Salt Lake City, Utah. Died in 1950.

RICHARDS, LUCY CURRIER.
(Mrs. F. P. Wilson). Sculptor. Born Lawrence, MA. Pupil of Boston Museum School; Kops in Dresden; Eustritz in Berlin; Julian Academy in Paris. Member: Copley Society; Boston Guild of Artists; National Association Women Painters and Sculptors; MacDowell Club. Address in 1933, Silvermine, Norwalk, CT.

RICHARDS, MYRA REYNOLDS.
Sculptor and painter. Born Indianapolis, Jan 31, 1882.

Pupil of Herron Art Institute under Otis Adams, Rudolf Schwartz and Geo. Julian Zolnay. Member: Hoosier Salon; Indianapolis Sculpture Society. Address in 1929, Indianapolis, IN. Died in 1934.

RICHARDS, N.
Sculptor and stone cutter. Worked in New Orleans, LA, 1841-46.

RICHARDSON, GRETCHEN.
Sculptor. Born in Detroit, MI, in 1910. Studied: Wellesley College; Art Students League with William Zorach; Academy Julian, Paris. Awards: National Association of Women Artists, 1952, 1955; Knickerbocker Artists. Exhibited at Penna. Academy of Fine Arts; Audubon Artists; Knickerbocker Artists. Represented by Bodley Gallery, NYC. Address in 1982, 530 Park Ave., NYC.

RICHARDSON, HELEN ELY.
Sculptor, who exhibited at the Penna. Academy of the Fine Arts, Philadelphia, 1924. Address in 1926, Detroit, MI.

RICHARDSON, SAM.
Sculptor and painter. Born in Oakland, CA, July 19, 1934. Studied at California College of Arts and Crafts, Oakland. Taught there, 1959-60; at Oakland City College, 1960-61; Art Director, American Craftsmen's Council, Museum of Contemporary Crafts, NYC, 1961-63; California State University at San Jose, from 1963. In collections of Fort Worth Museum of Art, Texas; Whitney, NYC; Milwaukee; others. Exhibited at Hansen-Fuller Gallery, San Francisco; Martha Jackson Gallery, NYC; San Francisco Museum of Art; Cranbrook; Denver; de Young, San Francisco; Janus Gallery, Los Angeles; Santa Barbara Museum of Art; Museum of Contemporary Crafts, NYC; Whitney, NYC; Museum of Modern Art; Hudson River Museum, Yonkers, NY; Honolulu Academy of Arts; many more. Address in 1982, Oakland, California.

RICHMAN, VIVIAN.
Sculptor. Studied: Columbia University; The Sculpture Center, New York City; Museum of Fine Arts, Boston. Awards: Silvermine Guild New England Annual, 1971; Cambridge Art Association, 1972; Providence Art Association, 1972; Newport, Rhode Island, American Annual, 1974.

RICHTER, HENRY CHARLES.
Sculptor and painter. Born in Cleveland, Ohio, in 1928. Studied at Philadelphia Museum College of Art, graduated 1953. Worked in advertising in Philadelphia, Cleveland, Phoenix. Specialty is Western subjects, past and present. Media include bronze and pewter. Member of American Indian and Cowboy Artists. Represented by Son Silver West, Sedona, AZ; Jolyn Art Ltd. handles his prints and pewter sculpture. Address since 1958, Phoenix, Arizona.

RICKETSON, WALTON.
Sculptor. Born May 27, 1839, in New Bedford, MA. Engaged as sculptor since 1870. Among his notable works are: Portrait busts of A. B. Alcott, Louisa May Alcott, Henry D. Thoreau, George William Curtis, R. W. Emerson; also intaglios, bas-reliefs; he was the designer of the Gesnold memorial tower on the Island of Cuttyhunk, MA, in 1902. Address in 1926, New Bedford, MA.

RICKEY, GEORGE W.
Sculptor. Born in South Bend, IN, June 6, 1907. Studied at Trinity College, Glenalmond, Scotland, 1921-26; Balliol College, Oxford, 1926-29, BA, 1941, MA with honors; Ruskin School of Drawing and of Fine Art, Oxford, 1928-29; Academie Andre Lhote and Academie Moderne, Paris, 1929-30; NY Univ., 1945-46; State Univ. of Iowa, 1947, with Mauricio Lasanky; Institute of Design, Chicago, 1948-49. Works: Addison Gallery, Andover, MA; Baltimore Museum of Art; Albright; Dallas Museum of Fine Art; Dartmouth College; Hamburg; Kansas City (Nelson); Museum of Modern Art; Tate; Hirshhorn Sculpture Garden, Washington, DC; Whitney; Walker; plus many commissions including Rijksmuseum Kroller-Muller, Hirshhorn, Singer Co. Exhibited: Denver Art Museum; Herron; The Little Gallery, Louisville; Kraushaar Galleries, NYC; Amerika Haus, Hamburg; Santa Barbara Museum of Art; Hyde Park Art Center, Chicago; Dartmouth College; Staempfli Gallery, NYC; Walker; Corcoran; Salon des Artistes Independants, Paris; Metropolitan Museum of Art, National Sculpture Exhibition; Whitney; Penna. Academy of Fine Arts; Art Institute of Chicago; Museum of Modern Art; Stedelijk, Art in Motion; Battersea Park, London, International Sculpture Exhibition; Documenta III & IV, Kassel; Palais des Beaux-Arts, Brussels; Staatliche Kunsthalle, Baden-Baden; Los Angeles Co. Museum of Art; Carnegie; XX-XIV Venice Biennial; Guggenheim; Albright-Knox. Awards: Guggenheim Foundation Fellowship, 1960, 61; American Institute of Architects, 1972. Taught: Groton School, 1930-33 (History Dept.); Knox College, 1941, 1946-48; Univ. of Washington, 1948; Indiana Univ., 1949-55; Tulane Univ., 1955-62; Univ. of California, Santa Barbara, 1960; Rensselaer Polytechnic Institute, 1961-65; director of Kalamazoo Institute, 1939-40. Address in 1982, East Chatham, NY.

RIDDLE, MARY ALTHEA.
Sculptor. Born in Chicago, IL. Pupil of Art Institute of Chicago and Boston School Fine Arts. Address in 1918, Chicago, IL.

RIDER, CHARLES JOSEPH.
Sculptor, painter, and designer. Born in Trenton, NJ, Jan 21, 1880. Pupil of W. M. Chase, S. Macdonald-Wright. Member: American Society of Bookplate Collectors and Designers. Address in 1933, San Pedro, CA.

RIECKE, GARY.
Sculptor. Born in Spencer, Iowa, in 1946. Studied mathematics and physics, Mankato State Univeristy, BS, 1968. Taught in Montana and Iowa. Worked at Ace Powell Bronze Foundry, Kalispell, Montana. Specialty is wildlife. Works in black walnut, Carrara marble; reproductions in bronze. Represented by Settlers West Galleries, Tucson, AZ; El Prado Gallery of Art. Address in 1982, Bigfork, Montana.

RIEKER, ALBERT GEORGE.
Sculptor. Born Stuttgart, Germany, October 18, 1889. Pupil of Academy of Fine Arts, Munich; Royal Academy of Fine Art, Stuttgart. Exhibited: Art Institute of Chicago, 1929; Penna. Academy of Fine Art, 1929, 30, 37. Awards: Prize, Stuttgart, 1910; Nuremberg, 1911; New Orleans Art Association, 1934, 40, 41; others. Member: New Orleans Arts and Crafts Club; New Orleans Art Association; Southern States Art League. Work: E. V. Mente Monument, Mente Park, New Orleans; Joseph Sinai memorial, Masonic Temple, New Orleans; Colonel William Temple Withers monument, Vicksburg National Military Park, Vicksburg, MS; Rabbi Max Heller memorial, Temple Sinai, New Orleans; bas-reliefs, "Life and Death," Vaccaro Mausoleum, Metairie Cemetery, New Orleans. Address in 1953, New Orleans, LA. Died in 1959.

RIES, GERTA.
Sculptor. Exhibited a portrait of John Cotton Dana at the Annual Exhibition of the National Academy of Design, 1925. Address in 1926, Brooklyn, NY.

RIFFLE, ELBA LOUISA.
(Mrs. Elba Riffle Vernon). Sculptor and painter. Born in Winamac, IN, January 3, 1905. Studied: John Herron Art Institute; Indiana University; Purdue University; and with Myra Richards, Forsythe. Member: Hoosier Salon; Indiana Art Club. Awards: Prizes, Northern Indiana Artists, 1931; Midwestern Exhibition, Wichita, Kansas, 1932; Hoosier Salon, 1934; Indiana State Fair, 1930-32, 34, 35, 38. Work: Christian Church, High School, Public Library, Winamac, Indiana; Public Library, Tipton, IN; Indiana University; Woman's Club House, Clay City, IN. Address in 1953, Nashville, IN.; h. Indianapolis, IN.

RIGALI, G.
Sculptor. Worked in NYC, 1856.

RIGDEN, CYNTHIA.
Sculptor. Born in Prescott, Arizona, in 1943. Studied art at Arizona State; summer seminar in Italy. Rancher. Specialty is statuettes of ranch animals. Works in bronze. Reviewed in *Southwest Art*, December, 1980; *Arizona Highways*, June, 1981. Represented by Troy's Gallery, Scottsdale, AZ. Address in 1982, Kirkland, Arizona.

RILEY, JACK.
Sculptor. Born in Weatherford, Oklahoma, in 1917. Studied at Southwestern State Teachers College; Kansas City School of Horology, (watchmaking and jewelry); self-taught in sculpture. Worked as watchmaker and jeweler. Began sculpting in 1970; full-time from 1977. Specialty is statuettes of Western figures. Works in bronze. Represented by Sculptured Arts Gallery, Sedona, AZ; El Prado Gallery of Art. Address in 1982, Yukon, Oklahoma.

RIMMER, CAROLINE HUNT.
Sculptor. Born in Randolph, MA, 1851. Died in Boston, MA, 1918. (Mallett's)

RIMMER, WILLIAM.
Sculptor and painter. Born February 20, 1816, in Liverpool, England. He came to Canada in 1818; to Boston in 1826. At 15, assisted his family in painting portraits and

signs. Began sculpture career after 1855, working in granite, clay, and marble. In 1860, modeled the "Falling Gladiator" now in the Boston Museum of Fine Arts. He painted a number of other pictures besides producing numerous works of sculpture. It is, however, as an art teacher that Dr. Rimmer is best known: School of Drawing and Modelling in Boston, 1864-66; Director of the School for Design for Women at Cooper Institute, NYC, 1866-70; re-opened his school and taught there until 1876; Boston Museum of Fine Arts, 1876-79. Died in South Milford, MA, August 20, 1879.

RINEHART, WILLIAM HENRY.
Sculptor. Born in Frederick, MD, Sept. 13, 1825. He worked with a stone cutter and studied drawing in Baltimore. In 1855 he went to Italy to study and while there executed the bas-reliefs of "Night" and "Morning." In 1857 he opened his studio in Baltimore, but soon returned to Italy. His best known statues are "Clytie" owned by the Peabody Institute; "Rebecca" in the Corcoran Art Gallery; and "Latona and Her Daughters," at the Metropolitan Museum of Art, NYC. He executed many portrait busts. His statue of Chief Justic Taney ordered by the State of Maryland was unveiled at Annapolis in 1872. Died Oct. 28, 1874, in Rome, Italy.

RINGGOLD, FAITH.
Sculptor and painter. Born in NYC, Oct. 8, 1934. Studied at City College, NY, B.S., 1955, M.A., 1959; also with Robert Gwathney. Works: Chase Manhattan Bank, NY. Commission: For the Women's House (mural), Women's House of Detention, Rikers Island, NY, 1971. Exhibitions: Memorial for Martin Luther King, Museum of Modern Art, NY, 1968; American Women Artists, Kunsthaus, Hamburg; Faith Ringgold Retrospective, Univ. Art Gallery, Rutgers University, 1973; Jubilee, Boston Museum, 1975. Taught: Bank Street College, NYC, from 1970; Wagner College, from 1970; Museum of Natural History, NYC, from 1973. Awards: Creative Arts Public Service Program, Grant, 1971. Media: Mixed. Address in 1982, 345 West 145th Street, NYC.

RIPLEY, LUCY PERKINS.
Sculptor. Born in Minnesota. Pupil of Saint-Gaudens, Daniel C. French, and Rodin. Member: National Association of Women Painters and Sculptors; National Sculpture Society. Awards: Barnett prize, National Association of Women Painters and Sculptors, 1919; bronze medal, St. Louis Exp., 1904. Exhibited at National Sculpture Society, 1923. Address in 1933, 9 East 17th Street; 12 West 10th Street, New York, NY. Died Sept. 5, 1949.

RISQUE, CAROLINE EVERETT.
Sculptor. Born St. Louis, MO, 1886. Pupil of St. Louis School of Fine Arts under Zolnay and Colarossi Academy in Paris under Injalbert and Paul Barlett. Member: St. Louis Artists Guild. Exhibited at National Sculpture Society, 1923. Awards: Western prize ($50), St. Louis Artists Guild, 1914; Halsey C. Ives Prize, St. Louis Artists Guild, 1922; thumbbox prize, St. Louis Artists' League, 1924; small sculpture prize, St. Louis Artists' Guild, 1924. Represented in Museum of New Orleans; St. Louis Artists' Guild. Specialty, decorative work and small bronzes. Address in 1933, Clayton, MO.

RISWOLD, GILBERT P.

Sculptor. Born in Sioux Falls, SD, in 1881. Pupil of Lorado Taft and of Charles Milligan. Work: "Statue of Stephen A. Douglass," Springfield, IL; "Mormon Pioneer Monument," Salt Lake City, Utah. Address in 1926, Chicago, IL.

RITTER, ANNE GREGORY.

(Anne Gregory Van Briggle). Sculptor, painter, and craftswoman. Born in Plattsburg, NY, July 11, 1868. Pupil of Charles Melville Dewey and Robert Reid; Colarossi Academy in Paris under Prinet and Girardot; Victoria Lyceum in Berlin. Member: Boston Society of Arts and Crafts; National Society of Craftsmen; American Federation of Arts. Awards: Bronze medal for pottery, St. Louis Expo., 1904; first prize, Boston Society of Arts and Crafts, 1907. President and art director, Van Briggle Pottery Co. Address in 1929, 1152 York Street, Denver, CO.

RIVERS, LARRY.

Sculptor and painter. Born in NYC, 1923. Studied at Juilliard School of Music, NYC, 1944-45; Hofmann School, 1947-48; NY Univ., 1947-48. Works: Brooklyn Museum; Art Institute of Chicago; Corcoran; Kansas City (Nelson); Metropolitan Museum of Art; Museum of Modern Art; Minneapolis Institute; New Paltz SUNY; Parrish; Tate; Utica; Victoria and Albert Museum; Whitney. Exhibitions: Tibor de Nagy Gallery, NYC; Martha Jackson Gallery, NYC; Dwan Gallery, NYC; Galerie Rive Droite, 1962; Gimpel Fils Ltd., London; Marlborough-Gerson Gallery Inc., NYC; Whitney; Museum of Modern Art; Sao Paulo Bienale, 1957; Carnegie; II Inter-American Paintings and Prints Biennial, Mexico City; Seattle World's Fair, 1962; Penna. Academy of Fine Art; Flint Institute, I Flint Invitational; Herron; San Francisco Museum of Art; Documenta IV, Kassel; Virginia Museum of Fine Art; plus many more. Awards: Corcoran, Third Prize, 1954. Professional jazz musician; began sculpture 1953. Represented by Marlborough Gallery, NYC. Illustrated "When the Sun Tries to Go On." Address in 1982, Southampton, NY.

RIVOLI, MARIO.

Sculptor. Born in NYC, January 31, 1943. Work in Museum of Contemporary Crafts, NY; Smithsonian Institution, Washington, DC; Philadelphia Museum of Art. Has exhibited at Smithsonian Institution; Show of Wearable Art, Philadelphia Museum of Art; Homage to the Bag, Museum of Contemporary Crafts, 1977; Denver Art Museum, 1982. Address in 1982, Denver, CO.

ROBB, KEVIN.

Sculptor. Born March 24, 1954. Studied at Rocky Mountain School of Art, Denver, CO; Metro State College, Denver, CO. Exhibitions include Sculpture in the Park, Boulder, CO; Shidoni Gallery, Tesuque, NM; Colorado Gallery of Contemporary Art, Denver; Zach's, Denver; Del Mar College, Corpus Christi, TX; others. Member of International Sculpture Center, Washington, DC; Metro Denver Arts Alliance, CO; others. Works in stainless steel, brass, bronze, aluminum, stone. Address in 1984, Denver, CO.

ROBB, SAMUEL ANDERSON.

Sculptor. Born in NYC, Dec. 16, 1851. Apprenticed as a ship carver to Thomas V. Brooks; later with William Demuth. Studied part-time at the National Academy of Design, 1869 to 1873; studied at the "Free Night School of Science and Art" at Cooper Union. Opened his own carving studio in 1876 on Canal St., Manhattan. Moved his shop to 114 Centre St. in Manhattan, where he was one of NY's most prolific carvers; made scores of cigar-store Indians, carousel horses, and circus wagons. Went to Philadelphia in 1917, where he was employed by the Ford Motor Company until 1919. Returned to NYC and died there May 5, 1928.

ROBERT.

Sculptor, painter, designer, craftsman, and teacher. Born in NYC, Sept. 23, 1909. Studied: With Leonard Garfinkel, Albert Jahr, Sylvia DeG. Coster. Work: Municipal Museum, Winston-Salem, N.C.; Carolyn Aid Society, Savings Bank, Bronx, NY. Exhibited: American Museum of Natural History, 1939; Golden Gate Exposition, San Francisco, 1939; Vendome Gallery, 1938; Salons of America, 1932; Weyhe Gallery, 1943; 8th Street Playhouse, NY (one-man). Address in 1953, 82 Sheriff Street, NYC.

ROBERTS, BLANCHE GILROY.

Sculptor, who exhibited "Beatrice" at Penna. Academy of Fine Arts in Philadelphia, 1915. Address in 1926, Bronx, NY.

ROBERTS, GILROY.

Sculptor and engraver. Born in Philadelphia, PA, March 11, 1905. Studied: Corcoran School of Art, and with John R. Sinnock, Paul Remy, Eugene Weis, Heinz Warneke. Member: National Sculpture Society. Awards: Gold medal, Madrid Exhibition of Medals, 1951; gold medal, Numismatic Association, 1956. Work: Medals, Drexel Institute, 1936; Brandeis Lawyers' Society, 1948; Einstein award medal, 1950; Schaefer Brewing Co. Achievement Award, 1951; American Medical Association, Dr. Hektoen Medal, 1952; plaques: Dr. Albert Hardt Memorial, 1950; Lewis N. Cassett Foundation, 1950; Theodore Roosevelt High School, 1952; State Seals: Valley Forge Patriots Memorial, 1952; US Mint, Philadelphia; Smithsonian; Kennedy half dollar; 1963; others. Exhibited: Penna. Academy of Fine Arts, 1930, 34, 45, 46; International Exhibition of coins and medals, Paris, France, 1949, Madrid, Spain, 1951; Corcoran, 1942; National Sculpture Society; many others. Banknote engraver, Bureau of Engraving and Printing, Wash., DC, 1938-44; chief sculptor engraver, US Mint, Philadelphia, PA, 1948-64; chief sculptor and chairman, Franklin Mint, from 1964. Address in 1982, Newtown Square, PA.

ROBERTS, HOWARD.

Sculptor. Born in Philadelphia, April 1843. He studied art at the Penna. Academy of the Fine Arts. Modeled statuettes of Hawthorne's "Scarlet Letter," "Hypathia" and "Lucille," and numerous portrait busts. His statue of Robert Fulton is in the Capitol in Washington, DC. He died in Paris in April, 1900.

ROBERTS, JOHN TAYLOR.
Sculptor. Born in Germantown, PA, 1878. Address in 1915, Philadelphia, PA. (Mallett's)

ROBERTSON, MADELEINE NIXON.
Sculptor, painter, and teacher. Born in Vancouver, B.C., Canada, August 14, 1912. Studied: Moore Institute of Design for Women; Penna. Academy of Fine Arts. Awards: Cresson traveling scholarship, Penna. Academy of Fine Arts, 1942; Ware Fellow, 1943; prize, Alumnae, American Academy in Rome, 1943. Work: Swedish Museum, Philadelphia; Philadelphia Sketch Club; Stevens Institute, Hoboken, NJ. Exhibited: Penna. Academy of Fine Arts, annually; Moore Institute of Design for Women. Address in 1953, Philadelphia, PA.

ROBINSON, ALONZO CLARK.
Sculptor and writer. Born Darien, CT, Sept. 3, 1876. Member: Societe Internationale des Beaux-Arts et des Lettres. Address in 1929, Paris, France.

ROBINSON, DAVID.
Sculptor, painter, and illustrator. Born in Warsaw, Russian Poland, July 31, 1886. Studied in US, France, and Germany. Member: Palette and Chisel Club; Society of Illustrators, 1910; Salmagundi Club; Society of Independent Artists; Artists' Guild; Silvermine Guild Artists; American Federation of Arts. Address in 1933, Silvermine Guild, Chicago, IL.

ROBINSON, H. L.
Sculptor and painter. Member: Pen and Pencil Club, Columbus. Address in 1916, Columbus OH.

ROBINSON, HELEN AVERY.
Sculptor. Born in Louisville, Kentucky. She studied under Solon H. Borglum. Exhibited at National Sculpture Society, 1923. Address in 1926, 200 West 58th Street, New York.

ROBINSON, KATHLEEN BEVERLEY.
Sculptor and teacher. Born in Aurora, Ontario, Canada, 1882. Pupil of Art Institute of Chicago under Taft. Member: Chicago Society of Artists. Instructor, Art Institute of Chicago. Award: Shaffer prize ($100), Art Institute of Chicago, 1913. Work in: Brooklyn Institute Museum. Address in 1916, Chicago, IL.

ROBLES, JULIAN.
Sculptor and painter. Born in the Bronx, New York City, in 1933. Studied art at Pratt Institute; Art Students League; National Academy of Design. Technical illustrator in US Air Force; commercial artist in New York City. Moved to Taos, New Mexico. Specialty is ceremonials of New Mexico and Arizona Indians as they are performed today. Primarily a painter. Work in New Mexico State Permanent Collection; Diamond M Museum, Snyder, TX; others. Has exhibited at Diamond M Museum; Cowboy Hall of Fame; others. Represented by Trailside Galleries, Scottsdale, AZ; Grand Central Galleries, NYC. Address since 1968, Taos, New Mexico.

ROBUS, HUGO.
Sculptor and painter. Born May 10, 1885, in Cleveland, OH. Studied at Cleveland Art Institute; National Academy Design; Academie de la Grande Chaumiere, with Bourdelle. Began career in painting, switched to sculpture in 1920. Work: Cleveland Museum of Art; Corcoran; Metropolitan Museum of Art; Museum of Modern Art; Whitney. Exhibited at Grand Central Artists Guild, NYC; Whitney; Penna. Academy of Fine Arts; Metropolitan Museum of Art; Corcoran. Awards: Metropolitan Museum of Fine Art, 1942; Penna. Academy of Fine Arts, Widener gold medal, 1950; National Institute Art League citation and grant, 1957. Taught: Columbia University (summers); Munson Williams Proctor Institute; Brooklyn Museum School. Lived in New York City. Died Jan. 14, 1964, in New York City.

ROCHE, M. PAUL.
Sculptor, painter, etcher, lithographer, and lecturer. Born in Cork, Ireland, January 22, 1888 (or 1885). Studied: St. John's College; Pratt Institute Art School; National Academy of Design, with Charles Hawthorne. Awards: Prizes, National Academy of Design; Brooklyn Society of Etchers; National Arts Club, New York; Art Institute of Chicago. Work: Brooklyn Museum; Cleveland Museum of Art; Library of Congress; California State Library; New York Public Library; murals, Washington College, Chestertown, MD; Enoch Pratt Library, Catholic Cathedral, St. Joseph's Church, all of Baltimore, MD. Exhibited: National Academy of Design. Lectures: American Mural Painting. Address in 1953, Baltimore, MD.

ROCHON, JULIUS.
Wax portraitist. Known to have executed a wax portrait of Washington. May never have visited US, however.

ROCKBURNE, DOROTHEA.
Sculptor. Cardboard floor and wall pieces which are based on a set theory.

ROCKLIN, RAYMOND.
Sculptor. Born in Moodus, CT, Aug. 18, 1922. Studied at Museum of Modern Art School, 1940; Cooper Union, 1951, with Milton Hebald, John Hovannes, Warren Wheelock; Educational Alliance, NYC, with Sam Ostrowsky; Temple Univ., 1942. Works: Provincetown (Chrysler); Skowhegan School; Temple Israel, St. Louis; Whitney; plus commissions, including religious sculptures, White Plains (NY) Hospital. Exhibitions: Tanager Gallery, NYC; Univ. of California, Berkeley; Dilexi Gallery, San Francisco; The Bertha Schaefer Gallery, NYC; Whitney (many); Univ. of Illinois; Claude Bernard, Paris; American Abstract Artists Annuals; Univ. of Nebraska. Awards: Fulbright Fellowship (Italy), 1952; Yaddo Fellowship, 1956. Member: American Abstract Artists; Federation of Modern Painters and Sculptors. Taught: American Univ., 1956; Univ. of California, Berkeley, 1959-60; Scarsdale Studio Workshop, from 1960. Address in 1982, Peekskill, NY.

ROCKWELL, FREDERICK (FRYE).
Sculptor and painter. Born in Brooklyn, NY, January 12, 1917. Studied: Columbia University; National Academy of Design; Tiffany Foundation; and with Oronzio Malderelli, Arnold Blanch, George Grosz, William Zorach, and others. Member: Audubon Artists. Award: Fellow, Tiffany Foundation, 1948. Work: US Marine

Hospital, Carville, LA. Exhibited: NY World's Fair, 1939; American Watercolor Society of New York, 1939, 42, 43; Art Institute of Chicago, 1940, 43, 44; Penna. Academy of Fine Arts, 1943, 46; National Gallery of Art, 1941; Whitney Museum of American Art, 1941; Portland Museum of Art, 1944; Ogunquit Art Center, 1945; Audubon Artists, 1945, 1949-52; Met. Museum of Art, 1952; Farnsworth Museum, 1949; Morton Gallery, 1941 (one-man), 1943; National Sculpture Society, 1956, 57; many others. Address in 1970, East Booth Bay, ME.

ROCKWELL, PETER BARSTOW.
Sculptor and lecturer. Born in New Rochelle, NY, September 16, 1936. Studied at Haverford College, B.A., 1958; Penna. Academy of Fine Arts, 1958-61, J. Henry Shiedt traveling fellowship, 1961; Scuola del Marmo, Carrara, Italy, 1962; also study with Wallace Kelly. Work: Monument with Norman Rockwell, Cathedral in the Pines, Rindge, NH; statue, St. Paul's American Church, Rome; gargoyles, Washington Cathedral, Washington, DC; Wolf Memorial Statue, Fairmount Park, Philadelphia. Has exhibited at Jewelry by Contemporary Painters and Sculptors, Museum of Modern Art, NY; V Biennale Della Scultura, Carrara; others. Teaching stone technology at International Center for Conservation, Rome, from 1974. Works in marble, limestone, and bronze. Address in 1982, Rome, Italy.

ROCKWELL, ROBERT HENRY.
Sculptor. Born Laurens, NY, Oct. 25, 1885. Represented in the Brooklyn Museum by small bronzes of animals.

RODDEN, BRIAN.
Sculptor. Award: Council of American Artist Societies' Award, 1976, National Sculpture Society.

RODINA, K. MICHALOFF.
Sculptor. Exhibited at Penna. Academy of Fine Arts, Philadelphia, in 1915. Address in Brooklyn, NY.

ROENNEBECK, ARNOLD.
(See Ronnebeck, Arnold.)

ROGERS, BARKSDALE (MISS).
Sculptor and illustrator. Born in Macon, Germany. Address in 1934, NY. (Mallett's)

ROGERS, JOHN H.
Sculptor and modeler. Born in Salem, MA, October 30, 1829. Studied in Paris and Rome. Began sculpture after 1858; gave it up for a short period; later received notoriety for humorous genre subjects in Chicago. Opened own studio in NYC where he produced over 80 groups; over 80,000 casts of his work have been made. His well-known "Rogers Groups" were familiar subjects connected with the Civil War. His best-known group of the "Slave Auction" was done in 1859. Rogers also executed the equestrian statue of General Reynolds which stands before the City Hall in Philadelphia. He was elected a member of the National Academy of Design in 1863, and belonged to the National Sculpture Society. Died in New Canaan, CT, July 26, 1904.

ROGERS, MARY.
Sculptor and painter. Born in Pittsburgh, PA, May 7,

1882. Pupil of Robert Henri; Simon and Menard in Paris. Member: Society Independent Artists. Address in 1918, 430 Lafayette St.; h. 1 West 85th St., NYC.

ROGERS, RANDOLPH.
Sculptor. Born in Waterloo, NY, on July 6, 1825. About 1848 he went to Italy to study art in Florence and Rome where he produced the well-known statue "Nydia." Returned to US in 1853 and opened his studio in New York. In 1858 he designed the bronze doors for the Capitol in Washington. He also executed portrait statues of Abraham Lincoln for Philadelphia and of William H. Seward for New York. He resided in Italy from 1860 and was important figure in the American colony at Rome. Died in Rome, January 15, 1892.

ROHL-SMITH, CARL.
See Smith, Carl Rohl.

ROHM, ROBERT.
Sculptor. Born in Cincinnati, OH, Feb. 6, 1934. Studied at Pratt Institute, B. Industrial Design, 1956; Cranbrook Academy of Art, with Berthold Schewitz, MFA, 1960. Works: Columbus; Finch College; The Penna. State Univ.; Museum of Modern Art; Whitney. Exhibitions: Aspen (CO) Art Gallery; Whitney; DeCordova; Fogg; Boston Museum of Art. Awards: Penna. Academy of Fine Art, Honorable Mention, 1959; Columbus, Sculpture Prize, 1957, 59; Guggenheim Foundation Fellowship, 1964; Univ. of Rhode Island Research Grant-in-Aid, 1965, 66, 69; Cassandra Foundation, 1966; National Endowment for the Arts Award, 1974. Member: Sculptors Guild. Taught: Columbus College of Art and Design, 1956-59; Pratt Institute, 1960-65; Univ. of Rhode Island, from 1965. Address in 1982, Wakefield, RI.

ROINE, JULES EDOUARD.
Sculptor. Born in Nantes, France, in 1857. Work: "Dawn of the Twentieth Century," Metropolitan Museum, NY. Member: Salmagundi Club, 1906; National Sculpture Society, 1907. Address in 1916, 139 East 23d Street, NYC. Died in 1916.

ROLAND, LORINDA.
Sculptor and instructor. Born in NYC, April 21, 1938. Studied at Art Students League, 1957-58; Skowhegan School Painting and Sculpture, 1959; Cranbrook Academy of Art, B.F.A. 1960. Works: Private collections only. Exhibitions: Sculpture Los Angeles, 1965, Munic. Art Gallery. Awards: Tiffany Award, 1961-62; Guggenheim Fellowship, 1963-64. Media: Raised copper, polyester resin, wood, and bone. Address in 1976, Los Angeles, CA.

ROLLER, GARY.
Sculptor and painter. Born in Amarillo, Texas, in 1951. Studied art at Amarillo College; with Lincoln Fox, Santa Fe. Professional musician and artist. Specialty is Southwestern subjects, including Indians and old-time cowboys; also modeled busts of The Beatles and Walt Disney. Sculpts in bronze. Exhibits sculpture at Grycner Gallery, Taos, NM; Shidoni Gallery and Foundry, Tesuque, NM. Address since 1980, Taos, New Mexico.

ROLLER, MARION BENDER.
Sculptor and painter. Born in Boston, Mass. Studied at Vesper George School Art, dipl.; Art Students League, with John Hovannes; Greenwich House, with Lu Duble; Queens College, B.A.; also watercolors with Edgar Whitney. Commisions: Head of child, Nassau Center for Emotionally Disturbed Children, Woodbury, NY, 1968. Exhibitions: Allied Artists of America, 1959-74; National Academy of Design, NY, 1962-69; American Artists Professional League, 1965, 66, and 68; National Sculpture Society, from 1969; Audubon Artists, 1973. Awards: Mrs. John Newington Award, American Artists Professional League, 1965; Archer Milton Huntington Award, 1968; Knickerbocker Artists Prize for Sculpture, 1966; Gold Medal, Pen and Brush, 1971, Honorable Mention for Sculpture and Watercolor, 1975, Brush Award for Etching, 1975. Address in 1982, 1 West 67th Street, NYC.

ROMANO, NICHOLAS.
Sculptor, painter, craftsman, and writer. Born in Montoro, Italy, Dec. 6, 1889. Pupil of Albert Laessle. Award: Honorable mention, Art Institute of Chicago, 1928. Represented in Pennsylvania Academy of the Fine Arts; Philadelphia Art Alliance; Graphic Sketch Club of Philadelphia; Albright Gallery, Buffalo; Memorial Gallery, Rochester. Address in 1933, Philadelphia, PA.

ROMANO, SALVATORE MICHAEL.
Sculptor and kinetic artist. Born in Cliffside Park, NJ, September 12, 1925. Studied at Art Students League, with Jon Corbino; Academie Grande Chaumiere, Paris, with Edouard Georges and Ehrl Kerkam. Has exhibited at Jewish Museum, NY; A. M. Sachs Gallery, NY; Max Hutchinson Gallery, NY; Aldrich Museum of Contemporary Art, Ridgefield, CT; others. Received award from National Endowment for the Arts, 1979-80; others. Taught sculpture at Cooper Union, 1968-70. Works in plastics, wood, metal, and water. Address in 1982, 83 Wooster St., NYC.

ROMANO, UMBERTO ROBERTO.
Sculptor, painter, engraver and teacher. Born in Italy, Feb. 26, 1905. Pupil of National Academy of Design. Member: L. C. Tiffany Foundation; Springfield Art League. Awards: Pulitzer Traveling Scholarship, 1926; Tiffany Fellowship, 1926; honorable mention, 1928 and Peabody prize, Art Institute Chicago, 1931; Art Guild medal, Tiffany Foundation, NY, 1931; prize, best modern, Springfield Art Club, 1930; first prize, Springfield Art League, 1931, best portrait, 1932; Atheneum prize, Conn. Academy of Fine Arts, 1931; Crowninshield prize, Stockbridge, MA, 1932. Represented in Worcester Art Museum; Smith College Museum of Art, Northampton, MA; Rhode Island School of Design, Providence; Fogg Museum, Cambridge, MA; Museum of Fine Arts, Springfield, MA. Teaching: Worcester Art Museum School, 1933-40; privately in NYC and Chatham, MA, from 1950. Address in 1982, NYC.

ROMNEY, MILES.
Wood carver. Born in Dalton, Lancashire, July 13, 1806. Worked on Mormon Temple at Nauvoo, IL, in the mid-1840's. Came to Nauvoo, IL, in 1841; moved to Utah in 1850. Died at St. George, UT, in May 1877.

ROMOSER, RUTH AMELIA.
Sculptor and painter. Born in Baltimore, MD, April 26, 1916. Studied at Baltimore Art Institute, grad.; sculpture with Xavier Corbera, Barcelona, Spain; Robert Motherwell Workshop; graphics with Joseph Ruffo. Works: Miami Museum of Modern Art, FL; Lowe Museum, Univ. of Miami; Miami Herald; National Cardiac Hospital, Miami; International Gallery, Baltimore, MD. Commissions: Two paintings for 12 productions, Actors Studio M, Coral Gables, FL, 1963-64. Exhibitions: Ringling Southeast National Art Show, Sarasota, FL, 1961-63; National Drawing Exhibition, Cheltenham, PA, 1964; Four Arts Plaza National, Palm Beach, 1966; Hortt Memorial Regional, Ft. Lauderdale Museum Arts, 1966; one-woman show, National Design Center, NY, 1967. Awards: Eighth Annual Hortt Memorial Award, Ft. Lauderdale Museum of Arts, 1967; Design Derby Award, Designers-Decorators Guild, 1969; Artspo 70, Coral Gables, 1970. Media: Oil and acrylic. Address in 1982, Miami, FL.

RONDONI, ROMOLO.
Sculptor. Exhibited at the Penna. Academy of the Fine Arts, Philadelphia, 1914. Address in 1926, 35 East 30th Street, New York City.

RONNEBECK, ARNOLD.
Sculptor, writer, and lecturer. Born Nassau, Germany, May 8, 1885. Pupil of Aristide Maillol and Emile Bourdelle in Paris. Awards: Silver medal, Kansas City MO, 1928; Fine Arts medal, City Club, Denver, 1928. Work: Sixteen panels "The History of Money," Denver National Bank; "Madonna and Angels," St. John's Cathedral; reredos of "The Ascension," Church of the Ascension, Denver, CO; Friezes of Indian Ceremonial Dances, La Fonda, Santa Fe, NM; others. Director, Denver Art Museum. Address in 1933, Denver, CO.

ROOD, JOHN.
Sculptor. Born in Athens, OH, Feb. 22, 1906. Self-taught in art. Travelled extensively. Works: Addison Gallery, Andover, MA; Corcoran; Cranbrook; Minneapolis Institute; Univ. of Minnesota; Ohio Univ.; Walker; plus commissions for Minneapolis Public Library; Wellesley College; St. Marks Cathedral, Minneapolis; and Hamline Univ. Exhibitions: (first) Passedoit Gallery, NYC; Durand-Ruel Gallery, NYC; Newark Museum; Minneapolis Institute; Ward Eggleston Gallery, Chicago, 1949; L'Obelisco, Rome; Whitney; Univ. of Minnesota; Walker; Corcoran; Cranbrook. Member: Artists Equity (President, 1959-63). Address in 1970, c/o Weintraub Gallery, NYC. Died in Minneapolis, MN, 1974.

RORHEIMER, LOUIS.
Sculptor and painter. Born in Cleveland, OH, Sept. 12, 1873. Pupil of Puech and Benjamin Constant in Paris; Wedeman and Romeis in Munich. Member: Cleveland Art Club; Cleveland Architectural Club. Address in 1908, Cleveland, OH.

RORIMER, LOUIS.
Sculptor, architect, craftsman, lecturer, and teacher. Born Cleveland, Sept. 12, 1872. Pupil of Puech, Widaman, Le Blanc. Member: Cleveland Society of Artists; Salma-

gundi Club; Arts in Trade Club. Died in 1939. Address in 1929, Cleveland, OH.

ROSATI, JAMES.
Sculptor. Born in Washington, PA, 1912. Works: Colby College; NY Univ.; Rockefeller Univ.; Whitney; Yale Univ.; Albright-Knox; Hirshhorn. Exhibited: The Peridot Gallery, NYC; Ninth St. Exhibition, NYC; Whitney Annuals, 1952, 53, 54, 60, 62, 66; Carnegie; Claude Bernard, Paris; American Federation of Arts, Contemporary Sculpture; International Outdoor Sculpture Exhibition, Otterlo, Holland; Art Institute of Chicago; Seattle World's Fair, 1962; Battersea Park, London, International Sculpture Exhibition; NY World's Fair, 1964-65; Flint Institute; Colby College; Museum of Contemporary Crafts. Awards: Brandeis Univ., Creative Arts Award, 1960; Art Institute of Chicago; Logan Medal and Prize, 1962; Carborundum Major Abrasive Marketing Award, 1963; Guggenheim Foundation Fellowship, 1964. Taught: Cooper Union; Pratt Institute; Yale Univ.; 1960-64, from 1968; Dartmouth College, 1963. Violinist with the Pittsburgh Symphony for two years. Address in 1982, 56 7th Ave., NYC.

ROSE, RUTH STARR.
Sculptor and painter. Born in Eau Claire, WI, July 12, 1887. Studied: Vassar College; Art Students League of NY; and with Hayley Lever. Exhibited: National Academy of Design, 1945, 46; National Association of Women Artists, 1944, 45, 49, 50; one-woman shows at Rehoboth Art League; Farnsworth Museum of Art, Rockland, ME, 1954; Howard University, 1958; City Hall, Alexandria, VA, 1964; others. Member of Southern States Art League; Montclair Art Association; National Arts Club, NY. Awards: National Association of Women Artists, 1937, 44; State of NJ, 1944; Washington Printmakers, 1951; Norfolk Museum of Art and Science, 1950; Corcoran Gallery of Art, 1951; Virginia Printmaker, 1957; Washington Area Printmakers, 1957; Art Fair, Alexandria and Washington, 1957; Religious Art Fair, 1958. Collections: Library of Congress; Metropolitan Museum of Art; Vassar College; Philadelphia Museum of Art; Wells College; Williams College; Milliken College; Norfolk Museum of Arts and Science. Address in 1970, Alexandria, VA.

ROSE, THOMAS ALBERT.
Sculptor. Born in Washington, DC, October 15, 1942. Studied at University of Wis-Madison, 1960-62; University of Illinois, Urbana, B.F.A., 1965; University of California, Berkeley, M.A., 1967, study grant to University of Lund, Sweden, 1967-68. Work in Library of Congress, Washington, DC; Minneapolis Institute of Art; Walker Art Center, Minneapolis; Brooklyn Museum, NY; others. Has exhibited at Walker Art Center; Downtown Whitney, NY; Hirshhorn Museum, Washington, DC; others. Taught sculpture at University of Minnesota, Minneapolis, 1972-81, associate professor, from 1981. Address in 1982, Minneapolis, MN.

ROSEBERRY, HELEN K.
Sculptor. Born in 1932. Studied: East Tennessee State University, Johnson City, Tennessee. Awards: Sinking

Creek Film Celebration, Nashville, Tennessee, 1973; Tennessee Arts Commission, 1974. Exhibitions: Beech Galleries, Beech Mountain, North Carolina, 1972; Milligan College, Milligan, Tennessee, 1973; Tennessee Drawings, 1974.

ROSEN, KAY.
Sculptor. Born in Corpus Christi, TX, in 1943. Studied: Newcomb College, New Orleans; Northwestern University; The Art Institute of Chicago. Exhibitions: Del Mar College, Texas; University of Chicago; ARC Gallery, Chicago, 1975.

ROSENBAUER, WILLIAM WALLACE.
Sculptor, craftsman, and teacher. Born Chambersburg, PA, June 12, 1900. Studied: St. Louis School of Fine Arts; Alexander Archipenko. Member: Kansas City Society Artists. Awards: Silver medal, Kansas City Art Institute, 1925, 1926, and 1929; gold medal, Kansas City Art Institute, 1927, prizes 1935, 36, 39, 40; first sculpture award, Second Missouri Art Exhibition, St. Louis, 1929. Address in 1953, Danbury, CT.

ROSENBLUM, RICHARD STEPHEN.
Sculptor. Born in New Orleans, LA, December 31, 1940. Studied at California School of Art; Cleveland Institute of Art; Cranbrook Academy of Art. Work in Columbus Museum of Art. Has exhibited at Addison Gallery of American Art, Andover, MA; National Academy of Design Annual, NY; Edwin Ulrich Museum of Art, Wichita, KS; others. Works in bronze. Represented by Coe Kerr Gallery, NYC. Address in 1982, Newton, MA.

ROSENBLUM, SADIE SKOLETSKY.
Sculptor and painter. Born in Odessa, Russia, Feb. 12, 1899; US citizen. Studied at Art Students League; New School for Social Research; also with Raphael Soyer, Kunioshr, Ben-Zion, and Samuel Adler. Works: Philadelphia Museum Art; Ohio Univ.; El Paso Museum of Art; Brandeis Univ. Museum; Lowe Art Museum, Univ. of Miami. Exhibitions: Museum of Modern Art, NY; Corcoran Gallery of Art, Washington, DC; one-woman shows, Museum Arts, Ft. Lauderdale, FL, 1962 and 65, Lowe Art Museum, Univ. of Miami, 1964; Columbia Museum, SC, 1972. Medium: Oil. Address in 1982, Miami Beach, FL.

ROSENGREN, HERBERT.
Sculptor, painter, and etcher. Born Kewanee, IL, Dec. 8, 1908. Member: Rockford Art Association; Iowa Art Club. Awards: First prize in etching and water color, IA State Fair, 1931; first prize, sculpture, Iowa Art Club, 1931. Address in 1933, Rockford, IL; summer, The Little Gallery, Cedar Rapids, IA.

ROSENSHINE, ANNETTE.
Sculptor. Born in San Francisco, CA, April 14, 1880. Pupil of California School of Fine Arts and Henri Matisse. Member: San Francisco Society of Women Artists. Address in 1933, San Francisco, CA.

ROSENSTEIN, FRIEDA.
Sculptor. Award: Lindsey Morris Memorial Prize, 1976, National Sculpture Society.

ROSENSTEIN, JOAN.
Sculptor and painter. Studied: The Art Institute of Chicago; Lake Forest College; Skidmore College; University of Michigan. Exhibitions: Artists' Guild of Chicago, 1961; Baltimore Museum of Art, 1971; Annapolis Art Festival, Maryland, 1974.

ROSENTHAL, LOUIS CHATEL.
Sculptor. Born Lithuania, Feb. 5, 1888. Came to US in 1907. After studying with Ephraim Keyser in Baltimore, he won scholarship to study abroad. Exhibited: Palace Legion of Honor, 1929; Philadelphia Art Alliance, 1930; Boston Museum of Art, 1923. Member: Royal Society of Miniature Painters and Sculptors, England; National Sculpture Society; College Art Association; Charcoal Club, Baltimore. Address in 1953, Baltimore, MD. Died in 1964.

ROSENTHAL, RACHEL.
Sculptor. Born in Paris, France, November 9, 1926; US citizen. Studied at New School for Social Research, NY; Sorbonne, Paris; also with Hans Hofmann, Karl Knaths, William S. Hayter, and John Mason. Exhibitions: Rental Gallery, Los Angeles Co. Museum, 1972; Ceramic International, Calgary, Canada, 1973; Ceramic Conjunction, Glendale, CA, 1973 and 75; one-woman show, Woman's Bldg., Los Angeles, Grandview Gallery, 1974; 1st Annual California Sculpture Exhibition, California State University, Northridge, 1974. Awards: Gold Medal Art, High School of Music and Art, NY, 1945. Member: Artists Equity Association; American Crafts Council. Media: Stoneware and raku. Address in 1982, Los Angeles, CA.

ROSENTHAL, TONY (BERNARD).
Sculptor. Born in Highland Park, IL, Aug. 9, 1914. Studied at University of Michigan, 1936, B.A.; Art Institute of Chicago School; Cranbrook Academy of Art, with Carl Milles. Works: Baltimore Museum of Art; Albright; University of Illinois; Herron; De Cordova; Long Beach Museum of Art; Los Angeles County Museum of Art; Museum of Modern Art; University of Michigan; Milwaukee; National College of Fine Art; NY University; Newark Museum; Santa Barbara Museum of Art; UCLA; Whitney; Guggenheim Museum; Museum of Modern Art; Albright-Knox Art Gallery. Commissions: Museum of Science and Industry, Chicago, 1941; New York World's Fair, 1939; RKO Studios, Hollywood; University of Michigan; Temple Beth-El, Birmingham, MI, 1973; Cranbrook, 1980. Exhibited at San Francisco Museum of Art; Long Beach Museum of Art; Carnegie; The Kootz Gallery, NYC; M. Knoedler & Co., NYC; Metropolitan Museum of Art; Museum of Modern Art; Sao Paulo Biennial; Brussels World's Fair, 1958; Art Institute of Chicago; Penna. Academy of Fine Arts; Sculptors Guild; Audubon Artists; Walker; Yale University; Whitney; Boston Museum of Fine Arts; Krannert Art Museum, University of Illinois, Champaign; Aldrich Museum of Contemporary Arts, Ridgefield, CT. Received San Francisco Museum of Art Sculpture Award, 1950; Los Angeles Co. Museum of Art, 1950; Los Angeles All-City Show, Sculpture Prize, 1951; Audubon Artists, Sculpture Award, 1953; Penna. Academy of Fine Arts, Honorable Mention, 1954; Los Angeles Co. Museum of Art, Sculpture Award, 1957; American Institute of Architects, Southern California Chapter, Honor Award, 1959; Ford Foundation, 1963; Tamarind Fellowship, 1964; University of Michigan, Outstanding Achievement Award, 1967; Carborundum Major Abrasive Marketing Award, 1969. Address in 1982, 173 E. 73rd St., NYC.

ROSENZEIG, LIPPA.
Sculptor. Exhibited at Penna. Academy of the Fine Arts, Philadelphia, 1926. Address in 1926, Philadelphia, PA.

ROSEY, ALEXANDER P.
(Abraham Rosenstein). Sculptor. Born in Baltimore, MD, July 4, 1890. Studied: National Academy of Design; Beaux-Arts Institute of Design, New York. Awards: Medal, National Academy of Design; Beaux-Arts Institute of Design. Exhibited: Penna. Academy of Fine Arts; Corcoran Gallery of Art; National Academy of Design; Baltimore Museum of Art. Address in 1953, 185 McClellan Street, New York, NY.

ROSIN, HARRY.
Sculptor and teacher. Born in Phila., PA, December 21, 1897. Studied: Philadelphia Museum School of Industrial Art, Philadelphia; Penna. Academy of Fine Arts; and in Paris, France. Awards: Cresson traveling scholarship, 1926, medal, 1939, 40, prize, 1941, Penna. Academy of Fine Arts; grant, American Academy of Arts and Letters, 1946; medal, Philadelphia Museum of Art, 1951; prize, Audubon Artists, 1956. Work: Penna. Academy of Fine Arts; Philadelphia Museum of Art; Papeete, Tahiti; memorial, Fairmount Park, Philadelphia. Exhibited: World's Fair, Chicago, 1934; Texas Centennial, 1936; Golden Gate Exp., 1939; NY World's Fair, 1939; Art Institute of Chicago, 1934, 46; Whitney Museum of American Art; Penna. Academy of Fine Arts, 1933-46, 58, 60; Carnegie Institute; Modern American Art, Paris, 1932; Salon de L'Oeuvre Unique, Paris, 1932; Metropolitan Museum of Art, 1951; Detroit Institute of Art, 1958. Taught: Instructor, Sculpture and Drawing, Penna. Academy of Fine Arts, Philadelphia, PA, from 1939. Address in 1970, New Hope, PA. Died in 1973.

ROSS, CATHERINE TERRY (MRS.).
Sculptor. Address in 1934, Nyack, NY. (Mallett's)

ROSS, CHARLES.
Sculptor. Born in Philadelphia, PA, Dec. 17, 1937. Studied at Univ. of California, AB, 1960, MA, 1962. Works: Indianapolis Museum of Art; Kansas City (Nelson); Whitney. Exhibitions: Dilexi Gallery, San Francisco; Cornell Univ.; Dwan Gallery, NYC; Musee Cantonal des Beaux-Arts, Lausanne, II Salon International de Galeries Pilotes, 1966; Paris Biennial; NY Architectural League; American Federation of Arts; Aldrich; Kansas City (Nelson); Newark Museum; Milwaukee; Flint Institute; Whitney Sculpture Annual; Hudson River Museum; Castelli Gallery, NYC. Awards: Univ. of California, James D. Phelan Traveling Scholarship, 1962; American Institute of Graphic Arts Award, 1976. Taught: Univ. of California, 1962, 65; Cornell Univ., 1964; Univ. of Kentucky, Artist-in-Residence, 1965; School of Visual Arts, NYC, 1967,

70, 71; Herbert Lehman College, 1968; Artist-in-Residence, MIT, 1977. Dance Theater: Judson Dance Theater, NYC, A Collaborative Event (with the Judson Dancers), 1963. Co-director and collaborator, Dancers Workshop Company, San Francisco, 1964-66; Dance Theater work, NYC. Address in 1982, 383 W. Broadway, NYC.

ROSS, WENDY M.
Sculptor. Studied: Univ. of Wisconsin, Madison, B.A., 1964-68; San Francisco Art Institute, California College of Arts and Crafts, 1968-69; Rhode Island School of Design, M.A.Ed., 1969-72. Exhibited: San Francisco Art Institute, 1969; Rhode Island School of Design, 1971; 8 ½ Ton Gallery, VA, 1973; Washington Women's Arts Center, Washington, DC, 1980; National Arts Club, NYC, 1983; Pendragon Gallery, Annapolis, MD, 1983, 84; Georgetown Fine Arts, Washington, DC, 1983-84. Commissions: Bronze heroic size statue of Justice William O. Douglas, US Supreme Court, Washington, DC, 1977; bronze "Phoenix Rising," 1982. Awards: First prize, bust of Alice Paul for the National Woman's Party, 1979; first prize, sculpture, Terrance Gallery National Juried Show, NY, 1982; first prize, sculpture, Pendragon Gallery (juried show), MD, 1984. Instructor at Rhode Island School of Design, 1973; Penland School of Crafts, NC, 1974; Univ. of Minnesota School of Design, 1977; Artist-in-residence, Glen Echo Park Arts Center, MD, 1972-78. Member: Artists Equity Association and International Sculpture Center. Publications: "Some Friendly Cynicism and Other Poems," written and illustrated, 1970; "How Round is Blue?"; National Handcraft Magazine, 1976; Children's Experimental Workshop, 1979. Media: Bronze, marble, resins. Address in 1984, Washington, DC.

ROSSE, MARYVONNE.
Sculptor. Member of the National Sculpture Society. Award: Tallix Foundry Prize, 1978, National Sculpture Society. Address in 1982, 431 Buena Vista Road, New York City.

ROSSI, PAUL A.
Sculptor and painter. Born in Denver, Colorado, in 1929. Studied at Denver University, advertising design. Employed in commercial art at Gilcrease Institute, Tulsa, Oklahoma. Turned full-time to art in 1972. Specialty is horse culture of historical West, frontier military history, cattle industry, Plains Indians, Western natural history subjects. Produced miniature bronze series entitled "Great Saddles of the West." Co-author, The Art of the Old West; has illustrated books, written articles, lectured, etc. Represented by his Canyonland Graphics. Address in 1982, Santa Fe, New Mexico.

ROSZAK, THEODORE J.
Sculptor. Born in Poznan, Poland, May 1, 1907. Studied at Columbia Univ., 1925-26; Chicago Art Institute School, 1922-29, with John W. Norton, Boris Ainsfeld; National Academy of Design, 1925-26, with C. W. Hawthorne. Works: Baltimore Museum of Art; Art Institute of Chicago; Cleveland Museum of Art; Univ. of Illinois; Industrial Museum, Barcelona; Museum of Modern Art; Univ.

of Michigan; Penna. Academy of Fine Arts; Guggenheim; Sao Paulo; Smithsonian; Tate; Whitney; Walker; Univ. of Wisconsin; Yale Univ.; plus commisions including: MIT (spire and bell tower); American Embassy, London; New Public Health Lab, NYC. Exhibitions: Albany Institute; Artists' Gallery, NYC; Julien Levy Gallery, NYC; Pierre Matisse Gallery, NYC; XXX Venice Biennial, 1960; Art Institute of Chicago, 1929-31, 33, 34, 38, 41, 47, 48, 51, 61; Whitney, 1932-38, 1941-45, 46-52, retrospective, 1956, 59; Museum of Modern Art; Penna. Academy of Fine Art; American Federation of Arts; Documenta I & II, Kassel, 1955, 59; Brussels World's Fair, 1958; Carnegie; National Institute of Arts & Letters; Tate; American Painting and Sculpting, Moscow, 1959; Seattle World's Fair, 1962; Silvermine Guild, 1962; Cleveland Museum of Art. Awards: World's Fair, Poland, 1930, Silver Medal; Art Institute of Chicago, Joseph N. Eisendrath Prize, 1934, Logan Medal, 1947, 51, Campagna Award, 1961; I Sao Paulo Biennial, 1951; Tate, International Unknown Political Prisoner Comp., 1953; Penna. Academy of Fine Arts, George D. Widener memorial Gold Medal, 1958; Ball State Teachers College, Griner Award, 1962. Elected to the National Institute of Arts and Letters. Member: Commission of Fine Arts, Washington, DC (appointed for 1963-67); Advisory Committee on the Arts, US State Dept. (appointed for 1963-67); National Adv. Committee, National Council on Arts and Gov't. Taught: Chicago Art Institute School, 1927-29; Design Lab., NYC, 1938-40; Sarah Lawrence College, 1940-56; lectured at many museum and universities. Address in 1970, One St. Lukes Place, NYC. Died in 1981.

ROTAN, WALTER.
Sculptor. Member of the National Sculpture Society. Address in 1982, 45 Christopher Street, New York City.

ROTH, FREDERICK GEORGE RICHARD.
Sculptor. Born Brooklyn, NY, April 28, 1872. Pupil of Edmund von Hellmer and Meyerheim in Vienna. Also studied at Academy of Fine Arts in Berlin. Member: Associate National Academy Design, 1906; New York Architectural League, 1902; National Institute Art League; Society of American Artists, 1903; National Sculpture Society, 1910; New Society of Artists; Society Animal Painters and Sculptors. Awards: Silver medal, St. Louis Exp., 1904; silver medal, Buenos Aires Exp., 1910; gold medal, P.-P. Exp., San Francisco, 1915; Ellen Speyer memorial prize, National Academy Design, 1924; National Art Club prize, 1924; William O. Goodman prize, 1928. Represented in Metropolitan Museum, NY; Detroit Institute of Arts; Cincinnati Museum; Children's Museum, Boston; San Francisco Museum; Museum, Newark, NJ; Equestrian Washington, Morristown, NJ. Exhibited at National Sculpture Society, 1923. Address in 1929, Englewood, NJ. Died in 1944.

ROTHBORT, SAMUEL.
Sculptor and painter. Born in Wolkovisk, Russia, November 25, 1882. Author: "Out of Wood and Stone." Director, Rothbort Home Museum of Direct Art, Brooklyn, NY, exhibiting work in paint, wood, glass, etc., by Samuel and Lawrence Rothbort. Address in 1953, Brooklyn, NY.

ROTHSCHILD, AMALIE (ROSENFELD).
Sculptor and painter. Born in Baltimore, MD, January 1, 1916. Studied at Maryland Institute College of Art, diploma; NY School of Fine and Applied Art; and with Herman Maril. Work in Corcoran Gallery of Art; Baltimore Museum of Art; Peale Museum, Baltimore; others. Has exhibited at Jewish Museum, NY; Corcoran Gallery of Art; Baltimore Museum of Art; National Academy of Science; others. Received prize for painting, Baltimore Museum of Art; award for painting, Corcoran Gallery of Art; others. Works in particle board, metal leaf; acrylic. Address in 1982, Baltimore, MD.

ROTHSCHILD, LINCOLN.
Sculptor, painter, writer, etcher, and lecturer. Born in NYC, August 9, 1902. Studied: Columbia Univ., A.B., A.M.; Art Students League, with K. H. Miller, B. Robinson, A. Tucker. Member: College Art Association of America; Artists Equity Association; Art Students League. Work: Metropolitan Museum of Art. Awards: Prize, Village Art Center, 1948. Author: *Sculpture Through the Ages*, 1942; *Style in Art*, 1960; *To Keep Art Alive* (Kenneth Hayes Miller), 1974; *Forms and their Meaning in Western Art*, 1976. Contributor to Journal of Philosophy, Parnassus, Sat. Review of Lit., World Book Encyclopaedia, Collier's Encyclopaedia. Taught: Instructor, of Fine Arts Dept., Columbia Univ., 1925-35; Director, NY Unit of American Design, 1938-40; Assistant Professor, Chairman of Art Department, Adelphi College, Garden City, NY, 1946-50; Lecturer, Art Students League, 1948-51; Executive Director, Artists Equity Association, NYC, 1951-57. Address in 1982, Dobbs Ferry, NY.

ROTHSTEIN, IRMA.
Sculptor. Born in Rostov, Russia. Studied in Vienna, Austria, and with Anton Hanak. Works: Newark Museum of Art; Syracuse Museum of Fine Arts; G.W.V. Smith Museum, Springfield, Mass. Awards: Mint Museum of Art, 1946; American Artists Professional League, 1946; NJ Painters and Sculptors Society, 1948; Springfield Art League, 1951, 58; National Association of Women Artists, 1954. Died in 1971.

ROUARD, JOHN.
Sculptor. At San Francisco, 1856-58.

ROUDEBUSH, JOHN HEYWOOD.
Sculptor. Born in New York. Awarded honorable mention, Paris Salon, 1898; bronze medal at the Paris Expo. of 1900; silver medal, Pan-American Expo., Buffalo, in 1901, for his group, "The Wrestlers." Address in 1910, 80 Irving Place, NYC.

ROWE, WILLIAM B.
Sculptor, painter, teacher, and lecturer. Born in Chicago, IL, May 25, 1910. Studied: Cornell University; Buffalo Art Institute; and with Edwin Dickinson. Member: Buffalo Society of Artists; The Patteran. Awards: Prizes, Buffalo Society of Artists, 1935; Albright Art Gallery, 1937. Work: Smithsonian Institution; Rochester Memorial Art Gallery; murals, Bennett High School, Marine Hospital, Buffalo, NY; Youngstown, NY. Exhibited: Metropolitan Museum of Art, 1938; Riverside Museum, 1937, 1941;

Golden Gate Exposition, San Francisco 1939; Corcoran Gallery of Art, 1935; Great Lakes traveling exh., 1937; Baltimore Watercolor Club, 1938; Kansas City Art Institute, 1941; Rochester Memorial Art Gallery, 1942; Syracuse Museum of Fine Arts, 1934; Albright Art Gallery, 1934-44; Art Institute, Buffalo, 1951; University of Illinois, 1952. Taught: Instructor, President, Buffalo Art Institute, Buffalo, New York, 1941-45. Address in 1953, Buffalo, NY.

ROX, HENRY.
Sculptor, etcher, designer, and illustrator. Born in Berlin, Germany, March 18, 1899. Studied: University of Berlin; Julian Academy, Paris, France. Member: Associate of the National Academy of Design, National Sculpture Society; College Art Association of America; Springfield Art League. Awards: Prizes, Springfield Art League, 1941, 43, 45, 47, 49; Architectural League, 1949; Silvermine Guild of Art, 1950, 52; Art Director Club, 1950; Audubon Art, (medal), 1951; National Academy of Design, 1952, (medal). Work: Springfield Museum of Fine Arts; Mt. Holyoke College; Addison Gallery of American Art; John Herron Art Institute; Dartmouth College; Syracuse Museum of Fine Arts; Faenza, Italy; Liturgical Art Society. Exhibited: Penna. Academy of Fine Arts; Whitney Museum; Philadelphia Museum; National Institute of Arts and Letters; Syracuse Museum of Fine Arts; Yale University; Art Directors Club; Addison Gallery of American Art; Wadsworth Atheneum; Met. Museum of Art; Smith College; Institute of Contemporary Art, Boston; Worcester Museum of Art; Boston Art Festival; and in Europe; one-man: Concord State Library, 1945; Art Headquarters Gallery, NY, 1945; Springfield Museum of Fine Arts, 1945; Kleeman Gallery, 1946; DeYoung Memorial Museum, 1947; Worcester Museum of Art, 1948; University of New Hampshire, 1950; Dartmouth College, 1950. Author of numerous children's books. Taught: Associate Professor of Art, Mount Holyoke College, 1939-64; Instructor of Sculpture, Worcester Art Museum, Worcester, Mass, 1946-52. Address in 1970, South Hadley, Mass.

ROYBAL, JAMES.
Sculptor. Born in Santa Fe, New Mexico, in 1952. At an early age learned jewelry and bronze casting from local sculptor; studied at Highlands University and New Mexico State University; with Ernest Berke. Worked in art foundries. Specialty is Old Western figures. Works in bronze and does own casting. Has exhibited at Santa Fe Festival of Arts; also served as judge. Represented by Signature Galleries, Scottsdale, AZ. Address in 1982, Santa Fe, New Mexico.

ROYCE, ELIZABETH R.
(Mrs. Edward Royce). Sculptor. Member of National Association of Women Painters and Sculptors. Address in 1926, 115 West 16th Street, NYC; 11 Greycourt, Ithaca, NY.

ROZZI, JAMES A.
Sculptor and painter. Born in Pittsburgh, PA, January 22, 1921. Raised in France, Italy, New York City, and Utah. Self-taught; studied Old Masters at Metropolitan Museum of Art, New York City; learned silkscreening during

military service. Taught at San Bernardino Valley College, California, 1949-60; Art League, Nevada. Work in Favell Museum, Klamath Falls, Oregon; State Capitol, Carson City, NV; others. Has exhibited at US Army National Art Exhibition, Dallas, TX; Death Valley Western Art Show, California, 1970-75; George Phippen Memorial Art Show, Prescott, AZ, 1975; others. Awarded third place medal, George Phippen Memorial Show, 1975; others. Specialty is Western Americana subjects. Paints in oil and watercolor; sculpts in bronze. Also designs custom roulette wheels and other casino gambling equipment. Reviewed in *Art West*, fall 1978. Represented by Newsom's Gallery, Las Vegas, NV. Address since 1961, Las Vegas, NV.

RUBIN, DONALD VINCENT.
Sculptor. Born in NYC, July 10, 1937. Exhibitions: (One-man shows) Brass Door Galleries, Houston, TX, 1977; Hunter Gallery, San Francisco, CA, 1977; Indian Paint Brush, Vail, CO, 1975, 76, 77, 78, 79; Huntsville Museum of Art, AL, 1978; (two-man show) Burk Gallery, Boulder City, NE, 1977; (three-man show) Hobe Sound Galleries, Hobe Sound, FL, 1980; Kennedy Galleries, NYC; National Sculpture Society, 1980; Society of Animal Artists, San Antonio, TX, 1980; National Academy of Design, NYC, 1982; Knickerbocker Artists, NYC, 1982. Works: Numerous sculptures in bronze, "First Bull Riding Event," 1974, "Too Much Slack," 1974, "Spring Spirit," 1974; "Freedom Lost;" "Rhythm" (nude), 1973; "Bathing" (nude), 1975; others. Awards: 2nd Prize Sculpture, 1975, Salmagundi Club, Richman Sculpture Award, 1975, 76, 77; Honorable Mention, Sculpture, Grand National Exhibition, American Artists Professional League, 1979; Elliot Liskin Sculpture Prize, Knickerbocker Artists, NYC, 1981; numerous others. Member: Salmagundi Club, NYC, from 1974; Society of Animal Artists, NYC, 1975; American Artists Professional League, NYC, from 1977; and Artists Fellowship Inc., NYC, from 1977. Taught: Lecturer, "Western Bronzes and the Art of Bronze Casting," Oct. 17, 1978, Huntsville Museum of Art, Huntsville, AL. Address in 1983, Huntsville, AL.

RUBINS, DAVID KRESZ.
Sculptor, lithographer, and teacher. Born Sept. 5, 1902. Studied: Dartmouth College; Beaux-Arts Institute of Design, NY; Ecole des Beaux-Arts, Julian Academy, Paris; and with James E. Fraser. Awards: Fellowship, American Academy in Rome, 1928; prize, Architectural League, 1932; National Institute of Arts and Letters Grant for Sculpture, 1954. Work: Minneapolis Institute of Art; John Herron Art Institute; Indiana Univ.; Archives Bldg., Washington, DC (in collaboration). Exhibited: Architectural League, 1933; National Academy of Design, 1933; Indiana Artists Annual, 1936-70. Taught: Professor emeritus, sculpture, anatomy, drawing, John Herron Art School, Indianapolis, IN, from 1935. Address in 1982, Indianapolis, IN.

RUBY, LAURA.
Sculptor and printmaker. Born in Los Angeles, CA, December 7, 1945. Studied at University of Southern California, B.A., 1967; San Francisco State College, 1969,

M.A.; University of Hawaii, 1978, M.F.A. Awards: Redondo Beach Festival of the Arts, California, 1973, 74; La Mirada Fiesta de Artes, California, 1974; First Annual Exhibition of Poets and Artists, GA, 1981. Exhibitions: Artists of Hawaii, 1974, 75, 77, 79, and 80; Monterey Park Art Association Competition, California, 1974; University of Hawaii Gallery, 1975; LaGrange College Art Gallery, GA, 1981; Westwood Clay National, Downey Museum of Art, CA, 1981; others. Taught: University of Hawaii, Honolulu, from 1977; Chaminade University, Honolulu, 1980-81. Address in 1982, Honolulu, HI.

RUCKSTULL, FREDERIC WELLINGTON.
Sculptor, lecturer, and writer. Born Breitenbach, Alsace, May 22, 1853. Pupil of Boulanger and Lefebvre, Julian Academy, Paris; and with Mercie, at the Rollins Academy. Member: National Sculpture Society, 1893; NY Architectural League, 1894; National Institute of Arts and Letters; NY Municipal Art Society; Brooklyn Society Artists. Awards: Honorable mention, Paris Salon, 1888; medal, Columbian Exp., Chicago, 1893. Positions: Secretary, committee for erection of Dewey Arch, 1898; chief of sculpture, St. Louis Exp., 1904. Work: "Evening," life-size marble, Metropolitan Museum, NY; equestrian statue, "Gen. J. F. Hartranft," Harrisburgh, PA; "Gen. Wade Hampton," Columbia, SC; "Confederate Monument," Baltimore; "Defense of the Flag," Little Rock, AR; "Women's Monument," Columbia, SC; "John C. Calhoun," "Wade Hampton," and "U. M. Rose," the Capitol, Washington; "Solon," "Goethe," "Franklin," "Macaulay," Library of Congress, Washington; "Wisdom" and "Force," Appellate Court, NY; "Three Partisan Generals Monument," Columbia, SC; "Confederate Monument," Salisbury, NC; "Soldiers' Monument," Jamaica, New York City; "Mercury Teasing Eagle of Jupiter," St. Louis; Pennsylvania Soldier Monument, Petersburg, VA; "Phoenicia," NY Customs House; "Minerva," Liberty Monument, Battlefield of Long Island; "America Remembers," Civil War Monument, Stafford Springs, CT. Address in 1933, Brooklyn, NY. Died in 1942.

RUDNICK, JOEL.
Sculptor. Award: Mrs. Lindsey Bennett Prize, 1974, National Sculpture Society.

RUDY, CHARLES.
Sculptor. Born York, PA, Nov. 14, 1904. Studied: Penna. Academy of Fine Arts; pupil of Charles Grafly and Albert Laessle. Member: Fellowship, Penna. Academy of Fine Arts; National Sculpture Society; National Academy of Design. Awards: Cresson Traveling Fellowship, Penna. Academy of Fine Arts, 1927 and 1928; Guggenheim Foundation Fellowship, 1942; gold medal, National Sculpture Society, 1973; others. Work: Penna. Museum of Fine Arts; Brookgreen Gardens; Philadelphia Museum, PA; Carnegie; Metropolitan Museum of Art, NY; Edgar Fahs Smith Memorial, Public School of York, PA; Shipley Memorial, Masonic Temple, York, PA; plus many commissions. Exhibited: Penna. Academy of Fine Arts, 1928-68; Whitney, 1936-53; Metropolitan Museum of Art, 1950; National Academy of Design, 1950-71; Art Insti-

tute of Chicago, 1939-52; others. Taught: Head of sculpture dept., Cooper Union, 1931-41; instructor of sculpture, Penna. Academy of Fine Arts, 1950-52; Philadelphia Museum College of Art, 1960-62. Address in 1982, Ottsville, PA.

RUEHLE, JON.
Sculptor and graphic artist. Born in Oakland, CA, in 1949. Studied pre-med and anthropology, and printmaking at University of California, Berkeley; DeYoung Museum, San Francisco, bronze casting; Vianello Foundry, San Leandro. Expeditions: Four months in Sierra Nevadas; six months in Amazon and Andes. Exhibited: National Academy of Design; Maxwell Gallery, San Francisco; others. Member: Society of Animal Artists; National Wildlife Federation; Audubon Society; Audubon Artists; Allied Artists; Safari Club. Specialty: North American wildlife. Media: Bronze and stone; graphics. Address in 1983, Sebastopol, CA.

RUGGLES, THEO ALICE.
See Mrs. H. H. Kitson.

RUHL, JOHN.
Sculptor. Born in NY, April 14, 1873. Pupil of Metropolitan Museum Art School, John Ward Stimson, and F. E. Elwell in NY. Address in 1910, 1389 Washington Ave.; h. 463 East 136th St., NYC.

RULE, GALLAGHER.
Sculptor. Born in Oklahoma City in 1930. Self-taught in art. Studied commercial art by correspondence; later earned degrees in engineering. Multi-lingual; employed in Switzerland and Spain; operated large cattle farm. Specialty is traditional portraits in bronze. Represented by Troy's Gallery, Scottsdale, AZ. Address in 1982, Ponca City, Oklahoma.

RUMBOLD-KOHN, ESTELLE.
Sculptor and painter. Studied: School of Fine Arts, St. Louis, the California School of Fine Arts, San Francisco, and later at the Art Students League of NY under Saint-Gaudens. Works: Stone group over entrance and wooden groups in interior of Meeting House, Society of Ethical Culture, NY; two stone figures, on the old Evening Post Building, NY. Awards: Spalding prize ($1,000), Art Institute of Chicago, 1925; first prize, Chicago Art Exhibition, 1926. Media: Wood, stone, and ivory. Address in 1929, 40 West 59th Street, NYC.

RUMOHR, LOIS.
Sculptor. Born in Bakersfield, California, in 1922. Studied at Art Center College of Design, Los Angeles; with sculptor Ralph Rathbone Preston; also studied anatomy, mold making, casting, patina application. Specialty is statuettes of Western Apache of Whiteriver, Arizona, and other figures. Works in bronze. Member, Women Artists of the American West. Participates in invitational exhibitions. Exhibits at Thor's Royal Danish Restaurant and Gallery, Fort Lauderdale, FL; Sanders Galleries, Tucson, AZ. Address in 1982, Arcadia, California.

RUMSEY, CHARLES CARY.
Sculptor. Born in Buffalo, NY, in 1879. Studied in Boston

Art School and later in Paris; with Bela Pratt and Paul Wayland Bartlett. Exhibited at National Sculpture Society, 1923. He worked principally in bronze, and modeled many statues of race horses. Nephew of Seward Cary, the sculptor. In collections of Whitney; Brooklyn; Cleveland; friezes at approach to Manhattan Bridge & Pelham Bay Park, NYC; Victory Statue, Brooklyn, NY. Died in Long Island, NY, Sept. 21, 1922.

RUMSEY, DANIEL LOCKWOOD.
Sculptor. Born in Buffalo, NY, 1900. Address in Buffalo, NY, 1934. (Mallett's)

RUNGIUS, CARL.
Sculptor, painter, and engraver. Born in Berlin, Germany, Aug. 18, 1869. Pupil of Paul Meyerheim in Berlin; came to US in 1894. Member: Associate, National Academy of Design, 1913; National Academy of Design, 1920; Salmagundi Club; National Arts Club; Society of Men who Paint the Far West; Society of American Animal Painters and Sculptors; American Federation of Artists. Exhibitions: National Academy of Design, 1898-1943; Penna. Academy of Fine Arts, 1910-34; Art Institute of Chicago. Awards: Vezin prize, Salmagundi Club, 1922; Plimpton prize, Salmagundi Club, 1923; Speyer Memorial prize, National Academy of Design, 1925; Carnegie prize, National Academy of Design, 1926, and Saltus medal, 1929. Specialty, American big game painting. Address in 1953, 33 West 67th St., NYC; summer, Banff, Alberta, Canada.

RUNNING DEER, MARY.
(Mary Lee Townsend). Sculptor and painter. Born in Ethel, OK, January 18, 1931. Studied at Art Instr. Inc., 1941-43, with Rockwell, John Witecomb, Howe, also with Hutton Webster. Commission: Three oil portraits, Levey's Dept. Store, 1970. Exhibitions: Wildlife Show, Gallery American West, Scottsdale, AZ, 1971; one-woman show, Mankato State College, Minn., 1971; Kermezaar, El Paso Art Museum, 1971-73; Art Shows, 1972-74 and Sculpture 2, 1974, Heard Museum, Phoenix, AZ. Awards: Second Prize Sculpture, 2nd Prima Co. Fair, 1971; First Prize Sculpture, 1973 and First Prize People's Choice Ribbon Sculpture, Pima Co. Fair, 1975. Media: Oil and clay.

RUPPERSBERG, ALLEN.
Sculptor. Born in Cleveland, OH, 1944; moved to California, 1962. Studied: Chouinard Art Institute, Los Angeles, B.F.A., 1966. One-man exhibitions: Eugenia Butler Gallery, Los Angeles, 1969; Pomona College Art Gallery, Claremont, CA, 1972; Stedelijk Museum, Amsterdam, 1973. Group exhibitions: 24 Young Los Angeles Artists, Los Angeles County Museum of Art, 1971; Documenta 5, Kassel, Germany, 1972; Southland Video Anthology, Long Beach Museum of Art, California, 1975; San Francisco Museum of Art, 1976; Smithsonian National Collection of Fine Arts, 1977; others. Address in 1977, Santa Monica, CA.

RUSH, JOHN.
Carver. Born in 1782. Son of William Rush. Worked with him carving figureheads. Active in Philadelphia. Died there on January 2, 1853.

RUSH, JON N.

Sculptor and educator. Born in Atlanta, GA, September 24, 1935. Studied at School of the Art Institute of Chicago, 1953-55; Cranbrook Academy of Art, Bloomfield Hills, MI, B.F.A., M.F.A., with Tex Schiwetz. Work in Columbus Museum of Art, OH; others. Has exhibited at Bundy Art Gallery, Waitsfield, VT; Detroit Institute of Fine Arts, MI; Flint Art Institute; others. Received Detroit Foundry Prize, Michigan Artists Show, Detroit Sculpture Foundry; Tiffany Foundation Grant for Sculpture. Teaching sculpture at University of Michigan, from 1962. Works in stainless steel, cor-ten steel, and bronze. Address in 1982, Dexter, MI.

RUSH, WILLIAM.

Sculptor. Born in Philadelphia, July 4, 1756. Apprenticed as a maker of figure-heads for ships under Edward Cutbush. Notable among these were the figures "Genius of the U.S." and "Nature" for the frigates "U.S." and "Constellation," and of celebrities such as Rousseau, Franklin and Penn for other vessels. The figure of the "Indian Trader" for the Ship "William Penn" excited great admiration in London, where carvers sketched it and made casts of the head, while the figure of a river-god, carved for the ship "Ganges," is said to have been worshipped by the Hindus on her calls to Indian ports. His "Tragedy" and "Comedy," done for the first Chestnut Street Theater, may now be seen at the Forrest Home at Phila.; his "Leda and the Swan," originally placed before the first waterworks on the site of the City Hall, was later moved to Fairmount, where a bronze replica—he himself worked in nothing but wood and clay—has since replaced it. For the first Custom House he designed the much admired figure of "Commerce;" for the permanent bridge at Market Street those of "Commerce" and "Agriculture;" for St. Augustine's Church a representation of the Crucifixion. Also carved portrait busts, anatomical models and ideal figures such as the well-known "Nymph of the Schuylkill." Among a large number of statues executed by him the most notable was that of Washington, purchased by the city in 1814 and still on exhibition in Independence Hall, Philadelphia. He served in the Revolutionary Army. Died in Philadelphia, 1833.

RUSS, HORACE ALEXANDER.

Sculptor, painter, craftsman, and teacher. Born Logtown, MS, Jan. 25, 1887. Studied: Tulane University; Louisiana State University; Columbia University; also a pupil of Penna. Academy of Fine Arts. Member: Southern States Art League; New Orleans Art Association; New Orleans Art League; New Orleans Arts and Crafts Club; Gulf Coast Art Association. Address in 1953, New Orleans, LA.

RUSSELL, CHARLES MARION.

Sculptor, painter, and illustrator. Born March 19, 1864, in St. Louis, MO. Moved to Montana in 1880. Self-taught. An experienced cowboy, he created many thousands of paintings and over 100 bronzes. Had 28 one-man shows in NYC; Chicago; London. In collections of Amon Carter Museum of Western Art, Fort Worth, TX; Buffalo Bill Cody Center, Wyoming; Montana Historical Society; The

Trigg-C. M. Russell Gallery, Great Falls; Norton Gallery, Shreveport; Woolaroc Museum, Bartlesville. Created mural, State Capitol, Helena, MT. Wrote books, including, *Trails Plowed Under*. Died Oct. 24, 1926, in Great Falls, MT.

RUSSELL, WALTER.

Sculptor, painter, and writer. Born Boston, May 19, 1871. Pupil of Albert Munsell and Ernest Major in Boston; Howard Pyle at Wilmington; Laurens in Paris. Member: Spanish Academy of Arts and Letters; Society of Arts and Sciences, (president). Award: Special mention, Turin Exposition, Italy, 1900. Specialty, portraits of children. Work: "The Might of Ages," an allegory, "A Southern Rose," Dallas Museum of Art. Art editor, *Collier's Weekly*, 1897. War correspondent and illustrator for *Collier* and *Century*. Author and illustrator of "The Sea Children;" "The Bending of the Twig;" "The Age of Innocence;" "The Universal One;" "Salutation to the Day;" "The New Electric Theory;" and "Russell Genero-Radiative Concept." Address in 1933, Washington, CT. Died May 19, 1963.

RUSSIN, ROBERT I.

Sculptor, painter, craftsman, and teacher. Born August 26, 1914. Studied: Beaux-Arts Institute of Design; College of City of NY. Member: Sculptors Guild; American Institute of Architects (Assoc.); Audubon Artists; National Sculpture Society; American Association of Univ. Professors. Awards: Prizes, Arizona Fine Arts Fair, 1947, 1949; Wyoming State Fair, 1950; Lincoln Sesquicentennial Medal, US Congress, 1959; Charles GB Steel Sculpture Award, Penna. Academy of Fine Arts, 1966; Order of Duarte, Sanchez, and Mella, by Pres. Joachim Balaguer, Dominican Republic, 1977. Work: US Post Office, Evanston, IL, Conshohocken, PA; carvings and plaques for numerous buildings at Univ. of Wyoming; mural, Park Hotel, Rock Springs, WY. Exhibited: Art Institute of Chicago; Denver Art Museum; Joslyn Art Museum; Nelson Gallery of Art; Kansas City Art Institute; Penna. Academy of Fine Arts; Colorado Springs Fine Arts Center; National Academy of New Orleans Arts and Crafts; Architectural League; Fairmount Park, Philadelphia; Philadelphia Art Alliance; NY World's Fair, 1939; Oakland Art Gallery; Syracuse Museum of Fine Arts; Penna. Academy of the Fine Arts Sculpture Biennial, Philadelphia, 1966; Galleria d'Art Modern, Santo Domingo, 1976-77; others. Position: Associate Professor of Art, Univ. of Wyoming, Laramie, WY. Address in 1982, Laramie, WY.

RUST, EDWIN C.

Sculptor, etcher, and art administrator. Born in Hammonton, CA, December 5, 1910. Studied: Cornell University; Yale University, B.F.A., and with Archipenko, Milles. Member: National Sculpture Society. Work: College of William and Mary; St. Regis Hotel, NY; U.S. Court House, Washington, DC. Exhibited: Whitney Museum, 1940; Carnegie Institute, 1940; Metropolitan Museum of Art, 1942; Virginia Museum of Fine Arts, 1938; Philadelphia Museum of Art, 1940, 49; Brooks Memorial Museum, 1950, 52. Taught: Associate Professor of Sculpture, 1936-43, Head of Fine Arts Department, 1939-43, Col-

lege of William and Mary, Williamsburg, VA; Director of Memphis Academy of Arts, from 1949. Director, Memphis Academy of Arts, 1949-75, emeritus director, from 1975. Address in 1982, Memphis, Tenn.

RUTKOWSKI, JAMES.
Sculptor. Born in Detroit, MI, 1946. Studied: Wayne State University, B.F.A.; Cranbrook Academy of Art, M.F.A. Exhibitions: Detroit Artists Market (two-person), 1973; Ball State University, Muncie, Indiana, 1973; Kent State University, OH, (Blossom Outdoor Sculpture Show), 1973; Studio San Giuseppe, Cincinnati, OH (Biennial); Willis Gallery, Detroit, 1974; Michigan Focus, Detroit Institute of Fine Arts, 1974-75. Address in 1975, Birmingham, MI.

RUTMAN, HERMAN S.
Sculptor, painter, designer, and teacher. Born in Russia, June 1, 1889. Studied: Philadelphia Museum School of Industrial Art; Penna. Academy of Fine Arts; Temple University; Barnes Foundation. Awards: Fellow, Penna. Academy of Fine Arts. Work: City Hall, Philadelphia, PA. Exhibited: National Academy of Design, 1940; Penna. Academy of Fine Arts, 1936-46; Butler Art Institute; Woodmere Art Gallery. Address in 1953, Philadelphia, PA.

RYAN, SALLY.
Sculptor and painter. Born in NYC, July 13, 1916. Exhibited: Paris Salon, 1934, 35; Royal Academy, London, 1935; Royal Scottish Academy, 1935, 36; one-man exhibitions include the Cooling Gallery, London, 1937; Am.-British Art Center, 1950. Member: National Sculpture Society. Address in 1953, Redding, CT. Died in 1968.

RYDEN, FLEMING.
Sculptor. Born in Ringamala, Sweden, 1869. Pupil of Art Institute of Chicago and Art Students League, NY. Address in 1898, Chicago, IL.

RYDEN, HENNING.
Sculptor, draftsman, and painter. Born Sweden, Jan. 21, 1869. Pupil of Art Institute of Chicago; studied in Berlin and London. Member: Salmagundi Club, 1908; American Federation of Arts. Award: Honorable mention, P.-P. Exp., San Francisco, 1915. Work in: American Numismatic Society. Address in 1933, NYC. Died in 1939.

RYERSON, MARY McILVAINE.
Sculptor. Born Philadelphia, PA. Pupil of Saint-Gaudens, Solon Borglum and Fraser. Address in 1933, Sherwood Studios, 58 West 57th Street, NYC. Died in 1936.

S

SAAR, BETYE.
Sculptor and collage artist. Born in Los Angeles, CA, July 30, 1926. Studied at University of California, Los Angeles, BA; University of Southern California; Long Beach State College; San Fernando Valley State College. Commissions: Poster design, Los Angeles Bicentennial, 1979. Exhibited: Sculpture Annual, 1970; Whitney Museum of American Art, NYC; Los Angeles County Museum of Art, 1972; Smithsonian Institution, Washington, DC, 1977; San Francisco Museum of Modern Art, 1977; Studio Museum, Harlem, NYC, 1980. Noted for her graphics and assemblages. Address in 1982, Los Angeles, CA.

SAARINEN, LILIAN.
Sculptor. Studied with Heinz Warneke, Albert Stewart, Brenda Putnam, Maija Grotell. Works: Bas-reliefs, foundations, US Post Office, Carlisle, Kentucky, and Bloomfield, Indiana; Crow Island School, Winnetka, Illinois; Toffenetti Restaurant, Chicago; Jefferson National Expansion Memorial, St. Louis, Missouri; Detroit Federal Reserve Bank; J. L. Hudson's Northland Shopping Center; International Business Machines collections. Awards: National Association of Women Artists, 1937, 47; Washington, DC Art Fair, 1943; Detroit Institute of Art, 1954. Authored and illustrated *Who Am I?*, Reynal and Hitchcock, 1946. Address in 1982, 224 Brattle Street, Cambridge, MA.

SABATINI, RAPHAEL.
Sculptor and teacher. Born in Philadelphia, PA, November 26, 1898. Studied: Penna. Academy of the Fine Arts; also under Fernand Leger, Antoine Bourdelle, Constentin Brancusi, and Charles Grafly. Member: Fellowship, Penna. Academy of Fine Arts; Artists Equity Assn. Commissions include a frieze for the Fine Art Building, in Phila., 1926; Mother Mary Drexel Chapel, Langhorn, PA, 1929. Exhibited: Sesquicentennial, at Phila., 1926; Golden Gate Exposition, San Fran.; Penna. Academy of the Fine Arts Annual. Taught: Professor of painting and sculpture, Tyler School of Art, Temple University, 1936-66, professor emeritus, from 1966. Awards: Limback Foundation Award for distinguished teaching, 1962; 400th Anniversary of Michelangelo Award, American Institute of Italian Culture. Address in 1982, Melrose, Park, PA.

SABO, IRVING.
Sculptor and designer. Born in New York City, March 27, 1920. Studied at Cooper Union School, 1940. Has exhibited at Walker Art Center, Minneapolis, 1957; New England Annual, Silvermine Guild Artists, New Canaan, CT, 1974, 76-79; Aldrich Museum, Ridgefield, CT, 1978; others. Awards from Olivetti Foundation; Silvermine Guild; others. Member of Sculptors Guild; Silvermine Guild; others. Taught at Cooper Union Art School, 1947-50; Brooklyn Museum Art School, 1950-54. Works in wood. Address in 1982, Westport, CT.

SAFER, JOHN.
Sculptor. Born in Washington, DC, September 6, 1922. Work in Baltimore Museum of Art, MD; Corcoran Gallery of Art, Washington, DC; Philadelphia Museum of Art, PA; San Francisco Museum of Art. Has exhibited at High Museum, Atlanta, 1978; Milwaukee Art Center. Address in 1982, Rockville, MD.

SAHLER, HELEN GERTRUDE.
Sculptor. Born Carmel, NY, in 1877. Pupil of Art Students League of New York; Enid Yandell and H. A. MacNeil. Exhibited: Architectural League; New York Municipal Art Society; National Academy of Design; National Sculpture Society; Panama-Pacific International Exp., 1915; Penna. Academy of Fine Arts. Work: Relief of Dr. George E. Brewer, Medical Center, medal of Edward P. York, Numismatic Museum, NYC; relief, Dr. Percy S. Grant, St. Mark's Church, Fall River, MA; Brush Memorial, Hackley Chapel, Tarrytown, NY. Member: National Association Women Painters and Sculptors; MacDowell Club; NY Municipal Art Society; Conn. American Federation of Art; Art Workers Club; Alliance; American Federation of Arts. Address in 1933, NYC. Died in 1950.

SAINT-GAUDENS, ANNETTA JOHNSON.
(Mrs. Louis Saint-Gaudens). Sculptor. Born Flint, OH, September 11, 1869. Pupil of Columbus Art School, Art Students League of New York under Twachtman and Saint-Gaudens. Exhibited: Penna. Academy of Fine Arts, 1924. Member: National Association of Women Painters and Sculptors. Awards: McMillin prize, National Association of Women Painters and Sculptors, 1913; honorable mention and silver medal, Pan-California Exp., San Diego, 1915. Work in Boston Museum of Art; Columbus Gallery of Fine Arts. Address in 1933, Windsor, VT. Died in 1943.

SAINT-GAUDENS, AUGUSTUS.
Sculptor. Born in Dublin, Ireland, March 1, 1848. Family moved to US same year. At age 13 apprenticed to stone cameo cutter and studied drawing at Cooper Institute. In 1864 changed employment to Jules LeBrethon and changed art school to National Academy of Design, where he began to model from life. In 1867 went to Paris to study at Petite Ecole, and later Ecole des Beaux-Arts under Jouffroy; cut cameos to earn living. Spent about 4 years studying in Rome. Located in NYC in 1873, anxious to complete the Farragut Statue. In 1876 he was engaged on his portrait bust of Chief Justice Taney for the Supreme Court Room. By 1885 Saint-Gaudens had

tested his abilities and had tasted success, after earlier years of poverty. Prominent works include the Shaw Memorial, Boston; the Lincoln Statue, Chicago; the Adams Memorial and many other important works. Represented in permanent collections of Metropolitan Museum of Art; Penna. Academy of Fine Art; Corcoran Art Gallery; Luxembourg, Paris; etc. Memorial collection of casts of his works in Cornish, NH, presented by Mrs. Saint-Gaudens to State of New Hampshire and open to the public. Died in Cornish, August 3, 1907.

SAINT-GAUDENS, LOUIS.
Sculptor. Brother of Augustus. Born in New York on January 1, 1854. Pupil of Augustus Saint-Gaudens. He studied in Paris. Modeled a "Faun" and "St. John" for the Church of the Incarnation, NY; and others statues, including lions at Boston Public Library; facade (6 statues), Union Station, Washington, DC; Homer, Library of Congress; Pipes of Pan, Museum Modern Art. He worked in his brother's studio and assisted him with most of his work. Awarded silver medal, Pan-American Exposition, Buffalo, 1901. Member: National Sculpture Society. Died March 8, 1913.

SAINT-GAUDENS, PAUL.
Sculptor, craftsman, and writer. Born Flint, OH, June 15, 1900. Pupil of Frank Applegate, O. L. Bachelor, Arnold Ronnebeck, Archipenko; also Boston Museum of Fine Arts School; British Academy, Rome; Julian Academy, Grande Chaumiere, Paris, France. Exhibited: Nationally and internationally. Contributor to *Craft Horizons*. Member: Boston Society Arts and Crafts; New York Society Craftsmen; Chicago Art Guild; American Federation of Arts. Address in 1953, Windsor, VT.

SAINT-LANNE, LOUIS.
Sculptor. Born in France, 1871. Member: National Sculpture Society, 1907. Address in 1933, 432 West 22nd St., New York, NY.

SAITO, SEIJI.
Sculptor. Born in Utsunomiya, Japan, 1933. Studied at Tokyo University of Art, BFA sculpture, MFA stone carving; Brooklyn Museum Art School; stone carving with Kametaro Akashi, granite carving with Odillio Beggi. Has exhibited at National Sculpture Society, NYC; National Academy of Design; Brooklyn Museum of NY. Awarded certificate of merit, National Academy of Design annual, 1973; others. Fellow of the National Sculpture Society. Works in stone, bronze, wood. Address in 1982, 925 Union Street, Brooklyn New York.

SAKAOKA, YASUE.
Sculptor and instructor. Born in Himaji-City, Japan, November 12, 1933, and is now a permanent resident of the US. Studied: Rinehart Institute of Sculpture, 1963-65; also with Fredrick Litman, Michel Russo, Manuel Izquierdo, and Jan Zach; Aoyama Gakuin Univ., Japan; Reed College; Univ. of Oregon. Awards: Playground sculpture, Albany, OR, 1960; International Alutrusan Award; Fellowship to Rinehart Institute of Sculpture, Baltimore, MD. Collections: South Hill Park, South Hill, VA; Parkside Gardens, Baltimore, MD. Exhibitions: Rine-

hart Institute Annual, Baltimore, 1964, 65; International Gall. Exhibition, Baltimore, 1965; others. Member: National Art Education Association; Virginia Art Education Assoc.; Southern Association Sculptors Inc. Teaching: Instructor, Univ. of OR, 1961-63; instructor of sculp., MD Institute, 1963-65; assistant professor of art, St. Paul's College, Lawrenceville, VA, from 1965. Media: Marble, bronze, and steel. Address in 1976, Lawrenceville, VA.

SALDIBAR, P.
Sculptor. Born in 1907. Address in 1934, West Haven, Conn. (Mallett's)

SALEMME, ANTONIO.
Sculptor and painter. Born in Gaeta, Italy, November 2, 1892. Student at Boston Museum of Fine Arts and afterwards abroad; with Angelo Zanelli; Artists Equity. Member of National Sculpture Society and New York Architectural League. Exhibited at National Sculpture Society, 1923; General International Exhibition, Salon des Tuileries, Paris, France, 1932, 34, 35; Penna. Academy of Fine Arts, 1930-50; Yellow Box Gallery, NYC, 1980. Works: Bronze statue, "Prayer," Newark Public Library; portrait, Mr. W. A. Read, Robert Stein and Stanley Kimmel. Media: Oil, watercolor; bronze, terracotta. Address in 1982, Easton, PA.

SALERNO, CHARLES.
Sculptor and teacher. Born in Brooklyn, NY, August 21, 1916. Studied at the Academie Grande Chaumiere, Paris; Escuela Pintura Y Escultura, Mexico City; State University, NY, teaching certificate. Exhibited: Museum of Modern Art, 1950; American Pavilion, at the Brussels World's Fair, Belgium, 1958; New York World's Fair, 1964; a one-man show at the Weyhe Gallery, NY; and a retrospective at the Sculpture Center, NY, 1975. Awards: Purchase Prize, Staten Island Museum, 1959; Louis Comfort Tiffany, Foundation Fellowship for Sculpture, 1948; Margaret Hirsch-Levine Prize in sculpture, Audubon Artists Annual, 1971. Member: National Sculpture Society; National Academy of Design; and Audubon Artists (director). Taught: Assistant professor of sculpture at City College, NYC, 1961-74, and the National Academy of Design, 1978-80. Works primarily in stone. Address in 1982, Melbourne, FL.

SALERNO, VINCENT.
Sculptor and illustrator. Born Sicily, Italy, February 10, 1893. Pupil of A. Stirling Calder, Francis C. Jones, Hermon A. MacNeil; National Academy of Design; Beaux Arts Institute. Awards: Bronze medal, Louisiana Purchase Exposition, St. Louis, MO, 1904; silver medal, Panama-Pacific International Exposition, San Francisco, CA, 1915. Works: Portraits, Justice Hendrick, Supreme Court, NYC; John B. Stanchfield, NYC. Specialty, portraiture. Exhibited at National Sculpture Society, 1923. Address in 1929, 50 East 34th Street, h. 1919 Seventh Ave., New York, NY.

SALTZMAN, WILLIAM.
Sculptor and painter. Born in Minneapolis, MN, July 9, 1916. Studied at University of Minnesota, B.S., 1940.

Work in Minneapolis Institute of Art; Walker Art Center; Joslyn Museum, Omaha; welded sculpture and candelabra, B'nai Abraham Synagogue, Minneapolis; copper relief sculptures, Adath Jeshurun Synagogue, Minneapolis; others. Has exhibited at Art Institute of Chicago, Paintings and Sculpture; Contemporary American Painting, Whitney Museum of American Art; others. Member of National Society of Mural Painters and Sculptors. Address in 1982, Minneapolis, MN.

SALVATORE, VICTOR D.
Sculptor, painter, and teacher. Born Italy, July 7, 1885. Pupil of Charles Niehaus and A. Phimister Proctor. Member: National Sculpture Society, 1913; Artists Aid Society; Architectural League of NY; Century Association. Awards: Bronze medal, St. Louis Exp., 1904; silver medal, P.-P. Exp., San Francisco, 1915; Barnett prize, National Academy of Design, 1919; honorable mention, Art Institute, Chicago, 1919; honorable mention, Concord Art Association, 1920. Work: Head of a Child, Metropolitan Museum of Art; Head of Child, Brooklyn Museum of Art; Head of Girl, Museum of Art, Portland, OR; James Fenimar Cooper, Hall of Fame, NY. Exhibited at National Sculpture Society, 1923. Address in 1933, 8 Mac Dougal Alley; h. 25 Washington Square, North, New York, NY; h. "Swanswick," Springfield Centre, Otsego Co., NY. Died in 1965.

SAMARAS, LUCAS.
Sculptor and painter. Born in Kastoria, Greece, September 14, 1936. Became a US citizen in 1955. Studied at Rutgers Univ., BA, 1959, with A. Kaprow and G. Segal; Columbia Univ., with M. Shapiro, MA, in art history, specializing in Byzantine art. Early works were pastels, paintings, drawings, and figurative sculptures made with rags dipped in plaster. Later made roughly textured boxes and reliefs utilizing found objects such as spoons and forks. The artist also participated in the happenings of Kaprow, Robert Whitman, and Claes Oldenberg. Worked in environmental sculptures; a well-known one is a reconstruction of his bedroom in NJ at the Green Gallery, NY, 1964. His later works consist of polaroid self-portraits and other photographic work. Exhibited: Art Institute of Chicago, 1967 and 74; The Obsessive Image, Institute of Contemporary Art, London, 1968; Dada, Surrealism and Their Heritage, Museum of Modern Art, NY, 1968; Documenta, Kassel, Germany, 1968, 72; Retrospective, Museum of Contemporary Arts, Chicago, 1971; Whitney Museum of American Art, 1972, 74; plus numerous others. Address in 1982, 52 West 71st St., NYC.

SAMERJAN, GEORGE E.
Sculptor, painter, designer, teacher, and lecturer. Born in Boston, MA, May 12, 1915. Studied at Otis Art Institute, 1940-41; Chouinard Art Inst., 1933; and with Alexander Brook and Willard Nash. Member: Calif. Water Color Society; Art Dir. Club, Los Angeles. Awards: Prizes, American Institute of Graphic Arts, 1941; Los Angeles Advertising Club, 1940; Art Fiesta, San Diego, 1938; Calif. Water Color Society, 1943; Santa Cruz Art League, 1942; med., Oakland Art Gallery, 1940. Work: San Diego Fine Arts Society; Hospital, Lexington, KY; American

Red Cross; murals, US Post Office, Maywood, Culver City, CA. Exhibited: National Academy of Design, 1941; Virginia Museum of Fine Art, 1940, 42, 43; Penna. Academy of Fine Art, 1938-40, 43; American Water Color Society, 1941, 42; Calif. Water Color Society, 1938-42; Denver Art Museum, 1941, 42; San Fran. Art Association, 1940-42; San Diego Fine Art Society, 1938-42; Los Angeles Museum of Art, 1939, 41, 42; New Haven Paint and Clay Club, 1941; Washington Water Color Club; Corcoran Gallery of Art; Riverside Museum; Oakland Art Gallery; Los Angeles County Fair, 1938, 39, 41; Calif. State Fair, 1939-41; Santa Paula, Calif., 1942-45; Santa Barbara Art Museum; Laguna Beach Art Association; Grand Central Art Gallery; Seattle Art Museum; Los Angeles Art Association; Santa Cruz Art League; Calif. Institute of Technology; Liege, Belgium; Paris, France. Position: Art Director, Los Angeles (CA) Times, from 1946. Address in 1982, Katonoh, NY.

SAMPSON, CHARLES A. L.
Sculptor. Born in Boston, MA, 1825. Apprenticed as a ship carver in Bath, ME, by G. B. McLain; opened his own shop in 1852 which thrived after the Civil War. Personally carved over thirty figureheads, only four of which are known to survive. Died in Bath ME, Jan. 1, 1881.

SAMUELS, EDWARD GEORGE.
Sculptor and painter. Born in NYC, November 8, 1941. Studied at State University of NY, New Paltz, painting with Ilya Bolotowsky, 1960-63; with Ben Johnson, Woodstock Studio, 1964-65; Boston Museum School, 1965-66. Work in Whitney Museum of American Art; others. Has exhibited at Milwaukee Art Center; Chicago Art Institute; Tokyo Museum of Modern Art; others. Silver and gold sculpture commissioned by Erica Jong, 1975; gold miniatures, commissioned by Jasper Johns, NY. Teaching metal working at New York University. Work in precious metals, marble; oil and acrylic. Address in 1982, 170 Varick St., NYC.

SANABRIA, ROBERT.
Sculptor. Born in El Paso, TX, August 20, 1931. Studied at University of Maryland, BA, 1965, MFA, 1979. Work in Wichita Art Museum, KS; Tweed Museum of Art, Duluth, MN; Mississippi Museum of Art, Jackson; abstract concrete sculptures, City of Philadelphia; others. Has exhibited at Heidenberg Gallery, Washington, DC; Regul Gallery, Chicago; Allied Artists of America 68th Annual, National Arts Club, NY; others. Taught sculpture at Art League Workshops, Alexandria, VA, 1975-78. Member of Artists Equity Association. Address in 1982, Washington, MD.

SANDBACK, FREDERICK LANE.
Sculptor. Born in Bronxville, NY, August 26, 1943. Studied at Yale University, BA, 1962-66, School of Art and Architecture, 1966-69, BFA and MFA. Work in Museum of Modern Art; Whitney Museum of American Art; National Gallery of Canada, Ottawa, Ontario; Kunsthalle, Basel, Switzerland; others. Has exhibited at Kunsthalle, Berne, Switzerland; Whitney Museum of American Art;

Museum of Modern Art; others. Address in 1982, c/o John Weber Gallery, NYC.

SANDER (or SANDERS), A. H. (MRS.).
Sculptor. Born in 1892. Work in Dallas Museum of Fine Art. Executed pair bronze bookends titled "Indian Head," cast by Griffoul, Newark, NJ. Address in 1948, Fort Worth, TX.

SANDER, SHERRY.
Sculptor. Born in McCloud, California, in 1941. Moved to Rocky Mountain area in 1963. Extensive study of animals in Alaska, Yukon, Northwestern US, Africa. Specialty is statuettes of animals; works in bronze. Has exhibited at Cowboy Hall of Fame Wildlife show, 1979; C. M. Russell Museum, solo. Awards include merit and best three-dimensional, Kalispell, Montana, 1980. Member of Society of Animal Artists. Represented by Trailside Galleries, Scottsdale, AZ; Sportsman's Edge, NYC. Address in 1982, Kalispell, Montana.

SANDER, TOM.
Sculptor and painter. Born in Bellingham, Washington, in 1938. Studied at University of Oregon. Worked as taxidermist, guide. Traveled from Alaska to the Yukon and to Africa. Work in C. M. Russell Museum; American Wildlife Foundation; Cincinnati Museum of Natural Science. Member: Society of Animal Artists. Reviewed in *Art West*, winter, 1978. Salt Creek Graphics, Casper, WY, publishes his work; represented by Settlers West Galleries, Tucson, AZ. Media: Oil and watercolor. Specialty: Wildlife. Address in 1982, Kalispell, Montana.

SANDERS, ADAM ACHOD.
Sculptor and teacher. Born Sweden, June 15, 1889. Pupil of Beaux Arts Institute of Design, NY. Exhibited: National Sculpture Society. Member: Brooklyn Society of Artists; Bronx Artists' Guild; Society of Independent Artists; Brooklyn Painters and Sculptors Society; American Federation of Artists. Work: "Abraham Lincoln," Lincoln Memorial Collection, Washington, DC; "Beethoven," Library of the Friends of Music, NY; Schubert medal, commemoration Schubert Centenary,, presented to Artur Brodanzky, Conductor of the Metropolitan Opera House, NY. Publications: *The Theory of Altoform*, 1945; *Cosmogony*, 1950. Address in 1953, Brooklyn, NY.

SANDERS, GERALD L.
Sculptor. Born in Krum, Texas, about 1924. Self-taught in art. Has lived on ranches and ridden in rodeos. Employed by Bell Telephone; worked part-time in taxidermy and making gunstocks (carved). Turned full-time to sculpture in 1981. Specialty is statuettes of Old West figures and wildlife; works in bronze. Exhibits with Texas Cowboy Artists Association. Address in 1982, Tampa, Texas.

SANDERS, ISAAC.
Sculptor. Address in 1919, 975 Union Ave., Bronx, NYC.

SANDERSON, RAYMOND PHILLIPS.
Sculptor. Born in Bowling Green, MO, July 9, 1908. Studied at Art Institute of Chicago; Kansas City Art Institute; and with Raoul Josset, in Chicago, IL. Work: Monument, Bisbee, AZ; carvings, US Maritime Comm. vessels; Hotel Westward Ho, Hotel Adams, Phoenix, AZ. Exhibi-

ted: New York World's Fair, 1939; Denver Art Museum, 1939-42; Tempe (AZ) State Teachers College, 1946 (one-man); Retrospective, AZ State Univeristy, 1973. Taught: Associate Professor of sculpture, Arizona State College, 1947-53. Media: Bronze and wood. Address in 1982, Oroville, CA.

SANDOR, JOSEPHINE BEARDSLEY.
Sculptor. Born in NYC, May 21, 1914. Studied at Grand Cent. School Art; Columbia University School Painting and Sculpture, with Oronzio Maldarelli, 1953-58; Art Students League, with William Zorach and John Hovannes, 1949-52 and Robert Beverly Hale. Exhibitions: National Sculpture Society, NY, 1961; Audubon Artists, NY, 1962 and 63; National Academy Design, NY, 1963-72; Allied Artists, NY, 1969 and 74; one-woman show, Pen and Brush, 1971. Awards: Sydney Taylor Mem. Award for Sculpture, Knickerbocker Artists, 1964, Award of Merit Medal for Sculpture, 1973; Pen and Brush Solo Award, 1970. Media: Stone and terra cotta. Address in 1982, Ramapo Park, Oakland, NJ.

SANFORD, EDWARD FIELD JR.
Sculptor. Born NY, April 6, 1886. Studied: Art Students League of New York; National Academy of Design; Julian Academy in Paris; Royal Academy in Munich. Member: National Sculpture Society; Beaux Arts Institute; National Arts Club. Exhibited at National Sculpture Society, 1923. Work: "Pegasus," bronze statuette, Rhode Island School of Design, Providence; Charles Francis Adams Memorial, Washington and Lee University, Lexington, VA; Commemorative Tablet, Columbia University; Core Memorial, Norfolk, VA; 2 pediments, 4 colossal figures and 20 bas-reliefs panels, State Capitol, Sacramento, CA; finial figure and 3 colossal Gothic figures for the Alabama Power Co. Building. Director, Dept. of Sculpture, Beaux Arts Institute of Design, 1923-25. Noted for his monumental sculpture. Address in 1933, New York, NY. Died in 1951.

SANFORD, MARION.
Sculptor. Born in Guelph, Ontario, Canada, February 4, 1904. Studied: Pratt Institute Art School; Art Students League; and with Brenda Putnam. Awards: Guggenheim fellowship, 1941-1943; National Academy of Design, 1943; Allied Artists of America, 1945; National Academy of Design, 1947; Meriden, CT, 1949; American Artists Professional League, 1945; Springfield Mass. Museum of Art, 1957. Collections: Penna. Academy of Fine Arts; Corcoran Gallery of Art; Brookgreen Gardens, SC; Warren (Penna.) Public Library; Haynes Collection, Boston; Norton Hall, Chautauqua, NY; Warren General Hospital, Penna.; Cosmopolitan Club, NY; Trinity Memorial Church, Warren, Penna.; St. Mary's Chapel, Faribault, Minn.; US Post Office, Winder, Georgia. Exhibited: Whitney Museum, 1940; Penna. Academy of Fine Art, 1943-46; National Acad. of Des., 1938-46; Allied Artists of America, 1944. Audubon Artists, 1945. Illustrated "The Sculptor's Way," 1942. Address in 1953, NYC.

SANGER, ANTHONY.
Sculptor. Born in Wuerttemberg, 1835. Living in Boston in 1860.

SANGER, WENDOLIN.
Sculptor. Born in Wuerttemberg, 1838. Living in Boston in 1860.

SANGERNEBO, ALEXANDER.
Sculptor. Born Estonia, Russia, May 1, 1856. Member: Indiana Art Club. Work in: Murat Temple, Lincoln Hotel, Union Station, Guaranty Building, Blind Institution, St. Joan of Arc Church, Ayres Building, Indiana National Guard Armory, and Indiana Theatre, Indianapolis; County Court House, Lebanon, IN. Address in 1929, Indianapolis, IN. Died there in 1930.

SANGERNEBO, EMMA EYLES.
(Mrs. Alexander Sangernebo). Sculptor and painter. Born Pittsburgh, PA, Janury 23, 1877. Pupil of William Forsyth. Member: Indiana Art Club; National League of American Pen Women; American Artists Professional League; Hoosier Salon. Work: Figure panels, Loew's Theatre, historic panel, Washington High School, Indianapolis; Elizabeth Bartnett Hitt memorial portrait tablet, Indianapolis (IN) Woman's Department Club; Garfield Park, Indianapolis; Union Building, Bloomington, IN. Address in 1953, Indianapolis, IN.

SANGUINO, LUIS.
Sculptor. Member of the National Sculpture Society. Address in 1982, Mexico City, Mexico.

SARDEAU, HELENE.
(Mrs. Georg Biddle). Sculptor. Born in Antwerp, Belgium, July 7, 1899. Studied: Art Students League; New York School of American Sculpture. Award: Architectural League, 1934. Collections: Croton-on-Hudson High School; US Post Office, Greenfield, MA; Fairmount Park, Philadelphia, PA; National Library, Rio de Janeiro; Supreme Court, Mexico City; Whitney Museum of American Art; Tel-Aviv Museum, Israel. Exhibited: Salon d'Automne, Paris, 1928; Museum of Modern Art, 1940; Penna. Academy of Fine Art, 1946; Metropolitan Museum of Art, 1940; Carlen Gallery, 1946; many others. Died in 1968.

SARET, ALAN DANIEL.
Sculptor. Born on December 25, 1944. Studied at Cornell University, architecture, under Peter Kahn and Alan Atwell; Hunter College, under Robert Morris. Exhibited: Bern Kunsthalle, 1969; Whitney Museum of American Art, 1969, 81; Museum of Modern Art, NYC, 1975-76. Awards: Guggenheim Fellowship, 1969. Taught: University of Calif., Irvine, 1978. Address in 1982, 854 West 181st Street, NYC.

SARGENT, MARGARETT W.
Sculptor. Born Wellesley, MA, August 31, 1892. Pupil of Woodbury and Borglum. Member: National Association of Women Painters and Sculptors. Address in 1933, c/o Mrs. L. A. S. McKean, Prides Crossing, MA; Wellesley, MA; summer, c/o Mrs. Moon, Dorset, VT.

SARGENT, MARY, F. (MRS. WILLIAM DUNLAP).
Sculptor and etcher. Born in Somerset, PA, July 4, 1875. Studied at Penna. College for Women; Art Students

League; Teachers College, Columbia Univ.; in Paris, London; and with William P. Robbins, Paul Bornet, St. Gaudens, Wickey, and others. Member: Conn. Academy of Fine Art; National Association of Women Artists; Silvermine Guild of Artists. Awards: Medal, Penna. College for Women. Work: Metropolitan Museum of Art; Library of Congress; Brooklyn Museum; Brooks Memorial Art Gallery; G. W. V. Smith Art Museum. Exhibited: Library of Congress, 1944; National Academy of Design, 1943; National Association of Women Artists, 1942, 43; Silvermine Guild Artists, 1940-43; Conn. Academy of Fine Art, 1940-42, 46; New England Print Association, 1941; Society of Liberal Arts, Omaha, NE, 1944; Morton Gallery, 1939 (one-woman); Studio Guild, 1940. Illustrated in *House Beautiful* magazine. Lectures: History and Appreciation of Etching. Address in 1953, Westport, CT.

SARNOFF, LOLO.
Sculptor and collector. Born in Frankfurt, Germany, January 9, 1916; US citizen, 1943. Study: Reimann Art School, Berlin, Germany, graduate, 1936; art history at Universities of Berlin & Florence, 1934-37. Work: Corning (NY) Museum of Glass; National Academy of Science, Washington, DC; The David Kreeger College, Washington, DC; Joseph H. Hirshhorn, Washington, DC; many other public and private colleges in US and abroad. Commission: "The Flame," J. F. Kennedy Center; "The Spiral Galaxy," National Air and Space Museum; "Today and Tomorrow," Federation of National Mortgage Association, all in Washington, DC. Exhibited: Agra Gallery, Washington, DC, solo, 1968; Corning (NY) Museum, solo, 1970; National League of American Pen Women, Washington, DC, 1977; Gallery Two, Woodstock, VT, 1977; Alwin Gallery, London, solo, 1981; Gallery von Bartha, Basel, Switzerland, solo, 1982; many other group and solo shows in US and abroad, from 1968 to present. Awards: "Medaglia d'Oro," Accademia Italia Delle Arti e del Lavoro; American Artists of Renown; many other honors. Member: Artists Equity Association; American Pen Women; Washington Women's Art Center; Trustee, Corcoran Gallery, Washington, DC. Collector of: 20th century drawing, painting, sculpture; 18th century Faience; 18th century porcelain, 1948-61, cardiovascular physiology and research, various capacities including research assistant, inventor, corp. VP, Pres.; author of many scientific articles. Media: Light sculpture, plexiglass, fiberoptics, acrylic. Dealer: Gallery K, Washington, DC; Gallery Two, Woodstock, VT; Gallery von Bartha, Basel, Switzerland. Address in 1983, 7507 Hampden Lane, Bethesda, MD.

SARTELLE, MILDRED E.
Sculptor, who exhibited at the Penna. Academy of Fine Arts, Philadelphia, 1924. Address in 1926, Wellesley, MA.

SARTORI, GIOVANNI.
Sculptor. Worked in Italy c. 1774-1793; in Philadelphia about 1794.

SAUBERT, TOM.
Sculptor and painter. Born in Missoula, Montana, in 1950. Studied at Eastern Montana College; Cleveland Institute of Art. Specialty is contemporary and historical

Northwestern people and wildlife. Reviewed in *Art West*, September 1981. Represented by Ponderosa Gallery, Kalispell, MT; Sanders Gallery, Tucson, AZ. Address since 1973, Kalispell, Montana.

SAULS, FREDERICK INABINETTE.
Sculptor and painter. Born in Seattle, WA, March 22, 1934. Studied at Stanford University, BA; California College of Arts and Crafts, MFA Program; University of California, MA. Work in Museum of Modern Art, Skopje, Yugoslavia; Ithaca Museum of Art, Cornell University, NY; others. Exhibited at San Francisco Museum of Modern Art Annual, CA; Paris Biennale, Paris Museum of Modern Art; UNESCO International traveling exhibition of modern art, 1968. Received grand prize American Sculptors, Paris Museum of Modern Art, 1963; others. Medium: Bronze and aluminum. Address in 1982, c/o Studio C, Hollywood, CA.

SAULTER, LEON.
Sculptor. Born in Wilno, Poland, March 31, 1908. Member: Council Allied Art. Work: Horace Mann Jr. High School; Sierra Bonita High School; mem., Hollywood Cemetery. Exhibited: Los Angeles Mus. of Art, annually; Contemporary Art Gallery; University of Calif. at Los Angeles; Occidental College. Address in 1953, Los Angeles, CA.

SAUNDERS, HENRY DMOCHOWSKI.
Sculptor. Born in Vilna, Lithuania, October 14, 1810. Educated in Vilna; studied sculpture in Paris about 1846. Lived in London before coming to America. Lived in Philadelphia 1853-57; in Washington, DC, 1857-60. Works include busts of Kosciuszko and Pulaski, now in the Capitol, Washington, DC. Exhibited at Pennsylvania Academy, 1853-57. Died in Poland in 1863.

SAVAGE, FRANCES (MRS. CURTIS).
Sculptor. Address in 1934, New York. (Mallett's)

SAVAGE, JIM.
Woodcarver and painter. Born near Sioux Falls, South Dakota, in 1932. Employed as carpenter and construction crew foreman for many years. Began woodcarving in 1967. Represented in Favell Museum (piece titled "Grabbin' Leather"); Kern Collectibles, Stillwater, MN. Exhibited at National Woodcarvers Convention; Phippen Memorial Outdoor Show. Awarded Best of Show, National Woodcarvers Convention; gold medal, sculpture, Phippen Memorial Outdoor Show, 1975. Specialty is Western figures and Indian portraits. Works in wood; creates color effects from inlays of various kinds of wood. Address in 1982, Sioux Falls, South Dakota.

SAVAGE-JONES, TRUDI.
Portrait sculptor. Born in Roselle Park, NJ, in 1908. Studied at Grand Central School of Art; Penna. Academy of Fine Art; Clay Club, NY. Award: Penna. Academy of Fine Art, 1930.

SAVILLE, BRUCE WILDER.
Sculptor and teacher. Born Quincy, MA, March 16, 1893. Pupil of Boston Normal Art School under Dallin, and of Mr. and Mrs. Kitson. Member: Copley Society; Boston Artists League; Boston Art Club; National Sculpture Society; NY Architectural League; National Arts Club; American Federation of Artists. Work: "John Hancock Statue," Quincy, MA; 3 memorials to Civil War veterans, Vicksburg (MS) National Park; Collingwood Memorial, Kansas City, MO; Potter Memorial, Annapolis; Memorial Angel, Quincy High School, Memorial Tablet to Unknown Dead of World War, Quincy; Canadian Infantryman, St. John's; Victory figure, in collaboration with Mossman at Chicopee, MA; Forrester Memorial, Worcester, MA; Memorial of 3 wars at Palmyra, ME; Memorial to 104th Infantry, 16th Division, Westfield, MA; World War Memorial, Upton, MA; World Memorial, Ravenna, OH; Peace memorial, Civil War, State House grounds, Columbus, OH; Mack Memorial, OH State University; 3 panels, Jeffrey Manufacturing Co. Office Building and OH State World War Memorial, Columbus, OH; World War Memorials, Glens Falls, NY and Quincy, MA; John Quincy Adams Memorial, Wollaston, MA; Anthony Wayne Memorial, Toledo, Ohio; memorial group, "Until the Dawn," White Chapel, Memorial Park, Detroit, MI. Exhibited at National Sculpture Society, 1923. Instructor at OH State University and Columbus (OH) Art School. Address in 1933, Santa Fe, NM. Died in 1938.

SAVOY, CHYRL LENORE.
Sculptor. Born in New Orleans, LA, May 23, 1944. Studied at Louisiana State University, BA (art); Academy of Fine Arts, Florence, with Gallo and Berti; diploma di Profitto, Universita degli Studi de Firenze, Florence; Wayne State University, MFA (sculpture). Work includes sculpture design, Our Lady Star of the Sea, Cameron, LA; monumental sculpture, Rural Dominican Missionaries, Abbeville, LA; others. Has exhibited at Detroit Institute of Arts Museum; New Orleans Museum of Art; Arkansas Art Center; others. Received honorable mentions, 13th Annual Piedmont Painting and Sculpture Exhibition; others. Media: Wood and metal. Address in 1982, Mamou, LA.

SAWYER, CONWAY.
Sculptor. Born in New York. Address in 1935, Wilmington, DE. (Mallett's)

SAWYER, EDWARD WARREN.
Sculptor. Born Chicago, IL, March 17, 1876. Pupil of J. P. Laurens, Injalbert, R. Verlet, Fremiet, A. Rodin; Art Institute of Chicago; Academie Julien. Awards: Bronze medal, St. Louis, 1904; prize Pan-Pacific, 1914; silver medal, Ghent, 1913; honorable mention, Paris Salon, 1914. Work: Medallions, "American Indians," American Numismatic Society, NY; Art Institute of Chicago; MA Historical Society, Boston; US Mint, Philadelphia; Musee Luxembourg, Paris. Exhibited at National Sculpture Society, 1923. Address in 1929, Clos Vert, La Palasse, Toulon, Var., France. Died in 1932.

SAYEN, HENRY LYMAN.
Sculptor and painter. Born in Philadelphia, PA, April 25, 1875. Pupil of Penna. Academy of Fine Arts. Member: Phila. Sketch Club. Specialty, mural decorations. Address in 1903, 206 South 43rd St., Philadelphia, PA.

SAZEVICH, ZYGMUND.
Sculptor. Born in Kovno, Russia, 1899. Went to the San Francisco Bay area in 1923. Studied at University of Kazan, Russia; University of Calif. at Berkeley, c. 1923; Calif. School of Fine Arts, San Francisco. Exhibited: San Francisco Museum of Art; Mills College; San Francisco Art Association Annuals; Golden Gate International Exposition, San Francisco; Museum of Modern Art, Sao Paulo, Brazil; others. Taught: Calif. School of Fine Arts, c. 1947-65; Mills College, Oakland, c. 1947-58. Much of his early work was direct-carved in wood. Died in San Francisco in 1968.

SCALA, JOSEPH (A).
Sculptor and museum director. Born Queens, NY, February 20, 1940. Studied at C. W. Post College, BS (math), 1962; Cornell University, MFA, (sculpture), 1971. Work in Metropolitan Museum of Art, NY; others. Exhibited: Brooklyn Museum, NY; Albright-Knox Gallery, Buffalo; Everson Museum, Syracuse, NY; others. Award: Young Sculptors Competition, Sculptors Guild, NY, 1969; others. Address in 1982, Syracuse, NY.

SCANGA, ITALO.
Sculptor. Born in Lago, Italy, June 6, 1932; US citizen; went to San Diego, Calif., 1978. Studied at Michigan State University, BA 1960 and MA, 1961. Exhibited: Whitney Annuals, NYC; Museum of Modern Art; Mus. of Contemporary Art, Chicago; Corcoran; Albright-Knox, Buffalo; L.A. Inst. of Contemporary Art; San Diego Museum of Art; Walker Art Center, Milwaukee; galleries in NYC, San Fran., Wash., DC, and Detroit. Awards: 48th Annual Wisconsin Painters and Sculptors show; Howard Foundation Grant, Brown University Cassandra Foundation Grant. Taught: University of Wisconsin at Madison, 1961-64; Rhode Island School of Design, 1964-66; Penna. State, 1966-67; Tyler School of Art, Temple University, Phila., 1967-78; University of Calif. at San Diego, from 1978. In collections of Metropolitan Museum of Art, NYC; Fogg, Cambridge, MA; Phila. Museum of Art; Rhode Island School of Design; Penna. Academy of Fine Arts. Address in 1982, La Jolla, Calif.

SCARAVAGLIONE, CONCETTA.
Sculptor. Born NYC, July 9, 1900. Pupil of Boardman Robinson, Robert Laurent; National Academy of Design; Art Students League. Awards: Prix de Rome, 1947-50; Penna. Academy of Fine Arts; American Academy Arts and Letters. Exhibited: Museum of Modern Art; Art Institute of Chicago; Fairmount Park, Philadelphia, PA; World's Fair, 1964; Vassar College, Poughkeepsie, NY; others. In collections of Whitney; Penna. Academy of Fine Arts. Exhibited: New York World's Fair, 1939. Member: National Association of Women Painters and Sculptors; Salons of America; National Sculpture Society. Address in 1970, NYC. Died in 1975.

SCARPITTA, G. SALVATORE CARTAINO.
Sculptor. Born Palermo, Italy, Feb. 28, 1887; settled in NY in 1910. Studied at Instituto di Belli Arti, Palermo, and in Rome. Member: National Sculpture Society; Allied Artists of America; New York Architectural League; New York Numismatic Society; decorated by Japanese and Cuban governments. Awards: Barnett prize, National Academy of Design, 1914; second mention, collaborative competition, New York Architectural League, 1913; honorable mention, Art Institute of Chicago, 1923. Work: Sculpture in Church of St. John the Evangelist, Los Angeles, CA. Address in 1933, Los Angeles, CA.

SCARPITTA, SALVATORE.
Sculptor. Born in NYC, 1919. Studied in Italy, 1936-59. Work in Stedelijk Museum, Amsterdam, Holland; Albright-Knox Art Gallery, Buffalo, NY; Los Angeles Co. Museum of Art; Museum of Modern Art, NY; others. Has exhibited at Corcoran Gallery of Art, Washington, DC; Art Institute of Chicago; others. Taught: Visiting critic, Maryland Institute, College of Art, from 1966. Address in 1982, c/o Leo Castelli Gallery, NYC.

SCHAAF, ANTON.
Sculptor. Born in Milwaukee, WI, February 22, 1869. Pupil of Shirlaw, Cox, Beckwith, Saint-Gaudens; Dewing; Cooper Union; National Academy of Design under Ward. Member: National Sculpture Society; Architectural League of NY; American Federation Arts. Work: Statue of General Ord, Vicksburg National Military Park; Glendale Monument and Ridgewood Monument, Brooklyn, NY; Shaw Memorial, Woodlawn Cemetery, NY; Meredith portrait tablet, Tompkins Avenue Church, Central Congregational Church War Memorial, 14th Inf. soldiers monument and Ridgewood monument, all in Brooklyn, NY; Glendale Brooklyn War Memorial; Ericson Memorial, NY. Exhibited at National Sculpture Society, 1923. Address in 1933, 1931 Broadway, New York, NY; h. 397 East 17th St., Brooklyn, NY. Died in 1943.

SCHABACKER, BETTY BARCHET.
Sculptor and painter. Born in Baltimore, MD, August 14, 1925. Studied: Dominican College, San Rafael, CA; Connecticut College, New London; Coronado School of Fine Arts, CA, with Monty Lewis; with Gerd and Irene Koch, Ojai, CA. Work: Erie Zoo, PA; corporate and gallery collections. Exhibitions: Museum of Modern Art, Paris, 1961-63; Butler Institute, annuals, 1964-77; Chautauqua Exhibitions, 1966-74; Audubon Artists, 1967-79; Nat. Acad. of Design, solos and 150th annual; Artists Equity, Phila.; others. Member: National Watercolor Society; Audubon Artists; Society of Animal Artists; others. Media: Steel silhouettes; watercolor, acrylic, and cloth collage. Address in 1983, Erie, PA.

SCHAEFER, GAIL.
Sculptor. Born in NJ, June 11, 1938. Studied at Art Students League with Kaz-Simon, 1977-80; Ramapo College, NJ, BA, 1979; National Academy of Design, Lucchesi scholarship, 1980-82. Has exhibited at Catherine Lorillard Wolfe National Arts Club, NY; Allied Artists of America, National Academy Galleries, NY; American Academy Institute of Arts and Letters; Salmagundi Club, NY; National Academy of Design; others. Received trustee awards, American Artists Professional League, 1978-80; honorable mention, Salmagundi Club, NY, 1980; William Auerbach-Levy Award, National Academy of Design, 1981. Member of Allied Artists of America; Painters and Sculptors Society of NJ; Portrait

Society of NJ. Works in clay. Address in 1982, Oradell, NJ.

SCHAEFER, HANS.
Sculptor. Born Sternberg, Czechoslovakia, February 13, 1875. Pupil of Kunstgewerbeschule, Vienna, Austria. Member: Chicago Modelers and Sculptors League. Address in 1933, NYC.

SCHAEFER, MATHILDE.
Sculptor. Born in New York City in 1909. Studied with Raoul Josset, Walter Lemcke. Works: International Business Machines; Museum of Northern Arizona; Katherine Legge Memorial, Hinsdale, Illinois.

SCHAEFFLER, LIZBETH.
Sculptor. Born in Sommerville, Mass., October 27, 1907. Studied at Pratt Institute Art School; National Academy of Design; Art Students League; Clay Club, NY; also with Mahonri Young. Works: Church of the Highlands, White Plains, NY. Exhibited: National Sculpture Society, 1936-38, 57, 58, 65; Nantucket Art Association (one-woman); others. Award: New Rochelle Art Association. Address in 1970, Nantucket, MA.

SCHALLINGER, MAX.
Sculptor, painter, and craftsman. Born in Ebensee, Austria, September 26, 1902. Studied at Academy of Fine Art, Vienna; Academy of Fine Art, Munich; Bauhaus, Dessau. Member: Balt. Art Guild. Work: Baltimore Museum of Art; American University, Wash., DC. Exhibited: Int. Craft Exhibition, Paris, 1926; Salzburg, Austria, 1930; one-man: Baltimore Museum of Art, 1938, 45; ACA Gallery, 1947. Position: Instructor, Hood College, Frederick, MD, 1944-47. Address in 1953, 170 East 63rd St., NYC.

SCHARBACH, B. K. (MS.).
Sculptor and watercolorist. Born in Louisville, KY, in 1936. Studied at University of Louisville; University of KY; Parsons School of Design; Art Students League; Silvermine Guild; University of Hartford, (CT) Art School. Exhibitions: NY Council for the Arts Sponsored Show, 1971; Webb and Parsons Gallery, New Canaan, CT, 1979, 80, 82; New England Annual, Silvermine Guild, 1981; SOHO 20 Gallery, NYC, 1981, 82, 83; Lever House, NYC, 1982; others. Received Amidar Memorial Award, Silvermine Guild. Address in 1983, Darien, CT.

SCHEIBE, ROYAL A.
Sculptor. Address in 1924, 819 Astor St., Milwaukee, Wisconsin.

SCHELER, ARMIN A.
Sculptor and educator. Born in Sonneberg, Germany, May 20, 1901. Studied at State School of Applied Art, State Academy of Fine Art, Munich, Germany. Member: National Sculpture Society; Louisiana Teachers Association; New Orleans Art Association. Awards: Prizes, Switzerland, 1923; Delgado Museum of Art; National Sculpture Comp., 1939; med., Paris Exp., 1936; New Rochelle, NY, 1938. Work: Government Office Building, New Orleans, LA; Government Printing Office, Wash., DC; US Post Office, Evanston, IL; Mattawan, NJ. Exhibited: National Academy of Design; Whitney Museum of American Art; Penna. Academy of Fine Art; Paris Exposition, 1937; Delgado Museum of Art, 1943-46; New Orleans Society of Arts and Crafts, 1946. Lectures: "The Meaning and Study of Sculpture." Address in 1953, Baton Rouge, LA.

SCHENCK, MARIE (PFEIFFER) (MRS. FRANK).
Sculptor and art director. Born in Columbus, OH, February 3, 1891. Studied at Cleveland School of Art; Columbus Art School; and with Hugo Robus, John Hussey, Bruce Saville, and others. Member: Columbus Art League; Miami Art League; American Society for Aesthetics. Exhibited: Columbus Art League; Miami Art League. Positions: Art Instructor, Coburn School, Miami, 1938-40; Art Director, City of Miami Beach, Miami Art Center, 1942, from 46. Address in 1953, Miami Beach, FL.

SCHILDT, GARY.
(Lone Bull). Sculptor and painter. Born in Helena, Montana, in 1938. Studied commercial art and photography, City College of San Francisco. Specialty is Western figures, mainly Indians and children, frequently the very old and very young. Has painted "Reservation Series," "Western Series," among other works. Member, Northwest Rendezvous Group. Reviewed in *Art West*, winter 1977. Represented by Western Art Investments, Kalispell, MT. Address in 1982, Kalispell, Montana.

SCHIMMEL, WILHELM.
Woodcarver. Born in 1817. Lived and worked in the area of Carlisle, Newburg, and occasionally Lancaster, Pennsylvania. Made toys, figures, animals, birds; small eagles for mantel and table decorations, larger ones as exterior ornaments. Represented in Abby Aldrich Rockefeller Collection, Williamsburg, VA. Died in Carlisle, Pennsylvanis, in 1890.

SCHLAFF, HERMAN.
Sculptor and painter. Born Odessa, Russia, December 19, 1884. Pupil of School of Fine Arts, Odessa, Russia. Member: American Federation of Arts. Address in 1929, Philadelphia, PA.

SCHLAG, FELIX OSCAR.
Sculptor. Born in Frankfurt-on-Main, Germany, September 4, 1891. Studied at Academy of Art, Munich, Germany. Work: Champaign, (IL) Jr. High School; Bloom Township High School, Chicago Heights, IL; US Post Office, White Hall, IL; designed Jefferson nickel, US Mint, Wash., DC. Exhibited: Art Institute of Chicago; Detroit, MI; NYC; and abroad. Address in 1953, Owosso, MI.

SCHLAM, MURRAY J.
Sculptor. Born in Tyczyn, Austria, May 7, 1911; US citizen. Studied at Langfuhr University, Free City Danzig; Archipenko Art School; New York University, with Professor Ross; Art Students League, with Robert Brackman. Work in Fordham University, Lincoln Center, NY; Museum of Bat-Yam, Israel; others. Has exhibited at Museum of Fine Arts, Argentina; National Museum of Fine Arts, Santiago, Chile; Metropolitan Museum, NY; others. Member, Royal Society of Art, London, fellow. Works in bronze. Address in 1982, Melville, NY.

SCHLANGER, JEFF.

Sculptor. Born in NYC, 1937. Studied at Swarthmore College, BA; Cranbrook Academy of Art, study with Maija Grotell. Work in Museum of Contemporary Crafts, NY; others. Has exhibited at Renwick Gallery, Smithsonian Institution, Washington, DC; Museum of Contemporary Crafts, NY; others. Received Tiffany Foundation Scholarship, 1967; Craftsmen's Fellowship, National Endowment for the Arts, 1973; others. Works in clay and wood. Address in 1982, New Rochelle, NY.

SCHLEMOWITZ, ABRAM.

Sculptor and educator. Born in NYC, July 19, 1911. Studied at Beaux-Arts Institute of Design, NYC, 1928-33; Art Students League, 1934; National Academy of Design, 1935-39. Works: University of Calif., Berkeley; Provincetown (Chrysler); others. Exhibitions: The Howard Wise Gallery, NYC; Claude Bernard, Paris; The Stable Gallery, Sculpture Annuals; Museum of Contemporary Crafts, Collaboration: Artist and Architect; Riverside Museum, 12 NY Sculptors; New School for Social Research, Humanists of the 60's; Museum of Modern Art, Art in Embassies, circ. internationally, 1963-64. Award: Guggenheim Foundation Fellowship, 1963. Taught: Contemporary Art Center, YMHA, NYC, 1936-39; Pratt Institute, 1962-63; University of Calif., Berkeley, 1963-64; distinguished lecturer, Kingsborough College, City University of New York, from 1970. Address in 1982, 139 W. 22nd St., NYC.

SCHLESINGER, LOUIS.

Sculptor. Born in Bohemia in 1874. Member of NY Architectural League. Address in 1926, 51 West 10th Street, New York.

SCHMID, RUPERT.

Sculptor. Born in Munich, Germany, in 1864. Studied at Royal Academy, Munich, in the early 1880's. Came to California c. 1889; active in San Francisco from about 1892. Instructor and director at Mark Hopkins Institute of Art, San Francisco. Works include a marble group symbolizing California for World's Columbian Exhibit, Chicago, 1893; "California Venus," now in Oakland Art Museum, 1894; Memorial Arch, Stanford University, 1900; McKinley Monument, St. James Park, San Jose, California; Ulysses S. Grant statue, Golden Gate Park, San Francisco, 1908. Exhibited at Mechanics' Institute Industrial Exhibitions, San Francisco, 1889-95; World's Columbian Exhibition, Chicago, 1893; others. Executed portrait busts and statues; worked in bronze and marble. Died in Alameda, California, in 1932.

SCHMIDT, AUGUST.

Sculptor. Born in Germany, 1809. Living in Philadelphia in 1850.

SCHMIDT, FREDERICK.

Sculptor. Working in Richmond, VA, in January 1838.

SCHMIDT, JULIUS.

Sculptor. Born June 2, 1923, in Stamford, CT. Earned B.F.A. (1952) and M.F.A. (1955) from Cranbrook Academy of Art (MI); studied with Ossip Zadkine in Paris (1953) and at Academy of Fine Arts, Florence (1954). Taught at Cranbrook; KS City Art Institute; RI School of Design; Berkeley; now at University of Iowa. Awarded Guggenheim (1963). Exhibited at Silvermine Guild, New Canaan, CT (1953); Santa Barbara Museum of Art; Penna. Academy of Fine Arts; Art Institute of Chicago; Walker; Museum of Modern Art; Rhode Island School; Carnegie. In collections of Art Institute of Chicago; Whitney; University of Illinois; Washington University; Museum of Modern Art; SUNY/Oswego and Buffalo; and Albright-Knox. Works in cast bronze and iron. Address in 1982, University of Iowa, Iowa City, IA.

SCHMITT, HENRY.

Sculptor. Born in Mainz, Germany, July 8, 1860; came to America in 1884. Studied in Munich. Member: German Soc. of Christian Arts, Munich; Buffalo Society of Artists. Most of his work was done in Roman Catholic churches in Buffalo. Specialty, ecclesiastical subjects. Died in Buffalo, NY, May 1, 1921.

SCHMITZ, CARL LUDWIG.

Sculptor. Born in Metz, France, September 4, 1900. Studied in Europe; Beaux-Arts Institute of Design, and with Maxim Dasio, Joseph Wackerle, and others. Member: Association of the National Academy of Design; National Sculpture Soc.; Arch. League; Audubon Artists; Allied Artists of America. Awards: Prizes, Syracuse Museum of Fine Art, 1939; National Sculpture Society, 1934, 40; Our Lady of Victory Comp., 1945; Allied Artists of America, 1951; Meriden, CT, 1952; medal, Paris, France, 1937; Penna. Academy of Fine Arts, 1940; Guggenheim Fellow, 1944; American Academy of Arts and Letters grant, 1947. Work: Syracuse Museum of Fine Art; IBM; New York Municipal College; Justice Bldg., US Post Office Dept. Building, Federal Trade Comm. Building, all in Wash., DC; Federal Building, Covington, KY; US Post Office, York, PA; designed, Delaware Tercentenary half-dollar and medal for City Planning; Bar Association medal; Electro-chemical Society medal; other work, Parkchester, NY; Michigan State College. Exhibited: Penna. Academy of Fine Arts, 1934-52; Whitney Museum of American Art, 1936, 38-42, 44; Art Institute of Chicago, 1936-40; Syracuse Museum of Fine Art, 1938-41, 46-51; Corcoran Gallery of Art, 1936, 39; Audubon Artists, 1945, 50, 51; San Fran. Museum of Art, 1935, 36, 41; National Academy of Design, 1934, 35, 42, 44, 48-51; Architectural League, 1936, 42, 44, 49-50; National Sculpture Society, 1934, 39-41, 43, 44, 46-52; Allied Artists of America, 1951. Position: Instructor of Sculpture, Michigan State College, 1947; Art Workshop, NYC, from 1948. Address in 1953, 2231 Broadway; h. 517 East 84th St., NYC. Died in 1967

SCHMOHLE, FRED C.

Sculptor. Born Wurtemburg, Germany, 1847. Died Los Angeles, California, 1922.

SCHMUTZHART, BERTHOLD JOSEF.

Sculptor and educator. Born in Salzburg, Austria, August 17, 1928; US citizen. Studied at Academy of Applied Art, Vienna, Austria; masterclass for ceramics and sculpture.

Work in Fredericksburg Gallery of Modern Art, VA; Christ (wood), St. James Church, Washington, DC; Bacchus fountain, Fredericksburg Gallery; others. Has exhibited at National Collection of Fine Arts, Washington, DC; Franz Bader Gallery, Washington, DC; others. Received first prize, Southern Sculpture, 1966; first prize, silver medal, Audubon Society, 1971. Member of Artists Equity Association. Teaching at Corcoran School of Art, Washington DC, from 1963. Address in 1982, Washington, DC.

SCHMUTZHART, SLAITHONG CHENGTRAKUL.
Sculptor and instructor. Born in Bangkok, Thailand, January 1, 1934; US citizen. Studied at Corcoran School of Art, Washington, DC, diploma sculpture, 1968, diploma ceramics, 1970; University of DC, BA (Fine Arts), 1977. Has exhibited at National Collection of Fine Arts, Washington, DC; Columbus Museum, GA; Corcoran Gallery, Washington, DC; Phillips Gallery, Washington, DC; others. Received Ford Foundation Scholarship in Sculpture. Works in welded steel, woodcarving. Address in 1982, Washington, DC.

SCHNABEL, DAY.
Sculptor and painter. Born in Vienna, Austria, March 1, 1905. Studied painting at the Vienna Academy of Fine Arts; architecture and sculpture in Holland, Italy, and Paris. Exhibitions: Betty Parsons Gallery, NYC, 1947, 51; Denise Rene, 1948; Salon des Realites Nouvelles, Paris, 1948, 49; Stedelijk Mus., Amsterdam, 1949; Whitney Museum Annual, NYC, 1949, 50, 52, 53; Jardin du Musee Rodin, Paris, 1948, 51, 52, 53; Salon de Mai, Paris, 1949, 50, 51, 52, 53; Third Open Air Biennial, Brussels, 1953; Palais des Beaux Arts, Brussels, 1953; Ministry of Reconstruction, Paris, 1954. Address in 1953, 969 Park Avenue, NYC.

SCHNEIDER, JANE.
Sculptor. Studied: Wellesley College; Columbia University; College of New Rochelle. Awards: Sekal Lehn Galleries, 1967; Woman's Club of Larchmont, 1967-68; Medal of Honor, National Association of Women Artists, 1975. Exhibitions: Westchester Art Society, 1970; Silvermine Guild, 1972; Fourteen Sculptors Gallery, New York City, 1974.

SCHNEIDER, NOEL.
Sculptor. Born in NYC, July 31, 1920. Studied at Art Students League, with William Zorach; City University of NY. Has exhibited at Sculpture Center, NY; Salmagundi Club; National Arts Club; Brooklyn Museum, NY; others. Received first prize for sculpture, Lever House; gold medal for sculpture, Salmagundi Club; first prize for sculpture, National Arts Club. Member of Artists Equity Association. Works in welded metal and wood. Address in 1982, Brooklyn, NY.

SCHNEIDERHAN, MAXIMILAN.
Sculptor. Born in Europe, 1844. Came to US in 1870. Worked: Washington, DC; Louisville, Kentucky; St. Louis, Missouri. Died in St. Louis, Missouri, 1923.

SCHNIER, JACQUES.
Sculptor. Born Roumania, December 25, 1898. Studied: Stanford University, AB; University of California, MA; California School of Fine Art. Awards: First sculpture award, San Francisco Art Association, 1928; first sculpture prize, North Western Art Exhibition, Seattle, Washington, 1928; Oakland Art Museum, 1936, medal, 1940, 48; Los Angeles Art Museum, 1934; Institute for Creative Art, University of California, 1963-64. Work: Fountain, San Francisco Playground Commission; Berkeley High School; Ann Buemer Memorial Library, San Francisco; Stanford University Museum; Santa Barbara Museum of Art; Hebrew University, Jerusalem; Oakland Art Museum; Crocker Art Gallery, Sacramento, CA; Smithsonian Institution; designed half-dollar commemorating San Francisco-Oakland Bay Bridge. Publications: Contributor of articles on psychoanalysis and art to *Journal of Aesthetics, Art Criticism, Journal of Psychoanalysis*; others. Lectured at the Menninger Foundations, 1969. Exhibited: Seattle Fine Art Institute, 1927; Art Institute of Chicago; San Francisco Museum of Art, 1934, 36, 39, 50; M. H. de Young Memorial Museum, 1947, 60; National Academy of Design; National Sculpture Society; and many more. Works in bronze and acrylic. Address in 1982, Lafayette, CA.

SCHNITTMANN, SASCHA S.
Sculptor. Born in NYC on September 1, 1913. Studied: Cooper Union Art School; National Academy of Design; Beaux-Arts Institute of Design; Columbia University; Ecole des Beaux-Arts, Paris; and with Attilio Piccirilli, Robert Aitken, and Olympio Brindisi, and others. Commissions: Martin Luther King, Jr., heroic memorial portrait bust four times life size, 1968; Elvis Presley Monument, 1978. Awards: Society of Independent Artists, 1942; City Art Museum of St. Louis, 1942; Junior League Missouri Exhibition, 1942; Kansas City Institute, 1942; Art Institute of Chicago, 1943; Pan-American Architectural Society, 1933; Fraser medal, 1937. Collections: Pan-American Society; American Museum of Natural History; Dayton Art Institute; Moscow State University, Russia; Memorial Plaza, St. Louis, Missouri; Dorsa Building, St. Louis, Missouri. Media: Marble and bronze. Address in 1980, San Jose, CA.

SCHOENFELD, LUCILLE.
Sculptor. Address in 1921, 912 Steiner St., San Francisco, CA.

SCHOENWETTER, FRANCES.
Sculptor. Studied: The Art Institute of Chicago; Illinois Institute of Technology. Exhibitions: Denver Art Museum, Colorado; Provincetown Arts Festival, Massachusetts; ARC Gallery, Chicago, Illinois.

SCHOFIELD, FLORA.
Sculptor and painter. Born in Chicago, IL, March 6, 1880. Studied at Art Institute of Chicago; and in Paris, France. Member: Chicago Society of Artists; Chicago Art Club; New York Society of Women Artists. Awards: Prizes, Art Institute of Chicago, 1929, 31; Wichita Museum of Art, 1939. Work: Detroit Institute of Art. Address in 1953, Chicago, IL.

SCHOFIELD, WILLIAM BACON.
Sculptor. Born in Hartford, Conn, 1864. Died in Worcester, Mass., 1930. (Mallett's)

SCHONHARDT, HENRI.
Sculptor, painter, and teacher. Born Providence, RI, April 24, 1877. Pupil of Julian Academy under Puech, Dubois and Verlet; Ecole des Arts Decoratifs under David and Chevinard. Member: Providence Art Club. Award: Honorable mention, Paris Salon, 1908. Work: "Elisha Dyer Memorial," St. Stevens Church, Providence; "Henry Harrison Young Memorial," City Hall Park, Providence; "Clytie" and "Cadmus," RI School of Design Museum, Providence; "Soldiers' and Sailors' Monument," Bristol, RI; "Col. Sissons Monument," Little Compton, RI. Address in 1933, Providence, RI.

SCHONLAU, REE.
Sculptor. Born in Omaha, Nebraska, in 1946. Studied: University of Nebraska at Omaha; Montaval School of the Arts, San Jose, California. Exhibitions: College of St. Mary, Omaha, 1971; Columbus Gallery of Fine Arts, Ohio, 1973; Solstice Marathon Tribute, Joslyn Art Museum, 1975.

SCHONWALTER, JEAN FRANCES.
Sculptor and painter. Born in Philadelphia, PA. Studied at Moore College of Art, BFA; Penna. Academy of Fine Arts, graduate fellowship. Work at Philadelphia Museum of Art; Brooklyn Museum, NY; Slater Museum, Norwich, CT; others. Has exhibited at Boston Museum Exhibitions; Butler Institute of American Art, Youngstown, OH; National Academy of Design, NY; others. Member of Artists Equity Association of NJ; Society of American Graphic Artists; National Association of Women Artists. Works in bronze and oil. Address in 1983, Roseland, NJ.

SCHRAMM, PAUL H.
Sculptor, painter, and teacher. Born in Heidenheim, Wuerttemberg, Germany, December 22, 1867. Pupil of Gruenenwald, Schrandolph, Kraeutle, McNeil and Arangi. Member: Progredi Art Club. Address in 1906, 46 West 28th St., NYC.

SCHRANKER, LOUIS.
Sculptor, painter, and printmaker. Born in New York City, July 20, 1903. Studied at Educational Alliance, NYC; Cooper Union; Art Students League. Works: Brooklyn Museum; Art Institute of Chicago; Metropolitan Museum of Art; University of Michigan; New York Public Library; Newark Museum; Phila. Museum of Art; Phillips; Toledo Museum of Art; Utica; Wesleyan University. Exhibitions: Contemporary Arts Gallery, NYC; Kleemann Gallery, NYC; New School for Social Research; Artists' Gallery, NYC; Brooklyn Museum, 1943; The Williard Gallery, NYC; Hacker Gallery, NYC; Grace Borgenicht Gallery Inc., NYC; Walker; Whitney; Brooklyn Museum; Metropolitan Museum of Art; Utica; Art Institute of Chicago; University of Michigan. Taught: New School for Social Research, 1940-60; Bard College, 1949-64; University of Colorado, 1953; University of Minnesota, 1959. Living in Conn. in 1970. Died in 1981.

SCHRATTER, MARLIS.
Sculptor. Born in Germany. Came to the United States in 1940. Studied: Baltimore Museum of Art School; Haystack Mountain School of Crafts in Maine. Awards: Boston Society of Arts and Crafts; Brockton Art Association; Cambridge Art Association. Collections: Everson Museum of Art, Syracuse, New York; Massachusetts College of Art, Boston, Massachusetts.

SCHRECKENGOST, DON.
Sculptor, painter, designer, craftsman, and educator. Born in Sebring, OH, September 23, 1911. Studied at Cleveland School of Art; and with Alexander Blazys, N. G. Keller. Member: American Ceramic Society; US Potters Association; Boston Society of Arts and Crafts; The Patteran. Awards: Med., American Ceramic Society, 1946; prizes, Syracuse Museum of Fine Art, 1941; Graphic Art Exhibition, NY, 1940; Albright Art Gallery, 1938; Finger Lakes Exhibition, Rochester, NY, 1940. Work: Rochester Memorial Art Gallery; IBM College; Universitaria de Bellas Artes, San Miguel, Mexico. Exhibited: Nationally and internationally. Contributor to: *American Artist* magazine. Lectures: History of Ceramics; Design; etc. Position: Prof., Industrial Ceramic Design, Alfred University, 1935-45; Art Director, Homer Laughlin China Co., Newell, West Virginia from 1953. Address in 1953, East Liverpool, OH.

SCHRECKENGOST, VIKTOR.
Sculptor and craftsman. Born in Sebring, Ohio, June 26, 1906. Pupil of Cleveland School of Art, Julius Mihalik, and Michael Powolny. Exhibited: Century Progress, Chicago, San Fran., and New York World's Fair; Paris Exposition. Member: Cleveland Society of Artists; New York Architectural League; American Watercolor Society; others. Awards: Annual Exh. of Work by Cleveland Artists and Craftsmen, Cleveland Museum of Art, first prize, 1931, special prize for outstanding excellence, 1932. Work: Ceramics, five pieces, Cleveland Museum of Art. Teaching: Instructor, Cleveland School of Art, from 1930. Address in 1982, Cleveland Heights, OH.

SCHREIBER, GEORGES.
Sculptor and painter. Born in Brussels, Belgium, April 25, 1904. Studied in Berlin, London, Rome, Paris, and Florence. Member: Alliance. Award: Tuthill prize, Twelfth International Exh. of Water Colors, Art Inst. of Chicago, 1932. Address in 1933, 17 East 9th St., NYC.

SCHRERO, RUTH LIEBERMAN.
Sculptor and painter. Born in NYC. Studied at Columbia University, with Oronzio Maldarelli; Art Students League, with George Grosz; Tyler School of Art of Temple University. Has exhibited at National Academy Design Galleries, NY; National Arts Club, NY; others. Received Estelle Goodman Prize, National Painters and Sculptors Society, 1975; Harriet J. Frishmuth Memorial, Catharine Lorillard Wolfe Art Club Annual, 1981. Member of Artists Equity Association of NY; New York Society of Women Artists; Sculptors Association of NJ; Catharine Lorillard Wolfe Art Club; life member, Art Students

League. Works in clay, stone; pastels, and ink. Address in 1982, Edgewater, NJ.

SCHREYVOGEL, CHARLES.
Sculptor, painter, illustrator, and lithographic artist. Born in NYC, 1861. Studied in Munich with Carl Marr and Frank Kirchbach. Worked as office boy; carved meerschaum; was apprenticed to gold engraver; became die sinker: later a lithographer. Traveled in the West sketching various scenes. Award: National Academy, 1900. Work in Metropolitan Museum of Art, CR Smith Collection, Harmsen Collection, Anschutz Collection. Associate member of National Academy, 1901. Works include "Dead Sure," 1902 (oil); "A Beeline for Camp" (oil); "The Last Drop" (bronze); "My Bunkie" (oil); etc. Known chiefly as genre painter; specialty was Western military life. Died in Hoboken, NJ, 1912.

SCHULE, DONALD KENNETH.
Sculptor and instructor. Born in Madison, MN, June 17, 1938. Studied with James Wines, 1964; University of Minnesota, B.F.A., 1964, M.F.A. 1967. Work at Walker Art Center, Minneapolis; Wichita Art Museum, KS; Minnesota Museum of Art, St. Paul. Has exhibited at Walker Art Center, Minneapolis; Phyllis Kind Gallery, Chicago; Allan Stone Gallery, NY; Whitney Museum of American Art, NY; others. Received purchase prizes, Ford Foundation, 1964; National Endowment for the Arts, 1970; first prize, Wichita Art Association. Works in wood and stone. Address in 1982, Dripping Springs, TX.

SCHULENBERG, ADELE.
(Mrs. Charles K. Gleeson). Sculptor. Born St. Louis, MO, Jan. 18, 1883. Pupil of George J. Zolnay; St. Louis School of Fine Arts; Grafly; studied in Berlin at Secessionist School with Funcke. Member: St. Louis Artists Guild. Received bronze medal at Alaska-Yukon-Pacific Exp., Seattle, 1901. Exhibited at National Sculpture Society, 1923. Address in 1933, Kirkwood, MO.

SCHULER, HANS.
Sculptor and painter. Born in Alsace-Lorraine, Germany, May 25, 1874. Pupil of Raoul Verlet in Paris. Member: National Sculpture Society, 1908; Charcoal Club. Awards: Rinehart scholarships in sculpture, 1900, Paris, 1901-1905; third class medal, Paris Salon, 1901; silver medal, St. Louis Exposition, 1904; Avery prize, New York Architectural League, 1915. Work: "Ariadne," Walters Gallery, Baltimore; "Johns Hopkins Monument," Baltimore. Exhibited at National Sculpture Society, 1923. Director, Maryland Institute. Address in 1929, c/o Maryland Institute, Baltimore, MD.

SCHULER, MELVIN ALBERT.
Sculptor and painter. Born in San Francisco, CA, April 29, 1924. Studied: California College of Arts and Crafts, BA, 1946, MFA, 1947; Danish Royal Academy of Fine Arts, Copenhagen, 1955-56. Work at National Collection of Fine Arts, Smithsonian Institution, Washington, DC; Hirshhorn Museum and Sculpture Garden, Washington, DC; Storm King Art Center, Mountainville, NY; others. Works in wood and watercolor. Address in 1982, Los Angeles, CA.

SCHULLER, GRETE.
Sculptor. Born in Vienna, Austria; US citizen. Studied at Academy of Art; Vienna Lyzeum; Vienna Kunstakademie; Art Students League; sculpture with W. Zorach; Sculpture Center, NY. Works: Norfolk Museum Arts and Science, VA; Museum of Natural History, NY; Museum of Science, Boston. Exhibitions: One-man shows Sculpture Center; group shows Allied Artists of Am.; Audubon Artists; Academy of Design; Des Moines Art Center; National Association of Women Artists; National Sculpture Society; Academy Arts and Letters, 1955; University of Notre Dame 1959; Detroit Institute Arts, 1959-60; Penna. Academy of Fine Arts, Phila., 1959-60; 150 Years of American Art, New Westbury Garden, NY, 1960; plus many others. Awards: Sculpture house prize, National Association Women Artists, 1953; Bronze medal of honor from the Knickerbocker Artists, 1959; Silvermine Guild, 1960; first prize for sculpture, 1956; Bronze Carving prize for sculpture, Art League of LI; Pauline Law Prize, Allied Artists of America, 1972; Roman Bronze Foundry Prize, National Sculpture Society, Lever House, 1973, Bronze Medal, 1975; Goldie Paley Prize, National Association of Women Artists, 1975; plus others. Member: Sculpture Center; National Association of Women Artists; George Society; Natural History Museum Club; New York Architectural League. Media: Stone. Address in 1982, 8 Barstow Road., Apt. 7G, Great Neck, NY.

SCHULTZ, ISABELLE.
Sculptor, lecturer, and teacher. Born Baltimore, April 20, 1896. Pupil of Ephraim Keyser and J. Maxwell Miller. Member: Baltimore Handicraft Club. Work: Memorial tablet to W. E. Kelliot, Goucher College, Baltimore; memorial tablet to John T. King, Medical and Chirurgical Bldg., Baltimore; testimonial tablet, Buckingham School, Frederick, MD; portrait relief, Dr. G. W. Carver, Tuskegee Institute, Alabama; and John Gardner Murray, Protestant Episcopal Cathedral, Baltimore, MD. Address in 1933, Baltimore, MD.

SCHULTZE, CARL EMIL ("BUNNY").
Sculptor and comic illustrator. Born in Lexington, KY, May 25, 1866. Educated in Germany. Originated "Foxy Grandpa" series in *New York Herald*, and *American*; "The Nursery Prayer" (bronze). Author "Bunny's Blue Book." Address in 1909, 101 West 78th Street, New York City.

SCHWALBACH, MARY JO.
Sculptor and painter. Born in Milwaukee, Wis., July 8, 1939. Studied at Pine Manor Jr. College, A.A.; University Wis., B.S.; New York University Institute Fine Arts; School Visual Arts; also in Paris and Rome. Works: University Calif. Museum, Berkeley; Jazz Museum, NY; Kellogg State Bank, Green Bay, Wis.; American City Bank, Menomonee Falls, Wis.; Kimberly State Bank, Wis. Comn: Sculpture, 1st Fed. Savings and Loan, Monomonee Falls, 1969; three hockey sculptures, Philadelphia Flyers, The Spectrum, Philadelphia, 1970; sculpture of Mario Andretti, Clipper Mag, NY, 1972. Exhibitions: One-woman shows, Rhoda Sande Gallery, NY, 1969, West Bend Museum Fine Arts, Wis., 1969 and Dannenberg, NY, 1972; retrospective, Bergstrom Museum,

Neenah, Wis., 1970; Beyond Realism, Upstairs Gallery, East Hampton, NY, 1972. Media: Mixed media. Address in 1982, 14 East 80th Street, NYC.

SCHWANEKAMP, ELSA.
Sculptor. Address in 1935, Eggertsville, NY. (Mallett's)

SCHWARTZ, LILLIAN (FELDMAN).
Sculptor and filmmaker. Born in Cincinnati, OH, July 13, 1927. Work at Museum of Modern Art, NY; Moderna Museet, Stockholm, Sweden; Stedelijk Museum of Art, Amsterdam, Holland; Los Angeles Co. Museum of Art; others. Has exhibited at Museum of Modern Art, NY; Metropolitan Museum, NY; Whitney Museum of American Art, NY; Albright-Knox Art Gallery, Buffalo; Grand Palais, Paris; others. Member of Artists Equity Association; National Academy of Television Arts and Science; Society of Motion Pictures and Television Engineers; others. Address in 1982, Watchung, NJ.

SCHWARTZ, RUDOLF.
Sculptor. Born in Germany, he settled in Indianapolis. In 1902 he won the competition for a statue of Governor Pingree, of Michigan. Address in 1910, Herron Art Institute, IN.

SCHWARZ, MARGARET.
Sculptor. Born in NYC, in 1900. Studied sculpture with Solon Borglum and Frederic V. Guinzburg in New York. Works: Dough Boy; portraits of H. S., Jimmy and Herbert; bird fountain, private estate, NY; also dancing figures, in private collections.

SCHWARZ, PAUL.
Sculptor. Born in Detroit, MI, 1946. Studied: Society of Arts and Crafts; Wayne State University. Exhibitions: Forsyth Saga, Detroit, 1973; All Michigan II, The Flint Institute of Arts, 1973; Willis Gallery, Detroit, 1974; Detroit Bank and Trust Artists Invitational, 1974; Michigan Focus, The Detroit Institute of Arts, 1974-75. Member: Society of Arts and Crafts. Address in 1975, 5820 Forsyth, No. 23, Detroit, MI.

SCHWARZOTT, MAXIMILIAN.
Sculptor. He exhibited at the National Sculpture Society.

SCHWEBEL, RENATA MANASSE.
Sculptor. Born in Zwickau, Germany, March 6, 1930; US citizen. Studied at Antioch College, BA, 1953; Columbia University, MFA, 1961; Art Students League, 1968. Has exhibited at Silvermine Guild New England Annual, CT; Wadsworth Atheneum; New Britain Museum; Sculpture Center, NY; National Association of Women Artists, 1983; NYC; others. Received Chaim Gross Foundation Award, 1980; Medal of Honor, National Association of Women Artists, 1981. Member of Sculptors Guild; Audubon Artists; National Association of Women Artists; Connecticut Academy of Fine Arts. Works in stainless steel and aluminum. Address in 1983, New Rochelle, NY.

SCHWEISS, RUTH KELLER.
Sculptor and designer. US citizen. Studied at Wash. University, St. Louis, Fine Arts cert.; Cranbrook Art Acad., Bloomfield Hills, MI, three year int. fellow, sculpture with Carl Milles. Works: Cranbrook Art Museum; plus many private collections. Comn: Life size garden sculpture, comn. by Lawrence Roos, St. Louis, 1965; bear for pool garden, comn. by J. A. Baer, II, St. Louis, 1970; Blachette (six ft. bronze), Founder Monument, St. Charles, Mo., 1972; Children in the Rain, German Council, Hamm., Germany, 1973; Sons of Founders (bronze reliefs), Stix, Baer, and Fuller, St. Louis, 1975. Exhibitions: National Academy Design, NY, 1943; Detroit Art Museum Regional Show, MI, 1943; Pacific Show, Hawaiian Art Museum, Honolulu, 1944; International Art Show, Rotunda Gallery, London, 1973; Ars Longa Gallery, Houston, 1974. Awards: Museum Purchase Prize, Cranbrook Art Museum, 1942; Ruth Renfrow Sculpture Prize, St. Louis Art Museum, 1945; Thalinger Sculpture Prize, St. Louis Artists Guild, 1950. Media: Bronze casting of limited editions from any carved or modeled medium. Address in 1982, St. Louis, MO.

SCHWEITZER, GERTRUDE.
Sculptor and painter. Born in NYC in 1911. Studied: Pratt Institute Art School; National Academy of Design; Julian Academy, Paris. Awards: Philadelphia Watercolor Club, 1936; Norton Art Gallery, 1946, 1947; Montclair Art Museum, 1947, 1952; Society of Four Arts, 1947, 1948, 1950, 1951; Miami, Florida, 1951; American Artists Professional League, 1934, 1953, 1956, 1957; American Watercolor Society, 1933. Collections: Brooklyn Museum; Canajoharie Gallery of Art; Toledo Museum of Art; Atlanta Art Association; Norton Gallery of Art; Hackley Art Gallery; Davenport Municipal Art Museum; High Museum of Art; Witte Memorial Museum; Museum of Modern Art, Paris; Museum of Albi, France; Montclair Art Museum; Philadelphia Art Alliance, 1969; Hokin Gallery, Palm Beach, 1971; numerous others. Address in 1980, Stone Hill Farm, Colts Neck, NJ.

SCHWEIZER, J. OTTO.
Sculptor. Born in Zurich, Switzerland, March 27, 1863. Pupil of Tuiller in Paris; Royal Academy, Dresden; Academy of Fine Arts, and Schilling in Dresden; Art School, Zurich; and in Italy. Member: National Sculpture Society. Exhibited at National Sculpture Society, 1923. Works: "Gen. Muhlenberg," and "James B. Nicholson," Philadelphia; "Gen. von Steuben," Utica, NY, and Valley Forge, PA; Abraham Lincoln and Generals Humphrey, Geary, Hays, Pleasanton, Gregg, PA State Memorial, Gettysburg; Gen. Wells Monument for State of Vermont; Molly Pitcher Monument for State of PA at Carlisle, PA; statue and relief work, "Lincoln," and portraits of Grant, Mead, Sherman, Sheridan, Gregg, Faragut, Hancock, L. Memorial Room, Union League of Philadelphia; "Senator Clay," Marietta, GA; Melchior Muhlenberg with heroic size relief groups, Germantown, PA; Adj. Gen. Stewart, and "Senator George Oliver," Capitol, Harrisburg, PA; equestrian statue of Major Gen. F. W. von Steuben, Milwaukee, WI; portrait bust and symbolic group, "James J. Davis," Moosehart, IL; East Germantown War Memorial; Central High School War Memorial; Schell Memorial, Preston Retreat; Stein Memorial; busts of James J. Davis and G. P. Morgan, all at Philadelphia, medals of Gov. Brumbaugh and Gov. Sproul of PA; Mexican War medal and World War medal, both for the State of Penna. Address in 1953, Philadelphia, PA. Died in 1955.

SCOFIELD, WILLIAM BACON.
Sculptor. Born Hartford, CT, Feb. 8, 1864. Pupil of Gutzon Borglum. Member: American Federation of Arts. Work: "Good and Bad Spirit," bronze, Worcester Art Museum. Author of "Verses," and "Poems of the War;" "A Forgotten Idyl;" "Sketches in Verse and Clay." Address in 1929, Worcester, MA.

SCOLAMIERO, PETER.
Sculptor, painter, illustrator, and teacher. Born in Newark, NJ, Aug. 12, 1916. Studied at Newark School of Fine and Industrial Arts, and with Louis Schanker. Awards: Brooklyn Mus., 1950. Work: Brooklyn Mus.; murals, Camp Kilmer, NJ. Exhibited: American Federation of Arts traveling exh., 1950; Exchange Exh. to Germany, 1952; Phila. Print Club, 1950, 51; Brooklyn Mus. 1950-52; Hacker Gal., 1951; Peridot Gal., 1950; Univ. of Arkansas, 1950; Rabin and Krueger Gal., Newark, 1951 (one-man); Newark Mus., 1952. Address in 1953, 14 Central Ave, Newark, NJ; h. 520 East 12th St., NYC.

SCOMA, MARIO.
Sculptor. Exhibited "The Birthday" in Annual Exhibition, 1915, of the Penna. Academy of the Fine Arts, Philadelphia. Address in 1926, Brooklyn, NY.

SCOTT, ARDEN.
Sculptor. Born in Port Chester, NY, October 21, 1938. Exhibited at Whitney Museum Biennial, 1973; 112 Green Street Gallery, NY, 1974; O. K. Harris Gallery, NY; others. Received Guggenheim Fellowship, 1981. Teaching sculpture at Bard College, from 1975. Works in wood. Address in 1982, 73 Leonard St., NYC.

SCOTT, CHARLES ARTHUR.
Sculptor. Born in San Diego, California, December 2, 1940. Studied art at San Diego State College, BA, 1968; University of California, Santa Barbara, MFA, 1970. Taught at University of California and at Western Washington University. Traveled in Europe; worked on sculpture at foundry in Italy. Specialty is 18th and 19th century Western American themes; Western landscape. Works in bronze. Has exhibited at American Art Gallery; Seattle, WA; Western Art Association, Ellensburg, WA; others. Teaching: Instructor, Western Washington University, Bellingham, 1970-77. Medium: Bronze. Address in 1982, Bellingham, Washington.

SCOTT, CHARLES THOMAS.
Sculptor and painter. Born in Chester County, PA, in 1876. Pupil of Penna. Museum School of Industrial Art, Philadelphia. Address in 1926, Philadelphia, PA.

SCOTT, MARTHA (FITTS).
Sculptor and printmaker. Born in Washington, DC, November 11, 1916. Works: Jewish Community Center, Cleveland, Ohio; Cooperstown Art Association, NY. Exhibitions: Artists of the Western Reserve Traveling Exhibition, Cleveland Museum Art, 1965; one-woman exhibition, Baltimore Museum Art, 1969; National Exhibition Prints and Drawings, Okla. Art Center, 1969-74; National Print Exhibition, Hunterdon Art Center, Clinton, NJ, 1971, 73, and 75; 2nd Miami Graphics Biennial, International Print Exhibition, Fla., 1975. Awards: First Prize Award, MD Institute Art, 1936; Purchase Prize and Awards, Jewish Community Center, Cleveland, 1962, 63, 64; Purchase Prize, Cooperstown Art Association, 1967. Media: Etching, aquatint, and intaglio. Address in 1976, Baltimore, MD.

SCRIVER, ROBERT MACFIE.
Sculptor. Born in Browning, MT, August 15, 1914. Studied: Vandercook School of Music, M.A. Became a taxidermist; established his own Museum of Montana Wildlife, including a gallery for his clay sculpture and dioramas. Began casting in bronze in 1962; turned to sculpture fulltime in 1967. Opened Bighorn Foundry. Work in Glenbow Foundation (Calgary), Whitney Gallery of Western Art (Cody), Montana Historical Society (Helena), Cowboy Hall of Fame (Oklahoma City), Panhandle Plains Museum (Canyon, TX). Awards: Gold Medals, Cowboy Hall of Fame, 1969-71, Silver Medal, 1972; Silver Medal, National Academy of Western Art, 1973. Specialty is Western animals; commissions of heroic bison and cowboy figures. Member: Cowboy Artists of America; National Sculpture Society; National Academy of Western Art. Medium: Bronze. Address in 1976, Browning, MT.

SCUDDER, JANET.
Sculptor. Born Terre Haute, IN, October 27, 1875. Pupil of Cincinnati Art Academy under Rebisso; Taft in Chicago; MacMonnies in Paris; Academies Vitti and Colarossi in Paris. Member: Association National Academy of Design; National Sculpture Society, 1904; National Association of Women Painters and Sculptors; National Art Club; American Federation of Art. Exhibited at National Sculpture Society, 1923. Awards: Medal, Columbian Exp., Chicago, 1893; honorable mention, Sun Dial Competition, NY, 1898; medal, St. Louis Exp., 1904; honorable mention, Paris Salon, 1911; sculpture prize, National Association Women Painters and Sculptors, 1914; silver medal P.-P. Exp., San Francisco, 1915; Chevalier de la Legion d'Honneur, 1925. First American woman to have sculpture bought for the Luxembourg, Paris. Work: Seal for the Association of the Bar of the City of NY; "Japanese Art," facade of Brooklyn Institute Museum; "Frog Fountain," Metropolitan Museum, NY; "Fighting Boy Fountain," Art Institute of Chicago, IL; 3 medallions in gold and 3 in silver, Art Association of Indianapolis, IN; portrait medallions in Congressional Library, Washington, DC; Metropolitan Museum, NY; Musee du Luxembourg, Paris; medal of Indiana Centennial, Minneapolis Institute; "Medal," Rhode Island School of Design, Providence; "Tortoise Fountain," Peabody Institute, Baltimore; "Seated Fawn," Brooklyn Museum; fountain, Public School, Richmond, IN. Fountains in many private estates. Publication: *Modeling My Life*. Address in 1933, Square de Vergennes 279 rue de Vaugirard, Paris, France; c/o The Colony Club, New York, NY. Died in Rockport, MA, June 9, 1940.

SCURIS, STEPHANIE.
Sculptor and educator. Born in Lacedaemonos, Greece, January 20, 1931. Studied at School Art and Architecture, Yale University, B.F.A. and M.F.A., with Josef Albers. Work: Jewish Community Center, Baltimore, West View

Center, Baltimore. Comn: Sculpture, Bankers Trust Co., NY; lobby sculpture, Cinema I and II, NY. Exhibitions: New Haven Art Festival, 1958-59; Art: USA Traveling Exhibition, 1958 and 60; Museum of Modern Art, NY, 1962; Whitney Museum American Art, NY, 1964; plus others. Awards: Winterwitz Award, Prize for Outstanding Work and Alumni Award, Yale University; Peabody Award, 1961-62; Rinehart Fel., 1961-64. Address in 1976, Baltimore, MD.

SEABORNE, WILLIAM.
Sculptor. Born 1849. Died in New York City, March, 1917.

SEAGER.
Sculptor. Active in Salem and New Bedford, Massachusetts, in 1834, making bronze portrait medallions.

SEAMAN, BONNIE.
Sculptor. Born in Bay City, TX, in 1913. Studied at Incarnate Wood College, San Antonio, TX; Museum of Fine Arts School, Houston, TX; Fourth International Sculpture Casting Conference, Univ. of Kansas. Awards: National Exhibition, Tyler, TX, 1969; Abilene Museum of Fine Arts, 1971; Jewish Community Center, Houston, TX, 1972. Included in "20th Century Women in Texas Art," Laguna Gloria Museum, Austin, TX, 1974.

SEAMANS, BEVERLY BENSON.
Sculptor. Born in Boston, MA, October 31, 1927. Studied at Museum School of Fine Arts, Boston, 1948-50; with George Demetrios, 1966-70; also with Peter Abate, from 1968. Work in Essex Institute and Peabody Museum, Salem, MA; bronze, Mass. Institute of Technology; others. Has exhibited at National Sculpture Society, NY; Essex Institute, Salem; Peabody Museum, Salem; others. Received honorable mention, National Sculpture Society, and silver medal; others. Member of National Sculpture Society; New England Sculptors Association. Works in wax and marble. Address in 1982, Marblehead, MA.

SEARLE, J. L. (JAN).
Sculptor and oil pastellist. Born in Ellensburg, Washington, in 1938. Studied art at Central Washington University. Employed as illustrator, fashion illustrator, design artist, art director, art agency owner. Began sculpting in 1977. Specialty is Indian subjects; sculpts in bronze. Accuracy of her Indian pieces certified by Colorado Commission of Indian Affairs. Exhibited at Knoxville World's Fair as featured American Indian artist. Reviewed in *Southwest Art*, July, 1979. Represented by Peacock Ltd.; Jackson, WY, and Scottsdale, AZ; American West, Loveland, Colorado. Address in 1982, near Walsenburg, Colorado.

SEARLES, STEPHEN.
Sculptor, designer, and teacher. Born in NYC, June 10, 1914. Studied at Art Students League, with George Bridgman, F. DuMond, and Reginald Marsh; Grand Central School of Art; Corcoran School of Art; Fontainebleau, France. Member: Salma. Club; Copley Society; North Shore Art Association; American Veterans Society of Art; American Artists Professional League; American Federation of Arts. Work: Sculpture, Grassy Gallery, Biarritz, France; Army Medical Museum, Wash., DC;

many portrait busts. Exhibited: Corcoran Gallery of Art; Grand Central Art Gallery; Montclair Art Museum, 1938-52; Ogunquit Art Center; Calif. Palace of the Legion of Honor; Allied Artists of America, 1950, 51. Awards: Salmagundi Club, 1952, Am. Artists Professional League, 1976, 77; others. Position: Instructor, Newark School of Fine and Industrial Arts, Newark, NJ, at present. Address in 1982, Boston, MA.

SEARS, ELINOR LATHROP.
Sculptor and painter. Born Hartford, CT, September 26, 1899. Pupil of Hale, Logan, Mora, and Calder. Member: Hartford Art Society. Address in 1933, Old Lyme, CT.

SEARS, PHILIP SHELTON.
Sculptor of busts, memorials, and statues. Born Boston, MA, November 12, 1867. Pupil of Daniel C. French and Boston Museum of Fine Arts School; studied law at Harvard Law School. Work in Indian statue, Boston Museum of Fine Arts; State House (Boston); American Indian Museum (Harvard). Member: Boston Guild of Artists; North Shore Art Association; Boston Sculpture Society; American Federation of Arts; City Art Com., Boston, MA; National Sculpture Society. Turned to sculpture in 1919. Address in 1953, Brookline, MA; summer, Prides Crossing, MA. Died in Brookline, MA, March 1953.

SEAVER, ELSBETH.
Sculptor. Address in 1934, Cleveland, OH. (Mallett's)

SEAVEY, THOMAS.
Figurehead carver. Active in Bangor, ME, during the first half of the 19th century. In partnership with his son, William L. Seavey, by 1843.

SEAVEY, WILLIAM L.
Figurehead carver. Active in Bangor, ME, 1843, with his father, Thomas Seavey.

SEAWRIGHT, JAMES L., JR.
Sculptor and educator. Born in Jackson, MS, May 22, 1936. Studied at University of Mississippi, BA, 1957; Art Students League, NY, 1961-62. Work in Museum of Modern Art; Whitney Museum of American Art; Solomon R. Guggenheim Museum, NY; Larry Aldrich Museum, Ridgefield, CT; others. Has exhibited at Whitney Museum of American Art; Museum of Modern Art; Focus on Light, NJ State Museum, Trenton; Solomon R. Guggenheim Museum, NY; Walker Art Center, Minneapolis; others. Received Theodoron Foundation Award, Guggenheim Museum, 1969. Teaching at Princeton University, NJ, from 1969, lecturer on sculpture. Address in 1982, 155 Wooster St., NYC.

SEDGWICK, FRANCIS (or FRANCES) MINTURN.
Sculptor and museum official. Born in New York City, 1904. Studied at Harvard University and at Trinity College (Cambridge University). Works in Colma, CA (Pioneer Monument); others in England, San Francisco, and Washington; heroic statue of cowboy, Earl Warren Showgrounds, Santa Barbara, CA. Specialty, Western monuments. Vice President of the Museum of Art in Santa

Barbara, CA. Address in 1968, Santa Ynez Valley, CA.

SEGAL, GEORGE.
Sculptor. Born in NYC, November 26, 1924. Studied at NYU, 1950, BS; Rutgers Univ., 1963, MFA. Works: Stedelijk; Albright; Charlotte (Mint); Art Inst. of Chicago; Mus. of Modern Art; Newark Mus.; Ottawa (National); Stockholm (National); Toronto; Whitney; Walker. Exhibitions: Hansa Gallery, NYC; Ileana Sonnabend Gal., Paris; Sidney Janis Gal., NYC; Toronto, 1967, (three-man, with Jim Dine, Claes Oldenburg); Boston Arts Festival, 1956; Jewish Mus.; Whitney; American Fed. of Arts; VII & IX Sao Paulo Biennials, 1963, 67; Stockholm (Nat'l.), Am. Pop Art; Corcoran Biennial; Palais des Beaux-Arts, Brussels, 1965; Guggenheim; Rhode Island Sch. of Design, Recent Still Life, 1966; Art Inst. of Chicago; Walker; Los Angeles Co. Mus. of Art, Amer. Sculpture of the 60's; Mus. of Modern Art, the 1960's; Carnegie; Trenton State, Focus on Light. Awards: Walter K. Gutman Found. Grant, 1962; Art Inst. of Chicago, 1st Prize, 1966. Rep. by Sidney Janis Gal., NYC. Address in 1982, South Brunswick, NJ.

SEGEL, (JACOB) YONNY.
Sculptor, craftsman, teacher, and designer. Born in NYC, February 14, 1912. Studied at Beaux-Arts Institute of Design; City College of New York, M.S. in Edu.; New York University. Exhibited: Metropolitan Museum of Art, 1942; University of Nebraska, 1944; Joslyn Art Museum, 1945; New School for Social Research, 1940; American Museum of Natural History, 1950; America House, 1952; St. Paul Art Gallery, 1952. Position: Instructor, New School for Social Research, NYC. Address in 1953, 9 Stuyvesant Oval, NYC.

SEIBERT, EDWARD.
Sculptor. Worked in New York City, 1856.

SEIDE, PAUL A.
Sculptor. Born in NYC, February 15, 1949. Studied at Egani Neon Glassblowing School, 1971; University of Wisconsin, BS (art), 1974. Work at National Museum of Modern Art, Kyoto, Japan; Corning Museum of Glass, NY; others. Has exhibited at Corning Museum of Glass, NY; National Museum of Modern Art, Kyoto, Japan; De Cordova Museum, Lincoln, MA; others. Member of Glass Art Society. Address in 1982, Rego Park, NY.

SEIDEL, EMORY P.
Sculptor. Member: Illinois Academy of Fine Arts; Oak Park Art League; Chicago Painters and Sculptors; Chicago Gallery of Art; Palette and Chisel Club. Award: John C. Shaffer prize, Art Institute of Chicago, 1925; Charles Worcester prize, Palette and Chisel Club, 1926; gold medal, Palette and Chisel Club, 1927; gold medal, Oak Park Art League, 1929. Address in 1933, Chicago, IL; h. River Forest, IL.

SELETZ, EMIL.
Sculptor. Born in Chicago, IL, February 12, 1909. Studied briefly with Jo Davidson and George Gray Barnard. Work: Einstein (heroic bronze), Albert Einstein College of Medicine, NY; heroic bust of Lincoln, San Jose Court House, CA; Franklin Roosevelt (heroic bust), President L. B. Johnson Library, TX. Exhibited at Painters and Sculp-

tors Club, 1952-68; California Art Club, 1955-68; others. Awards: First in sculpture, Painters and Sculptors Club of California, 1970. Member of California Art Club; Painters and Sculptors Club of California. Works in bronze. Address in 1982, Los Angeles, CA.

SELEY, JASON.
Sculptor. Born in Newark, NJ, May 20, 1919. Studied at Cornell University, 1936-40, BA; Art Students League, with Ossip Zadkine, 1943-45; Academie des Beaux-Arts, Paris, 1950. Works: University of Calif.; Dartmouth College; Museum of Modern Art; Newark Museum; Ottawa (National); Aldrich; Syracuse (Everson); Toronto; Whitney. Exhibited: American-British Art Center, NYC; AAA Gallery, NYC; Barone Gallery, NYC; The Kornblee Gallery, NYC; Whitney Sculpture Annuals, 1952, 53, 62, 64, 66, 68-69; Newark Museum; Guggenheim; Festival of Two Worlds, Spoleto, 1962; Battersea Park, London, International Sculpture Exhibition, 1963; Documenta III, Kassel, W. Germany, 1964; Museum of Modern Art. Awards: US State Dept. Grant, 1947-49; Fulbright Fellowship, (France), 1949; Silvermine Guild, First Prize for Sculpture, 1962. Member: Fed. of Modern Painters and Sculptors; Sculptors Guild; New Sculpture Group. Taught: Le Centre d'Art, Port-au-Prince, Haiti, 1946-49; Hofstra University, 1953-65; NYU, 1963-67; Dartmouth College, 1968; Cornell University, from 1968. Address in 1982, Ithaca, NY.

SELIGMAN, ALFRED L.
Sculptor. Born in New York, January 29, 1864. Pupil of Paul Nocquet. Address in 1910, 59 East 59th St.; h. 16 East 60th St., NYC.

SELLERS, WILLIAM FREEMAN.
Sculptor and educator. Born in Bay City, MI, June 1, 1929. Studied at University of Michigan, architecture, BA, 1954; MFA, 1962. Has exhibited at Whitney Museum of American Art, NY, 1966; Albright-Knox Art Gallery, Buffalo; Indianapolis Museum of Art; others. Works in metal and wood. Address in 1982, Salt Point, NY.

SELLORS, EVALINE C.
Sculptor. Address in 1934, Fort Worth, TX. (Mallett's)

SENCE, LEONARD.
Sculptor in plaster and marble. Worked in New York City from 1848-52, with Victor Flagella from 1848-50. Media: Plaster and marble.

SENCE & FLAGELLA.
Sculptors. Active in NYC, 1848-50. Exhibited plaster statuary at the American Institute 1848 and 1849; won diploma in 1848. Worked in plaster and marble.

SERRA, RICHARD.
Sculptor. Born in San Fran., CA, November 21, 1939. Studied at the University of CA, Berkeley, and University of CA at Santa Barbara, BA, while working in steel mills; Yale University, BA and MFA, 1964, with Josef Albers. Exhibited: Stedelijk Museum, Amsterdam, Holland, 1969; Kunsthalle, Bern, Switzerland, 1969; Solomon R. Guggenheim Museum, NY, 1969; Pasadena Art Museum, 1970; Whitney Museum of Art, NY, 1972; Los

Angeles Co. Museum; numerous other group and one-man exhibits. Awards: Fulbright Fellowship to study in Italy, where he participated in performance pieces and the "arte povera" movement; National Endowment for the Arts grant in sculpture, 1976, 78. Early in career made use of cages and boxes containing live and stuffed animals. In late 1960's, began experimenting with rubber tubing or thick sheets of vulcanized rubber intertwined with neon lights. Also works in steel and wood. Address in 1982, P.O. Box 645, Canal Street Station, NYC.

SERRA, RUDY.

Sculptor. Born in San Francisco, California, April 9, 1948. Studied at City College of San Francisco; San Francisco State College; University of California at Berkeley. Taught at California State at Chico; American River College, Sacramento; University of California at Davis; University of Connecticut at Storrs. Exhibited at San Francisco Art Institute; University Art Museum at Berkeley; Oakland Museum; Whitney, NYC; L.A. Institute of Contemporary Art; Hansen Fuller Gallery, San Francisco; etc. Received National Endowment for the Arts Grant in Sculpture. Works in wood and steel. Address in 1982, 465 Washington St., NYC.

SERRAO, LUELLA VARNEY (MRS.).

Sculptor. Born Angola, NY, 1865. Work: "An Archbishop of Odessa," in Roman Catholic Cathedral, Odessa, Russia; "Bust of Senator Rice," State Capitol of Minnesota; "Bust of Archbishop Wigger," Seaton Hall, Newark, NJ; busts of Mark Twain and Mr. Brett, Cleveland Public Library; "Monument of Archbishop Rappe," Catholic Cathedral, Cleveland, Ohio. Address in 1926, Cleveland, OH.

SETON, ERNEST THOMPSON.

Sculptor, painter, illustrator, and writer. Born Ernest Thompson in South Shields, England, 1860; lived in Canada. Studied at Toronto Collegiate Institute; the Royal Academy in London; in Paris, pupil of Bouguereau and Gerome, 1890-96. Work in Museum of New Mexico. Member: National Institute of Arts and Letters. Author and illustrator of *Mammals of Manitoba*, 1886; *Birds of Manitoba*, 1891; *Wild Animals I Have Known*, 1898; *The Birchbark Roll*, 1906; *Indian Lore*, 1912; *Woodcraft Indians*, 1915; *Gospel of the Red Man*, 1936; others. Illustrator of the *Century Dictionary*; lectured on Indians and woodcraft. Served as Chief Scout of the Boy Scouts, to 1915; founded the College of Indian Wisdom near Santa Fe. Specialty was animal subjects. Died near Santa Fe, NM, 1946.

SEVERANCE, JULIA GRIDLEY.

Sculptor, etcher, and teacher. Born Oberlin, Ohio, Jan. 11, 1877. Pupil of Art Students League of NY. Member: Cleveland Woman's Art Club; Florida Society Arts and Sciences. Work: "Rice Memorial Tablet," Oberlin Conservatory of Music, Oberlin College, OH; etching in Print Dept., Library of Congress, Washington, DC; Cobb Memorial Tablet, Warner Hall, Oberlin, OH; Leffingwell Tablet, St. Mary's School, Knoxville, IL; portrait of "Prof. G. F. Wright," Allen Memorial Museum, Oberlin, Ohio. Address in 1953, San Diego, CA.

SEWELL, ALICE.

Sculptor, painter, lecturer, teacher, and writer. Born Hillsboro, Ore. Pupil of DuMond, Avard Fairbanks, Voisin, Eugene Steimhof. Member: Ore. Society of Artists. Awards: For portrait, Ore. Society of Artists annual exh., 1932; Carnegie Fellowship, University of Oregon, 1933. Address in 1933, Hillsboro, Ore.

SEXTON, FREDERICK LESTER.

Sculptor, painter, illustrator, etcher, lecturer, and teacher. Born Cheshire, CT, September 13, 1889. Studied: Yale School of Fine Art, B.F.A.; also a pupil of Sergeant Kendall and Edwin Taylor. Member: New Haven Paint and Clay Club. Award: Second prize, New Haven Paint and Clay Club, 1923; Meridan Arts and Crafts Club, 1941; Carney Prize, Hartford, CT, 1944. Address in 1953, New Haven, CT.

SEYLER, DAVID WARREN.

Sculptor, painter, craftsman, designer, lithographer, and lecturer. Born in Dayton, KY, July 31, 1917. Studied at Cincinnati Art Academy; Art Institute of Chicago, B.F.A.; Univ. of Chicago; and with William Hentschel, Francis Chapin, Emil Zettler and others. Member: Modern Art Society, Crafters Club, Cincinnati, OH. Awards: Prizes, Syracuse Museum of Fine Art, 1938; Trebilcock prize, 1938; Wood Foundation Travel Grant, Italy, 1959-60; Univ. of Nebraska Foundation Grant, England, 1971-72. Work: Univ. of Chicago; Syracuse Museum of Fine Art; Cincinnati Museum Association; murals, Philippine Island Base, US Navy; Great Lakes Naval Station. Exhibited: Syracuse Museum of Fine Art, 1938-41; Art Institute of Chicago, 1939, 44 (one-man); NY World's Fair, 1939; Loring Andrew Gallery, Cincinnati, 1943 (one-man); Cincinnati Museum Association, 1939-46. Lectures: Contemporary Ceramics. Position: Sculpture, Des., Rookwood Pottery, Cincinn., OH, 1936-39. Address in 1982, Lincoln, NE.

SHADDLE, ALICE.

Sculptor and collage artist. Born in Hinsdale, IL, December 21, 1928. Studied at Oberlin College; University of Chicago, IL; School of Art Institute of Chicago, BFA and MFA. Work in Smithsonian Institution, Washington, DC. Has exhibited at Museum of Contemporary Art, Chicago; Art Institute of Chicago; Indianapolis Museum of Art, IN; others. Received Logan Medal, Art Institute of Chicago, 1975; National Endowment for the Arts Grants, 1979. Works in paper, latex, heavy wrapping paper; oil and canvas, watercolor on folded paper. Address in 1982, Chicago, IL.

SHAGIN, ALEX.

Sculptor and medallist. Born in USSR, c. 1948. Emigrated to US, 1979. Studied: Leningrad Fine and Decorative Art School, USSR, 1966-72. Exhibited: Numerous group shows in USSR, 1974-77; Young Leningrad Artists, Finland, 1977; Olympic Designs, Montreal, Canada, 1976; Leningrad Artists, Gdansk, Poland, 1977; Los Angeles Art Festival for Russian Newcomers, 1980; one-man show, Santa Barbara University, 1982; FIDEM Medallic Art Congress, Florence, Italy, 1983; Numismatic Society, NYC, 1983; American Medallic Sculpture Association

Show, NYC, 1983. Commissions: "Peter the Great-1972," "Decembrists—1825-1975," "Victory Day—1945-1975," "Space Mission Apollo-Sojuz-1975," "Michelangelo-500," 1975, "Titian-400," 1976, "Rubens," 1977, all commemorative medals for The Leningrad Mint; designed commemorative coins for 1980 Moscow Olympics, 1975-77; three medals designed for FIDEM-77 in Budapest, Hungary; three medals, "Prophets Awards," for Greater Los Angeles Federation Council, 1980-82; "Anatoly Shcharanscky," medal, 1983; "Solidarnosc" (Solidarity), medal, 1983; "1984 Olympic Games," Los Angeles, 1983-84. Address in 1984, Los Angeles, CA.

SHANNON, W.
Sculptor. At San Francisco, California, 1858.

SHANNONHOUSE, SANDRA LYNNE RIDDELL.
Sculptor and ceramist. Born in Petaluma, CA, May 19, 1947. Studied at University of California, Davis, BS, 1969, MFA (dramatic art), 1973; studied with Robert Arneson. Has exhibited at Quay Gallery, San Francisco; Museum of Contemporary Crafts, NY; Sculpture Now, San Francisco Museum of Modern Art; others. Works in clay and mixed media. Address in 1982, Benicia, CA.

SHAPIRO, JOEL (ELIAS).
Sculptor. Born in NYC, September 27, 1941. Studied at NY University, BA and MA. Work at Fogg Art Museum; Metropolitan Museum and Museum of Modern Art, NY; Whitney Museum of American Art, NY; Albright-Knox Art Gallery, Buffalo; Stedelijk Museum, Amsterdam. Has exhibited at Museum of Contemporary Art, Chicago; Albright-Knox Art Gallery; Akron Art Institute, OH; Institute of Contemporary Art, Boston; Whitney Museum of American Art; others. Address in 1982, c/o Paula Cooper, 155 Wooster St., NYC.

SHAPSHAK, RENE.
Sculptor. Born in Paris, France; US citizen. Studied at Ecole des Beaux Arts, Paris; Ecole des Beaux Arts, Bruxelles; Art School, London, England. Work in Butler Institute of American Art, Youngstown, OH; Municipal Museum, Paris; Pinakotheki, Athens, Greece; fountain, City of NY; others. Has exhibited at Palais des Beaux Arts, Paris; Whitney Museum of American Art, NY; Museum of Modern Art, Paris; others. Member of American Federal of Arts; Royal Society of Arts, fellow; National Society of Literature and Arts, fellow. Address in 1982, 163 W. 23rd St., NYC.

SHARMAN, FLORENCE. M.
Sculptor. Born in Bloomington, IL, March 27, 1876. Pupil of St. Louis School of Fine Arts under Robert P. Bringhurst. Member: St. Louis Artists Guild. Address in 1906, 1820 Locust St., St. Louis, MO.

SHARPE, CORNELIUS N.
Ship carver. Worked in New York City. Associated with Sharpe & Ellis, 1810-12; with Dodge and Sharpe, 1814-28. Died in 1828.

SHARPLESS, ADA MAY.
Sculptor. Born Hilo, Hawaii, August 16, 1904. Pupil of Antoine Bourdelle. Member: Calif. Art Club; Societe des Artistes Independents, Paris. Awards. Calif. Art Cl., first prizes, 1929 and 1930, hon. mention, 1931; second prize, Ebell Salon of Art, 1933. Work: "Cabrillo Monument," Historical Museum, Santa Ana, Calif.; decorative figures on entrance doors, New General Hospital, Los Angeles, Calif.

SHARPLESS, GRETCHEN.
Sculptor. Studied at University of Chicago; Tyler Art School, Temple University; Tulane University. Awards: Louisiana Crafts Council Spring Fiesta Show, 1971; Newcomb Jewelry Show, 1971; Del Mar College, 1973; Amarillo Artist Studio, 1973.

SHATTUCK, LOUISE F.
Sculptor and painter. Studied at Mass. College of Art, 1941; also with Cyrus Dallin and Raymond Porter. Awards: Various awards for animal art, Deerfield Valley Arts Association. Member: Deerfield Valley Arts Association; Leverett Artists and Craftsmen; Society of Animal Artists; and many dog clubs. Taught: Garland Jr. College; Museum of Natural History; Boston Center for Adult Education; Medford High School Adult Education. Does small sculpture casting in stone for dog show trophies, awards, etc.; also has a line of dog jewelry in pewter. Writes and illustrates for several dog magazines. Media: Bonded bronze, terracotta, and pewter; pastel portraits. Address in 1983, Lake Pleasant, MA.

SHAW, ELSIE BABBITT.
Sculptor and painter. Born in Charlotte, North Carolina, December 6, 1929. Studied: Salem Academy; Mt. Vernon Junior College; Rollins College; National Academy of Design, NYC, 1963, 67, 71; Isaac Delgado, New Orleand, LA, 1964; Butler Institute of Art, Youngstown, OH, 1966-68; Allied Artists of America, NYC, 1966, 67; others. Awards: Mint Museum, Charlotte, NC, 1964; Juried Arts National, Tyler, Texas, 1969; Salmagundi Club Prize, National Academy of Design, 1971. Collections: Mint Museum of Art; Wachovia National Bank, Charlotte, NC; American National Bank, Chattanooga, Tennessee. Address in 1982, DeLand, FL.

SHAW, ERNEST CARL.
Sculptor. Born in NYC, April 17, 1942. Exhibited: Storm King Art Center, Mountainville, NY, 1977; Contemporary Reflections, at the Aldrich Museum of Contemporary Art, 1977; one-man shows, Storm King Art Center, 1978; Hamilton Gallery of Contemporary Art, 1978; Allentown Art Museum, 1981; Wichita Art Museum, 1981; Huntington Galleries, West Virginia, 1981; Sculpture Now, NYC, 1978; Hamilton Gallery of Contemporary Art, 1978; and others. Commission: Orlando International Airport, Reading, PA; in collections of Aldrich Museum, Ridgefield, CT; Wichita Art Museum, Kansas, and others. Medium: Steel. Address in 1982, New Paltz, NY.

SHAW, FREDERICK A.
Sculptor. Born in 1855. Died Brookline, Mass., March 8, 1912.

SHAW, HELEN ADELE LERCH.
Sculptor, lecturer, teacher of art and dancing. Born in

Chicago, IL, September 28, 1891. Studied at Lewis Institute, Chicago, 1910-11; Wheaton (Ill.) College, 1911-1913; graduate of the Chicago Art Institute, 1917. Works include the sculptured head of American Manhood, presented to government, 1944; plaque Marie and Pierre Curie, 1949, to commemorate 50th anniversary of radium discovery. Awards: Gold medal, 1938, first awards and honors for poems and sculpture, 1938-44. Member: Chicago Art Institute Alumni; Ill. Society of Fine Arts. Teacher of art and dancing, Experimental School, Peterboro, NH, 1917-18; private classes art and dancing 1920-30. Illustrator, author children's stories; also poems and articles. Address in 1962, 655 62nd St. S., St. Petersburg, FL.

SHAW, RICHARD BLAKE.
Sculptor. Born in Hollywood, CA, September 12, 1941. Studied at Orange Coast College, 1961-63; San Francisco Art Institute, BFA, 1965; Alfred University, 1965; University of California, Davis, MA, 1968. Work in Oakland Museum, CA; San Francisco Museum; National Museum of Art, Tokyo; Stedelijk Museum, Amsterdam, Holland; Whitney Museum of American Art, NY. Has exhibited at Dilexi Gallery, San Francisco; San Francisco Museum of Art; Alan Frumkin Gallery, NY; Whitney Museum of American Art, NY; International Ceramics, 1972, Victoria and Albert Museum, London; Painting and Sculpture in California Modern Era, National Collection of Fine Arts, Washington, DC; others. Member of Order of Golden Brush; International Society of Ceramists. Works in ceramics, mixed media. Address in 1982, c/o Braunstein Gallery, San Francisco, CA.

SHEA, JUDITH.
Sculptor. Born in Philadelphia, PA, November 13, 1948. Studied at Parsons School of Design, 1969; Parsons/New School, BFA, 1975. Has exhibited at Clothing Constructions, Los Angeles Institute of Contemporary Art; Contemporary Art Museum, Chicago; Whitney Museum of American Art, NY; others. Works in cloth. Address in 1982, 124 Chambers St., NYC.

SHEAHAN, D. B.
Sculptor. Address in 1906, 267 West 140th St., New York City.

SHEBL, JOSEPH J.
Sculptor. Born in Crete, NE, 1913. Specialty is Western subjects, particularly historical and animals. Works in bronze. Also a medical doctor. Address in 1968, Salinas, CA.

SHEFFIELD, GLORIA ANGELA.
Sculptor, painter, craftswoman, and teacher. Born in Charlotte, MI. Studied at Olivet Col.; Art Inst. of Chicago; School of Universal Crafts and with Lorado Taft, John Vanderpoel, William M. Chase, Daniel C. French, and others. Lectures: Contemporary Sculptors. Address in 1953, Toledo, OH.

SHELDON, ROY VAN AUKEN.
Sculptor. Born in St. Louis, MO. Studied in Paris, Vienna, and Florence. Worked with Paul Landowsky, Henri Bou-

chard, and Antoine Bourdelle. In 1923, returned to US to study the problem of monumental sculpture in the modern American city. Later he returned to Paris, where he resided. Works: Cockatoo; Head of Salome; Elephant; Polar Bear; group, Pieta, Christ and the Two Marys; Potto; Kangaroo; Black Venus.

SHELLHASE, GEORGE.
Sculptor. Exhibited: White Plains, New York, 1933. (Mallett's)

SHELTON, PETER T.
Sculptor. Born in Troy, OH, January 18, 1951. Studied at Pomona College, BA (fine arts), 1973; Hobart School of Welding Technology, 1974; University of California, Los Angeles, MFA, 1979. Has exhibited at Los Angeles Institute of Contemporary Art; Los Angeles County Museum of Art; others. Received fellowship, National Endowment for the Arts, 1980. Teaching at Otis/Parsons School of Art and Design, from 1980, lecturer of sculpture. Address in 1982, Los Angeles, CA.

SHEPHERD, J. CLINTON.
Sculptor, painter, and teacher. Born in Des Moines, IA, Sept. 11, 1888. Studied at University of Missouri; Kansas City Institute of Fine Arts; Art Institute of Chicago; Beaux-Arts Institute of Design; with Walter Ufer and Harvey Dunn. Exhibited: National Academy of Design; Penna. Academy of Fine Arts; Silvermine Guild. Member: National Arts Club; Whitney Studio Club; Society of Illustrators; Artists Guild of the Authors' League of America. Awards: Miami Art League, 1940, and Palm Beach Art League, 1941. Collection: Herron Art Institute; memorial, Westport, CT. Address in 1953, Palm Beach, FL.

SHEPPARD, WILLIAM LUDWELL.
Sculptor, watercolorist, and illustrator. Born in Richmond, VA, in 1833. Painted series of watercolors of army life in the Civil War (Confederate Museum in Richmond). Died in Richmond, VA, March 27, 1912.

SHEPPARD, YOLANDE JACOBSON.
(Mrs. J. Craig Sheppard). Sculptor. Born in Norman, Okla., May 28, 1921. Studied: University Okla., B.F.A., 1941. Works: 7 ft. bronze statue of late Sen. Patrick McCarran, Statuary Hall, Washington, DC, 1960. Exhibitions: One-man shows Norman, Okla., 1941; Tulsa, 1944; Reno, Nev., 1953, 54, 56, 57; group shows Ames, IA; Tulsa; Denver; St. Louis; Oslo, Norway; and other cities. Awards: First prize sculpture, 47th Ann. Denver, 1941; American Association of University Women. Address in 1962, 1000 Primrose St., Reno, NV.

SHERBELL, RHODA.
Sculptor, consultant and collector. Born in Brooklyn, NY. Studied at Art Students League, with William Zorach; Brooklyn Museum Art School, with Hugo Robies; in Italy and France. Works: The Dancers, Okla. Museum Art, Okla. City; The Flying Acrobats, Colby College Art Museum, Waterville, ME; Sculpture Garden, Stony Brook Museum, NY. Commissions: Marguerite and William Zorach Bronze, National Arts Collection, Smithsonian Institute, Wash., DC, 1964; Casey Stengel, Country Art

Gallery Long Island, Baseball Hall of Fame, Cooperstown, NY; Yogi Berra, commissioned by Percy Uris; others. Exhibited: Penna. Academy of Fine Arts and Detroit Institute Art, 1960; American Academy Arts and Letters, 1960; Brooklyn Museum Art Award Winners, 1965; National Academy of Design and Heckscher Museum Show, 1967; Retrospective Sculpture and Drawing Show, Huntington Hartford Gallery, NY, 1970; Catherine Lorillard Wolfe Club; National Sculpture Society; Sculptors Guild; Salma. Club; many others. Awards: American Academy of Arts and Letters and National Institute of Arts and Letters Grant, 1960; Ford Foundation Purchase Award, 1965; Louis Comfort Tiffany Foundation Grant, 1966; H. F. Bennett prize, National Academy of Design; National Sculpture Society; many more. Member of National Academy; National Sculpture Soc.; National Association of Women Artists; Sculptors Guild; Allied Artists of America; Art Students League. Medium: Bronze. Address in 1983, Westbury, NY.

SHERER, RENSLOW PARKER.
Sculptor and painter. Born in Chicago, IL, Oct. 13, 1888. Studied at Univ. of Chicago. Exhibited: Art Inst. of Chicago, 1937, 39, 40, 44; Milwaukee Art Inst. Address in 1953, Highland Park, IL.

SHERIDAN, CLARE.
Sculptor. Address in 1924, 222 West 59th St., New York City.

SHERIDAN, JOSEPH MARSH.
Sculptor, painter, illustrator, writer, lecturer, and etcher. Born in Quincy, IL, March. 11, 1897. Studied at Beloit College, B.A.; Art Students League; Art Institute of Chicago; University of Calif., M.A.; and with Norton, Hofmann, Archipenko. Member: San Francisco Art Association; San Diego Artists Guild; Art Cong. Awards: Prizes, Minneapolis Institute of Art, 1931. Work: San Fran. Museum of Art; Berkeley (CA) Public Library, Oakland Public Library; University of Calif.; Beloit College; University of Minnesota; AF of L Building, San Francisco, Calif.; University of Arizona; Mills College; Westminster College, PA; Oakland (CA) High School; Piedmont (CA) High School. Exhibited: Minneapolis Institute of Art, 1930; European and Am. Abstractionists Exh., 1933; Oakland Art Gallery, 1932-45; San Fran. Museum of Art, 1932-45; Art Institute of Chicago, 1931, 33; many one-man exh. in US. Position: Instructor, Art, University of Minnesota, 1928-30; Assistant Prof. of Art, University of Arizona, 1944-45; Acting Head, Department of Art, Westminster College, New Wilmington, PA, 1945-46. Address in 1953, New Wilmington, PA.

SHERMAN, EDITH FREEMAN (MRS.)
Sculptor and writer. Born in Chicago, Ill. Pupil of Lorado Taft. Address in 1910, Brookfield Ill.

SHERMAN, GAIL.
See Mrs. H. W. Corbett.

SHERMAN, Z. CHARLOTTE.
Sculptor and painter. Born in Los Angeles, CA, June 18, 1924. Studied at University of California, Los Angeles; Kann Art Institute; and Otis Art Institute. Exhibited: Los Angeles County Museum, 1956, 58; Heritage Gallery, Los Angeles, 1963-81; Palm Springs Museum, 1976, 77, 80, 81; Laguna Art Museum, 1980; others. Awards: Pasadena Museum Annual Award, 1961; All City Exhibition Award, Barnsdale, Los Angeles, 1963, 65; others. Member: National Watercolor Society. Address in 1982, Pacific Palisades, CA.

SHERWOOD, A. (FRANCES ANN CRANE).
Sculptor and printmaker. Born in Birmingham, Ala., September 12, 1932. Studied at University Fla.; Hampton Institute; Wesley College; Del. State College; University Philippines; Okaloosa Walton College, Niceville, Fla.; University W. Fla., Pensacola. Work: Lilliputian Found., Washington, DC; Academy Art, Easton, MD; USN; USAF; Mobile Art Gallery, Ala. Comn: Oil paintings, Phillips School, Hampton, Va., 1966, Col. and Mrs. W. O. Brimberry, 1967 and Mrs. Lenora Whitmire Blackburn, 1974-75. Exhibitions: Norfolk Museum, VA, 1966, 67; Virginia Museum Fine Arts, Richmond, 1967; Audubon Society, Washington, DC, 1969; Royal Art Gallery, Manila, Philippines, 1972; Meat Packers Gallery, Pensacola, 1974. Awards: Atlantic City National Art Show, NJ, 1968 and 69; Mobile Art Fair, Ala., 1973 and 74; Billy Bowlegs Art Festival, Ft. Walton Beach, Fla., 1973, 74, and 75. Address in 1982, 6665 West Sixth Avenue, Hialeah, FL.

SHERWOOD, RUTH.
(Mrs. Albin Polasek). Sculptor and teacher. Born in Chicago in 1889. Pupil of Albin Polasek; Art Institute of Chicago. Member: Alumni, Art Inst. Chicago. Awards: Bryan Lathrop foreign scholarship, 1921; John Quincy Adams prize, Art Institute of Chicago, 1921; honorable mention, Art Institute of Chicago, 1922; Chicago Woman's Aid prize, Art Institute of Chicago; Mrs. E. Mansfield Jones prize, Chicago Gallery, 1928; Mrs. John C. Shaffer prize, Art Institute of Chicago, 1929. Work: Memorial tablet, River Forest Women's Club; memorial tablet to James V. Blake, Evanston, IL; safety trophy, Portland Cement Association; Lake Shore Bank medal for architecture. Exhibited: Penna. Acad. of Fine Arts; Nat. Sculpture Soc.; Century of Progress, Chicago, 1933, 34. Address in 1953, Chautauqua, NY. Died in 1953.

SHERWOOD, SHERRY (MR.).
Sculptor, painter, designer, and craftsman. Born in New Orleans, LA, January 5, 1902. Studied at Maryland Institute; Art Institute of Chicago; Chicago Academy of Fine Arts; and with James McBurney, Lorado Taft. Designed scenery for New York theatrical productions; exhibited at Atlantic City Auditorium, Chicago Century of Progress, San Diego Exp., Texas Centennial, Golden Gate Exp., 1939; Fed. Theatre Project, San Francisco; State Exhibition, Sacramento, Calif. Address in 1953, 175 West 85th St., Studio C-15, NYC.

SHIEBER, PHYLLIS CAROL.
Sculptor and painter. Born in New York City, 1934. Studied: Bard College, Annandale-on-Hudson, New York; State University of New York at New Paltz, New York; Louisiana State University, Baton Rouge, Louisiana. Collections; Louisiana Arts and Science Center, Baton

Rouge, Louisiana; Chancellor's Suite, Louisiana State University.

SHIMODA, OSAMU.
Sculptor. Born in Manchuria, June 4, 1924. Studied at St. Paul University, Tokyo; Academie de la Grande Chaumiere, Paris. Work at St. Paul University, Tokyo; Syracuse Museum; National Museum of Modern Art, Tokyo. Has exhibited at Granite Gallery, NY; National Museum of Modern Art Annual, Tokyo; Bertha Schaefer Gallery, NYC; Sculptors Guild; others. Member of Sculptors Guild. Works in iron. Address in 1982, Brooklyn, NY.

SHIPLEY, ROGER DOUGLAS.
Sculptor and educator. Born in Cleveland Heights, OH, December 27, 1941. Studied at American School at Fontainebleau, France, with Monsieur Goetz, 1962; Otterbein College, Westerville, OH, BA, 1964; Cleveland Institute of Art, 1964-65, painting with Louis Bosa and sculpture with William McVey; Cranbrook Academy of Art, Bloomfield Hills, MI, MFA, 1967. Has exhibited at Butler Institute of American Art, Youngstown, OH; Milwaukee Art Center, WI; San Francisco Museum of Art; Henri Gallery, Washington, 1980; others. Teaching: Associate professor of painting and drawing, printmaking, chairman of art department, Lycoming College, from 1967. Address in 1982, Williamsport, PA.

SHIRLEY, ALFARETTA DONKERSLOAT.
Sculptor, craftsman, and teacher. Born in NJ, August 2, 1891. Studied: Parsons School of Design; Columbia University, B.S., M.A.; Alfred University, with Charles F. Binns. Member: College Art Association of America; National Association of Art Education; American Association of University Women; New York Ceramic Society; National Education Association; New Jersey Educational Association; Newark Art Club. Exhibited: Syracuse Museum of Fine Art; Architectural League; Montclair Art Museum; Newark Museum; New York Ceramic Society traveling exh.; Rutgers Univ. Position: Instructor, Ceramics, Newark School of Fine and Industrial Arts, 1921-34; Instr., Art and Art History, Barringer High School, Newark, NJ, from 1935. Address in 1953, Short Hills, NJ.

SHONNARD, EUGENIE FREDERICA.
Sculptor, painter, and teacher. Born Yonkers, NY, April 29, 1886. Pupil of Bourdelle and Rodin in Paris; New York School of Applied Design for Women, with Mucha. Member: Alliance; National Sculpture Society (assoc.); National Association of Women Painters and Sculptors. Commissions: Decorative Wooden Panels for Waco, TX, Post Office, US Treasury Dept., decoration in terra cotta for Ruth Hanna Memorial Wing, Presbyterian Hospital, Albuquerque, NM; others. Exhibited many times in Paris to 1923; at National Sculpture Society, 1923; Art Institute of Chicago; Penna. Academy of Fine Arts; Museum of Modern Art; Whitney Museum of American Art; Brooklyn Museum; many others. Moved to Santa Fe, NM, in 1928. In collections of Museum of Modern Art; Brookgreen Gardens, SC; New York Zoological Society; and private collections. Address in 1976, Santa Fe, NM.

SHOSTAK, EDWIN BENNETT.
Sculptor. Born in NYC, August 23, 1941. Studied at Ohio University, 1959-60; Cooper Union, 1960-61. Has exhibited at Whitney Museum of American Art, NY; Museum of Modern Art, American Sculpture, NY; others. Received Guggenheim Fellowship, 1974-75. Works in wood and metals. Address in 1982, 303 E. Houston St., NYC.

SHRADY, FREDERICK CHARLES.
Sculptor. Born in NYC, 1907. Studied art at the Art Students League in 1928; under Yasushi Tanaka in Paris, 1931; in Florence, Italy, 1934. In collections of Metropolitan Museum, NYC; the Vatican; commissions for St. Patrick's Cathedral, NYC; FBI Building, Wash., and others. Works in metal and bronze. Address in 1982, Easton, CT.

SHRADY, HENRY MERVIN.
Sculptor. Born NYC in 1871. He was self-taught in sculpture. Member: National Sculpture Society; New York Architectural League; National Academy of Design, associate; National Institute of Arts and Letters. Works: Grant Memorial, Washington, DC; equestrian statues, General Washington at Valley Forge, Brooklyn, NY; General Williams, Detroit, MI; General Robert Lee, Charlottesville, VA; William the Silent, Holland Society; Jay Cooke, Duluth, MN; life-size bas-relief portrait, Dr. St. John Roosa; portrait bust, Gen. Grant; numerous statuettes and bas-relief portraits. Exhibited at National Sculpture Society, 1923. Died April 12, 1922, in New York City.

SHRAMM, PAUL H.
Sculptor and illustrator. Born in Heidenheim, Germany, in 1867. Pupil of Claudinso, Schrandolph and Jacob Grunenwald in Stuttgart; of MacNeil at Pratt Institute, Brooklyn. Member of NY Society of Cartoonists. Address in 1926, Buffalo, NY.

SHUSTER, WILLIAM HOWARD.
Sculptor, painter, graphic artist, and illustrator. Born in Philadelphia, PA, 1893; moved to Santa Fe in 1920. Studied electrical engineering, Drexel Institute, Philadelphia; with J. William Server in Philadelphia; with John Sloan, etching and painting, in Santa Fe. Work in Museum of New Mexico; Newark Art Museum; Anschutz Collection, Denver, CO; Brooklyn Museum; New York Public Library; sculpture at Carlsbad Caverns (NM) National Park. Illustrator of a frontier biography. Died in Albuquerque, NM, 1969.

SIBBEL, JOSEPH.
Sculptor. Born in Germany. Sculpted ecclesiastical statuary. Died July 10, 1907, in NYC.

SIBLEY, MARGUERITE.
(Mrs. Will Lang). Sculptor. Born in Butler, Indiana. Studied at Minneapolis School of Art; Grande Chaumiere, Paris; Rockford College; also studied with Marques Reitzel, Stephen Beams, and others. Works: Burpee Art Gallery, Rockford, Illinois; Chicago Temple, Chicago, Illinois; Emanuel Episcopal Church, Rockford, Illinois. Exhibitions: Burpee Art Gallery, 1931, 33-36, 38, 41-46, 51; Belle Keith Gallery, Rockford, 1932, 40; Smithsonian In-

stitution, 1947-51; others. Address in 1953, Rockford, IL.

SIEBERN, E.
Sculptor. Exhibited at the Annual Exhibition, 1923, Penna. Academy of Fine Arts, Philadelphia. Address in 1926, 99 Sixth Ave., New York. Died June 14, 1942, in NYC.

SIEGMANN, NAOMI RITA.
Sculptor. Born in NYC, October 12, 1933. Studied sculpture under Enrique Miralda, 1968-70; and under Tosis, 1963-68. Exhibited: Aldrich Museum of Contemporary Art, Ridgefield, 1976; International Week of Plastic Arts, United Nations Education Science and Cultural Organization, Mexico City, 1977; one-woman show at the Museo de Arte Moderno, Mexico City, 1979; and others. Commissions: Candelabras for the Beth Israel Community Center, Mexico, 1973; Fuente, bronze, Corporation Mexicana de Valores Bursatiles, Mexico, 1979; and many others. Work: Aldrich Museum, Ridgefield, CT; Museo de Arte Moderno, Mexico; others. Media: Stone and wood. Address in 1982, Alvaro Obregon, Mexico.

SIEVERS, FREDERICK WILLIAM.
Sculptor. Born Fort Wayne, IN, October 26, 1872. Studied in Richmond, VA; Royal Academy of Fine Arts in Rome under Ferrari; and Julian Academy in Paris. Exhibited: National Sculpture Society; Virginia Museum of Fine Arts. Work: Equestrian statue of Gen. Lee and group at Gettysburg, PA; equestrian statue of Stonewall Jackson, Richmond, VA; Confederate Monuments at Abingdon and Leesburg, VA; Matthew Fontaine Maury monument, Richmond, VA. Address in 1953, Forest Hill, Richmond, VA.

SILBERMAN, SARAH GETTLEMAN.
Sculptor. Born in Odessa, Russia, September 10, 1909. Pupil of Albert Laessle and Walker Hancock. Member: Fellowship Penna. Academy of Fine Arts. Award: Cresson Traveling Fellowship, Penna. Academy of Fine Arts, 1931. Address in 1933, 12 South Brighton Ave., Atlantic City, NJ.

SILVEIRA, BELLE.
(Mrs. W. O. Gorski). Sculptor, painter, and illustrator. Born in Erie, PA, September 21, 1877. Pupil of John Vanderpoel, William Chase, and Fred Richardson. Address in 1903, 202 East 57th St., Chicago, IL.

SILVER, THOMAS C.
Sculptor and educator. Born in Salem, OR, May 27, 1942. Studied at San Francisco Art Institute, 1960-61, with Joan Brown; California State College, Long Beach, BA, 1966; University of Kansas, MFA, with Elden Tefft. Exhibited: Oakland Museum, CA; Corcoran Gallery of Art, Washington, DC; Virginia Museum of Fine Arts, 1971-73; Cleveland Museum of Art, OH, 1972-77; others. Taught sculpture at Virginia Commonwealth University, 1965-72; teaching sculpture at Cleveland State University, OH, from 1972. Works in bronze. Address in 1982, Cleveland Heights, OH.

SILVERCRUYS, SUZANNE.
Sculptor and painter. Born in Maeseyck, Belgium. Stud-

ied at Yale School of Fine Arts; and in Belgium and England. Works: Louvain Library; McGill University, Canada; Yale School of Medicine; Reconstruction Hospital, NY; First Lutheran Church, New Haven, CT; Duell award for New York Press Photographers Association; Rumford (Rhode Island) Memorial; Government House, Ottawa, Canada; Metropolitan Museum of Art; Amelia Earhart Trophy for Zonta Club; Queen Astrid Memorial, Brussels; war memorial, Shawinigan Falls, Canada; gold medal, presented by Young Democrats to James Farley. Awards: Temple University, 1942; Rome Alumni prize, 1928; Beaux-Arts Institute of Design, 1927; others. Exhibited at Beaux-Arts Institute of Design; Salon de Printemps, 1931; Corcoran Gallery of Art. Address in 1953, East Norwalk, CT.

SILVERS, HERBERT (FERBER).
Sculptor and painter. Born in NYC, April 30, 1906. Address in 1933, 145 West 14th St., NYC.

SILVERTOOTH, (CARL) DENNIS.
Sculptor. Born in Killeen, Texas, August 20, 1957. Raised in Germany and Corpus Christi, Texas. Studied sculpture privately. Exhibitions: American Cowboy: Fact and Fiction, Eastman Kodak, NYC, 1975; Shidoni Foundry and Gallery, Santa Fe, NM, 1977-81; Philbrook Museum, Tulsa, OK, 1978; others. Awards: Best Sculpture, Art About Town, Dallas Crippled Childrens Society, 1977; Best Sculpture, 34th Annual American Indian Artists Exhibition, Philbrook Museum, OK, 1979; others. Specialty is Indian figures. Works in bronze and plaster. Reviewed in Southwest Art, January 1976. Represented by Two Grey Hills Gallery, Jackson, WY; Many Horses Gallery, Los Angeles CA. Address since 1980, Corpus Christi, Texas.

SIMKHOVITCH, HELENA.
Sculptor. Born in NYC. Studied in Paris. Exhibitions: Penna. Academy of Fine Arts; Museum of Modern Art; also throughout France and Belgium. Works: Whitney Museum of American Art; Wadsworth Atheneum. Awards: Palmes Academiques; Officier de l'Instruction Publique, Paris, 1955. Noted work: "The Pianist Ray Lev." Address in 1983, Robbinston, ME.

SIMKIN, PHILLIPS M.
Sculptor. Born in Philadelphia, PA, January 19, 1944. Studied at Tyler Art School, Temple University, BFA; Cornell University, MFA; University of Penna., post graduate fellowship. Has exhibited at Philadelphia Museum of Art; Brooklyn Museum; Penna. Academy of Fine Arts; Winter Olympics, Lake Placid, NY, 1980; others. Received National Endowment for the Arts Artist Fellowship, 1975-76; Creative Artists Public Service Sculpture Grant, NY, 1976; grant, Penna. State Council Arts, 1980. Address in 1982, 282 W. Fourth St., NYC.

SIMMANG, CHARLES JR.
Sculptor, engraver, and craftsman. Born Serbin, TX, February 7, 1874. Pupil of Charles Stubenrauch. Member: American Federation of Arts; San Antonio Artists' League. Specialty, steel relief engraving. Address in 1929, San Antonio, TX.

SIMMONS, FRANKLIN.

Sculptor. Born January 11, 1839, in Lisbon, ME. Studied in Boston with John Adams Jackson. He executed a bust of President Lincoln; also statues of Roger Williams and William King, for the state of Maine. Worked in Providence, RI, Maine and Washington, DC. Specialties were portrait busts, ideal figures, Civil War monuments. Died in Rome, December 6, 1913, where he had lived from 1867.

SIMMONS, MARGARET WELLS.

Sculptor. Born in Colorado Springs, Colo., August 4, 1901. Studied at University Colo., B.A., 1924. Exhibitions: Association of Fla. Sculptors Ann. Exhibition, 1959. Member: Sarasota Art Association (bd. mem.); Association of Fla. Sculptors (chmn. pub. relations). Address in 1962, Sarasota, Fla.

SIMMONS, WILL.

Sculptor, painter, illustrator, and etcher. Born Elche, Spain, June 4, 1884. Pupil of Julian Academy, Lefebvre and Alexander Harrison in Paris. Member: Societe des Independents; Chicago Society of Etchers; Painters Guild; Brooklyn Society of Etchers. Represented in New York Public Library. Died in 1949. Address in 1921, 137 East 57th St., New York, NY; Roxbury, Conn.

SIMON, BERNARD.

Sculptor and teacher. Born in Russia, January 6, 1896. Studied art at the Educational Alliance and Art Workshop, NY. Exhibited: Audubon Artists; Silvermine Guild Art; American Society of Contemporary Artists; plus many others. Awards: Prizes, Knickerbocker Artists; Audubon Artists; and New Jersey Society of Painters and Sculptors. Member: Brooklyn Society of Artists; Audubon Artists, and Artists Equity. Taught: Instructor at the Museum of Modern Art, NY; New School for Social Research; and the Bayonne Art Center. Media: Wood and marble. Address in 1982, 490 West End Ave., NYC.

SIMON, HELENE.

Sculptor. Born in Bagdad, Iraq; US citizen. Studied at Bedford College, London; Am. University, Beirut, Lebanon; Islamic Art with Mary Devonshire, Cairo, Egypt; painting with Anthony Toney and Jacob Lawrence; New School for Social Research, sculpture with Lorrie Goulet. Work: Phoenix Art Museum, Ariz.; Jewish Museum, NY; Hirshhorn Museum, Wash., DC; New York University Art Collections, NY; Fordham University Art Collections, Bronx, NY; also in private collections, Paris, London, Teheran, Iran and Milan, Italy. Exhibitions: One-woman shows, Bodley Gallery, NY, 1971 and 73, Fordham University, 1975; Sculptors 9, Caravan House, NY, 1971; Stable Gallery, Scottsdale, Ariz., 1973. Media: Marble and bronze. Address in 1982, 200 East 74th Street, NYC.

SIMON, JEWEL WOODARD.

Sculptor and painter. Born in Houston, Texas, July 28, 1911. Studied: Atlanta University, 1931, A.B.; Atlanta School of Art, 1967; Colorado University; and private study with B. L. Hellman, 1934; sculpture with Alice Dunbar, 1947. Was the first Black to graduate from the Atlanta School of Art. Awards: Bronze Woman of the

Year in Fine Arts, 1950; Plaque for Distinction, Atlanta University Alumni Association; John Hope Prize, 1966. Collections: Atlanta University, Georgia; Clark College; Girls Club of America, Inc.; National Archives Slide Collection; University of Maryland. Exhibited at Houston Fine Arts Museum; New York World's Fair, 1967; others. Address in 1982, S.W. Atlanta, GA.

SIMON, SIDNEY.

Sculptor and painter. Born in Pittsburgh, PA, June 21, 1917. Studied at Carnegie Institute of Technology; Penna. Academy of Fine Arts; University of Penna., with George Harding, BFA; Barnes Foundation. Works: Century Association; Chautauqua Institute; Colby College; Metropolitan Museum of Art; The Pentagon; US State Dept.; plus many commissions, including Downstate Med. Center, Brooklyn; Temple Beth Abraham, Tarrytown, NY; stage and film sets. Exhibitions: Penna. Academy of Fine Arts; Niveau Gallery, NYC; Grand Central Moderns, NYC; Grippi Gallery, NYC; Pittsburgh Plan for Art; Yale University; New School for Social Research; National Academy of Design Annuals, 1944-60; Penna. Academy of Fine Arts, 1948-53, 1962; Metropolitan Museum of Art, American Painters Under 35, 1950; Whitney; International Biennial Exhibition of Paintings, Tokyo; Brooklyn Museum; Corcoran; Museum of Modern Art; American Federation of Arts, Educational Alliance Retrospective. Awards: Penna. Academy of Fine Arts, Cresson Fellowship; Edwin Austin Abbey Fellowship, 1940; Art Institute of Chicago, Posner Painting Prize; Penna. Academy of Fine Arts, Fellowship, 1960; Chautauqua Institute, Babcock Memorial Award, 1963; Century Association, Gold Medal for Sculpture, 1969. Member: Artists Equity; Century Association; New York Architectural League. Taught: Cooper Union, 1947-48; Brooklyn Museum School, 1950-52, 1954-56; Parsons School of Design, 1962-63; Skowhegan School, 1946-58 (Vice President and Director). Address in 1982, 95 Bedford Street, NYC.

SIMONDS, CHARLES FREDERICK.

Sculptor and architect. Born in NYC, November 14, 1945. Studied at University of California, Berkeley, BA, 1967; Rutgers University, Douglass College, New Brunswick, NJ, MFA, 1967. Work in Museum of Modern Art, NY; Walker Art Center, Minneapolis; Centre Georges Pompidou, Paris; others. Has exhibited at Whitney Biennial; Art Institute of Chicago; Walker Art Center; Stedelijk Museum, Amsterdam; Museum of Modern Art, NY; Albright-Knox Art Gallery, Buffalo; Los Angeles County Museum of Art; others. Address in 1982, 26 E. 22nd St., NYC.

SIMONE, EDGARDO.

Sculptor. Born in Brindisi, Italy, 1890. Came to US in 1924. Studied at the Institute of Fine Arts in Rome, Univ. of Rome, and the Art Institute in Naples, Italy. Work: Bronze bust of Theodore Dreiser, 1944, Met. Mus. of Art; worked on decorative sculpture for Century of Progress Exposition in Chicago, 1933. Exhibited at Los Angeles Co. Mus.; Calif. Art Club, Los Angeles; Los Angeles Public Library. Died in Los Angeles, CA, 1948.

SIMONS, AMORY COFFIN.
Sculptor. Born Charleston, SC, April 5, 1869. Studied: Penna. Academy of Fine Arts; Rodin, Dampt, and Puech in Paris. Works: High Museum of Art; Baltimore Museum of Art; Brookgreen Gardens, SC; Charleston Museum; Crag Museum, Cody, WY; Metropolitan Museum of Art; Santa Barbara Public Library; Museum of Natural History, NY; others. Awards: Honorable mention, Paris Exp., 1900; honorable mention, Pan.-Am. Exp., Buffalo, 1901; silver medal, St. Louis Exp., 1904; honorable mention, Paris Salon, 1906; honorable mention, P.-P. Exp., San Francisco, 1915; Speyer memorial prize, National Academy of Design, 1922. Exhibited: National Sculpture Society, 1923. Member: American Federation of Arts; American Art Association of Paris; National Sculpture Society. Specialty, sculptures of horses. Address in 1953, Santa Barbara, CA. Died in 1959.

SIMPSON, WILLIAM MARKS, JR.
Sculptor. Born Norfolk, VA, August 24, 1903. Pupil of J. Maxwell Miller; Rinehart School of Sculpture; Maryland Inst. Member: Norfolk Society of Artists; Grand Central Artists Guild. Awards: Sloane prizes, 1920, 21, 23, 24 and Ferguson prize, 1923, Norfolk Society of Artists. Work: Portrait bust of Patrick Henry in Patrick Henry School, Norfolk; athletic sketches, V. M. I., Lexington. Address in 1929, Norfolk, VA.

SIMS, RALPH.
Sculptor. Member: Independent Society of Sculptors. Address in 1921, Delphi, Ind.

SIMS, SAMUEL.
(Simms or Syms). Plaster modeler. Worked in NYC, 1844-46. Exhibited plaster medallion of Andrew Jackson, American Institute, 1845-46; unidentified plaster bust, 1844.

SINAIKO, ARLIE.
Sculptor and collector. Born in Kapule, Russia, October 1, 1902; US citizen. Studied at University of Wisconsin, B.S.; Northwestern University, M.D.; Art Institute of Chicago; Sculpture Center, NY; Art Students League; Atelier, with Archipenko, Lassaw, and Harkavy. Work in Phoenix Art Museum, AZ; Witte Memorial Museum, San Antonio, TX; Delgado Museum, New Orleans; others. Has exhibited at Penna. Academy of Fine Arts; Detroit Institute of Art; Riverside Museum, NY; Provincetown Art Association, MA. Received purchase prize, Penna. Academy of Fine Arts, 1961; honorable mention for sculpture, Audubon Artists; others. Member of American Society of Contemporary Artists; Artists Equity Association; Audubon Artists; Sculptors League. Address in 1982, 115 Central Park W., NYC.

SINCLAIR, MARJORIE.
Sculptor. Born in the United States. Pupil of Bourdelle in Paris. Address in 1916, 38 bis Rue Boulard, Paris, France.

SINNARD, ELAINE (JANICE).
Sculptor and painter. Born in Ft. Collins, Colo., February 14, 1926. Studied at Art Students League, 1948-49, with Reginald Marsh; New York University, 1951, with Samuel Adler; also with Robert D. Kaufmann, 1951; Sculpture Center, 1955, with Dorothea Denslow; Academie de la Grande Chaumiere, Paris, 1956; also with Betty Dodson, 1960. Commissions: Five wall hangings (with Mrs. Cris Darlington, Marlin Studios), Scandinavian Airlines, NY, 1961; three oil paintings, Basker Building Corp. 5660, Miami Beach, Fla., 1970. Exhibited at City Center Gallery, NY, 1954; Riverside Museum 8th Annual, NY, 1955; 1st Annual Metropolitan Young Artists, National Arts Club, NY, 1958; one-woman shows, Ward Eggleston Galleries, NY, 1959, and Fairleigh Dickinson University, NJ, 1960. Medium: Oil. Address in 1982, New Hampton, NY.

SINZ, WALTER A.
Sculptor and teacher. Born Cleveland, Ohio, July 13, 1881. Studied: Cleveland School of Art; Julian Academy, Paris; also pupil of Herman N. Matzen; Landowski in Paris. Exhibited: Whitney Museum of American Art, 1941; Penna. Academy of Fine Arts, 1935; Cleveland Museum of Art, annually. Member: Cleveland Society of Artists; National Sculptors Society. Awards: Certificate of Merit, Cleveland Museum, 1922, 23, 33, and later. Work: Cleveland 125th Anniversary Medal; fountain, Y.M.C.A., Cleveland; Cleveland Flower Show Medal; sculpture group, St. Lukes Hospital, Cleveland, Ohio. Instructor in sculpture, Cleveland School of Art. Address in 1953, Cleveland, OH; h., Univ. Heights, OH. Died in 1966.

SKILES, JACQUELINE.
Sculptor, printmaker, and videotape artist. Born in St. Louis, MO, in 1937. Studied: Washington University, St. Louis; University of Wisconsin, Madison; New School for Social Research, NYC. Exhibitions: Vis-a-Vis Gallery, NYC; University of Bridgeport, Conn.; Ramapo College of NJ; Women's Interart Center, NYC. Publications: *Documentary History of Women Artists in Revolution; Columbus Started Something.* Posters: Threat to the Peace; For Life on Earth; Liberation; Rise Up Sisters; Arising. She has been very active in the women artists movement.

SKILLIN, JOHN.
Ship carver. Born in Boston, 1746. Son of Simeon Skillin, Sr. Worked in Boston from about 1767 until his death. Carved the figurehead for the *Confederacy*, a Continental frigate. In partnership with his brother, Simeon Skillin, Jr., c. 1780-1800. Died in Boston, January 24, 1800.

SKILLIN, SAMUEL.
Ship carver. Son of Simeon Skillin, Sr. Active in Boston from about 1780 to 1816. Died in 1816.

SKILLIN, SIMEON.
Ship carver. Worked in NYC, active 1799-1822; after 1822, dealt in crockery and earthenware. Any relationship to the Boston Skillins is uncertain. In partnership with Charles Dodge, 1810.

SKILLIN, SIMEON, JR.
Ship carver. Born in Boston, 1756. Son of Simeon Skillin, Sr. Active in Boston from 1776-1806; in partnership with his brother John. Carved first figurehead of USS *Constitution*; bust of Milton; four figures for the garden of Elias Hasket Derby in Salem. The partnership was well known from Salem to Philadelphia for their figureheads and ship carvings. Also specialized in ornamental and

garden figures. Did relief carving for Badlam chest of drawers, Yale University Garvan Collection; Corinthian capitals, State House, Boston, 1797; capitals, Derby mansion, Salem, 1799; ornament "Plenty" (attributed), from the Bolles secretary, Metropolitan Museum of Art; other attributed works at Old State House, Boston, and Winterthur Museum. Died in 1806.

SKILLIN, SIMEON, SR.
Sculptor and wood-carver. Born in Boston, MA, 1716. Active in Boston by 1738. Did ship carving and figure-heads, such as the "Minerva" for the brig *Hazard*, for about forty years. Three sons, John, Simeon Jr., and Samuel, became ship carvers. Died in Boston, 1778.

SKILLIN, SIMEON, 3d.
Ship carver. Born in Boston, 1766. Probably a son of Samuel Skillin. Active in Boston and in Charlestown, MA, in 1829. Died in 1830.

SKILLIN & DODGE.
Ship carvers. Worked in New York City, 1810. Probably Charles Dodge and Simeon Skillin.

SKODIK, ANTONIN.
Sculptor. Pupil of Art Students League and sculptor of "Montana."

SKOLNIK, SARA.
Sculptor. Born in Chicago, Illinois. Studied: University of Chicago; State University of New York at Albany; with sculptor Richard Stankiewicz. Awards: Albany Museum, New York; Schenectady, New York. Exhibitions: Associated American Artists, 1971; Metropolitan Structures, "Forty Women," 1974; ARC Gallery, Chicago, 1974.

SKOOG, KARL FREDERICK.
Sculptor and painter. Born Sweden, November 3, 1878. Pupil of Bela L. Pratt. Member: Conn. Academy of Fine Arts; Boston Sculptors Society; Boston Art Club. Awards: Prize, Rochester, NY, 1908; honorable mention, Society of American Artists, 1912; honorable mention, Conn. Academy of Fine Arts, 1915, 18; first prize, Society of American Artists, 1918; first prize, Swedish American Artists, 1918, 1921; honorable mention, Swedish American Artists, 1912, 1920; honorable mention, Chicago Society of American Artists, 1920; first prize for sculpture, Conn. Academy of Fine Arts, 1930. Work: Bust of John Ericsson in K. of P. Building, Brockton, MA; bronze tablet in Home for Aged Swedish People, West Newton, MA; Perry Monument, Forest Dale Cemetery; relief, J. A. Powers, Elks Building, Malden, MA; medallion, R. W. Emerson, Mus. of Numismatic Society, NY; Soldiers Monument, Cambridge, MA; Soldiers World War Monument, Cromwell, CT; "On Guard," Angell Memorial Hospital, Boston; memorial relief to A. N. Pierson, Cromwell Gardens, Cromwell, CT; "Light" and "Charity," bronze doors, Masonic Temple, Goshen, IN; memorial relief to A. P. Peterson, John Morton Memorial Museum, Philadelphia, PA. Address in 1933, Boston, MA. Died in 1934.

SLAVET, RUTH.
Sculptor. Studied: Bennington College, Bennington, VT;

Boston University, School of Fine Arts; Impression Workshop, Boston. Exhibitions: Boston Summerthing Traveling Art Exhibit, Boston, 1968; Brockton Art Center, Brockton, MA, 1972, 1973; Hayden Gallery, Mass. Institute of Technology, 1973.

SLEETH, L. MacD.
(Mrs. Francis V. Sleeth). Sculptor, painter, and teacher. Born Croton, IA, October 24, 1864. Pupil of Whistler, MacMonnies and Emil Carlsen. Member: San Francisco Art Association; Washington Water Color Club; Society of Washington Artists; Washington Art Club; Laguna Beach Art Association. Work: Portrait busts in marble of "Brig. Gen'l. John M. Wilson," Corcoran Gallery of Art; "Martha Washington," Memorial Continental Hall, and "Rt. Rev. Bishop Henry T. Satterlee," Cathedral Foundation, all in Washington, DC. Address in 1933, Cathedral School for Girls, Washington, DC.

SLICK, JOHN COLBURN.
Sculptor and printmaker. Born in Detroit, MI, 1946. Studied: Michigan Technological University, Houghton; Wayne State University, Detroit, BFA, 1970. Exhibitions: Ball State University, Muncie, IN, 1969; Young Printmakers, 1970; Herron School of Art, Indianapolis, IN; Wayne State University (Faculty Show); Detroit Institute of Arts, 1974/75 and 1982; Annual Mid-Michigan Exhibition, Midland Center for the Arts, 1976, 77, 78, 79, 82; Common Ground of the Arts, Manufacturers National Bank, Detroit, 1978; Cranbrook Academy of Art Museum, Bloomfield Hills, 1979; Detroit—The Summer Months, Park West Galleries, Southfield, 1981; 7th Michigan Biennial; Michigan State University, East Lansing, 1981. Awards: Annual Mid-Michigan Exhibition, Midland Center for the Arts, 1976, 82. Address in 1982, Detroit, MI.

SLINGHUFF, KATHLEEN.
Sculptor. Exhibited: Baltimore, MD, 1935. (Mallett's)

SLIVKA, DAVID.
Sculptor. Born in Chicago, IL. Studied at the California School of Fine Arts. Exhibited: Mus. of Modern Art, 1962; Guggenheim Mus., 1962-63; Mus. of Fine Arts, Boston, 1968; Albright-Knox Art Gal., Buffalo, NY, 1974; one-man shows include Everson Mus., Syracuse, NY, 1974, and the Univ. of Penn., 1975. Taught: Univ. of Mass., Amherst, 1964-67; artist in residence, Southern Illinois Univ., Carbondale, 1967-68; Queens College, NY, 1971-73; and at the Penn. Acad. of Fine Arts, Philadelphia, 1972-82. Media: Marble, wood, and bronze. Address in 1982, 549 West 52nd St., NYC.

SLOBODKIN, LOUIS.
Sculptor, writer, illustrator, lecturer, and teacher. Born Albany, NY, February 19, 1903. Studied: Beaux-Arts Institute of Design. Work: Madison Square Post Office, NY; memorial tower, Philadelphia, PA. Exhibited: Whitney, 1935-44; Penna. Academy of Fine Arts, 1941-45; World's Fair, NY, 1939; Art Institute of Chicago, 1939-43; Sculptors Guild, traveling exhibiton; Metropolitan Museum of Art, 1942, 44; others. Award: Caldecott medal, 1943. Member: Sculptors Guild; Artists Equity Association;

others. Author, *Sculpture Principles and Practice*, 1949, *First Book of Drawing*, 1958; illustrator, *Tom Sawyer*, 1946, *Robin Hood*, 1946, and many others. Positions: Head of sculpture dept., Master Institute, NYC, 1934-37; and New York City Art Project, 1941-42; board of directors, Sculptors Guild, 1940-45. Address in 1970, 209 West 86th Street, NYC. Died in 1975.

SLOBODKINA, ESPHYR.
Sculptor, painter, illustrator, writer, designer, and craftsman. Born in Tcheliabinsk, Russia, September 22, 1914. Studied: National Academy of Design; and abroad. Member: Am. Abstract Artists; Federation of Modern Painters and Sculptors. Work: Philadelphia Museum of Art; Whitney; Corcoran; others. Exhibited: Whitney Museum; John Heller Gallery; Federation of Modern Painters and Sculptors, NYC, 1983; American Abstract Artists. Awarded Yaddo Fellowships and MacDowell Fellowships. Author, illustrator, "The Little Fireman;" "Little Cowboy;" "Caps for Sale," and others books. Address in 1953, 20 West Terrace Road, Great Neck, NY; h. 108 East 60th St., New York, NY.

SLOCUM, ANNETTE MARCELLUS.
Sculptor. Born in Cleveland, OH. Studied at Penna. Academy of the Fine Arts, and with Edward Lanteri; also at Royal College of Arts, London. Exhibited at National Sculpture Society, 1923. Specialty, portraiture. Address in 1926, 250 West 154th St., NY.

SLOCUM, SAMUEL GIFFORD.
Sculptor and architect. Born in Leroy, NY, 1854. Pupil of Cornell University. Member: Salma. Club, Address in 1906, 1170 Broadway, NYC.

SLOCUM, VICTOR VAUGHAN.
Sculptor. Exhibited portraits in the Penna. Academy of the Fine Arts, 1924, Philadelphia, PA. Address in 1926, Philadephia, PA.

SLOMAN, JOSEPH.
Sculptor, painter, illustrator, and craftsman. Born in Philadelphia, PA, December 30, 1883. Pupil of Howard Pyle, B. W. Clinedinst and Clifford Grayson. Works: Art Dome, Town Hall, West NY, NJ; "Martin Luther," Church of St. John, West NY, NJ; stained glass memorial in Hoboken, NJ, Temple; work in Synagogue at Athens, GA; Public Library, Hoboken, NJ. Exhibited: Phila. Art Club; Penna. Academy of the Fine Arts; National Academy of Design; others. Illustrated "In Many Islands." Address in 1953, Union City, NJ.

SMALL, AMY GANS.
Sculptor. Born in New York City, in 1915. Studied at Hartford Art School; Art Students League with Wm. Zorach; National Park College; and with Seymour Lipton, New School for Social Research; others. Exhibited at Woodstock Presentation Show, NY, 1950; Woodstock Art Association; Krasner Gallery, NYC; many others. Head of sculpture section, Woodstock School of Art, 1969-71; others. Member of Woodstock Art Association; Artists Equity Association of New York. Works in stone, wood, metal. Address in 1976, Woodstock, NY.

SMALL, HANNAH L.
Sculptor. Born in New York City, January 9, 1908. Studied at Art Students League. Works: University of Nebraska. Award: Art Institute of Chicago, 1940. Exhibited at Fairmount Park, Phila.; Art Institute of Chicago; Whitney; Woodstock Art Association; Passedoit Gallery. Address in 1953, Woodstock, NY.

SMALL, MAY MOTT SMITH.
See Mott-Smith.

SMALL, NEAL.
Sculptor and designer. Born in NYC, August 4, 1937. Studied at Museum of Modern Art School; Texas A & M School of Architecture, 1954-56; West Virginia Wesleyan, 1956-58. Work at Museum of Modern Art, NY; Brooklyn Museum; Philadelphia Museum of Art; Albright-Knox Art Gallery, Buffalo; Dallas Museum of Fine Arts. Has exhibited at Brooklyn Museum Excellence in Design; Smithsonian Institution, Washington, DC; Museum of Science and Industry, Chicago; others. Works in acrylic, bronze, and collage. Address in 1982, 178 Fifth Ave., NYC.

SMALLEY, DAVID ALLAN.
Sculptor. Born in New London, CT, December 17, 1940. Studied at Rhode Island School of Design, 1958-60; University of Conn., with Anthony Padovano, B.F.A., 1963; Indiana University, M.F.A., 1965. Work at Lyman Allyn Museum and Conn. College, New London. Has exhibited at De Cordova Museum Outdoor Sculpture, Lincoln, MA; Kraushaar Galleries, NY; Lyman Allyn Museum, New London, CT; others. Member of Mystic Art Association. Works in stainless steel and brass. Address in 1982, New London, CT.

SMED, PEER.
Sculptor. Address in 1934, Woodhaven, Long Island, New York. (Mallett's)

SMEDLEY, WILL LARYMORE.
Sculptor, painter, craftsman and designer. Primarily painter. Born in Sandyville, Ohio, November 10, 1871. Studied: Case School of Applied Science. Member: Society of Artists and Illustrators; Cleveland Society of Artists; National Craftsmen. Exhibited: National Academy of Design; American Miniature Painters Society; Penna. Academy of Fine Arts; American Watercolor Society of New York; Albright Art Gallery; Art Institute of Chicago, and many others. Address in 1953, Chautauqua-on-the-Lake, New York.

SMITH, ANDRE.
Sculptor, painter, architect, etcher and writer. Born in Hong Kong, China, 1880. Studied: Cornell University, B.S. in Architecture, M.S. in Architecture. Founder and Director, The Research Studio, Maitland, Fla., an art center for the development of modern art. Died in 1959. Address in 1953, Maitland, FL.

SMITH, BARBARA.
Sculptor. Studied: Iowa University. Noted for her use of plexiglas and light.

SMITH, BRADFORD LEAMAN.

Sculptor and collage artist. Born in Los Angeles, CA, July 8, 1940. Studied at Chicago Art Institute, 1963; independent work and study, Florence, Italy, 1963-64. Work, cast stone relief mural, The Show Box, De Vargas Mall, Santa Fe, NM; carved black walnut door, Vorpal Gallery, San Francisco; others. Has exhibited at Southwest Crafts Biennial, International Folk Art Museum, Santa Fe; New Mexican Sculpture, Museum of Fine Arts, Santa Fe; Installations, Museum of Fine Arts, Santa Fe. Received Anna Louise Raymond traveling fellowship, sculpture, Chicago Art Institute, 1963; US Government award for development of new production method of lower limb prosthesis, Oak Knoll Naval Hospital, 1969. Works in cast metal and rubber. Address in 1982, Santa Fe, NM.

SMITH, CARL ROHL.

(Also Rohl-Smith). Sculptor. Born in Copenhagen, Denmark, April 3, 1848. He studied at Academy of Copenhagen, 1865-70; also travelled to Berlin, Italy, and Vienna. He was in NY, St. Louis, and Chicago 1886-1900. His studio was for years in Washington, DC, where he designed the Sherman Monument in front of the Treasury Building. His work is also in Memphis, TN, and Copenhagen. He died in Copenhagen, on August 20, 1900.

SMITH, CATHERINE N.

Fancy wax worker. Born in Philadelphia, PA, 1785. Still living there in 1860.

SMITH, CECIL A.

Sculptor, painter, illustrator, and teacher. Born in Salt Lake City, UT, 1910. Studied at Brigham Young University; University of Utah; art in NYC with John Carroll, Max Weber, Kenneth Hayes Miller, and Kuniyoshi. Cowboy and rancher, turned to painting full-time in 1960. Illustrator, *Sunset Magazine*. Painting selected for European tour of government collection, 1935. Specialty is contemporary Western life. Address in 1976, Somers, MT.

SMITH, DAVID.

Sculptor. Born in Decatur, Indiana, in 1906. Studied at Ohio Univ., 1924; Art Students League, 1926-30, with John Sloan, Jan Matulka. Works: Baltimore Mus. of Art; Brandeis U.; Carnegie; Cincinnati Art Mus.; Art Inst. of Chicago; Detroit Inst.; Met. Mus. of Art; Mus. of Modern Art; U. of Michigan; U. of Minnesota; San Fran. Mus. of Art; St. Louis City; Utica; Whitney; Walker. Exhibitions: The Willard Gal., NYC; Kalamazoo Inst.; Walker; Buchholz Gal., NYC; Cooling Gal., London; Utica; Tulsa (Philbrook); The Kootz Gal., NYC; Cincinnati Art Mus.; Otto Gerson Gal., NYC; Everett Ellin Gal., Los Angeles; Harvard U.; Tate; Guggenheim; XXIX Venice Biennial, 1958; Sao Paulo, 1959; Documenta II & III, Kassel, 1959, 64; Whitney; Art Inst. Chicago; Carnegie; Mus. Modern Art. Awards: Guggenheim Found. Fel., 1950, 51; Brandeis U., Creative Arts Award, 1964. Taught: Sarah Lawrence Coll., 1948; U. of Arkansas, 1953; Indiana U., 1954; U. of Mississippi, 1955. Died May 5, 1965, Bennington, VT.

SMITH, DONALD C.

Sculptor and painter. Born in New Orleans, LA, 1929. Studied: Tulane University, B.A., 1950. Exhibits at Troy's, Scottsdale, AZ; Merrill Chase Galleries, Chicago, IL. Specialty is Western scenes. Paints in oil; sculpts in bronze. Has sold Western paintings to national magazines. Sculpture subjects have included bulls and matadors; Indian studies. Address in 1982, Metaire, LA.

SMITH, EDWARD HERNDON.

Sculptor and painter. Born Mobile, July 9, 1891. Pupil of Weir, Tack and Yale School of Fine Arts. Member: Brooklyn Society of Modern Artists. Address in 1933, Mobile, AL.

SMITH, EDWARD ROBINSON.

Sculptor. Born in Beirut, Syria, January 3, 1854. Pupil of Wm. Rimmer and Frank Duveneck. Member: New York Architectural League 1910; New York Municipal Art Society; Archaeological Institute of America; American Numismatic Society; American Library Association. Librarian, Avery Architectural Library, Columbia University. Died in Stamford, CT, March 21, 1921.

SMITH, ERWIN E.

Sculptor, sketch artist, and photographer. Born in Honey Grove, TX, 1888. Studied modeling in Chicago with Lorado Taft, in Boston with Bela Pratt. Specialty was cowboy and Indian subjects. Sculpture titles include "Sioux Indians," head of "Nez Perce Indian." Photographs illustrated Western stories of George Patullo; also collected in *Life on the Texas Range*, 1952, by J. Evetts Haley. Died at Bermuda Ranch, Bonham, TX, 1947.

SMITH, FREDERICK.

Sculptor. Born in Germany c. 1807. Active in Washington, DC, 1850-55.

SMITH, GLADYS K.

Sculptor, painter, and teacher. Born Philadelphia, PA, April 30, 1888. Pupil of Phila. School of Design; Penna. Academy of Fine Arts. Member: Fellowship Penna. Academy of Fine Arts; Plastic Club; Alumni, Philadelphia School of Design; Eastern Art Association. Instructor in art, Shaw Junior High School, West Philadelphia. Address in 1933, Philadelphia, PA; summer, Locust Valley, LI, NY.

SMITH, ISHMAEL.

Sculptor, painter, and illustrator. Born Barcelona, Spain, July 16, 1886. Studied at Ecole Nationale des Arts Decoratifs, Paris; in schools of Rafael Atche, Baixas, Querol, Benlliure. Member: Salmagundi Club; American Federation of Arts; Alliance; American Numismatic Society. Works: Monument to Pablo Torull, Caja de Ahorros de Sabadell, Catalunya; portrait of Mila Y Fontanals, Institute des Estudies Catalans; portrait of Alphonse Maseras and group in sculpture, Museum of Barcelona, Spain. Represented in British Museum, London; Hispanic Museum, NY; Cleveland Museum; "Blessed Teresa," Carmelite Fathers, Washington, DC. Awards: Medal at International Exposition, Belguim, 1910, and International Exposition, Barcelona. Exhibited at National Sculp-

ture Society, 1923. Address in 1933, 173 Riverside Drive, NYC.

SMITH, JACK.
Sculptor. Born in Wichita, KS, 1947. Studied: Wichita State University (anthropology, geology, commercial art); Washburn University (psychology and studio art). Began art career as jeweler. Has exhibited at McCormick Art Gallery, Midland, TX; Shidoni Gallery, Tesuque, NM. Specialty is animals and figures. Works in stone, bronze. Address since 1974, Santa Fe, NM.

SMITH, JOHN.
Sculptor. Born c. 1805, in Ireland. Came to New York before 1831. Located: New York City, 1850.

SMITH, JOYNNYE.
Sculptor. Born in 1942. Noted for her ink figures on plexiglas.

SMITH, LAWRENCE BEALL.
Sculptor, painter and illustrator. Born in Washington, DC, October 2, 1909. Studied at the Art Institute of Chicago, University of Chicago, 1931; also under Ernest Thurn, Gloucester, MA; Harold Zimmerman, and Charles Hopkinson, both in Boston. Exhibited: Carnegie Institute, Pittsburgh, PA, 1941; Whitney Museum of American Art, 1960; National Academy of Design Annual, NYC, 1974 and 75; and many others. Illustrated *Robin Hood* for Grossett, 1954; *Girls are Silly*, Odgen Nash, Watts, 1962; *Tom Jones* by Henry Fielding, 1964; and others. In collections of Fogg, Cambridge, MA; Metropolitan Museum; Wichita; Herron; others. Sculpture work is in stone. Address in 1982, Cross River, NY.

SMITH, MAY MOTT.
See Mott-Smith.

SMITH, TONY.
Sculptor. Born in South Orange, NJ, 1912. Studied at the Art Students League, 1934-35; New Bauhaus, Chicago, for architectural study, in 1937-38; architectural apprentice of Frank Lloyd Wright, 1938-40. Gave up architecture for sculpture in 1960, of geometric forms. His works concentrate on unifying architecture, painting, and sculpture, exemplified by his "Gracehoper," (1961), the cubic piece "Black Box" (1962) and "The Snake is Out" (1962). Larger pieces include his "Smoke," based on a space grid. Noted for his cave-like sculpture executed for 1970 World's Fair at Osaka, Japan. Exhibited: Wadsworth Atheneum, Hartford, CT, 1964, 67, and 74; Phila. Institute of Contemporary Art, 1967; Whitney Museum of American Art Annual, 1970-73; Metropolitan Museum of Art, NY, 1970; Los Angeles Co. Museum of Art, 1971; San Fran. Museum of Art, 1971; Seattle Art Museum Pavilion, Wash., 1973; Cleveland Museum of Art, 1974; Painting and Sculpture Today, 1974, Indianapolis Museum of Art, 1974; Art Institute of Chicago, 1974; Walker Art Center, Minneapolis, 1974; New Orleans Museum of Art, LA, 1976; and others. Taught: New York University, 1946-50; at Cooper Union, Pratt Institute, Bennington College, and Hunter College from 1962. Associated with Barnett Newman, Clyfford Still, Jackson Pollock, and Mark Rothko. Address in 1982, c/o The Pace Gallery, NYC.

SMITH, WILLIAM.
Modeler of wax. Presumably American. Modelled a wax portrait of John Paul Jones.

SMITHSON, ROBERT.
Sculptor. Born in Passaic, NJ, January 2, 1938. Studied at Art Students League. Work: Whitney. Exhibitions: Galleria George Lester, Rome; Dwan Gallery, NYC; Konrad Fischer Gallery, Dusseldorf; Jewish Museum, Primary Structures; Whitney; Los Angeles County Museum of Art; Trenton State, Focus on Light; The Hague, Minimal Art; Museum of Modern Art; Albright; Milwaukee; Stedelijk. Address in 1970, 799 Greenwich St., NYC. Died in 1974.

SMOKLER, STAN.
Sculptor. Born in New York City, November 27, 1944. Studied: University of Pittsburgh, BA, 1967; Pratt Institute, Brooklyn, NY, MFA, 1975, Sculpture and Painting. Exhibitions: Pratt Institute, 1975; Rizzoli International Gallery, NYC, 1978; Fornal Gallery, NYC, 1978-79; Annual Sculpture Exhibition, juried, Salmagundi Club, NYC, 1981; Invitational Benefit Exhibition, Lotus Club, NYC, 1982; Invitational Benefit honoring Louise Nevelson, Palace Hotel, NYC, 1982; Vorpal Gallery, NYC, 1983; others. Managing director of interior design firm in NYC, Furniture Industries, 1971-79. Address in 1983, 873 Broadway, NYC.

SMOLEN, FRANCIS (FRANK).
Sculptor, painter, illustrator, designer, craftsman, and teacher. Born in Manor, PA, January 8, 1900. Studied at Fed. School, Inc.; Carnegie Institute; and with Bicknell, Readio, Ashe, and others. Member: Friends of Art, Youngstown, OH. Awards: Prizes, Sharon Art Association, 1935, 39, 43. Work: Buhl Girls Club, Sharon, PA. Exhibited: Devoe and Raynolds Exhibition, 1940; Associated Artists of Pittsburgh, 1928, 31-34; Butler Art Institute, 1935, 36, 38, 41, 43; Sharon Art Association, 1938-42, 45; Albright Art Gallery, 1949; Alliance College, Cambridge Springs, PA, 1951. Address in 1953, Sharon, PA.

SMOOT, MARGARET.
Sculptor. Born Lakeport, Calif., August 29, 1907. Pupil of Charles Grafly and Albert Laessle. Member: Fellowship Penna. Academy of Fine Arts. Awards: Cresson Traveling Fellowship, Penna. Academy of Fine Arts, 1930 and 1931. Address in 1933, Altamonte Springs; h. Route 2, Maitland, Fla.

SMYTH, DAVID RICHARD.
Sculptor. Born in Washington, DC, December 2, 1943. Studied at Corcoran School of Art, Washington, DC, 1962-64; Art Institute of Chicago, B.F.A., 1967, M.F.A., 1969. Work at Whitney Museum of American Art, NY; others. Has exhibited at Art Institute of Chicago; Whitney Museum of American Art, NY; Museum of Contemporary Art, Chicago; Prints, Brooklyn Museum; others. Received George D. Brown Traveling Fellowship, Art Institute of Chicago, 1969, and Richard Rice Jenkins Award; others. Address in 1982, c/o Ronald Feldman Fine Arts Inc., NYC.

SMYTHE, ROBERT L.
Sculptor. Born in Ireland, 1820. Worked in New York City in 1850.

SNEDEN, ELEANOR ANTOINETTE (MRS.).
Sculptor. Born in New York, 1876. Pupil of Mlle. Genevieve Granger in Paris. Specialty, portrait medallions. Address in 1913, Avon-by-the-Sea, NJ.

SNELSON, KENNETH D.
Sculptor. Born in Pendleton, OR, June 29, 1927. Studied at University of Oregon, with Jack Wilkinson; Black Mountain College, with Josef Albers, Buckminster Fuller, Willem de Kooning; Academie Montmartre, Paris, with Fernand Leger. Works: Museum of Modern Art; Whitney; Stedelijk Museum, Amsterdam; Hirshhorn. Exhibited: Pratt Institute; New York World's Fair; Dwan Gallery, NYC; Dwan Gallery, Los Angeles; Bryant Park, NYC; Rijksmuseum Kroller-Muller; Stadtische Kunsthalle, Dusseldorf; Museum of Modern Art, NYC; Milan Triennial, 1964; Whitney Sculpture Annual, 1966-69; Los Angeles County Museum of Art; Art Institute of Chicago; Albright; Phila. Museum of Art. Award: Milan Triennial, Silver Medal, 1964. Taught: Cooper Union; Pratt Institute; School of Visual Arts, NYC; Southern Illinois University; Yale University. Address in 1982, 140 Sullivan St., NYC.

SNIDOW, GORDON E.
Sculptor, painter, commercial artist, and lithographer. Born in Paris, MO, September 30, 1936; raised in Texas and Oklahoma; settled in Albuquerque, NM, 1959. Studied at Art Center School, Los Angeles. Work in Montana Historical Society; National Cowboy Hall of Fame; P T Cattle Co.; Gilcrease Museum, Tulsa; others. Has exhibited at National Cowboy Hall of Fame; Phoenix (AZ) Art Musem; Montana Historical Society. Member: Cowboy Artists of America. Specialty is contemporary Western subjects. Bibliography, *Bronzes of American West*, Broder; *American Painting Today*, Hassrick. Address in 1982, Ruidoso, NM.

SNOWDEN, GEORGE HOLBURN.
Sculptor. Born in New York, December 17, 1902. Studied at Yale School of Fine Arts; Ecole des Beaux-Arts; pupil of A. A. Weinman. Received Prix de Rome in 1927; New Haven Paint and Clay Club prize, 1926; Otis Elevator prize, Beaux-Arts Institute, NYC, 1926. Work: Law groups, Bronx County, NY; pediments, Drink Hall, Saratoga Springs, NY; Yale Memorial, Pershing Hall, Paris. Address in 1933, 154 West 55th Street, NYC.

SNVERNIZZI, PROSPER.
Sculptor, who exhibited in the Penna. Academy of the Fine Arts, Philadelphia, 1926. Address in 1926, 500 West 178th Street, New York City.

SNYDER, BERNARD G.
Sculptor. Born in Sacramento, CA, 1940. Private collections. Exhibitions: Michigan Artists Exhibition, The Detroit Institute of Arts, 1961, 63; Michigan Craftsmen Exhibition, 1962, 64; Michigan Focus, The Detroit Institute of Arts, 1974-75; Artists' Gallery, Ann Arbor, 1964. Awards: 1st Prize, Ford Motor Company Art Show, 1964. Address in 1975, Detroit, MI.

SNYDER, CORYDON GRANGER.
Sculptor, painter, illustrator, etcher, writer, and teacher. Born Atchison, KS, February 24, 1879. Member: Palette and Chisel Club and Chicago No-Jury Society of Art. Author of course in fashion illustration published by Federal Schools of Minneapolis; "Modern Advertising Arrangement," "Pen and Ink Technique," pub. by Myer Booth College, Chicago; "Retouching Not Difficult." Represented by work in Historical Society, St. Paul, Minn. Chiefly painter and illustrator by 1953. Address in 1953, Chicago, IL.

SNYDER, DAN.
Sculptor. Born in Philadelphia, PA, July 23, 1948. Studied at Penna. State University, B.F.A., 1970; University of California, Davis, M.F.A., 1972. Work in Oakland Museum, CA; E. B. Crocker Art Museum, Sacramento; American Academy, Rome, Italy; others. Has exhibited at Wisconsin Kohler Art Center, Sheboygan; Oakland Museum, CA; American Academy, Rome; San Francisco Museum of Modern Art; others. Received special project grant, National Endowment for the Arts, 1973; fellowship, Prix de Rome, 1973-75. Address in 1982, Oakland, CA.

SOLOMON, MAUDE BEATRICE.
(Mrs. Joseph Solomon). Sculptor, painter, and illustrator. Born Seattle, WA, June 6, 1896. Pupil of Liberty Todd, Hugh Breckenridge. Member: Fellowship Penna. Academy of Fine Arts. Illustrated "Aristocrats of the North." Address in 1933, NYC.

SOLOMON, MITZI.
Sculptor, designer and teacher. Born in NY, January 1, 1918. Studied: Columbia University, B.S., M.A.; Art Students League; and with Oronzio Maldarelli, Anne Goldthwaite, and others. Member: National Association of Women Artists; New York Society of Women Artists; Audubon Artists; Springfield Art League. Awards: Prizes, Smith Art Gallery, Springfield, MA, 1940, 43, 45; Irvington (NJ) Public Library, 1944. Exhibited: Whitney Museum of American Art, 1945, 46; Art Institute of Chicago, 1942; Cincinnati Museum Association, 1939, 41; Metropolitan Museum of Art, 1942; Denver Art Museum, 1942-44; National Association of Women Artists, 1943-46; Conn. Academy of Fine Arts, 1940; North Carolina Artists, 1943, 44; Newport Art Association, 1944, 45; Springfield Art League, 1941-44, 46; one-man exh.: Syracuse Museum of Fine Arts; Phila. Art Alliance; de Young Memorial Museum; Milwaukee Art Institute; Brooks Mem. Art Gallery. Address in 1953, 2 Columbus Circle; h. 115 Central Park West, NYC.

SOLON, LEON VICTOR.
Sculptor, painter and illustrator. Born in England, 1872. Studied at Royal College of Art, London. Member of Royal Society of British Artists; National Sculpture Society; others. Awarded medal, American Institute of Architects; Architectural League; others. Represented in Victoria and Albert, London; Rockefeller Center, NYC; Fairmount Park, Phila.; others. Living in NYC in 1934. Address in 1953, Lakeland, FL.

SOMMERBURG, MIRIAM.
Sculptor. Born in Hamburg, Germany, October 10, 1910. Studied with Friedrich Adler, Richard Luksch in Germany. Works: Florida Southern College; Metropolitan Museum of Art; Butler Institute; Springfield (Missouri) Art Museum. Exhibitions: Florida Southern College, 1952; Village Art Center, 1948, 49, 50, 51, 57; Creative Art Gallery, 1950; NJ Painters and Sculptors, 1955; Knickerbocker Art, 1954; National Association of Women Artists; Brooklyn; Whitney; others. Address in 1976, 463 West St., NYC.

SONDHEIMER, ROSALEE.
Sculptor. Address in 1934, Memphis, Tennessee. (Mallett's)

SONED, WARREN.
Sculptor, painter, designer, teacher, and lecturer. Born in Berlin, Germany, September 15, 1911. Studied at Fine Arts Academy, Duesseldorf, Germany; Beaux-Arts Institute, Grande Chaumiere, Paris, France; University of Miami, B.A. Member: Mural Artists Guild; Society of Independent Artists. Awards: Prize, National Army Exh. 1945. Work: Murals, US Post Office, Hapeville, GA; New York Telephone Building; Pildes Optical Co., NY; Barbizon School of Fashion Modeling, NY; Walter Reed Hospital, Wash., DC. Exhibited: Society of Independent Artists; Army Art Exhibition, Dallas, TX, 1945; Lowe Gallery, University of Miami, 1952, and in Europe. Position: Instructor and lecturer, University of Miami, Florida, from 1950. Died in 1966. Address in 1953, Miami Beach, FL.

SONNENBERG, FRANCES.
Sculptor and instructor. Born in Brooklyn, NY, September 17, 1931. Studied with Prof. Alfred Van Loen. Commissions: Five ft. carved acrylic sculpture, Aquarius, Fla., 1975. Exhibitions: Audubon Artists, National Academy Gallery, NY, 1973 and 74; National Sculpture Society, Lever House, NY, 1974; National Association of Women Artists, National Academy Gallery, 1975; one-woman shows, Stephan Gallery, NY, Buyways Gallery, Fla., and Shelter Rock Gallery, NY. Member of National Association of Women Artists; Metropolitan Painters and Sculptors; others. Address in 1982, Roslyn Heights, NY.

SONNIER, KEITH.
Sculptor and painter. Born in Mamou, LA, 1941. Studied at the University of Southwestern LA, 1959-63, BA; Rutgers University, 1965-66, MFA, where he met artists Robert Morris, Gary Kuehn, and Robert Watts. Continued to paint during a year in France. Exhibited: Douglass College, New Brunswick, NJ, 1966; Galerie Rolf, Inc., 1968, 71, 72, 75, 76, 78, 79; ACE Gallery, Los Angeles, CA, 1970, 75, 77; Creigh Gallery, Coronado, 1974, 76; Rosamund Felsen Gallery, Los Angeles, 1978; The Clocktower, NYC, 1978; Galerie Michele Lachowsky, Brussels, 1979; Eric Fabre Gallery, Paris, 1979; American Abstract Artists, 1968; Washington University, Here and Now, 1969; Museum of Modern Art, Information, 1971; Dusseldorf/Kunsthalle, Prospect '71, 1971; and many others. Noted early in career for his soft sculptures of inflatible boxes run by motors; also his use of neon tubing, latex, string, and glass in his non-sculptural

works. He has also executed works using sound recordings and videotape in conjunction with other materials. Awards include first prize, Tokyo Print Biennial, 1974; Guggenheim Foundation Fellowship, 1974. Address in 1982, 33 Rector Street, NYC.

SORENSEN, CARL SOFUS WILHELM.
Sculptor and painter. Born in Denmark, September 25, 1864. Pupil of the Academy of Fine Arts and of P. S. Kroyer in Copenhagen. Specialty, modeling in wax. Address in 1913, 3241 Pierce Place, Chicago, IL.

SORENSEN, REX.
Sculptor. Born in Omaha, Nebraska, 1908. Address in 1934, Oak Grove, Oregon. (Mallett's)

SORENSON-DIEMAN, CLARA LEONARD.
Sculptor. Born in Indianapolis, IN, in 1877. Pupil of Lorado Taft and Victor Brenner. Member: Chicago Society of Artists; Indiana Society of Artists; Alumnae, Chicago Art Institute. Work: Memorial Tablet, Shortridge High School, Indianapolis; Memorial Tablet, YMCA, Cedar Rapids, IA; Memorial Tablet, Art Association, Cedar Rapids, IA. Address in 1926, Cedar Rapids, IA.

SOUTHER, LYNA CHASE.
(Mrs. Latham T. Souther). Sculptor, painter, and writer. Born St. Louis, MO, October 14, 1880. Pupil of Edmund Wuerpel, Boris Lovatt-Lorski, Klasstorner. Member: Springfield Art Association; Illinois Academy of Fine Arts. Address in 1933, Springfield, IL.

SOWINSKI, JAN.
Sculptor and painter. Born in Opatow, Poland, October 2, 1885. Studied at Beaux-Arts Institute of Design; and in Poland. Works: St. Stephen's Church, Paterson, NJ; Trinity Church, Utica, NY. Award: Beaux-Arts Institute of Design. Member: Modelers and Sculptors of America and Canada. Address in 1953, Long Island City, NY.

SPACKMAN, CYRIL (SAUNDERS).
Sculptor, painter, etcher, engraver, lithographer, lecturer, teacher, and writer. Born in Cleveland, OH, August 15, 1887. Pupil of Henry G. Keller in Cleveland; Kings Col. Arch. Studio, London. Member: Royal Society of British Artists; American Federation of Arts; Society Graphic Arts; Cleveland Society of Artists; Chicago Society of Etchers. Represented in Cleveland Museum; Chicago Art Institute; Print Room of the British Museum; permanent collection of the City of Hull; The Nativity, The Crucifixion, The Ascension, altar panels in 13th Century Church, Grosmont, Monmouthshire; Crucifix in stone, Sanctuary of William Lillico Memorial Church of All Saints' at Selhurst, Surrey. Designed medal of Masonic Million Memorial. Art Editor of "The Parthenon." Address in 1933, East Croydon, Surrey, England.

SPAETH, JANET.
Sculptor. Exhibited in New York in 1934. (Mallett's)

SPAMPINATO (SPAM), CLEMENTE.
Sculptor. Born in Italy, January 10, 1912; US citizen. Studied at Royal School of the Medal, Rome; Academy of Fine Arts, Rome; others. Member: National Sculpture Society; International Fine Arts Council; others. Awards:

Prizes, American Artists Professional League, 1951; National prize, Rome, 1940, 41; gold medal, Municipal Art League, Chicago. Work: Statues, monuments, Navy Stadium, Italicum Forum, Rome; 2 lime-stone bas reliefs, Brooklyn Heights, Library, NY; Bobby Jones (12 ft. sculpture), World Golf Hall of Fame, Pinehurst, NC; Delgado Museum, New Orleans; Oklahoma Art Center; others. Exhibited: National Exhib. Sport Sculpture, Rome, 1940, 48; American Artists Professional League, 1947, 51; Allied Artists of America, 1948; National Sculpture Society, 1952-78; Grand Central Palace, NY, 1952; International Triennial, Naples, Italy, 1952; National Academy of Design, NY, 1964-76; others. Works in bronze and marble. Address in 1982, Sea Cliff, NY.

SPARLING, JOHN EDMOND (JACK).
Sculptor, painter, illustrator, and cartoonist. Chiefly illustrator and cartoonist. Born in Winnipeg, Canada, June 21, 1916. Studied at Arts and Crafts Club, New Orleans, LA; Corcoran School of Art. Member: Society of Illustrators; Cartoonists Society, NY. Awards: Treasury Dept. Citations, 1944, 45. Work: Hyde Park Collection. Created, wrote, and produced "Hap Hopper, Washington Correspondent," United Features Syndicate, 1939-43; "Claire Voyant," *Chicago Sun* and PM newspaper Syndicate, 1943-46. Position: Editorial Cartoonist, New Orleans *Item-Tribune*, 1935-37; *Washington Herald*, 1937-39. Address in 1953, Freeport, NY.

SPARROW, LOUISE WINSLOW KIDDER.
(Madame Paul E. H. Gripon). Sculptor and writer. Born Malden, MA, January 1, 1884. Pupil of Eric Pape, Bush-Brown, Ulric Dunbar, Frederick Allen, Bela Pratt. Member: Society of Washington Artists; Royal Society of Artists. Work: Bust of Capt. James F. Gilliss, US Government; statue of Col. Archibald Gracie, IV, National Gallery of Art, Washington, DC; US Military Academy at West Point; US Naval Academy at Anapolis, MD; US Senate, Washington; many others. Exhibited at Corcoran; National Gallery of Art, Washington; Newport Art Association; others. Specialty, busts, statues, memorial tablets. Author of "The Last Cruise" of the U.S.S. *Tacoma*. Address in 1953, Washington, DC.

SPAVENTA, GEORGE.
Sculptor. Born in NYC, February 22, 1918. Studied at Leonardo da Vinci Art School; Beaux-Arts Institute of Design; Academie de la Grande Chaumiere, Paris. Exhibited at Carnegie Institute; Museum of Modern Art traveling exhibition. Taught at New York Studio School; Skowhegan School of Painting and Sculpture; Maryland Institute of Art. Address in 1976, 463 West St., NYC.

SPEED, ULYSSES GRANT.
Sculptor. Born in San Angelo, TX, January 6, 1930. Studied animal husbandry at Brigham Young University. Worked on many ranches; taught. Turned full-time to sculpture in 1968. Work in Whitney Museum, Cody, WY; Diamond M Museum, Snyder, TX; others. Has shown at Phoenix Art Museum; Texas Art Gallery; Cowboy Artists of America Shows, 1970 (bronze edition sold out), 1976. Awarded gold medal, Cowboy Artists of America Show, 1976. Member: Cowboy Artists of America. Specialty is Old West subjects; works in bronze. Bibliography includes *The Cowboy in Art*, Ainsworth; *From Broncs to Bronze*, biography, 1979. Represented by Texas Art Gallery, Dallas; Main Trail Galleries, Jackson, WY. Address in 1982, Lindon, UT.

SPENCER, EDNA ISBESTER.
Sculptor, painter, and lecturer. Born in St. John, N. B., Canada, November 12, 1883. Pupil of Bela Pratt, Robert Aitken; Boston Museum of Fine Arts School; Art Students League. Award: Honorable mention, Concord Art Association, 1919; Paris Salon, 1929; Miami Art League, 1940. Exhibited at Paris Salon, 1926; Pennsylvania Academy of Fine Arts; Miami Art League; others. Address in 1953, Waban, MA.

SPENCER, G. P.
Sculptor or engraver. At St. Johnsbury, Vermont, 1849.

SPENCER, LORENE.
Sculptor and ceramist. Born in Wallace, Idaho, March 26, 1923. Studied at University Ore.; also with Kenneth Callabon and Hamada. Works: Folk Gallery, Japan; Homoda Folk Collection; pottery accessories, State Library, Olympia, Wash.; ceramic letters for building identification, Grade and High Schools, Seattle; tile screen for Seattle bus firm; plus many private comns. Exhibitions: Craftsmen Exhibition, Syracuse Museum; Northwest Artists Annual and Women of Washington, Seattle Art Museum; Craftsmen of Ore., Idaho and Mont., Spokane; Bellevue Fair. Awards: Award in Architecture and Painting and Pottery Grant, Bellevue Fair. Address in 1976, Seattle, WA.

SPENS, NATHANIEL.
Woodcarver, primitive painter, and decorator. Born in Edinburgh, Scotland, 1838; came to US in 1862; settled in Utah about 1865. Self-taught in art. Lived in American Fork, UT, about 1865-90; moved to Mountainville in 1890. Was a farmer, as well as artist. His decorations are in Latter-Day Saints Temples. Died in Mountainville, UT, 1916.

SPICER-SIMSON, THEODORE.
Sculptor and painter. Born Havre, France, June 25, 1871. Studied in England and Germany, at the Ecole des Beaux-Arts and Academie Julian in Paris and with Dampt. Exhibited: National Sculpture Society, 1923. Member: Societe Nationale des Beaux-Arts, 1928; Century Association; National Sculpture Society, 1911. Awards: Highest award for medals, Brussels Exp., 1911; and Ghent Exp., 1915; bronze medal for medals, P.-P. Exp., San Francisco, 1915. Work in: Metropolitan Museum and Numismatic Museum, NY; Chicago Art Institute; Detroit Institute; New Mexico Museum of Art; City Museum of Art, St. Louis; the Luxembourg, Paris; Victoria and Albert Museum, London; in Holland, Belgium, Germany, Austria, and Czechoslovakia. Address in 1953, Miami, Florida. Died in 1959.

SPITZER, ADELE R.
(Mrs. Oscar Spitzer). Sculptor. Address in 1934, New York. (Mallett's)

SPLIVATO, WILNA.
Sculptor. Exhibited: Paris, 1933. (Mallett's)

SPOHN, CLAY.
Sculptor and painter. Chiefly painter. Born in 1898 in San Francisco. Studied at University of Calif., Berkeley; Calif. School of Fine Arts; New York Art Students League; Academie Moderne, Paris. Exhibited at San Francisco Museum of Art; Mobiles and Articulated Sculpture, Calif. Palace of the Legion of Honor, 1948; Oakland Museum; others. Executed "junk constructions" in San Francisco, late 1940's. Address in 1977, NYC. Died in 1977.

SPONENBURGH, MARK.
Sculptor and art historian. Born in Cadillac, MI, June 15, 1916. Studied at Cranbrook Academy of Art, scholarship, 1940; Wayne State University; Ecole des Beaux-Arts, Paris, France; University of London; University of Cairo. Work in Detroit Institute of Arts; Portland Art Museum; Museum of Modern Art, Egypt; architectural sculpture, Corvallis Methodist Church, OR; others. Has exhibited at Penna. Academy of Fine Arts; Paris Salon, France; Institute of Fine Arts, Cairo; others. Received Fulbright Foundation fellowship, 1951-53. Member of International Association of Egyptologists; Royal Society of Artists; Royal Society of Antiquaries. Taught at University of Oregon, 1946-56; Oregon State University, from 1961. Works in wood and stone. Address in 1982, Department of Art, Oregon State University, Corvallis, OR.

SPOTH-BENSON, EDA.
Sculptor and painter. Born in Brooklyn, NY, March 25, 1898. Pupil of Dabo, Eggleston. Member: Lime Rock Art Association; Brooklyn Society of Artists; Palm Beach Art League. Awards: Hon. mention, Lime Rock Art Association, Conn., 1929; first prize, Fla. Federation of Arts, Miami Beach, 1930-31. Address in 1933, 140 West 57th Street, NYC; h. Pine Villa Park, West Cornwall, CT.

SPRAGUE, FLORENCE.
Sculptor and teacher. Born Paullina, IA. Pupil of Charles Mulligan, Albin Polasek. Member: Iowa Art Club; Des Moines Association of Fine Arts. Work: "Frog Mountain," Des Moines Water Works; bas-relief, "Harvest," Public Library, Des Moines. Head of Art Dept., Drake University. Address in 1933, Drake University, Des Moines, IA.

SPRAGUE, MARY.
Sculptor and graphic artist. Born in 1934. Studied: Stanford University. Noted for her constructions, assemblages, and cloth figures.

SPRAGUE, NANCY KUNZMAN.
Sculptor. Born in NYC, September 27, 1940. Studied at RI School Design; University Penna., B.F.A.; Tyler School Art, Temple University; University Kansas; University Iowa, M.A. and M.F.A. Works: Tenn. Sculpture '71, Tenn. Arts Comn., Fairleigh Dickinson University; bronze sculpture, Friends of Elvis Presley, 1971. Exhibitions include 16th Ann. Drawing and Small Sculpture, Ball State University, 1970; Brooks Mem. Art Gallery, Memphis, 1971; 24th Ann. Iowa Artists Exhibition, Des Moines Art

Center, 1972; Goldsmith Civic Center Sculpture Show, Memphis, Tenn., 1973; Mainstreams 74, Marietta College, Ohio. Works in cast bronze, welded steel. Address in 1982, Iowa City, IA.

SPRING, EDWARD ADOLPHUS.
Sculptor. Born in New York City in 1837. He studied with Henry K. Brown, John Q. A. Ward, and William Rimmer; also in France and England. He modeled many terra cotta panels. He established the Perth Amboy Terra Cotta Co. and the Eagleswood Art Pottery in 1877. Also lectured and taught.

SPRINGER, CHARLES H.
Sculptor, painter, designer, and illustrator. Born in Providence, RI, July 15, 1857. Pupil of Art Students League in New York; Hugo Breul in Providence; Frederick W. Freer (for water color); studied architecture in Providence. Member of Providence Art Club; Rhode Island School of Design. Teacher of modeling and wood carving, Pawtucket, RI. Specialty was woodcarving and furniture design. Address in 1919, 211 Lenox Avenue, Providence, RI. Died there in 1920.

SPRINGWEILER, ERWIN FREDERICK.
Sculptor and craftsman. Born in Pforzheim, Germany, January 10, 1896. Studied: Artcraft School, Pforzheim; Acad. of Fine Art, Munich; assistant to Paul Manship, Herbert Hazeltine. Member: National Sculpture Society; Associate, National Academy of Design; Allied Artists of America; McDowell Colony. Awards: National Sculpture Society, 1937; National Academy of Design, 1938, 1949; Architectural League, 1949. Work: Congressional gold medals of George M. Cohan and General W. L. Mitchell; statues, Washington Zoo and Detroit, Mich.; reliefs, Washington Zoo, USPO, Chester, PA, Manchester, GA. Exhibited: National Academy of Design; Penna. Academy of Fine Arts; Art Institute of Chicago; and other major exhibitions. Address in 1953, Wyandanch, LI, NY. Died in 1968.

SPROAT, CHRISTOPHER TOWNSEND.
Sculptor. Born in Boston, MA, September 23, 1945. Studied at Skowhegan School of Painting and Sculpture; Boston University; Boston Museum School of Fine Arts; also with George Aarons. Has exhibited at Institute of Contemporary Art, Boston; Museum of Fine Arts, Boston, 1971-72; Whitney Museum of American Art Biennial; Mass. Institute of Technology, Cambridge, MA; others. Received Mass. Art and Humanities Foundation Fellowship, 1975 and 78; National Endowment for the Arts Grant, 1975-76, 80-81; others. Member of Institute of Contemporary Art. Address in 1982, 7 Mercer St., NYC.

SQUIER, JACK LESLIE.
Sculptor. Born in Dixon, IL, February 27, 1927. Studied at Oberlin College; Indiana University, with Robert Laurent, Leo Steppat, 1950, BS; Cornell University, with John Hartell, 1952, MFA. Works: Cornell University; Ithaca College; Lima, Peru; Syracuse (Everson); Whitney; Museum of Modern Art; Hirshhorn. Exhibitions: The Alan Gallery, NYC; Cornell University; Lima, Peru; Whitney; Museum of Modern Art; Houston Museum of

Fine Art; Addison Gallery, Andover, MA; Boston Museum of Fine Art; Brussels World's Fair, 1958; University of Illinois; Art Institute of Chicago; Boston Arts Festival; Carnegie; Claude Bernard, Paris; Albright. Taught: Cornell since 1958. Works in resin and fiberglas. Address in 1982, Ithaca, NY.

SQUIRES, NORMA-JEAN.
Sculptor and painter. Born in Toronto, Ontario, Canada; US citizen. Studied at Art Students League; Cooper Union, cert., 1961; also spec. studies with James Rosati, sculptor. Works: Sterling Forest Gardens, Long Island, NY; Galeria Vandres, Madrid, Spain; others. Exhibitions: One-woman shows, Hudson River Museum, Yonkers, NY, 1966, East Hampton Gallery, NY, 1969, and Kieran Gallery, Riverside, Calif., 1974; Affect-Effect, La Jolla Museum Art, Calif., 1969; Recent Trends in American Art, Westmoreland Co. Museum Art, Greensburg, Penna., 1969; 4x4 plus 4x8, Newport Harbor Museum, 1975; plus others. Awards: Sarah Cooper Hewitt Award for the Advancement of Science and Art, Cooper Union, 1961. Media: Wood, aluminum, mirrors, and motors. Address in 1982, Los Angeles, CA.

STACKEL, ALIE.
Sculptor. Born in NYC, September 28, 1909. Studied at National Academy of Design; NYU; others. Member of Brooklyn Society of Artists. Exhibited at Brooklyn Museum; Riverside Museum; National Sculpture Society; Medallic Art Exhibition; others. Works: Educational Art School, Port Hope, Ontario, Canada. Address in 1953, Brooklyn, NY.

STACKPOLE, RALPH.
Sculptor, etcher, craftsman, and teacher. Born Williams, OR, May 1, 1885. Pupil of Arthur Putnam and G. Piazzoni and Ecole des Beaux-Arts, Paris; also of Mercie in Paris. Member: California Society of Etchers. Awards: Honorable mention, P.-P. Exp., San Francisco, 1915; gold medal, San Francisco Art Association, 1918; gold medal, San Francisco Art Association, 1920. Work: "Portrait bust of Prof. Hilgard", University of California; "Portrait bust of Prof. Flugel," Stanford University, CA; "Portrait bust of Judge Seawell," City Hall, two groups, "Mother Earth" and "Man and His Inventions," Stock Exchange, all in San Francisco. Address in 1933, Paris, France; San Francisco, CA.

STAGG, JESSIE A.
Sculptor, craftsman, and teacher. Born in England, April 10, 1891. Pupil of Art Students League of New York; Robert Aitken; C. McClure; also in London and Rome. Member: National Association of Women Painters and Sculptors; New York Society Ceramic Arts; American Federation of Arts. Address in 1929, 17 East 62nd St.; 1160 Fifth Ave., New York, NY; summer, Woodstock, NY. Living in Woodstock in 1953. Died in 1958.

STAGI, PIETRO.
Sculptor. Born in Italy. Worked in Carrara and Leghorn 1783-93; in Philadelphia 1795-99.

STAIR, IDA M. (MRS.).
Sculptor. Born at Logansport, IN, February 4, 1857. Was a pupil of Preston Powers, of Chase in NY, and of Taft at the Art Institute of Chicago. Awarded a medal at the Omaha Exposition in 1898. Member of the Artists' Club of Denver and an instructor at the Art Students Class of the Women's Club in Denver. Modeled statues of Myron Reed and ex-Governor Gilpin for parks in Denver and executed busts of Judge Merrick A. Rogers, John Clark Ridpath, and others. Died in Denver, CO, March 27, 1908.

STAMATO, FRANK.
Sculptor. Born US, January 16, 1897. Pupil of Charles Grafly, Albert Laessle. Member: Fellowship Penna. Academy of Fine Arts; Alliance; Graphic Sketch Club. Awards: Two Cresson Traveling Scholarships, and Stewardson prize, Penna. Academy of Fine Arts. Work: "Pandora," Reading Art Museum; "Head of an Old Man," "Wounded Dog," "Billy Goat," Graphic Sketch Club; painting, "St. Anne France," Penna. Academy of Fine Arts, Philadelphia. Address in 1933, Philadelphia, PA. Died in 1939.

STANKIEWICZ, RICHARD PETER.
Sculptor. Born Oct. 18, 1922, in Philadelphia, PA. Studied at Hans Hofmann School of Fine Art, 1949; with Fernand Leger and Ossip Zadkine in Paris. Taught at Maryland Institute, Baltimore; University of Penna.; Skowhegan (Maine); School of Visual Arts, NYC; Syracuse; Princeton; SUNY/Albany. Awards from Ford Foundation, Brandeis University and National Council on the Arts. Exhibited at Museum of Modern Art; Carnegie; Stable Gallery, NYC; in Sao Paulo; Whitney; Hansa Gallery, NYC; Walker; Guggenheim; many others. In collections of Guggenheim; Museum of Modern Art; Albright-Knox (Buffalo); Whitney; Harvard; Washington University in St. Louis; Stockholm Museum of Modern Art and private collections. Was an organizer of Hansa Gallery in NYC. Living in Huntington, MA, in 1982.

STANLEY, GEORGE M.
Sculptor. Born in Acadia Parish, LA, April 26, 1903. Lived and worked in Los Angeles, CA. Studied at Otis Art Institute, Los Angeles, 1923-26; Santa Barbara School of the Arts, CA, 1927. Taught at Otis Art Institute c. 1940. Works include the "Oscar" statuette for Academy of Motion Picture Arts and Sciences, 1927; three figures, Muses of Music, Dance, Drama, Hollywood Bowl, c. 1938-40; bas-reliefs at Bullock's Wilshire, and Telephone Building, L.A.; Dancer; Enigma; Bird-woman; Head of a Young Woman. Exhibited: L.A. Co. Museum; California Palace of Legion of Honor, San Francisco; California Pacific International Exp., San Diego, 1935; Golden Gate International Exp., San Francisco, 1939. Awards: Maintenance scholarship to study sculpture, bronze casting at the School of the Arts, Santa Barbara, CA. Died in 1977.

STANLEY, HARVEY.
Stonecutter. Born in Vermont, December 1811. Worked on sun-face capitals of Mormon Temple, Nauvoo, IL, mid-1840's. Later lived in Missouri and Iowa.

STANSON, GEORGE CURTIN.
Sculptor and painter. Born in Briscout, France, in 1885.

Member of Archaeological Institute of America; California Art Club. Work: 4 murals in the Biological Museum of the University of California, La Jolla, California; "After the Rain" (mural) in Golden Gate Park Museum, San Francisco; "On the Trail" in Museum of Archeology, Santa Fe, NM. Address in 1926, Los Angeles, CA.

STAPLES, EDNA FISHER STOUT.
(Mrs. Arthur Chase Staples). Sculptor, painter and teacher. Born in Philadelphia, PA, 1871. Pupil of Philadelphia School of Design, under Elliott Daingerfield, H. B. Snell, and Marianna Sloan. Prize, Wanamaker competition 1904. Member, Alumni Philadelphia School of Design. Specialty, landscapes in water color. Address in 1910, 2030 Cherry St., Philadelphia, PA.

STAPRANS, RAIMONDS.
Sculptor and painter. Born in Riga, Latvia, October 13, 1926; US citizen. Studied at School of Art, Esslinger, Stuttgart, 1946; University of Washington, B.A., 1952; University of California, M.A., 1955; also with Archipenko. Work in California Palace Legion of Honor, San Francisco; Oakland Museum, CA; Los Angeles Co. Museum; Phoenix Art Museum. Has exhibited at Portland Art Museum, OR; Oakland Art Museum; California Palace Legion of Honor; American Academy of Arts and Letters, NY. Works in plastic and oil. Address in 1982, San Francisco, CA.

STARK, FORREST F.
Sculptor, painter, and teacher. Born Milwaukee, Wis., May 29, 1903. Pupil of Charles Grafly, Albert Laessle, Leon Kroll, George Harding, George Oberteuffer, and Boardman Robinson; Art Students League. Awards: First sculpture prize, Twenty-fifth Annual Ind. Artists' Exhibition, John Herron Art Institute, 1932; first sculpture prize, Twentieth Annual Exhibition, Wis. Painters and Sculptors, Milwaukee Art Institute, 1933. Work: "David Jung," sculptured head, Art School of the John Herron Art Institute. Exhibited at Pennsylvania Academy of Fine Arts, 1938; Indiana Artists; others. Instructor in sculpture, Art School of the John Herron Art Inst., Indianapolis, Ind. Address in 1933, Mukwonago, Wis. Living in Wayne, IN, 1953.

STARKEY, E. J.
Sculptor. Active 1865. Patentee—statuette, 1865.

STARR, MAXWELL B.
Sculptor, painter, and teacher. Born Odessa, Russia, February 6, 1901. Studied at National Academy of Design; Beaux-Arts Institute of Design; pupil of Kenyon Cox, Charles W. Hawthorne, Ivan G. Olinsky. Member: Tiffany Artists Guild; Architectural League; National Society of Mural Painters; Allied Artists of America. Work: American Museum of Numismatics; murals in US Customs Office, NYC; others. Exhibited at National Academy of Design; Pennsylvania Academy of Fine Arts; Art Institute of Chicago; Whitney; Museum of Modern Art; Boston Museum of Fine Art; World's Fair, NY, 1939; others. Address in 1953, 54 West 74th St., New York, NY.

STATTLER, GEORGE.
Ship carver. Born in Charleston, SC. In 1798 carved a figurehead of General Charles C. Pinkney.

STAUCH, ALFRED.
Sculptor. Born c. 1836, Germany. Exhibited: Pennsylvania Academy, 1860-69. Worked: Philadelphia, c. 1860's.

STAUCH, EDWARD.
Sculptor. Born c. 1830, in Germany. Worked: Philadelphia, c. 1855-70. Exhibited: Pennsylvania Academy.

STEA, CESARE.
Sculptor and painter. Born Bari, Italy, August 17, 1893. Pupil of National Academy of Design; Cooper Union; Beaux-Arts Institute; Italian-American Art Association; Hermon MacNeil, Victor Salvatore, Carl Heber, Stirling Calder; Grande Chaumiere. Exhibited at National Sculpture Society, 1923; California Palace of Legion of Honor; Hispanic Museum; Penna. Academy of Fine Art, 1944; Brooklyn Museum, 1941; Metropolitan Museum of Art, 1942; Whitney; others. Member: Italian-American Art Association. Awards: Medal from Beaux-Arts for relief in Educational Building, San Francisco, 1915; prize for trophy cup, National Defense Society; Barnett prize, National Academy of Design, 1926. Work in Whitney Museum of American Art; others. Address in 1953, NYC. Died in 1960.

STEADMAN, L. ALICE.
Sculptor. Born in Stokes County, North Carolina, in 1907. Studied at Meredith College, Raleigh; Penna. Academy of Fine Arts; and with Breckenridge, O'Hara, and others. Awards: Margaret Graham silver cup, 1935; Raleigh Studio Club, gold medal, 1936; Ethel Parker silver cup, 1937; Blowing Rock, North Carolina, 1957, 58; Mint Museum of Art, 1958.

STEARNS, NEILSON.
(Mrs. Traphagen Stearns). Sculptor. Member: National Association of Women Painters and Sculptors. Address in 1924, 155 Henry St., 138 Joralemon St., Brooklyn, NYC.

STEARNS, THOMAS ROBERT.
Sculptor and educator. Born in Oklahoma City, OK, September 4, 1936. Studied at Memphis Academy of Art, TN, 1955-57; Cranbrook Academy of Art, Bloomfield Hills, MI, 1957-60; Academia de Belli Arti, Venice, Italy, 1960-61. Work in Minnesota Museum of Art, St. Paul; Museum of Art, Iowa City. Has exhibited at Seattle World's Fair, Washington, 1961; Brussels International, Belgium, 1961; Museum of Contemporary Crafts, NY; American Oil Painting and Sculpture, Penna. Academy of Fine Arts Museum; Smithsonian Institution, Washington, DC; others. Received Italian Government Award Fellowship, 1960-61; John Simon Guggenheim Fellowship, 1965-66; National Institute of Arts and Letters Grant, 1965-66. Taught sculpture and painting at Philadelphia College of Art, PA, 1970-82. Represented by Willard Gallery, NYC. Address in 1982, Philadelphia, PA.

STEBBINS, EMMA.
Sculptor and painter. Born in NYC, September 1, 1815. For years she devoted herself to painting oil and water color. In 1857 she went to Italy and began to model under Italian masters, also with Paul Akers until 1870. Moved to NYC. She produced the figure in Central Park fountain, "Angel of the Waters;" also statue of Horace Mann,

Boston (1860); numerous other portrait busts and statues. She was a friend of the actress Charlotte Cushman. She exhibited at the Penna. Academy and the National Academy. Elected to National Academy. She died October 25, 1882, in NYC.

STEDMAN, WILFRED (HENRY).
Sculptor, painter, illustrator, blockprinter, and teacher. Born in Liverpool, England, July 6, 1892. Pupil of Gustav Goetch, Lauros M. Phoenix, Harvy Dunn, Luis Mora, Frank V. DuMond, John F. Carlson, Birger Sandzen, Robert Reid, and Charles S. Chapman. Member: Houston Artists' Gal.; Texas Fine Art Assn. Work: "Freighters" and "Loading Coffee," paintings, James M. Lykes Shipping Co.; bronze memorial tablet, South End Christian Church; volumes, "Rice Campanile," Rice Institute, all in Houston, TX; bronze memorial tablet, Catholic Tubercular Hospital, Colorado Springs, CO; "Portrait of Col. Parsons," New York Engineering Society. Address in 1933, Houston, TX. Died in 1950.

STEELE, IVY NEWMAN.
Sculptor. Born in St. Louis, MO, April 15, 1908. Studied at Wellesley College, B.A.; School Fine Arts Washington University, St. Louis. Exhibitions: Paul Theobald Gallery, 1938, Hull House, Chicago, 1947; Public Library, 1952; American Institute of Architects, Chicago, 1959; Art Institute Chicago, 1935-52; Oakland Art Gallery, CA; Oklahoma Art Center. Member: Chicago Society of Artists; Chicago Art Institute; Artists' Equity Association; others. Taught: Children's art, Francis W. Parker School, Chicago, 1942-45; Hull House, 1947-56; others. Address in 1976, Chicago, IL.

STEENE, WILLIAM.
Sculptor and painter. Born Syracuse, NY, August 18, 1888. Pupil of Henri, Jones, Cox, National Academy of Design, Art Students League of NY, Chase; Beaux Arts, Colarossi and Julian Academies, Paris. Member: Mural Painters. Work: 3 murals, "History of Galveston," City Hall, Galveston, TX; "Commerce," Court House, Tulsa, OK; "The Coming of the Traders," Tulsa, OK; War Memorial to Cherokee Indians, Talequah, OK; war memorial, Washington County Court House, Arkansas; portraits of "Pres. Denny," University of Alabama; "Gov. Whitfield," Governor's mansion and "Judge Cambell," Historical Society, Jackson, MS; "Col. Woodward," GA Military Academy, Atlanta; "Melville R. Grant," Masonic Hall, Greenville, MS; "Mayor Wms.," City Auditorium, Macon, GA; "The Caravan," Macon Art Association; "Melody," Mississippi Art Association; "O'Henry Memorial," Asheville, NC; "Dr. and Mrs. D. B. Johnson," Winthrop College, Rock Hill, SC; "Dr. Alexander Graham," Central High School, Charlotte, NC; "Pres. W. M. Sparks," GSCW, Milledgeville, GA; "Pres. Angold Shamlee," Tift College, Forsyth, GA; "Pres. M. M. Walker," A. and M. College, Starkville, MS; "Pres. J. P. Fant," MSCW, Columbus, MS; "Early Traders," mural, High School, Tulsa, OK. Address in 1933, Tryon, NC. Died in 1965.

STEERE, LORA WOODHEAD.
Sculptor. Born Los Angeles, CA, March 13, 1888. Pupil of

Albert Toft in Berlin; Bela Pratt in Boston; Lentelli and Ralph Stackpole in San Francisco; Florence Wyle in Toronto, Canada. Member: San Diego Artists Guild; California Art Club; Southern California Sculptors Guild. Award: First prize, Clatsop Co. (Oregon) Exp., 1917. Work: "Ifugao Fire Dancer," marble bust of Pearl Keller, and "Dance of Pan," Pearl Keller School of Dramatic Arts, Glendale, CA. Represented in Los Angeles Museum of History, Science and Art; bronze bas-relief, David Starr Jordan High School, Los Angeles; bust of Abraham Lincoln, Lincoln Memorial, University of Tennessee; bronze of Dr. Geo. F. Bovard, Bovard Hall, USC. Exhibited: Art Institute of Chicago; Penna. Academy of Fine Art; Los Angeles Art Museum; Mission Gallery, Riverside, CA, 1933; San Fran. Museum of Modern Art. Teaching ceramics at Los Angeles high schools; Idyllwood School of Music and Art, CA. Address in 1953, Hollywood, CA.

STEFFEN, RANDY.
Sculptor. Born in Maverick County, TX, about 1915. Studied at United States Naval Academy at Annapolis. Lived among Sioux Indians. Later was stuntman in Hollywood. Sculpture titles include "Hoka Hey," "The 1851 Dragoon Troop Horse," "The Defiant Young Red Cloud," "The Strongheart." Illustrator, author of *The Horse Soldier*, study of US mounted forces. Work in American Quarter Horse Association. Specialty, American military and Indians; other horse and rider subjects. Fellow, The Company of Military Historians, 1959. Address in 1974, Dublin, TX.

STEGAGNINI (or STEGNANI), LOUIS.
Sculptor and marble mason. Worked: Philadelphia, 1823-40. Specialty was ornamental work.

STEIDER, DORIS.
Sculptor and painter. Born in Decatur, IL, April 10, 1924. Studied at Purdue Univ., applied design, B.S., 1945; Kirksville College of Osteopathy, 1949; Univ. of New Mexico, with Kenneth Adams, fine art, M.A., 1965. In collections of West Texas Museum, Lubbock; New Mexico Governor's Collection, Santa Fe; Public Library Print Collection, Albuquerque, NM. Has exhibited at Smithsonian (National League of American Pen Women); Witte Museum of Western Art, San Antonio, TX; Montana State Historical Society; many others. Awarded honorable mention, Gilcrease Institute; National League of American Pen Women; first prize, sculpture, 13th Annual National Art Show, La Junta, CO. Member of National League of American Pen Women; Artists' Equity. Specialty is subjects of the Old Southwest. Paints in egg tempera; sculpts in bronze. Reviewed in *Artists of the Rockies*; *New Mexico Magazine*. Represented by Baker Fine Art, Lubbock, TX; Galeria Del Sol, NM. Address in 1982, Albuquerque, NM.

STEIG, WILLIAM.
Sculptor and cartoonist. Born in NYC, November 14, 1907. Studied at City College, NY, 1923-25; National Academy of Design, 1925-29. Work: Wood sculpture, Rhode Island Museum of Art and Smith College; paint-

ings, Brooklyn Museum. Exhibitions: Downtown Gallery, NY, 1939; others. Published several books of his drawings, including "The Lonely Ones," "About People and Dreams of Glory." Sculpts in wood. Address in 1982, Kent, CT.

STEIN, RONALD JAY.
Sculptor. Born in NYC, September 15, 1930. Studied at Cooper Union, certificate in fine art, with Will Barnet; Yale University, with Joseph Albers, B.F.A.; Rutgers University, M.F.A. Work at Carnegie Institute, Pittsburgh; Guggenheim Museum, NY; Hirshhorn Collection, Washington, DC; Wadsworth Atheneum, Hartford, CT; others. Has exhibited at Carnegie International; Institute of Contemporary Art, Boston; Art Institute of Chicago; Museum of Modern Art, NY; others. Works in plastic and all media. Address in 1982, 76 E. 79th St., NYC.

STEINER, MICHAEL.
Sculptor and printmaker. Born in NYC, 1945. Work at Storm King Art Center, Mountainville, NY; Boston Museum of Fine Arts; Museum of Modern Art. Has exhibited at Whitney Museum of American Art; Everson Museum of Art, Syracuse; Galerie Gerald Piltzer, Paris, France. Received Guggenheim Award, 1971. Works in steel, aluminum, and brass. Address in 1982, 704 Broadway, NYC.

STEINHOF, EUGENE G.
Sculptor. Address in 1935, New York. (Mallett's)

STELZER, MICHAEL.
Sculptor. Born Brooklyn, NY, January 6, 1938. Studied at Pratt Institute, 1956; Art Students League, 1960-62; National Academy of Fine Arts, Edward Mooney traveling scholarship, 1966, and National Sculpture Society Joseph Nicolosi grant, 1967; and with Nathaniel Choate, 1964, Michael Lantz, 1964-67, and Donald DeLue, 1968-69. Exhibited at American Artists Professional League Grand National, 1963, 76-77; National Arts Club, 1963-64; National Academy of Design, 1964-67, 70-71 and 74-77; National Sculpture Society Annual Exhibition, 1968-81; others. Awards: Helen Foster Barnett Prize, National Academy of Design, 1966; Gold Medal, Grand National Exhibition, American Artists Profesional League, 1976. Member of the National Sculpture Society; American Artists Professional League; others. Address in 1982, Brooklyn, New York.

STENZLER, ERNA J.
Sculptor and instructor. Born in Reading, PA. Studied at Carnegie Institute of Technology, 1938; Tyler School of Fine Arts, B.S., B.F.A., M.F.A., 1944. Has exhibited at Metropolitan Museum of Art, NY; Philadelphia Museum of Art; Penna. Academy of Fine Arts; National Academy of Design, NY; Allied Artists of America, NY; others. Received Benjamin Bernstein Purchase Award, Philadelphia Art Alliance; fellowship, Tyler School of Fine Arts; others. Member of Artists Equity Association. Works in wood. Address in 1982, Elkins Park, PA.

STEPHEN, FRANCIS B.
Sculptor and jeweler. Born in Dublin, TX, March 7, 1916. Studied at Fine Art Center, Colorado Springs, CO; University of Oklahoma, M.F.A., with Jean Charlot and Robert von Neumann. Work in Witte Memorial Museum, San Antonio, TX; Oklahoma Art Center; others. Has exhibited at Museum of Contemporary Crafts, NY; Nelson Gallery, Kansas City, MO; Dallas Museum of Fine Arts; Denver Art Museum; The Metalsmith, Phoenix Art Museum, AZ; others. Member of Society of North American Goldsmiths. Works in metal, bronze, and clay. Address in 1982, Lubbock, TX.

STEPHENS, GEORGE FRANK.
Sculptor and craftsman. Born Rahway, NJ, December 28, 1859. Pupil of Penna. Academy of Fine Arts. Member: Fellowship Penna. Academy of Fine Arts; Philadelphia Sketch Club; Art Club of Philadelphia; National Arts Club. Taught modeling in several art schools. Was instructor at Drexel Institute. Worked on sculptures for City Hall, Philadelphia. Address in 1929, Arden, DE. Died in 1935.

STEPHENS, NANCY ANNE.
Sculptor and film maker. Born in Santa Barbara, Calif., November 18, 1939. Studied at University Kansas, 1957 and 1959-62; Northwestern University, 1958-59; Kansas City Art Institute, 1963. Works: Art Research Center, Kansas City, MO; Galeria Grada Zagreba, Zagreb, Yugoslavia. Exhibitions: New Center US Art Series, 1963-64; Art Research Center Series, 1966-72; Sir George Williams University, Montreal, 1967; Anonima Studio, NY, 1968; Novo Tendencija 4, Zagreb, Yugoslavia, 1969. Works in ceramics, plastic, and with magnets. Address in 1976, Kansas City, MO.

STEPHENSON, JOHN.
Sculptor. Born in Waterloo, IA, 1929. Studied: University of Northern Iowa, Cedar Falls, B.A.; Cranbrook Academy of Art, M.F.A. Exhibitions: Michigan Artists Exhibition, The Detroit Institute of Arts; Michigan Artists, The Grand Rapids Art Museum; All Michigan II, The Flint Institute of Arts, 1973; Michigan Focus, Detroit Institute of Arts, 1974-75; Everson, Syracuse, 1979-80; others. Collections: Objects USA; Alfred University; Oklahoma University; Parrish Museum of Art; Faenza Museum, Italy; The Detroit Institute of Arts; Everson Museum, Syracuse, NY; others. Awards: Gold Medal, City of Faenza, Italy; Rackham Research Grants (3). Address in 1975, Ann Arbor, MI.

STEPHENSON, PETER.
Sculptor and cameo portraitist. Born August 19, 1823, Yorkshire, England; came to US in 1827. Worked: Buffalo, New York; Boston, from 1843. Work held: American Antiquarian Society. Exhibited at Boston Atheneum. Specialty was cameos; also executed portrait busts and ideal figures. Died c. 1860.

STERLING, LINDSEY MORRIS (MRS.).
Sculptor. Born Mauch-Chunk, PA, November 8, 1876. Pupil of George Brewster at Cooper Union and Jas. Fraser at Art Students League; Bourdelle and Bartlett in Paris. Member: National Sculpture Society; National Association of Women Painters and Sculptors; New Haven Paint and Clay Club; Allied Artists of America. Awards:

Bronze medal, P.-P. Exp., San Francisco, 1915; prize, National Association of Women Painters and Sculptors, 1916; Joan of Arc medal, National Association of Women Painters and Sculptors, 1923. Exhibited at National Sculpture Society, 1923. Works include "Blown by the Winds of Destiny;" "The Afternoon of the Faun." Address in 1929, Edgewater, NJ; summer, Jay, Essex Co. (Adirondack Mts.), NY. Died in 1931.

STERN, GERD.
Sculptor. Born in Saarbrucken, Germany, October 12, 1928. Studied at Black Mountain College, with M. C. Richards. Works: Associated Coin Amusement Co.; Immaculate Heart College; San Francisco Museum of Art; commission for Whitney. Exhibitions: San Francisco Museum of Art; University of British Columbia; Dwan Gallery, NYC; University of Rochester; Los Angeles County Museum of Art; International Arts Festival, Newport, RI; Jewish Museum; Museum of Modern Art; Brooklyn Museum; Whitney; Eindhoven; Walker. Awards: New York State Council on the Arts; National Council on the Arts. Address in 1970, Cambridge, MA.

STERN, JAN PETER.
Sculptor. Born on November 14, 1926; US citizen. Studied at Syracuse University College of Fine Arts, B.I.D.; New School for Social Research. Work at National Collection, Smithsonian Institution; Pasadena Art Museum; Hirshhorn Museum; monumental sculpture, Prudential Center, Boston; Los Angeles City Hall Mall. Has exhibited at Phoenix Art Museum; San Francisco Museum of Art; Marlborough Gallery, NY; others. Works in stainless steel and metals. Address in 1982, Santa Monica, CA.

STERN, LUCIA.
Sculptor, painter, and craftswoman. Born in Milwaukee, WI, December 20, 1900. Member: Wis. Painters and Sculptors Society; Springfield Art League; Wisconsin Designer Craftsmen. Awards: Prizes, Milwaukee Art Institute, 1945, 46. Work: Smith College Museum; Milwaukee Art Institute; Museum of Non-Objective Painting, NY. Exhibited: Museum of Non-Objective Painting, 1944-52; Springfield Art League, 1945-51; Salon des Realites Nouvelles, Paris, France, 1948, 51, 52; Detroit Institute of Art, 1945; Milwaukee Art Institute, 1942. Address in 1953, Milwaukee, WI.

STERNE, MAURICE.
Sculptor, painter, and etcher. Born at Libau, Russia, July 13, 1878. Came to NY at age of 12. Studied: National Academy of Design and other schools in NY. Traveled extensively in Europe; special study of the people of Bali. Member: New Society of Art; National Academy of Design; National Institute of Arts and Letters; Sculptors Guild. Awards: Logan medal and prize, $750, Art Institute of Chicago, 1928; Golden Gate Exp., San Francisco, CA, 1939; others. Work in: Carnegie Institute, Pittsburgh; Rhode Island School of Design, Providence; Metropolitan Museum, NY; Boston Museum of Fine Arts; Detroit Institute of Art; Los Angeles Museum; Kaiser Friedrich Museum, Berlin; Cologne Museum; Tate Gallery, London. Taught at Art Students League, 1919-20, 1921-22. Died in 1957. Address in 1953, Mt. Kisco, NY.

STERNFELD, EDITH A.
Sculptor, painter, lecturer, and educator. Primarily painter. Studied at Northwestern University, B.A.; Art Institute of Chicago, B.A.E.; University of Iowa, M.A.; Cranbrook Academy of Art; Claremont Graduate School, and with Eliot O'Hara, Grant Wood, Jean Charlot. Member: College Art Association; American Association of University Women. Awards: Prizes, All-Iowa Exh., 1937; Joslyn Memorial, 1937, 40; Iowa Water Color Exhibition, 1945; numerous prizes in regional exh. Exhibited: Art Institute of Chicago; Wisconsin Painters and Sculptors; American Water Color Society; Phila. Water Color Club; Baltimore Water Color Club; Calif. Water Color Society; Washington Water Color Club; Kansas City Art Institute; Joslyn Memorial; New York World's Fair, 1939; Iowa Water Color Exhibition, since 1945; Des Moines, Iowa; Denver Art Museum; Mid-Am. Artists; Springfield (MO) Art Museum; several one-woman exh. Lectured on Painting. Address in 1953, Grinnell, IA.

STETSON, KATHERINE BEECHER.
(Mrs. Katherine Beecher Stetson Chamberlin). Sculptor, painter, and teacher. Born Providence, RI, March 23, 1885. Pupil of da Pozzo, Sabate, Noel and Breck in Rome; Penna. Academy of Fine Arts under Chase, Kendall and Beaux; landscape under H. D. Murphy and Birge Harrison, Leonard Ochtman and F. Tolles Chamberlin. Member: MacDowell Memorial Association; Sculptors Guild of Southern California; California Art Club; Pasadena Society of Artists. Awards: Gold medal for sculpture, California Art Club, 1925; honorable mention, San Diego Fine Arts Gallery, 1926; second prize, Los Angeles Co. Fair, 1927; Pasadena Society of Artists, 1940. Exhibited: Penna. Academy of Fine Arts, 1912, 14, 15, 16, 26; National Academy of Design, 1914-16, 19, 25; Pasadena Society of Artists, 1924-51. Address in 1953, Pasadena, CA.

STEVENS, EDITH BARRETTO.
See Parsons, Edith Barretto Stevens.

STEVENS, LAWRENCE TENNY.
Sculptor, painter, etcher, and teacher. Born Brighton, MA, July 16, 1896. Studied: Boston Museum of Fine Art School; American Academy in Rome, and with Charles Grafly and Bela Pratt. Member: National Sculpture Society; Society of Medalists; Architectural League of New York; others. Award: American Prix de Rome, 1922. Work: "Baptism of Christ" (marble), Congregational Church, Brighton, MA; statue, "John Harrison," Fairmount Park, Philadelphia; "Triptych," polychromed wood carving, St. Mathews Church, Bedford, NY; Brookgreen Gardens, SC; Brooklyn Museum; others. Exhibited at Penna. Academy of Fine Art, 1929; Grand Central Art Gallery; National Academy of Design; others. Address in 1953, Tulsa, OK. Died in 1972.

STEWARDSON, EDMUND AUSTIN.
Sculptor. Pupil of Penna. Academy of the Fine Arts. Elected a member of Society of American Artists in 1891. He died in 1892 at Newport, RI.

STEWART, ALBERT T.
Sculptor, painter, and illustrator. Born Kensington, Eng-

land, April 9, 1900. Studied: Beaux-Arts Institute of Design; Art Students League; also with Paul Manship. Member: Animal Painters and Sculptors; National Sculpture Society; National Academy of Design. Works: "Dolphins," Seamen's Church Institute, NY; "Memorial Tablet," Amherst College; "Memorial Tablet," Williams College, Williamstown, MA; "Louis Pope Gratacap Memorial," American Museum of Natural History, NY; "Hawk," Metropolitan Museum of Art; many others, including tablets, memorials, panels, doors, fountains. Won prizes at National Academy of Design; Pasadena Art Institute; others. Address in 1982, Claremont, CA.

STEWART, LIZBETH McNETT.
Sculptor and ceramist. Born in Philadelphia, PA, December 22, 1948. Studied at Moore College of Arts, B.F.A. (ceramics), 1971. Has exhibited Clay, Fiber, Metal, Bronx Museum; Tucson Museum of Art; Museum of Contemporary Crafts, NY; Porcelain, Renwick Gallery, Smithsonian Institution. Address in 1982, c/o Helen Drutt Gallery, Philadelphia, PA.

STEWART, SHERRY.
Sculptor. Noted for her earth and wood environmental-earthworks.

STEWART, THOMAS KIRK.
Sculptor and portraitist. Born in New York City in 1848. Died in Kansas City, MO, 1879.

STIERLIN, MARGARET E.
Sculptor, craftswoman, designer, and teacher. Born in St. Louis, MO, December 28, 1891. Studied at University of Missouri, A.B.; Art Institute of Chicago; and with Emil Zettler. Member: Chicago Art League; Chicago Potters Guild. Awards: American traveling scholarship, Art Institute of Chicago, 1932. Work: Springfield (IL) Museum of Art. Exhibited: Art Institute of Chicago, 1935, 36, 40, 41, 43; Syracuse Museum of Fine Art, 1940; Springfield Museum of Art, 1941. Position: Instructor, Modeling, Jr. Department, Art Institute of Chicago, 1932-38; Instr. Ceramics, Hull House, Chicago, IL, from 1939. Address in 1953, Chicago, IL.

STIHA, VLADIN.
Sculptor and painter. Born in Belgrade, Yugoslavia, 1908. Studied art in Yugoslavia; Academy of Fine Arts, Vienna; privately in Rome. Lived in Argentina and Brazil before coming to US (Beverly Hills) in 1968; settled in Santa Fe, NM. Painting specialty is Pueblo Indians and New Mexico landscape; sculpts figures of Indian children in action. Paints in oil; sculpts in bronze. Reviewed in *Southwest Art*, summer 1973, August 1979. Has own gallery. Address since 1970, Santa Fe, NM.

STILLMAN, EFFIE.
Sculptor. Born in London, England. Pupil of Charles Desvergnes in Paris. Awards: Bronze medal, St. Louis Exp. 1904. Address in 1906, 28 Campden Hill Gardens, London, England, and 468 Lexington Ave., NYC.

STIMSON, ANNA KATHARINE.
Sculptor. Born New York City, November 14, 1892. Pupil of Charles Grafly. Member: Philadelphia Alliance; Fellow, Penna. Academy of Fine Arts; Philadelphia Water Color Club. Address in 1933, Philadelphia, PA; summer, Bolton Landing, NY.

STINSON, HARRY EDWARD.
Sculptor and teacher. Born Wayland, IA, January 3, 1898. Pupil of Cumming, Aitken, Hawthorne, Olinsky, Bridgman; studied at University of Iowa; Cumming School of Art; National Academy of Design; Art Students League. Member: IA Artists Guild. Exhibited at National Academy of Design; Pennsylvania Academy of Fine Arts; Kansas City Art Institute; others. Address in 1933, 317 Physics Bldg.; h. 333 Magowan Ave., Iowa City; address in 1953, NYC.

STOCKMAN, HELEN PARK (MRS.).
Sculptor, painter, and teacher. Born Englewood, NJ, October 16, 1896. Pupil of Jonas Lie, Luis Mora, and Robert Henri. Member: Palisade Art Association. Address in 1933, Sherwood Place, Englewood, NJ.

STOKES, FRANK WILBERT.
Sculptor and painter. Born Nashville, TN. Pupil of Penna. Academy of Fine Arts under Thomas Eakins; Ecole des Beaux-Arts in Paris under Gerome; Colarossi Academy under Collin; Julian Academy under Boulanger and Lefebvre. Award: Medaille d'Argent, Prix de Montherot de Geographie de Paris. Specialty, arctic and antarctic scenes; member, Peary Greenland Expedition, 1892 and 1893-94; and Swedish Antarctic Expedition, 1901-02; artist member Amundsen Ellsworth Expedition, 1926. Member: Fellowship, Penna. Academy of Fine Arts. Work: Mural decorations, Museum of Natural History, NY. Address in 1933, 3 Washington Square N., New York, NY.

STOLL, FREDERICK H.
Sculptor, who exhibited at the Annual Exhibition, 1923, at Penna. Academy of the Fine Arts, Philadelphia. Address in 1926, American Museum of Natural History, New York.

STOLL, JOHN THEODOR EDWARD.
Sculptor, painter, illustrator, and etcher. Born Goettingen, Hanover, Germany, September 29, 1889. Studied at Academy of Fine Art, Dresden; Calif. School of Fine Art; otherwise self-taught. Member: San Francisco Art Association; California Society of Etchers. Represented in Art Museum of Legion of Honor, San Francisco; San Francisco Museum of Art; memorial mural and sculpture, Sailors Union of the Pacific; others. Exhibited at Detroit Institute of Art; Art Institute of Chicago; San Francisco Museum of Art; Carnegie; others. Address in 1953, San Francisco.

STOLL, VICTORIA.
Sculptor. Born in 1952. Studied: Goddard College, Plainfield, VT, 1970-71; University of Michigan, Ann Arbor, B.F.A., 1976; Cranbrook Academy of Art, Bloomfield Hills, M.F.A., 1979. Exhibitions: Ann Arbor Art Association, 1979; Apolitical Art, Contemporary Art Institute of Detroit, 1980; Detroit Artists Market, 1980; Detroit Institute of Art, 1982; Installations, Detroit Focus Gallery,

1982. Awards: The Road Show, First Federal Savings of Detroit, 1980; Creative Artists Grant, Michigan Council for the Arts, 1981; Resident, Millay Colony for the Arts, Austerlitz, NY, 1981; Fellowship, Fine Arts Work Center, Provincetown, MA, 1982; Resident, Ossabaw Island Project, Savannah, GA, 1982. Address in 1982, Detroit and Ann Arbor, MI.

STOLLER, ALEXANDER.
Sculptor. Born in NYC, 1902. Studied at Art Students League. Member: National Sculpture Society. Exhibited: Whitney Museum of American Art, 1936; Delphic Studios, NY, 1937 (one-man); New York World's Fair, 1939. Address in 1953, West Stockbridge, MA.

STOLOFF, IRMA.
Sculptor. Born in NYC. Studied at Art Students League, 1921; and with Alexander Stirling Calder, Boardman Robinson, Howard Giles, Yasao Kuniyoshi, and Alexander Archipenko. Exhibitions: Salons Am., 1931; Painter and Sculptors Guild, 1932; Woodstock Gallery, 1934; Argent Gallery, 1947, 54, 58; Nat. Acad. Gallery, 1947-53, 55, 57, 66; Art Students League Centennial, 1950; Artist Equity, 1952; Painters and Sculptors Soc. NJ, 1955; Silvermine Guild Artists, CT; National Assoc. of Women Artists, 1970; others. Award: National Assoc. of Women Artists, 1953; honorable mention, Painters and Sculptors Society, NJ, 1959; C. L. Wolfe Art Club, 1969; Audubon Artists, 1971; others. Member: National Assoc. Women Artists (mem. sculpture jury 1952-54, 55-57); Art Students League (life); Artists Equity; League Present Day Artists; Silvermine Guild Artists; Audubon Artists. In collections of Butler Inst.; Norfolk (VA) Museum; Wichita Art Museum; others; Address in 1982, 46 East 91st St., NYC.

STONE, ALICE BALCH.
(Mrs. Robert Bowditch Stone). Sculptor, painter, and craftsman. Born Swampscott, MA, July 12, 1876. Pupil of Caroline Rimmer, Wilbur Dean Hamilton, and John Wilson. Member: Copley Society; Alliance; Boston Society Arts and Crafts; National Association of Women Painters and Sculptors; American Federation of Arts. Work: Pottery plaque, Judson Memorial Building, Boston Floating Hospital. Address in 1933, h. Jamaica Plain, Boston, MA; summer, Chocorua, NH.

STONE, BEATRICE.
Sculptor. Born in NYC, December 10, 1900. Studied at Smith College; in Paris; with Heinz Warneke, Oronzio Maldarelli. Works: Ethical Culture Society; Hudson Guild; Aluminum Corporation of America. Awards: Huntington award, 1943; Scarsdale Art Association; Westchester Arts and Crafts Association; National Association of Women Artists. Exhibited at Pennsylvania Academy of Fine Arts; National Academy of Design; Art Institute of Chicago; Philadelphia Museum of Art; Whitney; others. Member of National Association of Women Artists; National Sculpture Society; others. Address in 1953, 375 Park Avenue, NYC. Died in 1962.

STONE, FRANK FREDERICK.
Sculptor. Born London, England, March 28, 1860. Pupil of Richard Belt. Member: American Numismatic Society.

Awards: First prize for sculpture, San Antonio State Fair; gold medal, Alaska-Yukon-Pacific Exposition, 1909. Work: "Gladstone," from life, Treasury Office, London; "Mark Twain Medallion," Sacramento State Library. Address in 1933, Los Angeles, CA.

STONE, GEORGE.
Wood carver and engraver. Born in New York State about 1811. Worked in Philadelphia, 1850-59.

STONE, HORATIO.
Sculptor. Born in Jackson, NY, December 25, 1808. Originally trained as a physician, practicing from 1841-47. At an early age he attempted wood carving. Began sculpting professionally after 1848 and lived in Washington, DC. Instrumental in the organization of the Washington Union Art Association, he was elected its president. This organization presented a memorial to Congress requesting recognition of American artists in the decoration of the Capitol, and as a result, the Art Commission of 1859, consisting of H. K. Brown, Jas. R. Lambdin, and John F. Kensett, was appointed by Pres. Buchanan. Stone was also significant in the establishment of the National Gallery of Art. He visited Italy twice in the study of his work as a sculptor. In 1857, he received the medal of the Maryland Institute for his busts of Benton and Taney, and exhibited his works in the National Academy of Design in 1849 and 1869. He is also credited with models for statues of Prof. Morse, Admiral Farragut, and Dr. Harvey, the discoverer of the circulation of blood. Died in Carrara, Italy, August 25, 1875.

STONE, MADELINE MASTERS (MRS.).
Sculptor. Born 1877. Died in Washington, DC, 1932.

STONE, MAYSIE.
Sculptor. Born in NYC. Studied at Cornell University; University of Wisconsin; Penna. Academy of Fine Arts; and with Albert Laessle and Charles Grafly. Exhibited at Penna. Academy of Fine Arts; National Academy of Design; Architectural League of New York; Salon de Printemps, Paris; Smithsonian; Artists' Equity Association. Address in 1953, 2 East 23rd Street; h. 414 West 118th Street, NYC.

STONE, SYLVIA.
Sculptor. Born in Toronto, Ontario, Canada. Studied at Art Students League; along with private study in Canada. Exhibited: Andre Emmerich Gallery, 1972, 75, 77, 79; Walker Art Center, Minneapolis, 1969; Whitney Museum of American Art Sculpture Annual, NY, 1969, 71, 73, and 200 Years of American Sculpture, 1975; Jewish Museum; Milwaukee Art Center; San Francisco, 1970; Hayward Gallery, London, England, 1975; others. Awards: Creative Artist Public Service Award, New York State, 1971; National Endowment for the Arts, 1976. Uses stainless steel to form abstract and primary forms. In collections of Walker Art Center; Whitney Museum; Hartford Atheneum; Aldrich, Ridgefield, CT; others. Address in 1982, 519 Broadway, NYC.

STONE, VIOLA PRATT.
(Mrs. Joseph H. Stone). Sculptor and painter. Born Omaha, NE. Pupil of J. Laurie Wallace; Kansas City Art

Institute; Edna Kelly. Member: Long Beach Art Association. Awards: Prizes, Long Beach Art Association; Ebell Club, 1934. Address in 1953, Long Beach, CA.

STONE, WILLARD.
Sculptor and designer. Born in Oktaha, OK, February 29, 1916. Studied: Bacone College, Muskogee, OK; also under Acee Blue Eagle and Woodrow Crumbo. Noted works: "Sequoyah the Teacher," 1965, Oklahoma Historical Society; bust of Henry Bellmon, Governor of OK, 1966; "The Good Earth," (mural); "Now What" (walnut), 1965. Exhibited: Kennedy Galleries, NYC; Gilcrease Museum, Tulsa; Philbrook Art Center, Tulsa; El Paso Museum Art, TX; Texas Technical University. Awarded: Three-year grant to serve as artist-in-residence at the Gilcrease Institute; Waite Phillips Trophy Grand Award, Philbrook Art Center, 1972; others. Member: Green Country Artists Association; Ozark Arts-Crafts Association. Represented in collections of Gilcrease Museum, Tulsa; National Cowboy Hall of Fame, Oklahoma City; others. Media: Bronze, wood. Address in 1982, Locust Grove, OK.

STONER, HARRY.
Sculptor, painter, and illustrator. Born in Springfield, OH, January 21, 1880. Member: New York Architectural League; Artists Guild; Society of Illustrators; American Artists Prof. League. Work: Design for glass mosaic curtain, executed by Tiffany Studios for the National Theatre of Mexico, Mexico City. Exhibited: American Water Color Society; National Academy of Design; Penna. Academy of Fine Arts; Phila. Water Color Club; Corcoran Gallery of Art; Chicago Water Color Club; Architectural League; American Institute of Architects; Toledo Museum of Art; Society of Illustrators; American Federation of Arts traveling exhibition. Address in 1953, c/o The Artists Guild, Inc., 129 East 10th St., NYC.

STORER, MARIS LONGWORTH.
Sculptor and potter. Born in Cincinnati, Ohio. Studied: Cincinnati Art School, which her father, Joseph Longworth, endowed. Awarded a Gold Medal at the Paris Exposition, 1900. She was appointed United States Minister to Belgium in 1897, and later, Ambassador to Austria. In 1880, after working four years at the Dallas White Ware Pottery, she opened the Rookwood Pottery.

STORM, HOWARD.
Sculptor and painter. Born in Newton, MA, October 26, 1946. Studied at Denison University; J. Ferguson Stained Glass Studio, Weston, MA, apprenticeship; San Francisco Art Institute, B.F.A., 1969; University of California, Berkeley, MA, 1970, M.F.A., 1972. Work in Roswell Museum, NM; others. Has exhibited at Berkeley Museum; Cincinnati Art Museum; others. Received Eisner Prize from University of California, Berkeley, 1972; and Purchase Award from Huntington Galleries. Works in wood, acrylic, and oil. Address in 1982, Fort Thomas, KY.

STORM, LARUE.
Sculptor and painter. Born in Pittsburgh, PA, in 1908. Studied at University of Miami, Coral Gables, FL; Art Students League, Woodstock, NY; and in France. Exhibi-

tions: Corcoran Gallery Art Biennial, Washington, DC, 1957; Butler Institute of American Art, Youngstown, Ohio, 1958-60; Miami Six, El Paso Museum, 1965; Lowe Museum of Art; Norton Gallery, and Columbia Museum of Art; others. Address in 1982, Miami, FL.

STORM, MARK.
Sculptor and painter. Born in Valdez, Alaska, September 4, 1911. Studied at University of Texas Architecture School. In collections of Museum of Natural Science, Houston; plus commissions. Has exhibited at annual Texas Cowboy Artists Association Shows from 1973. Awarded Best of Show, annual Texas Cowboy Artists Show. Worked in commercial art. Later turned full-time to fine art. Member of Texas Cowboy Artists Association. Selected Texas Cowboy Artist of the Year, 1980, 81. Specialty is historic and contemporary Western subjects. Reviewed in *Horseman Magazine*; *The Quarter Horse Journal*. Represented by Southwest Galleries, Houston, TX. Address since 1946, Houston, TX.

STORRS, JOHN H.
Sculptor and etcher. Born in Chicago, IL, June 29, 1885. Pupil of Grafly, Bartlett, Rodin. Member: Societe Anonyme; Chicago Art Club; Cliff Dwellers. Awards: Second Logan medal and $1,500, Art Institute of Chicago, 1929; third Logan prize ($750), Art Institute of Chicago, 1931. Represented by eleven panels, Hall of Science, Century of Progress Exposition, Chicago. Address in 1934, Chicago, IL. Died in 1956.

STORY, THOMAS WALDO.
Sculptor. Son of William Wetmore Story. Born in Rome, Italy, 1855. He was a pupil of his father. His work includes a statue of Sir William Vernon Harcourt, in the House of Commons, London; the bronze door of the Morgan Library, NYC, and a drinking fountain given by General Draper to the town of Hopedale, MA. His studio was in Rome. He died in NYC, October 23, 1915.

STORY, WILLIAM WETMORE.
Sculptor. Born February 12, 1819, in Salem, MA. Graduated from Harvard College in 1838, law degree, 1840; he adopted art as a profession and about 1848 went to Italy for study originally to prepare himself for the execution of a memorial to his father, US Supreme Court Justice Joseph Story. Returned to America to practice law; from 1856 lived in Italy, sculpting full time. His statues of Josiah Quincy, Edward Everett, and Colonel Shaw are well known. He died October 7, 1895, in Valombrosa, Italy.

STOUFFER, J. EDGAR.
Sculptor. Member: Charcoal Club. Award: Rinehart Scholarship to Paris, 1907-1911. Address in 1933, Baltimore, MD.

STOUT, IDA McCLELLAND.
Sculptor. Born in Decatur, IL. Pupil of Albin Polasek. Work: "Goose Girl Fountain," Mary W. French School, Decatur, IL; "Princess Badoura," Hillyer Gallery, Smith College; others. Member of Artist's Guild; Alumni Art Institute of Chicago; Chicago Galleries Association; and

MacDowell Club. Address in 1926, Chicago, IL. Died in Rome, Italy, September 2, 1927.

STRASBURGER, CHRISTOPHER.
Sculptor. Worked in Troy, New York, 1859.

STRECKER, HERMAN.
Sculptor, naturalist, and author. Born March 24, 1836, Philadelphia. Died November 30, 1901, in Reading, Pennsylvania.

STREETER, TAL.
Sculptor. Born in Oklahoma City, OK, Aug. 1, 1934. Study at University of Kansas, BFA, MFA; Colorado Springs Fine Art Center, with Robert Motherwell; Colorado College; with Seymour Lipton. In collections of Museum of Modern Art; San Francisco Museum of Art; Wadsworth Atheneum; Smithsonian; Storm King Art Center, Mountainville, NY; others. Commissions in Little Rock, AK; Atlanta, GA; NYC; Trenton, NJ. Exhibited at Aldrich Museum, Ridgefield, CT; Storm King Art Center, Mountainville, NY; American Cultural Center, Seoul, Korea; Contemporary Arts Museum, Houston; Corcoran (drawings); MIT; many others. Well-known for his work with kites. Has taught at numerous institutions; SUNY Purchase from 1973. Address in 1982, Millbrook, NY.

STREETT, TYLDEN WESTCOTT.
Sculptor and educator. Born in Baltimore, MD, November 28, 1922. Studied at Johns Hopkins University; St. John's College; Maryland Institute College of Art, with Sidney Waugh and Cecil Howard, B.F.A. and M.F.A.; also assistant to Lee Lawrie. Work, architectural sculpture, West Point, NY; architectural sculpture, National Cathedral, Washington, DC; 8 ft. bronze portrait statue, O'Donnell Square, Baltimore; others. Has exhibited at Corcoran Gallery of Art; Baltimore Museum of Art; others. Received Ford Foundation Grant, 1980; others. Member: National Sculpture Society; Artists Equity Association. Teaching sculpture at Maryland Institute College of Art, Baltimore, from 1959. Address in 1982, Baltimore, MD.

STRIDER, MARJORIE VIRGINIA.
Sculptor. Born in Guthrie, Okla. Studied at Kansas City Art Institute, MO; Okla. University, B.F.A. Works: Albright Knox Museum, Buffalo; Larry Aldrich Museum, Ridgefield, CT; New York University; Des Moines Art Center; Hirshhorn Museum, Washington, DC; Wadsworth Atheneum, Hartford; others. Exhibitions: American Federation of Arts Traveling New York Show, 1966; Hoffman Gallery, NY, 1973 and 74; Whitney Sculpture Annual, Whitney Museum American Art, NY, 1970; New York Cultural Center, 1971; The Clocktower, NYC, 1977; others. Awards: McDowell Colony Fellowship, 1973; Longview Foundation Grant, 1973; National Endowment for the Arts Grant, 1974. Media: Plastic, bronze, and aluminum. Address in 1982, 7 Worth Street, NYC.

STRUBING, LOUISA HAYES.
Sculptor, painter, and craftsman. Born Buffalo, NY, January 15, 1881. Pupil of Buffalo Albright Art School; Robert Reid. Member: Buffalo Society of Artists; Buffalo Guild Artists Association. Address in 1933, Eggertsville, NY.

STRUNK, HERBERT.
Sculptor. Born Shakopee, MN, April 9, 1891. Pupil of St. Paul Institute School of Art. Member: St. Paul Art Society. Awards: Silver medal, St. Paul Institute, 1915; first prize, Nassau County Art League, 1932. Work: "Chief Shakopee," model in St. Paul Institute Gallery. Address in 1933, Lava, NY. Died in 1950.

STUART, MICHELLE.
Sculptor and painter. Born in Los Angeles, CA, February 10, 1919. Studied at Chouinard Art Institute, Los Angeles; apprenticed to Diego Rivera, Mexico; New School for Social Research. Has exhibited at Museum of Modern Art; Drawings of the Seventies, Art Institute of Chicago; Albright-Knox Art Gallery, Buffalo; Hirshhorn Museum and Sculpture Garden, Washington, DC; Walker Art Center; others. Received Guggenheim Memorial Foundation Fellowship. Address in 1982, 152 Wooster St., NYC.

STUART, SHAW.
Sculptor. She has exhibited at 14 Sculptors Gallery, NYC, 1978, 80, 83; New England Center for Contemporary Art, Brooklyn, CT; Roko Gallery, NYC; Nexus Gallery, Philadelphia; Clay Works Gallery, NYC; Heckscher Museum, Huntington, LI, NY; Silvermine Guild. Awards include second in sculpture, New England Annual Exhibition, New Canaan, CT; first in sculpture, Connecticut Women Artists, New Haven; others. Address in 1984, Riverside, CT.

STUBBS, LU.
Sculptor. Born in NYC in 1925. Studied: Boston Museum of Fine Arts; Academia di Belle Arti, Perugia, Italy. Awards: Providence Art Club, 1972; Art Association of Newport, Rhode Island, 1972. Exhibitions: Milton Academy, Milton, MA, 1968; Thayer Academy, Braintree, MA, 1972; The American Woman, Jordan Marsh, 1975. Collections: Boston Center for Adult Education; Community Systems by Perini, Boston.

STULL, ROBERT J.
Sculptor and art administrator. Born in Springfield, OH, November 4, 1935. Studied at Ohio State University, B.S., 1962, M.A., 1963; New York University Japanese Language School, 1964-65; Fulbright Research Scholarship for Ceramics, Japan, 1965-67. Work at Smithsonian Institution, Washington, DC; others. Has exhibited at Brooklyn Museum; Everson Museum, Syracuse, NY; Detroit Institute of Art; Musee d'Art Moderne, Paris, France; others. Works in ceramic and acrylic. Address in 1982, Columbus, OH.

STURM, JUSTIN.
Sculptor and writer. Born in Nehawka, NE, April 21, 1899. Studied at Yale Univ., A.B. Work: Many portrait busts of prominent people. Author: *The Bad Samaritan*, 1926. Contributor to: *Harper's, Collier's, Pictorial Review, Redbook* magazines. Address in 1953, Westport, CT.

STUSSY, MAXINE KIM.
Sculptor. Born in Los Angeles, Calif., Nov. 11, 1923. Studied at University Southern Calif., 1943; University Calif., Los Angeles, A.B., 1947; also private study in Rome (Brunifoundry), France, England, Germany, 1959

and 1963. Commissions include Bob Hope Award Trophy, Bob Hope Athletic Award Commission, 1960; Bob Hope New Talent Award, Universal Studios, 1961; Wall Sculptures in Wood, Neuropsychiatric Hospital Lobby, University Calif., Los Angeles, 1968; Wood Sculpture, St. Martin of Tours Church, Brentwood, 1972. Has exhibited at Los Angeles Co. Museum, Los Angeles, 1954, 58, 59, 61; Art USA, Madison Sq. Garden, NY, 1958; Galleria Schneider, Rome, Italy, 1959; Denver Art Museum, 1960; 25 Calif. Women of Art, Lytton Center of Visual Arts, Los Angeles, 1968. Received First Prize, Sculpture, Bronze, Los Angeles Co. Art Museum, 1961. Media: Laminated or carved wood, metal; bronze, concrete. Address in 1982, Los Angeles, CA.

SUAREZ, MAGDALENA FRIMKESS.
Sculptor and painter. Born in Venezuela, July 22, 1929. Studied at Escuela de Artes Plasticas, Caracas, 1943-45; Cath. University, Chile, with Sewell Sillman, 1958-61; also with Norman Calberg and Paul Harris. Exhibitions: Venezuela Annual Salon, 1944; Chilean Annual Salon, 1953; one-woman show, Brazilian Institute of Culture, Chile, 1961; Fridmen Galerie, Encino, Calif., 1973; Fred Mayer Collection of Ceramics, Claremont, Calif., 1974. Address in 1980, Venice, CA.

SUGARMAN, GEORGE.
Sculptor and painter. Born in NYC, May 11, 1912. Studied at Zadkine School of Sculpture, Paris, 1955-56. Works: Basel, Switzerland; Geigy Chemical Corp.; Kalamazoo Institute; MIT; Museum of Modern Art; Museum Schloss Marberg; NYU; St. Louis City; Walker; Art Institute of Chicago. Exhibitions: Stephen Radich Gallery, NYC; Phila. Art Alliance; Kunsthalle, Basel, 1969; American Federation of Arts, Sculpture in Wood, circular, 1941-42; Salon de la Jeune Sculpture, Paris; Salon des Realites Nouvelles, Paris; Silvermine Guild; Claude Bernard, Paris; Carnegie; Seattle World's Fair, 1962; Wadsworth Atheneum; Art Institute of Chicago; VII Sao Paulo Biennial, 1963; Walker; Jewish Museum; New York World's Fair, 1964-65; NYU; Flint Institute; Whitney, Art of the US 1670-1966; Los Angeles Co. Museum of Art, American Sculpture of the Sixties; Foundation Maeght, l'Art Vivant, circular, French museums, 1968; XXXIV Venice Biennial, 1968; Museum of Modern Art; Stedelijk; Joslyn Art Museum, retrospective, 1981. Awards: Longview Foundation Grant, 1960, 61, 63; Carnegie, Second Prize, 1961; Ford Foundation, 1965; National Council on the Arts, 1966. Taught: Hunter College, 1960-70; Yale University, 1967-68. Works in metal and acrylic. Address in 1982, 21 Bond St., NYC.

SULLIVAN, LOUIS H.
Sculptor, architect, and writer. Born in Boston, MA, 1856. Studied at MA Inst. of Technology and Ecole des Beaux-Arts in Paris for architecture. Wrote numerous articles on architecture and his autobiography, *The Autobiography of an Idea*. Noted for the rediscovery of the aesthetic principle "form follows function," previously espoused by Horatio Greenough. One of Sullivan's most famous students was Frank Lloyd Wright. In collections of Metropolitan Museum of Art; Art Institute of Chicago; bronze door, Getty Tomb, Graceland Cemetery in Chicago. Died in Chicago, IL, 1924.

SULLIVAN, RONALD DEE.
Sculptor and educator. Born in Norman, OK, February 6, 1939. Studied at University of Oklahoma, B.F.A., 1963; California State University, Sacramento, M.A., 1969; East Texas State University, postgraduate. Has exhibited at Philbrook Art Institute, Tulsa, OK; Dallas Fine Arts Museum; others. Works in steel and wood; watercolor and pencil drawing. Address in 1982, Corpus Christi, TX.

SUMMERS, ROBERT.
Sculptor and painter. Born in Glen Rose, TX, 1940. Studied art in correspondence courses. Worked as a technical illustrator. Has exhibited since 1966; solo in Odessa, TX, 1967; Western Heritage Show, Houston, TX, 1979; American Artists Professional League, Lever House, NYC; others. Work reproduced by Franklin Mint, 1973; commission, heroic memorial, John Wayne, 1980. Selected official Texas Bicentennial Artist, 1976; received gold medal award, Franklin Mint, PA; others. Reviewed in *Southwest Art*, July 1980. Specialty is contemporary Western Subjects; works in acrylic, egg tempera, bronze. American Masters Foundation publishes his prints; represented by Altermann Art Gallery, Dallas, TX. Address in 1982, Glen Rose, TX.

SUNDERLAND, NITA KATHLEEN
Sculptor and educator. Born in Olney, IL, November 9, 1927. Studied at Duke Univ.; Bradley Univ., B.F.A. and M.A. Commissions include architectural sculpture, Bradley University Bookstore, 1964, and monumental sculpture, Williams Hall Mall, 1967; archit. sculpture, St. Johns's Cath. Church, Woodhull, Ill., 1969; bronze sculpture, City of Peoria, Fulton Street Mall, 1975. Has exhibited at Eastern Mich. University Sculpture Exhibition, 1964; Lakeview Center of Arts and Science, 1965; Gilman Gallery, 1965; Ill. State Museum Exhibition, Ill. Artists, 1966. Media: Stone, wood, bronze, aluminum. Teaching sculpture at Bradley University, from 1956. Address in 1982, Washington, IL.

SUNDIN, ADELAIDE A. T.
Sculptor. Born in Boston, Mass., in 1915. Studied at Mass. School of Art; Mass. Institute of Technology; and with Cyrus Dallin and Raymond Porter. Works: Portraits in porcelain, Boston, NYC, Baltimore, Washington, DC, St. Louis, Los Angeles, Wilmington, and in Sweden. Medium: Ceramics. Award: Mass. School of Art, 1936.

SUNDT, DUKE.
Sculptor. Born in Fort Leavenworth, KS, 1948; lived in Copenhagen, Denmark, 1957-61. Studied engineering, then art, at New Mexico State University, Las Cruces, 1968-70, B.F.A. Worked at foundry, Nambe Mills, near Santa Fe; worked as ranch hand. Specialty is present and recent past ranch life subjects. Works in bronze. Represented by Texas Art Gallery, Dallas, TX; Jamison Gallery, Santa Fe, NM; and Shidoni Gallery, Tesuque, NM. Address in 1982, Sapello, NM.

SURLS, JAMES.
Sculptor and educator. Born in Terrell, TX, 1943. Studied

at Sam Houston State College, B.S., 1966; Cranbrook Academy of Art, M.F.A., 1969. Work at Solomon R. Guggenheim Museum, NY; Fort Worth Art Museum, TX; others. Has exhibited at Fort Worth Art Museum; San Francisco Museum of Modern Art; Solomon R. Guggenheim Museum, NY; Whitney Museum of American Art Biennial, NY; others. Received National Endowment for the Arts individual artist's fellowship, 1979. Works in wood. Address in 1982, Splendora, TX.

SUSSMAN, MARGARET.
Sculptor, painter, and craftsman. Born in NYC, April 4, 1912. Studied at Smith College, B.A.; Grand Central Art School; Art Students League; and with William McNulty, George Bridgman, Will Barnet, and others. Member: National Arts Club, 1940, 45. Exhibited: National Academy of Design, 1943; Audubon Artists, 1945; Allied Artists of America, 1943, 44; Phila. Print Club, 1944; Veterans Exhibition, Art Students League, 1944; National Arts Club, 1940, 46; Contemporary Art Gallery, 1943. Position: Silversmith and jewelry assistant to Adda Husted-Andersen; Instructor, Craft Students League, YWCA, NYC. Address in 1953, 119 East 19th St., NYC.

SUTCLIFFE, RITA JEAN.
Sculptor. Studied: University of Michigan, B.A., 1968; B.F.A., 1970; M.A., 1971; also at the Ecole Nationale d'Art Decoratif, Nice, France. Exhibitions: Cheekwood Galleries, Nashville, TN, 1973; Parthenon Galleries, Nashville, TN, 1974; Harbor Gallery, Cold Spring Harbor, NY, 1978; Meridith Hunter Gallery, Tesuque and Santa Fe, NM, 1980, 81; Taos Spring Arts Celebration, Taos, NM, 1983; Stables Gallery, Taos, NM. Grants received from Yaddo, Saratoga Springs, NY, 1976, 77; Ossabaw Island Project, Ossabaw Island, GA, 1978, 80, 82; The Helene Wurlitzer Foundation, Taos, NM, 1979, 83. Works: Several large commissions in hollow concrete in Michigan, Texas, and Virginia. Taught: Volunteer State Community College, Gallatin, TN, 1972-76; numerous workshops on experimental concrete sculpture techniques in Tennessee, New York, Washington, DC, New Mexico, and elsewhere. Media: Hollow concrete, bronze, and clay. Address in 1984, Taos, NM.

SUTTER, JAMES STEWART.
Sculptor and educator. Born in Milwaukee, WI, February 12, 1940. Studied at University of Wisconsin, B.A. (art education), 1964; University of Iowa, M.A. (sculpture), 1965; University of Mass., university fellowships, 1965-67, M.F.A. (sculpture), 1967. Has exhibited at Wadsworth Atheneum, Hartford, CT; National Drawing, Watercolor, and Print Show, Philadelphia Museum of Fine Arts; Hansen Galleries, NY; Ball State University, Muncie, IN; others. Member of College Art Association. Teaching sculpture at State University of New York College, Potsdam, NY, from 1967. Works in bronze and aluminum. Address in 1982, Norwood, NY.

SUTTMAN, PAUL.
Sculptor. Born in Enid, Oklahoma, (or in New Mexico) July 16, 1933. Studied at Adelphi College, with Robert Cronbach; University of NM, with Adja Yunkers, Robert Mallory; Cranbrook Academy of Art, with Tex Schwetz,

Maija Groten. Works: Detroit Inst.; Kalamazoo Institute; Layton School of Art; Museum of Modern Art; University of Michigan; Roswell; Walker; Hirshhorn. Exhibitions: Terry Dintenfass, Inc., 1961, 64, 65, 66, 67, 69; Butler; Detroit Institute; University of Michigan; Santa Barbara Museum of Art; de Young; University of New Mexico; American Academy, Rome; Musee Rodin, Paris, International Sculpture; Herron; Penna. Academy of Fine Arts; Guggenheim; others. Awards: Cranbrook, Horace H. Rackham Research Grant (Florence, Italy), 1960; Fulbright Fellowship (Paris), 1963; Prix de Rome, 1965, 66, 67. Taught: University of Michigan, 1958-62; University of New Mexico, from 1976. Address in 1982, c/o Terry Dintenfass, Inc., 50 West 57 Street, NYC.

SUTZ, ROBERT.
Sculptor and painter. Born in Chicago, IL, 1929. Studied at Chicago Academy of Art; Chicago Art Institute; American Academy of Art, all from 1946-51. Worked as freelance illustrator; advertising agency art director. Turned full-time to fine art in 1980. Exhibited at Mongerson Gallery, among others. Work in National Cowboy Hall of Fame. Specialty is portraits, scenes, life masks, including Western and Indian subjects. Works in oil, pastel, bronze. Member: American Watercolor Society, elected in 1969. Represented by Fowler's Gallery. Address in 1982, Glenview, IL.

SVENSON, JOHN EDWARD.
Sculptor. Born in Los Angeles, Calif., May 10, 1923. Studied at Claremont Graduate School, Calif.; sculpture with Albert Stewart. Work in Alaska State Museum, Juneau; City Museum and National Orange Show Permanent Collection, San Bernardino, Calif.; medallion and sculpture, Alyeska Pipeline Service, Anchorage; others. Has exhibited at Los Angeles County Museum of Art; Newman Galleries, Philadelphia; Kennedy Galleries, New York; Alaska State Museum; others. Awards: Two Awards for Excellence in Sculpture, American Institute of Architecture, 1957 and 61; First Prize, Laguna Art Festival, 1961; others. Member of the National Sculpture Society, fellow; Society of Medalists, New York. Address in 1982, Upland, CA.

SWALLOW, WILLIAM W.
Sculptor, painter, and teacher. Born in Clark's Green, PA, September 30, 1921. Studied at the Philadelphia Museum School of Industrial Art. Work: "As the Earth Sings—Pennsylvania Dutch Family" (terra cotta), 1942, Metropolitan Museum of Art; Syracuse Museum of Fine Art; others. Exhibited at Penna. Academy of Fine Arts; National Academy of Design; Audubon Artists; others. Received awards from National Sculpture Society; Audubon Artists; others. Member of Audubon Artists; Philadelphia Watercolor Club; others. Address in 1953, Allentown, PA.

SWAN, PAUL.
Sculptor and painter. Born in Illinois. Studied drawing under John Vanderpoel and sculpture under Taft. Later he studied in NY and Paris. He exhibited his paintings and sculpture in the National Academy of Design, New York. Exhibited paintings at Paris Salon, 1922, and sculp-

ture ("Douleur") at National Sculpture Society, 1923. Address in 1926, Jackson Heights, NYC.

SWANSON, J. N.
Sculptor and painter. Born in Duluth, MN, February 4, 1927. Studied at College of Arts and Crafts, Oakland, CA; Carmel Art Institute; with Donald Teague, Armin Hansen. Has working horse ranch, trains stock horses. Work in Cowboy Hall of Fame, Oklahoma City; Read Mullin Collections, Phoenix; others, including private commissions. Has exhibited at Cowboy Artists annual show, Hall of Fame, Oklahoma City; De Young Museum (Society of Western Artists), San Francisco; others. Member: Cowboy Artists of America. Specialty is Western subjects. Works in oil, clay. Bibliography includes *The Cowboy in Art*, Ainsworth; *Western Painting Today*, Hassrick. Represented by Who's Who in Art; Copenhagen Galleri, Solvang, CA. Address in 1982, Carmel Valley, CA.

SWANSON, JONATHAN M.
Sculptor, painter, and illustrator. Born Chicago, IL, July 21, 1888. Pupil of John Vanderpoel at Art Institute of Chicago. Member: Art Institute of Chicago, alumni; American Numismatic Society; NY Numismatic Club. Work: Medals and portraits in low relief; portaits of former presidents J. Sanford Saltus, D. W. Valentine, George H. Blake, New York Numismatic Club; three portrait medals, French Mint Exhibit. Exhibited at National Sculpture Society, 1923. Address in 1933, 63 Washington Square South, NYC.

SWARTZ, HAROLD.
Sculptor, writer, lecturer, and teacher. Born San Marcial, NM, April 7, 1887. Studied in Berlin, Paris. Member: Sculptors Guild of Southern California; California Art Club; California Painters and Sculptors; Municipal Art Commission. Awards: First prize, Arcadia Exp., 1923; first prize, Pomona Exp., 1923; gold medal, Pacific Southwest Exp., 1928; first prize, California Art Club, 1932. Represented in Los Angeles Museum. Instructor of Sculpture, Chouinard Art School. Address in 1933, Los Angeles, CA.

SWARZ, SAHL.
Sculptor, painter, and teacher. Born in NYC, May 4, 1912. Studied at Art Students League. Member: Conn. Academy of Fine Art; Clay Club, NY. Work: Brookgreen Gardens, SC; Court House, US Post Office, Statesville, NC; US Post Office, Linden, NJ; Buffalo, NY; Whitney; Minneapolis Institute of Fine Arts; others. Exhibited: Syracuse Museum of Fine Art, 1938, 40; Conn. Academy of Fine Art, 1938; Penna. Academy of Fine Arts, 1949-58; Clay Club, 1934-46; Brooklyn Museum, 1936; Whitney Museum of American Art, 1947-62; Fairmount Park, Phila., 1949; Berkshire Museum, 1941; Rochester Mem. Art Gallery, 1940; Springfield Museum of Art, 1936; Lyman Allyn Museum, 1939; Plainfield (NJ) Art Association, 1943; Newark Museum, 1944. Position: Associate Dir., Clay Club, Sculpture Center, NYC, 1931-46. Awards include American Academy of Arts and Letters grant; Guggenheim Memorial Foundation grants; others. Address in 1953, 167 East 69th St., NYC; living in Japan in 1980.

SWAYNE, WILLIAM MARSHALL.
Sculptor. Born in 1828, in Chester County, Pennsylvania. Worked: Washington, 1859-62; Chester County, PA. Died in 1918, in Chester County. Executed busts of Lincoln and other sitters.

SWEEZEY, NELSON.
Sculptor and designer of monuments. At New York City, 1849-52.

SWENSON, HOWARD WILLIAM.
Sculptor and designer. Born in Rockford, IL, June 30, 1901. Studied at Corcoran School of Art. Member: Rockford Art Association; Potters Guild Greater Chicago. Work: Library of Congress; Masonic Cathedral, Rockford, IL. Exhibited: Society of Washington Artists; Corcoran Gallery of Art; Phila. Print Club; Rockport Art Association. Address in 1953, Rockford, IL. Died in 1960.

SWERGOLD, MARCELLE M.
Sculptor. Born in Antwerp, Belgium, September 6, 1927; US citizen. Studied at New York University, painting with Aaron Berkman and Henry Kallem; Art Students League, with John Hovannes and Jose de Creeft, wax with Harold Caster. Work in New Britain Museum of American Art, CT; others. Has exhibited at Cork Gallery, Philharmonic Hall, Lincoln Center, NY; Allied Artists, National Academy Galleries, NY; Audubon Artists Annual, NY; others. Member of New York Society of Women Artists; Artists Equity Association, NY; Contemporary Artists Guild. Works in bronze and stone. Address in 1982, 450 West End Ave., NYC.

SWICK, LINDA ANN.
Sculptor. Born in Bedford, OH, September 8, 1948. Studied at Kent State University, B.A., 1970; Florida State University, M.F.A., 1977. Has exhibited at Walter Hopps Museum, Washington, DC; Laguna Gloria Art Museum, Austin, Texas; Corcoran Gallery, Washington, DC. Works in wood. Address in 1982, Washington, DC.

SZATON, JOHN J.
Sculptor. Born in Ludlow, MA, November 18, 1907. Studied at Chicago Academy of Fine Arts; Chicago School of Sculpture; Art Institute of Chicago; and with Edouard Chassaing, Lorado Taft. Work: Panels, plaques, decorations: Recreation Building, Hammond, IN; Pilsudski plaque, Springfield, MA; Lincoln Mem., Vincennes, IN; Northwest Armory, Chicago. Exhibited: Art Inst. of Chicago, 1935; Penna. Academy of Fine Arts, 1940; National Academy of Design, 1941; Cincinnati Museum Association, 1941; Polish Art Club, Chicago, 1942; Society for Sanity in Art, 1940. Address in 1953, Chicago, IL.

SZUKALSKI, STANISLAUS.
Sculptor. Received Cahn honorable mention, Art Institute of Chicago, 1916. Address in 1918, Kimball Hall, Chicago, IL.

T

TAAKE, DAISY.
Sculptor and teacher. Born St. Louis, MO, March 21, 1886. Pupil of Art Institute of Chicago and St. Louis School of Fine Arts; Lorado Taft. Member: St. Louis Art League. Winner of St. Louis Art League Fountain Competition. Work: Eight-foot decorative figure at Washington University; several large fountains privately owned. Address in 1933, St. Louis, Missouri.

TACHA, ATHENA.
Sculptor and educator. Born in Larissa, Greece, April 23, 1936. Studied: National Academy of Fine Arts, Athens, Greece, MA (sculpture), 1959; Oberlin College, OH, MA (art history), 1961; Univ. Paris, Sorbonne, France. Exhibitions: Allen Art Museum, 1963-73; Womens Interart Cent., NYC, 1973; Dayton Art Institute, OH, 1974; Zabriskie Gallery, NYC, 1979, 81; many others. She is represented in the Cleveland Museum of Art, OH. Awards: First prize (sculpture), May Show; Cleveland Museum of Art, 1968, 71, 79; National Endowment for the Arts, 1975; Fellowship, Center for Advanced Visual Studies, MIT. Also active in film making. Member: Artists Equity Association; College Art Association of America (director, 1973-76). Taught: Professor of Art, Oberlin College, Ohio, from 1973. Address in 1982, Oberlin, OH.

TADLOCK, PAUL.
Sculptor. Born in Houston, TX, 1935. Studied at University of Texas; Arlington State College; North Texas State University, advertising arts. Turned full-time to sculpture in 1973. Specialty is North American wildlife, figures, domestic animals. Works in bronze. Reviewed in *Southwest Art*, September 1978. Has exhibited at Troy's Gallery, Scottsdale, AZ; Hanging Tree Gallery, Midland, TX. Address in 1982, New Braunfels, TX.

TAFT, LORADO ZADOC.
Sculptor, teacher, writer, and lecturer. Born Elmwood, IL, April 29, 1860. Pupil of Ecole des Beaux-Arts in Paris under Dumont, Bonnassieux, and Thomas. Member: National Sculpture Society, 1893; Assoc., National Academy of Design, 1909; Academician, National Acad. of Design, 1911; National Academy of Arts and Letters; Chicago Painters and Sculptors; American Federation of Arts; American Institute of Architects (honorary), 1907; IL State Art Com.; National Com. Fine Arts, 1925-29. Taught: Instructor, Chicago Art Institute, 1886-06; lecturer, Chicago Art Institute, 1886-29; lecturer on art, University of Chicago; non-resident professor of art, University of Illinois. Awards: Designers' medal, Columbian Exp., Chicago, 1893; silver medal, Pan-Am. Exp., Buffalo, 1901; gold medal, St. Louis Exp., 1904; Montgomery

Ward prize, Art Institute of Chicago, 1906; silver medal, P.-P. Exp., San Francisco, 1915. Author: "History of American Sculpture;" "Modern Tendencies in Sculpture." Work: "Solitude of the Soul," Art Institute, Chicago; Metropolitan Museum of Art; "Washington Monument," Seattle, WA; "Fountain," Paducah, KY; "Trotter Fountain," Bloomington, IL; "Columbus Memorial Fountain," Washington; Ferguson "Fountain of the Great Lakes," Chicago; "Thatcher Memorial Fountain," Denver, CO; "Blackhawk," Ogle Co. Soldiers' Memorial, Oregon, IL; "Fountain of Time," Chicago; Danville (IL) Soldiers' Monument; "Lincoln," Urbana, IL; "Pioneers," Elmwood, IL; "Alma Mater," University of Illinois, Urbana, IL; "The Crusader," memorial to Victor Lawson, Chicago; two colossal pylons, main entrance, Louisiana State Capitol, Baton Rouge. Exhibited at National Sculpture Society, 1923. Address in 1933, 6016 Ingleside Avenue; h. 5801 Dorchester Avenue, Chicago, IL; summer, "Eagle Nest Camp," Oregon, IL. Died in Chicago, IL, October 30, 1936.

TAGGART, EDWIN LYNN.
Sculptor, painter, illustrator, and etcher. Born Richmond, IN, April 23, 1905. Pupil of R. L. Coates, F. F. Brown, B. Waite, California School of Arts and Crafts. Member: Indiana Art Club; Junior Art Association. Awards: Five prizes at Wayne County Fair; U. C. T. Art Medal, 1925. Work: Murals in Morton High School, Richmond, IN. Address in 1933, San Mateo, CA; h. Richmond, IN.

TAIRA, FRANK.
Sculptor and painter. Born in San Francisco, CA, August 21, 1913. Study: California School of Fine Arts, 1935-38; Columbia University, 1945; Art Students League, 1956; New School for Social Research, 1957. Exhibited: San Francisco Museum of Arts, 1939; National Arts Club, 1968; Knickerbocker Artists, 1968; National Academy of Design, 1976; Allied Artists of America, 1976; Horizon Galleries, 1982; and others. Awards: First prize, painting, California School of Fine Arts, 1940; first prize, portrait, Cambridge, MA, 1943; National Arts Club, 1968; honorable mention, Knickerbocker Artists, 1968; Accademia Italia delle Arti e del Lavoro, 1981. Member: Artists Equity Association of NY. Media: Oil, watercolor; bronze. Address in 1983, 135 W. 106th St., NYC.

TAJIRI, SHINKICHI.
Sculptor and teacher. Born in Los Angeles, CA, December 7, 1923. Studied at the Art Institute of Chicago, under Ossip Zadkine; with F. Leger in Paris; the Academie Grande Chaumiere, Paris; trained at San Diego under American sculptor Donald Hord. In collections of Stedelijk, Amsterdam; Museum of Modern Art; Carnegie Institute; museums in Paris and Copenhagen. Exhibited:

Stedelijk Museum, 1960-67; Venice Biennial, 1962; Andre Emmerich Gallery, NY, 1965; Kunsthalle Lund, Sweden, 1971; Kunsthalle, Basel, Switzerland, 1969. Awards: Golden Lion, 8th International Festival Amateur Films, Cannes, France, 1955; Mainichi Shibum prize for Sculpture, Tokyo Biennial, 1963. Taught: Minneapolis College of Art and Design, 1964-65, as guest professor of sculpture; and at the Hochschule der Kunste, West Berlin, Germany, 1969. Published "The Wall," 1970, "May Day," 1970, and "Land Mine," 1970, others. Address in 1982, Castle Scheres, Baarlo, Netherlands.

TAKSA, DESHA A. MILCINOVIC.
Sculptor, painter, serigrapher, designer, and teacher. Born in Zagreb, Yugoslavia, March 3, 1914. Studied in Europe; and with Ivan Mestrovic. Member: American Artists Professional League; Greenwich Society of Artists. Work: Greenwich (CT) Library; Witte Memorial Museum, San Antonio, TX. Exhibited: American Artists Professional League, 1940-42; Art Directors Club, traveling exh., 1930-36; Arden Gallery, 1943; Dance International, NY, 1940; Witte Memorial Museum, 1944 (one-man); Kansas City, MO; Oakland Art Gallery, 1943; Dallas Museum of Fine Art, 1944; Library of Congress, 1946; Morgan Library, New Haven, CT, 1946; Greenwich, CT, 1946. Illustrated "Adventures in Monochrome." Address in 1953, 158 West 58th St., NYC.

TALABA, LINDA.
See Cummens, Linda.

TALBERT, BEN.
Sculptor. Born in Los Angeles, CA, 1933. Studied: Texas A & M, College Station; University of California, Los Angeles, 1957-58, B.A., 1957. One-man exhibitions: Pasadena Art Museum, 1961; Ten Years of Erotic Art, Mermaid Tavern, Topanga, CA, 1975. Group exhibitions: Object Makers, Pomona College, Claremont, CA, 1961; Directions in Collage: California, Pasadena Art Museum, California, 1962; Arena of Love, Dwan Gallery, Los Angeles, 1965; Assemblage in California, Art Gallery, University of California, Irvine, 1968; Painting and Sculpture in California, San Francisco Museum of Modern Art (1976) and Smithsonian National Collection of Fine Arts (1977). Died in Venice, CA, 1975.

TALBOT, GRACE HELEN.
(Mrs. Darley Randall). Sculptor. Born in North Billerica, MA, September 3, 1901. Pupil of Harriet W. Frishmuth. Member: National Association of Women Painters and Sculptors; National Sculpture Society. Awards: Avery prize, Architectural League, 1922; Joan of Arc medal, National Association of Women Painters and Sculptors, 1925. Exhibited at National Sculpture Society, 1923. Address in 1953, Syosset, LI, NY.

TALBOT, WILLIAM H. M.
Sculptor. Born in Boston, MA, January 10, 1918. Studied at Penna. Academy of Fine Arts, 1936-38, 1940-41, with Walker Hancock; privately with George Demitrios, Boston, 1938-39; Academie des Beaux-Arts, Paris, 1945-46, with Marcel Gaumont. Works: Bryn Mawr College; The Cambridge School; Earlham College; Rumsey Hall

School; St. Lawrence University; Whitney; Washington University. Exhibitions: Carroll-Knight Gallery, St. Louis; Andrew-Morris Gallery, NYC; Hartford (Conn.) Jewish Community Center; Federation of Modern Painters and Sculptors Annuals; Fairmount Park Association, Phila., Sculpture International; Boston Arts Festival; Whitney; Phila. Museum of Art; St. Louis City; Dallas Museum of Fine Art; De Cordova; Andover (Phillips); New York World's Fair, 1964-65; Penna. Academy of Fine Arts; Wadsworth Atheneum; Arts Club, Chicago; Sculptors Guild. Awards: Penna. Academy of Fine Art, Cresson Fellowship, 1941; Conn. Academy of Fine Arts, Howard Penrose Prize, 1950; National Institute of Arts and Letters Award, 1975. Member: Sculptors Guild; Federation of Modern Painters and Sculptors; New York Architectural League. Media: Concrete, stained glass with electronic components. Lived in Conn. Died in 1980.

TALBOTT, KATHARINE.
Sculptor. Born in Washington, DC, January 18, 1908. Pupil of H. P. Camden, Avard Fairbanks, and Robert Laurent. Award: First prize for portrait, Exhibition of Oregon Artists, Sculptors and Designers, Portland Museum of Art, 1932. Address in 1933, 644 San Luis Road, Berkeley, Calif.

TALCOTT, DUDLEY VAILL.
Sculptor, painter, illustrator, and writer. Born in Hartford, CT, June 9, 1899. Exhibited: Art Institute of Chicago, 1940; Valentine Dudensing Gallery, 1927; Museum of Modern Art, 1930; Whitney Museum of American Art, 1937; Grace Horne Gallery, Boston; Phillips Academy, Andover, MA. Author and illustrator of "Noravind," 1929; "Report of the Company," 1936. Address in 1953, Farmington, CT.

TALCOTT, SARAH WHITING.
Sculptor. Born in West Hartford, Conn., 1852. Address in 1934, Elmwood, Conn. (Mallett's)

TALEN, W. A.
Sculptor and carver. Worked: New Orleans, 1858-66.

TANIA, (SCHREIBER).
Sculptor and painter. Born in Warsaw, Poland, January 11, 1924. Studied at McGill University, 1941-42, M.A.; Columbia University, 1942-44; Art Students League, 1948-51, with Yasuo Kuniyoshi, Morris Kantor, Vaclav Vytlacil, Harry Sternberg. Works: Brandeis University; Morgan State College; New York University. Exhibitions: San Francisco Museum of Art, 1963; Albert Landry, NYC; The Bertha Schaefer Gallery, NYC; New York University, 3 Artists; University of Illinois; University of Virginia, Color and Space, 1964, 68; Guggenheim, 1963; Oakland Art Museum; World House Galleries, NYC, International, 1964; Museum of Modern Art, 1939; others. Taught: NYU, from 1963. Address in 1976, c/o Bertha Schaefer Galleries, 41 E. 57th St., NYC.

TARDO, (MANUEL) RODULFO.
Sculptor. Born in Matanzas, Cuba, February 18, 1919; US citizen. Studied at National Fine Arts School, Havana, Cuba (sculpture and drawing); Clay Club and Art Students League, scholarship. Work in National Museum of

Cuba; Cathedral of St. John the Divine, NY; bust, Mother Cabrini Park, Newark, NJ; outdoor bronze sculpture, Church Immaculad Corazon de Maria, Elizabeth, NJ; others. Has exhibited at Philadelphia Museum of Art; National Museum of Modern Art, Paris; Brooklyn Museum; Metropolitan Museum of Art; others. Received honorable mention, Audubon Artists. Address in 1982, Long Island City, NY.

TARLETON, MARY LIVINGSTON.
Sculptor, landscape and miniature painter. Born in Stamford, Conn. Pupil of Childe Hassam, Charles W. Hawthorne, W. M. Chase, Art Students League of New York. Member of National Association of Women Painters and Sculptors. Awarded Guggenheim Fellowship, 1933. Address in 1934, Great Neck, Long Island, New York.

TATERKA, HELENE.
Sculptor and painter. Born in Breslau, Germany, December 2, 1901. Studied at Munich Art and Craft School, Breslau, Germany, 3 years; Academy Fine Art, Breslau, Germany, 1 year; also sculpture with Harold Castor and painting with Revington Arthur, US. Works: Alfred Khouri Memorial Collection, Norfolk Museum Arts and Science, VA; Smithsonian Institution. Exhibitions: Audubon Artists Annual, NY; National League American Pen Women Biennial, Smithsonian Institution; Painter and Sculptors of New Jersey Annual; Silvermine Guild Artists Annual; Sculptors League Annual, NY. Awards: Julia Ford Pew Award for Sculpture, National Association Women Artists, 1964; Bronze Medal for Creative Sculpture, Audubon Artists, 1965; Mary and Gustave Kellner Award for Sculpture, American Society of Contemporary Artists, 1970. Media: Bronze, lost wax; polymer, watercolor. Address in 1976, 140 West End Avenue, NYC.

TATTI, BENEDICT MICHAEL.
Sculptor, painter, and teacher. Born in NYC, May 1, 1917. Studied at Art Students League, with William Zorach and O. Zadkine; Masters Institute Roerich Museum, with Louis Slobodkin; Hans Hofmann Art School; Da Vinci Art School, with A. Piccirilli. Member: Sculptors League; American Society of Contemporary Artists; Painters and Sculptors Society of New Jersey (vice-pres.); Brooklyn Society of Artists. Awards: Prizes, Brooklyn Society of Artists, 1944; Soldier Art Exhibition, National Gallery of Art, 1945; medal of honor for sculpture, Painters and Sculptors Society of New Jersey, 1972. Exhibited: Metropolitan Musuem of Art, 1942; National Gallery of Art, 1945; Brooklyn Society of Artists, 1943-46; Tribune Art Gallery, 1946 (one-man); Penna. Academy of Fine Arts, 1950-54; Museum of Modern Art, 1960; Roko Gallery, NY, 1967. Work: Harper's Row, Mr. and Mrs. Cass Canfield, NY; sundial, R. W. Bliss for Dumbarton Oaks, Wash., DC, 1952; medallions of D. Sarnoff, D. Eisenhower, and Mark Twain, Newell and Lennon, NY; others. Taught: Instructor of sculpture and head of department, High School of Art and Design; instructor of sculpture, Craft Students League, 1966-67. Address in 1982, 214 E. 39th Street, NYC.

TAUCH, WALDINE AMANDA.
Sculptor and collector. Born Schulenburg, Texas, January 28, 1894. Pupil of Pompeo Coppini. Member: Southern States Art League; Society of Western Sculptors; American Associated Press League. Work: Oldest inhabitant fountain, San Antonio, Texas; Henderson Memorial, Winchester, KY; Indiana monument to Civil and World War heroes and pioneers, Bedford, IN; "Baptismal Font," Grace Lutheran Church, San Antonio, TX; Wesleyan Museum, GA; "General Douglas MacArthur," Howard Payne College, Brownwood, TX. Exhibited: National Sculpture Society Traveling Show, 1931; Women Painters and Sculptors, NY, 1932; Witte Memorial Museum; National Academy of Design; Coppini Academy of Fine Arts, from 1954. Member: Fellow, National Sculpture Society; American Academy of Arts and Letters; fellow, American Artists Professional League; Coppini Academy of Fine Arts. Address in 1982, San Antonio, TX.

TAVSHANJIAN, ARTEMIS.
(Mrs. Charles A. Karagheusian). Sculptor and painter. Born Englewood, NJ, June 18, 1904. Pupil of Mabel R. Welch, Robert G. Eberhard. Awards: Sterling Prize, National Association of Women Painters and Sculptors, 1933; Boardman Prize, 34th Annual Miniature Exhibition, Grand Central Galleries, 1933. Member: National Association of Women Painters and Sculptors. Address in 1933, 91 Central Park West, New York, NY.

TAYLOR, BILL (WILLIAM BRADLEY).
Sculptor and instructor. Born in Atlantic City, NJ, January 1, 1926. Studied at Institute of Contemporary Art, Washington, DC, with Alexander Giampietro, 1951. Has exhibited at 200 Years of Black American Art, Los Angeles County Museum of Art; High Museum of Art, Atlanta, GA; Museum of Fine Arts, Dallas; Brooklyn Museum of Art. Taught sculpture at Corcoran School of Art, Washington, DC, 1965-68; sculpture at University of Washington, DC, 1968-80. Works in stone (granite field stone) and welded steel. Address in 1982, University of Washington, DC.

TAYLOR, CAROL (MRS.).
Sculptor. Address in 1934, New York. (Mallett's)

TAYLOR, CECELIA EVANS.
Sculptor. Born in Chicago, Ill., July 23, 1897. Pupil of Arthur Lee. Member: Buffalo Society of Artists. Awards: Honorable mention, Albright Art Gallery, 1932 and 1933. Address in 1933, Sheridan Dr., Williamsville, NY.

TAYLOR, JAMES H.
Sculptor and painter. Born in Washington, DC, 1946. Studied at Brigham Young University, M.A. art, 1972. Began full-time career in art in 1974. Paints Utah Valley and Wasatch Mountain region landscapes; Crow, Blackfoot tribes of Montana, Idaho, Wyoming. Sculpts waterfowl, including ducks, quail, geese. Works in watercolor; plastalina clay, bronze. Represented by Miner's Gallery Americana, Carmel-by-the-Sea, CA; Voris Gallery, Salt Lake City, Utah. Address in 1982, Orem, UT.

TAYLOR, JOSEPH RICHARD.
Sculptor and teacher. Born in Wilbur, Washington, February 1, 1907. Studied at University of Washington, B.F.A., 1931, M.F.A., 1932; University of Oklahoma; Columbia

University, 1940. Work at Philbrook Museum, Tulsa; walnut figure, Seattle Art Museum, Seattle, Washington. Has exhibited at Kansas City Art Institute; New York World's Fair, 1938-39; San Francisco World's Fair, 1940; Museum of Modern Art, NY. Awards: Bronze medal, Annual Mid-Western Exhibition, Kansas City Art Institute, 1932; Annual Northwest Art Exhibition, Seattle Art Museum, grand award, 1932, and honorable mention, 1933; Oklahoma Hall of Fame, 1960. Professor of art and head of sculpture department, 1932-63, emer. professor, from 1971, University of Oklahoma, Norman, OK. Works in bronze, wood, and stone. Address in 1982, Norman, OK.

TAYLOR, MARIE.
Sculptor. Born in St. Louis, MO, February 22, 1904. Studied at Art Students League; Wash. University School of Arts, 1923-24. Works: St. Louis Art Museum; also in many private collections. Commissions: Main altar, St. Paul's Church, Peoria, Ill., 1960; Jefferson Memorial National Expansion, St. Louis Riverfront, for Mansion House, St. Louis, 1967. Exhibitions: Joslyn Museum of Art; Kansas City Art Institute; Southern Ill. University, Carbondale, 1952; Brooks Memorial Art Gallery, Memphis, Tenn., 1955; Sculpture 1969, Span International Pavillion, 1969. Awards: Prizes, Cleveland Art Museum, St. Louis Art Guild and National Association of Women Artists. Address in 1982, St. Louis, MO.

TAYLOR, ROD ALLEN.
Sculptor and art administrator. Born February 29, 1932. Studied at Virginia State College, BS, 1958; Alabama State University, M.Ed., 1972; Penna. University, Ph.D. in art education, 1974. Exhibited: Smithsonian Institution, Wash., DC; President's Park Art Fair, White House Park, Wash., DC, 1965; Corcoran; and others. Taught at Alabama State University, Montgomery, AL, 1968-70; and Penna. State University, 1972 and 74. Media: Bronze and stone. Address in 1982, Chesapeake, VA.

TAYLOR, SCOTT.
Sculptor. Address in 1935, Paris, France. (Mallett's)

TAYLOR, WYNNE BYARD.
(Mrs. Edward A. Taylor). Sculptor. Address in 1934, Southport, Conn. (Mallett's)

TECLA.
Sculptor and painter. Studied: National Academy of Design; Cincinnati Art Academy; Art Students League, New York City. Exhibitions: Brooklyn Museum; Howard University; Butler Institute of American Art; Bates College in Maine.

TEFFT, CARL (or CHARLES) EUGENE.
Sculptor. Born September 22, 1874 in Brewer, Maine. Studied with Blankenship and Ruckstull, Artist-Artisan Institute, NYC. Also taught there. His figure of "Lake Superior" was acclaimed at the Buffalo Exposition. Works also include a fountain, Botanical Garden; war memorial, Belleville, NJ; statue, American Museum of Natural History, NYC; Statue, Bangor, ME; statue, Brookgreen Gardens, SC. He was chosen as director of sculp-

ture for the Sesqui-Centennial Exposition, Philadelphia, 1926. Tefft's studio was established at Tompkinsville, Staten Island, NY, and later at Guilford, ME. Died September 20, 1951, in Presque Isle, ME.

TEFFT, ELDEN CECIL.
Sculptor and educator. Born in Hartford, KS, December 22, 1919. Studied at University of Kansas, B.F.A., 1949, M.F.A., 1950; Cranbrook Academy of Art, 1951-52; with Bernard Frazier, William McVey. Has exhibited at Philbrook Art Center, Tulsa, OK; San Francisco Museum of Art; Carnegie Museum, Pittsburgh, PA; Joslyn Art Museum, NE; Denver Art Museum, CO; others. Teaching sculpture at University of Kansas, Lawrence, from 1950. Works in bronze and stone. Address in 1982, Lawrence, KS.

TEICHMAN, SABINA.
Sculptor and painter. Born in NYC in 1905. Studied at Columbia University, B.A., M.A.; also with C. J. Martin, A. J. Young. Works: Carnegie Institute; Brandeis University; Fogg; Tel-Aviv Museum, Israel; San Francisco Museum of Art; Whitney Museum of American Art; Butler Institute of American Art; Museum of the University of Puerto Rico; Living Arts Foundation Collection, NY. Exhibited at Argent and Phoenix Galleries, NYC; New York Cultural Center; Audubon Artists Annual; many others. Award: Women's Westchester Center, 1950. Media: Watercolor, oil; and clay. Address in 1982, 1120 Fifth Avenue, NYC.

TELLER, JANE (SIMON).
Sculptor. Born in Rochester, NY, in 1911. Studied at RIT; Skidmore College; Barnard College, B.A; and with Aaron Goodelman and Ibram Lassaw. Exhibited extensively throughout Penn.; Newark Museum, NJ; Skidmore College, Saratoga Springs, NY; Whitney Museum; Princeton University; Museum of Modern Art, NYC, 1975; others. Member: Sculptors Guild; Artists Equity Association. Awards: Purchase Awards, New Jersey State Museum, 1971, and Trenton State College, NJ, 1972-79; Philadelphia Art Alliance. Address in 1983, 200 Prospect Avenue, Princeton, NJ.

TENNANT, ALLIE VICTORIA.
Sculptor. Born in St. Louis, Missouri. Studied at Art Students League; also with George Bridgman and Edward McCartan. Works: State of Texas Building, Dallas; Brookgreen Gardens, South Carolina; Hockaday School, Southwest Medical College, Aquarium, Museum of Fine Arts, and Woman's Club, all of Dallas, Texas; memorial, Corsicana, Texas; memorial, Bonham, Texas; US Post Office, Electra, Texas. Exhitited: Penna. Academy of Fine Arts, 1935; Art Institute of Chicago, 1935; Texas Centennial, 1936; Architectural League, 1938; World's Fair, NY, 1939; Whitney, 1940; National Sculpture Society, 1940; Carnegie Institute, 1941; others. Member: National Sculpture Society; Dallas Art Association. Awards: Dallas Art Association, 1936; Southern States Art League, 1932, 33, 36. Address in 1953, Dallas, TX. Died in 1971.

TERKEN, JOHN.
Sculptor. Born in Rochester, NY, January 11, 1912. Stud-

ied at Beaux Arts Institute of Design, with Chester Beach, Lee Lawrie and Paul Manship; New York School of Fine and Industrial Arts; Columbia School of Fine Arts. Work: Roswell Museum, New Mexico; Eagle Fountain, Salisbury Park, East Meadow, NY; others. Exhibited: National Academy of Design, NY, 1968; National Arts Club, New York, 1970; National Sculpture Soc., New York, 1972; and others. Member of the National Sculpture Society, fellow; Hudson Valley Art Association, fellow; and others. Award: Lindsey Morris Memorial Prize, 1965, National Sculpture Society; Louis C. Tiffany Foundation Award; American Artists Professional League, 1972; others. Works in bronze. Address in 1982, East Meadow, New York.

TERRELL, ALLEN TOWNSEND.
Sculptor, painter, and writer. Born in Riverhead, NY, November 2, 1897. Studied at Columbia Univ.; Art Students League, with Edward McCartan; Julian Academy, Ecole des Beaux-Arts, Fontainebleau, France; Penna. Academy of Fine Arts, with Albert Laessle; and with Charles Despiau. Member: Fellow, National Sculpture Society; Allied Artists of America; National Arts Club; American Watercolor Society; Municipal Art Society; Fontainebleau Association. Awards: Prizes, Ernest Piexotto award, NY, 1941; Village Art Cent., 1943; IBM, 1945; bronze medal of honor for sculpture, National Arts Club, 1959; Greer prize for sculpture, National Academy of Design, 1972. Work: Metropolitan Museum of Art; Smithsonian Institution; Brooklyn Museum, NY; York Club, NY; IBM Collection; murals, S.S. America; Aluminum Corp. America, Garwood, NJ; modeled Vermilye med., Franklin Institute, Phila. Exhibited: Salon d'Automne, 1931; National Academy of Design, 1932-34, 37, 72; Penna. Academy of Fine Arts, 1933, 34, 36; American Watercolor Society, 1942-51; Allied Artists of America, 1965; one-man exhibitions: Decorators' Club, NY, 1939; Stendahl Gallery, 1944; Pasadena Art Institute, 1944; Village Art Center, 1943; National Arts Club, 1975. Author: "Drawing for Sculpture," *National Sculpture Review*, 1974. Address in 1982, 42 Stuyvesant St., NY.

TERRIS, ALBERT.
Sculptor and calligrapher. Born in NYC, November 10, 1916. Studied with Aaron J. Goodelman, 1933; Work Progress Administration Art School, NY; Beaux Arts Institute of Design, NY, 1933-34; City College of NY, 1936-39, B.S.S., 1939, with George W. Eggers; Institute of Fine Arts, NY University, 1939-42, with Walter Friedlander, Richard Krautheimer, A. Phillip McMahon. Has exhibited at Allan Stone Gallery, NY; Museum of Art, Carnegie International, Pittsburgh; Brooklyn Museum Biennale, NY; Museum of Modern Art, NY; Sculpture Center of NY; others. Received first prize, Brooklyn Museum Biennial, 1960. Teaching sculpture and theory of art at Brooklyn College, NY, from 1954. Works in steel, plaster, terra cotta, and acrylic. Address in 1982, Freeport, NY.

TERRIZZI, ANTHONY T.
Sculptor. Award: Collaborative Competition prize, New York Architectural League, 1915. Address in 1916, 401 East 56th St., NYC.

TESSIN, GERMAIN.
Sculptor. Born in France, 1829. Worked in New Orleans in 1860.

TEW, MARGUERITE R.
Sculptor. Born in Magdalena, NM, January 6, 1886. Pupil of Penna. Museum School of Independent Artists; Penna. Academy of Fine Arts (under Grafly). Member: California Art Club; Fellowship of Penna. Academy of the Fine Arts; National Association of Women Painters and Sculptors. Awards: Cresson European Scholarship, Penna. Academy of the Fine Arts, 1913; first sculpture prize, California Art Club, 1924. Work: Mayan ornament on portal of South West Museum, Los Angeles. Address in 1933, Los Angeles, Calif.

TEWI, THEA.
Sculptor. US citizen. Studied at Art Students League; Greenwich House, with Lou Duble; Clay Club, with D. Denslow; New School for Social Research, with Seymour Lipton. Works: Nat. Collection Fine Arts, Smithsonian Institution, Wash., DC; Cincinnati Art Museum; Chrysler Museum, Norfolk, VA; University Notre Dame. Exhibitions: 18th-20th Ann. New England Exhibition, Silvermine Guild Artists, 1965 and 1967-69; National Arts Club Exhibition Religious Art, 1966; Erie Summer Festival of Arts, Penna. State University, 1968; 6th Biennial of Sculpture, Carrara, Italy, 1969; others. Awards: Medal of Honor and First Prize for Sculpture, National Association of Women Artists, 1969, Sculpture Prize, 1975, 76; First Prize for Sculpture, American Society of Contemporary Artists, 1971, 75, 76, 79; National Arts Club Medal of Merit, 1974, 75. Medium: Stone. Address in 1982, 100-30 67th Drive, Forest Hills, NY.

THAL, SAMUEL.
Sculptor, painter, and etcher. Born in NYC, May 4, 1903. Studied at Art Students League; National Academy of Design; Beaux-Arts Academy; Boston Museum of Fine Art School. Member: Boston Architectural Club. Awards: Prizes, Conn. Academy of Fine Arts, 1943; Library of Congress, 1945. Work: Boston Museum of Fine Arts; Library of Congress; Bibliotheque Nationale, Paris; Boston Public Library; Marblehead Art Association; Tufts Medical College; Conn. Academy of Fine Arts; Carnegie Institute; arch. sculpture, panels for Cincinnati Bell Telephone Building; Harvard Medical School; Rindge Technical School, Cambridge, MA; East Boston Airport; Harvard Univ. Dormitory. Exhibited: Annual one-man exhibition: Doll and Richards, Boston; Rockport Art Association; Institute of Modern Art, Boston; Library of Congress; US National Museum. Address in 1953, Boston, MA.

THALINGER, FREDERIC JEAN.
Sculptor. Born in St. Louis, MO, August, 28, 1915. Studied at Antioch College, A.B.; Washington University; Art Institute of Chicago; and with Grant Wood. Awards: Prizes, Syracuse Museum of Fine Arts, 1937; Beaux-Arts Exhibition, 1939; Traveling Fellowship, Washington University, St. Louis, MO, 1939. Work: Syracuse Museum of Fine Arts; Illinois State Museum; Antioch College, Yellow Springs, OH; sculpture, US Post Office, Jenkins, KY;

Francis Cabrini Housing Project, Chicago, IL. Exhibited: Kansas City Art Institute, 1937; Art Institute of Chicago, 1940, 41; City Art Museum of St. Louis, 1943; Syracuse Museum of Fine Art, 1937; New-Age Gallery, NY, 1946. Address in 1953, 205 Main St., Ossining, NY; h. Croton-on-Hudson, NY.

THAXTER, EDWARD R.
Sculptor. Born in Maine. Died Naples, Italy, 1881.

THEIS, GLADYS HULING.
Sculptor. Born in Bartlesville, OK, August 24, 1903. Studied at Oklahoma Agricultural and Mechanical College; Cincinnati Art School; Corcoran School of Art; and with Miller, Malfrey, and Despiau; also in Paris. Works: Tulsa High School, Tulsa University, Boston Avenue Church, all in Tulsa; Oklahoma Agricultural and Mechanical College; University of New Mexico; Daufelser School of Music. Awards: Society of Washington Artists, 1931; National League of American Pen Women, 1950, 1952; Albuquerque, New Mexico. Exhibited: Society of Washington Artists, 1931, 32; Southwestern Art Exhibition, 1940; New Mexico Art League, 1937; Albuquerque, New Mexico, 1937 (one-woman). Address in 1953, Albuquerque, NM.

THEK, PAUL.
Sculptor. Born in Brooklyn, NY, November 2, 1933. Studied at Cooper Union; Art Students League; Pratt Institute, 1951-54. Works: Stedelijk Museum; Smithsonian; Modern Museum, Stockholm; designed costumes and sets for ballet, commissioned by Glen Tetley, Nederlands Dans Theater. Exhibitions: Galleria 88, Rome; The Pace Gallery, NYC; The Stable Gallery; Thelen Gallery, Essen; Amsterdam (Stedelijk); Stockholm (National); Carnegie; Documenta IV, Kassel; Cologne; Philadelphia Institute of Contemporary Art. Awards: Fulbright Fellowship, 1967; National Endowment for the Arts, 1977. Address in 1982, 58 E. 3rd Street, NYC.

THEO.
Sculptor. Born in Pennsylvania. She has exhibited in Paris, France, and was on the faculty of the Paris American Academy. She works with the lost wax method of bronze casting.

THEOBALD, ELIZABETH STURTEVANT.
(Mrs. Samuel Theobald, Jr.). Sculptor and painter. Born Cleveland, OH, July 6, 1876. Pupil of Chase, Mora, Hawthorne, F.C. Gottwald, Herman Matzen. Member: National Association of Women Painters and Sculptors. Address in 1933, 42 Barrow St., New York, NY. Died in 1939.

THEODORE, PAN.
Sculptor and teacher. Born in Lemnos, Greece, February 5, 1905. Studied at DaVinci Art School; Beaux-Arts Institute of Design; Art Students League. Work: Numerous portrait busts. Exhibited: Penna. Academy of Fine Arts, 1942; National Academy of Design, 1944; Society of Independent Artists, 1943. Address in 1953, 62 West 11th St., NYC.

THEW, (R.) GARRET.
Sculptor and painter. Born Sharon, CT, October 13, 1892.

Pupil of Edward Penfield, John Carlson, Walter Biggs. Member: Artists Guild of the Authors' League of America. Represented in the Newark Museum. Address in 1933, Westport, CT.

THIESSEN, CHARLES LEONARD, JR.
Sculptor, painter, designer, lecturer, teacher, and critic. Born in Omaha, NE, May 3, 1901. Studied at University of Nebraska; School Royal Academy, Stockholm, Sweden; Heatherley School of Art, London; Grande Chaumiere, Paris; Creighton University, honorary DFA, 1972. Work: Nebraska Historical Society, Lincoln, 1952-53; Nebraska Art Association; Art Guild, Lincoln, NE; Alfred East Mem. Gallery, Kettering, England; Univ. of Nebraska; Joslyn Art Museum. Exhibited: Royal Society of British Artists, London, 1949; Young Contemporaries, London, 1949; Midwest Biennial, Joslyn, 1952; Mid-America, Kansas City, 1953. Member of Artists Equity Association. Position: Art consultant, State Historical Society, Lincoln, NE, from 1951; instructor, painting, Joslyn Art Museum, Omaha, NE, from 1951; executive secretary, Nebraska Arts Council, 1966-74. Address in 1970, Nebraska Arts Council; h. Omaha, NE.

THOM, JAMES.
Sculptor. Born in Ayrshire, Scotland, 1799. Exhibited at the British Institute in London, 1815. Working in New Orleans, by 1834; at Newark, NJ, after 1836; settled farm near Ramapo, NJ. Group illustrating Burns's "Tam O'Shanter" in collection of the Franklin Institute in Philadelphia; exhibited at the Pennsylvania Academy, 1850 to 1870. Died in NYC on April 17, 1850.

THOMAS, (JAMES MICHAEL) JIM.
Sculptor. Born in Miami, FL, 1936. Self-taught in art; forestry degree. Specialty is traditional representation of modern cowboy and historical Texas subjects. Member of Texas Cowboy Artists Association. Has own studio. Address in 1982, Leander, TX.

THOMAS, PAUL K. M.
Sculptor, painter, writer, lecturer, and teacher. Born in Philadelphia, PA, January 31, 1875. Pupil of Penna. Academy of Fine Arts; Cecilia Beaux, Wm. M. Chase, and Charles Grafly. Awards: First and second Toppan prize, Penna. Academy of Fine Arts; Bronze medal, St. Louis Exposition, 1904. Member: Fellowship, Penna. Academy of Fine Arts; American Artists Professional League. Work: Portraits, Bryn Mawr College; University of Chicago; Williams College; Western Reserve University; Yale University; Smith College; University of Penna. Address in 1953, New Rochelle, NY.

THOMAS, RICHARD.
Sculptor and craftsman. Born Philadelphia, PA, September 4, 1872. Pupil of Charles Grafly, August Zeller, Ed Maene. Member: Trenton, NJ, Art Association. Address in 1929, Memorial Art Studio, Crosswich St.; h. Elizabeth St., Bordentown, NJ.

THOMAS, ROBERT CHESTER.
Sculptor. Born in Wichita, Kansas, April 19, 1924. Studied at Zadkine School of Sculpture, Paris, 1948-49; Univ. of California, Santa Barbara, 1951, BA; California College of

Arts and Crafts, 1952, MFA; and privately with David Green, Pasadena, 1946-47. Works: Bronze figure, Univ. of California, Santa Barbara, 1967; Santa Barbara Museum of Art; Hirshhorn. Exhibitions: Univ. of California, Santa Barbara; Santa Barbara Museum of Art; Esther Robles Gallery; Salon des Artistes Independants, Paris; Salon du Mai, Paris; City of Los Angeles Annual; Los Angeles County Museum of Art; Richmond (CA) Art Center; San Francisco Museum of Art; California State Fair; Oakland Art Museum; Denver Art Museum; La Jolla. Awards: Los Angeles Art Festival, Bronze Medal, 1949; Walnut Creek (Calif.) Pageant, Third Prize for Sculpture, 1951; San Francisco Art Association Annual, Bank of America Award, 1952; Richmond (CA) Art Center, First Prize, 1952; San Francisco Art Association, American Trust Co., Award, 1953; Richmond (CA) Art Cent., First Prize, Sculpture, 1953; California State Fair, Second Prize and Silver Medal, 1954; Santa Barbara Museum of Art, III Pacific Coast Biennial, 1959; Univ. of California Institute for Work in the Creative Arts, 1967-68; and others. Taught: Univ. of California, Santa Barbara, from 1954. Address in 1982, Goleta, CA.

THOMAS STEFFEN, WOLFGANG GEORGE.
Sculptor. Born Fuerth, Germany, January 7, 1906. Pupil of Zink School of Fine Arts, Nuremburg; Academy Fine Arts, with Herman Hahn, Bernhart Bleeker, and Josef Wakerle, Munich, Germany; and University of Bavaria, Munich. Member: Atlanta Art Assn.; Verein Student Haus, Munich; Deutscher Reichbund Der Kuenstler, Berlin. Works: "Head of Youth," "Baby" (fountain), City of Fuerth, Bavaria, Germany; "Bust of Dr. George H. Denny," University of Alabama; "Bust of Gov. Bibb Graves," State Teachers Collection, Jacksonville, AL; bronze bust, Judge John S. Candler, Emory University, GA; High Musuem, Atlanta, GA; bronze monument of Gov. Eugene Talmadge, State Capitol Grounds, Atlanta; "Mother and Child," Fulton County Court House garden, Atlanta. Exhibited: Smithsonian Institution, 1952; High Museum, 1936, and W. C. Hill Gallery, Atlanta, 1979; Kraskin Galleries, Atlanta and Wash., DC, 1980; others. Media: Bronze; painting, graphics. Address in 1982, 408 Glenn Bldg., Atlanta, GA.

THOMPSON, FREDERIC LOUIS.
Sculptor and painter. Born Chilmark, MA, in 1868. Pupil of George H. McCord. Member: Salmagundi Club; Societe des Beaux Arts. Address in 1926, 126 East 75th St., New York, NY.

THOMPSON, JOANNE.
Sculptor and painter. Born in Chicago, IL. Studied at University of Colo. Works: Americana Galleries, Northfield, IL. Exhibitions: National Arts Club Gallery, NY, 1965-69; Museum Fine Arts, Springfield, Mass., 1965-70; American Artists Professional League Grand National, NY, 1966-70; Hammond Museum, Westchester, NY, 1968; one-woman shows, Americana Galleries, 1968 and 70. Awards: Best of Show/Jury's Choice, Orange County Fair, Calif., 1964; honorable mention for still life, Academy Artists, 1967; first prize for sculpture, Mt.

Prospect, Ill., 1968. Member, Catharine Lorillard Wolfe Professional Women's Club; American Artists Professional League; others. Media: Bronze and oil. Address in 1980, Scottsdale, AZ.

THOMPSON, LAUNT.
Sculptor. Born in Abbeyleix, County Queens, Ireland, 1833. Came to America in 1847. Pupil of Erastus Dow Palmer. Produced several portrait busts and later opened a studio in New York. Elected an Associate Member of National Academy of Design in 1859 and an Academician in 1862. Work: Statues of Pierson, at Yale College; Bryant, at the Metropolitan Art Museum, NY; and Edwin Booth, as Hamlet. Died September 26, 1894, in Middletown, NY.

THOMPSON, MARGARET WHITNEY.
(Mrs. Randall Thompson). Sculptor. Born Chicago, IL, February 12, 1900. Pupil of Penna. Academy of Fine Arts; Charles Grafly; Schukieff in Paris. Member: Philadelphia Alliance; Fellowship, Penna. Academy of Fine Arts. Address in 1929, Wellesley Hills, MA.

THOMPSON, MYRA.
Sculptor and painter. Born in Manry Co., TN, November 23, 1860. Pupil of A. Saint Gaudens, French, Injalbert and Eakins. Address in 1916, Spring Hill, TN.

THOMPSON, NELLIE LOUISE.
Sculptor and painter. Born in Jamaica Plains, Boston, MA. Pupil of Sir James Linton and South Kensington School under Alyn Williams and Miss Ball Hughes in London; Cowles Art School in Boston under De Camp; Henry B. Snell. Studied sculpture under Roger Noble Burnham, Bela Pratt, John Wilson, Cyrus Dallin. Member: Copley Society, 1893; allied mem. MacDowell Club; North Shore Art Association; Gloucester Society of Artists; Boston Society of Sculptors. Address in 1933, Boston, MA.

THOMPSON, WILLIAM JOSEPH.
Sculptor and educator. Born in Denver, CO, April 19, 1926. Studied at Rhode Island School of Design, B.F.A., with Vladimir Raemaesch; Cranbrook Academy of Art, M.F.A., with William McVey; Art Students League, Woodstock, NY, summer with Kuniyoshi. Work, bronze sculptures, Columbus Museum of Fine Arts, OH; portrait figure, J. F. Kennedy, University of Dayton, OH; others. Has exhibited at High Museum, Atlanta; Grand Central Moderns, NY; Smithsonian Institution Traveling Exhibition, 1969-70; others. Received first prize in sculpture, Columbus Museum of Fine Arts, 1956; first prize, Southern Sculpture, 1967. Member of National Academy of Design. Works in bronze and carving. Address in 1982, Athens, GA.

THOMSEN, FREDERICK CARLTON.
Sculptor. Born in 1907. Address in 1934, Greenwich, Conn. (Mallett's)

THOMSEN, SANDOR VON COLDITZ.
Sculptor, lawyer, and philanthropist. Born in Chicago, 1879. He was a pupil of Lorado Taft. Died in Chicago, December 7, 1914.

THORBERG, TRYGVE.
Sculptor. Born in 1884. Specialty, busts of children and adults.

THORNE, THOMAS ELSTON.
Sculptor, painter, engraver, art historian, and illustrator. Born in Lewiston, ME, October 5, 1909. Pupil of Savage, Portland School of Fine and Applied Art; Alex. Bower; Yale School of Fine Arts, B.F.A., 1940; Art Students League, with Reginald Marsh. Work: "Crucifixion," "Last Supper," St. Lawrence Church; mural, "The Circus," children's ward, Maine General Hospital, Portland, ME; College of William and Mary, Williamsburg, VA; Colonial Williamsburg Foundation, VA. Exhibited: Penna. Academy of Fine Arts Watercolor Show, Philadelphia, 1930; New York Watercolor Club, 1940; Irene Leehe Memorial Exhibition, Norfolk, 1962. Taught: Instructor to professor of painting, College of William and Mary, 1940-75, head of fine arts department, 1943-69, professor emer., from 1975. By 1953, no longer listed as a sculptor. Address in 1976, Williamsburg, VA.

THORNHILL, ANNA.
Sculptor and painter. Born in Berlin, Germany, August 2, 1940; British citizen. Studied at St. Martins School Art, London, dipl. design; Royal Col. Art, London, ARCA. Work: World Bank, Washington, DC; Hong Kong Museum Art; Hofstra University. Commissions: Mosaic mural, P & O Shipping Lines, Ocean Terminal, Hong Kong, 1966; two murals, August Films, Hq., NY, 1969; mural, Johnson, Stokes, and Master, Hong Kong, 1969; painted sculpture, Wells TV, Hq., NY, 1972; wall mural, Larry Spegel Productions, Tarzana, Calif., 1973. Exhibitions: Royal Academy Art, London, 1962-64; Young Contemporaries, London; Brighton Museum of Art, England, 1964; one-woman show, Meisel Gallery, NY, 1973; A Multi-Media Evening, Guggenheim, NY, 1977. Media: Wood and plastic. Address in 1982, 205 Prince Street, NYC.

THRASH, DOX.
Sculptor, painter, etcher, lithographer, writer, lecturer, and designer. Born in Griffin, GA, March 22, 1892. Studied at Art Institute of Chicago; Phila. Graphic Sketch Club; and with H. M. Norton, Earl Horter. Member: Phila. Print Club. Work: Library of Congress; Baltimore Museum of Art; Lincoln University; Phila. Museum of Arts; Bryn Mawr College; West Chester (PA) Mus. of Fine Arts; New York Public Library; US Government. Exhibited: New York World's Fair, 1939; Phila. Museum of Art; Phila. Art Alliance, 1942 (one-man). Contributor to: *Magazine of Art; Art Digest*. Lectures: Modern Art Appreciation. Address in 1953, 2409 West Columbia Ave.; h. 2340 West Columbia Avenue, Philadelphia, PA.

THRASHER, HARRY (or HENRY) DICKINSON.
Sculptor. Born in Plainfield, NH, May 24, 1883. Pupil of Augustus Saint-Gaudens. Member: Mural Painters; National Sculpture Society (1917); Alumni Association of the American Academy in Rome. Awarded the scholarship offered by the American Academy in Rome, 1911-14. Address in 1917, Baltic, CT. Died in France, August 11, 1918.

THURSTON, JANE McDUFFIE.
Sculptor, painter, etcher. Born Ripon, WI, January 9, 1887. Pupil of Art Institute of Chicago; in Europe, and of Townsley, Mannheim, Miller. Member: California Watercolor Society; California Art Club; Laguna Beach Art Association; West Coast Arts; Pasadena Society of Artists. Work: Pasadena Art Institute. Exhibited: Los Angeles Museum of Art, 1945, 46; California Watercolor Society, 1946; Pasadena Society of Arts, 1946; Pomona (CA) College, 1946; San Gabriel Valley Exhibition, 1949, 51. Awards: Taft prize, West Coast Arts, 1923; honorable mention, California Art Club, 1925. Address in 1953, Pasadena, CA.

TILDEN, ANNA MEYER.
Sculptor. Born in Waupun, WI, July 9, 1897. Pupil of Albin Polasek. Member: Chicago Painters and Sculptors; Austin, Oak Park, and River Forest Art League. Work: World War memorial, River Forest, IL. Address in 1933, Hinsdale, IL.

TILDEN, DOUGLAS.
Sculptor. Born in Chico, CA, May 1, 1860. Pupil of National Academy of Design under Ward and Flagg; Gotham Students League under Mowbray; Choppin in Paris. Awarded honorable mention, Paris Salon, 1890; bronze medal, Paris Exp., 1900; gold medal, Alaska Yukon-Pacific Exp., Seattle, 1909; commemorative gold medal, St. Louis Exp., 1904. Work: "The Tired Boxer," Art Institute of Chicago; "Baseball Player," Golden Gate Park, San Francisco; memorial monuments at Portland (OR), Los Angeles, San Francisco, etc. Address in 1926, Oakland, CA. Died in Berkeley, CA, in 1935.

TILT, MAUDE M.
Sculptor. Address in 1898, 543 Evanston Ave., Chicago, IL.

TIMMERMAN, GERRIT.
Sculptor. Born in Salt Lake City, UT, 1942. Studied at University of Utah, science, dentistry, language. Employed to do interior design renderings; dental ceramics. Work includes bronze Lincoln portrait; has contract with Western Art Classics. Exhibits at L. K. Moss and Associates; Main Trail Galleries, Jackson Hole, WY, and Scottsdale, AZ. Specialty is Western subjects in traditional style. Address in 1982, Salt Lake City, UT.

TIMONTE, ALPHONSE.
Sculptor. Located: Buffalo, New York, 1858.

TITCOMB, VIRGINIA CHANDLER.
(Mrs. John Abbot Titcomb). Sculptor. Born in Otterville, IL. Specialty, bas-reliefs. Address in 1906, 101 Lafayette Ave., Brooklyn, NY.

TITUS, FRANCIS (FRANZ M).
Sculptor and carver. Born c. 1829, in Bavaria. Worked: New York City, c. 1854-60. Died c. 1862.

TOBERENTZ, ROBERT.
Sculptor. Address in 1898, 432 West 16th St., New York City.

TOBIAS, JULIUS.
Sculptor. Born in New York City, August 27, 1915. Stud-

ied: Atelier Fernand Leger, Paris, France, 1948-52. Exhibitions: Provincetown Art Association Exhibition, Mass., 1946; Galerie Creuze, Paris, 1958; Allan Stone Gallery, NYC, 1962; Whitney Annual, NYC, 1968; Bard College, Annandale, NY (with Christopher Gianakos); 55 Mercer Street Gallery, NYC; Esther Stuttman Gallery, NYC, 1959; Bleecker Gallery, NYC, 1961; 10 Downtown, NYC, 1968; Max Hutchinson Gallery, NYC, 1970, 71, 72; Pennsylvania Academy of Fine Arts; Museum of Modern Art Traveling Exhibition, Tokyo; Silvermine Guild. Awards: Creative Artists Public Service Program Grant, NYC, 1971; Guggenheim Fellowship, NYC, 1972; Mark Rothko Foundation Grant, NYC, 1973; National Endowment for the Arts Grant, Washington, DC, 1975-76. Address in 1982, 9 Great Jones Street, NYC.

TODD, MICHAEL CULLEN.
Sculptor and painter. Born in Omaha, Nebraska, June 20, 1935. In California, 1957-61, and from 1968. Studied at University of Notre Dame; UCLA. Taught at UCLA; Bennington College; University of California at San Diego. In collections of Whitney, NYC; L.A. Co. Museum of Art; others. Exhibited at Hanover Gallery, London; Pace Gallery, NYC; Zabriskie Gallery, NYC; Gallery Paule Anglim, San Francisco; Nicholas Wilder Gallery, L.A.; Whitney, NYC, annuals; Jewish Museum, NYC; L.A. Co. Museum of Art; Foundation Maeght, St. Paul, France; Storm King Art Center; San Francisco Museum of Modern Art; others. Awarded Woodrow Wilson fellowship; Fulbright, France. Works in steel and aluminum. Address in 1982, Los Angeles, California.

TOFFT, CARLE EUGENE.
Sculptor. Born in Brewer, ME, September 22, 1874. Pupil of Blankenship and Ruckstuhl. Member: National Sculpture Society. Address in 1903, 4 West 18th St., NY.

TOLERTON, DAVID.
Sculptor. Born in Toledo, Ohio. Went to California c. 1915. Studied at Stanford University; California School of Fine Arts, San Francisco; studied ironwork in Europe, 1929-30. Taught at San Francisco Art Institute and University of Minnesota; ornamental ironwork, Berkeley Metal Arts, California, and Allied Arts Guild, Menlo Park, California; with Tolerton Potteries, Los Gatos, California. Exhibited at Paul Kantor Gallery, Beverly Hills, California; de Young Museum, San Francisco; Golden Gate International Exposition, San Francisco; Denver (Colorado) Art Museum; Museum of Modern Art, Sao Paulo; Contemp. Arts Museum, Houston, Texas; other California museums.

TOLPO, CARL.
Sculptor, painter, writer, and lecturer. Born in Ludington, MI, December 22, 1901. Studied at Augustana College, Rock Island, IL; University of Chicago; Art Institute of Chicago, and with Frank O. Salisbury, in London, England; also with Gutzon Borglum. Awards: Prizes, Southtown, Chicago, National Portrait Competition and Exh., 1952; Illinois Abraham Lincoln Memorial Commission, 1955. Member of American Artists Professional League. Work: Augustana College; Augustana Hospital,

Chicago; Swedish-American Historical Museum, Phila., PA; Municipal Court, City of Chicago; Institute of Medicine, Marshall Law School, Chicago; Illinois State Capitol; two Lincoln bronze busts, Lincoln Room, Illinois State Historical Museum, Springfield; others. Exhibited: Five one-man exhibitions, 1938-44; National Sculpture Society, 1967. Address in 1970, Barrington, IL; Stockton, IL.

TOMEI, LUCILLE V.
Sculptor, painter, and teacher. Born in St. Joseph, MO, May 11, 1904. Studied at University of Kansas; Kansas City Art Institute; University of Pittsburgh; and with Charles Sasportas, Jane Heidner. Member: Association Artists of Pittsburgh. Awards: Prizes, Kansas City Art Institute, 1937, 38. Work: Immaculata High School, Ft. Leavenworth Museum, Ft. Leavenworth, KS; Churchill Country Club, Cathedral of Learning, Pittsburgh, PA; Kansas Historical Museum; Max Adkins Studios, Pittsburgh, PA. Address in 1953, Pittsburgh, PA.

TOMLIN, FLOYD S.
Sculptor and woodcarver. Born in Rifle, CO, 1910. Took classes in drawing, woodcarving, sculpture in Santa Barbara, CA, in early 1960's. Began carving as a child. Work has been exhibited at All Army Art Show, 1944, hung at Metropolitan Museum; Phippen Memorial Show; American Indian and Cowboy Artists Society Shows; Death Valley Shows. Member of American Indian Cowboy Artists Society. Specialty is statuettes of Western ranch and Indian scenes and Western animals. Works in bronze and wood. Address since 1971, Prescott, AZ.

TOMMEY, BOB.
Sculptor and painter. Born in Ozan, Arkansas, 1928. Studied, briefly, at University of Maryland (commercial art). Worked illustrating in Dallas, TX; resort designer at Liberty Lake, Washington. Work includes pastel portraits; scenes, in painting and sculpture, of historic Northwest. Specialty is Western and wildlife subjects. Member of Texas Cowboy Artists Association. Partner in Flatlander Gallery, Carthage, MO. Address in 1982, Carthage, MO.

TOMPKINS, LAURENCE.
Sculptor and painter. Born in Atlanta, GA, February 18, 1897. Studied at Beaux-Arts Institute of Design; Art Students League; Slade School, London; Grande Chaumiere, Paris. Member: National Sculpture Society. Work: Monuments, Augusta, Ocella, Atlanta, GA; Luxembourg Museum, Paris, France. Exhibited: Royal Academy, London; Paris Salon, 1924; Penna. Academy of Fine Arts; National Academy of Design. Address in 1953, 114 East 66th St., NYC. Died in 1972.

TONETTI, FRANCOIS MICHEL LOUIS.
Sculptor. Born in Paris, April 7, 1863. Came to US in 1899. Pupil of Ecole des Beaux-Arts, Paris, under Falguiere; and of Noel and MacMonnies. His work at the Chicago Fair in 1893 received an award: also received honorable mention, Paris Salon, 1892; bronze medal, St. Louis Expo., 1904. Represented by "Bust of General Charles C. Cook," Luxembourg, Paris; and his most recent work, the "Battle of the Marne." He worked on the fountain at

the Chicago World's Fair, 1893; and on the Brooklyn Arch., New York Custom House, and New York Public Library. Collaborated with Saint-Gaudens in work on the Congressional Library in Washington. Member of New York Architectural League. Address in 1919, 135 East 40th Street, NYC. Died in NYC, May 2, 1920.

TONETTI, MARY LAWRENCE.
(Mrs. F. Michel Tonetti). Sculptor. Address in 1908, 57 East 25th St., NYC.

TOOMBS, ADELAIDE ALTHIN.
Ceramic sculptor, craftswoman, lecturer, and teacher. Born in Boston, MA, May 8, 1915. Studied: Mass. School of Art; Mass. Institute of Technology, B.S. in Edu., and with Cyrus Dallin, Raymond Porter. Member: Boston Society of Arts and Crafts. Awards: Medal, Mass. School of Art, 1936. Work: Portraits in porcelain, Boston, NYC, Baltimore, Washington, DC, and Wilmington. Exhibited: Penna. Academy of Fine Arts, 1941; National Academy of Design, 1942; Corcoran Gallery of Art, 1942; Copley Society, Boston, 1941; Boston Art Club, 1942; Society of Miniature Sculptors, Painters, and Gravers, Wash., DC; Boston Art Festival; one-man: Doll and Richards, Boston, 1949; Veerhof Gal., Wash., DC, 1952; Artisans Shop, Balt., 1952. Address in 1953, Boston, MA; h. Roxbury, MA.

TORFFIELD, MARVIN.
Sculptor. Born in Brooklyn, NY, July 25, 1943. Studied at Skowhegan School of Painting and Sculpture, 1966; Yale University School of Art and Architecture, M.F.A., 1970. Work, sculpture, Central Park Lawn, NY, 1980. Has exhibited at Jewish Museum, NY; Carpenter Center for Visual Arts, Harvard University; Whitney Museum, NY; Paula Cooper Gallery, NY; others. Received National Endowment for the Arts Grant, 1970-71; Guggenheim Fellowship, Phonic Sculpture, 1975-76. Address in 1982, 50 Greene St., NYC.

TORREY, FRANKLIN.
Sculptor. Born October 25, 1830, probably in Scituate, MA. Studied: Rome. Worked: Italy. Died November 16, 1912, in Florence, Italy.

TORREY, FRED M.
Sculptor. Born in Fairmont, WV, July 29, 1884. Pupil of Art Institute of Chicago; Charles J. Mulligan; Lorado Taft. Member: Chicago Society of Painters and Sculptors; Western Society of Sculptors. Work: Rosenberger medal for the University of Chicago; Susan Colver medal of honor for Brown University; memorial tablet for Theta Delta Chi, Champaign, IL; Hutchinson memorial tablet for Hutchinson Hall, Chicago University; sculpture decorations for Paradise Theatre, Chicago; Esperson portrait bust, Houston, TX; C. C. Linthicum Foundation medal, Northwestern University, Evanston, IL; Beta Sigma Omicron medal, Denver, CO; Lincoln's Tomb, Springfield, IL; busts, Swedish Hall of Fame, Phila., PA; others. Address in 1953, Chicago, IL.

TORREY, MABLE LANDRUM.
Sculptor and teacher. Born Sterling, CO, June 23, 1886. Pupil of Charles J. Mulligan. Member: Chicago Society of

Painters and Sculptors; Chicago Galleries Association; Alumni Art Institute of Chicago; Cordon Club. Work: "Wynken, Blynken and Nod Fountain," City and County of Denver; "Buttercup—Poppy and Forget-me-not," South Bend (IN) Library; "Stanley Matthews," children's Hospital, Cincinnati, OH; University of Chicago; State Normal College, Greeley, CO; many portraits of Children. Exhibited: Art Institute of Chicago; Chicago Galleries Association. Awards: Prize, Chicago Galleries Association. Address in 1953, Chicago, IL.

TOTTEN, VICKEN VON POST.
(Mrs. George Oakley Totten). Sculptor and painter. Born in Sweden, March 12, 1886. Pupil of the Academie of Beaux-Arts, Stockholm. Member: Grand Central Art Galleries; Woman's Society of Painters and Sculptors, Stockholm; Painters and Sculptors Gallery Association; National Association of Women Painters and Sculptors. Represented in Metropolitan Museum; Church of the Immaculate Conception, Washington, DC; eleven panels, US Post Office, Waterbury, CT. Address in 1933, Washington, DC.

TOVISH, HAROLD.
Sculptor and educator. Born in NYC, July 31, 1921. Studied at WPA Art Project, with Andrew Berger; Columbia University, 1940-43, with Oronzio Maldarelli; Zadkine School of Sculpture, Paris, 1949-50; Academie de la Grande Chaumiere, 1950-51. Works: Andover (Phillips); Boston Museum of Fine Art; Art Institute of Chicago; Minneapolis Institute; University of Minnesota; Phila. Museum of Art; Guggenheim; Whitney; Walker; Worcester Art Museum; Hirshhorn. Exhibitions: Walker; The Swetzoff Gallery, Boston; Terry Dintenfass, Inc., NYC; Andover (Phillips); Guggenheim; Metropolitan Museum of Art; Toledo Museum of Art; San Francisco Museum of Art; Minneapolis Institute; Whitney; Denver Art Museum; Carnegie; Art Institute of Chicago; Museum of Modern Art; Venice Biennial; De Cordova; Penna. Academy of Fine Arts; Boston University Art Gallery. Awards: Minneapolis Institute, 1st Prize, Sculpture, 1954; Boston Arts Festival, 1st Prize for Drawing, 1958, 1st Prize for Sculpture, 1959; National Institute of Arts and Letters Grant; Guggenheim Fellowship. Member: Artists Equity. Taught: New York State College of Ceramics, 1947-49; University of Minnesota, 1951-54; Boston Museum School, 1957-66; Boston University, from 1971. Medium: Bronze. Address in 1982, Boston, MA.

TOWNE, CONSTANCE (GIBBONS).
(Mrs. F. T. Towne). Sculptor and portrait painter. Born in Wilmington, DE, September 9, 1868. Address in 1918, "Brick House," Norton, CT.

TOWNLEY, HUGH.
Sculptor and printmaker. Born in West Lafayette, Indiana, February 6, 1923. Studied at Univ. of Wisconsin, 1946-48; privately with Ossip Zadkine, Paris, 1948-49; Central School of Arts and Crafts, London, 1949-50, with Victor Passmore. Works: Andover (Phillips); Boston Museum of Fine Art; Brandeis Univ.; Brown Univ.; Fogg; Kalamazoo Institute; De Cordova; Museum of Modern

Art; Milwaukee; Rhode Island School of Design; San Fran. Museum of Art; Utica; Whitney; Williams College; Wrexham Foundation. Exhibitions: Studio 40, The Hague, 1950 (two-man); Gallerie Apollinaire, London, 1951; Milwaukee, 1957; The Swetzoff Gallery, Boston, 1958, 59; The Pace Gallery, Boston, 1960, 64, NYC, 1964; Yale Univ.; De Cordova; San Fran. Museum of Art; Museum of Modern Art; Art Institute of Chicago; Walker; Whitney; Carnegie; Boston Arts Festival, 1958, 61, 64; Silvermine Guild; Institute of Contemporary Art, Boston; Wadsworth Atheneum; M. Knoedler & Co., NYC; National Institute of Arts and Letters; Worchester Art Museum, MA, 1980; Wingspread Gallery, ME, 1977. Awards: San Francisco Museum of Art Annual, 1952; Art Institute of Chicago, Exhibition Momentum, 1952, 53; MIT, Summer Fellowship, 1956; Institute of Contemporary Art, Boston, View, 1960; Institute of Contemporary Art, Boston, Selections, 1961; Berkshire Art Association Annual, 1961, 63; Brown University, Honorable MFA, 1962; Rhode Island Arts Festival, 1962, 63; Silvermine Guild, 1963; Yaddo Fellowship, 1964; Kalamazoo Art Center, Lithographic Workshop, Fellowship, 1964; National Institute of Arts and Letters, 1967; Tamarind Fellowship, 1969. Member: Artists Equity, Boston, 1961. Taught: Layton School of Art, 1951-56; Beloit College, 1956-57; Boston University, from 1961; University of California, Berkeley, 1961, Santa Barbara, 1968; Harvard Univeristy, 1967. Media: Wood, concrete; lithography. Address in 1982, Bristol, RI.

TOWNSEND, JOHN F.
Sculptor and painter. Born in La Crosse, WI. Studied at Carroll College, Waukesha, WI, B.S., 1951; Minneapolis School of Art, 1953-55; University of Minnesota Graduate School, M.F.A., 1959. Work in Museum of Fine Art, Boston, MA; Rose Museum, Brandeis University, Waltham, MA; others. Exhibited at Institute of Contemporary Art, Boston; Museum of Modern Art, NY; others. Teaching sculpture, drawing, and design at University of Mass., Amherst, from 1960. Works in wood and acrylic. Address in 1982, Amherst, MA.

TOWNSEND, STORM D.
Sculptor. Born in London, England, August 31, 1937. Studied at London University, N.D.D., A.T.C., Goldsmiths' College of Art, with Harold Parker and Ivor Roberts Jones. Work at Fine Arts Museum New Mexico, Santa Fe. Has exhibited at Shidoni Summer Outdoor Exhibition; Survey of Contemporary New Mexico Sculpture, New Mexico Museum of Fine Art, Santa Fe; others. Works in cast bronze and clay. Address in 1982, Corrales, NM.

TRAIN, DANIEL N.
Ship carver. Pupil of William Rush. Worked in New York City from 1799 to about 1811. Did carving for the war ships *Adams* and *Trumbull*, 1799.

TRAKAS, GEORGE.
Sculptor. Born in Quebec, Canada, May 11, 1944. Studied at Brooklyn Museum Art School; Hunter College, New York University, B.S. Work in Solomon R. Guggenheim Museum. Has exhibited at Museum of Modern Art, NY;

Guggenheim Museum, NY; Detroit Institute of Art; Documenta 6, Kassel, West Germany; Walker Art Center; Whitney Museum of American Art, NY; others. Address in 1982, P.O. Box 395, NYC.

TRAKIS, LOUIS.
Sculptor and educator. Born in NYC, June 22, 1927. Studied at Cooper Union, B.F.A.; Columbia University; Art Students League; Politechneion, Athens, Greece; Fulbright grants, Academy of Fine Arts, Rome, Italy, 1959-60 and 60-61. Has exhibited at Penna. Academy of Fine Arts, Philadelphia; Metropolitan Museum of Art, Tokyo; Corcoran Gallery, Washington, DC; Brooklyn Museum, NY; others. Received Louis Comfort Tiffany Foundation Award for Sculpture, 1961 and 63. Address in 1982, Brooklyn, NY.

TRAQUAIR, JAMES.
Stonecutter and portrait sculptor. Born in 1756. Worked in Philadelphia from about 1802. Died there April 5, 1811.

TRASHER, HARRY DICKINSON.
Sculptor. Born in Plainfield, New Jersey, 1883. Address in 1915, Baltic, Conn. (Mallett's)

TRAUGH, S. A.
Sculptor. Active 1865. Patentee—bust of Lincoln, 1865.

TREGOR, NISON.
Sculptor. Born in Vilma, Russia. Address in 1934, United States. (Mallett's)

TRENTANOVE, GAETANO.
Sculptor. Born 1858 in Florence, Italy. Educated at the Fine Arts Academies of Florence and Rome. Knighted by King Humbert of Italy. Became an American citizen in 1892. Works: Statue of James Marquette, Statuary Hall, United States Capitol; statue of Daniel Webster, Washington, DC; statue of Albert Pike, Washington, DC; Kosciuszko equestrian statue, Milwaukee, WI; "The Last of the Spartans," Layton Art Gallery, Milwaukee, WI; Soldiers' Monument, Oshkosh, WI; Chief Oshkosh Statue, Oshkosh, WI; monument to Confederate soldiers, Springfield, MO; Soldiers' Monument, Appleton, WI; and in private collections. Address in 1900, Washington, DC.

TRICCA, MARCO A.
Sculptor and painter. Born in Italy, March 12, 1880. Awards: Shilling award, 1944, 48. Work: Art Institute of Chicago; Whitney Museum of American Art. Exhibited: Corcoran Gallery of Art, 1935; Art Institute of Chicago, 1935-38; Penna. Academy of Fine Arts, 1933-37; Mortimer Brandt Gallery, 1944; Brooklyn Museum; one-man exh.: Whitney Studio Club; Whitney Museum of American Art; Contemporary Artists, 1940. Address in 1953, 337 East 10th St., NYC.

TRICKER, FLORENCE.
Sculptor, painter, and teacher. Born Philadelphia, PA. Pupil of Elliot Daingerfield, Henry B. Snell, Daniel Garber, Charles Grafly, Samuel Murray, Albert Laessle. Member: Philadelphia Alliance; Plastic Club; Fellowship Penna. Academy of Fine Arts; Alumni Philadelphia

School of Design for Women. Awards: Gold medal, Graphic Sketch Club; silver medal, first prize, and honorable mention, Plastic Club; first prize, Tampa Art Institute; Douglas prize, Tampa Art Institute, 1927. Work: "Across the River," and "Apple Blossoms," Graphic Sketch Club. Instructor, Stage Design, Mary Lyon School, Swarthmore, PA. Address in 1933, Tricker School of Art, 405 Dartmouth Avenue, h. 250 Havorford Avenue, Swarthmore, PA.

TRIEBEL, FREDERIC ERNEST.
Sculptor and painter. Born in Peoria, IL, December 29, 1865. Pupil of Augusto Rivalta. Studied at Royal Academy in Florence, Italy. Member: Academician of Merit, Roman Royal Academy, San Luca, Rome, Italy. Awards: Galileo silver medal, Museo Nazionale di Antropologia, Florence, 1889, 1891. Works: Soldiers' Monument, Peoria, IL; Iowa State Monument, Shiloh, TN; Mississippi State Monument, Vicksburg; Robert G. Ingersoll Statue, Peoria, IL; statues of Senator George L. Shoup and late Senator Henry M. Rice, Statuary Hall, Washington, DC; Otto Pastor Monument, Petrograd, Russia; bronze, "Mysterious Music," Imperial Museum, Japan. Exhibited at National Sculpture Society, 1923. Superintendent of Sculpture and Secretary for International Jury on Awards, Columbian Expo., Chicago, 1893. Address in 1933, Long Island, NY.

TRINCHARD, J. B.
Sculptor. Worked in New Orleans, 1841-42, 1846.

TROUARD.
Sculptor. Born in Louisiana. Worked: New Orleans, 1848; Paris, 1850.

TROUBETZKOY, PAUL.
Sculptor. Born Lake Intra, Lake Maggiore, Italy, February 16, 1866. Studied in Italy, Russia, and France. Award: Grand prize, Paris Exp., 1900. Bronzes in the Luxembourg in Paris; National Gallery in Rome; National Gallery in Venice; Museum of Alexander III in Petrograd; Treliakofsky Gallery in Moscow; National Gallery in Berlin; Royal Gallery in Dresden; Leipsig Gallery; Chicago Art Institute; Detroit Institute; Toledo Museum; Buffalo Fine Arts Academy; Golden Gate Park Museum; Museum in Buenos Aires; Brera Museum, Milan. Address in 1933, Paris, France; Lago Maggiore, Italy. Died February 12, 1938.

TROVA, ERNEST TINO.
Sculptor and painter. Born in St. Louis, MO, February 19, 1927. Self-taught in art. Works: Museum of Modern Art; City Art Museum, St. Louis; Whitney; Hirshhorn; Guggenheim. Exhibitions: Oakland Art Museum, Pop Art USA; Art Institute of Chicago; Guggenheim; Walker; San Francisco Museum of Art; Whitney; Va. Museum of Fine Arts; University of Illinois; Dallas Museum of Fine Arts; Museum of Modern Art; Documenta IV, Kassel; Hirshhorn; many galleries. Represented by Pace Gallery, NYC. Address in 1982, St. Louis, MO.

TROWBRIDGE, HELEN FOX.
Sculptor. Born in New York, September 19, 1882. Address in 1918, 18 Lincoln St., Glen Ridge, NJ.

TRUDEAU, JUSTINIAN.
Sculptor. Born c. 1827, Louisiana. Worked: New Orleans, 1849-54.

TRUE, JOSEPH.
Sculptor. Active from 1816-1886. (Mallett's)

TRUITT, ANNE (DEAN).
Sculptor. Born in Baltimore, MD, March 16, 1921. Studied at Bryn Mawr College, BA, 1943; Institute Contemporary Art, Washington, DC, 1948-49; Dallas Museum Fine Arts, 1950. Works: University Ariz. Museum Art, Tucson; National Collection Fine Arts, Washington, DC; Museum of Modern Art; Whitney Museum of American Art; Walker Art Center. Exhibitions: Andre Emmerich Gallery, NYC, 1963, 65, 69, 75, and 80 Baltimore Museum Art, 1969 and 74; Pyramid Gallery, 1971-73, 75-77, 79; Whitney Mus. of American Art, 1974; Corcoran Gallery of Art, 1974; others. Awards: Guggenheim Fellowship, 1971; National Endowment for the Arts, 1972 and 1977. Media: Wood and acrylic. Address in 1982, Washington, DC.

TRYON, HORATIO L.
Sculptor and marble worker. Born c. 1826, in New York State. Worked: New York City, from 1852.

TSAI, WEN-YING.
Sculptor and painter. Born in Amoy, China, October 13, 1928; US citizen. Studied at University of Michigan, M.E., 1953; Art Students League, 1953-57; New School for Social Research, 1956-58. Work at Tate Gallery, London; Centre Nationale d'Art Contemporain, Paris; Albright-Knox Art Gallery, Buffalo; Whitney Museum of American Art, NY; others. Has exhibited at Corcoran Gallery of Art, Washington, DC; Museum of Modern Art, NY; Institute of Contemporary Arts, London; Carnegie Institute Museum of Art; others. Received Whitney Fellowship, 1963; Center for Advanced Visual Studies Fellowship, Mass. Institute of Technology, 1969-71; others. Works in water, fiber optics, fiberglas, and stainless steel. Address in 1982, 565 Broadway, NYC.

TSCHAEGLE, ROBERT.
Sculptor, curator, teacher, writer, and lecturer. Born in Indianapolis, IN, January 17, 1904. Studied at Art Institute of Chicago; University of Chicago, Ph.D., A.M.; University of London; and with Lorado Taft. Member: College Art Association of America. Exhibited: Art Institute of Chicago; Hoosier Salon; John Herron Art Institute; National Academy of Design. Contributor to Herron Art Institute Bulletins. Positions: Instructor, History of Art, University Missouri, 1935-36; Assistant Curator, John Herron Art Museum, Indianapolis, IN, 1937-41. Address in 1953, Indianapolis, IN.

TSUTAKAWA, GEORGE.
Sculptor and painter. Born in Seattle, WA, February 22, 1910. Studied with Alexander Archipenko, 1936; University of Washington School of Art, B.F.A., 1950. Work in Seattle Art Museum, WA; Denver Art Museum, CO; Santa Barbara Museum of Art; rain fountain (stainless steel), Design Center Northwest, Seattle; fountain sculpture, Tsutsujigaoka Park, Sendai, Japan; others. Has exhi-

bited at Third Biennial, Sao Paulo, Brazil; San Francisco Museum of Art; Santa Barbara Museum of Art; Denver Art Museum; Amerika Haus, Berlin, East Germany; others. Teaching art at University of Washington, from 1946. Address in 1982, Seattle, WA.

TUCKER, CORNELIA.
Sculptor. Born Loudonville, New York, July 21, 1897. Pupil of Grafly; Penna. Academy of Fine Arts. Member: Fellowship Penna. Academy of Fine Arts. Address in 1933, Sugar Loaf, NY.

TUCKER, WILLIAM G.
Sculptor. Born in Cairo, Egypt, February 28, 1935. Studied at Oxford University, B.A. (modern history), 1958; Central School of Art and St. Martin's School of Art, London, 1959-61. Work at Tate Gallery, London; Museum of Modern Art, NY; Metropolitan Museum, NY; S. R. Guggenheim Museum, NY; Kroller-Muller Museum, Holland; others. Has exhibited at Walker Art Center, Minneapolis; Solomon R. Guggenheim Museum, NY; Documenta 6, Kassel, Germany; Royal Academy, London; others. Received Guggenheim fellowship, 1980-81. Address in 1982, Brooklyn, NY.

TUDOR, ROSAMOND.
Sculptor, painter, etcher, and teacher. Born Buzzards Bay, MA, June 20, 1878. Pupil of Boston Museum School under Benson and Tarbell; W. H. W. Bicknell. Member: North Shore Art Association. Work: "Portrait of Father Zahm," Library Univ. of Notre Dame, Notre Dame, IN. Address in 1933, c/o Portrait Painters Gallery, 570 Fifth Ave., New York, NY; Redding, CT.

TUKE, (ELEANOR) GLADYS.
Sculptor and potter. Born in Linwood, WV, November 19, 1899. Studied at International Correspondence Schools, 1920-22; Corcoran School of Art, 1931-32; Penna. Academy of Fine Art, 1932-33; and sculpt. with Albert Laessle, 1933-37; Maxwell Miller; pottery with Charles Tennant, Wm. Scott, 1940-41. Exhibitions: Penna. Academy of Fine Arts; Phila. Art Alliance; Woodmere Gallery, Wash.; Charleston, WV; Cin.; NYC; Phila.; and others. Member: So. Appalachian Botanical Club; So. Highland Handicraft Guild. Taught: Art, Germantown, PA, YWCA, 1937-40; Steven's School, 1940-42; Ashford General Hospital, 1943-46; private studio, White Sulphur Springs, VA, 1946-52. Address in 1962, White Sulphur Springs, WV.

TUNIS, EDWIN B(URDETT).
Sculptor, painter, writer, and illustrator. Born in Cold Spring Harbor, NY, Dec. 8, 1897. Studied: Maryland Inst; pupil of Joseph Lauber, C. Y. Turner, Hugh Breckenridge. Work: Murals, McCormick & Co., Baltimore; Title Guarantee & Trust Co., City Hospital. Awards: Gold medal, Boys' Club of America, 1956; Edison Foundation Award, 1957. Illustrated "Eat, Drink and Be Merry in Maryland," 1932; author and illustrator of "Oars, Sails and Steam," 1952. "Colonial Living," 1957; "Frontier Living," 1961 (runner-up for Newbery Medal); "Shaw's Fortune," 1966; others. Contributor to *House Beautiful, Better Homes and Gardens*, with garden landscape and architec-

tural illustrations. No longer listed as a sculptor by 1953. Address in 1970, Reistertown, MD. Died in 1973.

TUNISON, RON.
Sculptor. Born in Brooklyn, NY, 1946. Studied at School of Visual Arts, NYC, 1965-69 (commercial art, painting, sculpting, photography); National Academy of Design (sculpting, anatomy). Did photographic sequences for CBS Television Bicentennial specials. Specialty is American military figures. Works in clay; fired figures painted with oils. Founding member, Society of American Historical Artists. Represented by The Soldier Shop, NYC; The Grizzly Tree Gallery, Gunnison, CO. Address in 1982, near Cairo, NY.

TURANO, DON.
Sculptor and medalist. Born in New York, NY, March 9, 1930. Studied at School of Industrial Art, with Albino Cavalido; Corcoran School of Art, with Heinz Warneke; Skowhegan School of Painting and Sculpture, with H. Tovish; Rinehart School of Sculpture, with R. Puccinelli. Work: carved oak panels, First Presbyterian Church, Royal Oak, Michigan; limestone figures, Cathedral of St. Peter and St. Paul, Washington, DC; four arks (locust wood), Temple Micah, Washington, DC; others. Exhibited: Penna. Academy of Fine Arts, Phila.; St. Louis Museum, MO; Audubon Annual, National Academy of Design Galleries; others. Member of the National Sculpture Society. Award: Mrs. Lindsey Bennett Prize, 1964; Honorable Mention, National Sculpture Society; others. Taught sculpture at George Washington University and Corcoran School of Art, 1961-65. Works in bronze and wood. Address in 1982, Washington, DC.

TURINO (or TURINI), GIOVANNI.
Sculptor. Born in Italy, May 23, 1841. Works: Statue of Garibaldi, Washington Square, NYC. Died in US, August 27, 1899.

TURNBULL, GRACE HILL.
Sculptor, painter, lecturer, and writer. Born in Baltimore, MD, December 31, 1880. Studied at Art Students League with Joseph De Camp; Penna. Academy of Fine Arts with Chase and Cecilia Beaux; Maryland Institute of Art; also painting with Willard Metcalf. Works: Metropolitan Museum of Art; Corcoran Gallery of Art; Baltimore Museum of Art; monument, Eastern High School, Baltimore. Awards: Whitelaw Reid first prize, Paris, France, 1914; Huntington prizes, National Association of Women Artists, Baltimore Museum of Art, 1939, 44, 45, 47; National Association of Women Artists, 1946; Metropolitan Museum of Art, 1942; Gimbel award, Philadelphia, 1932; Phi Beta Kappa, Southwestern University, 1956. Exhibited at National Sculpture Society (many times); National Association of Women Artists (many times); Corcoran; Penna. Academy of Fine Arts (many times); Art Institute of Chicago; Metropolitan Museum, 1942; National Academy Design; Architectural League; World's Fair, NY, 1939; and others. Author, "Tongues of Fire" (Macmillan Co.), 1929; "Chips from my Chisel," 1951. Media: Marble, wood; oil, pastel. Address in 1976, Baltimore, MD. Died in 1976.

TURNBULL, RUTH.
Sculptor. Born New City, January 25, 1912. Pupil of Ella Buchanan. Address in 1929, Hollywood, CA.

TURNER, JAMES THOMAS, SR.
Sculptor and painter. Born in Denver, CO, March 15, 1933. Studied: Famous Artist Course; Western Brass and Foundry; also sculpture with Edgar Britton. Work at White House; bronze busts of founders, Pro-Rodeo Hall of Fame, Colorado Springs; others. Has exhibited at Pacific Northwest Indian Center, Spokane, WA; C. M. Russell Art Auction and Sale, Great Falls, MT; others. Member of Denver Art Museum; American Federation of Arts; Artists Equity. Address in 1982, Littleton, CO.

TURNER, JEAN (LEAVITT).
(Mrs. Leroy C.) Sculptor, painter, illustrator, teacher, and lecturer. Born in NYC, March 5, 1895. Studied at Pratt Institute Art School; Cooper Union Art School; and with Ethel Traphagen. Member: American Artists Professional League; League of Am. Pen Women. Exhibited: Palace of the Legion of Honor, 1938-39; American Artists Professional League, 1940-46; League of Am. Pen Women, 1940, 41. Illustrated Progress Books (grades 1-2-3), 1926. Lectures: Art in War. Address in 1953, Victorville, CA.

TURNER, RAYMOND.
Sculptor. Born in Milwaukee, WI, May 25, 1903. Studied at Milwaukee Art Institute; Wisconsin Normal School; Layton School of Art; Cooper Union Art School; Beaux-Arts Institute of Design. Work: Smithsonian Institution, Wash., DC; Baseball Hall of Fame, Cooperstown, NY; numerous commemorative coins. Exhibited: National Academy of Design, 1932, 33, 35, 67; Penna. Academy of Fine Arts, 1936, 40; New York World's Fair, 1939; Salon d'Automne, Paris, 1928; National Sculpture Society, 1949, 50, 72; Medallic Art Co., 1950; Argent Gallery, 1951; Sports of the Olympics, National Art Museum of Sports, NYC, 1972; NYC WPA Art Exhibit, Parsons School of Design, 1977. Awards: August Helbig Prize for Man, Detroit Art Institute, 1927; Guggenheim Foundation Fellowship, 1928; Pauline Law Prize for Girl, Allied Artists of America, 1966. Address in 1983, 51 Seventh Ave., South, NYC.

TURNER, WILLIAM GREENE.
Sculptor. Born in Newport, Rhode Island, in 1833. Went abroad for study and spent much of his life in Italy. Exhibited in Philadelphia in 1876. Died in Newport, RI, December 22, 1917.

TUROFF, MURIEL PARGH.
Sculptor and painter. Born in Odessa, Russia, March 1, 1904; US citizen. Studied at Art Students League; Pratt Institution; Univ. Colo. Work: Smithsonian Institute Portrait Gallery, Washington, DC; Jewish Museum, NY. Comn: Enamel on copper artifacts, comn by St. James Lutheran Church, Coral Gables, Fla., 1974. Exhibitions: Syracuse Museum Art, NY, 1945; Museum Natural History, NY, 1958; Cooper Union Museum, NY, 1960; Lowe Museum Beaux Arts, Miami, Fla., 1968; YM-YWHA, Miami, Fla., 1971. Awards: Blue Ribbon for best in show, Blue Dome Art Fellowship, 1966 and 1973; Second Prize, YM-YWHA, 1971. Member: Artists Equity Association; Florida Sculptors; others. Media: Metal and enamel. Address in 1982, 517 Gerona Avenue, Coral Gables, FL.

TUTTLE, RICHARD.
Sculptor and painter. Born in Rahway, NJ, July 12, 1941. Studied at Trinity College, CT, 1963, BA, where he met artist Agnes Martin; Cooper Union; and worked as an assistant at the Betty Parsons Gallery. In collections of Corcoran; Kaiser-Wilhelm Museum, Germany; National Gallery, Canada. Exhibited: Betty Parsons Gallery, 1965; Galeria Schmela, Dusseldorf, 1968, NY, 1970; Museum Fine Art, Dallas, 1971; Amer. Fed. Arts, 1969; Nicholas Wilder Gallery, Los Angeles, 1969; Albright-Knox Art Gallery, Buffalo, NY, 1970; New Jersey State Mus., 1969; and Museum of Modern Art, NY, 1972; Anti-Illusion: Procedures/Materials, Whitney Museum of American Art, 1969, Retrospective, 1975; Corcoran Gallery of Art 31st Biennial, 1969; Documenta, Kassel, West Germany; others. Address in 1982, c/o Betty Parsons Gallery, 24 West 57th Street, NYC.

TYLER, JEAN.
Sculptor. Address in 1935, Cleveland, Ohio. (Mallett's)

TYLOR, STELLA ELMENDORF (MRS.).
Sculptor. Member: Wisconsin Painters and Sculptors. Address in 1928, 242½ Maple Ave., Oak Park, IL; 310 North Murray Ave., Madison, WI.

TYSON, CARROLL SARGENT JR.
Sculptor and painter. Born Philadelphia, November 23, 1878. Pupil of Penna. Academy of Fine Arts under Chase, Anshutz and Beaux; Carl Marr and Walter Thor in Munich. Member: Art Club Philadelphia; Fellowship Penna. Academy of Fine Arts; Society of Independent Artists. Awards: Sesnan gold medal, Penna. Academy of Fine Arts, 1915; bronze medal, P.-P. Exp., San Francisco, 1915. Work in: Art Club of Philadelphia; State College of Penna.; Penna. Museum of Art, Phila. Address in 1933, Philadelphia, PA. Died March 19, 1956.

U

UBALDI, MARIO CARMELO.
Sculptor and designer. Born in Monarch, Wyoming, July 16, 1912. Studied: Industrial Museum of Art, Rome, Italy; Art Institute of Chicago. Member: Renaissance Society, University of Chicago. Awards: Medal, 1943, prize, 1944, Art Institute of Chicago. Work: Pasteur School, Chicago; Chicago Commons Settlement House. Exhibited: Art Institute of Chicago; World's Fair, New York, 1939; Corcoran Gallery of Art; University of Chicago; Marc Gallery, New Orleans, LA; Palmer House, Chicago, 1952 (one-man). Address in 1953, Chicago, Illinois.

UDINOTTI, AGNESE.
Sculptor and painter. Born in Athens, Greece, January 9, 1940. US citizen. Studied: Arizona State University, B.A., M.A., Temple, AZ. Work: Phoenix Art Museum, AZ; Stanford Museum of Art; Vorres Museum, Athens, Greece, and others. Commissions: Steel doors, Wilson Jones and Associates, Scotsdale, AZ, 1970; Imagineering, Tucson, AZ, 1972; outdoor sculptures, Glendale Community College, 1974. Exhibitions: Vorpal Galleries, San Francisco, 1968, 71, 75, 76, 79, 81; Laguna Beach, 1979; Art Forms Gallery, Athens, Greece, 1969, 71, 75, 77. Taught: Workshop leader, welded sculpture, Orme School of Fine Arts Program, Mayer, AZ, 1971, 72; University of Southern Calif., summer, 1972. Awards: Phoenix Art Museum, 1971; Hellenic American Union Sculpture Award, 1968; Solomos Prize for Sculpture, Panos Nikoli Tselepi, Athens, Greece, 1971. Media: Oil; steel. Address in 1982, c/o 4215 North Marshall Way, Scottsdale, Arizona.

UDVARDY, JOHN WARREN.
Sculptor and administrator. Born in Elyria, OH. Studied at Skowhegan School of Painting and Sculpture, summer, 1957; Cleveland Institute of Art, 1955-58, B.F.A., 1963; Yale University, scholarship, 1964-65, M.F.A., 1965. Work at Cleveland Institute of Art; Betty Parsons Gallery, NY; Fogg Museum, Cambridge, MA; others. Received Mary C. Page Europe Traveling Scholarship, Cleveland Institute of Art, 1960-61. Member of National Audubon Society. Works in wood. Address in 1982, Providence, RI.

UHL, EMMY.
Sculptor. Born in Bremen, Germany, May 10, 1919; US citizen. Works: Hudson River Museum, Yonkers, NY. Exhibitions: Yonkers Art Association Annual, NY, 1967-70; Westchester Art Society Ann., NY, 1969-71; N. Shore Community Arts Center, NY, 1970; Knickerbocker Artists Annual, NY, 1970-72; Audubon Artists, NY, 1971. Awards: Armbruster Award, Yonkers Art Association, 1967; Knickerbocker Artists Award of Merit, 1972. Address in 1976, Mt. Vernon, NY.

ULBER, ALTHEA.
Sculptor, painter, designer, craftsman, and teacher. Born Los Angeles, CA, July 28, 1898. Studied: Chouinard Art Institute; pupil of Arthur D. Rozaire, F. Tolles Chamberlin, Hans Hofmann, Joseph Binder, Stanton McDonald Wright. Member: National Society of Mural Painters; California Art Club; Art Teachers Association of Southern California. Award: Prize, Los Angeles Museum of Art. Work: Los Angeles Museum of Art; high school, Los Angeles, CA. Exhibited at Los Angeles Museum of Art. Taught: Children's Dept., Chouinard Art Institute, Los Angeles, CA, 1921-41, and from 1952. Address in 1953, Chouinard Art Institute, Los Angeles, CA; h. La Crescenta, CA.

ULLBERG, KENT.
Sculptor. Born Goteberg, Sweden, July 15, 1945. Studied at Swedish State School of Art, Stockholm; Swedish Museum of Natural History, anatomy; Museum of Natural Science, Orleans, France. Worked as a merchant marine, taxidermist, and safari hunter in Botswana, Africa; curator, Botswana National Museum and Art Gallery, and Denver Museum of Natural History. Exhibited: National Academy of Design, NYC; Los Angeles County Museum, CA; Denver Museum of Natural History, CO; Salon d'Automne, Paris, France; National Sculpture Society, NYC; National Art Gallery, Botswana, Africa; National Cowboy Hall of Fame, Oklahoma City, OK; Society of Animal Artists, NYC; Museum of Natural History, Gothenburg, Sweden; numerous others. Awards: Barnett Prize for Sculpture, National Academy of Design; Percival Dietsch Award, 1979, Joel Meisner Award, 1981, both National Sculpture Society; Medals for Sculpture, 1979, 80, 82, Society of Animal Artists, NYC; Gold Medals for Sculpture, National Academy of Western Art; others. Member: National Academy of Design (Associate), NYC; National Sculpture Society, NYC; Society of Animal Artists, NYC; National Academy of Western Art, Oklahoma City, OK; others. Major works include "Puma," (bronze), Museum of Natural History, Gothenburg, Sweden, 1980; "Lincoln Centre Eagle," Dallas, 1981; "Watermusic," (polished stainless steel and black granite), Corpus Christi National Bank, TX, 1981; "Genesee Eagle," (bronze and stone), Genesee Country Museum, Rochester, NY, 1983; Los Angeles County Museum; National Academy of Design; National Cowboy Hall of Fame. Specialty is wildlife; works in bronze and steel. Reviewed in *Southwest Art*. Represented by Sportsman's Edge Gallery, NYC; Trailside Gallery, Scottsdale, AZ; Grand Central Gallery, NYC. Address in 1983, Corpus Christi, Texas.

ULLMAN, ALLEN.
Sculptor. Born in Paris, 1905. Works held: Brooklyn Museum. Exhibited: Paris.

ULREICH, EDUARD BUK.

Sculptor, painter, illustrator, and designer. Born Austria-Hungary. Studied: Kansas City Art Institute; Penna. Academy of Fine Arts; pupil of Mlle. Blumberg. Member: Artists Guild of the Authors' League of America; Architectural Lg. of NY; Fellowship Penna. Acad. of Fine Arts; Chicago Art Club; NY Architectural League. Exhibited: Anderson Gallery, NY (one-man); Dudensing Gallery, 1930; Philadelphia Art Alliance, 1939; and in Paris, France; Vienna, Austria. Works: Decorations, Denishawn Studios, California, and Edgewater Beach Hotel, Chicago; painted wall hangings, Chicago Temple Building; US Post Office, Columbia, MO; marble mosaic, Industrial Arts Building, Century of Progress Exposition, Chicago. Awards: Prizes, Art Directors Club, 1927, med., 1932; Chicago Exposition, 1933. Address in 1953, 145 East 40th Street; h. 143 East 40th Street, New York.

ULREICH, NURA WOODSON.

(Mrs. Eduard Buk Ulreich). Sculptor, painter, illustrator, and lithographer. Born in Kansas City, MO. Address in 1933, 145 East 40th St., New York, NY. Died October 25, 1950.

UMLAUF, CHARLES.

Sculptor. Born in South Haven, MI, July 17, 1911. Studied at the Art Institute of Chicago (with Albin Polasek) and the Chicago School of Sculpture (with Viola Norman). Work: Krannert Art Museum, University of Illinois, Urbana; Oklahoma Art Center; Museum of Fine Arts, Houston; nine other Texas museums; "Horse" (stone), 1953, Metropolitan Museum of Art; others. Commissions include marble reredos relief, St. Michael and All Angels Church, Dallas, TX, 1961; Torch Bearers, bronze, University of Texas, Austin, 1963; Family Group, Houston Museum of Natural Science, TX, 1972. Exhibited: Valley House, Dallas, TX; Denver Art Museum; Passedoit Gallery, NYC; Metropolitan Museum of Art; Everson Museum, Syracuse; Penna. Academy of Fine Arts; thirty solo exhibitions, including NY and Italy; others. Awards: Guggenheim grant, 1949-50; Ford Foundation grant, 1979. Member Sculptors Guild. Taught sculpture at University of TX, Austin, from 1952. Works in bronze and marble. Address in 1982, Austin, Texas.

UNDERHILL, KATHARINE.

Sculptor. Born in New York City, March 3, 1892. Pupil of Elizabeth Norton. Address in 1918, 307 West 93d St., NYC; summer, South Ashfield, Massachusetts.

UNDERWOOD, ELISABETH KENDALL.

Decorative sculptor and portrait painter. Born Gerrish Island, ME, September 22, 1896. Pupil of Lee Lawrie; Yale School Fine Arts, 1913-19; Art Students League, 1933. Exhibitions: One-woman show, Playhouse Gallery, Ridgefield, CT; George Washington University Library; New York Watercolor Society; National Academy of Design; Newport Art Association; New Haven Paint and Clay Club. Work: Stations of the Cross, permanently installed in chapel of Convent of Cenacle, Newport, RI. Memberships include the Women's Committee of National Symphony Orchestra from 1949; Cosmopolitan, (NYC); Arts Club (Wash.). Address in 1962, 2459 P St., Washington; summer, Shadow Green, South Salem, NY. Died in 1976.

UNDERWOOD, GEORGE CLAUDE LEON.

Sculptor, painter, illustrator, etcher, writer, and lecturer. Born in London, December 25, 1890. Award: Honorable mention, Carnegie Institute, 1923. Work: "Machine Gunners," Manchester Art Gallery, Manchester, England; watercolor drawings, The Whitworth Art Gallery, Manchester; etchings, British Museum and the Victoria and Albert Museum, London. Illustrated: "The Music from Behind the Moon," by James Branch Cabell (John Day Co.); wood engravings and verses for "Animalia" (Payson & Clarke). Address in 1929, c/o Brentano's, 225 Fifth Ave., New York, NY; h. London, England; summer, c/o Brentano's, London, England.

UOTILA, HEIDI (MS.).

Sculptor. Studied: Ohio State University, B.F.A. Member: Society of Animal Artists. Media: Bronze and terracotta. Columbus Zoo gave visiting Chinese delegation one of her stoneware gorillas. Specialty: Big game animals. Address in 1983, Bremen, Ohio.

URBAN, REVA.

Sculptor and painter. Born in Brooklyn, NY, October 15, 1925. Studied at Art Students League, Carnegie scholarship, 1943-45. Works: Museum of Modern Art, NY; Art Institute Chicago; University Museum, Berkeley; Finch College Museum, NY; Averthorp Gallery, Jenkintown, PA. Exhibitions: Pittsburgh Int., from 1958; 1st Biennale Chrislicher Kunst der Gegenwart, Salzburg, Austria, 1958; Continuity and Change, Wadsworth Atheneum, Hartford, Conn., 1962; Documenta III, Kassel, Germany, 1964; Seven Decades-Crosscurrents in Modern Art, 1895-1965, exhibitions at ten New York galleries, 1965. Award: Tamarind Fellowship. Media: Aluminum and oil. Address in 1982, P.O. Box 659, Radio City Station, NYC.

URBANI, F.

Sculptor and carver. Worked: Charleston, South Carolina, 1850. His specialties were busts and statues; repairing marble statues; bronzing and imitation iron work.

URIBE, GUSTAVO ARCILA.

Sculptor and painter. Born in Bogota, Colombia, March 2, 1895. Pupil of Silvanus Cuellas, Dioicis Cortes, and J. A. Cano. Address in 1924, 2970 Ellis Ave., Chicago, IL.

URICH, LOUIS J.

Sculptor and teacher. Born Paterson, NJ, July 4, 1879. Pupil of Art Students League of New York; Cooper Union; Beaux-Arts Architectural. Award: Barnett prize, National Academy of Design, 1914. Address in 1934, Elmhurst, Long Island, NY.

URNER, JOSEPH (WALKER).

Sculptor, painter, and etcher. Born in Frederick, MD, January 16, 1898. Studied: Baltimore Polytechnic Institute; Maryland Institute; and with Ettore Cadorin, Dwight Williams. Member: Southern States Art League.

Awards: Prize, Cumberland Valley Artists, 1939. Work: Alabama monument, Gettysburg, PA; Taney monument, Frederick, MD; Cedar Lawn Memorial; presentation portrait, General A. A. Vandergrift, USMC. Exhibited: Cumberland Valley Artists, annually. Address in 1953, 215 East Second Street; 110 West Patrick Street; h. Frederick, Maryland.

USHER, LEILA.
Sculptor and painter. Born Onalaska, La Crosse Co., WI, August 26, 1859. Pupil of G. T. Brewster in Cambridge, MA; Art Students League of New York under Augustus Saint-Gaudens; H. H. Kitson in Boston; also studied in Paris. Member: American Artist's Professional League; American Federation of Arts. Awards: Bronze medal, Atlanta Exposition, 1895; honorable mention for medals, P.-P. Exposition, San Francisco, 1915. Work: Bronze portraits in Harvard University; Bryn Mawr University; Rochester University; Bowdoin College; Tuskegee and Hampton Universities; medal in the Royal Danish Mint and Medal Collection, Copenhagen; bas-relief in Fogg Art Museum, Cambridge, MA; bas-relief portrait, National Museum, Washington, DC; Smithsonian Institution; "Portrait of John Wesley Powell," Powell Monument, Grand Canyon, AZ; portrait in bas-relief, Agassiz Museum, Cambridge, MA. Address in 1953, 105 West 55th Street, NYC. Died in 1955.

UTESCHER, GERD.
Sculptor and designer. Born in Germany; US citizen. Studied drawing, graphics, and sculpture with Professor Wadim Falileef; Academy of Fine Arts, Berlin, M.A. Work in Fleisher Art Memorial, Philadelphia; bronze, Philadelphia General Hospital; others. Has exhibited at Philadelphia Art Alliance; Philadelphia Museum of Art; Penna. Academy of Fine Arts; Detroit Art Institute; others. Member of Artists Equity; Philadelphia Art Alliance. Taught sculpture at Penna. Academy of Fine Arts, 1960-64; Philadelphia Museum of Art, 1962-69; sculptures and three-dimensional design, Philadelphia College of Art, 1962-68. Works in plaster, wax, bronze, and terra cotta. Address in 1982, Alassio, Italy.

UTHCO, T. R. (JOHN EMIL HILLDING)
Sculptor. Born in Seattle, WA, July 29, 1944. Studied at Kansas City Art Institute, B.F.A.; Maryland Institute College of Art, M.F.A. Work in Palace of Fine Arts, San Francisco; Whitney Museum of Architecture, NY; others. Has exhibited at Northwest Annual, Seattle Art Museum; Vancouver Art Museum, B.C.; Palace of Fine Arts, San Francisco; others. Address in 1982, Wilkeson, WA.

UTZ, THORNTON.
Sculptor and painter. Born in Memphis, TN, 1915. Lived in Chicago and Connecticut. Studied briefly at American Academy of Art, Chicago. Free-lance illustrator; did more than fifty covers for *The Saturday Evening Post*. Specialty is portraits of children, nudes, animals in motion. Reviewed in *Southwest Art*, July 1981. Prints published by Mill Pond Press, Venice, FL. Represented by Conacher Galleries, Venice, FL; and Brubaker Gallery, Sarasota, FL. Address since 1949, Sarasota, FL.

V

VACCARINO, ROBIN.
Sculptor and painter. Born in Seattle, WA, August 14, 1928. Studied at Los Angeles City College; Los Angeles Valley College; University of California, Los Angeles; Otis Art Institute, M.F.A., 1966. Work in Los Angeles Co. Museum; Santa Barbara Museum; Library of Congress, Washington, DC; De Cordova Museum; others. Has exhibited at Long Beach Museum of Art; Otis Museum, Los Angeles; Library of Congress National Print Exhibition, Washington, DC; others. Received National Endowment for the Arts individual fellowship, 1980-81; others. Teaching painting at Otis Art Institute currently. Works in aluminum; oil and acrylic. Address in 1982, Studio City, CA.

VAGIS, POLYGNOTOS GEORGE.
Sculptor. Born Island of Thasos, Greece, January 14, 1894. Studied: Cooper Union Art School; Beaux-Arts Institute of Design; pupil of Gutzon Borglum, Leo Lentelli, John Gregory. Work: "Greek Soldier," "The Defender," and "The Dreamer." Represented in Brooklyn Museum; Whitney; Art Students League; Toledo Museum of Art; Tel-Aviv Museum, Israel. Exhibited at National Academy of Design; Penna. Academy of Fine Arts; National Sculpture Society; Corcoran Gallery, 1934, 37; Museum of Modern Art Gallery, Wash., DC, 1938; World's Fair, NY, 1939; Carnegie Institute, 1940, 41; Boston Museum of Fine Arts, 1944; Wadsworth Atheneum, 1945; Brooklyn Museum, 1932, 38; Sculptors Guild, 1938-42; Phila. Museum of Art, 1940; Metropolitan Museum of Art, 1942, 52; Museum of Fine Arts of Houston, 1947; Museum of Modern Art, 1951; Whitney, 1950, 52; one-man: Painters and Sculptors Gallery, 1932; Kraushaar Gallery, 1934; Valentine Gallery, 1938; Hugo Gallery, 1946. Member of Artists Equity Association and the Federation of Modern Painters and Sculptors. Awards: Shilling prize, 1945; Levittown Art Festival, 1951. Address in 1953, Bethpage, Long Island, NY. Died in 1965.

VALAPERTA, GIUSEPPE.
Sculptor. Born in Milan, Italy. Worked in Genoa; in Madrid for Joseph Bonaparte, King of Spain; and in France at the palace of Malmaison before 1815. Came to Washington, DC, in 1815; employed as sculptor there until 1817. Executed eagle on the frieze of the south wall of Statuary Hall. Carved in ivory and modeled red wax portraits of Jefferson, Gallatin, Madison, Monroe, and Jackson. Presumably died in March 1817.

VALENTIEN (or VALENTINE), ANNA MARIE.
(Mrs. A. R. Valentien). Sculptor, painter, and illustrator. Born Cincinnati, OH, February 27, 1862. Pupil of Cincinnati Art Academy under Rebisso; Rodin, Injalbert, and Bourdelle in Paris. Member: San Diego Art Guild; La Jolla Art Association. Awards: Gold medal, Atlanta Exp., 1895; collaborative gold medal, Pan-Calif. Exp., San Diego, 1915; two gold medals, Pan-Calif. Exp., San Diego, 1916; highest award and cash prize, Sacramento State Fair, 1919; bronze medal, San Diego Fine Arts Society, 1931. Address in 1953, San Diego, CA.

VALENTINE, DEWAIN.
Sculptor. Born in Ft. Collins, CO, August 27, 1936. Studied at University of Colo., B.F.A., 1958, M.F.A., 1960; Yale-Norfolk Art School, Yale University fellowship, 1958. Went to Venice, Calif., in 1964. In collections of Whitney, NYC; L.A. Co. Museum of Art; Milwaukee Art Center; others. Exhibited: The Gallery, Denver; Douglas Gallery, L.A.; Gallery Bischofberger, Zurich; Pasadena (Calif.) Art Museum; Galerie Denise Rene, NYC; Santa Barbara (Calif.) Museum; Los Angeles County Museum of Art; Whitney, NYC; Museum of Contemporary Crafts, NYC; La Jolla (Calif.) Museum of Contemporary Art; Laguna Beach Museum of Art, CA; others. Received Guggenheim Fellowship in 1981; National Endowment for the Arts Grant, 1981. Taught: University of Colorado, 1958-61, 64-65; UCLA, 1965-67. Address in 1982, Venice, California.

VALENTINE, EDWARD VIRGINIUS.
Sculptor. Born in Richmond, VA, November 12, 1838. Pupil of Couture and Jouffroy in Paris; Bonanti in Italy; August Kiss in Berlin; also painting under William James Hubard. Member: Richmond Art Club (ex-pres.); President, Valentine Museum, Richmond, VA. Work: Made numerous busts and statues of Confederate heroes; "Gen. Robert E. Lee," Memorial Chapel, Lexington, VA, and US Capitol, Washington; "Thomas Jefferson," Richmond; "Gen. Hugh Mercer," Fredericksburg, VA; "I. I. Audubon," New Orleans, LA; "Jefferson Davis," Richmond, VA. Address in 1929, 809 East Leigh St.; h. 109 North Sixth Street, Richmond, VA. Died October 19, 1930.

VAN BRIGGLE, ANNE GREGORY.
See Ritter, Anne Gregory.

VAN BUREN, RICHARD.
Sculptor. Born in Syracuse, NY, 1937. Studied: San Francisco State College; The University of Mexico; Mexico City College. Group Exhibitions: Bay Area Artists, San Francisco Museum of Art, CA, 1964; Whitney Museum, NYC; Walker Art Center, Minneapolis; Jewish Museum, NYC, 1966; Aldrich Museum Contemporary Art, Ridgefield, Conn., 1968; Musee d'Art Moderne, Paris, 1970; Albright-Knox Gallery, Buffalo, NY, 1971; Museum of Modern Art, NYC, 1973; Fogg Art Museum, 1973; numerous other group and individual shows. Teaching at

School of Visual Arts, NYC, in 1976. Address in 1982, c/o Paula Cooper Gallery, 155 Wooster Street, NYC.

Van CLEVE, HELEN.
(Mrs. Eric Van Cleve). Sculptor, painter, and writer. Born in Milwaukee, WI, June 5, 1891. Studied: University of California; Boston Museum of Fine Arts School; Grande Chaumiere, Paris, and with Bela Pratt, E. Withrow, Eliot O'Hara, Oscar Van Young, Frederic Taubes. Member: Western Artists; Pacific Palisades Art Association; Westwood Village Art Association. Work: Calif. Palace of Legion of Honor; San Diego Public Library. Exhibited: Santa Barbara Museum of Art, 1940, 44, 45; Calif. Palace of Legion of Honor, 1940-45; Laguna Beach Art Association, 1944; San Diego Fine Arts Society, 1932; Montclair Art Museum, 1934; Kennebunk Village, 1934; Gump's, San Francisco; Rockefeller Center, 1934; Oakland Art Gallery, 1948; Westwood Village Art Association, 1949-52; deYoung Memorial Museum, 1949-51; Springville, Utah, 1951, 52; Pacific Palisades Art Association, annually. Address in 1953, Pacific Palisades, Calif.

Van De BOVENKAMP, HANS.
Sculptor. Born in Barneveld, Holland, June 1, 1938. Studied at Architecture School of Amsterdam, 1957; University of Michigan, Ann Arbor, B.Sc.Des., 1961. Has exhibited at Storm King Art Center, Mountainville, NY; American Institute of Arts and Letters, NY; Arnot Art Museum, Elmira, NY; National Academy of Design, NY; others. Member of NY Sculptors Guild. Received Emily Lowe Award, 1964. Works in aluminum and stainless steel. Address in 1982, Tillson, NY.

VAN DEN BERGHEN, ALBERT LOUIS.
Sculptor. Born in the city of Vilvorde, Belgium, (American descent), September 8, 1850. Came to America in 1876. Studied in Brussels, NYC, and Chicago. Address in 1903, 390 Fulton St., Chicago, IL; h. River Forest, IL.

Van HARLINGEN, JEAN.
Sculptor and painter. Born in Dayton, OH, in 1947. Studied at Ohio State University; Tyler School of Art. She has exhibited extensively in Ohio, Pennsylvania, and recently in New York. Noted for her large, vinyl, inflatable sculpture.

Van HOOK, NELL.
Sculptor, painter, and teacher. Born Virginia, October 29, 1897. Pupil of National Academy of Design, Art Students League of New York, Calder, Rittenberg. Member: Atlanta Art Association; Southern States Art League; GA State Art Association; Three Arts Club. Award: Sculpture prize, Atlanta Art Association, 1928. Work: "Rev. John Patterson Knox," Erskin College, Due West, SC; "The Resurrection" and "Madonna," Peachtree Christian Church; "In Memoriam," Westminster Presbyterian Church; "Dr. Virgil Gibney," Gibney Foundation, all in Atlanta, GA; "Richard March Hoe," Dean Russel, Columbia University, New York, NY. Address in 1933, 52 Inman Circle, Atlanta, GA.

Van LEYDEN, ERNST OSCAR MAURITZ.
Sculptor and painter. Born in Rotterdam, Holland, May 16, 1892. Awards: Medal, Exposition in Brussels, Paris,

Amsterdam, The Hague; prizes, Venice, Italy, 1932; Los Angeles Museum of Art. Work: Tate Gallery, London; and in museums throughout Europe. Exhibited: Virginia Museum of Fine Arts, 1946; Pepsi-Cola, 1946; Los Angeles Museum of Art; Santa Barbara Museum of Art; San Diego Fine Arts Society; Syracuse Museum of Fine Arts; San Francisco Museum of Art; and extensively in Europe. Creator of special glass-tile technique for murals. Address in 1953, Los Angeles, Calif.

Van LOEN, ALFRED.
Sculptor and educator. Born in Oberhausen-Osterfeld, Germany, September 11, 1924; US citizen. Studied at Royal Academy of Art, Amsterdam, Holland, 1941-46. Work in Metropolitan Museum of Art; Museum of Modern Art; Brooklyn Museum; National Museum, Jerusalem, Israel; others. Has exhibited at Whitney Museum of American Art Annual, NY; Hecksher Museum, Huntington, NY; others. Received award at Silvermine Guild Artists; first prize sculpture, American Society of Contemporary Artists. Works in ivory, wood, bronze, hammered brass, aluminum, and stone; acrylic. Address in 1982, Huntington Station, NY.

Van ROIJEN, HILDEGARDE GRAHAM.
Sculptor and painter. Born in Washington, DC, November 1, 1915. Studied at Rollins College; American University; Corcoran Gallery School Art, Washington, DC. Works: Drawings of Egypt, Brooklyn Museum, NY. Comn: Watercolor, Jr. League Hq., Washington, DC. Exhibitions: Am. House, Vienna, Austria; Virginia Museum, Richmond; Corcoran Gallery of Art, Washington, DC; Galerie im Ram Hof, Frankfurt, Germany, 1974; Kunstler Haus-Galerie, Vienna, Austria, 1974. Awards: First for "Pride's Sin," University of Virginia, Charlottesville, 1971. Media: Metal, graphics. Address in 1976, Washington, DC.

Van TONGEREN, HERK.
Sculptor. Born in Holland, MI, August 19, 1943. Studied in Europe, 1962-64; University of Colorado, B.A., 1969, M.F.A., 1970. Work in Weatherspoon Art Gallery, Greensboro, NC; Denver Art Museum; Oakland Museum, CA; others. Has exhibited at Weatherspoon Art Gallery, Greensboro, NC, 1973; Cordier and Ekstrom Gallery, NY, 1981; others. Address in 1982, c/o Ettl Farm, Princeton, NJ.

Van VRANKEN, ROSE.
See Rose Van Vranken Hickey.

Van WART, AMES.
Sculptor. Born in New York. Pupil of Hiram Powers. Member of Century Association, New York. Address in 1926, c/o Century Association, 7 West 43d Street, New York, NY; Neuilly-sur-Seine, France.

Van WERT, GORDON.
Sculptor. Born on reservation at Redlake, MN, March 21, 1952. Studied at Institute of American Indian Arts, Santa Fe, with Allen Houser; Rhode Island School of Design; apprenticed to Doug Hyde. Specialty is Southwestern animals and Chippewa Indian designs. Works in stone (alabaster) and welded steel. In collections of Whitney

Museum of American Art, NYC; Buffalo Bill Museum, Cody, Wyoming; Institute of American Indian Arts Museum. Has exhibited at Heard Museum, Phoenix, AZ; Sanders Galleries, Tucson, AZ; Linda McAdoo Galleries, Santa Fe, NM. Received Honorable Mention, Scottsdale National, AZ; Honorable Mention and First Prize, stone, Heard Museum. Address since 1981, Santa Fe, NM.

Van WINKLE, LESTER G.
Sculptor and educator. Born in Greenville, TX, January 11, 1944. Studied at Eastern Texas State University, B.S.; University of Kentucky, M.A.; also sculpture with Michael D. Hall. Has exhibited at Sculpt 70, Corcoran Gallery of Art, Washington DC; Whitney Museum, NY; Cranbrook Academy of Art Galleries; others. Teaching sculpture at Virginia Commonwealth University, from 1969. Address in 1982, Dept. of Art, Virginia Commonwealth University, Richmond, VA.

Van WOLF, HENRY.
Sculptor and painter. Born in Regensburg, Bavaria, April 14, 1898. Studied: Munich Art School, 1912-16; sculpture and bronze technique with Ferdinand von Miller, 1919-22; 23-26. Work: California Art Club Medal; Prof. Artists Guild Medal; bronze statue of Ben Hogan, Golf Writers' Association of America; bronze memorial bust, Einstein Memorial Foundation; bronze Madonna, St. Timothy Church, West Los Angeles; sculpted group, Garden Grove (CA) Community Church; many others. Exhibited: Brooklyn Museum, NY; Springfield Museum of Art; Allied Artists of America; Architectural League; Artists of the Southwest; Int. Exhibition of Contemporary Sculptured Medals, Athens, Greece, 1966, Paris, 1967; others. Awards: Los Angeles City Art Exhibition, 1949, 66, 70; National Award, National Sculpture Society, 1962; seven awards, Valley Artists Guild, 1948-72; Artists of the Southwest, 1950, 51, 53, 54; many more. Member: National Sculpture Society; fellow, American Institute of Fine Arts; Valley Artist's Guild (founder and past president). Address in 1982, Van Nuys, CA.

VanBEEK, WILLIAM.
Sculptor. Exhibited: New York, 1934. (Mallett's)

VANDENBERGE, PETER WILLEM.
Sculptor and muralist. Born in Voorburg, Zuid-Holland, Netherlands, October 16, 1935; US citizen. Studied at Art Academy, The Hague, Netherlands; California State University, Sacramento, B.A.; University of California, Davis, M.A. Work in Museum of Contemporary Crafts, NY; Crocker Art Museum, Sacramento; others. Has exhibited at International Ceramic Exhibition, Victoria and Albert Museum, London; Four Ceramic Sculptors from California, Alan Frumkin Gallery, NY; Whitney Museum of American Art, NY; Everson Museum of Art, Syracuse, NY. Taught ceramics and sculpture at San Francisco State University, 1966-73; teaching ceramics and sculpture at California State University, Sacramento, from 1973. Works in stoneware, porcelain, clay, terra cotta. Address in 1982, Sacramento, CA.

VANDER SLUIS, GEORGE J.
Sculptor, painter, and educator. Born in Cleveland, OH,

December 18, 1915. Studied at Cleveland Institute of Art, 1934-39; Colorado Springs Fine Arts Center, 1939-40, with Boardman Robinson; Fulbright Scholarship, Italy, 1951-52. Works: Cleveland Museum of Art; Colorado Springs Fine Arts Center; Kansas City (Nelson); Syracuse (Everson); Munson-Williams-Proctor Institute, Utica. Exhibitions: Columbia University; Galleria d'Arte Contemporanea, Florence, Italy; Syracuse (Everson); Cleveland Institute of Art; Utica; Cleveland Museum of Art; Smithsonian; Art Institute of Chicago; San Francisco Art Association Annuals; Metropolitan Museum of Art; Corcoran; Penna. Academy of Fine Arts; Museum of Contemporary Crafts, NY; Whitney. Awards: Fulbright Fellowship (Italy), 1951-52; Jurors' Award, Rochester Memorial Art Gallery, 1958, 69. Taught: Colorado Fine Arts Center, 1940-42, 45-47; Syracuse University. Address in 1982, Syracuse Univ., Syracuse, NY.

VANDERCOOK, MARGARET METZGER.
Sculptor. Born New York City, April 7, 1899. Pupil of Georg Lober in NY; Aristide Rousaud in Paris. Member: National Association of Women Painters and Sculptors. Address in 1929, 32 Union Sq.; h. 13 Gramercy Park, New York, NY. Died in 1936.

VANDEVELDE, PETRO.
Sculptor. Worked: New York City. Exhibited: American Institute, 1850, "Slave in Revolt."

VANNUCHI, F. OR S.
Wax modeller. Born in Italy c. 1800. Exhibited wax figures in Charleston, SC, in 1845; also "cosmorama" or collection of paintings of American views and historical scenes in NYC and Philadelphia, 1847. Settled in New Orleans by 1852; opened the American Museum and Waxworks.

VARGA, FERENC.
Sculptor. Born in Szekesfehervar, Hungary; US citizen. Studied at the Academy of Fine Arts, Budapest, Hungary, with Professor Eugene Broy and Professor Francis Sidlo. Work: National Art Gallery, Budapest; Museum of Fine Arts, Budapest; Vatican Museum, Rome, Italy; monument, City of Windsor, Ontario, Canada; group of statues, Ft. Lincoln Memorial, Washington, DC; others. Exhibitions: National Art Gallery, Budapest; National Sculpture Society, New York. Taught sculpture at Academy of Fine Arts, Budapest, 1928-40. Member of the National Sculpture Society. Awards: Mrs. Louis Bennett Prize, 1958, National Sculpture Society; others. Address in 1982, Delray Beach, Florida.

VECCHIO, LOUIS.
Sculptor, painter, and teacher. Born in New York, August 24, 1879. Pupil of Walter Shirlaw and National Academy of Design. Address in 1910, 105 East 14th St.; h. 2114 Prospect Ave., NYC.

VEDDER, ELIHU.
Sculptor, mural painter, illustrator, and writer. Born in NYC, February 26, 1836. Studied art under T. H. Mattison at Sherburne, NY; then Paris, in the atelier of Picot; also studied in Italy. Spent time in Florence and Rome and returned in 1861 to New York, where he remained

five years. Returned to Paris for one year; finally settled in Rome. Works: Five panels in the Library of Congress in Wash. and one in Bowdoin College; "The Pleiades" and "African Sentinel," Metropolitan Museum of Art, NY; "The Keeper of the Threshold," Carnegie Institute Pittsburgh; "The Lair of the Sea Serpent," "Lazarus," "The Sphinx," Boston Museum of Fine Arts; "Storm in Umbira," Art Institute of Chicago; Brooklyn Institute Museum; Rhode Island School of Design. His "Greek Actor's Daughter" was shown at the Centennial Exhibition in Phila. in 1876. Best known for illustrations of *The Rubaiyat of Omar Khayyam*. Was made a National Academician in 1865. Member of Society of American Artists; American Society of Mural Painters; National Institute of Arts and Letters; The Century Society, NY. Received honorable mention, Paris Exposition, 1889; gold medal, Pan-Am. Exposition, Buffalo, 1901. Exhibited at National Sculpture Society, 1923. Publication: *The Digressions of V.*, his autobiography. Died in Rome, Italy, January 29, 1923.

VEDDER, SIMON HARMON.
Sculptor, painter, and illustrator. Born in Amsterdam, NY, October 9, 1866. Pupil of Metropolitan Museum School in New York; Julian Academy in Paris under Bouguereau and Robert-Fleury; Ecole des Beaux-Arts under Gerome; and of Glaize. Awarded honorable mention, Paris Salon, 1899; second class medal, Crystal Palace, London. Address in 1918, Haverstock Hill, London; 253 West 42nd Street, NYC.

VEILER, JOSEPH.
Sculptor. Worked: New Orleans, 1840's. Presumably same as J. H. Veilex.

VELSEY, SETH M.
Sculptor, painter, teacher, and designer. Born Logansport, IN, September 26, 1903. Studied: University of Illinois; Art Institute of Chicago; pupil of Lorado Taft, Albin Polasek. Awards: Mrs. Keith Spalding prize, Hoosier Salon, Chicago, 1928; Indiana Artists, 1931; Hickox prize, 1934; medal, Paris Salon, 1937. Work: Dayton Art Institute; Wright Field, Dayton, OH; US Post Office, Pomeroy, OH; St. Peter and Paul's Church, Reading, OH; others. Address in 1953, Yellow Springs, OH.

VERANI, PATRICIA L.
Sculptor. Member of the National Sculpture Society. Award: Mrs. Louis Bennett Prize, 1979, National Sculpture Society. Address in 1982, Londonderry, NH.

VERGER, PETER C.
Sculptor, engraver, and hair worker. Born in Paris. Active in New York City from 1795 to 1797 and at Paris in 1806. Worked with John Francis Renault on his "Triumph of Liberty" print.

VERHAEGEN, LOUIS M.
Sculptor. Worked: New York City, 1851-60. Exhibited: American Institute, 1856, plaster figure of Tom Thumb, marble bust of Daniel Webster.

VERHAGEN & PEEIFFER.
Sculptors. Worked in New York City in 1851. Louis Verhaegen and an unidentified Peeiffer or Pfeiffer were their parties.

VIANELLO, FRANCO.
Sculptor. Born in Venice, Italy, 1937; came to US in 1959. Worked in foundry and as sculptor's apprentice; received M.A., Institute of Arts, Venice. Works include 18-foot monument, bronze, World's Fair, Seattle, 1962; heroic replica, Remmington's "Coming through the Rye," Cowboy Hall of Fame, 1981. Specialty is statuettes and statues of Western figures. Works in bronze. Represented by Hunter Gallery, San Francisco, CA; Meinhard Gallery, Houston, TX. Address in 1982, Napa, CA.

VIETH, CARL VALDEMAR.
Sculptor. Born in Copenhagen, Denmark, 1870. Worked: Bridgeport, Conn. Died in Meriden, Conn., 1922.

VIETT, E. T.
Sculptor. Address in 1903, Charleston, SC.

VIGNA, GLORIANO.
Sculptor, painter, illustrator, architect, craftsman, writer, and teacher. Born Paterson, August 20, 1900. Pupil of Bridgman, Du Mond, Fratelli Vigna in Turin, Italy. Decorator to the King and Queen of Italy. Address in 1933, 156 East 49th Street, New York, NY; h. 30 Ward St., Paterson, NJ.

VINCENTI, FRANCIS.
Sculptor. Born in Italy. Employed at the Capitol in Washington, 1853-58. Modeled busts of visiting Indians; anatomical models for other Capitol sculptors. Worked for Edward V. Valentine in Richmond, VA; returned to Europe and Paris.

VINELLA, RAIMONDO J.
Sculptor and painter. Born in Bari, Italy, 1933; came to US (NYC) in 1935. Studied at Art Center School, Los Angeles, B.F.A., 1958. Worked as illustrator. Moved to Taos, New Mexico, became Dean of Taos School of Fine Art. Has exhibited at Shriver Gallery, Taos, NM; Peking, China, show in 1981. Member of Taos Six. Specialty is landscape and people of New Mexico. Address since 1968, Taos, New Mexico.

VINEY, JILL.
Sculptor. Studied at Sarah Lawrence College, BA; Columbia University, MFA. Has exhibited at 14 Sculptors Gallery, NYC, and Birdhouse Annex Gallery, Central Park, NYC, both solos; group shows at 14 Sculptors Gallery, Hudson River Museum (Yonkers), Museum of Modern Art (lending service), Feminist Art Institute, NYC, Aldrich Museum, Ridgefield, CT; others. Address in 1984, 32 Union Square, NYC.

VITTOR, FRANK.
Sculptor. Born in Italy, January 6, 1888. Pupil of Bistolfi. Member: Academy of Brera, Milan, Italy; Washington Art Club. Work: Bronze bust of President Wilson in White House; heroic group, "The Human Vision," dedicated to Woodrow Wilson. Address in 1918, 140 West 57th Street, NYC.

VITTORI, ENRICO.
Sculptor. Address in 1919, c/o Dr. V. A. Lapenta, 347 Newton Claypool Bldg., Indianapolis, IN.

VODICKA, RUTH CHAI.
Sculptor. Born in New York City. Exhibitions: New York Cultural Center, "Women Choose Women," Hudson River Museum, 1973; Women's International Arts Festival, 1974-75. Collections: Norfolk Museum; Montclair State College; Grayson County Bank, TX.

VODICKA, RUTH KESSLER.
Sculptor. Born in NYC in 1921. Studied at City College of NY; Sculpture Center with O'Connor Barrett; Sculpture Center, NY; Art Students League. Exhibited at the Whitney Museum, NYC, 1952-57; Galerie Claude Bernard, Paris, 1960; Hudson River Museum, Yonkers, NY, 1973; plus many solo shows. Member: American Society of Contemporary Artists; Audubon Artists; National Association of Women Artists; Sculptors Guild (executive board, 1975); Women in Arts. Awards: National Association of Women Artists, 1954, 57, 66; National Academy of Design, 1955; Audubon Artists, 1957, 60; Silvermine Guild of Artists, 1957, 58; Painters and Sculptors Society, NJ, 1962. Taught: Instructor, sculpture, Queens Youth Center, Bayside, 1953-56; Emanuel Midtown YM and WHA, NY, 1966-69; Great Neck Arrandal School, 1969-70. Media: Brass, bronze, and wood. Address in 1982, 97 Wooster Street, New York City.

VOISIN, ADRIEN.
Sculptor. Born in Islip, NY, 1890. Lived in Newport, RI. Worked with a taxidermist; apprenticed to a French woodcarver; studied painting with Sargent Kendall, Yale School of Fine Arts; at Academie Colarossi, 1912, and Ecole National des Beaux-Arts, Paris. Saw Buffalo Bill Cody Show in Paris; inspired him to sculpt. Returned to US in 1916. After 1918 received commissions for sculpture on public buildings, including Hearst Castle; also memorial busts of public figures. Moved to Browning, Montana, 1929; sculpted Indian subjects. Went to Paris in 1930, where his works were cast in bronze. Exhibited: Exposition Coloniale, Paris. Awarded: Diplome d'Honneur; gold medal, International Art Exhibition, Paris, 1932. Returned to US, lived and worked in San Fran. In collection of Museum of Native American Culture, Spokane, Wash.; also in Harmsen Collection of American Western Art. Living in Southern Calif. in 1977.

VOLCK, FREDERICK.
Sculptor. Born 1833, in Bavaria. Worked: Baltimore. Work held: Peabody Institute. Died in 1891.

VOLK, LEONARD WELLS.
Sculptor. Born in Wellstown (now Wells), NY, November 7, 1828. In 1855 he was sent abroad for study. On returning in 1857 he settled in Chicago. Executed many busts and statues of prominent men. Among his works are the life-size statue of Stephen Douglass in marble, and a portrait bust of Abraham Lincoln. Died August 19, 1895, in Wisconsin.

VOLKMAR, CHARLES.
Sculptor, painter, etcher, and teacher. Born in Baltimore, MD, August 21, 1841. Pupil of Barye (sculptor) and Harpignies (painter). Member of National Society of Craftsmen; New York Architectural League, 1890; Salma. Club, 1880; National Arts Club. At first landscape and animal painter, but later maker of pottery. Address in 1910, Metuchen, NJ. Died in Metuchen, NJ, February 6, 1914.

VOLLMER, RUTH.
Sculptor. Born in Munich, Germany, 1903. US citizen. Work: Museum of Modern Art; National Collection of Fine Arts, Washington, DC; New York University; Riverside Museum; Guggenheim. Exhibitions: Betty Parsons Gallery, NYC; Brussels World's Fair, 1958; Penna. Academy of Fine Arts; American Abstract Artists Annuals, 1963-68; C. Ekstrom Gallery, NY, 1964; Whitney Annual, 1964-70; Sculptors Guild, 1964-68; Musee Cantonal des Beaux-Arts, Lausanne, II Salon International de Galeries Pilotes, 1966; Everson Museum of Art, Syracuse, NY, 1974. Member: Sculptors Guild; American Abstract Artists; American Craftsmen's Council. Media: Plastic, metal. Address in 1980, 25 Central Park West, NYC. Died in 1982.

VOLPE, ANTON.
Sculptor. Born in 1853. His home was in Philadelphia. Died in New York, May 26, 1910.

VOLZ, GERTRUDE.
(Gertrude V. Crosby). Sculptor and painter. Born in New York City, October 27, 1898. Pupil of Art Students League of New York. Address in 1933, 40 Fifth Ave., New York, NY.

VON AUW, EMILIE.
Sculptor, painter, designer, writer, craftswoman, and lecturer. Born in Flushing, LI, NY, September 1, 1901. Studied: New York School of Fine and Applied Arts; Columbia University, B.A., M.A.; University of New Mexico, B.F.A.; Grande Chaumiere, Paris; Ecole des Beaux-Arts, Fontainebleau, France; Academy of Art, Florence, Italy, etc. Member: New Mexico Art League; National League of American Pen Women; Sculpture Center, NY. Award: Prizes, New Mexico State Fair. Exhibited: National Gallery of Art, Washington, DC; Terry Art Institute; Albuquerque Artists; New Mexico Art League; State Museum, Santa Fe; New Mexico State Fair; Plaza Gallery, Ramage Gallery, Albuquerque. Taught: Professor of Art, University of New Mexico, 1940-45; Director, Studio Workshop, Albuquerque, New Mexico. Address in 1953, Albuquerque, New Mexico.

Von Der LANCKEN, FRANK.
Sculptor, painter, illustrator, craftsman, and teacher. Born Brooklyn, NY, September 10, 1872. Pupil of Pratt Institute under Herbert Adams; Art Students League of New York under Mowbray; Julian Academy in Paris under Constant and Laurens. Member: Tulsa Art Association; Art Students League in New York; Salmagundi Club; Rochester Art Club. Awards: Medal, Kentucky Federation of Women's Clubs, 1925; medal of first class, Rochester Exposition, 1926. Positions: Director of School of Applied and Fine Arts of the Mechanics Institute, Rochester, NY; lecturer on art at the University of Rochester; Director, Chautauqua School of Arts and Crafts. Address

in 1933, Tulsa, OK; summer, Chautauqua, NY. Died January, 1950.

Von HUENE, STEPHAN R.
Sculptor. Born in Los Angeles, CA, September 15, 1932. Studied at Pasadena City College, 1950-52; University of California, Los Angeles, 1952-53 and 63-65, M.A.; Chouinard Art Institute, 1955-59, B.F.A. Work in Los Angeles County Museum; Pasadena Art Museum, CA; Whitney Museum of American Art, NY; others. Has exhibited at Los Angeles County Museum; Kunsthalle, Dusseldorf, West Germany; Whitney Museum of American Art; others. Received National Endowment Grant, 1974. Taught drawing, painting, and sculpture at Chouinard Art Institute, Los Angeles, 1964-70; teaching drawing and sculpture at California Institute of Arts, Valencia, from 1971. Address in 1982, Valencia, CA.

Von MEYER, MICHAEL.
Sculptor and teacher. Born in Russia, June 10, 1894. Studied: Calif. School of Fine Arts, San Francisco, Calif. Member: San Francisco Art Association. Awards: Medal, San Francisco Art Association, San Francisco, 1934; prize, Women's Art Association, 1926; bronze medal, Oakland Art Gallery, 1934. Work: San Francisco Museum of Art; Palace of Legion of Honor; *Daily Californian* newspaper building, Salinas, Calif.; University of California Hospital; San Francisco City Hall; House Office Building, Washington, DC; US Post Office, Santa Clara, Calif. Exhibited: Oakland Art Gallery; Corcoran Gallery of Art, 1936; Whitney Museum, 1936; Calif Art Association; Palace of Legion of Honor; de Young Memorial Museum; Pomeroy Galleries, San Francisco, 1966; Monterey Peninsula Museum of Art, 1969. Contributor to *Asia*, *Art News*, *Pencil Paints*, and other publications. Address in 1982, San Francisco, Calif.

Von RINGELHEIM, PAUL.
Sculptor. Born in Vienna, Austria, in 1934. Studied at the Brooklyn Museum Art School, 1952-1956, and with Picasso at the Villa Californie, Cannes, 1958. Taught at the Brooklyn Museum Art School, 1957-1958, and at the Art Students League of New York, 1958-1959. Works: Farleigh Dickinson University; Metropolitan Museum of Art; Art Institute of Chicago; Whitney; and many private collections. Exhibitions: Fairleigh Dickinson University, Rutherford, NJ, 1959; Guenther Franke, Munich, 1963; Rose Fried Gallery, NY, 1964; Felix Landau Gallery, NY, 1965. Group Exhibitions: The Brooklyn Museum, NY, 1958-1959; Berlin and Hamburg, Germany, 1961; Guenther Franke, Munich, 1961; New York World's Fair, 1964; and others.

Von RYDINGSVARD, KARL.
Sculptor. Member: New York Architectural League, 1904. Specialty, wood carving. Address in 1908, 96 Fifth Ave., NYC; Brunswick, ME.

Von RYDINGSVARD, URSULA.
Sculptor. Born in Deensen, Germany, July 26, 1942. Studied at University of Miami, Coral Gables, FL, B.A., 1964, M.A., 1965; University of California, Berkeley, 1969-70; Columbia University, NY, M.F.A., 1975. Work at Aldrich

Museum of Contemporary Art, Ridgefield, CT; others. Has exhibited at Corcoran Gallery, Washington, DC; Aldrich Museum of Contemporary Art, Ridgefield, CT; Rosa Esman Gallery, NYC; others. Works in wood. Address in 1982, 210 Spring St., NYC.

Von SCHLEGELL, DAVID.
Sculptor. Born in St. Louis, MO, May 25, 1920. Studied at University of Mich., 1940-42; Art Students League, with William Von Schlegell (his father) and Yasuo Kuniyoshi, 1945-48. Works: Andover (Phillips); Carnegie; Lannan Foundation; MIT; University of Mass.; Ogunquit; Aldrich; Whitney; Hirshhorn; R. W. Godard Memorial, Worchester, MA, 1979; Indiana University, Indianapolis, 1980. Exhibitions: The Swetzoff Gallery, Poindexter Gallery, NYC; Stanhope Gallery, Boston; New York University (three-man); Whitney Annuals, 1960-68; Institute of Contemporary Art, Boston; Wadsworth Atheneum; Jewish Museum; Art Institute of Chicago; Los Angeles County Museum of Art, American Sculpture of the Sixties; Walker Art Center, 1971; others. Awards: RI Arts Festival, First Prize, 1962; Carnegie, 1967; National Council on the Arts, $5,000 Award, 1968; Guggenheim, 1974. Address in 1982, 190 Dromara Road, Guilford, CT.

VONNOH, BESSIE (ONAHOTEMA) POTTER.
(Mrs. Robert W. Vonnoh). Sculptor and painter. Born St. Louis, MO, August 17, 1872. Pupil of Art Institute of Chicago; Lorado Taft, 1895; and Florence, 1897. Member: Associate, National Academy, 1906; Academician, National Academy of Design, 1921; National Sculpture Society 1898; Portrait Painters; Allied Artists of America. Awards: 2nd prize, Nashville Exposition, 1897; bronze medal, Paris Exposition, 1900; honorable mention, Pan-American Exposition, Buffalo, 1901; gold medal, St. Louis Exposition, 1904; silver medal, P.-P. Exposition, San Fran., 1915; Watrous gold medal, National Academy of Design, 1921. Specialty, small groups. Work: "The Young Mother," and eleven statuettes, Art Institute of Chicago; thirteen statuettes, Brooklyn Institute Museum; "Girl Dancing," Carnegie Institute, Pittsburgh; two statuettes, Corcoran Gallery, Wash.; two statuettes, Phila. Academy; two statuettes, Newark Museum; two statuettes, Cincinnati Museum; two statuettes, Detroit Institute; Roosevelt Memorial Bird Fountain, Oyster Bay, LI, NY; "His First Journey," 1901; "Enthroned," 1902; Metropolitan Museum of Art; Burnette Fountain, Central Park, NYC; Brookgreen Gardens, SC; American Museum of Natural History, NY; others. Exhibited National Sculpture Society, 1923. Address in 1953, 33 West 67th St., NYC. Died in NY, 1955.

VOORHEES, HOPE HAZARD.
Sculptor, painter, block printer, teacher. Born Coldwater, Mich., January 28, 1891. Pupil of Detroit School of Design, Dickenson, Roerich Institute. Member: Detroit Society of Women Painters and Sculptors. Address in 1933, 8100 East Jefferson Ave., Detroit, Mich.

VOORHEES, JAMES P.
Sculptor. Born in 1855. Active in Washington, DC. (Mallett's)

VOS, MARIUS.
Sculptor. Address in 1935, Paris, France. (Mallett's)

VOSS, ELSA HORNE (MRS.).
Sculptor. Address in 1934, Westbury, Long Island, New York. (Mallett's)

VOULKOS, PETER.
Sculptor. Born in Bozeman, Montana, January 29, 1924. Studied at Montana State University, BS, 1968; California College of Arts and Crafts, MFA. Works: Baltimore Museum of Art; Archie Bray Foundation; Los Angeles County Museum of Art; Museum of Modern Art; Museum of Contemporary Crafts; Oakland Art Museum; Pasadena Art Museum; San Francisco Museum of Art; Santa Barbara Museum of Art; Smithsonian; Syracuse (Everson); Whitney; Wichita Art Museum. Exhibitions: Gump's Gallery; Felix Landau Gallery; Art Institute of Chicago; Pasadena Art Museum; Los Angeles County Museum of Art; Hansen Gallery, San Francisco; Metropolitan Museum of Art; Syracuse (Everson); Brussels World's Fair, 1958; de Young; Seattle World's Fair, 1962; Whitney; Denver Art Museum; Smithsonian; Los Angeles County Museum of Art; Battersea Park, London, International Sculpture Exhibition; Detroit Institute of Art, 1976; Braunstein Gallery, San Francisco, CA, March, 1984. Awards: Richmond (CA) Art Center, First Prize National Decorative Art Show, Wichita, Kansas, First Prize; Portland, Oregon Art Museum, Northwest Craft Show, First Prize; Pacific Coast Ceramic Show, First Prize; Denver Art Museum; Cranbrook; Smithsonian; Los Angeles County Fair; Pasadena Art Museum; Ford Foundation; International Ceramic Exhibition, Cannes, France, Gold Medal; I Paris Biennial, 1959, Rodin Museum Prize in Sculpture; San Francisco Museum of Art, Ford Foundation. Taught: Archie Bray Foundation, Helena, Montana; Black Mountain College; Los Angeles County Art Institute; Montana State University; University of California, Berkeley, from 1959; Greenwich House Pottery, NYC; Teachers College, Columbia University. Address in 1982, 1306 Third Street, Berkeley, CA.

VOZECH, ANTHONY.
Sculptor. Address in 1934, Berwyn, IL. (Mallett's)

VUCHINICH, VUK.
Sculptor, painter, and etcher. Born in Yugoslavia, December 9, 1901. Pupil of C. C. Curran; Francis Jones; Mestrovic. Member: National Sculpture Society; Kit Kat Club. Address in 1933, 54 West 74th Street, New York, NY.

VUELKER, BETTY.
Sculptor. Working in Texas with inflated vinyl sculpture.

VUILLEMENOT, FRED A.
Sculptor, painter, and illustrator. Born in Ronchamp, France, December 17, 1890. Pupil of Hector Lemaire, E. Deully, David, Benouard. Member: Alliance; Art Decoratif; Artistes Ronbaisiens. Awards: Prize for clock design, Cloister Clock Corp., 1923; Prix de Rome at David's; Prix du Ministre, France; honorable mention, Toledo Museum of Art. Work: Silver plaquette Gravereau Museum, France. Address in 1933, 2441 West Brook Dr., Toledo, OH. Died in February 26, 1952.

W

WAANO-GANO, JOE.
Sculptor and painter. Cherokee Indian, born in Salt Lake City, UT, March 3, 1906. Studied at Von Schneidau School of Art, 1924-28; extension courses and private instruction. Worked as commercial artist; decor designer, Western Air Lines. Represented in Southwest Museum and History & Art Museum, Los Angeles; Bureau of Indian Affairs, Washington, DC; plus others and commissions for Western Air Lines, ticket offices (murals); Los Angeles General Hospital (mural); others. Exhibited at Philbrook, Tulsa, OK (American Indian Artists National Exhibition); National American Indian Exhibition, Scottsdale, AZ; American Indian and Cowboy Artists National Exhibition, San Dimas, CA; many others. Has won numerous awards. Member of Valley Artists Guild; Artists of the Southwest; American Artists Professional League; American Institute of Fine Art; others. Primarily painter. Author and illustrator, *Art of the American Indian*; *Amerindian's, The Herbalist*. Bibliography includes *American Indian Painters*, Snodgrass; *Desert Magazine*, March 1977. Has own gallery. Address in 1982, Los Angeles, CA.

WADE, BOB.
(Robert Shrope Wade). Sculptor, photographer, and painter. Born in Austin, TX, January 6, 1943. Studied: University of Texas at Austin, 1961-65 (MFA in painting); University of Calif., Berkeley, 1965-66 (MA in painting); other universities informally. Group Exhibitions: Dallas Museum, TX, 1966, 68; New Orleans Museum, LA, 1969; Whitney Museum, NYC, 1969; Henri Gallery, Washington, DC, 1971; Otis Art Institute, Los Angeles, 1975; San Francisco Museum of Modern Art, 1976; Individual Exhibitions: Baylor University, Waco, TX, 1967; Kornblee Gallery, NYC, 1971, 76. Awarded: University of Texas Scholarship, 1964, 65; Brooklyn Museum Scholarship, NYC, 1965; named an Outstanding Educator of America, 1969; National Endowment for the Arts Fellowships, 1973, 74-75; others. In collections of Witte Museum, San Antonio, TX; Groningen Museum, Holland; Beaubourg Museum, Paris; others. Address in 1982, c/o Delahunty Gallery, Dallas, TX.

WADSWORTH, FRANCES LAUGHLIN.
Sculptor and painter. Born in Buffalo, NY, in 1909. Studied at Albright Art School; in Italy and France; and with Gutzon Borglum, Charles Tefft, John Effl, Antoinette Hollister. Awards: National League of American Pen Women, 1956, 1958. Works: Sculpture portraits, University of Virginia; Kingswood School, Hartford; American School for the Deaf, West Hartford; garden sculpture, Institute of Living, Hartford, CT; St. Catherine's School, Richmond, Virginia; Thomas Hooker Monument, Hartford; Gallaudet Monument; mural, Institute of Living.

Exhibited: Connecticut Academy of Fine Arts, 1930-58; National League of American Pen Women; National Sculpture Society, NY, 1970; others. Address in 1976, Granby, CT.

WAGANER, ANTHONY.
Sculptor. At New York City, 1834-35.

WAGNER, EDWARD Q.
Sculptor and painter. Born in 1855. Did work for Chicago World's Fair, 1904. Died in Detroit, Michigan, 1922.

WAGNER, FRANK HUGH.
Sculptor, painter, and illustrator. Born Milton, Wayne Co., IN, January 4, 1870. Pupil of Freer, Vanderpoel and Von Salza. Member: Indiana Art Association; Richmond Art Association; Indiana Traveling Art Association; Alumni Association Art Institute of Chicago; Hoosier Salon. Work: "Adoration of the Magi," St. Joseph's Chapel, West Pullman, IL; "Portrait of C. W. Hargrave," and "Portrait of A. Kate Huron," Chapel Hall, Danville, IN. Address in 1933, 1445 Plaisance Court, Chicago, IL.

WAGNER, GEORGE.
Sculptor. Born in the US. Pupil of Dumont in Paris. Specialty, statuettes of silver, gold, ivory, and precious stones. Address in 1908, 40 Rue de la Prevoyance, Vincennes (Seine) France.

WAGNER, MARY NORTH.
Sculptor, miniature painter, illustrator, writer, and lecturer. Born Milford, Ind., December 24, 1875. Pupil of John Vanderpoel, Charles Francis Browne, Mary S. West, Louis J. Millet, C. J. Mulligan and W. M. Chase. Member: Ind. Society of Artists; Richmond Art Association; Alumni Association, Art Institute of Chicago; Independent Society of Artists. Work: Four drawings for the *Second Brownie Book*, by Mrs. Alpha B. Benson. After 1926 (Fielding), no longer listed as sculptor. Address in 1933, 1445 Plaisance Court, Chicago, IL.

WAGONER, HARRY B.
Sculptor and painter. Born Rochester, Ind., November 5, 1889. Pupil of Homer Pollock. Member: Pasadena Society of Painters; Hoosier Salon; Int. Society of Sculptors and Painters Guild. Address in 1933, El Mirador Hotel, Palm Springs; h. 2737 Page Dr., Altadena, Calif.; summer, 9220 Pleasant Ave., Chicago, Ill.

WAHLBECK, CARLO.
Sculptor, painter, and designer. Born in Stockholm, Sweden, 1933; came to US in 1960. Studied at Stockholm School of Art, Sculpture and Drawing; solo study at museums in Italy, the Vatican; also studied jewelry design at Winnipeg, Canada, School of Art. Traveled widely in US (visiting Indian tribes), Canada, Mexico. Has exhibi-

ted in Europe, US, Mexico. In collections of King Gustav V, Sweden; Richard M. Nixon; Frank Sinatra; Barry Goldwater; public institutions in US and Israel. Speciality is subjects of "the American Saga." Represented by Lesli Art, Sherman Oaks, CA. Address in 1982, Los Angeles, CA.

WAITT, BENJAMIN FRANKLIN.
Sculptor, wood engraver and lithographer. Born March 3, 1817, in Malden, Massachusetts. Worked: Philadelphia, c. 1845-84.

WAITZKIN, STELLA.
Sculptor and painter. Born in NYC. Studied at Alfred University; New York University; Columbia University; also with Meyer Shapiro and Hans Hofmann. Works: Richmond Museum Fine Arts, VA; Newark Museum, NJ; Butler Museum American Art, Ohio; Walker Art Institute; others. Exhibitions: Contemporary American Sculpture, VA Museum Downtown Gallery, 1975; Renwick Gallery, Smithsonian Institution, Wash., DC; plus others. Awards: Yaddo Found. Fellowships, 1973 and 74; MacDowell Foundation Fellowships, 1974 and 75; Louis Comfort Tiffany Grant, 1977. Media: Sandstone, polyester resin. Taught: Columbia University Graduate School, 1973. Address in 1982, 222 West 23rd Street, NYC.

WAKEMAN, ROBERT CARLTON.
Sculptor. Born Norwalk, Oct. 26, 1889. Pupil of Lee Lawrie; Yale School of Fine Arts. Member: Nat'l. Arts Club; Silvermine Guild of Artists. Exhibited at Nat'l. Sculpture Soc., 1923. Awards: First prize in competition, Nat'l. Aeronautic Assn., Wash., DC; first prize in competition, Brown and Bigelow medal. Work: "Dr. W. S. Lively," Southern Sch. of Photography, McMinnville, TN; Dotha Stone Prineo Memorial, Norwalk Pub. Lib.; Com. John Rogers Memorial, US Naval Acad., Annapolis, MD. Supervisor of carving, Bok Singing Tower, Mountain Lake, FL. Address in 1929, 1923 Lexington Ave., New York, NY; h. 82 Ward St., Norwalk, CT. Died in 1964.

WALBURG, GERALD.
Sculptor and educator. Born in Berkeley, CA, May 5, 1936. Studied at California College of Arts and Crafts, 1954-56; California State University, San Francisco, B.A., 1965; University of California, Davis, M.F.A., 1967. Work at Storm King Art Center, Mountainville, NY; San Francisco Museum of Art, CA; Oakland Museum; and others. Has exhibited at San Francisco Museum of Art; Crocker Art Gallery, Sacramento; Joslyn Art Museum, Omaha, NE; Storm King Art Center, Mountainville, NY; Baltimore Museum of Art, MD; and others. Address in 1982, Sacramento, CA.

WALCUTT, WILLIAM.
Sculptor and portraitist. Born 1819, in Columbus, Ohio. Studied: Columbus; New York City; Washington; Cleveland, Ohio; London; Paris. Had studio in New York City; also worked in Cleveland, OH, 1859-60. Executed monument to Oliver Hazard Perry, Cleveland. Died 1882 or 1895.

WALD, SYLVIA.
Sculptor, painter, and serigrapher. Born in Philadelphia,

PA, October 30, 1914. Studied at Moore Institute of Art. Awards: Museum of Modern Art, 1941; Library of Congress, 1944; National Association of Women Artists, 1949; Serigraph Gallery, 1948, 49, 50; Brooklyn Museum, 1951, 54. Collections: Allen R. Hite Museum; J. B. Speed Memorial Museum; New York Public Library; Metropolitan Museum of Art; Munson-Williams-Proctor Institute; National Gallery, Canada; Philadelphia Museum of Art; Museum of Modern Art; Brooklyn Museum; Library of Congress; others. Exhibition: Carnegie; Whitney; Brooklyn; Museum of Modern Art; Philadelphia Museum of Art; numerous others; and abroad. Address in 1982, 417 Lafayette St., NYC.

WALINSKA, ROSA NEWMAN.
Sculptor, writer, and lecturer. Born in Russia, December 25, 1890. Studied: Art Students League; and with Robert Laurent, Alexander Archipenko. Member: National Association of Women Artists; American Artists Professional League; League Present-Day Artists. Work: Plaque, Women's Peace Society, NY; memorial, Lynn, Mass. Exhibited: World's Fair, 1939; Independents; American-British Art Center; National Association of Women Artists; Riverside Museum; New School for Social Research; Guild Artists Gallery; Anderson Gallery; Delphic Art Gallery, 1939 (one-woman). Author: *Ink and Clay*, 1942. Lectures: Modern Art and Poetry. Address in 1953, 875 West End Avenue, New York, NY.

WALKER FAMILY.
Gravestone sculptors. Worked: Charleston, South Carolina, 1790's-1830's. Family included Thomas Walker, his sons James E., Robert D. W., and William S. Walker, also A. W. and C. S. Walker.

WALKER, MARIAN D. BAUSMAN.
(Mrs. Otis L. Walker). Sculptor. Born Minneapolis, MN, June 21, 1889. Studied in Minneapolis. Member: Minneapolis Society Fine Arts. Award: Honorable mention, MN State Art Society, 1914. Address in 1933, Casper, WY.

WALKER, NELLIE VERNE.
Sculptor. Born Red Oak, IA, December 8, 1874. Pupil of Art Institute of Chicago under Lorado Taft. Member: National Sculpture Society 1911; Chicago Society of Artists; Society of Western Sculptors; Chicago Painters and Sculptors. Awards: First Chicago Municipal Art League prize, 1907; second Grover prize, Art Institute of Chicago, 1908; Shaffer prize, Art Institute Chicago 1911. Work: "Stratton Memorial," Colorado Springs, CO; portrait statue of "Senator Harlan," US Capitol, Washington; "Her Son," ideal group, Art Institute of Chicago; "Chief Keokuk," Keokuk, IA; Sen. Isaac Stephenson, monument, Marmette, Wisc.; memorial group at Cadillac, MI; two panels in library, State College, Ames, Iowa. Exhibited at National Sculpture Society, 1923. Address in 1933, The Midway Studios, Ingleside Ave., Chicago, IL. Died in 1973.

WALKER, SOPHIA A.
Sculptor, painter, and etcher. Born in Rockland, MA, in 1855. Pupil of Lefebvre in Paris; Mowbray and Chase in New York. Member of National Arts Club. Painted "Por-

trait of E. B. Woodward," State Normal School, Bridgewater, MA. Address in 1926, 70 West 49th St., New York, NY.

WALL, BRIAN.
Sculptor. Born in London, England, September 5, 1931. Moved to Calif. in 1969. Studied at Luton College of Art, Luton, England; with Barbara Hepworth, Cornwall, England, 1954-59. Works: Tate, London; National Gallery, Dublin; Art Gallery of New South Wales, Sydney; Oakland (CA) Museum; commissions at Thornaby, England, and Univ. of Houston, Texas. Exhibited: Galleries in London, including the Tate and Institute of Contemporary Art; Wm. Sawyer Gallery, San Fran., 1971; Braunstein/Quay Gallery, San Fran.; Max Hutchinson Gallery; New York City and Houston; San Fran. Art Institute; Oakland (CA) Museum; San Diego (CA) Museum of Art; XI International Sculpture Conference, Wash., DC; others. Taught: Earling College of Art, Middlesex, England; Central School of Art and Design, London; University of Calif. at Berkeley, from 1969. Address in 1982, San Fran., CA.

WALLACE, JAMES.
Sculptor. At New Orleans, 1852-56. Worked in marble.

WALLACE, J(OHN) LAURIE.
Sculptor, painter, and teacher. Born in Garvagh, Ireland, July 29, 1864. Pupil of Thomas Eakins. Member: Omaha Artists Guild (Pres.). Address in 1933, 5804 Leavenworth St., Omaha, Nebraska.

WALLACE, OREN J.
Sculptor. Active in 1932 in the United States. (Mallett's)

WALLACE, THOMAS J.
Sculptor. Born in Schenectady, New York, March 10, 1851. Pupil of Plassmann and Elwell. Address in 1910, 112 McClellan St., Schenectady, New York.

WALSH, ALIDA.
Film/sculptural environments. Studied at The Art Institute of Chicago; Northwestern Univ.; San Diego State College; Germain School of Photography and Filmmaking; New York University. Awards: Ethical Culture Society, 1967; Vogelstein Foundation in Environmental Sculpture, 1971; CAPS—Creative Artists Program Service, 1974. Exhibitions: Sculpture in Cultural Center Exhibit, "Women Choose Women," 1973; Women's Interart Center, 1973; Women's Film Festival, New York Cultural Center, 1973; Women's Interart Center, 1973; Women's Film Festival, New York Cultural Center, 1973; Vienna Museum of Modern Art, 1974.

WALTER, BETH CAMERON.
Sculptor. Born in Pittsburgh, Penna., in 1948. Studied at Carnegie-Mellon University. Exhibitions: Three Rivers Art Festival, 1969-73; Associated Artists Show, 1973; Apple Hill Playhouse, 1973.

WALTER, EDGAR.
Sculptor. Born in San Francisco, CA, in 1877. Studied at the Mark Hopkins Institute of Art, San Francisco; under Corman and Perrin; in Paris. Exhibited at Paris Salon,

1899, and subsequently; exhibited at National Sculpture Society, 1923. Awards: Honorable mention, Paris Salon, 1901; honorable mention, Panama-Pacific International Exposition, San Francisco, Calif., 1915. Works include "Nymph and Bears;" "Primitive Man." Address in 1926, 1803 Franklin St., San Francisco, CA. Died in 1938.

WALTER, JOHN.
Sculptor. At New Orleans, 1846.

WALTER, JOSEPH.
Sculptor. Member of the National Sculpture Society, fellow. Address in 1982, Washington, DC.

WALTER, VALERIE HARRISSE.
Sculptor. Born Baltimore, MD, February 15, 1892. Pupil of Ephriam Keyser; Augustus Lukeman; Mrs. Lefebvre's School; Maryland Institute, Baltimore; Art Students League; others. Executed portrait busts of Dr. Nicholas Sbarounis Tricorphos, Riccardo Bertelli, Marie Blandin, others; statues of Youth, Madonna and Child, Struggle, The Dip, Law, others; and bas-reliefs of Genevieve Lymans, Walter Walkinshaw, Jim the Master, and others. Also executed life-size bronze gorillas, Johns Hopkins University and Baltimore Zoo; many others. Exhibited at National Sculpture Society, 1923; Corcoran; Pennsylvania Academy of Fine Arts; Paris Salon; San Francisco Museum of Art. Address in 1929, 17 East 59th St., New York, NY; h. and summer, Brightside and Bellona Aves., Woodbrook, Baltimore, MD. Living in Baltimore in 1982.

WALTERS, CARL.
Ceramic sculptor and craftsman. Born in Ft. Madison, IA, June 19, 1883. Studied at Minneapolis School of Art; and with Robert Henri. Awards: Prize, Metropolitan Museum of Art, 1940; Guggenheim Fellow, 1935, 36. Work: Museum of Modern Art; Whitney Museum of American Art; Metropolitan Museum of Art; Art Institute of Chicago; Davenport Municipal Art Gallery; Cincinnati Museum; Minneapolis Institute of Art. Exhibited: Copenhagen, Denmark, 1927; Stockholm, Sweden, 1928; Metropolitan Museum of Art; Whitney Museum of American Art, 1929-45, 51, 52; Art Institute of Chicago, 1932-45; Penna. Academy of Fine Art, 1938-45, 51; Musee du Jeu de Paume, Paris, 1938; Syracuse Museum of Fine Art traveling exhibition to Denmark, Sweden, and Finland, 1937. Address in 1953, Woodstock, NY. Died in 1955.

WALTON, MARION.
Sculptor. Born in New Rochelle, NY, November 19, 1899. Studied at Art Students League; Grande Chaumiere, Paris, with Antoine Bourdelle; Borglum School of Sculpture. Collections: University of Nebraska; World's Fair, NY, 1939; numerous private collections in US and Europe. Exhib.: Museum of Modern Art; Metropolitan Museum of Art; Whitney; Art Institute of Chicago; Penna. Academy of Fine Arts; Rodin Museum, Paris; Carnegie; San Francisco Museum of Art; Weyhe Gallery, NYC; and others. Received gold medal, Biennale International, Ravenna, Italy, 1979 Member of Sculptors Guild; Artists' Equity Association. Works in marble and bronze. Address in 1982, 49 Irving Place, NYC.

WALZ, JOHN.
Sculptor. Born in Wuertemberg, Germany, August 31, 1844; came to America in 1859. Pupil of Aime Millet in Paris; Tilgner in Vienna. Address in 1910, 407 Liberty St., E., Savannah, GA.

WAMSLEY, FRANK C.
Sculptor. Born Locust Hill, MO, September 12, 1879. Pupil of C. J. Mulligan; Albin Polasek; Art Institute of Chicago; Beaux-Arts Institute of Design; Solon Borglum; John Gregory; Edward McCarten. Member: Artland Club (life); Painters and Sculptors of Los Angeles. Work: "Meditation," Hackley Art Gallery, Muskegon, MI; urn at Hollywood Crematory; Douglas Memorial Tablet, Covina, CA. Address in 1933, 1928 Hillhurst Avenue, Hollywood, CA.

WAMSLEY, LILLIAN BARLOW.
Sculptor, craftswoman, and teacher. Born in Ft. Worth, TX. Studied at Columbia University; and with Albert W. Heckman, Hans Reiss, Maude Robinson, and others. Member: New York Ceramic Society and Designers Guild; New York Society of Ceramic Arts. Awards: Prizes, Oklahoma Art Exh., 1923; New York Ceramic Society, 1931. Exhibited: New York World's Fair, 1939; Boston Society of Arts and Crafts, 1940; Oklahoma Art Exhibition, 1923; New York Ceramic Society, 1920-40; New York Ceramic Art, 1920-40. Contributor to: *Ceramic Studio* magazine. Lectures: Pottery. Position: Owner-Director, Pottery and Sculpture Studios, NYC, from 1939. Address in 1953, 215 East 11th St., NYC.

WANLASS, STANLEY GLEN.
Sculptor and painter. Born in American Fork, UT, April 3, 1941. Studied at Brigham Young University, B.F.A., 1966, M.A., 1968. In collections of Brigham Young University; Springville Art Museum, UT; Hutchings Museum, Lehi, UT; heroic bronze of Lewis and Clark, Fort Clatsop National Memorial, OR; others. Exhibited at Springville (UT) Art Museum; Brigham Young; University of Grenoble (France) and galleries there; Palais des Congres, Paris; others. Taught at Brigham Young; European Art Academy, Paris; University of Grenoble, France; University of Calgary (Canada); Clatsop College, OR, from 1971. Specialty is the Northwest and Indian subjects. Sculpture is bronze statuettes and monuments; also uses cor-ten steel. Paints in oil and acrylic. Represented by Grand Central Art Galleries, NYC. Address since 1971, Astoria, OR.

WARBOURG, EUGENE.
Sculptor. Born in New Orleans in 1825. This Black artist worked in New Orleans, 1840's -50's; Europe, from 1852. Executed busts, cemetery sculpture; "Ganymede Offering a Cup of Nectar to Jupiter;" bas-reliefs based on *Uncle Tom's Cabin*, commissioned by Duchess of Southerland. Died January 12, 1859, in Rome, Italy.

WARD, ALBERT PRENTISS.
Sculptor, painter, and illustrator. Pupil of S. Seymour Thomas and of Whistler. Address in 1910, 317 Park Ave., Rochester, New York.

WARD, ELSIE.
See Elsie Ward Hering.

WARD, HERBERT T.
Sculptor and explorer. American born in London 1862. Died Neuilly, France, August 2, 1919.

WARD, JIM.
Sculptor and painter. Born in Fort Worth, TX, 1931. Studied art in Famous Artists correspondence course; Oklahoma State University, animal husbandry degree. Worked in rodeos, as ranch manager, agriculture instructor, land appraiser, commercial artist. Specialty is Texas ranch life. Member (charter), Texas Cowboy Artists Association. Reviewed in *The Quarter Horse Journal*; *Paint Horse Journal*. Represented by The Galleries, San Angelo, TX. Address since 1965, Canyon, TX.

WARD, JOHN.
Sculptor. Born in Providence, Rhode Island, 1946. Studied: Wayne State University. Exhibitions: Impermanent Sculpture, 1974; Detroit Bank and Trust Artists Invitational, 1974; Michigan Focus, The Detroit Institute of Arts, 1974-75. Member: Society of Arts and Crafts. Address in 1975, Highland Park, MI.

WARD, JOHN QUINCY ADAMS.
Sculptor. Born June 29, 1830, near Urbana, OH. Studied with Henry K. Brown in Brooklyn, NY, remaining in his studio for six years. In 1857 made his first sketch for "The Indian Hunter," now in Central Park, NY. In 1861, opened his studio in NY. Elected Associate Member of National Academy Design in 1862, an Academician the following year, president in 1874. First president of National Sculpture Society. Member of original board of trustees of Metropolitan Museum of Art, NYC. In 1866, he executed the group of "The Good Samaritan," in Boston; bronze portrait statue of George Washington, 1883, Wall Street, NYC; statue of Henry W. Beecher in Brooklyn; of Commodore Oliver H. Perry in Newport, RI; and of Israel Putnam at Hartford, CT. Other noted statues were of Horace Greeley, Lafayette, President Garfield and the equestrian statue of General Thomas at Wash., DC. Also executed marble pediment figures (with P. W. Bartlett) for NY Stock Exchange. Died May 1, 1910 in NYC.

WARD, RICHARD, JR.
Sculptor, illustrator, cartoonist, and craftsman. Primarily illustrator. Born in NYC, April 30, 1896. Studied at Margate College, England; Beaux-Arts. Member: Society of Illustrators. Work: Free lance. Address in 1953, 270 Park Ave.; h. 51 West 10th St., NYC.

WARD, WILLIAM.
Sculptor. Born in Leicester, England. Came to US about 1852. Worked: Utah and St. Louis. Taught: University of Utah, from 1892. Executed work for Washington Monument, DC; lion, Brigham Young's house; served as assistant architect, Mormon Temple, Salt Lake City.

WARD, WINIFRED.
Sculptor. Born in Cleveland, OH, in 1889. Pupil of Charles Grafly. Member: Fellowship, Penna. Academy of Fine Arts; Plastic Club; National Association of Women Painters and Sculptors; Society of Independent Artists. Address in 1926, 2006 Mt. Vernon St., Philadelphia, PA.

WARDY, FREDERICK.
Sculptor and painter. Born in Los Angeles, CA, November 18, 1937. Studied at University of California, Los Angeles, B.A., 1960; Chouinard Art Institute, 1965. Work in Arnot Museum, Elmira, NY; Minnesota Museum of Art; outdoor wood sculpture, New York State Council on the Arts; and others. Has exhibited at Whitney Annual; and others. Address in 1982, 70 Thomas St., NYC.

WARE, JOSEPH.
Sculptor. Born 1827. Exhibited: Boston Athenaeum, 1846, marble bas-relief of St. John.

WARING, PEGOT.
Sculptor. Born in Dallas, Texas, 1909. She went to Calif. in 1936. Studied at Cranbrook Academy, Bloomfield Hills, Michigan, c. 1934, with Carl Milles. Exhibited: Nierendorf Galleries, NYC; Pasadena (Calif.) Art Institute; Los Angeles County Museum; Phila. Museum; Museum of Modern Art, Sao Paulo; Art Institute of Chicago; Calif. Palace of the Legion of Honor; City Art Museum, St. Louis, MO. Taught: In her studio in Los Angeles, 1950-68; Pomona College, Claremont, Calif.; Otis Art Institute, Los Angeles.

WARNEKE, HEINZ.
Sculptor. Born Bremen, Germany, June 30, 1895. Pupil of Academy of Fine Arts in Berlin; others. Awards: 1st prize for sculpture, St. Louis Artists Guild, 1924; 1st prize, St. Louis Artists Guild, 1925; Logan medal and $2500, Art Institute of Chicago, 1930; Widener gold medal, Penna. Academy of Fine Arts, 1935; others. Work: Eagle facade, Masonic Temple, Fort Scott, KS; memorial tablet, Medical Society, St. Louis; memorial tablet, YMCA Building, St. Louis; "Wild Boars," granite, Art Institute of Chicago; "Prodigal Son," granite, Wash. Cathedral, DC, as well as tympanum and clerestory decoration; elephant group, Phila. Zoological Gardens; Fairmount Park, Phila.; many others. Exhibited at Salon des Tuileries, Paris, 1929; Art Institute of Chicago; Museum of Modern Art Annuals, 1936-46; Whitney Annuals; others. Taught at Corcoran School of Art, 1943-68; George Washington University, 1943-69; others. Member of National Academy of Design; National Sculpture Society; International Institute of Arts and Letters; others. Address in 1982, East Haddam, CT.

WARNER, MYRTLE LOUISE.
Sculptor, painter, illustrator, craftswoman, and teacher. Born in Worcester, MA, June 25, 1890. Address in 1924, Sterling, MA; summer, Chatham, MA.

WARNER, OLIN LEVI.
Sculptor. Born in West Sheffield, CT, in 1844. Raised in Amsterdam, NY, and Brandon, VT. Studied in Paris at Ecole des Beaux-Arts, 1869; studio assistant to Augustus Saint-Gaudens. Returned to US in 1872 and opened his studio in New York. Elected an Associate of the National Academy in 1888; also member of National Sculpture Society and Architectural League of New York. Designed silverware and bronze gas fixtures; souvenir half dollar for World's Columbian Exposition in 1893; executed bronze doors for Library of Congress. Represented in collection of the Metropolitan Museum of Art, NYC. His portrait busts of Gov. Wm. A. Buckingham and Wm. Lloyd Garrison and his statuettes of "Twilight" and the "Dancing Faun" were well known. Died in 1896 in New York.

WARREN, CHARLES BRADLEY.
Sculptor. Born in Pittsburgh, PA, December 19, 1903. Studied: Carnegie Institute; Beaux-Arts Institute of Design. Member: Architectural League; Associated Artists of Pittsburgh; Society of Sculptors, Pittsburgh. Awards: Prize, Carnegie Institute, 1936, 41. Work: North Carolina State College; Greek Catholic Seminary, Pittsburgh; Department of Justice, Raleigh, NC; County Building, High Point, NC; Stevens School, Pittsburgh; Scott Township School, PA; Stephen Foster Mem. medal; St. Athanasius Church, West View, PA; Kaufmann tablet, Pittsburgh. Exhibited: Associated Artists of Pittsburgh, 1930-41, 50, 52; Architectural League, 1940-42; Society of Sculptors, Pittsburgh, 1935-45, 50, 51; National Sculpture Society, 1952. Address in 1953, Pittsburgh, PA.

WARREN, CONSTANCE WHITNEY.
Sculptor and poster artist. Born in NYC, 1888. Began designing and sketching posters. Exhibited: Many times at the Paris Salon and won numerous Honorable Mentions there. Noted for her modeling of horses and dogs. In 1926, she produced life-size equestrian statue of a cowboy for the State Capitol in Oklahoma City. Work in collection of Metropolitan Musuem of Art, NYC. Died in Paris, France, 1948.

WARREN, DUDLEY THOMPSON.
Sculptor. Born in East Orange, NJ, Febuary 17, 1890. Member: Richmond Academy of Arts. Work: "Age of Endearment," Church Home and Infirmary of the City of Baltimore, MD. Address in 1933, Roanoke, VA.

WARREN, MELVIN CHARLES.
Sculptor and painter. Born in Los Angeles, CA, March 19, 1920. Studied at Texas Christian University, 1949-53. Work in Cowboy Hall of Fame, Oklahoma City; bronze, Texas Rangers Commemorative Foundation; others. Has exhibited at National Cowboy Hall of Fame, Oklahoma City; Phoenix Art Museum, AZ; others. Received gold medal in oil, Cowboy Artists of America; silver medal in drawing, Cowboy Artists of America Exhibition, Phoenix Art Museum; others. Member of Cowboy Artists of America; Coppini Academy of Fine Arts. Address in 1982, Clifton, TX.

WARREN, PATRICIA.
Sculptor and painter. Born in Columbus, Mississippi, 1945. Daughter of Western painter Melvin Warren. Studied art at Art Museum, Fort Worth, and privately; also attended University of Texas, courses in medicine and business. Specialty is contemporary Southwestern Indian women. Sculpts in bronze and stone; paints in oil and pastel. Has had numerous exhibitions since 1979. Reviewed in *Southwest Art*, April 1981. Represented by Reminisce Gallery, Fort Worth, TX; Shidoni Gallery and Foundry, Tesuque, New Mexico. Address in 1982, Fort Worth, TX.

WARRICK, META VAUX.
(Mrs. Fuller). Sculptor, illustrator, craftsman, and teacher. Born Philadelphia, June 9, 1877. Studied at Philadelphia Museum School of Industrial Art, with Paul Lachenmeyer; Penna. Academy of Fine Arts, with C. Grafly; Collin, Carles; Colarossi Academy, and with Injalbert, Gauqui, and Rodin in Paris. Member: Alumni Association, Philadelphia School of Industrial Art; Fellowship Penna. Academy of Fine Art. Represented in Cleveland Art Museum; New York Public Library. Exhibited at Cleveland Art Museum; San Francisco Museum of Art; New York Public Library. Address in 1953, 31 Warren Road, Framingham, MA.

WARSHAWSKY, ABRAHAM G.
Sculptor, painter, and illustrator. Born in Sharon, PA, December 28, 1883. Pupil of H. Siddons Mowbray and Louis Loeb in New York; also Winslow Homer. Member: Salon d'Automne; Cincinnati Art Club; Salmagundi Club; others. Chevalier of the Legion of Honor of France. Work: Mural decoration, "The Dance," Rorheimer and Brooks Studios, Cleveland, OH; Cleveland Museum of Art; Minneapolis Art Institute; drawings, Art Institute of Chicago; Luxembourg Museum and Petit Palais, Paris. Address in 1933, rue Antoine Chantin, Paris, France.

WARSINSKE, NORMAN GEORGE, JR.
Sculptor and painter. Born in Wichita, KS, March 4, 1929. Studied at University of Montana, B.A.; Kunstwerkschule, Darmstadt, Germany; University of Washington, B.A. Works include bronze fountain, Theodora Retirement Home, Seattle, 1966; gold leaf steel stabile, IBM Building Lobby, Seattle; and others. Has exhibited sculpture, Los Angeles County Museum of Art; Northwest Annual, Seattle Art Museum; and others. Received first prize for sculpture, Bellevue Art Festival, 1960; and others. Works in metal, bronze, steel, and acrylic. Address in 1982, Bellevue, WA.

WARTHOE, CHRISTIAN.
Sculptor and writer. Born in Salten, Denmark, June 15, 1892. Studied at Royal Acad. of Fine Art, Copenhagen, Denmark; Minneapolis School of Art; Art Students League; Beaux-Arts Inst. of Design. Member: Nat. Sculpture Soc.; Am. Veterans Soc. of Arts. Work: Grand View Col., Des Moines, IA; in Denmark and Germany; memorial, Chicago, IL. Exhibited: Am. Veterans Soc. of Arts; Nat. Sculpture Soc.; Nat. Acad. of Design; Sculptors Guild. Contributor to Danish American Press. Address in 1953, Chicago, IL. Died in 1970.

WASEY, JANE.
Sculptor. Born in Chicago, IL, June 28, 1912. Studied with Simon Moselsio and John Flanagan in NY; with Paul Landowski in Paris; and with Heinz Warneke in CT. Awards: Lighthouse Exhibition, NY, 1951; National Association of Women Artists; Guild Hall, East Hampton, Long Island, 1949-1956; Architectural League, 1955; Parrish Museum, Southampton. Collections: Whitney Museum of American Art; Penna. Academy of Fine Arts; University of Nebraska; University of Arizona; University of Colorado; City Art Museum of St. Louis. Exhibi-

tions: Art Institute of Chicago; Brooklyn; Detroit Institute of Arts; Philbrook Art Center; Kraushaar Galleries, NYC, 1956-71; others. Address in 1982, Lincolnville, ME.

WASHBURN, KENNETH (LELAND).
Sculptor, painter, and educator. Born in Franklinville, NY, January 23, 1904. Studied at Cornell Univ., B.F.A., M.F.A. Member: American Water Color Society. Awards: Prizes, Cortland County (NY) State Exhibition, 1945; Finger Lakes Exhibition, Auburn, NY, 1944. Work: Springfield (IL) Museum of Art; Binghamton (NY) Museum of Art; IBM Collection; murals, plaque, US Post Office, Binghamton, NY; Moravia, NY. Exhibited: Texas Centennial, 1934; New York World's Fair, 1939; National Academy of Design, 1942-44; American Watercolor Society, 1942-45; Penna. Academy of Fine Arts, 1940, 41, 46; Rochester Memorial Art Gallery, 1943-46; Finger Lakes Exhibition, 1941-46; etc. Position: Instructor of Fine Arts, 1928-34, Assistant Professor of Fine Arts, 1934-44, Associate Professor of Art, 1944-50, Cornell University, Ithaca, NY; San Mateo Jr. College, San Mateo, CA, from 1950. Address in 1953, San Carlos, CA.

WASHBURN, MARY S.
Sculptor. Born Star City, IN. Pupil of Art Institute of Chicago; Edwin Sawyer in Paris. Awards: Bronze medal, P.-P. Exp., San Francisco, 1915. Work: "Statue of Gen. Milroy," Milroy Park, Rensselaer, IN; medal in Carnegie Institute, Pittsburgh, PA; Memorial to Lt. Joseph Wilson, Logansport, IN; Monument, Waite Memorial, Rock Creek, Washington, D.C.; character sketch medallions, Berkeley League of Fine Arts; bust of Dr. Byron Robinson, Medical Library, Chicago. Address in 1929, 2321 Haite St., Berkeley, CA.

WASHINGTON, JAMES W., JR.
Sculptor and painter. Born in Gloster, Miss., November 10, 1909. Studied painting privately with Mark Tobey in Seattle and at National Landscape Institute; Grad. Theological Union Center of Urban Black Studies, Berkeley, California. Works: Oakland Art Museum; San Francisco Museum of Art; Seattle Art Museum. Exhibitions: Vicksburg (Miss.) YMCA; Hall-Coleman Gallery, Seattle; Lee Nordness Gallery, NYC, 1962; Frye Art Museum, Seattle; others. Awards: San Francisco Museum of Art; Oakland Art Museum, 1957; Seattle World's Fair, 1962, Second Prize; Governor's Sculpture Award, 1920. Member: Sculptors Institute. Changed from painting to sculpture in 1956. Media: Marble, granite; tempera, oil. Address in 1982, Seattle, WA.

WATERS, GEORGE FITE.
Sculptor. Born San Francisco, CA, October 6, 1894. Pupil of Elwell of Art Students League of New York; Rodin in Paris; and studied in Italy and London. Member: American Art Association of Paris; Societe Moderne. Work: Portrait of President Cosgrave, Dublin Art Gallery; "Valdimir Rosing," Eastman School of Music, Rochester, NY; "Dr. Gordon Hewitt," Ottawa National Gallery; Statue of Abraham Lincoln, Portland, OR; "James K. Hackett," University of New York; "Capt. Sir Bertram Towse, V. C.," St. Dustan's, London; statue, "John

Brown," John Brown Memorial State Park, Osawatomie, KS; bust, "Pirandello," Osso Films, Inc.; "Gen. John J. Pershing," bust owned by French Government; others. Received honorable mention, Salon des Artistes Francais, 1932. Address in 1933, Hossegor (Landes), France. Died in 1961.

WATERWORTH, SHERRY.
Sculptor. Born in Annapolis, Maryland, in 1943. Studied at Towson State College; Ohio Univ. Exhibitions: Fine Arts Center, Salem College, Winston-Salem, North Carolina, 1970; Carrol Reece Museum, Johnson City, Tennessee, 1972; National Sculpture Society, 1973. Awards: Baltimore Art Festival, 1966; Atlantic City, NJ, 1967; Raleigh Art Museum, 1973; North Carolina Artist Exhibit, 1974. President, Southern Association of Sculptors, 1974-75.

WATSON, SUE E.
Sculptor. Address in 1919, 10 Forbes Terrace, Pittsburgh, PA.

WAUGH, ALFRED S.
Portrait sculptor, portrait and miniature painter, profilist, writer, and lecturer on the fine arts. Born in Ireland. Studied modelling in Dublin in 1827; toured Europe. Working in Baltimore, MD, by 1833; in Raleigh, NC, 1838; Alabama, 1842; Pensacola, FL, 1843; Moblile, AL, 1844; Missouri from 1845; visited Santa Fe, 1846. Died in St. Louis, MO, on March 18, 1856.

WAUGH, SIDNEY.
Sculptor and designer. Born Amherst, MA, January 17, 1904. Studied: Amherst College; MIT; Ecole des Beaux-Arts, Paris; American Academy in Rome. Member: National Academy of Design; National Sculpture Society; National Institute of Arts and Letters. Awards: Paris Salon, 1928, 29; Prix de Rome, 1929. Work: Metropolitan Museum of Art; Victoria & Albert Museum, London; Cleveland Museum of Art; Toledo Museum of Art; Art Institute of Chicago; Herron Art Institute; monument, Richmond, TX; Corning Building, NY; Smith College; Buhl Planetarium, Pittsburgh, PA; Federal Trade Commission Building, Wash., DC; Dept. of Justice Building, Wash., DC. Author: *The Art of Glassmaking*, 1938. Address in 1953, 101 Park Ave., New York, NY. Died in 1963.

WAWRYTKO, MARY FRANCES.
Sculptor and painter. Born in Sandusky, OH, April 28, 1950. Studied: Cleveland Institute of Art in sculpture and enameling, B.F.A. Studied lost wax bronze casting under Ron Dewey at the Studio Foundry in Cleveland. Exhibitions: Cleveland Natural History Museum's Art Society, 1978; three-person exhibit at Wichita Art Assn., 1979; two-woman exhibit at Women's City Club, Cleveland, 1978; 45th Annual National Sculpture Society Show, 1978; Ohio Invitational Enameling Exhibition. Awards: Butler Institute of American Art Annual Ceramic and Sculpture Show purchase prize for sculpture, 1977, 78; Nancy Hine Dunn Memorial Scholarship Award from Cleveland Institute of Art, 1977; sculpture prize at the Massillon Museum, 1978. Permanent collections: Butler

Institute of American Art, Youngstown, OH; numerous religious institutions and private collections. Member: New Organization of Visual Art, OH; Ohio Designer Craftsman; Natural History Art Society, OH; Artists Equity; American Crafts Council; Society of Animal Artists. Expeditions: Study and travel in Europe. Specialties: Reviving the lost art of enameling on specially alloyed bronze castings (from the Ming and Ching Dynasties 15th-17th c.). Media: Bronze and terracotta; enamel on copper. Address in 1983, Cleveland, OH.

WEAVER, B. MAIE.
Sculptor, painter, and teacher. Born New Hartford, December 12, 1875. Pupil of Ross Turner; Mme. La Forge; George T. Collins; M. Simone. Member: Springfield Art League; Holyoke Art Club. Work: Portraits of Ex-Governors Woodruff, Templeton, Holcomb and Weeks, State of CT. Exhibited at the Paris Salon; Springfield (MA) Museum of Art; others. Address in 1953, New Hartford, CT.

WEAVER, BEULAH BARNES.
Sculptor, painter, and teacher. Born in Washington, DC, July 8, 1882. Studied at Art Students League; Corcoran School of Art; and with Peppino Mangravite, Karl Knaths, and others. Member: Society of Wash. Artists. Awards: Prizes, Corcoran Gallery of Art; Wash. Woman's Club; Independent Artists Exchange, Wash., DC. Exhibited: Anderson Gallery, NY; Richmond, VA; Corcoran Gallery of Art; National Gallery of Art; Wash. Woman's Club. Position: Director, Art Teacher, Madeira School, Greenway, VA, from 1953. Address in 1953, Washington, DC.

WEAVER, JOHN BARNEY.
Sculptor. Born in Anaconda, MT, March 28, 1920; moved to Canada in 1966. Studied with his father; at Art Institute of Chicago, Albert Kuppenheimer scholarship; monumental sculpture with Albin Polasek. Exhibited: Art Institute of Chicago; Denver Art Museum; Milwaukee Art Institute; Natural History Building, DC; many more. In collections of Statuary Hall, Washington, DC (Charles Russell); Fort Walsh, Saskatchewan, Canada; New York State Museum, Albany (Archaic Indian); National Geographic Society; Libby Dam, Montana; many others. Taught: Layton Art School, Milwaukee; appointed curator, sculptor, Montana Historical Society, Helena; sculptor, Smithsonian Institution. Specialty is statuettes and monuments of Western figures. Works in bronze. Member: National Sculpture Society; Northwest Rendezvous Group. Reviewed in *Art West*, summer 1978. Address since 1966, Hope, British Columbia, Canada.

WEBBER, CHARLES T.
Sculptor, painter, and teacher. Born in Cayuga Lake, NY (or Cincinnati, OH), 1825; settled in Ohio in 1844. Charter member of the Cincinnati Sketch Club, 1860; Art Club, 1890. Organized McMickin School of Art and Design, 1869. Painting titles include "The Underground Railroad;" "Major Daniel McCook and His Nine Sons." Specialty was portraits, landscapes, and historical subjects. Died in Cincinnati, OH, 1911.

WEBER, FREDERICK (THEODORE).
Sculptor, painter, and etcher. Born Columbia, SC, March 9, 1883. Pupil of Laurens and Ecole des Beaux-Arts in Paris. Member: Southern States Art League; New York Water Color Club; Brooklyn Society Etchers (Pres.); American Artists Professional League. Collections: Etchings in the Library of Congress, Washington; New York Public Library; Smithsonian Institute, Wash.; Bibliotheque Nationale, Paris; Metropolitan Museum of Art; Brooklyn ; others.Exhibited: Corcoran; National Academy of Design; Detroit Institute of Art; Art Institute of Chicago; many others. Author, article on "Portrait Painting," *Encyclopedia Britannica*, 1929. Address in 1953, Jackson Heights, NY. Died in 1956.

WEBER, MAX.
Sculptor and painter. Born in Bialystok, Russia, April 18, 1881. Studied: Pratt Institute, NYC, 1898-1900, with Arthur Wesley Dow; Julian Academy, Paris; travelled throughout Europe, 1905-08; associated closely with Henri Rousseau; studied with Henri Matisse, 1907; also with Jean Paul Laurens. Work: Metropolitan Museum of Art; Museum of Modern Art; Jewish Theological Seminary of America; Art Institute of Chicago; Los Angeles Art Museum; California Palace of Legion of Honor; Santa Barbara Museum of Art; Walker Art Center; others. Awarded: Prizes, Art Institute of Chicago, 1928, 41; Pennsylvania Academy of Fine Arts, 1941; others. Noted paintings: "The Geranium," 1911; "Chinese Restaurant," 1915; "Adoration of the Moon," 1944; "Figure in Rotation," (bronze). Sculpture includes; "Still Life." Published: *Essays on Art*, 1916; *Primitives*, 1926. Address in 1953, Great Neck, LI, New York. Died in 1961.

WEBSTER, DANIEL.
Sculptor. Address in 1908, c/o Art Students League of New York, 215 West 57th St., NYC.

WEBSTER, FREDERICK.
Sculptor. Born in Grand Rapids, MI, November 12, 1869. Pupil of Royal Academy, Munich. Member of Chicago Water Color Club; Chicago Society of Artists. Address in 1919, Evanston, IL.

WEBSTER, H. DANIEL.
Sculptor. Born at Frankville, IA, April 21, 1880. Pupil of Barnard and Du Mond in New York. Represented by "Minute Man" (bronze), Campo Beach, Saugatuck, CT; Genl. W. H. Beadle (marble), State Capitol, Pierre, SD; the bronze doors for American National Bank Building, Austin, Texas. Member of Art Students League of New York; Silvermine Guild. Died in 1912, in Westport, CT.

WEBSTER, MARY HORTENSE.
Sculptor, painter, and teacher. Born Oberlin, OH. Pupil of Cincinnati Art Academy under Barnhorn and Nowottny; Injalbert, Verlet, and Waldmann in Paris; Hitchcock in Holland; Hawthorne in Provincetown; Lorado Taft in Chicago. Address in 1933, Midway Studios, Ingleside Avenue, Chicago, IL.

WEDDLE, JOY.
Sculptor and painter. Born in Wheaton, IL, 1933; moved to Arizona in 1934. Took Famous Artists correspondence course, oil painting, 1958; clay and ceramic classes, Indian School on San Carlos Indian Reservation. Specialty is Indian women and children in statuettes and miniatures. Works in clay and bronze. Represented by El Prado Gallery of Art; Burk Gallery, Boulder City, Nevada. Address in 1982, Dewey, AZ.

WEEKS, GARLAND A.
Sculptor. Born in Amarillo, TX, 1942. Studied at Texas Tech University in Lubbock, Texas, B.S. agricultural economics; later, sculpture and anatomy at Mustafa Naguib School of Sculpture, Chicago. Rodeoed; worked in cattle feed industry. Work includes limited edition for National Cattlemen's Association, commissions; in permanent collection of Buckingham Palace, London; others. Specialty is statuettes of Western subjects. Works in bronze. Represented by The Galleries, San Angelo, TX. Address since 1981, San Angelo, TX.

WEEMS, KATHARINE LANE.
Sculptor. Born in Boston, MA, February 22, 1899. Studied at Boston Museum Fine Arts School; also studied with Charles Grafly, Brenda Putnam, and Anna Hyatt Huntington. Awards: Sesqui-Centennial Exposition, Philadelphia, 1926; Boston Tercentenary Exhibition, 1930; Penna. Academy of Fine Arts, 1927; Paris Salon, 1928; National Association of Women Painters and Sculptors, 1928; Grand Central Art Gallery, 1929; National Academy of Design, 1931, 32, 60, 63, 73, 75; Architectural League, 1942; National Association of Women Artists, 1948; National Arts Club gold medal, 1961; others. Work: Boston Museum of Fine Arts; Reading Museum; Penna. Academy of Fine Arts; Brookgreen Gardens, SC; Baltimore Museum of Art; carvings, bronzes, doors, Harvard University; fountain, Boston, MA; many Medals for Merit. Member: National Academy of Design; National Sculpture Society; National Institute of Arts and Letters; NY Architectural League; Boston Guild of Artists. Address in 1982, Boston, MA.

WEHN, JAMES A.
Sculptor and teacher. Born Indianapolis, IN. Pupil of R. N. Nichols, Will Carson, August Hubert. Member: Seattle Art Institute; American Numismatic Society. Work: Monument, Seattle, Wash.; Meriwether-Lewis relief, Court House, Chehalis, Wash.; series of historical medallions, University of Washington; Henry L. Yesler medallion, Yesler Library, Seattle; medal, Garden Club, Seattle; Morgan relief, Northern Life Tower, Seattle; great seal of US and large stone eagles, US Post Office, Longview, Washington; and other memorials in Alaska. Address in 1933, 710 29th Avenue, South, Seattle, Wash.; summer, Cresent Beach, Wash.

WEIL, ARTHUR.
Sculptor. Born in Strassbourg, Alsace-Lorraine, June 8, 1883. Studied in Italy. Work: "Marshall Foch," owned by the Canadian Government. Address in 1919, 2519 Sheridan Road, Evanston, IL.

WEIL, CARRIE H.
Sculptor. Born New York, August 17, 1888. Pupil of P. Hamaan in New York and Paul Landowski in Paris.

Member: National Association Women Painters and Sculptors. Specialty, portrait busts. Address in 1929, 125 East 50th Street; h. Hotel Beverly, New York, NY.

WEILL, ERNA.
Sculptor. Born in Germany. Studied in Frankfurt, Germany with Helene von Beckerath; also with John Hovannes, NYC. Awards: International Exhibition of Women's Art, 1946, 47; Best in Sculpture, Artist-Craftsman, NYC, 1975. Collections: Tel-Aviv Museum, Israel; Bezalel Museum, Jerusalem; Hebrew University, Jerusalem; Georgia State Museum, Athens; Hyde Park Library, NY; Jewish Museum, NY; Birmingham Museum of Art, Ala.; others including commissioned bronze portrait sculptures of Linus Pauling, Martin Buber, Leonard Bernstein, Dr. Martin Luther King, Elie Wiesel. Exhibited at New York World's Fair; New Jersey State Museum (Trenton); Brooklyn Museum; Newark Museum; others. Instructor in sculpture, Brooklyn Museum and many others. Address in 1982, Teaneck, NJ.

WEIN, ALBERT W.
Sculptor and painter. Born in NYC, July 27, 1915. Studied with Hans Hofmann at the Beaux-Arts Institute; National Academy of Design; Grand Central School of Art. Exhibited: Whitney Museum of American Art Annual, NYC, 1950; American Sculpture at the Metropolitan Museum of Art, 1951; The San Francisco Museum of Art Annual, 1957; a 30 year retrospective at the Palm Springs Desert Museum, 1969. Awards: Henry Hering Medal, from the National Sculpture Society, 1976; Artists Fund Prize, 1976; and a Gold Medal for Sculpture, 1974, from the National Academy of Design. Member: National Academy of Design; a fellow of the International Institute of Arts and Letters; Huntington Hartford Foundation; and the National Sculpture Society. Taught: Sculpture at the Univ. of Wyoming, 1965-67; National Academy of Design, 1977-78; and Pace Univ., 1979. Work in Vatican Museum Numismatic Collection; Jewish Museum; Brookgreen Gardens, SC; plus numerous commissions. Address in 1982, Scarborough, NY.

WEINBERG, ELBERT.
Sculptor. Born in Hartford, CT, May 27, 1928. Studied at Hartford Art School; Rhode Island School of Design, 1951, BFA; Yale Univ., with Waldemar Raemisch, 1955, MFA. Works: Andover (Phillips); Brandeis Univ.; Colgate Univ.; 405 Park Ave., NYC; Wadsworth Atheneum; Jewish Museum; Museum of Modern Art; Whitney; Yale Univ.; plus numerous commissions. Exhibitions: Grace Borgenicht Gallery Inc., NYC; Whitney; Andover (Phillips); Silvermine Guild; Jewish Museum; Institute of Contemporary Art, Boston; Wadsworth Atheneum; American Academy of Arts and Letters; Carnegie; Museum of Modern Art; Art Institute of Chicago; Utica; Boston Arts Festival; Penna. Academy of Fine Arts; Smithsonian; others. Awards: Prix de Rome, 1951-53; Institute of Contemporary Art, Tate, International Unknown Political Prisoner Competition, Hon. Men., 1953; Guggenheim Foundation Fellowship, 1960; Sculpture Award, American Institute of Arts and Letters. Taught: Rhode Island School of Design; Yale Univ.; Cooper

Union; Boston Univ.; Tyler. Address in 1982, c/o Grace Borgenicht Gallery, NYC.

WEINBERG, LOUIS.
Sculptor, educator, and designer. Born in Troy, KS, June 19, 1918. Studied at University of Kansas, B.F.A. Member: Artists Equity Association; American Association of University Professors. Work: Philbrook Art Center. Exhibited: Penna. Academy of Fine Arts, 1949; Delgado Museum of Art; Syracuse Museum of Fine Art; Wichita Art Association; Nelson Gallery of Art; Joslyn Art Museum; Denver Art Museum; Dallas Museum of Fine Art; Philbrook Art Center, and others. Address in 1953, Tulsa, OK.

WEINER, EGON.
Sculptor. Born in Vienna, Austria, July 24, 1906; US citizen. Studied at School of Arts and Crafts, Academy of Fine Arts, Vienna. Work in Syracuse Museum of Fine Arts; bronze busts of Willy Brandt, Harvard University, Ernest Hemingway, Oak Park Library, IL; and others. Has exhibited at Art Institute of Chicago; Art Institute of Oslo Annual Exhibition; and others. Received gold medal, Society of Arts and Letters; Municipal Art League, Chicago; and others. Member, International Institute of Arts and Letters, life fellow; Cliff Dwellers of Chicago; National Institute of Arts and Letters; and others. Teaching sculpture and life drawing at Art Institute of Chicago, from 1945. Works in stone, wood, steel, and bronze. Address in 1982, Evanston, IL.

WEINER, LAWRENCE.
Sculptor. Born in Bronx, NY, February 10, 1940. Self-taught. Exhibited: Mill Valley, CA, 1960; Seth Siegelaub, NYC, 1964, 65; Galerie Folker Skulima, Berlin, 1970; Modern Art Agency, Naples, 1973; Max Protetch Gallery, Washington, DC, 1974; Leo Castelli Gallery, NYC, all individual shows; group shows at Museum of Modern Art, NYC; Jewish Museum; Art Institute of Chicago; many more. Awards from der Deutscher Akademische Austauschdienst, Berlin, 1975-76; National Endowment for the Arts Fellowship, 1976-77. In collections of Museum of Modern Art, NYC; Centre Georges Pompidou, Paris; others. Address in 1976, Amsterdam, Netherlands; 13 Bleecker Street, NYC.

WEINERT, ALBERT.
Sculptor. Born in Leipzig, Germany, June 13, 1863. Pupil of Ecole des Beaux-Arts in Brussels. Member: National Sculpture Society, 1909; Society of Independent Artists. Work: "Lake George Memorial," Lake George, NY; "McKinley Monument," Toledo, Ohio; "Statue of Lord Baltimore," Baltimore, MD; marble groups in vestibule of Hall of Records, NYC; "Stevens T. Mason Monument," Detroit, Mich.; historical tablets for Sons of the Revolution and Society of Colonial Wars; work at Panama-Pacific Exposition, San Francisco, Calif.; architectural sculpture, Congressional Library, Washington. Address in 1926, 256 West 55th Street, New York, NY.

WEINMAN, ADOLPH ALEXANDER.
Sculptor. Born in Karlsruhe, Germany, December 11, 1870; came to US in 1880. Pupil of Cooper Union, Art

Students League of NY, Augustus Saint-Gaudens, and Philip Martiny. Assistant to Niehaus, Warner, and French. Member: Society of American Artists, NY, 1903; National Academy, Associate, 1906, Academician, 1911; National Sculpture Society, 1900 (pres.); NY Architectural League; National Inst. of Arts and Letters; Century Association; American Numismatic Society; American Federation of Arts. Member of International Jury for Sculpture, P.-P. Exposition, San Fran., 1915; member of National Commission of Fine Arts, 1929. Awards: Honorable mention, Pan-Am. Exposition, Buffalo, 1901; silver medal, St. Louis Exposition, 1904; silver medal, Brussels Exposition, 1910; gold medal of honor for sculpture, NY Architectural League, 1913; Saltus Medal for medal, American Numismatic Society, 1920. Work: Lincoln memorials at Hodgenville, KY, and Madison, WI; "General Macomb Monument," Detroit; "Abraham Lincoln," statuette, and "The Rising Sun," Metropolitan Museum, NY; "Chief Black Bird," Brooklyn Inst. Museum; plaque, "Adelaide," Carnegie Inst., Pittsburgh; "Descending Night," Kansas City Museum; "Alexander J. Cassatt," NY; "The Rising Sun" and "Descending Night," Houston Museum, TX; "Fountain of the Tritons," Missouri State Capitol Grounds; pediment sculpture, Wisconsin State Capitol; pediment sculpture, Missouri State Capitol; frieze and bronze groups, facade of Elks National Memorial Headquarters Bldg., Chicago; all sculpture on exterior and interior of Penna. Railway Station, NY; sculpture on facade and top of tower, municipal Bldg., NY; sculpture for P.O. Dept. Bldg., Wash., DC; monumental frieze for US Supreme Court Room, US Supreme Court, Wash., DC; others. Designer of half dollar and dime for US Goverment, Victory Button for US Army and Navy. Trustee and chairman of Art Committee, Brookgreen Gardens, SC. Address in 1933, Forest Hills, NY. Died in 1952.

WEINMAN, ROBERT ALEXANDER.
Sculptor. Born in NYC, March 19, 1915. Studied at the National Academy of Design; under A. A. Weinmann, Paul Manship, Lee Lawrie, C. Jennewein, J. E. Fraser, and E. McCartan, all for sculpture; and the Art Students League. Exhibited: National Academy of Design Annual, 1937, 39, 49, and 53; Penna. Academy of Fine Art Annual, 1938 and 39; Allied Artists of America, 1946; Sculpture International, Phila., 1949; National Sculpture Society, 1952, 60, 65, 69, and 70. Member: National Academy of Design, Academician; National Sculpture Society, Fellow; Collectors Art Medals, 1971. Media: Plaster and clay. Address in 1982, Bedford, NY.

WEINRIB, DAVID.
Sculptor. Born in Brooklyn, NY, in 1924. Studied at Brooklyn College; Alfred/SUNY. Works: Los Angeles County Museum of Art; Whitney; Walker. Exhibitions: The Howard Wise Gallery, NYC, 1963; Royal Marks Gallery, NYC, 1966, 71; Whitney Annual, 1964-65, 66-67; VIII Sao Paulo Biennial, 1965; New York University, 1965; Los Angeles County Museum of Art. Award: J. S. Guggenheim Fellowship, 1968. Taught: School of Visual Arts, NYC. Address in 1982, c/o Royal Marks Gallery, NYC.

WEIR, JOHN FERGUSON.
Sculptor and painter. Born in West Point, NY, August 28, 1841. Elected an Associate Member of the National Academy of Design in 1864, and Academician in 1866. He was director of Yale School of Fine Arts, 1869-1913. Principal works in sculpture: Statues of Presidents Woolsey and Professor Silliman, of Yale. Executed many portraits and other works in painting, notably "The Gun Foundry," "The Forging of the Shaft," "The Confessional," "An Artist's Studio," "Christmas Eve," "Tapping the Furnace," "Rain and Sunshine," "The Column of St. Mark's, Venice." Author of *John Trumbull and His Works*, 1902. Address in 1926, Yale University, New Haven, CT. Died in 1926.

WEIS, GEORGE.
Sculptor and gilder. Located: New Orleans, 1830.

WEISS, HARVEY.
Sculptor. Born in NYC, April 10, 1922. Studied at National Academy of Design; Art Students League; and with Ossip Zadkine, Paris. Work in Albright-Knox Art Gallery; Krannert Museum; Silvermine Guild Collection; Nelson Rockefeller Collection; Joseph H. Hirshhorn Collection; and others. Has exhibited at Silvermine Guild; Sculptors Guild Annual Shows; and others. Received three Ford Foundation Purchase Awards; Olivetti Award, New England Annual Exhibition; National Institute of Arts and Letters Grant. Member of Sculptors Guild; Silvermine Guild of Artists. Teaching sculpture at Adelphi University, Garden City, NY. Works in bronze and welded brass. Address in 1982, Greens Farms, CT.

WEISTROP, ELIZABETH N.
Sculptor. Member of the National Sculpture Society. Award: Lindsey Morris Memorial Prize, 1974, National Sculpture Society. Address in 1982, Half Moon Bay, California.

WELCH, JOHN.
Wood carver. Born in Boston, August 19, 1711. Probably carved Codfish in the House of Representatives, Old State House, Boston. Also notable ship and ornamental carver and chairmaker. Died in Boston, February 9, 1789.

WELCH, LIVINGSTON.
Sculptor and painter. Born in New Rochelle, NY, August 8, 1901. Studied at Hunter college. Exhibited at Wellons Gallery, Caravan Gallery, World House Gallery, Shuster Gallery, Galeria International, all in NYC. Worked in lead and brass. Died in 1976.

WELCH, ROGER.
Sculptor and photographer. Born in Westfield, NJ, February 10, 1946. Studied at Miami University, OH, B.F.A., 1969; Whitney Museum Independent Study Program, 1970-71; School of the Chicago Art Institute, M.F.A., 1971. Work at Milwaukee Art Center, Wisconsin; Lund Kunsthalle, Lund, Sweden; Albright-Knox Art Gallery, Buffalo, NY; others. Has exhibited at Milwaukee Art Center; Albright-Knox Art Gallery; Museo de Arte Moderno, Mexico City; Whitney Museum of American Art; and others. Represented by Sonnabend Gallery, NYC. Address in 1982, 87 E. Houston St., NYC.

WELLIVER, LES.
Sculptor, woodcarver, and painter. Born in North Dakota about 1920; raised in Montana. Has worked as a bartender, cook, farm hand, and roughneck. Specialty is wildlife, Indian and Western subjects. Prefers woodcarving; works in cottonwood, juniper, other woods. Address in 1969, Kalispell, MT.

WELLS, CHARLES S.
Sculptor and teacher. Born Glasgow, Scotland, June 24, 1872. Pupil of Karl Bitter, Augustus Saint-Gaudens, George G. Barnard. Work: Fountain, Gateway Park, City of Minneapolis; Anna T. Lincoln Memorial, Northfield, MN. Taught at Minneapolis School of Art. Address in 1933, Minneapolis, MN.

WELLS, FRANCIS MARION.
Sculptor. Born in 1848. Sculptor of the giant figure of "Progress" which crowns the dome of the City Hall, San Francisco, CA. Designed Marshall Monument at Coloma, CA. Co-founder of Bohemian Club of San Francisco. Died July 22, 1903, in San Francisco.

WELLS (or WELL), HENRY.
Ship carver. Worked in Norfolk, VA. Carved figureheads for the brigs *Norfolk* and *Tetsworth*. Active 1748-1800.

WELLS, NEWTON A(LONZO).
Sculptor, painter, architect, craftsman, and teacher. Born in Lisbon, St. Lawrence Co., NY, April 9, 1852. Pupil of Constant and Laurens in Paris. Member: Mural Painters 1905; Architectural League of America; Chicago Society of Etchers; American Art Association of Paris. Instructor in painting, University of Illinois, from 1899. Work: Mural decoration in Library of University of Illinois; Sangamon Co. Court House, Springfield, IL; Colonial Theater, Boston; Englewood High School, Chicago. Address in 1924, University of Illinois; h. 803 West Oregon St., Urbana, IL.

WELLS, RACHEL.
Wax portraitist. Born in Bordentown, NJ. Moved to Philadelphia. Executed full-length figure of the Rev. George Whitefield, given to Bethesda College, GA. Destroyed in a fire.

WELLSTEAD, J. G.
Sculptor. Active 1844. Patentee—medallion bust of Theodore Freylinghuysen, 1844.

WENDT, JULIA M. BRACKEN.
Sculptor and painter. Born Apple River, IL, June 10, 1871. Pupil of Art Institute of Chicago under Taft. Member: Chicago Society Artists; Chicago Municipal Art League; Los Angeles Fine Arts Association; Calif. Art Club; National Arts Club; Three Arts Clubs of Los Angeles; Laguna Beach Art Association. Awards: Sculpture prize, Chicago, 1898; Chicago Municipal Art League prize, 1905; Harrison prize, gold medal, Pan-Calif. Exp., San Diego, 1915; CA Art Club, 1918. Work: "Illinois Welcoming the Nations," presented to the State by IL Woman's Bd., Columbian Exposition, 1893; group, "Art, Science, and History," Los Angeles Museum. Instructor, Otis Art Institute, Los Angeles. Exhibited at National Sculpture

Society, 1923. Address in 1933, 2814 N. Sichel St., Los Angeles, CA; Laguna Beach, CA. Died in 1942.

WENIGER, MARIA P.
Sculptor. Born in Bevensen, Germany, in 1880. Studied in Munich with von Debschitz and Vierthaler, and with Maria Cacer. Member of Art Alliance of America. Work: Miniature bronzes, "Dancers." Exhibited at Nat'l. Sculpture Soc., 1923. Address in 1926, 442 East 58th Street, New York, NY.

WERNER, NAT.
Sculptor. Born in NYC, December 8, 1910. Studied at Col. City of New York, B.A.; Art Students League; and with Robert Laurent. Member: Sculptors Guild. Work: Lyman Allyn Museum; US Post Office, Fowler, IN; Whitney; Tel Aviv Museum, Israel; sculpture commissions for New York World's Fair and others. Exhibited: Whitney Museum of American Art, 1936-46; Penna. Academy of Fine Arts, 1939-56; Art Institute of Chicago, 1942, 43; Metropolitan Museum of Art, 1941; Museum of Modern Art; ACA Gallery, 1938, 41, 42, 44; Benson Gallery, Bridgehampton, NY, 1973, 75, 78 (all one-man exhibits); many others. Lectures: Contemporary Sculpture. Instructor of Sculpture, Stuyvesant Adult Center, NY, from 1960. Address in 1982, 225 East 21st St., NYC.

WESCHLER, ANITA.
Sculptor and painter. Born in NYC. Studied at Parsons School of Design; Art Students League with Zorach; Penna. Academy of Fine Arts with Laessle; National Academy of Design; Columbia Univ. Barnes Foundation. Awards: Montclair Art Museum; Society of Washington Artists; San Franscisco Museum of Art; Friends of American Art, Grand Rapids, Michigan; fellowship, McDowell Colony; American Federation of Arts traveling exhibition, 1951; National Association of Women Artists, 1952; fellowship, Penna. Academy of Fine Arts, 1957. Collections: Whitney Museum of American Art; Univ. of Nebraska; Norfolk Museum of Art and Science; Tel-Aviv Museum; US Post Office, Elkin, North Carolina. Exhibitions: Whitney; National Institute of Arts and Letters; Phila. Museum of Art; Metropolitan Museum of Art; Museum of Modern Art; others. Address in 1982, 136 Waverly Place, New York City.

WEST, BERNICE DELMAR.
Sculptor. Born in NYC, April 26, 1906. Studied with Archipenko, E. Amateis, Lu Duble, W. Zorach, W. Reiss; Art Students League, 1928-30; grad. The Bennett School, Millbrook, NY, 1925. Works: Heroic Osceola, Silver Springs, FL; bronze statue of Dr. Fred H. Albee in Venice Bank (FL); bas-relief of Theodore L. Mead in Mead Botanical Gardens, Winter Park, FL; Wadsworth Atheneum; Mint Museum; cork mural in lobby of Little Theatre, Charlotte, NC; portraits of R. Werrenrath, R. Coleman, A. Bodanzky, and A. Corwin. Exhibitions: One-man shows, Contemporary Arts, 1931; Midtown Gallery, 1932; Ferargil Gallery, 1933; Federal Art Gallery (St. Petersburg, FL), 1936; Mint Museum (Charlotte, NC), 1941; National Academy of Design, 1941; Conn. Academy of Fine Art, 1941-52; many others. Awards: National Association of Women Artists, 1932, 40, 55; 2nd prize

Southern States Art League, 1940; 1st prize Conn. Academy Annual, 1943; 1st prize Bronxville (NY) Federation of Art Exhibit, 1955. Trustee Dallas Museum of Fine Art; Dallas Symphony Orchestra; Southern Vermont Art Center. Member: Conn. Academy; National Association of Women Artists; Pen and Brush; Dallas Art Association; Dallas Craft Guild; Southern Vermont Artists; Mid-VT Artists; American Artists Professional League; Dallas Museum League. Address in 1962, Dallas, Texas.

WEST, CHARLES MASSEY, JR.
Sculptor, painter, and teacher. Born in Centreville, MD, December 5, 1907. Studied at Penna. Academy of Fine Arts; University of Iowa; John Herron Art Institute, B.F.A. Member: Wilmington Society of Fine Art. Awards: Cresson traveling scholarship, Penna. Academy of Fine Arts, 1934; prizes, Indiana Art Association, 1940, 41; Hoosier Salon, 1942; Delaware Artists, 1942, 43. Exhibited: Corcoran Gallery of Art, 1941, 43; Art Institute of Chicago, 1942; Penna. Academy of Fine Arts, 1941; Baltimore Museum of Art, 1941; Delaware Artists, 1939-46; Cincinnati Museum Association, 1942. Position: Instructor of Painting, John Herron Art Institute, Indianapolis, IN, 1939-43. Address in 1953, Centreville, MD.

WEST, W. RICHARD (DICK).
Sculptor and painter. Born in Darlington, Oklahoma, September 8, 1912. Studied at Haskell Institute; Bacone College; University of Oklahoma, B.F.A. and M.F.A.; University of Redlands; also with Olaf Nordmark. Work in Smithsonian Institution, Washington, DC; Joslyn Memorial Art Museum, Omaha, Nebraska; Philbrook Art Center, Tulsa, Oklahoma; Gilcrease Museum, Tulsa; sculpture, North American Indian Center, Chicago, 1960's; others. Received Citation of Indian Arts and Crafts, 1960; Philbrook Art Center National Show, 1960, first place for sculpture. Address in 1982, Ft. Gibson, OK.

WESTCOAST, WANDA.
Sculptor. Born in Seattle, Washington, October 31, 1937. Studied at University of Washington; with Spencer Mosely, Alden Mason, Wendell Brazeau, Walter Isaacs. Has exhibited at San Francisco Art Institute; Henry Gallery, Seattle; Los Angeles Co. Museum of Art; Whitney Biennial, 1975; others. Associate professor at California State University, Los Angeles, from 1961; Otis Art Institute, Parsons School of Design, Los Angeles, from 1974. Works in plastic. Address in 1982, Venice, CA.

WESTCOTT, WILLIAM CARTER.
Sculptor. Born in Atlantic City, NJ, October 4, 1900. Studied: Sorbonne, Paris, France; Art Students League. Member: National Sculpture Society; Fellow, Royal Society of Arts, London. Awards: Earle award for sculpture. Work: Lou Gehrig Memorial bust, Boy's Town; monuments, busts, memorials, Staunton, VA; Virginia Military Academy; Mayfield, PA; St. Lo, France; Bush Terminal, Brooklyn, NY; Northwestern Military and Naval Acad.; many portrait busts of prominent persons. Exhibited nationally. Address in 1953, 248 East 33rd St., NYC; s. Barnstable, Devon, England.

WESTERMANN, H. C.
Sculptor. Born in Los Angeles, Calif., December 11, 1922.

Studied at Chicago Art Institute School, 1947-54, with Paul Wieghardt. Works: Art Institute of Chicago; Wadsworth Atheneum; Los Angeles County Museum of Art; Pasadena Art Museum; Whitney; Walker. Exhibitions: Allan Frumkin Gallery, Chicago and NYC; Dilexi Gallery, Los Angeles, 1962, San Francisco, 1963; Kansas City (Nelson); Los Angeles County Museum of Art; Houston Museum of Fine Art; Wadsworth Atheneum; American Federation of Arts; Museum of Modern Art; Tate; The Hague, New Realism; Art Institute of Chicago; Worcester Art Museum; Walker; Carnegie; Documenta IV, Kassel, Germany, 1968; others. Awards: Art Institute of Chicago, Campana Prize, 1964; National Council on the Arts, 1967; Tamarind Fellowship, 1968. Address in 1980, Brookfield Center, CT. Died in 1981.

WESTFALL, CAROL D.
Sculptor and educator. Born in Everett, PA, September 7, 1938. Studied at Rhode Island School of Design, BFA; Maryland Institute, College of Art, MFA. Work in New Jersey State Museum, Trenton, and others. Has exhibited at Delaware Museum of Art, Wilmington; Baltimore Museum of Art, MD; 7th Biennial of Tapestry, Museum Cantonal des Beaux Arts, Lausanne, Switzerland; Museum of Art, Carnegie Institute International, Pittsburgh; and others. Received awards from Baltimore Museum of Art, Levi Sculpture Award; and others. Member of Handweavers Guild of America; American Crafts Council. Works in mixed media. Address in 1982, Nutley, NJ.

WESTGERDES, GERALD.
Sculptor. Born on July 28, 1941. Studied: University of Dayton, B.S., Art Education, 1964; Otis Art Institute, Los Angeles, CA, B.F.A., 1971, M.F.A., 1973; also under Robert Koepnick, Lorenzo Fenci, Joseph Martinek, and David Green. Exhibited: Barnsdall Park, Los Angeles, CA, 1971, 72; Otis Art Gallery, Los Angeles, CA, 1971; Ann Arbor Art Association Gallery, 1977; Kalamazoo Institute of Art, 1982; others. Commissions: "Madonna and Child," cast stone, Kalamazoo, MI, 1982; figurative busts of Madonna and Katherine Tekakwitha, St. Edward Church, Mendon, MI; others. Awards: Honorable Mention, Beverly Hills Art League Festival, 1971; Award, Kalamazoo Area Show, 1975. Instructor of sculpture, Nazareth College, Nazareth, MI, from 1973. Member: National Association of Schools of Art and Design; Sculptors International; Foundations in Art Theory and Design. Media: Clay, wax, resin, bronze, concrete. Address in 1984, Nazareth College, Nazareth, MI.

WESTON, MORRIS.
Sculptor, painter, writer, and teacher. Born in Boston, MA, November 19, 1859. Member: League of American Artists. Address in 1924, 57 East 59th St.; 660 Lexington Ave., NYC.

WETHERBEE, ALICE NEY.
Sculptor. Born in NY. Pupil of Larroux in Paris. Address in 1910, 85 Avenue Malakoff, Paris, France.

WEYHE, ARTHUR.
Sculptor. Born in New York, NY. Work in Everson Museum of Art, Syracuse, NY; Herbert F. Johnson Museum

of Art, Cornell University; Storm King Art Center, Mountainville, NY; and others. Has exhibited at Mercer Gallery, NY, 1975, 77; O. K. Harris Gallery, NY, 1976; and others. Address in 1982, 140 Sullivan Street, New York, NY.

WHEATLEY, THOMAS JEFFERSON.
Sculptor, painter, and potter. Born in Cincinnati, OH, November 22, 1853. Member: Cincinnati Art Club. Address in 1908, 2518 Highland Ave.; h. Mt. Auburn, Cincinnati, OH.

WHEELER, E. KATHLEEN.
(Mrs. Kathleen Wheeler Crump). Sculptor. Born in Reading, England, October 15, 1884. Studied under Esther M. Moore and Frank Calderon, and also at the Slade School in London. Came to America in 1914. Exhibited at the Paris Salon in 1906; Royal Academy in 1910; National Sculpture Society, 1923. Member: Society of Wash. Artists; Guild of Boston Artists. Awards: Prizes, Art Institute of Chicago; Society of Wash. Artists. Work: "Death and Sleep," Harvey's Museum, St. John's Wood, London, England; Hackley Art Gallery, Muskegon, MI; "The Roundup," Canadian Pacific Railway, London. Specialized in animals, and made portraits in bronze of the leading horses of America. Address in 1953, Chevy Chase, MD.

WHEELER, HUGHLETTE TEX.
Sculptor. Born in Texas about 1900. Studied modeling in Chicago. Work in Amon Carter Museum of Western Art; Will Rogers State Park (Santa Monica); Santa Anita Racetrack (Arcadias, CA). Examples of his work are scarce; titles include life-size statue, "Seabiscuit;" "Foal." Specialty was Western subjects, chiefly horses and cowboys; worked in bronze. Living in Tucson, AZ, in 1935. Died in Christmas, Florida, 1955.

WHEELOCK, LILA AUDOBON.
Sculptor. Born 1890. Specialty, animals.

WHEELOCK, WARREN.
Sculptor, painter, and craftsman. Born Sutton, MA, January 15, 1880. Pupil of Pratt Institute, Brooklyn. Member: Society Independent Artists; Sculptors Guild. Award: Honorable mention, Pan-American Exhibition, Los Angeles, Calif., 1925. Work: "Old Man and Child," Los Angeles Museum of Art; Whitney; Art Institute of Chicago; others. Exhibited at Musee du Jeu de Paume, Paris; Museum of Modern Art, NYC; Carnegie; Art Institute of Chicago; Whitney; Metropolitan Museum of Art; others. Address in 1953, 400 East 57th Street, NYC.

WHETSTONE, JOHN S.
Portrait sculptor. Worked: Cincinnati, 1837-41.

WHINSTON, CHARLOTTE.
Sculptor, painter, and graphic artist. Born in NYC. Studied at NY School of Fine and Applied Arts; National Academy of Design; Cooper Union Art School; Art Students League; and with George Luks, George Maynard, and Frederick Roth. Awards: Scholarship, NY School of Fine and Applied Arts, 1915; Cooper Union Art School,

1921; American Artists Professional League, 1947; Yonkers Art Association, 1948; New Rochelle Women's Club, 1948, 1951; State Teachers College, Indiana, Penna., 1949; City College, NY, 1916; National Academy of Design, 1917; Pen and Brush Club, 1948; Argent Gallery, 1957; Church of the Covenant, 1958; gold medal, Catholic Art Society, 1958. Collections: Norfolk Museum of Art; Seton Hall Univ.; exterior mural, Avenue of the Americas, NY. Exhibitions: Audubon Artists Annual; Allied Artists American Annual, National Academy of Design Galleries, 1950-75; Artists Equity Association, NYC; Whitney; many others. Address in 1976, Tudor City Place, NYC.

WHITE, BRUCE HILDING.
Sculptor. Born in Bay Shore, New York, July 11, 1933. Studied at University of Maryland, BA; Columbia University, MA & EdD. Work at University of Illinois, Champaign; Indianapolis Museum of Art, IN; and others. Has exhibited at Art Institute of Chicago; Chicago Fine Arts Council, 1981; and others. Teaching sculpture, Northern Illinois University from 1968. Works in metal. Address in 1982, c/o Department Art, Northern Illinois University, De Kalb, IL.

WHITE, FRANKLIN.
Sculptor. At Philadelphia, 1852.

WHITE, FRITZ.
Sculptor. Born in Ohio. Studied art in Cincinnati. Moved west in 1954. Made architects renderings and developed commercial art business before devoting career to sculpture. Exhibited: "And Finally Crockett Fell," Phoenix Art Museum, 1974; "Beaver Thief," Phoenix Art Museum, 1975; "The Chisholm Trail Drover," Exhibition of Contemp. Western Art, Missouri Athletic Club, St. Louis. Awards: Elected to Cowboy Artists Association, 1973; received Cowboy Artists Association best of show award and gold medal for sculpture, Phoenix Art Museum, 1974; silver medal, Phoenix Art Museum, 1975; purchase award, "Chisholm Trail Drover." One of four combat artists selected by US Marine Corps to sculpt figures of American soldiers in Vietnam. In Harmsen Collection of Western American Art. Works in bronze. Living in Valley Mills, Texas.

WHITE, HELENE MAYNARD.
Sculptor and portrait painter. Born Baltimore, MD, May 26, 1870. Pupil of Moran, Chase, Cecilia Beaux and Grafly; studied in Paris. Member: Fellowship Penna. Academy of Fine Arts; Harmonic Society; Plastic Club; Lyceum Club; International Society; prize, Art Club of Phila.; medal, Calif. Work: "Last Mohicans" (sculpture), Roosevelt, Ariz.; "William H. Carpenter," Union National Bank; "Hugh Clarke" (sculpture), University of Penna.; "Robert Lee Jarvis," Bethany College Church. Modeled heroic figure, "Chingachgook," for Mohican Lodge, Red Bank, NJ; "Liberty," San Francisco. Address in 1929, Southeast corner Walnut at 16th Street, Philadelphia, PA; summer Overbrook, PA.

WHITE, RICHARDSON.
Sculptor. Born in Cohasset, MA, 1904. Studied: Harvard

College, 1927; apprenticed for several years under Boston sculptor, Joseph Colletti. Exhibited: Boston Tercentenary Fine Arts Exhibition at Horticultural Hall; numerous one-man exhibits, including Doll and Richards Gallery, Boston, MA; Fitchburg Art Museum, Andover Academy; Chicago Livestock Show; Dartmouth College; Harvard College; Sotheby Parke Bernet; Animal Artists Society. Awards: National Sculpture Society for his "Guernsey Bull;" Maurice Hexter Award for "Redring Clydesdale;" Chilmark Award for small scale study entitled "Fave-Gaited Horse," 1981. Member: Animal Artists Society, New England Sculpture Association, National Sculpture Society. Address in 1983, Holly Hill Farm, Cohasset, MA.

WHITE, ROBERT (WINTHROP).
Sculptor and educator. Born in New York, NY, September 19, 1921. Studied with Joseph Weisz, Munich, 1932-34; John Howard Benson, Rhode Island School of Design, 1938-42 and 1946; and with Waldemar Raemisch. Work in Brooklyn Museum, New York; Rhode Island School of Design Museum, Providence; Peabody Museum of Natural History, Yale University; and others. Has exhibited at Penna. Academy Annual, Philadelphia; Hirschl & Adler Galleries, New York; Pratt Institute, traveling exhibition; and others. Received American Academy in Rome Fellowship, 1952-55; National Academy of Design Proctor Memorial Prize, 1962; and others. Address in 1982, St. James, New York.

WHITFIELD, JOHN S. (OR W.).
Sculptor, portrait painter, and cameo portraitist. Active in Cambridge, MA, 1828; Philadelphia, 1829; Patterson, NJ, 1848; and NYC, 1849-1851.

WHITNEY, ANNE.
Sculptor and poet. Born in Watertown, MA, September 2, 1822. Studied sculpture in Rome, Munich, and Paris from 1859 to 1864. Set up a sculpture studio in Watertown, NY, 1860. In 1873 she established a studio in Boston, which she maintained until her death. Her works include a statue of Samuel Adams for the Capitol in Washington, of which a bronze replica is in Adams Square, Boston; Harriet Martineau at Wellesley College; Leif Eriksen, in bronze, in Boston and Milwaukee; "Roma" in Albany, Wellesley, St. Louis and Newton; Calla Fountain in Franklin Park; seated statue of Charles Sumner, Harvard Law School; others. Died in Boston, MA, January 23, 1915.

WHITNEY, FRANK.
Sculptor, painter, and illustrator. Born in Rochester, MN, April 7, 1860. Pupil of Julian Academy in Paris, under Puech, Bouguereau, and Ferrier. Specialty, animals. Address in 1910, Hubbardwoods, IL.

WHITNEY, GERTRUDE VANDERBILT.
(Mrs. Harry Payne Whitney). Sculptor. Born April 1877, NYC. Pupil of James E. Fraser, Harry Anderson at Art Students League; Andrew O'Connor in Paris. Member: National Association Women Painters and Sculptors; National Sculpture Society; National Association Portrait Painters; Newport Art Association; New Society Artists;

National Arts Club. Awards: Honorable mention, Paris Salon, 1913; National Arts Club prize, National Association Women Painters and Sculptors, 1914; bronze medal, P.-P. Exp., San Fran., 1915. Founded Whitney Club, forerunner of the Whitney Museum. Works: Aztec fountain, Pan-American building, Wash., DC; El Dorado fountain, San Fran. Exposition; two panels for Triumphal Arch, NYC; Soldiers memorial, Washington Heights, NYC; fountain, McGill Univ., Montreal; Titanic Memorial statue, Wash., DC. Exhibited at National Sculpture Society, 1923. Address in 1929, 871 Fifth Ave., NYC. Died on April 18, 1942.

WHITNEY, MARGARET Q.
Sculptor. Born in Chicago, IL, in 1900. Pupil of Charles Grafly. Member: Philadelphia Art Alliance; Fellowship, Penna. Academy of the Fine Arts. Address in 1926, 147 Gates Ave., Montclair, NJ.

WHITON, MARGARET LOW (MRS.).
Sculptor. Address in 1934, Westport, Conn. (Mallett's)

WICKER, MARY H. (MRS.).
Sculptor and painter. Born in Chicago, Ill. Pupil of Julian Academy in Paris, Brangwyn, Hawthorne, Pushman, Gaspard, Browne, Sgukalsky. Member: National Arts Club; American Artists Professional League; Ill. Academy of Fine Arts; Chicago Painters and Sculptors; Chicago Art Club; Hoosier Salon Patrons Association. Awards: American Artists Exhibition, Art Institute of Chicago, 1923 and 1924. Address in 1933, 450 St. James Pl., Chicago, Ill.

WICKES, WILLIAM JARVIS.
Sculptor, and painter. Born Saginaw, MI, May 26, 1897. Pupil of Art Inst. Chicago. Member: Alliance. Address in 1929, 1016 Genesee Ave., Saginaw, MI.

WIDSTROM, EDWARD FREDRICK.
Sculptor. Born in Wallingford, CT, November 1, 1903. Studied: Detroit School of Art; Art Students League; and with Arthur Lee, William Zorach. Commissions: 36 Presidents of US, International Silver Co., Meriden, 1939-70; portrait reliefs, St. Stevens School, Bridgeport, CT, 1950; Municipal Building, Meriden, 1966; Marionist School, Thompson, CT, 1968. Member: Conn. Academy of Fine Arts; New Haven Paint and Clay Club; Meriden Arts and Crafts Assn. Awards: Prizes, Meriden Arts and Crafts Association, 1937, 46. Exhibited: National Academy of Design, 1940; Penna. Academy of Fine Arts, 1939, 40; Fairmount Park, Phila., 1940; Conn. Academy of Fine Arts, 1934-46; New Haven Paint and Clay Club, 1939-46; Meriden Arts and Crafts Association, 1936-46. Address in 1982, Meriden, CT.

WIECHMANN, MARGARET HELEN.
Sculptor. Born in NY in 1886. Pupil of A. Phimister Proctor; Art Students League and National Academy of Design, NY. Specialty, small bronzes of animals. Address in 1926, Wainscott, LI, NY.

WIEDERSHEIM, GRACE GEBBIE.
See Mrs. Drayton.

WIEHLE, PAUL.
Sculptor. Member New York Architectural League 1901. Address in 1910, 409 East 24th St., New York City.

WIENER, MADELINE.
Sculptor. Born in NYC in 1947. Studied at New York School of Interior Design, 1966-67; New York School of Visual Arts, 1967-74; with Herb Kallem and Akiba Emanuel, 1971-74. Has exhibited at Unicorn Gallery, NYC; School of Visual Arts, NYC; Lynn Kottler, NYC; Gilpen County Arts Association (juried shows), Colorado; others. Address in 1984, Aurora, CO.

WIGGIN, JESSIE DUNCAN.
Sculptor. Born in Boston, Mass., 1872. Address in 1934, New York. (Mallett's)

WIGGLESWORTH, FRANK.
Sculptor and painter. Born in Boston, MA, February 7, 1893. Pupil of Charles Grafly. Member: Boston Society of Sculptors; Boston Art Club; North Shore Art Association; Gloucester Society of Artists. Address in 1933, Boston, MA.

WIKEN, DICK.
Sculptor, craftsman, designer, writer, teacher, and lecturer. Born in Milwaukee, WI, April 11, 1913. Studied: Univ. of Wis. Extension Division. Member: Wis. Painters and Sculptors. Awards: Prizes, Milwaukee Art Inst., 1934, medal, 1935; Wis. Painters and Sculptors, 1935; Madison Salon, 1935, 37. Work: Pub. Sch., Milwaukee, WI; Soldier's Field, Administration Bldg., Chicago; many sculptured portraits. Exhibited: Wis. Painters and Sculptors, 1934, 35, 37, 39-41; Madison Salon of Art, 1935, 37, 39, 40; Wash., DC, 1936, 37; Rockefeller Center, NY, 1934, 38; NY World's Fair, 1939; Penna. Acad. of Fine Arts, 1940; Mississippi Valley Artists, 1941; Art Inst. of Chicago, 1941; Syracuse Mus. of Fine Art, 1939; Nat. Exh. Am. Arts, NY, 1937, 38. Lectures: Woodcarving; Ceramic Sculpture, etc. Address in 1953, Milwaukee, WI.

WILBUR, MARGARET CRAVEN.
Sculptor. Address in 1934, New York. (Mallett's)

WILCOX, JOSEPH P.
Sculptor and marble cutter. Worked: Newark, New Jersey. Exhibited: American Institute, 1856; National Academy, 1859.

WILDENHAIN, FRANS RUDOLPH.
Sculptor, painter, ceramic craftsman, and teacher. Born in Leipzig, Germany, June 6, 1905. Studied: Bauhaus, Weimar, Germany, and with Walter Gropius, Klee, Kandinsky, Moholy-Nagy, Josef Albers, and others. Member: Boston Society of Arts and Crafts. Awards: Prizes, International Exp., Paris, 1939; Exh. Art, Los Angeles, 1949; Calif. State Fair, 1949; Wichita Art Association, 1951; Rochester Mem. Art Gallery, 1951; Albright Art Gallery, 1952. Work: Stedelijk Museum, Amsterdam; Stoke-Upon-Trent, England; Mons, Belgium; Faenza and Milan, Italy; Portland Art Museum; Seattle Art Museum; Scripps College; Baltimore Museum of Art; Indianapolis Art Association; Art Institute of Chicago. Exhibited: Metropolitan Museum of Art, 1929; San Fran. Museum of Art, 1949; de Young Memorial Museum, 1948; Portland Art Museum, 1949; San Diego Art Gallery; Art Institute of Chicago; Walker Art Center; Des Moines Art Center; Virginia Museum of Fine Art; University of Calif. at Los Angeles; Dallas Musuem of Fine Art; Ft. Worth Art Association; University Redlands; Henry Gallery, Seattle; Wichita Art Association; Baltimore Museum of Art; Syracuse Museum of Fine Art, 1952. Contributor of ceramic designs to *Art and Architecture, House Beautiful, Craft Horizons*, and other publications. Position: Instructor, Ceramics, School for Am. Craftsmen, Rochester, NY, from 1953. Address in 1976, Rochester, NY. Died in 1980.

WILDENRATH, JEAN A(LIDA).
Sculptor and painter. Born Denmark, November 3, 1892. Pupil of George Ford Morris, Joshua Dupont; Cooper Union; National Academy Design. Address in 1933, 2707 Sedgwick Ave., New York, NY.

WILDER, LOUISE HIBBARD.
(Mrs. Bert Wilder). Sculptor, etcher, and teacher. Born Utica, NY, October 15, 1898. Pupil of George T. Brewster. Member: National Association Women Painters and Sculptors. Award: Honorable mention, National Garden Show, New York, 1929. Work: Relief, Court House, Newark, NJ; memorial fountain, Home for Indigent Aged, Washington, DC. Taught: Instructor, School of Sculpture and Painting. Address in 1929, 10 East 8th St., New York, NY; summer, Homer, NY.

WILEY, WILLIAM T.
Sculptor and painter. Born in Bedford, IN, October 21, 1937. Grew up in Richmond, Washington, near Seattle. Studied at the San Francisco Art Institute, BFA, 1960, MFA, 1962. Exhibited: Looking West, Joslyn Art Museum, Omaha, NE, 1970; Retrospective, Univ. of CA, Berkeley, 1971; one-man shows, Studio Marconi, Milan, Italy, 1971; Art Institute of Chicago, 1972; Corcoran Gallery of Art, Wash., DC, 1972; and Museum of Modern Art, NY, 1975; Documenta, Kassel, W. Germany, 1972; Albright-Knox Gallery, Buffalo, NY, 1972; Whitney Museum of American Art, NY, 1973; Corcoran Gallery of Art, Wash., DC, 1975; and numerous others. Works in a variety of media: Drawing, watercolor, construction, earthworks, assemblage, film, combining several of them in one piece as in "Enigma Doggy," 1968, made of wood, paint, chain, canvas, and lead; also his "Random Remarks and Digs," 1971; "American Rope Trick," 1967-68; and "Pure Strain," 1970. Address in 1982, Box 654, Woodacre, CA.

WILFRED, THOMAS (RICHARD EDGAR LOVSTROM).
Sculptor. Born in Naestved, Denmark, June 18, 1889. Studied at Sorbonne. Works: Clairol Inc.; Cleveland Museum of Art; Honolulu Academy; Metropolitan Museum of Art; Museum of Modern Art; Omaha (Joslyn). Exhibitions: Museum of Modern Art; Stockholm (National); Eindhoven, Kunst-Licht-Kunst; Walker and Milwaukee, Light Motion Space; Trenton State, Focus on Light; The Howard Wise Gallery, NYC, Lights in Orbit, and Festival of Lights; Worcester Art Museum, Light and Motion. Awards: Philadelphia College of Art, Honorary Ph.D.,

1968. Died in West Nyack, NY, August 15, 1968.

WILKE, HANNAH.
Sculptor and instructor. Born in NYC, March 7, 1940. Studied at Temple Univ., B.F.A., 1961, B.S., 1962. Works: Albright-Knox Art Mus., Buffalo, NY; Allen Art Mus., Oberlin, Ohio; Brooklyn Mus., NY; Power Inst., Sydney, Australia; Metro-Media, Channel 5, NY. Exhibitions: One-woman shows, Sculpture and Drawing, Ronald Feldman Fine Arts, NY, 1972, 74, and 75; Drawing Show, Margo Leavin Gallery, Los Angeles, 1974; Whitney Mus. Biennial, NY, 1973; Women Choose Women and Soft Sculpture, New York Cultural Center, 1973; 5 Americans in Paris, Galerie Gerald Piltzer, France, 1975. Awards: Sculpture Award, Creative Arts Program Service, New York State Council on the Arts, 1974; National Endowment for the Arts; others. Taught: School of Visual Arts, NYC, from 1974. Media: Latex rubber, terra-cotta; video. Address in 1982, 62 Greene Street, NYC.

WILL, BLANCA.
Sculptor, painter, and illustrator. Born Rochester, NY, July 7, 1881. Pupil of Herbert Adams, James Fraser, G. G Barnard, D. W. Tryon, John Alexander; Tyrohn in Karlsruhe; Luhrig in Dresden; Castellucho in Paris. Award: First prize, portrait, Memorial Gallery, Rochester; Fairchild award, Rochester; NM State Fair, 1938-40. Exhibited at National Academy of Design; Penna. Academy of Fine Arts; others. Represented in Memorial Art Gallery, Rochester, NY; numerous oil portraits and busts, including Herman Le Roy Fairchild, University of Rochester. Director art instruction, Memorial Art Gallery, Rochester, NY. Address in 1929, 175½ Stonewood Avenue, Rochester, NY; summer, Birchlea Studio, Bluhill Falls, ME. Living in Blue Hill, ME, in 1953.

WILLARD, SOLOMON.
Carver in stone and wood, architect, teacher. Born in Petersham, MA, June 26, 1783. Learned carpenter's trade there. Settled in Boston in 1804. Began wood carving in 1809; turned to figurehead carving in 1813. Executed the figure for the frigate *Washington*. Became a leading architect in Boston, after 1820; also taught drawing and sculpture. Designed the Bunker Hill Monument, and supervised its erection. Died in Quincy on February 27, 1861.

WILLE, O. LOUIS.
Sculptor and teacher. Born in St. Paul, MN, April 27, 1917. Studied at University of Minnesota, B.A., M.A. Exhibited: Kraushaar Gallery; Sculpture Center, NY; Walker Art Center; Minneapolis Institute of Art; University of Minnesota; Denver Art Museum; San Francisco Museum of Art; Everson, Syracuse. Position: Dir., Aspen Art School, Aspen, CO, 1953. Address in 1982, Aspen, CO.

WILLENBECHER, JOHN.
Sculptor and painter. Born in Macungie, PA, May 5, 1936. Studied at Brown University, with William Jordy, George Downing, BA, 1958; NYU, with Craig Hugh Smyth, 1958-61. Works: Albright, Buffalo, NY; Aldrich, Ridgefield, CT; Whitney; Hirshhorn Sculpture Garden, Gug-

genheim; others. Exhibitions: Feigen-Herbert Gallery, NYC; Feigen-Palmer Gallery, Los Angeles; Richard Feigen Gallery, NYC and Chicago; Albright; Rhode Island School of Design; Whitney; Eindhoven, Kunst-Licht-Kunst; Everson, Syracuse, NY; Arts Club, Chicago; others. Address in 1982, 145 W. Broadway, NYC.

WILLIAMS, CHARLES WARNER.
See Williams, Warner.

WILLIAMS, FREDERIC ALLEN.
Sculptor. Born West Newton, MA, April 10, 1898. Pupil of National Academy of Design; Beaux-Arts Institute ·of Design; and Robert Aitken. Work: Sundial, "The Arrow Maker," Arkell Museum, Canajoharie, NY. Exhibitions: National Academy of Design, 1926, 28, 31, 33, 35, 36, 42-44; Penna. Academy of Fine Arts, 1926, 27; National Sculpture Society, 1929; Metropolitan Museum of Art, 1942. Address in 1953, New York, NY. Died in 1968.

WILLIAMS, GARTH MONTGOMERY.
Sculptor, painter, illustrator, writer, cartoonist, and designer. Born in NYC, April 16, 1912. Studied at Westminster School of Art; Royal College of Art, London, England. Awards: Prix de Rome, 1936. Exhibited: British Royal Academy, 1933-35, 38. Illustrator, "Stuart Little," 1945; "In Our Town;" "Little Fur Family;" "Wait 'Til the Moon is Full;" "Charlotte's Web," 1952; several Golden Books. Author and illustrator of "Benjamin Pink," 1951. Contributor cartoons to *New Yorker* magazine. Address in 1982, Guanajuato, Mexico.

WILLIAMS, JAMES ROBERT.
Sculptor, painter, and cartoonist. Born in Halifax, Nova Scotia, Canada, 1888. Studied at Mt. Union College in Alliance, OH. Worked as a fireman on the Pennsylvania Railroad; as a ranch hand in New Mexico; as a Fort Sill muleskinner with the Apaches in Oklahoma; in the US Cavalry; in factories as a machinist. As cartoonist created "Out Our Way," sold to newspaper syndicate in 1922; and many other cartoons. Painting and sculpture subjects were Western. Died probably in San Marino, CA, 1957.

WILLIAMS, LOUISE A.
Sculptor. Address in 1910, Tuttle Ave., corner Jenkins St., Augusta, GA.

WILLIAMS, RAMOND HENDRY.
Sculptor, painter, and teacher. Born Ogden, Utah, October 31, 1900. Pupil of Mabel Frazer, Charles J. Martin, William Varnum, and Arthur Gunther. Member: Utah Artists Guild; Lincoln Artists Guild; Madison Art Association. Work: "Southern Utah," Logan Junior High School, Logan, Utah. Address in 1933, 300 Morrill Hall, University of Nebraska; h. 721 North 24th St., Lincoln, Neb.

WILLIAMS, ROGER.
Sculptor. Born Dayton, OH, 1943. Studied: Cornell University, B. of Architecture, 1966; Hunter College, 1966-67. Member of the National Sculpture Society. Exhibited: Drawing Show, Bennington, College, VT, 1972; David Gallery, Rochester, NY, 1972; Sculpture by Roger Williams, Usdan Gallery, Bennington, VT, 1973; Janie Lee Gallery, Houston, 1974. Award: Lindsey Morris Memo-

rial Prize, 1973, National Sculpture Society. Address in 1982, Neosho, WI.

WILLIAMS, SHIRLEY C.
Sculptor. Born in Hackensack, NJ, August 22, 1930. Studied at Art Students League, with Sidney Dickenson, Gene Scarpantoni and William Dobbin; Frank Reilly School of Art, NY, with Jack Faragasso. Works: Northeastern Loggers Exhibition Hall, Old Forge, NY. Exhibitions: Catharine Lorillard Wolfe Art Club 70th Annual, Gramercy Park, NY, 1967; Vermont Lumberjack Roundup, State of Vt., Lake Dunmore-Killington, 1968-71; International Wood Collectors Exhibition, US National Arboretum, Wash., DC, 1971; American Artists Professional League Grand National, NY, 1972; Northeastern Loggers Exhibition Hall, 1972. Awards: Honorable Mention, American Artists Professional League, 1972. Media: Wood. Address in 1976, Rockland Lake, NY.

WILLIAMS, TODD.
Sculptor and painter. Born in Savannah, GA, January 6, 1939. Studied at City College of New York; School of Visual Arts, New York, certificate and scholarship, 1964. Work in Smithsonian Institution, Washington, DC; sculpture, Mexican Government, Olympic Village, Mexico City, 1968; and others. Has exhibited at Oakland Art Museum, Colored Sculpture; Witte Memorial Museum, Madison, Wis.; Cranbrook Academy of Art, Bloomfield Hills, Mich., 1966; Jewish Museum, New York, 1969; Contemporary Black Artists, Whitney Museum of American Art; and others. Teaching sculpture at Columbia University, New York, from 1976. Received John Hay Whitney Foundation Fellowship, 1965; Adolph and Clara Obrig Prize, National Academy of Design, 1972; and others. Address in 1982, Brooklyn, New York.

WILLIAMS, WALTER REID.
Sculptor. Born Indianapolis, IN, November 23, 1885. Pupil of Charles Mulligan, Bela Pratt; Paul Bartlett and Mercie in Paris. Member: Chicago Galleries Association; Hoosier Salon. Represented by "Goal," bronze, Woman's Athletic Club, Chicago. Address in 1933, Chicago, IL.

WILLIAMS, WARNER.
Sculptor and designer. Born in Henderson, KY, April 23, 1903. Studied at Berea College; Herron Art Institute; Art Institute of Chicago, BFA; Butler University. Work: Martin Luther King, bas-relief portrait, King Memorial, Atlanta, GA; Albert Schweitzer medallion, Schweitzer Memorial Museum, Switzerland; Thomas Edison Commemorative Medal, Smithsonian Institution; and many other memorials, medals, medallions, bas-reliefs, busts. Received awards from Hoosier Salon, 1928-42; City of Chicago, 1938; Herron Art Institute, 1925; Art Institute of Chicago, 1941; others. Member of Chicago Art Club; Chicago Art Association; Hoosier Salon; National Sculpture Society. Artist-in-residence, Culver Military Academy, Culver, IN, 1940-68. Address in 1982, Geodesic Dome Studio, Culver, IN.

WILLIAMS, WAYNE FRANCIS.
Sculptor. Born in Newark, NY, July 22, 1937. Studied at Syracuse University, B.F.A., 1958; M.F.A., 1962, Chaloner

Foundation fellowship, 1958 and 59; Skowhegan School of Painting and Sculpture, summer, 1956-57, with Harold Tovish. Work at Wichita Museum, KS; and others. Has exhibited at Belgium Salon des Beaux Arts, Museum voor Schone Kunsten, Ghent, Belgium; Frank Rehn Gallery, NY; NY Art Dealers Exhibition, Parke Bernet Gallery, NY; and others. Received Louis Comfort Tiffany Foundation Award for Sculpture. Works in metals. Address in 1982, Newark, NY.

WILLIAMS, WHEELER.
Sculptor, painter, and lithographer. Born Chicago, IL, November 3, 1897. Studied: Yale University, PhD.; Ecole des Beaux Arts, Paris, France. Pupil of John Wilson in Boston and Jules Coutau in Paris. Member: New York Architectural League; National Sculpture Society; American Institute of Fine Arts; others. Work: Tablet to French Explorers and Pioneers, Michigan Avenue Bridge, Chicago, IL; bust of Clifford Holland, entrance to Holland Tunnel, NYC; others. Exhibited: Salons des Artistes Francais, 1923-27; Salon d' Automne, Paris; Penna. Academy of Fine Arts; Art Institute of Chicago; National Academy of Design; Calif. Palace Legion of Honor; others. Address in 1970, 144 East 66th St., New York, NY. Died in 1972.

WILLIFORD, HOLLIS.
Sculptor and painter. Born in Waco, TX, in 1940. Studied at University of Texas; later at Art Center College of Design, Los Angeles. Worked as graphic artist in aerospace industry. Opened own studio in Denver in 1970. Exhibited at National Academy of Western Artists, 1980; Peking, China, show, 1981. Awarded Prix de West, National Academy of Western Artists, 1980. Member of Northwest Rendezvous Group. Specialty is Plains Indians (sculpture); Indians and Western landscapes (painting). Represented by Carson Gallery of Western American Art, Denver, CO. Reviewed in *Art West*, *Artists of the Rockies*, *Southwest Art*. Address since 1970, Denver, CO.

WILLIS, JAY STEWART.
Sculptor and educator. Born in Fort Wayne, IN, October 22, 1940. Studied at University of Illinois, Urbana, B.F.A. (sculpture), 1961, with Frank Gallo and Roger Majorweiz; University of California, Berkeley, M.A. (sculpture), 1966, with Donald Haskin, Harold Paris, Jacques Schneir and Peter Voulkos. Work at Metropolitan Museum of Art, NY; University of Southern California sculpture garden, Los Angeles; and others. Has exhibited at Los Angeles Institute of Contemporary Art; Crocker Art Museum, Sacramento, CA; and others. Received honorable mention, National Sculpture Exhibition, Southern Association of Sculptors; and others. Teaching sculpture at University of Southern California, Los Angeles, from 1969. Works in glass, metal, light metal, video, and photography. Address in 1982, Pasadena, CA.

WILLIS, R(ALPH) T(ROTH).
Sculptor, painter, illustrator, and etcher. Born Leesylvania, Freestone Point, VA, March 1, 1876. Pupil of Corcoran School of Art; Art Students League of NY; Academie Julian. Member: National Society of Mural Painters; CA Art Club. Works: Murals of 12 naval engage-

ments, Second Battalion Armory and murals in 22nd Regiment Armory, N.Y.N.G., NYC; decoration, Library of Congress, Wash., DC; murals, Pomona Building Loan Association, Pomona CA; and Angeles Temple, Los Angeles, CA; Brock Jewelry Store, Los Angeles. Address in 1933, Encinitas, CA.

WILMARTH, CHRISTOPHER MALLORY.
Sculptor and draftsman. Born in Sonoma, CA, June 11, 1943. Received BFA from Cooper Union, 1965; assistant to Tony Smith in late teens. Exhibited: Whitney Museum of American Art, 1966-79; Museum of Modern Art; Art Institute of Chicago, 1972; 20th Century Art Collection, Metropolitan Museum of Art, NY, 1974; one-man shows include Graham Gallery, 1968; Wadsworth Athenaeum, Hartford, CT, 1974, 77; Contemporary Sculpture, Museum of Modern Art, NY, 1979; Eight Artists, Albright-Knox Art Gallery, 1979; numerous others. Awards: Grant from the National Council on the Arts, 1969; Guggenheim Memorial Fellowship, 1972; Creative Artists Public Service Program, 1980; and others. Taught: Cooper Union, from 1969, as adjunct professor of sculpture; visiting critic of sculpture, Yale Univ., 1971-72; visiting artist, Columbia Univ., 1976-78. Noted for his exploration of the light-transmitting properties of glass in his art work. Address in 1982, P.O. Box 203, Canal St. Station, NYC.

WILSON, ALBERT.
Ship and ornamental carver. Born in Newburyport, MA, June 29, 1828. Son of Joseph Wilson. Worked in Newburyport with his father and brother (James Warner Wilson), c. 1850 until his death, November 26, 1893.

WILSON, CLARA POWERS.
Sculptor and painter. Address in 1919, 113 S. Seeley Ave., Chicago, IL.

WILSON, CRAIG.
Sculptor. Self-taught; influenced by his sculptor-father, Al Wilson. Exhibitions: Peterson Gallery, MA, 1970; Lillian Kornbluthe Gallery, NJ, 1970; Wilson Gallery, NY, 1970-81; 3 Crowns Gallery, NY, 1969-71; Memorial Art Gallery Finger Lakes Show, NY, 1971; Crossroads Show, NY, 1971; Kenan Center, NY, 1972; Kenneth Taylor Gallery, 1972; Kenneth Taylor Little Gallery, MA, 1972-74; Main St. Gallery, MA, 1973-75; State Fair Gallery, NM, 1973; Bodley Gallery, NYC, 1974; Wildlife Art Show, NY, 1978; Memorial Art Gallery Clothesline Show, NY, 1969-80; Kendall Gallery, MA, 1981; Society of Animal Artists Members Show, Salmagundi Club, NYC, 1980. Commissions: Harley School, Rochester, NY, 1975; Monroe County Club, NY, 1976; Genesee Savings Bank, NY, 1978; Voplex (Detroit) 1978; Columbia Savings Bank, NY, 1979; Parkridge Hospital, Rochester, NY, 1979; Don Nichols, NY, 1980. Member: Society of Animal Artists. Taught: Several artist-in-residence programs in Rochester Area high schools and colleges. Expeditions: Amherst Island. Specialty, wildlife (birds). Media: Steel. Address in 1983, Rochester, NY.

WILSON, EDWARD N.
Sculptor. Born in York, England. Pupil of Dalon. Address in 1898, Princeton, NJ.

WILSON, GILBERT BROWN.
Sculptor and painter. Born in Terre Haute, IN, March 4, 1907. Studied under Lucy Arthur Batten, W. T. Turman, E. L. Coe, Eugene Savage, E. A. Forsberg, and at Indiana State Teachers College; Art Institute of Chicago; Yale School of Fine Arts. Member: Terre Haute Paint & Brush Club; Art League of America. Awards: Culver Military Academy prize, Hoosier Salon, Chicago, 1929; second prize, Beaux-Arts Institute of Design, 1930; prize, IN State Kiwanis, Hoosier Salon, 1933. Work: Murals in Woodrow Wilson Jr. High Sch., Terre Haute; Indiana State Teachers College; Antioch College, Yellow Springs, OH. Address in 1953, 245 East 36th St., NYC; h. 1201 North 4th St., Terre Haute, IN.

WILSON, HELEN LOUISE.
Sculptor. Born in Chicago, IL. Studied at Wellesley College, A.B.; and with Bourdelle and Lauchantsky in Paris. Work: US Post Office, Lowville, NY. Exhibitions: Paris Salons; New York World's Fair; Whitney Museum, NY; National Academy of Design; Phila. Art Center; Richmond Museum; NJ Museum; others. Awards: National Association Women Artists, 1949, Medal of Honor, 1957; citation for sculpture, Architectural League, 1951; sculpture prize Audubon Artists, 1957. Member: Sculptor's Guild, Inc. (treas. 1956-57, exec. bd. 1957-61); Audubon Artists, Inc.; National Association Women Artists (exec. bd. 1959-60); Architectural League; Artists de Cagnes (France). Address in 1962, 68½ Morton St., NYC. Died in 1974.

WILSON, HENRY.
Marble cutter and painter. Worked in Chicago, 1849-60. Exhibited animal painting at Illinois State Fair, 1855. Painter of Oliver Wilson.

WILSON, J. H.
Sculptor. Active in Chesterfield, IL, 1855. Patentee—cast-iron monument, 1855.

WILSON, JAMES WARNER.
Ship and ornamental carver. Born in Newburyport, MA, July 2, 1825. Son of Joseph Wilson (1779-1857). Worked in Newburyport with his father and later with his brother Albert. Died in Newburyport on October 19, 1893.

WILSON, JOHN ALBERT.
Sculptor. Born in New Glasgow, Nova Scotia, April 10, 1878. Pupil of H. H. Kitson and B. L. Pratt in Boston. Address in 1910, 19 Grundmann Studios, Boston, MA.

WILSON, JOSEPH.
Ship and ornamental carver. Born in Marblehead, MA, November 2, 1779. Worked in Chester, NH, 1796-98; at Newburyport, MA, from 1798. Carved portrait statues and animal figures for the grounds of Timothy Dexter's house in Newbury. Subjects of these works include Washington, Adams, Jefferson, Dexter, Napoleon, Lord Nelson, and other prominent persons, as well as four lions, an eagle, lamb, unicorn, dog, horse, Adam and Eve, Fame, and a traveling preacher. Assisted by his sons, Albert and James Warner Wilson, after c. 1850. Died in

Newburyport, MA, March 25, 1857.

WILSON (or WILLSON), JOSEPH.
Sculptor. Born in Canton, NY, 1825. Active 1842-57. Worked in cameo cutting and die sinking in NYC, 1842-48; in Washington, DC, 1848-51; studied sculpture in Italy, 1851-54. Exhibited at National Academy of Design, NY. Died in NYC in 1857.

WILSON, KATE.
Sculptor. Born in Cincinnati, OH. Pupil of Louis Rebisso at Cincinnati Art Academy. Member: Cincinnati Women's Art Club. Teacher of drawing in public schools. Address in 1910, 2921 Montfort St., Cincinnati, OH.

WILSON, MAY.
Sculptor. Born in Baltimore, MD, September 28, 1905. Works: Whitney Museum American Art, NY; Baltimore Museum; Goucher College, Baltimore; Corcoran Gallery of Art, Wash., DC; Dela Banque de Pariset, Brussels, Belgium. Exhibitions: New Idea, New Media Show, Martha Jackson Gallery, NY, 1960; Museum of Modern Art Traveling Assemblage, NY, 1962; American Federation Arts Patriotic Traveling Show, NY, 1968; Human Concern Show, 1969, and Whitney Sculpture Annual, 1970, Whitney Museum. Awards: Baltimore Museum Art Show Awards, 1952 and 1959. Address in 1982, 208 West 23rd Street, NYC.

WILSON, MELVA BEATRICE.
Sculptor, mural painter, poet, and lecturer. Born in Madison, IN, in 1866. Studied: Cincinnati Art Museum; Cincinnati Art Academy; in Paris, with Rodin. Awarded an Honorable Mention, Paris Salon in 1897. Works: Corcoran Art Gallery, Washington, DC; State of NY; Tiffany & Company, NYC; Farley Memorial Chapel at Calvary, Long Island, NY; St. Louis Cathedral, St. Louis, MO. She was awarded the largest commission given any woman sculptor up to that time for the decoration of the buildings of the St. Louis Exposition. Died in NYC, June 2, 1921. Address in 1903, 467 Central Park West, NYC.

WILSON, MRS.
Sculptor. Born near Cooperstown, NY. Active about 1840-1850, in Cincinnati, OH. Work includes stone bust of her husband, Dr. Wilson; and other sculpture portraits.

WILSON, NICK.
Sculptor and painter. Self-taught. Exhibitions: Leigh Yawkey Woodson Museum of Bird Art, 1977-80; Smithsonian Institution, "Selections from the bird art exhibit," 1980. Awards: Third place award, First Annual "Royal Western Watercolor Competition," Cowboy Hall of Fame, Oklahoma City, OK. Member: Society of Animal Artists. Expeditions: Alaska, 1977; East Africa, 1977; Canada, 1981. Specialties: Mammals of the Southwest. Media: Bronze and porcelain; watercolor and graphics. Address in 1983, Payson, AZ.

WILSON, OLIVER.
Sculptor and marble cutter. Worked: Chicago, 1850's. Partner of Henry Wilson.

WILTZ, LEONARD JR.
Sculptor. At New Orleans, 1846-42. Worked in marble.

WINANS, WALTER.
Sculptor, painter, and illustrator. Born in St. Petersburg, Russia, of American parents, April 5, 1852. Pupil of Volkoff, Paul, Geroges and Corboult. Member: Peintres et Sculpteurs du Cheval. Work: Sculpture in Marble Palace, St. Petersburg; "Pegasus Alighting" and "Indian Fight," Hartsfeld House, London. Awarded Chevalier, Imperial Russian Order. Specialized in the horse. Worked in US. Died in London in 1920.

WINCHELL, ELIZABETH BURT.
(Mrs. John Patten Winchell). Sculptor and painter. Born in Brooklyn, NY, June 20, 1890. Pupil of Elliott Daingerfield, Henry B. Snell, Daniel Garber, W. W. Gilcrist, Jr., Harriet Sartain. Member: Haylofters, Portland, ME; Portland Watercolor Society. Awards: First prize, Wanamaker Exh., Phila., 1910-11; first prize, Flower Show Exh., Phila., 1911; second and third prizes, Flower Show Exh., Phila., 1928; honorable mention, C. L. Wolfe Art Club, NY, 1928. Address in 1933, Freeport, ME.

WINDISCH, MARION LINDA.
Sculptor. Born in Cincinnati, OH, June 20, 1904. Pupil of Clement J. Barnhorn and Edward McCartan. Awards: First and second prizes, Three Art Club, and honorable mention, Women's City Club, Cincinnati, OH. Address in 1933, 47 East 61st St., Apt. 8B, NYC.

WINEBRENNER, HARRY FIELDING.
Sculptor, illustrator, lecturer, and teacher. Born Summersville, W. VA, January 4, 1885. Studied at University of Chicago; Art Institute of Chicago; British Academy in Rome, Italy; Grande Chaumiere, Paris, France. Pupil of Taft, Mulligan, Sciortino. Member: Chicago Society of Artists; Calif. Art Club; Sculptors Guild of Southern Calif. Work: "Italian Boy" and "The Passing of the Indian," Oklahoma State Historical Society; "Fountain of Education," "Statue of Welcome," "The Soul of a Dancer," Venice. Art director, City of Venice, and head of art department, Venice Union Polytechnic High School. Author and illustrator of *Practical Art Education*. Address in 1953, Chatsworth, CA.

WINES, JAMES.
Sculptor and environmental artist. Born June 27, 1932, in Oak Park, IL. Earned B.A. at Syracuse Univ. School of Art, 1955; studied with Ivan Mestrovic. Lived in Rome. Taught at School of Visual Arts, NYC; Cornell; SUNY/Buffalo; Jersey Sch. of Arch. (Newark, NJ); Cooper Union, NY. Awarded Pulitzer Fellowship (1953); Guggenheim Fellowship (1962); Ford grant (1964); National Endowment for Architecture, 1973; National Endowment for Arts 1974. Exhibited at Everson Museum (Syracuse); Baltimore Museum of Art; Walker Art Center; Museum of Modern Art, and Sao Paulo Biennial (1963); Galleria Trastevere di Topazia Alliata, Rome; Los Angeles County Museum of Art; others. In collections of Whitney; Albright-Knox; Curries Gallery, NH; Syracuse; Stedelijk (Amsterdam); Tate; Colgate Univ.; NYU; Art Institute of Chicago; Cleveland Museum of Art; Herron (Indianapolis); Los Angeles Co. Museum of Art; plus many others. Address in 1982, NYC.

WINGATE, ARLINE (HOLLANDER).
Sculptor. Born in NYC in 1906. Studied at Smith College; in Europe; and with Alexander Archipenko. Works: Syracuse University Museum; Birmingham Museum of Art; National Museum, Stockholm, Sweden; Newark Museum; Ghent Museum, Belgium; Hirshhorn. Awards: National Association of Women Artists, 1945; Amelia Peabody award, 1956; Easthampton Guild Hall, 1958. Exhibitions at Metropolitan Museum of Art and Whitney Museum, NYC; Wadsworth Atheneum; San Francisco Museum; Art Institute of Chicago; Penna. Academy of Fine Arts; National Association of Women Artists; Brooklyn Museum; others in US and abroad. Address in 1983, East Hampton, NY.

WINGATE, CURTIS.
Sculptor and painter. Born in Dennison, TX, 1926. Studied with William Schimmel, watercolors. Rode in rodeos. Associate member of Cowboy Artists of America. Specialty is Western and rodeo subjects. Paints in oil and watercolors. Address in 1971, probably Phoenix, AZ.

WINKEL, NINA.
Sculptor. Born in Westfalen, Germany, May 21, 1905. US citizen. Studied in Germany. Works: War memorial, Seward Park High School, NY; monument, Charlotte, North Carolina; numerous others. Awards: National Academy of Design, 1945, 64, 78, 79; Avery award 1958; purchase prize, National Sculpture Society, 1981. Exhibited at Fairmount Park, Phila.; American Academy of Arts and Letters; many exhibitions at National Academy of Design; retrospective, Sculpture Center, 1972. Member: Fellow, National Sculpture Society; National Academy of Design; Sculptors Guild; Sculpture Center. Address in 1983, Keene Valley, NY.

WINN, JAMES HERBERT.
Sculptor, painter, craftsman, writer, and teacher. Born Newburyport, MA, September 10, 1866. Pupil of Art Inst. Chicago. Member: Cliff Dwellers Club; Alumni, Art Institute Chicago; Assn. of Arts and Industries. Awards: Arthur Heun prize, Art Institute Chicago, 1910; first prize and gold medal, Woman's Conservation Exhibition, Knoxville, TN, 1913. Instructor, Jewelry and Metal Work, Art Institute, Chicago. Address in 1929, 410 South Michigan Ave., h. 9522 Longwood Drive, Chicago, IL.

WINSLOW, GEORGE.
Sculptor. Address in 1934, Santa Fe, New Mexico. (Mallett's)

WINSOR, V. JACQUELINE.
Sculptor. Born in Newfoundland, Canada, October 20, 1941; US citizen. Studied: Yale Summer School of Art and Music; Mass. College of Art, B.F.A., 1965; Rutgers University, M.F.A., 1967. Collections: Museum of Modern Art; Whitney; Australia National Gallery, Canberra; Detroit Institute of Arts; Modern Museum, Paris. Numerous shows, including San Francisco Museum of Art; Museum of Modern Art; Whitney; Stedelijk (Amsterdam); VA Museum, Richmond; Zurich; and Hamburg. Received New York State Council on the Arts grant, 1973-74; National Endowment for the Arts grant, 1974-75.

Instructor of sculpture at the School of Visual Arts, NY, 1971, 75; also taught art and ceramics at several colleges and universities. Address in 1982, c/o Paula Cooper Gallery, NYC.

WINTER, ALICE BEACH.
(Mrs. Charles Allan Winter). Sculptor, painter, illustrator, and teacher. Born Green Ridge, MO, March 22, 1877. Pupil of St. Louis School of Fine Arts; Art Students League of New York; and with George de Forest Brush, Joseph De Camp. Member: North Shore Art Association; Business and Professional Women's Club, Gloucester; National Association of Women Painters and Sculptors. Specialty is childhood subjects. Exhibited: National Academy of Design; Penna. Academy of Fine Arts; Carnegie Institute; City Art Museum of St. Louis; National Association of Women Artists; Los Angeles Museum of Art; Contemporary New England Artists; North Shore Art Association. Child-life illustrator of covers and stories for national magazines. Address in 1953, 134 Mt. Pleasant Ave., East Gloucester, MA.

WINTER, CLARK.
Sculptor. Born in Cambridge, MA, April 4, 1907. Studied: Harvard Univ., B.A.; Indiana Univ., M.F.A.; Art Students League; Cranbrook Academy of Art; Fountainebleau Academy of Art; with Robert Laurent; and M. Saulo, in Paris. Work: Carnegie Inst.; Aldrich Museum of Contemp. Art; Carnegie-Mellon Univ. Member: Artists Equity Assoc.; Society of Sculptors; Mid-Am. Artists. Awards: Florida Southern College, 1952; Wichita Art Assoc.; prizes, Oakland Art Museum; Western Penna. Society of Sculptors, 1956-60; others. Exhibited: Metropolitan Museum of Art; Penna. Academy of Fine Arts; Audubon Artists; John Herrron Art Institute; Sculpture Center, NY; Whitney; Phila. Museum of Art; one-man: Carnegie Institute; Kansas City Art Institute; Carnegie College of Fine Arts. Position: Head of sculpture department, Kansas City Art Institute, Kansas City, MO, 1949-53; associate professor of sculpture, Carnegie-Mellon, Univ., 1955-72, emer. professor, from 1972. Address in 1980, San Rafael, CA.

WINTER, LUMEN MARTIN.
Sculptor and painter. Born in Ellery, IL, December 12, 1908. Studied at Grand Rapids Jr. College; Cleveland School of Art; National Academy of Design; also studied in France and Italy. Work in Library of Congress, Washington, DC; Vatican, Rome; mosaic and bas-relief sculpture for chapels, US Air Force Academy, Colorado Springs, CO; bas-relief frieze, Gerald R. Ford Center, Grand Rapids, MI; and others. Has exhibited at National Academy of Design, NY; American Watercolor Society Annual and Traveling Shows; American Academy Institute of Arts and Letters, NY; and others. Received Purchase Ranger Fund Award, National Academy of Design; William A. White Award, Salmagundi Club; and others. Member of Salmagundi Club; American Watercolor Society; National Society of Mural Painters. Works in marble and bronze; watercolor and oil. Address in 1982, New Rochelle, NY.

WINTERHALDER, ERWIN.
Sculptor. Born in Zurich, Switzerland, in 1879. Studied in Paris, France, 1903-05, and in Italy, 1905-07, also in Munich; and from 1908-13 in Zurich. Settled in San Fran. in 1913. Worked under Stirling Calder, 1914-15. During the past years he has been actively engaged in sculptural works in different parts of California on private and public buildings. Works: Statue, "Despair;" four panels, State Buildings, Sacramento, California. Address in 1918, 116 Page Street, San Francisco, CA.

WINTERICH, JOSEPH.
Sculptor. Born in Neuwied, Germany, 1861. Active in Cleveland, OH, 1920. Died in Coblenz, Germany, 1932. (Mallett's)

WINTERS, ELLEN.
Sculptor and painter. Address in 1934, New York. (Mallett's)

WINTERS, JOHN (RICHARD).
Sculptor and painter. Born in Omaha, NE, May 12, 1904. Studied at Chicago Academy of Fine Arts; Art Institute of Chicago; and with Frederick Poole, J. Allen St. John. Work: Murals, Steinmetz High School, Chicago; Northwest Airlines, Seattle; Cook County Hospital, IL; Hatch School, Oak Park, IL; Brookfield (IL) Zoo; mural, United States Post Office, Petersburg, IL. Exhibited: Corcoran Gallery of Art, 1934; Denver Art Museum; Wichita Art Association; Kansas State College; Tulsa Art Association; Topeka Art Guild; Salina (KS) Art Association; Art Institute of Chicago, 1935, 36, 38, 40, 44; Springfield (MA) Museum of Art, 1938; Little Gallery, Chicago; Chicago Woman's Club, 1938. Address in 1953, Chicago, IL.

WINTERS, PAUL VINAL.
Sculptor and painter. Born in Lowell, MA, September 8, 1906. Studied at Mass. State School of Art; and with Raymond A. Porter, Leo Toschi. Work: Statue, Monohoi, PA; bust, Boston Public Library. Exhibited: Robbins Mem. Town Hall, Arlington, MA. Address in 1953, Norwood, MA.

WIRTZ, WILLIAM.
Sculptor, painter, and teacher. Born in The Hague, Holland, May 9, 1888. Pupil of Fritz Jansen and W. A. van Konijnenburg. Address in 1928, 2322 Eutaw Pl., Baltimore, MD.

WISE, ETHEL BRAND.
(Mrs. L. E. Wise). Sculptor. Born New York City, March 9, 1888. Pupil of James Earle Fraser, Harry Trasher, Arthur Lee. Member: Syracuse Associated Artists; Syracuse Art Club Guild. Work: Plaisted Memorial, Masonic Temple, Syracuse, NY; Teachers Mem., Wichita Falls, Tex.; "Repose," permanent collection, University of Missouri, Columbia. Address in 1929, 201 Clarendon St., Syracuse, NY.

WISE, SARAH MORRIS GREEN (MRS.).
Sculptor. Pupil of Rodin. Died in New York City, May 11, 1919.

WISELY, JOHN HENRY.
Sculptor and teacher. Born in Woodward, OK, September 11, 1908. Studied at Kansas City Art Institute; and with

Wallace Rosenbauer, Ross Braught, Mildred Hammond. Awards: San Francisco Art Center, 1940; Kansas City Art Institute, 1941. Work: IBM Collection. Exhibited: Golden Gate Exposition, 1939; San Fran. Art Center, 1940; Kansas City Art Institute, 1936-40; St. Louis, MO, 1939; Tulsa, OK, 1938, 39; St. Joseph, MO, 1938, 39; MO State Fair, 1936-40. Address in 1953, Champaign, IL.

WITKIN, ISAAC.
Sculptor and instructor. Born in Johannesburg, South Africa, May 10, 1936; US citizen. Studied at St. Martins School of Art, London, with Anthony Caro; also with Henry Moore, England. Work in Joseph Hirshhorn Museum, Washington, DC; Tate Gallery, London; sculpture, Storm King Art Center, Mountainville, NY; and others. Has exhibited at Marlborough Gallery, NYC, from 1963; Paris Bienale, Museum of Modern Art; Primary Structures, Jewish Museum, NY; and others. Received Guggenheim fellowship, 1981. Teaching sculpture at Bennington College, from 1965; sculpture at Parsons School of Design, from 1975. Works in steel and bronze. Address in 1982, c/o Hamilton Gallery of Contemporary Art, NYC.

WOJCIK, GARY THOMAS.
Sculptor. Born in Chicago, IL, February 26, 1945. Studied at Art Institute of Chicago, B.F.A.; University of Kentucky, M.A. Work at High Museum of Art, Atlanta, GA; New York Port Authority, NY; others. Has exhibited at Whitney Museum of American Art; Art Institute of Chicago; Storm King Art Center, Mountainville, NY; and others. Received Art Institute of Chicago Traveling Fellowship. Works in welded metal. Address in 1982, Trumansburg, NY.

WOLCOTT, FRANK.
Sculptor, painter, etcher, and craftsman. Born in Mc Leansboro, IL. Pupil of Art Institute of Chicago. Member: Chicago Society of Artists. Address in 1925, 1504 East 17th Street, Chicago, IL.

WOLCOTT, KATHERINE.
Sculptor and painter. Born in Chicago, IL, April 8, 1880. Pupil of Art Institute of Chicago; Art Students League of New York; Benjamin-Constant and Auguste Rodin in Paris. Member: Art Institute of Chicago; Ill. Academy of Fine Art; The Cordon; North Shore Art Association; Chicago Society of Miniature Painters; American Federation of Arts. Address in 1933, c/o The Cordon, 410 S. Michigan Ave., Chicago, IL.

WOLCOTT, ROGER AUGUSTUS.
Sculptor, painter, designer, craftsman, and teacher. Born in Amherst, MA, Aug. 25, 1909. Studied at Mass. Col. of Art; NY School of Fine and Applied Art; and with Richard Andrew, Joseph Cowell, Ernest Major. Member: Rockport Art Assn.; Springfield Artists Guild. Work: Springfield Museum of Natural History. Position: Instructor of Arts, Springfield Museum of Fine Art, Springfield, MA, 1933-40; Industrial Design Research, Angler Research, Inc., Framingham, MA, 1940-43; Design Research, Nikor Products, Springfield, MA, 1943-46; Industrial Design Consultant, 1946-51; Asst. Prof., Visual

Edu., Univ. of Mass, Amherst, MA. Address in 1953, Agawam, MA.

WOLF, BOB.
Sculptor. Born in Lincoln, Nebraska, 1937. Has exhibited with Northwest Rendezvous Group. Represented by The May Gallery, Scottsdale, AZ, and Jackson, WY; Altermann Art Gallery, Dallas, TX. Specialty is wildlife, particularly birds in flight. Works in bronze. Address since 1951, La Porte, CO.

WOLF, GEORG.
Sculptor. Born in San Francisco, California, 1858.

WOLF, PEGOT (or PEGGY).
Sculptor. Active Chicago 1935, California 1939, NYC 1948. Her work was shown at New York World's Fair, 1939. Sculpture includes "Indian Madonna," Mexican onyx.

WOLFE, ANN (ANN WOLFE GRAUBARD).
Sculptor. Born in Mlawa, Poland, in 1905. US citizen. Studied at Hunter College, B.A.; and in Paris with Despiau and Vlerick at Academie Grande Chaumiere. Works: College of the City of New York; Museum of Art, Jerusalem; Hamline University; Colgate University; Museum of Western Art, Moscow; Mt. Zion Temple, St. Paul. Awards: Allied Artists of America, 1936; Society of Washington Artists, 1944-45; Minnesota State Fair, 1949; Minneapolis Institute of Arts, 1951; Minneapolis Women's Club, 1954. Exhibitions at Walker Art Center, Minneapolis, Grace Horne Gallery, Minneapolis Institute of Art, Phila. Museum of Art (all one-woman); Penna. Academy of Fine Arts; Whitney; Allied Artists of America; Grace Horne Gallery; Whyte Gallery, Wash., DC; Addison Gallery, Andover, MA; others. Address in 1982, Minneapolis, MN.

WOLFE, JAMES.
Sculptor. Born in NYC, April 28, 1944. Studied at Solebury School. Work at Museum of Fine Arts, Houston; Whitney Museum, NY; Museum of Fine Arts, Boston. Exhibited at Emmerich Gallery; Osuna Gallery; Clayworks Studio Workship, NY. Address in 1982, 736 Broadway, NYC.

WOLFE, NATALIE.
(Mrs. D. D. Michael). Sculptor. Born San Francisco, CA, March 16, 1896. Pupil of Ferrea and Calif. School of Fine Arts. Member: National League American Pen Women (fine arts dept.). Work: Bust of M. H. de Young, San Francisco Memorial Museum. Address in 1933, 745 Hyde St., San Francisco, CA. Died in 1939.

WOLFF, GUSTAVE H.
Sculptor and painter. Born in Germany, March 28, 1863. Came to America in 1866. Pupil of St. Louis School of Fine Arts under Paul Cornoyer; also studied in Europe. Member: Buffalo Society of Artists. Awards: Silver medal, Portland, OR, 1905; first Dolph prize, Competitive Ex., St. Louis, 1906; Wednesday Club silver medal, Society of Western Artists, 1907. Work: "The Brook," City Art Museum, St. Louis. Address in 1933, 503 West 175th Street, NYC. Died in Berlin, 1935.

WOLFF, ROBERT JAY.
Sculptor, painter, educator, designer, writer, and lecturer. Born in Chicago, IL, July 27, 1905. Studied at Yale University; and in Paris, with Georges Mouveau; pupil of Viola Norman. Work: Guggenheim Museum; Art Institute of Chicago; Tate; Wadsworth Atheneum. Member: American Abstract Artists. Exhibited: Art Institute of Chicago, 1934, 35 (one-man), 1938, 46; American Abstract Artists, 1938-50; Penna. Academy of Fine Arts Annual; Corcoran Gallery, Wash., DC, 1958; Whitney Annual, 1958; other one-man exhibitions include Quest and Kuh Gallery, Chicago; Reinhardt Gallery, Nierendorf Gallery, Kleemann Gallery, NY; also group exhibitions in US and abroad. Author and illustrator, "Elements of Design," 1945. Contributor to numerous art magazines. Position: Dean, head of painting and sculpture department, School of Design, Chicago, IL, 1938-42; prof. of art, Brooklyn College, City University of New York, 1946-71; visiting professor of design, MIT, 1961. Awards: Jenkins memorial prize, Annual Exh. by Artists of Chicago and Vicinity; Art Institute of Chicago, 1933, 34. Address in 1976, New Preston, CT. Died in 1978.

WOLFS, WILMA D.
Sculptor, painter, illustrator, educator, and lecturer. Born in Cleveland, OH. Studied at Western Reserve University, B.A., B.S.; Cleveland School of Art; University of Minn.; Ecole du Louvre; Radcliffe College, A.M.; Ecole des Beaux-Arts, Paris; Hans Hoffmann School (Munich & St. Tropez); and with Henry Keller and Rolf Stoll. Works: Univ. of Arkansas; Hendrix College, Conway, Arkansas; sculpture, Catholic Church, Winter Park, FL; Research Studio, Maitland, Florida. Exhibited: Corcoran Gallery; Cleveland Museum of Art; Butler Art Institute; Philbrook Art Museum; Ecole des Beaux Arts; Grand Central Palace; Institute of Fine Arts, NYU; Studio Guild, NYC; many others. Awards: Museum of Fine Arts, Little Rock, Arkansas, 1939; Arkansas Watercolor Society, 1938; Carnegie Scholarships for study in Paris, France, and at New York University, Harvard University, and University of Penna. Head of art dept., Hendrix College, Conway, AK, 1936-37; State Teachers College, Keene, NH, 1937-38; assistant professor of art, Florida State College for Women, Tallahasse, FL, 1939-40; others. Address in 1962, Lakewood, OH.

WOLFSON, SIDNEY.
Sculptor and painter. Born in NYC, June 18, 1914. Studied at Art Students League; Cooper Union; Pratt Institute. Work in Whitney; Wadsworth Atheneum; others. Exhibited at Carnegie Institute; Whitney; The Contemporaries Gallery, NYC (sculpture); IBM Gallery, NY (painting); others. Address in 1970, Salt Point, NY. Died in 1973.

WOLGAMUTH, H.
Sculptor. At San Francisco, 1856.

WOLTER, ADOLPH G.
(Adolph Gustav Wolter von Ruemelin). Sculptor, educator, craftsman, and lecturer. Born in Reutlingen, Germany, September 7, 1903. Studied: Kunstgewerbe Schule, Academy of Fine Art, Stuttgart, Germany; John Herron Art Institute, with David K. Rubins. Member:

Indiana Art Club (committee chm.); Alumni Association, John Herron Art Institute. Awards: Prizes, Herron Art Institute, 1938; Hoosier Salon, 1946; Indiana State Fair, 1935, 37-40. Work: Sculpture, Indiana State Library; Washington Park Cemetery, Indianapolis; memorial, Detroit, MI; American Legion Office Building, Wash., DC; Indianapolis Star, etc. Exhibited: National Exhibition of American Art, NY, 1938; Indiana State Fair, 1935-40, 51; Herron Art Institute, 1938, 43, 45; Hoosier Salon. Lectures on Art Appreciation. Position: Professor of Fine and Applied Art, I.C.N.S., Indianapolis, IN. Address in 1953, 1031 Carrollton Ave.; h. 642 East 32nd Street, Indianapolis, IN.

WOOD, GRANT.

Sculptor and painter. Born Anamosa, IA, February 13, 1892. Pupil of Art Institute of Chicago; Minneapolis Handicraft Guild; Julian Academy in Paris. Work: "Democracy," mural painting, Harrison School, Cedar Rapids; life membership medal, bas-relief, and paintings, "Doorway at Periguex," for Cedar Rapids Art Association; decoration in National Masonic Research Building, Anamosa, Iowa; war memorial window, Memorial Building, Cedar Rapids, IA; "American Gothic," Art Institute of Chicago; "Stone City," Art Institute of Omaha, NE. Award: Harris bronze medal and $300, Art Institute of Chicago, 1930. Address in 1933, No. 5 Turner Alley, Cedar Rapids, IA. Died February 12, 1942, in Iowa.

WOOD, NICHOLAS WHEELER.

Sculptor and painter. Born in San Francisco, CA, September 21, 1946. Studied at San Francisco State University, B.A., 1972; Alfred University, NY, M.F.A., 1977. Has exhibited at Oakland Museum of Art, CA; Dallas Museum of Fine Arts; Ft. Worth Art Museum; Janus Gallery, Los Angeles; and others. Received fellowship, National Endowment for the Arts, 1981-82. Works in clay and wood; acrylic and mixed media. Address in 1982, Department of Art, University of Texas, Arlington, TX.

WOOD, SOLOMON.

Plaster figuremaker. In Boston, first quarter of the 19th century.

WOODBURY, LLOYD.

Sculptor. Born in Baggs, Wyoming, 1917. Worked on railroad in Seattle until moved to NYC to work on museum commissions of mounted animal groups. Opened own taxidermy studio on return to Wyoming and later in Texas. Turned full-time to sculpture in 1974. Specialty is statuettes of horses, cowboys, cattle, wildlife of past and present West. Works in bronze. Represented by Shidoni Gallery and Foundry, Tesuque, New Mexico. Reviewed in *Paint Horse Journal*, January 1982. Address in 1982, Center Point, TX.

WOODHAM, DERRICK JAMES.

Sculptor. Born in Blackburn, England, November 5, 1940. Studied at Southeastern Essex Technological College School of Art; Hornsey College of Arts and Crafts; Royal College of Art. Work at Tate Gallery, London; Museum of Contemporary Art, Nagaoka, Japan; others. Has exhibited at Paris Biennale, Museum of Modern Art;

Der Geist Surrealismus, Baukunst Gallery, Koln, West Germany; Tweed Museum, Duluth; Jewish Museum. Received Prix de la Ville, Sculpture, Paris Biennale. Address in 1982, Department of Art, University of Kentucky, Lexington, KY.

WOODHAM, JEAN.

Sculptor. Born in Midland City, AL, August 16, 1925. Studied at Alabama Polytechnic Institute; Auburn University, B.A.; Sculpture Center, NYC; University of Illinois. Collections: Massillon Museum, OH; Norfolk Museum of Arts and Science, VA; Westport Permanent Collection, CT. Exhibited: Penna. Academy of Fine Arts Annual, 1950-54; Womens International Art Club, New Burlington Gallery, London, 1955; Selected Sculptors Guild, Albright-Knox Art Gallery, Buffalo, NY, 1971; others. Member: Sculptors Guild; Architectural League; Artists Equity Association; others. Awards: National Association of Women Artists, 1966; fellowship, University of Illinois, 1950; New England Annual, 1956-58, 60; Audubon Artists, 1958. Address in 1983, 26 Pin Oak Lane, Westport, CT.

WOODHOUSE, BETTY BURROUGHS.

Sculptor. Born in Norwich, Conn., August 17, 1899. Studied at Art Students League, NY; also studied in Paris, France, 1921, 25, 27. Member: Archeology Institute of America; College Art Association; Little Compton Historical Society; Preservation Society of Providence. Taught: History of art, and art at Birch Wathen School, NY, 1935-45; head of art department at Cambridge School, Weston, Mass., 1945-51; curator education, Museum Art, Rhode Island School of Design, Providence, from 1955. Author of *Vasari's Lives of the Artists*, 1947. Address in 1962, Little Compton, RI.

WOODMAN, TIMOTHY.

Sculptor. Born in Concord, NH, March 4, 1952. Studied at Skowhegan School of Painting and Sculpture, 1970; Cornell University, B.F.A. (sculpture), 1974; Yale University, M.F.A., (sculpture), 1976. Work at Hirshhorn Museum and Sculpture Garden, Washington, DC; Australian National Collection, Canberra. Has exhibited at Everson Museum, Syracuse, NY, 1980; others. Works in aluminum and paint. Address in 1982, c/o Zabriskie Gallery, NYC.

WOODRUFF, CORICE.

(Mrs. Henry S. Woodruff). Sculptor and painter. Born Ansonia, CT, December 26, 1878. Pupil of Minneapolis School of Fine Arts under Robert Koehler; Knute Akerberg; Art Students League of New York. Member: Artists Guild, Chicago; Attic Club, Minneapolis. Awards: First prize for sculpture, Minnesota State Art Society, second prize, 1914; hon. men. for sculpture, St. Paul Institute, 1916. Specialty, small sculpture, bas-relief portraits and portrait busts. Address in 1933, 2017 Pleasant Avenue.; h. 2431 Pleasant Ave., Minneapolis, MN.

WOODRUFF, JOHN KELLOGG.

Sculptor, painter, and teacher. Born Bridgeport, CT, September 6, 1879. Studied: Yale School of Fine Arts; Artist-Artisan Institute, NY; Teachers College, Columbia

University; pupil of Walter Shirlaw; Arthur W. Dow; Charles J. Martin. Member: Society of Independent Artists; Salons of America. Exhibited: Marie Sterner Gallery, Babcock Gallery, Dudensing Gallery, Argent Gallery, Findlay Gallery (all one-man); Brooklyn Museum. Died in 1956. Address in 1953, Nyack, NY.

WOODS, ENOCH S.
Sculptor. Active during the late 19th century in Hartford, CT. (Mallett's)

WOODS, GURDON GRANT.
Sculptor. Born in Savannah, GA, April 15, 1915. Studied at Art Students League; Brooklyn Museum School; San Francisco Art Institute, honory doctorate, 1966. Has exhibited at San Francisco Art Institute Annual; Denver Museum Annual; Janus Gallery, Los Angeles; Los Angeles Co. Museum of Art; Sao Paulo Biennial; and others. Member of San Francisco Art Institute. Taught sculpture at San Francisco Art Institute, 1955-65; prof. of art, University of California, Santa Cruz, 1966-74. Works in concrete and paper. Address in 1982, Los Angeles, CA.

WOODS, JACK D.
Sculptor and painter. Born in Tucumcari, NM, 1930; moved to Arkansas. Self-taught in art. Moved to Taos, NM, 1970; opened Western Art Gallery. Specialty is Old West subjects. Reviewed in *Southwest Art*, June 1978. Represented by In The Spirit Gallery, Kansas City, KS; Son Silver West, Sedona, AZ. Address since 1970, Taos, NM.

WOODWARD, HELEN M.
Sculpture, painter, craftsman, and teacher. Born Newton Stewart, IN, July 28, 1902. Studied: John Herron Art Institute; Butler University; Indiana University; pupil of William Forsyth, Charles Hawthorne, Wayman Adams, and Eliot O'Hara. Member: Indiana Art Club; Contemporary Club, Indianapolis. Awards: Prizes, Indiana State Fair, 1926, 27, 28; prize, Hoosier Salon, Chicago, 1928, 29; Herron Art Institute, 1939; Indiana Art Club. Work: Painting, Bedford High School, Bedford, IN. Exhibited: One-woman: Ball State College, Muncie, IN; Indiana University; Hoosier Salon; H. Lieber Gallery, Indianapolis. Address in 1953, 320 East Maple Road, Indianapolis, IN.

WOOLLETT, ANNA PELL.
Sculptor and painter. Born in Newport, Rhode Island. Pupil of Boston Museum School under Bela Pratt. Address in 1909, 1 Park Place, Jamaica Plain, Mass.

WOOLLETT, SYDNEY.
Sculptor. Address in 1935, Boston, Mass. (Mallett's)

WORDEN, LAICITA WARBURTON.
(Mrs. Kenneth Gregg). Sculptor, painter, and illustrator. Born in Philadelphia, September 25, 1892. Pupil of Penna. Academy of Fine Arts. Member: Fellowship, Penna. Academy of Fine Arts. Address in 1926, Belle Haven, Greenwich, CT; 4141 North Broad St., Philadelphia, PA.

WORSWICK, LLOYD.
Sculptor, craftsman, and teacher. Born Albany, NY, May

30, 1899. Pupil of Urich; Cedarstrom, Brewster; Olinsky; Weinman, Bufano. Member: American Federation of Arts. Address in 1933, 136 East 93rd St.; h. 19 East 94th St., NYC; summer, Washingtonville, New York, NY.

WORTH, KAREN.
Sculptor. Born in Philadelphia, PA, March 9, 1924. Studied at Tyler Art School, Temple University; Penna. Academy of Fine Arts; Academie de la Grande Chaumiere, Paris. Works: Smithsonian Institution; West Point Academy, NY; American Jewish Historical Association, Boston; Jewish Museum, NY; Israel Government Coins and Medals Div., Jerusalem. Exhibitions: National Academy, NY, 1965; Lever House, NY, from 1966; Ceramic Sculpture of Western Hemisphere. Awards: Second Place for Sculpture, Ceramic Sculpture Western Hemisphere, 1941; Penna. Academy of Fine Arts Award for Sculpture, 1942; Allied Artists of America Award for Sculpture, 1965. Member: Fellow, National Sculpture Society; Fine Arts Federation of New York. Media: Clay, bronze. Address in 1982, 19 Henry Street, Orangeburg, NY.

WORTH, PETER JOHN.
Sculptor, historian, and educator. Born in Ipswich, England, March 16, 1917. Studied at Ipswich School of Art, 1934-37; Royal College of Art, 1937-39, ARCA, 46, E. W. Tristram, Roger Powell, with Paul Nash, Edward Bawden, Douglas Cockerell. Member: Institute of Contemporary Art, London. Exhibited: San Fran. Museum of Art; Art Institute of Chicago, 1950; Walker Art Center, 1951; Mid-Am. Art, 1951; Denver Art Museum, 52, 53, 55-57, 60-63. Worked as photographer on *Life Library of Photography*. Position: Assistant Professor of Art, University of Nebraska, Lincoln, NE. Address in 1982, Lincoln, NE.

WORTMAN, JOHANN HENDRICK PHILIP.
Sculptor. Born at The Hague, 1872. Award: Prize from The Hague Academy of Fine Arts. Exhibited: "Calabrian Peasant," 1897. Work: Bust of Queen Wilhelmina. Died in Italy, September 3, 1898.

WOUNDED FACE, TEX.
Sculptor. Born in Watford City, North Dakota, 1955. Studied at Institute of American Indian Arts, with Allan Houser; Arizona State University, 1977-78; Boise State University, 1978-80; San Francisco Art Institute, 1980-81. Specialty is expression of Indian symbolism; works in alabaster and bronze. Address in 1982, Owyhee, NV.

WRENN, ELIZABETH JENCKS.
Sculptor. Born Newburgh, NY, December 8, 1892. Pupil of Abastenia Eberle, George Bridgman, Mahonri Young, Maryland Institute. Member: Norfolk Society Artists; Baltimore Friends of Art; Provincetown Art Association. Award: Irene Leach Memorial prize, Norfolk Society of Artists, 1922. Address in 1933, 202 Belvedere Ave., Baltimore, MD; summer, Wellfleet, MA.

WRIGHT, ALICE MORGAN.
Sculptor. Born Albany, NY, October 10, 1881. Pupil of MacNeil, Gutzon Borglum, Fraser; Art Students League; Injalbert in Paris; Academie Colorossi, Paris; Smith College; St. Agnes School, Albany, NY; Russell Sage College; Ecole des Beaux-Arts, Paris. Member: National Associa-

tion of Women Artists; Society of Independent Artists; fellow, Sculpture Society; Silvermine Guild of Artists. Awards: National Association of Women Artists; National Arts Club prize, 1923; National Academy of Design. Work: Portrait reliefs of President L. Clark Seelye, Professor Mary A. Jordan and John Doleman, Smith College, Northampton, MA; "Lady Macbeth," Newark Museum; "Faun," Bleecker Hall, Albany, NY, and National Academy of Design; National Museum, Wash., DC; Brookgreen Gardens, SC. Exhibited: National Sculpture Society, 1923; Penna. Academy of Fine Arts; Art Institute of Chicago; National Academy of Design; National Association of Women Artists; Paris Salon; Salon des Beaux-Arts, Paris; others. Contributor to *Harper's*. Address in 1953, Albany, New York. Died in 1976.

WRIGHT, G. ALAN.
Sculptor. Born in Seattle, WA, March 31, 1927. Studied with Willson Stamper, Ralston Crawford, and at the Honolulu School of Art. Work: Seattle Art Museum; Denver Art Museum; bronze owl, City Hall Renton, WA; others. Exhibited: Northwest Annual Show, at the Seattle Art Museum, 1962-65; Whitney Museum of American Art, NYC, 1968; Lee Nordness Gallery, NYC, 1968 and 69. Awards: First prizes, Renton Art Festival, 1962 and 64; first prize, New Arts and Crafts Fair, Bellevue, Washington, 1963; Ford Foundation Purchase Award, 1964. Media: Bronze and stone. Address in 1982, c/o Lee Nordness Galleries, 252 West 38th Street, NYC.

WRIGHT, JOSEPH.
Modeler in clay and wax, portrait painter, medalist, die sinker, and etcher. Born in Bordentown, NJ, July 16, 1756. Son of Patience Lovell Wright, wax modeler. Studied modeling under his mother in London; painting under West and his brother-in-law John Hoppner. Exhibited at the Royal Academy in 1780. Visited Paris; returned to US. Painted Washington's portrait at Princeton; later made other portraits from life as well as a clay bust. In Philadelphia, 1783-86; in NYC, 1786-90; returned to Philadelphia. Died in 1793 in Philadelphia.

WRIGHT, MIRIAM NOEL.
Sculptor. Died in Milwaukee, Wisconsin, 1930. (Mallett's)

WRIGHT, PATIENCE LOVELL.
Sculptor and wax modeler. Born in Bordentown, NJ, 1725. No formal training. Known for her small bas-relief portraits. Opened wax works in NYC; moved to England January 30, 1772. She had great success in producing profile relief portraits of upper middle class and the aristocracy, including the king and queen. Portraits range in size from two to ten inches. Her most celebrated works are those of Benjamin Franklin and George Washington, the latter being in the collection of the Maryland Historical Society. Lovell's wax statue of Lord Chatham was placed in Westminster Abbey. She intended to return to America, but she never did. Her daughter married portrait painter John Hoppner, and her son, Joseph, began studying with Benjamin West. Died March 23, 1786.

WRIGHT, ROSEMARY.
Sculptor. Born in Richmond, Indiana, in 1939. Studied at Indiana University; Columbia University; New York University. Exhibitions: Washington Gallery of Art, Washington, DC, 1974; Judson Memorial Church, NYC, 1969; 55 Mercer Gallery, NYC, 1972-73. Won an award for sculpture, Baltimore Museum of Fine Art, 1972. Founder: DC Registry of Women Artists.

WRIGHT, SARA GREENE.
Sculptor. Born in Chicago, IL, 1875. Pupil of Art Institute of Chicago; F. M. Charpentier and F. MacMonnies in Paris. Address in 1906, 27 West 67th St., NYC.

WU, LINDA YEE CHAU.
Sculptor. Born in Canton, China, July 4, 1919; later became a US citizen. Studied at the Calif. Sch. of Fine Arts, 1939-42; Nat. Acad. of Design, 1942-44; Sch. of Painting and Sculpture, at Columbia Univ., 1944-50. Exhibited: Nat. Acad. of Design Annuals; Phila. Art Mus., 1949; Audubon Artists Annuals; National Sculpture Society Annuals; Allied Artists of America Annuals, from 1947. Awards: Gold Medal of Honor for Sculpture, from Allied Artists of America, 1973; Dessie Greer Prize for Sculpture, National Academy of Design, 1965; Anna Hyatt Huntington Gold Medal, Catharine Lorillard Wolfe Art Club, 1968. Member of Allied Artists of America; National Academy of Design; and National Sculpture Society (fellow). Address in 1982, Studio 209-10, 185 Canal St., NYC.

WUERTZ, EMIL H.
Sculptor. Born in Germany. Died in Chicago, Illinois, 1898. (Mallett's)

WURTH, HERMAN.
Sculptor. Born in NY. Pupil of Falguiere and Mercie in Paris. Address in 1910, 152 West 55th St., NYC.

WYATT, GREG ALAN.
Sculptor. Born in Nyack, NY, October 16, 1949. Studied at Columbia College, B.A., 1971; National Academy School of Design, 1972-74; Columbia University, from 1974. Work at Brookgreen Gardens, SC; National Arts Club, Gramercy Park, NY; bronze eagle, American Bureau of Shipping, NYC; others. Has exhibited at Bodley Gallery, NY; National Academy of Design, NY; National Arts Club Annual, NY; and others. Received Helen Foster Barnett Award, National Academy of Design National Annual, 1979; Walter Lantz Award, National Sculpture Society Young Sculptors Annual, 1979. Member of National Arts Club. Works in bronze and marble. Address in 1982, 320 W. 86th St., NYC.

WYCKOFF, MARJORIE ANNABLE.
Sculptor. Born in Montreal, Quebec, Canada, September 23, 1904. Pupil of Arthur Lee. Address in 1933, 61 Oakland Pl.; h. 240 Middlesex Rd., Buffalo, NY.

WYLE, FLORENCE.
Sculptor. Born in Trenton, IL, 1881. Studied at the University of Illinois; Art Institute of Chicago. Work in National Gallery of Canada; Winnipeg Art Gallery, Canada; Toronto Art Gallery, Canada. Founding member, Sculptor's Society of Canada; Royal Canadian Academy of Arts. Artist for Canadian War Memorials, 1919. Awards include medal from Queen Elizabeth, 1953. Known for

"Edith Cavell" memorial, Toronto. Executed memorials, monuments, statues, fountains, tablets, figures, etc. Specialty is West Coast Indian subjects. Address in 1962, Toronto, Ontario, Canada.

WYLIE, LIDABELLE.
Sculptor and painter. Born in Kopiah, Washington, in 1915; moved to California in 1919. Studied art in high school; otherwise self-taught. Has exhibited at Women Artists of the American West shows. Member of Women Artists of the American West. Specialty is Western scenes, particularly of cowboy and pack mule; also Indian subjects. Media include bronze, oil, watercolor. Has own Canyon Gifts shop. Address since 1946, ranch near Three Rivers, CA.

WYLIE, PAUL.
Sculptor and painter. Born in Lubbock County, TX, 1933. Worked as ranch hand, ranch manager many years before art studies at South Plains College. Has exhibited with Texas Cowboy Artists Association; and in his own home gallery. Has won many awards in Texas Cowboy Artists Association shows. Member of Texas Cowboy Artists Association (elected in 1976). Specialty is contemporary Southwestern cowboy life. Sculpts in bronze. Represented by International Galleries, Ruidoso, NM. Address in 1982, Lubbock, TX.

WYLIE, ROBERT.
Sculptor and genre painter. Born on the Isle of Man, England, in 1839; family moved to US. Studied at the Pennsylvania Academy, 1859-62. Exhibited work in ivory and clay at Pennsylvania Academy. Moved to France in 1863. Known chiefly as a painter of Breton peasant scenes. Died in Brittany, France, February 4, 1877.

WYMAN, WILLIAM.
Sculptor. Born in Boston, MA, June 13, 1922. Studied at Mass. College of Art, B.S.; Columbia University, M.A.; Alfred University. Work at Des Moines Art Center; Museum of Contemporary Crafts; Everson Museum of Art; Smithsonian Institution; and others. Has exhibited at Metropolitan Museum of Art, NYC; Institute of Contemporary Arts, Boston; Victoria and Albert Museum, London; Everson Museum, Syracuse, NY; Max Hutchinson Gallery, New York and Houston; and others. Received National Endowment for the Arts visual artists grant; award from Smithsonian Institution. Address in 1982, Scituate, MA.

Y

YAFFEE, PAUL.
Sculptor. Exhibited: Baltimore, Maryland, 1934. (Mallett's)

YAMPOLSKY, OSCAR.
Sculptor and painter. Address in 1919, 2318 West Taylor Street, Chicago, IL; Crystal Lake, IL.

YANDELL, ENID (MISS).
Sculptor and teacher. Born in Louisville, KY, October 6, 1870. Pupil of Cincinnati Art School; Philip Martiny in NY; MacMonnies and Rodin in Paris. Member: National Sculpture Society, 1898; New York Municipal Art Society; New York Water Color Club; National Arts Club. Awards: Designer's medal, Columbian Exp., Chicago, 1893; silver medal, TN Exp., Nashville, 1897; honorable mention, Pan-American Exp., Buffalo, 1901; bronze medal, St. Louis Exp., 1904; Officier de l'Academy, French Government, 1906. Organized, 1907, Branstock Summer School of Art at Edgartown. Work: "Carrie Brown Memorial Fountain," Providence; bust, "Dr. W. T. Bull," College of Physicians and Surgeons, NY; "Emma Willard Memorial," Albany, NY; "Hogan Fountain" and "Boone Monument," Louisville, KY; "Indian and Fishes," Watch Hill, RI. Address in 1933, 219 Beacon St., Boston, MA; summer, Edgartown, MA. Died in 1934.

YANISH, ELIZABETH.
Sculptor and lecturer. Born in St. Louis, MO. Studied at Washington Univ.; Denver Univ.; also with Frank Varra, Wilbur Verhelst, Edgar Brittor, Marian Buchan, and Angelo DiBenedetto. Works: Tyler Mus., Texas; Colo. State Bank, Denver, CO; Colorado Womens College; Ball State College. Exhibitions: Denver Art Museum Exhib., 1961-75 and Western Ann., 1965; Midwest Biennial, Joslyn Museum, Omaha, Nebr., 1968; International Exhibition, Lucca, Italy, 1971; one-man show, Woodstock Gallery, London, England, 1973; Artrain, Mich. Fine Arts Council, 1974. Awards: Purchase Award Golden Web, Colo. Women's College, 1963; McCormick Award, Ball State University, 1964; Purchase Award, Tyler Museum, Texas, 1965. Media: Welded steel, bronze, and copper. Address in 1982, 131 Fairfax, Denver, CO.

YATES, JULIE CHAMBERLAIN (MRS.).
Sculptor. Died in NY, 1929.

YATES, JULIE NICHOLLS.
Sculptor. Born in St. Louis, MO. Studied with George Zolnay, St. Louis School of Fine Arts in America, and with Rodin and Bourdelle in Paris. Member: National Arts Club of New York; Art Association in Paris; Artists Guild of St. Louis; National Association of Women Painters and Sculptors. Has exhibited in many of the most prominent exhibitions including the Paris Salon. Specializes in portraits and garden figures.

YATES, RUTH.
Sculptor. Born in Greenville, OH, in 1896. Studied at Cincinnati Art Academy; Art Students League; Grand Central Art School; Academie Julian; and with Jose de Creeft. Works: Norfolk Museum of Art and Science; Brookgreen Gardens, SC. Exhibitions: National Academy; Penna. Academy; National Sculpture Society; Whitney Museum; National Arts Club; National Association of Women Artists; Pen and Brush; Metropolitan Museum of Art, 1942; one-woman show, NYC, 1939. Awards: Association of Women Artists, 1939, 51; Pen and Brush Club, 1945, 49; Art for Democratic Living award, 1951; Anna Hyatt Huntington prize, 1939. Member: Fellow, International Institute Arts and Letters; National Sculpture Society (rec. sec. 1943-46, 49-50); Artists Equity Association; Artists for Victory (rec. sec. 1945-46); National Association Women Artists (pres. 1949-51, treas. 1952, past corr. sec. and chmn. sculpture); Pen and Brush (v.p., chmn. sculpture 1946-50); New York Architectural League. Died in 1969.

YERUSHALMY, DAVID.
Sculptor. Born in Jerusalem, Palestine, Oct. 15, 1893. Pupil of Franz-Barwig, Joseph Mullner, and Franz Zelzny in Vienna. Member: Around the Palette; All-Ill. Society of Fine Arts. Award: Honorable mention, Annual Exhibition by Artists of Chicago and Vicinity, Art Institute of Chicago, 1931. Address in 1933, 2828 Prairie Ave.; h. 2720 Prairie Ave., Chicago, Ill.

YIANNES, (IORDANIDES).
Sculptor and ceramist. Born in Athens, Greece, December 16, 1943. Studied at Umanitaria Art Institute, Milan, Italy, 1962; Brooklyn Museum Art School, 1967-70; Max Beckmann scholarship, 1971-72. Exhibitions: Brooklyn Museum, 1971; Brockton Art Center, 1972; Whitney Museum of American Art Clay Exhibition, 1974; Long Beach Museum of Art, 1977; and others. Works in clay. Represented by Allan Stone Gallery, NYC. Address in 1982, 19 Commerce St., NYC.

YOCHIM, LOUISE DUNN.
Sculptor, painter, teacher, writer, and craftsman. Born in Jitomir, Ukraine, July 18, 1909. Studied at Art Institute of Chicago, M.A.E., certified, 1932; University of Chicago, 1956. Member: National Art Education Association; Western Art Education Association; Artists Equity Association; Chicago Society of Artists (pres. 1972-83). Exhibited: Art Institute of Chicago, 1935-37, 41, 42, 44; Detroit Institute of Art, 1945; Chicago Fine Art Gallery, 1945; University of Chicago, 1946; Todros Geller Gallery, Chicago, 1947, 51, 52; Assoc. Art Gallery, 1949; Riverside Museum, 1951; Kansas City, MO, 1948; Terry Art Institute, 1952; Northeastern Ill. University, 1972; Spertus

Museum, Chicago, 1979-81; others. Position: Instructor of Art, Chicago, High School, 1938-50; Academy of Fine Arts, Chicago, 1952; Supv. of Art, Dist. 3 and 4, Chicago Public Schools, from 1967. Address in 1982, 9545 Drake Ave., Evanston, IL.

YOKOI, RITA.
Sculptor and painter. Born in NYC, August 26, 1938. Studied at Alfred New York State College of Ceramics, Alfred University, 1956-59; San Francisco Art Institute, Agnes Brandenstein Memorial Scholar, 1959-61, B.F.A., 1961; Tokyo University of Japan, Fulbright Fellowship for Ceramics, 1962-63; University of California at Berkeley, 1966-70, M.A., 1970. Exhibited: Museum of Contemporary Crafts, NYC, 1962; M. H. DeYoung Memorial Museum, San Francisco, 1968; one-woman show at Kirk de Gooyer Gallery, Los Angeles, 1981; Santa Barbara Arts Forum, CA, 1981; others. Taught: Fresno City College, CA, 1972; Calif. State University, Fresno, 1971-73; Mt. St. Mary's College, 1975-76; Antioch College-W, Los Angeles, 1976; Otis Parsons, Los Angeles, from 1981. Noted for her ceramic sculpture and assemblage. Address in 1982, Los Angeles, CA.

YOSHIMURA, FUMIO.
Sculptor. Born in Kamakura, Japan, February 22, 1926. Studied at Tokyo University of Arts, M.F.A., 1949. Work at Philadelpia Art Museum; Penna. Academy of Fine Arts, Philadelphia; Albright-Knox Gallery, NY; and others. Has exhibited at Penna. Academy of Fine Arts; Wadsworth Atheneum, CT; Smithsonian Institution, Washington, DC; Nancy Hoffmann Gallery, NY; Norton Gallery of Art, FL. Teaching: Visiting professor, Dartmouth College, NH, 1981-82. Works in wood. Address in 1982, 5 E. Third St., NYC.

YOUNG, ALEXANDER.
Sculptor. Worked: New York City. Exhibited: American Institute, 1851. Medium: Terra-cotta.

YOUNG, DOROTHY O.
(Mrs. Jack J. Sophir). Sculptor. Born in St. Louis, Missouri, June 22, 1903. Studied at St. Louis School of Fine Arts, Washington University; Art Students League; and with E. Wuerpel, Leo Lentelli, and George Bridgman. Works: Office, St. Louis Council, Boy Scouts of America; Rockwoods, Missouri Museum; Jackson Park School, St. Louis. Awards: St. Louis Art Guild, 1925, 49; Society of Independent Artists, 1937, 40, 43, 44, 45, 47-49, 50, 52, 53, 55; Henry Shaw Cactus Society, 1955; St. Louis County Fair, 1947. Address in 1953, University City, MO.

YOUNG, MAHONRI MACKINTOSH.
Sculptor, painter, and etcher. Born Salt Lake City, UT, August 9, 1877. Pupil of Art Students League in NY; Academies Julian, Colarossi, and Delacluse in Paris; also with J. T. Harwood. Member: Associate, National Academy of Design, 1912; National Academy of Design, 1923; National Sculpture Society, 1910; Paris Art Association; Society of Utah Artists; New York Architectural League, 1911; Chicago Society of Etchers; New York Water Color Club; New York Society of Etchers; National Institute of Arts and Letters; New Society of Artists; National Arts Club. Awards: Honorable mention for etching, American Art Association of Paris; Barnett prize, National Academy of Design, 1911; silver medal for sculpture, P.-P. Exp., San Francisco, 1915. Work: Etchings and "Man with Pick," and "Stevedore," Metropolitan Museum, NY; Hopi, Navajo and Apache groups, American Museum of Natural History, NY; bronzes, "A Laborer" and "The Rigger," and etchings, Newark Museum; etchings, New York Public Library; "Sea Gull Monument," Salt Lake City; bronze, Peabody Institute, Baltimore, MD; Rhode Island School of Design, Providence; painting and sculpture, Art Institute of Utah, Salt Lake City; Whitney; Corcoran; others. Exhibited at National Sculpture Society, 1923. Instructor, School of American Sculpture and Art Students League, NY. Address in 1953, Ridgefield, CT. Died in Norwalk, CT, November 2, 1957.

YOUNGERMAN, JACK.
Sculptor and painter. Born in Louisville, KY, March 25, 1926. Study: University of North Carolina, 1944-46; University of Missouri, A.B. 1947; Ecole des Beaux-Arts, Paris, 1947-48. Work: Whitney Museum, Museum of Modern Art, Guggenheim, all NYC; Hirshhorn Museum, Washington, DC; Art Institute of Chicago. Commissions include First Penna. Bank, Philadelphia, 1966; The Ohio (fiberglas), Pittsburgh Plate Glass, 1977; etc. Exhibition: Guggenheim, NYC, 1961, 66, Whitney, 1965, Jewish Museum, NYU, all NYC; Carnegie Institute, Pittsburgh, 1971; Hirshhorn Museum, 1980; Haus der Kunst, Munich, 1981. Awards: National Council of Arts and Science award, 1966; National Endowment for the Arts award, 1972; fellow, Guggenheim Foundation, 1976. Taught at Yale University, 1974-75; Hunter College, 1981-82; NYU, from 1982-83. Represented in Washburn Gallery, NYC. Address in 1982, 130 W. 3rd St., NYC.

Z

ZAIDENBERG, ARTHUR.
Sculptor and writer. Born in NYC, 1908. Studied at Art Students League; National Academy of Design, NY; Beaux Arts, Paris; also in Rome and Munich. Work at Metropolitan Museum; Brooklyn Museum; New York Public Library; Albany Museum; SS *Rotterdam* (mural), Holland America Line; and others. Received Sally Jacobs Award, Woodstock Artists Association, 1969. Member of Woodstock Artists Association. Taught drawing at NY University, 1963-65; drawing at Institute of San Miguel, Mexico, 1972-73. Works in welded steel and oil. Address in 1982, San Miguel Allende, Mexico.

ZAJAC, JACK.
Sculptor and painter. Born December 13, 1929, in Youngstown, OH. Began as painter. Studied at Scripps College in CA; with Millard Sheets, Henry McFee, and Sueo Serisawa; also at American Academy in Rome. Taught at Dartmouth and Pomona. Awards: From Butler Institute of Art (Youngstown); Pasadena Art Museum; American Academy of Arts and Letters grant; Guggenheim fellowship; Limited Editions Club etching prize; Prix de Rome, 1954, 56, 57. Exhibited at Felix Landau Gallery (many times); Pasadena Art Museum; Scripps College; University of Illinois; Whitney Museum; Museum of Modern Art; Guggenheim Museum; UCLA Museum of Art, Santa Barbara, CA; Smithsonian Institution Temple University in Rome. In collections of University of Nebraska at Lincoln; Los Angeles Co. Museum; Penna. Academy of Fine Arts; California Federal Savings and Loan Association; Museum of Modern Art. Represented by Forum Gallery, NYC. Address in 1982, c/o Forum Gallery, 1018 Madison Ave., NYC.

ZAKHEIM, BERNARD BARUCH.
Sculptor, painter, craftsman, designer, and teacher. Born in Warsaw, Poland, April 4, 1898. Studied at San Fran. School of Fine Art; and in Europe. Award: Medal, San Fran. Art Association, 1935. Work: San Fran. Museum of Art; frescoes, Coit Mem. Tower, Jewish Community Center, University of Calif. Medical School, University of Calif. Hospital, all in San Fran.; murals, US Post Office, Mineola, TX. Exhibited: San Diego traveling exhibition, 1940; US Treasury Department, 1940; San Fran. Museum of Art, annually; Golden Gate Exp., 1939; Palace of the Legion of Honor. Position: Instructor, Adult Department, San Fran. Public School; Instructor, Occupational Therapy, Presidio, San Fran., CA. Address in 1953, Sebastopol, CA.

ZAMMITT, NORMAN.
Sculptor and painter. Born in Toronto, Canada, February 3, 1931. US citizen, 1956. Studied at Pasadena City College, AA, 1950-51, 1956-57; Otis Art Inst., MFA, 1957-61.

Works: Lib. of Congress; Mus. of Modern Art; Aldrich; Hirshhorn Mus., NYC. Exhibitions: Felix Landau Gal., Los Angeles; Robert Schoelkopf Gal., NYC; The Landau-Alan Gal., NYC; Santa Barbara Mus. of Art; Los Angeles County Mus. of Art; Pasadena Art Mus.; Mus. of Modern Art; Hansen Gal., San Fran.; Corcoran; others. Awards: Pasadena City College, Ruth Estes Bissiri Memorial Scholarship, 1957; Otis Art Inst., four-year scholarship, 1957-61, 50th Anniversary Sculpture Exhibition, 1968; Tamarind Fellowship; Guggenheim Foundation Fellowship, 1968; Long Beach Mus. of Art. Taught: School of Fine Arts, Los Angeles, 1962-63; Occidental Coll., 1963; Univ. of New Mexico, 1963-64; CSCS, Fullerton, 1964-66; Calif. Inst. of the Arts, Los Angeles, 1967; Univ. of Southern Calif., 1968-69. Address in 1982, Pasadena, CA.

ZARING, LOUISE ELEANOR.
Sculptor, painter, and craftsman. Born in Cincinnati, OH. Pupil of Oliver P. Merson, John Twachtman, MacMonnies, L. R. Garrido, and Charles Hawthorne; Art Students League of New York. Member: Paris Woman's Art Association; Provincetown Art Association; Art Students League of New York; Wash. Art Club; Ind. Society of Sculptors; North Shore Art Association. Work: First hon. mention, Richmond Art Association, 1900 and 1919. Address in 1933, Greencastle, IN. Summer address was listed as Provincetown, MA, in 1917.

ZEHR, CONNIE.
Sculptor. Noted for her environments of sand, earth, and rope.

ZEIDLER, AVIS.
Sculptor, painter, etcher, craftsman, and lecturer. Born in Madison, Wis., December 12, 1908. Pupil of Labault, Boynton, Stackpole, and Du Mond. Member: San Francisco Society of Women Artists. Address in 1933, 745 Forty-seventh Ave., San Francisco, Calif.

ZEISLER, CLAIRE (BLOCK).
Sculptor. Born in Cincinnati, OH, April 18, 1903. Studied: Institute of Design, Chicago, with Lazlo Moholy Nagy; also under Alexander Archipenko. Exhibited: Textile Objekte, Kunstgewerbe Museum, Berlin, Germany, 1975; Museum of Contemporary Art, Chicago, 1976; Renwick Gallery of the National Collection, Wash., DC, 1977; National Museum of Modern Art, Kyoto, Japan, 1977; one-woman shows include a retrospective at the Art Institute of Chicago, 1979; and the St. Louis Art Museum, 1980. Medium: Fiber. Address in 1982, c/o Young Hoffman Gallery, 215 West Superior, Chicago, IL.

ZEITLIN, ALEXANDER.
Sculptor. Born in Tiflis, Russia, July 28, 1872. Pupil of Falguiere at Beaux-Arts in Paris. Member: Alliance;

Painters and Sculptors; Brooklyn Society of Artists. Work: Senator Birarelli's heroic size statue, City of La Valence, France; Richard Hudnut's monument, Woodlawn Cemetery, NY; George Backer's monument, Betholom Fields Cemetery, Brooklyn. Address in 1933, 41 Gramercy Park, NYC.

ZELLER, AUGUST.
Sculptor. Born in Bordentown, NJ, March 7, 1863. Pupil of Franklin Inst. of Philadelphia; Penna. Academy of Fine Arts under Eakins; Ecole des Beaux-Arts in Paris under Thomas; studied and worked with Rodin. Taught: Instructor, Carnegie Technical Schools and Art Students League of Pittsburgh, PA. Member: Pittsburgh Art Association. Work: "Last Supper," Episcopal Church, Fox Chase, PA; Schuylkill Co. military monument, Pottsville, PA; etc. Address in 1914, Carnegie Institute, Pittsburgh, PA.

ZERBO, NINA THERESA.
Sculptor. Born in Turin, Italy. Studied under private instruction at the Art League, 1924-26. Awards: Daniel Chester French award, 1958. Member: Greenwich Chamber of Commerce; Greenwich Art Society; Allied Artists of America; Everglades (Palm Beach, Fla.) Address in 1962, Tower Rd., Riverside, Conn.; office, 159 E. 64th St., NYC.

ZESCH, GENE.
Sculptor and woodcarver. Born in Mason, TX, 1932. Studied at Texas A & M, animal husbandry, 1953; self-taught in art. Specialty is caricatures of the modern cowboy since about 1940. Works in wood and bronze. Represented by Trailside Galleries, Scottsdale, AZ, Overland Trail Galleries, Scottsdale, AZ and Jackson Hole, WY. Reviewed in *Artists of the Rockies*, winter, 1977; *Texas Highways*, August, 1975; *Art West*, spring, 1979; others. Address in 1982, Mason, TX.

ZETTLER, EMIL ROBERT.
Sculptor. Born Chicago. Studied at Art Institute of Chicago; Royal Academy of Berlin; Julian Academy in Paris. Awards: Honorable mention, Art Institute of Chicago, 1912; medal, Chicago Society of Artists, 1915; bronze medal, P.-P. Exp., San Francisco, 1915; silver medal, 1915, Potter Palmer gold medal, 1916, Logan medal, 1917, Harry A. Frank prize, 1921, and French memorial gold medal, 1925, all from Art Institute of Chicago. Work: Municipal Art Collection, Chicago. Taught: Professor and Head of School of Industrial Art of The Art Institute of Chicago; Assistant Professor, Armour Institute of Technology. Address in 1933, Chicago, IL. Died Jan. 10, 1946.

ZIBIT, MELANIE.
Sculptor. Born in Cambridge, MA, in 1948. Studied: Mount Holyoke College, South Hadley, MA; Pratt Institute, Brooklyn, NY. Exhibitions: Jags Gallery, Brookline, MA, 1971; Vineyard Haven Gallery, Martha's Vineyard, 1971; Rose Art Museum, Brandeis University, Waltham, MA.

ZIEGLER, FREDERICK J.
Sculptor. Born in New York, 1886. Address in 1935, Woodmere, Long Island, New York. (Mallett's)

ZIEGLER, JACQUELINE.
Sculptor and educator. Born in Mt. Vernon, NY, February 23, 1930. Studied with Frederick V. Guinzburg, 1943; Ruth Nickerson, 1944; Columbia University, sculpture with Oronzio Maldarelli and casting with Ettore Salvatore, 1947; Art Students League, life drawing with Klonis, 1948; Univ. Chicago, A.B., 1948; Fashion Institute of Technology, 1948-50; Royal Acad. Fine Arts, Copenhagen, Denmark, 1960-62. Works: Many Hands (3-ton wood carving), Enugu, Nigeria; Judge Charles Fahy (bronze portrait), Georgetown Law Library, Wash., DC; Portrait Plaques, Onondaga Community College, Syracuse, NY; Bushwoman of the Kalahari, Smithsonian Institution, Wash., DC. Exhibitions: Charlottenborg, Copenhagen, Denmark, 1962; National Collection of Fine Arts, Washington, DC, 1963; Washington Gallery Art, 1966; Everson Museum, Syracuse, NY, 1972; one-woman show, St. Peter's Gallery, Society for Art, Religion, and Culture, NY, 1975. Media: Clay, wood, stone; acrylic. Address in 1976, Syracuse, NY.

ZIEGLER, LAURA.
Sculptor. Born in Columbus, OH, in 1927. Studied: Columbus Art School; Ohio State University; Cranbrook Academy of Art; and in Italy. Awards: Columbus Art League, 1947-49; Fulbright grant, Rome, Italy, 1950. Collections: Museum of Modern Art; Columbus Gallery of Fine Arts; 18-foot Cross, St. Stephens Episcopal Church, Columbus OH; Burning Bush (44 ft. welded copper), Temple Israel, Columbus, OH, 1959; many portraits. Exhibited: International Venice Biennial, 1956-58; Institute of Contemporary Arts, Boston, 1967; one-woman show, Dartmouth College, 1974; others. Medium: Bronze. Living in Italy in 1982.

ZILVE, ALIDA.
Sculptor. Born Amsterdam, Holland. Pupil of Allen G. Newman, Earl Stetson, Crawford. Work: Bas-reliefs, "Four Master Schooner," Seaman's Savings Bank, New York; "Pioneer," Oil City, PA; "David H. Burrell," YMCA, Little Falls, NY; "John A. Collier," Canastota Memorial Hospital, Canastota, NY; "John S. Schofield," Macon, GA; "Herman Mahnkin," YWCA, Bayonne, NJ; "Woodrow Wilson," Independent Memorial Bldg., United Daughters of the Confederacy, Independence, MO; "Mayor Newman," Elks Club, Paterson, NJ; "Edw. V. Walton," Roselle High School, NJ; "George Washington," Hempstead, LI; "Lafayette," Junior High School, Elizabeth, NJ; "Theodore Roosevelt," Vocational School, Perth Amboy, NJ; "General John J. Pershing," Independence Memorial Building, Independence, MO. Address in 1933, 80 Winthrop Street, Brooklyn, New York, NY. Died in 1935.

ZIM, MARCO.
Sculptor, painter, and etcher. Born Moscow, Russia, January 9, 1880. Pupil of Art Students League of New York under George Grey Barnard; National Academy of Design under Ward and Maynard; Ecole des Beaux-Arts in Paris under Bonnat. Member: Artland Club, Los Angeles; Los Angeles Painters and Sculptors Club. Address in 1933, 54 West 74th Street, New York, NY.

ZIMM, BRUNO LOUIS.
Sculptor and artist. Born New York, December 29, 1876. Pupil of J. Q. A. Ward, Augustus Saint-Gaudens, and Karl Bitter. Member: National Sculpture Society. Award: First mention, collaborative competition, New York Architectural League, 1913; silver medal, Paris Exp., 1900. Work: Slocum Memorial and Memorial Fountain, NY; Finnegan Memorial, Houston; Murdoch Memorial, Wichita; sculpture in rotunda of Art Bldg., San Francisco; bust of Robert E. Lee, Baylor College, Belton, Texas; panels of Sergt. York and Paul Revere, Seaboard National Bank, NY; Edward C. Young tablet, 1st National Bank, Jersey City; sculptures, St. Pancras Church, and St. Thomas Church, Brooklyn, NY; Stations of the Cross, St. Clement's Church, Philadelphia, PA. Exhibited at National Sculpture Society, 1923. Address in 1933, Woodstock, NY. Died in 1943.

ZIMMELE, MARGARET SCULLY (MRS.).
Sculptor, painter, and illustrator. Born Pittsburgh, PA, September 1, 1872. Pupil of Chase, Shirlaw, Whittemore, Lathrop, Carlson, Hawthorne. Member: Society of Washington Artists; Pittsburgh Art Association; Washington Art Club. Address in 1933, Washington, DC; summer, Great Barrington, MA.

ZIMMERMAN, ELYN.
Sculptor and environmental artist. Born in Philadelphia, PA, December 16, 1945. Studied at University of California, Los Angeles, B.A. (psychology), 1968, M.F.A., 1972; and with Robert Irwin and Richard Diebenkorn, National Endowment for the Arts Artist's fellowship, 1976 and 80. Work in Los Angeles County Museum of Art, Los Angeles; Whitney Museum of American Art; and others. Has exhibited at Whitney Museum, NY; Winter Olympics, Lake Placid, NY, 1980; San Diego Museum of Art; Museum of Contemporary Art, Chicago, IL; and others. Received awards from Los Angeles County Museum of Art; Creative Artists Public Service Grant, 1980. Address in 1982, 57 Leonard St., NYC.

ZIMMERMAN, FREDERICK ALMOND.
Sculptor, painter, and teacher. Born Canton, OH, October 7, 1886. Pupil of University of Southern California and with Victor D. Brenner. Member: Scarab Club; California Art Club; Laguna Beach Art Association; Pasadena Society of Artists; Southern California Society of Arts and Crafts; American Federation of Arts; American Artists Professional League. Exhibited: Pasadena Society of Artists; Los Angeles Museum of Art; Detroit Institute of Art. Taught: Instructor, Pasadena Art Institute. Address in 1953, Pasadena, CA.

ZIMMERMAN, LILLIAN HORTENSE.
Sculptor. Born Milwaukee. Pupil of Art Institute of Chicago; Art Students League of New York. Member: Wisconsin Painters and Sculptors. Award: Medal and prize for sculpture, Milwaukee Art Institute, 1924. Address in 1933, Milwaukee, WI.

ZIMMERMAN, MARCO.
See Zim,Marco.

ZINSER, PAUL R.
Sculptor, painter, illustrator, and craftsman. Born in Wildbad, Germany, April 4, 1885. Pupil of J. Hopkins Adam. Member: Cincinnati Arts Club. Work: "Evening," Cincinnati Art Museum. Address in 1924, 3229 Sheffield Ave.; Highland Apts., Chicago, IL.

ZIOLKOWSKI, KORCZAK.
Sculptor. Born in Boston, MA, September 6, 1908. Self-taught. Awards: First Sculpture Prize for Marble Portrait of Paderewski; New York World's Fair, 1939; Trustee Award from the National Western Heritage and Cowboy Hall of Fame, 1974. Member: National Sculpture Society. Work: Symphony Hall, Boston, MA; marble portraits of Paderewski, Georges Enesco, Artur Schnable, John F. Kennedy, and others; San Francisco Art Museum; Vassar College. Commissions: Noah Webster Statue (marble), Town Hall Lawn, West Hartford, Conn.; a granite portrait of Wild Bill Hickok, Deadwood, SD; Chief Sitting Bull (granite portrait), Mobridge, SD; carving mountain into a monumental equestrian figure of Sioux Chief Crazy Horse, Custer, SD, from 1948. Address in 1982, Crazy Horse Black Hills, SD. Died in 1982.

ZIROLI, ANGELO.
Sculptor, craftsman, and writer. Born Italy, Aug. 10, 1899. Pupil of Albin Polasek, Antonin Sterba, Vittorio Gigliotti. Member: Chicago Gallery of Artists; Ill. Academy of Fine Arts; All-Ill. Society of Fine Arts; Society of Medalists. Awards: Dunham prize, 1923, Shaffer prize, 1924, Art Institute of Chicago; first prize for sculpture, Society of Washington Artists, Washington, DC, 1928; Barnett prize, National Academy of Design, 1931. Author of "The Life of a Chicago Sculptor." Address in 1933, 717 South Racine Ave., Chicago, IL. Died in 1948.

ZOGBAUM, WILFRID.
Sculptor. Born in Newport, RI, September 10, 1915. Studied at Yale Univ., 1933-34; with John Sloan, NYC, 1934-35; Hofmann School, NYC and Provincetown, 1935-37 (class monitor). Works: Univ. of California; International Institute for Aesthetic Research; New School for Social Research; San Francisco Museum of Art; Whitney. Exhibitions: Walker; Staempfli Gallery, NYC; Obelisk Gallery, Wash., DC; Dilexi Gallery, San Francisco; Grace Borgenicht Gallery, Inc., NYC; Oakland Art Museum; Baltimore Museum of Art; Museum of Modern Art; Seattle World's Fair, 1962; Whitney Annuals; Art Institute of Chicago; Carnegie. Awards: Guggenheim Fellowship for Painting, 1937; Univ. of California Institute for Creative Work in the Arts, 1963. Member: American Welding Society; Sculptors Guild. Taught: Univ. of California, Berkeley, 1957, 1961-63; Univ. of Minnesota, 1958; Pratt Institute, 1960-61; Southern Illinois Univ., 1961. Died in NYC, January 7, 1965.

ZOLNAY, GEORGE JULIAN.
Sculptor and teacher. Born July 4, 1863. Pupil of Imperial Academy of Fine Arts in Vienna; National Academy of Bucharest. Member: National Arts Club; St. Louis Art Guild; Washington Art Club; Union Inter. des Arts et

Sciences, Paris; Society of Washington Artists; Circolo Artistico, Rome; Tineremia Romana, Bucharest. Awards: Gold medal, St. Louis Exp., 1904; gold medal, Portland Exp., 1905. Decorated by the King of Romania with the Order "Bene Merenti" first class. Work: "Pierre Laclede Monument," and Confederate monument, St. Louis, MO; "Winnie Davis" and "Jefferson Davis" monuments, Richmond, VA; "Soldiers Monument" and "Sam Davis Monument," Nashville, TN; "Gen. Bartow" and "Gen. McLaws" monument, Savannah, GA; "Soldiers Monument," Owensboro, KY; "Edgar Allan Poe Monument," University of Virginia, Charlottesville, VA; colossal, "Lions," on City Gates, University City, MO; main group, US Customs House, San Francisco, CA; Labor Monument, New Bedford, MA; Sequoyah Statue, US Capitol, Washington; War Memorial, and sculpture of the Parthenon, Nashville, TN. Represented in the Bucharest Royal Institute; St. Louis Museum; Herron Art Institute, Indianapolis. Address in 1933, Washington, DC; 15 Gramercy Park, New York, NY.

ZORACH, WILLIAM.
Sculptor, painter, and teacher. Born February 28, 1887, in Eurburick-Kovno, Russia. Came to US in 1891. Lived in NYC and Maine. Studied at Cleveland Institute of Art; National Academy of Design (NYC), and in Paris. Taught at Des Moines Art Center; Art Students League (NYC) from 1929 to 1966. Awards: MFA (hon.), Bowdoin Club; DFA, Colby Club; Widener Memorial Medal; National Institute Arts and Letters gold medal; New York Architectural League honorable mention; prize, Art Institute of Chicago, 1931, medal and purchase prize, 1932; others. Exhibited at Taylor Gallery, Downtown Gallery, Whitney Museum, Queens College, Brooklyn Museum, Zabriskie Gallery (all in NYC); Art Institute of Chicago; Art Students League; Contemporary Arts Center, Cincinnati, OH. In collections of Phillips Academy, Andover; Newark Museum; Webb Gallery, VT; Butler Institute, Youngstown, OH; University of Nebraska, Lincoln; Whitney Museum, Columbia University (both in NYC); IBM. Contributor to *Magazine of Art, Creative Arts, National Encyclopedia,* and other publications. Author of *Zorach Explains Sculpture.* Address in 1953, NYC. Died in Bath, ME, November 15, 1966.

ZUCKER, BARBARA MARION.
Sculptor and instructor. Born in Phila., PA, August 2, 1940. Studied at Univ. of Mich., B.S. (design), 1962, sculpture with Joe Goto and Paul Suttman; Cranbrook Academy Art, Bloomfield Hills, Mich.; Kokoschka School Vision, Salzburg, Austria, 1961; Hunter College, M.A., 1977. Work: Whitney Museum of American Art; private collections of Lowell Nesbit, Claes Oldenburg, Helen Herrick, and Kermit Bloomgarten. Exhibitions: 26 Contemp. Women Artists, Aldrich Museum Art, Ridgefield, Conn., 1971; one-woman shows, Douglass College, Rutgers Univ., New Brunswick, NJ, 1973, Focus, Phila. Civic Center Museum, 1974, and 112 Greene St. Gallery, 1976; Seven Sculptors, Institute of Contemp. Art, Boston, 1974. Awards: Honor Society, Univ. of Michigan, 1952; National Endowment Arts Fellowship Grant, 1975. Positions: Associate Editor, *Art News Magazine,* from 1974;

Co-founder of AIR Gallery, NYC, 1972. Taught at various colleges and universities. Media: Sculpture; organic abstraction. Address in 1982, 21 East Tenth Street, NYC.

ZUCKERMAN, RUTH.
Sculptor. Studied at Art Students League, NY; School of Visual Arts, NYC; New School for Social Research, NYC; Instituto San Miguel de Allende, Mexico. Has exhibited at East End Temple, NYC; Tiffany, NYC; Arras Gallery, NYC; Aronson Gallery Ltd., Atlanta; Capricorn Gallery, Washington, DC; Allied Artists of America; Artists Equity Association of New York; Atlanta High Museum; Audubon; Catherine Lorillard Wolfe Annuals; National Sculpture Society; and many more in US and abroad. Works in bronze and marble. Address in 1982, Atlanta, GA.

ZURIK, JESSELYN BENSEN.
Sculptor. Born in New Orleans, LA, in 1916. Studied at Arts and Crafts School, New Orleans; Newcomb School of Art, Tulane University, New Orleans. Awards: Brandeis University Invitational; Rose Art Museum, Waltham, MA, 1963; Southern Association of Sculptors, Arkansas Art Center, 1966; Picayune Art Festival, Picayune, MS, 1970. Collections: Mead Packing Company, Atlanta, Georgia; Haspel Brothers, NYC; Manufacturer's Hanover Trust, Plaza Towers, New Orleans, LA.

ZWICK, ROSEMARY G.
Sculptor, printmaker, and etcher. Born in Chicago, Ill., July 13, 1925. Studied at University Iowa, with Phillip Guston and Abrizio, B.F.A., 1954; Art Institute Chicago, with Max Kahn, 1945-47; DePaul University, 1946. Works: Oak Park Library Collection, Ill.; Albion College Print Collection, Mich.; Reavis School Collection, Chicago; Phoenix Public Schools Collection, Ariz.; Crow Island School, Winnetka, Ill.; plus others. Exhibitions: Art Institute of Chicago, 1954-75; Ceramic National, Everson Museum of Art, Syracuse, NY, 1960, 62, and 64; Society of Washington Printmakers, National Museum, Washington, DC, 1964; Mundelein College, Chicago, 1964-71; Indianapolis Museum Art, 1970-75, 81. Member: Renaissance Society, University of Chicago; Chicago Society of Artists. Media: Ceramics. Address in 1982, 1720 Washington Street, Evanston, IL.

Illustrations

Former roof garden at Parke Bernet Building, 980 Madison Avenue, NYC. Photograph courtesy of National Sculpture Society.

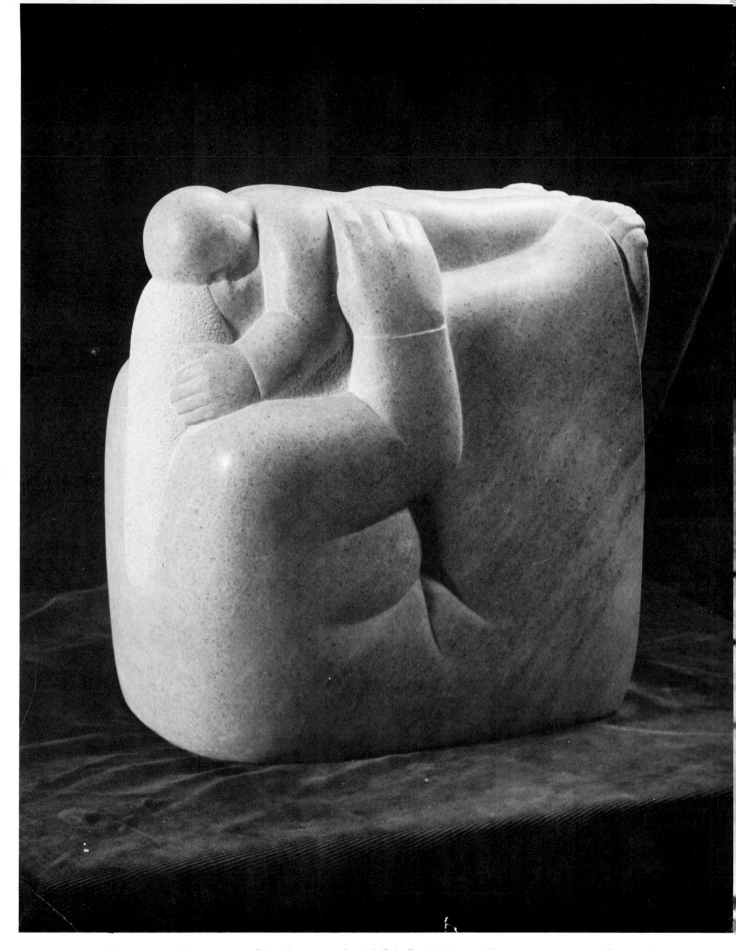

Aarons, George. "Mother and Child," 1949. Tennessee marble, 12 inches by 12 inches. Photograph courtesy of National Sculpture Society.

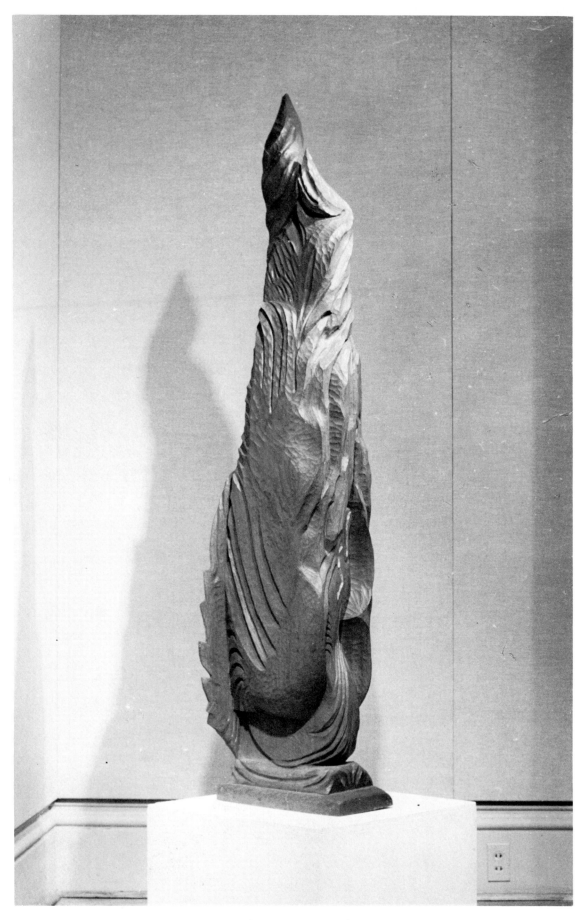

Abbe, Elfriede Martha. Phoenix. Mahogany, 6 1/2 feet high.
Photograph courtesy of National Sculpture Society.

451

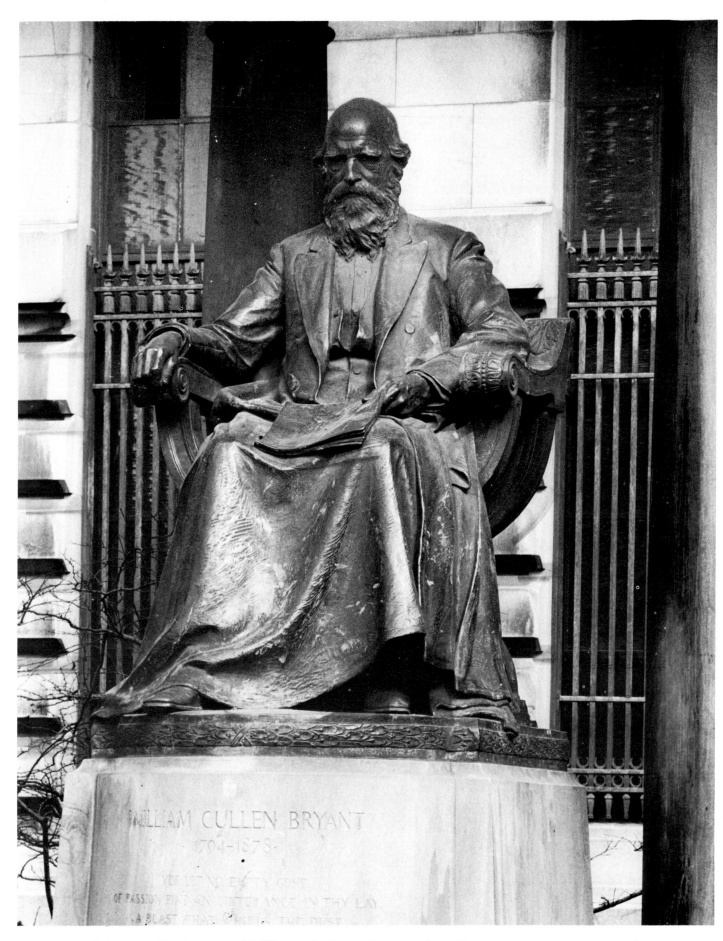

WILLIAM CULLEN BRYANT

1794-1878

YET LET NO BUSY GUST

OF PASSION FIND AN UTTERANCE IN THY LAY,

A BLAST THAT WHIRLS THE DUST

Adams, Herbert. "William Cullen Bryant." Photograph courtesy of
National Sculpture Society.

452

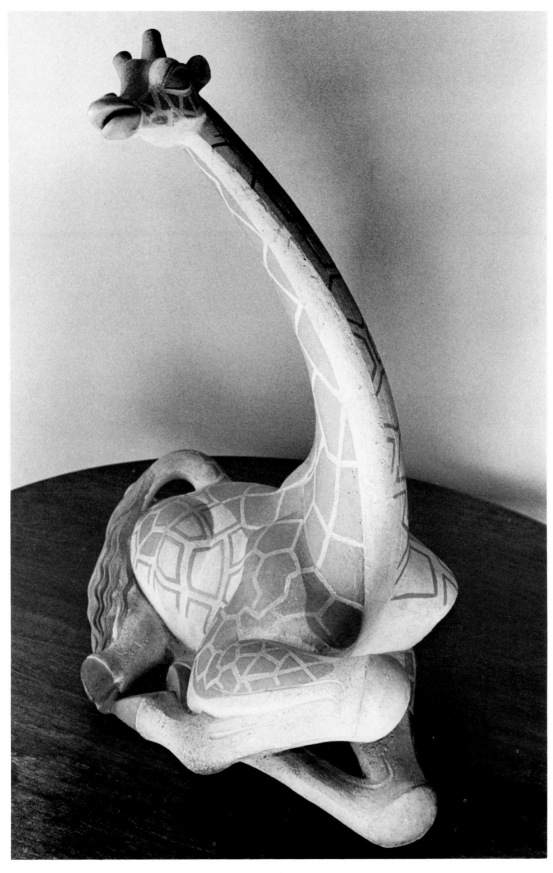

Addison, Walter. Giraffe, 1960. Terra cotta, 25 inches high by 14
inches wide. Photograph courtesy of the artist.

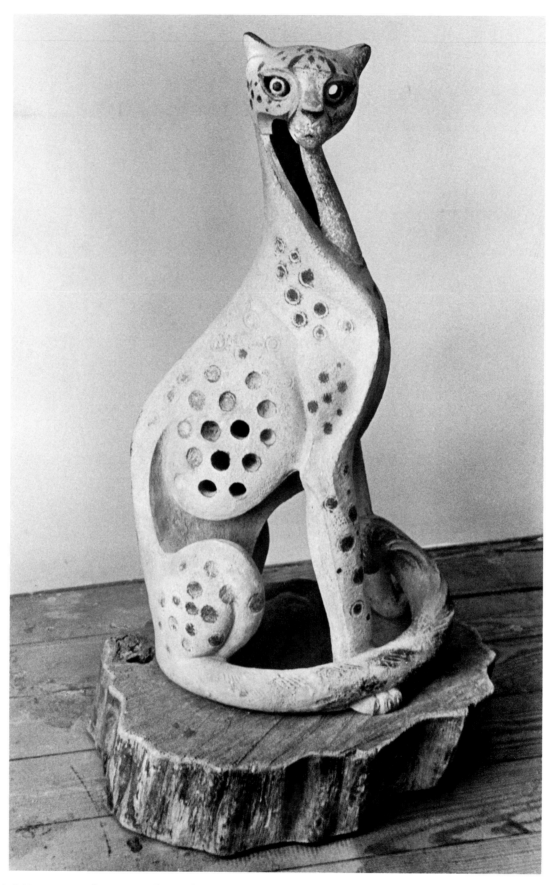

Addison, Walter. Cheetah, 1950. Terra cotta, 30 inches high by 16 inches wide. Photograph courtesy of the artist.

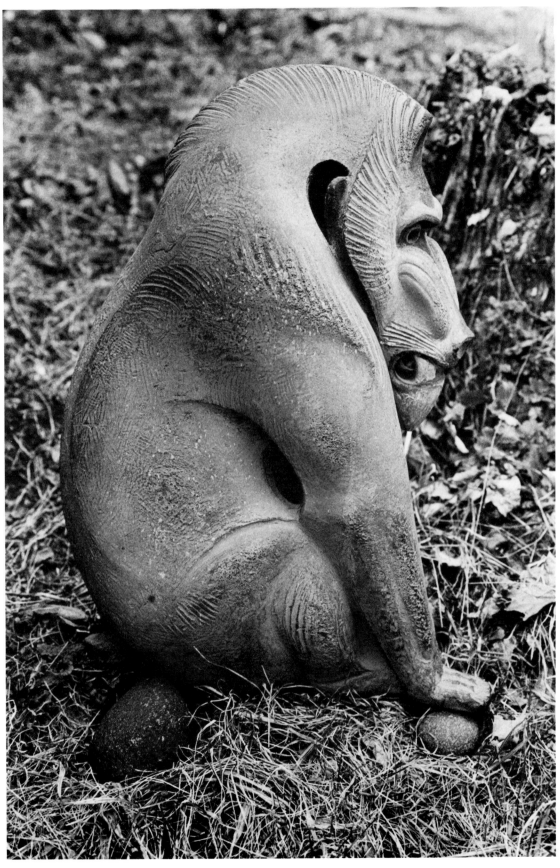

Addison, Walter. Mandrill, 1965. Terra cotta, 19 inches high by 9
inches wide. Photograph courtesy of the artist.

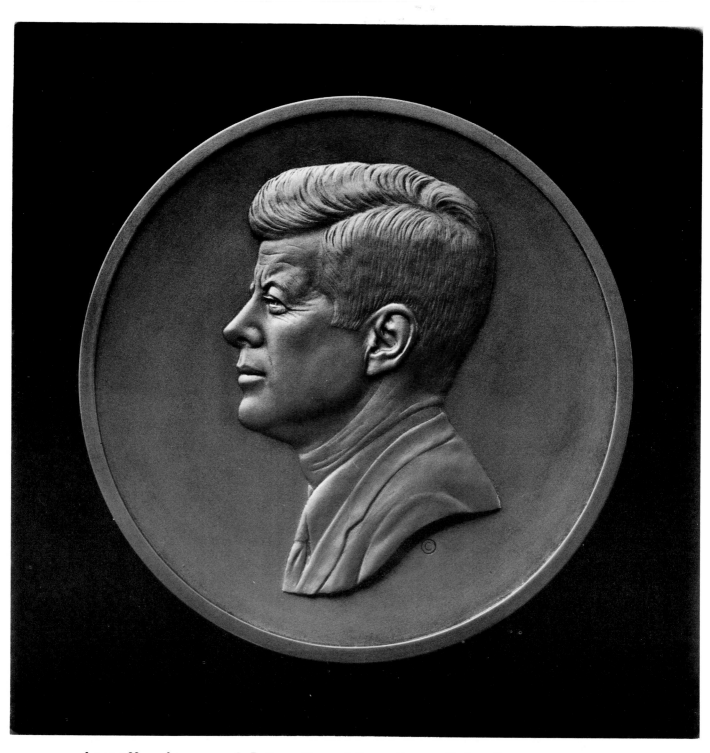

Agopoff, Agop. J.F.K. Memorial. Bas-relief plaque, 4 feet.
Photograph courtesy of National Sculpture Society.

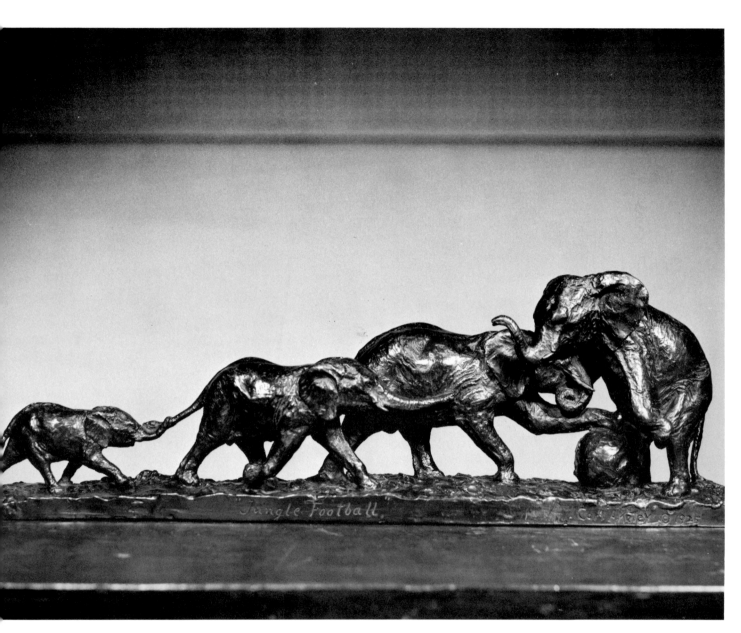

Akeley, Carl Ethan. "Jungle Football." Bronze. Ex Collection of Bob
Bahssin, Post Road Gallery, Larchmont, NY.

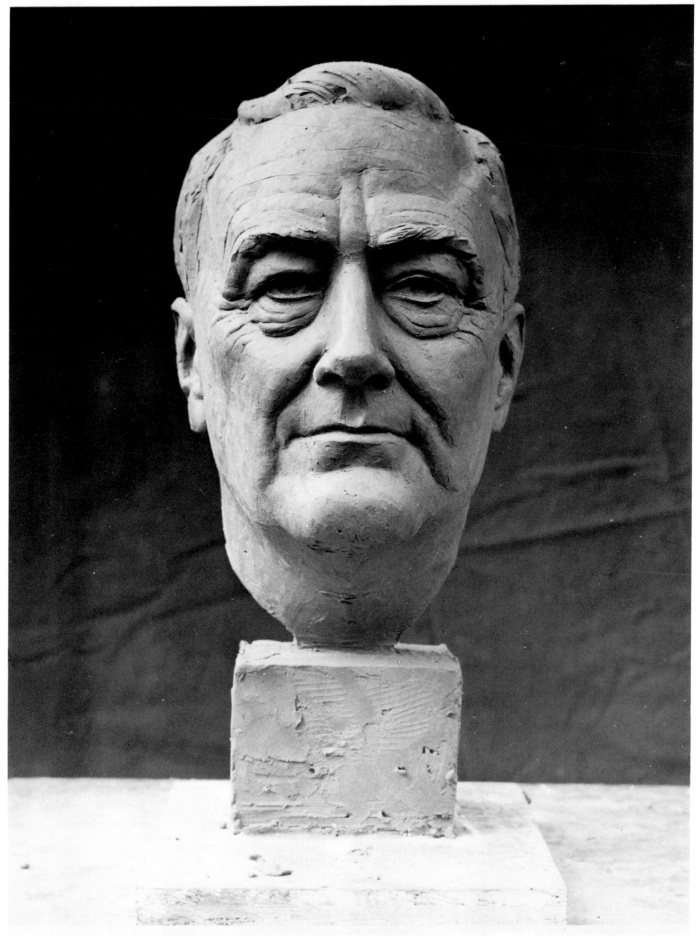

Amateis, Edmond Romulus. F. D. Roosevelt. Photograph courtesy of
National Sculpture Society.

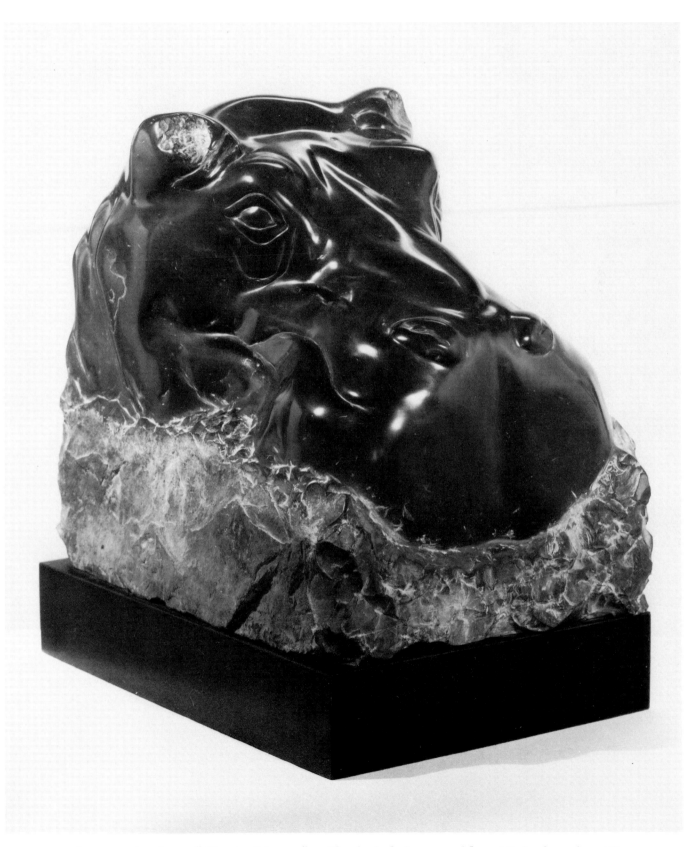

Anson, Lesia. "Black Hippo." Black belgian marble, 15 inches by 10
inches by 14 inches. Photograph courtesy of the artist.

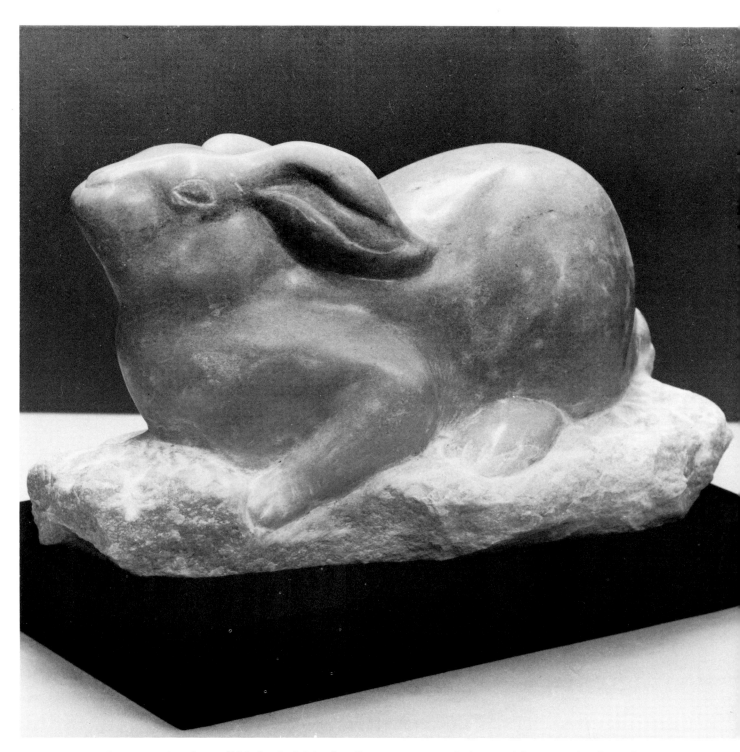

Anson, Lesia. "Pink Rabbit." Portuguese pink marble, 13 inches by
7 inches. Photograph courtesy of the artist.

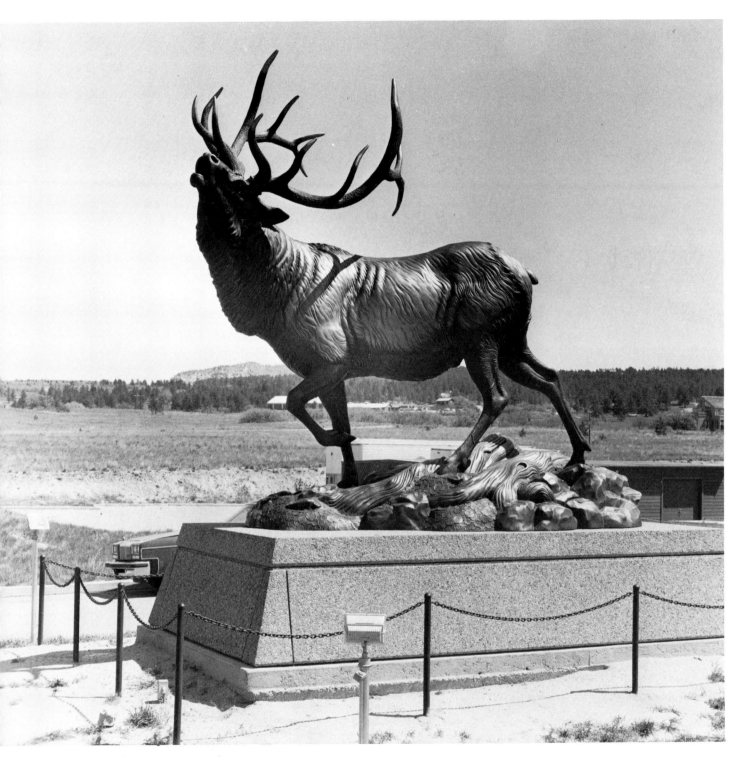

Balciar, Gerald G. "Challenge." Bronze, 17 feet high. Wildlife World Art Museum Monument. Photograph courtesy of the artist.

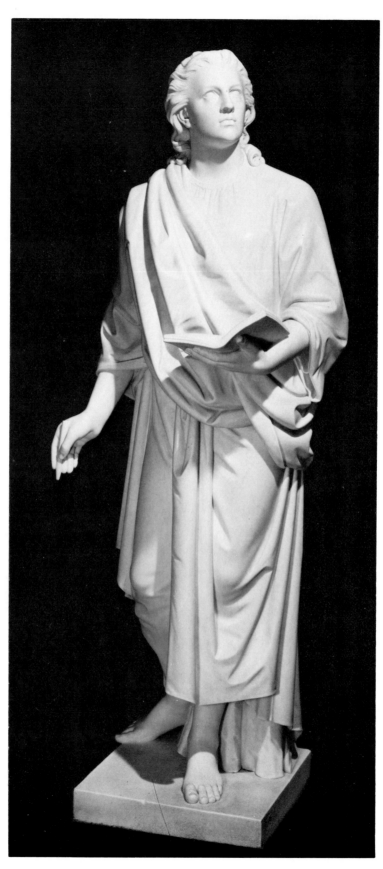

Ball, Thomas. "St. John the Baptist." Marble. Collection of Bob
Bahssin, Post Road Gallery, Larchmont, NY.

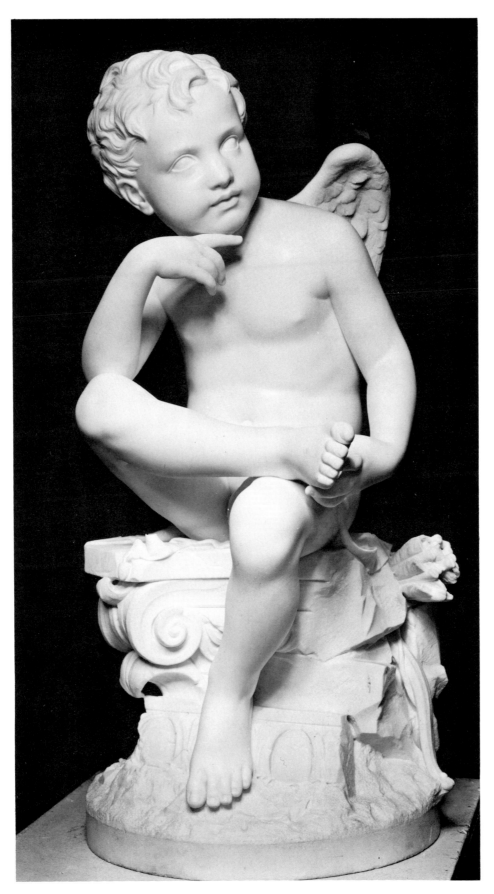

Ball, Thomas. "Amour." Marble. Collection of Bob Bahssin, Post
Road Gallery, Larchmont, NY.

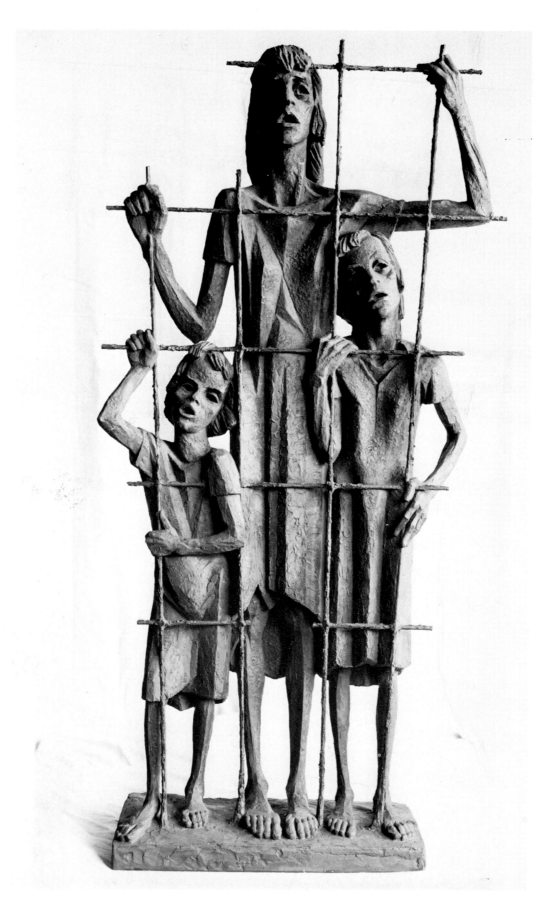

Barbarossa, Theodore C. "Iron Curtain." Bronze, 38 inches by 16 inches by 7 inches. Photograph courtesy of National Sculpture Society.

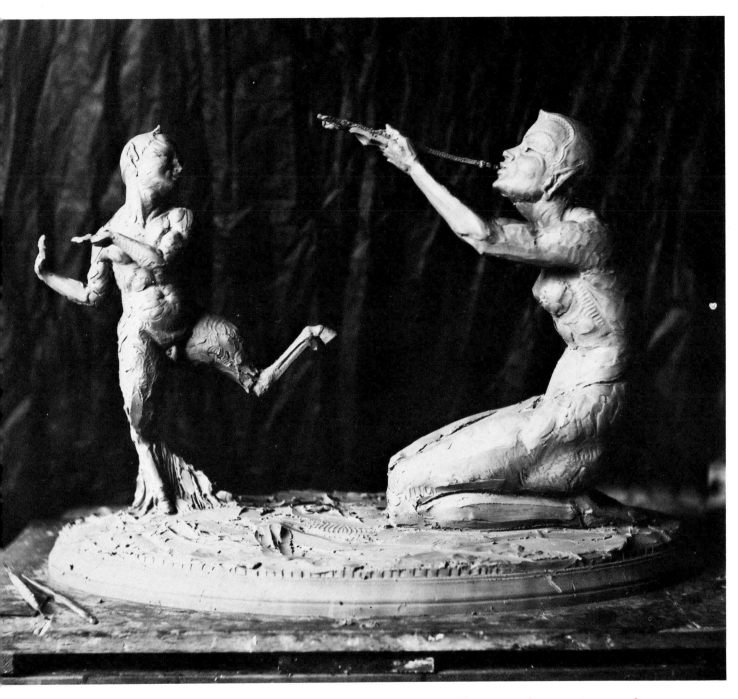

Barbarossa, Theodore C. 30 inches long. Photograph courtesy of
National Sculpture Society.

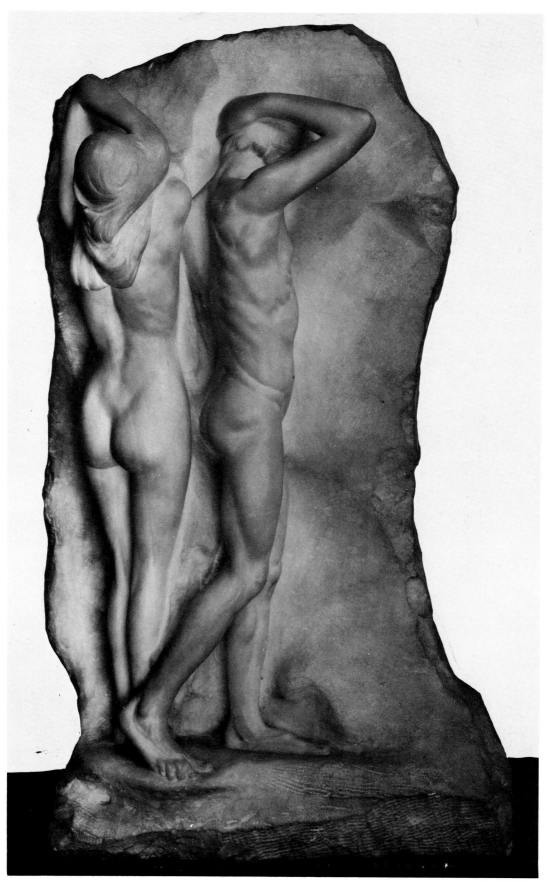

Barnard, George Grey. "Solitude," 1905-06. Marble, 21 3/4 inches
high. Collection, Vassar College Art Gallery, Poughkeepsie, New York.

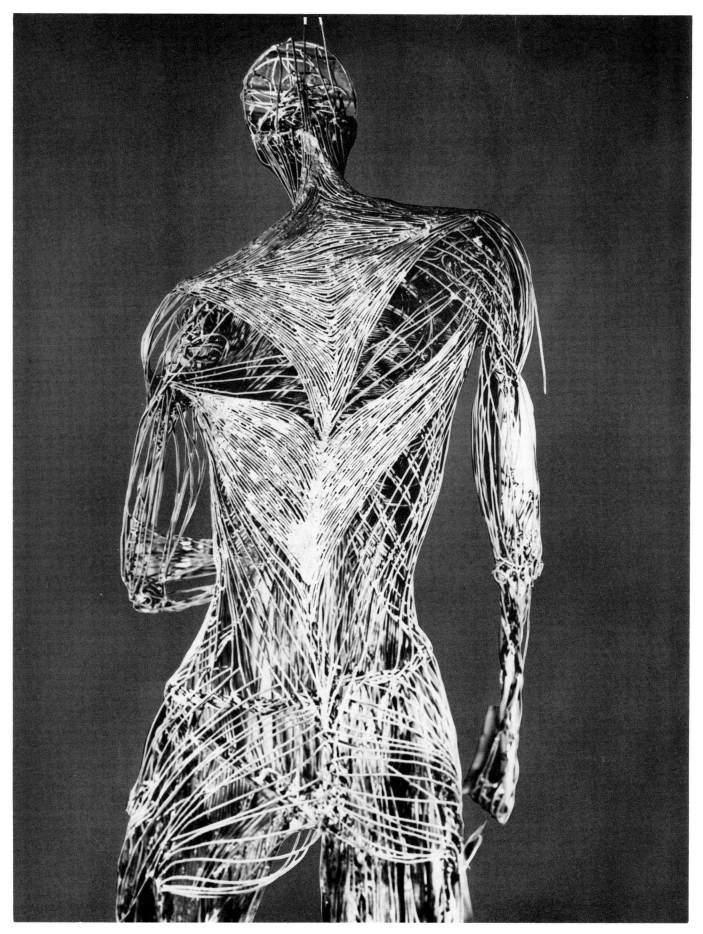

Bartlett, Paul Wayland. Photograph courtesy of National Sculpture
Society.

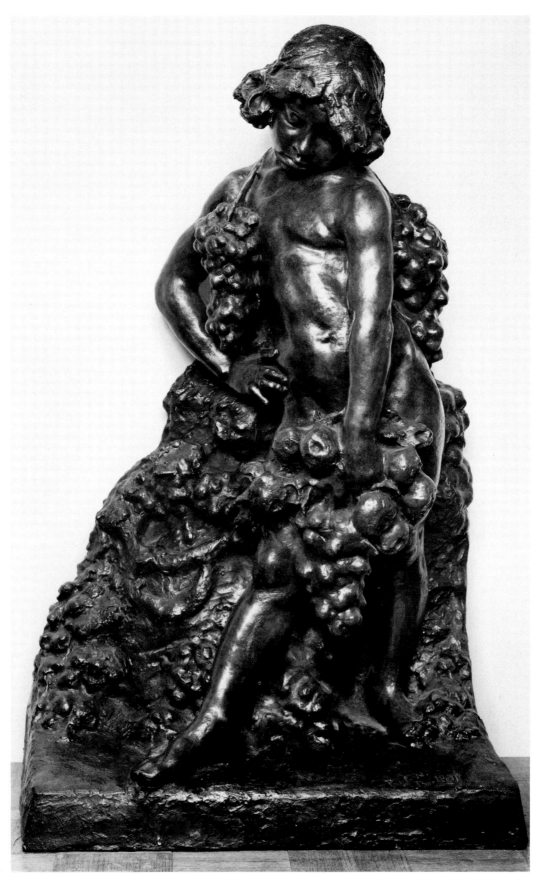

Bartlett, Paul Wayland. "Bacchante." Bronze. Ex Collection of Bob
Bahssin, Post Road Gallery, Larchmont, NY.

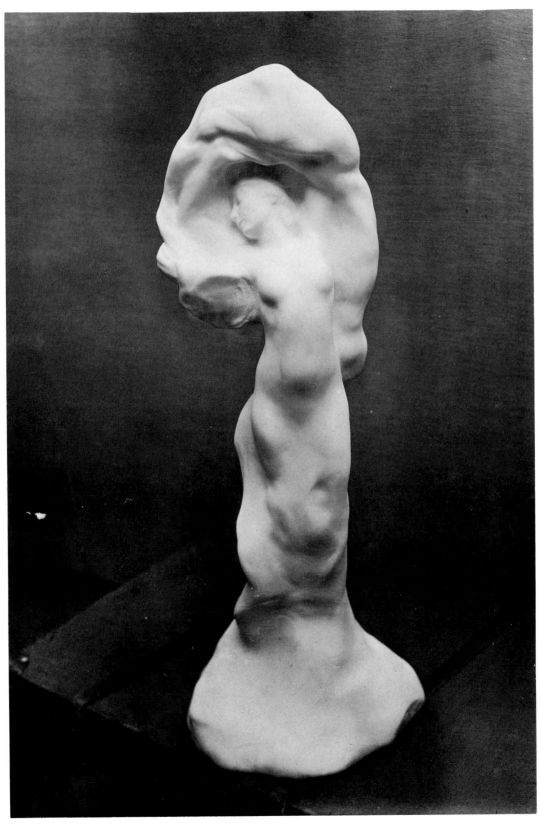

Beach, Chester. "Unveiling of Dawn." Photograph courtesy of National Sculpture Society.

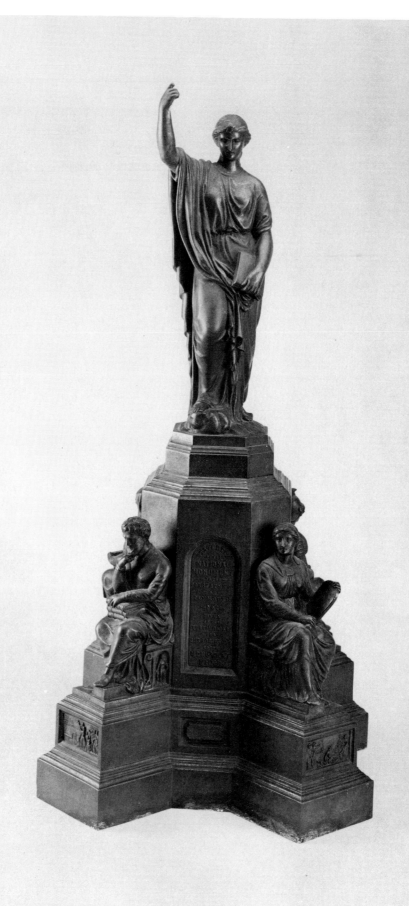

Billings, Hammatt. "Faith," 1867. Bronze, 22 1/4 inches high.
Collection, Vassar College Art Gallery, Poughkeepsie, New York.

470

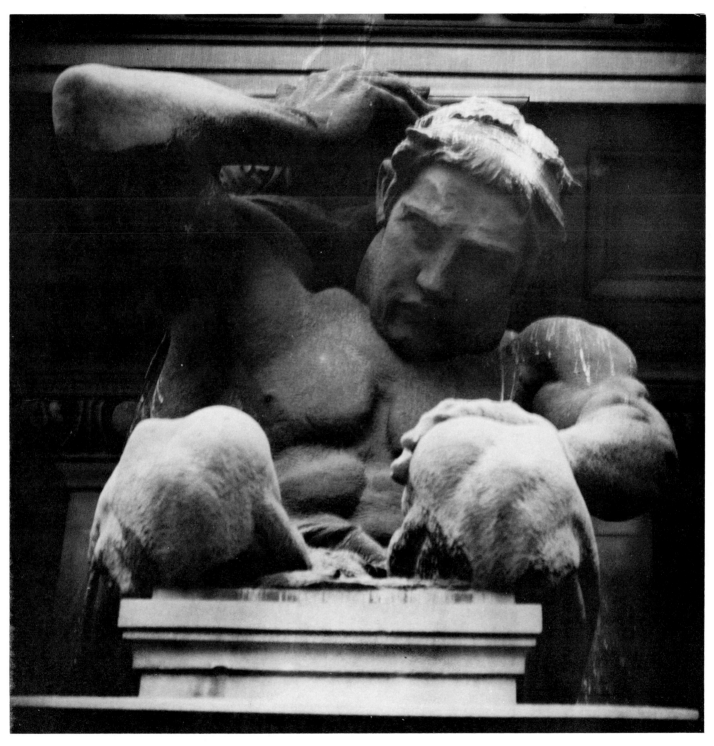

Bitter, Karl Theodore. Photograph courtesy of National Sculpture
Society.

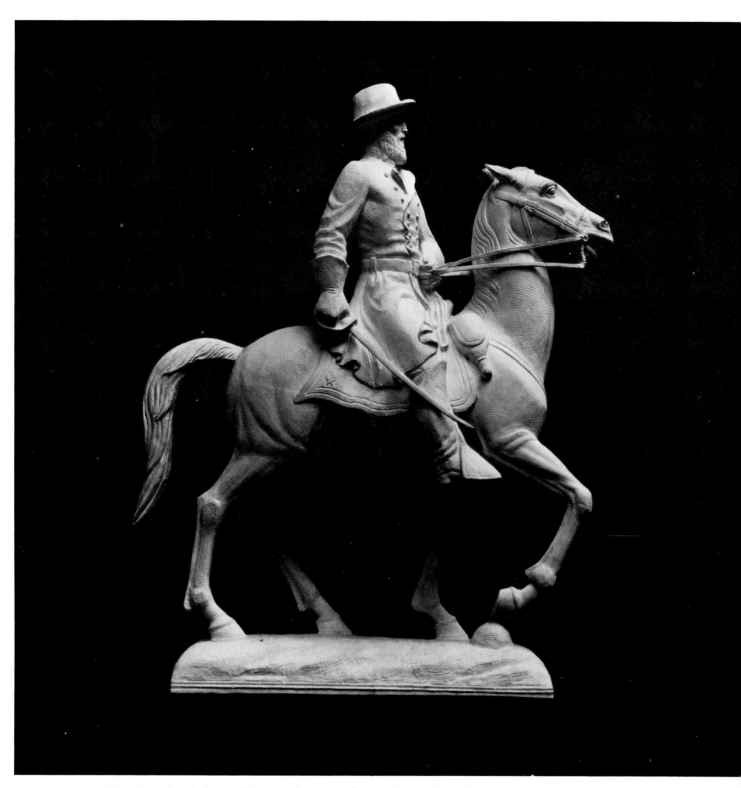

Block, Adolph. "Gen. Stonewall Jackson." Plaster, 22 inches high. Photograph courtesy of National Sculpture Society.

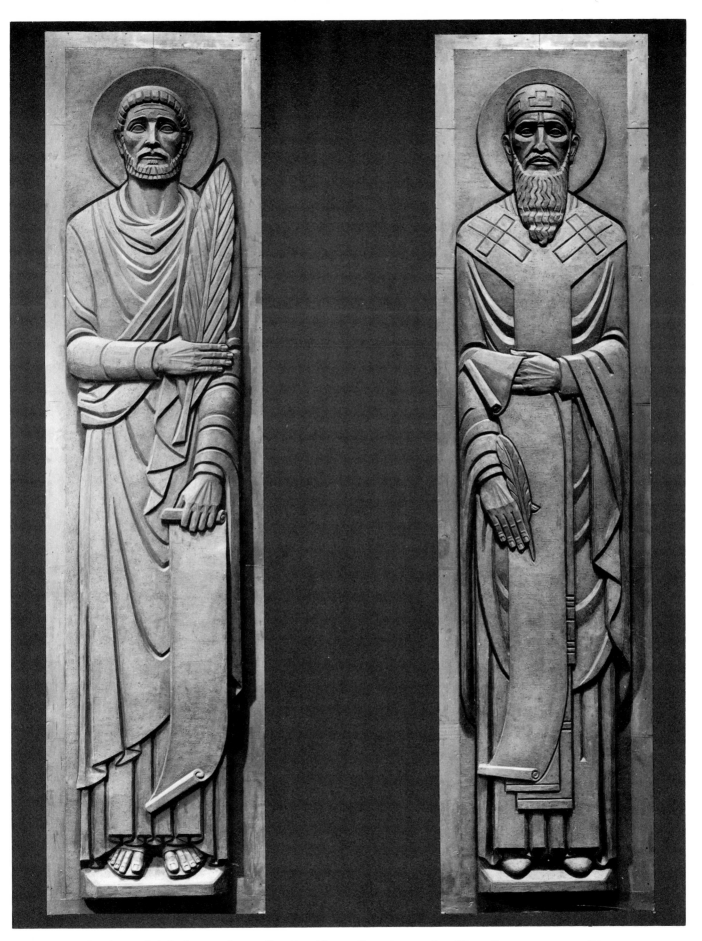

Block, Adolph. St. Basil the Great and St. Irenaeus. Stone bas-relief, 8 feet by 6 inches. Photograph courtesy of National Sculpture Society.

Boghosian, Varujan. Siberia, for James Clarence Mangan, 1973. Cast iron, wood, and bronze, 31 inches high. Collection, Vassar College Art Gallery, Poughkeepsie, New York.

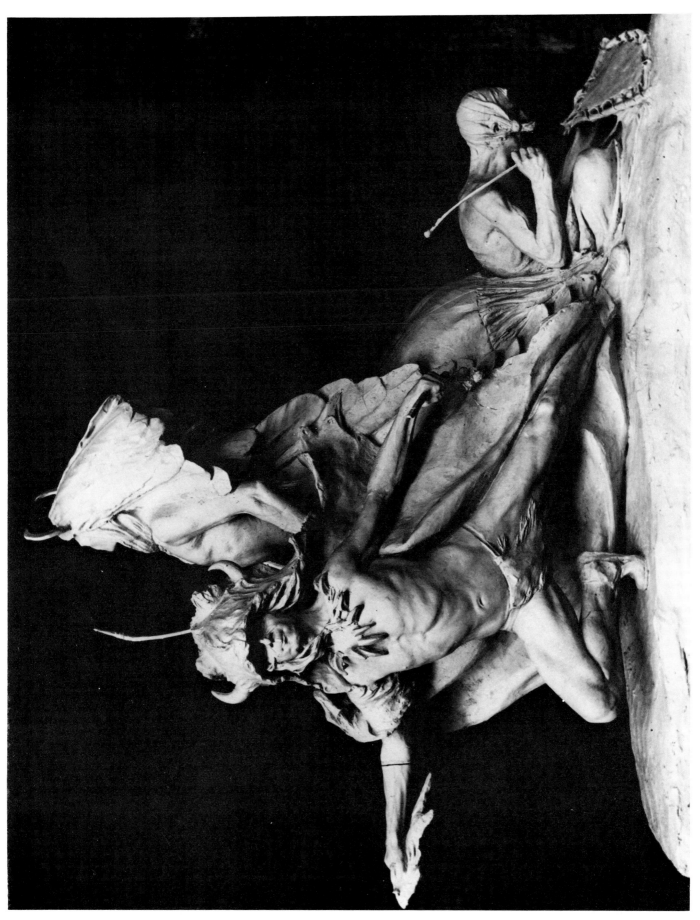

Borglum, Solon H. Sioux Indian Buffalo Dance, 1904. Plaster.
Photograph courtesy of National Sculpture Society.

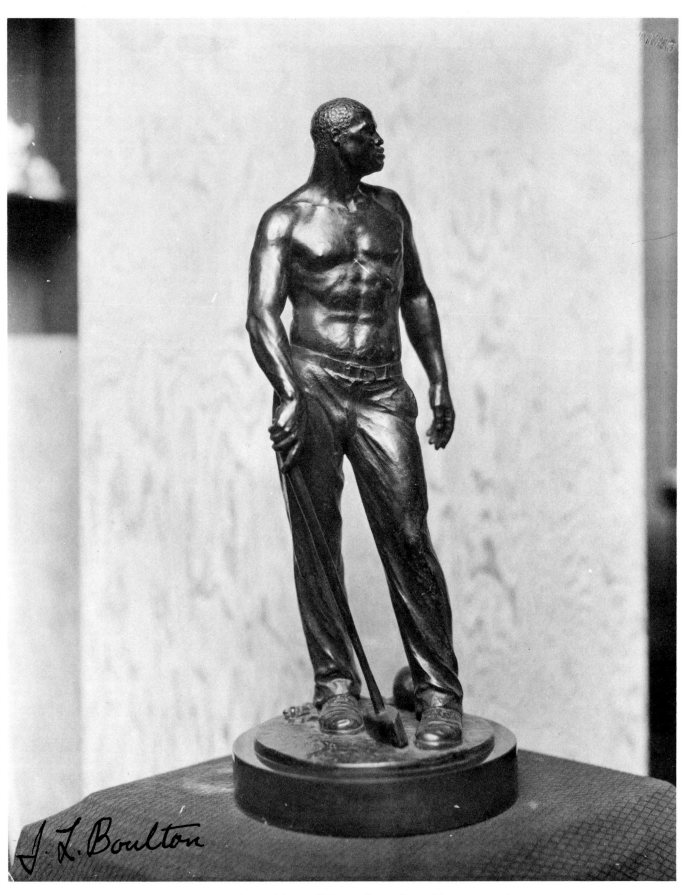

Boulton, Joseph Lorkowski. "Waterboy." Photograph courtesy of National Sculpture Society.

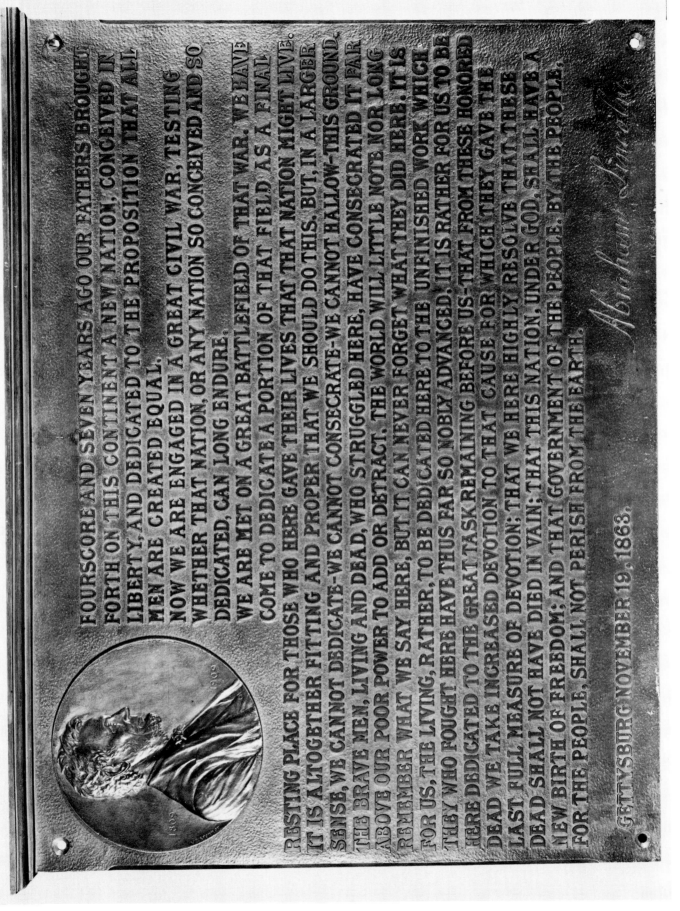

Brenner, Victor David. "Abraham Lincoln and the Gettysburg Address," for the Lincoln Centennial. Bronze, 22 inches by 28 3/4 inches. Collection of Victor D. Spark, NYC.

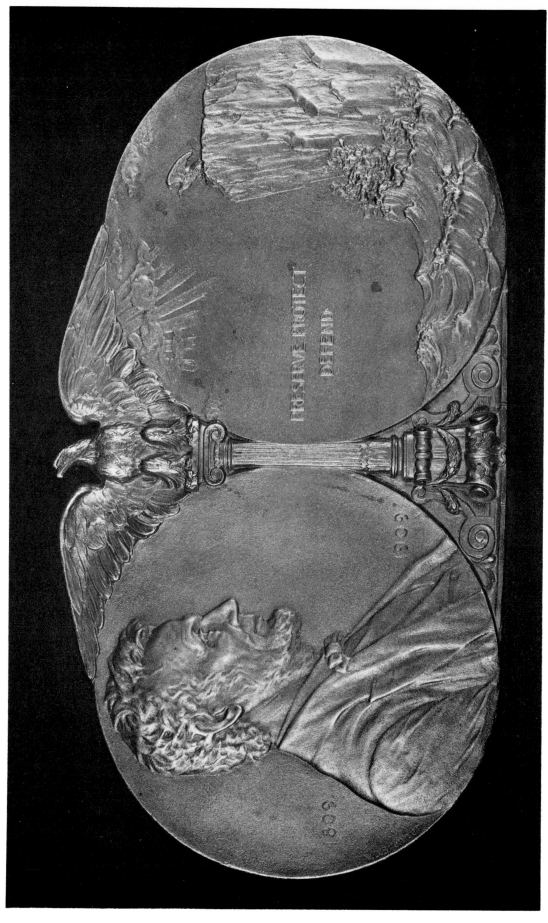

Brenner, Victor David. "Abraham Lincoln," Centennial plaque.
Bronze, 7 1/2 inches by 14 inches. Collection of Victor D. Spark,
NYC.

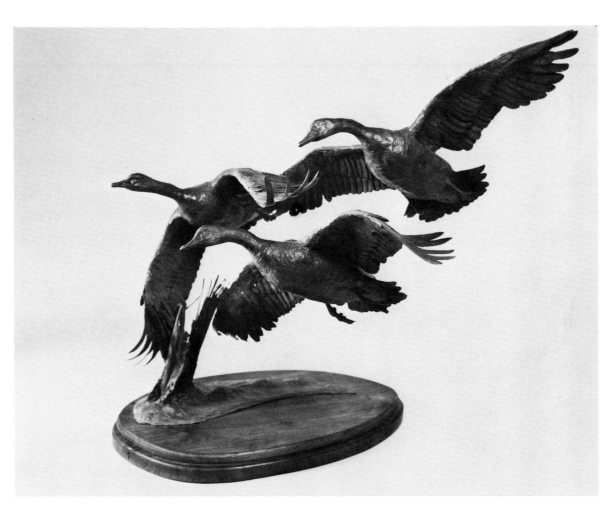

Bronson, Jonathan. "Spring Winds." 4 feet by 4 feet. Photograph courtesy of the artist.

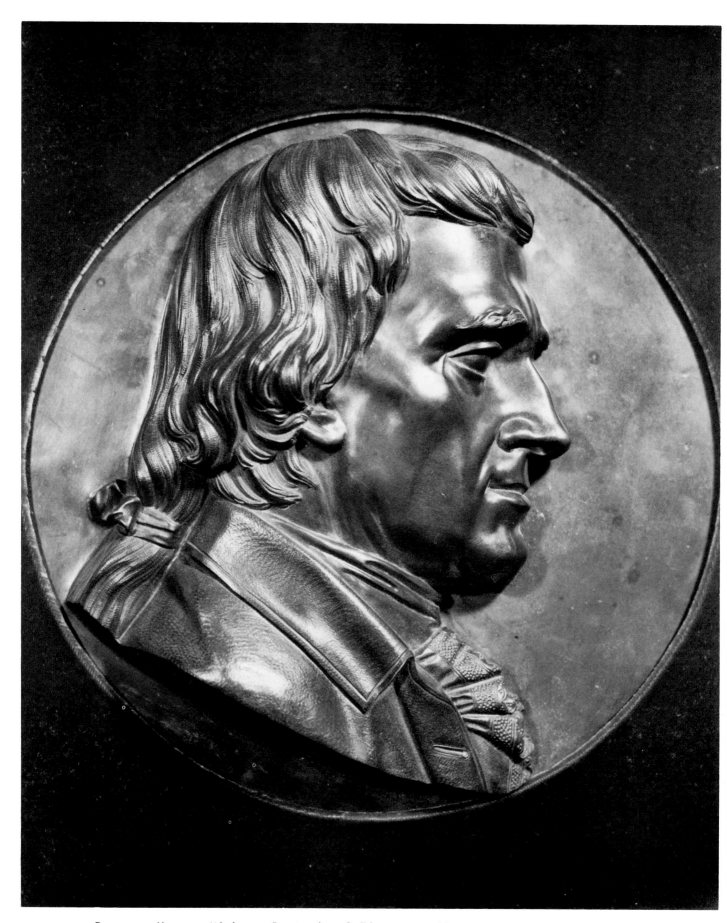

Brown, Henry Kirke. Portrait of Thomas Jefferson, 1852. High relief
bronze, 9 3/4 inches in diameter. Collection of Victor D. Spark, NYC.

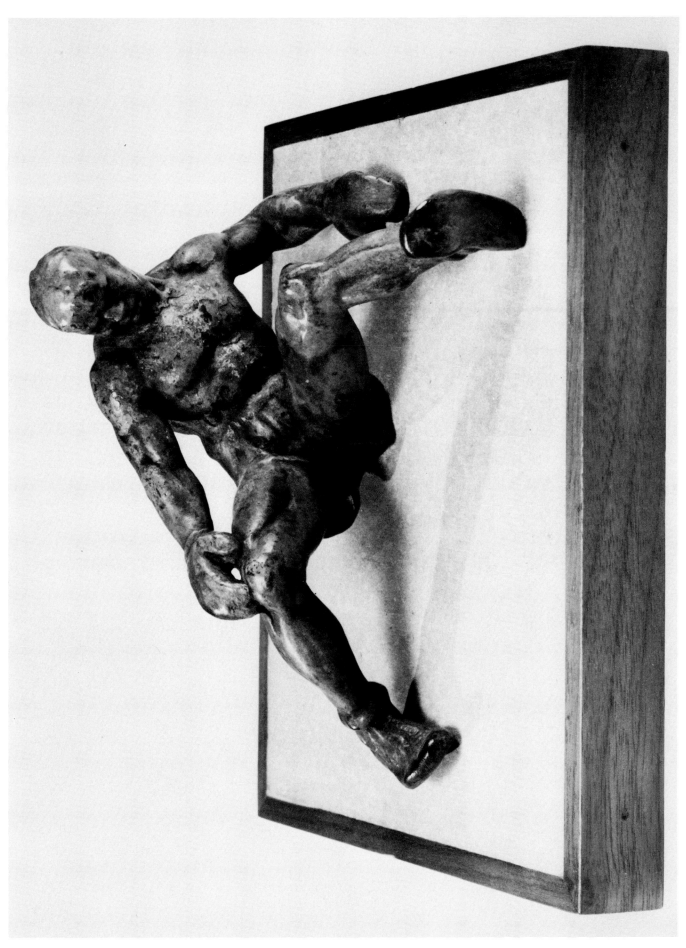

Brown, Joseph. "Dropped." Bronze with green patina, 3 5/8 inches
high. Collection, Vassar College Art Gallery, Poughkeepsie, New York.

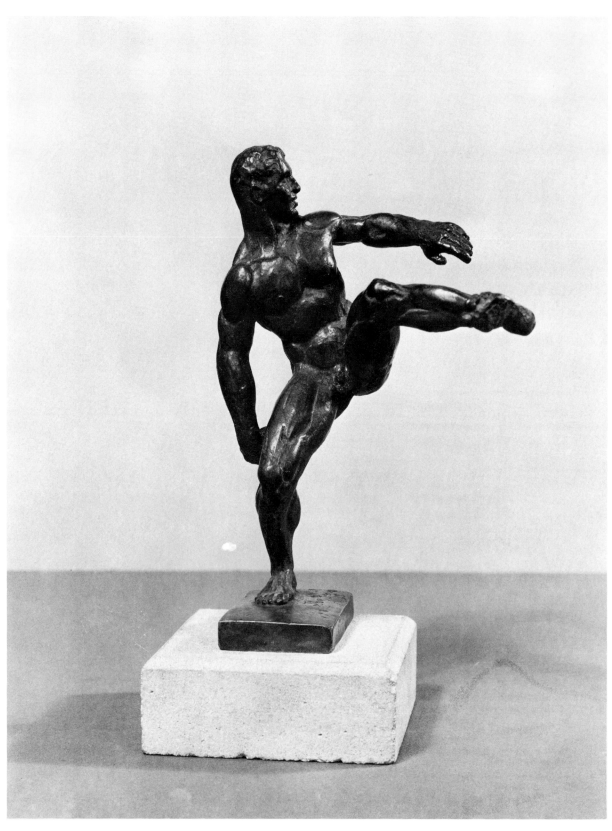

Brown, Joseph. "Hurler." 9 inches high. Photograph courtesy of National Sculpture Society.

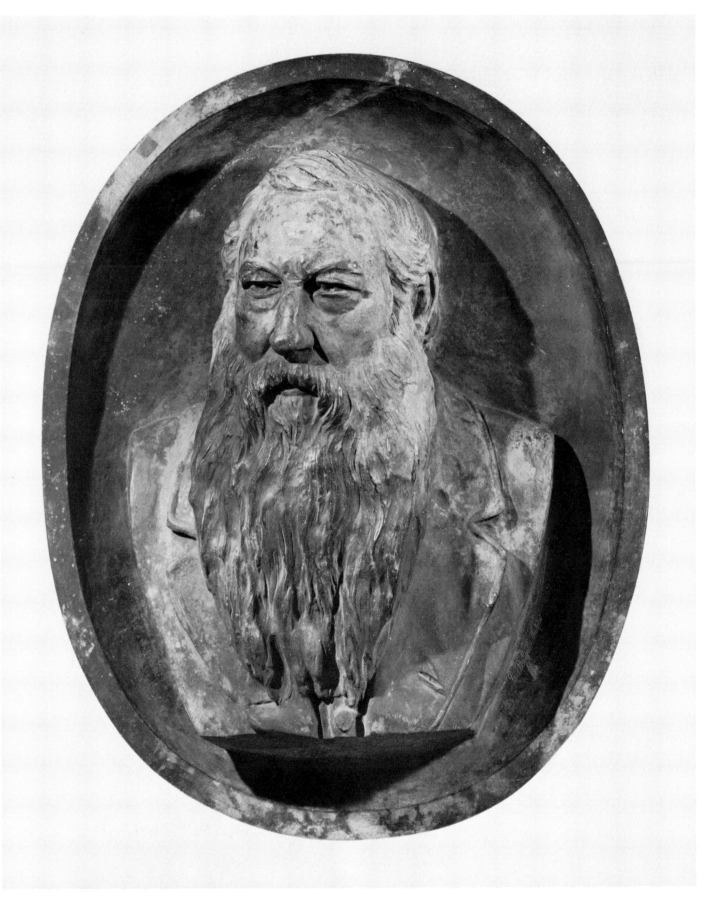

Buberl, Casper. "Admiral Dewey" (?). Collection of Bob Bahssin,
Post Road Gallery, Larchmont, NY.

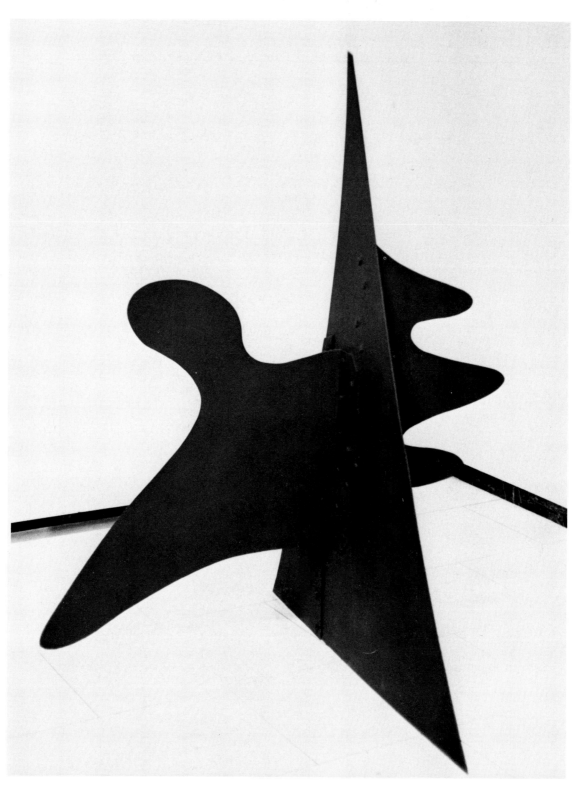

Calder, Alexander. "Triangle with Ears," 1966. Bolted steel plate painted black, 90 inches high. Collection, Vassar College Art Gallery, Poughkeepsie, New York.

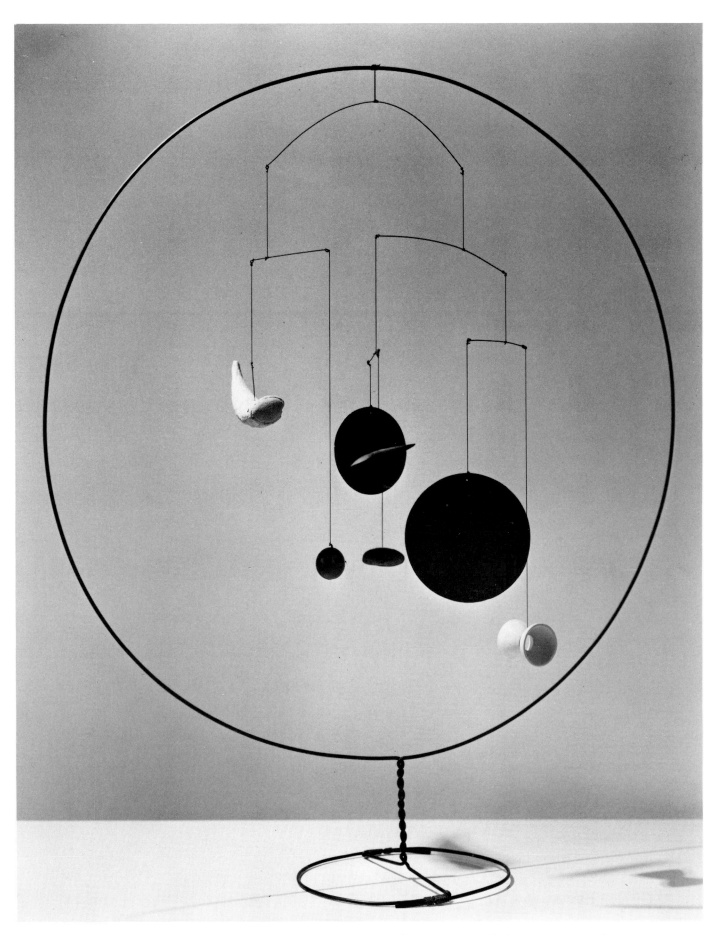

Calder, Alexander. "Agnes's Ring (The Circle)," 1935. Sheet aluminum, ceramic, wood, string, and steel wire, 36 inches high. Collection, Vassar College Art Gallery, Poughkeepsie, New York.

Calder, Alexander Milne. Benjamin Franklin. Statue in plaster before casting in bronze. Photograph courtesy of National Sculpture Society.

Calder, Alexander Milne. "Nude." Bronze. Ex Collection of Bob Bahssin, Post Road Gallery, Larchmont, NY.

Calder, Alexander Stirling. "The Last Dryad." 5 feet by 10 inches.
Photograph courtesy of National Sculpture Society.

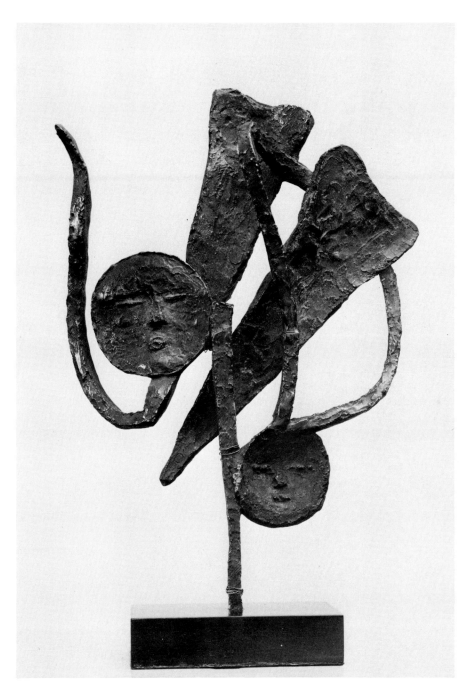

Callery, Mary. Study for "Orpheus," 1951. Bronze, 13 inches high.
Collection, Vassar College Art Gallery, Poughkeepsie, New York.

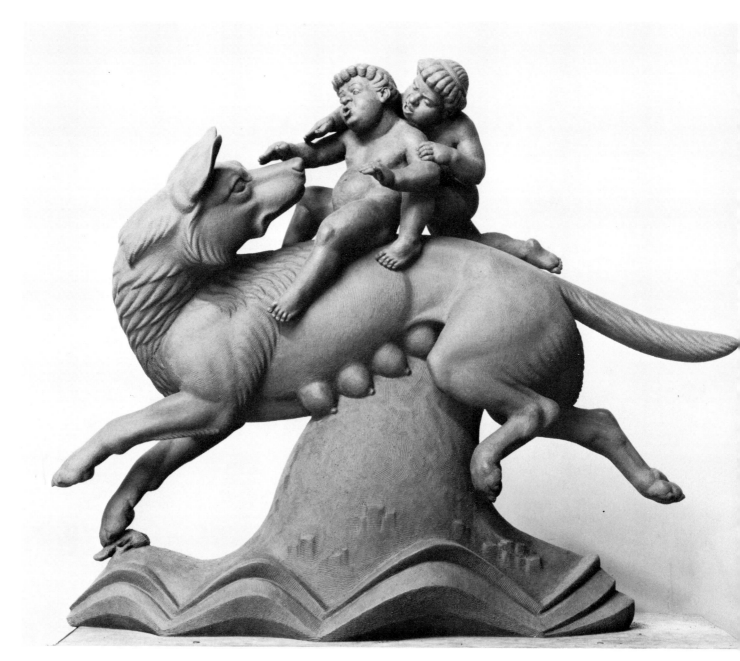

Carter, Granville W. Over the Palantine Hill and Tiber River. Bronze, 24 inches high. Photograph courtesy of National Sculpture Society.

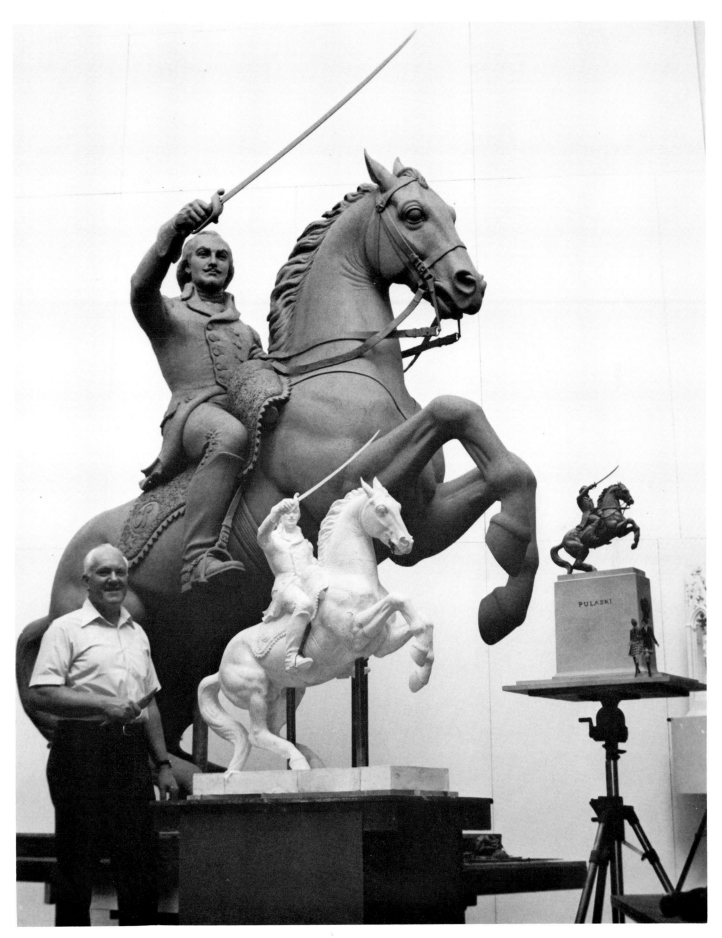

Carter, Granville W. P. Pulaski. Photograph courtesy of National
Sculpture Society.

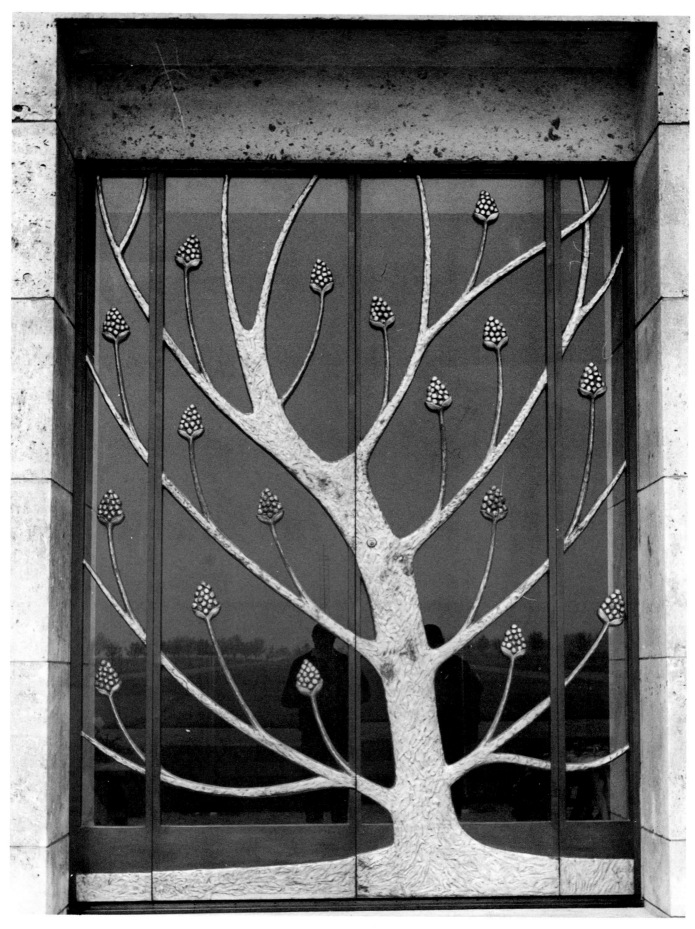

Cascieri, Arcangelo. Photograph courtesy of National Sculpture Society.

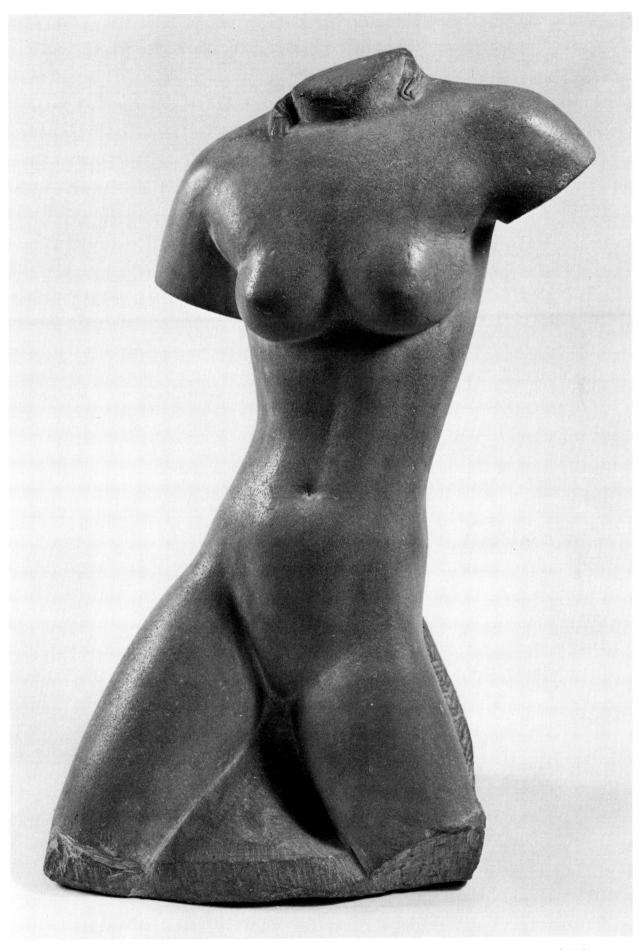

Cashwan, Samuel. Torso, 1937. Limestone, 22 inches high.
Collection, Vassar College Art Gallery, Poughkeepsie, New York.

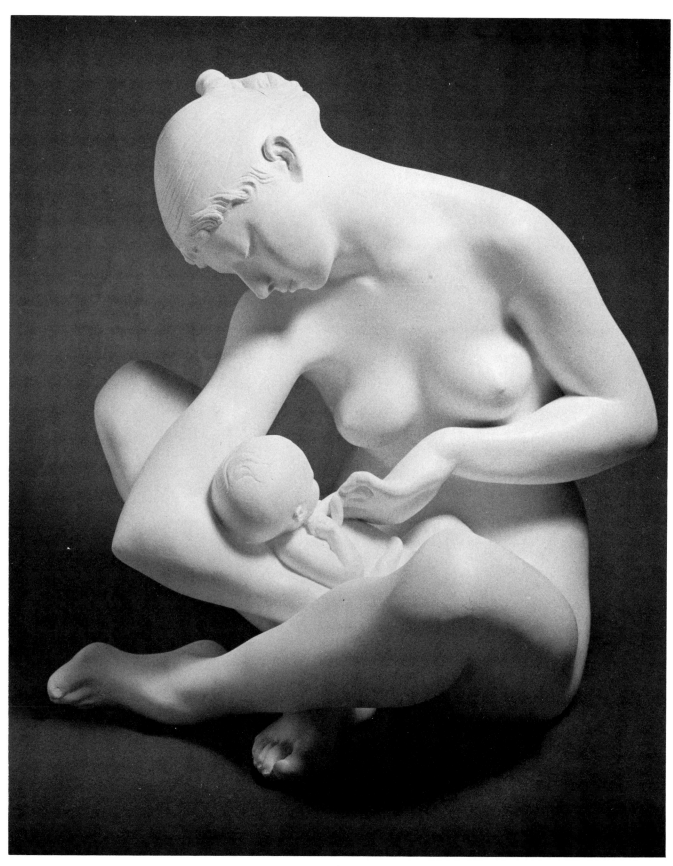

Chaudhuri, Patricia M. "Mother and Child." Photograph courtesy of
National Sculpture Society.

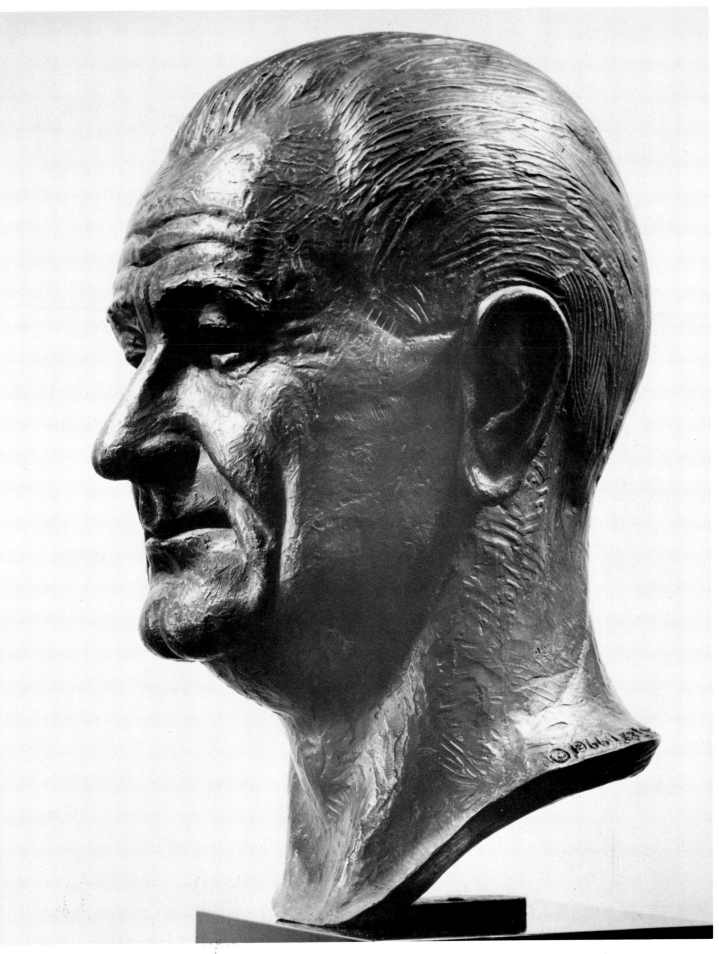

Cherne, Leo. "Lyndon B. Johnson." Photograph courtesy of National
Sculpture Society.

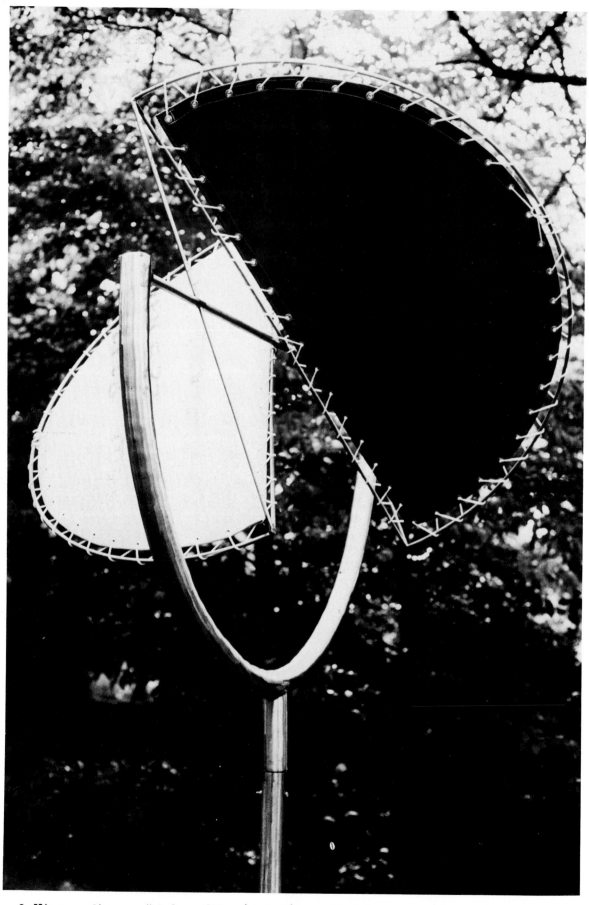

Collins, Jim. "Colormill" (detail). Stainless steel and canvas. Collection of Mr. & Mrs. William Holmberg, Chattanooga, TN. Photograph courtesy of the artist.

Cyprys, Allan. "Enclosure," 1982. Wood, 9 1/2 inches by 21 inches
by 3 inches. Photograph courtesy of the artist.

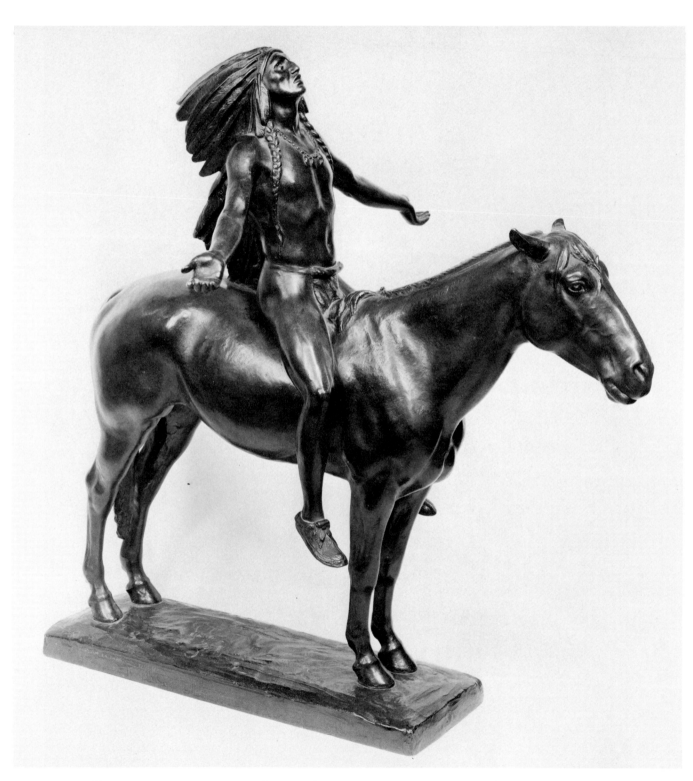

Dallin, Cyrus Edwin. "Appeal to the Great Spirit." Bronze. Ex
Collection of Bob Bahssin, Post Road Gallery, Larchmont, NY.

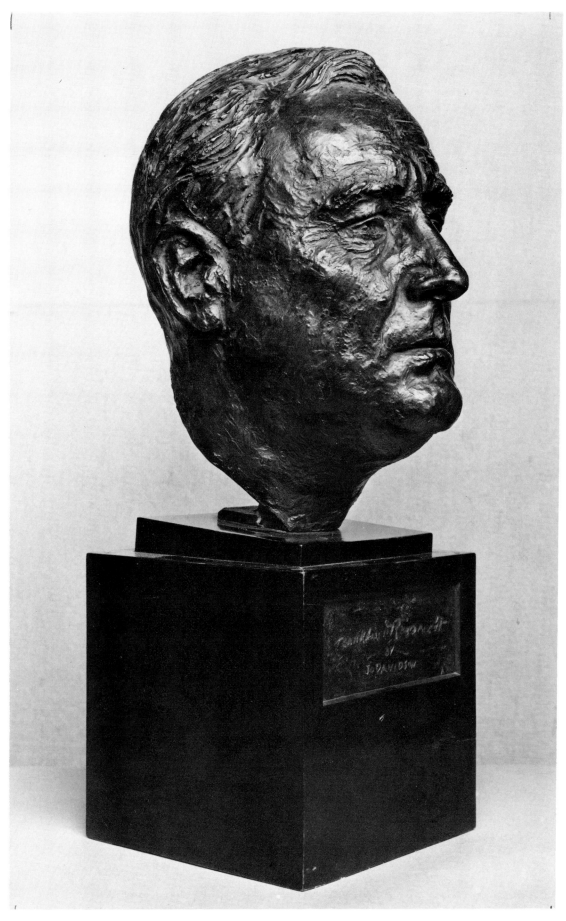

Davidson, Jo. Bust of Franklin Delano Roosevelt, 1933. Cast bronze, 12 1/2 inches high. Collection, Vassar College Art Gallery, Poughkeepsie, New York.

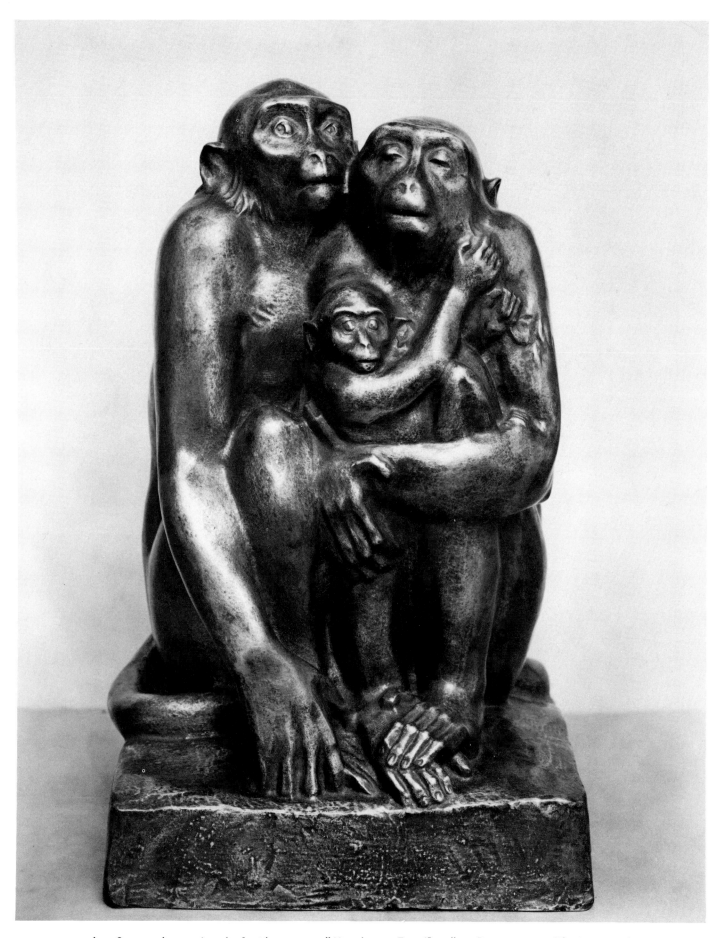

de Gerenday, Laci Anthony. "Monkey Family." Bronze. Photograph courtesy of National Sculpture Society.

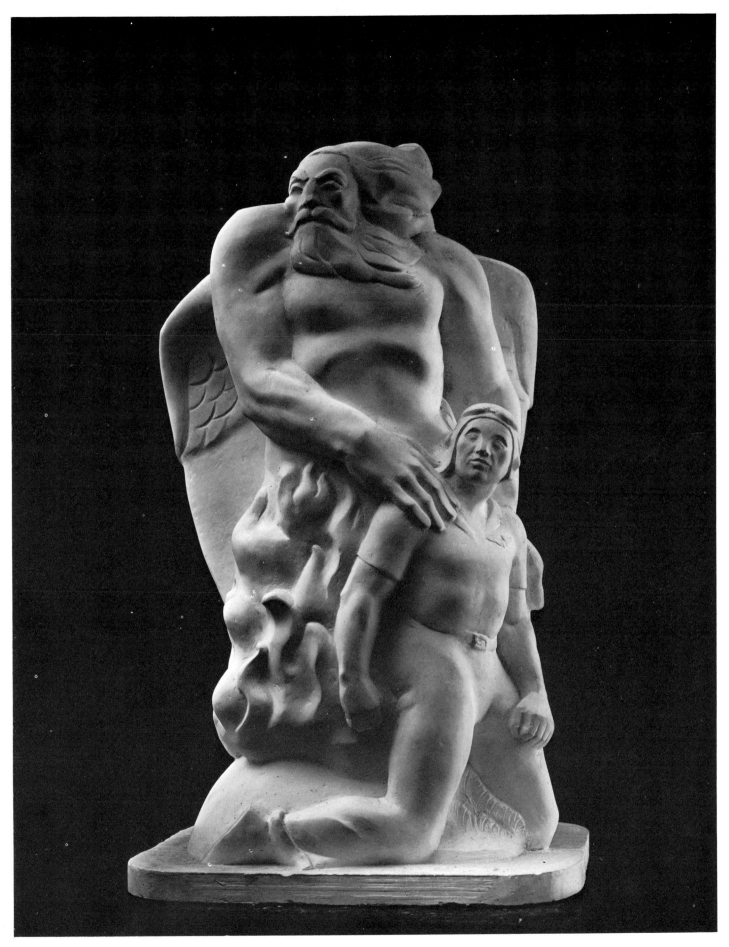

de Gerenday, Laci Anthony. Model for Air Force monument.
Photograph courtesy of National Sculpture Society.

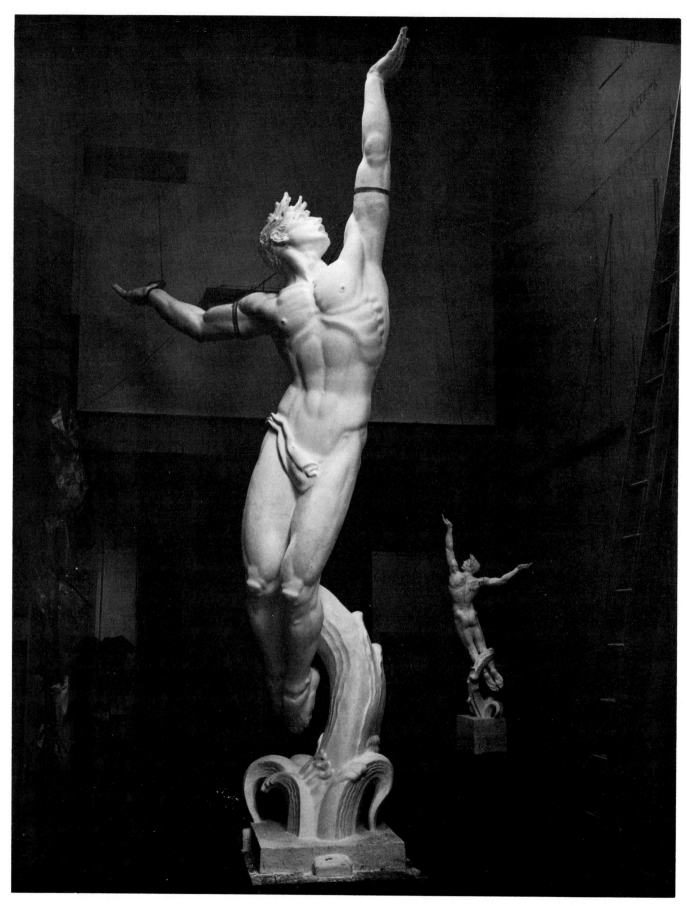

De Lue, Donald. US Battle Monument. Bronze, 22 feet high.
Photograph courtesy of National Sculpture Society.

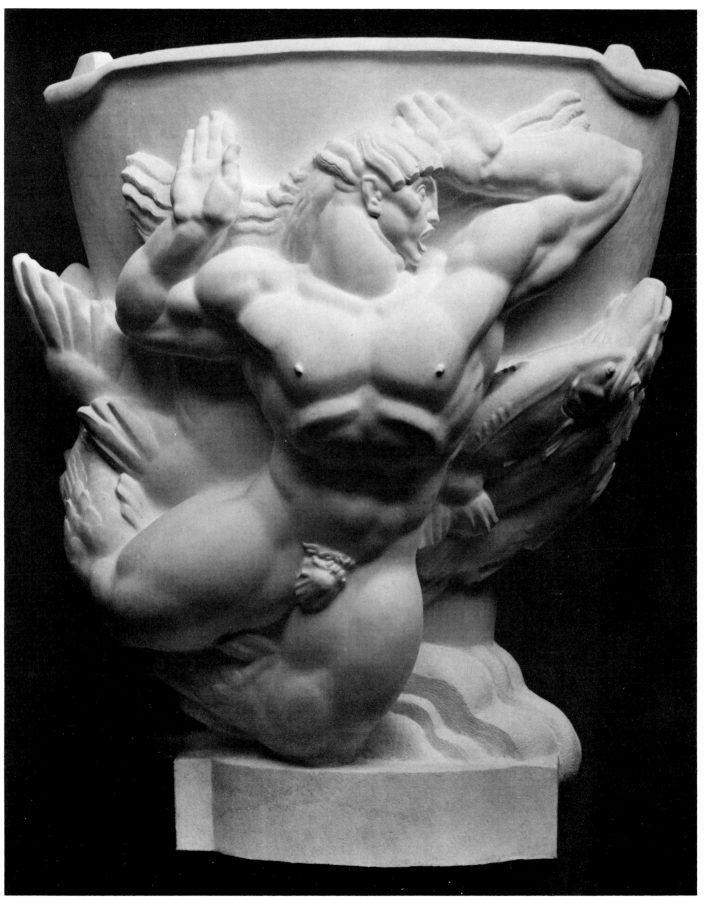

De Lue, Donald. "Triton." Marble. Photograph courtesy of National Sculpture Society.

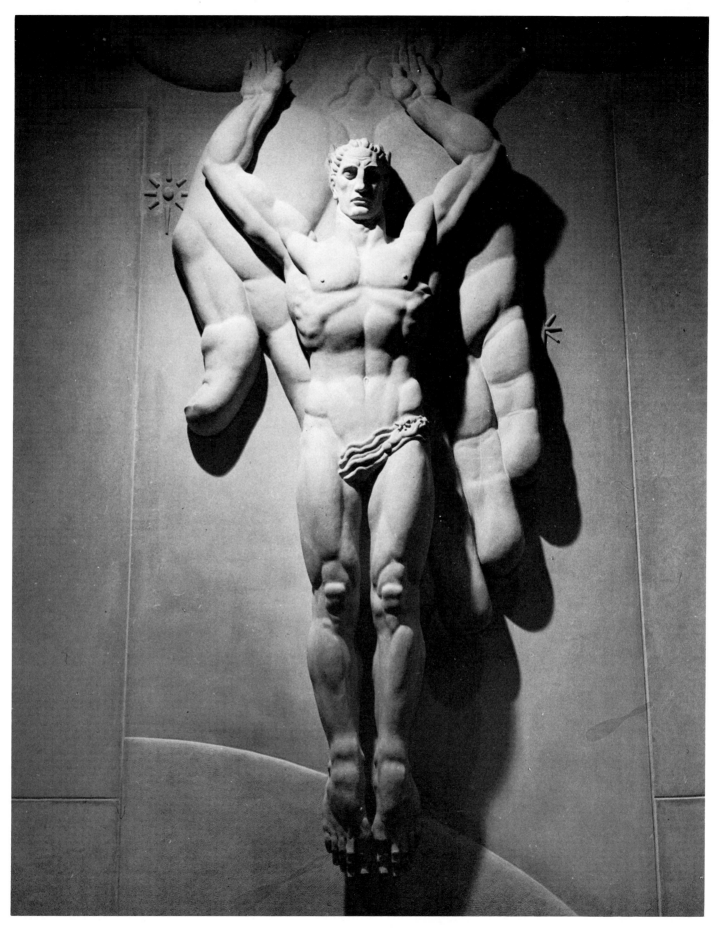

De Lue, Donald. Limestone wall, memorial chapel. 40 feet by 14 feet.
Photograph courtesy of National Sculpture Society.

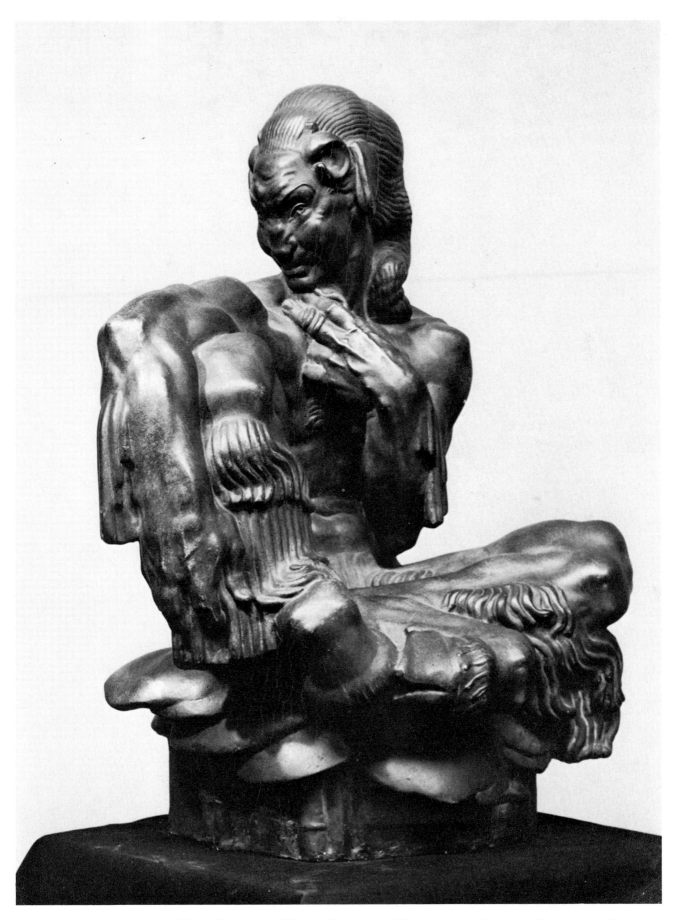

De Lue, Donald. Faun, 1937. Plaster, 24 inches high. Photograph
courtesy of National Sculpture Society.

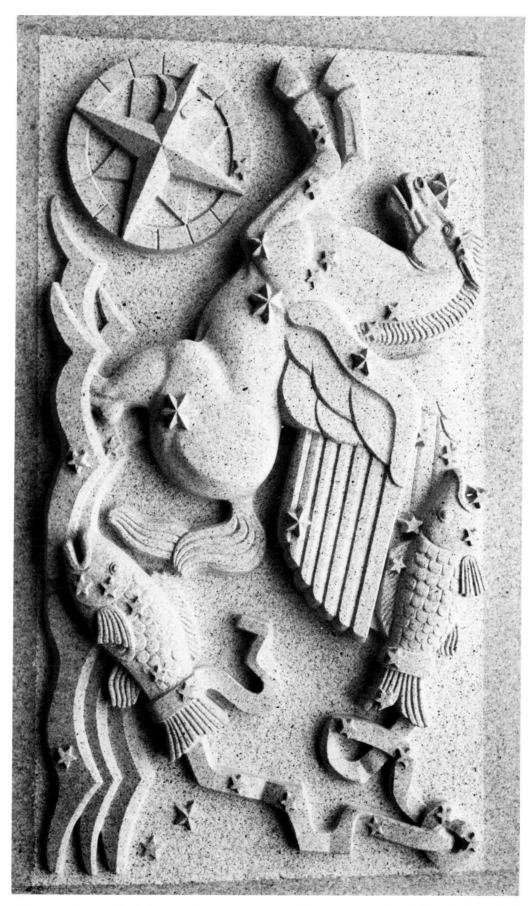

De Marco, Jean Antoine. Pegasus and Pisces, part of West Coast War
Memorial. Photograph courtesy of National Sculpture Society.

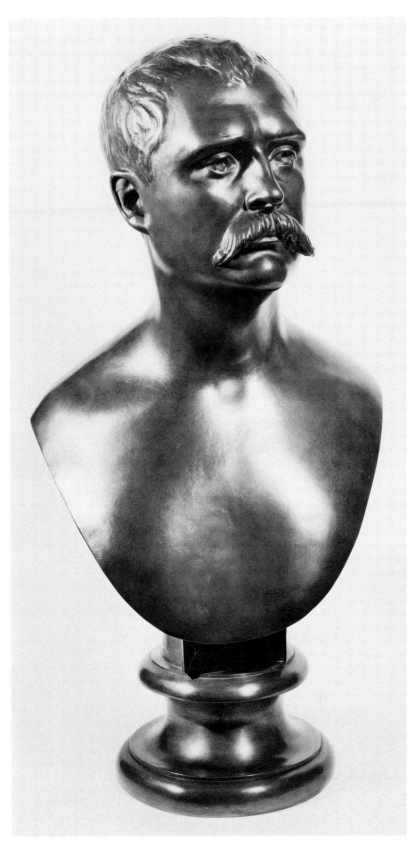

Donoghue, John. "John Boyle O'Reilly," 1844-1890. Bronze, 27 1/2 inches high. Collection of Victor D. Spark, NYC.

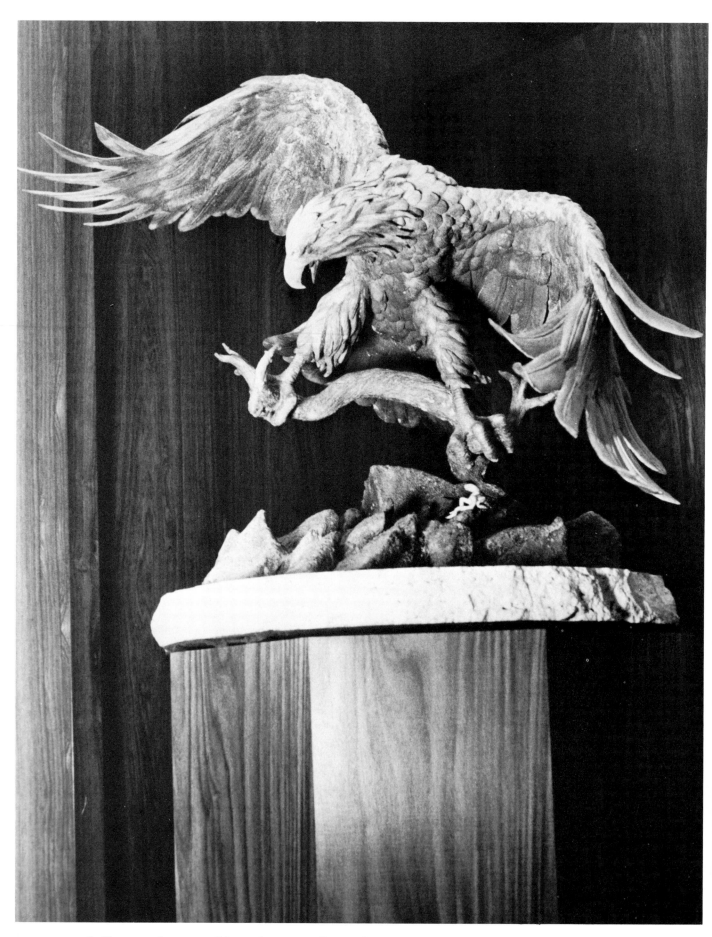

Eriksen, Gary. "American Eagle II," 1980. Bronze on marble, 33 inch wingspan. Photograph courtesy of the artist.

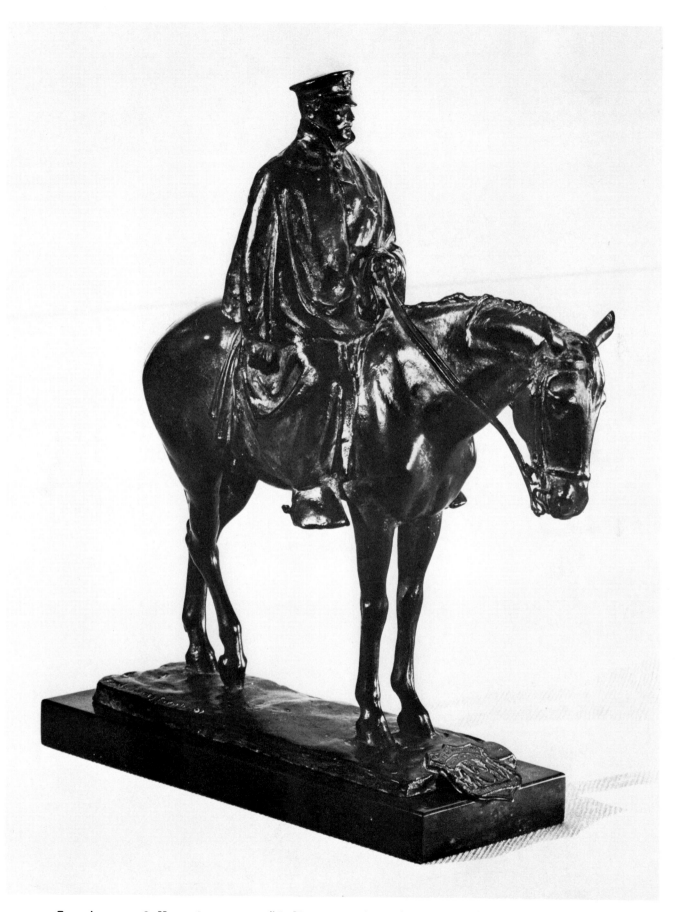

Farnham, Sally James. "Policeman in the Rain." Bronze. Ex
Collection of Bob Bahssin, Post Road Gallery, Larchmont, NY.

509

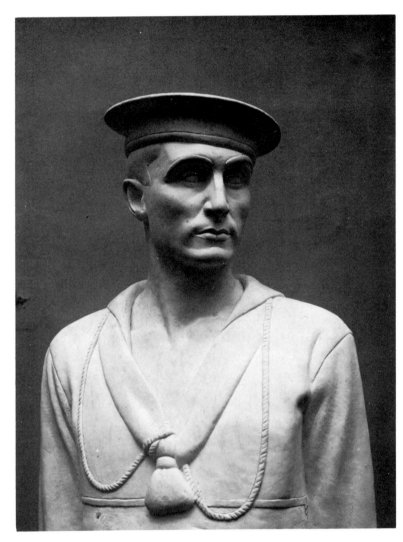

Fasano, Clara. "Italian Sailer," 1929. Photograph courtesy of National Sculpture Society.

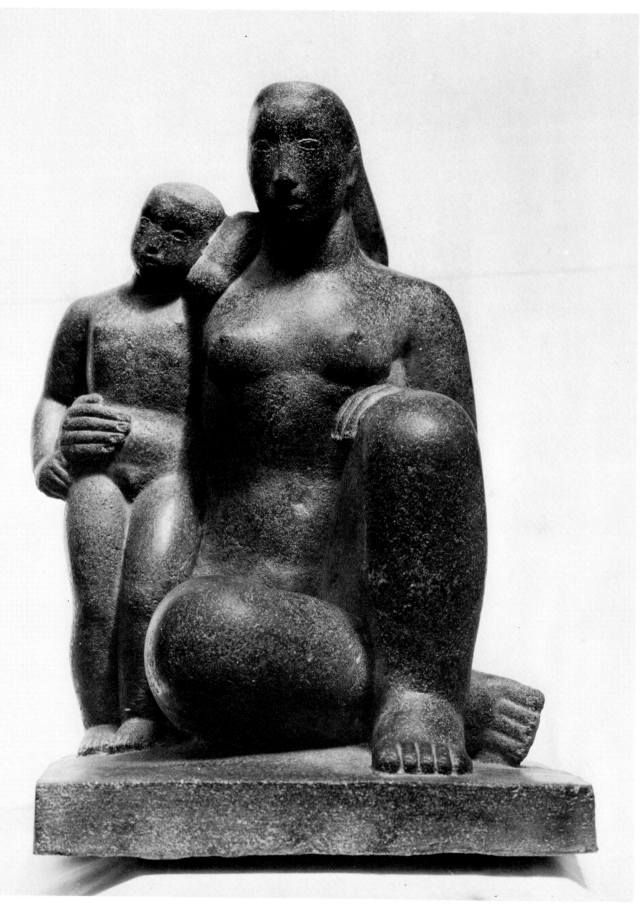

Fasano, Clara. Mother and Child. Gray Cement, 2 feet high, 40 pounds. Photograph courtesy of National Sculpture Society.

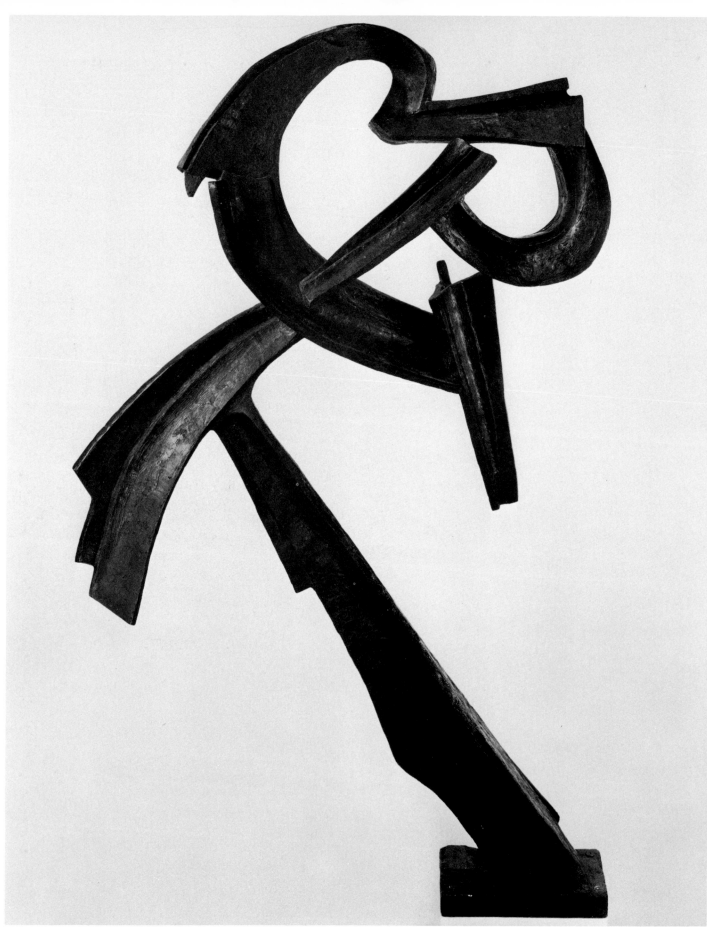

Ferber, Herbert. "Calligraphic Bee III," 1963. Painted wood, 43 1/2 inches high. Collection, Vassar College Art Gallery, Poughkeepsie, New York.

512

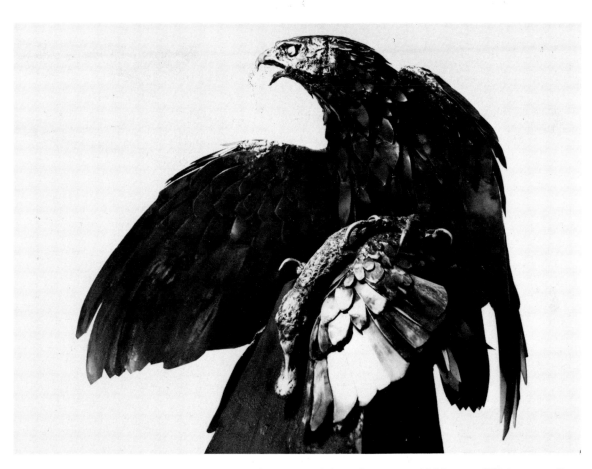

Filardi, Del. Peregrine Falcon with Prey, 1980. Mild steel.
Collection of Joe Bernal, Miami, FL. Photograph courtesy of the
artist.

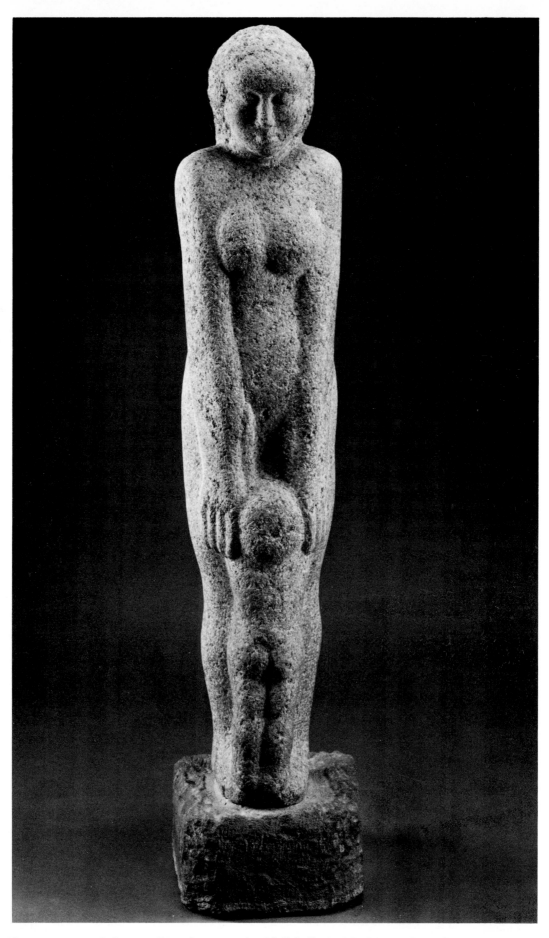

Flannagan, John. "Mother and Child," 1932-33. Granite, 41 inches high. Collection, Vassar College Art Gallery, Poughkeepsie, New York.

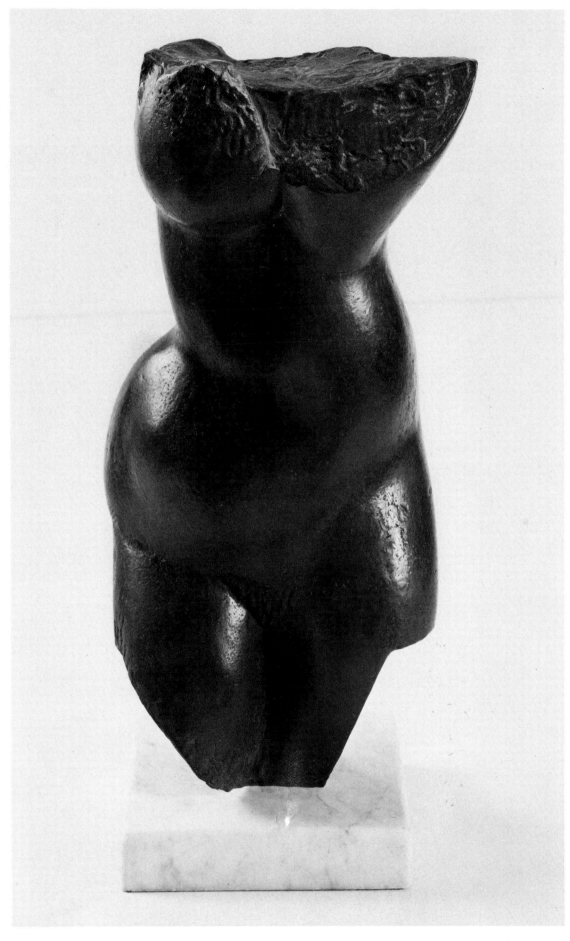

Franklin, Gilbert. Torso, 1965. Bronze, 23 inches high. Collection, Vassar College Art Gallery, Poughkeepsie, New York.

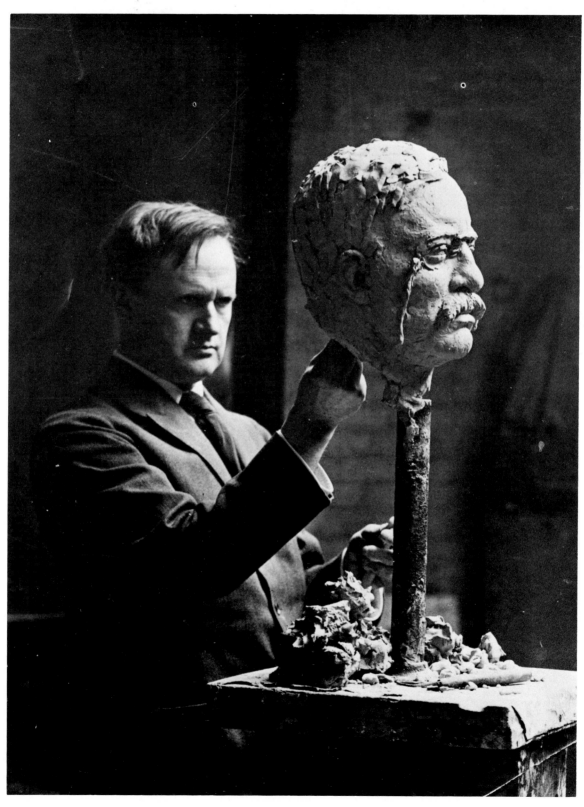

Fraser, James Earle. Theodore Roosevelt. Photograph courtesy of National Sculpture Society.

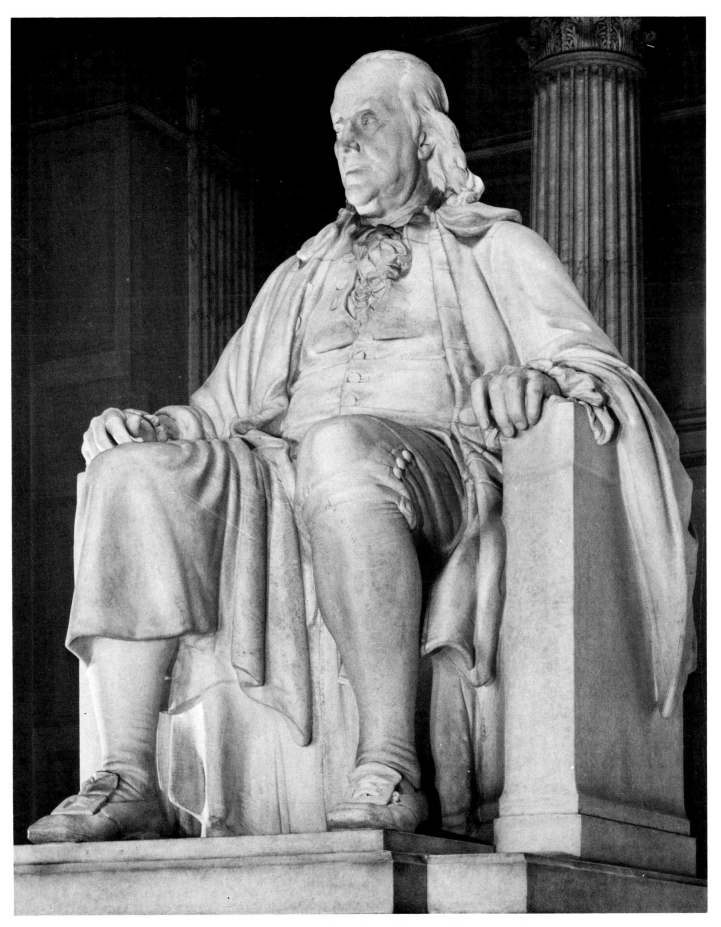

Fraser, James Earle. Benjamin Franklin. Photograph courtesy of
National Sculpture Society.

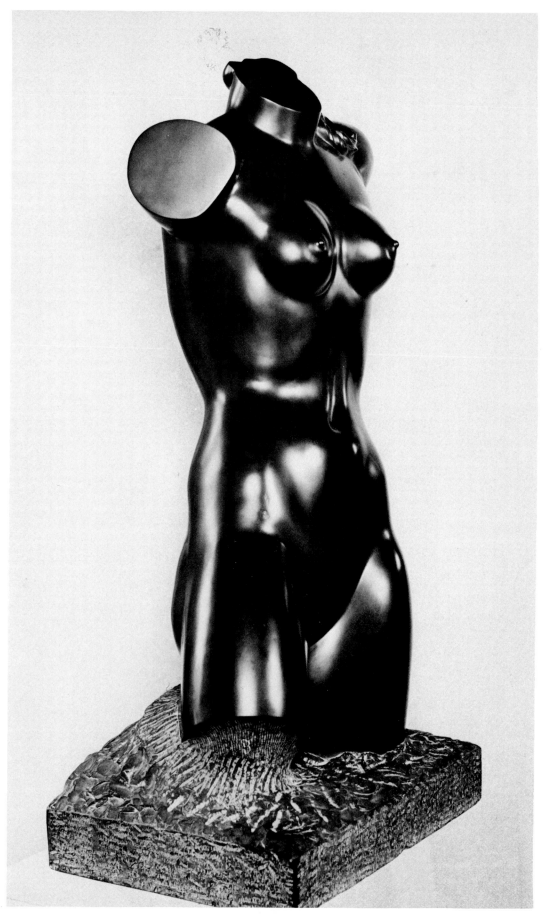

Fredericks, Marshall Maynard. "Torso of a Dancer." Polished belgian black marble, life-size. Photograph courtesy of National Sculpture Society.

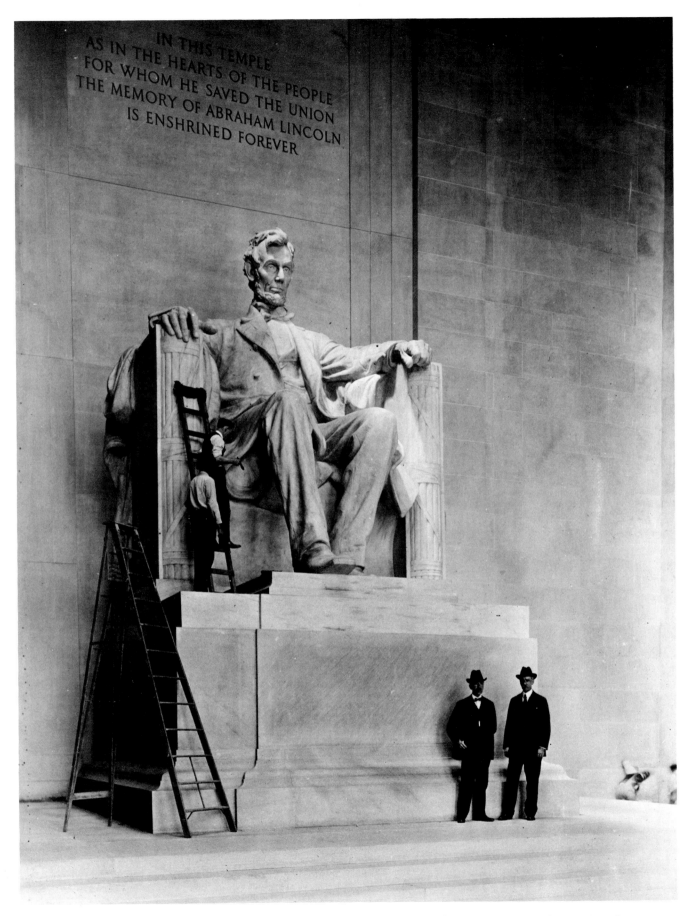

French, Daniel Chester. Lincoln. Photograph courtesy of National
Sculpture Society.

Studio of Daniel Chester French. Photograph courtesy of National
Sculpture Society.

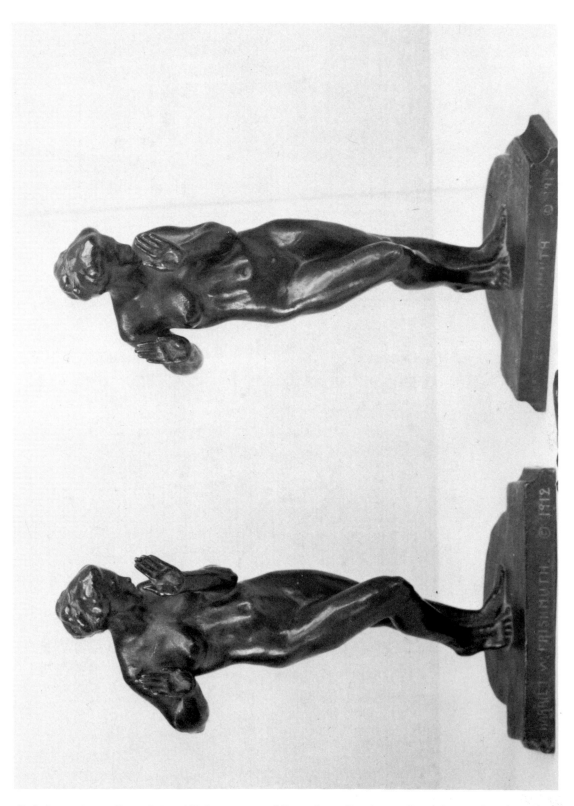

Frishmuth, Harriet Whitney. "Female Nudes Pushing Bookends."
Bronze. Collection of Bob Bahssin, Post Road Gallery, Larchmont,
NY.

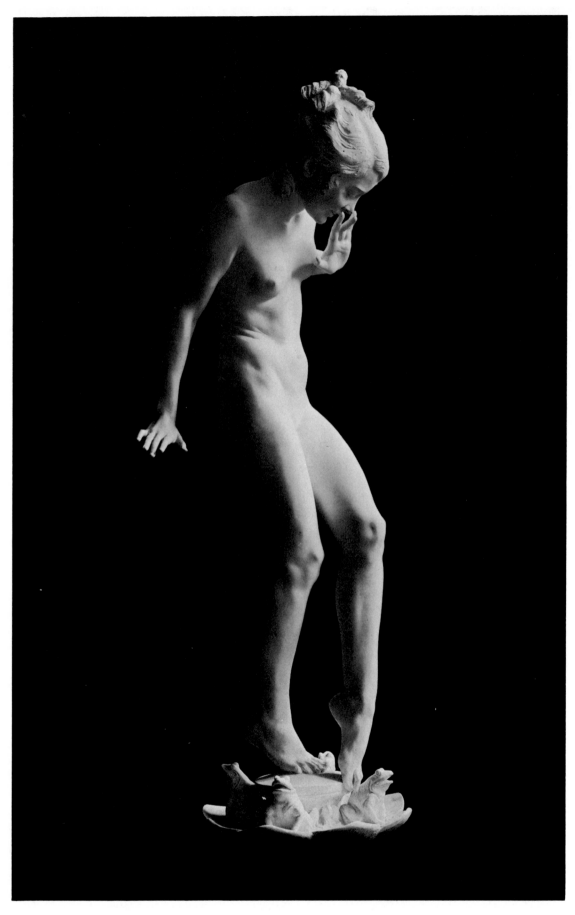

Frishmuth, Harriet Whitney. "Play Days." 4 feet 6 inches high.
Photograph courtesy of National Sculpture Society.

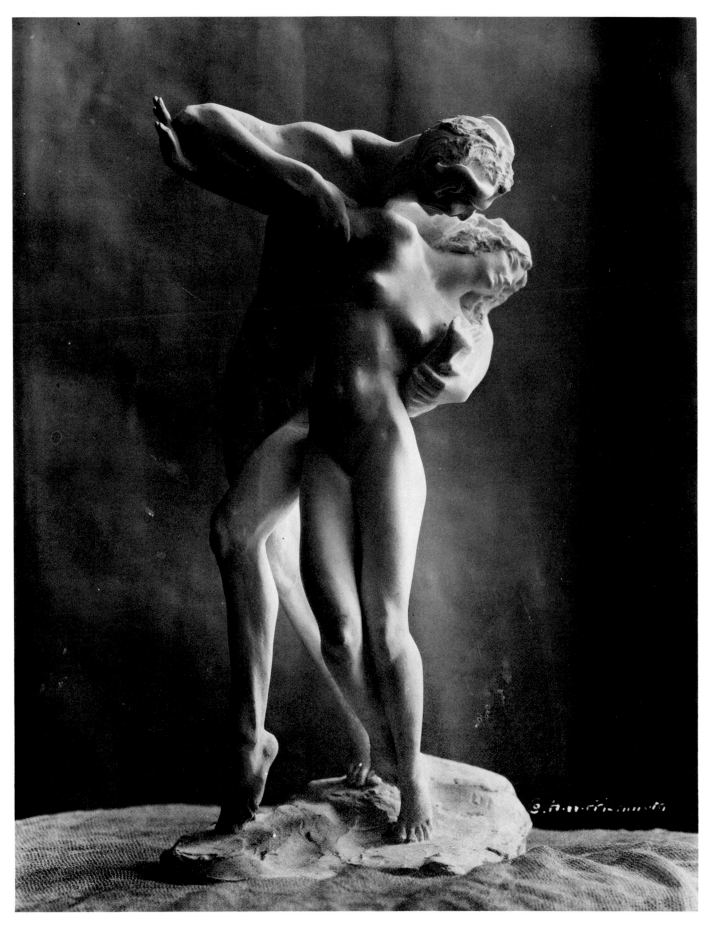

Frishmuth, Harriet Whitney. "Fantaisie." Photograph courtesy of National Sculpture Society.

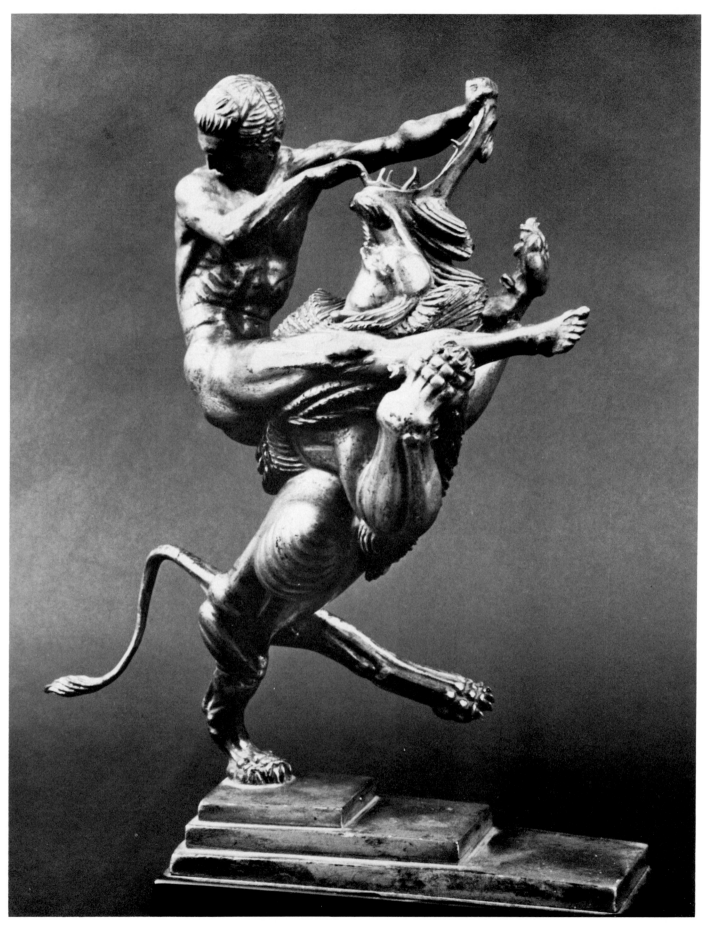

Frudakis, Evangelos William. Lion and Hercules. 12 inches high.
Photograph courtesy of National Sculpture Society.

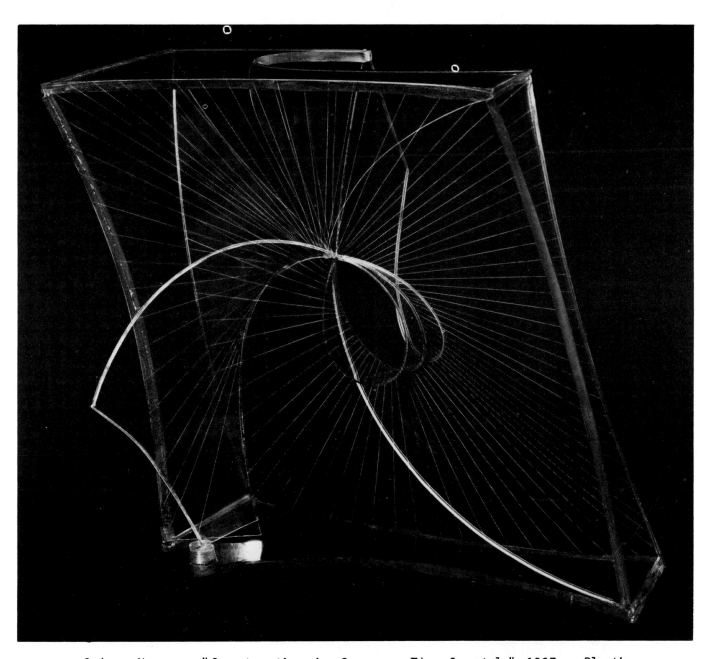

Gabo, Naum. "Construction in Space: The Crystal," 1937. Plastic (rhodoid), 8 3/4 inches high. Collection, Vassar College Art Gallery, Poughkeepsie, New York.

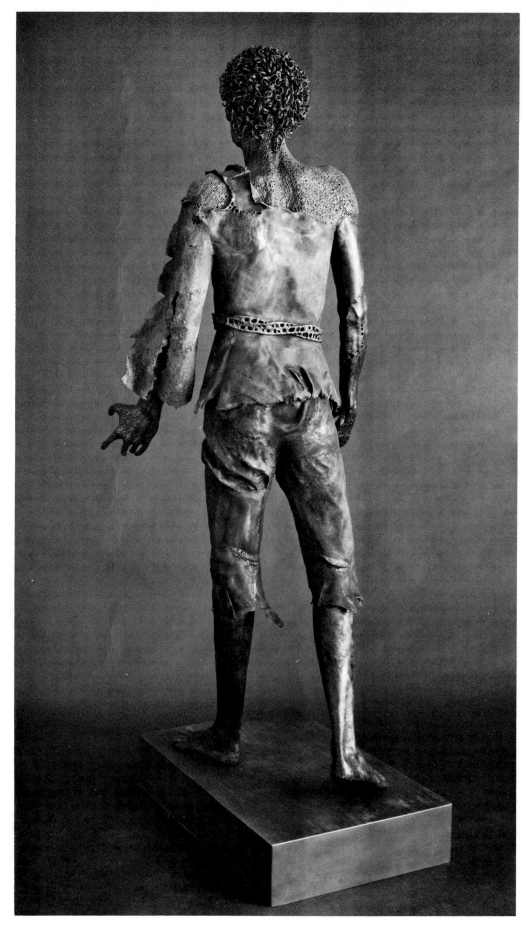

Gibran, Kahlil George. Figure. Photograph courtesy of National Sculpture Society.

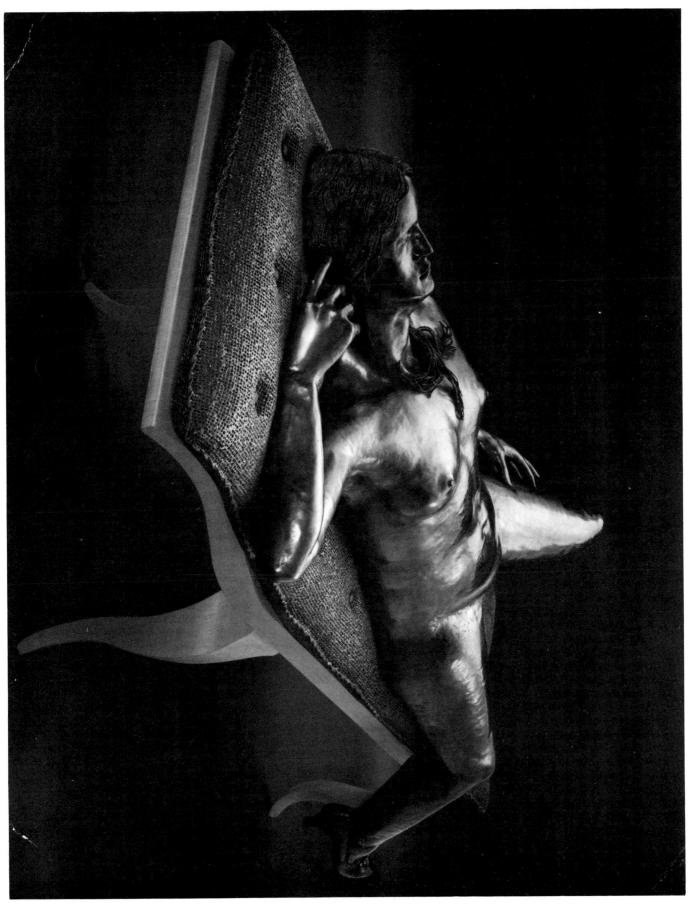

Gibran, Kahlil George. "Reclining Nude." Hammered steel.
Photograph courtesy of National Sculpture Society.

Goodstein, Barbara. "The Birth of Edie." Fired clay, 16 inches by
21 inches by 2 inches. Photograph courtesy of the artist.

Gordin, Sidney. "Construction," 1951. Metal and wire, 16 1/4 inches high. Collection, Vassar College Art Gallery, Poughkeepsie, New York.

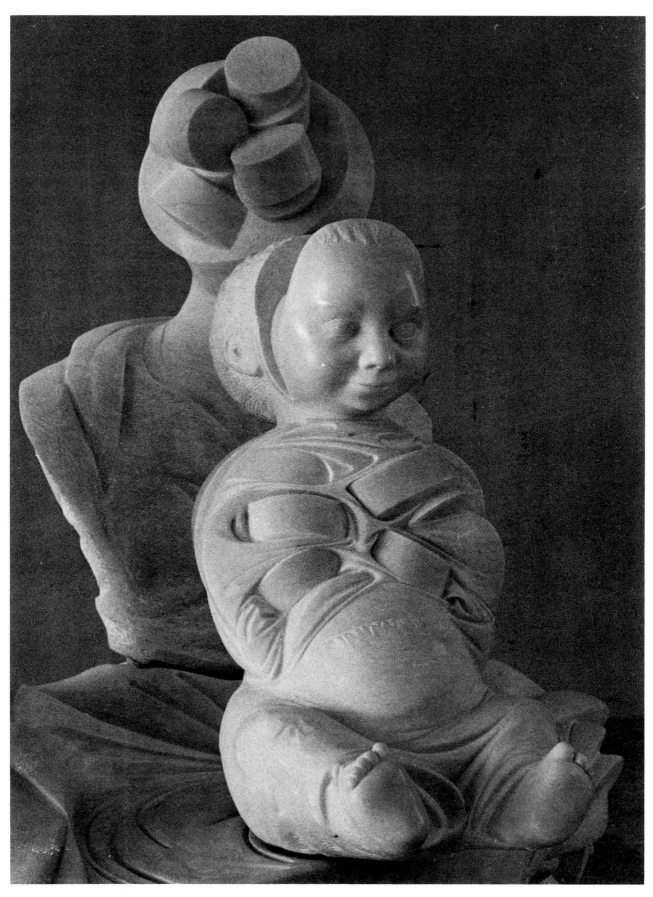

Grassi, Andrea. Child and Mother, detail from "The Family." Pure white carrara marble, 20 1/2 inches by 11 inches by 17 inches (child's dimensions). Photograph courtesy of the artist.

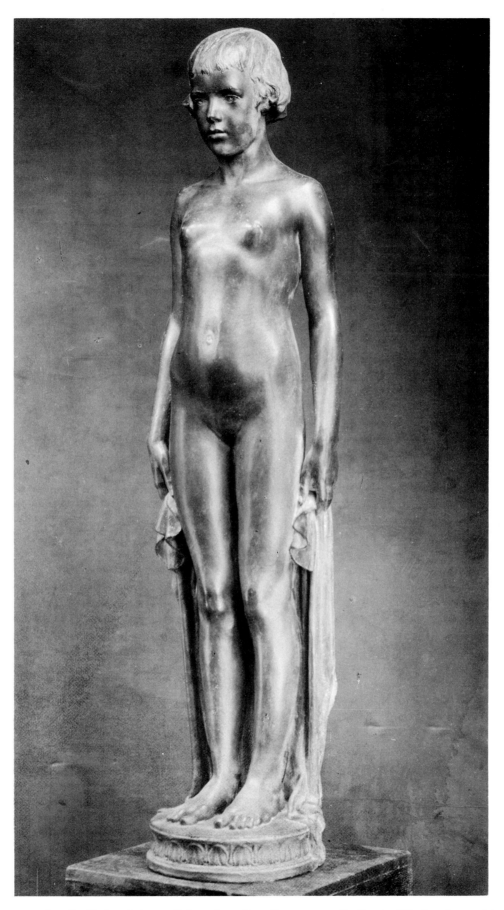

Gruppe, Karl Heinrich. "Candor." Bronze, 4 feet 11 inches high.
Photograph courtesy of National Sculpture Society.

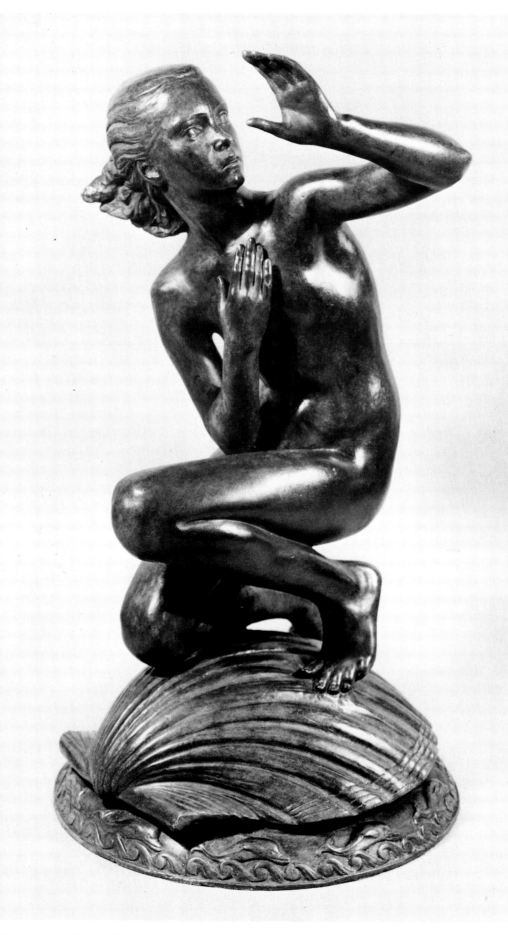

Gruppe, Karl Heinrich. "Return of Spring." Photograph courtesy of
National Sculpture Society.

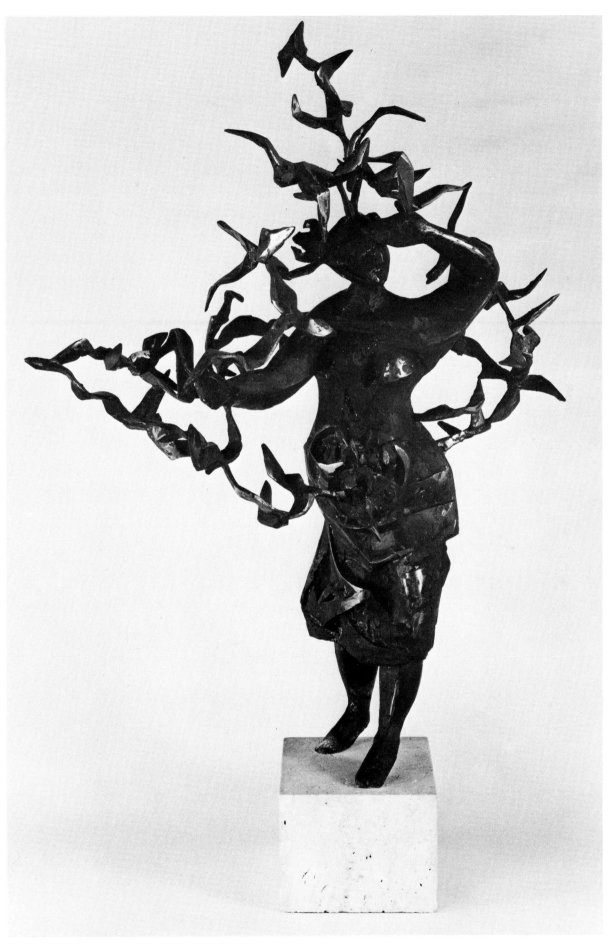

Hadzi, Dimitri. "Birdwoman." Bronze, 29 inches high. Collection, Vassar College Art Gallery, Poughkeepsie, New York.

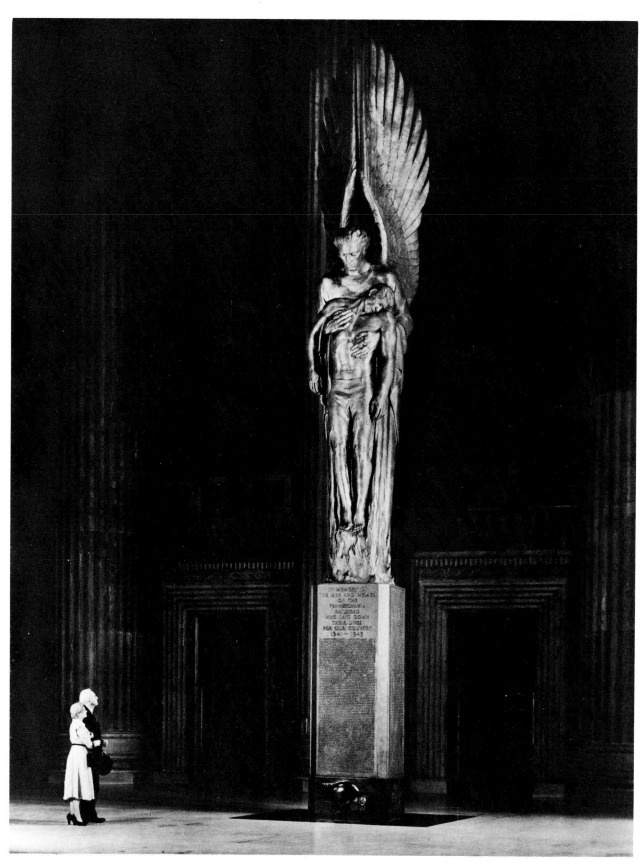

Hancock, Walker. Pennsylvania Railroad War Memorial. Photograph courtesy of National Sculpture Society.

534

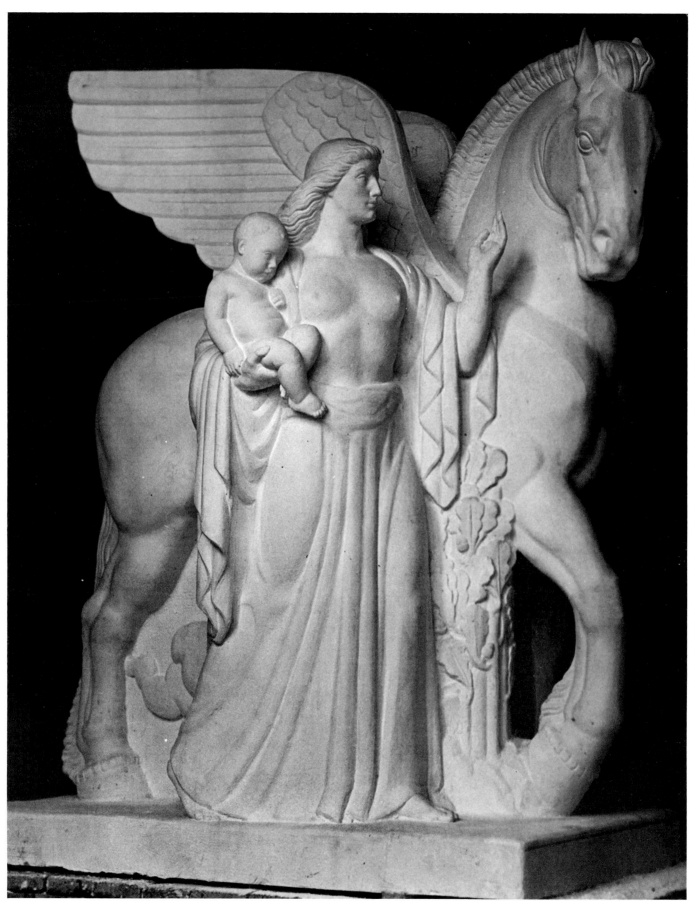

Hancock, Walker. St. Louis Soldiers' Memorial. Photograph courtesy
of National Sculpture Society.

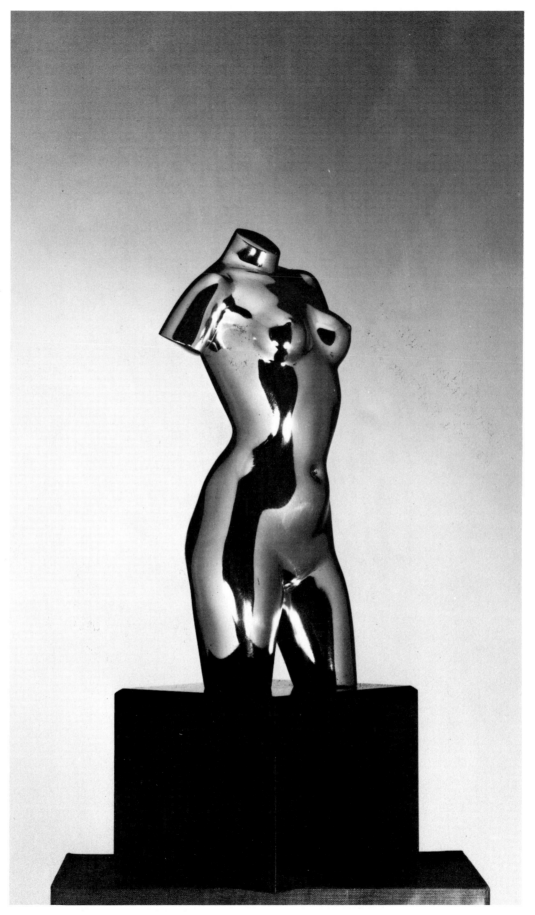

Hardin, Adlai S. "Torso." Bronze. Photograph courtesy of National Sculpture Society.

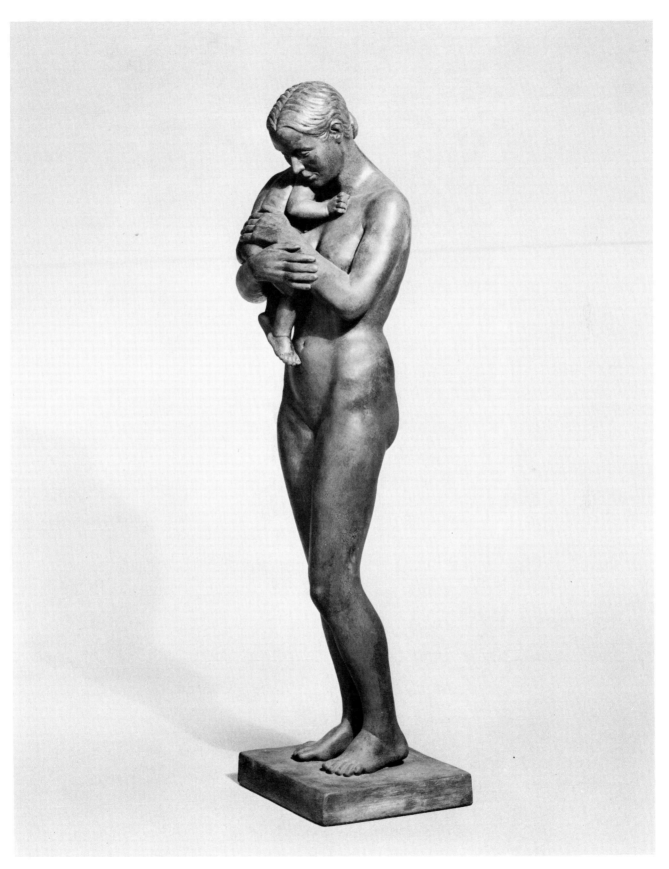

Hobson, Katherine Thayer. Mother and Child. Plastic toned, one-half life-size. Photograph courtesy of National Sculpture Society.

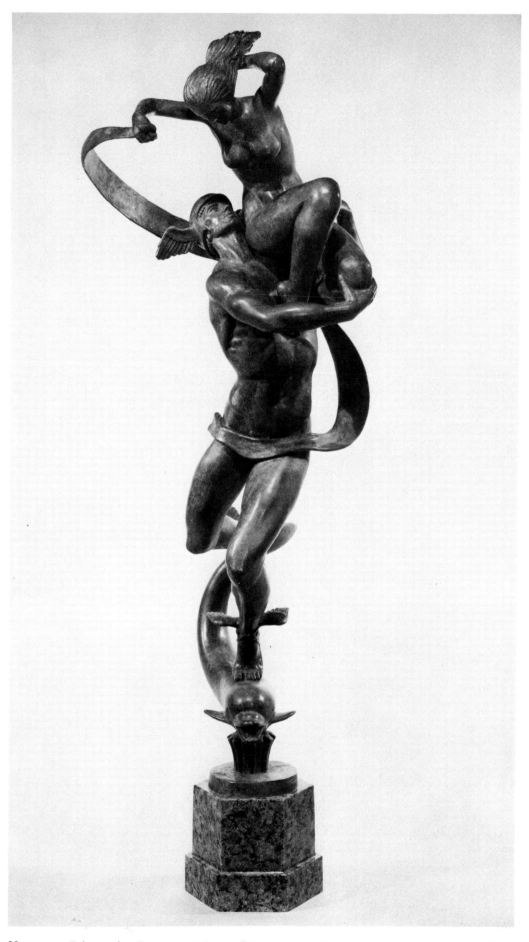

Hoffman, Edward Fenno III. "Perseus Rescuing Andromeda." 42 inches high. Photograph courtesy of National Sculpture Society.

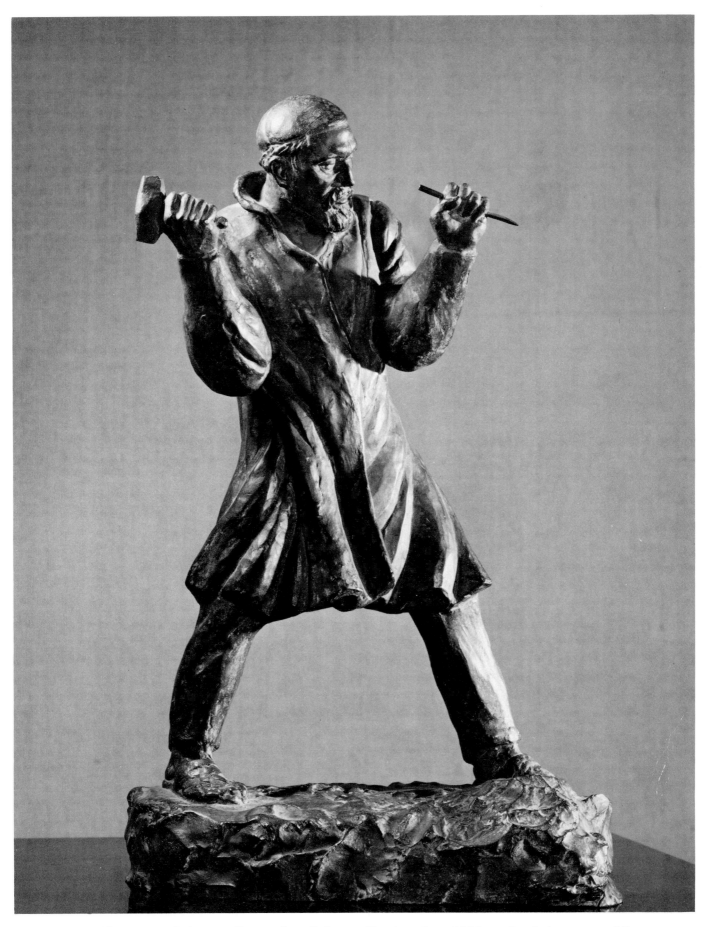

Hoffman, Malvina. Portrait of Ivan Mestrovic, 1949. Cast bronze, 16 1/2 inches high. Collection, Vassar College Art Gallery, Poughkeepsie, New York.

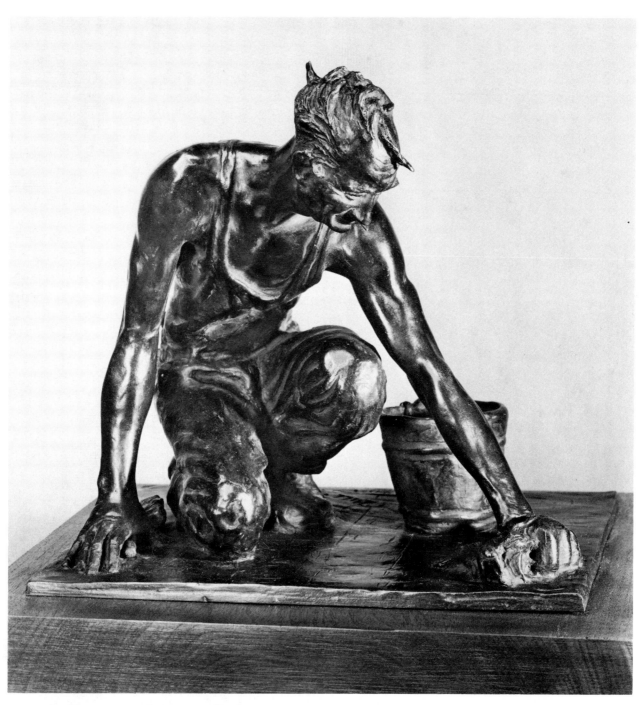

Hoffman, Malvina. "Bill Working." Bronze, 9 1/4 inches high.
Collection of Victor D. Spark, NYC.

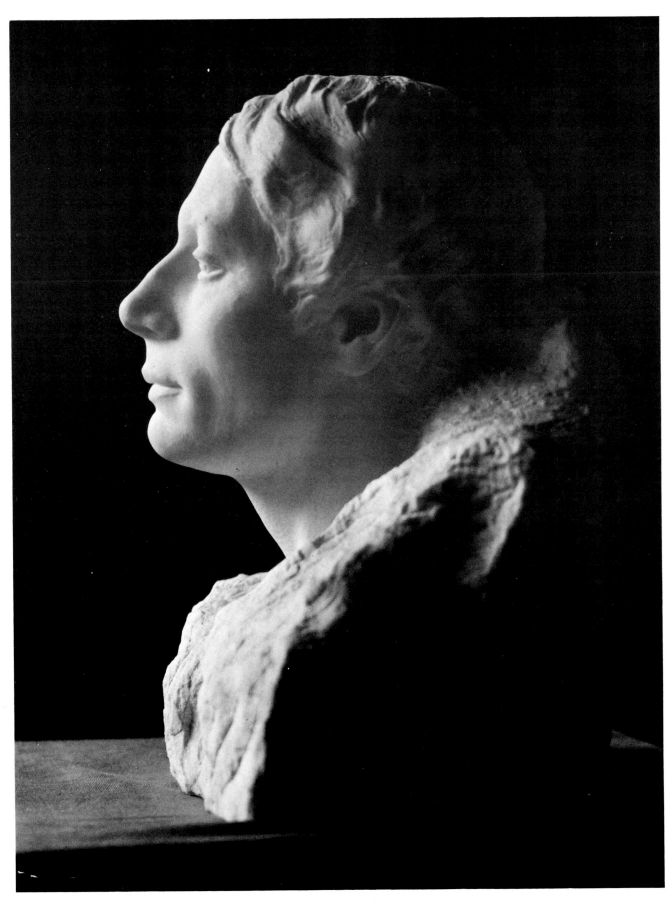

Hoffman, Malvina. "John Keats," 1958. Marble, life-size. Photograph courtesy of National Sculpture Society.

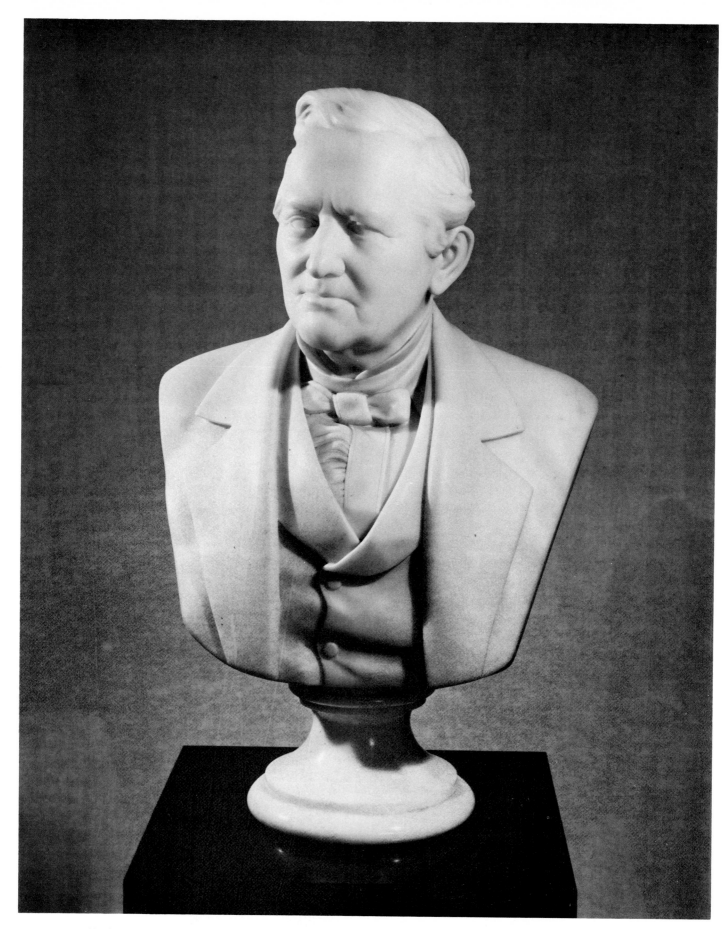

Hofmann, Laura Skeel. Bust of Matthew Vassar. Marble, 21 inches high. Collection, Vassar College Art Gallery, Poughkeepsie, New York. (Ed. note: Listed as Laura Skeel Pomeroy).

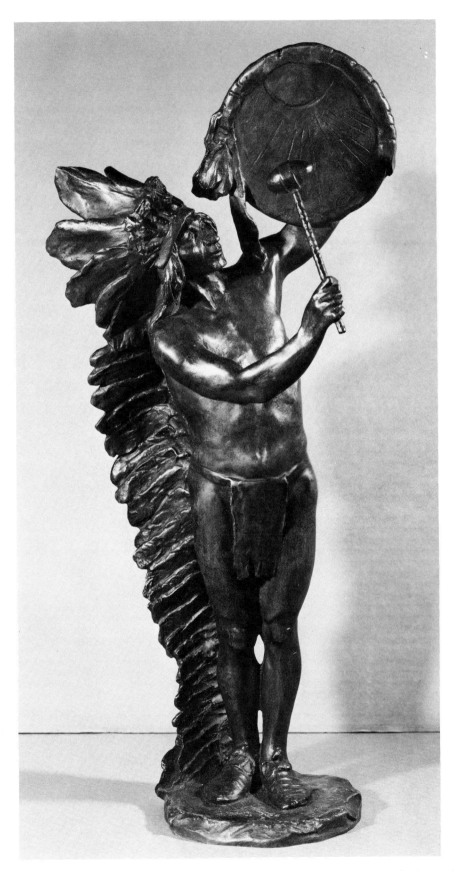

Humphries, Charles H. "Indian Warrior with Shield and Tomahawk."
Bronze, 18 1/2 inches high. Collection of Victor D. Spark, NYC.

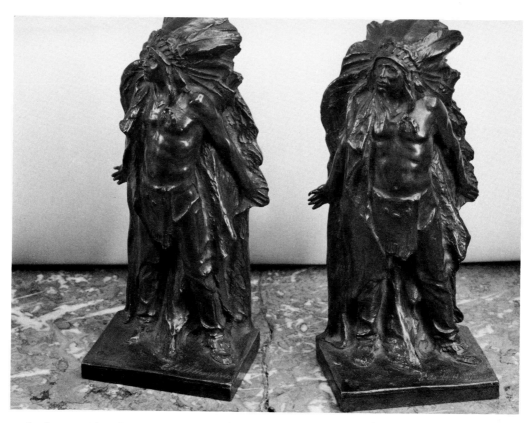

Humphries, Charles H. "Indian Bookends." Bronze. Collection of
Bob Bahssin, Post Road Gallery, Larchmont, NY.

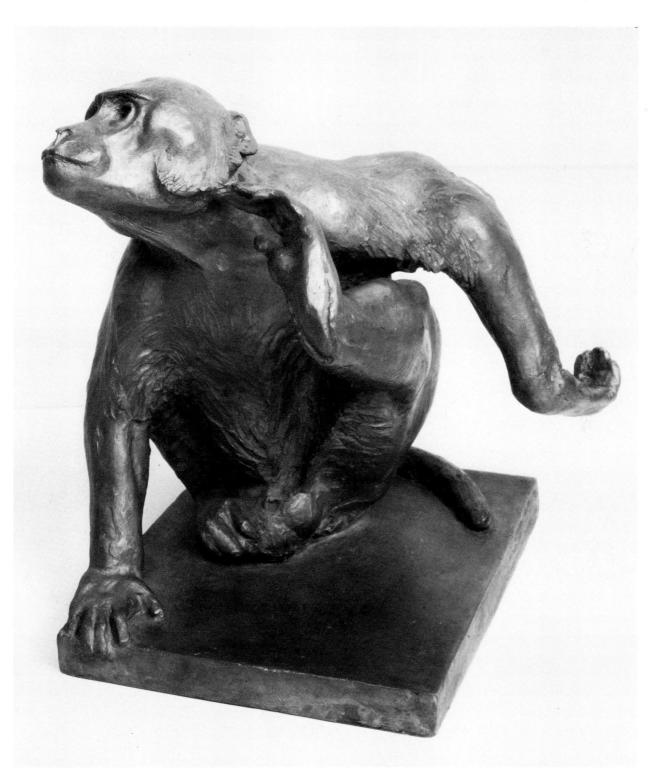

Huntington, Anna Hyatt. Rhesus Monkey (Study of Huey Scratching His Head), 1934-36. Gold-painted bronze, 10 1/4 inches high. Collection, Vassar College Art Gallery, Poughkeepsie, New York.

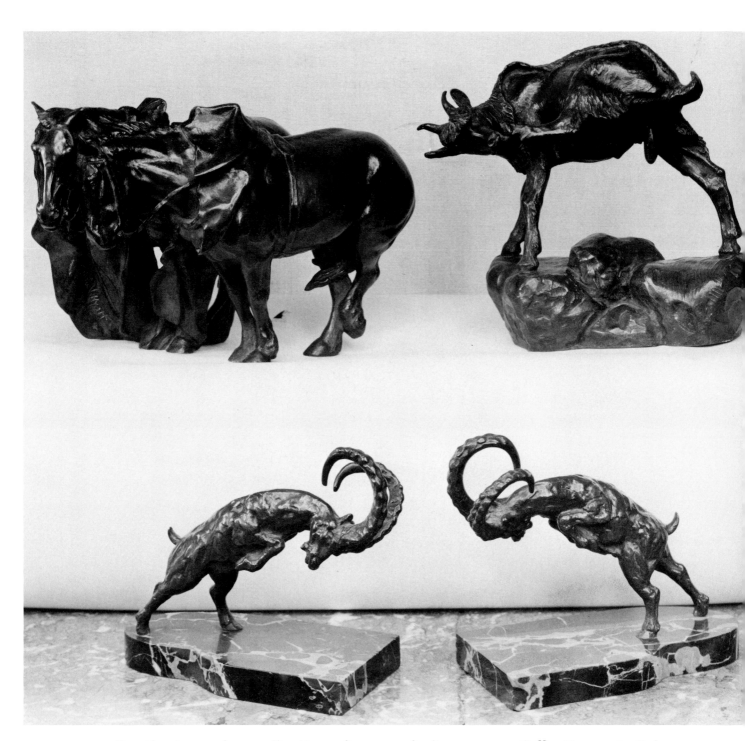

Huntington, Anna Hyatt. Group of Bronzes. Collection of Bob
Bahssin, Post Road Gallery, Larchmont, NY.

Huntington, Anna Hyatt. "Stalking Panther." Bronze. Collection of
Bob Bahssin, Post Road Gallery, Larchmont, NY.

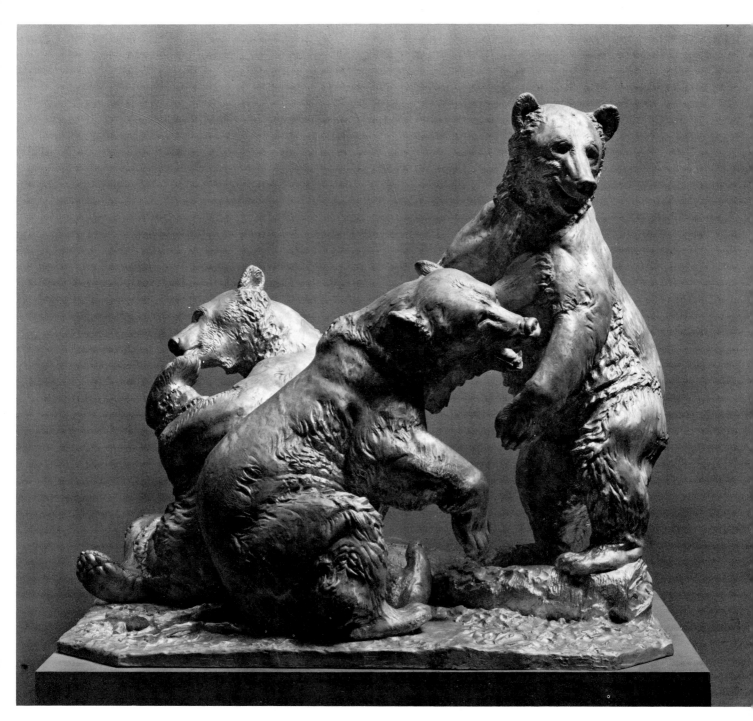

Huntington, Anna Hyatt. Bears. Photograph courtesy of National
Sculpture Society.

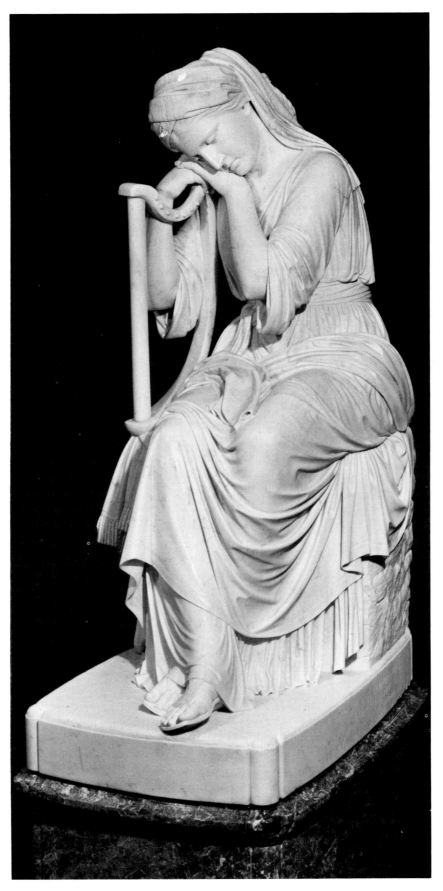

Ives, Chauncey Bradley. "Sappho." Marble. Collection of Bob Bahssin, Post Road Gallery, Larchmont, NY.

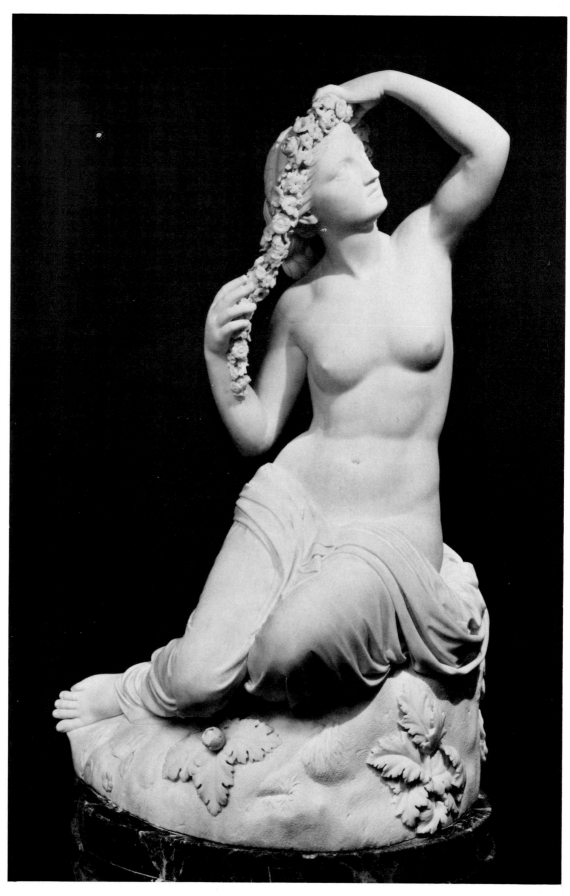

Ives, Chauncey Bradley. "Flora." Marble. Collection of Bob
Bahssin, Post Road Gallery, Larchmont, NY.

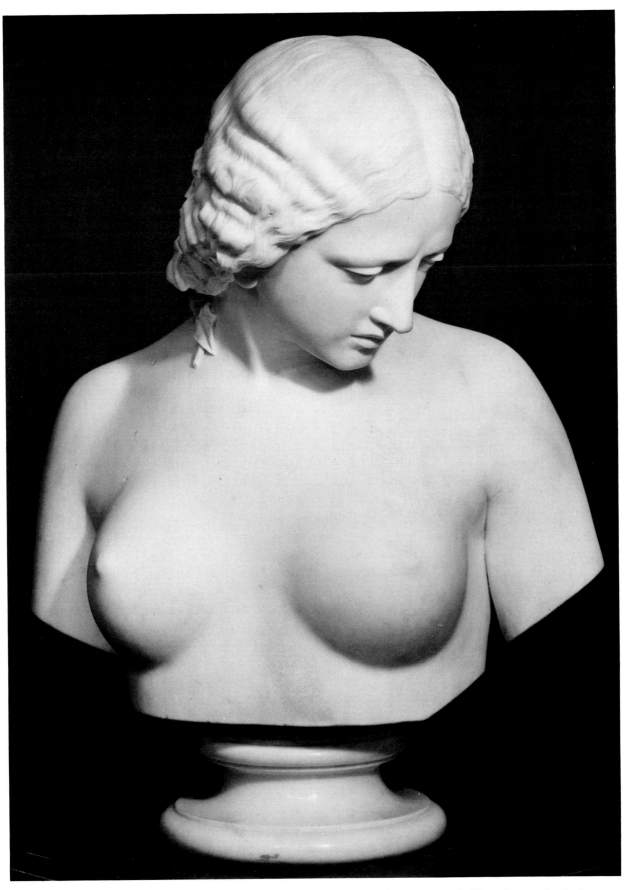

Jackson, John Adams. "Primavera." Marble. Ex Collection of Bob
Bahssin, Post Road Gallery, Larchmont, NY.

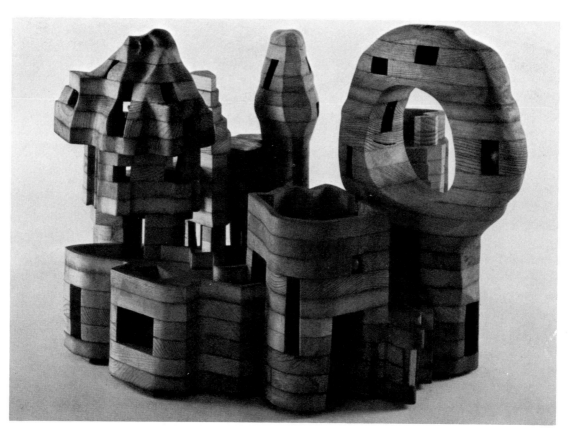

Janto, Phyllis. "Moon Child's Gift," 1983. Wood, 15 1/2 inches by 25 1/2 inches by 27 inches. Photograph courtesy of the artist.

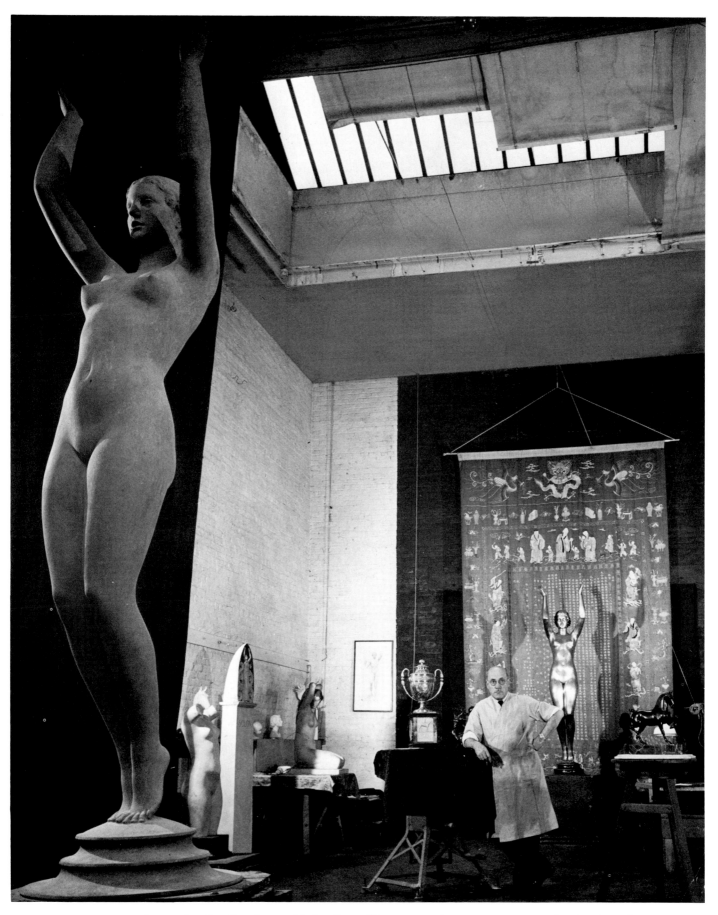

Jennewein, Carl Paul. "Iris." Photograph courtesy of National
Sculpture Society.

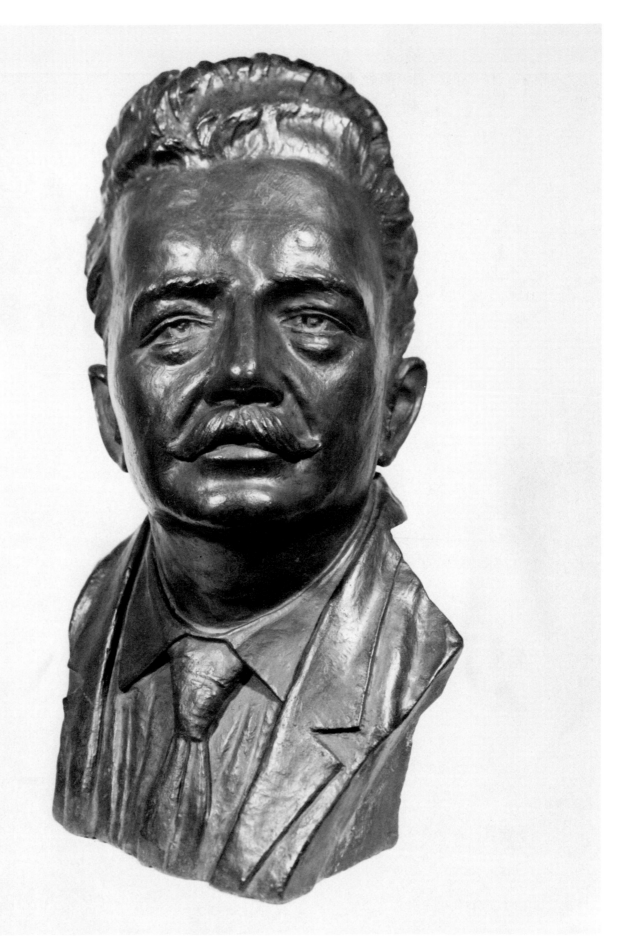

Jirouch, Frank Luis. Portrait of Victor Herbert, 1905. Bronze, 22 inches high. Collection of Victor D. Spark, NYC.

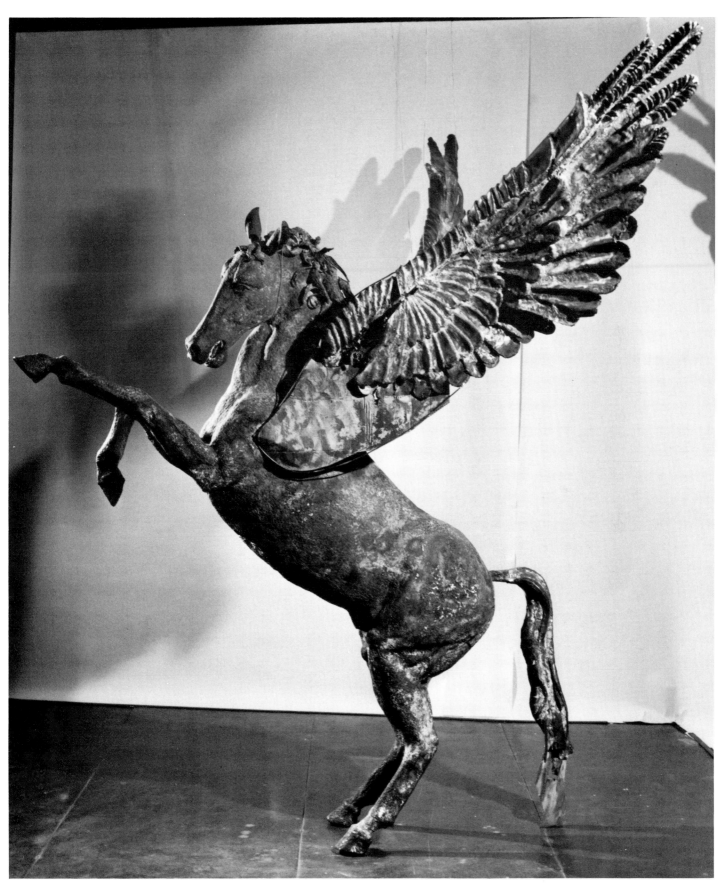

Klass, David. "Pegasus," work in progress 1984. Copper, brass, stainless steel, 10 feet high. Photograph courtesy of the artist.

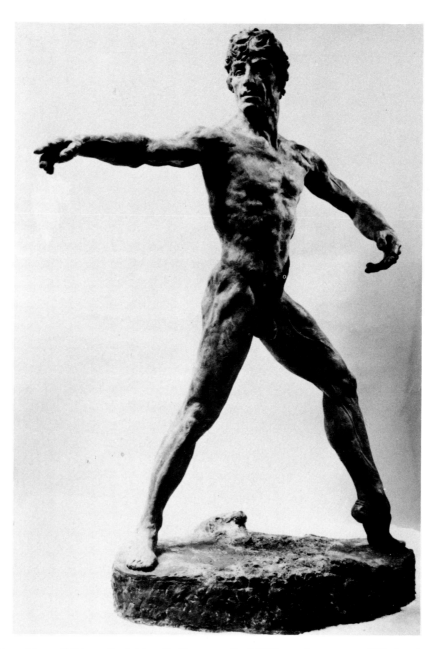

Klass, David. "The Spirit of Dance," 1976. Bronze, 75 inches high.
Photograph courtesy of the artist.

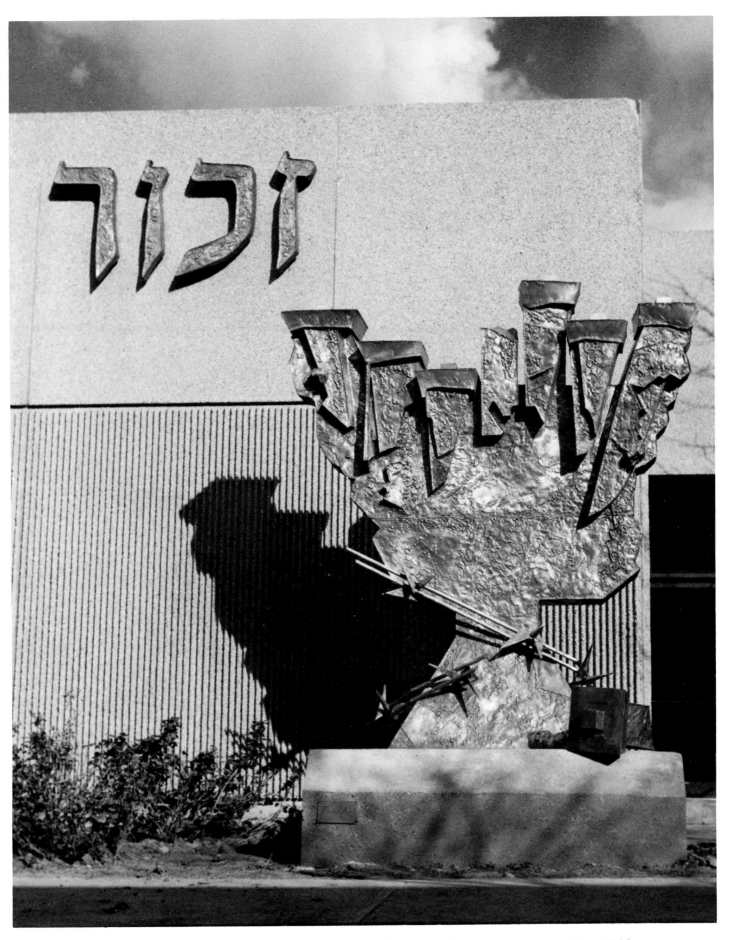

Klass, David. "Rochester Holocaust Memorial," Rochester, NY, 1982.
Cooper, brass, stainless steel, 10 feet high. Photograph courtesy of
the artist.

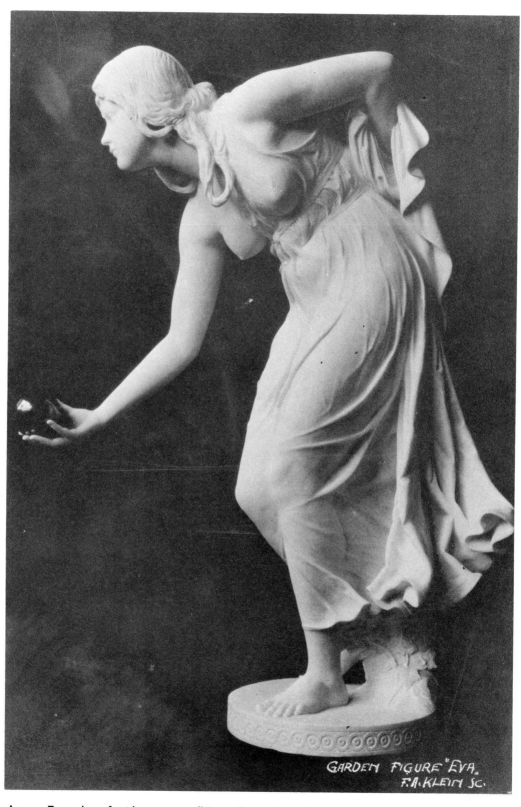

GARDEN FIGURE "EVA"
F.A. KLEIN SC.

Klein, Frank Anthony. "Eva." Marble, 4 feet 6 inches high.
Photograph courtesy of National Sculpture Society.

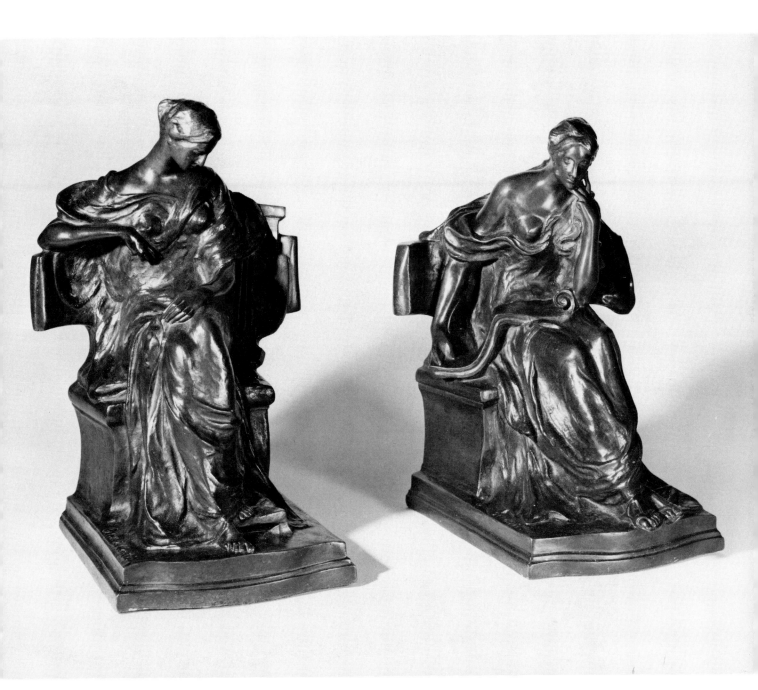

Konti, Isidore. Women Full Length Seated, Pair of Bookends, 1911.
Bronze, 9 inches high. Collection of Victor D. Spark, NYC.

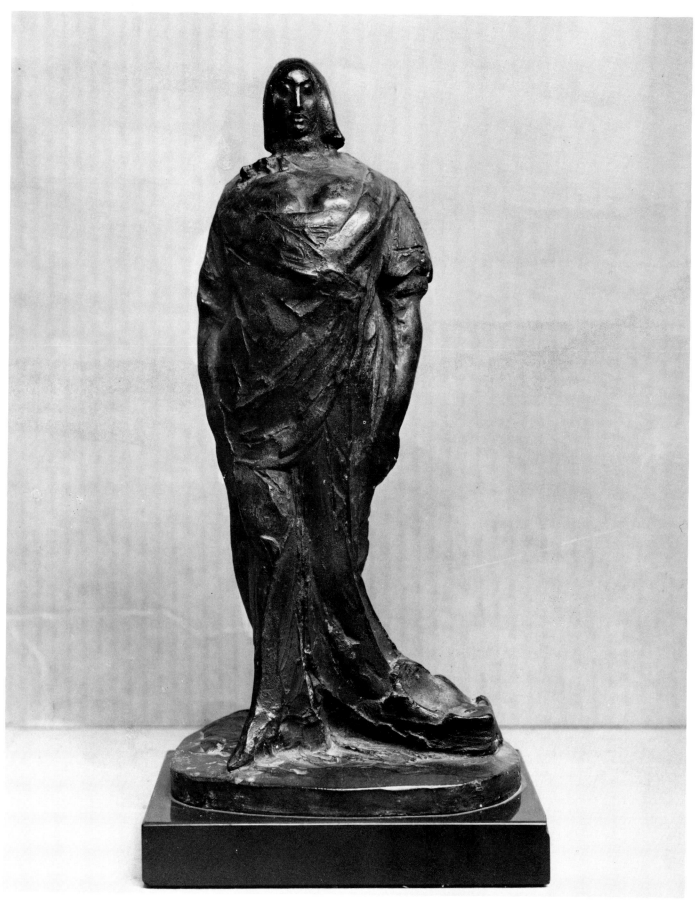

LaChaise, Gaston. Woman, 1910. Cast bronze with green patina, 10 7/8 inches high. Collection, Vassar College Art Gallery, Poughkeepsie, New York.

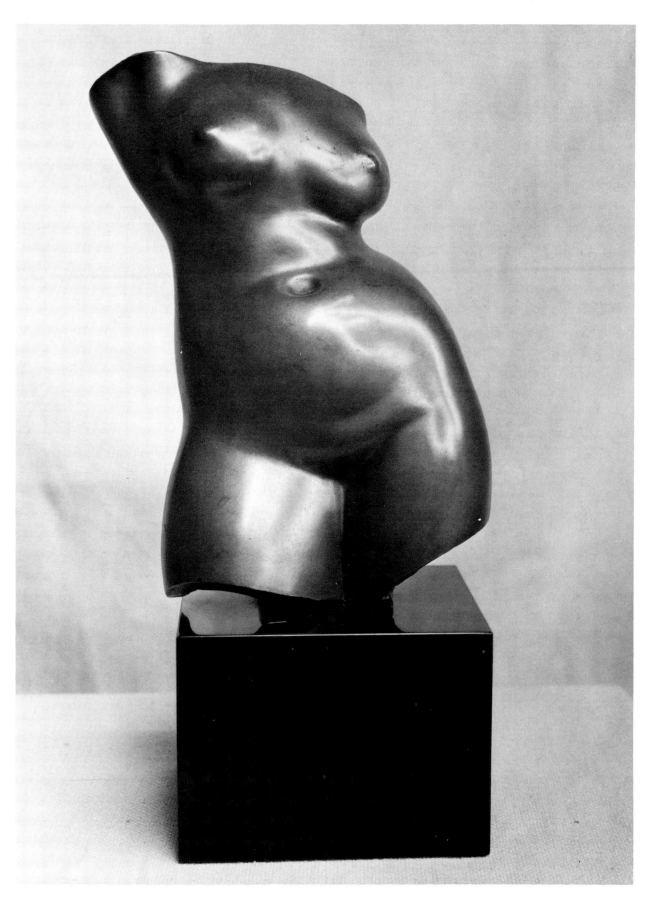

LaChaise, Gaston. Torso, 1927-28. Cast bronze, 10 inches high.
Collection, Vassar College Art Gallery, Poughkeepsie, New York.

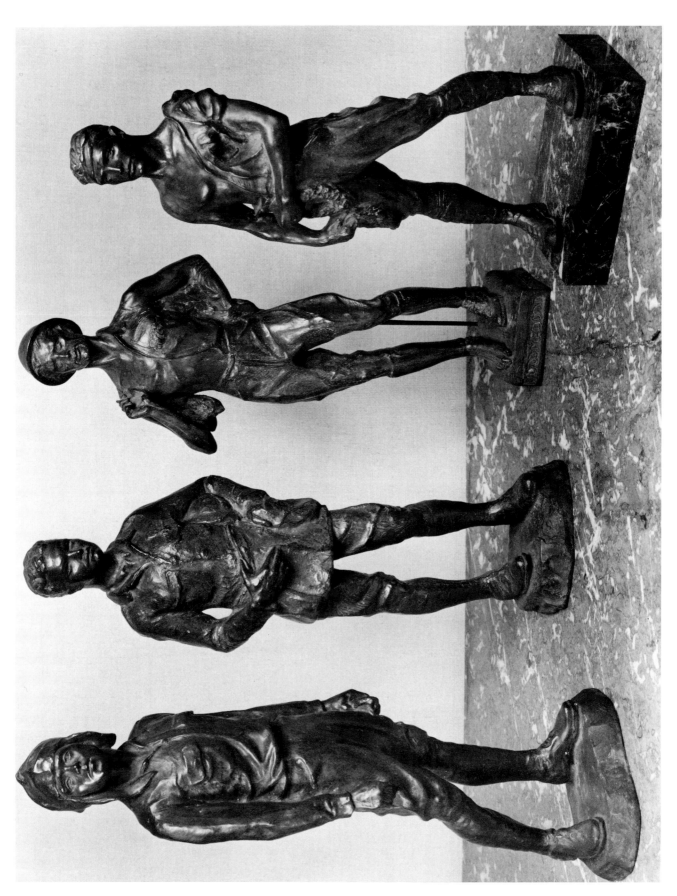

Ladd, Anna Coleman. Four Figures. Bronze. Ex Collection of Bob Bahssin, Post Road Gallery, Larchmont, NY.

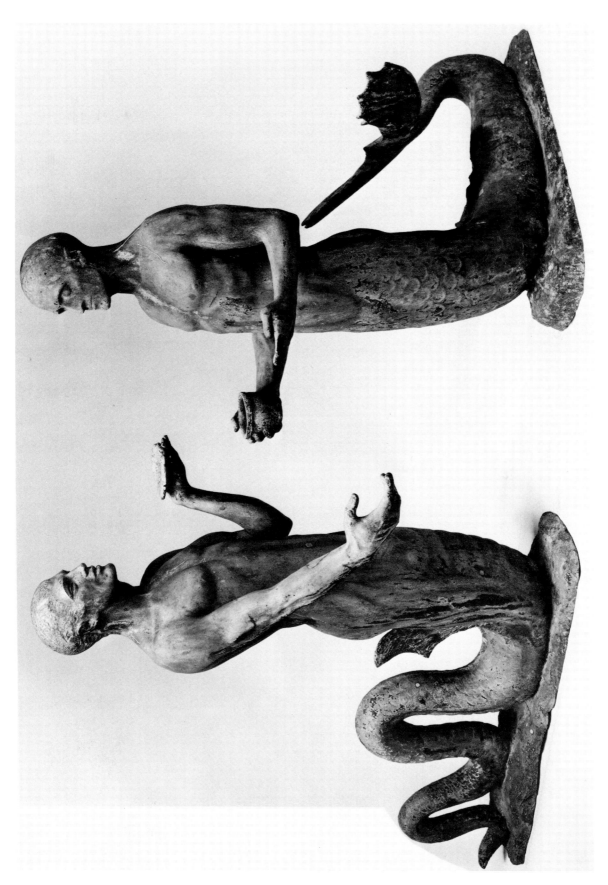

Ladd, Anna Coleman. Garden Figures. Collection of Bob Bahssin,
Post Road Gallery, Larchmont, NY.

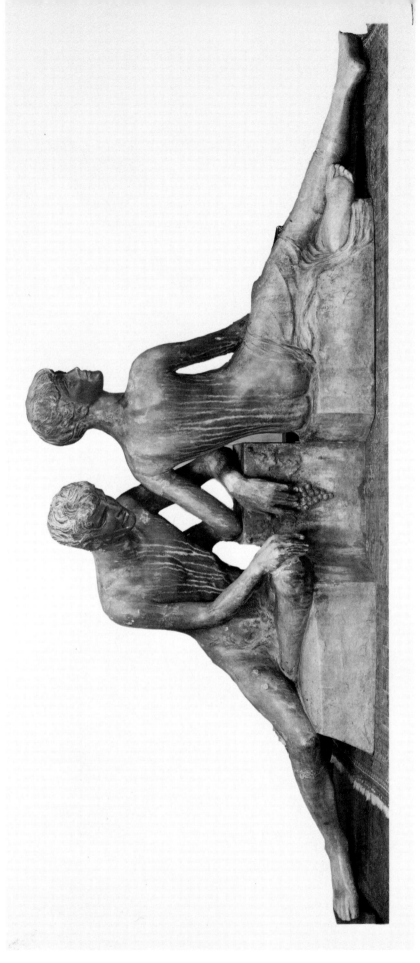

Ladd, Anna Coleman. "Eros & Anteros." Collection of Bob Bahssin,
Post Road Gallery, Larchmont, NY.

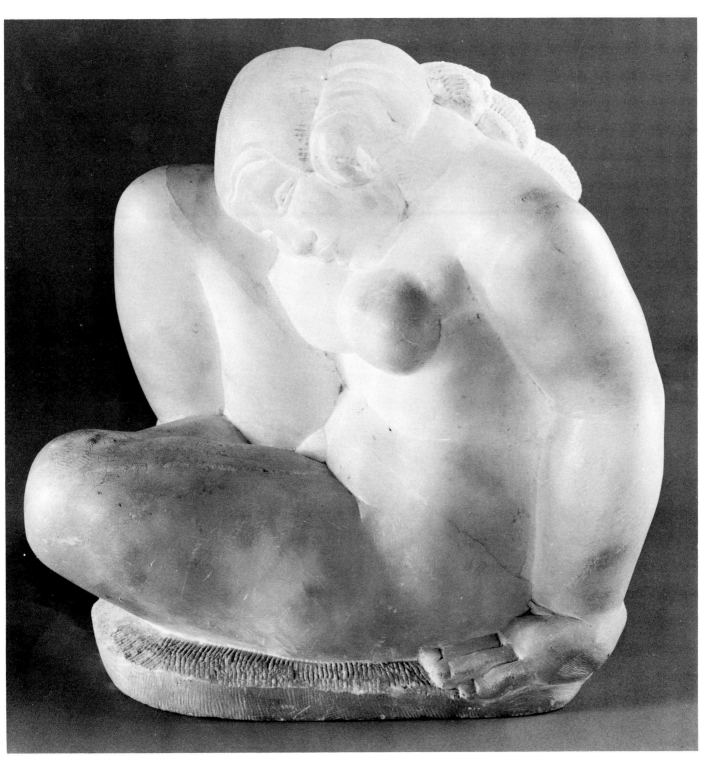

Laurent, Robert. "Sleep," 1938. Alabaster, 14 1/2 inches high.
Collection, Vassar College Art Gallery, Poughkeepsie, New York.

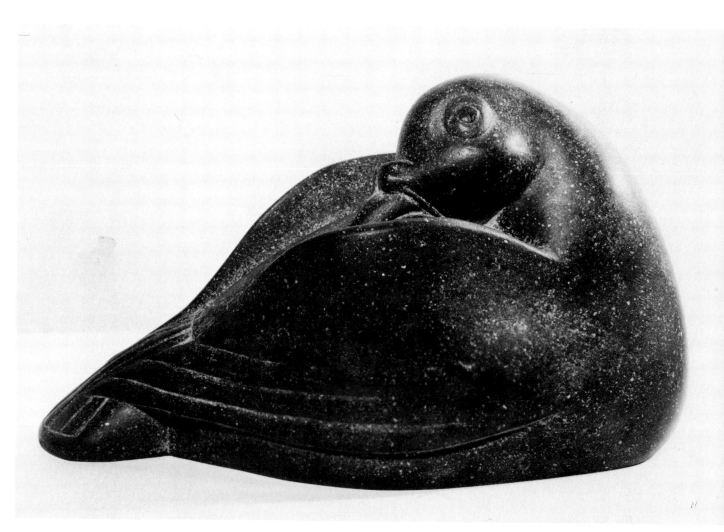

Laurent, Robert. "Pigeon," 1936. Cast red limestone, 5 1/2 inches high. Collection, Vassar College Art Gallery, Poughkeepsie, New York.

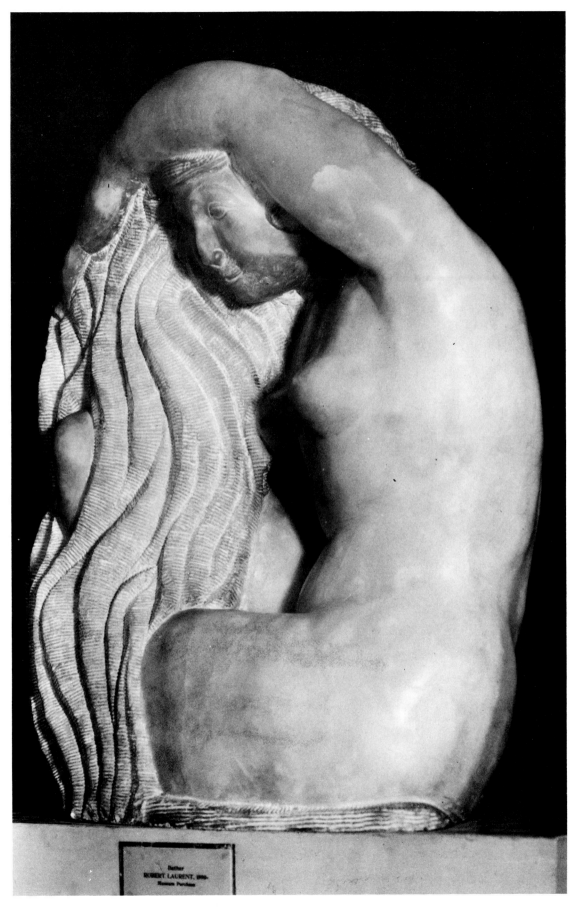

Laurent, Robert. "The Bather." Photograph courtesy of National
Sculpture Society.

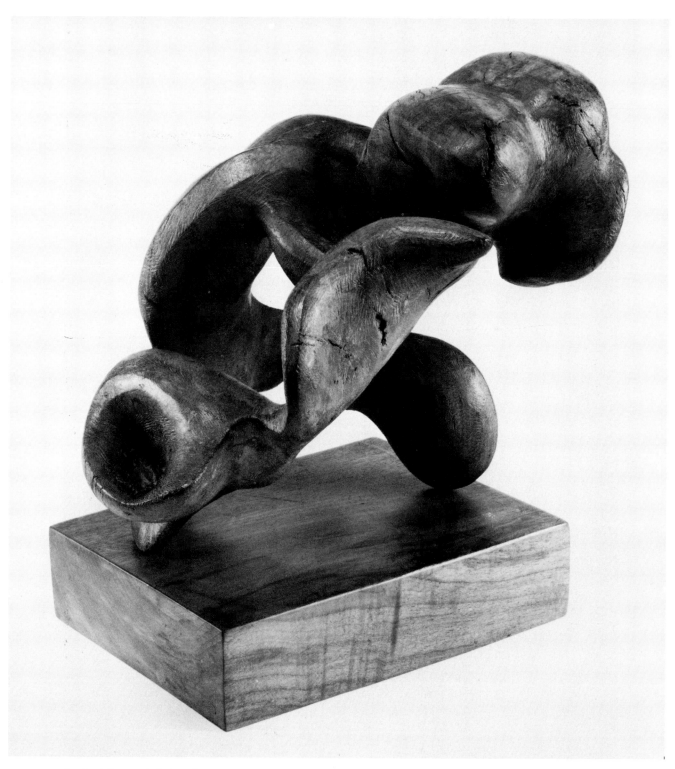

Lekakis, Michael. Untitled. Cherrywood, 13 3/4 inches high. Collection, Vassar College Art Gallery, Poughkeepsie, New York.

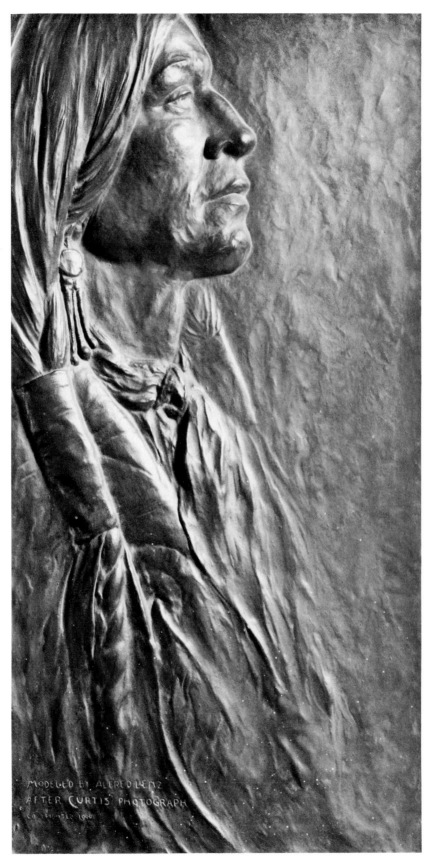

Lenz, Alfred. "Indian." Bronze. Ex Collection of Bob Bahssin, Post Road Gallery, Larchmont, NY.

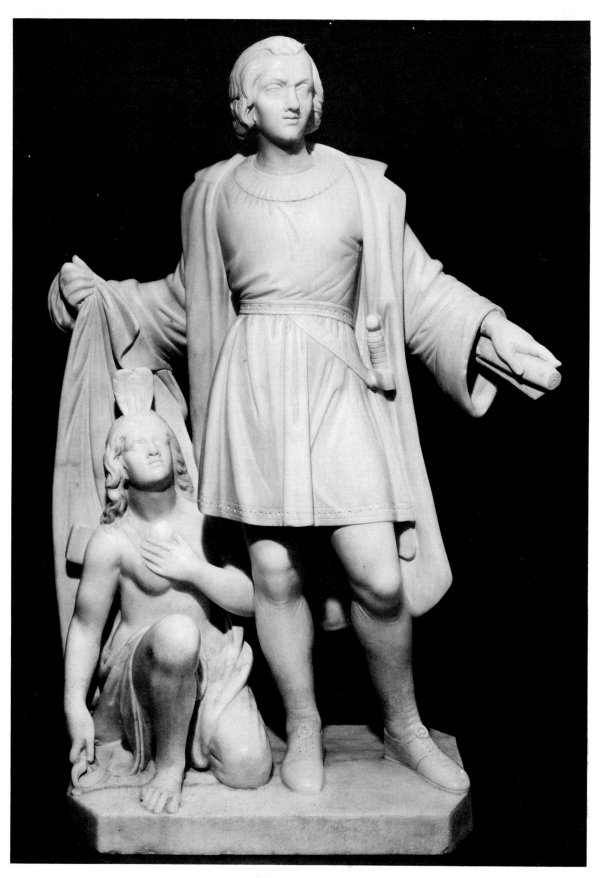

Lewis, Edmonia (attributed). "Columbus." Marble. Collection of Bob Bahssin, Post Road Gallery, Larchmont, NY.

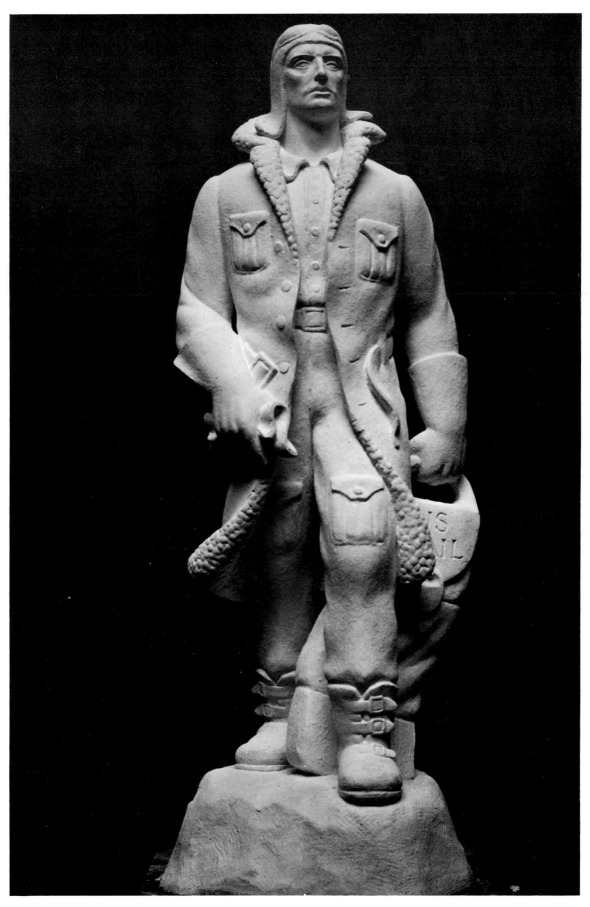

Lo Medico, Thomas Gaetano. "Pioneer Aviator." Plaster. Photograph courtesy of National Sculpture Society.

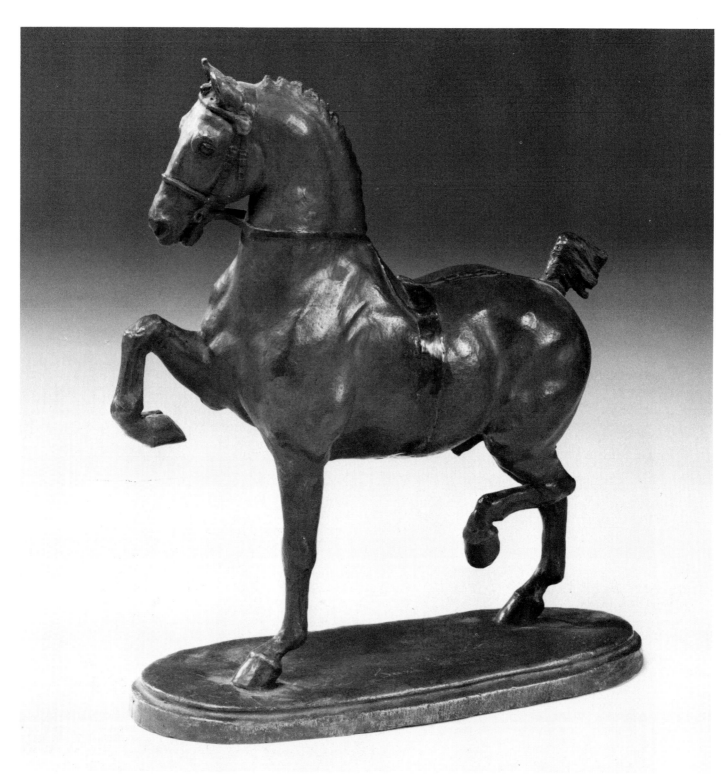

Lord, June Harrah. "Hackney Pony," 1946. Bronze, 9 1/8 inches high. Collection, Vassar College Art Gallery, Poughkeepsie, New York. (Ed. note: Listed as June Harrah).

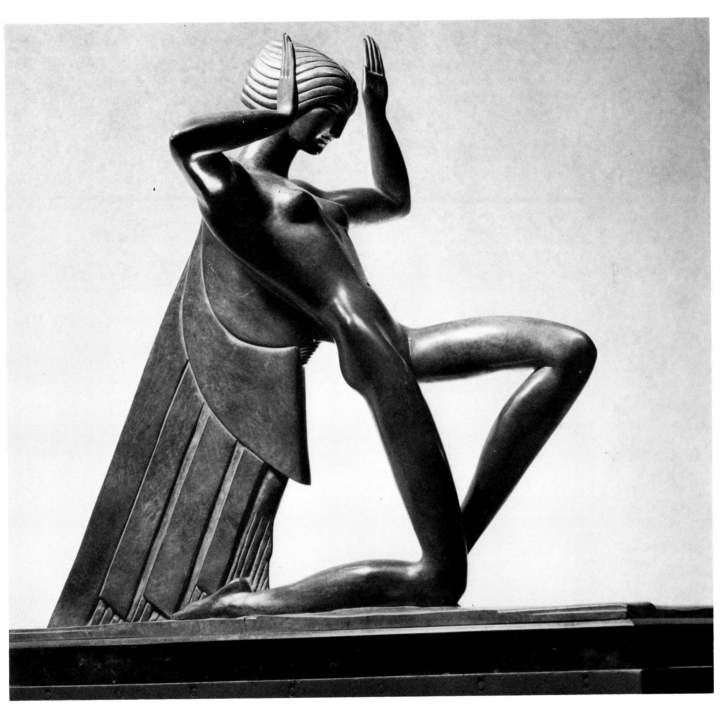

Lovet-Lorski, Boris. "Sun Dial," 1926. Bronze, 21 inches high.
Photograph courtesy of National Sculpture Society.

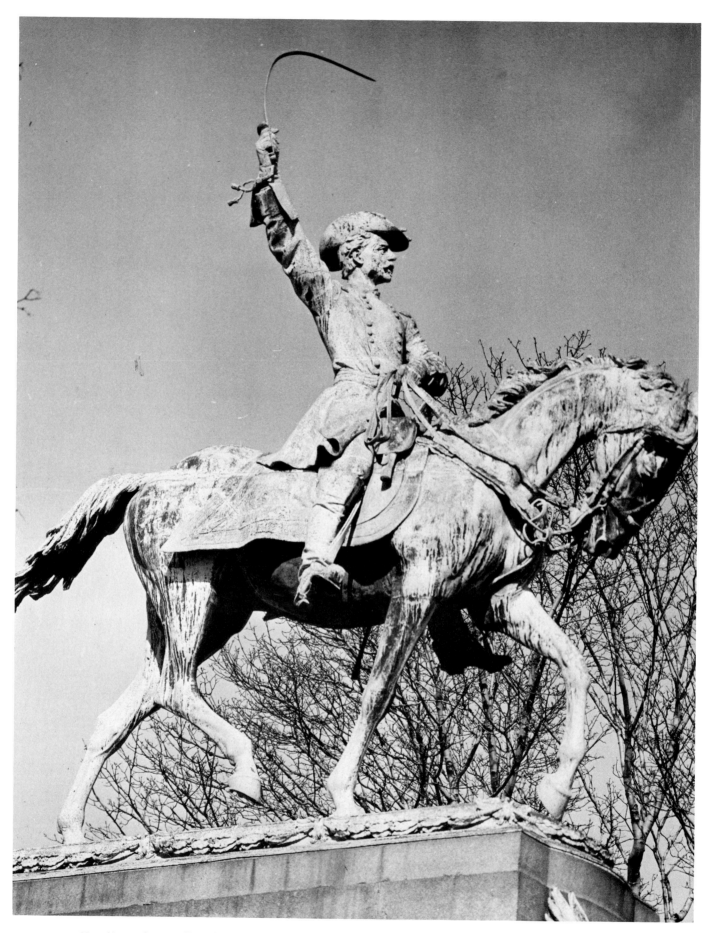

MacMonnies, Frederick William. "Gen. Henry Slocum." Photograph courtesy of National Sculpture Society.

574

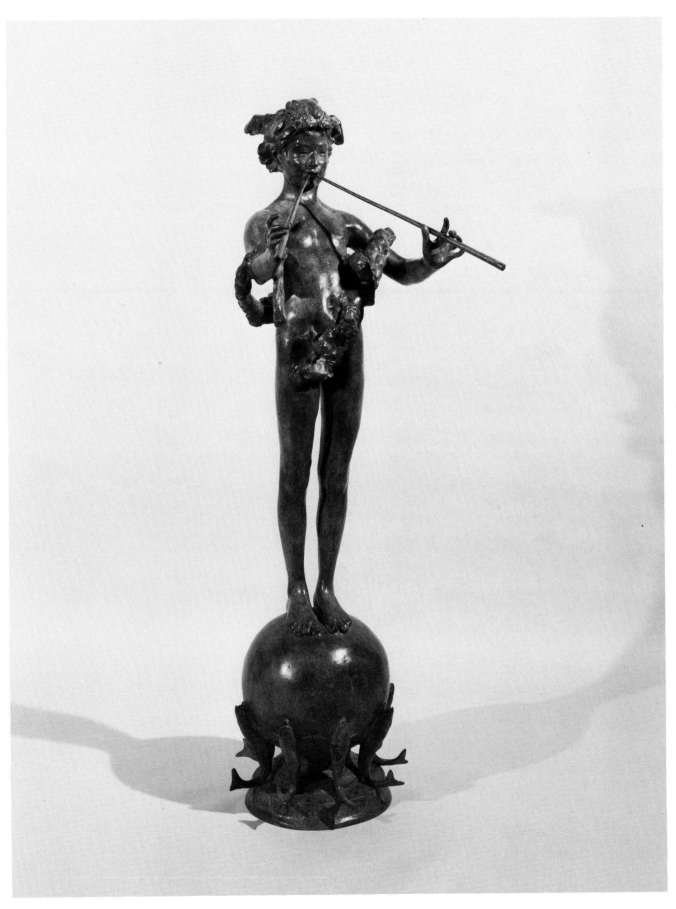

MacMonnies, Frederick William. "Pan of Rohallion." Bronze. Ex
Collection of Bob Bahssin, Post Road Gallery, Larchmont, NY.

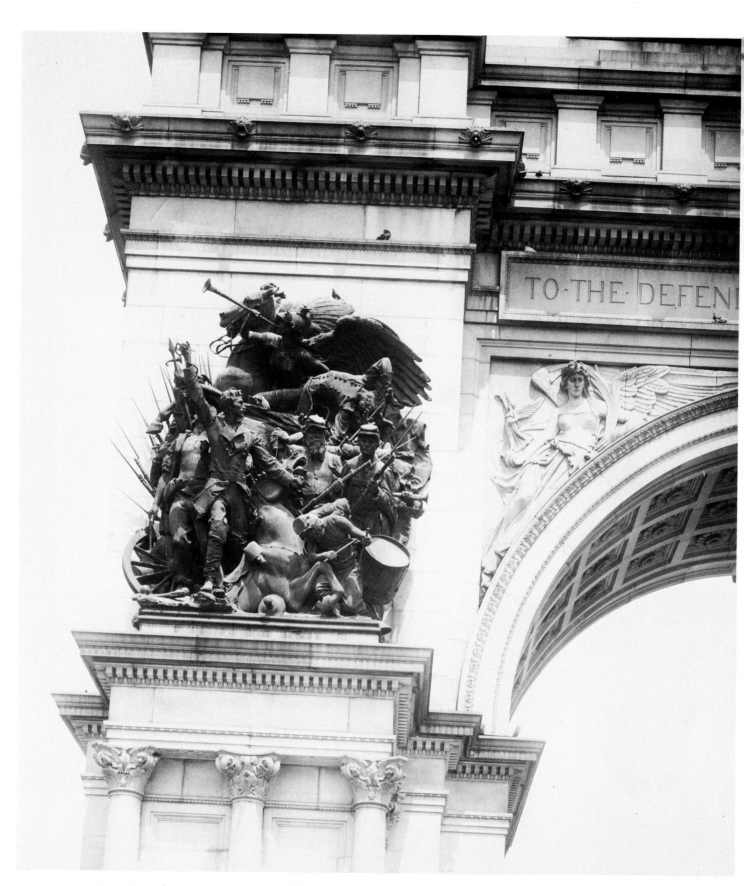

MacMonnies, Frederick William. "The Army." Victory Arch, Prospect Park Plaza, Brooklyn. Photograph courtesy of National Sculpture Society.

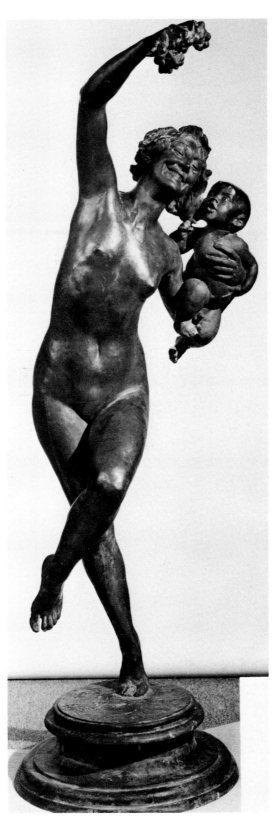

MacMonnies, Frederick William. "Bacchante with Infant Faun," c.
1893. Bronze, 68 inches high. Collection of Bob Bahssin, Post Road
Gallery, Larchmont, NY.

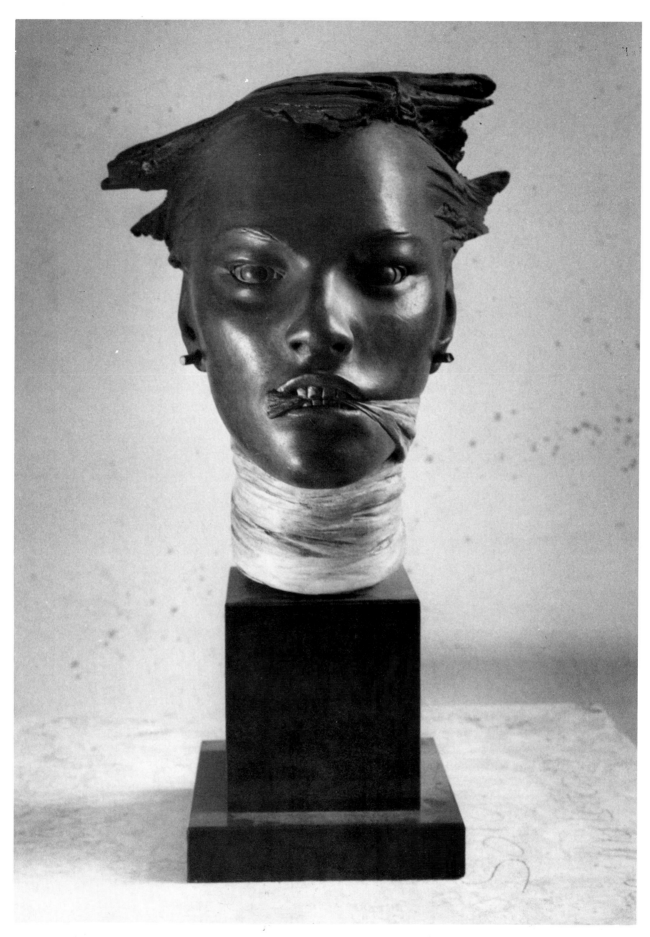

Malmstrom, Margit. "Silence." Terra cotta, life-size. Photograph
courtesy of the artist.

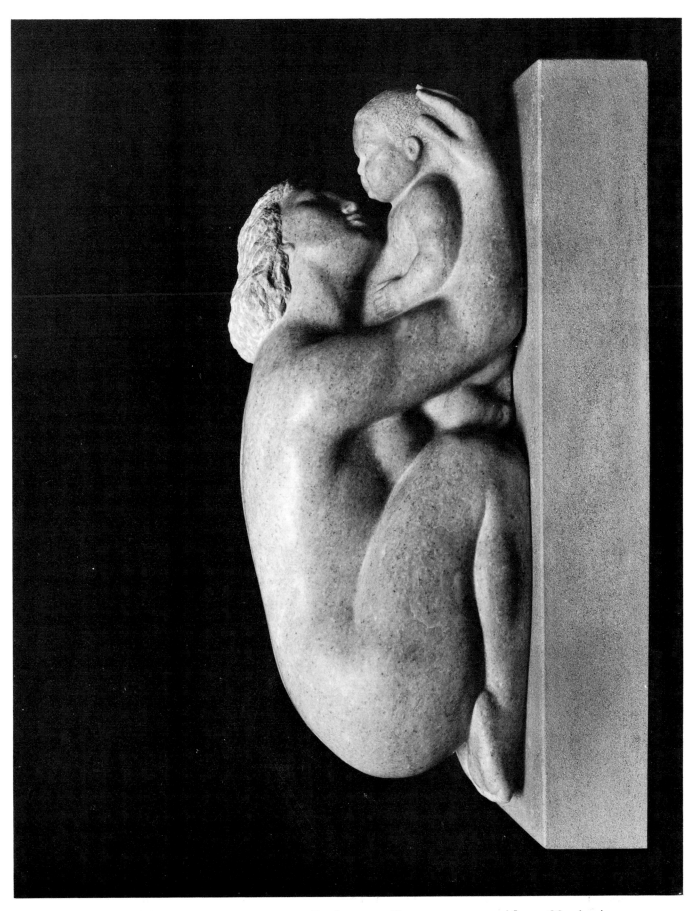

Mankowski, Bruno. Young Mother. Tennessee marble, 20 inches long. Photograph courtesy of National Sculpture Society.

Manship, Paul. Door Handle in the Form of an Indian Carrying an Antelope, 1921-29. Bronze with green patina, 17 inches high. Collection, Vassar College Art Gallery, Poughkeepsie, New York.

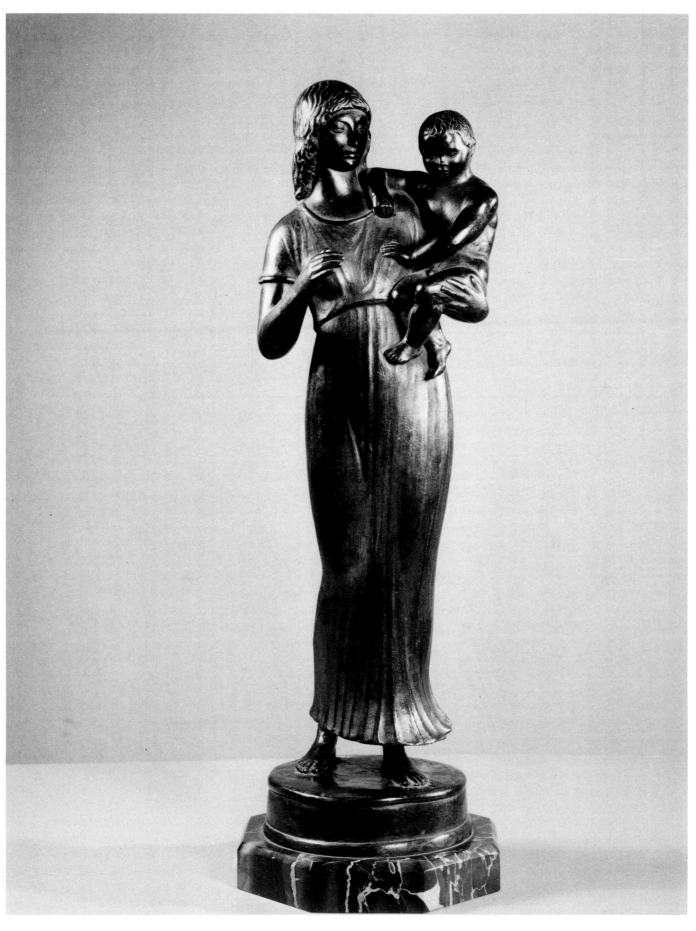

Manship, Paul. Standing Woman with Child. Bronze, 16 1/4 inches high. Collection, Vassar College Art Gallery, Poughkeepsie, New York.

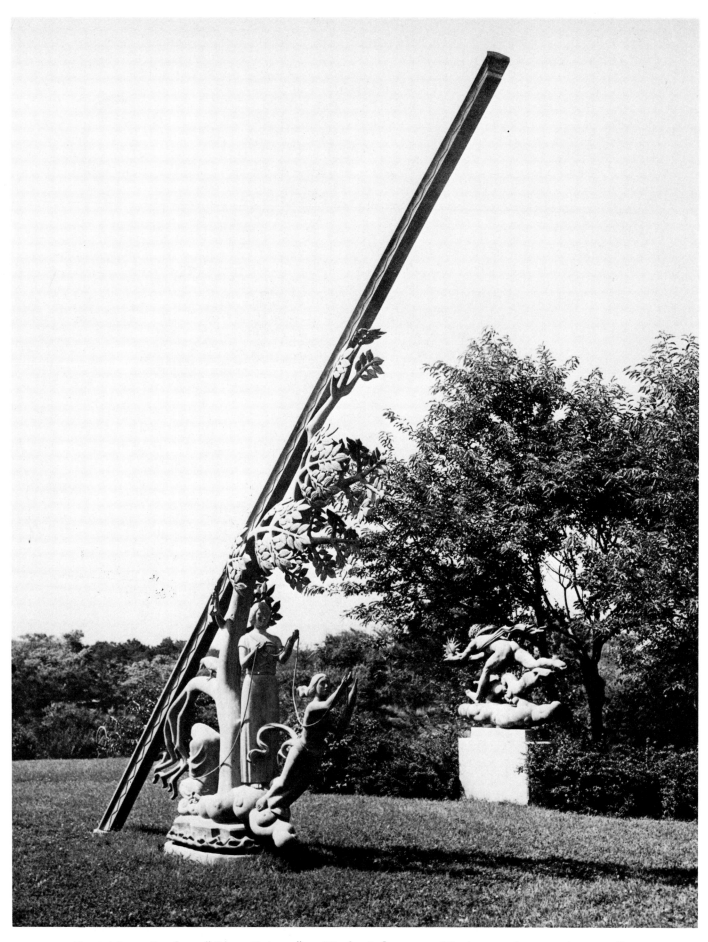

Manship, Paul. "The Fates." 26 feet long. Photograph courtesy of
National Sculpture Society.

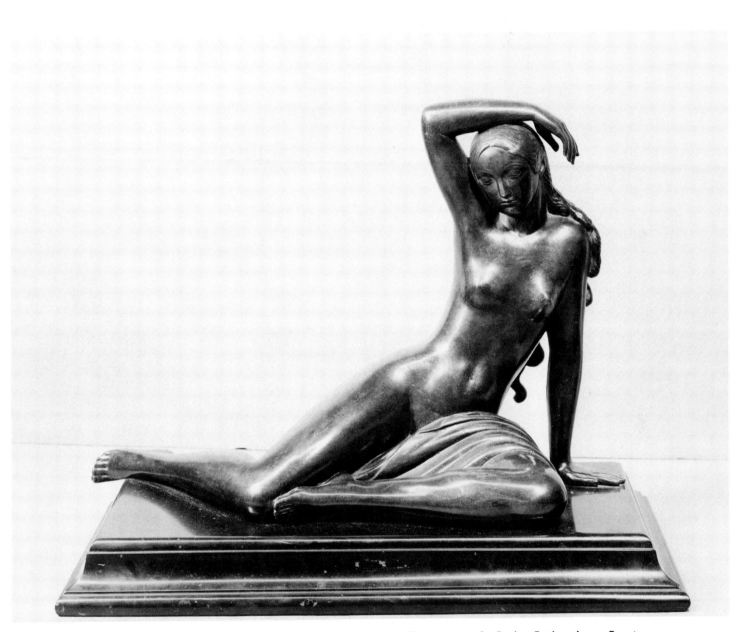

Manship, Paul. Female Figure. Ex Collection of Bob Bahssin, Post
Road Gallery, Larchmont, NY.

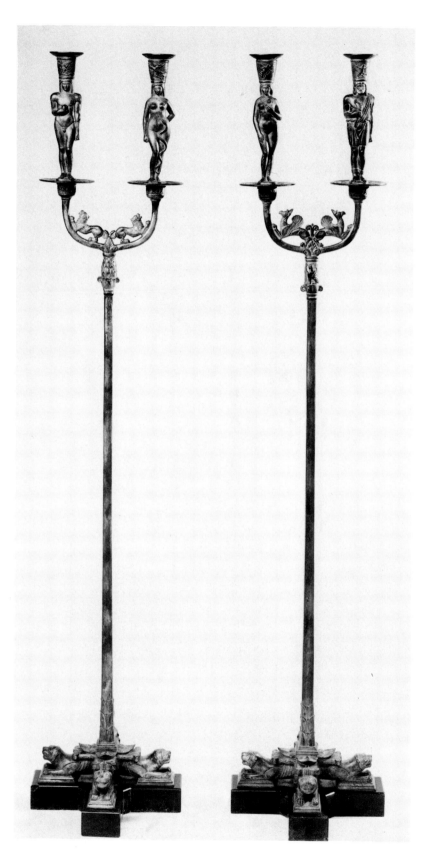

Manship, Paul. "Torchiers." Bronze. Ex Collection of Bob Bahssin, Post Road Gallery, Larchmont, NY.

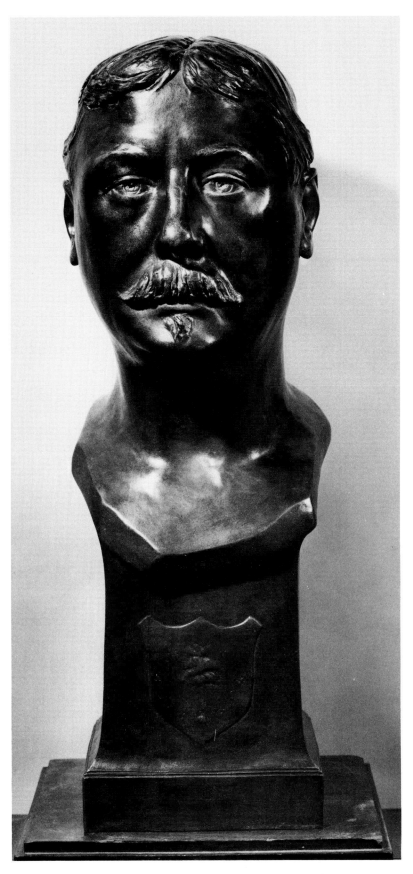

McCahill, Agnes McGuire. "Frederic Remington." Bronze. Collection
of Bob Bahssin, Post Road Gallery, Larchmont, NY.

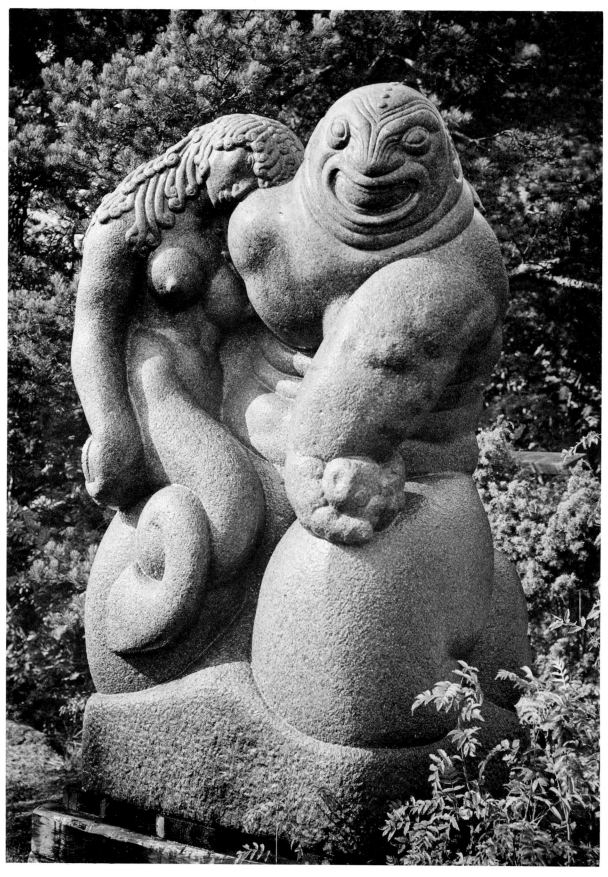

Milles, Carl. Photograph courtesy of National Sculpture Society.

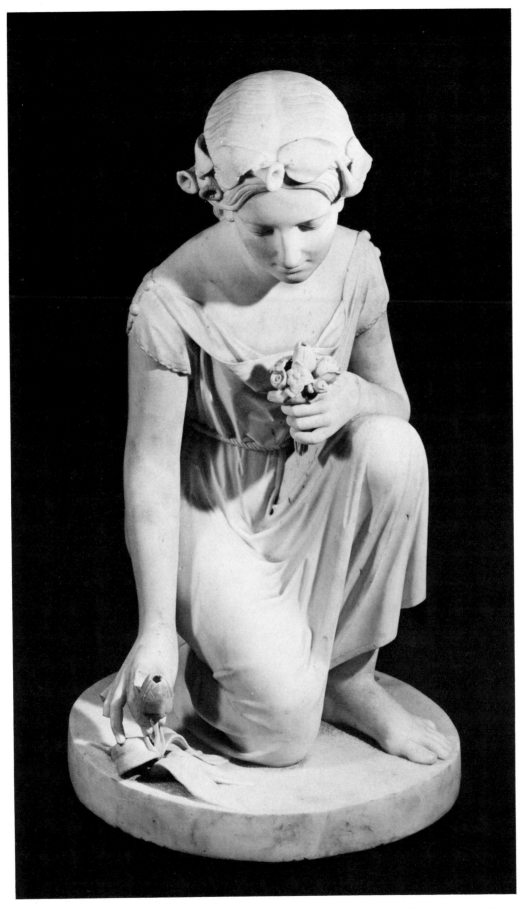

Mozier, Joseph. "Flower Girl." Marble. Ex Collection of Bob
Bahssin, Post Road Gallery, Larchmont, NY.

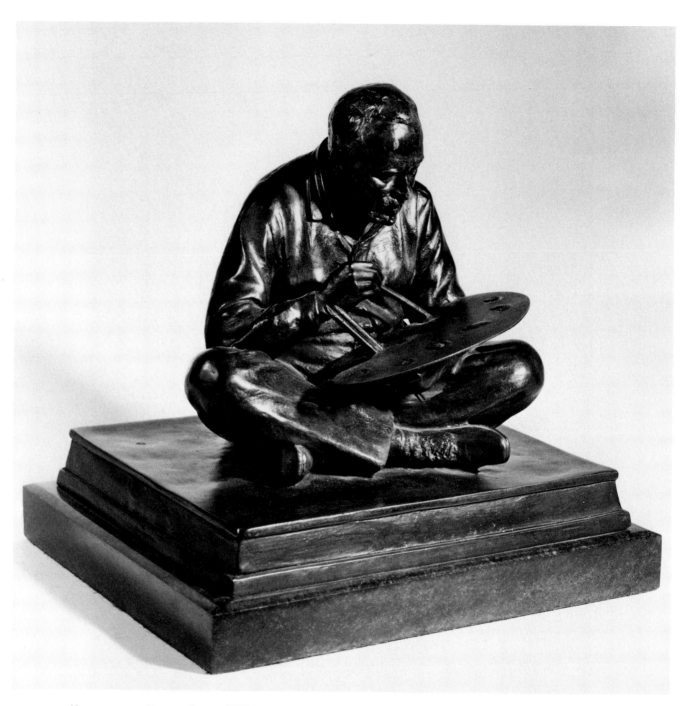

Murray, Samuel. "Thomas Eakins." Bronze. Collection of Bob Bahssin, Post Road Gallery, Larchmont, NY.

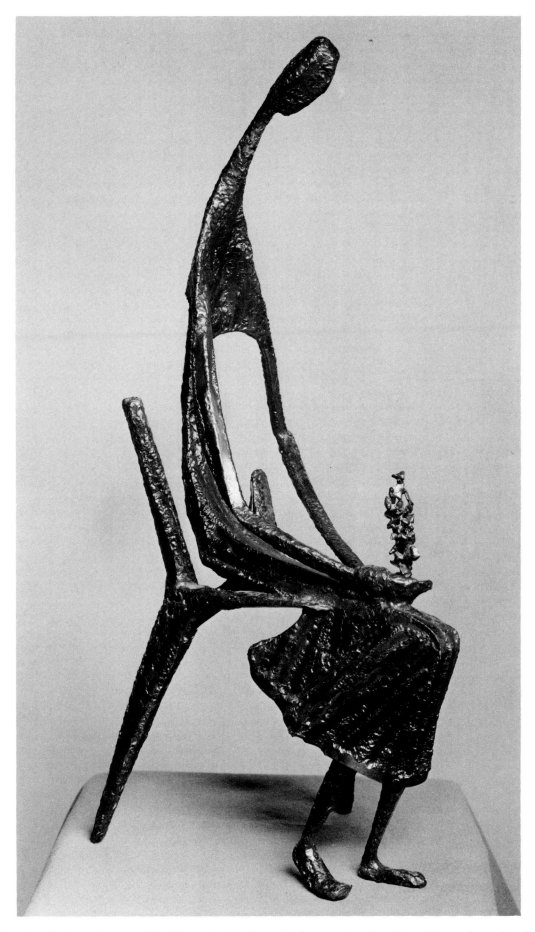

Nash, Katherine. "Waiting," 1956. Welded steel, 29 1/2 inches high.
Collection, Vassar College Art Gallery, Poughkeepsie, New York.

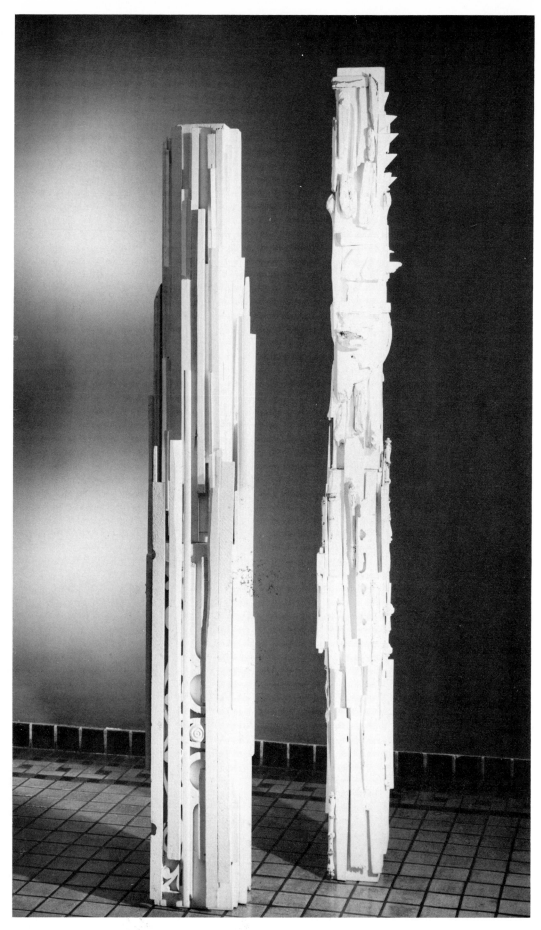

Nevelson, Louise. White Columns from "Dawn's Wedding Feast," 1959.
Painted wood, 90 inches high and 98 inches high. Collection, Vassar
College Art Gallery, Poughkeepsie, New York.

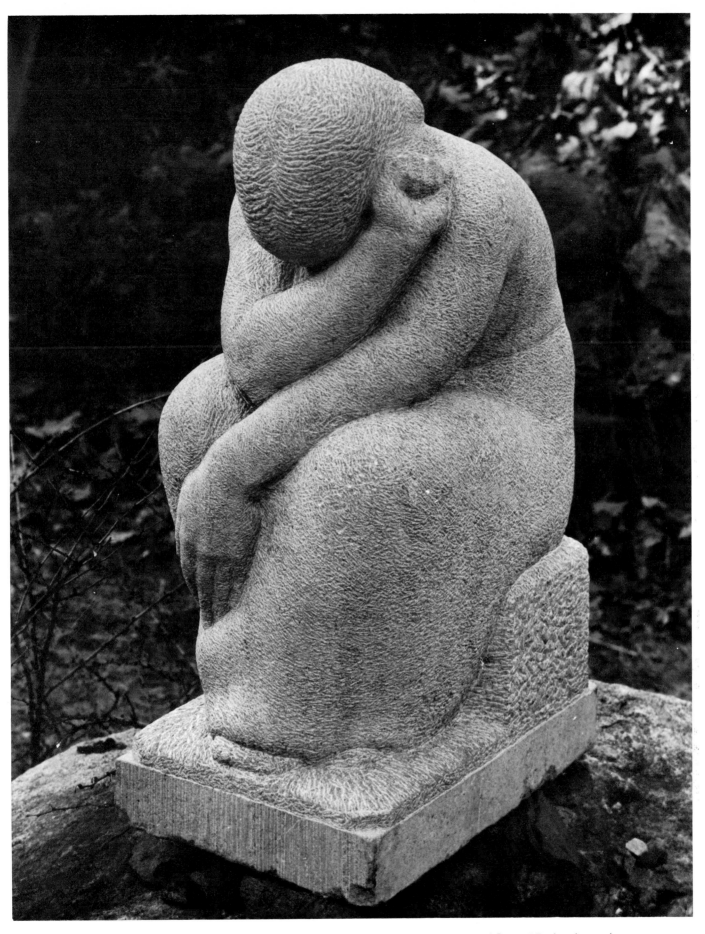

Nickerson, Ruth. Grieving Figure. Tennessee marble, 15 inches by
10 1/2 inches (base), 25 inches high. Photograph courtesy of National
Sculpture Society.

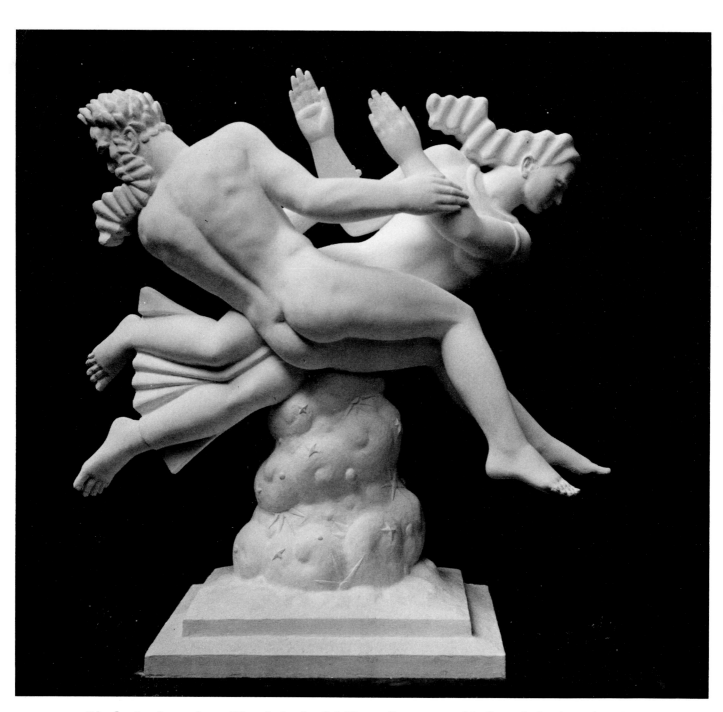

Nicolosi, Joseph. The Spiral of Life. Bronze, 11 feet 2 inches by 18 inches by 10 3/4 inches. Photograph courtesy of National Sculpture Society.

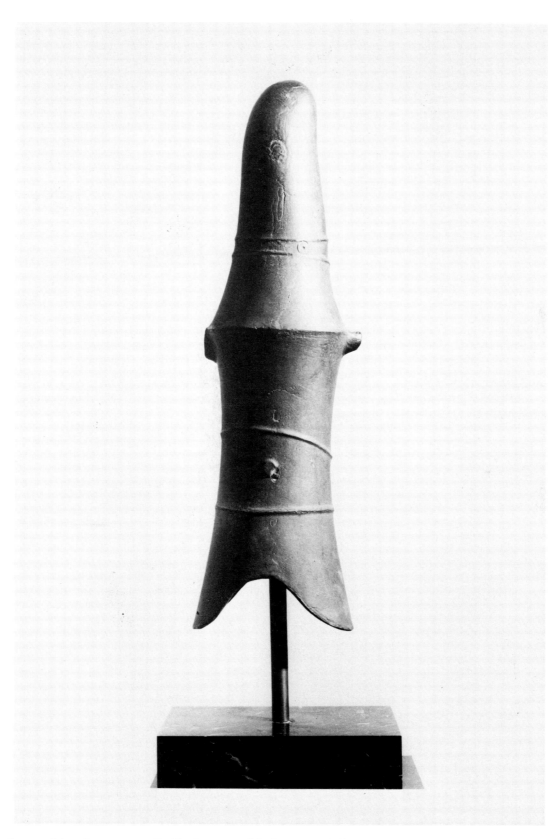

Noguchi, Isamu. Bell Image (Polygenesis), 1956-57. Cast iron, 32
inches high. Collection, Vassar College Art Gallery, Poughkeepsie,
New York.

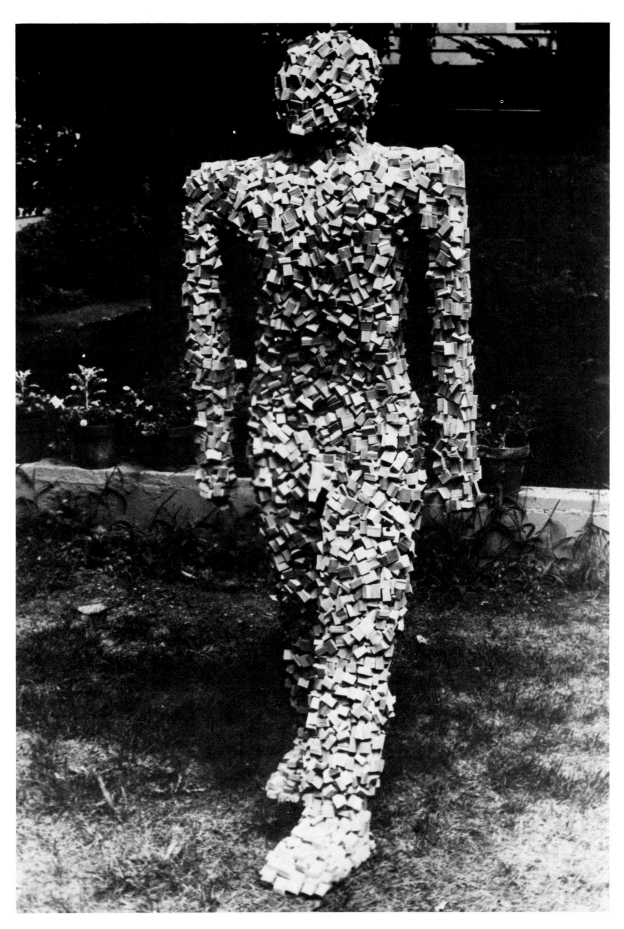

Olejarz, Harold. "Kouros," 1982. Hemlock fir, life-size, 6 feet high.
Collection of Lannon Museum. Photograph courtesy of the artist.

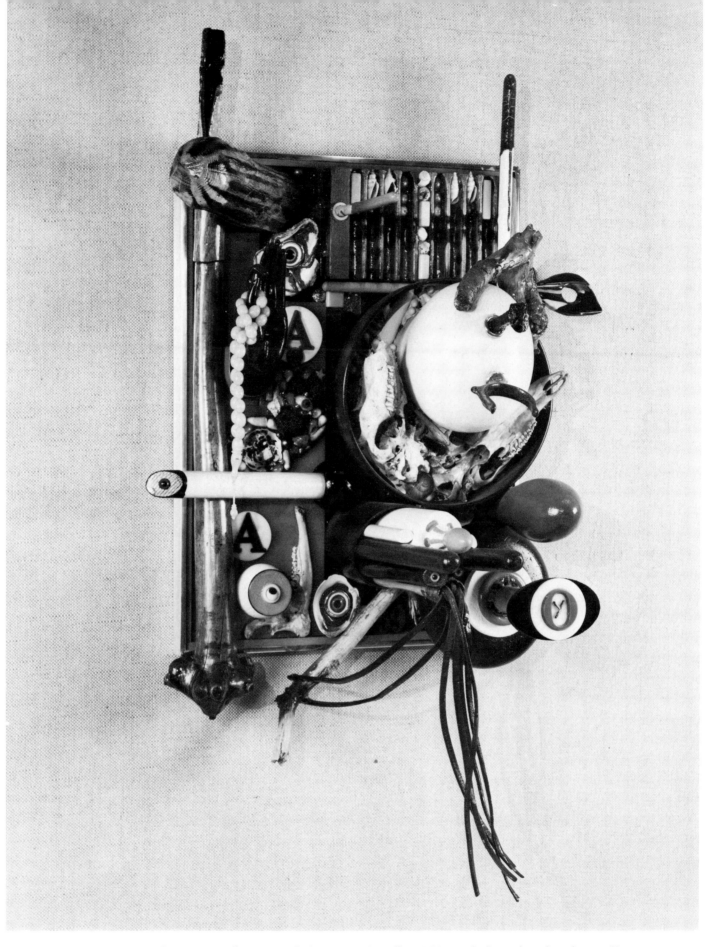

Ossorio, Alfonso. "Root Club No. 2, " 1969. Painted mixed media assemblage, 24 5/8 by 19 5/8 by 18 inches. Collection, Vassar College Art Gallery, Poughkeepsie, New York.

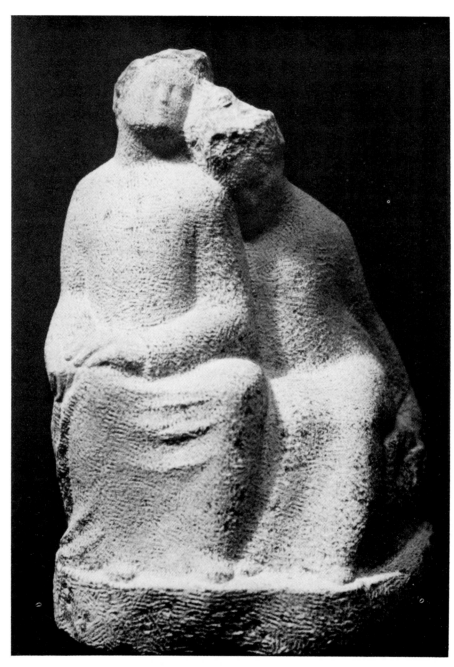

Palau, Fleur. "Amici." Bardillio marble. Photograph courtesy of the artist.

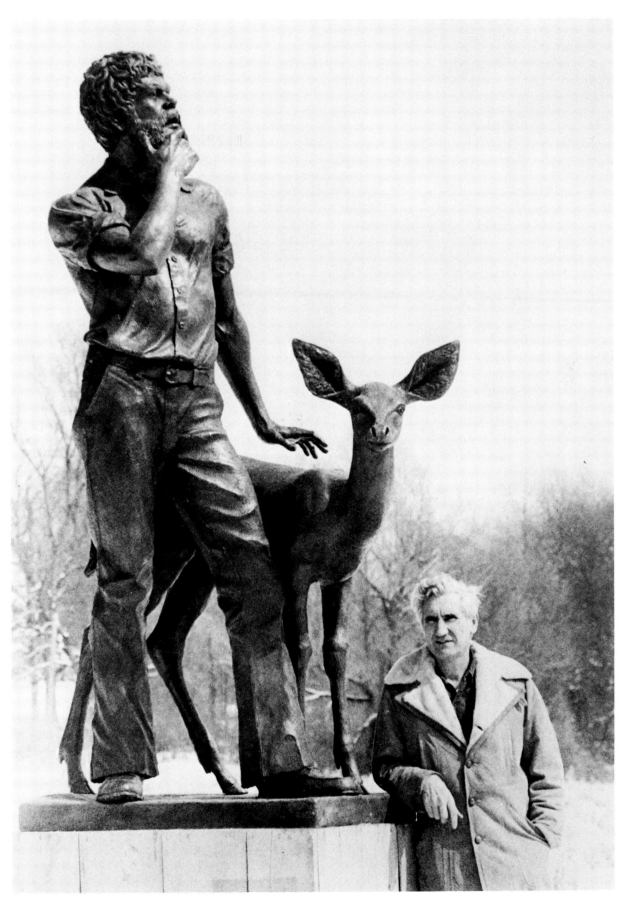

Parks, Charles Cropper. "Homer Judson." 8 feet high. Photograph
courtesy of National Sculpture Society.

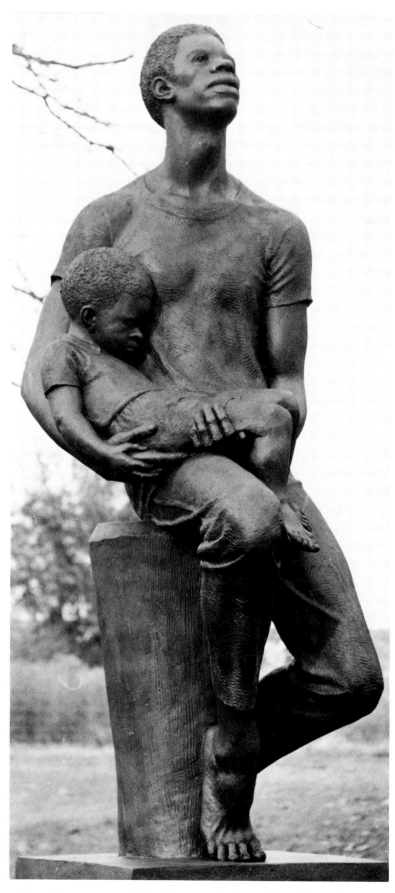

Parks, Charles Cropper. "Father and Son." Fiberglas, 6 feet high.
Photograph courtesy of National Sculpture Society.

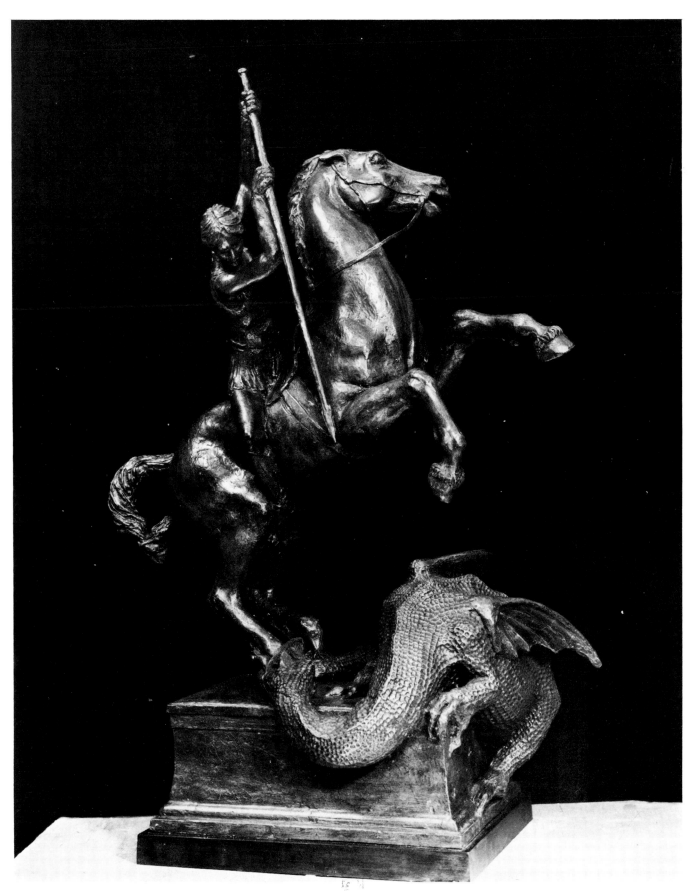

Parks, Eric Vernon. St. George and the Dragon. Bronze, 34 inches
high. Photograph courtesy of National Sculpture Society.

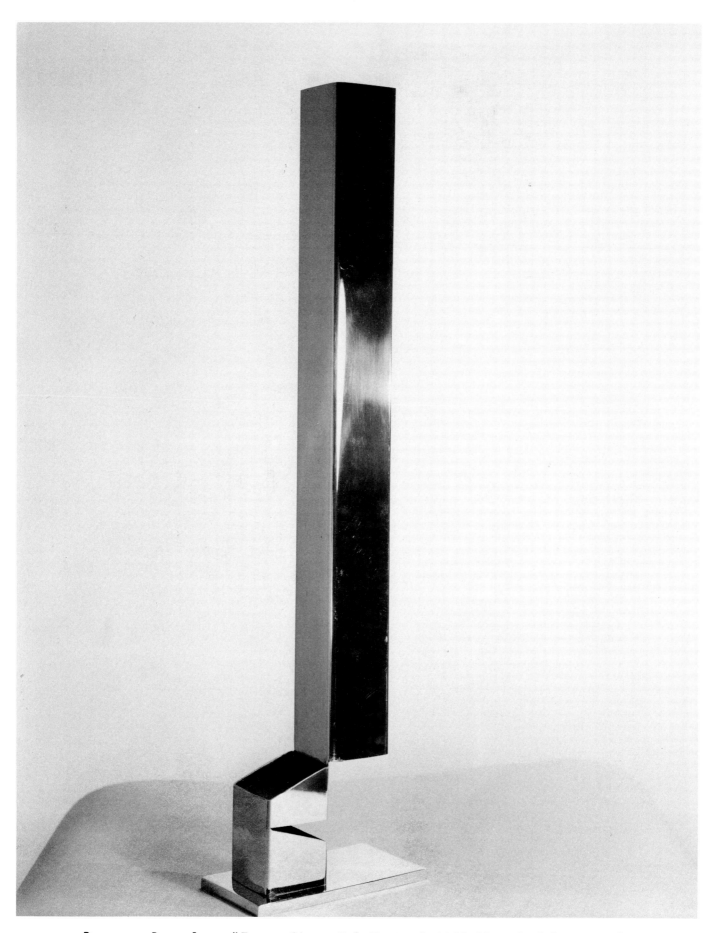

Pepper, Beverly. "Torre Pieno Nel Vuoto," 1966-67. Stainless steel, chromium plated, 21 1/4 inches high. Collection, Vassar College Art Gallery, Poughkeepsie, New York.

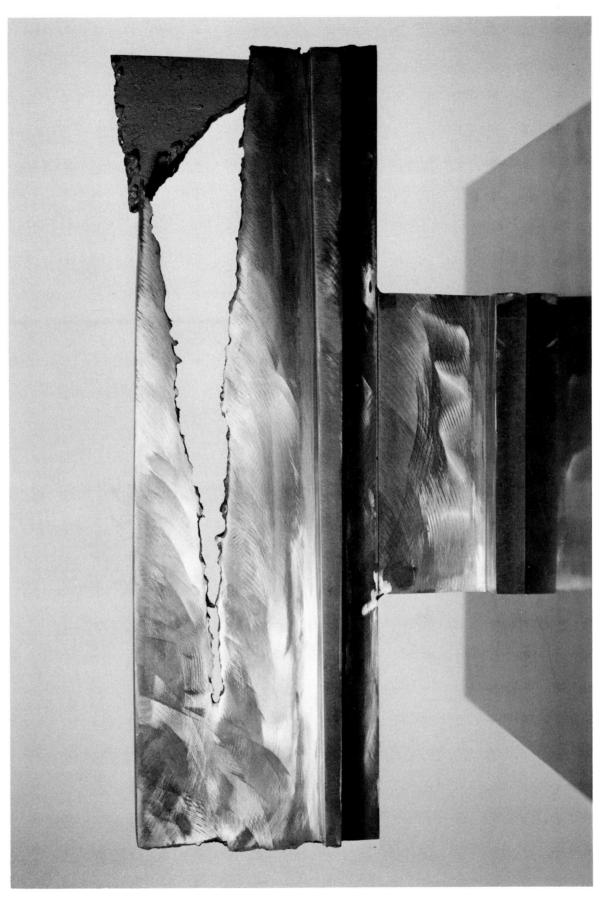

Pepper, Beverly. "The Carp," 1965. Stainless steel, 11 3/4 inches high. Collection, Vassar College Art Gallery, Poughkeepsie, New York.

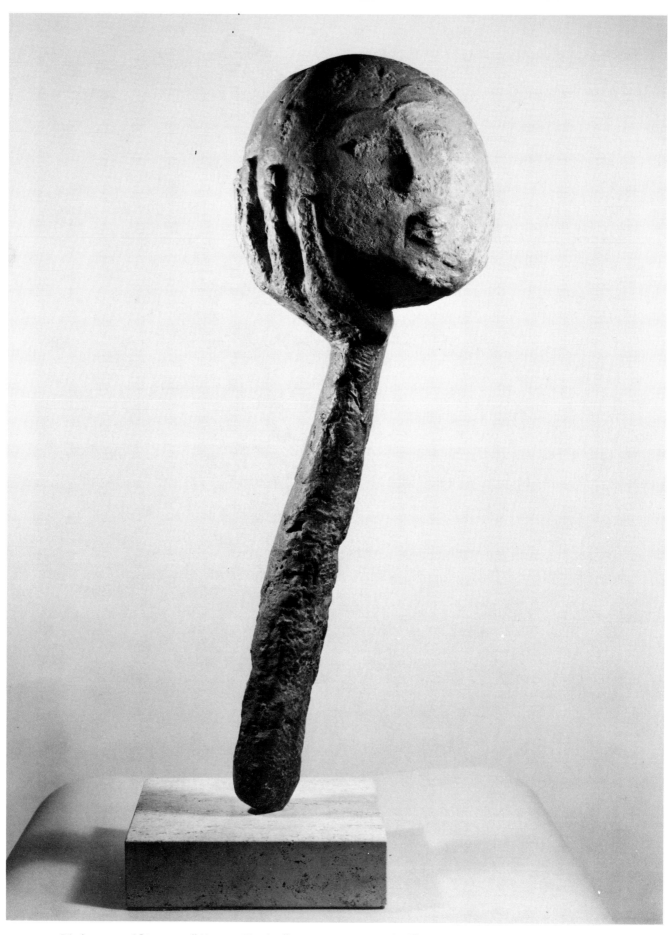

Pickens, Alton. "Moon Moth," ca. 1961. Shell bronze over plaster, 24 inches high. Collection, Vassar College Art Gallery, Poughkeepsie, New York.

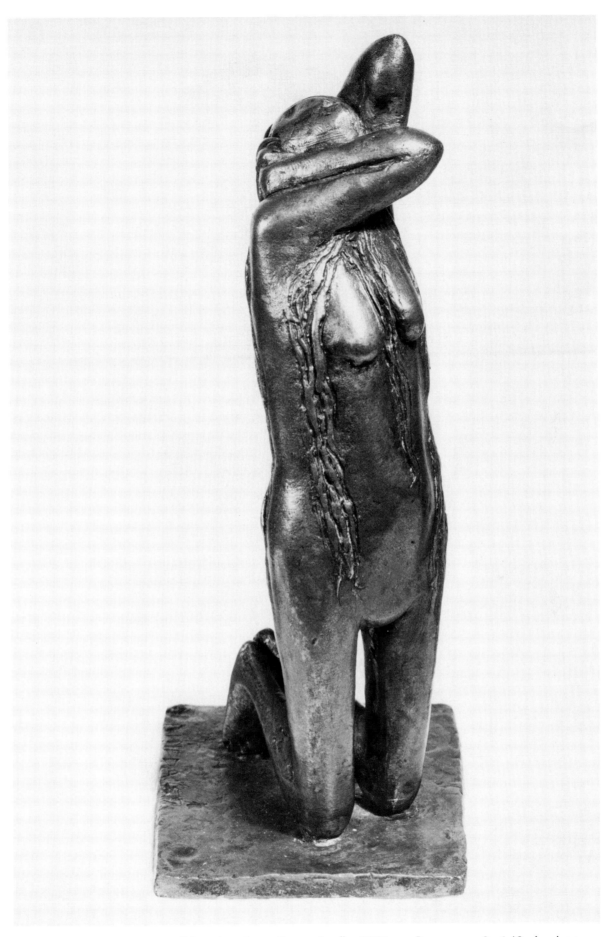

Pineda, Mariana. "Study for Despair," 1951. Bronze, 8 1/2 inches
high with base. Collection of Victor D. Spark, NYC.

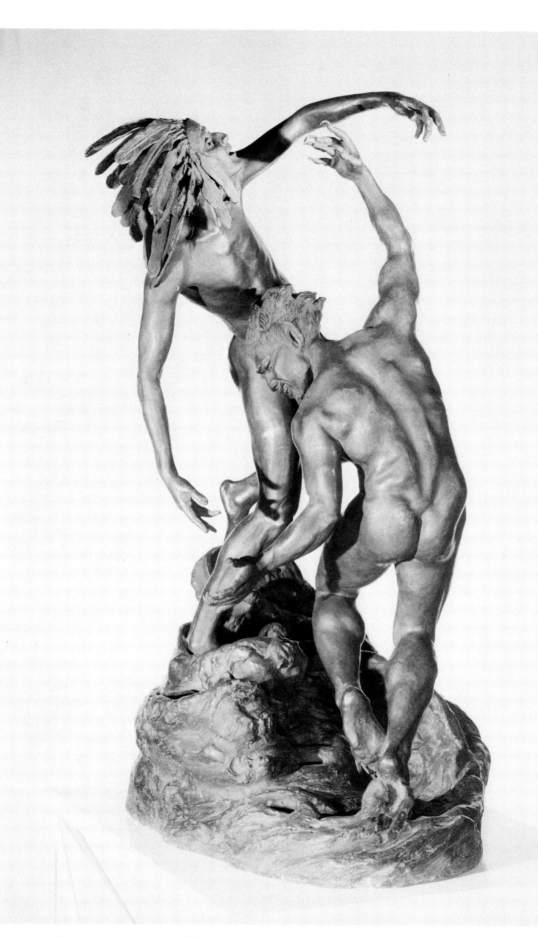

Potter, Lewis. "Dance of the Devil." Bronze. Ex Collection of Bob Bahssin, Post Road Gallery, Larchmont, NY. (Ed. note: Listed as Louis Potter).

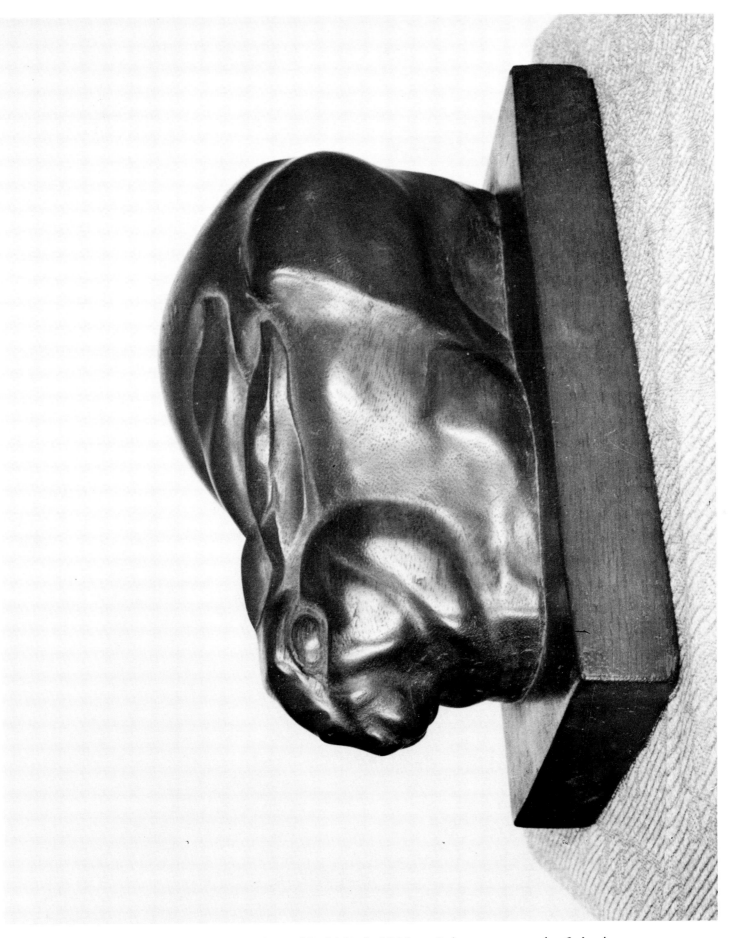

Poucher, Elizabeth Morris. "Rabbit," 1932. Primavera wood, 6 inches high. Collection, Vassar College Art Gallery, Poughkeepsie, New York.

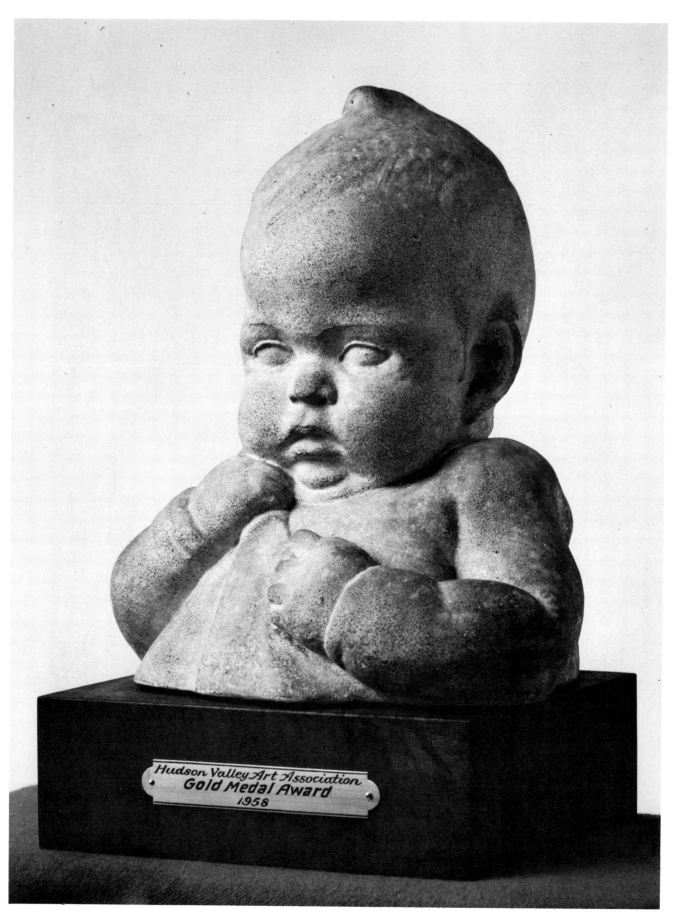

Poucher, Elizabeth Morris. "Young Donald." Photograph courtesy of National Sculpture Society.

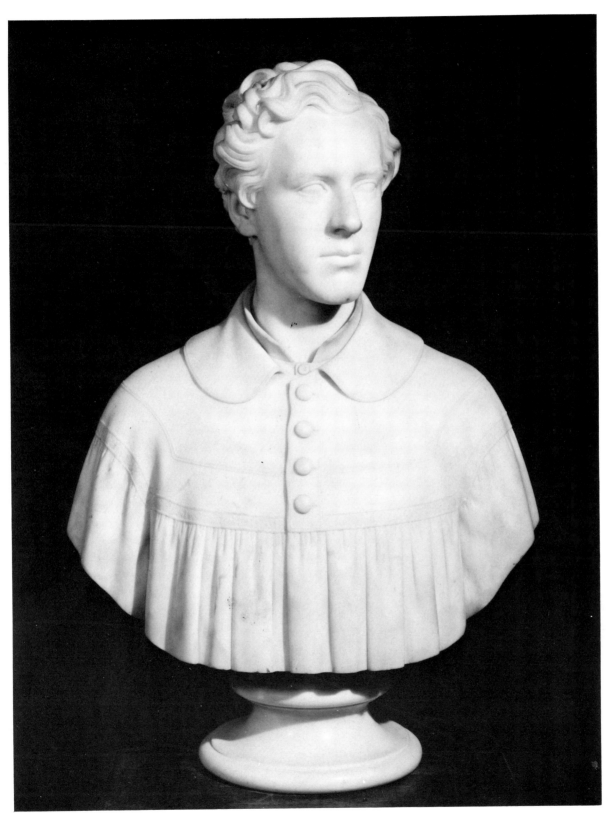

Powers, Hiram. "Longworth Powers." Marble. Collection of Bob Bahssin, Post Road Gallery, Larchmont, NY.

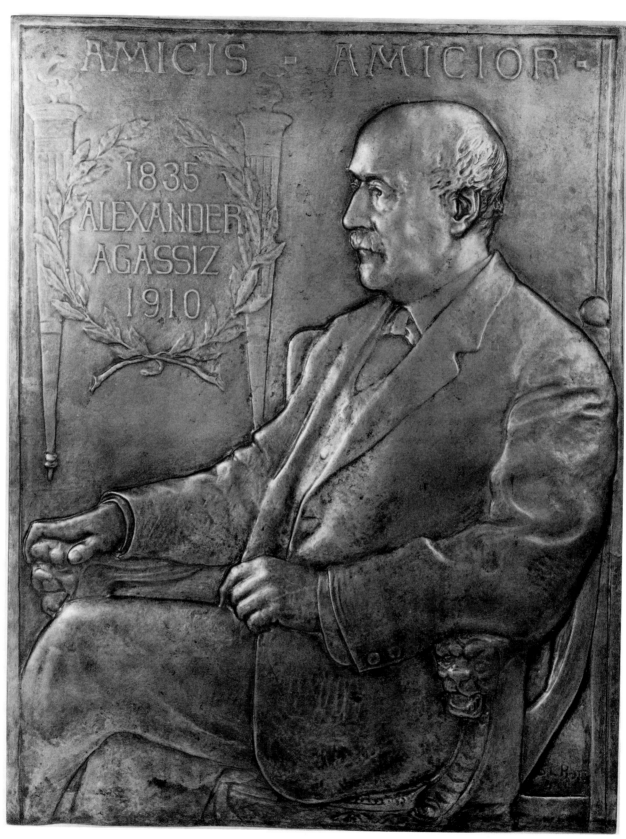

Pratt, Bela Lyon. Portrait of Alexander Agassiz, 1911. Low relief
bronze, 22 inches by 17 inches. Collection of Victor D. Spark, NYC.

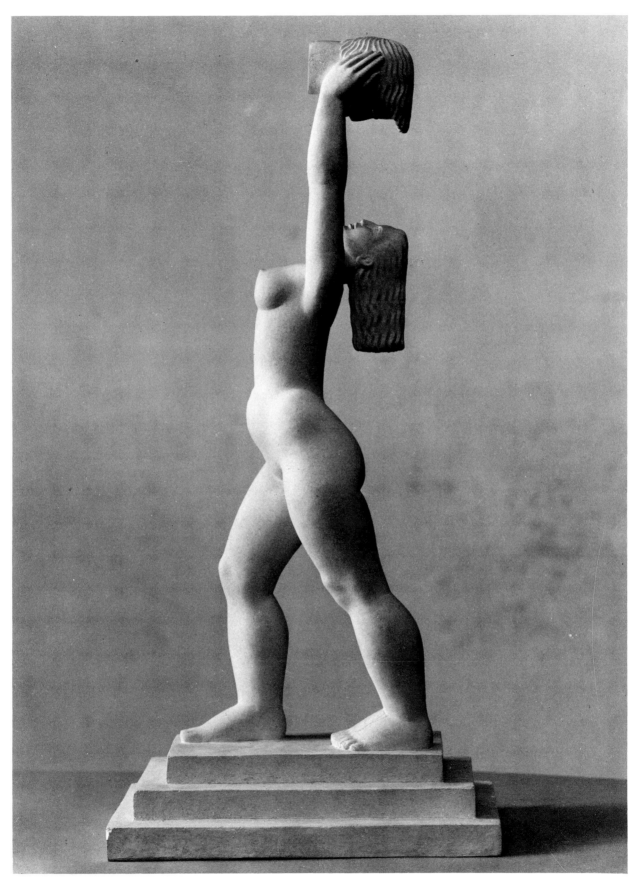

Richard, Betti. "Salome." Bronze, 23 inches high. Photograph courtesy of National Sculpture Society.

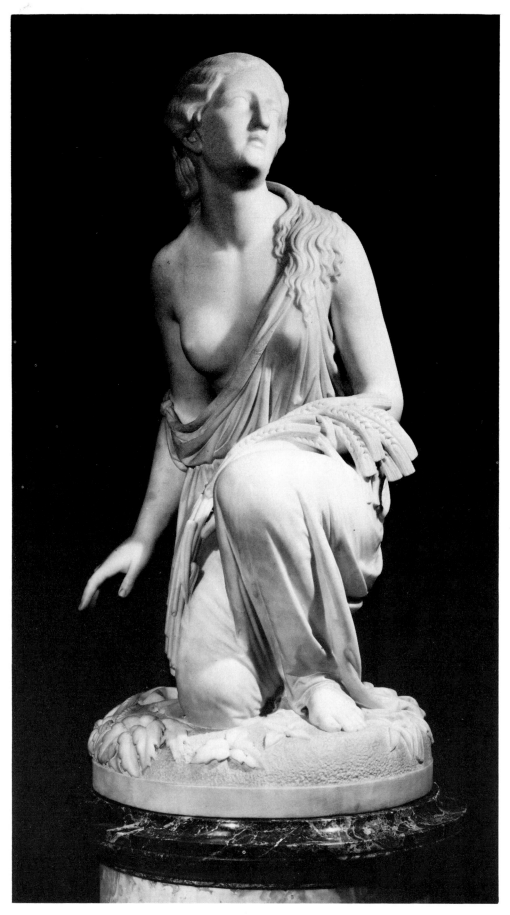

Rogers, Randolph. "Ruth." Marble. Ex Collection of Bob Bahssin, Post Road Gallery, Larchmont, NY.

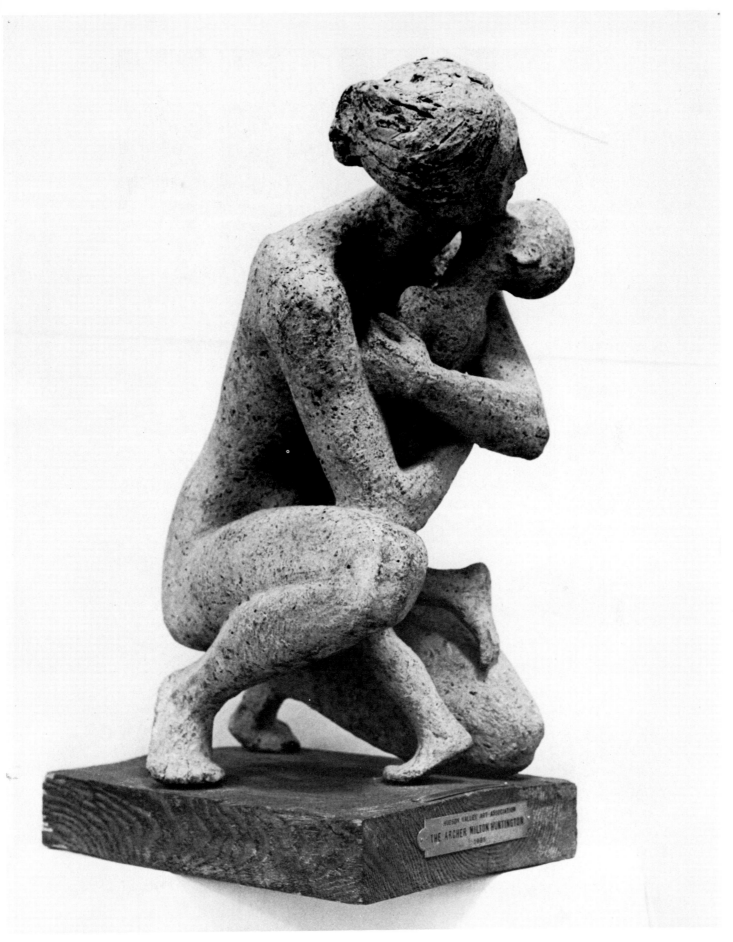

Roller, Marion Bender. Possession. Photograph courtesy of National Sculpture Society.

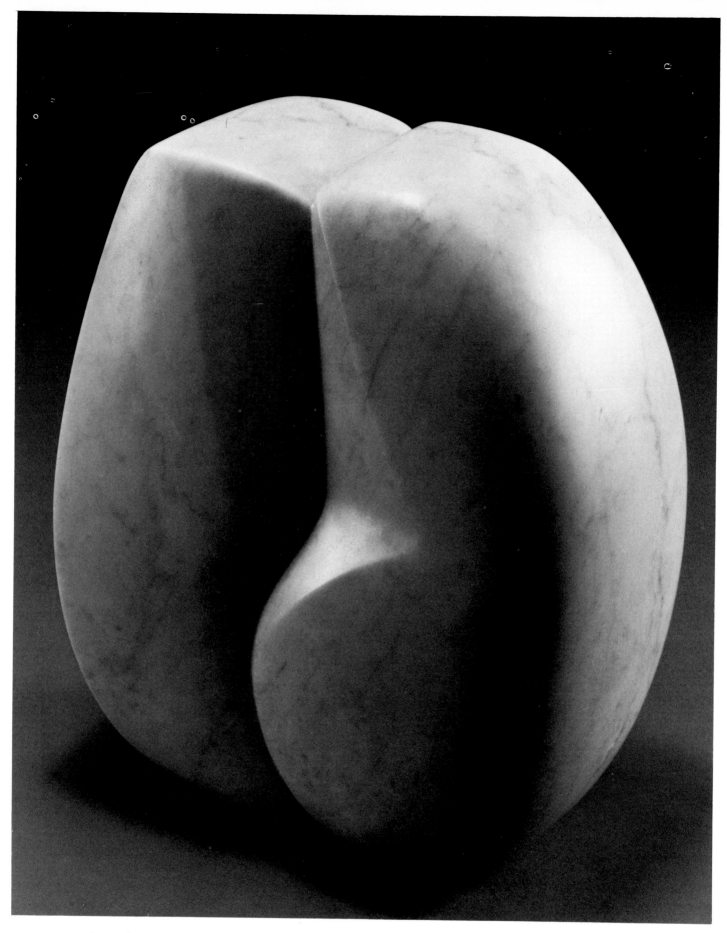

Rosati, James. "Amulet," 1959. Polished white marble, 12 inches high. Collection, Vassar College Art Gallery, Poughkeepsie, New York.

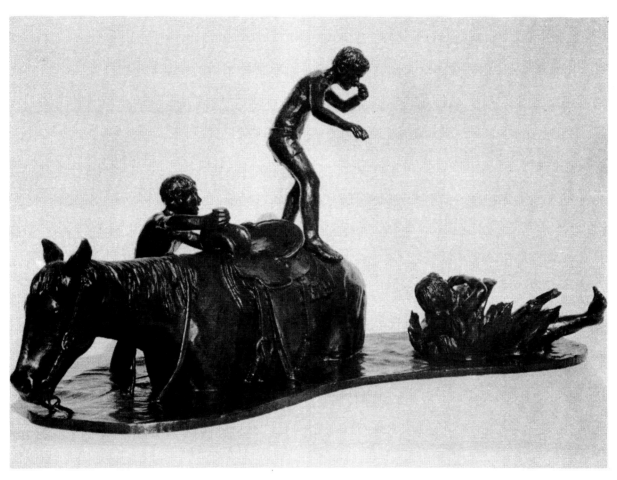

Rubin, Donald. "Swimming Hole." Bronze, 9 1/2 inches high by 19 inches long. Photograph courtesy of the artist.

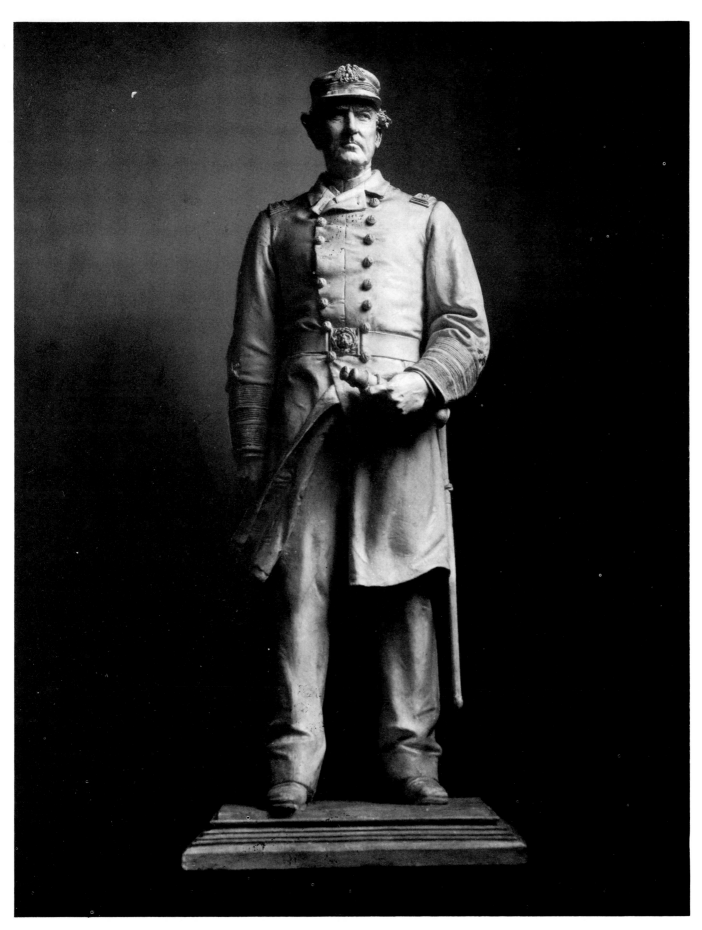

Saint-Gaudens, Augustus. Faragut. 11 1/2 inches high.
Photograph courtesy of National Sculpture Society.

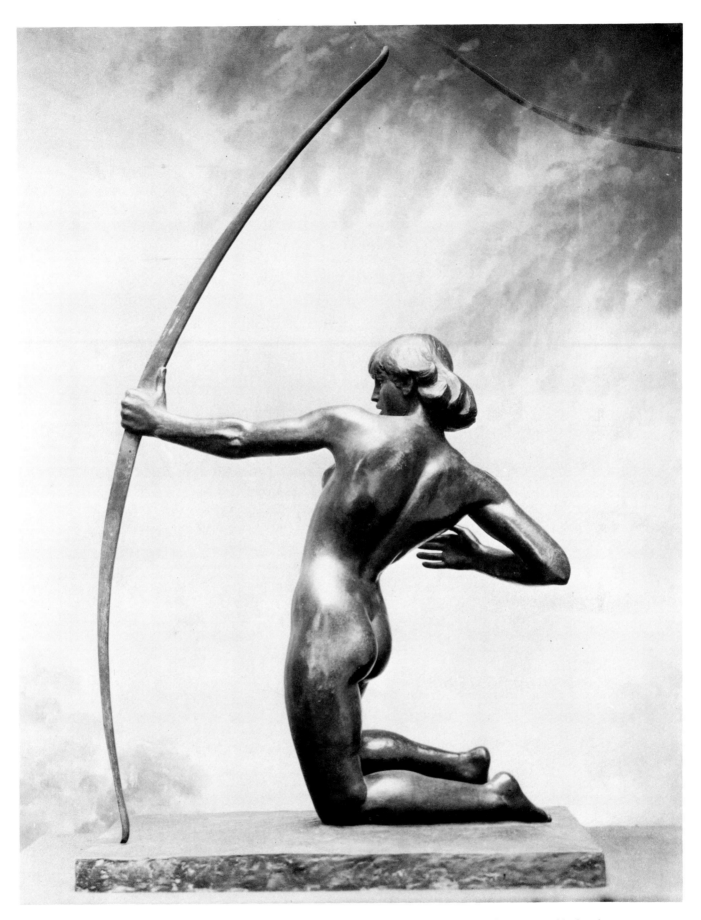

Sanford, Marion. "Diana." Black bronze, 24 inches by 13 1/4 inches (base), 39 inches to top of bow. Photograph courtesy of National Sculpture Society.

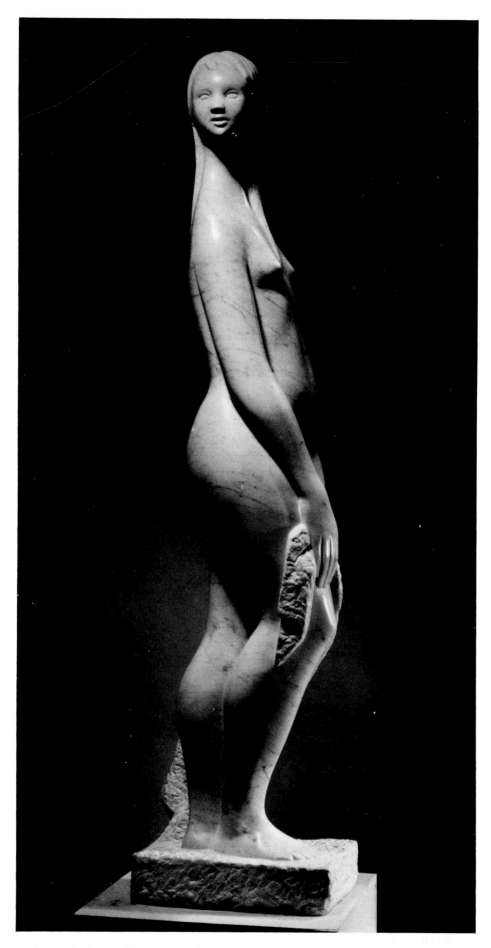

Sanguino, Luis. Photograph courtesy of National Sculpture Society.

616

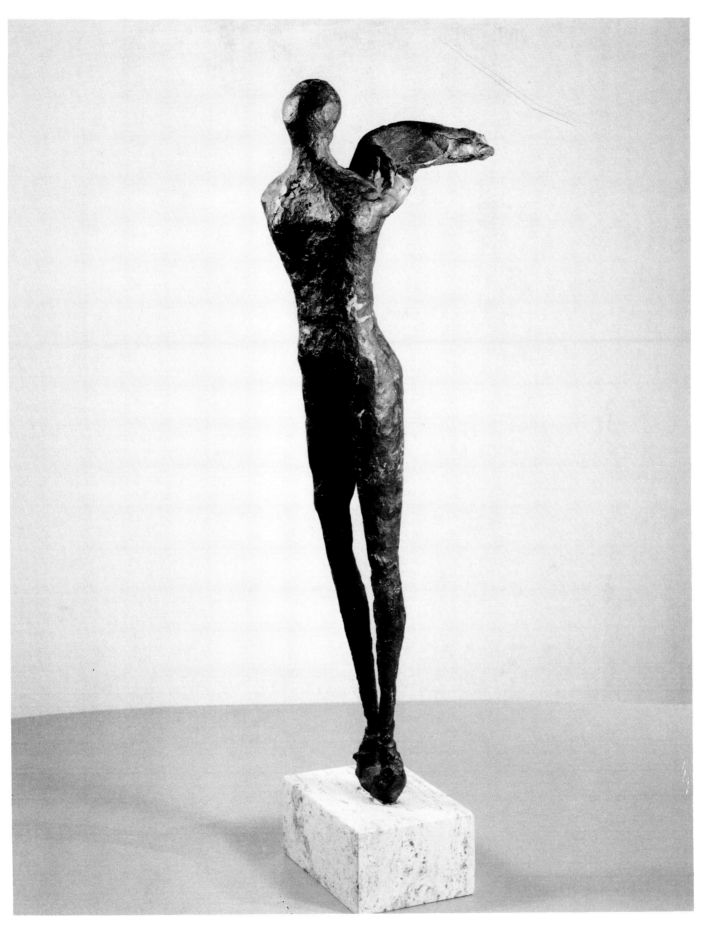

Scaravaglione, Concetta. "Angel," 1962. Bronze, 15 inches high.
Collection, Vassar College Art Gallery, Poughkeepsie, New York.

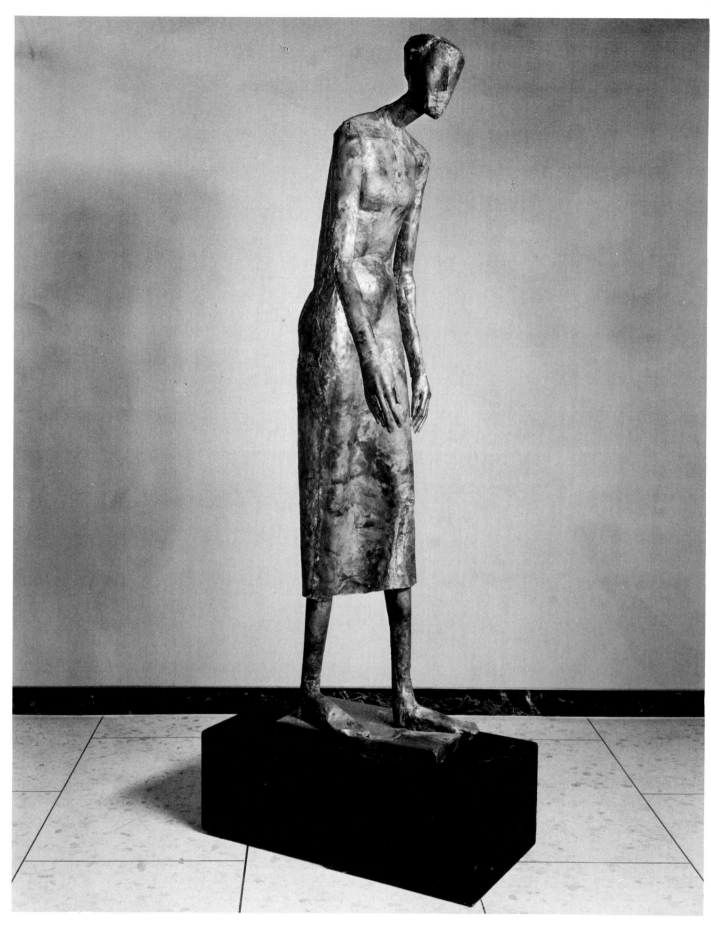

Scaravaglione, Concetta. "Woman Walking," 1961. Welded copper, 78 1/2 inches high. Collection, Vassar College Art Gallery, Poughkeepsie, New York.

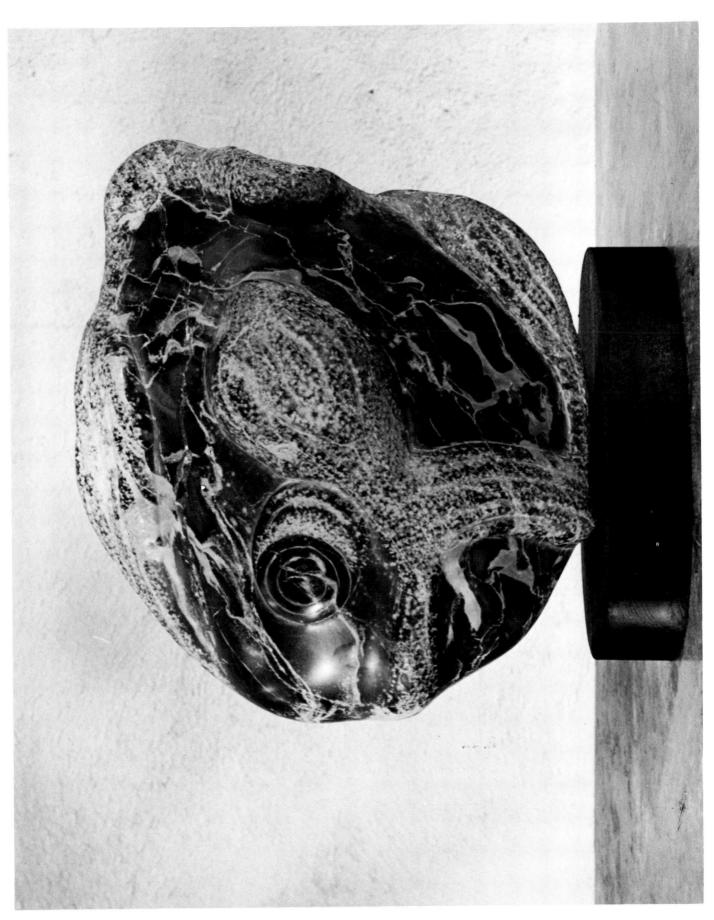

Schuller, Grete. "Fish." Black marble, 12 inches high, 30 pounds.
Photograph courtesy of National Sculpture Society.

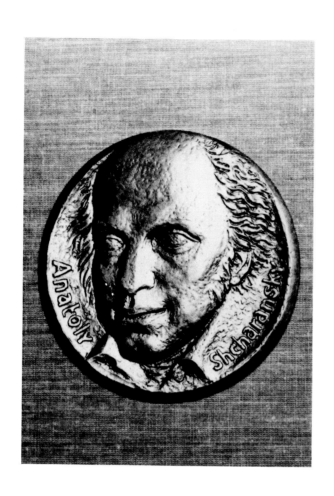

Shagin, Alex. Medals. Photograph courtesy of the artist.

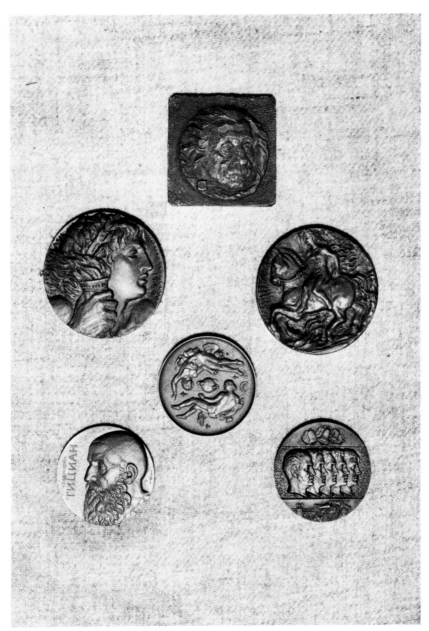

Shagin, Alex. Medals. Photograph courtesy of the artist.

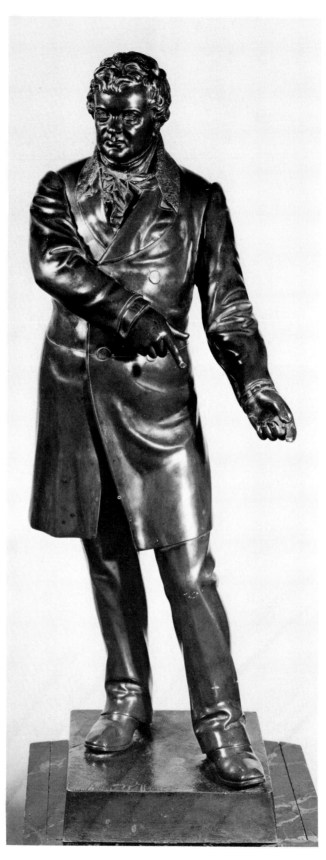

Sheahan, D. B. Portrait of a Statesman. Bronze, 28 inches high.
Collection of Victor D. Spark, NYC.

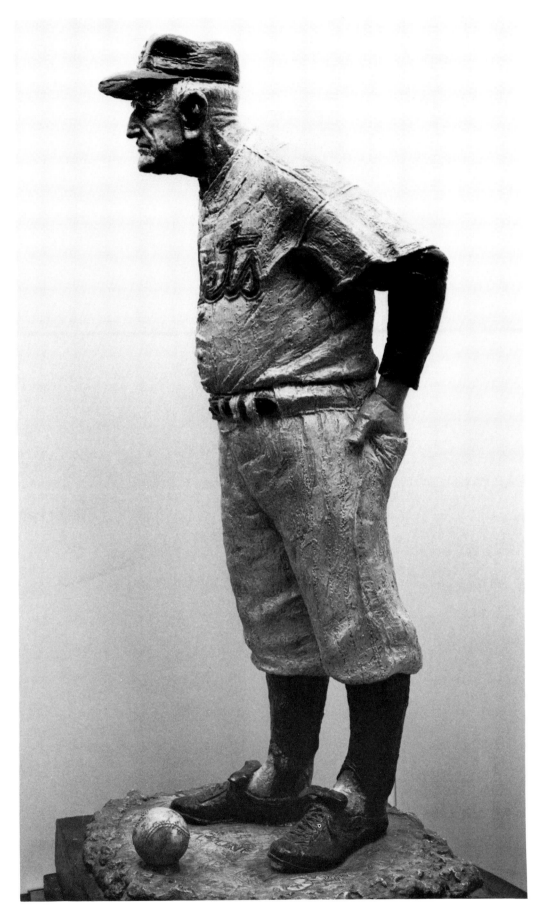

Sherbell, Rhoda. "Casey Stengel." Bronze, polychrome, 4 1/2 inches high. Photograph courtesy of the artist.

623

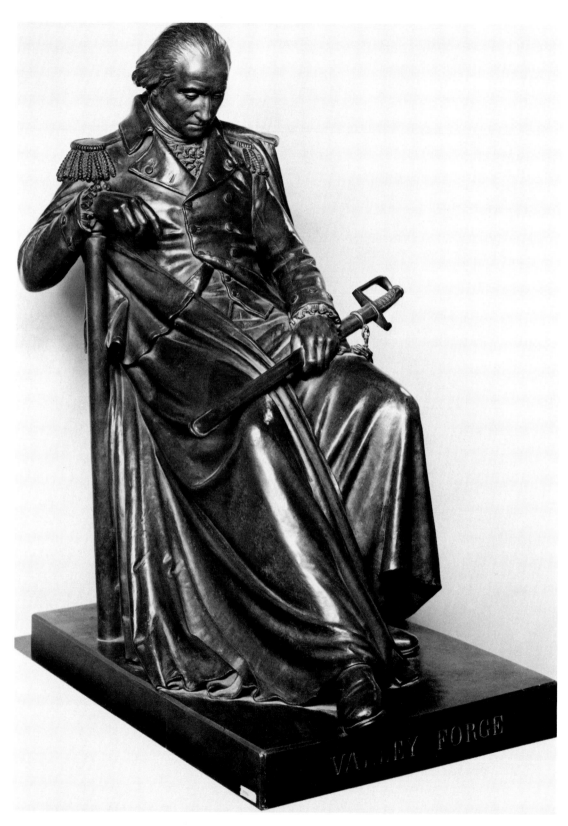

Simmons, Franklin. "Valley Forge." Bronze. Collection of Bob Bahssin, Post Road Gallery, Larchmont, NY.

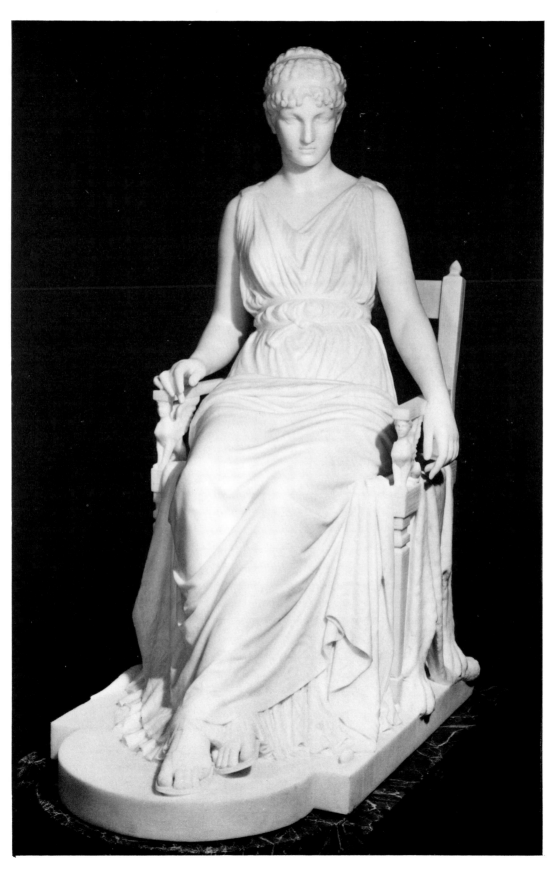

Simmons, Franklin. "Penelope." Marble. Collection of Bob Bahssin,
Post Road Gallery, Larchmont, NY.

Snowden, George Holburn. "The Bather." 3 inches by 4 3/16 inches.
Photograph courtesy of National Sculpture Society.

Sonnier, Keith. Untitled, 1967. Painted plaster over cheesecloth and paper, 18 inches by 43 inches. Collection, Vassar College Art Gallery, Poughkeepsie, New York.

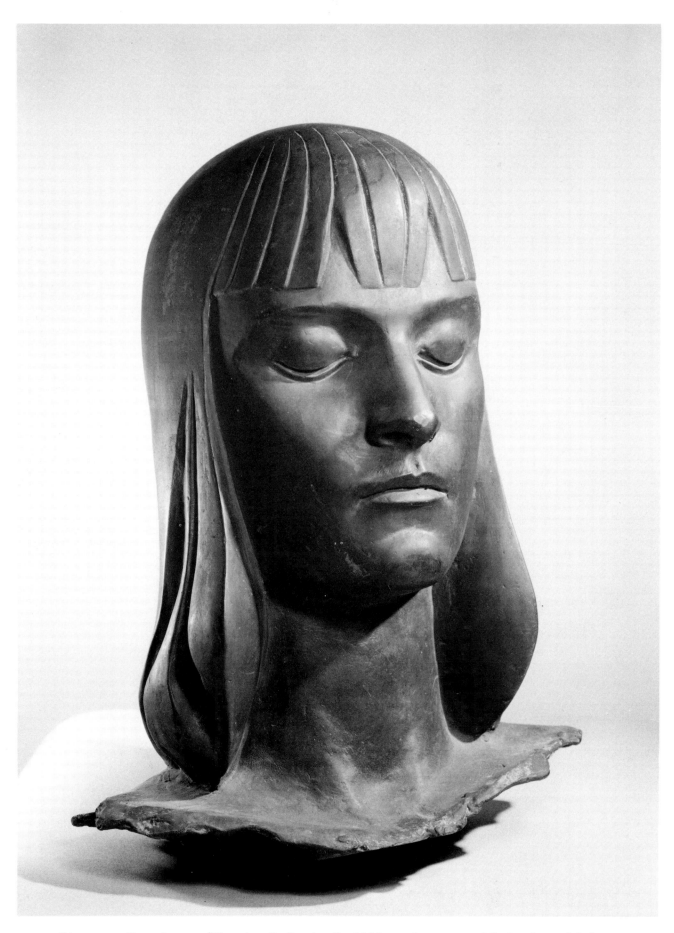

Sterne, Maurice. "Head of Senta," 1919. Bronze, 16 inches high.
Collection, Vassar College Art Gallery, Poughkeepsie, New York.

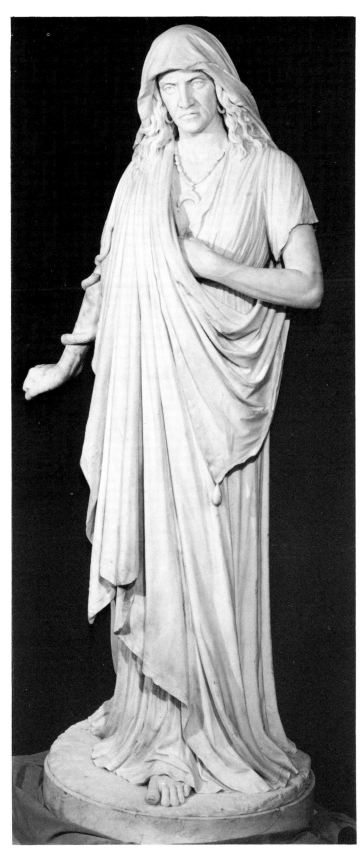

Story, William Wetmore. "Canidia." Marble. Ex Collection of Bob Bahssin, Post Road Gallery, Larchmont, NY.

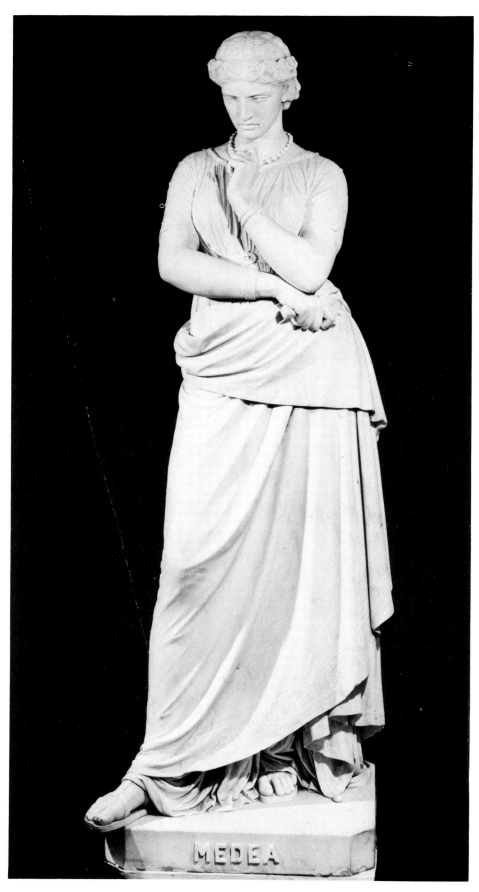

Story, William Wetmore. "Medea." Marble. Ex Collection of Bob Bahssin, Post Road Gallery, Larchmont, NY.

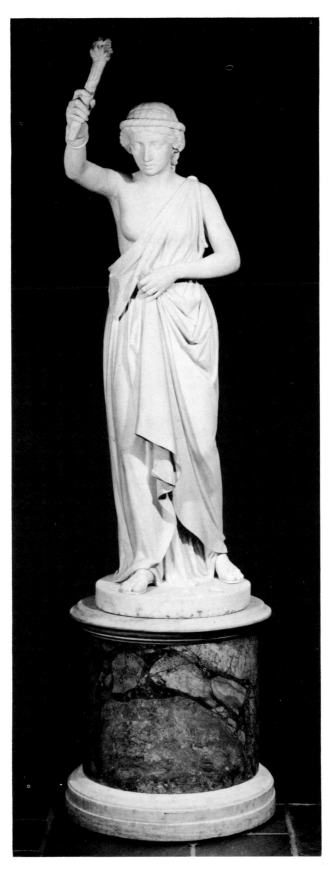

Story, William Wetmore. "Hero." Marble. Collection of Bob Bahssin, Post Road Gallery, Larchmont, NY.

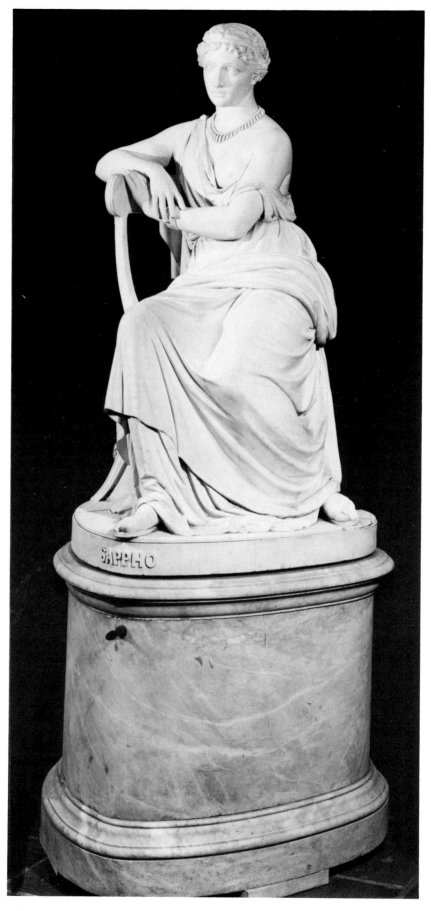

Story, William Wetmore. "Sappho." Marble. Collection of Bob
Bahssin, Post Road Gallery, Larchmont, NY.

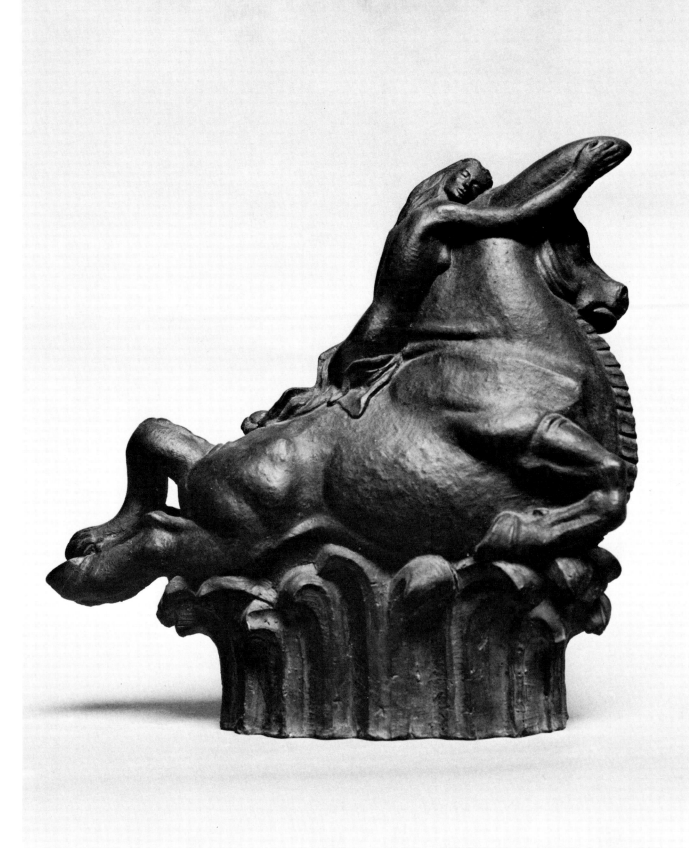

Streett, Tylden Westcott. "Europa." Stoneware, 16 inches high.
Photograph courtesy of National Sculpture Society.

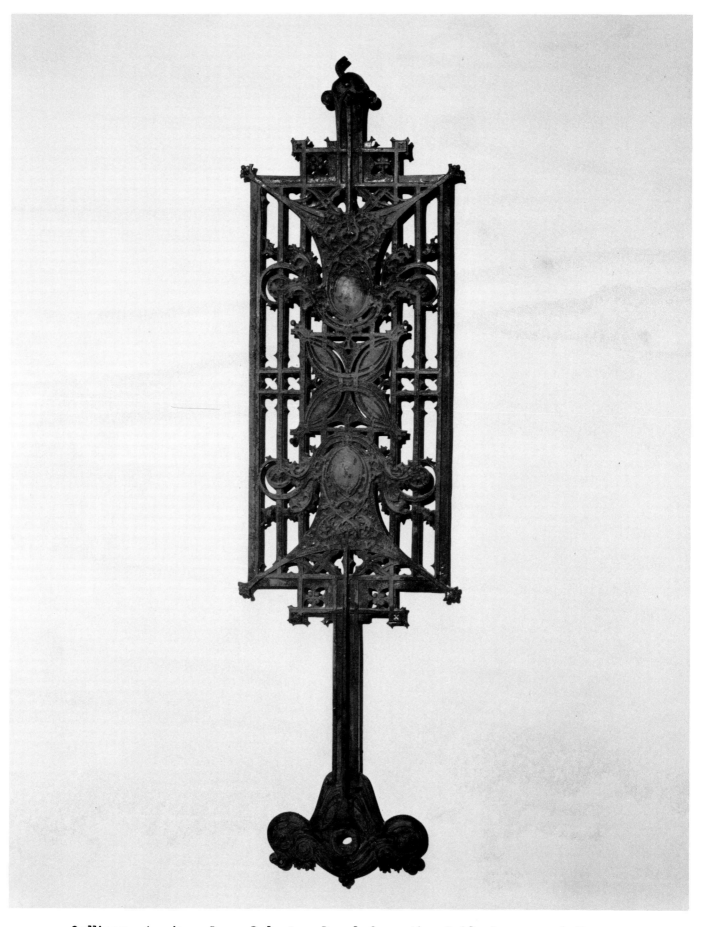

Sullivan, Louis. Iron Baluster Panel from the Schlesinger and Mayer
Store, Chicago, 1903-04. Cast iron with green patina, 35 inches high.
Collection, Vassar College Art Gallery, Poughkeepsie, New York.

Sutcliffe, Rita Jean. "Mudra 3." Model for hollow concrete sculpture,
15 inches by 22 inches. Photograph courtesy of the artist.

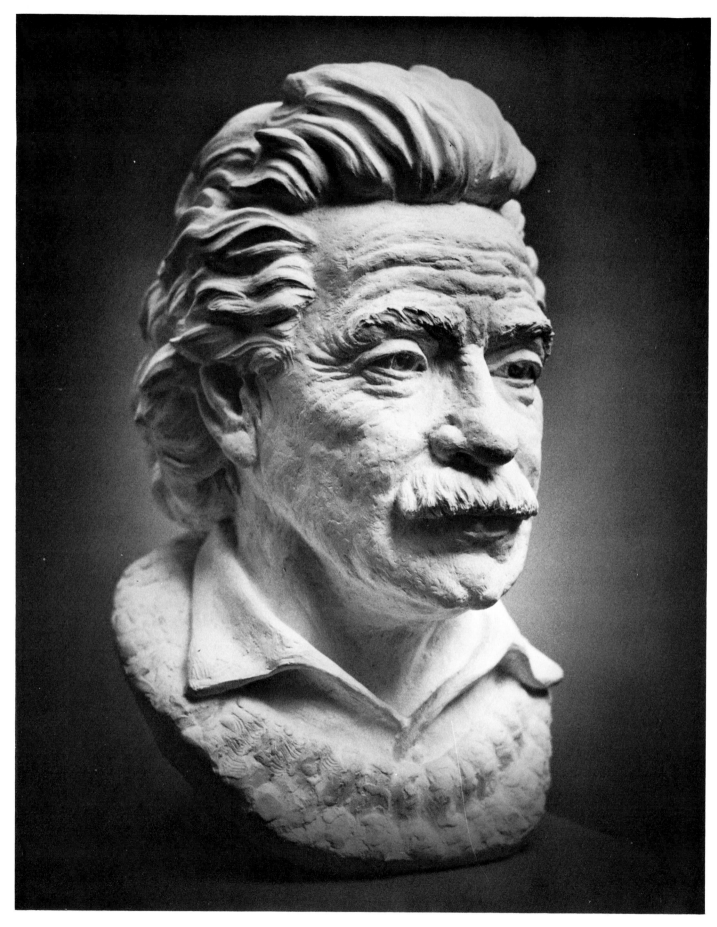

Terken, John. Albert Einstein. Photograph courtesy of National
Sculpture Society.

Truitt, Anne. "Signature," 1973. Acrylic on wood, 96 inches high.
Collection, Vassar College Art Gallery, Poughkeepsie, New York.

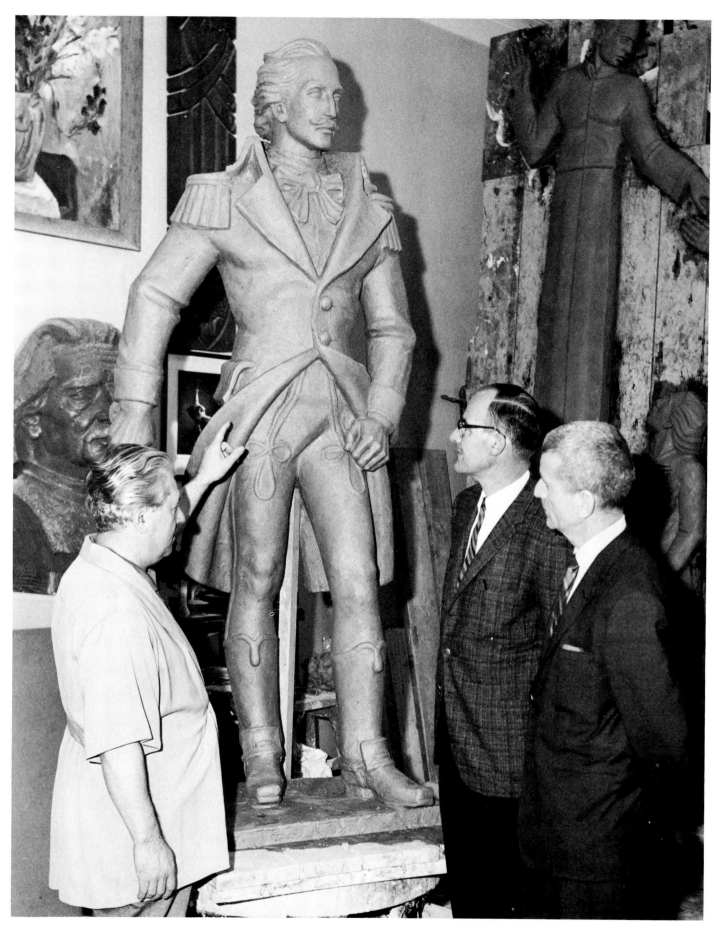

Varga, Ferenc. "P. Pulaski." Photograph courtesy of National Sculpture Society.

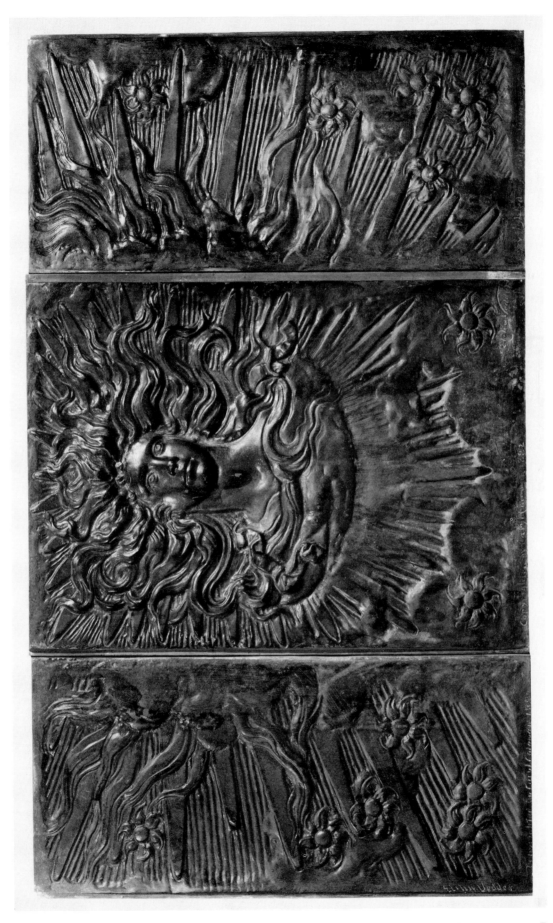

Vedder, Elihu. "Head of Medusa" Fire Screen. Bronze. Ex Collection of Bob Bahssin, Post Road Gallery, Larchmont, NY.

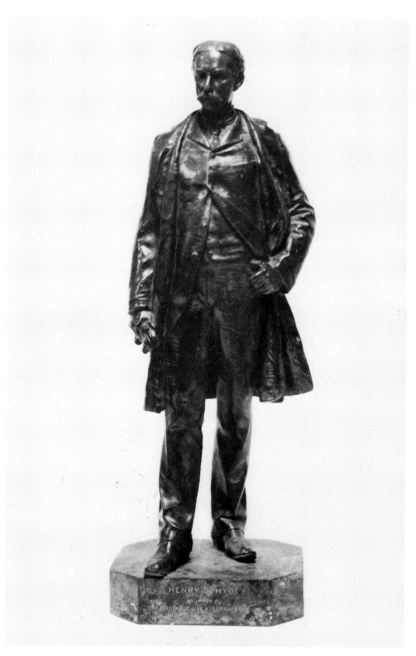

Ward, John Q. A. Henry Hyde. Photograph courtesy of National
Sculpture Society.

Ward, John Q. A. and Wayland, Paul. Photograph courtesy of National Sculpture Society.

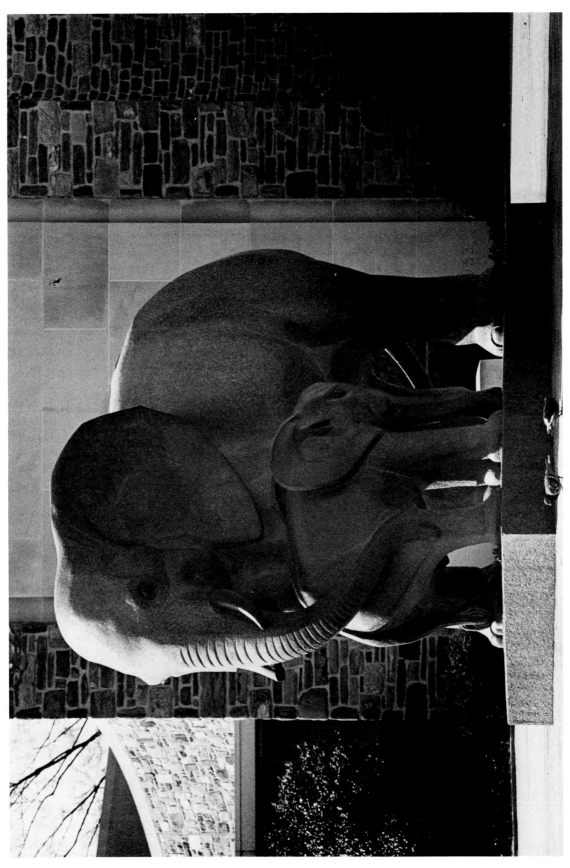

Warneke, Heinz. Elephants. Photograph courtesy of National Sculpture Society.

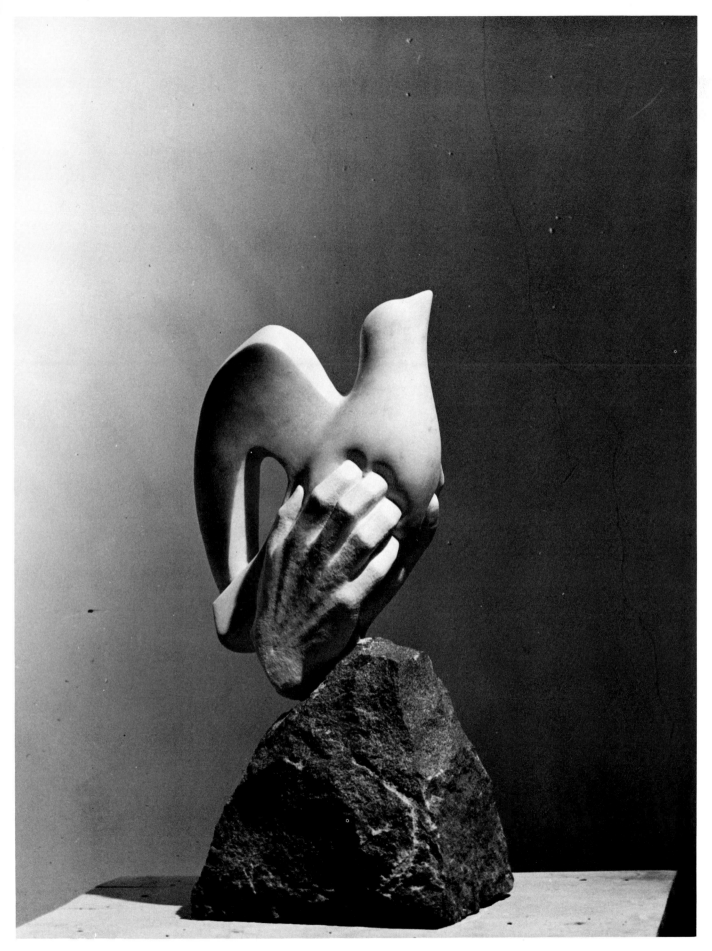

Wasey, Jane. "Noah." Marble, 20 inches high. Photograph courtesy
of National Sculpture Society.

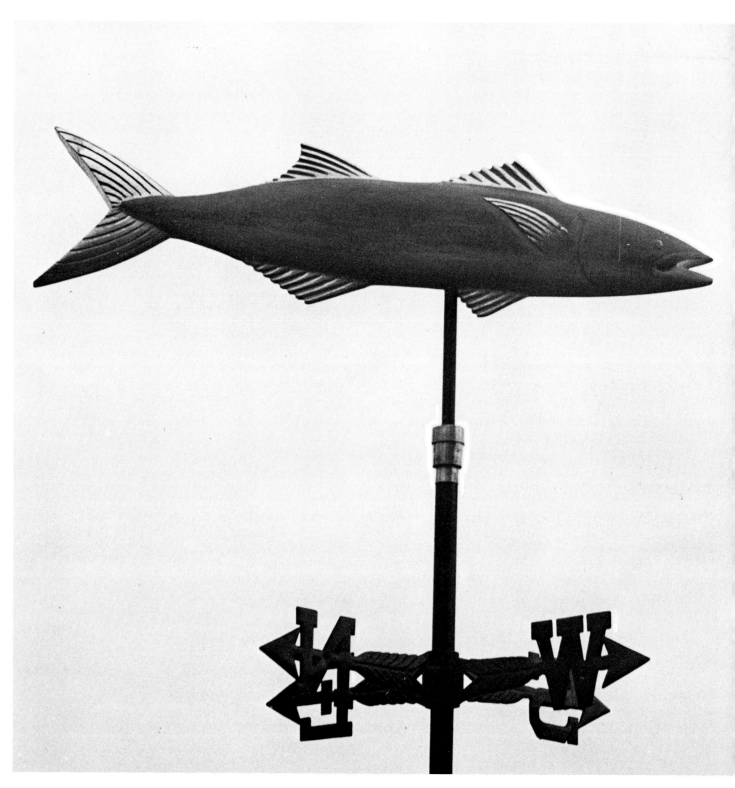

Wasey, Jane. "Weather Vane." Polychromed redwood, 30 inches long.
Photograph courtesy of National Sculpture Society.

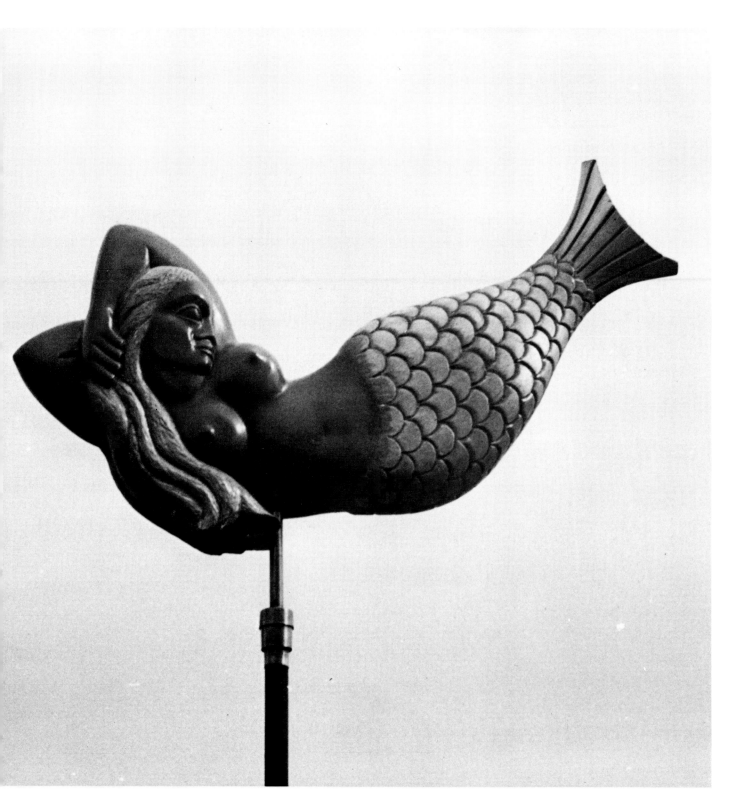

Wasey, Jane. "Mermaid." Sugar Pine, 32 inches long. Photograph courtesy of National Sculpture Society.

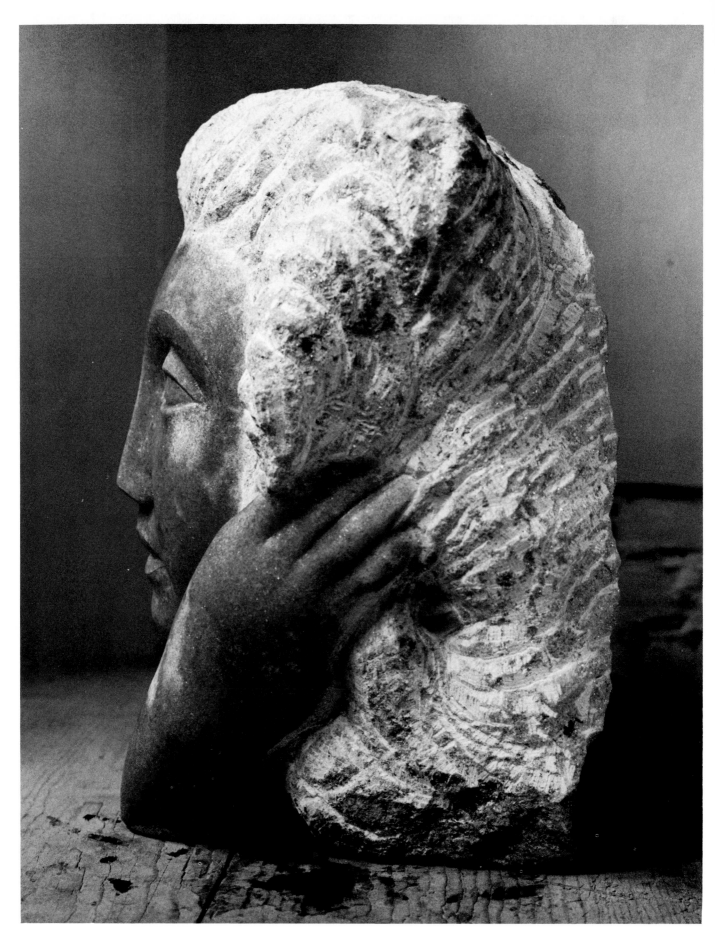

Wasey, Jane. "Sun Symbol." Lepidolite, 24 inches high. Photograph courtesy of National Sculpture Society.

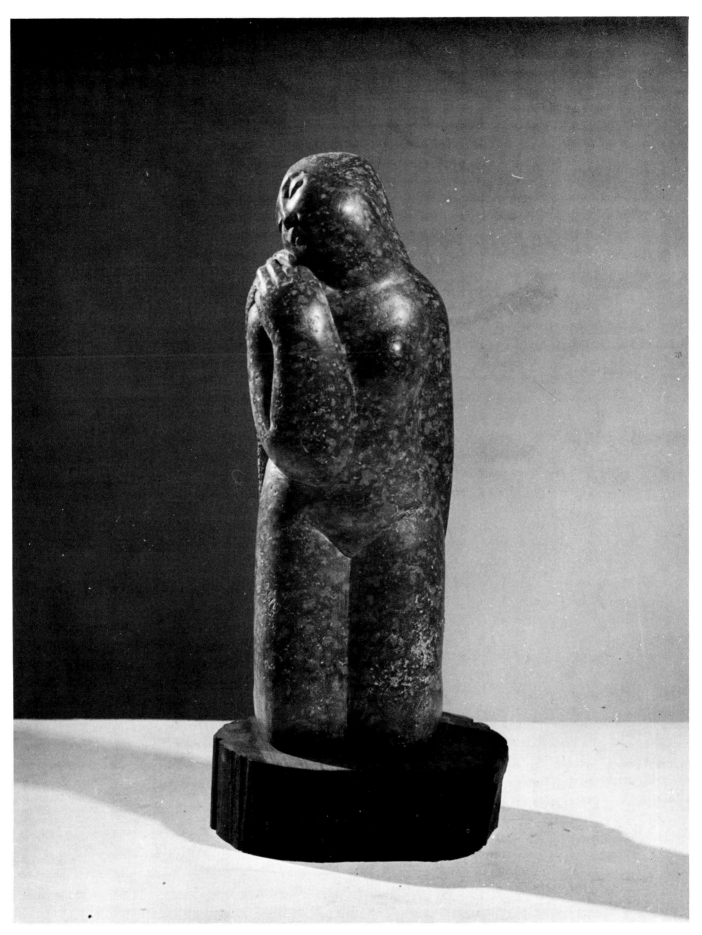

Wasey, Jane. "Naiad." Marble. Photograph courtesy of National
Sculpture Society.

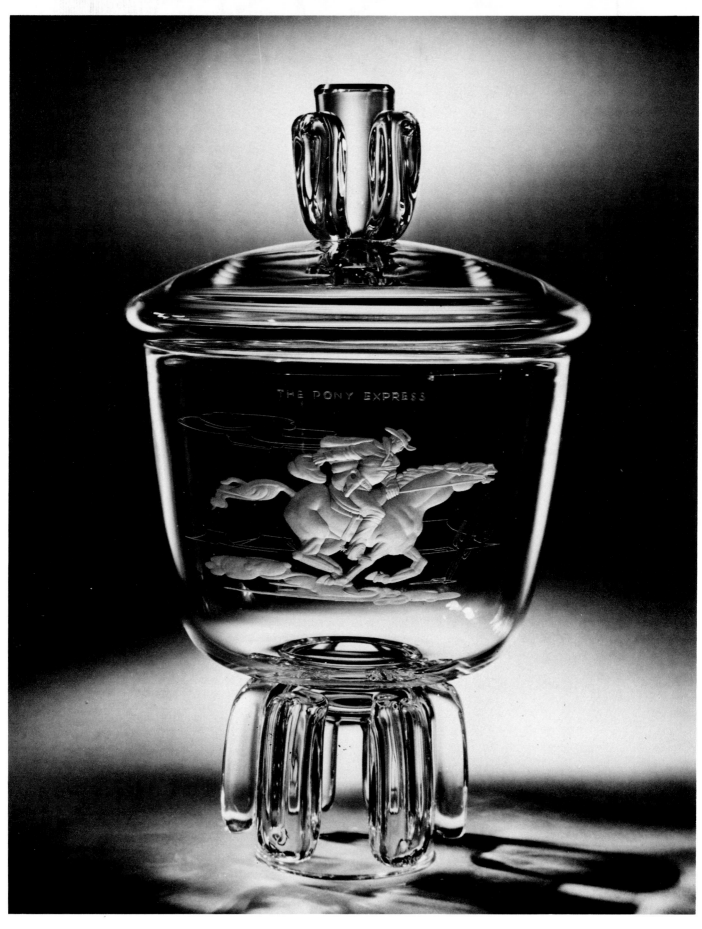

Wein, Albert W. "The Pony Express." 14 3/4 inches high.
Photograph courtesy of National Sculpture Society.

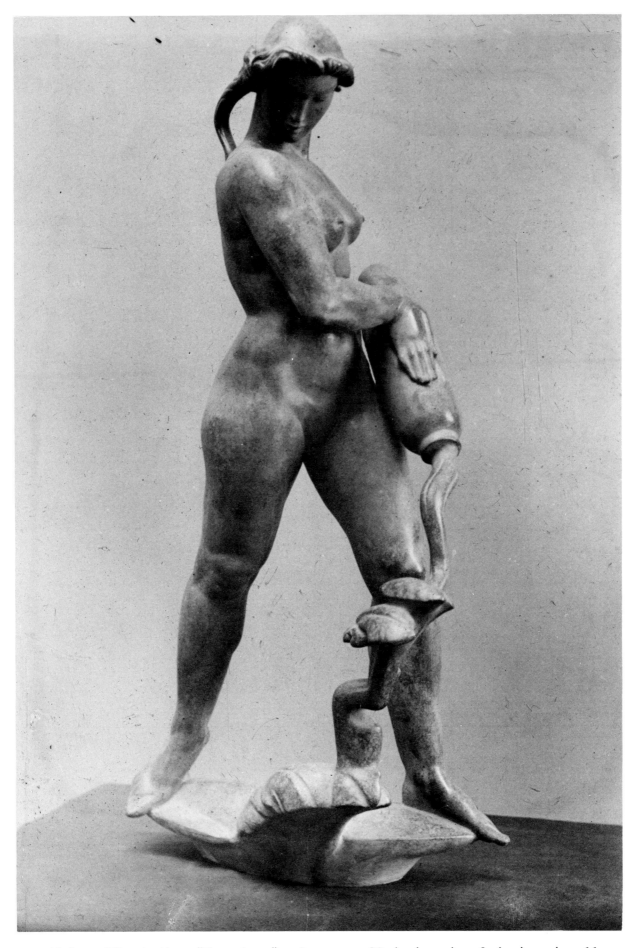

Wein, Albert W. "Demeter." Bronze, 23 inches by 8 inches by 11 inches. Photograph courtesy of National Sculpture Society.

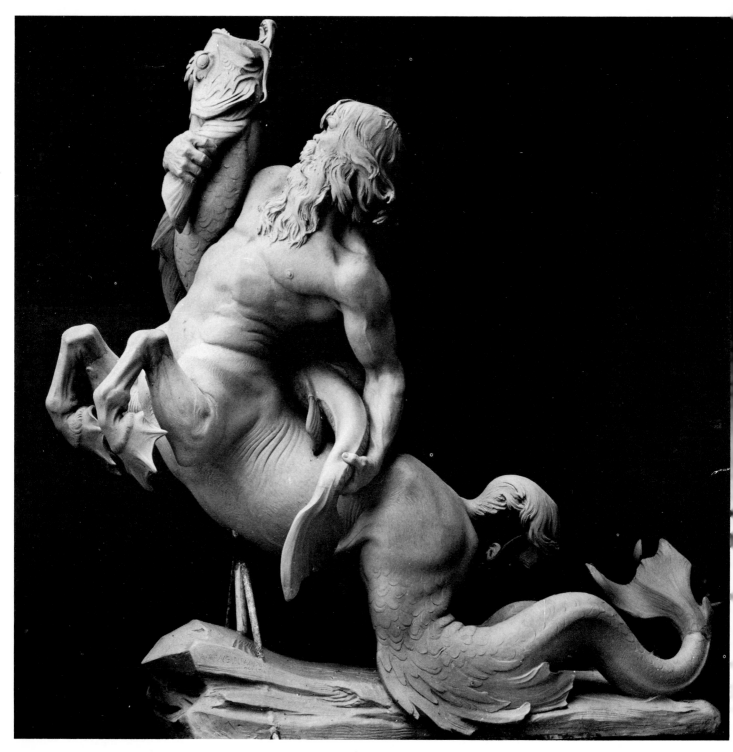

Weinman, Adolph Alexander. Photograph courtesy of National Sculpture Society.

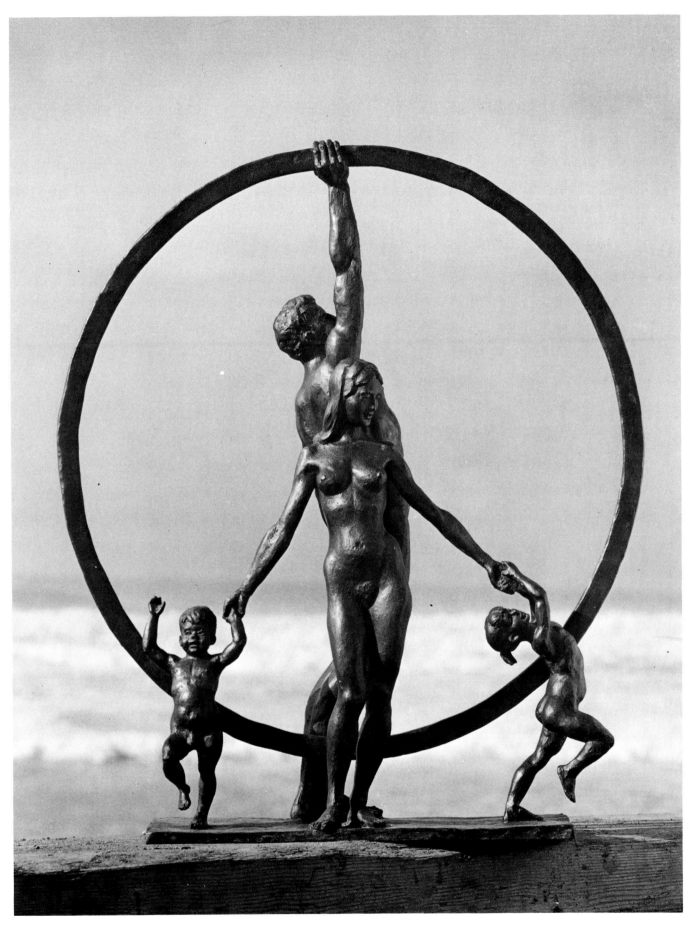

Weistrop, Elizabeth N. "Peace." Bronze, 26 inches high. Photograph courtesy of National Sculpture Society.

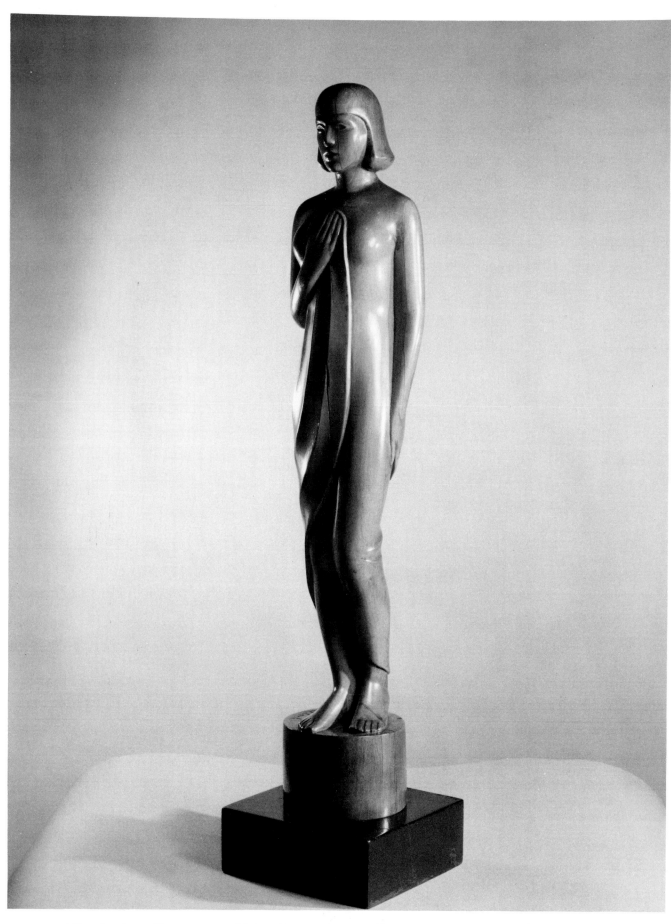

Wheelock, Warren. "Standing Woman," 1932-40. Cherrywood, 19
inches high. Collection, Vassar College Art Gallery, Poughkeepsie,
New York.

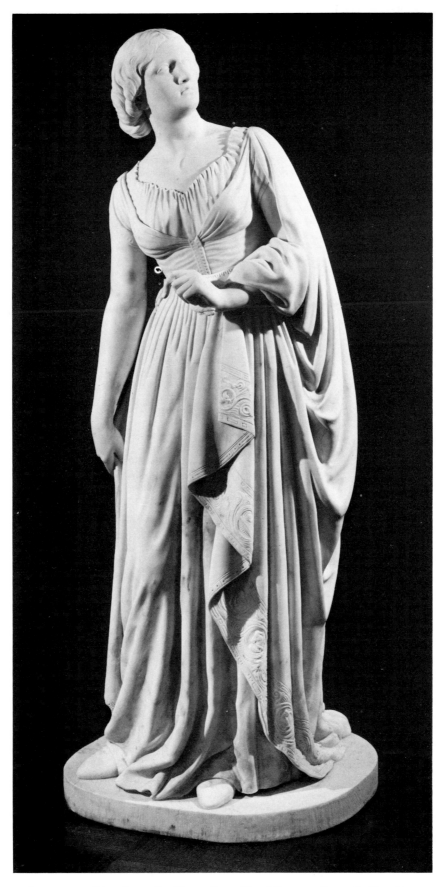

Whitney, Anne. "Lady Godiva." Marble. Ex Collection of Bob Bahssin, Post Road Gallery, Larchmont, NY.

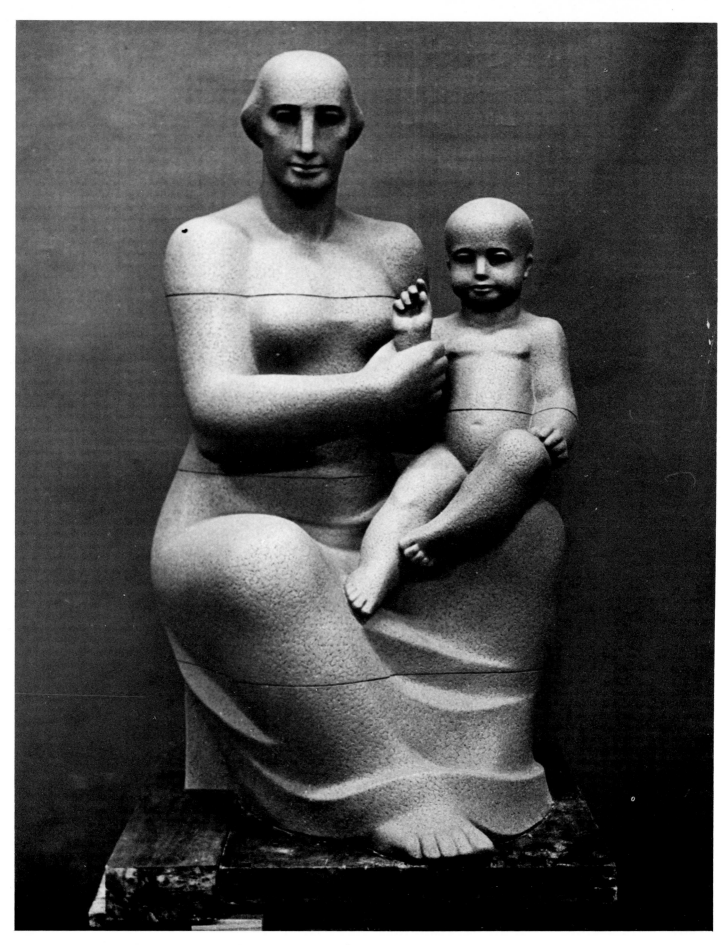

Winkel, Nina. Madonna and Child, 1954. Terra cotta, approximately life-size. Photograph courtesy of National Sculpture Society.

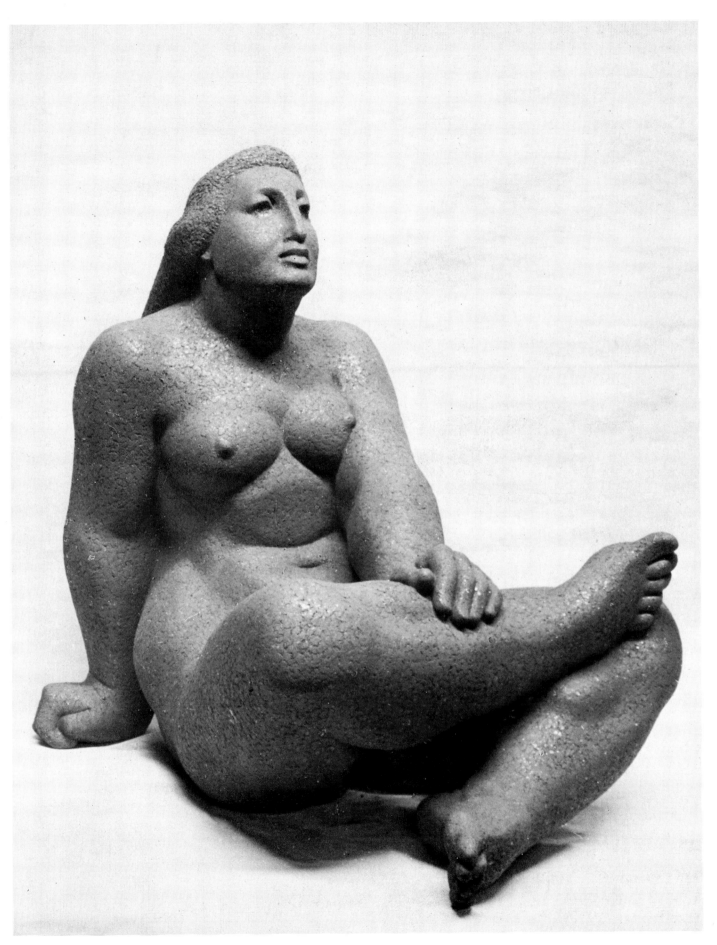

Winkel, Nina. "Out of Good Soil," 1953. Terra cotta with mica. Photograph courtesy of National Sculpture Society.

Witkin, Isaac. "Shogun," 1968. Welded and bolted steel, 72 inches high. Collection, Vassar College Art Gallery, Poughkeepsie, New York.